Drama of the English Renaissance

I

THE TUDOR PERIOD

DRAMA
OF THE
English Renaissance
I
THE TUDOR PERIOD

EDITED BY

RUSSELL A. FRASER
UNIVERSITY OF MICHIGAN

AND

NORMAN RABKIN
UNIVERSITY OF CALIFORNIA, BERKELEY

MACMILLAN PUBLISHING CO., INC.
NEW YORK
COLLIER MACMILLAN PUBLISHERS
LONDON

COPYRIGHT © 1976, MACMILLAN PUBLISHING CO., INC.

PRINTED IN THE UNITED STATES OF AMERICA

MACMILLAN PUBLISHING CO., INC.
866 Third Avenue, New York, New York 10022

COLLIER MACMILLAN CANADA, LTD.

Library of Congress Cataloging in Publication Data

Main entry under title:

Drama of the English Renaissance.

 Includes bibliographical references.
 CONTENTS: 1. The Tudor period.—2. The Stuart
period.
 1. English drama—Early modern and Elizabethan,
1500–1600. 2. English drama—17th century. I. Fraser,
Russell A. II. Rabkin, Norman.
PR1263.D75 822'.009 74-7709
ISBN 0-02-339570-2 (v. 1)
ISBN 0-02-339581-8 (v. 2)

Printing:	7 8	Year:	4 5

ISBN 0-02-339570-2

Preface

THE forty-one plays gathered in these volumes constitute the most extensive new survey of Renaissance drama in over forty years, and reflect both changes in taste and advances in scholarship since earlier collections. The editors have attempted to provide the materials for a truer view of the theater in which Shakespeare worked than has hitherto been possible in anthologies. Marlowe, Jonson, and Webster, by most accounts the best of Shakespeare's contemporaries, are represented by their major plays; the reader will not have to settle for half of TAMBURLAINE or for Jonson without BARTHOLOMEW FAIR. For such playwrights the choices were relatively easy to make. For others they were not so easy, largely because of the extraordinary number of plays worthy of attention that they left us.

In making selections, the editors have been guided by several principles. We have taken pains not to omit plays of unique quality that have, albeit for different reasons, held their interest through many generations—BUSSY D'AMBOIS, for example, and A WOMAN KILLED WITH KINDNESS. We have been concerned to include plays of major intrinsic and historical interest that have not previously been included in anthologies and in some cases are not readily available to the modern reader—THE ROARING GIRL and A CHASTE MAID IN CHEAPSIDE, SUMMER'S LAST WILL AND TESTAMENT and A LOOKING GLASS FOR LONDON AND ENGLAND, for example. We have tried where possible to substitute for plays repeatedly presented more for their typicality than for their unique value other plays equally characteristic but rather less shopworn—GALLATHEA, THE DUTCH COURTESAN, and A KING AND NO KING, for example. And we have attempted to represent some of the best playwrights by excellent plays too often overlooked (some of them, in fact, never previously anthologized)—THE WIDOW'S TEARS, for example, and HYDE PARK, PERKIN WARBECK, and DAVID AND BETHSABE. On the whole, *Drama of the English Renaissance* includes those plays that have inspired the warmest admiration and the most acute criticism in recent decades. No one will find here every play that he would like to; each of the editors, in fact, has had regretfully to accept the decision to omit several plays close to his heart. Given the generous limits we have been allowed, however, and the principles we have had to consider in making our selections, we are satisfied that the contents of these volumes come as close as we could hope to the just representation of a great corpus of drama.

In the decades since the last major anthologies of Renaissance drama, much has occurred in scholarship that has helped the editors and will work to the reader's advantage. In many instances, new methods of textual study that make it possible to distinguish between an author's words and later accretions have revealed the copytext most closely reflecting what the playwright originally wrote. Many of the plays included have been subjected to textual study that has solved problems and swept away the dust of earlier and sometimes rather casual editing. Lexicographical research, critical studies, and individual editions of the plays have made the glossing of difficulties a surer business than it once was. The texts here presented have been produced by collating the earliest reliable editions of each play with modern scholarly recensions where they exist. Like most recent texts, ours are conservative, admitting emendation only when we are certain that it is justified. Although we have not attempted to record all variants, or to give the history of speculation about particular cruces, we have flagged the important differences among early editions where relevant, and we have always indicated emendations and supplied the original readings in footnotes. Because of the nature and purposes of this collection, we have not thought it appropriate to assign individual credit to the countless editors over the past four centuries who have

solved particular puzzles, but we can assure the reader that the texts have been fortified by consultation of a vast body of work.

Spelling and punctuation have been made to accord throughout with modern American usage. We have retained old spellings only in certain instances: where modernization would affect scansion, where pronunciation would be obviously and radically different, where the meaning of the word has changed as much as its spelling, and in a few special cases, such as the retention of *Bethsabe* for *Bathsheba*. We have not attempted, like some editors, to retain old spellings (e.g., *murther* for *murder*, *vild* for *vile*, *wrack* for *wreck*, *bankrout* for *bankrupt*) that merely indicate slight differences in the pronunciation of words that have remained current. Editors who retain old spellings such as these inadvertently obscure the fact that the entire pronunciation of our language has changed considerably since Shakespeare's time, even when no archaic spelling signals the differences. The commendatory verses, epistles dedicatory, and other prefatory material reproduced with each play have been included only when they contribute to the appreciation of the selected authoritative text. We omit less pertinent prefatory matter and that derived from editions subsequent to the ones followed in this collection. Stage directions are those of the original editions unless they are printed between brackets, in which case they are editorial additions; we have added directions only when they are necessary to prevent confusion or obscurity, for Renaissance dramatists tend to make the action clear through their dialogue. In a few instances, for special reasons, the lists of dramatis personae are reproduced directly from the original texts; more often they have been rearranged and modernized.

Where act and scene divisions are missing or incomplete in the original texts they have been added, generally in accordance with the conventions of five-act structure and always in brackets; in a few cases—e.g., ARDEN OF FEVERSHAM, A WOMAN KILLED WITH KINDNESS, and MUCEDORUS—where the five-act structure is not so clear, scenes have been numbered serially. Jonson poses a unique problem in this respect. Scrupulously faithful to neoclassical convention, he indicates a new scene each time a new character enters. Not to follow his system is to misrepresent the appearance he wanted his texts to have, but to imitate it is to imply a lack of flow that in fact characterizes only the printed text and not the stage performance. For pedagogical purposes we have therefore settled on a compromise: two of the plays are divided according to Jonson's principles, the other two according to modern usage. In early editions, final *-ed* is often rendered *-'d*, sometimes though not always to indicate that the final *e* is not to be pronounced. We have consistently restored the missing *e*; to make the scansion clear, we have marked with an accent all final *-ed* syllables that are to be pronounced. Lineation is sometimes problematic in dramatic texts of the period, sometimes because the playwright did not give adequate signals to the compositor, sometimes because the compositor changed verse to prose to make an excessive text fit in the space left on his page or changed prose to verse when he needed to fill space. We have generally followed the division into verse and prose of the copytext, except where it is clear that the division was not the author's. We have chosen not to add scene locations at the heads of scenes. Contemporary editions generally did not have them, and in the absence of elaborate scenery playwrights trained their audiences to recognize all that needed to be known about the locale from the dialogue and action. More often than not, therefore, the heading is gratuitous, and it frequently clutters the text with such useless rubrics as "A Street" and "Another Part of the Forest."

Footnotes gloss words and phrases that are beyond the resources of standard modern desk dictionaries, foreign words, *doubles entendres* not immediately evident to the modern reader, and historical, geographical, and mythological allusions. In deciding how much to gloss, we have opted for too much rather than too little. Our own experience as teachers of the drama has warned us that students often come to the reading of Renaissance plays unequipped with the literary knowledge that editors of half a century ago could take for granted. Except where a playwright's borrowing of details of language from particular sources constitutes a significant allusion or a fact important

to an adequate response to the play, we have not footnoted sources. The introductions to individual plays discuss such matters as date, authorship, sources, and theatrical history, and offer brief and modest critical guidelines in no way intended to usurp the teacher's role or to impose on the student's creative response.

The initials at the end of the introduction to each play indicate which of the editors has had primary responsibility for the text and apparatus of that play.

The editors wish to express warm gratitude to Mr. D. Anthony English of Macmillan for his generous help and his sharp eye. We should also like to record our gratitude to Miss Frances Long, production supervisor, and Mr. Charles Farrell, designer, for their skill, care, and devoted commitment to a complex and exacting project.

R. A. F.
N. R.

Contents

INTRODUCTION I

JOHN HEYWOOD
The Four PP 21

MR. S
Gammer Gurton's Needle 35

THOMAS PRESTON
Cambyses 59

THOMAS SACKVILLE and THOMAS NORTON
Gorboduc 81

GEORGE GASCOIGNE
Supposes 101

JOHN LYLY
Gallathea 125

GEORGE PEELE
David and Bethsabe 145

THOMAS KYD
The Spanish Tragedy 167

CHRISTOPHER MARLOWE
Tamburlaine the Great, Part I 205
Tamburlaine the Great, Part II 235
The Jew of Malta 263
Doctor Faustus 295
Edward II 323

ROBERT GREENE
Friar Bacon and Friar Bungay 357

THOMAS LODGE and ROBERT GREENE
A Looking Glass for London and England 383

ANONYMOUS
Arden of Feversham 411

THOMAS NASHE
Summer's Last Will and Testament 439

ANONYMOUS
Mucedorus 463

THOMAS DEKKER
The Shoemaker's Holiday 481

THOMAS HEYWOOD
A Woman Killed with Kindness 511

Introduction

THE ENGLISH DRAMA FROM ITS BEGINNINGS
TO THE CLOSING OF THE THEATERS

ENGLISH Renaissance drama is primarily an exfoliating, perhaps a grand perversion, of the religious drama of the Middle Ages. The medieval playwright who gives the lead to his successors in the Renaissance differs from them significantly. He is an anonymous maker—compare for the difference the self-proclaiming Ben Jonson—and he is not consciously artistic—compare Webster repudiating popular taste in his high and mighty preface to THE WHITE DEVIL, Chapman getting up the classics for BUSSY D'AMBOIS, the *oeuvre* of Christopher Marlowe. Medieval plays are written, more or less laconically, to inculcate piety—the writer is heuristic or intentional—at the same time to communicate pleasure—the writer, paradoxically, has no fixed intention.

Sometimes the first or didactic impulse submerges the second and so obliterates the play. One rises benumbed from *The Castle of Perseverance*, sodden with the weight of the Seven Deadly Virtues. Sometimes the relation between teaching and delighting is reversed. The didactic element in the waning Middle Ages is often perfunctory, not so engrossing as theatrical "business." What is apt to be engrossing in the religious drama, not less than in the secular drama of the twentieth century, is visceral excitement without reference to meaning or cause.

When, in a fifteenth-century enacting of the conversion of Mary Magdalene, Christ utters the injunction *Vade in pace*, the stage direction requires to the satisfaction of the crowd, not sacred but profane satisfaction, that "seven devils devoid from the woman." The art is not disclosed with which the exorcizing of these devils is managed. In the Croxton Play of the Sacrament attention to theatrical "realism" is paramount, attention to morality is reflexive, like genuflecting before the altar. The subject is the enlightenment of Sir Jonathus the Jew. Having struck at the Host and caused it to bleed, the impious hero discovers that he cannot take his hand away. He is not persuaded of his folly. The Host is nailed to a pillar, the Jew's servants begin to pull, the arm of Sir Jonathus comes loose from his body. The vulgar hilarity adumbrates faithfully the Horse-Courser scene in DOCTOR FAUSTUS. And still the Jew remains obdurate. The Host and hand are unnailed and immersed in a burning cauldron that turns to blood and bursts asunder in full view of the crowd. Blood flows perceptibly over the stage. From the shattered fragments an image with bleeding wounds appears and disappears as it changes again into bread. It is the moment of epiphany. Sir Jonathus, as his eyes are opened, lapses from the tepid faith of his fathers.

Perhaps, in this fifteenth-century miracle play, there is more of designing than achieving. Verisimilar representations that really carry the impress of physical fact must wait on the more inventive techniques of the new theater of the Renaissance. In Andrea Palladio's Teatro Olimpico at Vicenza (1580–84), that theater is realized. But Palladio's reconstruction looks backward (not backward to the Middle Ages but to the Roman architect Vitruvius, the contemporary of Caesar Augustus). It is an academic exercise and as such without issue. But the spirit that animates the Renaissance architect really to represent the physical world, what Chapman calls the "superficies of the green center," quickens elsewhere and with notable issue. Inigo Jones is responsive to it in his engineering of scenes and machines for the masques and barriers of the Jacobean and Caroline stage. It is implicit in the zeal of painters like Mantegna and Michelangelo and Leonardo to impart perspective to what one sees on that stage. "Oh, what a delightful thing is this perspective!" says the fifteenth-century painter Paolo Uccello. To this expression of delight in realistic representation, the medieval maker turns a deaf ear.

Medieval man is incurious of the realistic art of classical Greece, which the Renaissance rediscovers and renews. He prefers the flat surfaces of ancient Assyria. His figures do not recede in the middle distance but are piled one on top of the other. His representation of life is not naturalistic. But that is not as he is ignorant or artless.

An ardor for the truth that inheres in superficies leads to the recovery, as by the designers Furtenbach (1632) and Sabbattini (1638), of the revolving prisms or *periaktoi* of the classical stage, which facilitate a more rapid changing of the set; or the elaborating of the *scena ductilis*, which permits a veritable Seacoast of Bohemia, arranged to produce the effect of perspective, to be run on in grooves from the flies.

The intent is to make superfluous the naive appeal to the inner eye. The result is an invading and diminishing of the playwright's domain. "Today," says Sabbattini, "no good show can be presented without complete or partial change of scenery." As each stipulated place is conceded physical integrity, the *intermezzi* or musical diversions that allow the *régisseur* to work his magic come to rival the play itself. To Jonson's disciple Thomas Nabbes, place is not poetry. It is a shifting and palpable scene,

> Which is translated as the music plays
> Betwixt the acts.

In this heightening of realism but not of the real, all the cunning of the *régisseur* is required to mask the slow

I

passage of time. Sebastiano Serlio, the most famous de-
signer of the sixteenth century, is sufficiently cunning.
"For these times," he advises, "when the actors are not
on the scene"—it is, in its implication, an extraordinary
phrase—"the architect will have ready some proces-
sions of small figures . . . cut of heavy cardboard and
painted. . . . [or] a troop of people passing over, some
on foot, some on horseback, with the muffled sound of
voices and drums and trumpets." Behind the scenes
the *régisseur*, whose labors are concealed by this press
of cardboard figures and this bruit of sound, makes
ready the new bit of business that is to come, in defer-
ence to a cinematic conception of reality.

As Hamlet's injunction to hold up the mirror to
nature is modified to mean a canonizing of the art of
trompe l'oeil, the immense apron stage of the Eliza-
bethans and their predecessors, which had been the
common ground of serious and farcical matter and on
which, with no shifting of scene, the drunken porter in
Macbeth had uttered his whimsical scurrilities and the
children of Lady Macduff had been murdered, is
attenuated to a boxlike and representational chamber.
Simultaneous action is a thing of the past. Settings are
made exclusive and are genuinely rendered, but not in
words. Serlio's drawings initiate the process. Palaces
denote the tragic scene, and humble shops and city
dwellings the comic. The satyric scene, as it is proper
to country persons, must "be composed of trees, rocks,
hills," and so forth. In this distinguishing among kinds,
decorum is observed; and the art of Shakespeare, which
depends for its habitation on a muse of fire, gives place
to the art of William Cartwright, in whose tragicomedy
The Royal Slave (1636) words are made nugatory by the
specifying and featuring of seven distinct scenes, de-
vised appropriately by Inigo Jones, the real contriver of
the whole, up there in the flies above the proscenium,
manipulating his *scena ductilis* like the god from the
machine.

Jones, a good man of the theater, is committed
primarily to entertain. Modern readers or auditors are
not likely to grudge the commitment. But the greatest
of English playwrights, though no slouch as an enter-
tainer, is also profoundly moral. The moral vision that
animates Shakespeare's plays is not dictated, however,
by an abstract notion of the shape the world ought to
take. It derives from hard scrutiny of the world as it is
and a devoted recording of what the playwright has
seen there.

Shakespeare is mostly himself alone. The art of his
predecessors tends increasingly to produce two discrete
dramas, each the same in origin (as the medieval drama
is Christian through and through) but different in moti-
vation. On the one hand there is the expressionist art of
the morality play in which the dramatis personae are
essentially cartoons who function to drive home the
truth that sets us free, on the other the imitative drama
of the man-god Jesus Christ and his friends and foes,
whose poignant or fearful laboring in a real world is
often aloof from doctrinal considerations.

When these two kinds or impulses (by whatever
name one calls them) are conjunctive, the drama

flourishes. When the two move apart, it verges on de-
cay. This is to summarize in a few words a great and
complicated story.

Imitative drama is nascent already in the perfor-
mances of wandering minstrels or *mimi*, who were pop-
ular before the Middle Ages began and who, in more
sophisticated avatars—for example, the French mime
Marcel Marceau, whose mimetic art is wholly non-
verbal—remain popular today. The minstrel is making
rudimentary drama as his repertory includes lyric and
narrative dialogue—the *aube* or lovers' parting, like the
parting of Romeo and Juliet; pastoral dialogue—like
that in Yeats's poem *Shepherd and Goatherd*, or the ec-
logues of Spenser and Sidney; most significantly the
enacting of a debate or *estrif* between protagonists—the
essence of the dramatic situation and illustrated by John
Heywood in his sixteenth-century interlude, THE
FOUR PP.

The drama is an argument in which important dif-
ferences are composed. It is also a celebration. The
festive roots of the drama are discovered in the morris
dance, an ancient and partly mysterious entertainment.
The morris dance is associated in the Middle Ages with
the descent of the pentecostal dove on Whitsunday. The
occasion is happy, also august, and across it falls a
shadow. On this shadow the Middle Ages are insistent.
The light needs the dark. Enter to the dance the hobby-
horse, capering grotesquely, even obscenely, in his
wicker frame. The miming of the half-human creature
—who can say from what recesses he derives—evokes
laughter but tinged with dismay. In SUMMER'S LAST
WILL AND TESTAMENT, Thomas Nashe brings the
hobbyhorse on stage. The archetypal drama in which
he figures is a comedy, like life itself. So rejoicing comes
first: "Spring, the sweet spring, is the year's pleasant
king." But Nashe knows that the description is meagre.
Already summer's testament is drawn:

> Beauty is but a flower,
> Which wrinkles will devour;
> Brightness falls from the air;
> Queens have died young and fair.
> Dust hath closed Helen's eye.
> I am sick, I must die.
> Lord have mercy on us!

The drama, not least in its origins, is a particolored
thing in which joy and sadness intermingle. Such enter-
tainment as it affords us is complex, therefore lifelike.
That is not what the poet means in resembling earth to
a player's stage. Perhaps in this context it is fair to
wrest his meaning.

The street pageant or *tableau vivant* plays its part in
the development of the drama, as it emphasizes what
the eye can see. So does the tournament, in its origins a
debate for mortal stakes. Another strand or source is
the primitive folk ceremony, which becomes the folk
play and begets, far later, the sacrificial epiphany of
EDWARD II. In the Revesby Sword Dance, symbolic
of the return of spring after the deadness of winter, a
character is slain and given life again, as in the medieval
Easter plays—or in *The Winter's Tale*. From the mask-

ing and mumming of the Feast of Fools, a burlesquing of the divine service, and secular burlesques like the *sotie* or fools' comedy, the road is a long one that leads to the *danse macabre* of THE DUCHESS OF MALFI. But the road is perceptible.

Literary history is prone to take the road at a gallop. Sometimes a more leisurely transit is indicated. What happens along the way is worth affectionate curiosity: because our ancestors were there before us and we will honor them as we are pious, but also because the end or hypothetical goal to which the historian tends is nascent in the beginning and often more clear as it is nascent.

The Feast of Fools is a beginning, the origin of dramatic art in France. It is also contributory to the drama in England. So far, that is only to offer a footnote. But how are we to understand this Christianized survival of the Roman Saturnalia, during which the conducting of all business is suspended and slaves displace their masters as rulers of the roast? The workaday world is turned upside down, the Golden Age returns. In the Middle Ages, during the "Liberty of December" or the Festival of the Ass, hell breaks loose—or say that the chains are struck. The priest puts away his clerical garb and puts on woman's clothing or the paraphernalia of the stage. He drinks on the high altar: the holy of holies is profaned. He dances in the choir and parodies the service, he chants ribald songs and burns rubbish in the censer. An ass, draped in a chasuble, is led down the nave while the congregation brays in chorus. "This is the day of gladness." So runs the proclamation. "Let those who are of doleful countenance get away from here. Those who celebrate the Feast of the Ass desire to be joyful."

They desire also to poke fun in farcical representations at the establishment under which they groan—or of which they form a part! That is a kind of joy. When the great man is pulled down, or when he is exorcized, we are sad—and glad. This ambiguous feeling is at the heart of our response to tragic drama.

Comic and serious scenes, set to rhyme or presented in dumb show, characterize the Feast of Buffoons, which the hierarchy succeeds at last in driving from the church—only to find itself confronted in the less docile world outside by the Kingdom of Sots, the irreverent creation of the lawyers. Like their Roman antecedents in the time of the Kalends, the lawyers want to be free of their station, and free for a little while of themselves. Aristotle's word is catharsis.

As speeches and dialogue begin to inform these crude entertainments—Philostrate in *A Midsummer Night's Dream* is charged with the auditioning, presumably with the censoring of the entertainers—the creating of an Office of Revels is indicated (1545) to guard against *lèse majesté*. The person of the sovereign is sacrosanct and so it is spared. But, as Hamlet remarks idly, the king is a thing. In terms of what really matters, nothing is spared. Censorship can hardly be efficacious, unless the drama is stifled altogether as by the Commonwealth of Saints in the mid-seventeenth century or by the Licensing Act in the time of Henry Fielding. For the rude handling of sacred totems is what the drama is all about.

The roots of the drama are many. Its chief source is one and is to be found in the ecclesiastical liturgy of the Roman Catholic Church. After all, the drama is a rite. What this means is suggested vividly in the Mass, "an extramundane and extratemporal act in which Christ is sacrificed and then resurrected in the transformed substances." The ritual of Christ's sacrificial death is not, Jung thinks, "a repetition of the historical event but the original, unique, and eternal act. The experience of the Mass is therefore a participation in the transcendence of life, which overcomes all bounds of space and time. It is a moment of eternity in time."

These are good words and true—except that the Mass, like the drama emerging from it, is not wholly extratemporal or extramundane. The varieties of religious experience resemble the multiform experience of art in that each is not for an age but for all time; and also as each is insistently provincial. God is actualized, not symbolized, in the bread and wine, the ordinary stuff on which the drama feeds.

As early as the ninth century, parts of the Mass are being amplified by mimetic action, soon to entail costume, and antiphonal chanting, in which the two halves of the Choir engage in a musical dialogue, to produce what is known as the trope. To the Introit or opening chant for the Easter service, which commemorates the most dramatic of all the Christian stories, a short and simple passage is added. Here are the words of the so-called *Quem quaeritis* trope, which presents the three Marys at the tomb of Jesus and the angel who watches there:

Whom seek ye in the sepulchre, O Christians?
Jesus of Nazareth, who was crucified, O angel.
He is not here, He has arisen as He foretold:
Go, announce that He has arisen from the grave.

Subsequently this musical colloquy is enriched by stage properties: the grave cloth in which Christ had been laid and which must be spread out "before the eyes of the clergy"; dynamic business that serves to move forward the "plot": women coming with spices to anoint their dead Lord, the angel showing the empty tomb; audience participation: the monks who look on but not tacitly, who crystallize for us the meaning of that communion which is the dramatic experience as they join in the singing that acknowledges the Resurrection. They are not spectators, or not wholly. They collaborate in the play in which their own vindication and renewal are accomplished. Quoting St. Paul: "If Christ be not risen, then is our preaching vain, and your faith also is vain." In nuclear form, here are all the elements of theater.

With the passion for literal representation goes a passion for complete representation. Death is always prolegomenary. Resurrection must follow as the day the night. It is complemented—necessarily, to an intelligence or psychology that sees our life as a mingled yarn—by the vulgar comedy of an oil merchant or *unguentarius* from whom ointment for the dead body is purchased, not without haggling over the cost. One trope introduces the Race to the Tomb of the apostles

Peter and John, another the appearance of the risen Christ to Mary Magdalene. "In the meantime let one come, prepared beforehand in the likeness of a gardener, and standing at the head of the sepulchre let him say.... 'Mary!' And falling prostrate at his feet, let Mary say: 'Rabboni!'" Anyone with a feeling for the stage will hold his breath at this intimation of the great recognition scenes in Renaissance drama.

The rudimentary play, transferred now to the Monday of Passion Week, continues to grow, incorporates the Journey to Emmaus or *Peregrini*, and the story of the Doubting Apostle, Didymus called Thomas, who, as he has got to thrust his fingers in the wounds to verify the Resurrection and the Life, is the perfect emblem of the impulse to dramatic representation.

A Christmas play, the *Officium Pastorum* or Office of the Shepherds, imitates the success of the Easter trope. *Obstetrices* or midwives assist at the divine birth, the Magi are presented as they follow the star (a chandelier carrying candles and suspended from the roof of the church), and heed the angelic warning to take another way home. Herod rages as his wicked purpose is balked, and resolves on and consummates the Massacre of the Innocents. Old Testament prophets like Daniel and Moses announce the coming of Christ (the so-called *Ordo Prophetarum*) and are corroborated by profane witnesses like Virgil and the Sibyl (more mingling of the yarn in deference to a catholic view of history). Daniel leads on the Babylonian king Nebuchadnezzar, who claps him in the fiery furnace, there "on stage," emitting flames.

By the twelfth century, the Christmas play has reached for its materials as far back as the Fall of the Angels. If the "whole" story is at issue, why not? The Easter play is dramatizing Christ's Harrowing of Hell, in its earliest version an *estrif* or *débat* declaimed by the Anglo-Saxon minstrel called the *scop*—the pagan past informing the Christian present—and the comic and sorry fortunes of Mary Magdalene, the archetype of the fallen woman.

With regard to these stories, the Bible is mute. And so non-Scriptural sources begin to be levied on—the Apocryphal Gospels, pseudo-histories like *The Golden Legend*—to appease the thirst for completeness. The son of Pontius Pilate, for whom we must consult our imaginary forces, is represented, flourishing his poleax. The conversion of Mary Magdalene conducts naturally to the conversion of St. Paul, thence to the metamorphosis of that fictitious hero-villain, Sir Jonathus the Jew.

In time and given its encyclopedic bias, the religious drama trenches on the integrity of the Mass. Stage directions, as they are increasingly complex, tell us what has happened: "Let a manger be prepared at the back of the altar." "Let there be many boys as if they were angels in the roof of the church." St. Paul, who puts on the new man to the ire of his contemporaries, is described as escaping "from some high place" and being "let down in a basket to the ground." By the eleventh century the Office of the Shepherds undergoes an obligatory transfer to the Matins or Morning Service. The Passion Play passes from the clergy, is presented now by laymen, as at Sienna in 1200. In the theatrical pageantry, in the art and architecture of this Tuscan city, which may stand as the apotheosis of the medieval spirit, the Kingdom of God appears to be realized on earth. The effective agency is, however, the devoted cunning of man.

Secular performers make for secular plays. The flamboyant Duke Moraud, who seduces his daughter and achieves the murder of his wife and incest-begotten child in a fourteenth-century chronicle drama, is brought at last to repentance. Ostensibly his story is a moral story. In fact it is as sensational as the lurid novels of Robert Greene or the crude pandering of Thomas Preston or the sickly phosphorescence of Marston and Ford. Something is gained in the new freedom conceded the playwright, and something is lost.

What is gained, as the drama moves from the choir to the nave, thence to the church porch, thence to the public square is the creating of a truly democratic or people's art, a phenomenon often willed by sentimentalists and legislated by cynics in our time—Berthold Brecht; Stalin and his congeners—but actualized only rarely. By the beginning of the fourteenth century this phenomenon is matter of fact. The lay guilds with which all townsmen were affiliated have assumed the creating and managing and performing of the play. The dramatizing of the Flight into Egypt is the business of the stable keepers, the Last Supper of the bakers. The audience for whom they perform is the total community. The great occasion of performance is the Feast of Corpus Christi, occurring in late May or early June. The sacrifice and resurrection of Christ are commemorated, and in the rites of spring the pagan past is resumed. The dead god is buried in the flower garden (*nell'orto del fiore*), and like the sleeping flower is biding his time. If the medieval Franciscan Jacopone da Todi sounds like T. S. Eliot in *The Waste Land*, that is because the same truths, or memories rather, are common to the present and the past.

An Elizabethan poet, who has seen St. Christopher "wade and pass with Christ amid the brook," recalls the miracles and mummings on the day of the feast:

> Sebastian full of feathered shafts the dint of dart
> doth feel,
> There walketh Catherine with her sword in hand,
> and cruel wheel,
> The chalice and the singing cake with Barbara is
> led,
> And sundry other Pageants played in worship of
> this bread.

The play remains at least formally worshipful. It is a *representatio miraculi*, a miracle play, or else its cousin german a mystery. To distinguish between the two kinds is ticklish. Each incorporates material not founded necessarily on biblical stories. With these stories the mystery play begins; then the net is widened. The miracle play deals more generally with the wonder-working and martyrdom of the saints. The greatest of

the mystery plays, and a work of perennial authenticity, is *The Second Shepherds' Play* by the anonymous Wakefield Master, who lived and wrote in the earlier fifteenth century and whose genius illuminated the theatrical cycle associated with his native city.

Humor is not scanted in the mysteries, nor pathos nor homely detail. The first murderer Cain is as villainous as Hell, he is a blasphemer, he is obscene; he is also a figure of fun. So are Herod and Pontius Pilate. And so is the Devil, "in his feathers all ragged and rent." Evil is incongruous, therefore comic.

Noah's wife Gib is comic, a real termagant made of flesh and blood; she is more than comic as she declines to take refuge in the Ark, leaving her "gossips" behind her. Mary and Joseph are not saccharine persons as in our popular iconography, nor are they cut from alabaster. We do not so much worship as salute them, a medieval couple beset with such problems as are the lot of the rest of us. Joseph, as the York *Birth of Jesus* presents him, is a man getting older and verging on petulance:

Ah, Lord, what! the weather is cold!
The fellest freeze that ever I feld!

We indulge him ironically and acknowledge his right to complain. In the Brome Manor *Abraham and Isaac*, the protagonists speak and act from their nature, hence tug at the heart. When Isaac, who has piled the faggots for his own immolation, discovers that he is about to die, when—as the sword is lifted to strike—he can say to his father: "I pray you bless me with your hand," the audience is moved exactly as it is persuaded of horror and pity, self-abasement, gain-giving, human love.

Specificity is the *métier* of the medieval playwright. The cubits or dimensions of the Ark are not less important to him than the moral of the piece: the unnatural behavior that makes for the Flood. In the Wakefield version of the Deluge, Noah lowers a plummet to sound the depth of the waters. We wait on the issue; he cares and so do we. As the soldiers of Herod begin the slaughter of the Innocents, a woman rushes on stage and strikes them with her pot ladle. The Coventry Manuscript is insistent on that ladle. It is worth a thousand words. In the enacting at York of the Crucifixion story, the soldiers who carry the Cross find it a heavy burden. They have got to set it down to catch their breath, they have got to drive wedges to make it stand upright: trivial business but stabbing the life into the scene.

To convey the touch of nature that "makes the whole world kin" is within the province of any writer in any time or tongue. The gradual displacing of Latin by vernacular speech—language, as Ben Jonson will put it many years later, "such as men do use"—seems, however, crucial to the illusion of reality as fabricated by the medieval playwright. The school plays of the Renaissance, in which Latin is resuscitated from blind fealty to the classical past, are dead. The native drama of the Middle Ages is living still. The Tailors and Shearmen in the N. Towne play sing all the better, they come home to us more nearly, as they sing in native accents:

As I rode out this enderes night,
Of three jolly shepherds I saw a sight,
And all about their fold a star shone bright.
They sang terli, terlow—
So merrily the shepherds their pipes can blow.

The music of Shakespeare, in *Love's Labor's Lost*, in *As You Like It*, is not so far in the future.

As the drama is naturalized, the impulse to panoramic representation grows more insistent. The common tongue, evidently, runs on without let. More than fifty plays or "pageants," which begin with the beginning or Creation of the World and end only with the Day of Doom, comprise the cycle at York. The vast panorama that unfolds before our eyes is sometimes naive, it is never less than palpable. If a hailstorm is required, starch rattles on stage; if thunder, hogsheads are beaten. An earthquake is not beyond the realm of possibility: the Drapers have fashioned an apparatus for suggesting it. On Judgment Day the dead are seen to rise in their shrouds. The creation of Eve is witnessed to as God lifts from Adam's side "a rib colored red." The carrying off of the student in Greene's FRIAR BACON AND FRIAR BUNGAY is anticipated in the presence on stage of devils incarnate who depart this middle earth with their prey through a fiery Hell Mouth with a "nether chap" made to open and close. Into that Hell Mouth Doctor Faustus will disappear.

The winding up of Marlowe's play is spectacular and quintessentially human. It riddles us with light, but it does not surprise us. We are inclined to say easily that Marlowe is of the Renaissance, "which is characterized by the discovery of the world and by the discovery of man." (The historian Jacob Burckhardt is echoing and predicting all those tiresome panegyrists of modern times for whom man is the measure and earth the kingdom into which he has entered at last.) Medieval man is customarily presented as indifferent to the pull of the physical world: this time and this place. If one thinks, however, of the substantial repertory of plays—always localized, temporalized—that constitute the Wakefield or Towneley Cycle and the N. Towne or Ludus Coventriae Cycle, and that survive from York and Chester, a different picture begins to come clear. The mind of the Middle Ages, whatever its formal obeisance, was not always beating on God.

To do well what one is doing is of course a form of prayer, though not as the churches conceive it. The medieval maker is prayerful as he devotes himself to the exigencies of his craft. Because the play must be available to the entire community, he utilizes a pageant wagon in which the play is reenacted, presumably from first to last light, to accommodate the crowds as they arrive from other stations. Alternatively, less probably, a single presentation suffices, and thereafter the total audience moves on. At each station the play is advertised by banner bearers or *vexillatores* who go before crying the Banns. The pageant itself, gay with vanes, a crest, and streamers, sided with wainscotting, looks

forward perhaps to the multilevel structure that is the Elizabethan stage.

Conjecture is necessary, for the latter not less than the former. It is tenable, however, to see in the mind's eye an upper level or stage, strewn with rushes and sometimes employing a curtain to "discover" the actors, and a lower level, also curtained, which functioned concurrently as a "green room" or tiring house and as another area for playing. "I am Alpha et Omega," God announces from the upper level in a play presented by the Grocers of Norwich. (God is recognizable as he wears a girdle and a white leather garment, for the making of which six skins are required.) Below him, in his view, the sacrifice of Isaac is readied, the humbling of Balaam is accomplished, as the hero manqué of the *Ordo Prophetarum* falls on his knees and addresses the deity "*in supremo loco.*"

Action is vertical, a possibility exploited eagerly by the Elizabethan playwright—Shakespeare, for instance. "Down, down, I come, like glistering Phaëton," cries Richard II to Bolingbroke in the "base court" below. The medieval playwright has it both ways. An angel, like King Richard, descends to Jesus in the Garden of Gethsemane, proffers him a chalice, then —says the N. Towne Manuscript—"ascendeth again suddenly." To make manifest her creation, "Eve rises from below": from the wainscotted section of the wagon where, as in a Cappers' Pageant, three men with windlasses are hidden.

What these men are up to is the glory and the tribulation of the stage to the present. It is their job—undertaken then as now with the abandon of the wholly sincere, hence blinkered man—to contrive a burning bush for Moses, to part the Red Sea and insure that it overwhelm the Egyptians, to make a mechanical serpent (*artificiose compositus*) crawl toward the tree of good and evil, somehow to manage the Conception of the Virgin: a stage direction from the N. Towne cycle envisages the three persons of the Trinity "entering all three to her bosom." Judas, in the N. Towne *Trial of Christ*, is required to hang himself. He fulfills the requirement with such fidelity to fact that he almost chokes to death, suffers a heart attack, and must be cut down and carried off by his fellows. A Passion Play of the fourteenth century is knocked to pieces by the discharging of a cannon in Hell. Flames and a tempest signalize the conversion of St. Paul, on whom the Holy Spirit is made to descend. Calm after storm.

As the art of the technician in the cellerage is perfected, the action of the play, more and more given over to hijinks, spills from the pageant, as generations before it had abandoned the narrow confines of the Mass. Now Herod, at Coventry, rages "in the street also," in the unencumbered area called the *platea*. He is availing himself of what space he can find. He needs it. He is "wode" or mad. So, in absurd and splendid ways, is his "designer" or "director," whose enthusiasm for sheer effect is already anticipating the art of Inigo Jones in Jonson's time or Jo Mielziner in our own.

The *platea* in which Herod's passion is vented recalls the nave of the church, in which action had oscillated

about permanent stations: cross, manger, sepulchre, and Hell Mouth. These stations survive in the drama of the later Middle Ages, which is always conventionalized, however frantic the action, and always incremental, incorporating faithfully whatever has gone before. (This faithfulness to the art of the past will be decisive for the art of the future.) No drop curtain obscures the *locus* or place, the *sedes* or seat, the *domus* or house that break the *platea* and serve to define it. On that otherwise unbroken area no factitious props obtrude. If the playwright desires that it represent the road to Calvary or the Den of Irksomeness or a city street between the houses of Damon and Erostrato, as later in Gascoigne's comedy SUPPOSES, he has only to say so. In Marlowe's EDWARD II, Queen Isabella, who was just now in Flanders, is discovered abruptly greeting friends at home. Marlowe makes her say: "Welcome to England all with prosperous winds." And we are there. An impoverished stage is paradoxically the richer for its impoverishment. To delineate place is the function of language. The gory tableaux in TAMBURLAINE are represented only sketchily but conveyed all the same— and are the better for want of representation.

The fixed stations, though palpable, can never be indigenous. They do not denote, or not in perpetuity. They are always confronting us and they are always one. This means that they must obliterate time and betoken different places, as by an act of will—and what potential for symbolic theater is embryonic in that merely physical imperative. The *domus* perhaps is the manger in which Jesus is born, and the sepulchre in which he is laid. *Respice finem.* Where Mosby and Alice (to look forward in time) dramatize their adulterous passion, "honeying and making love over the nasty sty," there Arden of Feversham is murdered—and there the conspirators are apprehended and condemned. The *sedes* or seat, in "real" fact a step or two from the *domus* or *locus*, in symbolic fact (which transcends and clarifies common-garden reality) many miles distant, will represent the throne of Herod and the throne of God. "We mind true things by what their mockeries be."

When Kent in *King Lear* is trussed up in the stocks, he is occupying the *sedes*; Edgar the Bedlam is seen simultaneously—failing the proscenium arch and the curtain depending from it, we have no recourse but to see him—on the heath or *locus*, supposedly far away: as eighteenth-century editors like to put it, in "another part of the forest." The modern theater knows better than to show us simultaneously, in the teeth of what is possible, two good men at the lowest point of Fortune's wheel. In fact their juxtaposition goes far to encapsulate the theme of the play. Simultaneous action, in which theme is embodied, is one legacy of the medieval drama to the drama of the Renaissance.

The more ample frame the play requires as it leaves the pageant wagon is provided by the building of scaffolds, sufficiently flexible to open and shut, sufficiently versatile to represent on demand the Interior of Hell, Damascus, the House of Wantonness.

Etymologically, a scaffold is a stage. In Andrew

Marvell's Horatian Ode to Oliver Cromwell, a great poem of the seventeenth century, the soldiers who are the auditors encompass this stage, clapping their bloody hands in token of the death of King Charles. The soldiers are applauding a performance. It is as often a sanguinary performance. For a stage is also a scaffold on which felons are executed. The Passion of Christ, as an Elizabethan chronicler remembers, is played "upon a scaffold." Black Will the murderer—quoting from the epilogue to ARDEN OF FEVERSHAM—was burned in Flushing "on a stage." The dramatist who works this ambiguous ground is like the public hangman. In his hands he carries life and death.

The medieval scaffold is more hospitable than the modern box set, is able to accommodate a house or *domus* for the high priests, a "mansion" for the devils, a pulpit for St. Paul. Around it is the old *platea*, then—another concentric circle—"the assembly that here sitteth or stands." No rigid demarcation separates this assembly from the actors beyond the "footlights" as in our more fastidious theater, where the actor keeps the wind between himself and the audience. Fluidity, interpenetrating, are of the essence in the staging of the medieval drama. The Apostle "rideth forth with his servants"—to quote from a Conversion play of the late fifteenth century—"about the place [*platea*], and out of the place." Sticklers—"stytelerys" or marshals—sweep his way through the crowd.

If the play is presented in the open fields or suburbs, like *The Pride of Life* or *The Castle of Perseverance*, the crowd is confined within a ditch or line of ramparts that defines the outer limits of this primitive theater. Or the hall of a great house is utilized, or an innyard, open only to the sky. The fixed periphery suggests the emergent character of the drama as a professional enterprise. *Mankind*, which is played in an atrium or innyard—like that of the George Inn below the Thames in Southwark—interrupts the action *in medias res*. Newguise and Now-a-Days pass among the crowd. They are speaking of Titivillus, the stock name for the devil in the medieval drama whose function is precisely to titillate:

He loveth no groats, no pence, or tuppence:
Give us red royals if ye will see his abominable presence!

The crowd gets its money's worth. A stage direction from *The Castle of Perseverance* enjoins on the fiend a volatile performance: "And he that shall play Belial, look that he have gunpowder burning in pipes in his hands and in his ears and in his arse when he goeth to battle."

But the battle is the thing. What the crowd is watching is the confrontation of characters who are increasingly tenuous even as the action in which they participate is rendered increasingly with an eye to verisimilar detail. That is not true in essentials of the mystery play. Though it has its fair share of exiguous characters like 1st and 2nd *Puer* and 1st and 2nd *Miles*, it is still its palpable self in the Age of Elizabeth, still commingling delight with instruction, until in Shakespeare's boyhood a reformed religion conspires to drive it from the boards. It is emphatically true of the final flowering of the medieval drama which is the morality play, a didactic dramatizing of life in allegorical terms. The watchword of the morality is *universalia ante rem*, the general before the particular exemplification.

Conrad says, in his preface to *The Nigger of the Narcissus*: "All art appeals primarily to the senses, and the artistic aim when expressing itself in the written word must also make its appeal through the senses, if its high desire is to reach the secret spring of responsive emotions." The morality play repudiates this judgment. Like Plato it contemns the senses and seeks a better way to truth.

The dramatis personae who populate the morality are recognized—but to speak of recognition is inapposite now—as the Devil and his colleagues, Envy and Wrath; or Caro the Flesh, and Sloth, Gluttony, and Lechery; or the World, and Covetousness and Pride: three abstractions or allegorical figures in the company of the Seven Deadly Sins. When, in *The Summoning of Everyman*, the greatest of the moralities, the hero is abandoned by Kindred and Cousin, the latter offers as excuse a cramp in his toe. That saving and indispensable gratuity is the exception that proves the rule.

From the morality play, toes and cramps and real persons are pretty much excluded. The author sees them as impertinent or as subversive of the thesis he wants to convey. This thesis is not objectified. If the hero of the play is duplicitous, like Volpone, he does not get his requital at the hands of the parasite Mosca. He is given, by Confession, a scourge called Penance, and by Knowledge a black garment in token of contrition. Rarely is he given a habitation and a name. We do not meet in these plays particular or parochial figures—like the fraudulent Socialist whom O'Casey in *The Plough and the Stars* calls the Covey. What the dramatist is bidding for is the type or essence of the fraudulent Socialist—such a one as Georg Kaiser's Gentleman in Gray. The difference between the two is the difference between the definite and the indefinite article. Truth, on one reading, inheres in the latter. To the Jacobean or Caroline playwright—Tourneur in THE REVENGER'S TRAGEDY, Ford in *The Broken Heart*—this reading remains powerfully seductive. Massinger in A NEW WAY TO PAY OLD DEBTS, Middleton in A CHASTE MAID IN CHEAPSIDE, as they fashion characters called Wellborn, Yellowhammer a goldsmith, Sir Walter Whorehound who needs no definition, are appealing from flesh and blood not less than their fifteenth-century forebears.

In comedy of the conventional (mathematical) kind, as the eye is on plot and the persons are counters, the appeal from their integrity is potentially successful. In tragedy it is foredoomed to fail. Tourneur at least is writing a kind of comedy. So by turns is Marlowe. The aesthetic of the morality play is a viable aesthetic so long as the governing intention is, in the broadest sense, comic. One can say that this intention is fulfilled as the pallid notation that is the hero is "safely stowed."

The ending of *Everyman* is a happy ending. If we do

not laugh we assuredly rejoice, the sense of a divine comedy. In the surviving drama of the fifteenth century —in *The Castle of Perseverance*, the most distended of the moralities, in *Mankind*, in *Wisdom, or Mind, Will, and Understanding*—this sense is pervasive. The first extant morality play, *The Pride of Life*, lacks its conclusion. No matter for that. It is *ipso facto* that the unregenerate king who is the protagonist should finally turn to repentance.

The putative repentance of the hero, if it makes for satisfaction, fails to get at us where we live. The hero is a cipher. He does not really impinge on the fortunes of his contemporaries, whose plight we do not take seriously so long as we can greet them as *Mulier* or *Senex* or those neighborly nonentities *Proximus* and *Vicinus*. By such reservations the playwright is, however, unperturbed. He is not out to wring our hearts but to dramatize for us the naked contention of attitudes and ideas. The latter are embodied only as far as they must be.

Generally in this contention we are not trusted by the playwright to look and listen, then to draw our conclusions. A Nuntius or Expositor gives the burden of the whole. In *Everyman* he fixes us with a bony finger:

Here shall you see how Fellowship and Jollity,
Both Strength, Pleasure, and Beauty,
Will fade from thee as flower in May.

The hero, expiring, has strength enough to exclaim: "Take example, all ye that this do hear or see." If, one feels, the play has predeceased him, that is possibly the reaction of a frivolous modern person who does not impute to the theater the power to save his soul. One should give the morality its due.

Belaboring of the moral, as by the homiletic "Doctor" to whom *Everyman* assigns the last word, distinguishes or vitiates the mystery play also. Crudity of exposition we have always with us. Even Shakespeare nods. The Nuntius survives, with a leg up from Senecan tragedy, in the plays of Chapman and Kyd. This is to say that the morality, in its failings, is hardly peculiar. But it is possible to represent the vices of style that denote it as speaking obliquely to a different view of theater from that one associates with Ibsen and Strindberg and O'Neill, a view of theater the Middle Ages transmit to the Renaissance. If there are no surprises in store for the audience, which is in possession of the ending of the play in the beginning, attention and interest are likely to shift from questions of vulgar curiosity—who did what: the province of melodrama— to questions of etiology or cause.

Edmund Wilson, in an irritable attack on the popularity of the mystery novel, inquires rhetorically: "Who gives a damn who murdered Roger Ackroyd?" The makers of the morality have put this question to themselves and resolved it: their indifference is patent. So is that of their greater successors in the Renaissance. *Macbeth* is sufficiently violent but not conventionally mysterious or suspenseful. Neither is THE DUCHESS OF MALFI. Shakespeare and Webster have their mind on other business.

As the medieval dramatist tips his hand in beginning the work, he overplays his hand in the ending. Everyman is not relinquished at the moment of climax. The body of the hero descends into the grave but the soul goes marching on. A didactic epilogue recapitulates his story. The plough is simply turned round in the furrow. The epilogue is redundant. But it functions to rationalize the event. We are not left mesmerized, as in the conclusion of Ibsen's *Ghosts* or Strindberg's *The Father* or O'Neill's *Long Day's Journey into Night*. The dramatist is unwilling to focus disproportionate attention—as he might put it if he were an analytical critic, the index of a more self-conscious age—on the great drop scene. What he wants is a frame. He blunders in fulfilling this desideratum, he fatigues us; but it is important to grasp the psychology that underlies his intention, for that psychology, again, is quick or vital in the succeeding age. "Cut is the branch that might have grown full straight." Marlowe is not appending a homily to DOCTOR FAUSTUS. He is willing us to avert our eyes from the sensational fact, to estimate the whole, to see it in perspective. That is the function of the chorus with which *Don Giovanni* concludes. It is the function of the epilogue Horatio delivers over the body of Hamlet.

Hamlet wins our allegiance partly as he figures in a consequential story, partly as we shall not see his like again. The story as moral fable or Psychomachia, a war to the death between vice and virtue, descends to the Renaissance from the morality play, the indigenous hero and his particularized milieu from the mystery. Mediating between these two kinds, taking from either, is a third, which is the interlude. With the vogue of the interlude in the earlier sixteenth century, the drama of the Renaissance begins.

Henry Medwall, the first dramatist writing in English with whose name we are familiar, defines the interlude on one side in *Fulgens and Lucrece*. The play is broken in two parts. We take collation, inter-ludus, and then the play resumes. But the definition is merely formal. More to the point is the playwright's attention to vulgar comedy and homely detail. The pietistic impulse is evidently on the wane. The impulse succeeding to it is often disingenuous and not the province of the interlude alone. A play like *Hickscorner* appears to dramatize the folly of sniping at religion, a play like *Youth* the sad declension of the Prodigal Son. Each of these plays is superficially moral, and in each—as showing is better than telling—juicy possibilities inhere. One says to oneself in the movies, How disgusting is the dalliance of David and Bethsabe.

Early sixteenth-century drama is not always so complacent. John Rastell's *Nature of the Four Elements* is what it purports to be, a dramatic lecture on geography. The plays of the early Tudor poet John Skelton are not so much plays as political tractates. Gascoigne's *Glass of Government*, a half century further on, instructs us in the right way to handle recalcitrant children. When Bishop John Bale, a theatrical champion of the Protestant cause, dramatizes the adventures of King John, he surrounds his eponymous hero with tenebrous char-

acters like Private Wealth, Dissimulation, Widow England and her blind son Commonalty. Maybe we are instructed.

The interlude as such has little to do with instruction. First of all it is mundane. Medwall, harking back to the morality play, denominates as A and B the servants who attend on his pair of rival lovers. But he fleshes them out. Medwall is a priest but in the world and of it. This same affiliation to thingness is manifest in Sir David Lindsay's *Satire of the Three Estates*, technically a morality play in its ethical bias and in its predilection for capital-letter abstractions, technically an interlude as it is divided in halves for collation, more significantly a portent of the renascent age or a throwing back to the age of cycle drama in that it stoops to comedy, stoops to examine the ground on which we stand. A veritable protagonist, John the Commonweal, appears—never mind the offputting name—to utter the immortal line: "Christ Jesus had no property but the gallows." In Nicholas Udall's propaganda play *Respublica*, we recognize in the speech of a real country fellow the dialect of the Cotswolds and are made aware instinctively—whatever the professed intention of the author—that more than polemicizing is in the cards. What does language "such as men do use"—like the southwestern dialect of GAMMER GURTON'S NEEDLE —have to do with the kingdom of God? There is an answer to the question but the makers of the morality would not have entertained it.

The interlude does not throw down a gauntlet to the past. At least the pretense of piety remains, as in the hortatory close of THE FOUR PP. But the warp and woof of Heywood's play—that of most of his plays— is farcical altercation. The shrewish heroine of *Johan-Johan*, a woman no better than she should be, would soon be dead, says her cuckolded husband, if the priest did not "now and then . . . give her absolution upon a bed."

Farce is not amenable to extended treatment and so the interlude is likely to be brief. Brevity, if the soul of wit, is not always productive of it. Characters in Heywood, who is pedantically faithful to the tradition of the medieval *débat*, are unrelievedly disputatious. Their talk is, however, not the talk of the homilies but of the *fabliaux*. Heywood's mentor is the Chaucer of *The Miller's Tale*. The consolations of philosophy are proffered but are not really to his purpose. That is true of John Redford's *Wit and Science*, a farce tricked out in the habiliments of the morality play, as also of Rastell's *Calisto and Melebea*. For each of these writers the Latin tag is applicable: *Cucullus non facit monachum*. "The cowl does not make the monk." Neither does moral garnishing make the play.

What makes the play and communicates to us the sense of an ending and beginning is suggested by Rastell, in his "New Comedy in English in manner of an Interlude." The Spanish source from which he is working is neither Scriptural nor hagiographical. It approximates the modern novel, especially in content, and that is more than inert information. Now for the first time, wholly secular material begins to infiltrate the drama. Mostly this material is made available to the Renaissance by the revival of interest, from the late fifteenth century forward, in the drama of classical Rome.

Pope's famous lines are simplistic; still they offer us a pointer to what is new or renascent in the Renaissance:

> At length Erasmus, that great injured name,
> (The glory of the priesthood and the shame!)
> Stemmed the wild torrent of a barbarous age,
> And drove those holy Vandals off the stage.

The Vandals are the monks, without whose assiduous cultivating of the drama Shakespeare & Co. would not be thinkable. Erasmus is only one of the fellowship of Humanists—More and Colet, Vives in Spain, Linacre, Grocyn, William Lilly—whose office was to stem or redivert the torrent descending from the medieval past. It is, however, true that monkish drama is provisional —its concern is with eschatology: last things; also true that the phenomenon called Humanism introduced to the practicing playwright the comedies of Plautus, and Terence in his original dress, and the tragedies of Seneca. Roman comedy is more carefully articulated than the medieval play. Senecan tragedy is less hopeful —not just by definition: sometimes tragedy cheers us up—also more sanguinary, and mannerist in language, exemplifying in every line the self-conscious artist, a classical personage out of favor in the Middle Ages and regenerate as the modern age begins.

The prayer Erasmus formulates, wittily but earnestly, in the early decades of the sixteenth century: "*Sancta Socrate, ora pro nobis*"—a prayer that elevates man to a position of primacy and disuses the anthropomorphic God who had dominated in the medieval drama— reverberates in the new drama as well as in the church.

The new drama is egocentric. Overreach, who writes *nil ultra* to his proudest hopes, is the typical protagonist. That is a nice setoff to the new or heliocentric universe hypothesized by Copernicus. Earth is diminished to a speck in the infinity of space, concurrently, perhaps defiantly, man is aggrandized. In rueful knowledge even more than in ignorance, man desires to know that the universe revolves around him. To this desire, the new drama addresses itself.

The new drama is also preoccupied with form. In all art, content is circumscribed by form. Of some art it is possible to speak more radically than this. Say: "*pièce bien faite*" and we know what is coming. Content is form in the comedies of Plautus, rediscovered by the Renaissance, as also in the comedies of Terence, the only classical playwright known to the Middle Ages but sicklied over or Christianized in the tenth century by a well-meaning nun of Gandersheim.

Form means the five-act structure, the division of the acts into scenes, the honoring of the Unities, as in Gascoigne's Roman comedy SUPPOSES: a single set, basically a single story, and unfolding in a few hours' space. Most of all, form is defined in the sense the play communicates of an integer or coherence.

Construction, the architect's province, is not to be scoffed at as mere carpentry. Many writers of quality— Marlowe, for example—are innocent of it. The Eliza-

bethan playwright who masters this finicking art—
Dekker in THE SHOEMAKER'S HOLIDAY, Jonson in
EPICOENE, Chapman in THE WIDOW'S TEARS, the
early Shakespeare—goes to school to Roman comedy,
sometimes redacted and brought up to date by the
theater of the Italian Renaissance. Performance of
Latin plays was common in Italy from the mid-
fifteenth century, in England a century later. As the
playwright is unwilling simply to translate, he will seek
to revivify the material at which he is laboring, to give
it a new and independent lease on life. That is how it is
with Nicholas Udall's Plautine comedy *Ralph Roister
Doister*, or GAMMER GURTON'S NEEDLE, each Eng-
lish to the core but exotic or Italianate English in the
feeling each manifests for classical form. "An Italianate
Englishman," says the humanist Roger Ascham, "is a
devil incarnate." But that is a half truth.

Sometimes in medieval art the Old Testament
prophets are seen to carry on their shoulders the
Apostles or Evangelists who promulgate the new dis-
pensation. This figure describes the hybrid that is
Renaissance comedy. Gascoigne is supported partly by
his English antecedents and also by Ariosto, the great
Italian. But Ariosto takes strength from Plautus and
Terence. His classical comedies of the early sixteenth
century, as they are refreshed in spirit by the self-
conscious artistry of the past, "stem the wild torrent"
of the panoramic play. The result, given time, is the
comelier artifact or supremely crafted machine that
Jonson patents and hands on to his successors.

In Italianate comedy as a kind, the intricate workings
of the machine take precedence. Character is of ancil-
lary importance and is assimilated by and large in the
type. We encounter the Braggart, usually a Spaniard
(like Don Armado in *Love's Labor's Lost*), or the
Pedant (like Lugier in Fletcher's THE WILD-GOOSE
CHASE), or the grumbling Servant (Grumio in *The
Taming of the Shrew*). The Friar, crooked, bumbling,
or omnicompetent as the plot requires, is the last resort
of every Renaissance playwright. An intriguing lady's
maid, designated the Soubrette, is familiar as Sybil in
THE SHOEMAKER'S HOLIDAY or Margaret in *Much
Ado About Nothing* or Pero in BUSSY D'AMBOIS. The
Professional Man, predictably the butt of ridicule, is
the doctor or lawyer in a hundred plays from Gascoigne
to the theater of the twentieth century: Cleander in
SUPPOSES, Voltore the advocate in Jonson's VOL-
PONE, Dr. Percy Paramour in *The Philanderer* by
Bernard Shaw. The Mage or Sorcerer recurs as
Faustus or Friar Bacon, the Parasite as Dodger or
Marall or Mosca (who is more than the type: always
the hallmark of greatness), the Nurse as Juliet's Nurse
or Putana in 'TIS PITY SHE'S A WHORE.

These enduring stereotypes lie ready to hand in
Roman comedy, in the *Commedia erudita* of Ariosto, in
the popular Italian drama known as the *Commedia
dell'arte*. But one finds them elsewhere and closer to
home. The psychology that prefers the type to the
indigenous thing is that of the morality play. It is often
said of Falstaff that he descends from the *Miles
Gloriosus* of Plautus, the story of a blustering soldier.

His more obvious antecedent is the medieval Vice. The
capital-letter characters who participate in the comical
farrago that is SUMMER'S LAST WILL AND TESTA-
MENT are classical only on their face. Their essential
provenance is the allegorical theater of the fifteenth
century; the business to which Nashe commits them—
the logomachy or word-war—is a resuming of the
medieval debate. In so many ways the cask, which is
Renaissance drama, still smells of the wine that steeped
it first.

The rediscovery of Vitruvius enforces the point. To
this classical architect the new drama is indebted for an
illusory backdrop made of canvas, which is stretched on
wooden frames, cut with doors and decorated by
"prospects" in perspective—like the "painted cloth"
of the City of Rome that the theatrical manager Philip
Henslowe records as among his properties. But what
the audience is looking at is still the monoscenic stage of
the mysteries and moralities. The medieval playwright
is banking on our good will as when his surrogate in-
forms us: "Here is the town of Emmaus in which Jesus
Christ was entertained." Two and three centuries later
the Elizabethan playwright is still put to asserting that
this is the Forest of Arden. The old *sedes* or *domus* is
still there, metamorphosed to the players' houses,
which give on the old *platea* through the openings in
the permanent structure across the back of the stage.
One corner of this structure will represent—you must
take the playwright's word—the palace of Alexander
the Great (as in Lyly's *Campaspe*, a play of the 1580s),
another the studio of Apelles the painter. Between the
doors that admit to these houses-by-courtesy is the
playing area, still much as it was when Termagant, the
ranting deity of the Moslems, tore a passion to tatters.
In logistical terms, radical innovation is still to seek.
God's "Alpha et Omega," the voice from the pageant
wagon, is proleptic.

In the conventional English comedy of the sixteenth
century, action is confined to the street before two
adjacent houses—as in *The Comedy of Errors* or
GAMMER GURTON'S NEEDLE. Perhaps this generic
street or playing area was encircled with galleries,
mostly for the spectators, partly for the use of the
players themselves, like the medieval innyard or
the "theater of cruelty"—Paris Garden, south of the
Thames—where bears and bulls were baited. Perhaps,
taking a hint from the mounting of street pageants on
scaffolding or trestles, it was raised aloft, like the
elevated stage of the pageant wagon, and closed at the
rear with a "tiring house" and a curtain or arras.
Behind the arras Falstaff is detected, fast asleep and
snorting like a horse. Through the arras Polonius is
stabbed. Perhaps the refectories of the London law
schools and the sister universities of Oxford and Cam-
bridge commended themselves to the players as they
were able to utilize for their entrances and exists the
paneled screen or reredos, pierced with two doors, that
gave access to the hall. Orsino enters through the
reredos, at the Middle Temple in 1602, to speak the
opening lines of *Twelfth Night*. The point to take hold
of, from this mingling of guesswork and ascertainable

fact, is that the Elizabethan theater is not so much new as reminiscent.

When the carpenter James Burbage constructs the first permanent playhouse in England—the Theater of 1576, rebuilt two decades later as the Globe—he combines the seating plan of the inn or bear garden—an octagon (or square or circle) of galleries surrounding an open yard—with the "stage" arrangement of the great hall. His theater, like the Rose and Swan and Fortune for which it serves as a model, is able to accommodate as many as three thousand people. But the old rapport between the auditor and actor remains undiminished. The Citizen and his Wife, in THE KNIGHT OF THE BURNING PESTLE, are amusing as they take the play to heart; their naive response is also instructive. It suggests the sense of verity, of the play as an intimate and personal experience, that radiates from the apron stage and communicates itself to the groundlings who stand in the pit and their hypothetical betters ensconced in the galleries above them.

As it happens, THE KNIGHT OF THE BURNING PESTLE is aggressively indifferent to the taste of the groundlings. The Citizen-Grocer has blundered into the performance, or so Francis Beaumont wants us to believe. Neither is he standing, unless to stretch his legs. Partly, Beaumont's play is interesting to us as it documents the increasing segregation of the audience along the lines of money and class. The author of an old-fashioned comedy like MUCEDORUS, as he is writing in the Age of Elizabeth, an ecumenical age and hence in terms of the theater more nearly democratic, can appeal simultaneously to the "boisterous butchers, cutting cobblers, hardhanded masons" and "the best of the nobility and gentry." Subsequently the chaff is winnowed from the wheat. The old refectory of the Blackfriars, equipped with seats and artificial lighting, is converted to a private theater whose more select patrons are no longer exposed to the vagaries of the weather or the stinking breath of the plebs whom the price of admission effectively excludes. The talents of boy actors are successfully exploited, like the Children of the Chapel whose habit is to "berattle" or abuse the public stage. "Do the boys carry it away?" Hamlet inquires; and is answered: "Ay, that they do, my lord, Hercules and his load, too"—a dispirited reference to the sign that hung before the Globe, a public theater, and exhibited Hercules bearing the world on his shoulders.

The medieval audience is heterogeneous and that is better for the commonweal, hence better for the play. Exclusivity breeds narrowness of vision. But Nashe in SUMMER'S LAST WILL AND TESTAMENT is writing evidently for private performance, and in this case—as the author is opening himself to his friends—the play is more assured for the exclusive *mise-en-scène*. Though Webster is very sore at the want of "a full and understanding auditory," it is in a public theater that THE WHITE DEVIL is first performed. "The breath that comes from the uncapable multitude"—living perforce on herring and onions—is not sufficiently noxious to poison the play. The split between private and public is consequential for the future—it is worth our asking: Who goes to the theater today?—but it does not serve, or not yet, to obliterate the character of dramatic representation as a living thing felt on the pulses.

The new theater, like the old, and whether public or private, is a multilevel structure. At Paul's or Blackfriars the audience is thankful in that it has a roof above its head. The audience at the Globe is not so lucky. The stage butts on a gallery ascending to the rear—from which Bel-Imperia in THE SPANISH TRAGEDY can look down on Hieronimo emoting in the arbor. The "heavens" or "shadow" that overtop the stage admit, as in *Cymbeline*, of the majestic descent of Jove, lowered like St. Paul in his basket. From the topmost tier of the galleries the pennant flies, announcing the afternoon's performance; the modern equivalent of the *vexillator* blows his trumpet: and Prospero "on the top" appears, like the God of the mysteries, accompanied by "solemn and strange music." Far below, in the floor of the stage, trap doors open on a subterranean area whence fog billows up, as in ARDEN OF FEVERSHAM, and the distillations of Subtle in THE ALCHEMIST are exploded.

Properties remain metonymic. The scene is suggested in one spectacular detail, like the golden cage in which Bajazeth is trundled or the tree with golden apples that emblematizes the contest between Vandermast and Friars Bacon and Bungay. Costumes are resplendent, as on the medieval stage—Gaveston in EDWARD II "wears a lord's revenue on his back"—and as careless as before of historical decorum—the imperial characters of Massinger's THE ROMAN ACTOR are well-attired gentlefolk, not of antiquity but of the London of Massinger's time. The memorable scenes of Renaissance drama still preserve their independence of technical gimmickry. Even after the triumph of "mountebank" Jones, they turn almost wholly on the intelligent use of an uncluttered stage.

Jonson, in the middle scenes of VOLPONE, illustrates superbly. The ambiguous hero, feigning deathly illness, lies on his bed in the alcove or inner stage. The curtains or traverse conceal him from sight on the unlucky entrance of the ingenuous Bonario. How to get Bonario out of the way? The task falls to Mosca, who hides the young man behind one of the pillars that hold up the "heavens" or thrusts him in at a door, left or right rear. Enter at this point the legacy hunter Corvino with his young and desirable wife. Mosca converses with them momentarily on the center apron, then man and wife "retire to one side" and talk together. Corvino departs. The parasite instructs Bonario to "walk the while Into that gallery at the upper end"—the balcony or second level above the inner stage, accessible through the doors that lead to the green room. Now the peak moment is at hand. Volpone, throwing aside the curtains, throwing off his pretended sickness, attempts the rape of Celia. In the nick of time, Jonson makes Bonario "leap out from where Mosca had placed him."

It is a great *coup de théatre*. Lustful purpose is foiled, and the proposition reaffirmed that the meat and drink of living theater is not verisimilar representation but

simultaneous action and the concurrent exploiting of different levels and parts of the stage. These resources are available already to the medieval playwright. He does not have at command the skills of the new professional companies like the King's Men or the Admiral's Men, but he has what he needs to have for the making of sufficient drama.

This is not to gainsay the importance to the theater of the Renaissance of humanistic scholarship or Italian comedy or the classical matrix from which it derives. Only it is to claim priority for the medieval matrix. Not until the erecting of the proscenium arch in the early years of the seventeenth century does the scene begin to alter.

John Lyly is a harbinger of the changing scene but not so much in stagecraft as in language. The Euphuistic movement Lyly inaugurates or makes notorious with the publication in 1579 of the cloying novel called *Euphues* or *The Anatomy of Wit* is signalized by the elaborate use of parallelism, analogy, antithesis. The style affected by Lyly and his epigones—Shakespeare among them in *Love's Labor's Lost*—is a highfalutins style and easy to ridicule—but only as one considers it with the eye of hindsight. The manage of that style— the metaphor from horsemanship seems congruous— needs a sinewy arm and a mind turning over. Lyly's comedies of the 1580s, written mostly for the popular companies of boy actors, constitute the forging house of Elizabethan rhetoric. Already in GALLATHEA there begins to emerge the disciplined and graceful utterance, the exactitude of phrasing that one associates with the greater dramatists of the seventeenth century. Lyly's language seems a parody made after the fact: Falstaff imitating King Henry. But that is because the palace of language is not entered through niggarding but first of all through the gates of excess.

Lyly's contemporary George Peele, his younger colleague Thomas Dekker, show us how this is so. In plays like DAVID AND BETHSABE, Peele is trying his hand at the fashioning of a new linguistic instrument for the purposes of theatrical declamation. He is the type of the opportunist—by no means a pejorative word when used of language—absorbed in the process of manipulating words. The entail of this process is the creating, even before Marlowe, of that blank verse line that is the vehicle now, not only for the poet in his closet, but also for dramatic give and take.

When Dekker in THE SHOEMAKER'S HOLIDAY wants to approximate the language of cultivated persons —or possibly to make a parade of words—he resorts to the formal bantering called *stichomythia*. Two characters—let them be Hic and Ille—engage in verbal altercation. One speaks a line of verse; the other answers, capping the rhyme:

H. Why do you stay, and not pursue your game?
I. I'll hold my life, their hunting-nags be lame.
H. A deer more dear is found within this place.
I. But not the deer, sir, which you had in chase.
H. I chased the deer, but this dear chaseth me.
I. The strangest hunting that ever I see.

The performance is anguishing. Dekker is applying the screws. But the violence he does to language has an unexpected issue. The more the writer is committed to artificiality in the beginning, the more spontaneous or natural-seeming will be the utterance he engenders, and even if, like Moses, he is only prophetic of it. Nashe is more than prophetic, but the same comment holds of his willful torturing of language. Shakespeare stands on the shoulders of Lyly and Nashe. Being natural, as Oscar Wilde makes a character observe, is so difficult a pose to keep up. The point is that the pose requires practice.

There is this further point: when language is highly stylized, virtuosity is everywhere to the fore. The playwright is pulling the strings and desires our witnessing and applause. When on the other hand he is seeking to rouse our emotions, he takes pains to conceal himself and his expertise. In tragic drama, he is invisible like the god of the creation. In comic drama, he is all brazenly the "god from the machine." Plot is conspicuous and turns on contrivance, characters are submerged in their extravagant function, attention to rhetoric is overt.

The cartoons Dekker sponsors take part in a romantic action that relates to life only incidentally. What Dekker is casting for is "fine tickling sport." The ultimate sport is the resolving of the riddle, a mathematical exercise and independent of volition. We need a *deus ex machina* to do the business for us. Dekker in the last act of the play suggests how this need will be met: "Enter the King and his train over the stage."

Though THE SHOEMAKER'S HOLIDAY smells of the East End of London and cheers us with its inoffensive smut: "she shall be laid at one side like an old pair of shoes"—where "she" is a wife bereft of her husband—"and be occupied for no use," though the play is interstitially a real and homely thing, it is essentially a well-turned machine.

The machine is still running four hundred years later. Its arbitrariness is, however, apparent when we compare it with the work of a more "organic" maker, like Greene in FRIAR BACON AND FRIAR BUNGAY. Greene looks to be writing the standard slick romance. And in fact, he is a great caterer to the prevailing fashion: see his essay, with Thomas Lodge, at exemplary drama, A LOOKING GLASS FOR LONDON AND ENGLAND. Like Dekker, he takes us from the cottage to the court. That is the indicated progress and is guaranteed to please. But his plot, or double plot, is a red herring. Though the major persons in each comedy undergo a radical change, the change in Dekker is exterior, a matter of clothing; in Greene it is intrinsic, a matter of character.

Beaumont in THE KNIGHT OF THE BURNING PESTLE is also exploiting disguise. Rafe, the grocer's apprentice, lives a lie. In this, he is potentially tragic. But the delusion of the hero is productive of laughter alone. We do not learn from his quixotic behavior that "there is no darkness but ignorance." Incongruity in Beaumont's play is not the means to an end but the end in itself. Beaumont thinks the middle class is amusing

as it is so little *au courant*. In Dekker, the middle class is exalted. Better a poor man's wife than a king's whore! Each playwright is more keen on riding his hobby horse than on depicting the foibles appurtenant to us all.

The astute maker of formulaic comedy will insure that all friends taste the wages of their virtue. MUCE-DORUS, a naive parable of the testing and rewarding of virtue, is the most popular of Renaissance comedies—it goes on, in its own time, like *East Lynne*—as it sticks so closely to convention. This implies, perhaps requires, that the testing is adventitious, the rewards are parceled out, the protagonists on whom they drop are not deserving but only lucky. Desert argues recognition.

First-class comedy begins with the delighted discovery of inapposite conduct but that is not where it ends. Already in the 1580s, Greene knows where it ends. He is not a comic dramatist of the first class. His humor is not so sophisticated as Beaumont's, his style is the old-fashioned aureate style—anybody's possession—not indelibly personal like the style of Thomas Nashe. If we laugh at the testing of his heroine, that is not as he would wish us to laugh. But Greene aspires to the seriousness that is the line of division between genuine comedy and farce. His deluded persons find out at last who they are. Friar Bacon, the white magician who assumes the role of God, breaks his wand as the depth of his opacity is borne in upon him. The resolution of the plot coincides with the doffing of disguise—not spectacles and wigs but mistaken identity. Iago will say, also Viola in *Twelfth Night*: "I am not what I am." Disguise in Robert Greene is more than skin deep. The romantic comedies of Shakespeare are predicted.

Greene is vastly inferior to Shakespeare. But the leap from Greene to Shakespeare is conceivable. The greater issues perceptibly from the lesser. This means that Renaissance comedy flowers quickly and makes a continuum. That is not true of Renaissance tragedy.

Early essays in this kind seek to take strength from the classical past and are enervated by it—GORBODUC, for instance, by intention a reprise of Senecan tragedy but surviving today largely for "historical" reasons. Sackville and Norton, the authors of this first attempt in English at the writing of dramatic blank verse, initiate the error that learned partisans of the theater have been compounding ever since. Essential Seneca is the tragic vision and lies outside their ken. Inessential Seneca is the unpropitious form—we call it closet drama as the closet is its proper preserve—and on this they rivet their attention. The form of Senecan tragedy is inimical to theater, unless in the hands of a great poet like Racine. Stasis describes it. Action is recapitulated after the fact—huddled up unnecessarily, Kyd and Marlowe will decide. The Chorus or Ghost or Nuntius does duty for ocular proof. That is partly because Seneca is a fastidious playwright, partly as he is emulating Greek drama. Horrifying incident is pervasive in what he writes. Possibly, he thinks, telling is better than showing?

Thomas Preston in the 1560s, a meretricious entertainer whom one sees as always counting the house,

does not think so. For the wrong reasons, Preston turns out to be right. CAMBYSES, his bastardizing of Senecan tragedy, is a revolting play and a portent of great things to come. Preston's achievement is to enact on stage the violence which Seneca consigns to report. The wicked king Cambyses is accused by his advisor Praxaspes of drinking to excess. To disprove the accusation Cambyses orders that the little son of the advisor be stood before him as a target. If the king is drunk, he will fail of his aim. The king is sober, if just sufficiently.

> I have dispatched him! Down he doth fall!
> As right as a line his heart I have hit.

But Cambyses—or Preston—has another card to play. "My knight," he says, "with speed his heart cut out and give it unto me." The knight, complying, hands over the heart, presumably a bladder filled with animal's blood. The audience is stupefied. This is revolution.

Two decades later Thomas Kyd, whose invention is dedicated to going Preston one better, concludes the greatest theatrical success in the whole repertory of Renaissance drama with a quarry of the slain that, for vulgar ferocity, is more like truth than fiction. Kyd takes the honors among writers of his time in accommodating Roman Seneca to the Elizabethan stage. He creates, in the process, the tragedy of blood. It is not possible to overestimate the impact of THE SPANISH TRAGEDY. Of its numerous progeny, *Hamlet* is only the most famous.

Both Kyd and Shakespeare are writing Senecan tragedy. Each of them, in the beginning, elects to focus on revenge and the horrors attendant on it—the sinister mumming of the Play-within-the-play, the Dumb Show in which murder is emblematized, the Ghost who, like Lazarus, has "come back to tell you all," the madness of the hero, real or feigned.

Here Kyd and Shakespeare go their different ways. Hamlet is mad as he falters beneath the burden of the mystery. Hieronimo is mad in fulfillment of the exigencies of the plot. Hamlet is a veritable protagonist who harrows us with fear and wonder, Hieronimo a stick figure whose antics are intended solely to tease our nerve endings.

But *Hamlet* and THE SPANISH TRAGEDY have this in common: each, building on Seneca, repudiates his static form in favor of vigorous action on stage. We do not gather from hearsay that Hieronimo has stabbed the Duke of Castille or Hamlet the King of Denmark. We see the business—and so we avouch it. In Kyd it is factitious business. But the pointless hurly burly of THE SPANISH TRAGEDY, as it is not simply reported but represented, is decisive for the greater art of the seventeenth century.

In the years just before and after the new century begins, nostalgic writers like Fulke Greville, Samuel Daniel, Jonson in two plays invoking "the reader extraordinary," seek to exhume the pure Senecan model. Luckily for the future, it is Kyd's impure amalgam that carries the day. If we, to whom Renaissance drama has come down, are the beneficiaries of

Kyd, how are we lucky? The answer is that living theater is not language alone. The heroes and heroines who dominate in the theater of the seventeenth century are apt to strike us in cold print as so many ephemerids. But the vengeful or splenetic man, the glosing courtesan, the honest whore, the roistering young woman with a heart of gold are more than the words that denote them not simply because Tourneur and Marston and Dekker and Middleton are more talented than Kyd but because these writers have gone to school to the author of THE SPANISH TRAGEDY.

Sometimes what they learn is flummery, as when Shirley in HYDE PARK parades real horses over the apron. We are on the way to *Fanciulla del West*. Jonson is more tactful in BARTHOLOMEW FAIR as his art is less realistic than mimetic. But Jonson, when he has got down from his high classical horse, also craves the witnessing of our eyes and ears. As to the story Heywood wants us to swallow in A WOMAN KILLED WITH KINDNESS, we would not take it from report. It is a groatsworth of vice with a million of repentance. Beaumont and Fletcher, assuaging easy tears with raucous laughter, are more practiced in legerdemain, and that is what A KING AND NO KING comes down to. Credibility goes to either play as adulterous passion is bodied forth on stage. The bodying forth is Kyd's signal contribution. Failing it, we should leave the theater, like the skeptical Didymus, shaking our heads in disbelief.

To say that the play's the thing is to say that a chemical transformation occurs when the words on the page are handed over to the players. Shakespeare is not better when we read him in our study, but wanting a dimension. Charles Lamb, contending for that passive view of drama, is wrong. It takes two to make a quarrel, more than two to make a play. The drama is public communion and the playwright one of many who participate in its creation. The lyric poet works alone. His achievement is not necessarily less considerable than that of the dramatic poet. But it is a different kind of achievement.

The Renaissance playwright who learns from Kyd to appeal to our senses tends in his solicitude to confound them. Like his medieval antecedents, he is mostly a panoramic playwright. The representation he wants to set before us is a total representation. John Ford does not chronicle the fall of Perkin Warbeck but first the rise and then the fall of that unlucky pretender. The risk he runs is of dispersing our attention. Senecan tragedy declines the gambit.

The *Hercules Furens* focuses narrowly on the consummating of a single and compendious design. As the play begins, the labors of Hercules are already behind him. The austerity that is willing to ignore such spectacular material just because it is impertinent material comes hard to the Elizabethans. Their eye is not so often on the whole as the parts. How relevant is the encounter of Theridamas and Olympia to the central action of TAMBURLAINE? Marlowe, whose play is a tissue of interpolated scenes, might answer that it makes a good story.

But another and more cogent answer is possible. The proliferating of incident, the refracting of the single plot are productive, at last and at best, not of confusion but complementary action. The subplot of the lustful idiot or Changeling in the tragedy by Middleton and Rowley illuminates the lustful business that deranges the major persons of the play. The comic anarchs or clowns whom Ford admits to PERKIN WARBECK comment in their folly on that greater anarch who is the equivocal hero and who, in a play that pays homage to the Unities, would hold the stage alone. Panoramic drama in the hands of its greatest practitioners confesses a unity that is more than formal, the unity of similar cause.

The forging of this unity makes an absorbing story. Marlowe in his brief and dazzling career struggles with the intractable data of history in the attempt to discover from the ebb and flow of things a pattern that is not imposed but organic. The two parts of TAMBURLAINE, the tragedies of Dido and the Guise, THE JEW OF MALTA, DOCTOR FAUSTUS, record his partial failure.

Failure is relative. Better to fail with Shakespeare in *Cymbeline* than to succeed with Dryden in *All for Love*. Earlier attempts at locating form in historical material —which is by definition formless—plays like the *Famous Victories of Henry V*, *The Troublesome Reign of King John*, Thomas Legge's Latin chronicle of *Richardus Tertius*—merit speedy interment in a footnote. Marlowe's failure is heroic. The great scene exerts its fatal fascination. It is something to be tempted. Marlowe's predecessors are secure as their stature is so much less than his. What they make is humdrum. Marlowe makes the mighty line and it reverberates forever. But in his work the sense of ineluctable progression, in which the ending is predicable of the beginning, goes by the boards.

The tragic history of EDWARD II is Marlowe's closest and most successful approximation of dramatic coherence, as opposed to the stringing together of a series of incandescent speeches. From the welter of miscellaneous detail that is his primary source— Holinshed's *Chronicles of England, Scotland, and Ireland* —he is canny enough to pick and choose, to aggrandize and depress. The result is tragedy that makes a total configuration. It is an inestimable achievement. Shakespeare is greater. But Marlowe comes first.

Marlowe and Kyd are close contemporaries whose paths cross sensationally in the year of Marlowe's violent death. It is Kyd who brings the charge of heresy against his fellow dramatist. But the connection between those two is only chronological, hence a fortuitous connection. Marlowe as a writer of tragedy is the genuine article. Kyd differs from Marlowe not in degree but in kind. Only a few years separate THE SPANISH TRAGEDY from DOCTOR FAUSTUS and EDWARD II. But in these years a quantum jump occurs. One can describe what happens. To account for what happens is harder.

Abraham and Isaac is a better piece of work than much of the brummagem stuff that survives from the

sixteenth and seventeenth centuries. In this play, how-ever—in every medieval play—God is always present, on stage or in the wings, to redress the balance. The makers of tragedy in the Renaissance, even when they have got to their wit's end, do not rely on the inter-position of God. Their religious persuasion does not matter. In last things, they are agnostic or Manichean. Massinger was perhaps a Catholic, Jonson and Shirley both Protestant and Catholic, Marston subsequently an Anglican priest, Chapman a Stoic, Marlowe an atheist, and Shakespeare everything and nothing. When they enter the theater, they leave the church behind. In Renaissance tragedy, no one follows Everyman into the grave. No one ventures to say what lies over yonder.

The source of this bleak taciturnity is moot. To invoke the classics is conventional. *Vide* the fall of Constantinople in 1453: "the second death of Homer and of Plato," Greek scholars trekking westward and bringing with them these sacred relics, Humanism edified and rising, the tragic afflatus rising with it. The vulgarity of this sequence, as it offers to explain, is apparent. There is a chain and also a missing link. Shakespeare did not know Sophocles and is closer to Sophocles in spirit than is Euripides, his fellow Greek.

But Shakespeare knew Seneca, so did everyone else (the publishing in 1581 of the so-called "Ten Trage-dies" is like a shot heard round the world), and though this fact is not strictly causal it is elucidatory. For Seneca is a mirror in which Renaissance tragedy reveals its essential features, and like a mirror or concave lens he does more than reflect: he gathers the light and transmits it. The Elizabethans discover their own lineaments in him, but this discovery not only corrobo-rates: it is itself a creative act, as when we say that images fresh images beget.

What Seneca sees, and the Elizabethans have glimpsed already, is the death of a countervailing good-ness. *Deus absconditus.* Seneca says to the Roman poet Lucretius: "we have made everything into darkness for ourselves" (*omnia nobis fecimus tenebras*). Like the medieval playwright he stresses human culpability. But in medieval drama the darkness, though self-imposed, always lifts at the end. The characteristic movement, as in Dante's *Commedia*, is upward from darkness to light. In Seneca's *Phaedra*, in his *Thyestes*, good meets evil and is borne under by it. Why is that?

In the *Hercules Oetaeus*, a woman maddened by jealousy tells of the wild beasts she harbors within her. Chapman in BUSSY D'AMBOIS, remembering this passage, sees it as definitive of our natural condition. Men are not "in human state Till they embrace within their wife's two breasts All Pelion and Cythaeron with their beasts." We want to remember that it was on Mount Cythaeron that Oedipus confronted the Sphinx.

Medieval man is sufficiently cognizant of the beast who journeys with us. The story of Tristan and Ysolt says it all. We are yoked to a roaring lion: the judgment of St. James the Apostle. When Seneca's Thyestes attests to our vagrant nature—"Out of experience I speak: one may choose ill fortune in preference to good"—he might be echoing St. Paul.

But the Christian Middle Ages are sustained in the conviction of grace abounding. It is precisely this con-viction that is wanting to Seneca as to the tragic dramatists of the Renaissance. Simply as we are men we put on the shirt of Nessus, commend the poison to ourselves. That has always been true. But now abruptly there is no succor. Chapman's heroine Tamyra, aware that even the sun cannot shine at pleasure, asks a question to which the answer is foreordained:

Oh, how can we, that are but motes to him . . .
Disperse our passions' fumes with our weak labors?

Out of this awareness, the rhetoric of high tragedy is made:

Man is a torch borne in the wind: a dream
But of a shadow, summed with all his substance.

Tragedy is daunting as it leaves us naked to our enemies. But tragedy is inspiriting as it presents the naked man against the sky. We are deflected but in-violate. In Seneca's *Medea* the tragic heroine is utterly lost. "Of all your great resources nothing remains." But the Nurse, who proffers this bitter truth, is answered: "Medea remains!" Integrity in the final toils is the possession of Webster's heroine, hence-forward our possession, as when she cries: "I am Duchess of Malfi still!"

Shakespeare seems to suggest that we are caught in the toils as we make our will lord of our reason. Perhaps an alternative is available to us? But the difference between Shakespeare and the others who are his satellites is only ostensible. Always, the vicious mole of nature is triumphant. The pales and forts of reason go down. "But oh, vain boast! Who can control his fate?" The fate Othello hypothesizes is not dispensed from Olympus, as in the melodramatic fiction of Thomas Hardy. It is an emanation of ourselves. "Man's character is his daimon," Heraclitus observes, and from this daimon there is evidently no escape.

In one particular, Shakespeare does really stand apart. Though the tragic denouement with which he confronts us is sufficiently dour, what happens in pre-face to it is felt as illustrative or contingent. In the tragedies of his contempories, meaning is elusive. Fact is exhausted in its own spectacular being. THE WHITE DEVIL, THE DUCHESS OF MALFI are replete with incongruous figures. Oxymoron describes them: the forcible associating of immiscible things. "You speak as if a man should know what kind of fowl is coffined in a baked meat before you cut it open." "Could I be one of their flattering panders, I would hang on their ears like a horse leech till I were full, and then drop off." In Shakespeare, language is bizarre to light up the dis-junction between the norm and the perverting of the norm. Macbeth calls his lady and accomplice "dearest chuck." In Webster there is no disjunction because there is no sense of declension or falling off. Horror is the norm. Hence the language is unexpectedly con-gruous. The Psychomachia or war of vice and virtue is given away. Webster disbelieves it and so it is unavail-able to him. Life is independent of moral agency or

choice. The Duchess of Malfi is destroyed not as she is moral or immoral but as she ventures to move in the world. The world, a bad dog, turns and rends her. The wilderness into which she is going is life itself.

If moral choice is irrelevant, the possibility of conflict is aborted. It is idle to speak of results. There are only events. No motive impels the hero or hero-villain. He is. The tragedy in which he figures is sound and fury. This is not to depreciate the art of John Webster, who is preeminent, also characteristic in his time—except that preeminence argues idiosyncrasy. To define is to delimit, also—as the definition is truly catholic—to praise. What is lost has been spoken to, what is left—by no means dregs and lees—is the untrammeled personality: megalopsychia or greatness of soul.

What claims and reservations are enjoined on us, who are the auditors, by this residual greatness? A sufficient answer will acknowledge that in Renaissance tragedy—always waiving Shakespeare, who is a vagrant star—we do not levy on moral judgment to censure or approve. Worth in the protagonist is a dependency of his caloric quotient. That is true for Marlowe and Chapman and Ford. Like Webster they put their money on one tremendous effect. They can do no other.

> The glory of my deed
> Darkened the midday sun, made noon as night.

But Giovanni in the final scene of ' T IS P ITY S HE ' S A W HORE is communing only with himself.

Kyd is a clumsy playwright who cannot manage without resort to cheap contrivance. Arbitrariness is at the heart of Websterian tragedy but not because Webster is clumsy, rather as he has no answers. We are here as on a darkling plain. Coincidence in Webster is not an expedient but a principle.

It is possible to see Kyd as an amiable man with a living to make, the shopkeeper type or *genus Britannicus*, who is shrewd enough to estimate the utility of trading in horror. Webster is not amiable nor does he dramatize horror because he thinks it will cash. His despairing vision is alien to Cyril Tourneur, whose name is always linked with Webster's but whose fundamental bias is radically different. Tourneur delights in horror for its own sake. He is the poet laureate of the Grand Guignol. One does not say of him, as perhaps of Kyd or Preston, that he wouldn't hurt a fly. Tourneur is nasty in the grain and that is the source of his continuing vitality.

Of the two plays attributed to him, *The Atheist's Tragedy* is the less successful—necessarily, for the whole bag of tricks had already been opened. What Tourneur does can be done only once. The Turkish caliph who puts his siblings to death is unattractive, and stands alone. To have no successors is a measure of Tourneur's greatness, also his limitation.

In T HE R EVENGER ' S T RAGEDY , the most macabre of the tragedies of blood, this jejune and talented writer reaches for immortality and achieves it. The achievement is narrow and correspondingly intense. Palpable virtue eludes him. The chaste sister of the revengers is a chess figure whose maneuvering or testing is meant to entertain. Evil is Tourneur's forte as it pierces to the quick. What he spreads before us, like a self-conscious craftsman delighting in his wares, almost hugging himself as he displays them, is a disinterested panoply of evil. Were we to recoil, as from the blinding of old Gloucester or Oedipus the King, we should frustrate his purpose. He wants us to attest to the harmony of the design. In this harmony he creates, murderous egoism is the common chord. It does not make for trepidation but applause.

The misogyny of *Hamlet* is corrosive. In Tourneur it is a flattering unction. Wives are made to go to bed and feed. Never tell a woman a secret overnight: your doctor may find it in the urinal in the morning. Any kindred, next to the rim of the sister, is men's meat in these days. Ford will make the reservation obsolete.

From the tragedy of blood, as opposed to the tragedy of terror like T HE D UCHESS OF M ALFI and *King Lear*, real flesh and blood are resolutely excluded. What Vendice calls "sweet occasions" take precedence. Their contriving, as in comedy, is an intellectual exercise. The Revenger, exclaiming pleasantly, "sa, sa, thump" as he stabs the old Duke, is committing violence on a mannequin. Comparison is proper to the machinations of Barabas and Ithamore in T HE J EW OF M ALTA . In either case, the right response is jocularity. Summing up his villainy for the benefit of those who are still left alive, Vendice observes complacently, "'Twas somewhat witty carried." The auditors are supposed to agree. Of course this agreement is perverse. People are not to be treated as things. But that is how Tourneur treats them and so long as he holds us in the grip of his monstrous and dispassionate *jeu d'esprit*, it is hard to complain.

There is this endemic difficulty in founding one's art on sensation. With each electrifying triumph it is necessary to step up the voltage, as the sensibilities of the audience grow progressively more jaded. Ford in *The Broken Heart* mines sexual frustration to make a powerful if overheated play. Perhaps in the carnal love of a brother and sister a richer lode is potential? Colonel Bob Ingersoll, that whimsical agnostic, stands on the stump before a crowd of true believers and dares God to strike him dead. Consternation reigns. But where does the blasphemer go from there? What is horrifying to Preston and Kyd is already old hat to Marlowe and Tourneur and embarrassing to James Shirley, to whom the obsequies of the drama are entrusted. The tragedy of blood, like an insatiable cormorant, preys on itself.

Well before the mid-seventeenth century, the distinction has begun to blur between the burgeoning horrors enacted on the London stage, which still claims title to be the custodian of form, and the haphazard carnage of the bear pit and the cock pit and the bull ring, all of them contiguous to the old Globe Theater in Southwark. Tragedy originates in these squalid places, down there on the bestial floor, and is always in danger of reverting to its origins. As the saving gulf is obliterated between art and life, dumb animals do not suffice any longer to slake the taste for blood. Men and women are gored and baited and tossed on the horns.

The Unnatural Combat, the title Massinger chooses in dramatizing the hideous tale of the Cenci, is the right generic title for the drama in the years of its decline. The Great Rebellion of the seventeenth century, which culminates in the beheading of the King—life imitating art—is generally represented as putting period to Renaissance tragedy. It only administers the *coup de grâce*.

Comedy dies harder and is still flourishing in England long after the Protector and his Presbyterian killjoys have compelled the closing of all theaters. That is partly because comedy, even at its highest pitch in Shakespeare and Jonson, does not require the participation of human beings in the round, who seem to act out their story independent of the god from the machine. In Renaissance comedy, as in the morality plays whence it derives, the protagonists are "all frail." It is up to the playwright to conduct them to salvation. To a degree he also is treating people as things.

Sometimes Shakespeare belies the proposition. Falstaff is comic, and autonomous. Pistol, Nym, and Bardolph are, however, "humorous" characters, not more voluntaristic than Jonson's Bobadil or Beaumont's Merrythought or Touchwood Senior in Middleton's A Chaste Maid in Cheapside. Mostly, Shakespeare is assimilated to his contemporaries in the making of comedy. Like the rest, he is Augustinian or Calvinistic in his psychology. By fiat he arranges that "tempests are kind and salt waves fresh in love!" The denouement to which he treats us— saying, in effect, "what you will"—is almost always a little cursory, it is even faintly contemptuous. "The man shall have his mare again, and all shall be well." But this negligent saying is instinct with affection— here he takes leave of Augustine and Calvin—for the aberrant characters who are in the playwright's charge, for the world these characters inhabit.

The Comedy of Humors is the agreed-on domicile for characters whose innate bias or want of sufficiency incline them to "run all one way." Over this domicile, Ben Jonson is supposed to preside. But Renaissance comedy from the beginning, and once more on its recrudescence in the late seventeenth century, is essentially the comedy of psychological determinism— or say, to be less emphatic: the capacity of characters envisaged by Marston and Chapman and Massinger is likely to be exhausted in the names these playwrights assign them. The substantiality of Allworth or George Downright in Jonson's *Everyman in His Humor* or Mr. Haircut in Shirley's comedy *The Lady of Pleasure* is not more in question than that of Abstinence or Chastity in *The Castle of Perseverance*. This suggests that the play as a total congeries is more than the cartoons it assembles and stakes out its claim to be real in ways independent of conventional reality.

Jonson, after Shakespeare, is the premier comic playwright of the Renaissance. But he is not *sui generis*, except in point of talent. This is not to blink the surpassing greatness of plays like Volpone, The Alchemist, Epicoene, Bartholomew Fair. Only it is to locate them.

Jonson's comedies are normative as character is fined down, normative also as they give their allegiance less to life than art. Mosca the fly is artistic as he fashions "the foxtrap," Jonson as he is the rhetorician par excellence. The hyperbolic speeches of Volpone and Sir Epicure Mammon are not accessible to traditional criticism, which is always talking about truth to life. In Jonson's plays, we are proffered a golden alternative. Villainy is transmogrified by language, and so moral judgment is effaced. Lovewit in The Alchemist speaks for us all: "I love a teeming wit as I love my nourishment."

Bitter business is pervasive in Jonson, and denotative of Jacobean comedy as a kind. Compare Chapman in The Widow's Tears. But as the play is a convention that abides by its own set of rules, the acrimony does not infect, at least it does not cancel the humor. The given in Volpone is the ancient game of legacy-hunting. Already the Romans have a name for it: *captatio*. The beauty of the game is that it engages the intellect alone.

The dramatis personae who figure in this game are incapable of suffering. If we prick them, they do not bleed. It is a source of relief to us and insures that aroused emotion does not distort the cold brilliance of the playwright's design.

In Elizabethan refurbishings of the old biblical drama, like Lodge and Greene's A Looking Glass for London and England, design means *parti pris*. The authors are jealous of our salvation. Anyway, that is what they want us to think. Design in Jonson, as mostly in the comic dramatists of the Jacobean and Caroline periods, is consummated in the enacting of an amoral conflict between knaves and fools. By custom, Jonson is designated a satirist who scourges our vices with a view to correcting them. It is more nearly just to present him as a savage ironist who sees and dramatizes social intercourse as "little more than the crimes, follies, and misfortunes of mankind." Perhaps in the ending of his plays vice is punished. If virtue is not often triumphant, that is because it is in scanty supply. More impressive and more pertinent is the hoisting of the engineer with his own petard. Like the villainous Subtle—but who dwells on the villainy?—Jonson aims to "blow up gamester after gamester, As they do [fire]crackers in a puppet-play."

Because Jonson is writing comedy, we laugh. Because a moral is incumbent upon him, he provides it. But the moral is *pro forma*. Are we edified by the conclusion of The Alchemist? The "moral" of Volpone is not that money is the root of all evil—a prescriptive saying, in its implication—but that "Money is the world's soul." Jonson, seeing so much, is satisfied to report. The fun is in the verifying of the observation. No sequitur follows.

In the illegitimate form known as tragicomedy, prescriptive sayings abound. So do salacity, melancholy posturing (always mixed judiciously with mirth), horror (but always nipped in the bud). The playwright is not reporting, like Jonson, but confecting. His confection is various, it is also bland. The idea is to insure

that everyone is satisfied, concurrently that no one is offended. Tragicomedy, says Fletcher, who is its most adroit exponent, "is not so called in respect of mirth and killing but in respect it wants deaths, which is enough to make it no tragedy, yet brings some near it, which is enough to make it no comedy." The definition, as it is translated to fact, enables the audience to have its cake and eat it.

The greatest writers of the Renaissance, and not only in England, seem to be paying homage to this dubious aesthetic. Characteristically, their art is a hybrid art as it yokes together genres or kinds that by convention are disparate. (It is the same in the art of their medieval forebears.) The result is a repertory of tragic and comic drama that is still sustaining us, four hundred years later. The result is not really surprising if, like Shakespeare in *The Two Noble Kinsmen*, one is taking for his pattern the crazy quilt that is our common experience. Truth to life, read prosaically, read myopically, is just as inapposite here as in the enameled verses of Ben Jonson. If "God's own truth is life"—what the poet Patrick Kavanagh asks us to accept—the equivalence will include "even the grotesque shapes of its foulest fire."

In *The Two Noble Kinsmen*, perhaps in *Henry VIII*, Fletcher collaborates with Shakespeare. (That is the conventional view, although it has been questioned.) When he goes it alone, as in the tragicomic *Philaster*, he sets himself to give us all the gloom of *Hamlet* but titivated with a happy ending. He also is making a hybrid but not as he is looking at life. His eye is on the box office.

The waning of dramatic integrity—as the drama of the Renaissance, like any other phenomenon in fee to time, moves downward to entropy—is not, however, to be read in terms of cupidity. The drama is in straits—so is the novel, so is pictorial art—as it eschews mimetic representation in favor of verisimilitude, which is truth to life conceived simplistically. With respect to the tragedy of blood, the point need not be labored. But the same point is unexpectedly tenable of elegant diversions like the pastoral and the masque. Bric-a-brac is "real" and so are gouts of blood. For each, the formula goes: the more real, the less lifelike.

Lyly, who expunges as he can every vestige of corporality from his plays, is verging—sequentially—on the writing of pastoral; so is Peele in *The Arraignment of Paris*, a rarefied composition and hence contrasting nicely with the horrors Peele indulges in his *Battle of Alcazar*. Daniel, taking as a model Guarini's *Pastor Fido*, than which no play was ever less in debt to reality, disposes mock shepherds in an artificial landscape. He is making good our flight to Arcadia or Eden's garden before the fall. Fletcher, in *The Faithful Shepherdess*, as he senses our growing ennui (for once that old chestnut, the "Jacobean temper," has its uses), so attenuates flesh and blood and probability that we need never advert to the vexatious business which is life outside the playhouse.

But exactly as real business is attenuated, the simulacrum of real business is enlarged. What we see is

nonsense, Fletcher's chastely erotic heroine who lives beside her lover's tomb, but this nonsense is presented with meticulous attention to detail. That is how the bucolic Peele and the sanguinary Peele come together. The common denominator is adherence to the truth that abides in superficies.

The fascination with this truth explains the vogue of the masque, a courtly entertainment excelling in novel and spectacular representation and relegating the drama, which one wants to distinguish from "theater," to the role of a picture frame. Jonson, who is preeminent as a writer of masques, dislikes the relegating and says so. His collaborator, the designer and architect Inigo Jones, dismisses the protest. As he is constant to the bent of his genius, Jones is right. But the vindicating of that genius is the death of the play, which dwindles to a production. Jonson, composing masques for the court of King James, is still primarily a playwright. A generation later, Milton writes *Comus* and calls it a masque. But Milton is wholecloth a poet.

The contention of genuine drama with other and inimical forms of entertainment is resolved or stifled in the closing of the theaters. The resolution is on one side untimely. For the drama, even in the years of its decadence, is not wholly petrified and has in fact begun to quicken just as the ax is laid to the root. This quickening is manifest in the growth of social comedy. Shirley in HYDE PARK and in *The Lady of Pleasure* is writing social comedy as his attention is more to manners than to plot. The accenting or attending is auspicious for the future. In the history of the drama, nothing wholly dies. The present is renewed as it looks to the past; at the same time it makes ready its own supercession.

In the new kind of play, which Fletcher executes triumphantly in THE WILD-GOOSE CHASE, ancillary characters still approximate to straw men. The footboy who enters grumbling as the play begins is only the truculent servant of the *Commedia dell'arte*. The mechanical exercise that is the snaring of the wild goose is more on Fletcher's mind, as he is what he is, than the moral situation in which his feckless hero is involved.

But after all what we remember in the comedy of manners, in Fletcher as later in Congreve, is not the mathematics of plot. It is the dramatizing of the war of the sexes. The grace note in this warfare is verbal felicity. The play is a witful altercation between well-bred men and women. The arrogant bachelor who is the hero of the play is confirmed in his misogyny. English women are distasteful to him as their buttocks are narrow as pins. But the heroine who pursues him is not to be rejected altogether. Were he half tippled and in want of a woman, he might turn and peruse her.

On the confounding of the impudent Don Juan, Fletcher hangs his story. This story is engrossing as it delineates, not the artificial courtship and the inevitable, hence inconsequential, marriage of a *papier-mâché* female and a little man on a wedding cake but the sexual and psychological relationship of a real man and woman. The heroine, like Shakespeare's Rosalind, is not crushed by her presumptive failure. "I shall live

after it," she thinks. "Whilst I have meat and drink, love cannot starve me."

For the last time in the history of Renaissance drama, we participate in the miracle of transubstantiation. The word is made flesh. In the beginning, almost eight hundred years before, is the ending. Once more, the Real Presence is vouchsafed us.

To the iconoclastic temperament, whose hegemony is confirmed in the reign of King Charles, this Presence betokens perdition. Substantiality is a fiction. The proposition is urged with increasing virulence by the religious reformer as also by the scientist or new philosopher, who appeals from the world of phenomenal fact to the abstract Forms that lie behind it. "What man," the Puritan preacher inquires, "could bear to have either his beauty likened to a misshapen picture or himself called the idol of a man?" It is the question Plato raises and, from the side of science, Galileo and Descartes.

The drama is idolatrous as it prefers the mendacious or trivial thing—the misshapen picture that is the man in his habit as he lived—to the universal representation. For that reason, the drama is reprehended. Already in the reign of King James, a puritanical poet is admonishing its patrons for their willingness to "affect vain shadows and let slide The true substance as a thing unspied." But shadow and substance are turned upside down, as in the play by Paul Vincent Carroll.

Words in their ordinary acceptance are no help to us here. Shadows, like those that flit across the stage, are to be read as denoting corporality, which is not substantial but ephemeral. That is what is meant by representing the playgoer as abandoning himself to "vainglorious show." The language to which he listens is "wrapped up . . . in dark riddles," but not as it is difficult, rather as it deals in the lower case. To the connoisseur of generic resemblances, truth is better perceived and more nearly itself as we thrust it forth "nakedly . . . without a covering."

The "player-like fashionist" who fills "the benches in taverns or theaters" is indifferent to truth or unable to perceive it. Like the owl at midday, he closes his eyes to the "light of the gospel which owls cannot see," preferring the refracted light of the playhouse. (We remember Plato's strictures on the Idols of the Cave.) His "partial love," says a covenanting minister, is "to a carnal liberty." The delimiting word is important.

By use and wont, we identify carnality with looseness. The seventeenth century decides that this identifying is misapprehension. Carnality means solidity. Etymologically, there is precedent for that. The real thing is ideal, what was never in nature. Carnality does not argue moral corruption, or not critically. It argues intellectual corruption. We have come to the heart of the matter in assessing the rising protest against the stage.

The playwright puts us out of the way of truth. But the "duty of a legislator," as Plato instructs the new draconians who inaugurate the kingdom of heaven on earth, "is and always will be to teach you the truth." In fulfillment of this duty, the drama is disfranchised. "Whereas," runs the pitiless and benevolent edict of September 2, 1642,

> the distracted state of England, threatened with a cloud of blood by a civil war, calls for all possible means to appease and avert the wrath of God, it is therefore thought fit and ordained by the Lords and Commons in this parliament assembled that, while these set causes and set times of humiliation continue, public stage plays shall cease and be forborne.

So there comes to an end the greatest period in the history of the English drama, perhaps in the history of the world. R. A. F.

John Heywood

[*c*. 1497–*c*. 1580]

THE FOUR PP

THE COLOPHON of the first edition of THE PLAY CALLED THE FOUR PP designates William Middleton as printer but fails to supply a date. Editors assign this quarto edition to the period 1541–47. A second edition, printed by William Copeland and also undated, is assigned tentatively to 1555; a third, by John Allde, appeared in 1569. The third quarto is usefully compared with the first in that it sometimes modernizes spelling (*or* becomes *ere*, *Hierusalem* is replaced by *Jerusalem*). The time of composition is moot: perhaps the early 1520s. No information is available regarding initial performances, which were most likely mounted in noble houses rather than on the public stage.

THE FOUR PP is perhaps the best exemplar of a form of entertainment known as the interlude, popular in England in the reign of Henry VIII and deriving ultimately from the medieval *débat*. The French word gives a part of its character. The interlude is a dramatic altercation, often more voluble than dramatic, between or among protagonists. See, for another and earlier illustration, Henry Medwall's *Fulgens and Lucrece* (*c*. 1497), an earnest canvassing between rivals for the hand of a senator's daughter. Because the complexities of plot are scanted, the interlude is short. It is generally comic, tending to farce, and like its medieval antecedent is both didactic and entertaining. Didacticism, though it may get short shrift (THE FOUR PP and its congeners are most prized as they are "new and very merry"), is always there, as in the conclusion of the work at hand.

The human comedy of Chaucer no doubt furnished inspiration for the writing of this particular play; so did the abstract and polemical art of the medieval moralities. In addition, parallels have been detected in certain French farces or *soties* of the period. The author, John Heywood, is the chief maker of the interlude. Four plays in this kind are certainly his work. Two others are often attributed to him. Of the first group, *The Play of the Weather* (question: What kind of weather is best?) keeps company successfully with THE FOUR PP; of the second, *John John, Tib, and Sir John*, a satiric account of a henpecked husband, his wife, and a cuckolding priest, still amuses after four centuries.

Heywood, a courtly musician and epigrammatist, was born in the closing years of the fifteenth century and died as a Catholic exile at Louvain in France, probably about 1580. His descendants included a son, Jasper, who participated in the famous and enormously influential translation of the tragedies of Seneca, and a daughter, Elizabeth, who became the mother of John Donne. Thus Heywood in his own life and in his progeny very nearly encompasses the whole period of Renaissance drama.

On the other hand, the single play of Heywood's reprinted here seems to stand somewhat apart from the period. In this collection of forty-one plays, it is the only work dating from the reign of King Henry VIII and antedates its earliest successor by at least a generation. There is, however, extraordinary justification for including it in any collection of this kind that purports to be representative. The work for theater of Bishop Bale and John Skelton and Sir David Lindsay has its historical interest, sometimes more than that. But it is off the main line of dramatic development, as perceptible already in THE FOUR PP. In terms of the theater, talk is not enough. Contention is requisite. Heywood, in the early years of the sixteenth century, is making primitive comedy. It is to be contrasted, also compared, with Shirley's highly sophisticated comedy, HYDE PARK, written more than a hundred years later. In between is a great efflorescence of drama. This is where it begins.

R. A. F.

The Four PP

A New and a Very Merry Interlude of
A Palmer[1]
A Pardoner
A Pothecary[2]
A Pedlar

[*Enter* PALMER.]

Palm. Now God be here! Who keepeth this place?
Now, by my faith, I cry you mercy!
Of reason I must sue for grace,
My rudeness showeth me now so homely.
Whereof your pardon axed[3] and won,
I sue[4] you, as courtesy doth me bind,
To tell this which shall be begun
In order as may come best in mind.
I am a palmer, as ye see,
Which of my life much part hath spent 10
In many a fair and far country,
As pilgrims do of good intent.
At Jerusalem have I been
Before Christ's blessèd sepulcher;
The Mount of Calvary have I seen,
A holy place, ye may be sure;
To Josophat and Olivet
On foot, God wot,[5] I went right bare,
Many a salt tear did I sweat
Before this carcass could come there. 20
Yet have I been at Rome also,
And gone the stations[6] all arow,[7]
Saint Peter's shrine, and many mo[8]
Than, if I told, all ye do know,
Except that there be any such
That hath been there and diligently
Hath taken heed and markèd much,
Then can they speak as much as I.
Then at the Rhodes also I was,
And round about to Amias; 30
At Saint Toncomber;[9] and Saint Trunnion;
At Saint Botolph; and Saint Anne of Buxton;
On the hills of Armony,[10] where I see Noah's ark;
With holy Job; and Saint George in Southwark;
At Waltham; and at Walsingham;
And at the good Rood[11] of Dagenham;
At Saint Cornelius; at Saint James in Gales;
And at Saint Winifred's Well in Wales;
At Our Lady of Boston; at Saint Edmundsbury;
And straight to Saint Patrick's Purgatory; 40
At Redburne; and at the Blood of Hales,
Where pilgrims' pains right much avails;
At Saint Davy's; and at Saint Denis;
At Saint Matthew; and Saint Mark in Venice;
At Master John Shorn; at Canterbury;
The great God of Catwade; at King Henry;

At Saint Savior's; at Our Lady of Southwell;
At Crome; at Willesden; and at Muswell;
At Saint Richard; and at Saint Roke;
And at Our Lady that standeth in the oak. 50
To these, with other many one,
Devoutly have I prayed and gone,
Praying to them to pray for me
Unto the Blessed Trinity;
By whose prayers and my daily pain
I trust the sooner to obtain
For my salvation grace and mercy.
For, be ye sure, I think surely
Who seeketh saints for Christ's sake
And namely[12] such as pain do take 60
On foot to punish their frail body
Shall thereby merit more highly
Than by anything done by man.

[*Enter* PARDONER.]

Pard. And when ye have gone as far as ye can,
For all your labor and ghostly[13] intent
Yet welcome home as wise as ye went!
Palm. Why, sir, despise ye pilgrimage?
Pard. Nay, 'fore God, sir! Then did I rage![14]
I think ye right well occupied
To seek these saints on every side. 70
Also your pain I not dispraise it;
But yet I discommend your wit;[15]
And, ere we go, even so shall ye,
If ye in this will answer me:
I pray you, show what the cause is
Ye went all these pilgrimages.
Palm. Forsooth, this life I did begin
To rid the bondage of my sin;
For which these saints, rehearsed ere this,[16]
I have both sought and seen, iwis,[17] 80

[1] *Palmer:* Pilgrim, whose visits to holy shrines were betokened by the palm leaf he carried.
[2] *Pothecary:* Pharmacist. [3] *axed:* asked.
[4] *sue:* challenge, appeal to. [5] *wot:* knows.
[6] *stations:* holy places. [7] *arow:* in sequence.
[8] *mo:* more.
[9] *Saint Toncomber:* The Pardoner in his listing of shrines mixes nonsense names with genuine places of pilgrimage.
[10] *Armony:* Armenia. [11] *Rood:* Cross.
[12] *namely:* particularly. [13] *ghostly:* spiritual.
[14] *did I rage:* were I mad. [15] *wit:* intelligence.
[16] *ere this:* above. [17] *iwis:* certainly.

Beseeching them to be record
Of all my pain unto the Lord
That giveth all remission
Upon each man's contrition.
And by their good mediation,
Upon mine humble submission,
I trust to have in very deed
For my soul's health the better speed.

Pard. Now is your own confession likely
To make yourself a fool quickly 90
For I perceive ye would obtain
None other thing for all your pain
But only grace your soul to save.
Now, mark in this what wit ye have
To seek so far, and help [18] so nigh!
Even here at home is remedy,
For at your door myself doth dwell,
Who could have saved your soul as well
As all your wide wandering shall do,
Though ye went thrice to Jericho. 100
Now, since ye might have sped [19] at home,
What have ye won by running at [20] Rome?

Palm. If this be true that ye have moved, [21]
Then is my wit indeed reproved!
But let us hear first what ye are.

Pard. Truly, I am a pardoner.

Palm. Truly a pardoner, that may be true,
But a true pardoner doth not ensue!
Right seldom is it seen, or never,
That truth and pardoners dwell together; [22] 110
For, be your pardons never so great,
Yet them to enlarge ye will not let [23]
With such lies that ofttimes, Christ wot,
Ye seem to have what ye have not.
Wherefore I went myself to the self [24] thing
In every place, and, without feigning,
Had as much pardon there assuredly
As ye can promise me here doubtfully.
Howbeit, [25] I think ye do but scoff.
But if ye had all the pardon ye speak of, 120
And no whit of pardon granted
In any place where I have haunted, [26]
Yet of my labor I nothing repent.
God hath respect [27] how each time is spent;
And, as in his knowledge all is regarded,
So by his goodness all is rewarded.

Pard. By the first part of this last tale
It seemeth you come late [28] from the ale!
For reason on your side so far doth fail
That ye leave reasoning and begin to rail; 130
Wherein ye forget your own part clearly,
For ye be as untrue as I;
And in one point ye are beyond me,
For ye may lie by authority,
And all that hath wandered so far
That no man can be their controller. [29]
And, where ye esteem your labor so much,
I say yet again my pardon be such
That, if there were a thousand souls on a heap,
I would bring them all to heaven as good cheap 140
As ye have brought yourself on pilgrimage
In the last quarter of your voyage,
Which is far a [30] this side heaven, by God!
There your labor and pardon is odd, [31]
With small cost and without any pain,
These pardons bringeth them to heaven plain.
Give me but a penny or two pence,
And as soon as the soul departeth hence,
In half an hour—or three quarters at most—
The soul is in heaven with the Holy Ghost! 150

[*Enter* POTHECARY.]

Poth. Send ye any souls to heaven by water?
Pard. If we did, sir, what is the matter?
Poth. By God, I have a dry soul should thither!
I pray you let our souls go to heaven togither. [32]
So busy you twain be in souls' health,
May not a pothecary come in by stealth?
Yes, that I will, by Saint Anthony!
And, by the leave of this company,
Prove ye false knaves both, ere we go,
In part of your sayings, as this, so: 160

[*To the* PALMER]

Thou by thy travel thinkest heaven to get;—

[*To* PARDONER]

And thou by pardons and relics countest no let [33]
To send thine own soul to heaven sure,
And all other whom thou list [34] to procure.
If I took an action, then were they blank;
For, like thieves, the knaves rob away my thank.
All souls in heaven having relief,
Shall they thank your crafts? Nay, thank mine,
 chief! [35]
No soul, ye know, entereth heaven-gate
Till from the body he be separate; 170
And whom have ye known die honestly
Without help of the pothecary?
Nay, all that cometh to our handling,
Except ye hap [36] to come to hanging—
That way, perchance, ye shall not mister [37]
To go to heaven without a glister! [38]
But, be ye sure, I would be woe
If ye should chance to beguile me so.
As good to lie with me a-night
As hang abroad in the moonlight! 180

[18] *help:* help being. [19] *sped:* prospered.
[20] *at:* to. [21] *moved:* urged.
[22] *Right . . . together:* Pardoners, as Chaucer's Tale makes
clear, were notorious for their corrupt exploiting of the re-
mission of sins. [23] *let:* hinder yourself.
[24] *self:* real. [25] *Howbeit:* Be that as it may.
[26] *haunted:* frequented. [27] *hath respect:* considers.
[28] *late:* recently. [29] *be . . . controller:* gainsay them.
[30] *a:* on.
[31] *is odd:* are disjunctive (the labor is excessive in view of
the return).
[32] *togither:* The old spelling is preserved for the sake of the
rhyme, as hereafter. [33] *let:* hindrance.
[34] *list:* desire. [35] *chief:* chiefly.
[36] *hap:* chance. [37] *mister:* need.
[38] *glister:* clyster (enema).

There is no choice to flee my hand
But, as I said, into the band.[39]
Since of our souls the multitude
I send to heaven, when all is viewed,
Who should but I, then, altogither
Have thank of all their coming thither?
 Pard. If ye killed a thousand in an hour's space,
When come they to heaven, dying from state of
 grace?
 Poth. If a thousand pardons about your necks were
 tied,
When come they to heaven if they never died? 190
 Palm. Long life after good works, indeed,
Doth hinder man's receipt of meed,[40]
And death before one duty done
May make us think we die too soon.
Yet better tarry[41] a thing, then have it,
Than go too soon and vainly crave it.
 Pard. The longer ye dwell in communication,
The less shall you like this imagination;[42]
For ye may perceive, even at the first chop,[43]
Your tale is trapped in such a stop 200
That, at the least, ye seem worse than we.
 Poth. By the mass, I hold us naught, all three!

[*Enter* PEDLAR.]

 Ped. By Our Lady, then have I gone wrong!
And yet to be here I thought long.
 Poth. Brother, ye have gone wrong no whit.[44]
I praise your fortune and your wit
That can direct you so discreetly
To plant you in this company:
Thou a palmer, and thou a pardoner,
I a pothecary.
 Ped. And I a pedlar! 210
 Poth. Now, on my faith, full well matched!
Where the devil were we four hatched?
 Ped. That maketh no matter, since we be matched.
I could be merry if that I catched[45]
Some money for part of the ware in my pack.
 Poth. What the devil hast thou there at thy back?
 Ped. Why, dost thou not know that every pedler
In every trifle must be a meddler,
Specially in women's triflings,—
Those use we chief above all things. 220
Which things to see, if ye be disposed,
Behold what ware here is disclosed.
This gear[46] showeth itself in such beauty
That each man thinketh it saith: "Come, buy me!"
Look, where yourself can like to be chooser,
Yourself shall make[47] price, though I be loser!
Is here nothing for my father Palmer?
Have ye not a wanton[48] in a corner
For your walking to holy places?
By Christ, I have heard of as strange cases! 230
Who liveth in love, or love would win,
Even at this pack he must begin,
Where is right many a proper token,
Of which by name part shall be spoken:
Gloves, pins, combs, glasses unspotted,
Pomanders,[49] hooks, and laces knotted,

Brooches, rings, and all manner beads,
Lace, round and flat, for women's heads,
Needles, thread, thimbles, shears and all such
 knacks[50]—
Where lovers be, no such things lacks— 240
Cypress, swathbands, ribands, and sleevelaces,[51]
Girdles, knives, purses, and pincases.
 Poth. Do women buy their pincases of you?
 Ped. Yea, that they do, I make God avow!
 Poth. So mote[52] I thrive, then, for my part,
I beshrew[53] thy knave's naked heart
For making my wife's pincase[54] so wide,
The pins fall out, they cannot abide.
Great pins must she have, one or other;
If she lose one, she will find another! 250
Wherein I find cause to complain,
New pins to her pleasure and my pain!
 Pard. Sir, ye seem well seen[55] in women's causes.
I pray you, tell me what causeth this,
That women, after their arising,
Be so long in their appareling?
 Ped. Forsooth, women have many lets,
And they be masked in many nets,
As frontlets, fillets, partlets[56] and bracelets;
And then their bonnets, and their poignets.[57] 260
By these lets and nets the let is such
That speed is small when haste is much.
 Poth. Another cause why they come not forward,
Which maketh them daily to draw backward,
And yet is a thing they cannot forbear—
The trimming and pinning up their gear,
Specially their fiddling with the tail-pin;
And, when they would have it prick in,
If it chance to double[58] in the cloth
Then be they wood[59] and sweareth an oath, 270
Till it stand right, they will not forsake it.
Thus, though it may not, yet would they make it.
But be ye sure they do but defar[60] it,
For, when they would make it, ofttimes mar it.
But prick them and pin them as much as ye will,
And yet will they look for pinnings[61] still!

[39] *band:* hangman's noose. [40] *meed:* reward.
[41] *tarry:* wait for. [42] *imagination:* conceit.
[43] *at . . . chop:* from the beginning.
[44] *no whit:* not at all. [45] *catched:* caught.
[46] *gear:* ware (in his pack). [47] *make:* set the.
[48] *wanton:* loose woman.
[49] *Pomanders:* Aromatic substances worn about the body
as a preservative from infection. [50] *knacks:* knickknacks.
[51] *Cypress . . . sleeve laces:* respectively, Fine linen, swad-
dling clothes, ribbons, lace with which sleeves were trimmed.
[52] *mote:* might. [53] *beshrew:* curse.
[54] *pincase:* with *entendre* on "pudendum" and hence
"pins" ("penis").
[55] *seen:* versed (though not so glossed by OED).
[56] *frontlets, fillets, partlets:* respectively, ornaments or
bands worn on the forehead, ribbons (etc.) for binding or
ornamenting the hair, ruffs (collars worn about the neck and
breast).
[57] *poignets:* ornaments for the wrist or hand, bracelets.
[58] *tail-pin . . . prick in . . . double:* penis . . . come on
strong, pierce (like a "prick" that "stands right") . . . relax,
fall (as from impotency). [59] *wood:* mad.
[60] *defar:* defer, put off. [61] *pinnings:* the sexual act.

So that I durst hold[62] you a joint[63]
Ye shall never have them at a full point.[64]
 Ped. Let women's matters pass, and mark mine!
Whatever their points be, these points be fine.[65] 280
Wherefore, if ye be willing to buy,
Lay down money! Come off quickly!
 Palm. Nay, by my troth, we be like friars.[66]
We are but beggars, we be no buyers.
 Pard. Sir, ye may show your ware for your mind,[67]
But I think ye shall no profit find.
 Ped. Well, though this journey acquit no cost,[68]
Yet think I not my labor lost;
For, by the faith of my body,
I like full well this company, 290
Up shall this pack, for it is plain
I came not hither all for gain.
Who may not play one day in a week
May think his thrift[69] is far to seek!
Devise what pastime ye think best,
And make ye sure to find me prest.[70]
 Poth. Why, be ye so universal
That you can do whatsoever ye shall?
 Ped. Sir, if ye list to appose[71] me,
What I can do then shall ye see. 300
 Poth. Then tell me this: be ye perfect in drinking?
 Ped. Perfect in drinking as may be wished by
 thinking!
 Poth. Then after your drinking, how? Fall ye to
 winking?
 Ped. Sir, after drinking, while the shot[72] is
 tinking,[73]
Some heads be swinking,[74] but mine will be sinking,
And upon drinking mine eyes will be pinking,[75]
For winking to drinking is always linking.[76]
 Poth. Then drink and sleep ye can well do.
But, if ye were desired thereto,
I pray you, tell me, can you sing? 310
 Ped. Sir, I have some sight[77] in singing.
 Poth. But is your breast anything sweet?
 Ped. Whatever my breast be, my voice is meet.[78]

62 *durst hold:* dare bet. 63 *joint:* of meat.
64 *at a full point:* completely. 65 *fine:* quibbling.
66 *friars:* of a mendicant order.
67 *for your mind:* as much as you like (?).
68 *acquit no cost:* doesn't quit the expense of it.
69 *thrift:* thriving. 70 *prest:* ready.
71 *appose:* pose, question. 72 *shot:* money.
73 *tinking:* clinking. 74 *swinking:* laboring (with drink).
75 *pinking:* blinking. 76 *linking:* linked.
77 *sight:* conversance. 78 *meet:* fit.
79 *than:* then (not glossed subsequently).
80 *froward:* perverse.
81 *Leave . . . curiosity:* Stop fooling about.
82 *mote I thee:* may I thrive. 83 *set:* engage.
84 *this man:* the Palmer. 85 *as use:* are accustomed.
86 *conscience:* remorse. 87 *Induction:* Introduction.
88 *endless:* eternal. 89 *matter:* at issue—controversy.
90 *Iwis:* Surely.
91 *keep . . . chair:* he need not even bestir himself.
92 *at pleasure:* when he will.
93 *list to jet:* wishes to hazard.
94 *daw:* fool—the Pothecary. 95 *avaunting:* bragging.
96 *meed:* reward. 97 *mist:* missed.

 Poth. That answer showeth you a right singing
 man!
Now what is your will, good father, than?[79]
 Palm. What helpeth will where is no skill?
 Pard. And what helpeth skill where is no will?
 Poth. For will or skill, what helpeth it
Where froward[80] knaves be lacking wit?
Leave of this curiosity;[81] 320
And who that list, sing after me!

 Here they sing.

 Ped. This liketh me well, so mote I thee![82]
 Pard. So help me God, it liketh not me!
Where company is met and well agreed,
Good pastime doth right well indeed;
But who can set[83] in dalliance
Men set in such a variance
As we were set ere ye came in?
Which strife this man[84] did first begin,
Alleging that such men as use,[85] 330
For love of God, and not refuse
On foot to go from place to place
A pilgrimage, calling for grace,
Shall in that pain with penitence
Obtain discharge of conscience,[86]
Comparing that life for the best
Induction[87] to our endless[88] rest.
Upon these words our matter[89] grew;
For, if he could avow them true,
As good to be a gardener 340
As for to be a pardoner.
But, when I heard him so far wide,
I then approachèd and replied,
Saying this: that this indulgence,
Having the foresaid penitence,
Dischargeth man of all offense
With much more profit than this pretense.
I ask but twopence at the most,
Iwis,[90] this is not very great cost,
And from all pain, without despair, 350
My soul for his—keep even his chair,[91]
And when he dieth he may be sure
To come to heaven, even at pleasure.[92]
And more than heaven he cannot get,
How far soever he list to jet.[93]
Then is his pain more than his wit
To walk to heaven, since he may sit!
Sir, as we were in this contention,
In came this daw[94] with his invention,
Reviling us, himself avaunting[95] 360
That all the souls to heaven ascending
Are most bound to the pothecary,
Because he helpeth most men to die;
Before which death he sayeth, indeed,
No soul in heaven can have his meed.[96]
 Ped. Why, do pothecaries kill men?
 Poth. By God, men say so now and then!
 Ped. And I thought ye would not have mist[97]
To make men live as long as ye list.
 Poth. As long as we list? Nay, long as they can! 370
 Ped. So might we live without you than.

Poth. Yea, but yet it is necessary
For to have a pothecary;
For when ye feel your conscience ready,
I can send you to heaven quickly.
Wherefore, concerning our matter here,
Above these twain I am best, clear.
And, if ye list to take me so,
I am content you, and no mo,
Shall be our judge as in this case, 380
Which of us three shall take the best place.
 Ped. I neither will judge the best nor worst;
For, be ye blest or be ye curst,
Ye know it is no whit my sleight [98]
To be a judge in matters of weight.
It behoveth no pedlars nor proctors [99]
To take on them judgment as doctors.
But if your minds be only set
To work for soul's health, ye be well met,
For each of you somewhat doth show 390
That souls toward heaven by you do grow.
Then, if ye can so well agree
To continue together all three,
And all you three obey one will,
Then all your minds ye may fulfill: [100]
As, if ye came all to one man
Who should go pilgrimage more than he can,

[*To* PALMER]

In that ye, palmer, as debite, [101]
May clearly discharge him, perdie;—

[*To* PARDONER]

And for all other sins, once had contrition, 400
Your pardons giveth him full remission;—

[*To* POTHECARY]

And then ye, master pothecary,
May send him to heaven by and by. [102]
 Poth. If he taste this box nigh about the prime, [103]
By the mass, he is in heaven ere evensong time!
My craft is such that I can right well
Send my friends to heaven and myself to hell.
But, sirs, mark this man, for he is wise
Who could devise such a device;
For if we three may be as one, 410
Then be we lords everychone; [104]
Between us all could not be missed
To save the souls of whom we list.
But, for good order, at a word,
Twain of us must wait on the third;
And unto that I do agree,
For both you twain shall wait on me!
 Pard. What chance is this that such an elf [105]
Command two knaves, [106] beside himself?
Nay, nay, my friend, that will not be; 420
I am too good to wait on thee!
 Palm. By Our Lady, and I would be loath
To wait on the better of you both!
 Ped. Yet be ye sure, for all this doubt,
This waiting must be brought about.
Men cannot prosper, willfully led;

All thing decayeth where is no head.
Wherefore, doubtless, mark what I say:
To one of you three twain must obey;
And, since ye cannot agree in voice 430
Who shall be head, there is no choice
But to devise some manner thing
Wherein ye all be like cunning; [107]
And in the same who can do best,
The other twain to make them prest
In every thing of his intent
Wholly to be at commandment.
And now have I found one mastery [108]
That ye can do indifferently, [109]
And is neither selling nor buying, 440
But even only very lying!
And all ye three can lie as well
As can the falsest devil in hell.
And, though afore ye heard me grudge [110]
In greater matters to be your judge,
Yet in lying I can [111] some skill;
And, if I shall be judge, I will.
And, be ye sure, without flattery,
Where my conscience findeth the mastery
There shall my judgment strait [112] be found, 450
Though I might win a thousand pound.
 Palm. Sir, for lying, though I can do it,
Yet am I loath for to go to it.
 Ped. [*To* PALMER] Ye have not cause to fear to be
 bold,
For ye may be here uncontrolled.—

[*To* PARDONER]

And ye in this have good advantage,
For lying is your common usage.—

[*To* POTHECARY]

And you in lying be well sped, [113]
For all your craft doth stand in falsehead.—
Ye need not care who shall begin, 460
For each of you may hope to win.
Now speak, all three, even as ye find:
Be ye agreed to follow my mind?
 Palm. Yea, by my troth, I am content.
 Pard. Now, in good faith, and I assent.
 Poth. If I denied, I were a noddy,
For all is mine, by God's body!

 Here POTHECARY *hoppeth.*

 Palm. Here were a hopper to hop for the ring! [114]
But, sir, this gear goeth not by hopping.

 [98] *sleight:* skill.
 [99] *proctors:* stewards, agents (more rhyme than reason
here). [100] *fulfill:* satisfy.
 [101] *debite:* deputy. [102] *by and by:* at once.
 [103] *prime:* church service for the first hour of the day.
 [104] *everychone:* every one. [105] *elf:* wretch.
 [106] *knaves:* servants.
 [107] *like cunning:* equally accomplished.
 [108] *mastery:* mystery, art.
 [109] *indifferently:* one as well as the other.
 [110] *grudge:* demur. [111] *can:* have.
 [112] *strait:* strict. [113] *sped:* accomplished.
 [114] *ring:* prize (in a hopping contest).

Poth. Sir, in this hopping I will hop so well 470
That my tongue shall hop as well as my heel;
Upon which hopping I hope, and not doubt it,
To hope so that ye shall hope without it.
Palm. Sir, I will neither boast nor brawl,
But take such fortune as may fall;
And, if ye win this mastery,
I will obey you quietly.
And sure I think that quietness
In any man is great riches,
In any manner company, 480
To rule or be ruled indifferently.[115]
Pard. By that boast thou seemest a beggar indeed.
What can thy quietness help us at need?
If we should starve, thou hast not, I think,
One penny to buy us one pot of drink.
Nay, if riches might rule the roast,[116]
Behold what cause I have to boast!
Lo, here[117] be pardons half a dozen.
For ghostly[118] riches they have no cozen;[119]
And, moreover, to me they bring 490
Sufficient succor for my living.
And here be relics of such a kind
As in this world no man can find.
Kneel down, all three, and, when ye leave kissing,
Who list to offer shall have my blissing![120]
Friends, here shall ye see even anone[121]
Of All-Hallows the blessed jawbone,
Kiss it hardily,[122] with good devotion!
Poth. This kiss shall bring us much promotion.
Fogh! by Saint Savior, I never kissed a worse! 500
Ye were as good kiss All-Hallows'[123] arse!
For, by All-Hallows, methinketh
That All-Hallows' breath stinketh.
Palm. Ye judge All-Hallows' breath unknown;
If any breath stink, it is your own.
Poth. I know mine own breath from All-Hallows',
Or else it were time to kiss the gallows.
Pard. Nay, sirs, behold, here may ye see
The great-toe of the Trinity.
Who to this toe any money vow'th, 510
And once may roll it in his mouth,
All his life after, I undertake,
He shall be rid of the toothache.
Poth. I pray you, turn that relic about!
Either the Trinity had the gout,
Or else, because it is three toes in one,
God made it much as three toes alone.
Pard. Well, let that pass, and look upon this;

Here is a relic that doth not miss
To help the least as well as the most. 520
This is a buttock-bone of Pentecost!
Poth. By Christ, and yet, for all your boast,
This relic hath beshitten the roast!
Pard. Mark well this relic—here is a whipper![124]
My friends, unfeigned, here is a slipper
Of one of the Seven Sleepers,[125] be sure.
Doubtless this kiss shall do you great pleasure,
For all these two days it shall so ease you
That none other savors shall displease you.
Poth. All these two days! Nay, all this two year!
For all the savors that may come here 531
Can be no worse; for, at a word,
One of the Seven Sleepers trod in a turd.
Ped. Sir, methinketh your devotion[126] is but small.
Pard. Small? Marry, methinketh he hath none at all!
Poth. What the devil care I what ye think?
Shall I praise relics when they stink?
Pard. Here is an eyetooth of the Great Turk.
Whose eyes be once set on this piece of work
May haply[127] lose part of his eyesight, 540
But not all till he be blind outright.
Poth. Whatsoever any other man seeth,
I have no devotion to Turks' teeth;
For, although I never saw a greater,
Yet methinketh I have seen many better.
Pard. Here is a box full of humble-bees[128]
That stung Eve as she sat on her knees
Tasting the fruit to her forbidden.
Who kisseth the bees within this hidden
Shall have as much pardon, of right, 550
As for any relic he kissed this night.
Palm. Sir, I will kiss them, with all my heart.
Poth. Kiss them again, and take my part,
For I am not worthy—nay, let be!
Those bees that stung Eve shall not sting me!
Pard. Good friends, I have yet herein this glass,
Which[129] on the drink at the wedding was
Of Adam and Eve undoubtedly.
If ye honor this relic devoutly,
Although ye thirst no whit the less, 560
Yet shall ye drink the more, doubtless,
After which drinking ye shall be as meet
To stand on your head as on your feet.
Poth. Yea, marry, now I can ye thank!
In presence of this the rest be blank.
Would God this relic had come rather![130]
Kiss that relic well, good father!
Such is the pain that ye palmers take
To kiss the pardon-bowl for the drink's sake.
O holy yeast, that looketh full sour and stale, 570
For God's body help me to a cup of ale!
The more I behold thee, the more I thirst;
The oftener I kiss thee, more like to burst!
But since I kiss thee so devoutly,
Hire me, and help me with drink till I die!
What, so much praying and so little speed?
Pard. Yea, for God knoweth when it is need
To send folks drink; but, by Saint Anthony,
I ween[131] he hath sent you too much already.

[115] *indifferently:* equally.
[116] *rule the roast:* be carver—sit at the head of the table.
[117] *here:* in his pack. [118] *ghostly:* spiritual.
[119] *cozen:* fellow (cousin)—taint of cozinage or cheating(?).
[120] *blissing:* blessing. [121] *anone:* straightway.
[122] *hardily:* with assurance.
[123] *All-Hallows':* All-Saints'. [124] *whipper:* winner.
[125] *Seven Sleepers:* of Ephesus; noble Christian youths who were immured in a cave by the persecuting Emperor Decius in A.D. 250 and slept miraculously for 187 years.
[126] *devotion:* faith. [127] *haply:* perhaps.
[128] *humble-bees:* bumblebees. [129] *Which:* that which.
[130] *rather:* sooner. [131] *ween:* believe.

Poth. If I have never the more for thee, 580
Then be the relics no riches to me,
Nor to thyself, except they be
More beneficial than I can see.
Richer is one box of this triacle [132]
Than all thy relics that do no miracle.
If thou hadst prayed but half so much to me
As I have prayed to thy relics and thee,
Nothing concerning mine occupation
But straight should have wrought in operation.
And, as in value I pass you an ace, 590
Here lieth much riches in little space—
I have a box of rhubarb here,
Which is as dainty as it is dear.
So help me God and halidom, [133]
Of this I would not give a dram
To the best friend I have in England's ground,
Though he would give me twenty pound;
For, though the stomach do it abhor,
It purgeth you clean from the color, [134]
And maketh your stomach sore to walter, [135] 600
That ye shall never come to the halter. [136]
 Ped. Then is that medicine a sovereign thing
To preserve a man from hanging.
 Poth. If ye will taste but this crumb that ye see,
If ever ye be hanged, never trust me!
Here have I diapompholicus—
A special ointment, as doctors discuss;
For a fistula [137] or a canker
This ointment is even sheet-anchor, [138]
For this medicine helpeth one and other, 610
Or bringeth them in case [139] that they need no other.
Here is syrapus de Byzansis—
A little thing is enough of this,
For even the weight of one scruple [140]
Shall make you strong as a cripple.
Here be other: [141] as, diosfialios,
Diagalanga, and sticados,
Blanka manna, diospoliticon,
Mercury sublime, and metridaticon,
Pelitory, and arsefetita, 620
Cassy, and colloquintita.
These be the things that break all strife
Between man's sickness and his life.
From all pain these shall you deliver,
And set you even at rest for ever!
Here is a medicine—no more like the same
Which commonly is called thus by name
Alikakabus or alkakengy—
A goodly thing for dogs that be mangy.
Such be these medicines that I can 630
Help a dog as well as a man.
Not one thing here particularly
But worketh universally,
For it doth me as much good when I sell it
As all the buyers that taste it or smell it.
Now, since my medicines be so special,
And in operation so general,
And ready to work whensoever they shall,
So that in riches I am principal,
If any reward may entreat ye, 640

I beseech your maship [142] be good to me,
And ye shall have a box of marmalade
So fine [143] that ye may dig it with a spade.
 Ped. Sir, I thank you; but your reward
Is not the thing that I regard.
I must, and will, be indifferent: [144]
Wherefore proceed in your intent.
 Poth. Now, if I wis [145] this wish no sin,
I would to God I might begin!
 Pard. I am content that thou lie first. 650
 Palm. Even so am I; and say thy worst!
Now let us hear of all thy lies
The greatest lie thou mayst devise,
And in the fewest words thou can.
 Poth. Forsooth, ye be an honest man.
 Palm. There said ye much! but yet no lie.
 Pard. Now lie ye both, by Our Lady!
Thou liest in boast of his honesty,
And he hath lied in affirming thee.
 Poth. If we both lie, and ye say true, 660
Then of these lies your part adieu!
And if ye win, make none avaunt; [146]
For ye are sure of one ill servant.

[*To* PALMER]

Ye may perceive by the words he gave
He taketh your maship but for a knave.
But who told true, or lied indeed,
That will I know ere we proceed.
Sir, after that I first began
To praise you for an honest man,
When ye affirmed it for no lie— 670
Now, by our faith, speak even truly—
Thought ye your affirmation true?
 Palm. Yea, marry, aye! for I would ye knew
I think myself an honest man.
 Poth. What, thought ye in the contrary than?
 Pard. In that I said the contrary,
I think from truth I did not vary.
 Poth. And what of my words?
 Pard. I thought ye lied.
 Poth. And so thought I, by God that died!
Now have you twain each for himself laid [147] 680
That none hath lied aught, but both true said;
And of us twain none hath denied,
But both affirmed, that I have lied:
Now since ye both your truth confess,
And that we both my lie so witness
That twain of us three in one agree—
And that the liar the winner must be—

132 *triacle:* treacle—medicinal remedy.
133 *halidom:* holydom.
134 *color:* choler—the angry "humor."
135 *sore to walter:* to grumble sorely.
136 *halter:* hangman's noose. 137 *fistula:* ulcer.
138 *sheet-anchor:* i.e., succor.
139 *in case:* to such a condition. 140 *scruple:* tiny measure.
141 *other:* In what follows, nonsense words mingle with
genuine medicinal preparations. 142 *maship:* mastership.
143 *fine:* in consistency. 144 *indifferent:* impartial.
145 *wist:* knew.
146 *none avaunt:* no boast.
147 *laid:* deponed, asserted.

Who could provide such evidence
As I have done in this pretense?

[*To* PEDLAR]

Methinketh this matter sufficient 690
To cause you to give judgment,
And to give me the mastery,
For ye perceive these knaves cannot lie.
 Palm. Though neither of us as yet had lied,
Yet what we can do is untried;
For yet we have devisèd nothing,
But answered you and given hearing.
 Ped. Therefore I have devised one way
Whereby all three your minds may say:
For each of you one tale shall tell; 700
And which of you telleth most marvel
And most unlike to be true,
Shall most prevail, whatever ensue.
 Poth. If ye be set in [148] marveling,
Then shall ye hear a marvelous thing;
And though, indeed, all be not true,
Yet sure the most part shall be new.
I did a cure, no longer ago
But *Anno Domini millesimo*,[149]
On a woman, young and so fair 710
That never have I seen a gayer.
God save all women from that likeness!
This wanton had the falling sickness,[150]
Which by descent came lineally,
For her mother had it naturally.
Wherefore, this woman to recure [151]
It was more hard, ye may be sure.
But, though I boast my craft is such
That in such things I can do much,
How oft she fell were much to report; 720
But her head so giddy and her heels so short
That, with the twinkling of an eye,
Down would she fall even by and by.
But, ere she would arise again,
I showed much practice, much to my pain;
For the tallest [152] man within this town
Should not with ease have broken her sown.[153]
Although for life I did not doubt her
Yet did I take more pain about her
Than I would take with my own sister. 730
Sir, at the last I gave her a glister,
I thrust a tampion in her tewel [154]
And bade her keep it for a jewel.

[148] *in:* on. [149] *L.:* deliberate nonsense.
[150] *falling sickness:* epilepsy.
[151] *recure:* restore to health.
[152] *tallest:* most formidable. [153] *sown:* swoon.
[154] *tampion . . . tewel:* plug (suppository) . . . anus.
[155] *hired:* used. [156] *ordinance:* cannon.
[157] *bombard:* cannon—also: what it shoots.
[158] *Regent:* Large warship. [159] *wroken:* wreaked, vented.
[160] *lust:* pleasure. [161] *in:* as to.
[162] *Namely:* In particular.
[163] *seven:* proverbial for a generalized or unspecified
number. [164] *clark:* parish clerk or priest.
[165] *whit . . . wark:* knowledge . . . work.
[166] *estate:* condition.

But I knew it so heavy to carry
That I was sure it would not tarry;
For where gunpowder is once fired
The tampion will no longer be hired.[155]
Which was well seen in time of this chance;
For, when I had charged this ordinance,[156]
Suddenly, as it had thundered, 740
Even at a clap loosed her bombard.[157]
Now mark, for here beginneth the revel:
This tampion flew ten long mile level,
To a fair castle of lime and stone—
For strength I know not such a one—
Which stood upon an hill full high,
At foot whereof a river ran by,
So deep, till chance had it forbidden,
Well might the Regent [158] there have ridden.
But when this tampion on this castle light, 750
It put the walls so far to flight
That down they came each upon other,
No stone left standing, by God's Mother!
But rollèd down so fast the hill
In such a number, and so did fill,
From bottom to brim, from shore to shore,
This foresaid river, so deep before,
That who list now to walk thereto,
May wade it over and wet no shoe.
So was this castle laid wide open 760
That every man might see the token.
But—in a good hour may these words be spoken!—
After the tampion on the walls was wroken,[159]
And piece by piece in pieces broken,
And she delivered with such violence
Of all her inconvenience,
I left her in good health and lust,[160]
And so she doth continue, I trust!
 Ped. Sir, in [161] your cure I can nothing tell;
But to our purpose ye have said well. 770
 Pard. Well, sir, then mark what I can say!
I have been a pardoner many a day,
And done greater cures ghostly
Than ever he did bodily;
Namely,[162] this one which ye shall hear,
Of one departed within this seven [163] year,
A friend of mine, and likewise I
To her again was as friendly—
Who fell so sick so suddenly
That dead she was even by and by, 780
And never spake with priest nor clark,[164]
Nor had no whit of this holy wark,[165]
For I was thence, it could not be;
Yet heard, I say, she asked for me.
But when I bethought me how this chanced,
And that I have to heaven advanced
So many souls to me but strangers
And could not keep my friend from dangers,
But she to die so dangerously
For her soul's health especially, 790
That was the thing that grieved me so
That nothing could release my woe
Till I had tried even out of hand
In what estate [166] her soul did stand.

For which trial, short tale to make,
I took this journey for her sake.
Give ear, for here beginneth the story!
From hence I went to purgatory,
And took with me this gear in my fist,
Whereby I may do there what I list. 800
I knockèd, and was let in quickly;
But, Lord, how low the souls made curtsy!
And I to every soul again
Did give a beck [167] them to retain,
And axèd them this question than:
If that the soul of such a woman
Did late [168] among them there appear.
Whereto they said she came not here.
Then feared I much it was not well.
Alas! thought I, she is in hell! 810
For with her life I was so acquainted
That sure I thought she was not sainted.
With this it chanced me to sneeze;
"Christ help!" quoth a soul that lay for his fees. [169]
"Those words," quoth I, "thou shalt not lees!" [170]
Then with these pardons of all degrees
I paid his toll, and set him so quite [171]
That straight to heaven he took his flight.
And I from thence to hell that night,
To help this woman, if I might, 820
Not as who saith by authority,
But by the way of entreaty.
And first to the devil that kept the gate
I came, and spake after this rate: [172]
"All hail, sir devil!" and made low curtsy.
"Welcome!" quoth he, this smilingly:
He knew me well, and I at last
Remembered him since long time past,
For, as good hap [173] would have it chance,
This devil and I were of old acquaintance, 830
For oft in the play of Corpus Christi [174]
He hath played the devil at Coventry.
By his acquaintance and my behavior
He showed to me right friendly favor.
And—to make my return the shorter—
I said to this devil: "Good master porter,
For all old love, if it lie in your power,
Help me to speak with my lord and your."
"Be sure," quoth he, "no tongue can tell
What time thou couldest have come so well, 840
For this day Lucifer fell,
Which is our festival in hell.
Nothing unreasonable craved this day
That shall in hell have any nay.
But yet beware thou come not in
Till time thou may thy passport win.
Wherefore stand still, and I will wit [175]
If I can get thy safe-conduct." [176]
He tarried not, but shortly gat [177] it,
Under seal, and the devil's hand at [178] it, 850
In ample wise, [179] as ye shall hear.
Thus it began: "Lucifer,
By the power of God chief devil of hell,
To all the devils that there do dwell,
And every of them, we send greeting,

Under straight charge and commanding,
That they aiding and assistant be
To such a pardoner"—and named me—
"So that he may at liberty
Pass safe without his jeopardy 860
Till that he be from us extinct [180]
And clearly out of hell's precinct.
And, his pardons to keep safeguard,
We will [181] they lie in the porter's ward.
Given in the furnace of our palace,
In our high court of matters of malice,
Such a day and year of our reign."
"God save the devil!" quoth I, "for plain,
I trust this writing to be sure."
"Then put thy trust," quoth he, "in ure, [182] 870
Since thou art sure to take no harm."
This devil and I walked arm in arm,
So far till he had brought me thither
Where all the devils of hell togither
Stood in array in such apparel
As for that day there meetly fell:
Their horns well gilt, their claws full clean,
Their tails well kempt, and, as I ween, [183]
With sothery [184] butter their bodies anointed—
I never saw devils so well appointed. 880
The master devil sat in his jacket,
And all the souls were playing at racket. [185]
None other rackets they had in hand
Save every soul a good firebrand;
Wherewith they played so prettily
That Lucifer laughed merrily,
And all the residue of the fiends
Did laugh full well together like friends.
But of my friend I saw no whit, [186]
Nor durst not axe for her as yet. 890
Anon all this rout [187] was brought in silence,
And I by an usher brought in presence.
Then to Lucifer low as I could
I knelt. Which he so well allowed
That thus he becked, and, by saint Anthony,
He smiled on me well-favoredly,
Bending his brows, as broad as barn durs, [188]
Shaking his ears, as rugged as burs,

167 *beck:* nod. 168 *late:* recently.
169 *lay . . . fees:* was imprisoned in Purgatory because he had not "paid off" the Church, either in the form of tithes or, more probably, by purchasing remission of sins from such a person as the Pardoner. 170 *lees:* lose.
171 *quite:* free. 172 *rate:* manner.
173 *hap:* fortune.
174 *Corpus Christi:* Feast of the Blessed Sacrament or Body of Christ, kept on the Thursday after Trinity Sunday, and the occasion for presenting, in centers like Coventry, the medieval cycle dramas. 175 *wit:* find out.
176 *conduit:* conduct. 177 *gat:* got.
178 *at:* on. 179 *In ample wise:* Circumstantially.
180 *extinct:* gone. 181 *will:* decree.
182 *ure:* use. 183 *ween:* suppose.
184 *sothery:* smooth(?) (OED, citing this passage, ventures no definition).
185 *racket:* originally "dice," though what follows suggests a game like tennis. 186 *no whit:* nothing.
187 *rout:* crowd. 188 *durs:* doors.

Rolling his eyes, as round as two bushels,
Flashing the fire out of his nose-thrills,[189] 900
Gnashing his teeth so vaingloriously
That methought time to fall to flattery.
Wherewith I told, as I shall tell:
"O pleasant picture! O prince of hell!
Featured in fashion abominable!
And since that it is inestimable [190]
For me to praise thee worthily,
I leave off praise, unworthy
To give thee praise, beseeching thee
To hear my suit, and then to be 910
So good to grant the thing I crave.
And, to be short, this would I have—
The soul of one which hither is flitted
Delivered hence, and to me remitted.
And in this doing, though all be not quit,[191]
Yet some part I shall deserve it,
As thus: I am a pardoner,
And over souls, as a controller,
Throughout the earth my power doth stand,
Where many a soul lieth on [192] my hand, 920
That speed [193] in matters as I use them,
As I receive them or refuse them;
Whereby, what time thy pleasure is
Ye shall require any part of this,
The least devil here that can come thither
Shall choose a soul and bring him hither."
"Now," quoth the devil, "we are well pleased!
What is his name thou wouldest have eased?"
"Nay," quoth I, "be it good or evil,
My coming is for a she devil." 930
"What callest her?" quoth he, "thou whoreson!" [194]
"Forsooth," quoth I, "Margery Coorson."
"Now, by our honor," said Lucifer,
"No devil in hell shall withold her!
And if thou wouldest have twenty mo,
Were not for justice, they should go.
For all we devils within this den
Have more to do with two women
Than with all the charge [195] we have beside.
Wherefore, if thou our friend will be tried,[196] 940
Apply thy pardons to women so
That unto us there come no mo."
To do my best I promised by oath.
Which I have kept; for, as the faith go'th,
At these days to heaven I do procure

Ten women to one man, be sure.
Then of Lucifer my leave I took,
And straight unto the master cook.
I was had into the kitchen,
For Margery's office was therein. 950
All things handled there discreetly,
For every soul beareth office meetly,
Which might be seen to see her sit
So busily turning of the spit;
For many a spit here hath she turned,
And many a good spit hath she burned,
And many a spit full hot hath toasted
Before the meat could be half roasted.
And, ere the meat were half roasted indeed,
I took her then from the spit for speed.[197] 960
But when she saw this brought to pass,
To tell the joy wherein she was,
And of all the devils, for joy how they
Did roar at her delivery,[198]
And how the chains in hell did ring,
And how all the souls therein did sing,
And how we were brought to the gate,
And how we took our leave thereat—
Be sure lack of time suffereth nat [199]
To rehearse [200] the twentieth part of that! 970
Wherefore, this tale to conclude briefly,
This woman thanked me chiefly
That she was rid of this endless death;
And so we departed [201] on Newmarket Heath.
And if that any man do mind [202] her,
Who list to seek her, there shall he find her!
 Ped. Sir, ye have sought her wondrous well;
And, where ye found her, as ye tell,
To hear the chance ye found in hell,
I find ye were in great parell.[203] 980
 Palm. His tale is all much parellous; [204]
But part is much more marvelous.
As where he said the devils complain
That women put them to such pain
By their conditions so crooked and crabbed,
Frowardly [205] fashioned, so wayward and wrabbed,[206]
So far in division, and stirring such strife,
That all the devils be weary of their life!
This in effect he told for truth;
Whereby much marvel to me ensu'th, 990
That women in hell such shrews can be,
And here so gentle, as far as I see.
Yet have I seen many a mile,
And many a woman in the while—
Not one good city, town, nor borough
In Christendom but I have been thorough,[207]
And this I would ye should understand:
I have seen women five hundred thousand
[Wives and widows, maids and married,]
And oft with them have long time tarried,[208] 1000
Yet in all places where I have been,
Of all the women that I have seen,
I never saw, nor knew, in my conscience,
Any one woman out of patience.
 Poth. By the Mass, there is a great lie!
 Pard. I never heard a greater, by Our Lady!

189 *nose-thrills:* nostrils. 190 *inestimable:* impossible.
191 *quit:* requited. 192 *on:* in.
193 *speed:* are fortunate.
194 *whoreson:* laconically contemptuous term.
195 *charge:* people with whom we are charged.
196 *tried:* attested. 197 *for speed:* speedily.
198 *delivery:* from durance. 199 *nat:* not.
200 *rehearse:* repeat. 201 *departed:* separated.
202 *mind:* care about. 203 *parell:* peril.
204 *parellous:* embellished(?). 205 *Frowardly:* Perversely.
206 *wrabbed:* difficult to handle. 207 *thorough:* through.
208 *tarried:* Original reads "married," here used for the
conclusion of the hypothesized line above, which has pre-
sumably dropped out.

Ped. A greater? nay, know ye any so great?
Palm. Sir, whether that I lose or get,[209]
For my part, judgment shall be prayed.[210]
 Pard. And I desire as he hath said. 1010
 Poth. Proceed, and ye shall be obeyed.
 Ped. Then shall not judgment be delayed.
Of all these three, if each man's tale
In Paul's Churchyard[211] were set on sale
In some man's hand that hath the sleight,
He should sure sell these tales by weight.
For, as they weigh, so be they worth.
But which weigheth best? To that now forth!

[*To* POTHECARY]

Sir, all the tale that ye did tell
I bear in mind;—[*To* PARDONER] and yours as well;
And, as ye saw the matter meetly, 1021
So lied ye both well and discreetly.
Yet were your lies with the least, trust me!—

[*To* POTHECARY]

For, if ye had said ye had made flee
Ten tampions, out of ten women's tails,
Ten times ten mile, to ten castles or jails,
And fill ten rivers, ten times so deep
As ten of that which your castle stones did keep—

[*To* PARDONER]

Or if ye ten times had bodily
Fet[212] ten souls out of purgatory, 1030
And ten times so many out of hell,
Yet, by these ten bones,[213] I could right well
Ten times sooner all that have believed
Than the tenth part of that he[214] hath meved.[215]
 Poth. Two knaves before one lacketh two knaves of
 five;
Then one, and then one, and both knaves alive;
Then two, and then two, and three at a cast;[216]
Thou knave, and thou knave, and thou knave, at last!
Nay, knave,[217] if ye try me by number,
I will as knavishly you accumber.[218] 1040
Your mind is all on your privy[219] tithe,
For all in ten[220] methinketh your wit lithe.[221]
Now ten times I beseech Him that high sits
Thy wife's ten commandments[222] may search thy five
 wits;
Then ten of my turds in ten of thy teeth,
And ten on thy nose, which every man seeth.
And twenty times ten this wish I wold,[223]
That thou hadest been hanged at ten year old!
For thou goest about to make me a slave.
I will thou know that I am a gentleman, knave! 1050
And here[224] is another shall take my part.
 Pard. Nay, first I beshrew your knave's heart
Ere I take part in your knavery!
I will speak fair, by Our Lady!

[*To* PEDLAR]

Sir, I beseech your maship to be
As good as ye can be to me.
 Ped. I would be glad to do you good,

And him also, be he never so wood.
But doubt you not I will now do
The thing my consience leadeth me to. 1060
Both your tales I take far impossible,
Yet take I his farther incredible.
Not only the thing itself alloweth it,
But also the boldness thereof avoweth it.

[*To* POTHECARY]

I know not where your tale to try,—[225]

[*To* PARDONER]

Nor yours, but in hell or purgatory;
But his boldness hath faced a lie
That may be tried even in this company,
As, if ye list, to take this order:
Among the women in this border,[226] 1070
Take three of the youngest and three of the oldest,
Three of the hottest and three of the coldest,
Three of the wisest and three of the shrewdest,[227]
Three of the chastest and three of the lewdest,
Three of the lowest and three of the highest,
Three of the farthest and three of the nighest,
Three of the fairest and three of the maddest,
Three of the foulest and three of the saddest[228]—
And when all these threes be had asunder,
Of each three, two, justly by number, 1080
Shall be found shrews, except this fall,[229]
That ye hap to find them shrews all!
Himself for truth all this doth know,
And oft hath tried some of this row;
And yet he sweareth, by his conscience,
He never saw woman break patience!
Wherefore, considered with true intent,
His lie to be so evident,
And to appear so evidently
That both you affirmed it a lie, 1090
And that my conscience so deeply
So deep hath sought this thing to try,
And tried it with mind indifferent,
Thus I award, by way of judgment—
Of all the lies ye all have spent
His lie to be most excellent.
 Palm. Sir, though ye were bound of equity
To do as ye have done to me,
Yet do I thank you of[230] your pain,
And will requite some part again. 1100
 Pard. Marry, sir, ye can no less do
But thank him as much as it cometh to.

[209] *get:* win. [210] *prayed:* craved.
[211] *Paul's Churchyard:* Outside old St. Paul's in London,
booksellers exhibited their wares; hence, a marketplace.
[212] *Fet:* fetched. [213] *bones:* fingers.
[214] *he:* the Palmer. [215] *meved:* urged.
[216] *cast:* reckoning. [217] *knave:* the Pedlar.
[218] *accumber:* bear down. [219] *privy:* private.
[220] *ten:* the tithe or tenth part. [221] *lithe:* lies.
[222] *ten commandments:* fingernails or "claws."
[223] *wold:* would. [224] *here:* addressing the Pardoner.
[225] *try:* test. [226] *border:* territory.
[227] *shrewdest:* most shrewish. [228] *saddest:* most serious.
[229] *fall:* happen. [230] *of:* for.

And so will I do for my part:

[*To* PEDLAR]

Now a vengeance on thy knave's heart!
I never knew pedlar a judge before,
Nor never will trust peddling-knave more!—

He sees the POTHECARY *curtsying about* PALMER

What does thou there, thou whoreson noddy?—
　Poth. By the mass, learn to make curtsy!
Curtsy before, and curtsy behind him,
And then on each side—the devil blind him!　1110
Nay, when I have it perfectly,
Ye shall have the devil and all of curtsy!
But it is not soon learned, brother,
One knave to make curtsy to another.
Yet, when I am angry, that is the worst,
I shall call my master knave at the first.
　Palm. Then would some master perhaps clout ye!
But, as for me, ye need not doubt ye;
For I had liefer[231] be without ye
Than have such business about ye.　1120
　Pard. So help me God, so were ye better!
What, should a beggar be a jetter?[232]
It were no whit your honesty
To have us twain jet after ye.
　Poth. Sir, be ye sure he telleth you true.
If we should wait,[233] this would ensue:
It would be said—trust me at a word—
Two knaves made curtsy to the third.
　Ped. [*To* PALMER] Now, by my troth, to speak my
　　　mind,
Since they be so loath to be assigned,[234]　1130
To let them loose I think it best,
And so shall ye live best in rest.
　Palm. Sir, I am not on them so fond
To compel them to keep their bond.

[*To* POTHECARY *and* PARDONER]

And, since ye list not to wait on me,
I clearly of waiting discharge ye.
　Pard. Marry, sir, I heartily thank you!
　Poth. And I likewise, I make God avow![235]
　Ped. Now be ye all even as ye begun;
No man hath lost, nor no man hath won.　1140
Yet in the debate wherewith ye began,
By way of advice I will speak as I can.

[*To* PALMER]

I do perceive that pilgrimage
Is chief the thing ye have in usage;
Whereto, in effect, for love of Christ

231 *liefer:* rather.　　232 *jetter:* braggart.
233 *wait:* on you.
234 *be assigned:* have their business appointed.
235 *avow:* avouch, warrant.　236 *ensue:* follow.
237 *manner kind:* tautological—"kind."
238 *wrest:* misconstrue by twisting.
239 *for:* to the end that.　240 *pretended:* purposed.
241 *all to begin:* wholly beginners.　242 *lewdly:* ignorantly.

Ye have, or should have, been enticed.
And who so doth, with such intent,
Doth well declare his time well spent.—

[*To* PARDONER]

And so do ye in your pretense,
If ye procure thus indulgence　1150
Unto your neighbors charitably
For love of them in God only.
All this may be right well applied
To show you both well occupied;
For, though ye walk not both one way,
Yet, walking thus, this dare I say,
That both your walks come to one end.
And so for all that do pretend,
By aid of God's grace, to ensue[236]
Any manner kind[237] of virtue:　1160
As, some great alms for to give,
Some in willful poverty to live,
Some to make highways and such other warks,
And some to maintain priests and clarks—
To sing and pray for soul departed—
These, with all other virtues well marked,
Although they be of sundry kinds,
Yet be they not used with sundry minds;
But, as God only doth those move,
So every man, only for His love,　1170
With love and dread obediently
Worketh in these virtues uniformly.
Thus every virtue, if we list to scan,
Is pleasant to God and thankful to man;
And who that by grace of the Holy Ghost
To any one virtue is moved most,
That man, by that grace, that one apply,
And therein serve God most plentifully!
Yet not that one so far wide to wrest,[238]
So liking the same to mislike the rest;　1180
For who so wresteth his work is in vain.
And even in that case I perceive you twain,
Liking your virtue in such wise
That each other's virtue you do despise.
Who walketh this way for[239] God would find him,
The farther they seek him, the farther behind him.
One kind of virtue to despise another
Is like as the sister might hang the brother.
　Poth. For fear lest such perils to me might fall,
I thank God I use no virtue at all!　1190
　Ped. That is of all the very worst way!
For more hard it is, as I have heard say,
To begin virtue where none is pretended[240]
Than, where it is begun, the abuse to be mended.
Howbeit, ye be not all to begin,[241]
One sign of virtue ye are entered in,
As this I suppose ye did say true,
In that ye said ye use no virtue;
In the which words, I dare well report,
Ye are well beloved of all this sort,　1200
By your railing here openly
At pardons and relics so lewdly.[242]
　Poth. In that I think my fault not great;
For all that he hath I know counterfeit.

Ped. For his, and all other that ye know feigned,[243]
Ye be neither counseled nor constrained
To any such thing in any such case
To give any reverence in any such place;
But where ye doubt the truth, not knowing,
Believing the best, good may be growing. 1210
In judging the best, no harm at the lest,[244]
In judging the worst, no good at the best.
But best in these things, it seemeth to me,
To take no judgment upon ye;
But, as the Church doth judge or take them,
So do ye receive or forsake them;
And so, be sure, ye cannot err,
But may be a fruitful follower.
 Poth. Go ye before, and, as I am true man,
I will follow as fast as I can. 1220

Pard. And so will I; for he hath said so well,
Reason would we should follow his counsel.
 Palm.[245] Then to our reason God give us His grace,
That we may follow with faith so firmly
His commandments that we may purchase
His love, and so consequently
To believe his Church fast and faithfully;
So that we may, according to his promise,
Be kept out of error in any wise.
And all that hath 'scaped us here by negligence, 1230
We clearly revoke and forsake it.
To pass the time in this without offense
Was the cause why the maker did make it;
And so we humbly beseech you take it;
Beseeching Our Lord to prosper you all
In the faith of his Church Universal!

F I N I S

[243] *feigned:* pretended. [244] *lest:* least.
[245] *Palmer:* His concluding speech is presumably addressed to the audience.

Mr. S

GAMMER GURTON'S NEEDLE

THE EARLIEST version of the university play in English is GAMMER GURTON'S NEEDLE, a "pithy, pleasant, and merry comedy," as the title page describes it, first "played on stage" in Christ's College, Cambridge, in the early 1550s and printed by Thomas Colwell in 1576. Because a play called *Diccon of Bedlam*, the name of the mischiefmaker or contriver of the plot in GAMMER GURTON'S NEEDLE, had been entered to Colwell in the *Stationers' Register* in 1562–63, it is possible that printing significantly antedated publication or, what is more likely, that the edition of 1575 is not the first edition. The work of the printer is occasionally slipshod. Minor misprints are frequent and have been corrected here, most of them silently.

Date of composition is fixed partly by an enjoining (in V.ii) "in the king's name." King Edward VI is presumably referred to. If that is an accurate supposition, it is reasonable to suppose further that Edward was still alive at the time the play was written. His death in 1553 is taken, therefore, as establishing a terminal date for GAMMER GURTON'S NEEDLE. Probably composition ought to be assigned to the period 1550–53.

Like the typical interlude, GAMMER GURTON'S NEEDLE turns its back resolutely on consequential business. In its treatment of incident it is farcical, though one should note that farce does not preclude careful construction. In its dialogue it is often coarse. Realization of homely character, however stereotyped, and attention to homely detail constitute its chief strength. In these respects it has moved far from the cursory representation of the morality play.

The author, a Master of Arts signalized by the printer only as "Mr. S," is probably William Stevenson, a bachelor of Christ's in 1550, subsequently an M.A. (1553), B.D. (1560), and fellow of the college. Ascription to Stevenson has been generally though not universally accepted since the eighteenth century. It is made more plausible by a record of payment to him for his "plays." However rustic the characters of this play, a scholar's hand seems to be deploying them, for the impress of classical comedy is perceptible in the unity imparted to plot, in the emphasis on a single scene— the village street between the houses of Gammer Gurton and Dame Chat—and in the division of the whole into acts and scenes, a division appropriate to classical comedy but not customary in English until the seventeenth century. Even the consistent adhering to southwestern dialect to suggest a particular type and the choice of the old-fashioned verse form called fourteeners, considered suitable for country persons, speak to the scholar's fastidious observance of what the sixteenth century understood as "decorum."

A further word is indicated regarding the verse form in which the play is cast. Though the fourteener seems cumbersome today, it was employed as the medium of highly sophisticated poetry from the beginning of the sixteenth century—sophisticated, at least by intention —and was not beneath the notice of W. B. Yeats in the poem from *The Tower* (1928) entitled "Owen Aherne and His Dancers." Yeats is perhaps consciously archaic or opportunistic in reverting to the fourteener; the Henrician poet and his successors in the reign of Elizabeth are, however, not reverting or experimenting: they are using what is to hand. Though blank verse had been attempted by the Earl of Surrey in the first half of the sixteenth century, its availability as a vehicle for stage declamation awaited the triumphant practice of Peele and Marlowe in the 1580s. Not until the advent of these writers did the potentialities of blank verse begin to be realized. In the interval the fourteener seemed an appropriate form for conveying dialogue in the poetic drama. In GAMMER GURTON'S NEEDLE, necessity and decorum work together.

R. A. F.

Gammer Gurton's Needle

DRAMATIS PERSONÆ

DICCON, *the Bedlam*[1]
HODGE, *Gammer*[2] *Gurton's servant*
TIB, *Gammer Gurton's maid*
GAMMER GURTON
COCK,[3] *Gammer Gurton's boy*
DAME CHAT

DOCTOR RAT, *the Curate*
MASTER BAILY[4]
DOLL, *Dame Chat's maid*
SCAPETHRIFT, *Master Baily's servant*
MUTES

GOD SAVE THE QUEEN.

THE PROLOGUE

As Gammer Gurton with many a wide stitch
Sat piecing[1] and patching of Hodge her man's breech,
By chance or misfortune as she her gear tossed,[2]
In Hodge' leather breeches her needle she lost.
When Diccon the bedlam had heard by report
That good Gammer Gurton was robbed in this sort,
He quietly persuaded with her in that stound[3]
Dame Chat, her dear gossip,[4] this needle had found.
Yet knew she no more of this matter, alas,
Than knoweth Tom, our clerk,[5] what the priest
 saith at Mass! 10

Hereof there ensued so fearful a fray
Mas' Doctor was sent for, these gossips to stay,
Because he was curate, and esteemed full wise,
Who found that[6] he sought not, by Diccon's device.
When all things were fumbled and clean out of fashion,
Whether it were by fortune or some other
 constellation,[7]
Suddenly the neele[8] Hodge found by the pricking,
And drew it out of his buttock where he felt it sticking.
Their hearts then at rest with perfect security,
With a pot of good nale[9] they stroke[10] up their
 plaudity.[11] 20

ACT ONE

SCENE ONE

[*Enter*] DICCON.

Dic. Many a mile have I walked, divers and sundry
 ways,
And many a good man's house have I been at in my
 days,
Many a gossip's cup in my time have I tasted,
And many a broach[1] and spit have I both turned and
 basted,
Many a piece of bacon have I had out of their balks[2]
In running over the country with long and weare[3]
 walks;
Yet came my foot never within those doorcheeks,[4]
To seek flesh, or fish, garlic, onions, or leeks,
That ever I saw a sort[5] in such a plight
As here within this house appeareth to my sight! 10
There is howling and scowling, all cast in a dump,
With whewling and puling, as though they had lost a
 trump;[6]
Sighing and sobbing they weep and they wail,
I marvel in my mind what the devil they ail.

The old trot[7] sits groaning, with "alas!" and "alas!"
And Tib wrings her hands, and takes on in worse case.
With poor Cock, their boy, they be driven in such fits
I fear me the folks be not well in their wits.

DRAMATIS PERSONÆ
 [1] *Bedlam:* Lunatic (from the London hospital for the insane called St. Mary of Bethlehem), and, when at large, a licensed beggar.
 [2] *Gammer:* rustic title for an old woman—"Grandmother." [3] *Cock:* First edition reads "Dock."
 [4] *Baily:* Bailiff, an officer of justice.

PROLOGUE
 [1] *piecing:* mending.
 [2] *her gear tossed:* worked at her sewing materials.
 [3] *stound:* state of amazement or stupefaction.
 [4] *gossip:* female friend.
 [5] *clerk:* originally "cleric"; here used in the modern sense and pronounced "clark." [6] *that:* what.
 [7] *constellation:* planetary influence. [8] *neele:* needle.
 [9] *nale:* ale. [10] *stroke:* struck. [11] *plaudity:* applause.

I.i.
 [1] *broach:* skewer.
 [2] *balks:* beams, whence the bacon was hung.
 [3] *weare:* weary(?). [4] *doorcheeks:* entrances.
 [5] *sort:* group. [6] *trump:* in a card game. [7] *trot:* hag.

Ask them what they ail, or who brought them in this
 stay,[8]
They answer not at all but "alack!" and "welaway!"
When I saw it booted[9] not, out at doors I hied me, 21
And caught a slip of bacon, when I saw that none spied
 me,
Which I intend not far hence, unless my purpose fail,
Shall serve for a shoeing-horn[10] to draw on two pots of
 ale.

I.ii

[*Enter*] HODGE, DICCON.

 Hod. See! So cham[1] arrayed with dabbling in the
 dirt!
She that set me to ditching, ich wold[2] she had the
 squirt![3]
Was never poor soul that such a life had!
Gog's bones,[4] this vilthy glay[5] has dressed me too bad!
God's soul, see how this stuff tears!
Ich were better to be a bearward and set to keep bears!
By the Mass, here is a gash! a shameful hole indeed!
And[6] one stitch tear furder,[7] a man may thrust in his
 head.
 Dic. By my father's soul, Hodge, if I shuld now be
 sworn,
I cannot choose but say thy breech is foul betorn! 10
But the next remedy in such a case and hap
Is to planch[8] on a piece as broad as thy cap.
 Hod. Gog's soul, man, 'tis not yet two days fully
 ended
Since my Dame Gurton, cham sure, these breeches
 amended!
But cham made such a drudge, to trudge at every need,
Chwold[9] rend it, though it were stitched with sturdy
 packthread.
 Dic. Hodge, let thy breeches go, and speak and tell
 me soon
What devil aileth Gammer Gurton and Tib, her maid,
 to frown.
 Hod. Tush, man, th'art deceived! 'Tis their daily
 look;
They cower so over the coals, their eyes be bleared
 with smoke. 20

 Dic. Nay, by the Mass, I perfectly perceived, as I
 came hether,
That either Tib and her dame hath been by the ears[10]
 together,
Or else as great a matter, as thou shalt shortly see.
 Hod. Now ich beseech our Lord they never better
 agree!
 Dic. By Gog's soul, there they sit as still as stones in
 the street,[11]
As though they had been taken[12] with fairies, or else
 with some ill sprite.
 Hod. Gog's heart, I durst have laid my cap to a
 crown
Chwould learn of some prancome[13] as soon as ich came
 to town!
 Dic. Why, Hodge, art thou inspired? Or didst thou
 thereof hear?
 Hod. Nay, but ich saw such a wonder as ich saw nat
 this seven year: 30
Tom Tankard's cow, by Gog's bones, she set me up her
 sail,
And flinging about his half-acre, fisking[14] with her tail,
As though there had been in her arse a swarm of bees,
And chad not cried, "Tphrowh,[15] whore!" she'd
 leaped out of his leas.[16]
 Dic. Why, Hodge, lies the cunning[17] in Tom
 Tankard's cow's tail?
 Hod. Well, ich chave hard[18] some say such tokens do
 not fail.
But canst thou not tell, in faith, Diccon, why she
 frowns, or whereat?
Hath no man stolen her ducks or hens, or gelded Gib,
 her cat?
 Dic. What devil can I tell, man? I cold not have one
 word;
They gave no more heed to my talk than thou woldst to
 a lord. 40
 Hod. Ich cannot still but muse what marvelous thing
 it is!
Chill[19] in and know myself what matters are amiss.
 Dic. Then farewell, Hodge, awhile, since thou dost
 inward haste,
For I will into the Goodwife Chat's, to feel how the ale
 doth taste.

 [*Exit.*]

 [8] *stay:* plight. [9] *booted:* availed.
 [10] *shoeing-horn:* i.e., a means of achieving.

I.ii.
 [1] *cham:* I am. [2] *ich wold:* I would.
 [3] *squirt:* the "runs," diarrhea.
 [4] *Gog's bones:* By God's bones. [5] *glay:* clay.
 [6] *And:* An, "if." [7] *furder:* further.
 [8] *planch:* clap. [9] *Chwold:* I would.
 [10] *by the ears:* fighting.
 [11] *street:* spelled "streite" in original to rhyme with
"sprite." [12] *taken:* bewitched. [13] *prancome:* prank.
 [14] *fisking:* frisking. [15] *Tphrowh:* Hodge's coinage.
 [16] *leas:* pasture. [17] *cunning:* magic power.
 [18] *hard:* heard. [19] *Chill:* I will.

I.iii.
 [1] *wot:* know. [2] *Chad:* I had. [3] *chwere:* I were.
 [4] *noddy:* fool. [5] *venter:* venture. [6] *cha':* I have.
 [7] *thours:* the hours.

I.iii

HODGE, TIB.

 Hod. Cham aghast, by the Mass! Ich wot[1] not what
 to do.
Chad[2] need bless me well before ich go them to!
Perchance some felon sprite may haunt our house
 indeed,
And then chwere[3] but a noddy[4] to venter[5] where cha'[6]
 no need!
 Tib. Cham worse than mad, by the Mass, to be at
 this stay!
Cham chid, cham blamed, and beaten all thours[7] on
 the day,

Lamed, and hunger-starved, pricked up all in jags,[8]
Having no patch to hide my back save a few rotten
 rags!
 Hod. I say, Tib—if thou be Tib, as I trow sure thou
 be—
What devil make-ado is this between our dame and
 thee? 10
 Tib. Gog's bread, Hodge, thou had a good turn thou
 wert not here this while!
It had been better for some of us to have been hence a
 mile!
My gammer is so out of course and frantic all at once
That Cock, our boy, and I, poor wench, have felt it on
 our bones.
 Hod. What is the matter—say on, Tib—whereat she
 taketh so on?
 Tib. She is undone, she saith; alas, her joy and life is
 gone!
If she hear not of some comfort, she is, saith, but dead;
Shall never come within her lips one inch of meat ne[9]
 bread!
 Hod. By'r Lady, cham not very glad to see her in
 this dump.
Chold a noble[10] her stool hath fallen and she hath
 broke her rump! 20
 Tib. Nay, and that were the worst, we wold not
 greatly care,
For bursting of her huckle[11] bone, or breaking of her
 chair;
But greater, greater, is her grief, as, Hodge, we shall all
 feel.
 Hod. Gog's wounds, Tib, my gammer has never
 lost her neele?
 Tib. Her neele!
 Hod. Her neele?
 Tib. Her neele!
By Him that made me, it is true, Hodge, I tell thee.
 Hod. Gog's sacrament, I would she had lost thart[12]
 out of her belly!
The devil, or else his dame, they ought[13] her, sure, a
 shame!
How a murrion[14] came this chance—say, Tib—unto
 our dame?
 Tib. My gammer sat her down on her pess,[15] and
 bade me reach thy breeches; 30
And by and by[16]—a vengeance in it!—or[17] she had
 take two stitches
To clap a clout[18] upon thine arse, by chance aside she
 leers,
And Gib, our cat, in the milk pan she spied over head
 and ears.
"Ah, whore! Out, thief!" she cried aloud, and swapt[19]
 the breeches down.
Up went her staff, and out leaped Gib at doors into the
 town,[20]
And since that time was never wight[21] cold set their
 eyes upon it.
Gog's malison[22] chave Cock and I bid twenty times
 light on it.
 Hod. And is not then my breeches sewed up,
 tomorrow that I shuld wear?

 Tib. No, in faith, Hodge, thy breeches lie, for all
 this, never the near.[23]
 Hod. Now a vengeance light on all the sort, that
 better shold have kept it— 40
The cat, the house, and Tib, our maid, that better
 shold have swept it!
See where she cometh crawling! Come on, in twenty
 devils' way!
Ye have made a fair day's work, have you not? Pray you,
 say!

I.iv

GAMMER, HODGE, TIB.

 Gam. Alas, Hodge, alas, I may well curse and ban[1]
This day, that ever I saw it, with Gib and the milk pan!
For these and ill luck together, as knoweth Cock, my
 boy,
Have stack[2] away my dear neele, and robbed me of my
 joy,
My fair, long, straight neele, that was mine only
 treasure!
The first day of my sorrow is, and last end of my
 pleasure!
 Hod. Might ha' kept it when ye had it, but fools will
 be fools still!
Lose that is vast[3] in your hands? Ye need not, but ye
 will!
 Gam. Go hie thee, Tib, and run, thou whore, to
 th'end here of the town!
Didst carry out dust in thy lap. Seek where thou
 pourest it down; 10
And, as thou sawest me roking[4] in the ashes where I
 mourned,[5]
So see in all the heap of dust thou leave no straw
 unturned.
 Tib. That chall, gammer, swith and tight,[6] and soon
 be here again!
 Gam. Tib, stoop and look down to the ground to it,
 and take some pain!
 [*Exit* TIB.]
 Hod. Here is a pretty matter, to see this gear[7] how it
 goes!
By Gog's soul, I think you wold lose your arse and it
 were loose!
Your neele lost? It is pity you shold lack care and
 endless sorrow.
Gog's death, how shall my breeches be sewed? Shall I
 go thus tomorrow?

[8] *pricked . . . jags:* dressed in tatters. [9] *ne:* nor.
[10] *Chold a noble:* Bet a coin (of value). [11] *huckle:* hip.
[12] *thart:* the heart. [13] *ought:* owed.
[14] *murrion:* plague. [15] *pess:* hassock.
[16] *by and by:* immediately. [17] *or:* ere.
[18] *clout:* cloth. [19] *swapt:* threw.
[20] *town:* enclosed yard. [21] *wight:* person.
[22] *malison:* curse. [23] *near:* nearer (to being mended).

I.iv
[1] *ban:* curse. [2] *stack:* stuck. [3] *vast:* fast.
[4] *roking:* raking, seeking.
[5] *morned:* passed the morning.
[6] *swith and tight:* quickly and soon. [7] *gear:* business.

Gam. Ah, Hodge, Hodge, if that ich cold find my
neele, by the Reed,[8]
Chould sew thy breeches, ich promise thee, with full
good double thread, 20
And set a patch on either knee, shuld last this moneths
twain.[9]
Now God and good Saint Sith I pray to send it home
again!
 Hod. Whereto served your hands and eyes but this
your neele to keep?
What devil had you else to do? Ye kept, ich wot, no
sheep!
Cham fain[10] abroad to dig and delve,[11] in water, mire,
and clay,
Sossing and possing[12] in the dirt still[13] from day to day;
A hundred things that be abroad, cham set[14] to see
them weal[15]—
And four of you sit idle at home, and cannot keep a
neele!
 Gam. My neele, alas! Ich lost it, Hodge, what time
ich me uphasted
To save the milk set up for thee, which Gib, our cat,
hath wasted. 30
 Hod. The devil he burst both Gib and Tib, with all
the rest!
Cham always sure of the worst end, whoever have the
best!
Where ha' you been fidging[16] abroad since you your
neele lost?
 Gam. Within the house, and at the door, sitting by
this same post,
Where I was looking a long hour before these folks
came here.
But, welaway! All was in vain; my neele is never the
near!
 Hod. Set me a candle; let me seek and grope
wherever it be.
Gog's heart, ye be so foolish, ich think you know it not
when you it see!
 Gam. Come hether, Cock! What, Cock, I say!

[*Enter* COCK.]

Cock. How,
gammer!
Gam. Go hie thee soon,
And grope behind the old brass pan; which thing when
thou hast done, 41
There shalt thou find an old shoe, wherein, if thou look
well,

Thou shalt find lying an inch of a white tallow candle.
Light it, and bring it tight away.
 Cock. That shall be done
anon.[17]

 [*Exit.*]

 Gam. Nay, tarry, Hodge, till thou hast light, and
then we'll seek each one.
 Hod. Come away, ye whoreson boy! Are ye asleep?
Ye must have a crier![18]
 Cock. [*Within*] Ich cannot get the candle light; here is
almost no fire.
 Hod. Chill hold[19] thee a penny chill make thee come
if that ich may catch thine ears!
Art deaf, thou whoreson boy? Cock, I say, why canst
not hear 's?
 Gam. Beat him not, Hodge, but help the boy, and
come you two together.

 [*Exit* HODGE.]

I.v

GAMMER, TIB.

 Gam. How now, Tib? Quick, let's hear what news
thou hast brought hether!
 Tib. Chave tossed and tumbled yender[1] heap over
and over again,
And winnowed it through my fingers as men wold
winnow grain;
Not so much as a hen's turd but in pieces I tare it,
Or whatsoever clod or clay I found, I did not spare it,
Looking within, and eke without, to find your neele,
alas!
But all in vain, and without help—your neele is where
it was!
 Gam. Alas, my neele! We shall never meet! Adieu,
adieu, for aye!
 Tib. Not so, gammer; we might it find if we knew
where it lay.

[*Enter* COCK.]

 Cock. Gog's Cross, gammer, if ye will laugh, look in
but at the door, 10
And see how Hodge lieth tumbling and tossing amids
the flour.[2]
Raking there some fire to find among the ashes dead,
Where there is not one spark so big as a pin's head,
At last in a dark corner two sparks he thought he sees,
Which were indeed naught else but Gib our cat's two
eyes.
"Puff!" quod[3] Hodge, thinking thereby to have fire
without doubt;
With that Gib shut her two eyes, and so the fire was
out,
And by and by them opened, even as they were before;
With that the sparks appeared, even as they had done
of yore.
And, even as Hodge blew the fire, as he did think, 20
Gib, as she felt the blast, straightway began to wink,[4]
Till Hodge fell of swearing, as came best to his turn,
The fire was sure bewitched, and therefore wold not
burn.

 [8] *Reed:* Rood, Cross. [9] *moneths twain:* two months.
 [10] *Cham fain:* I am obliged.
 [11] *delve:* dig (another tautology).
 [12] *Sossing and possing:* Sousing (myself) and pushing.
 [13] *still:* continuously. [14] *set:* appointed.
 [15] *weal:* in good shape. [16] *fidging:* wandering.
 [17] *anon:* immediately. [18] *crier:* town crier.
 [19] *hold:* bet.

I.v.
 [1] *yender:* yonder.
 [2] *flour:* powder, ashes (and rhyming with "door").
 [3] *quod:* said. [4] *wink:* close her eyes.

At last Gib up[5] the stairs among the old posts and
 pins;[6]
And Hodge he hied him after till broke were both his
 shins—
Cursing and swearing oaths, were never of his
 making,
That Gib wold fire the house if that she were not
 taken.
 Gam. See, here is all the thought that the foolish
 urchin taketh,
And Tib, methink, at his elbow almost as merry
 maketh!
This is all the wit ye have, when others make their
 moan. 30
Come down, Hodge! Where art thou? And let the cat
 alone!
 Hod. [*Within*] Gog's heart, help and come up! Gib
 in her tail hath fire,
And is like to burn all if she get a little higher!
"Come down," quoth you? Nay, then you might count
 me a patch![7]
The house cometh down on your heads if it take[8] once
 the thatch.
 Gam. It is the cat's eyes, fool, that shineth in the
 dark!
 Hod. [*Within*] Hath the cat, do you think, in every
 eye a spark?
 Gam. No, but they shine as like fire as ever man
 see.
 Hod. [*Within*] By the Mass, and she burn all, you sh'
 bear the blame for me!
 Gam. Come down, and help to seek here our neele,
 that it were found. 40
Down, Tib, on the knees, I say! Down, Cock, to the
 ground!
To God I make a vow, and so to good Saint Anne,
A candle shall they have apiece, get it where I can,
If I may my neele find in one place or in other.

 [*Enter* HODGE.]

 Hod. Now a vengeance on Gib light, on Gib and
 Gib's mother,
And all the generation of cats both far and near!
Look on the ground, whoreson? Thinks then the neele
 is here?
 Cock. By my troth, gammer, methought your neele
 here I saw,
But, when my fingers touched it, I felt it was a straw.
 Tib. See, Hodge, what's tis?[9] May it not be within
 it? 50
 Hod. Break it, fool, with thy hand, and see and thou
 canst find it.
 Tib. Nay, break it you, Hodge, according to your
 word.
 Hod. Gog's sides, fie, it stinks! It is a cat's turd!
It were well done to make thee eat it, by the Mass!
 Gam. This matter amendeth not; my neele is still
 where it was.
Our candle is at an end; let us all in quite,
And come another time, when we have more light.
 [*Exeunt.*]

ACT TWO

First a song.

Back and side, go bare, go bare;
 Both foot and hand, go cold;
But, belly, God send thee good ale enough,
 Whether it be new or old!

I cannot eat but little meat,
 My stomach is not good;
But sure I think that I can drink
 With him that wears a hood.[1]
Though I go bare, take ye no care,
 I am nothing acold, 10
I stuff my skin so full within
 Of jolly good ale and old.

Back and side, go bare, go bare;
 Both foot and hand, go cold;
But, belly, God send thee good ale enough,
Whether it be new or old!

I love no roast but a nut-brown toast
 And a crab[2] laid in the fire;
A little bread shall do me stead,
 Much bread I not desire. 20
No frost nor snow, no wind, I trow,
 Can hurt me if I wold,
I am so wrapped and throughly lapped
 Of jolly good ale and old.

 Back and side, go bare, etc.

And Tib, my wife, that as her life
 Loveth well good ale to seek,
Full oft drinks she till ye may see
 The tears run down her cheeks;
Then doth she troll[3] to me the bowl,
 Even as a maltworm[4] shuld, 30
And saith, "Sweetheart, I took my part
 Of this jolly good ale and old."

 Back and side, go bare, etc.

Now let them drink till they nod and wink,
 Even as good fellows should do;
They shall not miss to have the bliss
 Good ale doth bring men to.
And all poor souls that have scoured[5] bowls
 Or have them lustily trolled,
God save the lives of them and their wives,
 Whether they be young or old! 40

 Back and side, go bare, etc.

[5] *up:* as verb. [6] *posts and pins:* beams and hooks.
[7] *patch:* fool. [8] *take:* fire. [9] *tis:* this.
II. SONG.
 [1] *hood:* denoting a friar. [2] *crab:* crabapple.
 [3] *troll:* pass. [4] *maltworm:* tippler.
 [5] *scoured:* drunk off.

SCENE ONE

DICCON.

Dic. Well done, by Gog's malt! Well sung, and well
said!
Come on, Mother Chat, as thou art true maid;
One fresh pot of ale let's see, to make an end,
Against this cold weather my naked arms to defend!
This gear it warms the soul! Now, wind, blow on the
worst,
And let us drink and swill till that our bellies burst!
Now were he a wise man, by cunning cold define
Which way my journey lieth, or where Diccon will
dine.
But one good turn I have, be it by night or day,
South, east, north, or west, I am never out of my way!

[*Enter* HODGE.]

Hod. Cham goodly rewarded, cham I not, do you
think? 11
Chad a goodly dinner for all my sweat and swink![1]
Neither butter, cheese, milk, onions, flesh, nor fish,
Save this poor piece of barley bread—'tis a pleasant,
costly dish!
Dic. Hail, fellow Hodge, and will[2] to fare with thy
meat—if thou have any!
But by thy words, as I them smelled, thy daintrels[3] be
not many.
Hod. Daintrels, Diccon? Gog's soul, man, save this
piece of dry horsebread,
Cha' bit no bit this livelong day; no crumb come in my
head;
My guts they yawl,[4] crawl, and all my belly rumbleth;
The puddings[5] cannot lie still; each one over other
tumbleth. 20
By Gog's heart, cham so vexed and in my belly penned[6]
Chould one piece were at the spittle-house,[7] another at
the Castle's End!
Dic. Why, Hodge, was there none at home thy
dinner for to set?
Hod. Gog's bread, Diccon, ich came too late; was
nothing there to get.
Gib—a foul fiend might on her light—licked the milk
pan so clean!
See, Diccon, 'twas not so well washed this seven[8] year,
as ich ween!
A pestilence light on all ill luck! Chad thought yet, for
all this,
Of a morsel of bacon behind the door at worst shuld
not miss;

But when ich sought a slip to cut, as ich was wont to
do,
Gog's soul, Diccon, Gib, our cat, had eat the bacon
too! 30

Which bacon Diccon stole, as is declared before.

Dic. Ill luck, quod he? Marry, swear it, Hodge, this
day, the truth to tell.
Thou rose not on thy right side, or else blessed thee not
well.
Thy milk slopped up, thy bacon filched—that was too
bad luck, Hodge!
Hod. Nay, nay, there was a fouler fault: my gammer
ga' me the dodge![9]
Seest not how cham rent and torn—my heels, my
knees, and my breech?
Chad thought as ich sat by the fire, help here and there
a stitch;
But there ich was pooped[10] indeed!
Dic. Why, Hodge?
Hod. Boots[11]
not, man, to tell.
Cham so dressed[12] amongst a sort[13] of fools, chad
better be in hell!
My gammer, cham ashamed to say, by God, served me
not weel!
Dic. How so, Hodge?
Hod. Has she not gone, trowest now,
and lost her neele? 40
Dic. Her eel, Hodge? Who fished of late? That was a
dainty dish!
Hod. Tush, tush, her neele! her neele! her neele,
man! 'Tis neither flesh nor fish.
A little thing with an hole in the end, as bright as any
siller,[14]
Small, long, sharp at the point, and straight as any
pillar.
Dic. I know not what a devil thou meanest. Thou
bring'st me more in doubt.
Hod. Knowest not with what Tom Tailor's man sits
broaching[15] through a clout?
A neele! neele! a neele! My gammer's neele is gone!
Dic. Her neele, Hodge? Now I smell thee! That was
a chance alone![16]
By the Mass, thou hadst a shameful loss, and it were
but for thy breeches!
Hod. Gog's soul, man, could give a crown chad it
but three stitches! 50
Dic. How sayest thou, Hodge? What shuld he have,
again thy neele got?
Hod. Bem vather's[17] soul, and chad it, could give
him a new groat!
Dic. Canst thou keep counsel in this case?
Hod. Else
chwold my tongue were out.
Dic. Do thou but then by my advice, and I will fetch
it without doubt.
Hod. Chill run, chill ride, chill dig, chill delve, chill
toil, chill trudge, shalt see;
Chill hold, chill draw, chill pull, chill pinch, chill kneel
on my bare knee;

II.i.

II.i.
[1] *swink:* toil. [2] *will:* well(?).
[3] *daintrels:* delicacies. [4] *yawl:* yowl.
[5] *puddings:* guts. [6] *penned:* pinched.
[7] *spittle-house:* poor house.
[8] *seven:* conventional for a rough estimate.
[9] *ga' . . . dodge:* deceived me. [10] *pooped:* deceived.
[11] *Boots:* Avails. [12] *dressed:* ill served.
[13] *sort:* group. [14] *siller:* silver.
[15] *broaching:* piercing.
[16] *chance alone:* singular bit of (bad) fortune.
[17] *Bem vather's:* By my father's.

Chill scrape, chill scratch, chill sift, chill seek, chill
 bow, chill bend, chill sweat,
Chill stoop, chill stir, chill cap,[18] chill kneel, chill creep
 on hands and feet,
Chill be thy bondman, Diccon, ich swear by sun and
 moon.
And channot somewhat to stop this gap, cham utterly
 undone! 60

Pointing behind to his torn breeches.

Dic. Why, is there any special cause thou takest
 hereat such sorrow?
Hod. Kirstian Clack, Tom Simson's maid, by the
 mass, comes hether tomorrow!
Cham not able to say, between us what may hap—
She smiled on me the last Sunday when ich put off my
 cap.
Dic. Well, Hodge, this is a matter of weight, and
 must be kept close;
It might else turn to both our costs, as the world now
 goes.
Shalt swear to be no blab, Hodge?
Hod. Chill, Diccon!
Dic. Then,
 go to!
Lay thine hand here; say after me as thou shalt hear me
 do.
Hast no book?
Hod. Cha' no book, I!
Dic. Then needs must force
 us both
Upon my breech to lay thine hand, and there to take
 thine oath. 70
Hod. I, Hodge, breechless,
 Swear to Diccon rechless,[19]
 By the Cross that I shall kiss,
 To keep his counsel close,
 And always me to dispose
 To work that his pleasure is.

Here he kisseth Diccon's breech.

Dic. Now, Hodge, see thou take heed
 And do as I thee bid,
 For so I judge it meet.
 This needle again to win 80
 There is no shift[20] therein
 But conjure up a sprite.

Hod. What, the great devil, Diccon, I say?
Dic. Yea, in good faith, that is the way—
 Fet[21] with some pretty charm.
Hod. Soft, Diccon! Be not too hasty yet,
 By the Mass, for ich begin to sweat!
 Cham afraid of some harm!

Dic. Come hether then, and stir thee not
 One inch out of this circle[22] plot, 90
 But stand as I thee teach.
Hod. And shall ich be here safe from their claws?
Dic. The master devil with his long paws
 Here to thee cannot reach.

Now will I settle me to this gear.
Hod. I say, Diccon, hear me, hear!
 Go softly to this matter!
Dic. What devil, man, art afraid of naught?
Hod. Canst not tarry a little thought
 Till ich make a curtsy of water?[23] 100

Dic. Stand still to it! Why shuldest thou fear him?
Hod. Gog's sides, Diccon, methink ich hear him!
 And tarry, chall mar all!
Dic. The matter is no worse than I told it.
Hod. By the Mass, cham able no longer to hold it!
 Too bad ich must beray[24] the hall!

Dic. Stand to it, Hodge. Stir not, you whoreson!
 What devil, be thine arse-strings brusten?[25]
 Thyself awhile but stay;
 The devil—I smell him—will be here anon. 110
Hod. Hold him fast, Diccon! Cham gone! cham
 gone!
 Chill not be at that fray! *[Exit.]*

II.ii

DICCON.

Dic. Fie, shitten knave, and out upon thee!
 Above all other louts, fie on thee!
 Is not here a cleanly prank?
 But[1] thy matter was no better,
 Nor thy presence here no sweeter,
 To fly I can[2] thee thank.

 Here is a matter worthy glozing[3]
 Of Gammer Gurton's needle losing,
 And a foul piece of wark!
 A man, I think, might make a play 10
 And need no word to[4] this they say,
 Being but half a clerk.

 Soft, let me alone![5] I will take the charge
 This matter further to enlarge
 Within a time short.
 If ye will mark my toys,[6] and note,
 I will give ye leave to cut my throat
 If I make not good sport.

Dame Chat, I say, where be ye? Within?

[Enter DAME CHAT.*]*

Chat. Who have we there maketh such a din? 20

[18] *cap:* take off my cap.
[19] *rechless:* heedless (as Diccon is lunatic), or perhaps
modifying Hodge and meaning "without regard to the
consequences." [20] *no shift:* no other way.
[21] *Fet:* Fetched.
[22] *circle:* which Diccon is presumably drawing on the
ground and within which the two will be protected from the
Devil. [23] *make . . . water:* evidently, "defecate."
[24] *beray:* dirty. [25] *brusten:* burst.
II.ii
 [1] *But:* Except that(?). [2] *can:* give.
 [3] *glozing:* glossing, interpreting. [4] *to:* added to.
 [5] *let me alone:* leave it to me.
 [6] *mark my toys:* take notice of my tricks.

Dic. Here, is a good fellow, maketh no great
 danger.[7]
 Chat. What, Diccon? Come near; ye be no stranger!
We be fast set at trump, man, hard by the fire.
Thou shalt set on the king, if thou come a little nigher.
 Dic. Nay, nay, there is no tarrying, I must be gone
 again.
But, first, for you, in counsel I have a word or twain.
 Chat. Come hether, Doll!

[*Enter* DOLL.]

Doll, sit down and play this game,[8]
And, as thou sawest me do, see thou do even the same.
There is five trumps beside the queen—the hindmost
 thou shalt find her. 30
Take heed of Sim Glover's wife; she hath an eye
 behind her!

 [*Exit* DOLL.]

Now, Diccon, say your will.
 Dic. Nay, soft a little yet!
I wold not tell it my sister, the matter is so great.
There I will have you swear by our dear Lady of
 Bullain,[9]
Saint Dunstan, and Saint Donnick,[10] three Kings of
 Kullain,[11]
That ye shall keep it secret.
 Chat. Gog's bread, that will I do!
As secret as mine own thought, by God, and the devil
 too!
 Dic. Here is Gammer Gurton, your neighbor, a sad
 and heavy wight—
Her goodly fair red cock at home was stole this last
 night.
 Chat. Gog's soul! Her cock with the yellow legs, that
 nightly crowed so just?[12] 40
 Dic. That cock is stolen.
 Chat. What, was he fet out of the
 hens' rust?[13]
 Dic. I cannot tell where the devil he was kept, under
 key or lock;
But Tib hath tickled[14] in gammer's ear that you should
 steal[15] the cock.
 Chat. Have I? Strong whore! By bread and salt—
 Dic. What
 soft, I say! Be still!
Say not one word for all this gear.
 Chat. By the Mass, that I
 will!

I will have the young whore by the head and the old
 trot by the throat!
 Dic. Not one word, Dame Chat, I say! Not one
 word, for my coat!
 Chat. Shall such a beggar's brawl[16] as that, thinkest
 thou, make me a thief?
The pox light on her whore's sides, a pestilence and a
 mischief!
Come out, thou hungry, needy bitch! O, that my nails
 be short![17] 50
 Dic. Gog's bread, woman, hold your peace! This
 gear will else pass sport!
I wold not for an hundred pound this matter should be
 known,
That I am auctor[18] of this tale or have abroad it blown!
Did ye not swear ye wold be ruled, before the tale I
 told?
I said ye must all secret keep, and ye said sure ye wold.
 Chat. Wold you suffer, yourself, Diccon, such a sort
 to revile you,
With slanderous words to blot your name, and so to
 defile you?
 Dic. No, Goodwife Chat; I wold be loath such drabs
 shuld blot my name;
But yet ye must so order all that Diccon bear no blame.
 Chat. Go to, then! What is your rede?[19] Say on your
 mind; ye shall me rule herein. 60
 Dic. God-a-mercy[20] to Dame Chat! In faith, thou
 must the gear begin.
It is twenty pound to a goose turd, my gammer will not
 tarry,
But hetherward she comes as fast as her legs can her
 carry,
To brawl with you about her cock. For well I heard
 Tib say
The cock was roasted in your house to[21] breakfast
 yesterday;
And, when ye had the carcass eaten, the feathers ye out
 flung;
And Doll, your maid, the legs she hid a foot deep in the
 dung.
 Chat. O gracious God, my heart it bursts!
 Dic. Well, rule
 yourself a space!
And Gammer Gurton when she cometh anon into this
 place—
Then to the quean![22] Let's see! Tell her your mind,
 and spare not, 70
So[23] shall Diccon blameless be; and then go to, I care
 not!
 Chat. Then, whore, beware her throat! I can abide
 no longer!
In faith, old witch, it shall be seen which of us two be
 stronger!
And, Diccon, but[24] at your request, I wold not stay one
 hour.
 Dic. Well, keep it in till she be here, and then—out
 let it pour!
In the meanwhile get you in, and make no words of this.
More of this matter within this hour to hear you shall
 not miss.

 [7] *maketh . . . danger:* takes no great risks (not cited *OED*
before seventeenth century). The more obvious sense would
seem to be "causes no harm."
 [8] *game:* Dame Chat produces cards.
 [9] *Bullain:* Boulogne. [10] *Donnick:* Dominic.
 [11] *Kullain:* Cologne. [12] *just:* exactly (on time).
 [13] *rust:* roost. [14] *tickled:* whispered.
 [15] *should steal:* are the one who has stolen.
 [16] *brawl:* brat.
 [17] *O . . . short:* i.e., regretting that they are not longer.
 [18] *auctor:* author. [19] *rede:* counsel.
 [20] *God-a-mercy:* Thanks. [21] *to:* for.
 [22] *quean:* whore. [23] *So:* So long as.
 [24] *but:* except.

Because I know you are my friend, hide it I cold not, doubtless.
Ye know your harm; see ye be wise about your own business!
So fare ye well!

 Chat. Nay, soft, Diccon, and drink! What, Doll, I say! 80
Bring here a cup of the best ale; let's see! Come quickly away!

 [Exit.]

II.iii

DICCON.

 Dic. Ye see, masters, the one end taped[1] of this my short device!
Now must we broach tother[2] too, before the smoke arise.
And, by the time they have awhile run,
 I trust ye need not crave it;
But look, what lieth in both their hearts, ye are like, sure, to have it.

[Enter HODGE.]

 Hod. Yea, Gog's soul, art alive yet? What, Diccon, dare ich come?
 Dic. A man is well hied[3] to trust to thee! I will say nothing but mum.
But, and ye come any nearer, I pray you see all be sweet!
 Hod. Tush, man! Is gammer's neele found? That chould gladly weet![4]
 Dic. She may thank thee it is not found, for, if thou had kept thy standing,[5]
The devil he wold have fet it out, even, Hodge, at thy commanding. 10
 Hod. Gog's heart! And cold he tell nothing where the neele might be found?
 Dic. Ye foolish dolt, ye were to seek[6] ere we had got our ground;
Therefore his tale so doubtful was that I cold not perceive it.
 Hod. Then ich see well something was said. Chope[7] one day yet to have it.
But, Diccon, Diccon, did not the devil cry "Ho, ho, ho"?
 Dic. If thou hadst tarried where thou stood'st, thou woldest have said so.
 Hod. Durst swear of[8] a book, chard[9] him roar, straight after ich was gone!
But tell me, Diccon, what said the knave? Let me hear it anon.
 Dic. The whoreson talked to me, I know not well of what:
One while his tongue it ran and paltered[10] of a cat; 20
Another while he stammered still upon a rat;
Last of all, there was nothing but every word "Chat! Chat!"
But this I well perceived, before I wold him rid,
Between "Chat" and the "rat" and the "cat," the needle is hid.

Now, whether Gib, our cat, have eat it in her maw,
Or Doctor Rat, our curate, have found it in the straw,
Or this Dame Chat, your neighbor, have stolen it, God He knoweth!
But by the morrow at this time we shall learn how the matter goeth.
 Hod. Canst not learn tonight, man? Seest not what is here?

 Pointing behind to his torn breeches.

 Dic. 'Tis not possible to make it sooner appear. 30
 Hod. Alas, Diccon, then chave no shift but, lest ich tarry too long,
Hie me to Sim Glover's shop, there to seek for a thong,
Therewith this breech to tatch[11] and tie as ich may.
 Dic. Tomorrow, Hodge, if we chance to meet, shalt see what I will say.

 [Exit HODGE.]

II.iv

DICCON.

 Dic. Now this gear must forward go, for here my gammer cometh.
Be still awhile, and say nothing; make here a little romth![1]

[Enter GAMMER.]

 Gam. Good Lord, shall never be my luck my neele again to spy?
Alas the while, 'tis past my help! Where 'tis, still it must lie!
 Dic. Now Jesus, Gammer Gurton, what driveth you to this sadness?
I fear me, by my conscience, you will sure fall to madness.
 Gam. Who is that? What, Diccon? Cham lost, man. Fie! fie!
 Dic. Marry, fie on them that be worthy! But what shuld be your trouble?
 Gam. Alas, the more ich think on it, my sorrow it waxeth double!
My goodly tossing spurrier's[2] neele, chave lost, ich wot not where. 10
 Dic. Your neele! When?
 Gam. My neele! Alas, ich might full ill it spare!
As God himself he knoweth, ne'er one beside chave.
 Dic. If this be all, good gammer, I warrant you all is save.
 Gam. Why, know you any tidings which way my neele is gone?
 Dic. Yea, that I do, doubtless, as ye shall hear anon.

II.iii.
[1] *taped:* finished. [2] *tother:* the other.
[3] *is well hied:* made fortunate. [4] *weet:* know.
[5] *kept thy standing:* remained. [6] *to seek:* missing.
[7] *Chope:* I hope. [8] *of:* on. [9] *chard:* I heard.
[10] *paltered:* babbled. [11] *tatch:* fasten.
II.iv.
[1] *romth:* room.
[2] *tossing spurrier's:* for sewing the straps of spurs.

A[3] see a thing this matter toucheth, within these twenty
 hours,
Even at this gate, before my face, by a neighbor of
 yours:
She stooped me down, and up she took a needle or a
 pin.
I durst be sworn it was even yours, by all my mother's
 kin.
 Gam. It was my neele, Diccon, ich wot; for here,
 even by this post, 20
Ich sat what[4] time as ich upstart, and so my neele it
 lost.
Who was it, lief[5] son? Speak, ich pray thee, and quickly
 tell me that!
 Dic. A subtle quean as any in this town, your
 neighbor here, Dame Chat.
 Gam. Dame Chat, Diccon? Let me be gone! Chill
 thither in posthaste.
 Dic. Take my counsel yet or[6] ye go, for fear ye walk
 in waste!
It is a murrion crafty drab, and froward[7] to be
 pleasèd;
And ye take not the better way, our needle yet ye
 lose it.
For, when she took it up, even here before your doors,
"What, soft, Dame Chat," quoth I, "that same is none
 of yours!"
"Avaunt,"[8] quoth she, "sir knave! What pratest thou
 of that I find? 30
I wold thou hadst kissed me I wot where (she meant, I
 know, behind).
And home she went as brag[9] as it[10] had been a
 bodylouse,
And I after as bold as it had been the goodman[11] of the
 house.
But there and ye had hard her how she began to scold—
The tongue it went on pattens,[12] by Him that Judas
 sold!
Each other word I was a knave, and you a whore of
 whores,
Because I spake in your behalf and said the neele was
 yours.
 Gam. Gog's bread! And thinks the callet[13] thus to
 keep my neele me fro?[14]
 Dic. Let her alone, and she minds none other but
 even to dress you so!

 Gam. By the mass, chill rather spend the coat that is
 on my back! 40
Thinks the false quean by such a sleight that chill my
 neele lack?
 Dic. Slepe[15] not your gear, I counsel you, but of this
 take good heed:
Let not be known I told you of it, how well soever ye
 speed.
 Gam. Chill in, Diccon, a clean apern[16] to take and
 set before me;
And ich may my neele once see, chill sure remember
 thee!
 [*Exit.*]

II.v

DICCON.

 Dic. Here will the sport begin! If these two once may
 meet,
Their cheer, durst lay money, will prove scarcely sweet!
My gammer, sure, intends to be upon her bones
With staves or with clubs or else with cobblestones.
Dame Chat, on the other side, if she be far behind,
I am right far deceived; she is given to it of kind.[1]
He that may tarry by it awhile, and that but short,
I warrant him—trust to it—he shall see all the sport.
Into the town will I, my friends to visit there,
And hether straight again to see th'end of this gear.—
[*To* Musicians] In the meantime, fellows, pipe up your
 fiddles! I say, take them, 11
And let your friends hear such mirth as ye can make
 them!
 [*Exit.*]

ACT THREE

SCENE ONE

HODGE.

 Hod. Sim Glover, yet gramercy![1] Cham meetly well
 sped now.
Th'art even as good a fellow as ever kissed a cow!
Here is a thing[2] indeed; by the mass, though ich speak
 it,
Tom Tankard's great bald curtal,[3] I think, could not
 break it!
And, when he spied my need to be so straight and hard,
Hais[4] lent me here his nawl[5] to set the jib forward.[6]
As for my gammer's neele, the flying fiend go weet![7]
Chill not now go to the door again with it to meet.
Could make shift good enough and chad[8] a candle's
 end. 9
The chief hole in my breech with these two chill amend.

III.ii

GAMMER, HODGE.

 Gam. How, Hodge! mayst now be glad! Cha' news
 to tell thee.
Ich know who hais my neele; ich trust soon shalt it see.
 Hod. The devil thou does! Hast hard, gammer,
 indeed, or dost but jest?

 [3] *A:* I. [4] *what:* that. [5] *lief:* dear.
 [6] *or:* ere. [7] *froward:* difficult.
 [8] *Avaunt:* Be gone. [9] *brag:* briskly.
 [10] *as it:* as if she. [11] *goodman:* householder, husband.
 [12] *pattens:* wooden shoes, and hence making noise.
 [13] *callet:* slut. [14] *fro:* from. [15] *Slepe:* slip, neglect.
 [16] *apern:* apron.

II.v.
 [1] *of kind:* by nature.

III.i.
 [1] *gramercy:* thanks.
 [2] *thing:* the thong for fastening his breeches.
 [3] *bald curtal:* horse with a docked tail and a white patch
on its head. [4] *Hais:* Has. [5] *nawl:* awl.
 [6] *set . . . forward:* hasten progress (as when a jib on a
sailboat is set to take in more wind). [7] *weet:* with it.
 [8] *and chad:* if I had.

Gam. 'Tis as true as steel, Hodge.

Hod. Why, knowest well
where didst leese it?

Gam. Ich know who found it, and took it up; shalt
see, or [1] it be long.

Hod. God's Mother dear, if that be true, farewell
both nawl an' thong!

But who hais it, gammer? Say on! Could fain hear it
disclosed.

Gam. That false fixen,[2] that same Dame Chat, that
counts herself so honest!

Hod. Who told you so?

Gam. That same did Diccon the
bedlam, which saw it done.

Hod. Diccon? It is a vengeable knave, gammer!
'Tis a bonable[3] whoreson! 10

Can do mo things than that, else cham deceivèd evil.

By the mass, ich saw him of late call up a great black
devil!

O, the knave cried, "Ho! ho!" He roared, and he
thundered.

And ye'd been here, cham sure you'ld murrainly[4] ha'
wondered!

Gam. Was not thou afraid, Hodge, to see him in this
place?

Hod. No! And chad come to me, could have laid
him on the face,

Chould have promised him!

Gam. But, Hodge, had he no
horns to push?

Hod. As long as your two arms! Saw ye never Friar
Rush[5]

Painted on a cloth,[6] with a side[7] long cow's tail,

And crooked cloven feet, and many a hooked nail?[8] 20

For all the world, if I shuld judge, chould reckon him
his brother.

Look, even what face Friar Rush had, the devil had
such another!

Gam. Now Jesus' mercy, Hodge, did Diccon in him
bring?

Hod. Nay, gammer, hear me speak! Chill tell you a
greater thing.

The devil, when Diccon had him—ich hard him
wondrous weel[9]—

Said plainly, here before us, that Dame Chat had your
neele.

Gam. Then let us go and ask her wherefore she
minds to keep it!

Seeing we know so much, 'twere a madness now to
slepe it.

Hod. Go to her, gammer.

[*Enter* CHAT.]

See ye not where she stands in her doors? 30
Bid her give you the neele. 'Tis none of hers, but yours!

III.iii

GAMMER, CHAT, HODGE.

Gam. Dame Chat, chold pray thee fair, let me have
that is mine!

Chill not this twenty years take one fart that is thine.

Therefore give me mine own, and let me live beside
thee!

Chat. Why art thou crept from home hether to mine
own doors to chide me?

Hence, doting drab, avaunt, or I shall set thee
further!

Intends thou and that knave me in my house to
murther?

Gam. Tush, gape not so on me, woman! Shalt not
yet eat me!

Nor all the friends thou hast, in this shall not entreat
me!

Mine own goods I will have, and ask thee no[1] beleve.[2]

What, woman! poor folks must have right, though the
thing you aggrieve. 10

Chat. Give thee thy right, and hang thee up, with all
thy bagger's[3] brood!

What, wilt thou make me a thief, and say I stole thy
good?

Gam. Chill say nothing, ich warrant thee, but that
ich can prove it well.

Thou fet my good even from my door, cham able this
to tell!

Chat. Did I, old witch, steal oft[4] was thine? How
should that thing be known?

Gam. Ich cannot tell; but up thou tookest it, as
though it had been thine own.

Chat. Marry, fie on thee, thou old gib,[5] with all my
very heart!

Gam. Nay, fie on thee, thou ramp, thou rig,[6] with all
that take thy part!

Chat. A vengeance on those lips that layeth such
things to my charge!

Gam. A vengeance on those callet's hips[7] whose
conscience is so large![8] 20

Chat. Come out, Hodge!

Gam. Come out, Hodge, and let
me have right!

Chat. Thou arrant witch!

Gam. Thou bawdy bitch, chill
make thee curse this night!

III.ii:
[1] *or:* ere. [2] *fixen:* vixen. [3] *bonable:* abominable.
[4] *murrainly:* awfully (as if plague stricken).
[5] *Friar Rush:* Bruder Rausch, in German folklore a devil
disguised as a friar. An English translation of his story was
published in 1568.
[6] *cloth:* with which the walls were hung in Tudor houses.
[7] *side:* long (another tautology). [8] nail: claw.
[9] *weel:* will.

III.iii:
[1] *no:* emended from "on" of original.
[2] *beleve:* permission, by-your-leave.
[3] *bagger's:* beggar's(?). [4] *oft:* aught.
[5] *gib:* cat. [6] *ramp . . . rig:* coarse woman . . . wanton.
[7] *callet's hips:* a sneer at the girth of Dame Chat, the
callet or slut(?).
[8] *large:* easy-going (appropriate to the conscience of a
callet; but "conscience" does not associate logically with
"hips" unless the latter is made part of a collocation—
"calletships," like "masterships").

Chat. A bag and a wallet![9]

Gam. A cart[10] for a callet!

Chat. Why,
weenest[11] thou thus to prevail?
I hold thee a groat I shall patch thy coat!

Gam. Thou wart[12]
as good kiss my tail!
Thou slut, thou cut,[13] thou rakes,[14] thou jakes![15] Will
not shame make thee hide thee?

Chat. Thou scald,[16] thou bald, thou rotten, thou
glutton! I will no longer chide thee!
But I will teach thee to keep home.

Gam. Wilt thou, drunken
beast?

 [*They fight.*]

Hod. Stick to her, gammer! Take her by the head!
Chill warrant you this feast.[17]
Smite, I say, gammer! Bite, I say, gammer! I trow ye
will be keen! 30
Where be your nails? Claw her by the jaws! Pull me
out both her eyen![18]
Gog's bones, gammer, hold up your head!

Chat. I trow, drab,
I shall dress thee.
[*To* HODGE] Tarry, thou knave! I hold thee a groat I
shall make these hands bless thee!—
 [*Exit* HODGE.]
Take thou this, old whore, for amends, and learn thy
tongue well to tame,
And say thou met at this bickering, not thy fellow, but
thy dame![19]

 [HODGE *returns with a club.*]

Hod. Where is the strong stewed[20] whore? Chill
gear[21] a whore's mark!
Stand out one's way that ich kill none in the dark!
Up, gammer,[22] and ye be alive! Chill fight now for us
both.
Come no near me, thou scald callet! To kill thee ich
were loath.

Chat. Art here again, thou hoddypeak![23] What,
Doll, bring me out my spit! 40

[9] *wallet:* appropriate to a beggar.
[10] *cart:* at the rear of which a whore was publicly whipped.
[11] *weenest:* thinkest. [12] *wart:* wert.
[13] *cut:* docked or gelded horse.
[14] *rakes:* abandoned woman. [15] *jakes:* privy.
[16] *scald:* scabby person.
[17] *Chill . . . feast:* I promise you'll win. [18] *eyen:* eyes.
[19] *dame:* mistress, superior.
[20] *strong stewed:* conspicuously of the stews or whore
houses. [21] *Chill gear:* I'll give he.
[22] *Up, gammer:* who has evidently been knocked down.
[23] *hoddypeak:* simpleton. [24] *comes:* comest.
[25] *Ise:* I shall. [26] *losel:* wretched woman.
[27] *Thouse:* Thou shalt.
[28] *pray:* generally emended to "pay."
[29] *Hoise:* Lift up. [30] *throatboll:* Adam's apple.
[31] *on foot:* Chat has now gone down.
[32] *tarleather:* dried and salted sheepskin.
[33] *longs:* belongs. [34] *and chad:* if I had not.
[35] *chward:* I were. [36] *Wese:* We shall.

Hod. Chill broach thee with this! Bim father soul,
chill conjure that foul sprite!

 [*Enter* COCK.]

Let door stand, Cock! Why comes[24] indeed? Keep
door, thou whoreson boy!

Chat. Stand to it, thou dastard, for thine ears! Ise[25]
teach thee a sluttish toy!

Hod. Gog's wounds, whore, chill make thee
avaunt!
 [*Exit* HODGE *to one house;* COCK *follows.*]
Take heed, Cock, pull in the latch!

Chat. I' faith, sir loose-breech, had ye tarried, ye
shold have found your match!

Gam. Now ware thy throat, losel![26] Thouse[27] pray[28]
for all!

Hod. [*Within*] Well said, gammer, by my soul!
Hoise[29] her! Souse her! Bounce her! Trounce her!
Pull out her throatboll![30]

Chat. Com'st behind me, thou withered witch? And
I get once on foot,[31]
Thouse pay for all, thou old tarleather![32] I'll teach thee
what longs[33] to it! 50
Take thee this to make up thy mouth till time thou
come by more!
 [CHAT *beats* GAMMER *down and exits.*]

 [*Reenter* HODGE.]

Hod. Up, gammer! Stand on your feet. Where is the
old whore?
Faith, would chad her by the face! Chould crack her
callet crown!

Gam. Ah, Hodge, Hodge, where was thy help, when
fixen had me down?

Hod. By the Mass, gammer, but for my staff, Chat
had gone nigh to spill you!
Ich think the harlot had not cared, and chad[34] not
come, to kill you.
But shall we lose our neele thus?

Gam. No, Hodge, chward[35]
loath do so.
Thinkest thou chill take that at her hand? No, Hodge,
ich tell thee, no!

Hod. Chold yet this fray were well take up, and our
own neele at home.
'Twill be my chance else some to kill, wherever it be, or
whom! 60

Gam. We have a parson, Hodge, thou knows, a man
esteemèd wise,
Mast' Doctor Rat; chill for him send, and let me hear
his advice.
He will her shrive for all this gear, and give her
penance straight;
Wese[36] have our neele, else Dame Chat comes ne'er
within heaven-gate!

Hod. Yea, marry, gammer, that ich think best. Will
you now for him send?
The sooner Doctor Rat be here, the sooner wese ha' an
end.

And here, gammer! Diccon's devil, as ich remember well,

Of cat, and Chat, and Doctor Rat a felonious tale did tell.

Chold you forty pound that is the way your neele to get again!

 Gam. Chill ha' him straight! Call out the boy; wese make him take the pain. 70

 Hod. What, Cock, I say! Come out! What devil, canst not hear?

[*Enter* COCK.]

 Cock.[37] How now, Hodge? How does gammer? Is yet the weather clear?

What wold chave me to do?

 Gam. Come hether, Cock, anon!

Hence swith[38] to Doctor Rat! Hie thee that thou were gone!

And pray him come speak with me; cham not well at ease.

Shalt have him at his chamber, or else at Mother Bee's;

Else seek him at Hob Filcher's shop, for, as chard it reported,

There is the best ale in all the town, and now is most resorted.[39]

 Cock. And shall ich bring him with me, gammer?

 Gam. Yea, by and by, good Cock. 80

 Cock. Shalt see that shall be here anon, else let me have on the dock![40]

 [*Exit.*]

 Hod. Now, gammer, shall we two go in, and tarry for his coming?

What devil, woman, pluck up your heart, and leave off all this glumming![41]

Though she were stronger at the first, as ich think ye did find her,

Yet there ye dressed the drunken sow, what time ye came behind her.

 Gam. Nay, nay, cham sure she lost not all; for set th'end to the beginning,

And ich doubt not but she will make small boast of her winning.

III.iv

TIB [*with a cat*], HODGE, GAMMER [*remain*].

 Tib. See, gammer, gammer, Gib, our cat! Cham afraid what[1] she aileth!

She stands me gasping behind the door, as though her wind her faileth.

Now let ich doubt what Gib shuld mean, that now she doth so dote.[2]

 Hod. Hold hether![3] Ichold twenty pound your neele is in her throat!

Grope[4] her, ich say! Methinks ich feel it. Does not prick your hand?

 Gam. Ich can feel nothing.

 Hod. No? Ich know thar's not within this land

A murrainer cat than Gib is, betwixt the Thames and Tyne;

Sh'as as much wit in her head almost as chave in mine!

 Tib. Faith, sh'as eaten something that will not easily down.

Whether she gat it at home or abroad in the town 10 Ich cannot tell.

 Gam. Alas, ich fear it be some crooked pin!

And then, farewell Gib! She is undone and lost—all save the skin.

 Hod. Tib, your neele, woman, I say! Gog's soul, give me a knife,

And chill have it out of her maw, or else chall lose my life!

 Gam. What! Nay, Hodge, fie! Kill not our cat. 'Tis all the cats we ha' now!

 Hod. By the mass, Dame Chat hais me so moved ich care not what I kill, ma'[5] God avow!

Go to, then, Tib! To this gear! Hold up her tail, and take her!

Chill see what devil is in her guts! Chill take the pains to rake her!

 Gam. Rake a cat, Hodge? What woldst thou do?

 Hod. What! Think'st that cham not able?

Did not Tom Tankard rake his curtal t'or[6] day, standing in the stable? 20

[*Enter* COCK.]

 Gam. Soft, be content; let's hear what news Cock bringeth from Mast' Rat!

 Cock. Gammer, chave been there as you bade, you wot well about what.

'Twill not be long before he come, ich durst swear of a book.

He bids you see ye be at home, and there for him to look.

 Gam. Where didst thou find him, boy. Was he not where I told thee?

 Cock. Yes, yes, even at Hob Filcher's house, by him that bought and sold me.

A cup of ale had in his hand, and a crab[7] lay in the fire.

Chad much ado to go and come, all was so full of mire.

And, gammer, one thing I can tell: Hob Filcher's nawl was lost,

And Doctor Rat found it again, hard beside the doorpost. 30

Ichold a penny, can say something your neele again to fet.

 Gam. Cham glad to hear so much, Cock; then trust he will not let[8]

[37] *Cock:* whose words are given to Gammer in original.
[38] *swith:* swiftly. [39] *resorted:* frequented.
[40] *dock:* bottom; i.e., a beating.
[41] *glumming:* glooming.

III.iv.
 [1] *what:* that. [2] *dote:* droop.
 [3] *Hold hether:* Hand her to me (hither).
 [4] *Grope:* Give. [5] *ma':* I make. [6] *t'or:* t'other.
 [7] *crab:* apple. [8] *let:* hold off.

To help us herein best he can; therefore till time he
 come,
Let us go in. If there be aught to get, thou shalt have
 some.
 [Exeunt.]

ACT FOUR

SCENE ONE

DOCTOR RAT.

D. Rat. A man were better twenty times be a
 bandog [1] and bark,
Than here, among such a sort, be parish priest or clerk,
Where he shall never be at rest one pissing-while a day,
But he must trudge about the town, this way and that
 way,
Here to a drab, there to a thief, his shoes to tear and
 rent,
And, that which is worst of all, at every knave's
 commandment!
I had not sit the space to drink two pots of ale
But Gammer Gurton's sorry boy was straightway at my
 tail,
And she was sick, and I must come—to do I wot not
 what!
If once her finger's end but ache, "Trudge! Call for
 Doctor Rat!" 10
And, when I come not at their call, I only thereby lose;
For I am sure to lack therefore a tithe-pig or a goose.
I warrant you, when truth is known, and told they have
 their tale,
The matter whereabout I come is not worth a
 halfpennyworth of ale!
Yet must I talk so sage and smooth as though I were a
 glozier,[2]
Else, or the year come at an end, I shall be sure the
 loser.

 [Enter GAMMER GURTON.]

What work ye, Gammer Gurton! How,[3] here is your
 friend Master Rat!
 Gam. Ah, good Master Doctor, cha' troubled, cha'
 troubled you, chwot well that!
 D. Rat. How do ye, woman? Be ye lusty, or be ye
 not well at ease?
 Gam. By Gis,[4] master, cham not sick, but yet chave
 a disease. 20
Chad a foul turn now of late; chill tell it you, by Gigs!
 D. Rat. Hath your brown cow cast her calf, or your
 sandy sow her pigs?
 Gam. No, but chad been as good they had, as this,
 ich wot weel.

IV.i.
 [1] *bandog:* watchdog. [2] *glozier:* flatterer.
 [3] *How:* How now. [4] *Gis:* Jesus.
IV.ii.
 [1] *Gaffer:* used respectfully of an older man.
 [2] *Bym fay:* By my faith. [3] *yeed:* went.
 [4] *wroth:* angy (original reads "worth").
 [5] *were gone:* might go. [6] *of:* from.

 D. Rat. What is the matter?
 Gam. Alas! alas! cha' lost my
 good neele!
My neele, I say! And, wot ye what? A drab came by
 and spied it,
And, when I asked her for the same, the filth flatly
 denied it
 D. Rat. What was she that—
 Gam. A dame, ich warrant
 you! She began to scold and brawl—
Alas, alas! Come hether, Hodge! This wretch can tell
 you all.

IV.ii

HODGE, DOCTOR RAT, GAMMER.

 Hod. Good morrow, Gaffer [1] Vicar!
 D. Rat. Come on, fellow;
 let us hear.
Thy dame hath said to me, thou knowest of all this
 gear;
Let's see what thou canst say.
 Hod. Bym fay,[2] sir, that ye
 shall!
What matter soever here was done, ich can tell your
 ma'ship all.
My Gammer Gurton here, see now, sat her down at
 this door, see now;
And, as she began to stir her, see now, her neele fell in
 the floor, see now;
And, while her staff she took, see now, at Gib, her cat,
 to fling, see now,
Her neele was lost in the floor, see now.
 Is not this a wondrous thing, see now?
Then came the quean, Dame Chat, see now, to ask for
 her black cup, see now;
And even here at this gate, see now, she took that neele
 up, see now. 10
My gammer then she yeed,[3] see now, her neele again to
 bring, see now,
And was caught by the head, see now. Is not this a
 wondrous thing, see now?
She tare my gammer's coat, see now, and scratched her
 by the face, see now;
Chad though sh'ad stopped her throat, see now. Is not
 this a wondrous case, see now?
When ich saw this, ich was wroth,[4] see now, and start
 between them twain, see now;
Else, ich durst take a book oath, see now, my gammer
 had been slain, see now.
 Gam. This is even the whole matter, as Hodge has
 plainly told.
And could fain be quiet, for my part, that chould.
But help us, good master—beseech ye that ye do—
Else shall we both be beaten, and lose our neele too. 20
 D. Rat. What wold ye have me to do? Tell me, that
 I were gone.[5]
I will do the best that I can to set you both at one.
But be ye sure Dame Chat hath this your neele found?
 Gam. Here comes the man that see her take it up of[6]
 the ground;

Ask him yourself, Master Rat, if ye believe not me;
And help me to my neele, for God's sake and Saint
 Charity!

[*Enter* DICCON.]

D. Rat. Come near, Diccon, and let us hear what
 thou can express.
Wilt thou be sworn thou seest Dame Chat this woman's
 neele have?
 Dic. Nay, by Saint Benit,[7] will I not! Then might ye
 think me rave.[8]
 Gam. Why, didst not thou tell me so even here?
 Canst thou for shame deny it? 30
 Dic. Ay, marry, gammer; but I said I wold not
 abide by it.
 D. Rat. Will you say a thing, and not stick to it to
 try it?
 Dic. "Stick to it," quoth you, Master Rat? Marry,[9]
 sir, I defy it!
Nay, there is many an honest man, when he such blasts
 hath blown
In his friend's ears, he would be loath the same by[10]
 him were known.
If such a toy be usèd oft among the honesty,[11]
It may beseem[12] a simple man of your and my degree.
 D. Rat. Then we be never the nearer, for all that
 you can tell?
 Dic. Yes, marry, sir, if ye will do by mine advice
 and counsel.
If Mother Chat see all us here, she knoweth how the
 matter goes; 40
Therefore I rede[13] you three go hence, and within keep
 close;
And I will into Dame Chat's house, and so the matter
 use
That, or you cold go twice to church, I warrant you
 hear news.
She shall look well about her, but I durst lay a pledge,
Ye shall of gammer's neele have shortly better
 knowledge.
 Gam. Now, gentle Diccon, do so; and good sir, let us
 trudge.
 D. Rat. By the mass, I may not tarry so long to be
 your judge.
 Dic. 'Tis but a little while, man. What, take so much
 pain!
If I hear no news of it, I will come sooner again.
 Hod. Tarry so much, good Master Doctor, of your
 gentleness! 50
 D. Rat. Then let us hie us inward; and Diccon,
 speed thy business!

[*Exeunt* DOCTOR RAT, GAMMER, *and*
 HODGE.]

 Dic. Now, sirs, do you no more, but keep my
 counsel just,
And Doctor Rat shall thus catch some good, I trust.
 But Mother Chat, my gossip, talk first withal I
 must,
For she must be chief captain to lay the Rat in the dust.

[*Enter* DAME CHAT.]

God deven,[14] Dame Chat, in faith, and well met in this
 place!
 Chat. God deven, my friend Diccon. Whether[15]
 walk ye this pace?
 Dic. By my truth, even to you, to learn how the
 world goeth.
Hard ye no more of the other matter, say me now, by
 your troth?
 Chat. O, yes, Diccon. Here the old whore, and
 Hodge, that great knave— 60
But, in faith, I would thou hadst seen, O Lord, I dressed
 them brave![16]
She bare me two or three souses[17] behind in the nape
 of the neck,
Till I made her old wesen[18] to answer again, "keck"![19]
And Hodge, that dirty dastard that at her elbow stands.
If one pair of legs had not been worn two pair of hands,
He had had his beard shaven if my nails wold have
 served!
And not without a cause, for the knave it well deserved!
 Dic. By the Mass, I can thee thank, wench, thou
 didst so well acquit thee!
 Chat. And th'adst seen him, Diccon, it wold have
 made thee beshit thee
For laughter. The whoreson dolt at last caught up a
 club 70
As though he would have slain the master devil,
 Belsabub;
But I set him soon inward.
 Dic. O Lord, there is the thing
 That Hodge is so offended, that makes him start
 and fling!
 Chat. Why, makes the knave any moiling,[20] as ye
 have seen or hard?
 Dic. Even now I saw him last. Like a madman he
 fared,
And sware by heaven and hell he would awreak[21] his
 sorrow,
And leave you never a hen on live[22] by eight of the
 clock tomorrow.
Therefore mark what I say, and my words see that ye
 trust:
Your hens be as good as dead if ye leave them on the
 rust!
 Chat. The knave dare as well go hang himself as go
 upon my ground! 80
 Dic. Well, yet take heed, I say! I must tell you my
 tale round.[23]
Have you not about your house, behind your furnace or
 lead,[24]

[7] *Benit:* Benedict. [8] *rave:* mad.
[9] *Marry:* Interjection (originally from the Virgin Mary)
in response to question. [10] *by:* as having come from.
[11] *honesty:* quality, gentry. [12] *beseem:* become.
[13] *rede:* counsel. [14] *God deven:* God give you good even.
[15] *Whether:* Whither.
[16] *dressed . . . brave:* served them a good turn.
[17] *souses:* blows. [18] *wesen:* weazand, windpipe.
[19] *keck:* the sound emitted from Chat's windpipe.
[20] *moiling:* worrying, trouble. [21] *awreak:* avenge.
[22] *on live:* alive. [23] *round:* in a straightforward way.
[24] *lead:* pot.

A hole where a crafty knave may creep in for need?

 Chat. Yes, by the Mass, a hole broke down even
 within these two days.

 Dic. Hodge he intends this same night to slip in
 thereaways.

 Chat. O Christ, that I were sure of it! In faith, he
 shuld have his meed![25]

 Dic. Watch well, for the knave will be there as sure
 as is your creed.

I wold spend myself a shilling to have him swingèd[26]
 well.

 Chat. I am as glad as a woman can be of this thing
 to hear tell.

By Gog's bones, when he cometh, now that I know the
 matter, 90

He shall sure at the first skip to leap in scalding
 water—

With a worse turn besides! When he will, let him
 come!

 Dic. I tell you as my sister. You know what meaneth
 "mum"!—

 [*Exit* CHAT.]

Now lack I but my doctor to play his part again.

And lo, where he cometh towards—peradventure to
 his pain!

 [*Enter* RAT.]

 D. Rat. What good news, Diccon? Fellow, is Mother
 Chat at home?

 Dic. She is, sir, and she is not, but it please her to
 whom.[27]

Yet did I take her tardy,[28] as subtle as she was!

 D. Rat. The thing that thou went'st for, hast thou
 brought it to pass?

 Dic. I have done that I have done, be it worse, be it
 better! 100

And Dame Chat at her wit's end I have almost set her.

 D. Rat. Why, hast thou spied the neele? Quickly, I
 pray thee, tell!

 Dic. I have spied it, in faith, sir, I handled myself so
 well.

And yet the crafty quean had almost take my trump.

But, or all came to an end, I set her in a dump!

 D. Rat. How so, I pray thee, Diccon?

 Dic. Marry, sir, will
 ye hear?

She was clapped down on the back side,[29] by Cock's
 Mother dear,

And there she sat sewing a halter, or a band,

With no other thing save gammer's needle in her hand.

As soon as any knock, if the filth be in doubt, 110

She needs but once puff, and her candle is out.

Now I, sir, knowing of every door the pin,[30]

Came nicely,[31] and said no word till time I was within;

And there I saw the neele, even with these two eyes.

Whoever say the contrary, I will swear he lies!

 D. Rat. O Diccon, that I was not there then in thy
 stead!

 Dic. Well, if ye will be ordered and do by my rede,

I will bring you to a place, as the house stands,

Where ye shall take the drab with the neele in her
 hands.

 D. Rat. For God's sake, do so, Diccon, and I will
 gage[32] my gown 120

To give thee a full pot of the best ale in the town!

 Dic. Follow me but a little, and mark what I will
 say.

Lay down your gown beside you.

 [RAT *takes off his gown.*]

 Go to, come on your way!

See ye not what is here? A hole wherein ye may creep

Into the house, and suddenly unwares among them
 leap.

There shall ye find the bitch fox and the neele
 together.

Do as I bid you, man; come on your ways hether!

 D. Rat. Art thou sure, Diccon, the swilltub stands
 not hereabout?

 Dic. I was within myself, man, even now, there is no
 doubt.

Go softly, make no noise. Give me your foot, Sir
 John![33] 130

Here will I wait upon you till you come out anon.

 [RAT *climbs through the hole and is beaten.*]

 D. Rat. Help, Diccon! Out, alas! I shall be slain
 among them!

 Dic. If they give you not the needle, tell them that ye
 will hang them.

Ware that!—How, my wenches, have ye caught the
 fox

That used to make revel among your hens and cocks?

Save his life yet for his order,[34] though he sustain some
 pain.—

Gog's bread, I am afraid they will beat out his brain!

 [*Exit* DICCON.]

 [*Reenter* RAT.]

 D. Rat. Woe worth the hour that I came here!

And woe worth him that wrought this gear!

A sort of drabs and queans have me blessed![35] 140

Was ever creature half so evil dressed?

Whoever it wrought and first did invent it,

He shall, I warrant him, ere long repent it!

I will spend all I have, without[36] my skin,

But he shall be brought to the plight I am in!

Master Baily, I trow, and he be worth his ears,

Will snaffle[37] these murderers and all that them bears.[38]

I will surely neither bite nor sup

Till I fetch him hether, this matter to take up.

 [*Exit.*]

[25] *meed:* reward. [26] *swingèd:* beaten.

[27] *but . . . whom:* depending on who's calling.

[28] *tardy:* unprepared.

[29] *clapped . . . side:* sitting in the rear of the house.

[30] *pin:* lock. [31] *nicely:* carefully. [32] *gage:* as surety.

[33] *Sir John:* conventional name for a priest.

[34] *order:* religious order. [35] *blessed:* wounded.

[36] *without:* excepting.

[37] *snaffle:* restrain, as a horse is guided with a snaffle.

[38] *bears:* supports.

ACT FIVE

Scene One

MASTER BAILY, [SCAPETHRIFT,] DOCTOR RAT.

Bail. I can perceive none other, I speak it from my heart,
But either ye are in all the fault, or else in the greatest part.
 D. Rat. If it be counted his fault, besides all his grieves.[1]
When a poor man is spoiled[2] and beaten among thieves,
Then I confess my fault herein at this season;
But I hope you will not judge so much against reason.
 Bail. And methinks, by your own tale, of all that ye name,
If any played the thief, you were the very same.
The women they did nothing, as your words make probation,[3]
But stoutly withstood your forcible invasion. 10
If that a thief at your window to enter should begin,
Wold you hold forth your hand and help to pull him in?
Or you wold keep him out? I pray you, answer me.
 D. Rat. Marry, keep him out, and a good cause why!
But I am no thief, sir, but an honest, learned clerk.
 Bail. Yea, but who knoweth that when he meets you in the dark?
I am sure your learning shines not out at your nose.
Was it any marvel though the poor woman arose
And start up, being afraid of[4] that was in her purse?
Methink you may be glad that your luck was no worse.
 D. Rat. Is not this evil enough, I pray you, as you think? 21

Showing his broken head.

 Bail. Yea, but a man in the dark, if chances do wink,
As soon he smites his father as any other man,
Because for lack of light discern him he ne can.[5]
Might it not have been your luck with a spit to have been slain?
 D. Rat. I think I am little better—my scalp is cloven to the brain!
If there be all the remedy, I know who bears the knocks.
 Bail. By my troth, and well worthy besides to kiss the stocks!
To come in on the back side, when ye might go about![6]
I know none such, unless they long to have their brains knocked out. 30
 D. Rat. Well, will you be so good, sir, as talk with Dame Chat.
And know what she intended? I ask no more but that.
 Bail. [*To* SCAPETHRIFT] Let her be called, fellow, because of Master Doctor.

[*Exit* SCAPETHRIFT.]

I warrant in this case she will be her own proctor;[7]

She will tell her own tale, in meter or in prose,
And bid you seek your remedy, and so go wipe your nose!

V.ii

MASTER BAILY, CHAT, [SCAPETHRIFT,] DOCTOR RAT.

 Bail. Dame Chat, Master Doctor upon you here complained
That you and your maids shuld him much misorder,
And taketh many an oath that no word he feigned,
Laying to your charge how you thought him to murder;
And, on his part again, that same man saith furder
He never offended you in word nor intent.
To hear you answer hereto, we have now for you sent.
 Chat. That I wold have murdered him? Fie on him, wretch!
And evil mought he thee[1] for it, our Lord I beseech.
I will swear on all the books that opens and shuts, 10
He feigneth this tale out of his own guts!
For this seven weeks with me, I am sure, he sat not down.
Nay, ye have other minions,[2] in the other end of the town,
Where ye were liker to catch such a blow
Than anywhere else, as far as I know!
 Bail. Belike[3] then, Master Doctor, yon stripe there ye got not?
 D. Rat. Think you I am so mad that where I was bet[4] I wot not?
Will ye believe this quean before she hath tried[5] it?
It is not the first deed she hath done and afterward denied it.
 Chat. What, man, will you say I broke your head?
 D. Rat. How canst thou prove the contrary? 21
 Chat. Nay, how provest thou that I did the deed?
 D. Rat. Too plainly, by Saint Mary!
This, proof, I trow, may serve though I no word spoke!

Showing his broken head.

 Chat. Because thy head is broken, was it I that it broke?
I saw thee, Rat, I tell thee, not once within this fortnight.
 D. Rat. No, marry, thou sawest me not, forwhy[6] thou hadst no light;
But I felt thee, for all the dark, beshrew thy smooth cheeks!
And thou groped me—this will declare, any day this six weeks.

Showing his head.

V.i.
 [1] *grieves:* griefs. [2] *spoiled:* robbed.
 [3] *make probation:* attest. [4] *of:* for.
 [5] *ne can:* cannot. [6] *go about:* enter by the front.
 [7] *proctor:* attorney.

V.ii.
 [1] *thee:* prosper. [2] *minions:* sweethearts.
 [3] *Belike:* Perhaps. [4] *bet:* beaten.
 [5] *tried:* proved. [6] *forwhy:* because.

Bail. Answer me to this, Master Rat: when caught
you this harm of yours? 30
D. Rat. A while ago, sir, God He knoweth; within
less than these two hours.
Bail. Dame Chat, was there none with you—confess,
i'faith—about that season?
What, woman! Let it be what it will, 'tis neither felony
nor treason.
Chat. Yes, by my faith, Master Baily, there was a
knave not far
Who caught one good fillip on the brow with a door
bar,
And well was he worthy, as it seemed to me.
But what is that to this man, since this was not he?
Bail. Who was it then? Let's hear!
D. Rat. Alas, sir, ask you
that?
Is it not made plain enough by the own mouth of Dame
Chat?
The time agreeth, my head is broken, her tongue
cannot lie; 40
Only upon a bare "nay" she saith it was not I.
Chat. No, marry, was it not, indeed. Ye shall hear by
this one thing:
This afternoon a friend of mine, for good will, gave me
warning,
And bade me well look to my rust and all my capons'
pens,
For, if I took not better heed, a knave wold have my
hens.
Then I, to save my goods, took so much pains as him to
watch;
And, as good fortune served me, it was my chance him
for to catch.
What strokes he bare away, or other what was his
gains,
I wot not—but sure I am he had something for his
pains!
Bail. Yet tells thou not who it was.
Chat. Who it was? A
false thief, 50
That came like a false fox my pullen[7] to kill and
mischief!
Bail. But knowest thou not his name?
Chat. I know it. But
what than?
It was that craft cullion,[8] Hodge, my Gammer Gurton's
man.
Bail. Call me the knave hether. He shall sure kiss the
stocks.
I shall teach him a lesson for filching hens or cocks!
[*Exit* SCAPETHRIFT.]
D. Rat. I marvel, Master Baily, bleared be your
eyes!

An egg is not so full of meat as she is full of lies.
When she hath played this prank, to excuse all this gear
She layeth the fault in such a one as I know was not
there.
Chat. Was he not there? Look on his pate! That
shall be his witness! 60
D. Rat. I wold my head were half so whole, I wold
seek no redress!

[*Enter* GAMMER.]

Bail. God bless you, Gammer Gurton!
Gam. God dyld[9] you, master mine!
Bail. Thou hast a knave within thy house—Hodge, a
servant of thine.
They tell me that busy knave is such a filching one
That hen, pig, goose, or capon thy neighbor can have
none.
Gam. By God, cham much ameved[10] to hear any
such report!
Hodge was not wont, ich trow, to b'ave[11] him in that
sort.
Chat. A thievisher knave is not on live, more
filching nor more false!
Many a truer man than he has hanged up by the hals.[12]
And thou, his dame, of all his theft thou art the sole
receiver. 70
For Hodge to catch and thou to keep, I never knew
none better.
Gam. Sir[13] reverence of your masterdom, and you
were out-a-door,[14]
Chold be so bold, for all her brags, to call her arrant
whore!
And ich knew Hodge so bad as tow,[15] ich wish me
endless sorrow
And could not take the pains to hang him up before
tomorrow!
Chat. What have I stolen from thee or thine, thou
ill-favored old trot?
Gam. A great deal more, by God's blest,[16] than
chever[17] by thee got!
That thou knowest well. I need not say it.
Bail. Stop there, I
say!
And tell me here, I pray you, this matter by the way:
How chance Hodge is not here? Him wold I fain have
had. 80
Gam. Alas, sir, he'll be here anon; ha' be handled
too bad!
Chat. Master Baily, sir, ye be not such a fool, well I
know,
But ye perceive by this lingering there is a pad[18] in the
straw.

Thinking that HODGE *his head was broke, and that*
GAMMER *would not let him come before them.*

Gam. Chill show you his face, ich warrant thee.—
Lo now, where he is!

[*Enter* HODGE *and* SCAPETHRIFT.]

Bail. Come on, fellow! It is told me thou art a shrew,
iwis.[19]

[7] *pullen:* poultry. [8] *cullion:* base fellow.
[9] *dyld:* yield, reward. [10] *ameved:* distressed.
[11] *b'ave:* behave. [12] *hals:* neck.
[13] *Sir:* Saving your (but meant sardonically in Elizabethan
English). [14] *out-a-door:* not present.
[15] *tow:* thou. [16] *blest:* wounds. [17] *chever:* I ever.
[18] *pad:* toad. [19] *iwis:* for certain.

Thy neighbors' hens thou takest, and plays the two-
 legged fox;
Their chickens and their capons too, and now and then
 their cocks.
 Hod. Ich defy them all that dare it say! Cham as
 true as the best!
 Bail. Wart not thou take within this hour in Dame
 Chat's hens' nest?
 Hod. Take there? No, master. Chold not do't for a
 house full of gold! 90
 Chat. Thou, or the devil in thy coat! Swear this, I
 dare be bold.
 D. Rat. Swear me no swearing, quean! The devil he
 give thee sorrow!
All is not worth a gnat thou canst swear till tomorrow.
Where is the harm he hath? Show it, by God's
 bread!
Ye beat him, with a witness, but the stripes light on my
 head!
 Hod. Bet me? Gog's blessed body, chold first, ich
 trow, have burst thee.
Ich think, and chad my hands loose, callet, should have
 crust[20] thee!
 Chat. Thou shitten knave, I trow thou knowest the
 full weight of my fist!
I am foully deceived unless thy head and my door bar
 kissed!
 Hod. Hold thy chat, whore! Thou criest so loud, can
 no man else be hard. 100
 Chat. Well, knave, and I had thee alone, I wold
 surely rap thy costard![21]
 Bail. Sir, answer me to this: is thy head whole or
 broken?
 Chat. Yea, Master Baily, blessed be every good
 token!
 Hod. Is my head whole? Ich warrant you 'tis neither
 scurvy nor scald![22]
What, you foul beast, does think 'tis either pilled[23] or
 bald?
Nay, ich thank God, chill not, for all that thou mayst
 spend,
That chad one scab on my narse[24] as broad as thy
 finger's end.
 Bail. Come nearer here!
 Hod. Yes, that ich dare.
 Bail. By our
 Lady, here is no harm.
Hodge's head is whole enough, for all Dame Chat's
 charm.[25]
 Chat. By Gog's blest, however the thing he clocks or
 smolders,[26] 110
I know the blows he bare away either with head or
 shoulders.
Camest thou not, knave, within this hour creeping into
 my pens,
And there was caught within my house groping among
 my hens?
 Hod. A plague both on thy hens and thee! A cart,
 whore, a cart!
Chould I were hanged as high as a tree and chware as
 false as thou art!

Give my gammer again her washical[27] thou stole away
 in thy lap!
 Gam. Yea, Master Baily, there is a thing you know
 not on, mayhap.
This drab she keeps away my good—the devil he might
 her snare!
Ich pray you that ich might have a right action on her.
 Chat. Have I thy good, old filth, or any such old
 sows?[28] 120
I am as true, I wold thou knew, as skin between thy
 brows!
 Gam. Many a truer hath been hanged, though you
 escape the danger!
 Chat. Thou shalt answer, by God's pity, for this thy
 foul slander!
 Bail. Why, what can ye charge her withal? To say so,
 ye do not well.
 Gam. Marry, a vengeance to her heart, that whore
 has stolen my neele!
 Chat. Thy needle, old witch? How so? It were
 alms[29] thy skull to knock!
So didst thou say the other day that I had stolen thy
 cock,
And roasted him to my breakfast—which shall not be
 forgotten.
The devil pull out thy lying tongue and teeth that be so
 rotten!
 Gam. Give me my neele! As for my cock, could be
 very loath 130
That chuld hear tell he shuld hang on thy false faith and
 troth.
 Bail. Your talk is such I can scarce learn who shuld
 be most in fault.
 Gam. Yet shall ye find no other wight save she, by
 bread and salt!
 Bail. Keep ye content awhile; see that your tongues
 ye hold;
Methinks you shuld remember this is no place to scold.
How knowest thou, Gammer Gurton, Dame Chat thy
 needle had?
 Gam. To name you, sir, the party, could not be
 very glad.
 Bail. Yea, but we must needs hear it, and therefore
 say it boldly.
 Gam. Such one as told the tale full soberly and
 coldly;
Even he that looked on—will swear on a book— 140
What time this drunken gossip my fair long neele up
 took:
Diccon, master, the bedlam. Cham very sure ye know
 him.
 Bail. A false knave, by God's pity! Ye were but a
 fool to trow[30] him.

[20] *crust:* crushed. [21] *costard:* head (apple).
[22] *scald:* scabby. [23] *pilled:* shaved. [24] *narse:* arse.
[25] *charm:* noise.
[26] *clocks or smolders:* cloaks or smothers.
[27] *washical:* whatever-you-call-it.
[28] *sows:* small coin; hence "trifles." Alternatively, one
may read "sows" as descriptive of Gammer—"drunk"—
though OED does not cite in this sense before seventeenth
century. [29] *alms:* charity. [30] *trow:* believe.

I durst aventure[31] well the price of my best cap
That when the end is known all will turn to a jape.[32]
Told he not you that, besides, she stole your cock that
 tide?[33]
 Gam. No, master, no, indeed; for then he shuld have
 lied!
My cock is, I thank Christ, safe and well, a-fine.[34]
 Chat. Yea, but that ragged colt, that whore, that Tib
 of thine,
Said plainly thy cock was stolen and in my house was
 eaten. 150
That lying cut[35] is lost that she is not swinged and
 beaten,
And yet for all my good name it were a small amends!
I pick not this gear, hear'st thou, out of my fingers'
 ends;[36]
But he that hard it told me, who thou of late didst name:
Diccon, whom all men knows; it was the very same.
 Bail. This is the case: you lost your needle about the
 doors,
And she answers again she has no cock of yours;
Thus, in your talk and action, from that you do intend
She is whole five mile wide from that she doth defend.[37]
Will you say she hath your cock?
 Gam. No, marry, sir, that
 chill not! 160
 Bail. Will you confess her neele?
 Chat. Will I? No, sir, will
 I not!
 Bail. Then there lieth all the matter.
 Gam. Soft, master, by
 the way!
Ye know she could do little and she cold not say nay.
 Bail. Yea, but he that made one lie about your
 cock-stealing,
Will not stick to make another what time lies be in
 dealing.
I ween the end will prove this brawl did first arise
Upon no other ground but only Diccon's lies.
 Chat. Though some be lies, as you belike have
 espied them,
Yet other some be true—by proof I have well tried them.
 Bail. What other thing beside this, Dame Chat?
 Chat. Marry,
 sir, even this: 170
The tale I told before, the selfsame tale it was his;
He gave me, like a friend, warning against my loss,
Else had my hens be stolen, each one, by God's Cross!
He told me Hodge wold come, and in he came indeed;
But, as the matter chanced, with greater haste than
 speed.
This truth was said, and true was found, as truly I
 report.

 Bail. If Doctor Rat be not deceived, it was of another
 sort.
 D. Rat. By God's Mother, thou and he be a couple
 of subtle foxes!
Between you and Hodge I bear away the boxes.[38]
Did not Diccon appoint the place where thou shuldst
 stand to meet him? 180
 Chat. Yes, by the Mass; and, if he came, bade me
 not stick to speet[39] him.
 D. Rat. God's sacrament, the villain knave hath
 dressed us round about!
He is the cause of all this brawl, that dirty, shitten lout!
When Gammer Gurton here complained, and made a
 rueful moan,
I heard him swear that you had gotten her needle that
 was gone;
And this to try, he furder said, he was full loath;
 howbeit
He was content, with small ado, to bring me where to
 see it.
And where ye sat, he said full certain, if I wold follow
 his rede,
Into your house a privy way he wold me guide and
 lead,
And where ye had it in your hands, sewing about a
 clout; 190
And set me in the back hole, thereby to find you out.
And, whiles I sought a quietness, creeping upon my
 knees,
I found the weight of your door bar for my reward and
 fees.
Such is the luck that some men gets while they begin to
 mell[40]
In setting at one such as were out,[41] minding to make
 all well.
 Hod. Was not well blessed, gammer, to scape that
 scour?[42] And chad been there,
Then chad been dressed, belike, as ill, by the Mass, as
 Gaffer Vicar.
 Bail. Marry, sir, here is a sport alone. I looked for
 such an end.
If Diccon had not played the knave, this had been soon
 amend.
My gammer here he made a fool, and dressed her as she
 was; 200
And Goodwife Chat he set to scole,[43] till both parts
 cried "alas";
And Doctor Rat was not behind, whiles Chat his crown
 did pare;
I wold the knave had been stark blind, if Hodge had not
 his share!
 Hod. Cham meetly well sped already amongs; cham
 dressed like a colt![44]
And chad not had the better wit, chad been made a dolt.
 Bail. [*To* SCAPETHRIFT] Sir knave, make haste
 Diccon were here; fetch him wherever he be!
 [*Exit* SCAPETHRIFT.]
 Chat. Fie on the villain, fie, fie, that makes us thus
 agree!
 Gam. Fie on him, knave, with all my heart! Now fie!
 and fie again!

D. Rat. "Now fie on him!" may I best say, whom he
hath almost slain.

[*Enter* DICCON, *with* SCAPETHRIFT.]

Bail. Lo, where he cometh at hand. Belike he was
not far! 210
Diccon, here be two or three thy company cannot
spare.
Dic. God bless you—and you may be blessed, so
many all at once!
Chat. Come, knave, it were a good deed to geld thee,
by Cock's bones!
Seest not thy handiwark? Sir Rat, can ye forbear[45]
him?

[DOCTOR RAT *beats* DICCON.]

Dic. A vengeance on those hands light, for my hands
came not near him!
The whoreson priest hath lift the pot[46] in some of these
alewives' chairs,
That his head wold not serve him, belike, to come
down the stairs.
Bail. Nay, soft! Thou mayst not play the knave and
have this language too!
If thou thy tongue bridle awhile, the better mayst thou
do.
Confess the truth, as I shall ask, and cease awhile to
fable; 220
And for thy fault, I promise thee, thy handling shall be
reasonable.
Hast thou not made a lie or two to set these two by the
ears?[47]
Dic. What if I have? Five hundred such have I seen
within these seven years.
I am sorry for nothing else but that I see not the sport
Which was between them when they met, as they
themselves report.
Bail. The greatest thing—Master Rat! Ye see how
he is dressed!
Dic. What devil need he be groping so deep in
Goodwife Chat's hens' nest?
Bail. Yea, but it was thy drift[48] to bring him into the
briers.
Dic. God's bread! hath not such an old fool wit to
save his ears?
He showeth himself herein, ye see, so very a cox[49] 230
The cat was not so madly allured by the fox
To run into the snares was set for him, doubtless;
For he leaped in for mice, and this Sir John for
madness.
D. Rat. Well, and ye shift no better, ye losel, lither[50]
and lazy,
I will go near, for this, to make ye leap at a daisy.[51]
In the king's name, Master Baily, I charge you set him
fast!
Dic. What, fast at cards, or fast on sleep? It is the
thing I did last.
D. Rat. Nay, fast in fetters, false varlet, according to
thy deeds!
Bail. Master Doctor, there is no remedy; I must
entreat you needs

Some other kind of punishment.
D. Rat. Nay, by All Hallows,[52]
His punishment, if I may judge, shall be naught else
but the gallows. 241
Bail. That were too sore. A spiritual man to be so
extreme!
D. Rat. Is he worthy any better, sir? How do ye
judge and deem?
Bail. I grant him worthy punishment, but in no wise
so great.
Gam. It is a shame, ich tell you plain, for such false
knaves entreat!
He has almost undone us all; that is as true as steel.
And yet for all this great ado cham never the near my
neele!
Bail. Canst thou not say anything to that, Diccon,
with least or most?[53]
Dic. Yea, marry, sir, thus much I can say well: the
needle is lost!
Bail. Nay, canst not thou tell which way that needle
may be found? 250
Dic. No, by my fay, sir, though I might have an
hundred pound.
Hod. Thou liar, lickdish,[54] didst not say the neele
wold be gitten?[55]
Dic. No, Hodge, by the same token you were that
time beshitten
For fear of Hobgobling—you wot well what I mean;
As long as it is sence,[56] I fear me yet ye be scarce clean.
Bail. Well, Master Rat, you must both learn and
teach us to forgeve.
Since Diccon hath confession made and is so clean
shreve,[57]
If ye to me consent, to amend this heavy chance
I will enjoin him here some open kind of penance,
Of this condition. Where ye know my fee is twenty
pence, 260
For[58] the bloodshed I am agreed with you here to
dispense.
Ye shall go quite,[59] so that ye grant the matter now to
run,
To end with mirth among us all, even as it was begun.
Chat. Say yea, Master Vicar, and he shall sure
confess to be your debtor,
And all we that be here present will love you much the
better.
D. Rat. My part is the worst; but, since you all
hereon agree,
Go even to,[60] Master Baily—let it be so for me!
Bail. How sayest thou, Diccon? Art content this
shall on me depend?
Dic. Go to, Master Baily, say on your mind. I know
ye are my friend.

[45] *forbear:* put up with. [46] *pot:* of ale.
[47] *by the ears:* at odds. [48] *drift:* intention.
[49] *cox:* coxcomb: fool. [50] *lither:* lazy (a tautology).
[51] *leap . . . daisy:* be hanged. [52] *Hallows:* Saints.
[53] *with . . . most:* at all.
[54] *lickdish:* one who works in the kitchen, "menial."
[55] *gitten:* got. [56] *sence:* since (then).
[57] *shreve:* shriven. [58] *For:* Because of.
[59] *quite:* quit, free of charge. [60] *even to:* ahead then.

Bail. Then mark ye well to recompense this thy
 former action, 270
Because thou hast offended all, to make them
 satisfaction,
Before their faces here kneel down, and as I shall thee
 teach.
For thou shalt take an oath of Hodge's leather breech:
First, for Master Doctor, upon pain of his curse,
Where he will pay for all, thou never draw thy purse,
And when ye meet at one pot, he shall have the first pull,
And thou shalt never offer him the cup but it be full;
To Goodwife Chat thou shalt be sworn, even on the
 same wise,[61]
If she refuse thy money once, never to offer it twice;
Thou shalt be bound by the same, here as thou dost
 take it, 280
When thou mayst drink of free cost, thou never forsake
 it;
For Gammer Gurton's sake, again sworn shalt thou be,
To help her to her needle again, if it do lie in thee;
And likewise be bound, by the virtue of that,
To be of good abearing[62] to Gib, her great cat;
Last of all, for Hodge, the oath to scan,
Thou shalt never take him for fine gentleman.
 Hod. Come on, fellow Diccon! Chall be even with
 thee now!
 Bail. Thou wilt not stick[63] to do this, Diccon, I
 trow?
 Dic. No, by my father's skin; my hand down I lay it!
Look! As I have promised, I will not denay it. 291
But, Hodge, take good heed now thou do not beshit me!

 And gave him a good blow on the buttock.

 Hod. Gog's heart! Thou false villain, dost thou bite
 me?
 Bail. What, Hodge, doth he hurt thee or ever he
 begin?
 Hod. He thrust me into the buttock with a bodkin or
 a pin!

 [He draws out the needle.]

I say, gammer! gammer!
 Gam. How now, Hodge? How now?
 Hod. God's malt, Gammer Gurton!
 Gam. Thou art mad,
 ich trow!
 Hod. Will you see the devil, gammer?
 Gam. The devil,
 son? God bless us!
 Hod. Could ich were hanged, gammer?
 Gam. Marry, see,
 ye might dress us—
 Hod. Chave it, by the Mass, gammer!
 Gam. What, not my
 neele, Hodge? 300

 Hod. Your neele, gammer, your neele!
 Gam. No, fie, dost
 but dodge![64]
 Hod. Cha' found your neele, gammer! Here in my
 hand be it!
 Gam. For all the loves on earth, Hodge, let me see it!
 Hod. Soft, gammer!
 Gam. Good Hodge!
 Hod. Soft, ich say; tarry
 awhile!
 Gam. Nay, sweet Hodge, say truth, and do not me
 beguile!
 Hod. Cham sure on it, ich warrant you it goes no
 more astray.
 Gam. Hodge, when I speak so fair, wilt still say me
 nay?
 Hod. Go near the light, gammer. This—well, in
 faith, good luck!—
Chwas almost undone, 'twas so far in my buttock!
 Gam. 'Tis mine own dear neele, Hodge, sikerly I
 wot![65] 310
 Hod. Cham I not a good son, gammer, cham I not?
 Gam. Christ's blessing light on thee! Hast made me
 forever!
 Hod. Ich knew that ich must find it, else could 'a[66]
 had it never!
 Chat. By my troth, Gossip Gurton, I am even as glad
As though I mine own self as good a turn had!
 Bail. And I, by my conscience, to see it so come forth,
Rejoice so much at it as three needles be worth!
 D. Rat. I am no whit sorry to see you so rejoice!
 Dic. Nor I much the gladder for all this noise!
Yet say, "Gramercy, Diccon," for springing of the
 game.
 Gam. Gramercy, Diccon, twenty times! O, how glad
 cham! 321
If that could do so much, your masterdom to come
 hether,
Master Rat, Goodwife Chat, and Diccon, together—
Cha' but one halfpenny, as far as ich know it,
And chill not rest this night till ich bestow it.
If ever ye love me, let us go in and drink!
 Bail. I am content, if the rest think as I think.
Master Rat, it shall be best for you if we so do;
Then shall you warm you and dress yourself too.
 Dic. Soft, sirs, take us with you; the company shall
 be the more! 330
As proud comes behind, they say, as any goes before!—
[To the audience] But now, my good masters, since we
 must be gone
And leave you behind us here, all alone—
Since at our last ending thus merry we be,
For Gammer Gurton's needle sake let us have a
 plaudity![67]

 Finis, Gurton. Perused and Allowed,[68] etc.

[61] *on ... wise:* in the same manner.
[62] *abearing:* behavior. [63] *stick:* grudge.
[64] *dodge:* fool (me). [65] *sikerly I wot:* surely I know.
[66] *chould 'a:* I would have. [67] *a plaudity:* your applause.
[68] *Perused and Allowed:* By the state censorship as vested in the Office of Revels and the Stationers' Register.

Thomas Preston

CAMBYSES, KING OF PERSIA

IN 1569–70 the printer John Allde entered CAMBYSES in the Stationers' Register, and at some time thereafter—probably shortly—the first quarto edition appeared (Q1). A second edition (Q2), the best text and the basis of this as of all other modern editions, was published by Allde's son Edward, who took over his father's enterprise in 1584. Like the first, the second edition is undated, and since the play remained long enough in the popular consciousness to be worth jokes in the 1590s in *A Midsummer Night's Dream* and *1 Henry IV*, it may have been printed at any time during Edward Allde's career, which ended in 1628. The dates of composition and first performance are still unknown; from the unflattering allusion to Bishop Bonner, who did not die until 1569, though he earned his bad reputation under Queen Mary, and from the Epilogue it is clear only that the play belongs to Elizabeth's reign; one would like to be able to identify it confidently as the *Huff, Suff, and Ruff* put on at court in 1560–61, but even if those characters are our Huf, Snuf, and Ruf, they may have figured in another comedy. The play's authorship is as murky as its date. One Thomas Preston was a fellow at King's College, Cambridge, by 1556 and got his M.A. in 1561; debating before the Queen in 1564, he earned a stipend that continued until 1581, and ultimately he became Master of Trinity Hall and Vice-Chancellor. Another Thomas Preston published some ballads in broadside. And the title page of CAMBYSES attributes authorship to Thomas Preston. All three may well be the same man; there were other Thomas Prestons in the period, too.

To the reader the most intriguing mystery may well be not the details of date and authorship but that a work so patently atrocious warranted two editions and deserves inclusion in a collection of drama from one of the great theaters in the world's history. To know the answers to these questions is to understand a great deal about the drama of the English Renaissance. Consider, for example, the full title of the piece: "*A Lamentable Tragedy, Mixed Full of Pleasant Mirth, Containing the Life of Cambyses, King of Persia*, from the beginning of his kingdom unto his death, his one good deed of execution, after that many wicked deeds and tyrannous murders committed by and through him, and last of all his odious death by God's justice appointed, done in such order as followeth." If the naive mixture of genres announced—further complicated by the play's running title, "A Comedy of King Cambyses"—inspired Shakespeare's laughter in his rude mechanicals' "tedious brief scene of young Pyramus and his love Thisby; very tragical mirth," it also points, much more directly than anything in the far more artful and respectable GOR-BODUC, at a characteristic mingling of comedy and tragedy that was as natural to Shakespeare as writing plays. If the title promises exaggerated villainy, it anticipates a host of supervillains to come; if it offers sensational wickedness within a frame of providential governance (with all the contradictions potential in such dual concern), if it implies inner development within its protagonist, hindsight permits us to see how much of what we assume essential to the freedom and power of Elizabethan and Jacobean plays is already here.

That such features can be found in the work of a writer innocent of dramaturgic or verbal skill indicates the force of the developing popular conventions. For CAMBYSES, unlike the academic GORBODUC, is unabashedly popular. Written for performance, as its Dramatis Personae tells us, by a standard professional company of six men and two boys, it is composed in a variety of metrical forms, but above all in the jog-trot fourteener couplets that reproduce in two lines the meter of a ballad stanza. We may know that in such a meter one cannot be taken seriously, but Elizabethans did not think so, and were willing to read some serious poetry—even psalms—comprised of just such lines. The invention of dramatic blank verse would be as liberating as the introduction of sound in the movies, but it would find an audience that had already learned to cherish metrical conventionality and rhetorical artifice in the theater. If CAMBYSES held the stage, much of the reason must lie in Ambidexter, its utterly typical Vice, schizophrenically malevolent and amusing, invulnerable to royal power but beaten by the village trull, as familiar with real pickpockets in the pit as with imaginary characters on the stage, acting as surrogate playwright as he sets actions into motion and remarks on their outcome. Derived from the morality plays, the Vice would soon be thoroughly secularized, absorbed into characters as different from one another as Falstaff and Iago; doubtless he would be remembered throughout the period as the embodiment of all that was frightening and funny and theatrical to those who were children in Shakespeare's childhood. Cambyses was in fact the son of Cyrus the Great and King of Persia from 529 to 521 B.C.; Herodotus had written about him, and Preston seems to have read about him in a collection of moralized stories published as *The Garden of Wisdom* by one Richard Taverner in 1539. The last major mark of CAMBYSES as a popular play of early Elizabethan days is its hybrid nature, perched between such real history and the personification of the morality play, so that an authentic monarch debates with a character named Commons' Cry and employs another named Execution. The abandon with which the stew is

mixed is akin to the enthusiasm with which classical pagans swear by the Virgin and acknowledge the values and deity of the Anglican Church, and the implied assumptions—that a theatrical work represents reality in multiple and complex ways; that anachronism suggests above all the essential synchronicity, contemporaneity, availability, and relevance of history——augur well for a theater about to emerge into greatness. N. R.

Cambyses, King of Persia

DRAMATIS PERSONÆ

PROLOGUE
CAMBYSES, *King of Persia*
SMERDIS, *his brother*
SISAMNES, *the judge*
OTIAN, *his son*
PRAXASPES, *a counsel*
YOUNG CHILD, *his son*
FIRST LORD ⎫
SECOND LORD ⎬ *attendants of the King*
THIRD LORD ⎭
A LADY, *kinswoman of the King and later*
 QUEEN
WAITING-MAID, *attending her*
MOTHER *of Young Child and wife of Praxaspes*
HUF ⎫
RUF ⎬ *ruffianly soldiers*
SNUF ⎭
MERETRIX, *a courtesan*
HOB ⎫ *clownish countrymen*
LOB ⎭

MARIAN-MAY-BE-GOOD, *Hob's wife*
LORD
KNIGHT
COUNSEL
SHAME
ATTENDANCE
DILIGENCE
PREPARATION
SMALL ABILITY
COMMONS' CRY
COMMONS' COMPLAINT
TRIAL
PROOF
EXECUTION
CRUELTY
MURDER
AMBIDEXTER, *the Vice*
VENUS
CUPID

The Scene : *Persia.*

THE DIVISION OF THE PARTS

COUNSEL
HUF
PRAXASPES
MURDER ⎬ *for one man*
LOB
THE THIRD LORD

CAMBYSES ⎬ *for one man*
EPILOGUS

PROLOGUE
SISAMNES
DILIGENCE
CRUELTY ⎬ *for one man*
HOB
PREPARATION
THE FIRST LORD

LORD
RUF
COMMONS' CRY
COMMONS' COMPLAINT ⎬ *for one man*
LORD SMERDIS
VENUS

KNIGHT
SNUF
SMALL ABILITY
PROOF ⎬ *for one man*
EXECUTION
ATTENDANCE
SECOND LORD

AMBIDEXTER ⎬ *for one man*
TRIAL

MERETRIX
SHAME
OTIAN
MOTHER ⎬ *for one man*
LADY
QUEEN

YOUNG CHILD ⎬ *for one man*
CUPID

61

[Prologue]

The Prologue *entereth.*

Agathon,[1] he whose counsel wise to princes' weal[2]
 extended,
By good advice unto a prince three things he hath
 commended:
First is that he hath government and ruleth over men;
Secondly, to rule with laws, eke[3] justice, saith he, then;
Thirdly, that he must well conceive he may not always
 reign.
Lo, thus the rule unto a prince Agathon squarèd[4] plain.
Tully[5] the wise, whose sapience in volumes great doth
 tell,
Who in wisdom in that time did many men excel,
"A prince," saith he, "is of himself a plain and speaking
 law;
The law, a schoolmaster divine"—this by his rule I
 draw. 10
The sage and witty Seneca[6] his words thereto did
 frame:
"The honest exercise of kings, men will ensue[7] the
 same;
But, contrariwise, if that a king abuse his kingly seat,
His ignomy and bitter shame in fine shall be more
 great."
In Persia there reigned a king, who Cyrus hight[8] by
 name,
Who did deserve, as I do read, the lasting blast[9] of
 fame;
But he, when sisters three[10] had wrought to shear his
 vital thread,

As heir due, to take the crown Cambyses did proceed.
He in his youth was trainèd up by trace[11] of virtue's
 lore;
Yet, being king, did clean forget his perfect race[12]
 before; 20
Then, cleaving more unto his will, such vice did imitate
As one of Icarus[13] his kind; forewarning then did hate,
Thinking that none could him dismay, ne[14] none his
 fact[15] could see.
Yet at the last a fall he took, like Icarus to be;
Else,[16] as the fish, which oft had take the pleasant bait
 from hook,
In safe[17] did spring and pierce the streams when fisher
 fast[18] did look
To hoist up from the wat'ry waves unto the drièd land,
Then scaped, at last by subtle bait come to the fisher's
 hand;
Even so this King Cambyses here, when he had
 wrought his will, 29
Taking delight the innocent his guiltless blood to spill,
Then mighty Jove would not permit to prosecute
 offense;
But, what measure the King did mete,[19] the same did
 Jove commence,
To bring to end with shame his race. Two years he did
 not reign.
His cruelty we will dilate[20] and make the matter plain.
Craving that this may suffice now your patience to win,
I take my way. Behold, I see the players coming in.
 [*Exit.*]

FINIS

[i]

First enter CAMBYSES *the King,* KNIGHT,
[LORD,] *and* COUNSEL[1].

Cam. My counsel grave and sapient, with lordes of
 legal train,
Attentive ears towards me bend, and mark what shall
 be sain;[2]
So you likewise, my valiant knight, whose manly acts
 doth fly
By bruit of fame, that sounding trump doth pierce the
 azure sky.[3]
My sapient words, I say, perpend,[3] and so your skill[4]
 dilate.[5]
You know that Mors[6] vanquishèd hath Cyrus, that
 King of state,
And I, by due inheritance, possess that princely crown,
Ruling by sword of mighty force in place of great
 renown.
You know, and often have heard tell, my father's
 worthy facts; 9
A manly Mars's heart he bare, appearing by his acts.
And what, shall I to ground let fall my father's golden
 praise?
No, no! I mean for to attempt this same more large to
 raise.

In that, that I his son succeed his kingly seat as due,
Extend your counsel unto me in that I ask of you.
I am the King of Persia, a large and fertile soil.
The Egyptians against us repugn[7] as varlets slave and
 vile;

PROLOGUE
 [1] *Agathon:* Greek tragic poet, died 401 B.C.
 [2] *weal:* welfare. [3] *eke:* also.
 [4] *squared:* set out. [5] *Tully:* Cicero.
 [6] *Seneca:* 5/4 B.C.–A.D. 65, Stoic philosopher, tutor to
Nero.
 [7] *ensue:* follow. [8] *hight:* was called.
 [9] *blast:* of the trumpet Fame is frequently imagined
holding.
 [10] *sisters three:* the fates. [11] *trace:* course.
 [12] *race:* family line.
 [13] *Icarus:* Escaping from prison with his father Daedalus
on artificial wings, the legendary boy flew too close to the
sun; the wax melted, and he drowned in the Aegean Sea.
 [14] *ne:* nor. [15] *fact:* deed.
 [16] *Else:* i.e., to make another comparison.
 [17] *safe:* safety. [18] *fast:* confidently.
 [19] *mete:* deal out. [20] *dilate:* relate at length.

i.
 [1] *Counsel:* Counsellor Q2. [2] *sain:* said.
 [3] *perpend:* weigh. [4] *skill:* knowledge.
 [5] *dilate:* enlarge. [6] *Mors:* Death.
 [7] *repugn:* contend.

Therefore I mean with Mars's heart with wars them to
 frequent,
Them to subdue as captives mine. This is my heart's
 intent;
So shall I win honor's delight, and praise of me shall go.
My counsel, speak, and, lordings, eke: is it not best do
 so? 20
 Coun. O puissant King, your blissful words
 deserves[8] abundant praise,
That you in this do go about your father's fame to raise.
O blissful day, that King so young such profit should
 conceive,
His father's praise and his to win from those that would
 deceive.
Sure, my true and sovereign King, I fall before you
 prest,[9]
Answer to give as duty mine in that your grace request.
If that your heart addicted be the Egyptians to
 convince,[10]
Through Mars's aid the conquest won, then deed of
 happy prince
Shall pierce the skies unto the throne of the supernal
 seat
And merit there a just reward of Jupiter the great. 30
But then your grace must not turn back from this
 pretensèd[11] will;
For to proceed in virtuous life employ endeavor still;[12]
Extinguish vice, and in that cup to drink have no
 delight;
To martial feats and kingly sport fix all your whole
 delight.
 King. My counsel grave, a thousand thanks with
 heart I do you render,
That you my case so prosperous entirely do tender.
I will not swerve from those your steps whereto you
 would me train.
But now, my lord and valiant knight, with words give
 answer plain:
Are you content with me to go the Mars's games to try?
 Lord. Yea, peerless prince, to aid your grace myself
 will live and die. 40
 Kni. And I, for my ability, for fear will not turn back,
But, as the ship against the rocks, sustain and bide the
 wrack.
 King. O willing hearts! A thousand thanks I render
 unto you.
Strike up your drums with courage great; we will march
 forth even now.
 Coun. Permit, O King, few words to hear; my duty
 serves no less.
Therefore give leave to counsel thine his; mind for to
 express.
 King. Speak on, my counsel; what it be, you shall
 have favor mine.

 Coun. Then will I speak unto your grace as duty
 doth me bind.
Your grace doth mean for to attempt of war the manly
 art;
Your grace therein may hap receive, with others, for
 your part, 50
The dint[13] of death—in those affairs all persons are
 alike.
The heart courageous oftentimes his detriment doth
 seek.
It's best therefore for to permit a ruler of your land
To sit and judge with equity when things of right are
 scanned.
 King. My grace doth yield to this your talk. To be
 thus now it shall.
My knight, therefore prepare yourself Sisamnes for to
 call.
A judge he is of prudent skill; even he shall bear the
 sway
In absence mine, when from the land I do depart my
 way.
 Kni. Your knight before your grace even here
 himself hath ready pressed
With willing heart for to fulfill as your grace made
 request. 60
 Exit.
 Coun. Pleaseth your grace, I judge of him to be a
 man right fit;
For he is learnèd in the law, having the gift of wit.
In your grace's precinct I do not view for it a meeter
 man.
His learning is of good effect; being proof thereof I can.
I do not know what is his life, his conscience hid from
 me;
I doubt not but the fear of God before his eyes to be.
 Lord. Report declares he is a man that to himself is
 nigh,[14]
One that favoreth much the world and sets too much
 thereby.
But this I say of certainty: if he your grace succeed
In your absence but for a while, he will be warned
 indeed 70
No injustice for to frequent,[15] no partial judge to prove,
But rule all things with equity to win your grace's love.
 King. Of that he shall a warning have my hests[16] for
 to obey;
Great punishment for his offense against him will I lay.

 [*Enter* SISAMNES.]

 Coun. Behold, I see him now agress[17] and enter into
 place.
 Sis. O puissant prince and mighty King, the gods
 preserve your grace.
Your grace's message came to me, your will purporting
 forth;
With grateful mind I it received according to mine
 oath,
Erecting then myself with speed before your grace's
 eyes,
The tenor of your princely will from you for to
 agnize.[18] 80

[8] *deserves:* Agreement of number between subject and verb is looser in this period than later.
[9] *prest:* promptly. [10] *convince:* overcome.
[11] *pretensed:* intended. [12] *still:* always.
[13] *dint:* blow. [14] *to . . . nigh:* self-interested.
[15] *frequent:* resort to. [16] *hests:* commands.
[17] *aggress:* approach. [18] *agnize:* learn.

King. Sisamnes, this the whole effect the which for
 you I sent:
Our mind it is to elevate you to great preferment.
My grace and gracious counsel eke hath chose you for
 this cause;
In judgment you do office bear which have the skill in
 laws.
We think that you accordingly by justice's rule will
 deal,
That for offense none shall have cause, of wrong you to
 appeal.[19]
 Sis. Abundant thanks unto your grace for this
 benignity.
To you, his counsel, in like case, with lords of
 clemency.
Whatso your grace to me permits, if I therein offend,
Such execution then commence—and use it to this
 end— 90
That all other, by that my deed, example so may take
To admonish them to flee same by fear it may them
 make.
 King. Then, according to your words, if you therein
 offend,
I assure you even from my breast, correction shall
 extend.
From Persia I mean to go into the Egypt land,
Them to convince by force of arms and win the upper
 hand.
While I therefore absent shall be, I do you full permit,
As governor in this my right, in that estate to sit,
For to detect and eke correct those that abuse my grace.
This is the total of my will. Give answer in this case.
 Sis. Unworthy much, O prince, am I, and for this
 gift unfit; 101
But, sith[20] that it hath pleased your grace that I in it
 must sit,
I do avouch unto my death, according to my skill,
With equity for to observe your grace's mind and will,
And naught from it to swerve, indeed, but sincerely to
 stay;
Else let me taste the penalty, as I before did say.
 King. Well then, of this authority I give you full
 possession.
 Sis. And I will it fulfill also as I have made profession.
 King. My counsel, then let us depart a final stay[21] to
 make;
To Egypt land now forth with speed my voyage I will
 take. 110
Strike up your drums, us to rejoice to hear the warlike
 sound.
Stay you here, Sisamnes, judge, and look well to your
 bond!
 Exeunt KING, LORD, *and* COUNSEL.
 Sis. Even now the King hath me extolled and set me
 up aloft.
Now may I wear the bordered guard[22] and lie in down-
 bed soft;
Now may I purchase house and land and have all at my
 will;
Now may I build a princely place my mind for to fulfill;
Now may I abrogate the law as I shall think it good;

If anyone me now offend, I may demand his blood.
According to the proverb old, my mouth I will
 up-make.[23] 119
Now it doth lie all in my hand to leave or else to take,
To deal with justice to me bound, and so to live in hope.
But oftentimes the birds be gone while one for nest
 doth grope.
Do well or ill, I dare avouch some evil on me will speak.
No, truly—yet I do not mean the King's precepts to
 break;
To place I mean for to return my duty to fulfill.
 Exit.

[ii]

 Enter the VICE, *with an old capcase*[1] *on his head,
 an old pail about his hips for harness,*[2] *a scummer*[3]
 and a potlid by his side, and a rake on his shoulder.

 Amb. Stand away, stand away, for the passion of
 God.
Harnessed I am, prepared to the field!
I would have been content at home to have bode,
But I am sent forth with my spear and shield.
I am appointed to fight against a snail,
And Wilkin Wren the ancient[4] shall bear.
I doubt not but against him to prevail—
To be a man my deeds shall declare!
If I overcome him, then a butterfly takes his part.
His weapon must be a blue-specked hen; 10
But you shall see me overthrow him with a fart.
So, without conquest, he shall go home again.
If I overcome him, I must fight with a fly,
And a black-pudding[5] the fly's weapon must be.
At the first blow on the ground he shall lie;
I will be sure to thrust him through the mouth to the
 knee.
To conquest these fellows the man I will play.
Ha, ha, ha! now ye will make me to smile.
 . . .[6]
To see if I can all men beguile. 20
Ha! my name? My name would ye so fain know?
Yea, iwis,[7] shall ye, and that with all speed!—
I have forgot it; therefore I cannot show
Ah! ah! now I have it! I have it, indeed!
My name is Ambidexter. I signify one
That with both hands finely can play.
Now with King Cambyses, and by and by[8] gone.
Thus do I run this way and that way.
For while I mean with a soldier to be;
Then give I a leap to Sisamnes the judge. 30

19 *appeal:* accuse. 20 *sith:* since.
21 *stay:* sojourn.
22 *bordered guard:* ornamented fringe, signifying rank.
23 *mouth . . . up-make:* please my palate.
ii.
1 *capcase:* hatbox. 2 *harness:* armor.
3 *scummer:* skimming-ladle. 4 *ancient:* ensign.
5 *black-pudding:* sausage made with blood and suet.
6 Line missing from Qq. 7 *iwis:* surely.
8 *by and by:* immediately.

I dare avouch you shall his destruction see.
To all kind of estates I mean for to trudge.
Ambidexter? Nay, he is a fellow, if ye knew all.
Cease for a while hereafter hear more ye shall.

Enter three ruffians,
HUF, RUF, *and* SNUF, *singing.*

Huf. Gog's[9] flesh and His wounds, these wars rejoice
 my heart.
By His wounds, I hope to do well, for my part.
By Gog's heart, the world shall go hard if I do not shift;
At some old carl's[10] budget[11] I mean for to lift.
 Ruf. By His flesh, nose, eyes, and ears, I will
 venture, void of all cares. 40
He is not a soldier that doth fear any doubt,
If that he would bring his purpose about.
 Snuf. Fear that fear list,[12] it shall not be I.
By Gog's wounds, I will make some neck stand awry.
If I lose my share—I swear by Gog's heart—
Then let another take up my part.
 Huf. Yet I hope to come the richest soldier away.
 Ruf. If a man ask ye, ye may hap to say nay.
 Snuf. Let all men get what they can; not to leese[13] I
 hope;
Wheresoever I go, in each corner I will grope. 50
 Amb. What and[14] ye run in the corner of some pretty
 maid?
 Snuf. To grope there, good fellow, I will not be
 afraid.
 Huf. Gog's wounds, what art thou that with us dost
 mell?[15]
Thou seemest to be a soldier, the truth to tell;
Thou seemest to be harnessed—I cannot tell how;
I think he came lately from riding some cow.
Such a deformed slave did I never see!
Ruf, dost thou know him? I pray thee, tell me.
 Ruf. No, by my troth, fellow Huf, I never see him
 before.
 Snuf. As for me, I care not if I never see him more.
Come, let us run his arse against the post. 61
 Amb. Ah, ye slaves! I will be with you at host.[16]

Here let him swinge[17] them about.

Ah, ye knaves! I will teach ye how ye shall me deride.
Out of sight! I can ye not abide.
Now, goodman pouchmouth, I am a slave with you?
Now have at ye afresh, again, even now.
Mine arse against the post you will run?
But I will make you from that saying to turn.
 Huf. I beseech ye heartily to be content.
 Ruf. I insure[18] you, by mine honesty, no hurt we
 meant. 70

Beside that, again, we do not know what ye are.
Ye know that soldiers their stoutness will declare;
Therefore, if we have anything offended,
Pardon our rudeness, and it shall be amended.
 Amb. Yea, God's pity, begin ye to entreat me?
Have at ye once again! By the Mass, I will beat ye.

Fight again.

 Huf. Gog's heart, let us kill him. Suffer no longer.

Draw their swords.

 Snuf. Thou slave, we will see if thou be the
 stronger.
 Ruf. Strike off his head at one blow.
That we be soldiers, Gog's heart, let him know. 80
 Amb. O the passion of God, I have done, by mine
 honesty.
I will take your part hereafter, verily.
 All. Then come, let us agree.
 Amb. Shake hands with me; I shake hands with thee.
Ye are full of courtesy; that is the best.
And you take great pain; ye are a mannerly guest.
Why, masters, do you not know me? The truth to me
 tell.
 All. No, trust us, not very well.
 Amb. Why, I am Ambidexter, who many soldiers do
 love.
 Huf. Gog's heart, to have thy company needs we
 must prove. 90
We must play with both hands, with our hostess and
 host,
Play with both hands, and score on the post;[19]
Now and then, with our captain, for many a delay,
We will not stick with both hands to play.
 Amb. The honester man, ye may me trust.

Enter MERETRIX, *with a staff on her shoulder.*

 Mer. What! is there no lads here that hath a lust
To have a passing trull[20] to help at their need?
 Huf. Gog's heart, she is come, indeed.
What, Mistress Meretrix, by His wounds, welcome to
 me. 99
 Mer. What will ye give me? I pray you, let me see.
 Ruf. By His heart, she looks for gifts by and by.
 Mer. What? Master Ruf? I cry you mercy.
The last time I was with you I got a broken head
And lay in the street all night for want of a bed.
 Snuf. Gog's wounds, kiss me, my trull so white![21]
In thee I swear is all my delight.
If thou shouldst have had a broken head for my sake,
I would have made his head to ache.
 Mer. What? Master Ambidexter? Who looked for
 you?
 Amb. Mistress Meretrix, I thought not to see you
 here now. 110
There is no remedy; at meeting I must have a kiss!
 Mer. What, man, I will not stick for that, by gis![22]

Kiss.

 Amb. So now, gramercy.[23] I pray thee be gone.
 Mer. Nay, soft, my friend; I mean to have one.

 9 *Gog's:* God's. 10 *carl:* yokel. 11 *budget:* wallet.
 12 *list:* pleases. 13 *leese:* lose.
 15 *mell:* meddle.
 14 *and:* if.
 16 *lie . . . host:* lodge at an inn with, be on familiar terms
with.
 17 *swinge:* beat. 18 *insure:* assure.
 19 *score . . . post:* keep the reckoning on the tavern
doorpost.
 20 *trull:* whore. 21 *white:* dear.
 22 *gis:* corruption of Jesus. 23 *gramercy:* thanks.

Nay, soft! I swear, and if ye were my brother,
Before I let go, I will have another.

Kiss, kiss, kiss.

Ruf. Gog's heart, the whore would not kiss me yet.
Mer. If I be a whore, thou art a knave; then it is quit.
Huf. But hear'st thou. Meretrix? With who this
 night wilt thou lie?
Mer. With him that giveth the most money. 120
Huf. Gog's heart, I have no money in purse, ne yet
 in clout.[24]
Mer. Then get thee hence and pack, like a lout.
Huf. Adieu, like a whore.

Exit HUF.

Mer. Farewell, like a knave!
Ruf. Gog's nails, Mistress Meretrix, now he is gone,
A match ye shall make straight with me:
I will give thee sixpence to lie one night with thee.
Mer. Gog's heart, slave, dost think I am a sixpenny
 Jug?[25]
No, wis[26] ye, Jack, I look a little more smug.
Snuf. I will give her eighteenpence to serve me first.
Mer. Gramercy, Snuf, thou art not the worst. 130
Ruf. By Gog's heart, she were better be hanged to
 forsake me and take thee.
Snuf. Were she so? That shall we see.
Ruf. By Gog's heart, my dagger into her I will thrust.
Snuf. Ah, ye boy, ye would do it and ye durst.
Amb. Peace, my masters; ye shall not fight.
He that draws first, I will him smite.
Ruf. Gog's wounds, Master Snuf, are ye so lusty?
Snuf. Gog's sides, Master Ruf, are ye so crusty?
Ruf. You may happen to see.
Snuf. Do what thou darest to me. 140

*Here draw and fight. Here she must lay on and coil[27]
 them both; the* VICE *must run his way for fear;*
SNUF *fling down his sword and buckler and run his
 way.*

Mer. Gog's sides, knaves, seeing to fight ye be so
 rough,
Defend yourselves, for I will give ye both enough.
I will teach ye how ye shall fall out for me.
Yea, thou slave, Snuf, no more blows wilt thou bide?
To take thy heels a time hast thou spied?
Thou villain, seeing Snuf has gone away,
A little better I mean thee to pay.

*He falleth down; she falleth upon him and beats him
 and taketh away his weapons.*

Ruf. Alas, good Mistress Meretrix, no more!
My legs, sides, and arms with beating be sore.
Mer. Thou a soldier, and lose thy weapon! 150
Go hence, sir boy; say a woman hath thee beaten.
Ruf. Good Mistress Meretrix, my weapon let me
 have;
Take pity on me, mine honesty[28] to save.
If it be known this repulse I sustain,
It will redound to my ignomy and shame.
Mer. If thou wilt be my man and wait upon me,
This sword and buckler I will give thee.

Ruf. I will do all at your commandment;
As servant to you I will be obedient.
Mer. Then let me see how before me you can go.
When I speak to you, you shall do so: 161
Off with your cap at place[29] and at board[30]
"Forsooth, Mistress Meretrix," at every word.
Tut! tut! in the camp such soldiers there be,
One good woman would beat away two or three.
Well, I am sure customers tarry at home
Mannerly before, and let us be gone.

Exeunt.

[iii]

Enter AMBIDEXTER.

[*Amb.*] Oh the passion of God! Be they here still or
 no?
I durst not abide to see her beat them so.
I may say to you I was, in such a fright,[1]
Body of me, I see the hair of my head stand upright.
When I saw her so hard upon them lay on,
"Oh the passion of God!" thought I, "she will be with
 me anon."
I made no more[2] ado, but avoided the thrust,
And to my legs began for to trust,
And fell a-laughing to myself when I was once gone.
"It is wisdom," quoth I, "by the Mass, to save one."
Then into this place I intended to trudge, 11
Thinking to meet Sisamnes the judge.
Behold where he cometh. I will him meet,
And like a gentleman I mean him to greet.

Enter SISAMNES.

Sis. Since that the King's grace's majesty in office
 did me set,
What abundance of wealth to me might I get.
Now and then some vantage I achieve; much more yet
 may I take,
But that I fear unto the King that some complaint will
 make.
Amb. Jesu, Master Sisamnes, you are unwise.
Sis. Why so? I pray thee, let me agnize. 20
What, Master Ambidexter, is it you?
Now welcome to me, I make God avow!
Amb. Jesu, Master Sisamnes, with me you are well
 acquainted.
By me rulers may be trimly painted.[3]
Ye are unwise if ye take not time while ye may;
If ye will not now, when ye would ye shall have nay.
What is he that of you dare make exclamation,
Of your wrong-dealing to make explication?
Can you not play with both hands and turn with the
 wind? 29
Sis. Believe me, your words draw deep in my mind.
In color[4] wise unto this day, to bribes I have inclined;

[24] *in clout:* in my clothing.
[25] *jug:* pet name for Joan; "whore." [26] *wis:* know.
[27] *coil:* beat. [28] *honesty:* honor.
[29] *place:* marketplace. [30] *board:* table.

iii.
[1] *I was . . . fright:* iwis . . . flight Q2. [2] *more:* mare Q2.
[3] *painted:* cheated. [4] *color:* appearance.

More the same for to frequent, of truth I am now
 minded.
Behold, even now unto me suitors do proceed.

[*Enter* SMALL ABILITY.]

Sm. Ab. I beseech you here, good master judge, a poor
 man's cause to tender.[5]
Condemn me not in wrongful wise that never was
 offender.
You know right well my right it is. I have not for to
 give.
You take away from me my due that should my corpse[6]
 relieve.
The commons of you do complain from them you
 devocate;[7]
With anguish great and grievous words their hearts do
 penetrate;
The right you sell unto the wrong, your private gain to
 win; 40
You violate the simple man and count it for no sin.
 Sis. Hold thy tongue, thou prattling knave, and give
 to me reward;
Else, in this wise, I tell thee truth, thy tale will not be
 heard.
Ambidexter, let us go hence, and let the knave alone.
 Amb. Farewell, Small Ability, for help now get you
 none;
Bribes hath corrupt him good laws to pollute.
 Exeunt [SISAMNES *and* AMBIDEXTER].
 Sm. Ab. A naughty man, that will not obey the king's
 constitute.[8]
With heavy heart I will return, till God redress my
 pain.
 Exit.

[iv]

Enter SHAME, *with a trump, black.*

Sha. From among the grisly ghosts I come, from
 tyrants' testy train.
Unseemly Shame of sooth I am, procurèd to make
 plain
The odious facts and shameless deeds that Cambyses
 King doth use.
All piety and virtuous life he doth it clean refuse;
Lechery and drunkenness he doth it much frequent.
The tiger's kind[1] to imitate he hath given full consent.
He naught esteems his counsel grave ne virtuous
 bringing-up,
But daily still receives the drink of damnèd Vice's cup.
He can bide no instruction, he takes so great delight
In working of iniquity for to frequent his spite. 10

[5] *tender:* regard graciously.
[6] *corpse:* body. [7] *devocate:* make demands of(?).
[8] *constitute:* law.

iv.
[1] *kind:* nature. [2] *strained:* vehement.

v.
[1] *of:* on. [2] *doubt:* suspect. [3] *trade:* course.
[4] *erected forth:* set forth. [5] *fell:* painful.

As Fame doth sound the royal trump of worthy men
 and trim,
So Shame doth blow with strainèd[2] blast the trump of
 shame on him.
 Exit.

[v]

Enter the KING, LORD, PRAXASPES, *and* SISAMNES.

 King. My judge, since my departure hence, have
 you used judgment right?
If faithful steward I ye find, the same I will requite.
 Sis. No doubt your grace shall not once hear that I
 have done amiss.
 Prax. I much rejoice to hear so good news as this.

Enter COMMONS' CRY *running in, speak this verse,
 and go out again hastily.*

 Com. Cr. Alas, alas, how are the commons oppressed
By that vile judge, Sisamnes by name.
I do not know how it should be redressed.
To amend his life no whit he doth frame. 20
We are undone and thrown out of door;
 His damnable dealing doth us so torment;
At his hand we can find no relief nor succor.
 God grant him grace for to repent.
 Run away crying.
King. What doleful cries be these, my lord, that sound
 do in mine ear?
Intelligence if you can give, unto your King declare.
To me it seemeth my commons all they do lament and
 cry.
Out of[1] Sisamnes, judge most chief, even now standing
 us by.
 Prax. Even so, O King, it seemed to me, as you
 rehearsal made.
I doubt[2] the judge culpable be in some respect or
 trade.[3] 30
 Sis. Redoubted King, have no mistrust; no whit
 your mind dismay.
There is not one that can me charge or aught against
 me lay.

Enter COMMONS' COMPLAINT,
with PROOF *and* TRIAL.

 Com. Co. Commons' Complaint I represent, with
 thrall of doleful state.
My urgent cause erected forth[4] my grief for to dilate.
Unto the King I will prepare my misery to tell,
To have relief of this my grief and fettered feet so fell.[5]
Redoubted prince and mighty King, myself I prostrate
 here.
Vouchsafe, O King, with me to bear for this that I
 appear.
With humble suit I pardon crave of your most royal
 grace
To give me leave my mind to break before you in this
 place. 40
 King. Commons' Complaint, keep nothing back.
 Fear not thy tale to tell.
Whate'er he be within this land that hath not used thee
 well,

As prince's mouth shall sentence give, he shall receive
the same.
Unfold the secrets of thy breast, for I extinguish blame.
 Com. Co. God preserve your royal grace and send
you blissful days,
That all your deeds might still accord to give the God
the praise.
My complaint is, O mighty King, against that judge
you by,
Whose careless deeds, gain to receive, hath made the
commons cry.
He, by taking bribes and gifts, the poor he doth oppress,
Taking relief from infants young, widows, and
fatherless. 50
 King. Untrustful traitor and corrupt judge, how
likest thou this complaint?
Forewarning I to thee did give of this to make
restraint;
And hast thou done this devilish deed mine ire for to
augment?
I sentence give, thou Judas judge. Thou shalt thy deed
repent.
 Sis. O puissant prince, it is not so.
His complaint I deny.
 Com. Co. If it be not so, most mighty King, in place
then let me die.
Behold that I have brought with me both Proof and
Trial true,
To stand even here and sentence give what by him did
ensue.
 Pr. I, Proof, do him in this appeal; he did the
commons wrong;
Unjustly he with them hath dealt, his greed was so
strong. 60
His heart did covet in to get, he carèd not which way;
The poor did leese their due and right because they
want[6] to pay
Unto him for bribes. Indeed, this was his wonted
use.
Whereas your grace good laws did make, he did the
same abuse.
 Tri. I, Trial, here to verify what Proof doth now
unfold,
To stand against him in his wrong, as now I dare be
bold.
 King. How likest thou this, thou caitiff[7] vile? Canst
thou the same deny?
 Sis. O noble King, forgive my fact.
I yield to thy mercy.
 King. Complaints and Proof, redress will I all this
your misery.
Depart with speed from whence you came, and straight
command by me 70
The execution man to come before my grace with haste.
 All. For to fulfill this your request no time we mean
to waste.
 Exeunt they three.
 King. My lord, before my grace go call Otian, this
judge's son,
And he shall hear and also see what his father hath
done.

The father he shall suffer death, the son his room
succeed;
And, if that he no better prove, so likewise shall he
speed.
 Prax. As your grace hath commandment given, I
mean for to fulfill.

 Step aside and fetch him.

 King. Accursèd judge, couldst thou consent to do
this cursèd ill?
According unto thy demand, thou shalt for this thy
guilt
Receive thy death before mine eyes. Thy blood it shall
be spilt. 80

 [*Enter* PRAXASPES *with* OTIAN.]

 Prax. Behold, O King, Sisamnes' son before you
doth appear.
 King. Otian, this is my mind; therefore to me come
near:
Thy father here for judgment wrong procurèd hath his
death,
And thou, his son, shalt him succeed when he hath lost
his breath;
And, if that thou dost once offend, as thou seest thy
father have,
In like wise thou shalt suffer death. No mercy shall thee
save.
 Ot. O mighty King, vouchsafe your grace my father
to remit.
Forgive his fault. His pardon I do ask of you as yet.
Alas, although my father hath your princely heart
offended,
Amends for miss[8] he will now make, and faults shall be
amended. 90
Instead of his requested life, pleaseth your grace take
mine.
This offer I as tender child, so duty doth me bind.
 King. Do not entreat my grace no more, for he shall
die the death.
Where is the execution man him to bereave of breath?

 Enter EXECUTION.

 Ex. At hand, and if it like your grace, my duty to
dispatch,
In hope that I, when deed is done, a good reward shall
catch.
 King. Dispatch with sword this judge's life;
extinguish fear and cares.
So done, draw thou his cursèd skin straight over both
his ears.
I will see the office done, and that before mine eyes.
 Ex. To do the thing my King commands I give the
enterprise.[9] 100
 Sis. Otian, my son, the King to death by law hath
me condemned,
And you in room and office mine his grace's will hath
placed;

 [6] *want:* lack (wherewithal) [7] *caitiff:* villain.
 [8] *miss:* wrongdoing.
 [9] *give . . . enterprise:* readily undertake.

Use justice, therefore, in this case, and yield unto no
 wrong,
[Lest thou do purchase the like death ere ever it be
 long.]¹⁰
 Ot. O father dear, these words to hear, that you must
 die by force,
Bedews my cheeks with stillèd tears. The King hath no
 remorse.
The grievous griefs and strainèd sighs my heart doth
 break in twain,
And I deplore, most woeful child, that I should see you
 slain.
O false and fickle frowning dame that turneth as the
 wind,
Is this the joy in father's age thou me assignest to
 find?
O doleful day, unhappy hour, that loving child should
 see 111
His father dear before his face thus put to death should
 be.
Yet, father, give me blessing thine, and let me once
 embrace
Thy comely corpse in folded arms and kiss thy ancient
 face.
 Sis. O child, thou makes my eyes to run as rivers do,
 by stream.
My leave I take of thee, my son. Beware of this my
 Beam.¹¹
 King. Dispatch even now, thou man of death; no
 longer seem to stay.
 Ex. Come, Master Sisamnes, come on your way.
My office I must pay; forgive therefore my deed.
 Sis. I do forgive it thee, my friend; dispatch
 therefore with speed. 120

 Smite him in the neck with a sword to signify his death.

 Prax. Behold, O King, how he doth bleed, being of
 life bereft.
 King. In this wise he shall not yet be left.
Pull his skin over his eyes to make his death more vile.
A wretch he was, a cruel thief, my commons to beguile.

 Flay him with a false skin.

 Ot. What child¹² is he of nature's mold could bide
 the same to see,
His father flayèd in this wise? O, how it grieveth me!
 King. Otian, thou seest thy father dead, and thou art
 in his room;
If thou beest proud, as he hath been, even thereto shalt
 thou come.
 Ot. O King, to me this is a glass; with grief in it I
 view
Example that unto your grace I do not prove untrue.
 Prax. Otian, convey your father hence to tomb
 where he shall lie. 131

 Ot. And if it please your lordship, it shall be done
 by and by.
Good Execution man, for need help me with him away.
 Ex. I will fulfill as you to me did say.

 They take him away.

 King. My lord, now that my grace hath seen that
 finished is this deed,
To question mine give tentive¹³ ear and answer make
 with speed:
Have not I done a gracious deed to redress my
 commons' woe?
 Prax. Yea, truly, if it please your grace, you have
 indeed done so.
But now, O King, in friendly wise I counsel you in this:
Certain vices for to leave that in you placèd is: 140
The vice of drunkenness, O King, which doth you sore
 infect,
With other great abuses which I wish you to detect.
 King. Peace, my lord! What needeth this? Of this
 I will not hear.
To palace now I will return and thereto make good
 cheer.
God Bacchus he bestows his gifts—we have good store
 of wine—
And also that the ladies be both passing brave and fine.
But stay! I see a lord now come, and eke a valiant knight.
What news, my lord? To see you here my heart it
 doth delight.

 Enter LORD *and* KNIGHT *to meet the* KING.

 Lord. No news, O King; but of duty come to wait
 upon your grace.
 King. I thank you, my lord and loving knight. I
 pray you with me trace.¹⁴ 150
My lords and knight, I pray ye tell—I will not be
 offended—
Am I worthy of any crime once to be reprehended?
 Prax. The Persians much do praise your grace, but
 one thing discommend,
In that to wine subject you be, wherein you do offend.
Sith that the might of wine's effect doth oft subdue
 your brain,
My counsel is, to please their hearts, from it you would
 refrain.
 Lord. No, no, my lord, it is not so. For this of
 prince they tell,
For virtuous proof and princely facts Cyrus he doth
 excel.
By that his grace by conquest great the Egyptians did
 convince,
Of him report abroad doth pass to be a worthy prince.
 Kni. In person of Croesus¹⁵ I answer make: we may
 not his grace compare 161
In whole respect for to be like Cyrus, the King's father,
Insomuch your grace hath yet no child as Cyrus left
 behind;
Even you I mean, Cambyses King, in whom I favor
 find.
 King. Croesus said well in saying so. But, Praxaspes,
 tell me why

¹⁰ Line omitted from Q2, taken from Q1.
¹¹ *Beam:* Cross. ¹² *child: thilde* Q2.
¹³ *tentive:* attentive. ¹⁴ *trace:* walk.
¹⁵ *Croesus:* Lydian king legendary for wealth, overthrown
by Cyrus.

That to my mouth in such a sort thou should avouch a
 lie,
Of drunkenness me thus to charge. But thou with speed
 shalt see
Whether that I a sober king or else a drunkard be.
I know thou hast a blissful babe, wherein thou dost
 delight;
Me to revenge of these thy words I will go wreak this
 spite. 170
When I the most have tasted wine, my bow it shall be
 bent.
At heart of him even then to shoot is now my whole
 intent,
And if that I his heart can hit, the King no drunkard is;
If heart of his I do not kill, I yield to thee in this.
Therefore, Praxaspes, fetch to me thy youngest son
 with speed.
There is no way, I tell thee plain, but I will do this deed.
 Prax. Redoubted prince, spare my sweet child; He
 is mine only joy.
I trust your grace to infant's heart no such thing will
 employ.
If that his mother hear of this, she is so nigh her
 flight,[16]
In clay her corpse will soon be shrined to pass from
 world's delight. 180
 King. No more ado! Go fetch me him. It shall be as
 I say.
And if that I do speak the word, how dare ye once say
 nay?
 Prax. I will go fetch him to your grace; but so, I
 trust, it shall not be.
 King. For fear of my displeasure great, go fetch him,
 unto me.
 [Exit PRAXASPES.*]*
Is he gone? Now, by the gods, I will do as I say!
My lord, therefore fill me some wine, I heartily you
 pray,
For I must drink to make my brain somewhat
 intoxicate.
When that the wine is in my head, O, trimly I can
 prate.
 Lord. Here is the cup, with fillèd wine, thereof to
 take repast. 189
 King. Give it me to drink it off, and see no wine be
 waste.

 Drink.

Once again enlarge this cup, for I must taste it still.

 Drink.

By the gods, I think of pleasant wine I cannot take my
 fill.
Now drink is in, give me my bow and arrows from sir
 knight.
At heart of child I mean to shoot, hoping to cleave it
 right.
 Kni. Behold, O King, where he doth come, his
 infant young in hand.

 [Enter PRAXASPES *with the* CHILD.*]*

 Prax. O mighty King, your grace' behest with
 sorrow I have scanned,
And brought my child fro mother's knee before you to
 appear,
And she thereof no whit doth know that he in place is
 here.
 King. Set him up, my mark to be, I will shoot at his
 heart.
 Prax. I beseech your grace not so to do. Set this
 pretense apart. 200
Farewell, my dear and loving babe; Come, kiss thy
 father dear.
A grievous sight to me it is to see thee slain even here.
Is this the gain now from the King for giving counsel
 good—
Before my face with such despite to spill my son's
 heart-blood?
O heavy day to me this is, and mother in like case.
 Y. Ch. O father, father, wipe your face;
 I see the tears run from your eye.
My mother is at home sewing of a band.[17]
 Alas, dear father, why do you cry?
 King. Before me as a mark now let him stand; 210
I will shoot at him my mind to fulfill.
 Y. Ch. Alas, alas, father, will you me kill?
Good master King, do not shoot at me; my mother
 loves me best of all.

 Shoot.

 King. I have dispatched him. Down he doth fall.
As right as a line his heart I have hit.
Nay, thou shalt see, Praxaspes, stranger news yet.
My knight, with speed his heart cut out and give it
 unto me.
 Kni. It shall be done, O mighty King, with all
 celerity.
 Lord. My lord Praxaspes, this had not been but
 your tongue must be walking.
To the king of correction you must needs be talking.
 Prax. No correction, my lord, but counsel for the
 best. 221
 Kni. Here is the heart, according to your grace's
 behest.
 King. Behold, Praxaspes, thy son's own heart. O,
 how well the same was hit.
After this wine to do this deed I thought it very fit.
Esteem thou mayst right well thereby no drunkard is
 the king
That in the midst of all his cups could do this valiant
 thing.
 My lord and knight, on me attend. To palace we
 will go,
And leave him here to take his son when we are gone
 him fro.
 All. With all our hearts we give consent to wait upon
 your grace.
 [Exeunt all but PRAXASPES.*]*
 Prax. A woeful man, O lord, am I, to see him in this
 case! 230

[16] *flight:* i.e., to heaven. [17] *band:* ribbon.

My days, I deem, desires their end. This deed will help
 me hence.
To have the blossoms of my field destroyed by
 violence!

Enter MOTHER.

[*Moth.*] Alas, alas, I do hear tell the King hath killed
 my son.
If it be so, woe worth the deed that ever it was done.
It is even so. My lord I see, how by him he doth weep.
What meant I that from hands of him this child I did
 not keep?
Alas, husband and lord, what did you mean to fetch this
 child away?
 Prax. O lady wife, I little thought for to have seen
 this day.
 Moth. O blissful babe! O joy of womb! Heart's
 comfort and delight!
For counsel given unto the King is this thy just requite?
O heavy day and doleful time, these mourning tunes to
 make! 241
With blubb'rèd eyes into mine arms from earth I will
 thee take
And wrap thee in mine apron white. But, O my heavy
 heart!
The spiteful pangs that it sustains would make it in two
 to part,
The death of this my son to see. Oh heavy mother now,
That from thy sweet and sug'rèd joy to sorrow so
 shouldst bow!
What grief in womb did I retain before I did thee see!
Yet at last, when smart was gone, what joy wert thou to
 me!
How tender was I of thy food, for to preserve thy
 state!
How stillèd I thy tender heart at times early and late!
With velvet paps I gave thee suck with issue from my
 breast, 251
And dancèd thee upon my knee to bring thee unto rest.
Is this the joy of thee I reap? O king of tiger's brood!
O tiger's whelp, hadst thou the heart to see this child's
 heart-blood?
Nature enforceth me, alas, in this wise to deplore,
To wring my hands. Oh wellaway, that I should see this
 hour!
Thy mother yet will kiss thy lips, silk-soft and pleasant
 white,
With wringing hands lamenting for to see thee in this
 plight.
My lording dear, let us go home our mourning to
 augment.
 Prax. My lady dear, with heavy heart to it I do
 consent, 260
Between us both the child to bear unto our lordly
 place.
 Exeunt.

 [1] *sped:* succeeded. [2] *repines:* discontents.
 [3] *mo:* more. [4] *pair:* repair.
 [5] *square:* orderliness.

[vi]

Enter AMBIDEXTER.

[*Amb.* (*To the audience*)] Indeed, as ye say, I have
 been absent a long space.
But is not my cousin Cutpurse with you in the
 meantime?
To it, to it, cousin, and do your office fine.
How like you Sisamnes for using of me?
He played with both hands, but he sped [1] ill-favoredly.
The King himself was godly uptrained;
He professed virtue—but I think it was feigned.
He plays with both hands, good deeds and ill;
But it was no good deed Praxaspes' son for to kill.
As he for the good deed on the judge was commended,
For all his deeds else he is reprehended. 11
The most evil-disposèd person that ever was
All the state of his life he would not let pass;
Some good deeds he will do, though they be but few.
The like things this tyrant Cambyses doth show.
No goodness from him to none is exhibited,
But still malediction abroad is distributed;
And yet ye shall see in the rest of his race
What infamy he will work against his own grace.
Whist! No more words! Here comes the King's
 brother. 20

Enter LORD SMERDIS
with ATTENDANCE *and* DILIGENCE.

 Smer. The King's brother by birth am I, issued from
 Cyrus' loins;
A grief to me it is to hear of this the King's repines. [2]
I like not well of those his deeds that he doth still
 frequent;
I wish to God that other ways his mind he could
 content.
Young I am, and next to him; no mo [3] of us there be.
I would be glad a quiet realm in this his reign to see.
 Att. My lord, your good and willing heart the gods
 will recompense,
In that your mind so pensive is for those his great
 offense.
My lord, his grace shall have a time to pair [4] and to
 amend.
Happy is he that can escape and not his grace offend.
 Dil. If that wicked vice he could refrain, from
 wasting wine forbear, 31
A moderate life he would frequent, amending this his
 square. [5]
 Amb. My lord, and if your honor it shall please,
I can inform you what is best for your ease:
Let him alone; of his deeds do not talk;
Then by his side ye may quietly walk.
After his death you shall be king;
Then may you reform each kind of thing.
In the meantime live quietly; do not with him deal;
So shall it redound much to your weal. 40
 Smer. Thou say'st true, my friend; that is the best.
I know not whether he love me or do me detest.
 Att. Lean from his company all that you may.
I, faithful Attendance, will your honor obey;

If against your honor he take any ire,
His grace is as like to kindle his fire
To your honor's destruction as otherwise.
　Dil. Therefore, my lord, take good advice,
And I, Diligence, your case will so tender
That to his grace your honor shall be none offender.
　Smer. I thank you both, entire friends.　51
With my honor still remain.
　Amb. Behold where the King doth come with his
　　train.

Enter KING *and a* LORD.

　King. O lording dear and brother mine, I joy your
　　state to see,
Surmising⁶ much what is the cause you absent thus
　from me.
　Smer. Pleaseth your grace, no absence I, but ready
　to fulfill,
At all assays, my prince and King, in that your grace
　me will.
What I can do in true defense to you, my prince, aright,
In readiness I always am to offer forth my might.
　King. And I the like to you again do here avouch the
　　same.
　All. For this your good agreement here, now praisèd
　　be God's name!　60
　Amb. [*To* SMERDIS.] But hear ye, noble prince;
　　hark in your ear:
It is best to do as I did declare.
　King. My lord and brother Smerdis, now this is my
　　mind and will:
That you to court of mine return and there to tarry still
Till my return within short space your honor for to
　greet.
　Smer. At your behest so will I do till time again we
　meet.
My leave I take from you, O King; even now I do
　depart.
Exeunt SMERDIS, ATTENDANCE, *and*
DILIGENCE.
　King. Farewell, lord and brother mine; farewell with
　all my heart.
My lord, my brother Smerdis is of youth and manly
　might,
And in his sweet and pleasant face my heart doth take
　delight.　70
　Lord. Yea, noble prince, if that your grace before
　his honor die,
He will succeed, a virtuous king, and rule with equity.
　King. As you have said, my lord, he is chief heir
　　next my grace,
And, if I die tomorrow, next he shall succeed my place.
　Amb. And, if it please your grace, O King, I heard
　him say,
For your death unto the God day and night he did
　pray;
He would live so virtuously and get him such a praise
That Fame by trump his due deserts in honor should
　upraise;
He said your grace deservèd had the cursing of all men,
That ye should never after him get any praise again.

　King. Did he speak thus of my grace in such
　　despiteful wise?　81
Or else dost thou presume to fill my princely ears with
　lies?
　Lord. I cannot think it in my heart that he would
　report so.
　King. How sayst thou? Speak the truth: was it so or
　no?
　Amb. I think so, if it please your grace, but I cannot
　tell.
　King. Thou play'st with both hands, now I perceive
　well.
But, for to put all doubts aside and to make him leese
　his hope,
He shall die by dint of sword or else by choking rope.
Shall he succed when I am gone, to have more praise
　than I?
Were he father, as brother mine, I swear that he shall
　die.　90
To palace mine I will therefore his death for to pursue.
　　　　　　　　　　Exit [KING *with the* LORD].
　Amb. Are ye gone? Straightway I will follow you—
[*To the audience*] How like ye now, my masters? Doth
　not this gear⁷ cotton?⁸
The proverb old is verified: "Soon ripe, and soon
　rotten."
He will not be quiet till his brother be killed;
His delight is wholly to have his blood spilled.
Marry, sir, I told him a notable lie.
If it were to do again, I durst [not] do it, I.
Marry when I had done, to it I durst not stand;　99
Thereby ye may perceive I use to play with each hand.
But how now, cousin Cutpurse, with whom play you?
Take heed, for his hand is groping even now.
Cousin, take heed, if you do secretly grope;
If ye be taken, cousin, ye must look through a rope.
　　　　　　　　　　　　　　　　　　　　　Exit.

[vii]

Enter LORD SMERDIS *alone.*

　[*Smer.*] I am wandering alone, here and there to
　walk;
The court is so unquiet, in it I take no joy.
Solitary to myself now I may talk.
If I could rule, I wist what to say.

Enter CRUELTY *and* MURDER *with bloody hands.*

　Cru. My coequal partner Murder, come away;
From me long thou mayst not stay.
　Mur. Yes, from thee I may stay, but not thou from
　me;
Therefore I have a prerogative above thee.
　Cru. But in this case we must together abide.
Come, come. Lord Smerdis I have spied.　10
Lay hands on him with all festination,¹
That on him we may work our indignation.

　　　　　　　　　　　　　　　　They seize him.

　⁶ *Surmising:* Suspecting.　⁷ *gear:* stuff.　⁸ *cotton:* work.
vii.
　¹ *festination:* haste.

Smer. How now, my friends? What have you to do
 with me?

Mur. King Cambyses hath sent us unto thee,
Commanding us straightly, without mercy or favor,
Upon thee to bestow our behavior,
With cruelty to murder you and make you away.

Smer. Yet pardon me, I heartily you pray.
Consider, the King is a tyrant tyrannious,
And all his doings be damnable and pernicious. 20
Favor me therefore; I did him never offend.

Cru. No favor at all! Your life is at an end.
Even now I strike, his body to wound.

<div align="right">Strike him in divers places.</div>

Behold, now his blood springs out on the ground.

<div align="right">A little bladder of vinegar pricked.</div>

Mur. Now he is dead, let us present him to the
 King.

Cru. Lay to your hand, away him to bring.

<div align="right">Exeunt.</div>

[viii]

<div align="center">Enter A<small>MBIDEXTER</small>.</div>

Amb. O the passion of God, yonder is a heavy
 court.
Some weeps, some wails, and some make great sport.
Lord Smerdis by Cruelty and Murder is slain;
But Jesus! for want of him how some do complain!
If I should have had a thousand pound I could not
 forbear weeping.
Now Jesus have his blessèd soul in keeping!
Ah, good Lord, to think on him, how it doth me
 grieve!
I cannot forbear weeping, ye may me believe.

<div align="right">Weep.</div>

O my heart, how my pulses do beat!
With sorrowful lamentations I am in such a heat. 10
Ah, my heart, how for him it doth sorrow!
Nay, I have done, in faith, now. And God give ye good
 morrow!
Ha, ha! Weep? Nay, laugh, with both hands to play!
The King through his cruelty hath made him away;
But hath not he wrought a most wicked deed
Because king after him he should not proceed,
His own natural brother, and having no more,
To procure his death by violence sore?
In spite, because his brother should never be king,
His heart, being wicked consented to this thing. 20
Now he hath no more brothers nor kindred alive.
If the King use this gear still, he cannot long thrive.

<div align="center">Enter H<small>OB</small> and L<small>OB</small>.</div>

Hob. God's hat, neighbor, come away; it's time to
 market to go.

Lob. God's vast,[1] neighbor, zay[2] ye zo?
The clock hath stricken vive, ich[3] think, by Lakin.[4]
Bum vay,[5] vrom sleep cham[6] not very well waken.
But neighbor Hob, neighbor Hob, what have ye to
 zell?

Hob. Bum troth, neighbor Lob, to you I chill[7] tell:
Chave two goslings and a chine of pork—
There is no vatter between this and York. 30
Chave a pot of strawberries and a calve's head;
A zennight[8] zince, tomorrow, it hath been dead.

Lob. Chave a score of eggs and of butter a pound:
Yesterday a nest of goodly young rabbits I vound;
Chave vorty things mo, of more and of less—
My brain is not very good them to express.
But, God's hat, neighbor, wot'st[9] what?

Hob. No, not well, neighbor; what's that?

Lob. Bum vay, neighbor, Master King is a zhrode[10]
 lad!
Zo God help me, and halidom,[11] I think the vool be
 mad. 40
Zome zay he deal cruelly: his brother he did kill,
And also a goodly young lad's heart-blood he did spill.

Hob. Vorbod of God,[12] neighbor! Has he played
 zuch a voolish deed?

Amb. Goodman Hob and Goodman Lob, God be
 your speed.
As you two towards market do walk,
Of the King's cruelty I did hear you talk.
I insure you he is a king most vile and pernicious;
His doings and life are odious and vicious.

Lob. It were a good deed zomebody would break his
 head. 49

Hob. Bum vay, neighbor Lob, I chuld he were dead!

Amb. So would I, Lob and Hob, with all my heart!—
[*To audience*] Now with both hands will you see me
 play my part.—
Ah, ye whoreson[13] traitorly knaves,
Hob and Lob, out upon you, slaves!

Lob. And thou call'st me knave, thou art another.
My name is Lob, and Hob my next neighbor.

Amb. Hob and Lob! Ah, ye country patches,[14]
Ah, ye fools, ye have made wrong matches.
Ye have spoken treason against the King's grace.
For it I will accuse ye before his face; 60
Then for the same ye shall be martyred.
At the least ye shall be hanged, drawn, and quartered.

Hob. O gentleman, ye shall have two pear-pies, and
 tell not of me.

Lob. By God, a vat goose chill give thee.
I think no hurt, by my vather's soul I zwear!

Hob. Chave lived well all my lifetime, my neighbors
 among.
And now chould be loath to come to zuch wrong—
To be hanged and quartered, the grief would be great.

Lob. A foul evil on thee, Hob! Who bid thee on it
 treat?
Vor it was thou that first did him name. 70

Hob. Thou liest like a varlet and thou zayst the zame.
It was zuch a foolish Lob as thou.

viii.
[1] *vast: v* = stage rustic dialect for *f*. [2] *zay: z = s.*
[3] *ich:* I. [4] *Lakin:* Ladykin, the Virgin.
[5] *Bum vay:* By my faith. [6] *cham:* I am.
[7] *chill:* will. [8] *zennight:* week.
[9] *wot'st:* do you know. [10] *zhrode:* shrewd.
[11] *halidom:* holiness. [12] *Vorbod . . . God:* God forbid.
[13] *whoreson:* scoundrelly. [14] *patches:* fools.

Lob. Speak many words, and, by Cod's nails I vow,
Upon thy pate my staff I will lay.
 Amb. [*Aside*] By the Mass, I will cause them to make
 a fray.—
Yea, Lob, thou sayst true: all came through him.
 Lob. Bum vay, thou Hob,[15] a little would make me
 ye trim.
Give thee a zwap on thy nose till thy heart ache.
 Hob. If thou darest, do it! Else, man, cry "creak!"[16]
I trust, before thou hurt me, 80
With my staff chill make a Lob of thee.

Here let them fight with their staves, not come near
another by three or four yards; the VICE *set them*
on as hard as he can; one of their wives come out,
and all-to[17] *beat the* VICE; *he run away.*

Enter MARIAN-MAY-BE-GOOD, *Hob's wife,*
running in with a broom, and part them.

 Mar. Oh the body of me! husband Hob, what mean
 ye to fight?
For the passion of God, no more blows smite.
Neighbors and friends so long, and now to fall out?
What! in your age to seem so stout?
If I had not parted ye, one had killed another.
 Lob. I had not cared, I swear by God's Mother.
 Mar. Shake hands again at the request of me;
As ye have been friends, so friends still be.
 Hob. Bum troth, cham content and zayst word,
 neighbor Lob. 90
 Lob. I am content; agreed, neighbor Hob.

 Shake hands and laugh heartily one at another.

 Mar. So, get you to market; no longer stay,
And with yonder knave let me make a fray.
 Hob. Content, wife Marian; chill do as thou dost
 say.
But buss me, ich pray thee, at going away.
 Exeunt HOB, LOB.
 Mar. Thou whoreson knave and prickeared boy, why
 didst thou let them fight?
If one had killed another here, couldst thou their deaths
 requite?
It bears a sign by this thy deed a cowardly knave thou
 art,
Else wouldst thou draw that weapon thine, like a man[18]
 them to part.
 Amb. What, Marian-May-Be-Good, are you come
 prattling? 100
Ye may hap get a box on the ear with your talking.
If they had killed one another, I had not cared a pease.

 Here let her swinge him in her broom; she gets him
 down, and he her down; thus one on the top of
 another make pastime.

 Mar. Ah, villain, myself on thee I must ease.
Give me a box on the ear? That will I try.
Who shall be master, thou shalt see by and by.
 Amb. Oh, no more, no more, I beseech you heartily.
Even now I yield, and give you the mast'ry.

 Run his way out while she is down.

 Mar. Ah, thou knave! dost thou throw me down and
 run thy[19] way?
If he were here again, oh, how I would him pay!
I will after him, and, if I can him meet, 110
With these my nails his face I will greet.

 [*Exit.*]

[ix]

Enter VENUS *leading out her son* CUPID, *blind.*
He must have a bow and two shafts, one headed with gold
and the other with lead.

 Ven. Come forth, my son. Unto my words attentive
 ears resign;
What I pretend[1] see you frequent to force this game of
 mine.
The King a kinswoman hath, adorned with beauty
 store;[2]
And I wish that Diana's gifts[3] they twain shall keep no
 more,
But use my silver sug'rèd game their joys for to
 augment.
When I do speak, to wound his heart, Cupid my son,
 consent,
And shoot at him the shaft of love that bears the head of
 gold,
To wound his heart in lover's wise, his grief for to
 unfold.
Though kin she be unto his grace, that nature me
 expel,
Against the course thereof he may in my game please
 me well. 10
Wherefore, my son, do not forget; forthwith pursue the
 deed.
 Cup. Mother, I mean for to obey as you have whole
 decreed;
But you must tell me, mother dear, when I shall arrow
 draw,
Else your request to be attained will not be worth a
 straw;
I am blind and cannot see, but still do shoot by guess.
The poets well, in places store, of my might do express.
 Ven. Cupid my son, when time shall serve that thou
 shalt do this deed,
Then warning I to thee will give; but see thou shoot
 with speed.

 Enter a LORD, *a* LADY, *and a* WAITING-MAID.

 1 Lord. Lady dear, to King akin, forthwith let us
 proceed
To trace abroad the beauty fields as erst we had
 decreed. 20
The blowing buds whose savory scents our sense will
 much delight,

[15] *Hob:* hod Q2. [16] *cry "creak":* give up.
[17] *all-to:* thoroughly. [18] *man:* knave Q2.
[19] *thy:* the Q2.

ix.
[1] *pretend:* intend. [2] *store:* abundant.
[3] *Diana's gifts:* chastity.

The sweet smell of musk white-rose to please the
 appetite,
The chirping birds whose pleasant tunes therein shall
 here record
That our great joy we shall it find in field to walk
 abroad,
On lute and cittern [4] there to play a heavenly harmony;
Our ears shall hear, heart to content, our sports to
 beautify.
 Lady. Unto your words, most comely lord myself
 submit do I;
To trace with you in field so green I mean not to deny.

 Here trace up and down, playing.

 Maid. And I, your waiting-maid, at hand with
 diligence will be,
For to fulfill with heart and hand when you shall
 command me. 30

 Enter KING, LORD, *and* KNIGHT.

 King. Come on, my lord and knight, abroad; our
 mirth let us employ.
Since he is dead, this heart of mine in corpse I feel it
 joy.
Should brother mine have reignèd king when I had
 yielded breath?
A thousand brothers I rather had to put them all to
 death.
But, O behold, where I do see a lord and lady fair.
For beauty she most worthy is to sit in prince's chair.
 Ven. Shoot forth, my son. Now is the time that thou
 must wound his heart.
 Cup. Content you, mother; I will do my part.

 Shoot there, and go out VENUS *and* CUPID.

 King. Of truth, my lord, in eye of mine all ladies she
 doth excel.
Can none report what dame she is, and to my grace it
 tell? 40
 Lord. Redoubted prince, pleaseth your grace, to you
 she is akin,
Cousin-german, [5] nigh of birth, by mother's side come
 in.
 Kni. And that her waiting-maiden is, attending her
 upon.
He is a lord of prince's court, and will be there anon.
They sport themselves in pleasant field, to former usèd
 use. [6]
 King. My lord and knight, of truth I speak. My
 heart it cannot choose
But with my lady I must speak and so express my
 mind—
My Lord and Ladies, walking there, if you will favor
 find,

 [4] *cittern:* guitar-like instrument.
 [5] *Cousin-german:* First cousin.
 [6] *former . . . use:* what they were wont to do.
 [7] *Titan:* one of the older gods, often identified poetically
with the sun.
 [8] *mind:* desire.

Present yourselves unto my grace and by my side come
 stand.
 1 Lord. We will fulfill, most mighty King, as your
 grace doth command. 50
 King. Lady dear, intelligence my grace hath got of
 late,
You issued out of mother's stock and kin unto my state.
According to rule of birth you are cousin-german
 mine;
Yet do I wish that farther off this kindred I could find;
For Cupid he, that eyeless boy, my heart hath so
 enflamed
With beauty, you me to content the like cannot be
 named;
For, since I entered in this place and on you fixed mine
 eyes,
Most burning fits about my heart in ample wise did
 rise.
The heat of them such force doth yield, my corpse they
 scorch, alas!
And burns the same with wasting heat as Titan [7] doth
 the grass. 60
And, sith this heat is kindled so and fresh in heart of
 me,
There is no way but of the same the quencher you must
 be.
My meaning is that beauty yours my heart with love
 doth wound;
To give me love mind [8] to content, my heart hath you
 out found;
And you are she must be my wife, else shall I end my
 days.
Consent to this, and be my queen, to wear the crown
 with praise.
 Lady. If it please your grace, O mighty King, you
 shall not this request.
It is a thing that nature's course doth utterly detest,
And high it would the God displease; of all, that is the
 worst.
To grant your grace to marry so, it is not I that durst.
Yet humble thanks I render now unto you, mighty
 King, 71
That you vouchsafe to great estate so gladly would me
 bring.
Were it not it were offense, I would it not deny,
But such great honor to achieve my heart I would apply.
Therefore, O King, with humble heart in this I pardon
 crave;
My answer is: in this request your mind ye may not
 have.
 King. May I not? Nay, then, I will, by all the gods I
 vow;
And I will marry thee as wife. This is mine answer now.
Who dare say nay what I pretend, who dare the same
 withstand,
Shall lose his head, and have report as traitor through
 my land. 80
There is no nay. I will you have, and you my queen
 shall be.
 Lady. Then, mighty King, I crave your grace to hear
 the words of me:

Your counsel take of lordings' wit; the laws aright
 peruse;
If I with safe may grant this deed, I will it not refuse.
 King. No, no! What I have said to you, I mean to
 have it so.
For counsel theirs I mean not, I, in this respect to go;
But to my palace let us go the marriage to prepare;
For to avoid [9] my will in this, I can it not forbear.
 Lady. Oh God forgive me, if I do amiss. The King
 by compulsion enforceth me this. 90
 Maid. Unto the gods for your estate I will not cease
 to pray
That you may be a happy queen and see most joyful
 day.
 King. Come on, my lords; with gladsome hearts let
 us rejoice with glee.
Your music show to joy this deed at the request of me.
 Both. For to obey your grace's words our honors do
 agree.
 Exeunt.

[x]

Enter AMBIDEXTER.

 Amb. Oh the passion of me! Marry, as ye say, yonder
 is a royal court.
There is triumphing and sport upon sport,
Such loyal lords, with such lordly exercise,
Frequenting such pastime as they can devise,
Running at tilt, jousting, with running at the ring,[1]
Masking and mumming with each kind of thing,
Such dancing, such singing, with musical harmony.
Believe me, I was loath to absent their company.
But will you believe? Jesu, what haste they made till
 they were married!
Not for a million of pounds one day longer they would
 have tarried. 10
O, there was a banquet royal and super-excellent!
Thousands and thousands at that banquet was spent.
I muse of nothing but how they can be married so soon.
I care not if I be married before tomorrow at noon,
If marriage be a thing that so may be had.
[*To a girl in the audience*] How say you, maid? To marry
 me will ye be glad?—
Out of doubt, I believe it is some excellent treasure;
Else to the same belongs abundant pleasure.
Yet with mine ears I have heard some say,
"That ever I was married, now cursèd be the day!" 20
Those be they [that][2] with curst[3] wives are matched.
That husband for hawk's meat[4] of[5] them is
 up-snatched,
Head broke with a bedstaff,[6] face all-to bescratched—
"Knave!" "Slave!" and "Villain!"—a coiled coat[7]
 now and then.
When the wife hath given it, she will say, "Alas, good
 man!"
Such were better unmarried, my masters, I trow,
Than all their life after be matchèd with a shrew.

Enter PREPARATION.

[*Prep.*] With speed I am sent all things to prepare,
My message to do as the King did declare.

His grace doth mean a banquet to make, 30
Meaning in this place repast for to take.
Well, the cloth shall be laid, and all things in readiness
To court to return when done is my business.
 Amb. A proper man and also fit
For the King's estate to prepare a banquet!
 Prep. What, Ambidexter? Thou art not unknown.
A mischief on all good faces, so that I curse not mine
 own!
Now, in the knave's name, shake hands with me.
 Amb. Well said, goodman pouch-mouth; your
 reverence I see.
I will teach ye, if your manners no better be. 40
Ah, ye slave, the King doth me a gentleman allow;
Therefore I look that to me ye should bow.

 Fight.

 Prep. Good Master Ambidexter, pardon my
 behavior;
For this your deeds you are a knave, for your labor.
 Amb. Why, ye stale counterly[8] villain, nothing but
 "knave"?

 Fight.

 Prep. I am sorry your mastership offended I have;
Shake hands, that between us agreement may be.
I was overshot with myself, I do see.
Let me have your help this furniture to provide.
The King from this place will not long abide. 50

 Set the fruit on the board.

 Amb. Content; it is the thing that I would wish.
I myself will go fetch one dish.

 Let the VICE *fetch a dish of nuts, and let them fall in*
 the bringing of them in.

 Prep. Cleanly, Master Ambidexter, for fair on the
 ground they lie.
 Amb. I will have them up again by and by,
 Prep. To see all in readiness I will put you in trust;
There is no nay, to the court needs I must.

 Exit PREPARATION.

 Amb. Have ye no doubt but all shall be well.—
Marry, sir, as you say, this gear doth excel.
All things is in a readiness, when they come hither,
The King's grace and the Queen both togither.— 60
[*To the audience*] I beseech ye, my masters, tell me, is it
 not best
That I be so bold as to bid a guest?
He is as honest a man as ever spurred cow—
My cousin Cutpurse, I mean; I beseech ye, judge you.
Believe me, cousin, if to be the King's guest ye could
 be taken,
I trust that offer will never be forsaken.

 [9] *avoid:* give up.

x.

 [1] *running . . . ring:* trying to catch a ring on the end of a
lance. [2] *that:* from Q2, not in Q1. [3] *curst:* shrewish.
 [4] *hawk's meat:* something snatched greedily. [5] *of:* by.
 [6] *bedstaff:* slat for mattress. [7] *coiled coat:* beating.
 [8] *counterly:* worthy of the Counter, debtors' prison
attached to a city court.

But, cousin, because to that office ye are not like to
 come,
Frequent your exercises—a horn [9] on your thumb,
A quick eye, a sharp knife, at hand a receiver. [10]
But then take heed, cousin, ye be a cleanly conveyor. 70
Content yourself, cousin; for this banquet you are unfit
When such as I at the same am unworthy to sit.

 Enter KING, QUEEN, *and his* TRAIN.

King. My Queen and lords, to take repast, let us
 attempt the same.
Here is the place; delay no time, but to our purpose
 frame.
 Que. With willing hearts your whole behest we mind
 for to obey.
 All. And we, the rest of prince's train, will do as you
 do say.

 Sit at the banquet.

King. Methink mine ears doth wish the sound of
 music's harmony;
Here, for to play before my grace, in place I would them
 spy.

 Play at the banquet.

Amb. They be at hand, sir, with stick and fiddle;
They can play a new dance, called "Hey-diddle-
 diddle." 80
 King. My Queen, perpend. [11] What I pronounce I
 will not violate,
But one thing which my heart makes glad I mind to
 explicate.
You know in court uptrainèd is a lion very young;
Of one litter two welps [12] beside, as yet not very strong.
I did request one whelp to see and this young lion fight,
But lion did the whelp convince by strength of force
 and might.
His brother whelp, perceiving that the lion was too
 good,
And he by force was like to see the other whelp his
 blood,
With force to lion he did run his brother for to help.
A wonder great it was to see that friendship in a whelp.
So then the whelps between them both the lion did
 convince, 91
Which thing to see before mine eyes did glad the heart
 of prince.

 At this tale told, let the QUEEN *weep.*

Que. These words to hear makes stilling tears issue
 from crystal eyes.
King. What dost thou mean, my spouse, to weep for
 loss of any prize?
Que. No, no, O King, but, as you see, friendship in
 brother's whelp;
When one was like to have repulse, the other yielded
 help.

And was this favor showed in dogs, to shame of royal
 King?
Alack, I wish these ears of mine had not once heard this
 thing.
Even so should you, O mighty King, to brother been a
 stay,
And not, without offense to you, in such wise him to
 slay. 100
In all assays it was your part his cause to have defended,
And whosoever had him misused to have them
 reprehended.
But faithful love was more in dog than it was in your
 grace.
 King. O cursed caitiff, vicious and vile, I hate thee in
 this place.
This banquet is at an end; take all these things away.
Before my face thou shalt repent the words that thou
 dost say.
O wretch most vile, didst thou the cause of brother
 mine so tender
The loss of him should grieve thy heart, he being none
 offender?
It did me good his death to have; so will it to have
 thine!
What friendship he had at my hands, the same even
 thou shalt find. 110
I give consent, and make a vow that thou shalt die the
 death.
By Cruel's sword and Murder fell even thou shalt lose
 thy breath.
Ambidexter, see with speed to Cruelty ye go;
Cause him hither to approach, Murder with him also.
 Amb. I ready am for to fulfill if that it be your grace's
 will.
 King. Then naught oblite [13] my message given;
 absent thyself away.
 Amb. Then in this place I will no longer stay.—
[*Aside to the* QUEEN] If that I durst, I would mourn
 your case;
But, alas, I dare not, for fear of his grace.
 Exit AMBIDEXTER.
 King. Thou cursèd jill, [14] by all the gods I take an
 oath and swear 120
That flesh of thine these hands of mine in pieces small
 could tear.
But thou shalt die by dint of sword; there is no friend
 ne fee [15]
Shall find remorse at prince's hand to save the life of
 thee.
 Que. O mighty King and husband mine, vouchsafe
 to hear me speak,
And license give to spouse of thine her patient mind to
 break.
For tender love unto your grace my words I did so
 frame;
For pure love doth heart of King me violate and
 blame.
And to your grace is this offense that I should purchase
 death?
Then cursèd time that I was Queen to shorten this my
 breath!

 [9] *horn:* thimble to facilitate cutting purse strings.
 [10] *receiver:* accomplice to whom stolen goods are passed.
 [11] *perpend:* listen. [12] *whelps:* dogs.
 [13] *oblite:* forget. [14] *jill:* wench. [15] *fee:* foe.

Your grace doth know by marriage true I am your wife
and spouse, 130
And one to save another's health at trothplight made
our vows.
Therefore, O King, let loving Queen at thy hand find
remorse;
Let pity be a mean to quench that cruel raging force,
And pardon, plight from prince's mouth, yield grace
unto your Queen,
That amity with faithful zeal may ever be us between.
 King. Ah, caitiff vile, to pity thee my heart it is not
bent;
Ne yet to pardon your offense it is not mine intent.
 1 Lord. Our mighty prince, with humble suit of your
grace this I crave,
That this request it may take place your favor for to
have. 139
Let mercy yet abundantly the life of Queen preserve
Sith she in most obedient wise your grace's will doth
serve.
As yet your grace but while with her hath had
cohabitation,
And sure this is no desert why to yield her
indignation.[16]
Therefore, O King, her life prolong to joy her days in
bliss!
 2 Lord. Your grace shall win immortal fame in
granting unto this.
She is a queen whose goodly hue excels the royal rose,
For beauty bright Dame Nature she a large gift did
dispose.
For comeliness who may compare? Of all she bears the
bell.[17]
This should give cause to move your grace to love her
very well.
Her silver breast in those your arms to sing the songs of
love,— 150
Fine qualities most excellent to be in her you prove;
A precious pearl of price to prince, a jewel passing all.
Therefore, O King, to beg remorse on both my knees I
fall;
To grant her grace to have her life, with heart I do
desire.
 King. You villains twain, with raging force ye set my
heart on fire.
If I consent that she shall die, how dare ye crave her
life?
You two to ask this at my hand doth much enlarge my
strife.
Were it not for shame, you two should die that for her
life do sue.
But favor mine from you is gone, my lords, I tell you
true.
I sent for Cruelty of late; if he would come away, 160
I would commit her to his hands his cruel part to play.
Even now I see where he doth come; it doth my heart
delight.

 Enter CRUELTY *and* MURDER.

 Cru. Come, Murder, come; let us go forth with
might;

Once again the King's commandment we must fulfill.
 Mur. I am contented[18] to do it with a good will.
 King. Murder and Cruelty, for both of you I sent
With all festination your offices to frequent.
Lay hold on the Queen; take her to your power,
And make her away within this hour.
Spare for no fear; I do you full permit. 170
So I from this place do mean for to flit.[19]
 Both. With courageous hearts, O King, we will
obey.
 King. Then come, my lords, let us depart away.
 Both L. With heavy hearts we will do all your Grace
doth say.
 Exeunt KING *and* LORD[S].
 Cru. Come, lady and Queen, now are you in our
handling;
In faith, with you we will use no dandling.
 Mur. With all expedition I, Murder, will take place;
Though thou be a queen, ye be under my grace.
 Que. With patience I will you both obey.
 Cru. No more words, but go with us away. 180
 Que. Yet before I die, some psalm to God let me
sing.
 Both. We be content to permit you that thing.
 Que. Farewell, you ladies of the court, with all your
masking hue.
I do forsake these broidered guards, and all the fashions
new,
The court and all the courtly train wherein I had
delight;
I banished am from happy sport, and all by spiteful
spite;
Yet with a joyful heart to God a psalm I mean to sing,
Forgiving all [men] and the King of each kind of thing.
 Sing, and exeunt.

 Enter AMBIDEXTER *weeping.*

 Amb. Ah, ah, ah, ah! I cannot choose but weep for
the Queen. 189
Nothing but mourning now at the court there is seen.
Oh, oh, my heart, my heart! Oh, my bum will break!
Very grief so torments me that scarce I can speak.
Who could but weep for the loss of such a lady?
That cannot I do, I swear by mine honesty.
But, Lord! so the ladies mourn, crying "Alack!"
Nothing is worn now but only black.
I believe all [the] cloth in Watling Street[21] to make
gowns would not serve.
If I make a lie, the devil let ye sterve![22]
All ladies mourn, both young and old;
There is not one that weareth a point's worth of gold.
There is a sort for fear for the King do pray 201
That would have him dead, by the Mass, I dare say.

[16] *indignation:* indignity.
[17] *bears . . . bell:* wins the prize.
[18] *contented:* contended Q2. [19] *flit:* go.
[20] *Sing:* The song is lost.
[21] *Watling Street:* principal London street of the drapers.
[22] *sterve:* die.

What a king was he that hath used such tyranny!
He was akin to Bishop Bonner,[23] I think verily.
For both their delights was to shed blood,
But never intended to do any good.
Cambyses put a judge to death. That was a good deed;
But to kill the young child was worse to proceed;
To murder his brother, and then his own wife—
So help me God and halidom, it is pity of his life! 210
Hear ye? I will lay twenty thousand pound
That the King himself doth die by some wound;
He hath shed so much blood that his will be shed.
If it come to pass, in faith, then he is sped.

Enter the KING, *without a gown,*
a sword thrust up into his side, bleeding.

King. Out, alas! What shall I do? My life is
 finishèd.
Wounded I am by sudden chance, my blood is
 minishèd.[24]
Gog's heart, what means might I make my life to
 preserve?
Is there naught to be my help, nor is there naught to
 serve?
Out upon the court and lords that there remain!
To help my grief in this my case will none of them take
 pain? 220
Who but I in such a wise his death's wound could have
 got?
As I on horseback up did leap, my sword from scabbard
 shot
And ran me thus into the side, as you right well may
 see.
A marvel's chance unfortunate that in this wise should
 be.
I feel myself a-dying now; of life bereft am I;
And Death hath caught me with his dart; for want of
 blood I spy.[25]
Thus, gasping, here on ground I lie; for nothing I do
 care.
A just reward for my misdeeds my death doth plain
 declare.

Here let him quake and stir.

Amb. How now, noble King? Pluck up your heart.
What, will you die, and from us depart? 230
Speak to me and ye be alive.
He cannot speak. But behold, how with Death he doth
 strive.

[*The* KING *dies.*]

Alas, good King! Alas, he is gone!
The devil take me if for him I make any moan.
I did prognosticate of his end, by the Mass.
Like as I did say, so is it come to pass.
I will be gone. If I should be found here,
That I should kill him it would appear.
For fear with his death they do me charge,
Farewell, my masters, I will go take barge. 240
I mean to be packing; now is the tide;
Farewell, my masters, I will no longer abide.

Exit AMBIDEXTER.

Enter three LORDS.

1 Lord. Behold, my Lord, it is even so as he to us did
 tell.
His Grace is dead, upon the ground, by dint of sword
 most fell.
2 Lord. As he in saddle would have leaped, his sword
 from sheath did go,
Goring him up into the side. His life was ended so.
3 Lord. His blood so fast did issue out that naught
 could him prolong;
Yet, before he yielded up the ghost, his heart was very
 strong.
1 Lord. A just reward for his misdeeds the God above
 hath wrought,
For certainly the life he led was to be counted naught.[26]
2 Lord. Yet a princely burial he shall have, according
 to his estate; 251
And more of him here at this time we have not to dilate.
3 Lord. My lords, let us take him up and carry him
 away.
Both. Content we are with one accord to do as you
 do say.

Exeunt all.

EPILOGUE

Right gentle audience, here have you perused
 The tragical history of this wicked King.
According to our duty, we have not refused,
 But to our best intent expressed everything.
 We trust none is offended for this our doing.
Our author craves likewise, if he have squared[1] amiss,
By gentle admonition to know where the fault is.

[23] *Bishop Bonner:* Bishop of London 1540–59, notorious
for persecution of Protestants in reign of Queen Mary.
[24] *minishèd:* diminished. [25] *spy:* expire(?).
[26] *naught:* worthless, evil.

EPILOGUE
[1] *squared:* built.

His good will shall not be neglected to amend the same.
 Praying all to bear, therefore, with this simple deed
Until the time serve a better he may frame; 10
 Thus yielding you thanks, to end we decreed
 That you so gently have suffered us to proceed,
In such patient wise as to hear and see,
We can but thank ye therefor; we can do no more, we.

As duty binds us, for our noble Queen let us pray,
 And for her honorable council, the truth that they
 may use,
To practice justice and defend her grace each day;
 To maintain God's word they may not refuse,
 To correct all those that would her grace and grace's
 laws abuse;
Beseeching God over us she may reign long, 20
To be guided by truth and defended from wrong.

AMEN, QUOD[2] THOMAS PRESTON.

[2] *Quod:* Saith.

Thomas Sackville

[1536–1608]

Thomas Norton

[1532–1584]

GORBODUC, OR FERREX AND PORREX

THE AUTHORS of GORBODUC were fellow members of the Inner Temple, one of the law schools and guildhalls for legal professionals that were to furnish not only holiday occasions for amateur theatricals but also a comfortable environment for many a later dramatist in the period and an audience that loved theater (A. W. Green's *The Inns of Court and Early English Drama* is a fascinating account of the extraordinary literary life of these establishments, which extends from Chaucer to Dickens). Both men were relatively young, Norton having been born in 1532 and Sackville in 1536, and both showed the classics-oriented, humanistic bent encouraged by the curriculum of the Inns. But here the similarity ends, and remarkably so. For Thomas Norton was a Puritan, son-in-law to Cranmer, translator of Calvin, and parliamentarian, whereas Sackville, of higher birth, was to become Lord Buckhurst, treasurer to both Elizabeth and James, chancellor of Oxford University, and ultimately Earl of Dorset; his commitment was thus royalist, and an opposition between his antiparliamentarian views and Norton's hostility to absolute monarchy has been noted in GORBODUC itself by at least one scholar as successive scenes espouse conflicting positions. Eighty years later a civil war would divide England along precisely these lines of class, religion, and political philosophy. Of the two authors, Sackville had the more authentic literary credentials; his most famous nondramatic work is his contribution to the 1559 edition of *A Mirror for Magistrates*, particularly the evocative *Induction*. The title page of GORBODUC claims that three acts (the first three) are Norton's and the rest Sackville's, but not all critics have agreed that the division was so cut and dried.

GORBODUC was written for the 1561–62 Christmas festivities at the Inner Temple. On January 18, 1562, it was performed at Whitehall before Queen Elizabeth, who was doubtless curious to hear its treatment of a subject that had implications—not entirely accidental—for her administration of the realm. Landmark though it is in the history of English drama, the play was probably not performed again in its own period. It was first printed in 1565 in an unauthorized version (Q1), still valuable for its preservation of some lines (V.i, see footnotes) later excised. This edition was followed by an authorized version (Q2) in 1570, scrupulously followed in the present text, and once more by a derivative text (Q3) in 1590. The tragedy was called GORBODUC in its first edition, FERREX AND PORREX in its second, and modern editors give it both titles.

The play is famous for having introduced to the drama the blank verse that Surrey had adapted from an Italian meter only a few years before; and, indeed, discovering for English drama a medium as dignified, flexible, and natural to its language as Greek hexameter had been for classical literature would be ample cause to celebrate the play. To a modern reader the verse seems hopelessly overstructured, with its ceaseless endstopping and its symmetries of syntax and sound; but for a contemporary audience hearing for the first time a dramatic speech without rhyme it was essential to demonstrate clearly that the verse was still verse: artificial, useful for rhetorical ornament, a medium for elevated diction. But blank verse is only one of the contributions GORBODUC made to English drama. Though Sidney would mock its naïveté and its ignoring of the classical unities, the play is nevertheless a sophisticated and self-conscious attempt at native classical drama. Some of the devices the educated audience would have identified with classical origins are the carefully structured orations, the Nuntius and Chorus with their respective narratives and odes, names like Eubulus and Philander, allusions to gods and other mythological material, the five acts, and the occasional stichomythia. Yet for all that GORBODUC draws much from native roots: the symbolic dumb shows, unlike the Italian *intermezzi* they imitate, are integrated into the play's thematic unity as subplot elements had been in the morality and mystery traditions; crucial scenes consist of debates influenced by medieval art; and the unity of time is abandoned as irrelevant. The authors' refusal to bring the play to a neat end in which beneficent order is reestablished is an interesting foretaste of what will happen in much later tragedy. Above all, the play is interested in English politics, and it treats its materials—drawn from chronicle recensions of a story in Geoffrey of Monmouth's *Histories of the Kings of Britain*—with the homiletic intensity of the moralities. Whether the tragedy derives its manner more from the plays of Seneca, not yet published in England, or from an English literary tradition influenced by Virgil and other classical authors is still a matter of academic debate. N. R.

Gorboduc, or Ferrex and Porrex

THE P[RINTER] TO THE READER

WHERE this tragedy was for furniture[1] of part of the grand Christmas in the Inner Temple first written about nine years ago by the right honorable Thomas, now Lord Buckhurst, and by T. Norton, and after showed before her Majesty, and never intended by the authors thereof to be published; yet one W. G.,[2] getting a copy thereof at some young man's hand that lacked a little money and much discretion, in the last great plague, an[no] 1565, about five years past, while the said Lord was out of England, and T. Norton far out of [10] London, and neither of them both made privy, put it forth exceedingly corrupted—even as if by means of a broker,[3] for hire, he should have enticed into his house a fair maid and done her villainy, and after all-to-be-scratched[4] her face, torn her apparel, berayed[5] and disfigured her, and then thrust her out of doors dishonested.[6] In such plight, after long wandering, she came at length home to the sight of her friends, who scant knew her but by a few tokens and marks remaining. They, the authors I mean, though they were very much [20] displeased that she so ran abroad without leave, whereby she caught her shame, as many wantons do, yet seeing the case, as it is, remediless, have for common honesty and shamefastness new appareled, trimmed, and attired her in such form as she was before. In which better form since she hath come to me, I have harbored her for her friends' sake and her own, and I do not doubt her parents, the authors, will not now be discontent that she go abroad among you good readers, so it be in honest company. For she is by my encourage- [30] ment and others' somewhat less ashamed of the dishonesty done to her because it was by fraud and force. If she be welcome among you and gently entertained, in favor of the house from whence she is descended and of her own nature courteously disposed to offend no man, her friends will thank you for it. If not, but that she shall be still reproached with her former mishap or quarreled at by envious persons, she, poor gentlewoman, will surely play Lucrece's[7] part and of herself die for shame, and I shall wish that she had tarried still [40] at home with me, where she was welcome; for she did never put me to more charge, but this one poor black gown lined with white that I have now given her to go abroad among you withal.

THE ARGUMENT OF THE TRAGEDY

GORBODUC, King of Britain, divided his realm in his lifetime to his sons, Ferrex and Porrex. The sons fell to dissension. The younger killed the elder. The mother, that more dearly loved the elder, for revenge killed the younger. The people, moved with the cruelty of the fact,[1] rose in rebellion and slew both father and mother. The nobility assembled and most terribly destroyed the rebels. And afterwards, for want of issue of the Prince, whereby the succession of the crown became uncertain, they fell to civil war, in which both they and many [10] of their issues were slain, and the land for a long time almost desolate and miserably wasted.

DRAMATIS PERSONÆ

GORBODUC, *King of Great Britain*
VIDENA, *Queen and wife to King Gorboduc*
FERREX, *elder son to King Gorboduc*
PORREX, *younger son to King Gorboduc*
CLOTYN, *Duke of Cornwall*
FERGUS, *Duke of Albany*[1]
MANDUD, *Duke of Logris*[1]
GWENARD, *Duke of Camberland*[1]
EUBULUS, *Secretary*[2] *to the King*
AROSTUS, *a counselor to the King*
DORDAN, *a counselor assigned by the King to his eldest son, Ferrex*
PHILANDER, *a counselor assigned by the King to his youngest son, Porrex; both being of the old King's council before*

THE P[RINTER] TO THE READER
[1] *furniture:* embellishment.
[2] *W. G.:* William Gifford, printer of the first quarto.
[3] *broker:* pander.
[4] *all-to-bescratched:* scratched thoroughly and all over.
[5] *berayed:* disfigured, made filthy.
[6] *dishonested:* dishonored.
[7] *Lucrece's:* Lucrece was a young Roman woman who committed suicide after being raped by Tarquin, son of the King.
THE ARGUMENT
[1] *fact:* evil deed or crime (the most common sense of the word in the sixteenth and seventeenth centuries).
DRAMATIS PERSONÆ
[1] *Albany . . . Logris . . . Camberland:* Scotland, England, and Wales, supposed to have derived their names from the three sons of the legendary Brutus, great-grandson of Aeneas and founder of Britain. [2] *Secretary:* Confidential advisor.

HERMON, *a parasite³ remaining with Ferrex*
TYNDAR, *a parasite remaining with Porrex*
NUNTIUS, *a messenger of the elder brother's death*

NUNTIUS, *a messenger of Duke Fergus' rising in arms*
MARCELLA, *a lady of the Queen's privy-chamber*
CHORUS, *four ancient and sage men of Britain*

ACT ONE

The Order of the Dumb Show Before the First Act,
and the Signification Thereof

FIRST the music of violins began to play, during which
came in upon the stage six wild men clothed in leaves,
of whom the first bare in his neck a fagot of small sticks,
which they all, both severally and together, assayed with
all their strengths to break; but it could not be broken
by them. At the length, one of them plucked out one of
the sticks and brake it; and the rest, plucking out all the
other sticks one after another, did easily break them,
the same being severed; which being conjoined, they
had before attempted in vain. After they had this 10
done, they departed the stage, and the music ceased.
Hereby was signified that a state knit in unity doth con-
tinue strong against all force, but being divided is easily
destroyed; as befell upon King Gorboduc dividing his
land to his two sons, which he before held in monarchy,
and upon the dissension of the brethren to whom it was
divided.

I.i

[*Enter*] VIDENA [*and*] FERREX.

Vid. The silent night, that brings the quiet pause
From painful travails of the weary day,
Prolongs my careful¹ thoughts, and makes me blame
The slow Aurore,² that so, for love or shame,
Doth long delay to show her blushing face;
And now the day renews my griefful plaint.
 Fer. My gracious lady and my mother dear,
Pardon my grief for your so grievèd mind
To ask what cause tormenteth so your heart.
 Vid. So great a wrong and so unjust despite,³ 10
Without all cause against all course of kind!⁴
 Fer. Such causeless wrong and so unjust despite
May have redress or, at the least, revenge.

Vid. Neither, my son; such is the froward⁵ will,
The person such, such my mishap and thine.
 Fer. Mine know I none, but grief for your distress.
 Vid. Yes, mine for thine, my son. A father? No,
In kind a father, not in kindliness.
 Fer. My father? Why? I know nothing at all 20
Wherein I have misdone unto his grace.
 Vid. Therefore the more unkind to thee and me.
For knowing well, my son, the tender love
That I have ever borne and bear to thee,
He, grieved thereat, is not content alone
To spoil⁶ me of thy sight, my chiefest joy,
But thee of thy birthright and heritage,
Causeless, unkindly, and in wrongful wise,
Against all law and right, he will bereave.⁷
Half of his kingdom he will give away.
 Fer. To whom?
 Vid. Even to Porrex, his younger son, 30
Whose growing pride I do so sore suspect
That, being raised to equal rule with thee,
Methinks I see his envious heart to swell,
Filled with disdain and with ambitious hope.
The end the gods do know, whose altars I
Full oft have made in vain of cattle slain
To send the sacred smoke to Heaven's throne
For thee, my son, if things do so succeed,
As now my jealous⁸ mind misdeemeth⁹ sore.
 Fer. Madam, leave care and careful plaint for me.
Just hath my father been to every wight.¹⁰ 41
His first unjustice he will not extend
To me, I trust, that give no cause thereof.
My brother's pride shall hurt himself, not me.
 Vid. So grant the gods! But yet thy father so
Hath firmly fixèd his unmovèd mind
That plaints and prayers can no whit avail;
For those have I assayed,¹¹ but even this day
He will endeavor to procure assent
Of all his council to his fond¹² device.¹³ 50
 Fer. Their ancestors from race¹⁴ to race have borne
True faith to my forefathers and their seed;
I trust they eke¹⁵ will bear the like to me.
 Vid. There resteth all. But if they fail thereof,
And if the end bring forth an ill success,¹⁶
On them and theirs the mischief shall befall.
And so I pray the gods requite it them.
And so they will, for so is wont to be.
When lords and trusted rulers under kings,
To please the present fancy of the prince, 60
With wrong transpose the course of governance,
Murders, mischief, or civil sword at length,
Or mutual treason or a just revenge,
When right succeeding line returns again,
By Jove's just judgment and deservèd wrath,

³ *parasite*: one who eats at the table or at the expense of
another, often by means of flattery.

I.i.
 ¹ *careful*: full of care.
 ² *Aurore*: Aurora, goddess of the dawn.
 ³ *despite*: outrage.
 ⁴ *kind*: nature (note plays on this meaning and the modern
sense elsewhere throughout the play).
 ⁵ *froward*: perverse, difficult to deal with.
 ⁶ *spoil*: despoil. ⁷ *bereave*: deprive.
 ⁸ *jealous*: vigilant.
 ⁹ *misdeemeth*: foresees with apprehension.
 ¹⁰ *wight*: man. ¹¹ *assayed*: tried.
 ¹² *fond*: foolish. ¹³ *device*: plan. ¹⁴ *race*: generation.
 ¹⁵ *eke*: also. ¹⁶ *success*: outcome.

Brings them to cruel and reproachful death
And roots their names and kindreds from the earth.
 Fer. Mother, content you, you shall see the end.
 Vid. The end? Thy end, I fear! Jove end me first.
 [*Exeunt.*]

I.ii

[*Enter*] GORBODUC, AROSTUS, PHILANDER,
 [*and*] EUBULUS.

 Gorb. My lords, whose grave advice and faithful aid
Have long upheld my honor and my realm
And brought me to this age from tender years,
Guiding so great estate with great renown,
Now more importeth me [1] than erst [2] to use
Your faith and wisdom, whereby yet I reign;
That, when by death my life and rule shall cease,
The kingdom yet may with unbroken course
Have certain prince, by whose undoubted right
Your wealth and peace may stand in quiet stay, [3] 10
And eke that they, whom nature hath prepared
In time to take my place in princely seat,
While in their father's time their pliant youth
Yields to the frame of skillful governance,
May so be taught and trained in noble arts,
As what their fathers, which have reigned before,
Have with great fame derivèd [4] down to them,
With honor they may leave unto their seed;
And not be thought, for their unworthy life,
And for their lawless swerving out of kind, 20
Worthy to lose what law and kind them gave;
But that they may preserve the common peace,
The cause that first began and still maintains
The lineal course of kings' inheritance,
For me, for mine, for you, and for the state
Whereof both I and you have charge and care.
Thus do I mean to use your wonted faith
To me and mine and to your native land.
My lords, be plain without all wry [5] respect
Or poisonous craft to speak in pleasing wise, [6] 30
Lest as the blame of ill-succeeding things
Shall light on you, so light the harms also.
 Aros. Your good acceptance so, most noble King,
Of such our faithfulness as heretofore
We have employed in duties to your grace
And to this realm, whose worthy head you are,
Well proves that neither you mistrust at all,
Nor we shall need in boasting wise to show
Our truth to you, nor yet our wakeful care
For you, for yours, and for our native land. 40
Wherefore, O King, I speak as one for all,
Sith [7] all as one do bear you egal [8] faith:
Doubt not to use our counsels and our aids,
Whose honors, goods, and lives are whole avowed
To serve, to aid, and to defend your grace.
 Gorb. My lords, I thank you all. This is the case:
Ye know, the gods, who have the sovereign care
For kings, for kingdoms, and for common weals, [9]
Gave me two sons in my more lusty age
Who now in my decaying years are grown 50
Well towards riper state of mind and strength

To take in hand some greater princely charge.
As yet they live and spend their hopeful days
With me and with their [10] mother here in court.
Their age now asketh other place and trade,
And mine also doth ask another change:
Theirs to more travail, mine to greater ease.
When fatal death shall end my mortal life,
My purpose is to leave unto them twain
The realm divided in two sundry parts. 60
The one Ferrex, mine elder son, shall have;
The other shall the younger, Porrex, rule.
That both my purpose may more firmly stand
And eke that they may better rule their charge,
I mean forthwith to place them in the same,
That in my life they may both learn to rule
And I may joy to see their ruling well.
This is, in sum, what I would have ye weigh:
First, whether ye allow [11] my whole device,
And think it good for me, for them, for you, 70
And for our country, mother of us all.
And if ye like it and allow it well,
Then, for their guiding and their governance,
Show forth such means of circumstance
As ye think meet to be both known and kept.
Lo, this is all; now tell me your advice.
 Aros. And this is much and asketh great advice.
But for my part, my sovereign lord and King,
This do I think: your majesty doth know
How under you, in justice and in peace, 80
Great wealth and honor long we have enjoyed,
So as we cannot seem with greedy minds
To wish for change of prince or governance.
But if we like your purpose and device,
Our liking must be deemèd to proceed
Of rightful reason and of heedful care,
Not for ourselves, but for the common state,
Sith our own state doth need no better change.
I think in all as erst your grace hath said.
First, when you shall unload your agèd mind 90
Of heavy care and troubles manifold
And lay the same upon my lords, your sons,
Whose growing years may bear the burden long—
And long I pray the gods to grant it so—,
And in your life, while you shall so behold
Their rule, their virtues, and their noble deeds,
Such as their kind behighteth [12] to us all,
Great be the profits that shall grow thereof.
Your age in quiet shall the longer last;
Your lasting age shall be their longer stay. [13] 100
For cares of kings that rule as you have ruled,
For public wealth [14] and not for private joy,
Do waste man's life and hasten crookèd age,

I.ii
 [1] *more . . . me:* it is more important to me.
 [2] *erst:* before. [3] *stay:* condition.
 [4] *derivèd:* handed down.
 [5] *wry:* marked by perversion, unfairness, or injustice.
 [6] *wise:* manner. [7] *Sith:* Since. [8] *egal:* equal.
 [9] *weals:* welfares. [10] *their:* Q1, Q3; not in Q2.
 [11] *allow:* approve of. [12] *behighteth:* promises.
 [13] *stay:* prop. [14] *wealth:* well-being.

With furrowed face and with enfeebled limbs,
To draw on creeping death a swifter pace.
They two, yet young, shall bear the parted reign
With greater ease than one, now old, alone,
Can wield the whole, for whom much harder is
With lessened strength the double weight to bear.
Your eye, your counsel, and the grave regard 110
Of father, yea, of such a father's name,
Now at beginning of their sundered reign,
When is the hazard of their whole success,
Shall bridle so their force of youthful heats
And so restrain the rage of insolence,
Which most assails the young and noble minds,
And so shall guide and train in tempered stay
Their yet green bending wits with reverent awe.
As—now inured with virtues at the first—
Custom, O King, shall bring delightfulness; 120
By use of virtue, vice shall grow in hate.
But if you so dispose it that the day
Which ends your life shall first begin their reign,
Great is the peril what will be the end,
When such beginning of such liberties,
Void of such stays as in your life do lie,
Shall leave them free to randon [15] of their will,
An open prey to traitorous flattery,
The greatest pestilence of noble youth;
Which peril shall be past, if in your life 130
Their tempered youth with agèd father's awe
Be brought in ure [16] of skillful stayèdness. [17]
And in your life, their lives disposèd so
Shall length your noble life in joyfulness.
Thus think I that your grace hath wisely thought
And that your tender care of common weal
Hath bred this thought, so to divide your land
And plant your sons to bear the present rule
While you yet live to see their ruling well,
That you may longer live by joy therein. 140
What further means behooveful are and meet
At greater leisure may your grace devise,
When all have said, and when we be agreed
If this be best, to part the realm in twain
And place your sons in present government;
Whereof, as I have plainly said my mind,
So would I hear the rest of all my lords.
 Phil. In part I think as hath been said before;
In part, again, my mind is otherwise.
As for dividing of this realm in twain 150
And lotting out the same in egal parts
To either of my lords, your grace's sons,
That think I best for this your realm's behoof,
For profit and advancement of your sons,
And for your comfort and you honor eke.
But so to place them while your life do last,
To yield to them your royal governance,
To be above them only in the name
Of father, not in kingly state also,

I think not good for you, for them, nor us. 160
This kingdom, since the bloody civil field
Where Morgan slain did yield his conquered part
Unto his cousin's sword in Camberland,
Containeth all that whilom [18] did suffice
Three noble sons of your forefather Brute;
So your two sons it may suffice also,
The moe [19] the stronger, if they 'gree in one.
The smaller compass that the realm doth hold,
The easier is the sway thereof to weld, [20]
The nearer justice to the wrongèd poor, 170
The smaller charge, and yet enough for one.
And when the region is divided so
That brethren be the lords of either part,
Such strength doth nature knit between them both,
In sundry bodies by conjoinèd love,
That, not as two, but one of doubled force,
Each is to other as a sure defense.
The nobleness and glory of the one
Doth sharp the courage of the other's mind
With virtuous envy to contend for praise. 180
And such an egalness hath nature made
Between the brethren of one father's seed
As an unkindly wrong it seems to be
To throw the brother subject under feet
Of him whose peer he is by course of kind.
And nature, that did make this egalness,
Oft so repineth at so great a wrong
That oft she raiseth up a grudging grief
In younger brethren at the elder's state,
Whereby both towns and kingdoms have been razed,
And famous stocks of royal blood destroyed. 191
The brother, that should be the brother's aid
And have a wakeful care for his defense,
Gapes for his death and blames the lingering years
That draw not forth his end with faster course;
And oft, impatient of so long delays,
With hateful slaughter he prevents [21] the fates
And heaps a just reward for brother's blood
With endless vengeance on his stock for aye.
Such mischiefs here are wisely met withal, 200
If egal state may nourish egal love,
Where none hath cause to grudge at other's good.
But now the head to stoop beneath them both,
Ne [22] kind, ne reason, ne good order bears.
And oft it hath been seen where nature's course
Hath been perverted in disordered wise,
When fathers cease to know that they should rule,
The children cease to know they should obey.
And often overkindly tenderness
Is mother of unkindly stubbornness. 210
I speak not this in envy or reproach,
As if I grudged the glory of your sons,
Whose honor I beseech the gods increase;
Nor yet as if I thought there did remain
So filthy cankers in their noble breasts,
Whom I esteem—which is their greatest praise—
Undoubted children of so good a king.
Only I mean to show, by certain rules
Which kind hath graft within the mind of man,
That nature hath her order and her course, 220

[15] *randon:* rove. [16] *ure:* use.
[17] *stayedness:* firmness. [18] *whilom:* formerly.
[19] *moe:* more. [20] *weld:* wield, govern.
[21] *prevents:* anticipates. [22] *Ne:* Neither, nor.

Which, bring broken, doth corrupt the state
Of minds and things, even in the best of all.
My lords, your sons, may learn to rule of you:
Your own example in your noble court
Is fittest guider of their youthful years.
If you desire to see some present joy
By sight of their well ruling in your life,
See them obey; so shall you see them rule.
Whoso obeyeth not with humbleness
Will rule with outrage and with insolence. 230
Long may they rule I do beseech the gods;
But long may they learn ere they begin to rule.
If kind and fates would suffer,[23] I would wish
Them agèd princes and immortal kings.
Wherefore, most noble King, I well assent
Between your sons that you divide your realm;
And as in kind, so match them in degree.
But while the gods prolong your royal life,
Prolong your reign; for thereto live you here,
And therefore have the gods so long forborne 240
To join you to themselves that still you might
Be prince and father of our common weal.
They, when they see your children ripe to rule,
Will make them room and will remove you hence,
That yours, in right ensuing of your life,
May rightly honor your immortal name.
 Eub. Your wonted true regard of faithful hearts
Makes me, O King, the bolder to presume
To speak what I conceive within my breast,
Although the same do not agree at all 250
With that which other here my lords have said,
Nor which yourself have seemèd best to like.
Pardon I crave, and that my words be deemed
To flow from hearty zeal unto your grace
And to the safety of your common weal.
To part your realm unto my lords, your sons,
I think not good for you, ne yet for them,
But worst of all for this our native land.
Within one land one single rule is best.
Divided reigns do make divided hearts, 260
But peace preserves the country and the prince.
Such is in man the greedy mind to reign,
So great is his desire to climb aloft,
In worldly stage the stateliest parts to bear,
That faith and justice and all kindly love
Do yield unto desire of sovereignty,
Where egal state doth raise an egal hope
To win the thing that either would attain.
Your grace rememb'reth how in passèd years
The mighty Brute, first prince of all this land, 270
Possessed the same and ruled it well in one.
He, thinking that the compass[24] did suffice
For his three sons three kingdoms eke to make,
Cut it in three, as you would now in twain.
But how much British blood hath since been spilt
To join again the sundered unity,
What princes slain before their timely hour,
What waste of towns and people in the land,
What treasons heaped on murders and on spoils,
Whose just revenge even yet is scarcely ceased; 280
Ruthful remembrance is yet raw in mind.

The gods forbid the like to chance again.
And you, O King, give not the cause thereof.
My lord Ferrex, your elder son, perhaps,
Whom kind and custom gives a rightful hope
To be your heir and to succeed your reign,
Shall think that he doth suffer greater wrong
Than he perchance will bear, if power serve.
Porrex, the younger, so upraised in state,
Perhaps in courage will be raised also. 290
If flattery then, which fails not to assail
The tender minds of yet unskillful[25] youth,
In one shall kindle and increase disdain,
And envy in the other's heart inflame,
This fire shall waste their love, their lives, their land,
And ruthful ruin shall destroy them both.
I wish not this, O King, so to befall,
But fear the thing that I do most abhor.
Give no beginning to so dreadful end.
Keep them in order and obedience, 300
And let them both by now obeying you
Learn such behavior as beseems[26] their state:
The elder, mildness in his governance,
The younger, a yielding contentedness.
And keep them near unto your presence still
That they, restrainèd by the awe of you,
May live in compass of well tempered stay
And pass the perils of their youthful years.
Your agèd life draws on to feebler time,
Wherein you shall less able be to bear 310
The travails that in youth you have sustained,
Both in your person's and your realm's defense.
If, planting now your sons in further parts,
You send them further from your present reach,
Less shall you know how they themselves demean.
Traitorous corrupters of their pliant youth
Shall have, unspied, a much more free access;
And if ambition and inflamed disdain
Shall arm the one, the other, or them both,
To civil war or to usurping pride, 320
Late shall you rue that you ne recked[27] before.
Good is, I grant, of all to hope the best,
But not to live still[28] dreadless of the worst.
So trust the one that the other be foreseen.
Arm not unskillfulness with princely power.
But you, that long have wisely ruled the reins
Of royalty within your noble realm,
So hold them, while the gods for our avails[29]
Shall stretch the thread of your prolongèd days.
Too soon he clamb[30] into the flaming car 330
Whose want of skill did set the earth on fire.[31]
Time and example of your noble grace
Shall teach your sons both to obey and rule.
When time hath taught them, time shall make them
 place,

[23] *suffer:* permit. [24] *compass:* extent.
[25] *unskillful:* lacking in knowledge.
[26] *beseems:* is appropriate to. [27] *recked:* heeded.
[28] *still:* always. [29] *avails:* profit.
[30] *clamb:* climbed.
[31] *Too . . . fire:* Apollo's son Phaëthon borrowed his father's sun-chariot and scorched the earth.

The place that now is full; and so I pray
Long it remain, to comfort of us all.
 Gorb. I take your faithful hearts in thankful part.
But sith I see no cause to draw my mind
To fear the nature of my loving sons,
Or to misdeem that envy or disdain 340
Can there work hate where nature planteth love,
In one self purpose do I still abide.
My love extendeth egally to both;
My land sufficeth for them both also.
Humber shall part the marches [32] of their realms.
The southern part the elder shall possess;
The northern shall Porrex, the younger, rule.
In quiet I will pass mine agèd days,
Free from the travail and the painful cares
That hasten age upon the worthiest kings. 350
But, lest the fraud that ye do seem to fear
Of flattering tongues corrupt their tender youth
And writhe [33] them to the ways of youthful lust,
To climbing pride, or to revenging hate,
To neglecting of their careful charge,
Lewdly [34] to live in wanton recklessness,
Or to oppressing of the rightful cause,
Or not to wreak [35] the wrongs done to the poor,
To tread down truth or favor false deceit,
I mean to join to either of my sons 360
Some one of those whose long approvèd faith
And wisdom tried may well assure my heart
That mining [36] fraud shall find no way to creep
Into their fencèd [37] ears with grave advice.
This is the end, and so I pray you all
To bear my sons the love and loyalty
That I have found within your faithful breasts.
 Aros. You, nor your sons, our sovereign lord, shall
 want [38]
Our faith and service while our lives do last.
 [*Exeunt.*]
 Chor. When settled stay doth hold the royal throne
 In steadfast place, by known and doubtless right,
And chiefly when descent on one alone 372
 Makes single and unparted reign to light,
Each change of course unjoints the whole estate
 And yields it thrall to ruin by debate. [39]

The strength that, knit by fast accord in one
 Against all foreign power of mighty foes,
Could of itself defend itself alone,
 Disjoinèd once, the former force doth lose.
The sticks that sundered brake so soon in twain 380
 In fagot bound attempted were in vain.

<div>

[32] *marches:* borders. [33] *writhe:* twist.
[34] *Lewdly:* Basely. [35] *wreak:* avenge.
[36] *mining:* undermining. [37] *fencèd ears:* ears defended.
[38] *want:* lack. [39] *debate:* strife. [40] *partial:* biased.

THE DUMB SHOW
 [1] *brave:* splendidly dressed.
 [2] *lusty:* pleasing in appearance, lively.
 [3] *boweth:* bends, submits.
 [4] *destroyeth:* Q1; *destroyed:* Q2.

II.i.
 [1] *reave me:* rob me of.

</div>

Oft tender mind that leads the partial [40] eye
 Of erring parents in their children's love
Destroys the wrongly lovèd child thereby.
 This doth the proud son of Apollo prove
Who, rashly set in chariot of his sire,
 Inflamed the parchèd earth with heaven's fire.

And this great king, that doth divide his land
 And change the course of his descending crown
And yields the reign into his children's hand, 390
 From blissful state of joy and great renown,
A mirror shall become to princes all
 To learn to shun the cause of such a fall.

ACT TWO

The Order and Signification of the Dumb Show Before the Second Act

FIRST, the music of cornets began to play, during which
came in upon the stage a king accompanied with a num-
ber of his nobility and gentlemen. And after he had
placed himself in a chair of estate prepared for him,
there came and kneeled before him a grave and aged
gentleman and offered up a cup unto him of wine in a
glass, which the King refused. After him comes a brave [1]
and lusty [2] young gentleman and presents the King with
a cup of gold filled with poison, which the King accept-
ed, and, drinking the same, immediately fell down 10
dead upon the stage, and so was carried thence away by
his lords and gentlemen, and then the music ceased.
Hereby was signified, that as glass by nature holdeth no
poison, but is clear and may easily be seen through, ne
boweth [3] by any art, so a faithful counselor holdeth no
treason, but is plain and open, ne yieldeth to any undis-
creet affection, but giveth wholesome counsel, which
the ill-advised prince refuseth. The delightful gold filled
with poison betokeneth flattery, which under fair seem-
ing of pleasant words beareth deadly poison, which 20
destroyeth [4] the prince that receiveth it. As befell in the
two brethren, Ferrex and Porrex, who, refusing the
wholesome advice of grave counselors, credited these
young parasites and brought to themselves death and
destruction thereby.

II.i

[Enter] FERREX, HERMON, *[and]* DORDAN.

 Fer. I marvel much what reason led the King,
My father, thus, without all my desert,
To reave me [1] half the kingdom which by course
Of law and nature should remain to me.
 Her. If you with stubborn and untamèd pride
Had stood against him in rebelling wise,
Or if with grudging mind you had envied
So slow a sliding of his agèd years,
Or sought before your time to haste the course
Of fatal death upon his royal head, 10
Or stained your stock with murder of your kin,

Some face of reason might perhaps have seemed
To yield some likely cause to spoil ye thus.
 Fer. The wreakful[2] gods pour on my cursèd head
Eternal plagues and never-dying woes;
The hellish prince[3] adjudge my damnèd ghost
To Tantale's thirst, or proud Ixion's wheel,[4]
Or cruel gripe[5] to gnaw my growing heart,
To during[6] torments and unquenchèd flames,
If ever I conceived so foul a thought, 20
To wish his end of life or yet of reign.
 Dor. Ne yet your father, O most noble prince,
Did ever think so foul a thing of you.
For he, with more than father's tender love,
While yet the Fates do lend him life to rule
(Who long might live to see your ruling well),
To you, my lord, and to his other son,
Lo, he resigns his realm and royalty;
Which never would so wise a prince have done
If he had once misdeemed that in your heart 30
There ever lodgèd so unkind a thought.
But tender love, my lord, and settled trust
Of your good nature and your noble mind
Made him to place you thus in royal throne,
And now to give you half his realm to guide;
Yea, and that half which in abounding store
Of things that serve to make a wealthy realm,
In stately cities and in fruitful soil,
In temperate breathing of the milder heaven,
In things of needful use which friendly sea 40
Transports by traffic from the foreign parts,
In flowing wealth, in honor, and in force,
Doth pass[7] the double value of the part
That Porrex hath allotted to his reign.
Such is your case, such is your father's love.
 Fer. Ah love, my friends? Love wrongs not whom
 he loves.
 Dor. Ne yet he wrongeth you that giveth you
So large a reign ere that the course of time
Bring you to kingdom by descended right,
Which time perhaps might end your time before. 50
 Fer. Is this no wrong, say you, to reave from me
My native right of half so great a realm?
And thus to match his younger son with me
In egal power and in as great degree?
Yea, and what son? The son whose swelling pride
Would never yield one point of reverence
When I, the elder and apparent heir,
Stood in the likelihood to possess the whole;
Yea, and that son which from his childish age
Envieth mine honor and doth hate my life. 60
What will he now do, when his pride, his rage,
The mindful malice of his grudging heart
Is armed with force, with wealth, and kingly state?
 Her. Was this not wrong, yea, ill-advisèd wrong,
To give so mad a man so sharp a sword,
To so great peril of so great mishap,
Wide open thus to set so large a way?
 Dor. Alas, my lord, what griefful thing is this,
That of your brother you can think so ill?
I never saw him utter likely sign 70
Whereby a man might see or once misdeem

Such hate of you, ne such unyielding pride.
Ill is their counsel, shameful be their end,
That raising such mistrustful fear in you,
Sowing the seed of such unkindly hate,
Travail by treason to destroy you both.
Wise is your brother and of noble hope,
Worthy to wield a large and mighty realm.
So much a stronger friend have you thereby,
Whose strength is your strength if you gree[8] in one. 80
 Her. If nature and the gods had pinchèd so
Their flowing bounty and their noble gifts
Of princely qualities from you, my lord,
And poured them all at once in wasteful wise
Upon your father's younger son alone,
Perhaps there be that in your prejudice[9]
Would say that birth should yield to worthiness.
But sith in each good gift and princely art
Ye are his match, and in the chief of all,
In mildness and in sober governance, 90
Ye far surmount, and sith there is in you
Sufficing skill and hopeful towardness
To weld the whole and match your elder's praise,
I see no cause why ye should lose the half,
Ne would I wish you yield to such a loss,
Lest your mild sufferance of so great a wrong
Be deemèd cowardish and simple dread,
Which shall give courage to the fiery head
Of your young brother to invade the whole.
While yet therefore sticks in the people's mind 100
The loathèd wrong of your disheritance;
And ere your brother have by settled power,
By guileful cloak of an alluring show,
Got him some force and favor in the realm;
And while the noble Queen, your mother, lives,
To work and practice[10] all for your avail;
Attempt redress by arms and wreak yourself
Upon his life that gaineth by your loss,
Who now, to shame of you and grief of us,
In your own kingdom triumphs over you. 110
Show now your courage meet for kingly state,
That they which have avowed[11] to spend their goods,
Their lands, their lives, and honors in your cause
May be the bolder to maintain your part,
When they do see that coward fear in you
Shall not betray ne fail[12] their faithful hearts.
If once the death of Porrex end the strife
And pay the price of his usurpèd reign,
Your mother shall persuade the angry King.
The lords, your friends, eke shall appease his rage. 120
For they be wise, and well they can foresee
That ere long time your agèd father's death

 [2] *wreakful:* vengeful. [3] *hellish prince:* Hades.
 [4] *Tantale's . . . wheel:* Tantalus was punished by eternal
longing for water and grapes that escaped his reach, Ixion by
being bound to a wheel of fire.
 [5] *gripe:* griffin, perhaps alluding to the punishment of
Tityus, whose liver was eternally gnawed by vultures.
 [6] *during:* enduring. [7] *pass:* surpass.
 [8] *gree:* agree, come to terms with one another.
 [9] *in . . . prejudice:* to your damage.
 [10] *practice:* scheme. [11] *avowed:* sworn.
 [12] *fail:* deceive (a rare sense).

Will bring a time when you shall well requite
Their friendly favor or their hateful spite,
Yea, or their slackness to advance your cause.
Wise men do not so hang on passing state
Of present princes, chiefly in their age,
But they will further cast their reaching eye,
To view and weigh the times and reigns to come.
Ne is it likely, though the King be wroth, 130
That he yet will, or that the realm will bear,
Extreme revenge upon his only son;
Or, if he would, what one is he that dare
Be minister to such an enterprise?
And here you be now placèd in your own
Amid your friends, your vassals, and your strength.
We shall defend and keep your person safe
Till either counsel turn his tender mind,
Or age or sorrow end his weary days.
But if the fear of gods and secret grudge [13] 140
Of nature's law, repining at the fact,
Withhold your courage from so great attempt,
Know ye that lust of kingdoms hath no law.
The gods do bear and well allow in kings
The thinges [14] they abhor in rascal routs. [15]
When kings on slender quarrels run to wars,
And then in cruel and unkindly wise
Command thefts, rapes, murders of innocents,
The spoil of towns, ruins of mighty realms;
Think you such princes do suppose themselves 150
Subject to laws of kind and fear of gods?
Murders and violent thefts in private men
Are heinous crimes and full of foul reproach;
Yet none offense, but decked with glorious name
Of noble conquests in the hands of kings.
But if you like not yet so hot devise
Ne list to take such vantage of the time,
But, though with peril of your own estate,
You will not be the first that shall invade,
Assemble yet your force for your defense 160
And for your safety stand upon your guard.
 Dor. O heaven! Was there ever heard or known
So wicked counsel to a noble prince?
Let me, my lord, disclose unto your grace
This heinous tale, what mischief it contains:
Your father's death, your brother's, and your own,
Your present murder and eternal shame.
Hear me, O King, and suffer not to sink
So high a treason in your princely breast.
 Fer. The mighty gods forbid that ever I 170
Should once conceive such mischief in my heart.
Although my brother hath bereft my realm
And bear perhaps to me an hateful mind,
Shall I revenge it with his death therefore?
Or shall I so destroy my father's life
That gave me life? The gods forbid, I say.
Cease you to speak so any more to me,
Ne you, my friend, with answer once repeat
So foul a tale. In silence let it die.

What lord or subject shall have hope at all 180
That under me they safely shall enjoy
Their goods, their honors, lands, and liberties,
With whom neither one only brother dear,
Ne father dearer, could enjoy their lives?
But, sith I fear my younger brother's rage,
And sith, perhaps, some other man may give
Some like advice, to move his grudging head
At mine estate—which counsel may perchance
Take greater force with him than this with me—
I will in secret so prepare myself, 190
As [16] if his malice or his lust to reign
Break forth in arms or sudden violence,
I may withstand his rage and keep mine own.
 [*Exeunt* FERREX *and* HERMON.]
 Dor. I fear the fatal time now draweth on
When civil hate shall end the noble line
Of famous Brute and of his royal seed.
Great Jove, defend [17] the mischiefs now at hand!
O that the secretary's wise advice
Had erst been heard when he besought the King
Not to divide his land, nor send his sons 200
To further parts from presence of his court,
Ne yet to yield to them his governance.
Lo, such are they now in the royal throne
As was rash Phaëthon in Phoebus' car;
Ne then the fiery steeds did draw the flame
With wilder randon [18] through the kindled skies
Than traitorous counsel now will whirl about
The youthful heads of these unskillful kings.
But I hereof their father will inform;
The reverence of him perhaps shall stay 210
The growing mischiefs while they yet are green.
If this help not, then woe unto themselves,
The prince, the people, the divided land.
 [*Exit.*]

II.ii

[*Enter*] PORREX, TYNDAR, [*and*] PHILANDER.

 Por. And is it thus? And doth he so prepare
Against his brother as his mortal foe?
And now, while yet his agèd father lives?
Neither regards he him nor fears he me?
War would he have? And he shall have it so!
 Tyn. I saw, myself, the great preparèd store
Of horse, of armor, and of weapon there;
Ne bring I to my lord reported tales
Without the ground of seen and searchèd truth.
Lo, secret quarrels run about his court 10
To bring the name of you, my lord, in hate.
Each man almost can now debate the cause
And ask a reason of so great a wrong,
Why he, so noble and so wise a prince,
Is, as unworthy, reft his heritage,
And why the King, misled by crafty means,
Divided thus his land from course of right.
The wiser sort hold down their grieeful heads;
Each man withdraws from talk and company
Of those that have been known to favor you. 20

[13] *grudge:* misgiving, scruple. [14] *thinges:* disyllabic.
[15] *rascal routs:* companies of rabble. [16] *As:* So that.
[17] *defend:* prevent. [18] *randon:* random course.

To hide the mischief of their meaning there,
Rumors are spread of your preparing here.
The rascal numbers of unskillful sort
Are filled with monstrous tales of you and yours.
In secret I was counseled by my friends
To haste me thence, and brought you, as you know,
Letters from those that both can truly tell
And would not write unless they knew it well.
 Phil. My lord, yet ere you move unkindly war,
Send to your brother to demand the cause. 30
Perhaps some traitorous tales have filled his ears
With false reports against your noble grace;
Which, once disclosed, shall end the growing strife
That else, not stayed with wise foresight in time,
Shall hazard both your kingdoms and your lives.
Send to your father eke; he shall appease
Your kindled minds and rid you of this fear.
 Por. Rid me of fear! I fear him not at all,
Ne will to him ne to my father send.
If danger were for one to tarry there, 40
Think ye it safety to return again?
In mischiefs, such as Ferrex now intends,
The wonted courteous laws to messengers
Are not observed, which in just war they use.
Shall I so hazard any one of mine?
Shall I betray my trusty friends to him,
That have disclosed his treason unto me?
Let him entreat that fears; I fear him not.
Or shall I to the King, my father, send?
Yea, and send now, while such a mother lives 50
That loves my brother, and that hateth me?
Shall I give leisure, by my fond[1] delays,
To Ferrex to oppress[2] me all unware?
I will not; but I will invade his realm
And seek the traitor prince within his court.
Mischief for mischief is a due reward.
His wretched head shall pay the worthy price
Of this his treason and his hate to me.
Shall I abide and treat[3] and send and pray
And hold my yielden[4] throat to traitor's knife, 60
While I, with valiant mind and conquering force,
Might rid myself of foes and win a realm?
Yet rather, when I have the wretch's head,
Then to the King, my father, will I send.
The bootless case[5] may yet appease his wrath;
If not, I will defend me as I may.
 [*Exeunt* PORREX *and* TYNDAR.]
 Phil. Lo, here the end of these two youthful kings,
The father's death, the ruin of their realms!
O most unhappy state of counselors,
That light on so unhappy lords and times 70
That neither can their good advice be heard,
Yet must they bear the blames of ill success.
But I will to the King, their father, haste
Ere this mischief come to the likely end;
That, if the mindful wrath of wreakful gods
(Since mighty Ilion's[6] fall not yet appeased
With these poor remnants of the Trojan name)
Have not determined by unmovèd fate
Out of this realm to raze the British line;
By good advice, by awe of father's name, 80

By force of wiser lords, this kindled hate
May yet be quenched ere it consume us all.
 [*Exit.*]
 Chor. When youth, not bridled with a guiding stay,
 Is left to randon of their own delight
And welds whole realms by force of sovereign sway,
 Great is the danger of unmastered might,
Lest skilless rage throw down with headlong fall
Their lands, their states, their lives, themselves and all.

When growing pride doth fill the swelling breast,
 And greedy lust[7] doth raise the climbing mind, 90
Oh, hardly may the peril be repressed.
 Ne fear of angry gods, ne lawes[8] kind,
Ne country's care can fired hearts restrain
When force hath armèd envy and disdain.

When kings of foreset[9] will neglect the rede[10]
 Of best advice and yield to pleasing tales
That do their fancies' noisome humor feed,
 Ne reason nor regard of right avails.
Succeeding heaps of plagues shall teach too late
To learn the mischiefs of misguided state. 100

Foul fall the traitor false that undermines
 The love of brethren to destroy them both.
Woe to the prince that pliant ear inclines
 And yields his mind to poisonous tale that floweth
From flattering mouth! And woe to wretched land
That wastes itself with civil sword in hand!
 Lo, thus it is, poison in gold to take,
And wholesome drink in homely cup forsake.

ACT THREE

*The Order and Signification of the Dumb Show
Before the Third Act*

FIRST, the music of flutes began to play, during which
came in upon the stage a company of mourners, all clad
in black, betokening death and sorrow to ensue upon the
ill-advised misgovernment and dissension of brethren,
as befell upon the murder of Ferrex by his younger
brother. After the mourners had passed thrice about the
stage, they departed, and then the music ceased.

III.i

[*Enter*] GORBODUC, EUBULUS, [*and*] AROSTUS.

 Gorb. O cruel Fates, O mindful wrath of gods,
Whose vengeance neither Simois'[1] stainèd streams
Flowing with blood of Trojan princes slain,

II.ii.
 [1] *fond:* foolish. [2] *oppress:* overpower.
 [3] *treat:* entreat. [4] *yielden:* yielded.
 [5] *bootless case:* pointless suit. [6] *Ilion's:* Troy's.
 [7] *lust:* ambition. [8] *lawes:* disyllabic.
 [9] *of foreset:* on purpose. [10] *rede:* advice.
III.i.
 [1] *Simois':* of a river in the Trojan plain.

Nor Phrygian[2] fields, made rank with corpses dead
Of Asian kings and lords, can yet appease;
Ne slaughter of unhappy Priam's[3] race,
Nor Ilion's fall, made level with the soil,
Can yet suffice; but still continued rage
Pursues our lives and from the farthest seas
Doth chase the issues of destroyèd Troy. 10
O no man happy till his end be seen.
If any flowing wealth and seeming joy
In present years might make a happy wight,
Happy was Hecuba,[4] the woeful'st wretch
That ever lived to make a mirror of;
And happy Priam with his noble sons;
And happy I till now, alas, I see
And feel my most unhappy wretchedness.
Behold, my lords, read ye this letter here;
Lo, it contains the ruin of our realm 20
If timely speed provide not hasty help.
Yet, O ye gods, if ever woeful king
Might move ye, kings of kings, wreak it on me
And on my sons, not on this guiltless realm.
Send down your wasting flames from wrathful skies
To reave me and my sons the hateful breath.
Read, read, my lords; this is the matter why
I called ye now to have your good advice.

The letter from DORDAN, *the counselor of the*
elder prince.
EUBULUS *readeth the letter.*

[*Eub.*] "My sovereign lord, what I am loath to write,
But loathest am to see, that I am forced 30
By letters now to make you understand.
My lord Ferrex, your eldest son, misled
By traitorous fraud of young untempered wits,
Assembleth force against your younger son,
Ne can my counsel yet withdraw the heat
And furious pangs of his inflamèd head.
Disdain, saith he, of his disheritance
Arms him to wreak the great pretended[5] wrong
With civil sword upon his brother's life.
If present help do not restrain this rage, 40
This flame will waste your sons, your land, and you.
 Your majesty's faithful and most
 humble subject, Dordan."
Aros. O King, appease your grief and stay your plaint.
Great is the matter and a woeful case,
But timely knowledge may bring timely help.
Send for them both unto your presence here;
The reverence of your honor, age, and state,
Your grave advice, the awe of father's name
Shall quickly knit again this broken peace. 50
And if in either of my lords, your sons,
Be such untamèd and unyielding pride
As will not bend unto your noble hests;[6]

If Ferrex, the elder son, can bear no peer,
Or Porrex, not content, aspires to more
Than you him gave above his native right,
Join with the juster side; so shall you force
Them to agree and hold the land in stay.
 Eub. What meaneth this? Lo, yonder comes in haste
Philander from my lord your younger son. 60

 [*Enter* PHILANDER.]

 Gorb. The gods send joyful news!
 Phil. The mighty Jove
Preserve your majesty, O noble King.
 Gorb. Philander, welcome; but how doth my son?
 Phil. Your son, sir, lives, and healthy I him left.
But yet, O King, the want of lustful health
Could not be half so griefful to your grace
As these most wretched tidings that I bring.
 Gorb. O heavens, yet more? No end of woes to me?
 Phil. Tyndar, O King, came lately from the court
Of Ferrex to my lord your younger son 70
And made report of great preparèd store
For war, and saith that it is wholly meant
Against Porrex, for high disdain that he
Lives now a king and egal in degree
With him that claimeth to succeed the whole,
As by due title of descending right.
Porrex is now so set on flaming fire,
Partly with kindled rage of cruel wrath,
Partly with hope to gain a realm thereby,
That he in haste prepareth to invade 80
His brother's land, and with unkindly war
Threatens the murder of your elder son;
Ne could I him persuade that first he should
Send to his brother to demand the cause,
Nor yet to you to stay this hateful strife.
Wherefore, sith there no more I can be heard,
I come myself now to inform your grace
And to beseech you, as you love the life
And safety of your children and your realm,
Now to employ your wisdom and your force 90
To stay this mischief ere it be too late.
 Gorb. Are they in arms? Would he not send to me?
Is this the honor of a father's name?
In vain we travail to assuage their minds,
As if their hearts, whom neither brother's love,
Nor father's awe, nor kingdom's cares can move,
Our counsels could withdraw from raging heat.
Jove slay them both and end the cursèd line!
For though perhaps fear of such mighty force
As I, my lords, joined with your noble aids, 100
May yet raise, shall repress their present heat,
The secret grudge and malice will remain.
The fire not quenched, but kept in close restraint,
Fed still within, breaks forth with double flame.
Their death and mine must pease[7] the angry gods.
 Phil. Yield not, O King, so much to weak despair.
Your sons yet live, and long I trust they shall.
If Fates had taken you from earthly life
Before beginning of this civil strife,
Perhaps your sons in their unmastered youth, 110
Loose from regard of any living wight,

 [2] *Phrygian:* of a country comprising part of the central plateau and the western flank of Asia Minor, near Troy.
 [3] *Priam's:* Priam was King of Troy.
 [4] *Hecuba:* wife of Priam, grieving mother of Hector and many other slain sons.
 [5] *pretended:* intended. [6] *hests:* behests.
 [7] *pease:* appease.

Would run on headlong with unbridled race
To their own death and ruin of this realm.
But sith the gods, that have the care for kings,
Of things and times, dispose the order so
That in your life this kindled flame breaks forth,
While yet your life, your wisdom, and your power
May stay the growing mischief and repress
The fiery blaze of their enkindled heat,
It seems, and so ye ought to deem thereof, 120
That loving Jove hath tempered so the time
Of this debate to happen in your days
That you yet living may the same appease
And add it to the glory of your latter age;
And they, your sons, may learn to live in peace.
Beware, O King, the greatest harm of all,
Lest by your wailful plaints your hastened death
Yield larger room unto their growing rage.
Preserve your life, the only hope of stay.
And if your highness herein list to use 130
Wisdom or force, counsel or knightly aid,
Lo, we, our persons, powers, and lives are yours.
Use us till death, O King; we are your own.
 Eub. Lo, here the peril that was erst foreseen
When you, O King, did first divide your land
And yield your present reign unto your sons.
But now, O noble prince, now is no time
To wail and plain and waste your woeful life.
Now is the time for present good advice.
Sorrow doth dark the judgment of the wit. 140
The heart unbroken and the courage free
From feeble faintness of bootless despair
Doth either rise to safety or renown
By noble valor of unvanquished mind,
Or yet doth perish in more happy sort.
Your grace may send to either of your sons
Some one both wise and noble personage
Which, with good counsel and with weighty name
Of father, shall present before their eyes
Your hest, your life, your safety, and their own, 150
The present mischief of their deadly strife.
And in the while, assemble you the force
Which your commandment and the speedy haste
Of all my lords here present can prepare.
The terror of your mighty power shall stay
The rage of both, or yet of one at least.

[*Enter* NUNTIUS.]

 Nunt. O King, the greatest grief that ever prince did
 hear,
That ever woeful messenger did tell,
That ever wretched land hath seen before,
I bring to you. Porrex, your younger son,
With sudden force invaded hath the land 160
That you to Ferrex did allot to rule;
And with his own most bloody hand he hath
His brother slain and doth possess his realm.
 Gorb. O heavens, send down the flames of your
 revenge!
Destroy, I say, with flash of wreakful fire
The traitor son and then the wretched sire!

But let us go, that yet perhaps I may
Die with revenge and pease the hateful gods.

 [*Exeunt.*]
 Chor. The lust of kingdom knows no sacred faith,
 No rule of reason, no regard of right, 171
No kindly love, no fear of heaven's wrath;
 But with contempt of gods and man's despite,
Through bloody slaughter doth prepare the ways
 To fatal scepter and accursèd reign.
The son so loathes the father's lingering days,
 Ne dreads his hand in brother's blood to stain.

O wretched prince, ne dost thou yet record
 The yet fresh murders done within the land
Of thy forefathers, when the cruel sword 180
 Bereft Morgan his life with cousin's hand?
Thus fatal plagues pursue the guilty race,
 Whose murderous hand, imbrued with guiltless
 blood,
Asks vengeance still before the heaven's face
 With endless mischiefs on the cursèd brood.

The wicked child thus brings to woeful sire
 The mournful plaints to waste his very life.
Thus do the cruel flames of civil fire
 Destroy the parted reign with hateful strife. 189
And hence doth spring the well from which doth flow
 The dead black streams of mourning, plaints, and
 woe.

ACT FOUR

*The Order and Signification of the Dumb Show
Before the Fourth Act*

FIRST, the music of hautboys[1] began to play, during
which there came from under the stage, as though out of
hell, three Furies,[2] Alecto, Megaera, and Tisiphone,
clad in black garments sprinkled with blood and flames,
their bodies girt with snakes, their heads spread with
serpents instead of hair, the one bearing in her hand a
snake, the other a whip, and the third a burning fire-
brand, each driving before them a king and a queen
which, moved by Furies, unnaturally had slain their
own children. The names of the kings and queens 10
were these: Tantalus, Medea, Athamas, Ino, Cambyses,
Althea. After that the Furies and these had passed about
the stage thrice, they departed, and then the music ceas-
ed. Hereby was signified the unnatural murders to fol-
low; that is to say, Porrex slain by his own mother, and
of King Gorboduc and Queen Videna, killed by their
own subjects.

IV.i

[*Enter*] VIDENA.

 Vid. Why should I live and linger forth my time,
In longer life to double my distress?

THE DUMB SHOW
 [1] *hautboys:* high-pitched double-reed instrument, similar
to modern oboe. [2] *Furies:* avenging deities.

Oh me, most woeful wight, whom no mishap
Long ere this day could have bereavèd hence.
Mought [1] not these hands, by fortune or by fate,
Have pierced this breast and life with iron reft?
Or in this palace here, where I so long
Have spent my days, could not that happy hour
Once, once have happed in which these hugy frames
With death by fall might have oppressèd me? 10
Or should not this most hard and cruel soil,
So oft where I have pressed my wretched steps,
Sometime had ruth of mine accursèd life
To rend in twain and swallow me therein?
So had my bones possessèd now in peace
Their happy grave within the closèd ground,
And greedy worms had gnawn this pinèd [2] heart
Without my feeling pain; so should not now
This living breast remain the ruthful tomb,
Wherein my heart, yelden [3] to death, is graved; [4] 20
Nor dreary thoughts, with pangs of pining grief,
My doleful mind had not afflicted thus.
O my beloved son! O my sweet child!
My dear Ferrex, my joy, my life's delight!
Is my belovèd son, is my sweet child,
My dear Ferrex, my joy, my life's delight,
Murdered with cruel death? O hateful wretch!
O heinous traitor both to heaven and earth!
Thou, Porrex, thou this damnèd deed hast wrought;
Thou, Porrex, thou shalt dearly bye [5] the same. 30
Traitor to kin and kind, to sire and me,
To thine own flesh, and traitor to thyself,
The gods on thee in hell shall wreak their wrath,
And here in earth this hand shall take revenge
On thee, Porrex, thou false and caitiff [6] wight.
If after blood so eager were thy thirst,
And murderous mind had so possessèd thee,
If such hard heart of rock and stony flint
Lived in thy breast that nothing else could like [7]
Thy cruel tyrant's thought but death and blood, 40
Wild savage beasts, mought not their slaughter serve
To feed thy greedy will, and in the midst
Of their entrails to stain thy deadly hands
With blood deserved and drink thereof thy fill?
Or if naught else but death and blood of man
Mought please thy lust, could none in Britain land,
Whose heart betorn out of his panting breast
With thine own hand, or work what death thou wouldst.
Suffice to make a sacrifice to pease
That deadly mind and murderous thought in thee, 50
But he who in the selfsame womb was wrapped,
Where thou in dismal hour receivèdst life?
Or if needs, needs thy hand must slaughter make,

Moughtest thou not have reached a mortal wound,
And with thy sword have pierced this cursèd womb
That the accursèd Porrex brought to light,
And given me a just reward therefor?
So Ferrex yet sweet life mought have enjoyed,
And to his agèd father comfort brought
With some young son in whom they both might live. 60
But whereunto waste I this ruthful speech,
To thee that hast thy brother's blood thus shed?
Shall I still think that from this womb thou sprung?
That I thee bare? Or take thee for my son?
No, traitor, no; I thee refuse for mine!
Murderer, I thee renounce; thou art not mine.
Never, O wretch, this womb conceivèd thee,
Nor never bode [8] I painful throes for thee.
Changeling [9] to me thou art, and not my child,
Nor to no wight that spark of pity knew. 70
Ruthless, unkind, monster of nature's work,
Thou never sucked the milk of woman's breast,
But from thy birth the cruel tiger's teats
Have nursèd thee; nor yet of flesh and blood
Formed is thy heart, but of hard iron wrought;
And wild and desert woods bred thee to life.
But canst thou hope to 'scape my just revenge,
Or that these hands will not be wroke [10] on thee?
Dost thou not know that Ferrex' mother lives,
That lovèd him more dearly than herself? 80
And doth she live, and is not venged on thee?

 [*Exit.*]

IV.ii

[*Enter*] GORBODUC [*and*] AROSTUS.

Gorb. We marvel much whereto this lingering stay
Falls out so long. Porrex unto our court,
By order of our letters, is returned;
And Eubulus received from us by hest, [1]
At his arrival here, to give him charge
Before our presence straight to make repair,
And yet we have no word whereof he stays.
Aros. Lo, where he comes, and Eubulus with him.

[*Enter* EUBULUS *and* PORREX.]

Eub. According to your highness' hest to me,
Here have I Porrex brought, even in such sort [2] 10
As from his wearied horse he did alight,
For that your grace did will such haste therein.
Gorb. We like and praise this speedy will in you,
To work the thing that to your charge we gave.
Porrex, if we so far should swerve from kind
And from those bounds which law of nature sets
As thou hast done by vile and wretched deed
In cruel murder of thy brother's life,
Our present hand could stay no longer time,
But straight should bathe this blade in blood of thee 20
As just revenge of thy detested crime.
No; we should not offend the law of kind
If now this sword of ours did slay thee here;
For thou hast murdered him, whose heinous death
Even nature's force doth move us to revenge

IV.i.
 [1] *Mought:* Might. [2] *pinèd:* wasted by suffering.
 [3] *yelden:* surrendered. [4] *graved:* buried.
 [5] *bye:* pay for. [6] *caitiff:* vile, contemptible.
 [7] *like:* please. [8] *bode:* endured.
 [9] *Changeling:* Infant substituted for another shortly after
birth.
 [10] *wroke:* revenged.

IV.ii.
 [1] *by hest:* by command (may be a misprint for "behest").
 [2] *sort:* condition.

By blood again; and justice forceth us
To measure, death for death, thy due desert.
Yet sithens³ thou art our child, and sith as yet
In this hard case what word thou canst allege
For thy defense by us hath not been heard, 30
We are content to stay our will for that
Which justice bids us presently to work,
And give thee leave to use thy speech at full,
If aught thou have to lay for thine excuse.
 Por. Neither, O King, I can or will deny
But that this hand from Ferrex life hath reft;
Which fact how much my doleful heart doth wail,
Oh, would it mought as full appear to sight
As inward grief doth pour it forth to me.
So yet, perhaps, if ever ruthful heart, 40
Melting in tears within a manly breast,
Through deep repentance of his bloody fact,
If ever grief, if ever woeful man
Might move regret with sorrow of his fault,
I think the torment of my mournful case,
Known to your grace as I do feel the same,
Would force even Wrath herself to pity me.
But as the water troubled with the mud
Shows not the face which else the eye should see,
Even so your ireful mind with stirrèd thought 50
Cannot so perfectly discern my cause.
But this unhap,⁴ amongst so many heaps,
I must content me with, most wretched man,
That to myself I must reserve my woe
In pining thoughts of mine accursèd fact,
Since I may not show here my smallest grief
Such as it is and as my breast endures,
Which I esteem the greatest misery
Of all mishaps that fortune now can send.
Not that I rest in hope with plaint and tears 60
To purchase life; for to the gods I clepe⁵
For true record of this my faithful speech;
Never this heart shall have the thoughtful dread
To die the death that by your grace's doom,⁶
By just desert, shall be pronounced to me;
Nor never shall this tongue once spend the speech
Pardon to crave or seek by suit to live.
I mean not this as though I were not touched
With care of dreadful death or that I held
Life in contempt, but that I know the mind 70
Stoops to no dread, although the flesh be frail.
And for my guilt, I yield the same so great
As in myself I find a fear to sue
For grant of life.
 Gorb. In vain, O wretch, thou showest
A woeful heart; Ferrex now lies in grave,
Slain by thy hand.
 Por. Yet this, O father, hear;
And then I end. Your majesty well knows
That, when my brother Ferrex and myself
By your own hest were joined in governance
Of this your grace's realm of Britain land, 80
I never sought nor travailed for the same;
Nor by myself nor by no friend I wrought,
But from your highness' will alone it sprung,
Of your most gracious goodness bent to me.

But how my brother's heart even then repined
With swollen disdain against mine egal rule,
Seeing that realm, which by descent should grow
Wholly to him, allotted half to me.
Even in your highness' court he now remains,
And with my brother then in nearest place, 90
Who can record what proof thereof was showed,
And how my brother's envious heart appeared?
Yet I that judgèd it my part to seek
His favor and good will, and loath to make
Your highness know the thing which should have
 brought
Grief to your grace and your offense to him,
Hoping my earnest suit should soon have won
A loving heart within a brother's breast,
Wrought in that sort that, for a pledge of love
And faithful heart, he gave to me his hand. 100
This made me think that he had banished quite
All rancor from his thought, and bare to me
Such hearty love as I did owe to him.
But after once we left your grace's court
And from your highness' presence lived apart,
This egal rule still, still did grudge him so
That now those envious sparks, which erst lay raked⁷
In living cinders of dissembling breast,
Kindled so far within his heart disdain
That longer could he not refrain from proof⁸ 110
Of secret practice to deprive me life
By poison's force, and had bereft me so,
If mine own servant, hired to this fact
And moved by truth with hate to work the same,
In time had not bewrayed it unto me.
When thus I saw the knot of love unknit,
All honest league and faithful promise broke,
The law of kind and truth thus rent in twain,
His heart on mischief set and in his breast
Black treason hid, then, did I despair 120
That ever time could win him friend to me;
Then saw I how he smiled with slaying knife
Wrapped under cloak; then saw I deep deceit
Lurk in his face and death prepared for me.
Even nature moved me then to hold my life
More dear to me than his, and bade this hand,
Since by his life my death must needs ensue
And by his death my life to be preserved,
To shed his blood and seek my safety so.
And wisdom willèd me without protract⁹ 130
In speedy wise to put the same in ure.
Thus have I told the cause that movèd me
To work my brother's death; and so I yield
My life, my death, to judgment of your grace.
 Gorb. O cruel wight, should any cause prevail
To make thee stain thy hands with brother's blood?
But what of thee we will resolve to do
Shall yet remain unknown. Thou in the mean¹⁰

³ *sithens*: since; the disyllabic form, which makes the meter irregular, may be a compositor's error.
⁴ *unhap*: misfortune. ⁵ *clepe*: call.
⁶ *doom*: judgment.
⁸ *proof*: attempt. ⁷ *raked*: covered.
¹⁰ *mean*: meantime. ⁹ *protract*: delay.

Shalt from our royal presence banished be
Until our princely pleasure further shall 140
To thee be showed. Depart therefore our sight,
Accursèd child!

 [*Exit* Porrex.]
 What cruel destiny,
What froward fate hath sorted[11] us this chance,
That even in those where we should comfort find,
Where our delight now in our agèd days
Should rest and be, even there our only grief
And deepest sorrows to abridge our life,
Most pining cares and deadly thoughts do grow?
 Aros. Your grace should now, in these grave years
 of yours,
Have found ere this the price of mortal joys, 150
How short they be, how fading here in earth,
How full of change, how brittle our estate,
Of nothing sure save only of the death
To whom both man and all the world doth owe
Their end at last; neither should nature's power
In other sort against your heart prevail,
Than as the naked hand whose stroke assays
The armèd breast where force doth light in vain.
 Gorb. Many can yield right sage and grave advice
Of patient sprite[12] to others wrapped in woe 160
And can in speech both rule and conquer kind,
Who, if by proof they might feel nature's force
Would show themselves men as they are indeed,
Which now will needs be gods. But what doth mean
The sorry cheer[13] of her that here doth come?

 [*Enter* Marcella.]

 Marc. Oh, where is ruth, or where is pity now?
Whither is gentle heart and mercy fled?
Are they exiled out of our stony breasts,
Never to make return? Is all the world
Drowned in blood and sunk in cruelty? 170
If not in women mercy may be found,
If not, alas, within the mother's breast
To her own child, to her own flesh and blood;
If ruth be banished thence, if pity there
May have no place, if there no gentle heart
Do live and well, where should we seek it then?
 Gorb. Madam, alas, what means your woeful tale?
 Marc. Oh, silly[14] woman I, why to this hour
Have kind and fortune thus deferred[15] my breath
That I should live to see this doleful day? 180
Will ever wight believe that such hard heart
Could rest within the cruel mother's breast,
With her own hand to slay her only son?
But out, alas, these eyes beheld the same;
They saw the dreary[16] sight and are become
Most ruthful records[17] of the bloody fact.

Porrex, alas, is by his mother slain,
And with her hand—a woeful thing to tell—
While slumbering on his careful bed he rests,
His heart, stabbed in with knife, is reft of life. 190
 Gorb. O Eubulus, oh, draw this sword of ours
And pierce this heart with speed! O hateful light,
O loathsome life, O sweet and welcome death!
Dear Eubulus, work this, we thee beseech!
 Eub. Patient, your grace; perhaps he liveth yet,
With wound received, but not of certain death.
 Gorb. O let us then repair unto the place,
And see if Porrex live or thus be slain.
 [*Exeunt* Gorboduc *and* Eubulus.]
 Marc. Alas, he liveth not! It is too true
That with these eyes, of him a peerless prince, 200
Son to a king, and in the flower of youth,
Even with a twink[18] a senseless stock I saw.
 Aros. O damnèd deed!
 Marc. But hear his ruthful end:
The noble prince, pierced with the sudden wound,
Out of his wretched slumber hastely[19] start,[20]
Whose strength now failing, straight he overthrew,[21]
When in the fall his eyes, even new unclosed,
Beheld the Queen and cried to her for help.
We then, alas, the ladies which that time
Did there attend, seeing that heinous deed, 210
And hearing him oft call the wretched name
Of mother and to cry to her for aid
Whose direful hand gave him the mortal wound,
Pitying, alas,—for nought else could we do—
His ruthful end, ran to the woeful bed,
Despoilèd[22] straight his breast, and all we might,
Wiped in vain with napkins next at hand
The sudden streams of blood that flushèd fast
Out of the gaping wound. Oh, what a look,
Oh, what a ruthful steadfast eye methought 220
He fixed upon my face, which to my death
Will never part fro me, when with a braid[23]
A deep-fet[24] sigh he gave, and therewithal,
Clasping his hands, to heaven he cast his sight.
And straight, pale death pressing within his face,
The flying ghost his mortal corpse forsook.
 Aros. Never did age bring forth so vile a fact.
 Marc. Oh, hard and cruel hap that thus assigned
Unto so worthy a wight so wretched end;
But most hard, cruel heart that could consent 230
To lend the hateful destinies that hand
By which, alas, so heinous crime was wrought.
O queen of adamant, O marble breast!
If not the favor of his comely face,
If not his princely cheer and countenance,
His valiant active arms, his manly breast,
If not his fair and seemly personage,
His noble limbs in such proportion cast
As would have wrapt a silly woman's thought;
If this mought not have moved thy bloody heart 240
And that most cruel hand the wretched weapon
Even to let fall and kissed him in the face,
With tears for ruth to reave such one by death,
Should nature yet consent to slay her son?
O mother, thou to murder thus thy child!

[11] *sorted:* allotted. [12] *sprite:* spirit.
[13] *cheer:* countenance. [14] *silly:* weak, helpless.
[15] *deferred:* protracted. [16] *dreary:* gory.
[17] *records:* witnesses. [18] *with a twink:* in a twinkling.
[19] *hastely:* hastily. [20] *start:* started.
[21] *overthrew:* tumbled down.
[22] *Despoilèd:* Undressed. [23] *braid:* start.
[24] *deep-fet:* deep-fetched.

Even Jove with justice must with lightning flames
From heaven send down some strange revenge on thee.
Ah, noble prince, how oft have I beheld
Thee mounted on thy fierce and trampling steed,
Shining in armor bright before the tilt, 250
And with thy mistress' sleeve²⁵ tied on thy helm,
And charge thy staff,²⁶ to please thy lady's eye,
That bowed the head-piece of thy friendly foe!
How oft in arms on horse to bend the mace,
How oft in arms on foot to break the sword,
Which never now these eyes may see again!
 Aros. Madam, alas, in vain these plaints are shed;
Rather with me depart and help to swage²⁷
The thoughtful griefs that in the agèd King
Must needs by nature grow by death of this 260
His only son whom he did hold so dear.
 Marc. What wight is that which saw that I did see
And could refrain to wail with plaint and tears?
Not I, alas! That heart is not in me.
But let us go, for I am grieved anew
To call to mind the wretched father's woe.
 [Exeunt.]
 Chor. When greedy lust in royal seat to reign
 Hath reft all care of gods and eke of men;
And cruel heart, wrath, treason, and disdain
 Within ambitious breast are lodged, then 270
Behold how mischief wide herself displays,
And with the brother's hand the brother slays.

When blood thus shed doth stain the heaven's face,
 Crying to Jove for vengeance of the deed,
The mighty god even moveth from his place
 With wrath to wreak. Then sends he forth with speed
The dreadful Furies, daughters of the night,
 With serpents girt, carrying the whip of ire,
With hair of stinging snakes, and shining bright
 With flames and blood, and with a brand of fire. 280
These, for revenge of wretched murder done,
Do make the mother kill her only son.

Blood asketh blood, and death must death requite.
 Jove, by his just and everlasting doom,
Justly hath ever so requited it.
 The times before record and times to come
Shall find it true, and so doth present proof
Present before our eyes for our behoof.

O happy wight that suffers not the snare
 Of murderous mind to tangle him in blood; 290
And happy he that can in time beware
 By other's harms and turn it to his good.
But woe to him that, fearing not to offend,
Doth serve his lust and will not see the end.

ACT FIVE

*The Order and Signification of the Dumb Show
Before the Fifth Act*

FIRST, the drums and flutes began to sound, during
which there came forth upon the stage a company of

harquebussiers and of armed men, all in order of battle.
These, after their pieces discharged, and that the armed
men had three times marched about the stage, departed,
and then the drums and flutes did cease. Hereby was
signified tumults, rebellions, arms, and civil wars to
follow as fell in the realm of Great Britain which, by the
space of fifty years and more, continued in civil war
between the nobility after the death of King Gor- 10
boduc and of his issues, for want of certain limitation in
succession of the crown, till the time of Dunwallo Mol-
mutius, who reduced the land to monarchy.

V.i

[Enter] CLOTYN, MANDUD, GWENARD, FERGUS,
 [and] EUBULUS.

 Clot. Did ever age bring forth such tyrants' hearts?
The brother hath bereft the brother's life;
The mother, she hath dyed her cruel hands
In blood of her own son; and now at last
The people, lo, forgetting truth and love,
Contemning quite both law and loyal heart,
Even they have slain their sovereign lord and Queen.
 Man. Shall this their traitorous crime unpunished
 rest?
Even yet they cease not, carried on with rage
In their rebellious routs, to threaten still 10
A new bloodshed unto the prince's kin,
To slay them all, and to uproot the race
Both of the King and Queen; so are they moved
With Porrex' death, wherein they falsely charge
The guiltless King, without desert at all,
And traitorously have murdered him therefor,
And eke the Queen.
 Gwen. Shall subjects dare with force
To work revenge upon their prince's fact?
Admit the worst that may—as sure in this
The deed was foul, the Queen to slay her son— 20
Shall yet the subject seek to take the sword,
Arise against his lord, and slay his King?
O wretched state, where those rebellious hearts
Are not rent out even from their living breasts,
And with the body thrown unto the fowls
As carrion food for terror of the rest.
 Ferg. There can no punishment be thought too great
For this so grievous crime. Let speed therefore
Be used therein, for it behooveth so.
 Eub. Ye all, my lords, I see consent in one, 30
And I as one consent with ye in all.
I hold it more than need, with sharpest law
To punish this tumultuous bloody rage.
For nothing more may shake the common state
Than sufferance of uproars without redress;
Whereby how some kingdoms of mighty power,
After great conquests made, and flourishing
In fame and wealth, have been to ruin brought.
I pray to Jove that we may rather wail

 ²⁵ *sleeve:* favor. ²⁶ *charge thy staff:* level thy lance.
 ²⁷ *swage:* mollify, assuage.

Such hap in them than witness in ourselves. 40
Eke fully with the duke my mind agrees,
[That no cause serves whereby the subject may
Call to account the doings of his prince,
Much less in blood by sword to work revenge,
No more than may the hand cut off the head;
In act nor speech, no, not in secret thought
The subject may rebel against his lord,
Or judge of him that sits in Caesar's seat,
With grudging mind to damn those he mislikes.] [1]
Though kings forget to govern as they ought, 50
Yet subjects must obey as they are bound.
But now, my lords, before ye farther wade, [2]
Or spend your speech, what sharp revenge shall fall
By justice' plague on these rebellious wights,
Methinks ye rather should first search the way
By which in time the rage of this uproar
Mought be repressed and these great tumults ceased.
Even yet the life of Britain land doth hang
In traitors' balance of unegal weight.
Think not, my lords, the death of Gorboduc, 60
Nor yet Videna's blood, will cease their rage.
Even our own lives, our wives and children dear,
Our country, dearest of all, in danger stands,
Now to be spoiled, now, now made desolate,
And by ourselves a conquest to ensue.
For give once sway unto the people's lusts
To rush forth on and stay them not in time,
And as the stream that rolleth down the hill,
So will they headlong run with raging thoughts
From blood to blood, from mischief unto moe, 70
To ruin of the realm, themselves, and all,
So giddy are the common people's minds,
So glad of change, more wavering than the sea.
Ye see, my lords, what strength these rebels have,
What hugy number is assembled still;
For though the traitorous fact for which they rose
Be wrought and done, yet lodge they still in field;
So that how far their furies yet will stretch
Great cause we have to dread. That we may seek
By present battle to repress their power, 80
Speed must we use to levy force therefor;
For either they forthwith will mischief work,
Or their rebellious roars forthwith will cease.
These violent things may have no lasting long.
Let us therefore use this for present help:
Persuade by gentle speech and offer grace
With gift of pardon, save unto the chief;
And that upon condition that forthwith
They yield the captains of their enterprise
To bear such guerdon [3] of their traitorous fact 90
As may be both due vengeance to themselves
And wholesome terror to posterity.
This shall, I think, scatter the greatest part
That now are holden with desire of home,

Wearied in field with cold of winter's nights,
And some, no doubt, stricken with dread of law.
When this is once proclaimèd, it shall make
The captains to mistrust the multitude,
Whose safety bids them to betray their heads;
And so much more because the rascal routs 100
In things of great and perilous attempts
Are never trusty to the noble race.
And while we treat and stand on terms of grace,
We shall both stay their fury's rage the while
And eke gain time, whose only help sufficeth
Withouten war to vanquish rebels' power.
In the meanwhile, make you in readiness
Such band of horsemen as ye may prepare.
Horsemen, you know, are not the commons' strength,
But are the force and store of noble men, 110
Whereby the unchosen and unarmèd sort
Of skill-less rebels, whom none other power
But number makes to be of dreadful force,
With sudden brunt may quickly be oppressed.
And if this gentle mean of proffered grace
With stubborn hearts cannot so far avail
As to assuage their desperate courages,
Then do I wish such slaughter to be made
As present age and eke posterity
May be adrad [4] with horror of revenge 120
That justly then shall on these rebels fall.
This is, my lords, the sum of mine advice.
 Clot. Neither this case admits debate at large,
And, though it did, this speech that hath been said
Hath well abridged the tale I would have told.
Fully with Eubulus do I consent [5]
In all that he hath said; and if the same
To you, my lords, may seem for best advice,
I wish that it should straight be put in ure.
 Man. My lords, then let us presently [6] depart 130
And follow this that liketh us so well.
 [*Exeunt* CLOTYN, MANDUD, GWENARD, *and*
 EUBULUS.]
 Ferg. If ever time to gain a kingdom here
Were offered man, now it is offered me.
The realm is reft both of their King and Queen;
The offspring of the prince is slain and dead;
No issue now remains, the heir unknown;
The people are in arms and mutinies;
The nobles, they are busied how to cease
These great rebellious tumults and uproars; 140
And Britain land, now desert, left alone
Amid these broils, uncertain where to rest,
Offers herself unto that noble heart
That will or dare pursue to bear her crown.
Shall I, that am the Duke of Albany,
Descended from that line of noble blood
Which hath so long flourished in worthy fame
Of valiant hearts, such as in noble breasts
Of right should rest above the baser sort,
Refuse to venture life to win a crown? 150
Whom shall I find enemies that will withstand
My fact herein, if I attempt by arms
To seek the same now in these times of broil?
These dukes' power can hardly well appease

V.i.
 [1] Not in Q2, perhaps suppressed for political reasons;
printed from Q1.
 [2] *wade:* go. [3] *guerdon:* reward. [4] *adrad:* adread.
 [5] *consent:* agree. [6] *presently:* immediately.

The people that already are in arms.
But if perhaps my force be once in field,
Is not my strength in power above the best
Of all these lords now left in Britain land?
And though they should match me with power of men,
Yet doubtful is the chance of battles joined.
If victors of the field we may depart, 160
Ours is the scepter then of Great Britain;
If slain amid the plain this body lie,
Mine enemies yet shall not deny me this,
But that I died giving the noble charge
To hazard life for conquest of a crown.
Forthwith, therefore, will I in post depart
To Albany and raise in armor there
All power I can; and here my secret friends
By secret practice shall solicit still
To seek to win to me the people's hearts. 170
 [*Exit.*]

V.ii

[*Enter*] EUBULUS.

Eub. O Jove, how are these people's hearts abused!
What blind fury thus headlong carries them!
That though so many books, so many rolls
Of ancient time, record what grievous plagues
Light on these rebels aye, and though so oft
Their ears have heard their agèd fathers tell
What just reward these traitors still receive,
Yea, though themselves have seen deep death and blood
By strangling cord and slaughter of the sword
To such assigned, yet can they not beware, 10
Yet cannot stay their lewd rebellious hands;
But suffering, lo, foul treason to distain [1]
Their wretched minds, forget their loyal heart,
Reject all truth, and rise against their prince.
A ruthful case, that those whom duty's bond,
Whom grafted law by nature, truth, and faith
Bound to preserve their country and their king,
Born to defend their commonwealth and prince,
Even they should give consent thus to subvert
Thee, Britain land, and from thy womb should spring,
O native soil, those that will needs destroy 21
And ruin thee and eke themselves in fine. [2]
For lo, when once the dukes had offered grace
Of pardon sweet, the multitude, misled
By traitorous fraud of their ungracious heads,
One sort [3] that saw the dangerous success
Of stubborn standing in rebellious war
And knew the difference of prince's power
From headless number of tumultuous routs,
Whom common country's care and private fear 30
Taught to repent the error of their rage,
Laid hands upon the captains of their band
And brought them bound unto the mighty dukes.
And other sort, not trusting yet so well
The truth of pardon, or mistrusting more
Their own offense than that they could conceive
Such hope of pardon for so foul misdeed,
Or for that they their captains could not yield,

Who, fearing to be yielded, fled before,
Stale [4] home by silence of the secret night. 40
The third unhappy and enragèd sort
Of desperate hearts who, stained in princes' blood,
From traitorous furor could not be withdrawn
By love, by law, by grace, ne yet by fear,
By proffered life, ne yet by threatened death,
With minds hopeless of life, dreadless of death,
Careless of country and aweless of God,
Stood bent to fight, as Furies did them move,
With violent death to close their traitorous life.
These all by power of horsemen were oppressed 50
And with revenging sword slain in the field
Or with the strangling cord hanged on the tree,
Where yet their carrion carcasses do preach
The fruits that rebels reap of their uproars
And of the murder of their sacred prince.
But lo, where do approach the noble dukes
By whom these tumults have been thus appeased?

[*Enter* CLOTYN, MANDUD, GWENARD, *and* AROSTUS.]

Clot. I think the world will now at length beware
And fear to put on arms against their prince.
Man. If not, those traitorous hearts that dare rebel,
Let them behold the wide and hugy fields 61
With blood and bodies spread of rebels slain,
The lofty trees clothed with the corpses dead
That, strangled with the cord, do hang thereon.
Aros. A just reward; such as all times before
Have ever lotted [5] to those wretched folks.
Gwen. But what means he that cometh here so fast?

[*Enter* NUNTIUS.]

Nunt. My lords, as duty and my troth doth move
And of my country work a care in me,
That, if the spending of my breath availed 70
To do the service that my heart desires,
I would not shun to embrace a present death;
So have I now, in that wherein I thought
My travail mought perform some good effect,
Ventured my life to bring these tidings here.
Fergus, the mighty Duke of Albany,
Is now in arms, and lodgeth in the field
With twenty thousand men. Hither he bends
His speedy march and minds to invade the crown.
Daily he gathereth strength and spreads abroad 80
That to this realm no certain heir remains,
That Britain land is left without a guide,
That he the scepter seeks for nothing else
But to preserve the people and the land,
Which now remain as ship without a stern. [6]
Lo, this is that which I have here to say.
 [*Exit* NUNTIUS.]
Clot. Is this his faith? and shall he falsely thus
Abuse the vantage of unhappy times?

V.ii.
[1] *distain:* stain, defile. [2] *in fine:* finally.
[3] *sort:* part. [4] *Stale:* Stole. [5] *lotted:* allotted.
[6] *stern:* rudder.

O wretched land, if his outrageous pride,
His cruel and untempered willfulness, 90
His deep dissembling shows of false pretense,
Should once attain the crown of Britain land!
Let us, my lords, with timely force resist
The new attempt of this our common foe
As we would quench the flames of common fire.
 Man. Though we remain without a certain prince
To weld the realm or guide the wandering rule,
Yet now the common mother of us all,
Our native land, our country, that contains
Our wives, children, kindred, ourselves, and all 100
That ever is or may be dear to man,
Cries unto us to help ourselves and her.
Let us advance our powers to repress
This growing foe of all our liberties.
 Gwen. Yea, let us so, my lords, with hasty speed.
And ye, O gods, send us the welcome death,
To shed our blood in field, and leave us not
In loathsome life to linger out our days
To see the hugy heaps of these unhaps
That now roll down upon the wretched land, 110
Where empty place of princely governance,
No certain stay now left of doubtless heir,
Thus leave this guideless realm an open prey
To endless storms and waste of civil war.
 Aros. That ye, my lords, do so agree in one,
To save your country from the violent reign
And wrongfully usurpèd tyranny
Of him that threatens conquest of you all,
To save your realm, and in this realm yourselves,
From foreign thralldom of so proud a prince, 120
Much do I praise; and I beseech the gods
With happy honor to requite it you.
But, O my lords, sith now the heaven's wrath
Hath reft this land the issue of their prince,
Sith of the body of our late sovereign lord
Remains no moe since the young kings be slain,
And of the title of descended crown
Uncertainly the divers minds do think,
Even of the learned sort, and more uncertainly
Will partial[7] fancy and affection deem, 130
But most uncertainly will climbing pride
And hope of reign withdraw to sundry parts
The doubtful right and hopeful lust to reign.
When once this noble service is achieved
For Britain land, the mother of ye all,
When once ye have with armèd force repressed
The proud attempts of this Albanian[8] prince
That threatens thralldom to your native land,
When ye shall vanquishers return from field
And find the princely state an open prey 140
To greedy lust and to usurping power,
Then, then, my lords, if ever kindly care
Of ancient honor of your ancestors,

Of present wealth and noblesse[9] of your stocks,
Yea, of the lives and safety yet to come
Of your dear wives, your children, and yourselves,
Might move your noble hearts with gentle ruth,
Then, then, have pity on the torn estate;
Then help to salve the well-near hopeless sore;
Which ye shall do if ye yourselves withhold 150
The slaying knife from your own mother's throat;
Her shall you save, and you, and yours in her
If ye shall all with one assent forbear
Once to lay hand or take unto yourselves
The crown, by color[10] of pretended right,
Or by what other means so ever it be,
Till first by common counsel of you all
In parliament the regal diadem
Be set in certain place of governance;
In which your parliament, and in your choice, 160
Prefer the right, my lords, without[11] respect
Of strength or friends, or whatsoever cause
That may set forward any other's part.
For right will last, and wrong cannot endure.
Right mean I his or hers upon whose name
The people rest by mean of native line,
Or by the virtue of some former law,
Already made their title to advance.
Such one, my lords, let be your chosen king,
Such one so born within your native land; 170
Such one prefer; and in no wise admit
The heavy yoke of foreign governance.
Let foreign titles yield to public wealth.
And with that heart wherewith ye now prepare
Thus to withstand the proud invading foe,
With that same heart, my lords, keep out also
Unnatural thralldom of stranger's[12] reign;
Ne suffer you, again the rules of kind,
Your motherland to serve a foreign prince.
 Eub. Lo, here the end of Brutus' royal line, 180
And lo, the entry to the woeful wreck
And utter ruin of this noble realm.
The royal King and eke his sons are slain;
No ruler rests within the regal seat;
The heir, to whom the scepter 'longs, unknown;
That to each force of foreign princes' power,
Whom vantage of our wretched state may move
By sudden arms to gain so rich a realm,
And to the proud and greedy mind at home
Whom blinded lust to reign leads to aspire, 190
Lo, Britain realm is left an open prey,
A present spoil by conquest to ensue.
Who seeth not now how many rising minds
Do feed their thoughts with hope to reach a realm?
And who will not by force attempt to win
So great a gain, that hope persuades to have?
A simple color shall for title serve.
Who wins the royal crown will want no right,
Nor such as shall display by long descent
A lineal race to prove him lawful king. 200
In the meanwhile these civil arms shall rage,
And thus a thousand mischiefs shall unfold,
And far and near spread[13] thee, O Britain land!
All right and law shall cease, and he that had

 [7] *partial:* biased.
 [8] *Albanian:* Scots (see note to *Albany* in Dramatis Personæ).
 [9] *noblesse:* nobility. [10] *color:* alleged ground, excuse.
 [11] *without:* Q1, Q3; *with:* Q2. [12] *stranger's:* foreigner's.
 [13] *spread:* spread over.

Nothing today tomorrow shall enjoy
Great heaps of gold, and he that flowed in wealth,
Lo, he shall be bereft of life and all;
And happiest he that then possessseth least.
The wives shall suffer rape, the maids deflowered;
And children fatherless shall weep and wail; 210
With fire and sword thy native folk shall perish;
One kinsman shall bereave another's life;
The father shall unwitting slay the son;
The son shall slay the sire and know it not.
Women and maids the cruel soldier's sword
Shall pierce to death, and silly children, lo,
That playing [14] in the streets and fields are found,
By violent hands shall close their latter day.
Whom shall the fierce and bloody soldier
Reserve to life? Whom shall he spare from death? 220
Even thou, O wretched mother, half alive,
Thou shalt behold thy dear and only child
Slain with the sword while he yet sucks thy breast.
Lo, guiltless blood shall thus each where be shed.
Thus shall the wasted soil yield forth no fruit,
But dearth and famine shall possess the land.
The towns shall be consumed and burnt with fire,
The peopled cities shall wax desolate;
And thou, O Britain, whilom in renown,
Whilom in wealth and fame, shalt thus be torn, 230
Dismembered thus, and thus be rent in twain,
Thus wasted and defaced, spoiled and destroyed.
These be the fruits your civil wars will bring.
Hereto it comes when kings will not consent
To grave advice, but follow willful will.
This is the end when in fond princes' hearts
Flattery prevails and sage rede hath no place.
These are the plagues, when murder is the mean
To make new heirs unto the royal crown. 239
Thus wreak the gods when that the mother's wrath
Naught but the blood of her own child may swage;
These mischiefs spring when rebels will arise
To work revenge and judge their prince's fact.
This, this ensues when noble men do fail
In loyal troth, and subjects will be kings.

And this doth grow, when lo, unto the prince
Whom death or sudden hap of life bereaves,
No certain heir remains, such certain heir,
As not all-only [15] is the rightful heir,
But to the realm is so made known to be, 250
And troth thereby vested in subjects' hearts
To owe faith there where right is known to rest.
Alas, in parliament what hope can be,
When is of paliament no hope at all,
Which, though it be assembled by consent,
Yet is not likely with consent to end;
While each one for himself, or for his friend,
Against his foe shall travail what he may;
While now the state, left open to the man
That shall with greatest force invade the same, 260
Shall fill ambitious minds with gaping hope;
When will they once with yielding hearts agree?
Or in the while, how shall the realm be used?
No, no; then parliament should have been holden,
And certain heirs appointed to the crown,
To stay the title of established right
And in the people plant obedience
While yet the prince did live whose name and power
By lawful summons and authority
Might make a parliament to be of force, 270
And might have set the state in quiet stay.
But now, O happy man whom speedy death
Deprives of life, ne is enforced to see
These hugy mischiefs and these miseries,
These civil wars, these murders, and these wrongs
Of justice. Yet must God in fine restore
This noble crown unto the lawful heir;
For right will always live and rise at length,
But wrong can never take deep root to last.

 [*Exeunt.*]

 The End of the Tragedy of King Gorboduc.[16]

[14] *playing*: Q1, Q3; *play*: Q2. [15] *all-only*: solely.
[16] *The . . . Gorboduc*: supplied from Q1, Q3; missing in
Q2.

George Gascoigne

[*c.* 1537–1577]

SUPPOSES

GASCOIGNE'S SUPPOSES is not only the first example in English of Italianate comedy and the first surviving English play to be written wholly in prose, it is also in its own right a well-turned play, and important subsequently for the fortunes of Shakespeare. The anonymous *Taming of a Shrew*, which lies behind Shakespeare's play, takes its sub-plot—familiar to students of Shakespeare as the story of Bianca's disguised suitor and his pretended father—from SUPPOSES, which appears also to have afforded hints for a few lines in *Richard II* and *Richard III*.

Essentially, SUPPOSES is a translation of Ariosto's prose comedy (afterward versified) *Gli Suppositi* (1509), itself a remodeling of classical Roman comedy as written by Plautus and Terence. Gascoigne in his version makes use of both the prose and verse editions of Ariosto. Every schoolboy knows Ariosto (or ought to know him) as the author of the *Orlando Furioso*, the most influential epic of the Renaissance. But Ariosto deserves to be remembered as well for his creating of the so-called *commedia erudita*. His five Latinate comedies, written in the opening years of the sixteenth century, are scrupulously concerned with mechanical form. This concern is mostly alien to the Elizabethans. It is, however, notable in Gascoigne's adroit recension, also in the early comedies of Shakespeare. Gascoigne in SUPPOSES, like Shakespeare in *The Comedy of Errors*, is working in a line not to be widely followed thereafter. That the panoramic drama of the Elizabethans is triumphantly successful no one will argue. To read Gascoigne is to see what it ignores or gives away.

SUPPOSES was first performed by the law students of Gray's Inn in 1566 (hence the peculiar appropriateness of poking fun at the niggardly barrister, Cleander), and again at Trinity College, Oxford, in 1582. A first quarto appeared in 1572 or 1573, a second in 1575. Because the second quarto is advertised as "corrected, perfected, and augmented by the author," it is accorded primacy in the making of a modern text.

George Gascoigne was probably the most talented, certainly the most significant, literary figure in the earlier years of Elizabeth's reign, the years just before the great floodtide of Elizabethan literature. His birth was roughly coincident with the writing of the best Henrician poetry by Wyatt and Surrey, his death with the emergence of Edmund Spenser. His own literary activity was considerable and of more than merely historical interest. He is sometimes a good poet, and important for the development of blank verse. For the famous entertainment at Kenilworth Castle in 1575, prepared by the Earl of Leicester to honor the Queen, he wrote what has been called the first English masque. He is worth remembering also as a writer of criticism, of prose fiction, and of two other extant plays. In the decade before SUPPOSES and in collaboration with Francis Kinwelmarsh, he adapted from the Italian of Lodovico Dolce the tragedy of *Jocasta*, thus introducing at a remove Euripides' *Phoenissae* to his colleagues at Gray's Inn (1566). His third play, *The Glass of Government*, was printed in 1575. It also is derivative, finding its model in the school plays of Dutch humanists writing in Latin and in the work of native English predecessors who had treated dramatically the story of the Prodigal Son.

In life as in art, Gascoigne's career was varied. He was educated at Trinity College, Cambridge, and at Gray's Inn. He served in Parliament, and as a soldier in the Netherlands in the early 1570s, fighting the Spaniards.

His motto, which professes allegiance to military prowess and to learning, gives his character as he conceived it: *Tam Marti quam Mercurio.* R. A. F.

Supposes

DRAMATIS PERSONÆ

BALIA, *the nurse*
POLYNESTA, *the young woman*
CLEANDER, *the doctor,*[1] *suitor to Polynesta*
PASIPHILO, *the parasite*
CARION, *the doctor's man*
DULIPPO, *feigned servant, and lover of Polynesta*
EROSTRATO, *feigned master, and suitor to Polynesta*
DALIO *and* ⎤
CRAPINO[2] ⎦ *servants to feigned Erostrato*
SIENESE, *a gentleman stranger*

PAQUETTO *and* ⎤ *his servants*
PETRUCHIO ⎦
DAMON, *father to Polynesta*
NEVOLA *and Two Other His Servants*
PSITERIA, *an old hag in his house*
PHILOGANO, *a Sicilian gentleman, father to Erostrato*
LITIO, *his servant*
FERRARESE, *an innkeeper of Ferrara*

The comedy presented as it were in Ferrara.

THE PROLOGUE OR ARGUMENT

I SUPPOSE you are assembled here supposing to reap the fruit of my travails;[1] and, to be plain, I mean presently to present you with a comedy called *Supposes,* the very name whereof may peradventure drive into every[2] of your heads a sundry suppose, to suppose the meaning of our Supposes. Some, percase,[3] will suppose we mean to occupy your ears with sophistical handling of subtle suppositions; some other will suppose we go about to decipher unto you some quain conceits,[4] which hitherto have been only sup- 10 posed, as it were, in shadows;[5] and some I see smiling as though they supposed we would trouble you with the vain suppose of some wanton suppose.[6] But, under-stand, this our Suppose is nothing else but a mistaking or imagination of one thing for another. For you shall see the master supposed for the servant, the servant for the master, the freeman for a slave, and the bondslave for a freeman, the stranger for a well-known friend, and the familiar for a stranger. But what? I suppose that even already you suppose me very fond[7] that have 20 so simply disclosed unto you the subtleties of these our Supposes; where otherwise, indeed, I suppose you should have heard almost the last of our Supposes before you could have supposed any of them aright. Let this then suffice.

ACT ONE

SCENE ONE

BALIA, *the nurse,* POLYNESTA, *the young woman.*

Bal. Here is nobody. Come forth, Polynesta. Let us look about, to be sure lest any man hear our talk; for I think within the house the tables, the planks, the beds, the portals,[1] yea, and the cupboards themselves have ears.

Poly. You might as well have said the windows and the doors. Do you not see how they hearken?

Bal. Well, you jest fair; but I would advise you take heed! I have bidden you a thousand times beware. You will be spied one day talking with Dulippo. 10

Poly. And why should I not talk with Dulippo as well as with any other, I pray you?

Bal. I have given you a wherefore for this why many times. But go to! Follow your own advice till you over-whelm us all with sudden mishap.

Poly. A great mishap, I promise you! Marry, God's blessing on their heart that set such a brooch on my cap.[2]

Bal. Well, look well about you! A man would think it were enough for you secretly to rejoice that by 20 my help you have passed so many pleasant nights to-gether. And yet, by my troth, I do it more than half against my will, for I would rather you had settled your fancy in some noble family. Yea, and it is no small grief

DRAMATIS PERSONÆ
 [1] *doctor:* barrister.
 [2] *Crapino:* usually spelled Crapine in the text.

PROLOGUE
 [1] *travails:* labors. [2] *every:* each.
 [3] *percase:* perchance.
 [4] *quaint conceits:* ingeniously imagined ideas.
 [5] *shadows:* pictures ("emblems" or "impreses," the technical terms for illustrated devices, generally accompanied by a motto, and current in the sixteenth century).
 [6] *wanton suppose:* whore. [7] *fond:* foolish.

I.i.
 [1] *portals:* passages, recessed places.
 [2] *set . . . cap:* gave me such a reputation.

unto me that, rejecting the suits of so many nobles and gentlemen, you have chosen for your darling a poor servant of your father's, by whom shame and infamy is the best dower you can look for to attain.

Poly. And, I pray you, whom may I thank but gentle nurse, that continually praising him, what for his 30 personage,[3] his courtesy, and, above all, the extreme passions[4] of his mind—in fine, you would never cease till I accepted him, delighted in him, and at length desired him with no less affection than he erst[5] desired me.

Bal. I cannot deny but at the beginning I did recommend him unto you (as, indeed, I may say that for myself I have a pitiful heart), seeing the depth of his unbridled affection, and that continually he never ceased to fill mine ears with lamentable complaints. 40

Poly. Nay, rather that he filled your purse with bribes and rewards, nurse!

Bal. Well, you may judge of nurse as you list. Indeed, I have thought it always a deed of charity to help the miserable young men whose tender youth consumeth with the furious flames of love. But, be you sure, if I had thought you would have passed to the terms you now stand in, pity nor pension, penny nor paternoster,[6] should ever have made nurse once to open her mouth in the cause. 50

Poly. No? Of honesty, I pray you: who first brought him into my chamber, who first taught him the way to my bed but you? Fie, nurse, fie! Never speak of it for shame! You will make me tell a wise tale anon.

Bal. And have I these thanks for my good will? Why then, I see well I shall be counted the cause of all mishap.

Poly. Nay, rather the author of my good hap, gentle nurse. For I would thou knewest I love not Dulippo, nor any of so mean estate, but have bestowed my love more worthily than thou deemest. But I will say no more at this time. 62

Bal. Then I am glad you have changed your mind yet.

Poly. Nay, I neither have changed nor will change it.

Bal. Then I understand you not. How said you?

Poly. Marry, I say that I love not Dulippo, nor any such as he; and yet I neither have changed nor will change my mind. 69

Bal. I cannot tell. You love to lie with Dulippo very well. This gear[7] is Greek to me. Either it hangs not well

together or I am very dull of understanding. Speak plain, I pray you.

Poly. I can speak no plainer; I have sworn to the contrary.

Bal. How! Make you so dainty[8] to tell it nurse, lest she should reveal it? You have trusted me as far as may be (I may show to you) in things that touch your honor if they were known, and make you strange[9] to tell me this? I am sure it is but a trifle in comparison of 80 those things whereof heretofore you have made me privy.[10]

Poly. Well, it is of greater importance than you think, nurse; yet would I tell it you—under condition and promise that you shall not tell it again, nor give any sign or token to be suspected that you know it.

Bal. I promise you, of my honesty. Say on.

Poly. Well, hear you me then. This young man whom you have always taken for Dulippo is a noble-born Sicilian, his right name Erostrato, son to Philogano, one of the worthiest men in that country. 91

Bal. How, Erostrato? Is it not our neighbor which—

Poly. Hold thy talking, nurse, and hearken to me that I may explain the whole case unto thee. The man whom to this day you have supposed to be Dulippo is, as I say, Erostrato, a gentleman that came from Sicilia to study in this city;* and even at his first arrival met me in the street, fell enamored of me, and of such vehement force were the passions he suffered that immediately he cast aside both long gown and 100 books, and determined on me only to apply his study. And to the end he might the more commodiously[12] both see me and talk with me, he exchanged both name, habit, clothes, and credit with his servant Dulippo, whom only he brought with him out of Sicilia. And so, with the turning of a hand, of Erostrato, a gentleman, he became Dulippo, a serving-man, and soon after sought service of my father and obtained it.

Bal. Are you sure of this? 109

Poly. Yea, out of doubt. On the other side, Dulippo took upon him the name of Erostrato, his master, the habit,[13] the credit, books, and all things needful to a student, and in short space profited very much, and is now esteemed as you see.

Bal. Are there no other Sicilians here nor none that pass this way, which may discover them?

Poly. Very few that pass this way, and few or none that tarry here any time.

Bal. This hath been a strange adventure! But, I pray you, how hang these things together—that the 120 student, whom you say to be the servant and not the master, is become an earnest suitor to you and requireth you of your father in marriage?

Poly. That is a policy devised between them to put Doctor Dotipole[14] out of conceit[15]—the old dotard!— he that so instantly doth lie upon[16] my father for me. But look where he comes—as God help me, it is he. Out upon him! What a lusky yonker[17] is this! Yet I had rather be a nun a thousand times than be cumbered with such a coistrel.[18] 130

[3] *personage:* physique.
[4] *extreme passions:* elevated sentiments.
[5] *erst:* first.
[6] *pension . . . paternoster:* neither remuneration nor prayers. [7] *gear:* business.
[8] *Make . . . dainty:* Are you so fastidious not.
[9] *make you strange:* hold you off.
[10] *made me privy:* taken me into your confidence.
[11] The author's comments, of which this is the first, were set as marginal side notes in the original edition, a style that cannot be duplicated in a double-column format.
[12] *commodiously:* conveniently. [13] *habit:* dress.
[14] *Dotipole:* Blockhead. [15] *conceit:* suspicion.
[16] *instantly . . . upon:* insistently urges his suit to.
[17] *lusky yonker:* lazy youth (presumably said satirically of "the old dotard"). [18] *coistrel:* base fellow.

* *The first suppose and ground of all the supposes.*[11]

Bal. Daughter, you have reason. But let us go in before he come any nearer.

POLYNESTA *goeth in, and* BALIA *stayeth a little while after, speaking a word or two to the doctor, and then departeth.*

I.ii

CLEANDER, *doctor;* PASIPHILO, *parasite;*
BALIA, *nurse.*

Cle. Were these dames[1] here, or did mine eyes dazzle?

Pasi. Nay, sir, here were Polynesta and her nurse.

Cle. Was my Polynesta here? Alas, I knew her not!

Bal. [*Aside*] He must have better eyesight that should marry your Polynesta—or else he may chance to oversee the best point in his tables[2] sometimes.

[*Exit.*]

Pasi. Sir, it is no marvel; the air is very misty today. I myself knew her better by her apparel than by her face. 10

Cle. In good faith, and I thank God, I have mine eyesight good and perfit[3]—little worse than when I was but twenty years old.

Pasi. How can it be otherwise? You are but young.

Cle. I am fifty years old.

Pasi. [*Aside*] He tells[4] ten less than he is.

Cle. What sayst thou of ten less?

Pasi. I say I would have thought you ten less; you look like one of six-and-thirty, or seven-and-thirty at the most. 20

Cle. I am no less than I tell.

Pasi. You are like enough to live fifty more. Show me your hand.

Cle. Why, is Pasiphilo a chiromancer?[5]

Pasi. What is not Pasiphilo? I pray you, show me it a little.

Cle. Here it is.

Pasi. Oh, how straight and infract[6] is this line of life! You will live to the years of Melchisedec.

Cle. Thou wouldest say Methusalem. 30

Pasi. Why, is it not all one?

Cle. I perceive you are no very good Bibler, Pasiphilo.

Pasi. Yes, sir, an excellent good bibbler,[7] specially in a bottle. Oh, what a mount of Venus[8] here is! But this light serveth not very well. I will behold it another day, when the air is clearer, and tell you somewhat, peradventure, to your contentation.[9]

Cle. You shall do me great pleasure. But tell me, I pray thee, Pasiphilo, whom dost thou think Polynesta liketh better, Erostrato or me? 41

Pasi. Why, you, out of doubt! She is a gentlewoman of a noble mind, and maketh greater accompt of the reputation she shall have in marrying your worship, than that poor scholar, whose birth and parentage God knoweth, and very few else.

Cle. Yet he taketh it upon him bravely[10] in this country.

Pasi. Yea, where no man knoweth the contrary. But let him brave it, boast his birth, and do what 50 he can, the virtue and knowledge that is within this body of yours is worth more than all the country he came from.

Cle. It becometh not a man to praise himself; but indeed I may say, and say truly, that my knowledge hath stood me in better stead at a pinch than could all the goods in the world. I came out of Otranto when the Turks won it, and first I came to Padua, after[11] hither, where, by reading,[12] counseling, and pleading,[13] within twenty years I have gathered and gained as good as ten thousand ducats. 61

Pasi. Yea, marry, this is the right knowledge! Philosophy, Poetry, Logic, and all the rest are but pickling[14] sciences in comparison to this.

Cle. But pickling indeed, whereof we have a verse:

The trade of law doth fill the boisterous bags;[15]
They swim in silk, when others roist[16] in rags.

Pasi. Oh, excellent verse! Who made it? Virgil?

Cle. Virgil? Tush, it is written in one of our glosses.[17] 70

Pasi. Sure, whosoever wrote it, the moral is excellent, and worthy to be written in letters of gold. But to the purpose! I think you shall never recover the wealth that you lost at Otranto.

Cle. I think I have doubled it, or rather made it four times as much.* But, indeed, I lost mine only son there, a child of five years old.

Pasi. Oh, great pity!

Cle. Yea, I had rather have lost all the goods in the world. 80

Pasi. Alas! alas! by God! And grafts of such a stock are very gayson[18] in these days.

Cle. I know not whether he were slain, or the Turks took him and kept him as a bondslave.

Pasi. Alas, I could weep for compassion! But there is no remedy but patience. You shall get many by this young damsel, with the grace of God.

Cle. Yea, if I get her.

Pasi. Get her? Why doubt you of that?

Cle. Why? Her father holds me off with delays, so that I must needs doubt. 91

Pasi. Content yourself, sir. He is a wise man and desirous to place his daughter well. He will not be too

* *Another suppose.*

I.ii.

 [1] *dames:* ladies.

 [2] *oversee . . . tables:* be cuckolded (metaphor from backgammon, known as "tables"). [3] *perfit:* perfect.

 [4] *tells:* counts.

 [5] *chiromancer:* adept at chiromancy or palmistry.

 [6] *infract:* unbroken. [7] *bibbler:* imbiber.

 [8] *mount of Venus:* portending sexual prowess.

 [9] *contentation:* satisfaction. [10] *bravely:* with great show.

 [11] *after:* thereafter. [12] *reading:* lecturing.

 [13] *pleading:* at law. [14] *pickling:* trifling.

 [15] *boisterous bags:* massive pouches that contained the back hair of the wig; because the pouches were generally small, the adjective suggests greed for money. [16] *roist:* riot.

 [17] *glosses:* legal commentaries. [18] *gayson:* rare.

rash in his determination; he will think well of the matter. And let him think, for the longer he thinketh, the more good of you shall he think. Whose wealth, whose virtue, whose skill, or whose estimation can he compare to yours in this city?

Cle. And hast thou not told him that I would make his daughter a dower of two thousand ducats? 100

Pasi. Why, even now. I came but from thence since.[19]

Cle. What said he?

Pasi. Nothing but that Erostrato had proffered the like.

Cle. Erostrato? How can he make any dower, and his father yet alive?

Pasi. Think you I did not tell him so? Yes, I warrant you, I forgot nothing that may furder[20] your cause. And doubt you not, Erostrato shall never have her— unless it be in a dream. 111

Cle. Well, gentle Pasiphilo, go thy ways and tell Damon I require nothing but his daughter; I will none of his goods; I shall enrich her of mine own; and, if this dower of two thousand ducats seem not sufficient, I will make it five hundreth more, yea, a thousand, or what- soever he will demand, rather than fail. Go to, Pasi- philo! Show thyself friendly in working this feat for me; spare for no cost. Since I have gone thus far, I will be loath to be outbidden. Go! 120

Pasi. Where shall I come to you again?

Cle. At my house.

Pasi. When?

Cle. When thou wilt.

Pasi. Shall I come at dinner time?

Cle. I would bid thee to dinner, but it is a saint's even, which I have ever fasted.

Pasi. [*Aside*] Fast till thou famish!

Cle. Hark!

Pasi. [*Aside*] He speaketh of a dead man's fast.[21]

Cle. Thou hearest me not. 131

Pasi. [*Aside*] Nor thou understandest me not.

Cle. I dare say thou art angry I bid thee not to din- ner, but come if thou wilt. Thou shalt take such as thou findest.

Pasi. What! think you I know not where to dine?

Cle. Yes, Pasiphilo, thou art not to seek.[22]

Pasi. No, be you sure; there are enow will pray[23] me.

Cle. That I know well enough, Pasiphilo. But thou canst not be better welcome in any place than to me. I will tarry for thee. 141

[19] *since:* just now. [20] *furder:* further.
[21] *dead man's fast:* eternal, describing both Cleander's absolute parsimony and his hypocrisy (he never leaves off eating though he pretends to fast).
[22] *to seek:* wanting in that. [23] *pray:* invite.
[24] *Rood:* Cross. [25] *L.:* remains.

I.iii.
[1] *Dulippo:* who does not appear until later in the scene.
[2] *because:* as the reason why.
[3] *points . . . hose:* laces to hold up my breeches.
[4] *wise case:* sorry state. [5] *mo:* more.
[6] *Domine:* Master. [7] *caters:* caterers.
[8] *joyly:* jolly. [9] *How:* What do you mean.

Pasi. Well, since you will needs, I will come.

Cle. Dispatch then, and bring no news but good.

Pasi. [*Aside*] Better than my reward, by the Rood![24]

CLEANDER *exit;* PASIPHILO *restat.*[25]

I.iii

PASIPHILO, DULIPPO.[1]

Pasi. Oh, miserable, covetous wretch! He findeth an excuse by St. Nicholas' fast, because[2] I should not dine with him—as though I should dine at his own dish! He maketh goodly feasts, I promise you! It is no wonder though he think me bound unto him for my fare; for, over and besides that his provision is as scant as may be, yet there is great difference between his diet and mine. I never so much as sip of the wine that he tasteth; I feed at the board's end with brown bread. Marry, I reach always to his own dish, for there are 10 no more but that only on the table. Yet he thinks that for one such dinner I am bound to do him all the service that I can, and thinks me sufficiently rewarded for all my travail with one such festival promotion! And yet, peradventure, some men think I have great gains under him, but I may say, and swear, that this dozen year I have not gained so much in value as the points at my hose,[3] which are but three, with codpiece-point and all. He thinks that I may feed upon his favor and fair words, but, if I could not otherwise provide for 20 one, Pasiphilo were in a wise case.[4] Pasiphilo hath mo[5] pastures to pass in than one, I warrant you! I am of household with this scholar Erostrato, his rival, as well as with Domine[6] Cleander—now with the one, and then with the other, according as I see their caters[7] provide good cheer at the market—and I find the means so to handle the matter that I am welcome to both. If the one see me talk with the other, I make him believe it is to hearken news in the furtherance of his cause, and thus I become a broker on both sides. 30 Well, let them both apply the matter as well as they can, for indeed I will travail for none of them both, yet will I seem to work wonders on each hand. But is not this one of Damon's servants that cometh forth? It is. Of him I shall understand where his master is. Whither goeth this joyly[8] gallant?

[*Enter* DULIPPO *from* Damon's house.]

Dul. I come to seek somebody that may accompany my master at dinner. He is alone and would fain have good company. 39

Pasi. Seek no further. You could never have found one better than me.

Dul. I have no commission to bring so many.

Pasi. How,[9] many? I will come alone.

Dul. How canst thou come alone that hast con- tinually a legion of ravening wolves within thee?

Pasi. Thou dost, as servants commonly do, hate all that love to visit their masters.

Dul. And why?

Pasi. Because they have too many teeth, as you think. 50

Dul. Nay, because they have too many tongues.

Pasi. Tongues? I pray you, what did my tongue ever hurt you?

Dul. I speak but merrily with you, Pasiphilo. Go in; my master is ready to dine.

Pasi. What, dineth he so early?

Dul. He that riseth early, dineth early.

Pasi. I would I were his man. Master Doctor never dineth till noon, and how delicately then, God knoweth! I will be bold to go in, for I count myself bidden. 60

Dul. You were best so.

<center>PASIPHILO <i>intrat;</i> [10] DUL[IPPO] <i>restat.</i></center>

Hard hap had I when I first began this unfortunate enterprise! For I supposed the readiest medicine to my miserable affects [11] had been to change name, clothes, and credit with my servant, and to place myself in Damon's service; thinking that, as shivering cold by glowing fire, thirst by drink, hunger by pleasant repasts, and a thousand such like passions find remedy by their contraries, so my restless desire might have found quiet by continual contemplation. But, alas, I find 70 that only love is unsatiable, for, as the fly playeth with the flame till at last she is cause of her own decay, so the lover that thinketh with kissing and colling [12] to content his unbridled appetite, is commonly seen the only cause of his own consumption. Two years are now past since, under the color [13] of Damon's service, I have been a sworn servant to Cupid—of whom I have received as much favor and grace as ever man found in his service. I have free liberty at all times to behold my desired, to talk with her, to embrace her, yea, be it 80 spoken in secret, to lie with her. I reap the fruits of my desire; yet, as my joys abound, even so my pains increase. I fare like the covetous man that, having all the world at will, is never yet content. The more I have, the more I desire. Alas! what wretched estate have I brought myself unto, if in the end of all my far fetches [14] she be given by her father to this old doting doctor, this buzzard, this bribing villain, that by so many means seeketh to obtain her at her father's hands! I know she loveth me best of all others. But what may that 90 prevail when perforce she shall be constrained to marry another? Alas! the pleasant taste of my sugared joys doth yet remain so perfect in my remembrance that the least sop of sorrow seemeth more sour than gall in my mouth. If I had never known delight, with better contentation might I have passed these dreadful dolors. And if this old *mumpsimus* [15]—whom the pox consume! —should win her, then may I say, "Farewell the pleasant talk, the kind embracings, yea, farewell the 100 sight of my Polynesta!" For he, like a jealous wretch, will pen her up, that I think the birds of the air shall not win the sight of her. I hoped to have cast a block in his way by the means that my servant, who is supposed to be Erostrato and with my habit and credit is well esteemed, should proffer himself a suitor—at the least to countervail the doctor's proffers. But my master, knowing the wealth of the one and doubting the state [16] of the other, is determined to be fed no longer with fair words, but to accept the doctor, whom he right well knoweth, for his son-in-law. Well, my 110

servant promised me yesterday to devise yet again some new conspiracy to drive Master Doctor out of conceit, and to lay a snare that the fox himself might be caught in! What it is, I know not, nor I saw him not since he went about it. I will go see if he be within, that at least if he help me not, he may yet prolong my life for this once. But here cometh his lackey. Ho, Jackpack, where is Erostrato?

<center>Here must CRAPINE <i>be coming in with a basket and a stick in his hand.</i></center>

I.iv

<center>CRAPINO, <i>the lackey;</i> DULIPPO.</center>

Cra. Erostrato? Marry, he is in his skin.

Dul. Ah, whoreson [1] boy! I say, how shall I find Erostrato?

Cra. Find [2] him? How mean you—by the week or by the year?

Dul. You crackhalter! [3] If I catch you by the ears, I shall make you answer me directly.

Cra. Indeed?

Dul. Tarry me a little.

Cra. In faith, sir, I have no leisure. 10

Dul. Shall we try who can run fastest?

Cra. Your legs be longer than mine; you should have given me the advantage.

Dul. Go to! Tell me where is Erostrato?

Cra. I left him in the street, where he gave me this casket—this basket, I would have said—and bade me bear it to Dalio, and return to him at the Duke's palace.

Dul. If thou see him, tell him I must needs speak with him immediately; or abide awhile! I will go seek him myself rather than be suspected by going to his house. 21

<center>CRAPINO <i>departeth, and</i> DULIPPO <i>also; after,</i>
DULIPPO <i>cometh in again seeking</i> EROSTRATO.</center>

<center>FINIS ACTUS I.</center>

<center># ACT TWO</center>

<center>## SCENE ONE</center>

<center>DULIPPO, EROSTRATO. [1]</center>

Dul. I think if I had as many eyes as Argus [2] I could not have sought a man more narrowly in every street

10 *L.:* goes in. 11 *affects:* desires.
12 *colling:* embracing. 13 *color:* pretense.
14 *far fetches:* clever tricks.
15 *mumpsimus:* ignoramus, stubborn old fogey, alluding to an old anecdote about an ignorant priest's error for "sumpsimus." 16 *state:* estate.

I.iv
 1 *whoreson:* a generalized term of contempt—"rascal."
 2 *Find:* with a pun on "board," furnish with food and lodging. 3 *crackhalter:* gallows bird.

II.i
 1 *Erostrato:* who enters later.
 2 *Argus:* fabled as "all-seeing" because of his hundred eyes.

and every by-lane. There are not many gentlemen, scholars, nor merchants in the city of Ferrara but I have met with them, except him. Peradventure he is come home another way. But look where he cometh at the last!

[*Enter* EROSTRATO.]

Ero. In good time have I spied my good master!

Dul. For the love of God, call me "Dulippo," not "master." Maintain the credit that thou hast hitherto kept, and let me alone.[3] 11

Ero. Yet, sir, let me sometimes do my duty unto you, especially where nobody heareth.

Dul. Yea, but so long the parrot useth to cry "knap"[4] in sport that at the last she calleth her master "knave" in earnest; so long you will use to call me "master," that at the last we shall be heard. What news?

Ero. Good!

Dul. Indeed? 19

Ero. Yea, excellent. We have as good as won the wager.

Dul. Oh, how happy were I if this were true.

Ero. Hear you me. Yesternight in the evening I walked out and found Pasiphilo, and with small entreating I had him home to supper; where, by such means as I used, he became my great friend, and told me the whole order of our adversary's determination,[5] yea, and what Damon doth intend to do also; and hath promised me that from time to time, what he can espy he will bring me word of it. 30

Dul. I cannot tell whether you know him or no. He is not to trust unto—a very flattering and a lying knave.

Ero. I know him very well; he cannot deceive me. And this that he hath told me I know must needs be true.

Dul. And what was it in effect?

Ero. That Damon had purposed to give his daughter in marriage to this* doctor upon the dower that he hath proffered. 39

Dul. Are these your good news, your excellent news?

Ero. Stay awhile; you will understand me before you hear me.

Dul. Well, say on.

Ero. I answered to that, I was ready to make her the like dower.

Dul. Well said.

Ero. Abide; you hear not the worst yet.

Dul. O God, is there any worse behind?

Ero. Worse? Why, what assurance could you suppose that I might make without some special consent from Philogano, my father? 51

Dul. Nay, you can tell; you are better scholar than I.

Ero. Indeed, you have lost your time, for the books that you toss[6] nowadays treat of small science!

* *Another suppose.*

[3] *let me alone:* leave the rest to me.
[4] *knap:* knave. [5] *determination:* plan.
[6] *toss:* con. [7] *admiration:* look of wonder.
[8] *County:* Count. [9] *charettes:* carts.

Dul. Leave thy jesting and proceed.

Ero. I said, further, that I received letters lately from my father, whereby I understood that he would be here very shortly to perform all that I had proffered. Therefore I required him to request Damon on my behalf that he would stay his promise to the doctor for a fortnight or more. 61

Dul. This is somewhat yet, for by this means I shall be sure to linger and live in hope one fortnight longer. But, at the fortnight's end when Philogano cometh not, how shall I then do? Yea, and though he came, how may I any way hope of his consent, when he shall see that to follow this amorous enterprise I have set aside all study, all remembrance of my duty, and all dread of shame? Alas, alas, I may go hang myself! 69

Ero. Comfort yourself, man, and trust in me. There is a salve for every sore, and, doubt you not, to this mischief we shall find a remedy.

Dul. O friend, revive me, that hitherto, since I first attempted this matter, have been continually dying.

Ero. Well, hearken awhile then. This morning I took my horse and rode into the fields to solace myself; and, as I passed the ford beyond St. Anthony's Gate, I met at the foot of the hill a gentleman riding with two or three men; and, as methought by his habit and his looks, he should be none of the wisest. He saluted 80 me, and I him. I asked him from whence he came, and whither he would. He answered that he had come from Venice, then from Padua, now was going to Ferrara, and so to his country, which is Siena. As soon as I knew him to be a Sienese, suddenly lifting up mine eyes, as it were with an admiration,[7] I said unto him, "Are you a Sienese, and come to Ferrara?" "Why not?" said he. Quoth I, half and more with a trembling voice, "Know you the danger that should ensue if you be known in Ferrara to be a Sienese?" He, more than half 90 amazed, desired me earnestly to tell him what I meant.

Dul. I understand not whereto this tendeth.

Ero. I believe you. But hearken to me.

Dul. Go to, then.

Ero. I answered him in this sort: "Gentleman, because I have heretofore found very courteous entertainment in your country, being a student there, I accompt myself, as it were, bound to a Sienese, and therefore if I knew of any mishap towards any of that country, God forbid but I should disclose it. And 100 I marvel that you knew not of the injury that your countrymen offered this other day to the ambassadors of County[8] Hercules."

Dul. What tales he telleth me! What appertain these to me?

Ero. If you will hearken awhile, you shall find them no tales, but that they appertain to you more than you think for.

Dul. Forth. 109

Ero. I told him further, these ambassadors of County Hercules had divers mules, wagons, and charettes,[9] laden with divers costly jewels, gorgeous furniture, and other things, which they carried as presents, passing that way, to the King of Naples; the which were not only stayed in Siena by the officers

whom you call customers,[10] but searched, ransacked, tossed, and turned, and in the end exacted for tribute, as if they had been the goods of a mean merchant.

Dul. Whither the devil will he? Is it possible that this gear appertain anything to my cause? I find neither head nor foot in it. 121

Ero. Oh, how impatient you are! I pray you, stay awhile.

Dul. Go to[11] yet awhile, then.

Ero. I proceeded that upon these causes the duke sent his chancellor to declare the case unto the senate there, of whom he had the most uncourteous answer that ever was heard; whereupon he was so enraged with all of that country that for revenge he had sworn to spoil[12] as many of them as ever should come to 130 Ferrara, and to send them home in their doublet and their hose.

Dul. And, I pray thee, how couldest thou upon the sudden devise or imagine such a lie, and to what purpose?

Ero. You shall hear by and by[13] a thing as fit for our purpose as any could have happened.

Dul. I would fain hear you conclude.

Ero. You would fain leap over the stile before you come at the hedge. I would you had heard me, and 140 seen the gestures that I enforced to make him believe this!

Dul. I believe you, for I know you can counterfeit well.

Ero. Further, I said, the duke had charged, upon great penalties, that the innholders and victualers should bring word daily of as many Sieneses as came to their houses. The gentleman, being, as I guessed at the first, a man of small *sapientia*,[14] when he heard these news, would have turned his horse another way. 150

Dul. By likelihood he was not very wise when he would believe that of his country which, if it had been true, every man must needs have known it.

Ero. Why not, when he had not been in his country for a month past, and I told him this had happened within these seven days?

Dul. Belike[15] he was of small experience.

Ero. I think, of as little as may be. But best of all for our purpose, and good adventure[16] it was, that I met with such an one. Now hearken, I pray you. 160

Dul. Make an end, I pray thee.

Ero. He, as I say, when he heard these words, would have turned the bridle. And I, feigning a countenance as though I were somewhat pensive and careful for him, paused awhile, and after, with a great sigh, said to him: "Gentleman, for the courtesy that, as I said, I have found in your country, and because your affair shall be the better dispatched, I will find the means to lodge you in my house, and you shall say to every man that you are a Sicilian of Cathanea, your name Philogano, father to me—that am indeed of that country and 171 city—called here Erostrato. And I, to pleasure you, will during your abode here do you reverence as you were my father."

Dul. Out upon me! What a gross-headed fool am I! Now I perceive whereto this tale tendeth.

Ero. Well, and how like you of it?

Dul. Indifferently.[17] But one thing I doubt.

Ero. What is that? 179

Dul. Marry, that when he hath been here two or three days, he shall hear of every man that there is no such thing between the Duke and the town of Siene.

Ero. As for that, let me alone. I do entertain and will entertain him so well that within these two or three days I will disclose unto him all the whole matter, and doubt not but to bring him in for performance of as much as I have promised to Damon. For what hurt can it be to him, when he shall bind[18] a strange name and not his own? 189

Dul. What! Think you he will be entreated to stand bound for a dower of two thousand ducats by the year?

Ero. Yea, why not, if it were ten thousand, as long as he is not indeed the man that is bound?

Dul. Well, if it be so, what[19] shall we be the nearer to our purpose?

Ero. Why, when we have done as much as we can, how can we do any more?

Dul. And where have you left him?

Ero. At the inn, because of his horses. He and his men shall lie in my house. 200

Dul. Why brought you him not with you?

Ero. I thought better to use your advice first.

Dul. Well, go take him home. Make him all the cheer you can; spare for no cost. I will allow it.

Ero. Content. Look where he cometh.

Dul. Is this he? Go meet him. By my troth, he looks even like a good soul! He that fisheth for him might be sure to catch a cod's head![20] I will rest here awhile to decipher[21] him.

EROSTRATO *espieth the* SIENESE *and goeth towards him;* DULIPPO *standeth aside.*

II.ii

The SIENESE; PAQUETTO *and* PETRUCHIO, *his servants;* EROSTRATO.

Sien. He that traveleth in this world passeth by many perils.

Paq. You say true, sir. If the boat had been a little more laden this morning at the ferry, we had been all drowned, for I think there are none of us that could have swum.*

Sien. I speak not of that.

Paq. Oh, you mean the foul way that we had since we came from this Padua. I promise you, I was afraid

* *Another suppose.*

[10] *customers:* customs. [11] *Go to:* Continue.
[12] *spoil:* plunder. [13] *by and by:* now.
[14] *L.:* wisdom. [15] *Belike:* Perhaps.
[16] *adventure:* chance. [17] *Indifferently:* Pretty well.
[18] *bind:* make liable for the fulfillment of an obligation; by signing a marriage contract and pledging a dowry, he commits the name he signs, not his own. [19] *what:* how.
[20] *cod's head:* fool. [21] *decipher:* read (make him out).

twice or thrice that your mule would have lien[1] fast in
the mire. 11

Sien. Jesu, what a blockhead thou art! I speak of the
peril we are in presently[2] since we came into this city.

Paq. A great peril, I promise you, that we were no
sooner arrived but you found a friend that brought you
from the inn and lodged you in his own house!

Sien. Yea, marry, God reward the gentle young man
that we met, for else we had been in a wise case by this
time. But have done with these tales.* And take you
heed, and you also, sirrah, take heed that none of 20
you say we be Sieneses; and remember that you call me
Philogano of Cathanea.

Paq. Sure, I shall never remember these outlandish
words! I could well remember Haccanea.[3]

Sien. I say, "Cathanea," and not "Haccanea," with
a vengeance![4]

Paq. Let another name it, then, when need is, for I
shall never remember it.

Sien. Then hold thy peace, and take heed thou name
not Siene. 30

Paq. How say you if I feign myself dumb, as I did
once in the house of Crisobolus?

Sien. Do as thou thinkest best.

[EROSTRATO *advances.*]

But look where cometh the gentleman whom we are
so much bound unto.

Ero. Welcome, my dear father Philogano.

Sien. Gramercy,[5] my good son Erostrato.

Ero. That is well said. Be mindful of your tongue,
for these Ferrareses be as crafty as the devil of hell. 39

Sien. No, no; be you sure we will do as you have
bidden us!

Ero. For, if you should name Siene, they would
spoil you immediately, and turn you out of the town
with more shame than I would should befall you for a
thousand crowns.

Sien. I warrant you, I was giving them warning as I
came to you; and I doubt not but they will take good
heed.

Ero. Yea, and trust not the servants of my household
too far, for they are Ferrareses all, and never knew 50
my father, nor came never in Sicilia.—This is my house.
Will it please you to go in? I will follow.

They go in. DULIPPO *tarrieth, and espieth the*
Doctor coming in with his Man.

* *A doltish suppose.*

II.ii.
 [1] *lien:* lain. [2] *presently:* now.
 [3] *Haccanea:* Editors conjecture a pun on "hackney"
(prostitute). [4] *vengeance:* curse.
 [5] *Gramercy:* Thanks ("May God reward you greatly").
II.iii.
 [1] *side:* large, long.
 [2] *duck eggs:* ducats, coin; and almost surely with a sexual
entendre, though lexical authority is unavailable.
 [3] *lobcock:* lubber.
II.iv.
 [1] *harlotry shotterell:* worthless pike. [2] *spurlings:* smelts.
 [3] *stance:* distance. [4] *since:* ago.

II.iii

DULIPPO *alone.*

Dul. This gear hath had no evil beginning. If it con-
tinue so and fall to happy end! But is not this the silly
doctor with the side[1] bonnet—the doting fool that dare
presume to become a suitor to such a peerless paragon?
Oh, how covetousness doth blind the common sort of
men! Damon, more desirous of the dower than mindful
of his gentle and gallant daughter, hath determined to
make him his son-in-law, who for his age may be his
father-in-law, and hath greater respect to the abundance
of goods than to his own natural child. He beareth 10
well in mind to fill his own purse, but he little remem-
bereth that his daughter's purse shall be continually
empty—unless Master Doctor fill it with double duck
eggs.[2] Alas, I jest, and have no joy! I will stand here
aside and laugh a little at this lobcock.[3]

DULIPPO *espieth the* Doctor *and his* Man *coming.*

II.iv

CARION, *the* doctor's man; CLEANDER;
DULIPPO.

Car. Master, what the devil mean you to go seek
guests at this time of the day? The mayor's officers
have dined ere this time, which are alway the last in the
market.

Cle. I come to seek Pasiphilo, to the end he may dine
with me.

Car. As though six mouths, and the cat for the
seventh, be not sufficient to eat an harlotry shotterell,[1] a
pennyworth of cheese, and half a score spurlings![2] This
is all the dainties you have dressed for you and your
family. 11

Cle. Ah, greedy gut, art thou afeard thou shalt want?

Car. I am afeared indeed! It is not the first time I
have found it so.

Dul. [*Aside*] Shall I make some sport with this
gallant? What shall I say to him?

Cle. Thou art afeard, belike, that he will eat thee and
the rest.

Car. Nay, rather that he will eat your mule, both
hair and hide. 20

Cle. Hair and hide? And why not flesh and all?

Car. Because she hath none. If she had any flesh, I
think you had eaten her yourself by this time.

Cle. She may thank you, then, for your good atten-
dance.

Car. Nay, she may thank you for your small allow-
ance.

Dul. [*Aside*] In faith, now, let me alone.

Cle. Hold thy peace, drunken knave, and espy me
Pasiphilo. 30

Dul. [*Aside*] Since I can do no better, I will set such a
stance[3] between him and Pasiphilo that all this town
shall not make them friends.

Car. Could you not have sent to seek him, but you
must come yourself? Surely you come for some other
purpose, for, if you would have had Pasiphilo to dinner,
I warrant you he would have tarried here an hour since.[4]

Cle. Hold thy peace! Here is one of Damon's servants.* Of him I shall understand where he is. Good fellow, art not thou one of Damon's servants? 40

Dul. Yes, sir, at your commandment.[5]

Cle. Gramercy. Tell me, then, hath Pasiphilo been there this day or no?

Dul. Yes, sir, and I think he be there still. Ah, ah, ah!

Cle. What[6] laughest thou?

Dul. At a thing that every man may not laugh at.

Cle. What?

Dul. Talk that Pasiphilo had with my master this day.

Cle. What talk, I pray thee? 50

Dul. I may not tell it.

Cle. Doth it concern me?

Dul. Nay, I will say nothing.

Cle. Tell me.

Dul. I can say no more.

Cle. I would but know if it concern me, I pray thee tell me.

Dul. I would tell you if I were sure you would not tell it again. 59

Cle. Believe me, I will keep it close.[7] Carion, give us leave a little; go aside.

[CARION *stands aside.*]

Dul. If my master should know that it came by me, I were better die a thousand deaths.

Cle. He shall never know it. Say on.

Dul. Yea, but what assurance shall I have?

Cle. I lay thee my faith and honesty in pawn.

Dul. A pretty pawn! The fulkers[8] will not lend you a farthing on it.

Cle. Yea, but amongst honest men it is more worth than gold. 70

Dul. Yea, marry, sir, but where be they? But will you needs have me tell it unto you?

Cle. Yea, I pray thee, if it anything appertain to me.

Dul. Yes, it is of you. And I would gladly tell it you, because I would not have such a man of worship so scorned by a villain ribald.[9]

Cle. I pray thee tell me then.

Dul. I will tell you, so that you will swear never to tell it to Pasiphilo, to my master, nor to any other body.

Car. [*Aside*] Surely it is some toy[10] devised to get some money of him. 81

Cle. I think I have a book here.

Car. [*Aside*] If he knew him as well as I, he would never go about it, for he may as soon get one of his teeth from his jaws with a pair of pinchers as a penny out of his purse with such a conceit.

Cle. Here is a letter will serve the turn. I swear to thee by the contents hereof never to disclose it to any man. 89

Dul. I will tell you. I am sorry to see how Pasiphilo doth abuse you, persuading you that always he laboreth for you, where, indeed, he lieth on[11] my master continually, as it were with tooth and nail, for a stranger, a scholar, born in Sicilia. They call him Roscus, or

* *Another suppose.*

Arsekiss—he hath a mad name; I can never hit upon it.

Cle. And thou reckonest it as madly. Is it not Erostrato?

Dul. That same. I should never have remembered it. And the villainy[12] speaketh all the evil of you that can be devised. 100

Cle. To whom?

Dul. To my master; yea, and to Polynesta herself sometimes.

Cle. Is it possible? Ah, slave! And what saith he?

Dul. More evil than I can imagine: that you are the miserablest and most niggardly man that ever was.

Cle. Sayeth Pasiphilo so by me?

Dul. And that as often as he cometh to your house he is like to die for hunger, you fare so well.

Cle. That the devil take him else! 110

Dul. And that you are the testiest[13] man, and most divers[14] to please, in the whole world, so that he cannot please you unless he should even kill himself with continual pain.

Cle. Oh, devilish tongue!

Dul. Furthermore, that you cough continually and spit, so that a dog cannot abide it.

Cle. I never spit nor cough more than thus—uho, uho; and that but since I caught this murre.[15] But who is free from it? 120

Dul. You say true, sir. Yet further, he saith your armholes stink, your feet worse than they, and your breath worst of all.

Cle. If I quite[16] him not for this gear!

Dul. And that you are bursten in the cods.[17]

Cle. Oh, villain! He lieth! And if I were not in the street thou shouldest see them.

Dul. And he saith that you desire this young gentlewoman as much for other men's pleasure as for your own. 130

Cle. What meaneth he by that?

Dul. Peradventure that by her beauty you would entice many young men to your house.

Cle. Young men? To what purpose?

Dul. Nay, guess you that.

Cle. Is it possible that Pasiphilo speaketh thus of me?

Dul. Yea, and much more.

Cle. And doth Damon believe him?

Dul. Yea, more than you would think; in such sort that long ere this he would have given you a flat 140 repulse, but Pasiphilo entreated him to continue you a suitor for his advantage.

Cle. How for his advantage?

Dul. Marry, that during your suit he might still have some reward for his great pains.

Cle. He shall have a rope, and yet that is more than

[5] *commandment:* early editions read "knamandement."
[6] *What:* Why. [7] *close:* secret.
[8] *fulkers:* moneylenders (from German banking house of Fugger). [9] *ribald:* scoundrel.
[10] *toy:* trick. [11] *lieth on:* puts forward.
[12] *villainy:* villain. [13] *testiest:* most irritable.
[14] *divers:* diverse; hence "changeable."
[15] *murre:* catarrh. [16] *quite:* requite.
[17] *cods:* scrotum.

he deserveth. I had thought to have given him these hose when I had worn them a little nearer, but he shall have a &c.[18] 149

Dul. In good faith, sir, they were but lost on him. Will you anything else with me, sir?

Cle. Nay, I have heard too much of[19] thee already.

Dul. Then I will take my leave of you.

Cle. Farewell! But tell me, may I not know thy name?

Dul. Sir, they call me Foul-fall-you.

Cle. An ill-favored name, by my troth! Art thou this countryman?[20]

Dul. No, sir, I was born by a castle men call Scab-catch-you. Fare you well, sir! 160

[*Exit.*]

Cle. Farewell! O God, how have I been abused! What a spokesman! What a messenger had I provided!

Car. Why, sir, will you tarry for Pasiphilo till we die for hunger?

Cle. Trouble me not. That the devil take you both!

Car. [*Aside*] These news, whatsoever they be, like him not.

Cle. Art thou so hungry yet? I pray to God thou be never satisfied! 169

Car. By the Mass, no more I shall, as long as I am your servant.

Cle. Go, with mischance!

Car. Yea, and a mischief to you and to all such covetous wretches!

[*Exeunt.*]

FINIS ACTUS II.

ACT THREE

SCENE ONE

DALIO, *the cook;* CRAPINE, *the lackey;* EROSTRATO; DULIPPO.[1]

Dal. By that time we come to the house I trust that of these twenty eggs in the basket we shall find but very few whole. But it is a folly to talk to him. What the devil! Wilt thou never lay that stick out of thy hand? He fighteth with the dogs, beateth the bears; at every-thing in the street he findeth occasion to tarry. If he spy a slipstring[2] by the way—such another as himself, a page, a lackey, or a dwarf—the devil of hell cannot hold him in chains but he will be doing with him. I cannot go two steps but I must look back for my yonker. Go 10

[18] *&c.:* Presumably the actor says or does something obscene. [19] *of:* from.

[20] *this countryman:* of this country.

III.i.

[1] *Erostrato; Dulippo:* who come on later.

[2] *slipstring:* one who deserves to be hanged.

[3] *haltersick:* haltersack, gallows bird.

[4] *horned:* familiar joke on the cuckold's horns.

[5] *L.:* enter unexpectedly (though not, as subsequent business makes clear, together). [6] *rule:* misrule.

[7] *clear as glass:* transparent; hence "empty."

[8] *against:* in anticipation of the time when.

[9] *school point:* sharp lesson. [10] *L.:* horns.

to, haltersick![3] If you break one egg, I may chance break &c.

Cra. What will you break? Your nose in mine, &c.?

Dal. Ah, beast!

Cra. If I be a beast, yet I am no horned[4] beast.

Dal. Is it even so? Is the wind in that door? If I were unloaden, I would tell you whether I be a horned beast or no.

Cra. You are alway laden either with wine or with ale. 20

Dal. Ah, spiteful boy! Shall I suffer him?

[*Strikes him.*]

Cra. Ah, cowardly beast, darest thou strike and say never a word?

Dal. Well, my master shall know of this gear. Either he shall redress it or he shall lose one of us.

Cra. Tell him the worst thou canst by me.

EROSTRA[TO] *et* DU[LIPPO] *ex improviso.*[5]

Ero. What noise, what a rule[6] is this?

Cra. Marry, sir, he striketh me because I tell him of his swearing. 29

Dal. The villain lieth deadly! He reviles me because I bid him make haste.

Ero. Holla! no more of this. Dalio, do you make in a readiness those pigeons, stock doves, and also the breast of veal;[7] and let your vessel be as clear as glass against[8] I return, that I may tell you which I will have roasted and which boiled.

[*Exit* DALIO.]

Crapine, lay down that basket and follow me. Oh, that I could tell where to find Pasiphilo!—But look where he cometh that can tell me of him.

DULIPPO *is espied by* EROSTRATO.

Dul. What have you done with Philogano, your father? 41

Ero. I have left him within. I would fain speak with Pasiphilo. Can you tell me where he is?

Dul. He dined this day with my master, but whither he went from thence I know not. What would you with him?

Ero. I would have him go tell Damon that Philogano, my father, is come, and ready to make assurance of as much as he will require. Now shall I teach Master Doctor a school point.[9] He travaileth to none 50 other end but to catch *cornua*,[10] and he shall have them, for, as old as he is, and as many subtleties as he hath learned in the law, he cannot go beyond me one ace.

Dul. O dear friend, go thy ways, seek Pasiphilo, find him out, and conclude somewhat to our contentation.

Ero. But where shall I find him?

Dul. At the feasts, if there be any, or else in the market with the poulters or the fishmongers.

Ero. What should he do with them? 59

Dul. Marry, he watcheth whose caters buy the best meat. If any buy a fat capon, a good breast of veal, fresh salmon, or any such good dish, he followeth to the house, and either with some news or some stale jest, he will be sure to make himself a guest.

Ero. In faith, and I will seek there for him.

Dul. Then must you needs find him, and, when you have done, I will make you laugh.

Ero. Whereat?

Dul. At certain sport I made today with Master Doctor. 70

Ero. And why not now?

Dul. No, it asketh further leisure. I pray thee dispatch and find out Pasiphilo, that honest man.

DULIPPO *tarrieth.* EROSTRATO *goeth out* [*followed by* CRAPINE].

III.ii

DULIPPO *alone.*

Dul. This amorous cause that hangeth in controversy between Domine Doctor and me may be compared to them that play at primero:[1] of whom someone, peradventure, shall leese[2] a great sum of money before he win one stake, and at last, half in anger, shall set up his rest,[3] win it, and after that another, another, and another, till at last he draw the most part of the money to his heap, the other by little and little still diminishing his rest, till at last he be come as near the brink as erst the other was; yet again, peradventure, fortune 10 smiling on him, he shall, as it were by piecemeal, pull out the guts of his fellow's bags, and bring him barer than he himself was tofore;[4] and so in play continue still, fortune favoring now this way, now that way, till at last the one of them is left with as many crosses[5] as God hath brethren.[6] Oh, how often have I thought myself sure of the upper hand herein!—but I triumphed before the victory. And then how oft again have I thought the field lost! Thus have I been tossed, now 20 over, now under, even as fortune list to whirl the wheel, neither sure to win nor certain to lose the wager. And this practice that now my servant hath devised, although hitherto it hath not succeeded amiss,[7] yet can I not count myself assured of it; for I fear still that one mischance or other will come and turn it topsy-turvy. But look where my master cometh.

DAMON, *coming in, espieth* DULIPPO *and calleth him.*

III.iii

DAMON, DULIPPO, NEVOLA, *and two* Servants.[1]

Dam. Dulippo!

Dul. Here, sir.

Dam. Go in and bid Nevola and his fellows come hither, that I may tell them what they shall go about. And go you into my study; there upon the shelf you shall find a roll of writings which John of the Dean[2] made to my father when he sold him the Grange farm, endorsed with both their names. Bring it hither to me.

Dul. It shall be done, sir. 9
[*Exit.*]

Dam. Go. I will prepare other manner of writings for you than you are aware of. O fools, that trust any man but themselves nowadays! O spiteful fortune! Thou dost me wrong, I think, that from the depth of

hell-pit thou hast sent me this servant to be the subversion of me and all mine!—Come hither, sirs, and hear what I shall say unto you.

[*The* Servants *come in.*]

Go into my study, where you shall find Dulippo. Step to him all at once, take him, and, with a cord that I have laid on the table for the nonce,[3] bind him hand and foot, carry him into the dungeon under the stairs, 20 make fast the door, and bring me the key—it hangeth by upon a pin on the wall. Dispatch, and do this gear as privily as you can. And thou, Nevola, come hither to me again with speed.

Nev. Well, I shall.

[*Exit with* Servants.]

Dam. Alas, how shall I be revenged of this extreme despite?[4] If I punish my servant according to his devilish deserts, I shall heap further cares upon mine own head. For to such detestable offenses no punishment can seem sufficient but only death, and in 30 such cases it is not lawful for a man to be his own carver. The laws are ordained, and officers appointed to minister justice for the redress of wrongs; and, if to the potestates[5] I complain me, I shall publish mine own reproach[6] to the world. Yea, what should it prevail[7] me to use all the punishments that can be devised? The thing, once done, cannot be undone. My daughter is deflowered, and I utterly dishonested.[8] How can I then wipe that blot off my brow? And on whom shall I seek revenge? Alas, alas, I myself have been the cause of 40 all these cares, and have deserved to bear the punishment of all these mishaps! Alas, I should not have committed my dearest darling in custody to so careless a creature as this old nurse, for we see by common proof that these old women be either peevish[9] or pitiful, either easily inclined to evil or quickly corrupted with bribes and rewards. O wife, my good wife, that now liest cold in the grave, now may I well bewail the want of thee, and, mourning, now may I bemoan that I miss thee! If thou hadst lived, such was thy 50 government of the least things that thou wouldest prudently have provided for the preservation of this pearl. A costly jewel may I well accompt[10] her, that hath been my chief comfort in youth, and is now become the corrosive of mine age! O Polynesta, full evil hast thou requited the clemency of thy careful father! And yet to excuse thee guiltless before God and to condemn thee guilty before the world, I can count none other but my

III.ii.
 [1] *primero:* cards. [2] *leese:* lose.
 [3] *rest:* hand in primero (stake everything on one play).
 [4] *tofore:* before.
 [5] *crosses:* coins (marked with a cross).
 [6] *brethren:* God has none.
 [7] *succeeded amiss:* gone wrong.

III.iii.
 [1] *Nevola . . . Servants:* who enter later.
 [2] *Dean:* Vale, hollow. [3] *nonce:* occasion.
 [4] *despite:* outrage. [5] *potestates:* magistrates.
 [6] *reproach:* shame. [7] *prevail:* avail.
 [8] *dishonested:* dishonored. [9] *peevish:* foolish.
 [10] *accompt:* account.

wretched self the caitiff[11] and causer of all my cares.
For of all the duties that are requisite in human 60
life, only obedience is by the parents to be required of
the child, where, on the other side, the parents are
bound, first to beget them, then to bring them forth,
after to nourish them, to preserve them from bodily
perils in the cradle, from danger of soul by godly
education, to match them in consort[12] inclined to
virtue, to banish them all idle and wanton company, to
allow them sufficient for their sustentation,[13] to cut off
excess (the open gate of sin), seldom or never to smile
on them unless it be to their encouragement in 70
virtue, and finally to provide them marriages in time
convenient, lest, neglected of us, they learn to set either
too much or too little by themselves. Five years are past
since I might have married her, when by continual
excuses I have prolonged it to my own perdition. Alas,
I should have considered she is a collop[14] of my own
flesh. What should I think to make her a princess?
Alas, alas, a poor kingdom have I now caught to endow
her with! It is too true that of all sorrows this is the head
source and chief fountain of all furies: the goods 80
of the world are incertain, the gains[15] to be rejoiced
at, and the loss not greatly to be lamented; only the
children, cast away, cutteth the parents'-throat with the
knife of inward care, which knife will kill me surely—I
make none other accompt.

Damon's Servants come to him again.

III.iv

NEVOLA, DAMON, PASIPHILO.[1]

Nev. Sir, we have done as you bade us, and here is
the key.
Dam. Well, go then, Nevola, and seek Master
Casteling, the jailor; he dwelleth by St. Antony's Gate.
Desire him to lend me a pair of the fetters he useth for
his prisoners, and come again quickly.
Nev. Well, sir.
Dam. Hear you. If he ask what I would do with
them, say you cannot tell. And tell neither him nor any
other what is become of Dulippo. 10
 DAMON goeth out.
Nev. I warrant you, sir.—Fie upon the devil! It is a
thing almost unpossible for a man nowadays to handle
money but the metal will stick on his fingers.* I mar-

* *Another suppose.*

[11] *caitiff:* captive; hence "wretch."
[12] *consort:* company. [13] *sustentation:* sustenance.
[14] *collop:* slice.
[15] *gains:* a qualifying word like "little" has perhaps
dropped out.
III.iv.
[1] *Pasiphilo:* who enters later. [2] *graner:* granary.
[3] *L.:* master of all doing.
[4] *crusado:* coin impressed with a cross.
[5] *L.:* suddenly and unexpectedly enters (from Damon's
house). [6] *on sleep:* asleep. [7] *stale:* cheap lure.
[8] *corn:* horns. [9] *let:* hinder. [10] *quean:* hag.
III.v.
[1] *gossip:* woman friend.

veled alway at this fellow of mine, Dulippo, that of the
wages he received he could maintain himself so bravely
appareled, but now I perceive the cause. He had the
disbursing and receipt of all my master's affairs, the
keys of the graner;[2] Dulippo here, Dulippo there; in
favor with my master, in favor with his daughter—
what would you more? He was *magister factotum.*[3] 20
He was as fine as the crusado,[4] and we silly wretches as
coarse as canvas. Well, behold what it is come to in the
end! He had been better to have done less.

PASI[PHILO] subito et improviso venit.[5]

Pasi. Thou sayst true, Nevola! He hath done too
much, indeed.
Nev. From whence comest thou, in the devil's name?
Pasi. Out of the same house thou camest from, but
not out of the same door.
Nev. We had thought thou hadst been gone long
since. 30
Pasi. When I arose from the table, I felt a rumbling
in my belly, which made me run to the stable, and there
I fell on sleep[6] upon the straw and have lain there ever
since. And thou—whither goest thou?
Nev. My master hath sent me on an errand in great
haste.
Pasi. Whither, I pray thee?
Nev. Nay, I may not tell. Farewell.
 [*Exit.*]
Pasi. As though I need any further instructions! O
God, what news I heard even now, as I lay in the 40
stable! O good Erostrato, and poor Cleander, that have
so earnestly stroven for this damsel! Happy is he that
can get her, I promise you!* He shall be sure of mo
than one at a clap that catcheth her—either Adam or
Eve within her belly. O God, how men may be deceived
in a woman! Who would have believed the contrary
but that she had been a virgin? Ask the neighbors, and
you shall hear very good report of her. Mark her
behaviors, and you would have judged her very
maidenly—seldom seen abroad but in place of 50
prayer and there very devout, and no gazer at outward
sights, no blazer of her beauty above in the windows, no
stale[7] at the door for the bypassers. You would have
thought her a holy young woman. But much good do it
Domine Doctor! He shall be sure to lack no corn[8] in a
dear year, whatsoever he have with her else. I beshrew
me if I let[9] the marriage any way. But is not this the old
scabbed quean[10] that I heard disclosing all this gear to
her master as I stood in the stable ere now? It is she.
Whither goeth, Psiteria? 60

PASIPHILO espieth PSITERIA coming.

III.v

PSITERIA, PASIPHILO.

Psit. To a gossip[1] of mine hereby.
Pasi. What, to tattle of the goodly stir that thou
keptst concerning Polynesta?

* *Another suppose.*

Psit. No, no. But how knew you of that gear?

Pasi. You told me.

Psit. I? When did I tell you?

Pasi. Even now when you told it to Damon. I both saw you and heard you, though you saw not me. A good part, I promise you, to accuse the poor wench, kill the old man with care, over and besides the danger you 10 have brought Dulippo and the nurse unto, and many mo! Fie! fie!

Psit. Indeed, I was to blame, but not so much as you think.

Pasi. And how not so much? Did I not hear you tell?

Psit. Yes, but I will tell you how it came to pass. I have known for a great while that this Dulippo and Polynesta have lien together, and all by the means of the nurse; yet I held my peace and never told it. 20 Now this other day the nurse fell on scolding with me, and twice or thrice called me "drunken old whore" and such names that it was too bad; and I called her "bawd" and told her that I knew well enough how often she had brought Dulippo to Polynesta's bed. Yet all this while I thought not that anybody had heard me; but it befell clean contrary, for my master was on the other side of the wall and heard all our talk, whereupon he sent for me and forced me to confess all that you heard. 30

Pasi. And why wouldest thou tell him? I would not for &c.

Psit. Well, if I had thought my master would have taken it so, he should rather have killed me.

Pasi. Why, how could he take it?

Psit. Alas, it pitieth me to see the poor young woman, how she weeps, wails, and tears her hair, not esteeming her own life half so dear as she doth poor Dulippo's; and her father, he weeps on the other side, that it would pierce an heart of stone with pity. But I must be gone.

Pasi. Go! That the gunpowder consume thee, old trot![2] 42

[*Exeunt.*]

FINIS ACTUS III.

ACT FOUR

SCENE ONE

EROSTRATO, *feigned*[1], [*with* CRAPINO].

Ero. What shall I do? Alas! what remedy shall I find for my rueful estate? What escape or what excuse may I now devise to shift over[2] our subtle supposes? For, though to this day I have usurped the name of my master, and that without check or control of any man, now shall I be openly deciphered, and that in the sight of every man. Now shall it openly be known whether I be Erostrato the gentleman, or Dulippo the servant. We have hitherto played our parts in abusing[3] others, but now cometh the man that will not be 10 abused—the right Philogano, the right father of the right Erostrato. Going to seek Pasiphilo and hearing

that he was at the water gate, behold I espied my fellow Litio, and by and by my old master Philogano setting forth his first step on land. I to fuge,[4] and away hither as fast as I could to bring word to the right Erostrato of his right father Philogano, that to so sudden a mishap some subtle shift might be upon the sudden devised. But what can be imagined to serve the turn, although we had months' respite to beat our brains about it, 20 since we are commonly known—at the least supposed— in this town, he for Dulippo, a slave and servant to Damon, and I for Erostrato, a gentleman and a student? But behold, run, Crapine, to yonder old woman before she get within the doors, and desire her to call out Dulippo. But hear you—if she ask who would speak with him, say thyself and none other.

[EROSTRATO *espieth* PSITERIA *coming, and sendeth his* Lackey *to her.*

IV.ii

CRAPINE, PSITERIA, EROSTRATO, *feigned.*

Cra. Honest woman! you gossip! thou rotten whore! Hearest thou not, old witch?

Psit. A rope stretch your young bones! Either you must live to be as old as I or be hanged while you are young.

Cra. I pray thee, look if Dulippo be within.

Psit. Yes, that he is, I warrant him!

Cra. Desire him, then, to come hither and speak a word with me. He shall not tarry.

Psit. Content yourself; he is otherwise occupied. 10

Cra. Yet tell him so, gentle girl.

Psit. I tell you, he is busy.

Cra. Why, is it such a matter to tell him so, thou crooked crone?

Psit. A rope stretch you, marry![1]

Cra. A pox[2] eat you, marry!

Psit. Thou wilt be hanged, I warrant thee, if thou live to it.

Cra. And thou wilt be burnt, I warrant thee, if the canker[3] consume thee not. 20

Psit. If I come near you, hempstring,[4] I will teach you to sing sol fa![5]

Cra. Come on! And if I get a stone[6] I will scare crows with you.

Psit. Go, with a mischief! I think thou be some devil that would tempt me.

[*Exit.*]

Ero. Crapine! Hear you? Come away. Let her go,

[2] *trot:* slut.

IV.i.

[1] *feigned:* and, as subsequent business makes clear, attended by Crapine. [2] *shift over:* make good.
[3] *abusing:* deceiving. [4] *to fuge:* took flight.

IV.ii.

[1] *marry:* by the Virgin Mary. [2] *pox:* venereal disease.
[3] *canker:* chancre, venereal sore.
[4] *hempstring:* gallows bird. [5] *sol fa:* i.e., in pain.
[6] *get a stone:* pick up a stone, as for throwing(?); find a (specular) stone or mirror; make an idol (in your image).

with a vengeance! Why come you not? Alas, look where my master Philogano cometh! What shall I do? Where shall I hide me? He shall not see me in these 30 clothes, nor before I have spoken with the right Erostrato.

 EROSTRATO *espieth* PHILOGANO *coming and runneth about to hide him.*

IV.iii

PHILOGANO; FERRARESE, *the innkeeper;* LITIO, *a servant.*

Phi. Honest man, it is even so. Be you sure there is no love to be compared like the love of the parents towards their children. It is not long since I thought that a very weighty matter should not have made me come out of Sicilia; and yet now I have taken this tedious toil and travail upon me, only to see my son and to have him home with me.

Fer. By my faith, sir, it hath been a great travail indeed, and too much for one of your age. 9

Phi. Yea, be you sure. I came in company with certain gentlemen of my country, who had affairs to dispatch as far as to Ancona, from thence by water to Ravenna, and from Ravenna hither, continually against the tide.

Fer. Yea, and I think that you had but homely lodging by the way.

Phi. The worst that ever man had. But that was nothing to the stir that the searchers[1] kept with me when I came aboard the ship. Jesus, how often they untrussed my male[2] and ransacked a little capcase[3] 20 that I had, tossed and turned all that was within it, searched my bosom, yea, my breeches, that I assure you I thought they would have flayed me to search between the fell[4] and the flesh for fardings.[5]

Fer. Sure, I have heard no less, and that the merchants bob[6] them sometimes; but they play the knaves still.

Phi. Yea, be you well assured; such an office is the inheritance of a knave, and an honest man will not meddle with it. 30

Fer. Well, this passage shall seem pleasant unto you when you shall find your child in health and well. But, I pray you, sir, why did you not rather send for him into Sicilia than to come yourself, specially since you had none other business? Peradventure you had rather endanger yourself by this noisome[7] journey than hazard[8] to draw him from his study.

Phi. Nay, that was not the matter, for I had rather have him give over his study altogether and come home.

Fer. Why, if you minded not to make him 40

learned, to what end did you send him hither at the first?

Phi. I will tell you. When he was at home, he did as most young men do—he played many mad pranks and did many things that liked me not very well; and I, thinking that by that time he had seen the world he would learn to know himself better, exhorted him to study and put in his election[9] what place he would go to. At the last he came hither, and I think he was scarce here so soon as I felt the want of him, in such sort 50 as from that day to this I have passed few nights without tears. I have written to him very often that he should come home, but continually he refused, still beseeching me to continue his study, wherein he doubted not, as he said, but to profit greatly.

Fer. Indeed, he is very much commended of all men, and specially of the best reputed students.

Phi. I am glad he hath not lost[10] his time, but I care not greatly for so much knowledge. I would not be without the sight of him again so long for all the 60 learning in the world. I am old now, and, if God should call me in his absence, I promise you I think it would drive me into desperation.

Fer. It is commendable in a man to love his children, but to be so tender over them is more womanlike.

Phi. Well, I confess it is my fault. And yet I will tell you another cause of my coming hither, more weighty than this. Divers of my country have been here since he came hither, by whom I have sent unto him, and some of them have been thrice, some four or five 70 times at his house, and yet could never speak with him. I fear he applies his study so that he will not leese the minute of an hour from his book. What, alas, he might yet talk with his countrymen for awhile! He is a young man, tenderly brought up, and, if he fare thus continually night and day at his book, it may be enough to drive him into a frenzy.

Fer. Indeed, enough were as good as a feast. Lo you, sir, here is your son Erostrato's house. I will knock.

Phi. Yea, I pray you knock. 80

[Knocks on the door.]

Fer. They hear not.

Phi. Knock again.

Fer. I think they be on sleep.

Lit. If this gate were your grandfather's soul, you could not knock more softly. Let me come! *[Knocks violently.]* Ho, ho! Is there anybody within?

DALIO *cometh to the window, and there maketh them answer.*

IV.iv

DALIO, *the cook;* FERRARESE, *the innholder;* PHILOGANO; LITIO, *his man.*

Dal. What devil of hell is there? I think he will break the gates in pieces!

Lit. Marry, sir, we had thought you had be none sleep within, and therefore we thought best to wake you. What doth Erostrato?

Dal. He is not within.

Phi. Open the door, good fellow, I pray thee.

IV.iii.
 [1] *searchers:* customs officials.
 [2] *untrussed my male:* opened my trunk.
 [3] *capcase:* traveling bag. [4] *fell:* skin.
 [5] *fardings:* farthings, trifling coins (collected to pay customs duty). [6] *bob:* revile; also "deceive."
 [7] *noisome:* obnoxious; also "stinking."
 [8] *hazard:* venture. [9] *election:* choice.
 [10] *lost:* wasted.

Dal. If you think to lodge here, you are deceived, I tell you; for here are guests enow already. 9

Phi. A good fellow, and much for thy master's honesty, by Our Lady! And what guests, I pray thee?

Dal. Here is Philogano, my master's father, lately come out of Sicilia.*

Phi. Thou speakest truer than thou art aware of. He will be, by that time thou hast opened the door. Open, I pray thee heartily.

Dal. It is a small matter for me to open the door, but here is no lodging for you. I tell you plain, the house is full.

Phi. Of whom? 20

Dal. I told you. Here is Philogano, my master's father, come from Cathanea.

Phi. And when came he?

Dal. He came three hours since, or more. He alighted at the Angel and left his horses there. Afterward my master brought him hither.

Phi. Good fellow, I think thou hast good sport to mock me.

Dal. Nay, I think you have good sport to make me tarry here, as though I have nothing else to do. I 30 am matched with an unruly mate in the kitchen. I will go look to him another while.

Phi. I think he be drunken.

Fer. Sure he seems so. See you not how red he is about the gills?

Phi. Abide, fellow. What Philogano is it whom thou talkest of?

Dal. An honest gentleman, father to Erostrato, my master.

Phi. And where is he? 40

Dal. Here within.

Phi. May we see him?

Dal. I think you may if you be not blind.

Phi. Go to! Go tell him here is one would speak with him.

Dal. Marry, that I will willingly do.

DALIO *draweth his head in at the window.*[1]

Phi. I cannot tell what I should say to this gear. Litio, what thinkest thou of it?

Lit. I cannot tell you what I should say, sir. The world is large and long; there may be mo Philo- 50 ganos and mo Erostratos than one, yea, and mo Ferraras, mo Sicilias, and mo Cathaneas.† Peradventure this is not that Ferrara which you sent your son unto.

Phi. Peradventure thou art a fool, and he was another that answered us even now.—But be you sure, honest man, that you mistake not the house?

Fer. Nay, then God help! Think you I know not Erostrato's house? Yes, and himself also. I saw him here no longer since than yesterday. But here comes one that will tell us tidings of him. I like his coun- 60 tenance better than the other's that answered at the window erewhile.

The SIENESE *cometh out.*

* *Another suppose.*
† *Another suppose.*

IV.v

SIENESE, PHILOGANO, [FERRARESE, LITIO,] DALIO.

Sien. Would you speak with me, sir?

Phi. Yea, sir; I would fain know whence you are.

Sien. Sir, I am a Sicilian, at your commandment.

Phi. What part of Sicilia?

Sien. Of Cathanea.

Phi. What shall I call your name?

Sien. My name is Philogano.

Phi. What trade do you occupy?

Sien. Merchandise.

Phi. What merchandise brought you hither? 10

Sien. None. I came only to see a son that I have here whom I saw not these two years.

Phi. What call they your son?

Sien. Erostrato.

Phi. Is Erostrato your son?

Sien. Yea, verily.

Phi. And are you Philogano?

Sien. The same.

Phi. And a merchant of Cathanea? 19

Sien. What need I tell you so often? I will not tell you a lie.

Phi. Yes, you have told me a false lie, and thou art a villain, and no better!

Sien. Sir, you offer me great wrong with these injurious words.

Phi. Nay, I will do more than I have yet proffered to do, for I will prove thee a liar and a knave to take upon thee that thou art not.

Sien. Sir, I am Philogano of Cathanea, out of all doubt. If I were not, I would be loath to tell you so.*

Phi. Oh, see the boldness of this brute beast! 31 What a brazen face he setteth on it!

Sien. Well, you may believe me if you list. What wonder you?

Phi. I wonder at thy impudency; for thou, nor nature that framed thee, can ever counterfeit thee to be me, ribald villain and lying wretch that thou art!

Dal. Shall I suffer a knave to abuse my master's father thus? [*Draws his sword*] Hence, villain!† Hence, or I will sheathe this good fawchion[1] in your 40 paunch! If my master Erostrato find you prating here on this fashion to his father, I would not be in your coat for mo cony skins[2] than I got these twelve months. Come you in again, sir, and let this cur bark here till he burst!

DALIO *pulleth the* SIENESE *in at the doors.*

* *A stout suppose.*
† *A pleasant suppose.*

IV.iv.
 [1] *Dalio . . . window:* Stage direction is given at the end of the scene in early editions.

IV.v.
 [1] *fawchion:* falchion (sword).
 [2] *cony skins:* rabbit skins, kept and sold by the cook.

IV.vi

PHILOGANO, LITIO, FERRARESE.

Phi. Litio, how likest thou this gear?

Lit. Sir, I like it as evil as may be. But have you not often heard tell of the falsehood of Ferrara? And now may you see, it falleth out accordingly.

Fer. Friend, you do not well to slander the city. These men are no Ferrareses, you may know by their tongue.

Lit. Well, there is never a barrel better herring[1] between you both. But indeed your officers are most to blame, that suffer such faults to escape unpunished. 10

Fer. What know the officers of this? Think you they know of every fault?

Lit. Nay, I think they will know as little as may be, specially when they have no gains by it. But they ought to have their ears as open to hear of such offenses as the inn gates be to receive guests.

Phi. Hold thy peace, fool!

Lit. By the mass, I am afeard that we shall be proved fools, both two.

Phi. Well, what shall we do? 20

Lit. I would think best we should go seek Erostrato himself.

Fer. I will wait upon you willingly, and, either at the schools or at the convocations,[2] we shall find him.

Phi. By Our Lady, I am weary. I will run no longer about to seek him. I am sure hither he will come at the last.

Lit. Sure, my mind gives[3] me that we shall find a new Erostrato ere it be long.* 29

Fer. Look where he is! Whither runs he? Stay you awhile; I will go tell him that you are here. Erostrato! Erostrato! ho, Erostrato! I would speak with you!

EROSTRATO *is espied upon the stage running about.*[4]

IV.vii

Feigned EROSTRATO, FERRARESE, PHILOGANO, LITIO, DALIO.

Ero. Now can I hide me no longer. Alas! what shall I do? I will set a good face on, to bear out the matter.

* *A true suppose.*

IV.vi.

[1] *never . . . herring:* no difference (proverbial).

[2] *convocations:* the legislative assembly of registered graduates in English universities. [3] *gives:* instructs.

[4] *Erostrato . . . about:* Perhaps this stage direction should precede the speech of Ferrarese.

IV.vii.

[1] *take . . . amiss:* mistake (presumably "what you think you recognize"). [2] *face us down:* seek to impose on us.

[3] *mates:* fellows. [4] *pestil:* pestle, pig's leg.

[5] *cackabed:* contemptuous term like "pissabed" ("cack" is "excrement"). [6] *costard:* head (literally, "apple").

[7] *pass not of:* care not for.

Fer. O Erostrato, Philogano, your father, is come out of Sicilia.

Ero. Tell me that I know not. I have been with him, and seen him already.

Fer. Is it possible? And it seemeth by him that you know not of his coming.

Ero. Why, have you spoken with him? When saw you him, I pray you? 10

Fer. Look you where he stands. Why go you not to him? Look you, Philogano; behold your dear son Erostrato.

Phi. Erostrato? This is not Erostrato. This seemeth rather to be Dulippo—and it is Dulippo indeed.

Lit. Why, doubt you of that?

Ero. What saith this honest man?

Phi. Marry, sir, indeed you are so honorably clad it is no marvel if you look big.

Ero. To whom speaketh he? 20

Phi. What! God help! Do you not know me?

Ero. As far as I remember, sir, I never saw you before.

Phi. Hark, Litio, here is good gear! This honest man will not know me!

Ero. Gentleman, you take your marks amiss.[1]

Lit. Did I not tell you of the falsehood of Ferrara, master?* Dulippo hath learned to play the knave indifferently well since he came hither.

Phi. Peace, I say. 30

Ero. Friend, my name is not Dulippo. Ask you thoroughly this town of great and small; they know me. Ask this honest man that is with you, if you will not believe me.

Fer. Indeed, I never knew him otherwise called than Erostrato; and so they call him, as many as know him.

Lit. Master, now you may see the falsehood of these fellows.† This honest man, your host, is of counsel with him, and would face us down[2] that it is Erostrato. Beware of these mates![3] 41

Fer. Friend, thou doest me wrong to suspect me, for sure I never heard him otherwise called than Erostrato.

Ero. What name could you hear me called by but by my right name? But I am wise enough to stand prating here with this old man! I think he be mad.

Phi. Ah, runagate! Ah, villain traitor! Dost thou use thy master thus? What hast thou done with my son, villain? 50

Dal. Doth this dog bark here still? And will you suffer him, master, thus to revile you?

Ero. Come in, come in. What wilt thou do with this pestil?[4]

Dal. I will rap the old cackabed[5] on the costard.[6]

Ero. Away with it! And you, sirrah, lay down these stones! Come in at door, every one of you. Bear with him, for his age. I pass not of[7] his evil words.

EROSTRATO *taketh all his Servants in at the doors.*

* *A shameless suppose.*

† *A needless suppose.*

IV.viii

PHILOGANO, FERRARESE, LITIO.

Phi. Alas, who shall relieve my miserable estate? To whom shall I complain, since he whom I brought up of a child, yea, and cherished him as if he had been mine own, doth now utterly deny to know me? And you, whom I took for an honest man and he that should have brought me to the sight of my son, are compact[1] with this false wretch, and would face me down that he is Erostrato. Alas, you might have some compassion of mine age,* to the misery I am now in, and that I am a stranger desolate of all comfort in this country; or, 10 at the least, you should have feared the vengeance of God, the supreme judge, which knoweth the secrets of all hearts, in bearing this false witness with him whom heaven and earth do know to be Dulippo and not Erostrato.

Lit. If there be many such witnesses in this country, men may go about to prove what they will in controversies here.

Fer. Well, sir, you may judge of me as it pleaseth you; and how the matter cometh to pass I know 20 not, but, truly, ever since he came first hither I have known him by the name of Erostrato, the son of Philogano, a Cathanese. Now, whether he be so indeed or whether he be Dulippo, as you allege, let that be proved by them that knew him before he came hither. But I protest before God that which I have said is neither a matter compact with him nor any other, but even as I have heard him called and reputed of all men.

Phi. Out and alas! He whom I sent hither with my son to be his servant and to give attendance on 30 him, hath either cut his throat or by some evil means made him away, and hath not only taken his garments, his books, his money, and that which he brought out of Sicilia with him, but usurpeth his name also, and turneth to his own commodity the bills of exchange that I have always allowed for my son's expenses.† O miserable Philogano, O unhappy old man! O eternal God, is there no judge, no officer, no higher powers whom I may complain unto for redress of these wrongs?

Fer. Yes, sir, we have potestates, we have 40 judges, and, above all, we have a most just prince. Doubt you not but you shall have justice, if your cause be just.

Phi. Bring me then to the judges, to the potestates, or to whom you think best; for I will disclose a pack of the greatest knavery, a fardel[3] of the foulest falsehood, that ever was heard of!

Lit. Sir, he that will go to the law must be sure of four things: first, a right and a just cause; then, a righteous advocate to plead; next, favor *coram* 50 *judice;*[4] and, above all, a good purse to procure it.

Fer. I have not heard that the law hath any respect to favor; what you mean by it I cannot tell.

* *Another suppose.*
† *A shrewd[2] suppose.*

Phi. Have you no regard to his words; he is but a fool.

Fer. I pray you, sir, let him tell me what is favor.

Lit. Favor call I to have a friend near about the judge, who may so solicit thy cause as, if it be right, speedy sentence may ensue without any delays; if it be not good, then to prolong it, till at the last thine 60 adversary, being weary, shall be glad to compound[5] with thee.

Fer. Of thus much (although I never heard thus much in this country before) doubt you not, Philogano: I will bring you to an advocate that shall speed you accordingly.

Phi. Then shall I give myself, as it were, a prey to the lawyers, whose insatiable jaws I am not able to feed, although I had here all the goods and lands which I possess in mine own country—much less, being a 70 stranger in this misery. I know their cautels[6] of old. At the first time I come they will so extol my cause as though it were already won; but within a seven-night or ten days, if I do not continually feed them, as the crow doth her brats, twenty times in an hour, they will begin to wax cold and to find cavils[7] in my cause, saying that at the first I did not well instruct them; till, at the last, they will not only draw the stuffing out of my purse but the marrow out of my bones. 79

Fer. Yea, sir; but this man that I tell you of is half a saint.

Lit. And the other half a devil, I hold[8] a penny!

Phi. Well said, Litio. Indeed, I have but small confidence in their smooth looks.

Fer. Well, sir, I think this whom I mean is no such manner of man. But if he were, there is such hatred and evil-will between him and this gentleman (whether he be Erostrato or Dulippo, whatsoever he be) that I warrant you he will do whatsoever he can do for you, were it but to spite him.* 90

Phi. Why, what hatred is betwixt them?

Fer. They are both in love and suitors to one gentlewoman, the daughter of a wealthy man in this city.

Phi. Why, is the villain become of such estimation that he dare presume to be a suitor to any gentlewoman of a good family?

Fer. Yea, sir, out of all doubt.

Phi. How call you his adversary?

Fer. Cleander, one of the excellentest doctors in our city. 100

Phi. For God's love, let us go to him!

Fer. Go we then.

[*Exeunt.*]

* *Another suppose.*

FINIS ACTUS IV

ACT FIVE

SCENE ONE

Feigned EROSTRATO.

Ero. What a mishap was this, that before I could meet with Erostrato I have light[1] even full in the lap of Philogano, where I was constrained to deny my name, to deny my master, and to feign that I knew him not, to contend with him, and to revile him in such sort that, hap what hap can,[2] I can never hap well[3] in favor with him again! Therefore, if I could come to speak with the right Erostrato, I will renounce unto him both habit and credit, and away as fast as I can trudge into some strange country where I may never see Philogano again— 10 alas, he that of a little child hath brought me up unto this day and nourished me as if I had been his own, and, indeed, to confess the truth, I have no father to trust unto but him.* But look where Pasiphilo cometh, the fittest man in the world to go on my message to Erostrato.

EROSTRATO *espieth* PASIPHILO *coming towards him.*

V.ii

PASIPHILO, EROSTRATO.

Pasi. Two good news have I heard today already: one, that Erostrato prepared a great feast this night; the other, that he seeketh for me. And I, to ease him of his travail, lest he should run up and down seeking me, and because no man loveth better than I to have an errand where good cheer is, come in posthaste even home to his own house. And look where he is.

Ero. Pasiphilo, thou must do one thing for me, if thou love me.

Pasi. If I love you not, who loves you? Command me. 11

Ero. Go then a little there, to Damon's house; ask for Dulippo, and tell him—

Pasi. Wot[1] you what? I cannot speak with him. He is in prison.

Ero. In prison! How cometh that to pass? Where is he in prison?

Pasi. In a vile dungeon, there, within his master's house.

Ero. Canst thou tell wherefore? 20

Pasi. Be you content to know he is in prison. I have told you too much.

Ero. If ever you will do anything for me, tell me.

* *Another suppose.*

V.i.
 [1] *light:* alighted. [2] *hap . . . can:* whatever chances.
 [3] *hap well:* have fortune.
V.ii.
 [1] *Wot:* Know. [2] *it . . . upon:* I am obliged.
 [3] *homely:* straightforward. [4] *to:* added to.
V.iii.
 [1] *careful:* full of care. [2] *lingered:* delayed.
 [3] *drifts:* plots.

Pasi. I pray you, desire me not. What were you the better if you knew?

Ero. More than thou thinkest, Pasiphilo, by God.

Pasi. Well, and yet it stands me upon,[2] more than you think, to keep it secret.

Ero. Why, Pasiphilo, is this the trust I have had in you? Are these the fair promises you have always made me? 31

Pasi. By the Mass, I would I had fasted this night with Master Doctor rather than have come hither.

Ero. Well, Pasiphilo, either tell me, or, at few words, never think to be welcome to this house from henceforth.

Pasi. Nay, yet I had rather leese all the gentlemen in this town. But, if I tell you anything that displease you, blame nobody but yourself now. 39

Ero. There is nothing can grieve me more than Dulippo's mishap—no, not mine own; and therefore I am sure thou canst tell me no worse tidings.

Pasi. Well, since you would needs have it, I will tell you. He was taken abed with your beloved Polynesta.*

Ero. Alas, and doth Damon know it?

Pasi. An old trot in the house disclosed it to him; whereupon he took both Dulippo and the nurse, which hath been the broker of all this bargain, and clapped them both in a cage—where, I think, they shall have sour sops to[4] their sweetmeats. 50

Ero. Pasiphilo, go thy ways into the kitchen; command the cook to boil and roast what liketh thee best. I make thee supervisor of this supper.

Pasi. By the Mass, if you should have studied this seven-night you could not have appointed me an office to please me better! You shall see what dishes I will devise.

PASIPHILO *goeth in;* EROSTRATO *tarrieth.*

V.iii

Feigned EROSTRATO *alone.*

Ero. I was glad to rid him out of the way, lest he should see me burst out of these swelling tears, which hitherto with great pain I have prisoned in my breast, and lest he should hear the echo of my doubled sighs, which bounce from the bottom of my heavy heart. Oh, cursed I! Oh, cruel fortune, that so many dispersed griefs as were sufficient to subvert a legion of lovers hast suddenly assembled within my careful[1] carcass to fret this fearful heart in sunder with desperation! Thou that hast kept my master all his youth within the realm 10 of Sicilia, reserving the wind and waves in a temperate calm—as it were at his command—now to convey his aged limbs hither, neither sooner nor later, but even in the worst time that may be! If, at any time before, thou haddest conducted him, this enterprise had been cut off without care in the beginning; and, if never so little longer thou hadst lingered[2] his journey, this happy day might then have fully finished our drifts[3] and devises. But, alas, thou hast brought him even in the very worst time, to plunge us all in the pit of perdition! 20 Neither art thou content to entangle me alone in thy

* *Another plain and homely[3] suppose.*

ruinous ropes, but thou must also catch the right Erostrato in thy crooked claws, to reward us both with open shame and rebuke. Two years hast thou kept secret our subtle supposes, even this day to decipher them with a sorrowful success. What shall I do? Alas, what shift shall I make? It is too late now to imagine any further deceit, for every minute seemeth an hour till I find some succor for the miserable captive Erostrato. Well, since there is no other remedy, I will 30 go to my master Philogano, and to him will I tell the whole truth of the matter, that at the least he may provide in time before his son feel the smart of some sharp revenge and punishment. This is the best, and thus will I do. Yet I know that for mine own part I shall do bitter penance for my faults forepassed! But such is the good will and duty that I bear to Erostrato as even with the loss of my life I must not stick to adventure[4] anything which may turn to his commodity. But what shall I do? Shall I go seek my master about the town, or shall 40 I tarry his return hither? If I meet him in the streets, he will cry out upon me, neither will he hearken to anything that I shall say till he have gathered all the people wondering about me as it were at an owl. Therefore I were better to abide here. And yet, if he tarry long, I will go seek him rather than prolong the time to Erostrato's peril.

 PASIPHILO *returneth to* EROSTRATO.

V.iv

PASIPHILO, *feigned* EROSTRATO.

Pasi. [*To* DALIO *within*] Yea, dress them,[1] but lay them not to the fire till they will be ready to sit down.— This gear goeth in order, but if I had not gone in, there had fallen a foul fault.

Ero. And what fault, I pray thee?

Pasi. Marry, Dalio would have laid the shoulder of mutton and the capon both to the fire at once, like a fool! He did not consider that the one would have more roasting than the other.

Ero. Alas, I would this were the greatest fault. 10

Pasi. Why? And either the one should have been burned before the other had been roasted, or else he must have drawn them off the spit, and they would have been served to the board either cold or raw.

Ero. Thou hast reason, Pasiphilo.

Pasi. Now, sir, if it please you, I will go into the town and buy oranges, olives, and capers; for without such sauce the supper were more than half lost.

Ero. There are[2] within already, doubt you not; there shall lack nothing that is necessary. 20

 EROSTRATO *exit.*

Pasi. Since I told him these news of Dulippo, he is clean beside himself. He hath so many hammers in his head that his brains are ready to burst. And let them break. So I may sup with him tonight, what care I? But is not this *Dominus noster Cleandrus*[3] that cometh before?* Well said. By my truth, we will teach Master

* *A knavish suppose.*

Doctor to wear a cornered cap[4] of a new fashion. By God, Polynesta shall be his! He shall have her, out of doubt; for I have told Erostrato such news of her that he will none of her. 30

CLEANDER *and* PHILOGANO *come in,* talking of
the matter in controversy

V.v

CLEANDER, PHILOGANO, LITIO, PASIPHILO.

Cle. Yea, but how will ye prove that he is not Erostrato, having such presumptions to the contrary? Or how shall it be thought that you are Philogano, when another taketh upon him this same name, and for proof bringeth him for a witness which hath been ever reputed here for Erostrato?

Phi. I will tell you, sir. Let me be kept here fast in prison, and at my charges let there be some man sent into Sicilia that may bring hither with him two or three of the honestest men in Cathanea, and by them let 10 it be proved if I or this other be Philogano, and whether he be Erostrato or Dulippo my servant; and, if you find me contrary,[1] let me suffer death for it.

Pasi. I will go salute Master Doctor.

Cle. It will ask great labor and great expenses to prove it this way, but it is the best remedy that I can see.

Pasi. God save you, sir!

Cle. And reward you as you have deserved.

Pasi. Then shall he give me your favor continually.

Cle. He shall give you a halter, knave and villain that thou art! 21

Pasi. I know I am a knave, but no villain. I am your servant.

Cle. I neither take thee for my servant nor for my friend.

Pasi. Why, wherein have I offended you, sir?

Cle. Hence to the gallows, knave!

Pasi. What! Soft and fair, sir, I pray you. "*I præ, sequar;*"[2] you are mine elder. 29

Cle. I will be even with you, be you sure, honest man.

Pasi. Why, sir? I never offended you.

Cle. Well, I will teach you. Out of my sight, knave!

Pasi. What! I am no dog, I would you wist.[3]

Cle. Pratest thou yet, villain? I will make thee—

Pasi. What will you make me? I see well the more a man doth suffer[4] you, the worse you are.

Cle. Ah, villain, if it were not for this gentleman, I would tell you what I—

Pasi. Villain? Nay, I am as honest a man as you. 40

Cle. Thou liest in thy throat,[5] knave!

Phi. Oh, sir, stay[6] your wisdom.

Pasi. What! Will you fight? Marry, come on!

Cle. Well, knave, I will meet with you another time. Go your way.

Pasi. Even when you list, sir, I will be your man.

Cle. And if I be not even with thee, call me cut![7]

Pasi. Nay, by the Mass, all is one. I care not, for I have nothing. If I had either lands or goods, peradventure you would pull me into the law. 50

[*Exit.*]

Phi. Sir, I perceive your patience is moved.

Cle. This villain! But let him go. I will see him punished as he hath deserved. Now to the matter. How said you?

Phi. This fellow hath disquieted you, sir. Peradventure you would be loath to be troubled any further.*

Cle. Not a whit. Say on, and let him go—with a vengeance! 59

Phi. I say, let them send at my charge to Cathanea.

Cle. Yea, I remember that well, and it is the surest way as this case requireth. But tell me, how is he your servant, and how come you by him? Inform me fully in the matter.

Phi. I will tell you, sir. When the Turks won Otranto—

Cle. Oh, you put me in remembrance of my mishaps!

Phi. How, sir?

Cle. For I was driven among the rest out of the town (it is my native country), and there I lost more than ever I shall recover again while I live. 71

Phi. Alas, a pitiful case, by St. Anne!

Cle. Well, proceed.

Phi. At that time, as I said, there were certain of our country that scoured those coasts upon the seas with a good bark, well appointed for the purpose, and had espial of a Turkey vessel that came laden from thence with great abundance of riches.

Cle. And peradventure most of mine.† 79

Phi. So they boarded them, and in the end overcame them, and brought the goods to Palermo, from whence they came; and amongst other things that they had was this villain, my servant, a boy at that time, I think not past five years old.

Cle. Alas, I lost one of that same age there!

Phi. And I, being there, and liking the child's favor[8] well, proffered them four and twenty ducats for him, and had him.

Cle. What! was the child a Turk? Or had the Turks brought him from Otranto? 90

Phi. They said he was a child of Otranto. But what is

* *Lawyers are never weary to get money.*

† *A gentle suppose.*

that to the matter?[9] Once four and twenty ducats he cost me—that I wot well.

Cle. Alas, I speak it not for that, sir. I would it were he whom I mean.

Phi. Why, whom mean you, sir?

Lit. Beware, sir; be not too lavish![10]*

Cle. Was his name Dulippo then or had he not another name?

Lit. Beware what you say, sir! 100

Phi. What the devil hast thou to do!—Dulippo? No, sir, his name was Carino.

Lit. Yea, well said! Tell all, and more too; do!

Cle. O Lord, if it be as I think, how happy were I! And why did you change his name then?

Phi. We called him Dulippo because when he cried, as children do sometimes, he would always cry on that name Dulippo.

Cle. Well, then I see well it is my own only child, whom I lost when I lost my country! He was 110 named Carino after his grandfather; and this Dulippo, whom he always remembered in his lamenting, was his foster-father that nourished him and brought him up.

Lit. Sir, have I not told you enough of the falsehood of Ferrara? This gentleman will not only pick your purse, but beguile you of your servant also, and make you believe he is his son.

Cle. Well, good fellow, I have not used[11] to lie.

Lit. Sir, no; but everything hath a beginning. 119

Cle. Fie! Philogano, have you not the least suspect[12] that may be of me.

Lit. No, marry; but it were good he had the most suspect that may be.

Cle. Well, hold thou thy peace a little, good fellow. I pray you tell me, Philogano, had the child any remembrance of his father's name, his mother's name, or the name of his family?

Phi. He did remember them, and could name his mother also, but sure I have forgotten the name.

Lit. I remember it well enough! 130

Phi. Tell it then.

Lit. Nay, that I will not, marry! You have told him too much already.

Phi. Tell it, I say, if thou can.

Lit. Can? Yes, by the Mass, I can well enough! But I will have my tongue pulled out rather than tell it unless he tell it first. Do you not perceive, sir, what he goeth about?

Cle. Well, I will tell you, then. My name you know already; my wife, his mother's, name was Sophronia; the house that I came of they call Spiagia. 141

Lit. I never heard him speak of Spiagia, but indeed I have heard him say his mother's name was Sophronia. But what of that? A great matter, I promise you! It is like enough that you two have compact together to deceive my master.

Cle. What needeth me more evident tokens? This is my son out of doubt, whom I lost eighteen years since, and a thousand thousand times have I lamented for him. He should have also a mold[13] on his left shoulder. 150

* *A crafty suppose.*

[5] *in thy throat*: a deadly insult. [6] *stay*: be faithful to.
[7] *cut*: gelding. [8] *favor*: looks. [9] *matter*: purpose.
[10] *lavish*: extravagant (in what you say).
[11] *used*: been accustomed. [12] *suspect*: suspicion.
[13] *mold*: mole.

Lit. He hath a mold there indeed, and an hole in another place, too—I would your nose were in it!

Cle. Fair words, fellow Litio! Oh, I pray you, let us go talk with him! O fortune, how much am I bound to thee if I find my son!

Phi. Yea, how little am I beholden to fortune, that know not where my son is become; and you, whom I chose to be mine advocate, will now, by the means of this Dulippo, become mine adversary! 159

Cle. Sir, let us first go find mine, and, I warrant you, yours will be found also ere it be long.*

Phi. God grant! Go we then.

Cle. Since the door is open, I will never knock nor call, but we will be bold to go in.

Lit. [*To* PHILOGANO] Sir, take you heed lest he lead you to some mischief.

Phi. Alas, Litio, if my son be lost, what care I what become of me?

Lit. Well, I have told you my mind, sir. Do you as you please. 170
 Exeunt.

DAMON *and* PSITERIA *come in.*

V.vi

DAMON, PSITERIA.

Dam. Come hither, you old callet,[1] you tattling huswife![2] That the devil cut out your tongue! Tell me, how could Pasiphilo know of this gear but by you?

Psit. Sir, he never knew it of me; he was the first that told me of it.

Dam. Thou liest, old drab! But I would advise you tell me the truth, or I will make those old bones rattle in your skin.

Psit. Sir, if you find me contrary, kill me.

Dam. Why, where should he talk with thee? 10

Psit. He talked with me of it here in the street.

Dam. What did you here?

Psit. I was going to the weaver's for a web of cloth you have there.

Dam. And what cause could Pasiphilo have to talk of it, unless thou began the matter first?

Psit. Nay, he began with me, sir, reviling me because I had told you of it. I asked him how he knew of it, and he said he was in the stable when you examined me erewhile.[3] 20

Dam. Alas, alas, what shall I do then? In at doors, old whore! I will pluck that tongue of thine out by the roots one day.

[*Exit* PSITERIA.]

Alas, it grieveth me more that Pasiphilo knoweth it than all the rest. He that will have a thing kept secret, let him tell it to Pasiphilo! The people shall know it, and as many as have ears, and no mo. By this time he hath told it in a hundreth places! Cleander was the first, Erostrato the second; and so from one to another throughout the city. Alas, what dower, what marriage shall I now 30 prepare for my daughter? Oh, poor dolorous Damon,

* *A right suppose.*

more miserable than misery itself! Would God it were true that Polynesta told me erewhile—that he who hath deflowered her is of no servile estate, as hitherto he hath been supposed in my service, but that he is a gentleman, born of a good parentage in Sicilia.* Alas, small riches should content me if he be but of an honest family! But I fear that he hath devised these toys to allure my daughter's love. Well, I will go examine her again. My mind giveth me that I shall perceive by her tale 40 whether it be true or not. But is not this Pasiphilo that cometh out of my neighbor's house? What the devil aileth him to leap and laugh so like a fool in the highway?

PASIPHILO *cometh out of the house laughing.*

V.vii

PASIPHILO, DAMON.

Pasi. O God, that I might find Damon at home!

Dam. What the devil would he with me?

Pasi. That I may be the first that shall bring him these news!

Dam. What will he tell me, in the name of God?

Pasi. O Lord, how happy am I!—Look where he is.

Dam. What news, Pasiphilo, that thou art so merry?

Pasi. Sir, I am merry to make you glad. I bring you joyful news!

Dam. And that I have need of, Pasiphilo. 10

Pasi. I know, sir, that you are a sorrowful man for this mishap that hath chanced in your house. Peradventure you thought I had not known of it. But let it pass! Pluck up your sprites,[1] and rejoice! For he that hath done you this injury is so well born and hath so rich parents that you may be glad to make him your son-in-law.

Dam. How knowest thou?

Pasi. His father, Philogano, one of the worthiest men in all Cathanea, is now come to the city, and is here in your neighbor's house. 21

Dam. What, in Erostrato's house?

Pasi. Nay, in Dulippo's house. For where you have always supposed this gentleman to be Erostrato, it is not so; but your servant, whom you have imprisoned, hitherto supposed to be Dulippo, he is indeed Erostrato, and that other is Dulippo. And thus they have always, even since their first arrival in this city, exchanged names, to the end that Erostrato, the master, under the name of Dulippo, a servant, might be 30 entertained in your house and so win the love of your daughter.

Dam. Well, then I perceive it is even as Polynesta told me.

Pasi. Why, did she tell you so?

* *The first suppose brought to conclusion.*

V.vi.
 [1] *callet*: whore. [2] *huswife*: pert woman.
 [3] *erewhile*: a while ago.
V.vii.
 [1] *sprites*: spirits.

Dam. Yea, but I thought it but a tale.

Pasi. Well, it is a true tale. And here they will be with you by and by—both Philogano, this worthy man, and Master Doctor Cleander.

Dam. Cleander? What to do? 40

Pasi. Cleander? Why thereby lies another tale—the most fortunate adventure that ever you heard! Wot you what? This other Dulippo, whom all this while we supposed to be Erostrato, is found to be the son of Cleander, whom he lost at the loss of Otranto, and was after sold in Sicilia to this Philogano. The strangest case that ever you heard! A man might make a comedy of it. They will come even straight and tell you the whole circumstance of it themselves. 49

Dam. Nay, I will first go hear the story of this Dulippo, be it Dulippo or Erostrato, that I have here within, before I speak with Philogano.

Pasi. So shall you do well, sir. I will go tell them that they may stay awhile.—But look where they come.

DAMON *goeth in;* SIENESE, CLEANDER, *and* PHILOGANO *come upon the stage.*

V.viii

SIENESE, CLEANDER, [CARINO,][1] PHILOGANO.

Sien. Sir, you shall not need to excuse the matter any further. Since I have received no greater injury than by words, let them pass like wind. I take them well in worth and am rather well pleased than offended. For it shall both be a good warning to me another time how to trust every man at the first sight, yea, and I shall have good game hereafter to tell this pleasant story another day in mine own country.

Cle. Gentleman, you have reason; and be you sure that as many as hear it will take great pleasure in 10 it. And you, Philogano, may think that God in heaven above hath ordained your coming hither at this present[2] to the end I might recover my lost son, whom by no other means I could ever have found out.

Phi. Surely, sir, I think no less; for I think that not so much as a leaf falleth from the tree without the ordinance of God. But let us go seek Damon, for me-thinketh every day a year, every hour a day, and every minute too much, till I see my Erostrato. 19

Cle. I cannot blame you. Go we, then. Carino, take you that gentleman home in the meantime. The fewer the better to be present at such affairs.

PASIPHILO *stayeth their going in.*

V.viii.

 [1] *Carino:* the original name of Cleander's son, the real "Dulippo," who, though he does not speak, is addressed in the ending of the scene. [2] *present:* i.e., moment.

V.x.

 [1] *Nevola . . . Servants:* who enter later.
 [2] *of force:* perforce, necessarily. [3] *proper:* my own.
 [4] *quit:* relinquish my. [5] *meetest:* fittest.

V.ix

PASIPHILO, CLEANDER.

Pasi. Master Doctor, will you not show me this favor, to tell me the cause of your displeasure?

Cle. Gentle Pasiphilo, I must needs confess I have done thee wrong, and that I believed tales of thee, which indeed I find now contrary.

Pasi. I am glad, then, that it proceeded rather of ignorance than of malice.

Cle. Yea, believe me, Pasiphilo.

Pasi. Oh, sir, but yet you should not have given me such foul words. 10

Cle. Well, content thyself, Pasiphilo. I am thy friend, as I have always been; for proof whereof, come sup with me tonight, and from day to day this seven-night be thou my guest. But behold, here cometh Damon out of his house.

Here they come all together.

V.x

CLEANDER, PHILOGANO, DAMON, EROSTRATO, PASIPHILO, POLYNESTA; NEVOLA *and other* Servants.[1]

Cle. [*To* DAMON] We are come unto you, sir, to turn your sorrow into joy and gladness—the sorrow, we mean, that of force[2] you have sustained since this mis-hap of late fallen in your house. But be you of good comfort, sir, and assure yourself that this young man, which youthfully and not maliciously hath committed this amorous offense, is very well able, with consent of this worthy man, his father, to make you sufficient amends, being born in Cathanea of Sicilia, of a noble house, no way inferior unto you, and of wealth, 10 by the report of such as know it, far exceeding that of yours.

Phi. And I here, in proper[3] person, do present unto you, sir, not only my assured friendship and brother-hood, but do earnestly desire you to accept my poor child, though unworthy, as your son-in-law. And for recompense of the injury he hath done you, I proffer my whole lands in dower to your daughter; yea, and more would, if more I might. 19

Cle. And I, sir, who have hitherto so earnestly desired your daughter in marriage, do now willingly yield up and quit[4] claim to this young man, who, both for his years and for the love he beareth her, is most meetest[5] to be her husband. For where I was desirous of a wife by whom I might have issue, to leave that little which God hath sent me, now have I little need that, thanks be to God, have found my dearly beloved son, whom I lost of a child at the siege of Otranto.

Dam. Worthy gentleman, your friendship, your alliance, and the nobility of your birth are such as 30 I have much more cause to desire them of you than you to request of me that which is already granted. There-fore I gladly and willingly receive the same, and think myself most happy now of all my life past that I have

gotten so toward[6] a son-in-law to myself and so worthy a father-in-law to my daughter. Yea, and much the greater is my contentation[7] since this worthy gentleman, Master Cleander, doth hold himself satisfied. And now, behold your son!

Ero. O father! 40

Pasi. Behold the natural love of the child to the father. For inward joy he cannot pronounce one word; instead whereof he sendeth sobs and tears to tell the effect of his inward intention. But why do you abide here abroad? Will it please you to go into the house, sir?

Dam. Pasiphilo hath said well. Will it please you to go in, sir?

[*Enter* NEVOLA *with fetters.*]

Nev. Here I have brought you, sir, both fetters and bolts. 50

Dam. Away with them, now!

Nev. Yea, but what shall I do with them?

Dam. Marry, I will tell thee, Nevola. To make a right end of our supposes, lay one of those bolts in the fire, and make thee a suppository[8] as long as mine arm —God save the sample![9]—[*To the audience*] Nobles and gentlemen, if you suppose that our Supposes have given you sufficient cause of delight show some token whereby we may suppose you are content.

Et plauserunt.[10]

FINIS

[6] *toward:* promising. [7] *contentation:* satisfaction.
[8] *suppository:* laxative (with a pun on "supposes").
[9] *sample:* example(?). [10] *L.:* And they applauded.

John Lyly

[c. 1554–1606]

GALLATHEA

GRANDSON of William Lily, the famous master of St. Paul's grammar school and author of a widely circulated grammar, and son of a Canterbury church official, John Lyly was educated at Magdalen College, Oxford, where he obtained his B.A. in 1573 and M.A. in 1575. In 1578 he published his clever prose romance *Euphues, or the Anatomy of Wit*, a work that exercised a profound influence on English style, and two years later a sequel called *Euphues and His England*. He spent much of his energy in feckless attempts to secure a court position such as that of Master of the Revels, but never managed to do so; he did, however, get the patronage of Edward de Vere, Earl of Oxford, who assisted him in organizing a company of boy actors who played at the Blackfriars; his enterprise did not succeed, and at one point he was imprisoned for his debts. Lyly's life is convincingly presented by G. K. Hunter, in *John Lyly: The Humanist As Courtier*, as typifying the problems of a generation of trained intellectuals who discovered that they were no longer needed, as their predecessors had been, to educate the court, and that society had no secure place for them. For such men as Lyly and the other University Wits the theater provided a new means of support, and the confluence of these brilliant young people and a medium just emerging into the realization of its possibilities is one of the lucky facts of literary history. Apart from *Euphues*, Lyly is important for the eight plays he wrote between 1584 and 1590 (one of them possibly later). The plays have so much in common with one another that what is said here about GALLATHEA may be taken to characterize the others in significant respects, though they deserve to be read themselves. The first of them, *Campaspe*, is a charming comedy about an unsuccessful attempt by Alexander the Great to conquer in the field of love, and has a subplot featuring some famous philosophers. In another, *Endymion, or The Man in the Moon* (1588), Lyly plays with mythology as in GALLATHEA to create as complex and elaborate a work as the English stage had yet seen.

GALLATHEA was probably written between 1583 and 1585, and possibly but not necessarily revised for its court performance in 1588 (the reference to the latter year can be explained by predictions made during the entire decade by astrologers). It was entered in the Stationers' Register in 1585 but not printed until 1592; it appeared in a second edition in Edward Blount's 1632 collection of six of Lyly's court comedies. The text followed in the present edition is the 1592 quarto, with the songs (which have never been proved to be Lyly's but probably are) and a few corrections added from the 1632 edition. Like most of Lyly's plays, GALLATHEA was written to be performed by a company of boys acting in court and private theaters. The title page of the 1592 quarto tells us that the piece was played before the Queen on New Year's Day, in the evening, by the Children of Paul's.

GALLATHEA is typical of its author's plays. It is written in a witty and elegant prose, developed in Lyly's famous novel *Euphues: The Anatomy of Wit*, which is characterized by balanced phrasing, patterning devices such as alliteration and verbal parallelism, carefully arranged rhythms, a comical use of logic and chop-logic, puns, classical allusions (often deliberately garbled), and constant reference to the legendary natural history of proverb and the bestiaries. Typical also are the allusions to the famous Latin of Lyly's grandfather William Lily and the English domestication of classical mythology. The playwright derived the plot motif of virgin tribute to a sea monster sent by Neptune from the legend of Hesione, but drew some details from Natalis Comes' *Mythologiae* (1551), an extraordinarily popular and influential handbook, in easy Latin, of classical myths. The plot line of the two girls who, each in disguise under her father's name, fall in love with one another, is a free version of the tale of Iphis and Ianthe in Ovid's *Metamorphoses*, IX, 666–797. The episodes involving Venus, Diana, and Cupid may owe something to Lyly's earlier comedy *Sappho and Phao*, which is mentioned in GALLATHEA. All the plot materials of the play could and may have been found in Renaissance Italian pastoral literature and comedy. But Lyly draws also on a variety of English matter: the floods in Lincolnshire; the tidal "bore" of the Humber; the Danish invasions of the ninth century A.D. which, with their destruction of English temples, are claimed with delightful anachronism to have angered Neptune; alchemy, for his allusions to which Lyly uses Chaucer's *Canon Yeoman's Tale*; astrology, in vogue at Elizabeth's court in the mid-1580s and a frequent butt of satire; and the court masque, an allegorical entertainment that flattered and involved its audience and that frequently presented the Virgin Queen in the guise of Diana. The brilliant weaving together of such disparate traditions as English folk wisdom, Italian *commedia erudita*, classical mythology, and the machinery of masques and pastoral figures (Tityrus and Melebeus) into an integral, swift-moving, and tonally harmonious whole is Lyly's crucial and influential contribution to English drama. Without his model, *A Midsummer Night's Dream* and others of Shakespeare's great comedies could scarcely have been possible in the shape they assumed.

N. R.

Gallathea

DRAMATIS PERSONÆ

TITYRUS, *a shepherd*
GALLATHEA, *his daughter*
MELEBEUS, *a shepherd*
PHYLLIDA, *his daughter*
VENUS
CUPID
NEPTUNE
DIANA
TELUSA
EUROTA } *nymphs of Diana*
RAMIA
LARISSA
HEBE, *a virgin*

ERICTHINIS
AUGUR
RAFE
ROBIN } *sons of a miller*
DICK
MARINER
ALCHEMIST
PETER, *his boy*
ASTRONOMER
NYMPH *of Diana*
FAIRIES
POPULUS

THE PROLOGUE

Ios[1] AND Smyrna[2] were two sweet cities, the first named of the violet, the latter of the myrrh. Homer was born in the one and buried in the other. Your majesty's judgment and favor are our sun and shadow, the one coming of your deep wisdom, the other of your wonted grace. We in all humility desire that, by the former receiving our first breath, we may in the latter take our last rest.

Augustus Caesar had such piercing eyes that whoso looked on him was constrained to wink.[3] Your 10 highness hath so perfect a judgment that whatsoever we offer we are enforced to blush; yet as the Athenians were most curious that the lawn[4] wherewith Minerva[5] was covered should be without spot or wrinkle, so have we endeavored with all care that what we present your highness should neither offend in scene nor syllable, knowing that as in the ground where gold groweth nothing will prosper but gold, so in your majesty's mind, where nothing doth harbor but virtue, nothing can enter but virtue. 20

ACT ONE

SCENE ONE

[Enter] TITYRUS, GALLATHEA *[disguised as a boy]*

Tit. The sun doth beat upon the plain[1] fields, wherefore let us sit down, Gallathea, under this fair oak, by whose broad leaves being defended from the warm beams we may enjoy the fresh air which softly breathes from Humber[2] floods.

Gall. Father, you have devised well, and whilst our flock doth roam up and down this pleasant green you shall recount to me, if it please you, for what cause this tree was dedicated unto Neptune,[3] and why you have thus disguised me. 10

Tit. I do agree thereto, and when thy state and my care be considered, thou shalt know this question was not asked in vain.

Gall. I willingly attend.

Tit. In times past, where thou seest a heap of small pebble, stood a stately temple of white marble, which was dedicated to the god of the sea (and in right, being so near the sea). Hither came all such as either ventured by long travel to see countries or by great traffic to use merchandise,[4] offering sacrifice by fire to get 20 safety by water, yielding thanks for perils past, and making prayers for good success to come; but fortune, constant in nothing but inconstancy, did change her copy[5] as the people their custom, for the land being oppressed by Danes,[6] who instead of sacrifice committed

PROLOGUE
 [1] *Ios:* Aegean island.
 [2] *Smyrna:* city on west coast of Asia Minor.
 [3] *wink:* close his eyes. [4] *lawn:* linen.
 [5] *Minerva:* the statue of Athena, covered when carried in processions.
I.i.
 [1] *plain:* clear, open.
 [2] *Humber:* estuary of Ouse and Trent rivers, Yorkshire and Lincolnshire, thirty-one miles long.
 [3] *Neptune:* god of the sea.
 [4] *use merchandise:* engage in trade.
 [5] *copy:* course of action. [6] *Danes:* an anachronism.

126

sacrilege, instead of religion, rebellion, and made a prey of that in which they should have made their prayers, tearing down the temple even with the earth, being almost equal with the skies, enraged so the god who binds the winds in the hollows of the earth that he caused 30 the seas to break their bounds, sith[7] men had broke their vows, and to swell as far above their reach as men had swerved beyond their reason. Then might you see ships sail where sheep fed, anchors cast where ploughs go, fishermen throw their nets where husbandmen sow their corn, and fishes throw their scales where fowls do breed their quills; then might you gather froth where now is dew, rotten weeds for sweet roses, and take view of monstrous mermaids instead of passing[8] fair maids.

Gall. To hear these sweet marvels I would mine eyes were turned also into ears. 41

Tit. But at the last, our countrymen repenting, and not too late because at last, Neptune, either weary of his wroth or wary to do them wrong, upon condition consented to ease their miseries.

Gall. What condition will not miserable men accept?

Tit. The condition was this, that at every five years' day[9] the fairest and chastest virgin in all the country should be brought unto this tree, and here being bound (whom neither parentage shall excuse for honor 50 nor virtue for integrity) is left for a peace offering unto Neptune.

Gall. Dear is the peace that is bought with guiltless blood.

Tit. I am not able to say that; but he sendeth a monster called the Agar,[10] against whose coming the waters roar, the fowls fly away, and the cattle in the field for terror shun the banks.

Gall. And she bound to endure that horror?

Tit. And she bound to endure that horror. 60

Gall. Doth this monster devour her?

Tit. Whether she be devoured of him or conveyed to Neptune or drowned between both it is not permitted to know and incurreth danger to conjecture. Now, Gallathea, here endeth my tale and beginneth thy tragedy.

Gall. Alas, father, and why so?

Tit. I would thou hadst been less fair or more fortunate; then shouldst thou not repine that I have disguised thee in this attire, for thy beauty will make thee to 70 be thought worthy of this god. To avoid, therefore, destiny, for wisdom ruleth the stars, I think it better to use an unlawful means, your honor preserved, than intolerable grief, both life and honor hazarded, and to prevent, if it be possible, thy constellation[11] by my

craft. Now hast thou heard the custom of this country, the cause why this tree was dedicated unto Neptune, and the vexing care of thy fearful father.

Gall. Father, I have been attentive to hear, and by your patience am ready to answer. Destiny may be 80 deferred, not prevented, and therefore it were better to offer myself in triumph than to be drawn to it with dishonor. Hath nature, as you say, made me so fair above all, and shall not virtue make me as famous as others? Do you not know, or doth overcarefulness make you forget, that an honorable death is to be preferred before an infamous life? I am but a child and have not lived long, and yet not so childish as I desire to live ever. Virtues I mean to carry to my grave, not gray hairs. I would I were as sure that destiny would light on 90 me as I am resolved it could not fear[12] me. Nature hath given me beauty, virtue courage; nature must yield me death, virtue honor. Suffer me therefore to die, for which I was born, or let me curse that I was born, sith I may not die for it.

Tit. Alas, Gallathea, to consider the causes of change thou art too young, and that I should find them out for thee, too, too fortunate.

Gall. The destiny to me cannot be so hard as the disguising hateful. 100

Tit. To gain love the gods have taken shapes of beasts, and to save life art thou coy[13] to take the attire of men?

Gall. They were beastly gods, that lust could make them seem as beasts.

Tit. In health it is easy to counsel the sick, but it's hard for the sick to follow wholesome counsel. Well, let us depart, the day is far spent.

Exeunt.

[I.ii]

[Enter] CUPID, NYMPH *of Diana.*

Cup. Fair nymph, are you strayed from your company by chance, or love you to wander solitarily on purpose?

Nym. Fair boy, or god, or whatever you be, I would you knew these woods are to me so well known that I cannot stray though I would, and my mind so free that to be melancholy I have no cause. There is none of Diana's train that any can train,[1] either out of their way or out of their wits. 9

Cup. What is that Diana, a goddess? What her nymphs, virgins? What her pastimes, hunting?

Nym. A goddess? Who knows it not? Virgins? Who thinks it not? Hunting? Who loves it not?

Cup. I pray thee, sweet wench, amongst all your sweet troop is there not one that followeth the sweetest thing, sweet love?

Nym. Love, good sir? What mean you by it, or what do you call it?

Cup. A heat full of coldness, a sweet full of bitterness, a pain full of pleasantness, which maketh thoughts 20 have eyes and hearts ears, bred by desire, nursed by delight, weaned by jealousy, killed by dissembling, buried by ingratitude, and this is love. Fair lady, will you any?

[7] *sith*: since. [8] *passing*: very.
[9] *five years' day*: once regularly every five years.
[10] *Agar*: variant (Trent and Humber district) of "eagre," the "bore," a high tidal wave caused by the rushing of the tide up a narrowing estuary (particularly the Humber and Trent).
[11] *constellation*: configuration of "stars" (planets) at time of one's birth, hence one's destiny. [12] *fear*: frighten.
[13] *coy*: shy.

I.ii.
[1] *train*: lead astray.

Nym. If it be nothing else, it is but a foolish thing.

Cup. Try, and you shall find it a pretty thing.

Nym. I have neither will nor leisure, but I will follow Diana in the chase, whose virgins are all chaste, delighting in the bow that wounds the swift hart in the forest, not fearing the bow that strikes the soft heart in the chamber. This difference is between my 30 mistress, Diana, and your mother, as I guess, Venus, that all her nymphs are amiable and wise in their kind, the other amorous and too kind for their sex; and so farewell, little god.

Exit.

Cup. Diana and thou and all thine shall know that Cupid is a great god. I will practice² awhile in these woods, and play such pranks with these nymphs that while they aim to hit others with their arrows they shall be wounded themselves with their own eyes.

Exit.

[I.iii]

[Enter] MELEBEUS, PHYLLIDA.

Mel. Come, Phyllida, fair Phyllida, and I fear me too fair, being my Phyllida; thou knowest the custom of this country, and I, the greatness of thy beauty; we both, the fierceness of the monster Agar. Everyone thinketh his own child fair, but I know that which I most desire and would least have, that thou art fairest. Thou shalt therefore disguise thyself in attire, lest I should disguise myself in affection in suffering thee to perish by a fond¹ desire whom I may preserve by a sure deceit. 10

Phyl. Dear father, nature could not make me so fair as she hath made you kind,² nor you more kind than me dutiful. Whatsoever you command I will not refuse, because you command nothing but my safety and your happiness. But how shall I be disguised?

Mel. In man's apparel.

Phyl. It will neither become my body nor my mind.

Mel. Why, Phyllida?

Phyl. For then I must keep company with boys and commit follies unseemly for my sex, or keep com- 20 pany with girls and be thought more wanton than becometh me. Besides, I shall be ashamed of my long hose and short coat and so unwarily blab out something by blushing at everything.

Mel. Fear not, Phyllida. Use will make it easy, fear must make it necessary.

Phyl. I agree, since my father will have it so, and fortune must.

Mel. Come, let us in, and when thou art disguised roam about these woods till the time be past and Neptune pleased. 31

Exeunt.

[I.iv]

[Enter] MARINER, RAFE, ROBIN, *and* DICK.

Rob. Now, mariner, what callest thou this sport on the sea?

Mar. It is called a wreck.¹

Rafe. I take no pleasure in it. Of all deaths, I would not be drowned; one's clothes will be so wet when he is taken up.

Dick. What callest thou the thing we were bound to?

Mar. A rafter.

Rafe. I will rather hang myself on a rafter in the house than be so haled² in the sea. There one may 10 have a leap for his life. But I marvel how our master speeds.³

Dick. I'll warrant by this time he is wet-shod. Did you ever see water bubble as the sea did? But what shall we do?

Mar. You are now in Lincolnshire, where you can want no fowl if you can devise means to catch them. There be woods hard by, and at every mile's end houses, so that if you seek on the land you shall speed better than on the sea. 20

Rob. Sea! Nay, I will never sail more. I brook⁴ not their diet. Their bread is so hard that one must carry a whetstone in his mouth to grind his teeth, the meat so salt that one would think after dinner his tongue had been powdered⁵ ten days.

Rafe. O, thou hast a sweet life, mariner, to be pinned⁶ in a few boards and to be within an inch of a thing bottomless. I pray thee, how often hast thou been drowned?

Mar. Fool, thou seest I am yet alive. 30

Rob. Why, be they dead that be drowned? I had thought they had been with the fish, and so by chance been caught up with them in a net again. It were a shame a little cold water should kill a man of reason, when you shall see a poor minnow lie in it that hath no understanding.

Mar. Thou art wise from the crown of thy head upwards. Seek you new fortunes now; I will follow mine old. I can shift⁷ the moon and the sun, and know by one card⁸ what all you cannot do by a whole pair.⁹ 40 The loadstone that always holdeth his nose to the north, the two and thirty points¹⁰ for the wind, the wonders I see would make all you blind. You be but boys. I fear the sea no more than a dish of water. Why, fools, it is but a liquid element. Farewell.

Starts to go.

Rob. It were good we learned his cunning at the cards, for we must live by cozenage. We have neither lands nor wit nor masters nor honesty.

Rafe. Nay, I would fain have his thirty-two, that is, his three dozen lacking four points, for you see betwixt us three there is not two good points. 51

Dick. Let us call him a little back, that we may learn

² *practice:* scheme.

I.iii.
¹ *fond:* affectionate, foolish
² *kind:* considerate, natural

I.iv.
¹ *wreck:* "wrack" in original. ² *haled:* dragged about.
³ *speeds:* fares. ⁴ *brook:* enjoy, digest.
⁵ *powdered:* salted. ⁶ *pinned:* confined.
⁷ *shift:* record the positions of (nautical).
⁸ *card:* compass-card, map. ⁹ *pair:* pack.
¹⁰ *points:* on the compass.

those points.[11]—Sirrah, a word. I pray thee, show us thy points.

Mar. Will you learn?

Dick. Ay.

Mar. Then, as you like this, I will instruct you in all our secrets, for there is not a clout[12] nor card nor board[13] nor post[14] that hath not a special name or singular nature. 60

Dick. Well, begin with your points, for I lack only points in this world.

Mar. North, north and by east, north-northeast, northeast and by north, northeast, northeast and by east, east-northeast, east and by north, east.

Dick. I'll say it. North, northeast, northeast, nor'-nor' and by nor'-east—I shall never do it.

Mar. This is but one quarter.

Rob. I shall never learn a quarter of it. I will try. North, north-east, is by the west side, north and by north— 71

Dick. Passing ill.

Mar. Hast thou no memory?—Try thou.

Rafe. North north and by north—I can go no further.

Mar. O dullard, is thy head lighter than the wind and thy tongue so heavy it will not wag? I will once again say it.

Rafe. I will never learn this language. It will get but small living, when it will scarce be learned till one be old. 80

Mar. Nay, then, farewell, and if your fortunes exceed not your wits you shall starve before ye sleep.

Exit.

Rafe. Was there ever such cozening? Come, let us to the woods and see what fortune we may have before they be made ships. As for our master, he is drowned.

Dick. I will this way.

Rob. I, this.

Rafe. I, this, and this day twelve-month let us all meet here again. It may be we shall either beg together or hang together. 90

Dick. It skills[15] not, so we be together. But let us sing now, though we cry hereafter.

SONG

Omnes. *Rocks, shelves, and sands and seas, farewell.*
 Fie! Who would dwell
 In such a hell
 As is a ship, which, drunk, does reel,
 Taking salt healths from deck to keel?

Robin. *Up were we swallowed in wet graves,*
Dick. *All soused in waves*
Rafe. *By Neptune's slaves.* 100
Omnes. *What shall we do being tossed to shore?*
Robin. *Milk*[16] *some blind*[17] *tavern, and there roar.*[18]

Rafe. *'Tis brave, my boys, to sail on land,*
 For, being well manned,[19]
 We can cry, "Stand!"[20]
Dick. *The trade of pursing*[21] *ne'er shall fail*
 Until the hangman cries, "Strike sail!"[22]

Omnes. *Rove then no matter whither,*
 In fair or stormy weather,
 And, as we live, let's die together. 110
 One hempen[23] *caper cuts a feather.*[24]

Exeunt.

ACT TWO

SCENE ONE

[Enter] GALLATHEA *alone.*

Gall. Blush, Gallathea, that must frame thy affection fit for thy habit, and therefore be thought immodest because thou art unfortunate. Thy tender years cannot dissemble this deceit, nor thy sex bear it. Oh, would the gods had made me as I seem to be, or that I might safely be what I seem not! Thy father doteth, Gallathea, whose blind love corrupteth his fond judgment, and, jealous[1] of thy death, seemeth to dote on thy beauty, whose fond care carrieth his partial eye as far from truth as his heart is from falsehood. But 10 why dost thou blame him, or blab what thou art, when thou shouldst only counterfeit what thou art not? But whist, here cometh a lad. I will learn of him how to behave myself.

Enter PHYLLIDA *in man's attire.*

Phyl. I neither like my gait nor my garments, the one untoward,[2] the other unfit, both unseemly. O Phyllida!—but yonder stayeth one, and therefore say nothing. But O Phyllida!

Gall. I perceive that boys are in as great disliking of themselves as maids; therefore, though I wear the apparel, I am glad I am not the person. 21

Phyl. It is a pretty boy and a fair. He might well have been a woman; but because he is not, I am glad I am, for now under the color[3] of my coat I shall decipher the follies of their kind.

Gall. I would salute him, but I fear I should make a curtsy instead of a leg.[4]

Phyl. If I durst trust my face as well as I do my habit, I would spend some time to make pastime, for say what they will of a man's wit, it is no second[5] thing to be a woman. 31

Gall. All the blood in my body would be in my face if he should ask me, as the question among men is common, "Are you a maid?"[6]

[11] *points:* clothing-laces with metal tags. [12] *clout:* sail.
[13] *board:* ship's side, ship's course when tacking.
[14] *post:* upright timber on which rudder is hung.
[15] *skills:* matters. [16] *milk:* "bleed."
[17] *blind:* out of the way. [18] *roar:* swagger.
[19] *manned:* furnished with men. [20] *Stand:* Halt.
[21] *pursing:* stealing purses. [22] *Strike sail:* Surrender.
[23] *hempen:* at the end of a (hangman's) rope.
[24] *cuts a feather:* of a ship, makes the water foam before her; makes fine distinctions; strips one of finery.
II.i.
[1] *jealous:* fearful: [2] *untoward:* ungraceful.
[3] *color:* disguise. [4] *leg:* bow. [5] *second:* inferior.
[6] *maid:* virgin.

Phyl. Why stand I still? Boys should be bold; but here cometh a brave[7] train that will spill[8] all our talk.

Enter DIANA, TELUSA, *and* EUROTA.

Diana. God speed, fair boy.
Gall. You are deceived, lady.
Diana. Why, are you no boy?
Gall. No fair boy. 40
Diana. But, I see, an unhappy boy.
Tel. Saw you not the deer come this way? He flew down the wind, and I believe you have blanched[9] him.
Gall. Whose deer was it, lady?
Tel. Diana's deer.
Gall. I saw none but mine own dear.
Tel. This wag is wanton[10] or a fool. Ask the other, Diana.
Gall. [*Aside*] I know not how it cometh to pass, but yonder boy is in mine eye too beautiful. I pray gods the ladies think him not their dear. 51
Diana. [*to* PHYLLIDA] Pretty lad, do your sheep feed in the forest, or are you strayed from your flock, or on purpose come ye to mar Diana's pastime?
Phyl. I understand not one word you speak.
Diana. What, art thou neither lad nor shepherd?
Phyl. My mother said I could be no lad till I was twenty year old, nor keep sheep till I could tell[11] them, and therefore, lady, neither lad nor shepherd is here.
Tel. These boys are both agreed. Either they are very pleasant[12] or too perverse. You were best, lady, 61 make them tusk[13] these woods whilst we stand with our bows, and so use them as beagles since they have so good mouths.
Diana. I will. [*To* PHYLLIDA] Follow me without delay or excuse, and if you can do nothing, yet shall you hallow[14] the deer.
Phyl. I am willing to go—[*Aside*] not for these ladies' company, because myself am a virgin, but for that fair boy's favor, who I think be a god. 70
Diana. [*To* GALLATHEA] You, sir boy, shall also go.
Gall. I must if you command—[*Aside*] and would if you had not.

Exeunt.

[II.ii]

[*Enter*] CUPID *alone, in nymph's apparel, and* NEPTUNE *listening.*

Cup. Now, Cupid, under the shape of a silly[1] girl show the power of a mighty god. Let Diana and all her coy nymphs know that there is no heart so chaste but thy bow can wound, nor eyes so modest but thy brands can kindle, nor thoughts so stayed[2] but thy shafts can make wavering, weak, and wanton. Cupid, though he be a child, is no baby. I will make their pains my pastimes and so confound their loves in their own sex that they shall dote in their desires, delight in their affections, and practice only impossibilities. Whilst I 10 truant from my mother I will use some tyranny in these woods, and so shall their exercise in foolish love be my excuse for running away. I will see whether fair faces

be always chaste, or Diana's virgins only[3] modest, else will I spend both my shafts and shifts;[4] and then, ladies, if you see these dainty dames entrapped in love, say softly to yourselves, "We may all love."

Nep. Do silly[5] shepherds go about to deceive great Neptune, in putting on man's attire upon women, and Cupid, to make sport, deceive them all by using a 20 woman's apparel upon a god? Then, Neptune, that hast taken sundry shapes to obtain love, stick not to practice some deceit to show thy deity, and, having often thrust thyself into the shape of beasts to deceive men, be not coy to use the shape of a shepherd to show thyself a god. Neptune cannot be overreached by swains, himself is subtle; and if Diana be overtaken by craft, Cupid is wise. I will into these woods and mark all, and in the end will mar all.

Exit.

[II.iii]

Enter RAFE *alone.*

Rafe. Call you this seeking of fortunes, when one can find nothing but birds' nests? Would I were out of these woods, for I shall have but wooden[1] luck; here's nothing but the screaking of owls, croaking of frogs, hissing of adders, barking of foxes, walking of hags.[2] But what be these?

Enter Fairies *dancing and playing, and so, exeunt.*

I will follow them. To hell I shall not go, for so fair faces never can have such hard fortunes. What black boy is this?

Enter the Alchemist's boy, PETER.

Pete. What a life do I lead with my master! Nothing but blowing of bellows, beating of spirits,[3] and 11 scraping of crosslets![4] It is a very secret science, for none almost can understand the language of it: sublimation,[5] almigation,[6] calcination,[7] rubification,[8] incor-

[7] *brave:* finely dressed. [8] *spill:* spoil.
[9] *blanched:* turned aside, headed back.
[10] *wanton:* fond of broad jesting, unruly.
[11] *tell:* count. [12] *pleasant:* merry.
[13] *tusk:* beat the bushes (in a wood) in order to raise the game.
[14] *hallow:* pursue with shouts.

II.ii.
[1] *silly:* defenseless. [2] *stayed:* steady.
[3] *Diana's virgins only:* only Diana's virgins.
[4] *shifts:* stratagems, entertaining devices.
[5] *silly:* simple, foolish.

II.iii.
[1] *wooden:* worthless (opposed to "golden").
[2] *hags:* female demons.
[3] *spirits:* liquid essences obtained by distillation.
[4] *crosslets:* crucibles.
[5] *sublimation:* chemical process of converting a solid by means of heat into vapor that resolidifies on cooling.
[6] *almigation:* Peter's error for "amalgamation."
[7] *calcination:* reduction by fire to a "calx" or powder.
[8] *rubification:* heating to redness.

poration, circination,[9] cementation,[10] albification,[11] and frementation,[12] with as many terms unpossible to be uttered as the art to be compassed.

Rafe. Let me cross myself. I never heard so many great devils in a little monkey's mouth.

Pete. Then our instruments: crosslets, sublivatories,[13] cucurbits,[14] limbecks,[15] descensories,[16] vials manual[17] and mural for imbibing[18] and conbibing,[19] bellows mollificative[20] and indurative.[21] 21

Rafe. What language is this? Do they speak so?

Pete. Then our metals: saltpeter, vitriol, sal-tartar, sal perperate,[22] argol,[23] resagar,[24] sal-armonick, egrimony,[25] lumany,[26] brimstone, valerian,[27] tartar alam,[28] breemwort,[29] glass, unsleked[30] lime, chalk, ashes, hair, and whatnot, to make I know not what.

Rafe. My hair beginneth to stand upright. Would the boy would make an end! 31

Pete. And yet such a beggarly science it is, and so strong on multiplication,[31] that the end is to have neither gold, wit, nor honesty.

Rafe. Then am I just of thy occupation. What, fellow, well met!

Pete. Fellow, upon what acquaintance?

Rafe. Why, thou sayst the end of thy occupation is to have neither wit, money, nor honesty, and methinks at a blush thou shouldst be one of my occupation. 40

Pete. Thou art deceived. My master is an alchemist.

Rafe. What's that? A man?

Pete. A little more than a man and a hair's-breadth less than a god. He can make of thy cap gold, and by multiplication of one groat, three old angels.[32] I have known him of the tag of a point to make a silver bowl of a pint.[33]

Rafe. That makes thee have never a point; they be all turned to pots. But if he can do this, he shall be a god altogether. 50

Pete. If thou have any gold to work on, thou art then made forever, for with one pound of gold he will go near to pave ten acres of ground.

Rafe. How might a man serve him and learn his cunning?

Pete. Easily. First seem to understand the terms, and specially mark these points. In our art there are four spirits.

Rafe. Nay, I have done, if you work with devils. 59

Pete. Thou art gross.[34] We call those spirits that are the grounds of our art, and, as it were, the metals more incorporative for domination. The first spirit is quicksilver.[35]

Rafe. That is my spirit, for my silver is so quick that I have much ado to catch it, and when I have it, it is so nimble that I cannot hold it; I thought there was a devil in it.

Pete. The second, orpiment.[36]

Rafe. That's no spirit, but a word to conjure a spirit.

Pete. The third, sal-armoniack.[37] 70

Rafe. A proper word.

Pete. The fourth, brimstone.

Rafe. That's a stinking spirit. I thought there was some spirit in it, because it burnt so blue. For my mother would often tell me that when the candle burnt blue there was some ill spirit in the house, and now I perceive it was the spirit Brimstone.

Pete. Thou canst remember these four spirits?

Rafe. Let me alone to conjure them.

Pete. Now are there also seven bodies[38]—but here cometh my master. 81

Enter ALCHEMIST.

Rafe. This is a beggar.

Pete. No such cunning men must disguise themselves as though there were nothing in them, for otherwise they shall be compelled to work for princes and so be constrained to bewray[39] their secrets.

Rafe. I like not his attire, but am enamored of his art.

Alch. [*To himself*] An ounce of silver limed, as much of crude mercury, of spirits four, being tempered 90 with the bodies seven, by multiplying of it ten times comes for one pound eight thousand pounds, so that I may have only beechen coals.[40]

Rafe. [*To* PETER] Is it possible?

Pete. It is more certain than certainty.

Rafe. I'll tell thee one secret. I stole a silver thimble. Dost thou think that he will make it a pottle[41] pot?

Pete. A pottle pot! Nay, I dare warrant it, a whole cupboard of plate! Why, of the quintessence of a leaden plummet he hath framed twenty dozen of silver 100 spoons. Look how he studies. I durst venture my life he is now casting about[42] how of his breath he may make

golden bracelets, for oftentimes of smoke he hath made silver drops.[43]

Rafe. What do I hear?

Pete. Didst thou never hear how Jupiter came in a golden shower to Danae?[44]

Rafe. I remember that tale.

Pete. That shower did my master make of a spoonful of tartar alom; but with the fire of blood and 110 the corrosive of the air he is able to make nothing infinite. But whist, he espieth us.

Alch. What, Peter, do you loiter, knowing that every minute increaseth our mine?

Pete. I was glad to take air, for the metal came so fast that I feared my face would have been turned to silver.

Alch. But what stripling is this?

Pete. One that is desirous to learn your craft.

Alch. Craft, sir boy! You must call it mystery.[45] 120

Rafe. All is one, a crafty mystery and a mystical craft.

Alch. Canst thou take pains?

Rafe. Infinite.

Alch. But thou must be sworn to be secret, and then I will entertain[46] thee.

Rafe. I can swear, though I be a poor fellow, as well as the best man in the shire. But, sir, I much marvel that you, being so cunning, should be so ragged. 128

Alch. O, my child, gryphes[47] make their nests of gold though their coats are feathers, and we feather our nests with diamonds though our garments be but frieze. If thou knewest the secret of this science, the cunning would make thee so proud that thou wouldst disdain the outward pomp.

Pete. My master is so ravished with his art that we many times go supperless to bed, for he will make gold of his bread, and such is the drouth[48] of his desire that we all wish our very guts were gold.

Rafe. I have good fortune to light upon such a master. 140

Alch. When in the depth of my skill I determine to try the uttermost of mine art, I am dissuaded by the gods; otherwise I durst undertake to make the fire as it flames gold, the wind as it blows silver, the water as it runs lead, the earth as it stands iron, the sky brass, and men's thoughts firm metals.

Rafe. I must bless myself and marvel at you.

Alch. Come in, and thou shalt see all. 148

Rafe. I follow, I run, I fly! They say my father hath a golden thumb; you shall see me have a golden body.

Exit.

Pete. I am glad of this, for now I shall have leisure to run away. Such a bald[49] art as never was! Let him keep his new man, for he shall never see his old again. God shield me from blowing gold to nothing, with a strong imagination to make nothing anything!

Exit.

[II.iv]

[*Enter*] GALLATHEA *alone.*

Gal. How now, Gallathea, miserable Gallathea, that having put on the apparel of a boy thou canst [not] also

put on the mind! O fair Melebeus!—ay, too fair, and therefore, I fear, too proud. Had it not been better for thee to have been a sacrifice to Neptune than a slave to Cupid? To die for thy country than to live in thy fancy? To be a sacrifice than a lover? Oh, would when I hunted his eye with my heart he might have seen my heart with his eyes! Why did nature to him, a boy, give a face so fair, or to me a virgin, a fortune so 10 hard? I will now use for the distaff the bow, and play at quoits abroad that was wont to sew in my sampler at home. It may be, Gallathea—foolish Gallathea, what may be? Nothing. Let me follow him into the woods, and thou, sweet Venus, be my guide.

Exit.

[II.v]

Enter PHYLLIDA *alone.*

Phyl. Poor Phyllida, curse the time of thy birth and rareness of thy beauty, the unaptness of thy apparel and the untamedness of thy affections. Art thou no sooner in the habit of a boy but thou must be enamored of a boy? What shalt thou do when what best liketh[1] thee most discontenteth thee? Go into the woods, watch the good times, his best moods, and transgress in love a little of thy modesty. I will—I dare not; thou must— I cannot. Then pine in thine own peevishness.[2] I will not—I will. Ah, Phyllida, do something, nay, any- 10 thing, rather than live thus. Well, what I will do, myself knows not, but what I ought I know too well, and so I go resolute, either to bewray my love or suffer shame.

Exit.

ACT THREE

SCENE ONE

[*Enter*] TELUSA *alone.*

Tel. How now? What new conceits,[1] what strange contraries, breed in thy mind? Is thy Diana become a Venus, thy chaste thoughts turned to wanton looks, thy conquering modesty to a captive imagination? Beginnest thou with pyralis[2] to die in the air and live in the fire, to leave the sweet delight of hunting and to follow the hot desire of love? O Telusa, these words are unfit

[43] *drops:* pendants, eardrops.

[44] *Danae:* mother of Perseus by Jupiter, who penetrated the windowbars of her sanctuary in a shower of gold.

[45] *mystery:* trade (here with connotations of the modern sense). [46] *entertain:* accept.

[47] *gryphes:* griffins, legendary creatures with lion's body and eagle's head and wings.

[48] *drouth:* thirst. [49] *bald:* paltry.

II.v.

[1] *liketh:* pleases. [2] *peevishness:* folly.

III.i.

[1] *conceits:* fancy.

[2] *pyralis:* a fabulous fly supposed to live in or be generated by fire and to die out of the flame.

for thy sex, being a virgin, but apt for thy affections, being a lover. And can there in years so young, in education so precise, in vows so holy, and in a heart 10 so chaste enter either a strong desire or a wish or a wavering thought of love? Can Cupid's brands[3] quench Vesta's[4] flames, and his feeble shafts headed with feathers pierce deeper than Diana's arrows headed with steel? Break thy bow, Telusa, that seekest to break thy vow, and let those hands that aimed to hit the wild hart scratch out those eyes that have wounded thy tame heart. O vain and only[5] naked name of chastity, that is made[6] eternal and perisheth by time; holy, and is infected by fancy; divine, and is made mortal by 20 folly! Virgins' hearts, I perceive, are not unlike cotton trees, whose fruit is so hard in the bud that it soundeth like steel, and, being ripe, poureth forth nothing but wool, and their thoughts like the leaves of lunary,[7] which, the further they grow from the sun, the sooner they are scorched with his beams. O Melebeus, because thou art fair must I be fickle, and false my vow because I see thy virtue? Fond girl that I am, to think of love; nay, vain profession that I follow, to disdain love! But here cometh Eurota. I must now put on a red mask and blush, lest she perceive my pale face and laugh. 31

Enter EUROTA.

Eur. Telusa, Diana bid me hunt you out, and saith that you care not to hunt with her, but if you follow any other game than she hath roused, your punishment shall be to bend all our bows and weave all our strings. Why look ye so pale, so sad, so wildly?

Tel. Eurota, the game I follow is the thing I fly; my strange disease my chief desire.

Eur. I am no Oedipus, to expound riddles, and I muse how thou canst be Sphinx[8] to utter them. 40 But I pray thee, Telusa, tell me what thou ailest. If thou be sick, this ground hath leaves to heal; if melancholy, here are pastimes to use; if peevish wit must wean[9] it, or time, or counsel. If thou be in love (for I have heard of such a beast called love), it shall be cured. Why blushest thou, Telusa?

Tel. To hear thee in reckoning my pains to recite thine own. I saw, Eurota, how amorously you glanced your eye on the fair boy in the white coat, and how cunningly, now that you would have some talk of love, you hit me in the teeth with love. 51

Eur. I confess that I am in love, and yet swear that I know not what it is. I feel my thoughts unknit, mine eyes unstaid, my heart I know not how affected, or

infected, my sleeps broken and full of dreams, my wakeness sad and full of sighs, myself in all things unlike myself. If this be love, I would it had never been devised.

Tel. Thou hast told what I am in uttering what thyself is. These are my passions, Eurota, my un- 60 bridled passions, my intolerable passions, which I were as good acknowledge and crave counsel as to deny and endure peril.

Eur. How did it take you first, Telusa?

Tel. By the eyes, my wanton eyes, which conceived the picture of his face and hanged it on the very strings of my heart. O fair Melebeus, O fond Telusa! But how did it take you, Eurota?

Eur. By the ears, whose sweet words sunk so deep into my head that the remembrance of his wit hath 70 bereaved me of my wisdom. O eloquent Tityrus, O credulous Eurota! But soft, here cometh Ramia. But let her not hear us talk; we will withdraw ourselves and hear her talk.

They retire.

Enter RAMIA.

Ram. I am sent to seek others that have lost myself.

Eur. You shall see Ramia hath also bitten on a love leaf.

Ram. Can there be no heart so chaste but love can wound, nor vows so holy but affection can violate? Vain art thou, virtue, and thou, chastity, but a 80 byword, when you both are subject to love, of all things the most abject. If love be a god, why should not lovers be virtuous? Love is a god, and lovers are virtuous.

[TELUSA *and* EUROTA *come forward.*]

Eur. Indeed, Ramia, if lovers were not virtuous, then wert thou vicious.

Ram. What, are you come so near me?

Tel. I think we came near you when we said you loved.

Eur. Tush, Ramia, 'tis too late to recall it, to repent it a shame. Therefore, I pray thee tell what is love? 90

Ram. If myself felt only this infection, I would then take upon me the definition, but being incident to so many, I dare not myself describe it. But we will all talk of that in the woods. Diana stormeth that sending one to seek another she loseth all. Servia, of all the nymphs the coyest,[10] loveth deadly,[11] and exclaimeth against Diana, honoreth Venus, detesteth Vesta, and maketh a common scorn of virtue. Clymene, whose stately looks seemed to amaze[12] the greatest lords, stoopeth, yieldeth, and fawneth on the strange boy in the woods. 100 Myself (with blushing I speak it) am thrall to that boy, that fair boy, that beautiful boy.

Tel. What have we here? All in love? No other food than fancy? No, no, she shall not have the fair boy.

Eur. Nor you, Telusa.

Ram. Nor you, Eurota.

Tel. I love Melebeus, and my deserts shall be answerable[13] to my desires. I will forsake Diana for him. I will die for him. 109

Ram. So saith Clymene, and she will have him. I

[3] *brands:* torches.

[4] *Vesta's:* Vesta was a Roman hearth-goddess, in whose temple virgins tended a sacred fire.

[5] *only:* of itself alone. [6] *made:* made out to be.

[7] *lunary:* the plant moonwort.

[8] *Oedipus ... Sphinx:* Oedipus saved Thebes from the mythical monster by solving its riddle about the three ages of man.

[9] *wean:* abate. [10] *coyest:* most reluctant to love.

[11] *deadly:* extremely.

[12] *amaze:* drive mad, overwhelm with wonder.

[13] *answerable:* fitting.

care not; my sweet Tityrus, though he seem proud, I impute it to childishness, who, being yet scarce out of his swath-clouts,[14] cannot understand these deep conceits. I love him.

Eur. So do I, and I will have him.

Tel. Immodest all that we are, unfortunate all that we are like to be! Shall virgins begin to wrangle for love and become wanton in their thoughts, in their words, in their actions? O divine love, which art therefore called divine, because thou overreachest[15] the wisest, 120 conquerest the chastest, and dost all things both unlikely and impossible, because thou art love! Thou makest the bashful impudent, the wise fond, the chaste wanton, and workest contraries to our reach, because thyself is beyond reason.

Eur. Talk no more, Telusa; your words wound. Ah, would I were no woman!

Ram. Would Tityrus were no boy!

Tel. Would Telusa were nobody!

Exeunt.

[III.ii]

[Enter] PHYLLIDA *and* GALLATHEA.

Phyl. It is pity that nature framed you not a woman, having a face so fair, so lovely a countenance, so modest a behavior.

Gall. There is a tree in Tylos[1] whose nuts have shells like fire, and, being cracked, the kernel is but water.

Phyl. What a toy[2] is it to tell me of that tree, being nothing to the purpose! I say it is pity you are not a woman.

Gall. I would not wish to be a woman, unless it were because thou art a man. 10

Phyl. Nay, I do not wish thee to be a woman, for then I should not love thee, for I have sworn never to love a woman.

Gall. A strange humor in so pretty a youth, and according to mine, for myself will never love a woman.

Phyl. It were a shame, if a maiden should be a suitor (a thing hated in that sex), that thou shouldst deny to be her servant.

Gall. If it be a shame in me, it can be no commendation in you, for yourself is of that mind. 20

Phyl. Suppose I were a virgin (I blush in supposing myself one), and that under the habit of a boy were the person of a maid: if I should utter my affection with sighs, manifest my sweet love by my salt tears, and prove my loyalty unspotted and my griefs intolerable, would not then that fair face pity this true heart?

Gall. Admit that I were as you would have me suppose that you are, and that I should with entreaties, prayers, oaths, bribes, and whatever can be invented in love, desire your favor, would you not yield? 30

Phyl. Tush, you come in[3] with "admit."

Gall. And you with "suppose."

Phyl. [Aside] What doubtful[4] speeches be these! I fear me he is as I am, a maiden.

Gall. [Aside] What dread riseth in my mind! I fear the boy to be as I am, a maiden.

Phyl. [Aside] Tush, it cannot be; his voice shows the contrary.

Gall. [Aside] Yet I do not think it, for he would then have blushed. 40

Phyl. Have you ever a sister?

Gall. If I had but one, my brother must needs have two. But, I pray, have you ever a one?

Phyl. My father had but one daughter, and therefore I could have no sister.

Gall. [Aside] Ay me, he is as I am, for his speeches be as mine are.

Phyl. [Aside] What shall I do? Either he is subtle or my sex simple. 49

Gall. [Aside] I have known divers of Diana's nymphs enamored of him, yet hath he rejected all, either as too proud, to disdain, or too childish, not to understand, or for that he knoweth himself to be a virgin.

Phyl. [Aside] I am in a quandary. Diana's nymphs have followed him, and he despised them, either knowing too well the beauty of his own face, or that himself is of the same mold. I will once again try him. *[To* GALLATHEA]* You promised me in the woods that you would love me before all Diana's nymphs.

Gall. Ay, so you would love me before all Diana's nymphs. 61

Phyl. Can you prefer a fond boy as I am before so fair ladies as they are?

Gall. Why should not I as well as you?

Phyl. Come, let us into the grove and make much one of another, that cannot tell what to think one of another.

Exeunt.

[III.iii]

[Enter] ALCHEMIST, RAFE.

Alch. Rafe, my boy is run away. I trust thou wilt not run after.

Rafe. I would I had a pair of wings, that I might fly after.

Alch. My boy was the veriest thief, the arrantest liar, and the vilest[1] swearer in the world, otherwise the best boy in the world. He hath stolen my apparel, all my money, and forgot nothing but to bid me farewell.

Rafe. That will not I forget. Farewell, master. 9

Alch. Why, thou hast not yet seen the end of my art.

Rafe. I would I had not known the beginning. Did not you promise me of my silver thimble to make a whole cupboard of plate, and that of a Spanish[2] needle you would build a silver steeple?

Alch. Ay, Rafe, the fortune of this art consisteth in the measure of the fire, for if there be a coal too much

[14] *swath-clouts:* swaddling clothes.
[15] *overreachest:* overpower.

II.ii.
[1] *Tylos:* an unknown place. [2] *toy:* foolish thing.
[3] *come in:* begin. [4] *doubtful:* ambiguous, worrisome.

III.iii.
[1] *vilest:* "vildest" in original.
[2] *Spanish:* Most English needles were made in Spain.

or a spark too little, if it be a little too hot or a thought too soft, all our labor is in vain. Besides, they that blow must beat time with their breaths, as musicians do with their breasts,[3] so as there must be of the metals, the fire, and workers a very harmony. 21

Rafe. Nay, if you must weigh your fire by ounces, and take measure of a man's blast,[4] you may then make of a dram of wind a wedge of gold, and of the shadow of one shilling make another, so as you have an organist to tune your temperatures.

Alch. So is it, and often doth it happen that the just proportion of the fire and all things concur.

Rafe. Concur, condog![5] I will away.

Alch. Then away. 30

 Exit ALCHEMIST.

Enter ASTRONOMER [*gazing upward*].

Rafe. An art, quoth you,[6] that one multiplieth so much all day that he wanteth money to buy meat at night! But what have we yonder? What devout man? He will never speak till he be urged. I will salute him. Sir, there lieth a purse under your feet. If I thought it were not yours, I would take it up.

Astron. Dost thou not know that I was calculating the nativity[7] of Alexander's great horse?[8]

Rafe. Why, what are you?

Astron. An astronomer. 40

Rafe. What, one of those that makes almanacs?[9]

Astron. Ipsissimus.[10] I can tell the minute of thy birth, the moment of thy death, and the manner. I can tell thee what weather shall be between this and *octogessimus octavus mirabilis annus.*[11] When I list, I can set a trap for the sun, catch the moon with lime twigs, and go a-batfowling[12] for stars. I can tell thee things past and things to come, and with my cunning measure how many yards of clouds are beneath the sky. Nothing can happen which I foresee not; nothing shall. 50

Rafe. I hope, sir, you are no more than a god.

Astron. I can bring the twelve signs out of their zodiacs and hang them up at taverns.[13]

Rafe. I pray you sir, tell me what you cannot do, for I perceive there is nothing so easy for you to compass as impossibilities. But what be those signs?

Astron. As a man should say, signs which govern the body.[14] The Ram governeth the head.

Rafe. That is the worst sign for the head.[15]

Astron. Why? 60

Rafe. Because it is a sign of an ill ewe.

Astron. Tush, that sign must be there. Then the Bull for the throat, Capricornus for the knees.

Rafe. I will hear no more signs, if they be all such desperate signs. But seeing you are—I know not who to term you—shall I serve you? I would fain serve.

Astron. I accept thee.

Rafe. Happy am I, for now shall I reach thoughts, and tell how many drops of water goes to the greatest shower of rain. You shall see me catch the moon in the clips[16] like a cony[17] in a pursenet.[18] 71

Astron. I will teach thee the golden number,[19] the epact,[20] and the prime.[21]

Rafe. I will meddle no more with numbering of gold, for multiplication is a miserable action. I pray, sir, what weather shall we have this hour threescore year?[22]

Astron. That I must cast by our judicials astronomical.[23] Therefore come in with me, and thou shall see every wrinkle of my astrological wisdom, and I will make the heavens as plain to thee as the highway. 80 Thy cunning shall sit cheek by jowl with the sun's chariot. Then shalt thou see what a base thing it is to have others' thoughts creep on the ground, whenas[24] thine shall be stitched to the stars.

Rafe. Then I shall be translated from this mortality.

Astron. Thy thoughts shall be metamorphosed and made hail-fellows with the gods.

Rafe. O fortune! I feel my very brains moralized, and, as it were, a certain contempt of earthly actions is crept into my mind, by an ethereal contemplation. Come, let us in. 91

 Exeunt.

[III.iv]

[*Enter*] DIANA, TELUSA, EUROTA, RAMIA, LARISSA.

Diana. What news have we here, ladies? Are all in love? Are Diana's nymphs become Venus' wantons? Is it a shame to be chaste because you be amiable, or must you needs be amorous because you are fair? O Venus, if this be thy spite I will requite it with more than hate. Well shalt thou know what it is to drib[1] thine arrows up and down Diana's leas. There is an unknown nymph that straggleth up and down these woods, which I suspect hath been the weaver of these woes. I saw her

[3] *breasts:* voices. [4] *blast:* breath.
[5] *condog:* pun on "concur(?)."
[6] *quoth you:* indeed (used with sarcastic force in repeating another's phrase). [7] *nativity:* horoscope.
[8] *Alexander's . . . horse:* Bucephalus, favorite horse of Alexander the Great, in whose honor Alexander founded a town after his battlefield death in 326 B.C.
[9] *almanacs:* popular (and frequently ridiculed) books of tables and information regarding astronomical, meteorological, and astrological forecasts and calculations, dates of eclipses and movable feasts, etc.
[10] *L.:* The very same.
[11] *L.:* 1588, predicted to be a year of wonders.
[12] *a-batfowling:* catching roosting birds at night.
[13] *hang . . . taverns:* tavern signs often featured appropriate astrological figures.
[14] *signs . . . body:* each zodiacal sign was thought to govern a part of the body.
[15] *sign . . . head:* allusion to cuckold's horns.
[16] *clips:* eclipse, grips. [17] *cony:* rabbit.
[18] *pursenet:* net used for catching rabbits.
[19] *golden number:* number of a year in nineteen-year lunar cycle.
[20] *epact:* number of days by which the solar year exceeds the twelve-month lunar year; number of days in the moon's age on March 1 or 22, the first day of the year.
[21] *prime:* first appearance of new moon.
[22] *hour . . . year:* at this hour sixty years from now.
[23] *judicials astronomical:* system of predicting future events from positions of celestial bodies.
[24] *whenas:* when.

III.iv.
[1] *drib:* shoot an arrow wide or short of the mark.

slumbering by the brookside. Go search her and 10
bring her. If you find upon her shoulder a burn, it is
Cupid; if any print on her back like a leaf, it is Medea;[2]
if any picture on her left breast like a bird, it is Calypso.[3]
Whoever it be, bring her hither, and speedily bring her
hither.

Tel. I will go with speed.

Diana. Go you, Larissa, and help her.

Lar. I obey.

[*Exeunt* TELUSA *and* LARISSA.]

Diana. Now, ladies, doth not that make your cheeks
blush that makes mine ears glow, or can you re- 20
member that without sobs which Diana cannot think
on without sighs? What greater dishonor could happen
to Diana, or to her nymphs shame, than that there can
be any time so idle that should make their heads so
addle? Your chaste hearts, my nymphs, should re-
semble the onyx, which is hottest when it is whitest,
and your thoughts, the more they are assaulted with
desires, the less they should be affected. You should
think love like Homer's moly,[4] a white leaf and a black
root, a fair show and a bitter taste. Of all trees the 30
cedar is greatest and hath the smallest seeds; of all
affections love hath the greatest name and the least
virtue. Shall it be said, and shall Venus say it, nay, shall
it be seen, and shall wantons see it, that Diana, the
goddess of chastity, whose thoughts are always answer-
able to her vows, whose eyes never glanced on desire,
and whose heart abateth[5] the point of Cupid's arrows,
shall have her virgins to become unchaste in desires,
immoderate in affection, untemperate in love, in foolish
love, in base love? Eagles cast their evil feathers in 40
the sun, but you cast your best desires upon a shadow.
The birds Ibes[6] lose their sweetness when they lose their
sights, and virgins all their virtues with their unchaste
thoughts. Unchaste Diana calleth that that hath either
any show or suspicion of lightness. O my dear nymphs,
if you knew how loving thoughts stain lovely faces, you
would be as careful to have the one as unspotted as the
other beautiful.

Cast before your eyes the loves of Venus' trulls,[7]
their fortunes, their fancies, their ends. What are 50
they else but Silenus' pictures[8] without, lambs and
doves within, apes and owls, who like Ixion embrace
clouds for Juno,[9] the shadows of virtue instead of the
substance? The eagle's feathers consume the feathers
of all others, and love's desire corrupteth all other
virtues. I blush, ladies, that you, having been hereto-
fore patient of labors, should now become prentices to
idleness, and use the pen for sonnets, not the needle for
samplers. And how is your love placed? Upon pelting[10]
boys, perhaps base of birth, without doubt weak of 60
discretion. Ay, but they are fair. O ladies, do your eyes
begin to love colors,[11] whose hearts was wont to loath
them? Is Diana's chase[12] become Venus' court, and
are your holy vows turned to hollow thoughts?

Ram. Madam, if love were not a thing beyond
reason we might then give a reason of our doings, but
so divine is his force that it worketh effects as contrary
to that we wish as unreasonable against that we ought.

Eur. Lady, so unacquainted[13] are the passions of love

that we can neither describe them nor bear them. 70

Diana. Foolish girls, how willing you are to follow
what which you should fly. But here cometh Telusa.

Enter TELUSA *and* LARISSA *with* CUPID.

Tel. We have brought the disguised nymph and have
found on his shoulder Psyche's[14] burn, and he confes-
seth himself to be Cupid.

Diana. How now, sir, are you caught? Are you
Cupid?

Cup. Thou shalt see, Diana, that I dare confess
myself to be Cupid. 79

Diana. And thou shalt see, Cupid, that I will show
myself to be Diana, that is, conqueror of thy loose
and untamed appetites. Did thy mother, Venus, under
the color of a nymph send thee hither to wound my
nymphs? Doth she add craft to her malice, and, mis-
trusting her deity, practice deceit? Is there no place but
my groves, no persons but my nymphs? Cruel and
unkind Venus, that spiteth only chastity, thou shalt see
that Diana's power shall revenge thy policy and tame
this pride. As for thee, Cupid, I will break thy bow and
burn thine arrows, bind thy hands, clip thy wings, 90
and fetter thy feet. Thou that fattest others with hopes
shalt be fed thyself with wishes, and thou that bindest
others with golden thoughts shalt be bound thyself
with golden fetters. Venus' rods are made of roses,
Diana's of briars. Let Venus, that great goddess, ransom
Cupid, that little god. These ladies here whom thou
hast infected with foolish love shall both tread on thee
and triumph over thee. Thine own arrow shall be shot
into thine own bosom, and thou shalt be enamored not
on Psyches but on Circes. I will teach thee what 100
it is to displease Diana, distress her nymphs, or disturb
her game.

Cup. Diana, what I have done cannot be undone,
but what you mean to do, shall. Venus hath some gods
to her friends; Cupid shall have all.

Diana. Are you prating? I will bridle thy tongue and
thy power, and in spite of mine own thoughts I will set
thee a task every day, which if thou finish not thou shalt
feel the smart. Thou shalt be used as Diana's slave, not
Venus' son. All the world shall see that I will use 110

[2] *Medea:* mythological enchantress.

[3] *Calypso:* nymph-enchantress with whom Odysseus
stayed seven years.

[4] *moly:* herb given by Hermes to Odysseus to prevent
the enchantress Circe's magic from turning him into an
animal as it did his men.

[5] *abateth:* turns aside, blunts.

[6] *Ibes:* long-legged, slender-billed birds venerated in
ancient Egypt; the singular form is "ibis."

[7] *trulls:* women who prostituted themselves in service of
the love-goddess.

[8] *Silenus' pictures:* In classical Athens, busts of the ugly
satyr contained images of gods.

[9] *Ixion ... Juno:* When Ixion attempted to seduce
Zeus's wife Hera, Zeus substituted a cloud-image of her, on
which the seducer begat the Centaurs, or their father, and
was punished by being chained to a revolving wheel.

[10] *pelting:* paltry. [11] *colors:* complexions, appearances.

[12] *chase:* hunting-ground. [13] *unacquainted:* unfamiliar.

[14] *Psyche:* mythological embodiment of the soul, loved by
Eros or Cupid.

thee like a captive and show myself a conqueror. Come, have him in, that we may devise apt punishments for his proud presumptions.

Eur. We will plague ye for a little god.

Tel. We will never pity thee though thou be a god.

Ram. Nor I.

Lar. Nor I.

Exeunt.

ACT FOUR

SCENE ONE

[*Enter*] AUGUR, MELEBEUS, TITYRUS, POPULUS.

Aug. This is the day wherein you must satisfy Neptune and save yourselves. Call together your fair daughters, and for a sacrifice take the fairest, for better it is to offer a virgin than suffer ruin. If you think it against nature to sacrifice your children, think it also against sense to destroy your country. If you imagine Neptune pitiless to desire such a prey, confess yourselves perverse to deserve such a punishment. You see this tree, this fatal tree, whose leaves though they glister like gold, yet it threateneth to fair virgins grief. To this 10 tree must the beautifullest be bound until the monster Agar carry her away, and if the monster come not, then assure yourselves that the fairest is concealed, and then your country shall be destroyed. Therefore consult with yourselves, not as fathers of children but as favorers of your country. Let Neptune have his right if you will have your quiet. Thus have I warned you to be careful and would wish you to be wise, knowing that whoso hath the fairest daughter hath the greatest fortune, in losing one to save all; and so I depart to provide cere- 20 monies for the sacrifice and command you to bring the sacrifice.

Exit AUGUR.

Mel. They say, Tityrus, that you have a fair daughter. If it be so, dissemble not, for you shall be a fortunate father. It is a thing holy to preserve one's country and honorable to be the cause.

Tit. Indeed, Melebeus, I have heard you boast that you had a fair daughter, than the which none was more beautiful. I hope you are not so careful of a child that you will be careless of your country, or add so much to nature[1] that you will detract from wisdom. 31

Mel. I must confess that I had a daughter, and I know you have, but alas, my child's cradle was her grave, and her swath-clout her winding sheet. I would she had lived till now; she should willingly have died now; for what could have happened to poor Melebeus more comfortable than to be the father of a fair child and sweet country?

IV.i.
 [1] *nature:* natural feeling. [2] *mischief:* injury.
 [3] *halt:* limp.

IV.ii.
 [1] *Oyez:* court-officer's cry to command attention.
 [2] *lering:* leering, guiding.

Tit. O Melebeus, dissemble you may with men, deceive the gods you cannot. Did not I see, and 40 very lately see, your daughter in your arms, whenas you gave her infinite kisses with affection I fear me more than fatherly? You have conveyed her away that you might cast us all away, bereaving her the honor of her beauty and us the benefit, preferring a common inconvenience before a private mischief.[2]

Mel. It is a bad cloth, Tityrus, that will take no color, and a simple father that can use no cunning. You make the people believe that you wish well, when you practice nothing but ill, wishing to be thought reli- 50 gious towards the gods when I know you deceitful towards men. You cannot overreach me, Tityrus; overshoot yourself you may. It is a wily mouse that will breed in the cat's ear, and he must halt[3] cunningly that will deceive a cripple. Did you ever see me kiss my daughter? You are deceived, it was my wife. And if you thought so young a piece unfit for so old a person, and therefore imagined it to be my child, not my spouse, you must know that silver hairs delight in golden locks, and the old fancies crave young nurses, and 60 frosty years must be thawed by youthful fires. But this matter set aside, you have a fair daughter, Tityrus, and it is pity you are so fond a father.

1 *Pop.* You are both either too fond or too froward, for whilst you dispute to save your daughters we neglect to prevent our destruction.

2 *Pop.* Come, let us away and seek out a sacrifice. We must sift out their cunning and let them shift for themselves.

Exeunt.

[IV.ii]

CUPID, [RAMIA,] TELUSA, EUROTA, LARISSA
 enter, [*the latter three*] *singing.*

Tel. Oyez, Oyez,[1] if any maid
 Whom lering[2] Cupid has betrayed
 To frowns of spite, to eyes of scorn,
 And would in madness now see torn—
All 3. The boy in pieces, let her come
 Hither, and lay on him her doom.

Eur. Oyez, Oyez, has any lost
 A heart which many a sigh hath cost?
 Is any cozened of a tear
 Which, as a pearl, Disdain does wear? 10
All 3. Here stands the thief. Let her but come
 Hither, and lay on him her doom.

Lar. Is anyone undone by fire,
 And turned to ashes through desire?
 Did ever any lady weep,
 Being cheated of her golden sleep—
All 3. Stolen by sick thoughts? The pirate's found,
 And in her tears he shall be drowned.
 Read his indictment, let him hear
 What he's to trust to! Boy, give ear! 20

Tel. Come, Cupid, to your task. First you must undo all these lovers' knots, because you tied them.

Cup. If they be true love knots, 'tis unpossible to unknit them; if false, I never tied them.

Eur. Make no excuse, but to it.

Cup. Love knots are tied with eyes and cannot be undone with hands, made fast with thoughts and cannot be unloosed with fingers. Had Diana no task to set Cupid to but things impossible?

[*They threaten him.*]

I will to it. 30

Ram. Why, how now? You tie the knots faster.

Cup. I cannot choose. It goeth against my mind to make them loose.

Eur. Let me see. Now 'tis unpossible to be undone.

Cup. It is the true love knot of a woman's heart, therefore cannot be undone.

Ram. That falls in sunder of itself.

Cup. It was made of a man's thought, which will never hang together.

Lar. You have undone that well. 40

Cup. Ay, because it was never tied well.

Tel. To the rest, for she will give you no rest. These two knots are finely untied.

Cup. It was because I never tied them. The one was knit by Pluto,[3] not Cupid, by money, not love; the other by force, not faith, by appointment, not affection.

Ram. Why do you lay that knot aside?

Cup. For death.

Tel. Why?

Cup. Because the knot was knit by faith, and must only be unknit of death. 51

Eur. Why laugh you?

Cup. Because it is the fairest and the falsest, done with greatest art and least truth, with best colors and worst conceits.

Tel. Who tied it?

Cup. A man's tongue.

Lar. Why do you put that in my bosom?

Cup. Because it is only for a woman's bosom.

Lar. Why, what is it? 60

Cup. A woman's heart.

Tel. Come, let us go in and tell that Cupid hath done his task. Stay you behind, Larissa, and see he sleep not, for love will be idle, and take heed you surfeit not, for love will be wanton.

Exit TELUSA, [RAMIA, EUROTA].

Lar. Let me alone,[4] I will find him somewhat to do.

Cup. Lady, can you for pity see Cupid thus punished?

Lar. Why did Cupid punish us without pity?

Cup. Is love a punishment?

Lar. It is no pastime. 70

Cup. O Venus, if thou sawest Cupid as a captive, bound to obey that was wont to command, fearing ladies' threats that once pierced their hearts, I cannot tell whether thou wouldst revenge it for despite or laugh at it for disport. The time may come, Diana, and the time shall come, that thou that settest Cupid to undo knots shall entreat Cupid to tie knots, and you ladies that with solace have beheld my pains shall with sighs entreat my pity.

He offereth to sleep.

Lar. How now, Cupid, begin you to nod? 80

[*Enter* RAMIA *and* TELUSA.]

Ram. Come, Cupid. Diana hath devised new labors for you that are god of loves. You shall weave samplers all night and lackey after Diana all day. You shall shortly shoot at beasts for men, because you have made beasts of men, and wait on ladies' trains[5] because thou entrappest ladies by trains. All the stories that are in Diana's arras[6] which are of love you must pick out with your needle, and in that place sew Vesta with her nuns and Diana with her nymphs. How like you this, Cupid?

Cup. I say I will prick as well with my needle as ever I did with mine arrows. 91

Tel. Diana cannot yield; she conquers affection.

Cup. Diana shall yield; she cannot conquer destiny.

Lar. Come, Cupid, you must to your business.

Cup. You shall find me so busy in your heads that you shall wish I had been idle with your hearts.

Exeunt.

[IV.iii]

[*Enter*] NEPTUNE *alone.*

Nep. This day is the solemn sacrifice at this tree, wherein the fairest virgin, were not the inhabitants faithless, should be offered unto me, but so overcareful are fathers to their children that they forget the safety of their country, and, fearing to become unnatural, become unreasonable. Their sleights[1] may blear[2] men; deceive me they cannot. I will be here at the hour and show as great cruelty as they have done craft, and well shall they know that Neptune should have been entreated, not cozened. 10

Exit.

[IV.iv]

Enter GALLATHEA *and* PHYLLIDA.

Phyl. I marvel what virgin the people will present. It is happy you are none, for then it would have fallen to your lot because you are so fair.

Gall. If you had been a maiden too, I need not to have feared, because you are fairer.

Phyl. I pray thee, sweet boy, flatter not me. Speak truth of thyself, for in mine eye of all the world thou art fairest.

Gall. These be fair words, but far from thy true thoughts. I know mine own face in a true glass, and desire not to see it in a flattering mouth. 11

Phyl. O, would I did flatter thee, and that fortune would not flatter me. I love thee as a brother, but love not me so.

[3] *Pluto:* god of underworld and wealth.
[4] *Let . . . alone:* Leave it to me. [5] *trains:* deceits.
[6] *arras:* tapestry wall-hanging.

IV.iii.
[1] *sleights:* tricks. [2] *blear:* dim the vision of.

Gall. No, I will not, but love thee better, because I cannot love as a brother.

Phyl. Seeing we are both boys, and both lovers, that our affection may have some show, and seem as it were love, let me call thee mistress.

Gall. I accept that name, for divers before have called me mistress.[1] 21

Phyl. For what cause?

Gall. Nay, there lie the mistress.[2]

Phyl. Will not you be at the sacrifice?

Gall. No.

Phyl. Why?

Gall. Because I dreamt that if I were there I should be turned to a virgin, and then, being so fair (as thou sayst I am), I should be offered as thou knowest one must. But will not you be there? 30

Phyl. Not unless I were sure that a boy might be sacrificed and not a maiden.

Gall. Why, then you are in danger.

Phyl. But I would escape it by deceit. But seeing we are resolved to be both absent, let us wander into these groves till the hour be past.

Gall. I am agreed, for then my fear will be past.

Phyl. Why, what dost thou fear?

Gall. Nothing but that you love me not. 39
 Exit.

Phyl. I will. Poor Phyllida, what shouldst thou think of thyself, that lovest one that I fear me is as thyself is? And may it not be that her father practiced the same deceit with her that my father hath with me, and, knowing her to be fair, feared she should be unfortunate? If it be so, Phyllida, how desperate is thy case! If it be not, how doubtful! For if she be a maiden, there is no hope of my love; if a boy, a hazard. I will after him or her, and lead a melancholy life, that look for a miserable death.
 Exit.

ACT FIVE

SCENE ONE

Enter RAFE *alone.*

Rafe. No more masters now but a mistress, if I can light on[1] her. An astronomer? Of all occupations that's the worst. Yet well fare the alchemist, for he keeps good fires though he gets no gold. The other stands warming himself by staring on the stars, which I think he can as soon number as know their virtues. He told me a long tale of *octogessimus octavus* and the meeting of the conjunctions and planets, and in the meantime he fell backward himself into a pond. I asked him why he foresaw not that by the stars; he said he knew it but contemned it. But soft, is not this my brother Robin? 11

Enter ROBIN.

Rob. Yes, as sure as thou art Rafe.

Rafe. What, Robin! What news? What fortune?

Rob. Faith, I have but bad fortune, but I prithee, tell me thine.

Rafe. I have had two masters, not by art but by nature. One said that by multipying he would make of a penny ten pound.

Rob. Ay, but could he do it? 19

Rafe. Could he do it, quoth you! Why, man, I saw a pretty wench come to his shop, where with puffing, blowing, and sweating he so plied her that he multiplied her.

Rob. How?

Rafe. Why, he made her of one, two.

Rob. What, by fire?

Rafe. No, by the philosophers' stone.[2]

Rob. Why, have philosophers such stones?

Rafe. Ay, but they lie in a privy cupboard. 29

Rob. Why, then, thou art rich if thou have learned this cunning.

Rafe. Tush, this was nothing. He would of a little fasting-spittle[3] make a hose and doublet of cloth of silver.[4]

Rob. Would I had been with him, for I have had almost no meat but spittle[5] since I came to the woods.

Rafe. How then didst thou live?

Rob. Why, man, I served a fortuneteller, who said I should live to see my father hanged and both my brothers beg. So I conclude the mill shall be mine, and I live by imagination still. 41

Rafe. Thy master was an ass and looked on the lines of thy hands, but my other master was an astronomer, which could pick my nativity out of the stars. I should have half a dozen stars in my pocket if I have not lost them. But here they be. Sol, Saturn, Jupiter, Mars, Venus.

Rob. Why, these be but names.

Rafe. Ay, but by these he gathereth that I was a Jovialist,[6] born of a Thursday,[7] and that I should 50 be a brave Venerean[8] and get all my good luck on a Friday.[9]

Rob. 'Tis strange that a fish day should be a flesh day.

Rafe. O Robin, *Venus orta mari,*[10] Venus was born of the sea; the sea will have fish, fish must have wine, wine will have flesh, for *caro carnis est muliebre.*[11] But soft, here cometh that notable villain that once preferred[12] me to the alchemist.

Enter PETER.

Pete. So I had a master, I would not care what became of me. 60

IV.iv.
 [1] *mistress:* sweetheart; lady, as a courteous title.
 [2] *mistress:* pun on "mysteries."

V.i.
 [1] *light on:* meet with.
 [2] *philosophers' stone:* a substance sought by alchemists that would turn base metals into precious ones.
 [3] *fasting-spittle:* saliva produced while fasting.
 [4] *cloth of silver:* tissue woven of threads of silver and other materials. [5] *spittle:* saliva, froth found on herbs.
 [6] *Jovialist:* born under the influence of the planet Jupiter.
 [7] *Thursday:* Jupiter's day.
 [8] *Venerean:* born under the influence of Venus.
 [9] *Friday:* Venus's day.
 [10] L.: translated in text; from Ovid, *Heroides,* and Lily's *Short Introduction to Grammar.*
 [11] L.: flesh is feminine in gender; quotation from Lily's *Grammar.* [12] *preferred:* recommended.

Rafe. Robin, thou shalt see me fit [13] him. [*Loudly*] So I had a servant, I care neither for his conditions, [14] his qualities, [15] nor his person.

Pete. What, Rafe? Well met! No doubt you had a warm service of my master the alchemist?

Rafe. 'Twas warm indeed, for the fire had almost burnt out mine eyes, and yet my teeth still watered with hunger, so that my service was both too hot and too cold. I melted all my meat and made [16] only my slumber thoughts and so had a full head and an empty belly. But where hast thou been since? 71

Pete. With a brother of thine, I think, for he hath such a coat, and two brothers, as he saith, seeking of fortunes.

Rob. 'Tis my brother Dick. I prithee, let's go to him.

Rafe. Sirrah, what was he doing that he came not with thee?

Pete. He hath gotten a master now that will teach him to make you both his younger brothers. 79

Rafe. Ay, thou passest for [17] devising impossibilities. That's as true as thy master could make silver pots of tags of points.

Pete. Nay, he will teach him to cozen you both and so get the mill to himself.

Rafe. Nay, if he be both our cozens, [18] I will be his great-grandfather [19] and Robin shall be his uncle. But I pray thee, bring us to him quickly, for I am great-bellied [20] with conceit till I see him.

Pete. Come, then, and go with me, and I will bring ye to him straight. 90

 Exeunt.

[V.ii]

[*Enter*] AUGUR, ERICTHINIS.

Aug. Bring forth the virgin, the fatal [1] virgin, the fairest virgin, if you mean to appease Neptune and preserve your country.

Eric. Here she cometh, accompanied only with men, because it is a sight unseemly, as all virgins say, to see the misfortune of a maiden, and terrible to behold the fierceness of Agar, that monster.

Enter HEBE *with other to the sacrifice.*

Hebe. Miserable and accursed Hebe, that, being neither fair nor fortunate, thou shouldst be thought most happy and beautiful. Curse thy birth, thy 10 life, thy death, being born to live in danger, and, having lived, to die by deceit. Art thou the sacrifice to appease Neptune and satisfy the custom, [2] the bloody custom, ordained for the safety of thy country? Ay, Hebe, poor Hebe, men will have it so, whose forces command our weak natures. Nay, the gods will have it so, whose powers dally with our purposes. The Egyptians never cut their dates from the tree because they are so fresh and green. It is thought wickedness to pull roses from the stalks in the garden of Palestine, 20 for that they have so lively a red; and whoso cutteth the incense tree in Arabia, before it fall, committeth sacrilege.

Shall it only be lawful amongst us in the prime of youth and pride of beauty to destroy both youth and beauty, and what was honored in fruits and flowers as a virtue to violate in a virgin as a vice? But alas, destiny alloweth no dispute. Die, Hebe, Hebe, die, woeful Hebe and only accursed Hebe. Farewell the sweet delights of life, and welcome now the bitter pangs 30 of death. Farewell, you chaste virgins, whose thoughts are divine, whose faces fair, whose fortunes are agreeable to your affections, Enjoy and long enjoy the pleasure of your curled locks, the amiableness of your wished looks, the sweetness of your tuned voices, the content of your inward thoughts, the pomp of your outward shows. Only Hebe biddeth farewell to all the joys that she conceived and you hope for, that she possessed and you shall. Farewell the pomp of prince's courts whose roofs are embossed with gold and whose 40 pavements are decked with fair ladies, where the days are spent in sweet delights, the nights in pleasant dreams, where chastity honoreth affections and commandeth, yieldeth to desire and conquereth.

Farewell, the sovereign of all virtue and goddess of all virgins, Diana, whose perfections are impossible to be number'd and therefore infinite, never to be matched and therefore immortal. Farewell sweet parents, yet, to be mine, unfortunate parents. How blessed had you been in barrenness, how happy had I been if I had 50 not been! Farewell life, vain life, wretched life, whose sorrows are long, whose end doubtful, whose miseries certain, whose hopes innumerable, whose fears intolerable. Come, death, and welcome, death, whom nature cannot resist, because necessity ruleth, nor defer, because destiny hasteth. Come, Agar, thou unsatiable monster of maidens' blood and devourer of beauties' bowels, glut thyself till thou surfeit, and let my life end thine. Tear these tender joints with thy greedy jaws, these yellow locks with thy black feet, this fair face 60 with thy foul teeth. Why abatest thou thy wonted swiftness? I am fair, I am a virgin, I am ready. Come, Agar, thou horrible monster, and farewell world, thou viler monster.

Aug. The monster is not come, and therefore I see Neptune is abused, whose rage will, I fear me, be both infinite and intolerable. Take in this virgin, whose want of beauty hath saved her own life and [spoiled] all yours.

Eric. We could not find any fairer.

Aug. Neptune will. Go deliver her to her father. 70

Hebe. Fortunate Hebe, how shalt thou express thy joys! Nay, unhappy girl, that art not the fairest. Had it not been better for thee to have died with fame than to live with dishonor, to have preferred the safety of thy country and rareness of thy beauty before sweetness of life and vanity of the world? But, alas, destiny would

[13] *fit:* punish as he deserves.
[14] *conditions:* morals, behavior. [15] *qualities:* abilities.
[16] *made:* ate, thought. [17] *passest for:* excel in.
[18] *cozens:* cheaters, cousins.
[19] *great-grandfather:* more than his elder at cheating.
[20] *great-bellied:* pregnant.
V.ii.
[1] *fatal:* fated. [2] *custom:* tradition, tribute.

not have it so, destiny could not, for it asketh the beautifullest. I would, Hebe, thou hadst been beautifullest.　　　　　　　　　　　　　　　　　79

Eric. Come, Hebe, here is no time for us to reason. It had been best for us thou hadst been most beautiful.

Exeunt.

[V.iii]

[Enter] PHYLLIDA, GALLATHEA.

Phyl. We met the virgin that should have been offered to Neptune. Belike either the custom is pardoned or she not thought fairest.

Gall. I cannot conjecture the cause, but I fear the event.

Phyl. Why should you fear? The god requireth no boy.

Gall. I would he did; then should I have no fear.

Phyl. I am glad he doth not, though, because if he did, I should have also cause to fear. But soft,　10 what man or god is this? Let us closely withdraw ourselves into the thickets.

Exeunt ambo.

Enter NEPTUNE *alone.*

Nep. And do men begin to be equal with gods, seeking by craft to overreach them that by power oversee them? Do they dote so much on their daughters that they stick not to dally with our deities? Well shall the inhabitants see that destiny cannot be prevented by craft nor my anger be appeased by submission. I will make havoc of Diana's nymphs, my temple shall be dyed with maidens' blood, and there shall be　20 nothing more vile than to be a virgin. To be young and fair shall be accounted shame and punishment, insomuch as it shall be thought as dishonorable to be honest[1] as fortunate to be deformed.

Enter DIANA *with her nymphs.*

Diana. O Neptune, hast thou forgotten thyself, or wilt thou clean forsake me? Hath Diana therefore brought danger to her nymphs because they be chaste? Shall virtue suffer both pain and shame, which always deserveth praise and honor?　　　　　　　　29

Enter VENUS.

Ven. Praise and honor, Neptune, nothing less, except it be commendable to be coy[2] and honorable to be peevish.[3] Sweet Neptune, if Venus can do anything, let her try it in this one thing, that Diana may find as small comfort at thy hands as love hath found courtesy at hers.

This is she that hateth sweet delights, envieth loving desires, masketh wanton eyes, stoppeth amorous ears, bridleth youthful mouths, and under a name, or a word, constancy, entertaineth all kind of cruelty. She hath taken my son Cupid, Cupid my lovely son, using　40 him like a prentice, whipping him like a slave, scorning him like a beast. Therefore, Neptune, I entreat thee, by no other god than the god of love, that thou evil entreat[4] this goddess of hate.

Nep. I muse not a little to see you two in this place, at this time, and about this matter. But what say you, Diana? Have you Cupid captive?

Diana. I say there is nothing more vain than to dispute with Venus, whose untamed affections have bred more brawls in heaven than is fit to repeat in　50 earth or possible to recount in number. I have Cupid, and will keep him, not to dandle in my lap, whom I abhor in my heart, but to laugh him to scorn that hath made in my virgins' hearts such deep scars.

Ven. Scars, Diana, call you them that I know to be bleeding wounds? Alas, weak deity, it stretcheth not so far both to abate the sharpness of his arrows and to heal the hurts. No, love's wounds, when they seem green,[5] rankle, and, having a smooth skin without, fester to the death within. Therefore, Neptune, if ever Venus　60 stood thee in stead, furthered thy fancies, or shall at all times be at thy command, let either Diana bring her virgins to a continual massacre or release Cupid of his martyrdom.

Diana. It is known, Venus, that your tongue is as unruly as your thoughts, and your thoughts as unstaid as your eyes. Diana cannot chatter, Venus cannot choose.[6]

Ven. It is an honor for Diana to have Venus mean ill when she so speaketh well; but you shall see I　70 come not to trifle. Therefore once again, Neptune, if that be not buried which can never die, fancy, or that quenched which must ever burn, affection,[7] show thyself the same Neptune that I knew thee to be when thou wast a shepherd, and let not Venus' words be vain in thine ears, since thine were imprinted in my heart.

Nep. It were unfit that goddesses should strive, and it were unreasonable that I should not yield, and therefore, to please both, both attend. Diana I must honor, her virtue deserveth no less, but Venus I must love, I must confess so much.　　　　　　　　　81

Diana, restore Cupid to Venus, and I will forever release the sacrifice of virgins. If therefore you love your nymphs as she doth her son, or prefer not a private grudge before a common grief, answer what you will do.

Diana. I account not the choice hard, for had I twenty Cupids I would deliver them all to save one virgin, knowing love to be a thing of all the vainest, virginity to be a virtue of all the noblest. I yield. Larissa, bring out Cupid.　　　　　　　　　91

[Exit LARISSA.*]*

And now shall it be said that Cupid saved those he thought to spoil.

Ven. I agree to this willingly, for I will be wary how my son wander again. But Diana cannot forbid him to wound.

V.iii.

　[1] *honest:* chaste.　　　　　　　[2] *coy:* disdainful.
　[3] *peevish:* obstinate.　　　　[4] *evil entreat:* treat badly.
　[5] *green:* fresh.
　[6] *cannot choose:* i.e., cannot choose but chatter.
　[7] *Therefore ... affection:* Seeing her naked under Vulcan's net, Neptune had fallen in love with Venus.

Diana. Yes, chastity is not within the level[8] of his bow.

Ven. But beauty is a fair mark to hit. 99

Nep. Well, I am glad you are agreed, and say that Neptune hath dealt well with beauty and chastity.

Enter CUPID.

Diana. Here, take your son.

Ven. Sir boy, where have you been? Always taken, first by Sappho,[9] now by Diana: how happeneth it, you unhappy elf?

Cup. Coming through Diana's woods, and seeing so many fair faces with fond hearts, I thought for my sport to make them smart, and so was taken by Diana.

Ven. I am glad I have you. 110

Diana. And I am glad I am rid of him.

Ven. Alas, poor boy, thy wings clipped? Thy brands quenched? Thy bow burned and thy arrows broke?

Cup. Ay, but it skilleth not. I bear now mine arrows in mine eyes, my wings on my thoughts, my brands in mine ears, my bow in my mouth, so as I can wound with looking, fly with thinking, burn with hearing, shoot with speaking.

Ven. Well, you shall up to heaven with me, for on earth thou wilt lose me. 121

Enter TITYRUS, MELEBEUS [*at one door*], GALLATHEA *and* PHYLLIDA [*at another*].

Nep. But soft, what be these?

Tit. Those that have offended thee to save their daughters.

Nep. Why, had you a fair daughter?

Tit. Ay, and Melebeus a fair daughter.

Nep. Where be they?

Mel. In yonder woods, and methinks I see them coming.

Nep. Well, your deserts have not gotten pardon, but these goddesses' jars.[10] 131

Mel. This is my daughter, my sweet Phyllida.

Tit. And this is my fair Gallathea.

Gall. Unfortunate Gallathea, if this be Phyllida!

Phyl. Accursed Phyllida, if that be Gallathea!

Gall. And wast thou all this while enamored of Phyllida, that sweet Phyllida?

Phyl. And couldst thou dote upon the face of a maiden, thyself being one, on the face of fair Gallathea?

Nep. Do you both, being maidens, love one another? 141

Gall. I had thought the habit agreeable[11] with the sex, and so burned in the fire of mine own fancies.

Phyl. I had thought that in the attire of a boy there could not have lodged the body of a virgin, and so was inflamed with a sweet desire which now I find a sour deceit.

Diana. Now, things falling out as they do, you must leave these fond, fond affections. Nature will have it so, necessity must. 150

Gall. I will never love any but Phyllida. Her love is engraven in my heart with her eyes.

Phyl. Nor I any but Gallathea, whose faith is imprinted in my thoughts by her words.

Nep. An idle choice, strange and foolish, for one virgin to dote on another and to imagine a constant faith where there can be no cause of affection. How like you this, Venus?

Ven. I like well and allow it. They shall both be possessed of their wishes, for never shall it be said 160 that nature or fortune shall overthrow love and faith. Is your loves unspotted, begun with truth, continued with constancy, and not to be altered till death?

Gall. Die, Gallathea, if thy love be not so.

Phyl. Accursed be thou, Phyllida, if thy love be not so.

Diana. Suppose all this, Venus; what then?

Ven. Then shall it be seen that I can turn one of them to be a man, and that I will.

Diana. Is it possible? 170

Ven. What is to love or the mistress of love unpossible? Was it not Venus that did the like to Iphis and Ianthes?[12] How say ye, are ye agreed, one to be a boy presently?

Phyl. I am content, so I may embrace Gallathea.

Gall. I wish it, so I may enjoy Phyllida.

Mel. Soft, daughter, you must know whether I will have you a son.

Tit. Take me with you,[13] Gallathea. I will keep you as I begat you, a daughter. 180

Mel. Tityrus, let yours be a boy, and if you will, mine shall not.

Tit. Nay, mine shall not, for by that means my young son shall lose his inheritance.

Mel. Why, then get him to be made a maiden, and then there is nothing lost.

Tit. If there be such changing, I would Venus could make my wife a man.

Mel. Why?

Tit. Because she loves always to play with men. 190

Ven. Well, you are both fond; therefore agree to this changing or suffer your daughters to endure hard chance.

Mel. How say you, Tityrus, shall we refer it to Venus?

Tit. I am content, because she is a goddess.

Ven. Neptune, you will not dislike it?

Nep. Not I.

Ven. Nor you, Diana?

Diana. Not I. 200

Ven. Cupid shall not.

Cup, I will not.

Ven. Then let us depart. Neither of them shall know whose lot it shall be till they come to the church door.[14] One shall be; doth it suffice?

8 *level:* range.
9 *Sappho:* the Greek poetess, b. 612 B.C., about whose legendary love affair Lyly had written *Sappho and Phao.*
10 *jars:* contentions. 11 *agreeable:* according.
12 *Iphis and Ianthes:* heroines of a parallel story in Ovid's *Metamorphoses.*
13 *Take . . . you:* Do what I can follow or accept.
14 *church door:* where marriages were performed.

Phyl. And satisfy us both, doth it not, Gallathea?

Gall. Yes, Phyllida.

Enter RAFE, ROBIN, *and* DICK.

Rafe. Come, Robin. I am glad I have met with thee, for now we will make our father laugh at these tales.

Diana. What are these that so malapertly[15] thrust themselves into our companies? 211

Rob. Forsooth, madam, we are fortune tellers.

Ven. Fortunetellers! Tell me my fortune.

Rafe. We do not mean fortunetellers, we mean fortune-tellers. We can tell what fortune we have had these twelve months in the woods.

Diana. Let them alone, they be but peevish.[16]

Ven. Yet they will be as good as minstrels at the marriage, to make us all merry.

Dick. Ay, ladies, we bear a very good consort.[17]

Ven. Can you sing? 221

Rafe. Basely.[18]

Ven. And you?

Dick. Meanly.[19]

Ven. And what can you do?

Rob. If they double[20] it, I will treble[21] it.

Ven. Then shall ye go with us, and sing Hymen[22] before the marriage. Are you content?

Rafe. Content? Never better content, for there we shall be sure to fill our bellies with capons' rumps or some such dainty dishes. 231

Ven. Then follow us.

Exeunt [all but GALLATHEA].

The Epilogue

Gall. Go all, 'tis I only that conclude all. You ladies may see that Venus can make constancy fickleness, courage cowardice, modesty lightness, working things impossible in your sex and tempering hardest hearts like softest wool. Yield, ladies, yield to love, ladies, which lurketh under your eyelids whilst you sleep and playeth with your heartstrings whilst you wake, whose sweetness never breedeth satiety, labor weariness, nor grief bitterness. Cupid was begotten in a mist, nursed in clouds, and sucking[1] only upon conceits. Con- 10 fess him a conqueror, whom ye ought to regard,[2] sith it is unpossible to resist, for this is infallible, that love conquereth all things but itself, and ladies all hearts but their own.

[Exit].

F I N I S

[15] *malapertly:* impudently. [16] *peevish:* silly.

[17] *consort:* agreement, harmony.

[18] *Basely:* Badly, in the bass range.

[19] *Meanly:* Badly, in the tenor range.

[20] *double:* sing in two parts.

[21] *treble:* sing a third part, sing in treble range.

[22] *Hymen:* wedding hymn.

EPILOGUE

[1] *sucking:* suckled. [2] *regard:* respect.

George Peele

[1556–1596]

DAVID AND BETHSABE

A LONDONER, son of a clerk of Christ's Hospital, educated at Oxford (B.A. 1577, M.A. 1579), his years making him the slightly older contemporary of Nashe, Marlowe, Greene, and Kyd, Peele must have been a lively member of the company of University Wits. Whether or not, as has been suggested, he was a model for Falstaff, he was the hero of the rowdy *Merry Conceited Jests of George Peele*, a collection of stories of which many are traditional, and numerous writers of his day spoke of him as a wit. As a playwright he seems to have tried his hand at virtually every mode in fashion: English chronicle in *Edward I*, foreign history in *The Battle of Alcazar*, folk comedy in *The Old Wives' Tale*, courtly pastoral *à la* Lyly in *The Arraignment of Paris*, even—in a lost manuscript—a rare translation of a tragedy by Euripides.

DAVID AND BETHSABE was first printed in London in 1599 in a quarto on which the present text is based; estimates as to its date range over the last fifteen years of Peele's life, but it was entered in the Stationers' Register on May 14, 1594, and there is no reason to doubt seriously that this date is probably close to the time of composition. There is no record of performance. The primary source is the story of David's life in II Samuel (which translation Peele used has not been ascertained, because he uses language from a number of versions), but it has been demonstrated that Peele also used several sections of *The Divine Weeks*, a biblical epic by the French Huguenot poet du Bartas.

Like most of Peele's extant work DAVID AND BETHSABE is episodic, to the point where one cannot be sure that some important scenes are not missing. (A particularly intriguing bit of evidence for such doubts is the curious tag "5. Chorus" introducing a choric speech that, even if one counts the Prologue, is only the third in the play.) But like the similarly episodic *Edward I* and the similarly incomplete *Old Wives' Tale*, Peele's biblical tragedy is powerfully coherent. In fact, it is a remarkable translation of its materials into a play whose point—that David's tragic life is a punishment for his mistreatment of Uriah and Bathsheba—accounts for the selection of elements from a biblical story that offers almost as many as a novel. Peele astutely seizes on some of the most dramatic details of his original—the hateful priggishness of Joab, who is always right, for example—and makes more pointed comparisons between the bad son Absalon and the ultimately good son Solomon than the Bible suggests. But the most remarkable achievement, apart from a blank verse that at its best resembles Marlowe's, is the unmistakable Renaissance quality of the play. Solomon is a kind of Faustus, longing for knowledge men cannot have, and like Milton's Adam he must be warned to seek what is appropriate to his moral role. As the Prologue makes clear at once, the play is an attempt to turn biblical narrative into classical tragedy—hence the majestic verse, the Chorus and Prologue, the conflation of Jove with Jehovah, the allusions to God's oracle and the golden world of Eden and the Platonic Ideas, the image of Solomon as Phaëthon. Such an effort looks forward, of course, to *Paradise Lost* and *Samson Agonistes* while reminding us of countless other Renaissance works; and it radically transforms biblical drama from the tradition of the mystery cycles by setting biblical materials in a framework that triumphantly asserts the unity of the classical and Christian worlds.

N. R.

David and Bethsabe

DRAMATIS PERSONÆ

DAVID
AMNON, *son of David by Ahinoam*
CHILEAB, *son of David by Abigail*
ABSALON, *son of David by Maacah*
ADONIJAH, *son of David by Haggith*
SOLOMON, *son of David by Bethsabe*
JOAB, *captain of the host to David,*
ABISHAI, } *nephews of David and sons of his sister Zeruiah*
AMASA, *nephew of David and son of his sister Abigail; captain of the host to Absalon*
JONADAB, *nephew of David and son of his brother Shimeah; friend to Amnon*
URIAS, *husband of Bethsabe, and a soldier in David's army*
NATHAN, *a prophet*
ZADOK, *high priest*
AHIMAAZ, *his son*

ABIATHAR, *a priest*
JONATHAN, *his son*
ACHITOPHEL, *chief counselor to Absalon*
CUSAY, *a follower of David.*
ITTAI, *a follower of David*
SHIMEI, *David's accuser*
JETHRAY
HANUN, *King of Ammon*
MACHAAS, *King of Gath*
Messenger, Soldiers, Shepherds, and Attendants

TAMAR, *daughter of David by Maacah*
BETHSABE, *wife of Urias*
Widow of Tekoah
Concubines *to David*
Maid *to Bethsabe*

Chorus

PROLOGUE

Of Israel's sweetest singer now I sing,
His holy style[1] and happy victories,
Whose Muse was dipped in that inspiring dew
Archangels stillèd[2] from the breath of Jove,
Decking her temples with the glorious flowers
Heavens rained on tops of Sion and Mount Sinai.
Upon the bosom of his ivory lute
The cherubins and angels laid their breasts;
And, when his consecrated fingers struck
The golden wires of his ravishing harp, 10
He gave alarum to the host of heaven,
That, winged with lightning, brake[3] the clouds and cast
Their crystal armor at his conquering feet.
Of this sweet poet, Jove's musician,
And of his beauteous son, I prease[4] to sing.
Then help, divine Adonai, to conduct
Upon the wings of my well-tempered verse
The hearers' minds above the towers of heaven,
And guide them so in this thrice-haughty flight,
Their mounting feathers scorch not with the fire 20
That none can temper but thy holy hand
To thee for succor flies my feeble Muse,
And at thy feet her iron pen doth use.

He draws a curtain and discovers BETHSABE, *with her Maid, bathing over a spring; she sings, and* DAVID *sits above viewing her.*

[i]

THE SONG

Hot sun, cool fire, tempered with sweet air,
Black shade, fair nurse, shadow my white hair.
Shine, sun; burn, fire; breathe, air, and ease me;
Black shade, fair nurse, shroud me and please me;
Shadow, my sweet nurse, keep me from burning,
Make not my glad cause of mourning.

Let not my beauty's fire
Inflame unstaid desire,
Nor pierce any bright eye
That wandereth lightly. 10

Beth. Come, gentle Zephyr,[1] tricked with those perfumes
That erst[2] in Eden sweetened Adam's love,

PROLOGUE
 [1] *style:* composition.
 [3] *brake:* broke.
 [2] *stillèd:* distilled.
 [4] *prease:* strive.
i.
 [1] *Zephyr:* the west wind. [2] *erst:* in earliest time.

146

And stroke my bosom with thy[3] silken fan;
This shade, sun-proof, is yet no proof for thee.
Thy body, smoother than this waveless spring
And purer than the substance of the same,
Can creep through that his lances cannot pierce;
Thou, and thy sister, soft and sacred air,
Goddess of life, and governess of health,
Keep every fountain fresh and arbor sweet; 20
No brazen gate her passage can repulse,
Nor bushy[4] thicket bar thy subtle breath.
Then deck thee with thy loose delightsome robes,
And on thy wings bring delicate perfumes,
To play the wantons[5] with us through the leaves.
 Dav. What tunes, what words, what looks, what
 wonders pierce
My soul, incensèd with a sudden fire?
What tree, what shade, what spring, what paradise
Enjoys the beauty of so fair a dame?
Fair Eva, placed in perfect happiness, 30
Lending her praise-notes to the liberal heavens,
Struck with the accents of archangels' tunes,
Wrought not more pleasure to her husband's thoughts
Than this fair woman's words and notes to mine.
May that sweet plain that bears her pleasant weight
Be still[6] enameled with discolored[7] flowers,
That precious fount bear sand of purest gold;
And, for the pebble,[8] let the silver streams
That pierce earth's bowels to maintain the source,
Play upon rubies, sapphires, chrysolites;[9] 40
The brims let be embraced with golden curls
Of moss that sleeps with sound the waters make
For joy to feed the fount with their recourse;[10]
Let all the grass that beautifies her bower
Bear manna every morn instead of dew,
Or let the dew be sweeter far than that
That hangs, like chains of pearl, on Hermon hill,[11]
Or balm which trickled from old Aaron's[12] beard.—
Cusay, come up and serve thy lord the King.

Enter CUSAY.

 Cu. What service doth my lord the king command?
 Dav. See, Cusay, see the flower of Israel, 51
The fairest daughter that obeys the King
In all the land the Lord subdued to me;
Fairer than Isaac's lover[13] at the well,
Brighter than inside bark of new-hewn cedar,
Sweeter than flames of fine-perfumèd myrrh,
And comelier than the silver clouds that dance
On Zephyr's wings before the King of Heaven.
 Cu. Is it not Bethsabe the Hittite's wife,
Urias, now at Rabbah siege with Joab? 60

 Dav. Go now,[14] and bring her quickly to the King;
Tell her, her graces have found grace with him.
 Cu. I will, my lord.
 Exit CUSAY *to* BETHSABE.
 Dav. Bright Bethsabe shall wash, in David's bower,
In water mixed with purest almond-flower,
And bathe her beauty in the milk of kids.
Bright Bethsabe gives earth to my desires,
Verdure to earth, and to that verdure flowers,
To flowers sweet odors, and to odors wings
That carry pleasures to the hearts of kings. 70

CUSAY, *to* BETHSABE, *she starting as something
 afright.*

 Cu. Fair Bethsabe, the King of Israel
From forth his princely tower hath seen thee bathe,
And thy sweet graces have found grace with him.
Come, then, and kneel unto him where he stands;
The king is gracious, and hath liberal hands.
 Beth. Ah, what is Bethsabe to please the king?
Or what is David, that he should desire,
For fickle beauty's sake, his servant's wife?
 Cu. David, thou know'st, fair dame, is wise and just,
Elected to the heart of Israel's God; 80
Then do not thou expostulate with him
For any action that contents his soul.
 Beth. My lord the King, elect to God's own heart,
Should not his gracious jealousy[15] incense
Whose thoughts are chaste; I hate incontinence.
 Cu. Woman, thou wrong'st the King, and doubt'st
 his honor,
Whose truth maintains the crown of Israel,
Making him stay that bade me bring thee straight.
 Beth. The King's poor handmaid will obey my lord.
 Cu. Then come, and do thy duty to his grace; 90
And do what seemeth favor in his sight.
 Exeunt.
 Dav. Now comes my lover tripping like the roe,
And brings my longings tangled in her hair.
To joy[16] her love I'll build a kingly bower,
Seated in hearing of a hundred streams,
That, for their homage to her sovereign joys,
Shall, as the serpents fold into their nests
In oblique turnings, wind their[17] nimble waves
About the circles of her curious[18] walks;
And with their murmur summon easeful sleep 100
To lay his golden scepter on her brows.—
Open the doors, and entertain[19] my love;
Open, I say, and, as you open, sing,
Welcome, fair Bethsabe, King David's darling.

Enter CUSAY, *with* BETHSABE.

Welcome, fair Bethsabe, King David's darling.
Thy bones' fair covering, erst discovered fair,
And all mine eyes[20] with all thy beauties pierced,
As heaven's bright eye burns most when most he climbs
The crookèd zodiac with his fiery sphere,
And shineth furthest from this earthly globe; 110
So, since thy beauty scorched my conquered soul,
I called thee nearer for my nearer cure.
 Beth. Too near, my lord, was your unarmèd heart

 [3] *thy:* the Q. [4] *bushy:* bushly Q.
 [5] *play the wantons:* dally. [6] *still:* always.
 [7] *discolored:* variously colored. [8] *pebble:* gem.
 [9] *chrysolites:* green gemstones. [10] *recourse:* flowing.
 [11] *Hermon hill:* mountain in Palestine.
 [12] *Aaron's:* Aaron was Moses' brother, first annointed
priest, traditionally held to have had pearllike drops of
ointment in his beard. [13] *Isaac's lover:* Rebecca.
 [14] *now:* know Q. [15] *jealousy:* anger. [16] *joy:* enjoy.
 [17] *their:* the Q. [18] *curious:* exquisite.
 [19] *entertain:* receive. [20] *And ... eyes:* text corrupt.

When furthest off my hapless beauty pierced;
And would this dreary day had turned to night,
Or that some pitchy cloud had cloaked the sun,
Before their lights had caused my lord to see
His name disparaged and my chastity!
 Dav. My love, if want of love have left thy soul
A sharper sense of honor than thy King, 120
(For love leads princes sometimes from their seats,)
As erst my heart was hurt, displeasing thee,
So come and taste thy ease with easing me.
 Beth. One medicine cannot heal our different harms;
But rather make both rankle [21] at the bone:
Then let the King be cunning in his cure,
Lest flattering both, both perish in his hand.
 Dav. Leave it to me, my dearest Bethsabe,
Whose skill is conversant in deeper cures.—
And, Cusay, haste thou to my servant Joab, 130
Commanding him to send Urias home,
With all the speed can possibly be used.
 Cu. Cusay will fly about the king's desire.

Exeunt.

[ii]

 Enter JOAB, ABISHAI, URIAS, *and others,*
 with drum and ensign.

 Joab. Courage, ye mighty men of Israel,
And charge [1] your fatal instruments of war
Upon the bosoms of proud Ammons's sons, [2]
That have disguised [3] your King's ambassadors,
Cut half their beards and half their garments off,
In spite of Israel and his daughters' sons.
Ye fight the holy battles of Jehovah,
King David's God, and ours, and Jacob's God,
That guides your weapons to their conquering strokes,
Orders your footsteps, and directs your thoughts 10
To stratagems that harbor victory.
He casts his sacred eyesight from on high,
And sees your foes run seeking for their deaths,
Laughing their labors and their hopes to scorn;
While 'twixt your bodies and their blunted swords
He puts on armor of his honor's proof,
And makes their weapons wound the senseless winds.
 Abis. Before this city Rabbah we will lie,
And shoot forth shafts as thick and dangerous
As was the hail that Moses mixed with fire, 20
And threw with fury round about the fields,
Devouring Pharaoh's friends and Egypt's fruits.
 Ur. First, mighty captains, Joab and Abishai,
Let us assault and scale this kingly tower,
Where all their conduits and their fountains are;
Then we may easily take the city too.
 Joab. Well hath Urias counseled our attempts;
And as he spake us, so assault the tower:
Let Hanun now, the King of Ammon's sons,
Repulse our conquering passage if he dare. 30

 HANUN *with* KING MACHAAS,
 and others upon the walls.

 Ha. What would the shepherd's dogs of Israel
Snatch from the mighty issue of King Ammon,

The valiant Ammonites and haughty Syrians?
'Tis not your late successive victories
Can make us yield or quail our courages;
But if ye dare assay to scale this tower,
Our angry swords shall smite ye to the ground,
And venge our losses on your hateful lives.
 Joab. Hanun, thy father Nahash gave relief
To holy David in his hapless exile, 40
Lived his fixèd date, and died in peace:
But thou, instead of reaping his reward,
Hast trod it under foot, and scorned our King;
Therefore thy days shall end with violence,
And to our swords thy vital blood shall cleave.
 Mach. Hence, thou that bear'st poor Israel's
 shepherd-hook,
The proud lieutenant of that base-born King,
And keep within the compass of his fold;
For, if ye seek to feed on Ammon's fruits,
And stray into the Syrians' fruitful meads, 50
The mastiffs of our land shall worry [4] ye,
And pull the weesels [5] from your greedy throats.
 Abis. Who can endure these pagan's blasphemies?
 Ur. My soul repines [6] at this disparagement.
 Joab. Assault, ye valiant men of David's host,
And beat these railing dastards from their doors.

 Assault, and they win the tower, and JOAB *speaks*
 above.

Thus have we won the tower, which we will keep,
Maugre [7] the sons of Ammon and of Syria.

 Enter CUSAY *beneath.*

 Cu. Where is Lord Joab, leader of the host?
 Joab. Here is Lord Joab, leader of the host. 60
Cusay, come up, for we have won the hold.
 Cu. In happy hour, then, is Cusay come.

 He comes.

 Joab. What news, then, brings Lord Cusay from the
 King?
 Cu. His majesty commands thee out of hand [8]
To send him home Urias from the wars,
For matter of some service he should do.
 Ur. 'Tis for no choler hath surprised the King,
I hope, Lord Cusay, 'gainst his servant's truth?
 Cu. No; rather to prefer Urias' truth.
 Joab. Here, take him with thee, then, and go in
 peace; 70
And tell my lord the King that I have fought
Against the city Rabbah with success,
And scalèd where the royal palace is,
The conduit heads and all their sweetest springs.
Then let him come in person to these walls,
With all the soldiers he can bring besides,

[21] *rankle:* fester.

 [1] *charge:* place in position for action.
 [2] *Ammon's sons:* Ammonites. [3] *disguised:* disfigured.
 [4] *worry:* seize by the throat and tear.
 [5] *weesels:* windpipes. [6] *repines:* feels discontent.
 [7] *Maugre:* In spite of. [8] *out of hand:* right away.

And take the city as his own exploit,
Lest I surprise it, and the people give
The glory of the conquest to my name.
 Cu. We will, Lord Joab, and great Israel's God 80
Bless in thy hands the battles of our King!
 Joab. Farewell, Urias; haste away the King.
 Ur. As sure as Joab breathes a victor here,
Urias will haste him and his own return.
 Exeunt [CUSAY *and* URIAS].
 Abis. Let us descend, and ope the palace gate,
Taking our soldiers in to keep the hold.
 Joab. Let us, Abishai;—and, ye sons of Judah,
Be valiant, and maintain your victory.
 Exeunt.

[iii]

 Enter AMNON, JONADAB, JETHRAY,
 and Amnon's Page.

 Jonad. What means my lord, the King's belovèd son,
That wears upon his right triumphant arm
The power of Israel for a royal favor,
That holds upon the tables of his hands
Banquets of honor and all thought's content,
To suffer pale and grisly abstinence
To sit and feed upon his fainting cheeks,
And suck away the blood that cheers his looks?
 Am. Ah, Jonadab, it is my sister's looks,
On whose sweet beauty I bestow my blood, 10
That make me look so amorously lean;
Her beauty having seized upon my heart,
So merely [1] consecrate to her content,
Sets now such guard about his vital blood,
And views the passage with such piercing eyes,
That none can scape to cheer my pining cheeks,
But all is thought too little for her love.
 Jonad. Then from her heart thy looks shall be
 relieved,
And thou shalt joy her as thy soul desires.
 Am. How can it be, my sweet friend Jonadab, 20
Since Tamar is a virgin and my sister?
 Jonad. Thus it shall be: lie down upon thy bed,
Feigning thee fever-sick and ill at ease,
And when the King shall come to visit thee,
Desire thy sister Tamar may be sent
To dress some dainties for thy malady:
Then when thou hast her solely with thyself,
Enforce some favor to thy manly love.
See where she comes: entreat her in with thee.

 Enter TAMAR.

 Tam. What aileth Amnon, with such sickly looks 30
To daunt the favor [2] of his lovely face?

iii.
 [1] *merely:* entirely. [2] *favor:* beauty.
 [3] *cates:* delicacies. [4] *crazèd:* diseased.
 [5] *kindless:* unnatural. [6] *rack:* storm.
 [7] *parbreak:* vomit. [8] *Unkind:* Unnatural.
 [9] *bating:* fluttering their wings.

 Am. Sweet Tamar, sick, and wish some wholesome
 cates [3]
Dressed with the cunning of thy dainty hands.
 Tam. That hath the King commanded at my hands.
Then come and rest thee, while I make thee ready
Some dainties easeful to thy crazèd [4] soul.
 Am. I go, sweet sister, easèd with thy sight.
 Exeunt. Restat JONADAB.
 Jonad. Why should a prince, whose power may
 command,
Obey the rebel passions of his love,
When they contend but 'gainst his conscience, 40
And may be governed or suppressed by will?
Now, Amnon, loose those loving knots of blood,
That sucked the courage from thy kingly heart,
And give it passage to thy withered cheeks.
Now, Tamar, ripened are the holy fruits
That grew on plants of thy virginity,
And rotten is thy name in Israel.
Poor Tamar, little did thy lovely hands
Foretell an action of such violence
As to contend with Amnon's lusty arms 50
Sinewed with vigor of his kindless [5] love.
Fair Tamar, now dishonor hunts thy foot,
And follows thee through every covert shade,
Discovering thy shame and nakedness,
Even from the valleys of Jehosaphat
Up to the lofty mounts of Lebanon;
Where cedars, stirred with anger of the winds,
Sounding in storms the tale of thy disgrace,
Tremble with fury, and with murmur shake
Earth with their feet and with their heads the heavens,
Beating the clouds into their swiftest rack,[6] 61
To bear this wonder round about the world.
 Exit.

 [*Enter*] AMNON *thrusting out* TAMAR
 [*and* JETHRAY].

 Am. Hence from my bed, whose sight offends my
 soul
As doth the parbreak [7] of disgorgèd bears!
 Tam. Unkind,[8] unprincely, and unmanly Amnon,
To force, and then refuse thy sister's love,
Adding unto the fright of thy offense
The baneful torment of my published shame!
O, do not this dishonor to thy love,
Nor clog thy soul with such increasing sin. 70
This second evil far exceeds the first.
 Am. Jethray, come thrust this woman from my sight,
And bolt the door upon her if she strive.
 Exit.
 Jeth. Go, madam, go; away; you must be gone;
My lord hath done with you; I pray, depart.
 He shuts her out.
 Tam. Whither, alas, ah, whither shall I fly,
With folded arms and all-amazèd soul?
Cast as was Eva from that glorious soil,
(Where all delights sat bating, [9] winged with thoughts,
Ready to nestle in her naked breasts) 80
To bare and barren vales with floods made waste,
To desert woods, and hills with lightning scorched,

With death, with shame, with hell, with horror sit;
There will I wander from my father's face;
There Absalon, my brother Absalon,
Sweet Absalon shall hear his sister mourn;
There will I lure [10] with my windy sighs
Night-ravens and owls to rend my bloody side,
Which with a rusty weapon I will wound,
And make them passage to my panting heart. 90
Why talk'st thou, wretch, and leav'st the deed undone?

Enter ABSALON.

Rend hair and garments, as thy heart is rent
With inward fury of a thousand griefs,
And scatter them by these unhallowed doors,
To figure Amnon's wresting cruelty,
And tragic spoil of Tamar's chastity.
 Abs. What causeth Tamar to exclaim so much?
 Tam. The cause that Tamar shameth to disclose.
 Abs. Say; I thy brother will revenge that cause.
 Tam. Amnon, our father's son, hath forcèd me, 100
And thrusts me from him as the scorn of Israel.
 Abs. Hath Amnon forcèd thee? By David's hand,
And by the covenant God hath made with him,
Amnon shall bear his violence to hell;
Traitor to heaven, traitor to David's throne,
Traitor to Absalon and Israel.
This fact hath Jacob's ruler seen from heaven,
And through a cloud of smoke and tower of fire,
As he rides vaunting him upon the greens,
Shall tear his chariot wheels with violent winds, 110
And throw his body in the bloody sea;
At him the thunder shall discharge his bolt;
And his fair spouse, with bright and fiery wings,
Sit ever burning on his hateful bones.
Myself, as swift as thunder or his spouse,
Will hunt occasion with a secret hate,
To work false Amnon an ungracious end.—
Go in, my sister; rest thee in my house;
And God in time shall take his shame from thee. 119
 Tam. Nor God nor time will do that good for me.
 Exit TAMAR, *restat* ABSALON.

Enter DAVID *with his train.*

 Dav. My Absalon, what mak'st thou here alone,
And bear'st such discontentment in thy brows?
 Abs. Great cause hath Absalon to be displeased,
And in his heart to shroud the wounds of wrath.
 Dav. 'Gainst whom should Absalon be thus
 displeased?
 Abs. 'Gainst wicked Amnon, thy ungracious son,
My brother and fair Tamar's by the King,
My stepbrother by mother and by kind: [11]
He hath dishonored David's holiness
And fixed a blot of lightness [12] on his throne, 130
Forcing my sister Tamar when he feigned
A sickness, sprung from root of heinous lust.
 Dav. Hath Amnon brought this evil on my house,
And suffered sin to smite his father's bones?
Smite, David, deadlier than the voice of heaven
And let hate's fire be kindled in thy heart;
Flame [13] in the arches of thy angry brows,

Making thy forehead like a comet shine,
To force false Amnon tremble at thy looks.
Sin, with his sevenfold crown and purple robe, 140
Begins his triumphs in my guilty throne;
There sits he watching with his hundred eyes
Our idle minutes and our wanton thoughts;
And with his baits, made of our frail desires,
Gives us the hook that hales our souls to hell:
But with the spirit of my kingdom's God
I'll thrust the flattering tyran [14] from his throne,
And scourge his bondslaves from my hallowed court
With rods of iron and thorns of sharpened steel.
Then, Absalon, revenge not thou this sin; 150
Leave it to me, and I will chasten him.
 Abs. I am content; then grant my lord the King
Himself with all his other lords would come
Up to my sheep-feast on the plain of Hazor.
 Dav. Nay, my fair son, myself with all my lords
Will bring thee too much charge; [15] yet some shall go.
 Abs. But let my lord the King himself take pains;
The time of year is pleasant for your grace,
And gladsome summer in her shady robes,
Crowned with roses and with planted flowers, 160
With all her nymphs, shall entertain my lord,
That, from the thicket of my verdant groves,
Will sprinkle honey dews about his breast,
And cast sweet balm upon his kingly head:
Then grant thy servant's boon, and go, my lord.
 Dav. Let it content my sweet son Absalon
That I may stay, and take my other lords.
 Abs. But shall thy best-belovèd Amnon go?
 Dav. What needeth it that Amnon go with thee?
 Abs. Yet do thy son and servant so much grace. 170
 Dav. Amnon shall go, and all my other lords,
Because I will give grace to Absalon.

Enter CUSAY *and* URIAS, *with others.*

 Cu. Pleaseth my lord the King, his servant Joab
Hath sent Urias from the Syrian wars.
 Dav. Welcome, Urias, from the Syrian wars,
Welcome to David as his dearest lord.
 Ur. Thanks be to Israel's God and David's grace,
Urias finds such greeting with the King.
 Dav. No other greeting shall Urias find
As long as David sways th' elected seat 180
And consecrated throne of Israel.
Tell me, Urias, of my servant Joab;
Fights he with truth the battles of our God,
And for the honor of the Lord's anointed?
 Ur. The servant Joab fights the chosen wars
With truth, with honor, and with high success,
And 'gainst the wicked king of Ammon's sons
Hath, by the finger of our sovereign's God,
Beseiged the city Rabbah, and achieved
The court of waters, where the conduits run, 190
And all the Ammonites' delightsome springs;
Therefore he wisheth David's mightiness

[10] *lure:* live Q. [11] *kind:* nature.
[12] *lightness:* wantonness. [13] *Flame:* Frame Q.
[14] *tyran:* tyrant. [15] *charge:* expense.

Should number out the host of Israel,
And come in person to the city Rabbah,
That so her conquest may be made the King's,
And Joab fight as his inferior.

Dav. This hath not God and Joab's prowess done
Without Urias' valors, I am sure,
Who, since his true conversion from a Hittite
To an adopted son of Israel, 200
Hath fought like one whose arms were lift by heaven,
And whose bright sword was edged with Israel's wrath.
Go, therefore, home, Urias, take thy rest;
Visit thy wife and household with the joys
A victor and a favorite of the King's
Should exercise with honor after arms.

Ur. Thy servant's bones are yet not half so crazed,
Nor constitute on such a sickly mold,
That for so little service he should faint,
And seek, as cowards, refuge of his home: 210
Nor are his thoughts so sensually stirred,
To stay the arms with which the Lord would smite
And fill their circle with his conquered foes,
For wanton bosom of a flattering [16] wife.

Dav. Urias hath a beauteous sober wife,
Yet young, and framed of tempting flesh and blood;
Then, when the King hath summoned thee from arms,
If thou unkindly shouldst refrain her bed,
Sin might be laid upon Urias' soul,
If Bethsabe by frailty hurt her fame: 220
Then go, Urias, solace [17] in her love;
Whom God hath knit to thee, tremble to lose.

Ur. The King is much too tender [18] of my ease:
The ark and Israel and Judah dwell
In palaces and rich pavilions;
But Joab and his brother in the fields,
Suffering the wrath of winter and the sun:
And shall Urias (of more shame than they)
Banquet, and loiter in the work of heaven?
As sure as thy soul doth live, my lord, 230
Mine ears shall never lean to such delight,
When holy labor calls me forth to fight.

Dav. Then be it with Urias' manly heart,
As best his fame may shine in Israel.

Ur. Thus shall Urias' heart be best content;
Till thou dismiss me back to Joab's bands,
This ground before the King my master's doors
 He lies down.
Shall be my couch, and this unwearied arm
The proper pillow of a soldier's head;
For never will I lodge within my house, 240
Till Joab triumph in my secret vows.

Dav. Then fetch some flagons of our purest wine,
That we may welcome home our hardy friend
With full carouses [19] to his fortunes past
And to the honors of his future arms;
Then will I send him back to Rabbah siege,
And follow with the strength of Israel.

Enter one with the flagons of wine.

[16] *flattering:* caressing. [17] *solace:* console yourself.
[18] *tender:* considerate. [19] *carouses:* toasts.
[20] *presently:* immediately.

Arise, Urias; come and pledge the King.
 Ur. If David think me worthy such a grace,
 He riseth.
I will be bold and pledge my lord the King. 250
 Dav. Absalon and Cusay both shall drink
To good Urias and his happiness.
 Abs. We will, my lord, to please Urias' soul.
 Dav. I will begin, Urias, to thyself,
And all the treasure of the Ammonites,
Which here I promise to impart to thee,
And bind that promise with a full carouse.
 Drinks.
 Ur. What seemeth pleasant in my sovereign's eyes,
That shall Urias do till he be dead.
 Dav. Fill him the cup.
 [URIAS *drinks.*]
 —Follow, ye lords that love
Your sovereign's health, and do as he hath done. 261
 Abs. Ill may he thrive, or live in Israel,
That loves not David or denies his charge.—
Urias, here is to Abishai's health,
Lord Joab's brother and thy loving friend.
 Drinks.
 Ur. I pledge Lord Absalon and Abishai's health.
 He drinks.
 Cu. Here now, Urias, to the health of Joab,
And to the pleasant journey we shall have
When we return to mighty Rabbah siege.
 Drinks.
 Ur. Cusay, I pledge thee all with all my heart—
Give me some drink, ye servants of the King; 271
Give me my drink.
 He drinks.
 Dav. Well done, my good Urias; drink thy fill,
That in thy fullness David may rejoice.
 Ur. I will, my lord.
 Abs. Now, Lord Urias, one carouse to me.
 Ur. No, sir, I'll drink to the King;
Your father is a better man than you.
 Dav. Do so, Urias; I will pledge thee straight.
 Ur. I will indeed, my lord and sovereign, 280
Ay, once in my days be so bold.
 Dav. Fill him his glass.
 Ur. Fill me my glass.
 He gives him the glass.
 Dav. Quickly, I say.
 Ur. Quickly, I say.—Here, my lord, by your favor
 now I drink to you.
 Drinks.
 Dav. I pledge thee, good Urias, presently. [20]
 He drinks.
 Abs. Here, then, Urias, once again for me,
And to the health of David's children.
 Drinks.
 Ur. David's children!
 Abs. Ay, David's children: wilt thou pledge me,
 man? 290
 Ur. Pledge me, man!
 Abs. Pledge me, I say, or else thou lov'st us not.
 Ur. What, do you talk? Do you talk? I'll no more;
I'll lie down here.

Dav. Rather, Urias, go thou home and sleep.

Ur. Oh, ho, sir, would you make me break my sen-
tence?[21]

 [*He lies down.*]

Home, sir! no, indeed, sir: I'll sleep upon mine arm,
like a soldier; sleep like a man as long as I live in Israel.

Dav. [*Aside*] If naught will serve to save his wife's
 renown, 300
I'll send him with a letter unto Joab
To put him in the forefront of the wars,
That so my purposes may take effect.—
Help him in, sirs.

 Ex[*eunt*] DAVID *and* ABSALON.

Cu. Come, rise, Urias; get thee in and sleep.

Ur. I will not go home, sir; that's flat.

Cu. Then come and rest thee upon David's bed.

Ur. On afore, my lords, on afore.

 Exeunt

[I Chorus]

 Enter CHORUS.

Chor. Oh, proud revolt of a presumptuous man,
Laying his bridle in the neck of[1] sin,
Ready to bear him past his grave to hell!
Like as the fatal raven, that in his voice
Carries the dreadful summons of our deaths,
Flies by the fair Arabian spiceries,
Her pleasant gardens and delightsome parks,
Seeming to curse them with his hoarse exclaims,
And yet doth stoop with hungry violence
Upon a piece of hateful carrion; 10
So wretched man, displeased with those delights
Would yield a quickening savor to his soul,
Pursues with eager and unstanchèd thirst
The greedy longings of his loathsome flesh.
If holy David so shook hands with sin,
What shall our baser spirits glory in?
This kingly giving lust her rein[2]
Pursues the sequel with a greater ill.
Urias in the forefront of the wars
Is murdered by the hateful heathens' sword, 20
And David joys his too dear Bethsabe.
Suppose this past, and that the child is born,
Whose death the prophet solemnly doth mourn.

 [*Exit.*]

[iv]

 Enter BETHSABE *with her* Handmaid.

Beth. Mourn, Bethsabe, bewail thy foolishness,
Thy sin, thy shame, the sorrow of thy soul.
Sin, shame, and sorrow swarm about thy soul;
And in the gates and entrance of my[1] heart
Sadness, with wreathèd arms, hangs her complaint.
No comfort from the ten-stringed instrument,
The tinkling[2] cymbal, or the ivory lute;
Nor doth the sound of David's kingly harp
Make glad the broken heart of Bethsabe.
Jerusalem is filled with thy complaint, 10
And in the streets of Sion sits thy grief.
The babe is sick, sick to the death, I fear,

The fruit that sprung from thee to David's house;
Nor may the pot of honey and of oil
Glad David or his handmaid's countenance.
Urias—woe is me to think hereon!
For who is it among the sons of men
That saith not to my soul, "The King hath sinned;
David hath done amiss, and Bethsabe
Laid snares of death unto Urias' life"? 20
My sweet Urias, fallen into the pit
Art thou, and gone even to the gates of hell
For Bethsabe, that wouldst not shroud her shame.
Oh, what is it to serve the lust of kings!
How lion-like th[e]y rage when we resist!
But, Bethsabe, in humbleness attend
The grace that God will to his handmaid send.

 Ex[*eunt*.]

[v]

 Enter DAVID *in his gown, walking sadly.*

Dav. [*Aside*] The babe is sick, and sad is David's
 heart,
To see the guiltless bear the guilty's pain.
David, hang up thy harp; hang down thy head,
And dash thy ivory lute against the stones.
The dew that on the hill of Hermon falls
Rains not on Sion's tops and lofty towers;
The plains of Gath and Askaron rejoice,
And David's thoughts are spent in pensiveness.[1]
The babe is sick, sweet babe, that Bethsabe
With woman's pain brought forth to Israel.— 10

 Enter NATHAN.

But what saith Nathan to his lord the King?

Na. Thus Nathan saith unto his lord the King.
There were two men, both dwellers in one town.
The one was mighty and exceeding rich
In oxen, sheep, and cattle of the field;
The other poor, having nor ox nor calf
Nor other cattle, save one little lamb
Which he had bought and nourished by the hand,
And it grew up, and fed with him and his,
And ate and drank as he and his were wont, 20
And in his bosom slept, and was to him[2]
As was his daughter or his dearest child.
There came a stranger to this wealthy man,
And he refused and spared[3] to take his own,
Or of his store to dress or make him meat,
But took the poor man's sheep, the[4] poor man's store,
And dressed it for this stranger in his house.
What, tell me, shall be done to him for this?

Dav. Now, as the Lord doth live, this wicked man

Is judged and shall become the child of death;　30
Fourfold to the poor man shall he restore,
That without mercy took his lamb away.
　　Na.　Thou art the man; and thou hast judged thyself.
David, thus saith the Lord thy God by me:
I thee anointed King in Israel,
And saved thee from the tyranny of Saul;
Thy master's house I gave thee to possess;
His wives into thy bosom did I give,
And Judah and Jerusalem withal;
And might, thou know'st, if this had been too small,　40
Have given thee more:
Wherefore, then, hast-thou gone so far astray,
And hast done evil, and sinnèd in my sight?
Urias thou hast killèd with the sword;
Yea, with the sword of the uncircumcised
Thou hast him slain: wherefore, from this day forth,
The sword shall never go from thee and thine;
For thou hast ta'en this Hittite's wife to thee;
Wherefore, behold, I will, saith Jacob's God,
In thine own house stir evil up to thee;　50
Yea, I before thy face will take thy wives,
And give them to thy neighbor to possess:
This shall be done to David in the day,
That Israel openly may see thy shame.
　　Dav.　Nathan, I have against the Lord, I have
Sinned, oh, sinnèd grievously; and lo,
From heaven's throne doth David throw himself,
And groan and grovel to the gates of hell!
　　　　　　He falls down. [NATHAN *raises him.*]
　　Na. David, stand up. Thus saith the Lord by
　　me:
David the King shall live, for he hath seen　60
The true repentant sorrow of thy heart;
But, for thou hast in this misdeed of thine
Stirred up the enemies of Israel
To triumph and blaspheme the God of Hosts
And say, he set a wicked man to reign
Over his lovèd people and his tribes,
The child shall surely die, that erst [5] was born,
His mother's sin, his kingly father's scorn.
　　　　　　　　　　　Exit [NATHAN].
　　Dav. How just is Jacob's God in all his works!
But must it die that David loveth so?　70
Oh, that the Mighty One of Israel
Nill [6] change his doom, [7] and says the babe must die!
Mourn, Israel, and weep in Sion gates;
Wither, ye cedar trees of Lebanon;
Ye sprouting almonds, with your flowering tops,
Droop, drown, and drench in Hebron's fearful streams.
The babe must die that was to David born,
His mother's sin, his kingly father's scorn.
　　　　　　　　　　DAVID sits sadly.

　　　　　　　Enter CUSAY.

　　1 Serv. What tidings bringeth Cusay to the King?
　　Cu. To thee, the servant of King David's court,　80

This bringeth Cusay, as the prophet spake;
The Lord hath surely stricken to the death
The child new-born by that Urias' wife,
That by the sons of Ammon erst was slain.
　　1 Serv. Cusay, be still; the King is vexèd sore:
How shall he speed that brings this tidings first,
When, while the child was yet alive, we spake,
And David's heart would not be comforted?
　　Dav. David's heart will not be comforted!
What murmur ye, the servants of the King?　90
What tidings telleth Cusay to the King?
Say, Cusay, lives the child, or is he dead?
　　Cu. The child is dead, that of Urias' wife
David begat.
　　Dav.　　　Urias' wife, saist thou?
The child is dead, then ceaseth David's shame.
Fetch me to eat, and give me wine to drink,
Water to wash, and oil to clear my looks;
Bring down your shawms, [8] your cymbals, and your
　　pipes;
Let David's harp and lute, his hand and voice,
Give laud to him that loveth Israel,
And sing his praise that shendeth [9] David's fame,　100
That put away his sin from out his sight,
And sent his shame into the streets of Gath.
Bring ye to me the mother of the babe,
That I may wipe the tears from off her face
And give her comfort with this hand of mine,
And deck fair Bethsabe with ornaments,
That she may bear to me another son,
That may be lovèd of the Lord of Hosts;
For where he is, of force must David go,
But never may he come where David is.　110

　　*They bring in water, wine, and oil, music, and a
　　　　　　　　　　　　　　　　　banquet.*

　　　　　　[*Enter* BETHSABE].

Fair Bethsabe, sit thou, and sigh no more;—
And sing and play, you servants of the King.
Now sleepeth David's sorrow with the dead,
And Bethsabe liveth to Israel.

　　They use all solemnities [10] together and sing, etc.

Now arms and warlike engines for assault
Prepare at once, ye men of Israel,
Ye men of Judah and Jerusalem,
That Rabbah may be taken by the King,
Lest it be callèd after Joab's name,
Nor David's glory shine in Sion streets.　120
To Rabbath marcheth David with his men,
To chastise Ammon and the wicked ones.
　　　　　　　　　　　Exeunt omnes.

[vi]

　　　Enter ABSALON *with two or three.*

　　Abs. Set up your mules, and give them well to eat,
And let us meet our brothers at the feast.
Accursèd is the master of this feast,
Dishonor of the house of Israel,
His sister's slander, and his mother's shame.

[5] *erst:* recently.　　　　　　[6] *Nill:* Will not.
[7] *doom:* sentence.　　　　　[8] *shawms:* oboe-like instruments.
[9] *shendeth:* defends.　　　[10] *solemnities:* formal ceremonies.

Shame be his share that could such ill contrive,
To ravish Tamar, and without a pause
To drive her shamefully from out his house;
But may his wickedness find just reward.
Therefore doth Absalon conspire with you, 10
That Amnon die what time he sits to eat;
For in the holy temple have I sworn
Wreak [1] of his villainy in Tamar's rape.
And here he comes. Bespeak him gently, all,
Whose death is deeply gravèd in my heart.

 Enter AMNON *with* ADONIJAH, *and* JONADAB.

 Am. Our shearers are not far from hence, I wot; [2]
And Amnon to you all his brethren
Giveth such welcome as our fathers erst
Were wont in Judah and Jerusalem;—
But, specially, Lord Absalon, to thee, 20
The honor of thy house and progeny.
Sit down and dine with me, King David's son,
Thou fair young man, whose hairs shine in mine eye
Like golden wires of David's ivory lute.
 Abs. Amnon, where be thy shearers and thy men,
That we may pour in plenty of thy wines,
And eat thy goats' milk, and rejoice with thee?
 Am. Here cometh Amnon's shearers and his men:—
Absalon, sit and rejoice with me.

 Enter a company of Shepherds, *and dance and sing.*

Drink, Absalon, in praise of Israel; 30
Welcome to Amnon's fields from David's court.
 [ABSALON *stabs* AMNON.]
 Abs. Die with thy draught; perish, and die accursed;
Dishonor to the honor of us all;
Die for the villainy to Tamar done,
Unworthy thou to be King David's son!
 Exit ABSALON [*with followers*].
 Jonad. Oh, what hath Absalon for Tamar done,
Murdered his brother, great King David's son!
 Ad. Run, Jonadab, away, and make it known
What cruelty this Absalon hath shown.
Amnon, thy brother Adonijah shall 40
Bury thy body 'mong the dead men's bones;
And we will make complaint to Israel
Of Amnon's death and pride of Absalon.
 Exeunt omnes.

[vii]

 Enter DAVID *with* JOAB, ABISHAI, CUSAY,
[*and others,*] *with drum and ensign against* RABBAH.

 Dav. This is the town of the uncircumcised,
The city of the kingdom, this is it,
Rabbah, where wicked Hanun sitteth king.
Despoil this King, this Hanun, of his crown;
Unpeople Rabbah and the streets thereof;
For in their blood, and slaughter of the slain,
Lieth the honor of King David's line.
Joab, Abishai, and the rest of you,
Fight ye this day for great Jerusalem. 9

 [*Enter* HANUN *and others on the walls.*]

 Joab. And see where Hanun shows him on the walls;
Why, then, do we forbear to give assault,
That Israel may, as it is promisèd,
Subdue the daughters of the Gentiles' tribes?
All this must be performed by David's hand.
 Dav. Hark to me, Hanun, and remember well:
As sure as He doth live that kept my host,
What time our young men, by the pool of Gibeon,
Went forth against the strength of Ishboseth,
And twelve to twelve did with their weapons play,
So sure art thou and thy men of war 20
To feel the sword of Israel this day,
Because thou hast defièd Jacob's God,
And suffered Rabbath with the Philistine
To rail upon the tribe of Benjamin.
 Ha. Hark, man: as sure as Saul thy master fell,
And gored his sides upon the mountain-tops,
And Jonathan, Abinadab, and Melchisua,
Watered the dales and deeps of Askaron
With bloody streams that from Gilboa ran
In channels through the wilderness of Ziph, 30
What time the sword of the uncircumcised
Was drunken with the blood of Israel;
So sure shall David perish with his men
Under the walls of Rabbah, Hanun's town.
 Joab. Hanun, the God of Israel hath said,
David the King shall wear that crown of thine
That weighs a talent [1] of the finest gold,
And triumph in the spoil of Hanun's town,
When Israel shall hale thy people hence,
And turn them to the tile-kiln, [2] man and child, 40
And put them under harrows made of iron,
And hew their bones with axes, and their limbs
With iron swords divide and tear in twain.
Hanun, this shall be done to thee and thine,
Because thou hast defièd Israel.—
To arms, to arms, that Rabbah feel revenge,
And Hanun's town become King David's spoil!

 Alarum, excursions, assault; exeunt omnes. Then the
 trumpets sound, and DAVID *with* HANUN'S
 crown, [JOAB, *etc.*].

 Dav. Now clattering arms and wrathful storms of war
Have thundered over Rabbah's razèd [3] towers;
The wreakful ire of great Jehovah's arm, 50
That for his people made the gates to rend,
And clothed the cherubins in fiery coats
To fight against the wicked Hanun's town.
Pay thanks, ye men of Judah, to the King,
The God of Sion and Jerusalem,
That hath exalted Israel to this,
And crownèd David with this diadem.
 Joab. Beauteous and bright is he among the tribes.
As when the sun, attired in glistering robe,
Comes dancing from his oriental gate, 60
And bridegroom-like hurls through the gloomy air

vi.
 [1] *Wreak:* Revenge. [2] *wot:* know
vii.
 [1] *talent:* measure of weight and value.
 [2] *tile-kiln:* kiln for baking tile. [3] *razèd:* raced Q.

His radiant beams, such doth King David show,
Crowned with the honor of his enemies' town,
Shining in riches like the firmament,
The starry vault that overhangs the earth;
So looketh David King of Israel.

Abis. Joab, why doth not David mount his throne
Whom heaven hath beautified with Hanun's crown?
Sound trumpets, shawms, and instruments of praise,
To Jacob's God for David's victory. 70

[*Instruments sound.*] Enter JONADAB.

Jonad. Why doth the King of Israel rejoice?
Why sitteth David crowned with Rabbah's rule?
Behold, there hath great heaviness befall'n
In Amnon's fields by Absalon's misdeed;
And Amnon's shearers and their feast of mirth
Absalon hath o'erturnèd with his sword;
Nor liveth any of King David's sons
To bring this bitter tidings to the King.

Dav. Ay me, how soon are David's triumphs dashed,
How suddenly declineth David's pride! 80
As doth the daylight settle in the west,
So dim is David's glory and his gite.[4]
Die, David, for to thee is left no seed
That may revive thy name in Israel.

Jonad. In Israel is left of David's seed.

Enter ADONIJAH *with other* Sons [*of* DAVID].

Comfort your lord, you servants of the King.—
Behold, thy sons return in mourning weeds,
And only Amnon Absalon hath slain.

Dav. Welcome, my sons; dearer to me you are
Than is this golden crown or Hanun's spoil. 90
O, tell me, then, tell me, my sons, I say,
How cometh it to pass that Absalon
Hath slain his brother Amnon with the sword?

Ad. Thy sons, O King, went up to Amnon's fields,
To feast with him and eat his bread and oil;
And Absalon upon his mule doth come,
And to his men he saith, "When Amnon's heart
Is merry and secure, then strike him dead,
Because he forcèd Tamar shamefully,
And hated her, and threw her forth his doors." 100
And this did he; and they with him conspire,
And kill thy son in wreak[5] of Tamar's wrong.

Dav. How long shall Judah and Jerusalem
Complain, and water Sion with their tears!
How long shall Israel lament in vain,
And not a man among the mighty ones
Will hear the sorrows of King David's heart!
Amnon, thy life was pleasing to thy lord,
As to mine ears the music of my lute,
Or songs that David tuneth to his harp; 110
And Absalon hath ta'en from me away
The gladness of my sad distressèd soul.

Exeunt omnes. Manet DAVID.

Enter Widow of Tekoah. [*She kneels.*]

[4] *gite:* splendor. [5] *wreak:* revenge.
[6] *Whenas:* When.

Widow of Tek. God save King David, King of Israel,
And bless the gates of Sion for his sake!

Dav. Woman, why mournest thou? Rise from the
earth;
Tell me what sorrow hath befall'n thy soul.

[*Widow rises.*]

Widow of Tek. Thy servant's soul, O King, is troubled
sore,
And grievous is the anguish of her heart;
And from Tekoah doth thy handmaid come.

Dav. Tell me, and say, thou woman of Tekoah, 120
What aileth thee or what is come to pass.

Widow of Tek. Thy servant is a widow in Tekoah.
Two sons thy handmaid had; and they, my lord,
Fought in the field, where no man went betwixt,
And so the one did smite and slay the other.
And, lo, behold, the kindred doth arise,
And cry on him that smote his brother,
That he therefore may be the child of death;
"For we will follow and destroy the heir."
So will they quench that sparkle that is left, 130
And leave nor name nor issue on the earth
To me or to thy handmaid's husband dead.

Dav. Woman, return; go home unto thy house;
I will take order that thy son be safe.
If any man say otherwise than well,
Bring him to me, and I shall chastise him;
For, as the Lord doth live, shall not a hair
Shed from thy son or fall upon the earth.
Woman, to God alone belongs revenge:
Shall, then, the kindred slay him for his sin? 140

Widow of Tek. Well hath King David to his
handmaid spoke:
But wherefore, then, hast thou determinèd
So hard a part against the righteous tribes,
To follow and pursue the banishèd,
Whenas[6] to God alone belongs revenge?
Assuredly thou saist against thyself;
Therefore call home again the banishèd;
Call home the banishèd, that he may live,
And raise to thee some fruit in Israel.

Dav. Thou woman of Tekoah, answer me, 150
Answer me one thing I shall ask of thee:
Is not the hand of Joab in this work?
Tell me, is not his finger in this fact?

Widow of Tek. It is, my lord; his hand is in this work:
Assure thee, Joab, captain of thy host,
Hath put these words into thy handmaid's mouth;
And thou art as an angel from on high,
To understand the meaning of my heart:
Lo, where he cometh to his lord the King.

Enter JOAB.

Dav. Say, Joab, didst thou send this woman in 160
To put this parable for Absalon?

Joab. Joab, my lord, did bid this woman speak,
And she hath said, and thou hast understood.

Dav. I have, and am content to do the thing.
Go fetch my son, that he may live with me.

Joab. Now God be blessèd for King David's life!
Thy servant Joab hath found grace with thee,

In that thou sparest Absalon thy child.
A beautiful and fair young man is he;
In all his body is no blemish seen; 170
His hair is like the wire of David's harp,
That twines about his bright and ivory neck;
In Israel is not such a goodly man;
And here I bring him to entreat for grace.

Enter ABSALON *with* JOAB.

Dav. Hast thou slain [Amnon] in the fields of
 Hazor—?
Ah, Absalon, my son! ah, my son, Absalon!
But wherefore do I vex thy spirit so?
Live, and return from Gesur to thy house;
Return from Gesur to Jerusalem.
What boots it to be bitter to thy soul? 180
Amnon is dead, and Absalon survives.
Abs. Father, I have offended Israel,
I have offended David and his house;
For Tamar's wrong hath Absalon misdone;
But David's heart is free from sharp revenge,
And Joab hath got grace for Absalon.
Dav. Depart with me, you men of Israel,
You that have followed Rabbah with the sword,
And ransack Ammon's richest treasuries.—
Live, Absalon, my son, live once in peace: 190
Peace with thee, and with Jerusalem!

Exeunt omnes. Manet ABSALON.

Abs. David is gone, and Absalon remains,
Flowering in pleasant springtime of his youth:
Why liveth Absalon and is not honored
Of tribes and elders and the mightiest ones,
That round about his temples he may wear
Garlands and wreaths set on with reverence;
That every one that hath a cause to plead
Might come to Absalon and call for right?
Then in the gates of Sion would I sit, 200
And publish[7] laws in great Jerusalem;
And not a man should live in all the land
But Absalon would do him reason's due.
Therefore I shall address me, as I may,
To love the men and tribes of Israel.

Exit.

[viii]

Enter DAVID, ITTAI, ZADOK, AHIMAAZ,
 JONATHAN, *with others;* DAVID *barefoot,*
with some loose covering over his head; and all mourning.

Dav. Proud lust, the bloodiest traitor to our souls,
Whose greedy throat nor earth, air, sea, or heaven,
Can glut or satisfy with any store,
Thou art the cause these torments suck my blood,
Piercing with venom of thy poisoned eyes
The strength and marrow of my tainted bones.
To punish Pharaoh and his cursèd host,
The waters shrunk[1] at great Adonai's voice,
And sandy bottom of the sea appeared,
Offering his service at his servant's feet;
And, to inflict a plague on David's sin, 10
He makes his bowels traitors to his breast,

Winding about his heart with mortal gripes.[2]
Ah, Absalon, the wrath of heaven inflames
Thy scorchèd bosom with ambitious heat,
And Satan sets thee on a lusty[3] tower,
Showing thy thoughts the pride of Israel,
Of choice to cast thee on her ruthless stones.—
Weep with me, then, ye sons of Israel;

Lies down, and all the rest after him.

Lie down with David, and with David mourn 20
Before the Holy One that sees our hearts;
Season this heavy soil with showers of tears,
And fill the face of every flower with dew;
Weep, Israel, for David's soul dissolves,
Lading[4] the fountains of his drownèd eyes,
And pours her substance on the senseless earth.
Zad. Weep, Israel, oh, weep for David's soul,
Strewing the ground with hair and garments torn,
For tragic witness of your hearty woes.
Ahi. Oh, would our eyes were conduits to our hearts,
And that our hearts were seas of liquid blood, 31
To pour in streams upon this holy mount,
For witness we would die for David's woes.
Jonath. Then should this Mount of Olives seem a
 plain
Drowned with a sea, that with our sighs should roar,
And, in the murmur of his mounting waves,
Report our bleeding sorrows to the heavens,
For witness we would die for David's woes.
Itt. Earth cannot weep enough for David's woes;
Then weep, you heavens, and, all you clouds dissolve,
That piteous stars may see our miseries 41
And drop their golden tears upon the ground,
For witness how they weep for David's woes.
Zad. Now let my sovereign raise his prostrate bones,
And mourn not as a faithless man would do;
But be assured that Jacob's righteous God,
That promised never to forsake your throne,
Will still be just and pure in his vows.
Dav. Zadok, high priest, preserver of the ark,
Whose sacred virtue keeps the chosen crown, 50
I know my God is spotless in his vows,
And that these hairs shall greet my grave in peace;
But that my son should wrong his tendered soul,
And fight against his father's happiness,
Turns all my hopes into despair of him,
And that despair feeds all my veins with grief.
Itt. Think of it, David, as a fatal plague
Which grief preserveth but preventeth not;
And turn thy drooping eyes upon the troops
That, of affection to thy worthiness, 60
Do swarm about the person of the King:
Cherish their valors and their zealous loves
With pleasant looks and sweet encouragements.
Dav. Methinks the voice of Ittai fills mine ears.

[7] *publish:* promulgate.
viii.
[1] *shrunk:* shrinke Q. [2] *gripes:* grip.
[3] *lusty:* of lust. [4] *Lading:* Draining.

Itt. Let not the voice of Ittai loathe[5] thine ears,
Whose heart would balm[6] thy bosom with his tears.
Dav. But wherefore goest thou to the wars with us?
Thou art a stranger here in Israel,
And son to Achis, mighty King of Gath;
Therefore return, and with thy father stay. 70
Thou cam'st but yesterday; and should I now
Let thee partake these troubles here with us?
Keep both thyself and all thy soldiers safe;
Let me abide the hazards of these arms,
And God requite the friendship thou hast showed.
Itt. As sure as Israel's God gives David life,
What[7] place or peril shall contain the King,
The same will Ittai share in life and death.
Dav. Then, gentle Ittai, be thou still with us,
A joy to David and a grace to Israel.— 80
Go, Zadok, now, and bear the ark of God
Into the great Jerusalem again.
If I find favor in his gracious eyes,
Then will he lay his hand upon my heart
Yet once again before I visit death,
Giving it strength and virtue to mine eyes,
To taste the comforts and behold the form
Of his fair ark and holy tabernacle;
But, if he say, "My wonted love is worn,[8]
And I have no delight in David now," 90
Here lie I armèd with an humble heart
T' embrace the pains that anger shall impose,
And kiss the sword my lord shall kill me with.
Then, Zadok, take Ahimaaz, thy son,
With Jonathan son to Abiathar;
And in these fields will I repose myself,
Till they return from you some certain news.
Zad. Thy servants will with joy obey the king,
And hope to cheer his heart with happy news.
 Exeunt ZADOK, AHIMAAZ, *and*
 JONATHAN.
Itt. Now that it be no grief unto the King, 100
Let me for good inform his majesty
That with unkind and graceless Absalon
Achitophel your ancient counselor
Directs the state of this rebellion.
Dav. Then doth it aim with danger at my crown.—
O thou, that hold'st his raging bloody bound
Within the circle of the silver moon,
That girds earth's center with his watery scarf,
Limit the counsel of Achitophel,
No bounds extending to my soul's distress, 110
But turn his wisdom into foolishness!

Enter CUSAY *with his coat turned and head covered.*

Cu. Happiness and honor to my lord the King!
Dav. What happiness or honor may betide

His state that toils in my extremities?
Cu. Oh, let my gracious sovereign cease these griefs,
Unless he wish his servant Cusay's death,
Whose life depends upon my lord's relief.
Then let my presence with sighs perfume
The pleasant closet of my sovereign's soul.
Dav. No, Cusay, no; thy presence unto me 120
Will be a burden, since I tender[9] thee,
And cannot brook[10] thy sighs for David's sake;
But if thou turn to fair Jerusalem,
And say to Absalon, as thou hast been
A trusty friend unto his father's seat,
So thou wilt be to him, and call him King,
Achitophel's counsel may be brought to naught.
Then having Zadok and Abiathar,
All three may learn the secrets of my son,
Sending the message by Ahimaaz 130
And friendly Jonathan, who both are there.
[*Cu.*] Then rise, referring the success to heaven.
Dav. Cusay, I rise, though with unwieldy bones
I carry arms against my Absalon.
 [*Exeunt.*]

[ix]

ABSALON, AMASA, ACHITOPHEL, *with the*
Concubines *of* David, *and others,*
are discovered in great state; ABSALON *crowned.*

Abs. Now you that were my father's concubines,
Liquor to his inchaste and lustful fire,
Have seen his honor shaken in his house,
Which I possess in sight of all the world.
I bring ye forth for foils[1] to my renown,
And to eclipse the glory of your King,
Whose life is with his honor fast enclosed
Within the entrails of a jetty[2] cloud,
Whose dissolution shall pour down in showers
The substance of his life and swelling pride; 10
Then shall the stars light earth with rich aspects,
And heaven shall burn in love with Absalon,
Whose beauty will suffice to chase[3] all mists
And clothe the sun's sphere with a triple fire,
Sooner than his clear eyes should suffer stain
Or be offended with a louring day.
1 Conc. Thy father's honor, graceless Absalon,
And ours thus beaten with thy violent arms,
Will cry for vengeance to the host of heaven,
Whose power is ever armed against the proud, 20
And will dart plagues at thy aspiring head
For doing this disgrace to David's throne.
2. Conc. To David's throne, to David's holy throne,
Whose scepter angels guard with swords of fire,
And sit as eagles on his conquering fist,
Ready to prey upon his enemies:
Then think not thou, the captain of his foes,
Wert thou much swifter than Azahel[4] was,
That could outpace the nimble-footed roe,
To scape the fury of their thumping beaks 30
Or dreadful scope of their commanding wings.
Ach. Let not my lord the King of Israel

ix.

[5] *loathe:* be displeasing to. [6] *balm:* anoint.
[7] *What:* Whatever. [8] *worn:* wornout.
[9] *tender:* cherish. [10] *brook:* breake Q.

[1] *foils:* brightening by contrast to themselves.
[2] *jetty:* black. [3] *chase:* chast Q.
[4] *Azahel:* brother of Joab and Abishai.

Be angry with a silly woman's threats;
But, with the pleasure he hath erst enjoyed,
Turn them into their cabinets [5] again,
Till David's conquest be their overthrow.
 Abs. Into your bowers, ye daughters of disdain,
Gotten by fury of unbridled lust,
And wash your couches with your mourning tears,
For grief that David's kingdom is decayed. 40
 1 Conc. No, Absalon, his kingdom is enchained
Fast to the finger of great Jacob's God,
Which will not loose it for a rebel's love.
 Exeunt [Concubines].
 Ama. If I might give advice unto the King.
These concubines should buy their taunts with blood.
 Abs. Amasa, no, but let thy martial sword
Empty the plains [6] of David's armèd men,
And let these foolish women scape our hands
To recompense the shame they have sustained.
First, Absalon was by the trumpet's sound 50
Proclaimed through Hebron King of Israel,
And now is set in fair Jerusalem
With complete state and glory of a crown:
Fifty fair footmen by my chariot run,
And to the air whose rupture rings my fame,
Where'er I ride they offer reverence.
Why should not Absalon, that in his face
Carries the final purpose of his God,
That is, to work him grace in Israel,
Endeavor to achieve with all his strength 60
The state that most may satisfy his joy,
Keeping his statutes and his covenants pure?
His thunder is entangled in my hair,
And with my beauty is his lightning quenched:
I am the man he made to glory in,
When by the errors of my father's sin
He lost the path that led into the land
Wherewith our chosen ancestors were blessed.

Enter CUSAY.

 Cu. Long may the beauteous King of Israel live,
To whom the people do by thousands swarm! 70
 Abs. What meaneth Cusay so to greet his foe?
Is this the love thou showd'st to David's soul,
To whose assistance thou hast vowed thy life?
Why leav'st thou him in this extremity?
 Cu. Because the Lord and Israel chooseth thee;
And as before I served thy father's turn
With counsel acceptable in his sight,
So likewise will I now obey his son.
 Abs. Then welcome, Cusay, to King Absalon.—
And now, my lords and loving counselors, 80
I think it time to exercise our arms
Against forsaken David and his host.
Give counsel first, my good Achitophel,
What times and orders we may best observe
For prosperous manage of these high exploits.
 Ach. Let me choose out twelve thousand valiant
 men,
And, while the night hides with her sable mists
The close [7] endeavors cunning soldiers use,
I will assault thy discontented sire;

And, while with weakness of their weary arms, 90
Surcharged [8] with toil, to shun thy sudden power,
The people fly in huge disordered troops
To save their lives, and leave the King alone,
Then will I smite him with his latest [9] wound,
And bring the people to thy feet in peace.
 Abs. Well hath Achitophel given his advice.
Yet let us hear what Cusay counsels us,
Whose great experience is well worth the ear.
 Cu. Though wise Achitophel be much more meet [10]
To purchase hearing with my lord the King, 100
For all his former counsels, than myself,
Yet, not offending Absalon or him,
This time it is not good nor worth pursuit;
For, well thou know'st, thy father's men are strong,
Chafing as she-bears robbèd of their whelps.
Besides, the King himself a valiant man,
Trained up in feats and stratagems of war;
And will not, for prevention of the worst,
Lodge with the common soldiers in the field;
But now, I know, his wonted policies 110
Have taught him lurk within some secret cave,
Guarded with all his stoutest soldiers;
Which, if the forefront of his battle faint,
Will yet give out that Absalon doth fly,
And so thy soldiers be discouragèd:
David himself withal, whose angry heart
Is as a lion's letted of [11] his walk,
Will fight himself, and all his men to one,
Before a few shall vanquish him by fear.
My counsel therefore is, with trumpet's sound 120
To gather men from Dan to Beersheba
That they may march in number like sea sands,
That nestle close in another's neck.
So shall we come upon him in our strength,
Like to the dew that falls in showers from heaven,
And leave him not a man to march withal.
Besides, if any city succor him,
The numbers of our men shall fetch us ropes,
And we will pull it down the river's stream,
That not a stone be left to keep us out. 130
 Abs. What says my lord to Cusay's counsel now?
 Ama. I fancy Cusay's counsel better far
Than that is given us from Achitophel;
And so, I think, doth every soldier here.
 All. Cusay's counsel is better than Achitophel's.
 Abs. Then march we after Cusay's counsel all.
Sound trumpets through the bounds of Israel,
And muster all the men will serve the King,
That Absalon may glut his longing soul
With sole fruition [12] of his father's crown. 140
 Exeunt [*all but* ACHITOPHEL *and* CUSAY].
 Ach. [*Aside*] Ill shall they fare that follow thy
 attempts,
That scorns the counsel of Achitophel.
 [*Exit.*] *Restat* CUSAY.

 [5] *cabinets:* boudoirs. [6] *plains:* paines Q.
 [7] *close:* secret. [8] *Surcharged:* Oppressed.
 [9] *latest:* last. [10] *meet:* suitable.
 [11] *letted of:* prevented from. [12] *fruition:* enjoyment.

Cu. Thus hath the power of Jacob's jealous God
Fulfilled his servant David's drifts [13] by me,
And brought Achitophel's advice to scorn.

 Enter ZADOK, ABIATHAR, AHIMAAZ,
 and JONATHAN.

Zad. God save Lord Cusay, and direct his zeal
To purchase [14] David's conquest 'gainst his son!
 Abi. What secrets hast thou gleaned from Absalon?
 Cu. These, sacred priests that bear the ark of God:
Achitophel advised him in the night 150
To let him choose twelve thousand fighting men,
And he would come on David at unwares, [15]
While he was weary with his violent toil;
But I advised to get a greater host,
And gather men fron Dan to Beersheba,
To come upon him strongly in the fields.
Then send Ahimaaz and Jonathan
To signify these secrets to the King,
And will [16] him not to stay this night abroad;
But get him over Jordan presently, 160
Lest he and all his people kiss the sword.
 Zad. Then go, Ahimaaz and Jonathan,
And straight convey this message to the King.
 Ahi. Father, we will, if Absalon's chief spies
Prevent not this device, and stay us here.
 [*Exeunt.*]

[x]

 [*Enter*] SHIMEI *solus*

 Shim. The man of Israel that hath ruled as king,
Or rather as the tyrant of the land,
Bolstering his hateful head upon the throne
That God unworthily hath blessed him with,
Shall now, I hope, lay it as low as hell,
And be deposed from his detested chair.
Oh, that my bosom could by nature bear
A sea of poison, to be poured upon
His cursèd head that sacred balm hath graced
And consecrated King of Israel; 10
Or would my breath were made the smoke of hell,
Infected with the sighs of damnèd souls,
Or with the reeking [1] of that serpent's gorge
That feeds on adders, toads, and venomous roots,
That, as I opened my revenging lips
To curse the shepherd for his tyranny,
My words might cast rank poison to his pores,
And make his swol'n and rankling sinews crack,
Like to the combat blows that break the clouds
When Jove's stout champions fight with fire. 20
See where he cometh that my soul abhors!
I have prepared my pocket full of stones

To cast at him, mingled with earth and dust,
Which, bursting with disdain, I greet him with.

 [*Enter*] DAVID, JOAB, ABISHAI, ITTAI, *and others.*

Come forth, thou murderer and wicked man.
The Lord hath brought upon thy cursèd head
The guiltless blood of Saul and all his sons,
Whose royal throne thy baseness hath usurped;
And, to revenge it deeply on thy soul,
The Lord hath given the kingdom to thy son, 30
And he shall wreak the traitorous wrongs of Saul;
Even as thy sin hath still importuned heaven,
So shall thy murders and adultery
Be punished in the sight of Israel,
As thou deserv'st, with blood, with death, and hell.
Hence murderer, hence!
 He throws at him.
 Abis. Why doth [t]his dead dog curse my lord the
 King?
Let me alone to take away his head.
 Dav. Why meddleth thus the son of Zeruiah
To interrupt the action of our God? 40
Shimei useth me with this reproach
Because the Lord hath sent him to reprove
The sins of David, printed in his brows
With blood, that blusheth for his conscience' guilt;
Who dares then ask him why he curseth me?
 Shim. If, then, thy conscience tell thee thou hast
 sinned,
And that thy life is odious to the world,
Command thy followers to shun thy face;
And by thyself here make away thy soul,
That I may stand and glory in thy shame. 50
 Dav. I am not desperate, Shimei, like thyself,
But trust unto the covenant of my God,
Founded on mercy, with repentance built,
And finished with the glory of my soul.
 Shim. A murderer, and hope for mercy in thy end!
Hate and destruction sit upon thy brows
To watch the issue [2] of thy damnèd ghost,
Which with thy latest gasp they'll take and tear,
Hurling in every pane [3] of hell a piece.
Hence, murderer, thou shame to Israel, 60
Foul lecher, drunkard, plague to heaven and earth!
 He throws at him.
 Joab. What, is it piety in David's thoughts,
So to abhor from laws of policy
In this extremity of his distress,
To give his subjects cause of carelessness? [4]
Send hence the dog with sorrow to his grave.
 Dav. Why should the sons of Zeruiah seek to check
His spirit, which the Lord hath thus inspired?
Behold, my son which issued from my flesh
With equal fury seeks to take my life: 70
How much more then the son of Jemini,
Chiefly since he doth naught but God's command?
It may be he will look on me this day
With gracious eyes, and for his cursing bless
The heart of David in his bitterness.
 Shim. What dost thou fret my soul with sufferance?
O, that the souls of Ishboseth and Abner,

13 *drifts:* plans. 14 *purchase:* strive for.
15 *at unwares:* by surprise. 16 *will:* urge.

x.
 1 *reeking:* exhalation. 2 *issue:* going out.
 3 *pane:* piece. 4 *carelessness:* negligence.

Which thou sent'st swimming to their graves in blood,
With wounds fresh bleeding, gasping for revenge,
Were here to execute my burning hate! 80
But I will hunt thy foot with curses still;
Hence, monster, murderer, mirror of contempt!
 He throws dust again.

Enter AHIMAAZ *and* JONATHAN.

Ahi. Long life to David, to his enemies death!
Dav. Welcome, Ahimaaz and Jonathan:
What news sends Cusay to thy lord the King?
Ahi. Cusay would wish my lord the King
To pass the river Jordan presently,
Lest he and all his people perish here;
For wise Achitophel hath counseled Absalon
To take advantage of your weary arms, 90
And come this night upon you in the fields.
But yet the Lord hath made his counsel scorn,
And Cusay's policy with praise preferred;
Which was to number every Israelite,
And so assault you in their pride of strength.
Jonath. Abiathar besides entreats the King
To send his men of war against his son,
And hazard not his person in the field.
Dav. Thanks to Abiathar, and to you both,
And to my Cusay, whom the Lord requite; 100
But ten times treble thanks to his soft hand
Whose pleasant touch hath made my heart to dance,
And play him praises in my zealous breast,
That turned the counsel of Achitophel
After the prayers of his servant's lips.
Now will we pass the river all this night,
And in the morning sound the voice of war,
The voice of bloody and unkindly war.
Joab. Then tell us how thou wilt divide thy men,
And who shall have the special charge herein. 110
Dav. Joab, thyself shall for thy charge conduct
The first third part of all my valiant men,
The second shall Abishai's valor lead;
The third fair Ittai, which I most should grace
For comfort he hath done to David's woes;
And I myself will follow in the midst.
Itt. That let not David; for, though we should fly,
Ten thousand of us were not half so much
Esteemed with David's enemies as himself:
Thy people, loving thee, deny thee this. 120
Dav. What seems them best, then, that will David do.
But now, my lords and captains, hear his voice
That never yet pierced piteous heaven in vain;
Then let it not slip lightly through your ears;
For my sake spare the young man Absalon.
Joab, thyself didst once use friendly words
To reconcile my heart incensed to him;
If then thy love be to thy kinsman sound,
And thou wilt prove a perfect Israelite,
Friend him with deeds,[5] and touch no hair of him, 130
Not that fair hair with which the wanton winds
Delight to play and love to make it curl,
Wherein the nightingales would build their nests,
And make sweet bowers in every golden tress
To sing their lover every night asleep:

Oh, spoil not, Joab, Jove's fair ornaments,
Which he hath sent to solace David's soul.
The best, ye see, my lords, are swift to sin;
To sin our feet are washed with milk of roes,
And dried again with coals of lightning. 140
O Lord, thou see'st the proudest sin's poor slave,
And with his bridle pull'st him to the grave!
For my sake, then, spare lovely Absalon.
Itt. We will, my lord, for thy sake favor him.
 Exeunt.

[xi]

[Enter] ACHITOPHEL *[solus] with a halter.*

Ach. Now hath Achitophel ordered his house,
And taken leave of every pleasure there.
Hereon depend Achitophel's delights,
And in this circle must his life be closed.
The wise Achitophel, whose counsel proved
Ever as sound for fortunate success
As if men asked the oracle of God,
Is now used like the fool of Israel.
Then set thy angry soul upon her wings,
And let her fly into the shade of death; 10
And for my death let heaven forever weep,
Making huge floods upon the land I leave,
To ravish[1] them and all their fairest fruits.
Let all the sighs I breathed for this disgrace
Hang on my hedges like eternal mists,
As mourning garments for their master's death.
Ope, earth, and take thy miserable son
Into the bowels of thy cursèd womb.
Once in a surfeit thou didst spew him forth;
Now for fell[2] hunger suck him in again, 20
And be his body poison to thy veins.
And now, thou hellish instrument of heaven,
Once execute th' arrest of Jove's just doom,
And stop his breast that curseth Israel.
 Exit.

[Enter] ABSALON, AMASA, *with all his train.*

Abs. Now for the crown and throne of Israel,
To be confirmed with virtue of my sword,
And writ with David's blood upon the blade.
Now, Jove, let forth the golden firmament,
And look on him with all thy fiery eyes
Which thou hast made to give their glories light. 30
To show thou lov'st the virtue of thy hand,
Let fall a wreath of stars upon my head,
Whose influence may govern Israel
With state exceeding all her other kings.
Fight, lords and captains, that your sovereign's face
May shine in honor brighter than the sun;
And with the virtue of my beauteous rays
Make this fair land as fruitful as the fields
That with sweet milk and honey overflowed.
God, in the whissing[3] of a pleasant wind, 40

[5] *Friend . . . deeds:* Prove a friend to him in deed.

xi.
[1] *ravish:* ravage. [2] *fell:* cruel. [3] *whissing:* hissing.

Shall march upon the tops of mulberry trees,
To cool all breasts that burn with any griefs,
As whilom he was good to Moses' men.
By day the Lord shall sit within a cloud
To guide your footsteps to the fields of joy;
And in the night a pillar bright as fire
Shall go before you, like a second sun,
Wherein the essence of his godhead is,
That day and night you may be brought to peace,
And never swerve from that delightsome path 50
That leads your souls to perfect happiness.
This shall he do for joy whem I am King.
Then fight, brave captains, that these joys may fly
Into your bosoms with sweet victory.
 [*Exeunt.*]

[xii]

 The battle, and ABSALON *hangs by the hair.*

 Abs. What angry angel, sitting in these shades,
Hath laid his cruel hands upon my hair,
And holds my body thus 'twixt heaven and earth?
Hath Absalon no soldier near his hand
That may untwine me this unpleasant curl,
Or wound this tree that ravisheth his lord?
O God, behold the glory of thy hand,
And choicest fruit of nature's workmanship,
Hang, like a rotten branch, upon this tree,
Fit for the axe and ready for the fire! 10
Since thou withhold'st all ordinary help
To loose my body from this bond of death,
Oh, let my beauty fill these senseless plants
With sense and power to loose me from this plague,
And work some wonder to prevent his death
Whose life thou mad'st a special miracle!

 [*Enter*] JOAB *with another* Soldier.

 Sold. My lord, I saw the young Prince Absalon
Hang by the hair upon a shady oak,
And could by no means get himself unloosed.
 Joab. Why slew'st thou not the wicked Absalon, 20
That rebel to his father and to heaven,
That so I might have given thee for thy pains
Ten silver shekels and a golden waist?[1]
 Sold. Not for a thousand shekels would I slay
The son of David, whom his father charged
Nor thou, Abishai, nor the son of Gath,[2]
Should touch with stroke of deadly violence.
The charge was given in hearing of us all;
And, had I done it, I know, thyself,
Before thou wouldst abide the King's rebuke, 30
Wouldst have accused me as a man of death.
 Joab. I must now stand trifling here with thee.
 Abs. Help, Joab, help, oh, help thy Absalon.
Let not thy angry thoughts be laid in blood,

In blood of him that sometimes nourished thee,
And softened thy sweet heart with friendly love.
Oh, give me once again my father's sight,
My dearest father and thy princely sovereign,
That, shedding tears of blood before his face,
The ground may witness and the heavens record 40
My last submission sound and full of ruth.[3]
 Joab. Rebel to nature, hate to heaven and earth!
Shall I give help to him that thirsts[4] the soul
Of his dear father and my sovereign lord?
Now see, the Lord hath tangled in a tree
The health and glory of thy stubborn heart,
And made thy pride curbed with a senseless plant:
Now, Absalon, how doth the Lord regard
The beauty whereupon thy hope was built,
And which thou thought'st his grace did glory in? 50
Find'st thou not now, with fear of instant death,
That God affects[5] not any painted shape
Or goodly personage, when the virtuous soul
Is stuffed with naught but pride and stubbornness?
But, preach I to thee, while I should revenge
Thy cursèd sin that staineth Israel,
And makes her fields blush with her children's blood?
Take that as part of thy deservèd plague,
Which worthily no torment can inflict.
 [*Stabs him.*]
 Abs. O Joab, Joab, cruel, ruthless Joab! 60
Herewith thou wound'st thy kingly sovereign's heart,
Whose heavenly temper hates his children's blood,
And will be sick, I know, for Absalon.
O my dear father, that thy melting eyes
Might pierce this thicket to behold thy son,
Thy dearest son, gored with a mortal dart.
Yet, Joab, pity me; pity my father, Joab;
Pity his soul's distress that mourns my life,
And will be dead, I know, to hear my death.
 Joab. If he were so remorseful[6] of thy state, 70
Why sent he me against thee with the sword?
All Joab means to pleasure thee withal
Is to dispatch thee quickly of thy pain.
Hold, Absalon, Joab's pity is in this;
In this, proud Absalon, is Joab's love.
 [*Stabs him again;*] *he goes out.*
 Abs. Such love, such pity Israel's God send thee,
And for his love to David pity me.
Ah, my dear father, see thy bowels bleed;
See death assault thy dearest Absalon;
See, pity, pardon, pray for Absalon. 80

 Enter five or six Soldiers.

 [*1 Sold.*] See where the rebel in his glory hangs.
Where is the virtue of thy beauty, Absalon?
Will any of us here now fear thy looks,
Or be in love with that thy golden hair
Wherein was wrapt rebellion 'gainst thy sire,
And cords prepared to stop thy father's breath?
Our captain Joab hath begun to us;
And here's an end to thee and all thy sins.
 [*Stabs* ABSALON, *who dies.*]
Come, let us take the beauteous rebel down,
And in some ditch, amids this darksome wood, 90

 [1] *waist:* girdle. [2] *son of Gath:* Ittai.
 [3] *ruth:* contrition. [4] *thirsts:* longs for.
 [5] *affects:* likes. [6] *remorseful:* compassionate.

Bury his bulk beneath a heap of stones,
Whose stony heart did hunt his father's death.

> *Re-enter, in triumph with drum and ensign,*
> JOAB, ABISHAI, *and* Soldiers.

Joab. Well done, tall[7] soldiers! take the traitor down,
And in this miry ditch inter his bones,
Covering his hateful breast with heaps of stones.
This shady thicket of dark Ephraim
Shall ever lower on his cursèd grave;
Night-ravens and owls shall ring his fatal knell,
And sit exclaiming on his damnèd soul;
There shall they heap their preys of carrion, 100
Till all his grave be clad with stinking bones,
That it may loathe the sense of every man:
So shall his end breed horror to his name,
And to his traitorous fact[8] eternal shame.

> *Exeunt.*

[II Chorus[1]]

> *Enter* Chorus.

Chor. O dreadful president[2] of his just doom,
Whose holy heart is never touched with ruth
Of fickle beauty or of glorious shapes,
But with the virtue of an upright soul,
Humble and zealous in his inward thoughts,
Though in his person loathsome and deformed!
Now since this story lends us other store,
To make a third discourse of David's life,
Adding thereto his most renownèd death,
And all their deaths that at his death he judged, 10
Here end we this, and what here wants to please
We will supply with treble willingness.[3]

> [*Exit.*]

[xiii]

> *Trumpets sound. Enter* JOAB, AHIMAAZ, CUSAY;
> AMASA, *with all the rest* [*of* ABSALON'*s*
> *followers*].

Joab. Soldiers of Israel, and ye sons of Judah,
That have contended in these irksome broils,
And ripped old Israel's bowels with your swords,
The godless general of your stubborn arms
Is brought by Israel's helper to the grave,
A grave of shame, and scorn of all the tribes.
Now, then, to save your honors from the dust,
And keep your bloods in temper[1] by your bones,
Let Joab's ensign shroud[2] your manly heads;
Direct your eyes, your weapons, and your hearts, 10
To guard the life of David from his foes.
Error hath masked your much too forward minds,
And you have sinned against the chosen state,
Against his life, for whom your lives are blessed,
And followed an usurper to the field,
In whose just death your deaths are threatenèd.
But Joab pities your disordered souls,
And therefore offers pardon, peace, and love,

To all that will be friendly reconciled
To Israel's weal, to David, and to heaven. 20
Amasa, thou art leader of the host
That under Absalon have raised their arms;
Then be a captain wise and politic,
Careful and loving for thy soldiers' lives,
And lead them to this honorable league.
Ama. I will; at least, I'll do my best;
And for the gracious offer thou hast made
I give thee thanks as much as for my head.—
Then, you deceived poor souls of Israel,
Since now ye see the errors you incurred, 30
With thanks and due submission be appeased;
And as ye see your captain's precedent,
Here cast we then our swords at Joab's feet,
Submitting with all zeal and reverence
Our goods and bodies to his gracious hands.

> [*Kneels with others.*]

Joab. Stand up, and take ye all your swords again:

> *All stand up.*

David and Joab shall be blessed herein.
Ahi. Now let me go inform my lord the King
How God hath freed him from his enemies.
Joab. Another time, Ahimaaz, not now.— 40
But, Cusay, go thyself, and tell the King
The happy message of our good success.
Cu. I will, my lord, and thank thee for thy grace.

> *Exit* CUSAY.

Ahi. What if thy servant should go too, my lord?
Joab. What news hast thou to bring since he is gone?
Ahi. Yet do Ahimaaz so much content,
That he may run about so sweet a charge.

> *Exit.*

Joab. Run, if thou wilt; and peace be with thy steps.
Now follow, that you may salute the King
With humble hearts and reconcilèd souls. 50
Ama. We follow, Joab, to our gracious King;
And him our swords shall honor to our deaths.

> *Exeunt.*

[xiv]

> *Enter* DAVID, BETHSABE, SOLOMON, NATHAN,
> ADONIJAH, CHILEAB, *with their train.*

Beth. What means my lord, the lamp of Israel,
From whose bright eyes all eyes receive their light,
To dim the glory of his sweet aspects[1]

 [7] *tall:* brave. [8] *fact:* deed.
II CHORUS
 [1] *II Chorus:* 5. Chorus Q. [2] *president:* deity.
 [3] Q has the following fragment filling out the page after
this speech:
"Absalon *with three or four of his servants or gentlemen.* ABS.
What boots it, Absalon, unhappy Absalon, / Sighing I say
what boots it Absalon, / To have disclosed a far more worthy
womb / Then"
xiii.
 [1] *temper:* good health. [2] *shroud:* protect.
xiv.
 [1] *aspects:* face.

And paint his countenance with his heart's distress?
Why should his thoughts retain a sad conceit
When every pleasure kneels before his throne
And sues for sweet acceptance with his grace?
Take but your lute, and make the mountains dance,
Retrieve the sun's sphere, and restrain the clouds,
Give ears to trees, make savage lions tame, 10
Impose still silence to the loudest winds,
And fill the fairest day with foulest storms.
Then why should passions of much meaner power
Bear head against the heart of Israel?
 Dav. Fair Bethsabe, thou mightst increase the
 strength
Of these thy arguments, drawn from my skill,
By urging thy sweet sight to my conceits,
Whose virtue ever served for sacred balm
To cheer my pinings past all earthly joys.
But, Bethsabe, the daughter of the Highest, 20
Whose beauty builds the towers of Israel,
She that in chains of pearl and unicorn [2]
Leads at her train the ancient golden world,
The world that Adam held in paradise,
Whose breath refineth all infectious airs
And makes the meadows smile at her repair, [3]
She, she, my dearest Bethsabe,
Fair Peace, the goddesss of our graces here,
Is fled the streets of fair Jerusalem,
The fields of Israel, and the heart of David, 30
Leading my comforts in her golden chains,
Linked to the life and soul of Absalon.
 Beth. Then is the pleasure of my sovereign's heart
So wrapped within the bosom of that son,
That Solomon, whom Israel's God affects,
And gave the name unto him for his love,
Should be no salve to comfort David's soul?
 Dav. Solomon, my love, is David's lord;
Our God hath named him lord of Israel.
In him (for that, and since he is thy son,) 40
Must David needs be pleasèd at the heart;
And he shall surely sit upon my throne.
But Absalon, the beauty of my bones,
Fair Absalon, the counterfeit [4] of love,
Sweet Absalon, the image of content,
Must claim a portion in his father's care,
And be in life and death King David's son.
 Na. Yet, as my lord hath said, let Solomon reign,
Whom God in naming hath anointed king.
Now is he apt to learn th' eternal laws, 50
Whose knowledge being rooted in his youth
Will beautify his age with glorious fruits;
While Absalon, incensed with graceless pride,
Usurps and stains the kingdom with his sin.
Let Solomon be made thy staff of age,
Fair Israel's rest, and honor of thy race.
 Dav. Tell me, my Solomon, wilt thou embrace
Thy father's precepts gravèd in thy heart,

And satisfy my zeal to thy renown
With practice of such sacred principles 60
As shall concern the state of Israel?
 Sol. My royal father, if the heavenly zeal,
Which for my welfare feeds upon your soul,
Were not sustained with virtue of mine own;
If the sweet accents of your cheerful voice
Should not each hour beat upon mine ears
As sweetly as the breath of heaven to him
That gaspeth scorchèd with the summer's sun,
I should be guilty of unpardoned sin,
Fearing the plague of heaven and shame of earth; 70
But since I vow myself to learn the skill
And holy secrets of his mighty hand
Whose cunning tunes the music of my soul,
It would content me, father, first to learn
How the Eternal framed the firmament;
Which bodies lead their influence by fire,
And which are filled with hoary winter's ice;
What sign is rainy, and what star is fair;
Why by the rules of true proportion
The year is still divided into months, 80
The months to days, the days to certain hours;
What fruitful race shall fill the future world;
Or for what time shall this round building stand;
What magistrates, what kings shall keep in awe
Men's minds with bridles of th' eternal law.
 Dav. Wade not too far, my boy, in waves too deep.
The feeble eyes of our aspiring thoughts
Behold things present, and record things past,
But things to come exceed our human reach,
And are not painted yet in angels' eyes; 90
For those, submit thy sense, and say, "Thou power,
That now art framing of the future world,
Know'st all to come, not by the course of heaven,
By frail conjectures of inferior signs,
By monstrous floods, by flights and flocks of birds,
By bowels of a sacrificèd beast,
Or by the figures [5] of some hidden art,
But by a true and natural presage,
Laying the ground and perfect architect [6]
Of all our actions now before thine eyes, 100
From Adam to the end of Adam's seed;
O heaven, protect my weakness with thy strength.
So look on me that I may view thy face,
And see these secrets written in thy brows.
O sun, come dart thy rays upon my moon,
That now mine eyes, eclipsèd to the earth,
May brightly be refined and shine to heaven;
Transform me from this flesh, that I may live,
Before my death, regenerate with thee.
O thou great God, ravish my earthly sprite, 110
That for the time a more than human skill
May feed the organons [7] of all my sense,
That when I think thy thoughts may be my guide,
And when I speak I may be made by choice
The perfect echo of thy heavenly voice."
Thus say, my son, and thou shalt learn them all.
 Sol. A secret fury [8] ravisheth my soul,
Lifting my mind above her human bounds;
And, as the eagle, rousèd from her stand

[2] *unicorn:* i.e., unicorn horn. [3] *repair:* arrival.
[4] *counterfeit:* portrait. [5] *figures:* mystic symbols.
[6] *architect:* architecture. [7] *organons:* organs.
[8] *fury:* frenzy.

With violent hunger, towering in the air, 120
Seizeth her feathered prey and thinks to feed,
But seeing then a cloud beneath her feet,
Lets fall the fowl, and is emboldenèd
With eyes intentive⁹ to bedare¹⁰ the sun,
And styeth¹¹ close unto his stately sphere;
So Solomon, mounted on the burning wings
Of zeal divine, lets fall his mortal food,
And cheers his senses with celestial air,
Treads in the golden starry labyrinth,
And holds his eyes fixed on Jehovah's brows. 130
Good father, teach me further what to do.
 Na. See, David, how his haughty spirit mounts,
Even now of height to wield a diadem:
Then make him promise that he may succeed,
And rest old Israel's bones from broils¹² of war.
 Dav. Nathan, thou prophet, sprung from Jesse's
 root,
I promise thee and lovely Bethsabe,
My Solomon shall govern after me.
 Beth. He that hath touched thee with this
 righteous thought
Preserve the harbor of thy thoughts in peace. 140

Enter Mess[enger].

 Mess. My lord, thy servants of the watch have seen
One running hitherward from forth the wars.
 Dav. If he be come alone, he bringeth news.
 Mess. Another hath thy servant seen, my lord,
Whose running much resembles Zadok's son.
 Dav. He is a good man, and good tidings brings.

Enter AHIMAAZ.

 Ahi. Peace and content be with my lord the King,
Whom Israel's God hath blessed with victory.
 Dav. Tell me, Ahimaaz, lives my Absalon?
 Ahi. I saw a troop of soldiers gatherèd, 150
But know not what the tumult might import.
 Dav. Stand by, until some other may inform
The heart of David with a happy truth.

Enter CUSAY.

 Cu. Happiness and honor live with David's soul,
Whom God hath blessed with conquest of his foes.
 Dav. But, Cusay, lives the young man Absalon?
 Cu. The stubborn enemies to David's peace,
And all that cast their darts against his crown,
Fare ever like the young man Absalon!
For as he rid the woods of Ephraim, 160
Which fought for thee as much as all thy men,
His hair was tangled in a shady oak;
And hanging there, by Joab and his men
Sustained the stroke of well deservèd death.
 Dav. Hath Absalon sustained the stroke of death?
Die, David, for the death of Absalon,
And make these cursèd news the bloody darts
That through thy bowels rip thy wretched breast.
Hence, David, walk the solitary woods,
And in some cedar's shade the thunder slew 170
And fire from heaven hath made his branches black,
Sit mourning the decease of Absalon.

Against the body of that blasted plant
In thousand shivers¹³ break thy ivory lute,
Hanging thy stringless harp upon his boughs;
And through the hollow sapless sounding trunk
Bellow the torments that perplex thy soul.
There let the winds sit sighing till they burst;
Let tempest, muffled with a cloud of pitch,
Threaten the forests with her hellish face, 180
And mounted fiercely on her iron wings,
Rend up the wretched engine¹⁴ by the roots
That held my dearest Absalon to death.
Then let them toss my broken lute to heaven,
Even to his hands that beats me with the strings,
To show how sadly his poor shepherd sings.

Goes to his pavilion and sits close a while.

 Beth. Die, Bethsabe, to see thy David mourn,
To hear his tunes of anguish and of hell.
Oh, help, my David, help thy Bethsabe,
She kneels down.
Whose heart is piercèd with thy breathy swords, 190
And bursts with burden of ten thousand griefs.
Now sit thy sorrows sucking of my blood;
Oh, that it might be poison to their powers,
And that their lips might draw my bosom dry,
So David's love might ease him, though she die!
 Na. These violent passions come not from above;
David and Bethsabe offend the Highest,
To mourn in this immeasurable sort.
 Dav. O Absalon, Absalon! O my son, my son!
Would God that I had died for Absalon; 200
But he is dead, ah, dead, Absalon is dead;
And David lives to die for Absalon.
He looks forth, and at the end sits close again.

Enter JOAB, ABISHAI, ITTAI, *with their train.*

 Joab. Why lies the queen so prostrate on the ground?
Why is this company so tragic hued?
Why is the king now absent from his men,
And marcheth not in triumph through the gates?
He unfolds the pavilion.
David, awake; if sleep have shut thine eyes,
Sleep of affection,¹⁵ that thou canst not see
The honor offered to the victor's head,
Joab brings conquest piercèd on his spear, 210
And joy from all the tribes of Israel.
 Dav. Thou man of blood, thou sepulcher of death,
Whose marble breast entombs my bowels quick,¹⁶
Did I not charge thee, nay, entreat thy hand,
Even for my sake, to spare my Absalon?
And hast thou now, in spite of David's health,
And scorn to do my heart some happiness,
Given him the sword and spilt his purple soul?
 Joab. What irks it David, that the victor breathes,

⁹ *intentive:* intently bent.　　　　¹⁰ *bedare:* defy.
¹¹ *styeth:* mounts up.　　　　¹² *broils:* turmoils.
¹³ *shivers:* fragments.
¹⁴ *engine:* instrument of torture, trap.
¹⁵ *Sleep of affection:* caused by passion or illness.
¹⁶ *quick:* alive.

That Judah and the fields of Israel 220
Should cleanse their faces from their children's blood?
What, art thou weary of thy royal rule?
Is Israel's throne a serpent in thine eyes,
And he that set thee there so far from thanks,
That thou must curse his servant for his sake?
Hast thou not said that, as the morning light,
The cloudless morning, so should be thine house,
And not as flowers by the brightest rain
Which grow up quickly and as quickly fade?
Hast thou not said, the wicked are as thorns, 230
That cannot be preservèd[17] with the hand,
And that the man shall touch them must be armed
With coats of iron and garments made of steel,
Or with the shaft of a defensèd[18] spear?
And art thou angry he is now cut off
That led the guiltless swarming to their deaths,
And was more wicked than an host of men?
Advance thee from thy melancholy den,
And deck thy body with thy blissful robes,
Or, by the Lord that sways the heaven I swear, 240
I'll lead thine armies to another king
Shall cheer them for their princely chivalry,
And not sit daunted, frowning in the dark,
When his fair looks, with oil and wine refreshed,
Should dart into their bosoms gladsome beams,
And fill their stomachs with triumphant feasts;
That when elsewhere stern war shall sound his trump,
And call another battle to the field,
Fame still may bring thy valiant soldiers home,
And for their service happily confess 250
She wanted worthy trumps to sound their prowess.

Take thou this course and live; refuse and die.
 Abis. Come, brother, let him sit there till he sink;
Some other shall advance the name of Joab.
 Offers to go out. He riseth up.
 Beth. Oh, stay, my lords, stay! David mourns no
 more,
But riseth to give honor to your acts.
 Dav. Then happy art thou, David's fairest son,
That, freèd from the yoke of earthly toils,[19]
And sequestered from sense of human sins,
Thy soul shall joy the sacred cabinet 260
Of those divine ideas that present
Thy changèd spirit with a heaven of bliss.
Then thou art gone; ah, thou art gone, my son!
To heaven I hope my Absalon is gone.
Thy soul there placed in honor of the saints,
Or angels clad with immortality,
Shall reap a sevenfold grace for all thy griefs;
Thy eyes, now no more eyes but shining stars,
Shall deck the flaming heavens with novel[20] lamps;
There shalt thou taste the drink of seraphins, 270
And cheer thy feelings with archangels' food;
Thy day of rest, thy holy sabbath-day,
Shall be eternal; and, the curtain drawn,
Thou shalt behold thy sovereign face to face,
With wonder, knit in triple unity,
Unity infinite and innumerable.—
Courage, brave captains! Joab's tale hath stirred,
And made the suit of Israel preferred.
 Joab. Bravely resolved and spoken like a king;
Now may old Israel and his daughters sing. 280
 Exeunt.

F I N I S

[17] *preservèd:* retained. [18] *defensèd:* protected.
[19] *toils:* snares. [20] *novel:* newly created.

Thomas Kyd

[1558-1594]

THE SPANISH TRAGEDY

Though The Spanish Tragedy entered the world anonymously, it was attributed by Thomas Heywood in his *Apology for Actors* (1612) to Thomas Kyd, whose most famous achievement was the lost *Hamlet* on which Shakespeare is thought to have drawn in writing his own play. The Spanish Tragedy dates from no earlier than 1582, no later than 1592, and such questionable evidence as punning allusions to Kyd's name in one man's preface to another's work, failure to mention the Armada, and parallels between the play and another that Kyd may or may not have written have led various scholars to suggest virtually every year that falls between these dates. The most probable guess is that the play was written late in the 1580s. Its first recorded performances took place at the Rose, played under Henslowe's entrepreneurship by a company composed of Lord Strange's Men and the Admiral's Men; one may infer from the frequency of printing and of allusions to it well into the seventeenth century that it remained popular.

The play was first printed in 1592 in a quarto (technically, an "octavo in fours") edition, reprinted in 1594 and 1599, and printed once again in 1602 in an edition enlarged by five new passages totaling about 320 lines. Printed in the present edition between brackets [] at their proper places in the text, these additions have been attributed to a number of playwrights, including Ben Jonson, who did in fact receive payment from Henslowe for some work on the play in 1601 and 1602, but no attribution has convinced a majority of scholars. It should be noted that some of the "additions" are actually replacements for episodes still in the text.

No sources have been found, but Kyd draws much of the play from Seneca's tap, including plot elements, the revenge ambiance, the supernatural matter, elements of characterization, and language, sometimes quoted directly, more often garbled or fused with bits of Virgil and other Latin writers.

The unusual four-act format, with its long third act, has been retained. Though it is possible that five acts were intended, it is more likely that Kyd or the person who prepared the text for the printer was imitating the four-act division of some Senecan models.

Little can be said about Kyd's career as a writer. The attribution of the *Ur-Hamlet* derives from a pun in a preface by Nashe to Greene's romance *Menaphon*, and of another play, *Soliman and Perseda*, from the fact that Kyd used its material in the last act of The Spanish Tragedy. His translation of Garnier's *Cornelie* is his only certain other work. His life records are no less spotty. His father, a scrivener, was a citizen of London. He was educated at the Merchant Taylors' school; though he is one of the so-called University Wits, no record remains of his university education. History has preserved only one episode in his life, in fact, and it involves his most famous fellow dramatist. In 1591 Kyd and Marlowe began to share a room in which they did their writing. When in May 1593 Kyd was arrested in connection with some libels against foreigners that proved to be none of his doing, a search of his room turned up a number of "atheistical" documents that Kyd revealed to be Marlowe's, and the latter was summoned before the Privy Council for an examination that began ominously and was prevented from a sinister conclusion only by his violent death. Though Kyd himself was released and exonerated, he lost his patron's support, and he died intestate and impecunious in 1594; his parents disclaimed any interest in his possessions.

The Spanish Tragedy was as important for its day as Gorboduc had been a generation earlier, a liberating new beginning that amalgamated what had gone before it and with a single leap made audiences and playwrights aware of the possibilities of their medium. Its rhetoric, for example, parades every device taught in the schools with a gusto that would soon be mocked by Shakespeare and Jonson and countless others; but that rhetoric, together with Marlowe's, provides a substance that Shakespeare needed only to mold for his earliest tragedies and histories. Hieronimo's soliloquies are easy to mock by the standards Shakespeare was to teach, but they provided a tragic actor with a role of super-human size such as only Marlowe had thus far created, and they make their speaker one of the enduring fictions of the age. And, as Wolfgang Clemen has demonstrated, Kyd's soliloquies represent an enormous advance in dramaturgical technique by incorporating time into their duration: as Hieronimo speaks, events continue to move so that in the course of a single speech he responds to new stimuli from the outside world as to his own inner life. If one had to isolate the single most important aspect of the play, it would be its embodiment of the essence of revenge tragedy. This peculiar subgenre, so rich in recognizable conventions, so durable in the period, so important to Shakespeare, provides an excuse for effects both physical and psychological to satisfy an audience's need to be frightened, but it does much more than that. It regularly creates a situation in which the hero must turn villain in order to do what his initial virtue and his victimization demand, and his gyrations provide the kind of ambiguous hero-villain that would

fascinate the audiences of Webster and Shakespeare and Middleton and Ford. It also provides a crucial test of the possibilities for justice: by creating in the audience an ambivalent awareness that a wrong must be righted and that the only feasible vengeance is unacceptable, the revenge play insists on the tragic complexity of the human predicament. The debt of the revenge tradition to Senecan and other models, the history of its various uses of supernatural machinery, the changes it makes in such conventions as the mad and the feigning-mad protagonist, the breadth and depth of Shakespeare's interest in its possibilities, and its permutations in the later years when Kyd would seem laughably old hat but his influence would continue to work ineluctably, all these are subjects that would need far more space than is either appropriate or possible here. Suffice it to say that THE SPANISH TRAGEDY, like some other pivotal plays of its period, like some of our most successful films, is the right work at the right time, a piece that seizes with a combination of luck and brilliance on precisely the most vital and rewarding elements of a developing theater to speak both to and for its age.

N. R.

The Spanish Tragedy

DRAMATIS PERSONÆ

Ghost of ANDREA, a *Spanish Nobleman* ⎱ *Chorus*
REVENGE ⎰

KING of Spain
DON CYPRIAN, Duke of Castile, *his brother*
LORENZO, *the Duke's son*
BEL-IMPERIA, *Lorenzo's sister*
GENERAL *of the Spanish Army*

VICEROY of Portugal ("King")
DON PEDRO, *his brother*
BALTHAZAR, *his son*
ALEXANDRO ⎱ *noblemen at the Portuguese court*
VILLUPPO ⎰
AMBASSADOR *of Portugal to the Spanish court*

HIERONIMO, *Knight Marshal of Spain*
ISABELLA, *his wife*
HORATIO, *his son*

PEDRINGANO, *servant to Bel-imperia*
SERBERINE, *servant to Balthazar*
CHRISTOPHIL, *servant to Lorenzo*
Page ("Boy") *to Lorenzo*
Three Watchmen
Messenger

Deputy
Hangman
Maid *to Isabella*
Two Portuguese
Servant
Three Citizens
An Old Man, BAZULTO ("Senex")

Portuguese Nobles, Soldiers, Officers, Attendants, Halberdiers

Three Knights, Three Kings, a Drummer *in the first Dumb-show*
Hymen, Two Torch-bearers *in the second Dumb-show*

In HIERONIMO's play:

SOLIMAN, Sultan of Turkey (BATHAZAR)
ERASTO, Knight of Rhodes (LORENZO)
Bashaw (HIERONIMO)
PERSEDA (BEL-IMPERIA)

In the Additions:

PEDRO ⎱ *servants to Hieronimo*
JAQUES ⎰
A Painter, BAZARDO

ACT ONE

SCENE ONE: INDUCTION

Enter the Ghost of ANDREA, *and with him* REVENGE.

Andr. When this eternal substance of my soul
Did live imprisoned in my wanton flesh,
Each in their function serving other's need,
I was a courtier in the Spanish court.
My name was Don Andrea, my descent,
Though not ignoble, yet inferior far
To gracious fortunes of my tender youth:
For there in prime and pride of all my years,
By duteous service and deserving love,
In secret I possessed a worthy dame, 10
Which hight[1] sweet Bel-imperia by name.
But in the harvest of my summer joys
Death's winter nipped the blossoms of my bliss,
Forcing divorce betwixt my love and me.
For in the late conflict with Portingale[2]
My valor drew me into danger's mouth,
Till life to death made passage through my wounds.
When I was slain, my soul descended straight
To pass the flowing stream of Acheron;[3]
But churlish Charon, only boatman there, 20
Said that, my rites of burial not performed,
I might not sit amongst his passengers.
Ere Sol[4] had slept three nights in Thetis's[5] lap
And slaked his smoking chariot in her flood,
By Don Horatio, our knight marshal's[6] son,
My funeral and obsequies were done.
Then was the ferryman of hell content
To pass me over to the slimy strond[7]
That leads to fell Avernus' ugly waves.
There, pleasing Cerberus[8] with honeyed speech, 30

I.i.
[1] *hight:* was called. [2] *Portingale:* Portugal.
[3] *Acheron:* a river depicted in classical poetry (notably Virgil, *Aeneid,* Book VI, source of details in these lines) as flowing into Hades. [4] *Sol:* the sun.
[5] *Thetis:* Thetis was a daughter of the old sea-god Nereus, here a figure for the sea.
[6] *knight marshal's:* The knight marshal was a law officer in the King's house.
[7] *strond:* strand, shore.
[8] *Cerberus:* monstrous, three-headed dog who guards the entrance to the underworld.

169

I passed the perils of the foremost porch.
Not far from hence, amidst ten thousand souls,
Sat Minos, Aeacus, and Rhadamanth,[9]
To whom no sooner gan [10] I make approach,
To crave a passport for my wand'ring ghost,
But Minos, in graven leaves of lottery,[11]
Drew forth the manner of my life and death.
"This knight," quoth he, "both lived and died in love,
And for his love tried fortune of the wars,
And by war's fortune lost both love and life." 40
"Why, then," said Aeacus, "convey him hence,
To walk with lovers in our fields of love,
And spend the course of everlasting time
Under green myrtle trees and cypress shades."
"No, no," said Rhadamanth, "it were not well
With loving souls to place a martialist,[12]
He died in war, and must to martial fields,
Where wounded Hector lives in lasting pain,
And Achilles' Myrmidons [13] do scour the plain."
Then Minos, mildest censor [14] of the three, 50
Made this device to end the difference.
"Send him," quoth he, "to our infernal King,
To doom [15] him as best seems his majesty."
To this effect my passport straight was drawn.
In keeping on my way to Pluto's [16] court,
Through dreadful shades of ever-glooming night,
I saw more sights than thousand tongues can tell,
Or pens can write, or mortal hearts can think.
Three ways there were; that on the right-hand side
Was ready way unto the foresaid fields, 60
Where lovers live, and bloody martialists,
But either [17] sort contained within his bounds.
The left-hand path, declining fearfully,
Was ready downfall to the deepest hell,
Where bloody furies shakes [18] their whips of steel,
And poor Ixion [19] turns an endless wheel;
Where usurers are choked with melting gold,
And wantons are embraced with ugly snakes,
And murderers groan with never-killing wounds,
And perjured wights scalded in boiling lead, 70
And all foul sins with torments overwhelmed.
'Twixt these two ways, I trod the middle path,
Which brought me to the fair Elysian green,[20]
In midst whereof there stands a stately tower,
The walls of brass, the gates of adamant.[21]
Here finding Pluto with his Proserpine,
I showed my passport, humbled on my knee;
Whereat fair Proserpine began to smile,
And begged that only she might give my doom.
Pluto was pleased and sealed it with a kiss. 80
Forthwith, Revenge, she rounded [22] thee in th' ear,
And bade thee lead me through the gates of horn,[23]
Where dreams have passage in the silent night.
No sooner had she spoke but we were here,
I wot not how, in twinkling of an eye.
 Rev. Then know, Andrea, that thou art arrived
Where thou shalt see the author of thy death,
Don Balthazar the Prince of Portingale,
Deprived of life by Bel-imperia.
Here sit we down to see the mystery,[24] 90
And serve for Chorus in this tragedy.

[I.ii]

Enter Spanish KING, GENERAL, CASTILE,
 HIERONIMO.

 King. Now say, lord general, how fares our camp?
 Gen. All well, my sovereign liege, except some few
That are deceased by fortune of the war.
 King. But what portends thy cheerful countenance,
And posting to our presence thus in haste?
Speak, man, hath fortune given us victory?
 Gen. Victory, my liege, and that with little loss.
 King. Our Portingals will pay us tribute then?
 Gen. Tribute and wonted homage therewithal.
 King. Then blest be heaven, and guider of the
 heavens, 10
From whose fair influence such justice flows.
 *Cast. O multum dilecte Deo, tibi militat aether,
Et conjuratae curvato poplite gentes
Succumbunt; recti soror est victoria juris.*[1]
 King. Thanks to my loving brother of Castile.
But, general, unfold [2] in brief discourse
Your form of battle and your war's success,
That adding all the pleasure of thy news
Unto the height of former happiness,
With deeper wage [3] and greater dignity 20
We may reward thy blissful chivalry.[4]
 Gen. Where Spain and Portingale do jointly knit
Their frontiers, leaning on each other's bound,
There met our armies in their proud array,
Both furnished well, both full of hope and fear,
Both menacing alike with daring shows,
Both vaunting sundry colors of device,[5]
Both cheerly sounding trumpets, drums and fifes,
Both raising dreadful clamors to the sky,
That valleys, hills, and rivers made rebound, 30
And heaven itself was frighted with the sound.

 [9] *Minos, Aeacus, and Rhadamanth:* judges in the under-
world. [10] *gan:* began.
 [11] *graven . . . lottery:* slips on which Andrea's fate, now
fulfilled, is recorded.
 [12] *martialist:* warrior.
 [13] *Myrmidons:* Achilles' soldiers, who fought with him
against Hector and the Trojans.
 [14] *censor:* judge. [15] *doom:* judge, sentence.
 [16] *Pluto's:* Pluto is the Latin name for Hades, who with
his wife Persephone (Proserpine) rules the underworld.
 [17] *either:* each. [18] *shakes:* an Elizabethan plural form.
 [19] *Ixion:* In Greek mythology Ixion was punished for
attempting to seduce Hera (Juno). He had committed an
earlier crime like that of Cain by murdering a relative.
 [20] *Elysian green:* that part of the underworld reserved for
the blessed dead.
 [21] *adamant:* diamond. [22] *rounded:* whispered.
 [23] *gates of horn:* in the *Aeneid*, the gate of sleep from which
true dreams emerge (false dreams passing through the gate
of ivory).
 [24] *mystery:* events beyond human comprehension, or with
a secret meaning.
I.ii.
 [1] *L.:* O man much loved of God, the heavens fight for
you, and the conspiring peoples fall on bended knee; victory
is the sister of just right.
 [2] *unfold:* relate. [3] *wage:* reward.
 [4] *chivalry:* prowess in war.
 [5] *colors of device:* heraldic banners.

Our battles[6] both were pitched in squadron[7] form,
Each corner strongly fenced with wings of shot:[8]
But ere we joined and came to push of pike,[9]
I brought a squadron of our readiest shot
From out our rearward to begin the fight.
They brought another wing to encounter us.
Meanwhile our ordnance played on either side,
And captains strove to have their valors tried.
Don Pedro, their chief horsemen's colonel,[10] 40
Did with his cornet[11] bravely make attempt
To break the order of our battle ranks.
But Don Rogero, worthy man of war,
Marched forth against him with our musketeers,
And stopped the malice of his fell approach.
While they maintain hot skirmish to and fro,
Both battles join and fall to handy[12] blows,
Their violent shot resembling th' ocean's rage,
When, roaring loud and with a swelling tide,
It beats upon the rampiers[13] of huge rocks, 50
And gapes to swallow neighbor-bounding lands.
Now while Bellona[14] rageth here and there,
Thick storms of bullets rain like winter's hail,
And shivered lances dark the troubled air.
 Pede pes et cuspide cuspis,
Arma sonant armis, vir petiturque viro.[15]
On every side drop captains to the ground,
And soldiers, some ill-maimed, some slain outright.
Here falls a body scindered[16] from his head,
There legs and arms lie bleeding on the grass, 60
Mingled with weapons and unbowelled steeds,
That scattering overspread the purple plain.
In all this turmoil, three long hours and more,
The victory to neither part inclined,
Till Don Andrea, with his brave lanciers,[17]
In their main battle made so great a breach,
That, half dismayed, the multitude retired.
But Balthazar, the Portingales' young prince,
Brought rescue and encouraged them to stay.
Here-hence[18] the fight was eagerly renewed, 70
And in that conflict was Andrea slain,
Brave man at arms, but weak to Balthazar.
Yet while the prince, insulting[19] over him,
Breathed out proud vaunts, sounding to our reproach,
Friendship and hardy valor, joined in one,
Pricked[20] forth Horatio, our knight marshal's son,

To challenge forth that prince in single fight.
Not long between these twain the fight endured,
But straight the prince was beaten from his horse
And forced to yield him prisoner to his foe. 80
When he was taken, all the rest they fled,
And our carbines[21] pursued them to the death,
Till, Phoebus waning to the western deep,
Our trumpeters were charged to sound retreat.
 King. Thanks, good lord general, for these good
 news,
And for some argument[22] of more to come,
Take this and wear it for thy sovereign's sake.

 Give him his chain.

But tell me now, hast though confirmed a peace?
 Gen. No peace, my liege, but peace conditional,
That if with homage tribute be well paid, 90
The fury of your forces will be stayed;
And to this peace their viceroy hath subscribed,

 Give the KING *a paper.*

And made a solemn vow that during life
His tribute shall be truly paid to Spain.
 King. These words, these deeds, become thy person
 well.
But now, knight marshal, frolic[23] with thy King,
For 'tis thy son that wins this battle's prize.
 Hier. Long may he live to serve my sovereign liege,
And soon decay unless he serve my liege. 99

 A tucket[24] afar off.

 King. Nor thou nor he shall die without reward.
What means the warning of this trumpet's sound?
 Gen. This tells me that your grace's men of war,
Such as war's fortune hath reserved from death,
Come marching on towards your royal seat
To show themselves before your majesty,
For so I gave in charge[25] at my depart.
Whereby by demonstration shall appear
That all (except three hundred or few more)
Are safe returned and by their foes enriched.

 The Army enters, BALTHAZAR *between* LORENZO
 and HORATIO, *captive.*

 King. A gladsome sight, I long to see them here. 110

 They enter and pass by.

Was that the warlike Prince of Portingale,
That by our nephew was in triumph led?
 Gen. It was, my liege, the Prince of Portingale.
 King. But what was he that on the other side
Held him by th' arm as partner of the prize?
 Hier. That was my son, my gracious sovereign,
Of whom though from his tender infancy
My loving thoughts did never hope but well,
He never pleased his father's eyes till now,
Nor filled my heart with overcloying joys. 120
 King. Go let them march once more about these
 walls,
That staying them we may confer and talk
With our brave prisoner and his double guard.

 [6] *battles:* battalions. [7] *squadron:* square.
 [8] *shot:* troops with firearms.
 [9] *push of pike:* close fighting.
 [10] *colonel:* trisyllabic.
 [11] *cornet:* cavalry squad (from the banner carried at its
head); officer who carries the colors.
 [12] *handy:* hand-to-hand. [13] *rampiers:* ramparts.
 [14] *Bellona:* Roman war-goddess.
 [15] *L.:* Foot against foot and lance against lance, arms
clash on arms, and man is assailed by man.
 [16] *scindered:* sundered. [17] *lanciers:* lancers.
 [18] *Here-hence:* Because of this.
 [19] *insulting:* exulting scornfully.
 [20] *Pricked:* spurred.
 [21] *carbines:* i.e., troops equipped with carbines.
 [22] *argument:* token. [23] *frolic:* make merry.
 [24] *tucket:* flourish of trumpets.
 [25] *gave in charge:* ordered.

Hieronimo, it greatly pleaseth us,
That in our victory thou have a share,
By virtue of thy worthy son's exploit.

Enter [the Army] again.

Bring hither the young Prince of Portingale;
The rest march on, but ere they be dismissed,
We will bestow on every soldier
Two ducats, and on every leader ten, 130
That they may know our largess welcomes them.

Exeunt all [the Army] but BALTHAZAR,
LORENZO, HORATIO.

Welcome Don Balthazar, welcome nephew,
And thou, Horatio, thou art welcome too.
Young prince, although thy father's hard misdeeds,
In keeping back the tribute that he owes,
Deserve but evil measure at our hands,
Yet shalt thou know that Spain is honorable.
 Bal. The trespass that my father made in peace
Is now controlled[26] by fortune of the wars:
And cards once dealt, it boots not ask why so. 140
His men are slain, a weakening to his realm,
His colors seized, a blot unto his name,
His son distressed, a corsive[27] to his heart.
These punishments may clear his late offence.
 King. Ay, Balthazar, if he observe this truce
Our peace will grow the stronger for these wars.
Meanwhile live thou, though not in liberty,
Yet free from bearing any servile yoke,
For in our hearing thy deserts were great,
And in our sight thyself art gracious. 150
 Bal. And I shall study to deserve this grace.
 King. But tell me, for their holding makes me doubt,
To which of these twain art thou prisoner?
 Lor. To me, my liege.
 Hor. To me, my sovereign.
 Lor. This hand first took his courser by the reins.
 Hor. But first my lance did put him from his horse.
 Lor. I seized his weapon and enjoyed[28] it first.
 Hor. But first I forced him lay his weapons down.
 King. Let go his arm, upon our privilege.[29]

Let him go.

Say, worthy prince, to whether[30] didst thou yield?
 Bal. To him in courtesy, to this perforce. 161
He spake me fair, this other gave me strokes;
He promised life, this other threatened death;
He wan[31] my love, this other conquered me;
And truth to say I yield myself to both.
 Hier. But that I know your grace for just and wise,
And might seem partial in this difference,
Enforced by nature and by law of arms
My tongue should plead for young Horatio's right.
He hunted well that was[32] a lion's death, 170
Not he that in a garment wore his skin.
So hares may pull dead lions by the beard.
 King. Content thee, marshal, thou shalt have no
 wrong,
And for thy sake thy son shall want no right.
Will both abide the censure[33] of my doom?

 Lor. I crave no better than your grace awards.
 Hor. Nor I, although I sit beside[34] my right.
 King. Then by my judgment thus your strife shall
 end:
You both deserve and both shall have reward.
Nephew, thou took'st his weapon and his horse; 180
His weapons and his horse are thy reward.
Horatio, thou didst force him first to yield;
His ransom therefore is thy valor's fee.
Appoint the sum as you shall both agree.
But, nephew, thou shalt have the prince in guard,
For thine estate[35] best fitteth such a guest;
Horatio's house were small for all his train.
Yet in regard thy substance[36] passeth[37] his,
And that just guerdon[38] may befall desert,
To him we yield the armor of the prince. 190
How likes Don Balthazar of this device?
 Bal. Right well, my liege, if this proviso were,
That Don Horatio bear us company,
Whom I admire and love for chivalry.
 King. Horatio, leave him not that loves thee so.
Now let us hence to see our soldiers paid,
And feast our prisoner as our friendly guest.

Exeunt.

[I.iii]

Enter VICEROY, ALEXANDRO, VILLUPPO,
[Attendants].

 Vice. Is our ambassador dispatched for Spain?
 Alex. Two days, my liege, are passed since his depart.
 Vice. And tribute payment gone along with him?
 Alex. Ay, my good lord.
 Vice. Then rest we here awhile in our unrest,
And feed our sorrows with some inward sighs,
For deepest cares break never into tears.
But wherefore sit I in a regal throne?
This better fits a wretch's endless moan.

Falls to the ground.

Yet this is higher than my fortunes reach, 10
And therefore better than my state deserves.
Ay, ay, this earth, image of melancholy,
Seeks him whom fates adjudge to misery.
Here let me lie, now am I at the lowest.
 Qui jacet in terra non habet unde cadat.
In me consumpsit vires fortuna nocendo,
 Nil superest ut jam possit obesse magis.[1]
Yes, Fortune may have bereave me of my crown.

26 *controlled:* held in check.
27 *corsive:* corrosive, a caustic medicine.
28 *enjoyed:* had use of. 29 *privilege:* prerogative.
30 *whether:* which of the two. 31 *wan:* won.
32 *was:* i.e., was cause of. 33 *censure:* judgment.
34 *sit beside:* forgo. 35 *estate:* social position, means.
36 *substance:* wealth. 37 *passeth:* surpasses.
38 *guerdon:* reward.

I.iii.
1 *L.:* He who lies on the ground has nowhere to fall from.
In hurting me Fortune has used up her power; nothing
remains now that can hurt me more.

Here, take it now, let Fortune do her worst,
She will not rob me of this sable weed;[2] 20
Oh, no, she envies none but pleasant things.
Such is the folly of despiteful chance!
Fortune is blind and sees not my deserts,
So is she deaf and hears not my laments;
And could she hear, yet is she willful mad,
And therefore will not pity my distress.
Suppose that she could pity me, what then?
What help can be expected at her hands,
Whose foot is standing on a rolling stone
And mind more mutable than fickle winds? 30
Why wail I then, where's hope of no redress?
Oh, yes, complaining makes my grief seem less.
My late ambition hath distained[3] my faith,
My breach of faith occasioned bloody wars,
Those bloody wars have spent my treasure,[4]
And with my treasure my people's blood,
And with their blood, my joy and best beloved,
My best beloved, my sweet and only son.
Oh, wherefore went I not to war myself?
The cause was mine, I might have died for both. 40
My years were mellow, his but young and green,
My death were natural, but this was forced.
 Alex. No doubt, my liege, but still the prince survives.
 Vice. Survives! ay, where?
 Alex. In Spain, a prisoner by mischance of war.
 Vice. Then they have slain him for his father's fault.
 Alex. That were a breach to common law of arms.
 Vice. They reck no laws that meditate revenge.
 Alex. His ransom's worth will stay from foul revenge
 Vice. No, if he lived, the news would soon be here.
 Alex. Nay, evil news fly faster still[5] than good. 51
 Vice. Tell me no more of news, for he is dead.
 Vill. My sovereign, pardon the author of ill news,
And I'll bewray[6] the fortune of thy son.
 Vice. Speak on, I'll guerdon thee whate'er it be.
Mine ear is ready to receive ill news,
My heart grown hard 'gainst mischief's battery;
Stand up, I say, and tell thy tale at large.[7]
 Vill. Then hear that truth which these mine eyes
 have seen.
When both the armies were in battle joined. 60
Don Balthazar, amidst the thickest troops,
To win renown did wondrous feats of arms.
Amongst the rest I saw him hand to hand
In single fight with their lord-general;
Till Alexandro, that here counterfeits
Under the color of a duteous friend,
Discharged his pistol at the prince's back,

As though he would have slain their general.
But therewithal Don Balthazar fell down,
And when he fell, then we began to fly; 70
But had he lived, the day had sure been ours.
 Alex. Oh, wicked forgery![8] Oh, traitorous miscreant!
 Vice. Hold thou thy peace! But now, Villuppo, say,
Where then became[9] the carcass of my son?
 Vill. I saw them drag it to the Spanish tents.
 Vice. Ay, ay, my nightly dreams have told me this.
Thou false, unkind, unthankful, traitorous beast,
Wherein had Balthazar offended thee,
That thou shouldst thus betray him to our foes?
Was't Spanish gold that bleared so thine eyes 80
That thou couldst see no part of our deserts?[10]
Perchance because thou art Terceira's[11] lord
Thou hadst some hope to wear this diadem,
If first my son and then myself were slain;
But thy ambitious thought shall break thy neck.
Ay, this was it that made thee spill his blood,

 Take the crown and put it on again.

But I'll now wear it till thy blood be spilt.
 Alex. Vouchsafe, dread sovereign, to hear me speak.
 Vice. Away with him, his sight is second hell,
Keep him till we determine of his death. 90
 [*Exeunt* Attendants *with* ALEXANDRO.]
If Balthazar be dead, he shall not live.
Villuppo, follow us for thy reward.
 Exit VICEROY.
 Vill. Thus have I with an envious,[12] forgèd tale
Deceived the King, betrayed mine enemy,
And hope for guerdon of my villainy.
 Exit.

[I.iv]

 Enter HORATIO *and* BEL-IMPERIA.

 Bel. Signior Horatio, this is the place and hour
Wherein I must entreat thee to relate
The circumstance of Don Andrea's death,
Who, living, was my garland's sweetest flower,
And in his death hath buried my delights.
 Hor. For love of him and service to yourself,
I nill[1] refuse this heavy doleful charge;
Yet tears and sighs, I fear, will hinder me.
When both our armies were enjoined in fight,
Your worthy chevalier amidst the thickest, 10
For glorious cause still aiming at the fairest,
Was at the last by young Don Balthazar
Encountered hand to hand; their fight was long,
Their hearts were great, their clamors menacing,
Their strength alike, their strokes both dangerous.
But wrathful Nemesis, that wicked power,
Envying at Andrea's praise and worth,
Cut short his life to end his praise and worth.
She, she herself, disguised in armor's mask
(As Pallas was before proud Pergamus),[2] 20
Brought in a fresh supply of halberdiers,
Which paunched[3] his horse and dinged[4] him to the
 ground.

 [2] *weed:* garment. [3] *distained:* stained.
 [4] *treasure:* here and in the next line trisyllabic—"treas-u-er." [5] *still:* always. [6] *bewray:* reveal.
 [7] *at large:* in full. [8] *forgery:* deception.
 [9] *Where . . . became:* What became of.
 [10] *deserts:* what we have deserved of you.
 [11] *Terceira's:* an island in the Azores, belonging to Portugal. [12] *envious:* spiteful.
I.iv.
 [1] *nill:* will not.
 [2] *Pallas . . . Pergamus:* cf. Virgil, *Aeneid,* II, 615–616.
 [3] *paunched:* stabbed in the belly. [4] *dinged:* knocked.

Then young Don Balthazar with ruthless rage,
Taking advantage of his foe's distress,
Did finish what his halberdiers begun,
And left not till Andrea's life was done.
Then, though too late, incensed with just remorse,[5]
I with my band set forth against the prince,
And brought him prisoner from his halberdiers.

Bel. Would thou hadst slain him that so slew my
 love. 30
But then was Don Andrea's carcass lost?

Hor. No, that was it for which I chiefly strove,
Nor stepped I back till I recovered him.
I took him up and wound him in mine arms,
And, welding[6] him unto my private tent,
There laid him down and dewed him with my tears,
And sighed and sorrowed as became a friend.
But neither friendly sorrow, sighs nor tears,
Could win pale death from his usurpèd right.
Yet this I did, and less I could not do, 40
I saw him honored with due funeral;
This scarf I plucked from off his liveless arm,
And wear it in remembrance of my friend.

Bel. I know the scarf; would he had kept it still,
For had he lived he would have kept it still,
And worn it for his Bel-imperia's sake;
For 'twas my favor at his last depart.
But now wear thou it both for him and me,
For after him thou hast deserved it best.
But for thy kindness in his life and death, 50
Be sure while Bel-imperia's life endures,
She will be Don Horatio's thankful friend.

Hor. And, madam, Don Horatio will not slack
Humbly to serve fair Bel-imperia.
But now if your good liking stand thereto,
I'll crave your pardon to go seek the prince,
For so the duke your father gave me charge.

 Exit.

Bel. Ay, go, Horatio, leave me here alone,
For solitude best fits my cheerless mood.
Yet what avails to wail Andrea's death, 60
From whence Horatio proves my second love?
Had he not loved Andrea as he did,
He could not sit in Bel-imperia's thoughts.
But how can love find harbor in my breast,
Till I revenge the death of my belovèd?
Yes, second love shall further my revenge.
I'll love Horatio, my Andrea's friend,
The more to spite the prince that wrought his end.
And where Don Balthazar, that slew my love,
Himself now pleads for favor at my hands, 70
He shall, in rigor of my just disdain,
Reap long repentance for his murd'rous deed.
For what was 't else but murd'rous cowardice,
So many to oppress one valiant knight,
Without respect of honor in the fight?
And here he comes that murdered my delight.

 Enter LORENZO *and* BALTHAZAR.

Lor. Sister, what means this melancholy walk?
Bel. That for a while I wish no company.
Lor. But here the prince is come to visit you.

Bel. That argues that he lives in liberty. 80
Balth. No, madam, but in pleasing servitude.
Bel. Your prison then belike is your conceit.[7]
Balth. Ay, by conceit my freedom is enthralled.
Bel. Then with conceit enlarge[8] yourself again.
Balth. What if conceit have laid my heart to gage?[9]
Bel. Pay that you borrowed and recover it.
Balth. I die if it return from whence it lies.
Bel. A heartless man and live? A miracle!
Balth. Ay, lady, love can work such miracles. 89
Lor. Tush, tush, my lord, let go these ambages.[10]
And in plain terms acquaint her with your love.
Bel. What boots[11] complaint, when there's no
 remedy?
Balth. Yes, to you gracious self must I complain,
In whose fair answer lies my remedy,
On whose perfection all my thought attend,
On whose aspect mine eyes find beauty's bower,
In whose translucent breast my heart is lodged.
Bel. Alas, my lord, these are but words of course,[12]
And but device[13] to drive me from this place.

 She, in going in, lets fall her glove, which HORATIO,
 coming out, takes up.

Hor. Madam, your glove. 100
Bel. Thanks, good Horatio, take it for thy pains.
Balth. Signior Horatio stooped in happy time.
Hor. I reaped more grace than I deserved or hoped.
Lor. My lord, be not dismayed for what is past;
You know that women oft are humorous.[14]
These clouds will overblow with little wind;
Let me alone, I'll scatter them myself.
Meanwhile let us devise to spend the time
In some delightful sports and reveling.
Hor. The King, my lords, is coming hither straight,
To feast the Portingal ambassador; 111
Things were in readiness before I came.
Balth. Then here it fits us to attend the King,
To welcome hither our ambassador
And learn my father and my country's health.

 Enter the Banquet, Trumpets, the KING *and*
 AMBASSADOR.

King. See, lord ambassador, how Spain entreats[15]
Their prisoner Balthazar, thy viceroy's son:
We pleasure more in kindness than in wars.
Amb. Sad is our King, and Portingale laments,
Supposing that Don Balthazar is slain. 120
Balth. So am I slain, by beauty's tyranny.
You see, my lord, how Balthazar is slain:
I frolic with the Duke of Castile's son,
Wrapped every hour in pleasures of the court,
And graced with favors of his majesty.

[5] *remorse:* pity, regret.
[6] *welding:* carrying ("wielding").
[7] *conceit:* imagination. [8] *enlarge:* set free.
[9] *to gage:* as a pledge.
[10] *ambages:* circumlocutions, indirect modes of speech.
[11] *boots:* good is. [12] *words of course:* stock phrases.
[13] *but device:* just a trick. [14] *humorous:* temperamental.
[15] *entreats:* treats.

King. Put off your greetings till our feast be done;
Now come and sit with us and taste our cheer.

Sit to the banquet.

Sit down, young prince, you are our second guest;
Brother, sit down, and, nephew, take your place.
Signior Horatio, wait thou upon our cup,[16] 130
For well thou hast deservèd to be honored.
Now, lordings, fall to; Spain is Portugal,
And Portugal is Spain; we both are friends;
Tribute is paid, and we enjoy our right.
But where is old Hieronimo, our marshal?
He promised us, in honor of our guest,
To grace our banquet with some pompous jest.[17]

Enter HIERONIMO *with a* Drum,[18] *three* Knights, *each
his scutcheon:*[19] *then he fetches three* Kings, *they
take their crowns and them captive.*

Hieronimo, this masque contents mine eye,
Although I sound not well the mystery.[20]
 Hier. The first armed knight that hung his scutcheon
up, 140

He takes the scutcheon and gives it to the KING.

Was English Robert, Earl of Gloucester,
Who, when King Stephen bore sway in Albion,
Arrived with five and twenty thousand men
In Portingale, and by success of war
Enforced the King, then but a Saracen,
To bear the yoke of the English monarchy.
 King. My Lord of Portingale, by this you see
That which may comfort both your King and you,
And make your late discomfort seem the less.
But say Hieronimo, what was the next? 150
 Hier. The second knight that hung his scutcheon up,

He doth as he did before.

Was Edmund, Earl of Kent in Albion,
When English Richard wore the diadem.
He came likewise and razèd Lisbon walls,
And took the King of Portingale in fight;
For which, and other suchlike service done,
He after was created Duke of York.[21]

[16] *wait . . . cup:* serve our wine.
[17] *pompous jest:* stately entertainment.
[18] *Drum:* Drummer.
[19] *scutcheon:* shield with coat of arms.
[20] *sound . . . mystery:* understand the hidden meaning.
[21] Hieronimo has presented a rather unhistorical narrative.
[22] *sit . . . delicate:* we sit at table longer than the quality of the food warrants.
[23] *be dispatched:* conclude your business.

I.v.
[1] *league:* alliance. [2] *despite:* outrage, indignation.

II.i.
[1] *coy:* unresponsive. [2] *sustains:* endures.
[3] *haggard:* untamed.
[4] *stoop to lure:* come down to food (during training).
[5] *sufferance:* patient endurance.
[6] *blot:* dishonor. [7] *fault:* imperfection.
[8] *feature:* form.

King. This is another special argument,
That Portingale may deign to bear our yoke
When it by little England hath been yoked. 160
But now, Hieronimo, what were the last?
 Hier. The third and last, not least in our account,

Doing as before.

Was as the rest a valiant Englishman,
Brave John of Gaunt, the Duke of Lancaster,
As by his scutcheon plainly may appear.
He with a puissant army came to Spain,
And took our King of Castile prisoner.
 Amb. This is an argument for our viceroy,
That Spain may not insult for her success,
Since English warriors likewise conquered Spain, 170
And made them bow their knees to Albion.
 King. Hieronimo, I drink to thee for this device,
Which hath pleased both the ambassador and me.
Pledge me, Hieronimo, if thou love the King.

Takes the cup of HORATIO.

My lord, I fear we sit but over-long,
Unless our dainties were more delicate;[22]
But welcome are you to the best we have.
Now let us in, that you may be dispatched,[23]
I think our council is already set.

Exeunt omnes.

[I.v]

 Andr. Come we for this from depth of underground,
To see him feast that gave me my death's wound?
These pleasant sights are sorrow to my soul,
Nothing but league,[1] and love, and banqueting!
 Rev. Be still, Andrea; ere we go from hence,
I'll turn their friendship into fell despite,[2]
Their love to mortal hate, their day to night,
Their hope into despair, their peace to war,
Their joys to pain, their bliss to misery.

ACT TWO

SCENE ONE

Enter LORENZO *and* BALTHAZAR.

 Lor. My lord, though Bel-imperia seem thus coy,[1]
Let reason hold you in your wonted joy.
In time the savage bull sustains[2] the yoke;
In time all haggard[3] hawks will stoop to lure;[4]
In time small wedges cleave the hardest oak,
In time the flint is pierced with softest shower,
And she in time will fall from her disdain,
And rue the sufferance[5] of your friendly pain.
 Balth. No, she is wilder, and more hard withal,
Than beast, or bird, or tree, or stony wall. 10
But wherefore blot[6] I Bel-imperia's name?
It is my fault,[7] not she, that merits blame.
My feature[8] is not to content her sight,
My words are rude and work her no delight.
The lines I send her are but harsh and ill,

Such as do drop from Pan and Marsyas' [9] quill. [10]
My presents are not of sufficient cost,
And being worthless all my labor's lost.
Yet might she love me for my valiancy,
Ay, but that is slandered [11] by captivity. 20
Yet might she love me to content her sire,
Ay, but her reason masters his desire.
Yet might she love me as her brother's friend,
Ay, but her hopes aim at some other end.
Yet might she love me to uprear her state,
Ay, but perhaps she hopes some nobler mate.
Yet might she love me as her beauty's thrall,
Ay, but I fear she cannot love at all.
 Lor. My lord, for my sake leave these ecstasies, [12]
And doubt not but we'll find some remedy. 30
Some cause there is that lets you not be loved;
First that must needs be known and then removed.
What if my sister love some other knight?
 Balth. My summer's day will turn to winter's night.
 Lor. I have already found a stratagem
To sound the bottom of this doubtful theme.
My lord, for once you shall be ruled by me.
Hinder me not, whate'er you hear or see.
By force or fair means will I cast about
To find the truth of all this question out. 40
Ho, Pedringano!
 Ped. Signior!
 Lor. *Vien qui presto.* [13]

 Enter PEDRINGANO.

 Ped. Hath your lordship any service to command
me?
 Lor. Ay, Pedringano, service of import;
And, not to spend the time in trifling words,
Thus stands the case: It is not long, thou know'st,
Since I did shield thee from my father's wrath
For thy conveyance [14] in Andrea's love,
For which thou wert adjudged [15] to punishment.
I stood betwixt thee and thy punishment;
And since, thou know'st how I have favored thee. 50
Now to these favors will I add reward,
Not with fair words, but store of golden coin,
And lands and living joined with dignities,
If thou but satisfy my just demand.
Tell truth, and have me for thy lasting friend.
 Ped. Whate'er it be your lordship shall demand,
My bounden duty bids me tell the truth,
If case [16] it lie in me to tell the truth.
 Lor. Then, Pedringano, this is my demand:
Whom loves my sister Bel-imperia? 60
For she reposeth all her trust in thee.
Speak, man, and gain both friendship and reward.
I mean, whom loves she in Andrea's place?
 Ped. Alas, my lord, since Don Andrea's death,
I have no credit with her as before,
And therefore know not if she love or no.
 Lor. Nay, if thou dally then I am thy foe,

 [*Draws his sword.*]

And fear shall force what friendship cannot win.
Thy death shall bury what thy life conceals,

Thou diest for more esteeming her than me. 70
 Ped. Oh, stay, my lord!
 Lor. Yet speak the truth and I will guerdon thee,
And shield thee from whatever can ensue,
And will conceal whate'er proceeds from thee,
But if thou dally once again, thou diest.
 Ped. If Madam Bel-imperia be in love—
 Lor. What, villain, ifs and ands?

 [*Offers to kill him.*]

 Ped. Oh, stay, my lord, she loves Horatio.

 BALTHAZAR *starts back.*

 Lor. What, Don Horatio, our knight marshal's son?
 Ped. Even him, my lord. 80
 Lor. Now say but how know'st thou he is her love,
And thou shalt find me kind and liberal.
Stand up, I say, and fearless tell the truth.
 Ped. She sent him letters which myself perused,
Full fraught with lines and arguments of love,
Preferring him before Prince Balthazar.
 Lor. Swear on this cross [17] that what thou say'st is
 true,
And that thou wilt conceal what thou hast told.
 Ped. I swear to both by Him that made us all.
 Lor. In hope thine oath is true, here's thy reward;
But if I prove thee perjured and unjust, 91
This very sword whereon thou took'st thine oath
Shall be the worker of thy tragedy.
 Ped. What I have said is true, and shall for me
Be still concealed from Bel-imperia.
Besides, your honor's liberality
Deserves my duteous service, even till death.
 Lor. Let this be all that thou shalt do for me:
Be watchful when, and where, these lovers meet,
And give me notice in some secret sort. [18] 100
 Ped. I will, my lord.
 Lor. Then shalt thou find that I am liberal.
Thou know'st that I can more advance thy state
Than she; be therefore wise and fail me not.
Go and attend her as thy custom is,
Lest absence make her think thou dost amiss.

 Exit PEDRINGANO.

Why so: *tam armis quam ingenio;* [19]
Where words prevail not, violence prevails;
But gold doth more than either of them both.
How likes Prince Balthazar this stratagem? 110
 Balth. Both well, and ill; it makes me glad and sad;
Glad, that I know the hinderer of my love,
Sad, that I fear she hates me whom I love.
Glad, that I know on whom to be revenged,

 [9] *Pan and Marsyas:* musical divinities who made the
mistake of challenging Apollo to compete at flute-playing.
 [10] *quill:* reed. [11] *slandered:* brought into disrepute.
 [12] *ecstasies:* frenzies, loss of self-control.
 [13] *It.:* Come here quickly.
 [14] *conveyance:* going between as secret agent.
 [15] *adjudged:* sentenced.
 [16] *If case:* If it should prove that.
 [17] *cross:* his sword-hilt. [18] *sort:* manner.
 [19] *L.:* as much by force as by cunning.

Sad, that she'll fly me if I take revenge.
Yet must I take revenge or die myself,
For love resisted grows impatient.
I think Horatio be my destined plague.
First in his hand he brandishèd a sword,
And with that sword he fiercely wagèd war, 120
And in that war he gave me dangerous wounds,
And by those wounds he forcèd me to yield,
And by my yielding I became his slave.
Now in his mouth he carries pleasing words,
Which pleasing words do harbor sweet conceits,[20]
Which sweet conceits are limed[21] with sly deceits,
Which sly deceits smooth[22] Bel-imperia's ears,
And through her ears dive down into her heart,
And in her heart set him where I should stand.
Thus hath he ta'en my body by his force, 130
And now by sleight would captivate my soul;
But in his fall I'll tempt the destinies,
And either lose my life, or win my love.

 Lor. Let's go, my lord, your staying stays revenge.
Do you but follow me and gain your love;
Her favor must be won by his remove.

 Exeunt.

[II.ii]

 Enter HORATIO *and* BEL-IMPERIA.

 Hor. Now, madam, since by favor of your love
Our hidden smoke is turned to open flame,
And that with looks and words we feed our thoughts
(Two chief contents, where more cannot be had),
Thus, in the midst of love's fair blandishments,
Why show you sign of inward languishments?

 PEDRINGANO *showeth all to the* PRINCE *and*
 LORENZO, *placing them in secret [above].*

 Bel. My heart, sweet friend, is like a ship at sea:
She wisheth port, where, riding all at ease,
She may repair what stormy times have worn,
And leaning on[1] the shore, may sing with joy 10
That pleasure follows pain, and bliss annoy.
Possession of thy love is th' only port
Wherein my heart, with fears and hopes long tossed,
Each hour doth wish and long to make resort,
There to repair the joys that it hath lost,

And sitting safe, to sing in Cupid's choir
That sweetest bliss is crown of love's desire.

 Balth. Oh, sleep, mine eyes, see not my love
 profaned;
Be deaf, my ears, hear not my discontent;
Die, heart, another joys[2] what thou deserv'st. 20

 Lor. Watch still, mine eyes, to see this love disjoined,
Hear still mine ears, to hear them both lament,
Live heart, to joy at fond[3] Horatio's fall.

 Bel. Why stands Horatio speechless all this while?

 Hor. The less I speak, the more I meditate.

 Bel. But whereon dost thou chiefly meditate?

 Hor. On dangers past, and pleasures to ensue.

 Balth. On pleasures past, and dangers to ensue.

 Bel. What dangers and what pleasures dost thou
 mean?

 Hor. Dangers of war, and pleasures of our love. 30

 Lor. Dangers of death, but pleasures none at all.

 Bel. Let dangers go; thy war shall be with me,
But such a war, as breaks no bond of peace.
Speak thou fair words, I'll cross them with fair words;
Send thou sweet looks, I'll meet them with sweet looks;
Write loving lines, I'll answer loving lines;
Give me a kiss, I'll countercheck[4] thy kiss.
Be this our warring peace, or peaceful war.

 Hor. But, gracious madam, then appoint the field
Where trial of this war shall first be made. 40

 Balth. Ambitious villain, how his boldness grows!

 Bel. Then by thy father's pleasant bower the field,
Where first we vowed a mutual amity.
The court were dangerous; that place is safe.
Our hour shall be when Vesper[5] gins to rise,
That summons home distressful travelers.[6]
There none shall hear us but the harmless birds.
Happily[7] the gentle nightingale
Shall carol us asleep ere we be ware,
And singing with the prickle at her breast,[8] 50
Tell[9] our delight and mirthfull dalliance.
Till then each hour will seem a year and more.

 Hor. But, honey sweet, and honorable love,
Return we now into your father's sight;
Dangerous suspicion waits on our delight.

 Lor. Ay, danger mixed with jealious[10] despite
Shall send thy soul into eternal night.

 Exeunt.

[20] *conceits:* thoughts.
[21] *limed:* made to snare, as birds with lime.
[22] *smooth:* flatter.

II.ii.
[1] *leaning on:* lying by. [2] *joys:* enjoys.
[3] *fond:* foolish. [4] *countercheck:* rebuff by returning it.
[5] *Vesper:* the evening star.
[6] *travelers:* both wanderers and laborers ("travailers").
[7] *Happily:* Haply, perhaps.
[8] *prickle . . . breast:* the legendary thorn that keeps her
awake and lamenting. [9] *tell:* relate.
[10] *jealious:* trisyllabic form of "jealous."

II.iii.
[1] *coy it:* affect reserve.
[2] *as . . . kind:* as is natural to a woman.
[3] *dissemble:* hide. [4] *stoop:* submit.
[5] *froward:* perverse, refractory.

[II.iii]

 Enter KING *of Spain, Portingale* AMBASSADOR,
 DON CYPRIAN, *etc.*

 King. Brother of Castile, to the prince's love
What says your daughter Bel-imperia?

 Cast. Although she coy it[1] as becomes her kind,[2]
And yet dissemble[3] that she loves the prince,
I doubt not, I, but she will stoop[4] in time.
And were she froward,[5] which she will not be,
Yet herein shall she follow my advice,
Which is to love him or forgo my love.

 King. Then, Lord Ambassador of Portingale,
Advise thy King to make this marriage up, 10

For strengthening of our late-confirmèd league.
I know no better means to make us friends.
Her dowry shall be large and liberal;
Besides that she is daughter and half-heir
Unto our brother here, Don Cyprian,
And shall enjoy the moiety[6] of his land,
I'll grace her marriage with an uncle's gift,
And this it is: in case the match go forward,
The tribute which you pay shall be released,
And if by Balthazar she have a son, 20
He shall enjoy the kingdom after us.
 Amb. I'll make the motion to my sovereign liege,
And work it if my counsel may prevail.
 King. Do so, my lord, and if he give consent,
I hope his presence here will honor us
In celebration of the nuptial day;
And let himself determine of the time.
 Amb. Will't please your grace command me aught
 beside?
 King. Commend me to the King, and so farewell.
But where's Prince Balthazar to take his leave? 30
 Amb. That is performed already, my good lord.
 King. Amongst the rest of what you have in charge,
The prince's ransom must not be forgot.
That's none of mine, but his that took him prisoner,
And well his forwardness[7] deserves reward:
It was Horatio, our knight marshal's son.
 Amb. Between us there's a price already pitched,[8]
And shall be sent with all convenient speed.
 King. Then once again, farewell, my lord. 39
 Amb. Farewell, my Lord of Castile, and the rest.
 Exit.

 King. Now, brother, you must take some little
 pains
To win fair Bel-imperia from her will.
Young virgins must be rulèd by their friends.
The prince is amiable and loves her well;
If she neglect him and forgo his love,
She both will wrong her own estate[9] and ours.
Therefore, whiles I do entertain the prince
With greatest pleasure that our court affords,
Endeavor you to win your daughter's thought;
If she give back,[10] all this will come to naught. 50
 Exeunt.

[II.iv]

Enter HORATIO, BEL-IMPERIA, *and*
PEDRINGANO.

 Hor. Now that the night begins with sable wings
To overcloud the brightness of the sun,
And that in darkness pleasures may be done,
Come, Bel-imperia, let us to the bower,
And there in safety pass a pleasant hour.
 Bel. I follow thee, my love, and will not back,
Although my fainting heart controls[1] my soul.
 Hor. Why, make you doubt of Pedringano's faith?
 Bel. No, he is as trusty as my second self.
Go, Pedringano, watch without[2] the gate,
And let us know if any make approach. 10

 Ped. [*Aside*] Instead of watching, I'll deserve more
 gold
By fetching Don Lorenzo to this match.
 Exit PEDRINGANO.
 Hor. What means my love?
 Bel. I know not what myself;
And yet my heart foretells me some mischance.
 Hor. Sweet, say not so; fair fortune is our friend,
And heavens have shut up day to pleasure us.
The stars, thou seest, hold back their twinkling shine,
And Luna hides herself to pleasure us. 19
 Bel. Thou hast prevailed; I'll conquer my misdoubt,
And in thy love and counsel drown my fear.
I fear no more; love now is all my thoughts.
Why sit we not? For pleasure asketh ease.
 Hor. The more thou sit'st within these leavy bowers,
The more will Flora deck it with her flowers.
 Bel. Ay, but if Flora spy Horatio here,
Her jealous eye will think I sit too near.
 Hor. Hark, madam, how the birds record[3] by night,
For joy that Bel-imperia sits in sight.
 Bel. No, Cupid counterfeits the nightingale, 30
To frame sweet music to Horatio's tale.
 Hor. If Cupid sing, then Venus is not far;
Ay, thou art Venus or some fairer star.
 Bel. If I be Venus, thou must needs be Mars;
And where Mars reigneth, there must needs be wars.
 Hor. Then thus begin our wars: put forth thy hand,
That it may combat with my ruder hand.
 Bel. Set forth thy foot to try the push of mine.
 Hor. But first my looks shall combat against thine.
 Bel. Then ward thyself, I dart this kiss at thee. 40
 Hor. Thus I retort[4] the dart thou threw'st at me.
 Bel. Nay then, to gain the glory of the field,
My twining arms shall yoke and make thee yield.
 Hor. Nay then, my arms are large and strong withal;
Thus elms by vines are compassed till they fall.
 Bel. Oh, let me go, for in my troubled eyes
Now may'st thou read that life in passion dies.
 Hor. Oh, stay awhile and I will die[5] with thee;
So shalt thou yield and yet have conquered me. 49
 Bel. Who's there? Pedringano! We are betrayed!

Enter LORENZO, BALTHAZAR, SERBERINE,
PEDRINGANO, *disguised.*

 Lor. My lord, away with her; take her aside.
O sir, forbear, your valor is already tried.
Quickly dispatch, my masters.

 They hang him in the arbor.

 Hor. What, will you murder me?
 Lor. Ay, thus, and thus, these are the fruits of love.

 They stab him.

[6] *moiety:* half. [7] *forwardness:* zeal.
[8] *pitched:* settled. [9] *estate:* lineage.
[10] *give back:* turn her back on us.

II.iv.
[1] *controls:* overpowers. [2] *without:* outside.
[3] *record:* sing. [4] *retort:* hurl back.
[5] *die:* The customary sexual meaning is clear here.

Bel. Oh, save his life, and let me die for him!
Oh, save him, brother, save him, Balthazar.
I loved Horatio but he loved not me.
 Balth. But Balthazar loves Bel-imperia.
 Lor. Although his life were still ambitious proud, 60
Yet is he the highest now he is dead.
 Bel. Murder! murder! Help, Hieronimo, help!
 Lor. Come stop her mouth, away with her.
 Exeunt[, *leaving* HORATIO's *body*].

II.v]

Enter HIERONIMO *in his shirt, etc.*

Hier. What outcries pluck me from my naked[1] bed,
And chill my throbbing heart with trembling fear,
Which never danger yet could daunt before?
Who calls Hieronimo? Speak, here I am.
I did not slumber; therefore 'twas no dream.
No, no, it was some woman cried for help,
And here within this garden did she cry,
And in this garden must I rescue her.
But stay, what murd'rous spectacle is this?
A man hanged up and all the murderers gone! 10
And in my bower, to lay the guilt on me!
This place was made for pleasure, not for death.

 He cuts him down.

Those garments that he wears I oft have seen—
Alas, it is Horatio, my sweet son!
Oh, no, but he that whilom[2] was my son.
Oh, was it thou that calledst me from my bed?
Oh, speak, if any spark of life remain.
I am thy father. Who hath slain my son?
What savage monster, not of human kind,
Hath here been glutted with thy harmless blood, 20
And left thy bloody corpse dishonored here,
For me, amidst this[3] dark and deathful shades,
To drown thee with an ocean of my tears?
O heavens, why made you night to cover sin?
By day this deed of darkness had not been.
O earth, why didst thou not in time devour
The vile profaner of this sacred bower?
O poor Horatio, what hadst thou misdone,
To leese[4] thy life ere life was new begun?
O wicked butcher, whatsoe'er thou wert, 30
How could thou strangle virtue and desert?
Ay, me most wretched, that have lost my joy,
In leesing my Horatio, my sweet boy!

 Enter ISABELLA.

Isab. My husband's absence makes my heart to
throb—Hieronimo!

Hier. Here, Isabella, help me to lament,
For signs are stopped, and all my tears are spent.
 Isab. What world of grief—My son Horatio!
Oh, where's the author of this endless woe?
 Hier. To know the author were some ease of grief,
For in revenge my heart would find relief. 41
 Isab. Then is he gone? And is my son gone too?
Oh, gush out, tears, fountains and floods of tears,
Blow, sighs, and raise an everlasting storm;
For outrage[5] fits our cursèd wretchedness.

[FIRST ADDITION][6]

[Ay me, Hieronimo, sweet husband, speak.
 Hier. He supped with us tonight, frolic and merry,
And said he would go visit Balthazar
At the duke's palace; there the prince doth lodge.
He had no custom to stay out so late; 50
He may be in his chamber, some go see.
Roderigo, ho!

 Enter PEDRO *and* JAQUES.

 Isab. Ay me, he raves!—sweet Hieronimo!
 Hier. True, all Spain takes note of it.
Besides, he is so generally beloved.
His majesty the other day did grace him
With waiting on his cup; these be favors
Which do assure[7] he cannot be short-lived.
 Isab. Sweet Hieronimo! 59
 Hier. I wonder how this fellow got his clothes!—
Sirrah, sirrah, I'll know the truth of all.
Jaques, run to the Duke of Castile's presently,
And bid my son Horatio to come home.
I and his mother have had strange dreams tonight.
Do ye hear me, sir?
 Jaq. Ay, sir.
 Hier. Well sir, begone.
Pedro, come hither. Knowest thou who this is?
 Pedro. Too well, sir.
 Hier. Too well, who? Who is it?—Peace, Isabella!—
Nay, blush not, man.
 Pedro. It is my Lord Horatio.
 Hier. Ha, Ha! Saint James, but this doth make me
 laugh, 70
That there are more deluded than myself.
 Pedro. Deluded?
 Hier. Ay, I would have sworn myself within this hour
That this had been my son Horatio,
His garments are so like. Ha!
Are they not great persuasions?[8]
 Isab. Oh, would to God it were not so!
 Hier. Were not, Isabella? Dost thou dream it is?
Can thy soft bosom entertain a thought
That such a black deed of mischief should be done 80
On one so pure and spotless as our son?
Away, I am ashamed.
 Isab. Dear Hieronimo,
Cast a more serious eye upon thy grief;
Weak apprehension gives but weak belief.
 Hier. It was a man, sure, that was hanged up here,
A youth, as I remember; I cut him down.

II.v.
 [1] *naked*: i.e., wearing only nightclothes.
 [2] *whilom*: formerly.
 [3] *this*: an acceptable Elizabethan plural form.
 [4] *leese*: lose.
 [5] *outrage*: violent outcry.
 [6] *First Addition*: See headnote, p. 167.
 [7] *assure*: give assurance. [8] *persuasions*: evidence.

If it should prove my son now after all—
Say you? Say you? Light! lend me a taper,
Let me look again—O God!
Confusion, mischief, torment, death and hell, 90
Drop all your stings at once in my cold bosom,
That now is stiff with horror; kill me quickly.
Be gracious to me, thou infective[9] night,
And drop this deed of murder down on me;
Gird in my waste of grief with thy large darkness,
And let me not survive to see the light
May put me in the mind I had a son.
 Isab. O sweet Horatio, O my dearest son!
 Hier. How strangely had I lost my way to grief.]

[END OF FIRST ADDITION]

 Hier. Sweet lovely rose, ill-plucked before thy
 time; 100
Fair worthy son, not conquered but betrayed;
I'll kiss thee now, for words with tears are stayed.
 Isab. And I'll close up the glasses of his sight,
For once these eyes were only my[10] delight.
 Hier. Seest thou this handkercher besmeared with
 blood?
It shall not from me till I take revenge.
Seest thou those wounds that yet are bleeding fresh?
I'll not entomb them till I have revenge.
Then will I joy amidst my discontent;
Till then my sorrow never shall be spent. 110
 Isab. The heavens are just; murder cannot be hid;
Time is the author both of truth and right,
And time will bring this treachery to light.
 Hier. Meanwhile, good Isabella, cease thy plaints,
Or at the least dissemble them awhile;
So shall we sooner find the practice[11] out,
And learn by whom all this was brought about.
Come, Isabel, now let us take him up,

 They take him up.

And bear him in from out this cursèd place.
I'll say his dirge, singing fits not this case. 120
O aliquis mihi quas pulchrum ver educat herbas

 HIERONIMO *sets his breast unto his sword.*

Misceat, et nostor detur medicina dolori;
Aut, si qui faciunt animis oblivia, succos
Praebeat; ipse metam magnum quaecunque per orbem
Gramina Sol pulchras effert in luminis oras;
Ipse bibam quicquid meditatur saga veneni,
Quicquid et herbarum vi caeca nenia nectit.
Omnia perpetiar, lethum quoque, dum semel omnis
Noster in extincto moriatur pectore sensus.
Ergo tuos oculos nunquam, mea vita, videbo, 130
Et tua perpetuus sepelivit lumina somnus?
Emoriar tecum—sic, sic juvat ire sub umbras.
At tamen absistam properato cedere letho,
Ne mortem vindicta tuam tum nulla sequatur.[12]

 Here he throws it from him and bears the body away.

[II.vi]

 Andr. Brought'st thou me hither to increase my
 pain?
I looked that Balthazar should have been slain;
But 'tis my friend Horatio that is slain,
And they abuse fair Bel-imperia,
On whom I doted more than all the world,
Because she loved me more than all the world.
 Rev. Thou talk'st of harvest when the corn is green.
The end is crown of every work[1] well done;
The sickle comes not till the corn be ripe.
Be still, and ere I lead thee from this place, 10
I'll show thee Balthazar in heavy case.

ACT THREE

SCENE ONE

Enter VICEROY of Portingale, Nobles, VILLUPPO.

 Vice. Infortunate condition of kings,
Seated amidst so many helpless doubts!
First we are placed upon extremest height,
And oft supplanted[1] with exceeding heat,[2]
But ever subject to the wheel of chance;
And at our highest never joy we so,
As we both doubt[3] and dread our overflow.
So striveth not the waves with sundry winds
As fortune toileth in the affairs of kings,
That would be feared, yet fear to be beloved, 10
Sith[4] fear or love to kings is flattery.
For instance, lordings, look upon your King,
By hate deprivèd of his dearest son,
The only hope of our successive line.
 1 Nob. I had not thought that Alexandro's heart
Had been envenomed with such extreme hate;
But now I see that words have several works,[5]
And there's no credit in the countenance.[6]

[9] *infective:* infectious. [10] *only my:* my only.
[11] *practice:* plot, contrivance.
[12] *L.:* Let someone mix me the herbs which the beautiful spring draws forth, and may medicine be given for our grief; or let him offer juices, if such there be that will bring oblivion to our minds. May I myself gather whatever herbs the sun brings forth, over all the great world, into the lovely realms of light. May I myself drink whatever poison the sorceress contrives, and whatever herbs too the goddess weaves by her secret power. May I try all things, even death, until all feeling dies at once in my dead heart. My life, shall I never again see your eyes? And has eternal sleep buried your light? Let me die with you—thus, thus is it pleasant to go down to the shades. Nevertheless I shall abstain from a swift death, lest then no vengeance might follow your death.

II.vi.
[1] The end ... work: *Finis coronat opus,* a Latin commonplace.

III.i.
[1] *supplanted:* thrown down. [2] *heat:* passion.
[3] *doubt:* fear. [4] *Sith:* Since.
[5] *words ... works:* words are related to events in various ways.
[6] *no ... countenance:* faces cannot be trusted.

Vill. No; for, my lord, had you beheld the train[7]
That feignèd love had colored[8] in his looks, 20
When he in camp consorted Balthazar,
Far more inconstant had you thought the sun,
That hourly coasts the center of the earth,
Than Alexandro's purpose to the prince.

Vice. No more, Villuppo; thou hast said enough,
And with thy words thou slay'st our wounded thoughts.
Nor shall I longer dally with the world,
Procrastinating Alexandro's death;
Go some of you and fetch the traitor forth,
That as he is condemnèd he may die. 30

Enter ALEXANDRO *with a* Nobleman *and*
Halberts.[9]

2 Nob. In such extremes will naught but patience
serve.

Alex. But in extremes what patience shall I use?
Nor discontents it me to leave the world,
With whom there nothing can prevail but wrong.

2 Nob. Yet hope the best.

Alex. 'Tis heaven is my hope.
As for the earth, it is too much infect[10]
To yield me hope of any of her mold.[11]

Vice. Why linger ye? Bring forth that daring fiend,
And let him die for his accursèd deed.

Alex. Not that I fear the extremity of death, 40
For nobles cannot stoop to servile fear,
Do I, O King, thus discontented live.
But this, oh, this torments my laboring soul,
That thus I die suspected of a sin,
Whereof, as heavens have known my secret thoughts,
So am I free from this suggestion.[12]

Vice. No more, I say! to the tortures! when![13]
Bind him, and burn his body in those flames

They bind him to the stake.

That shall prefigure those unquenchèd fires
Of Phlegethon[14] preparèd for his soul 50

Alex. My guiltless death will be avenged on thee,
On thee, Villuppo, that hath maliced[15] thus,
Or for thy meed[16] hast falsely me accused.

Vill. Nay, Alexandro, if thou menace me,
I'll lend a hand to send thee to the lake
Where those thy words shall perish with thy works,
Injurious traitor, monstrous homicide!

Enter AMBASSADOR.

Amb. Stay, hold a while;

[7] *train:* treachery.
[8] *colored:* disguised; actually Viluppo means "masked."
[9] *Halberts:* Halberdiers. [10] *infect:* infected.
[11] *mold:* perhaps a pun—"earth," "form."
[12] *suggestion:* false accusation.
[13] *when!:* exclamation of impatience.
[14] *Phlegethon:* legendary river of fire in the underworld
(the "lake" later in the speech). [15] *maliced:* shown malice.
[16] *meed:* reward. [17] *entrance:* trisyllabic.
[18] *commends:* greetings. [19] *quital:* requital.
[20] *kindness:* nature. [21] *fact:* deed.
[22] *unkindness:* unnatural deed. [23] *preferred:* advanced.
[24] *mean:* moderate.

And here, with pardon of his majesty,
Lay hands upon Villuppo.

Vice. Ambassador, 60
What news hath urged this sudden entrance?[17]

Amb. Know, sovereign lord, that Balthazar doth
live.

Vice. What say'st thou? Liveth Balthazar our son?

Amb. Your highness' son, Lord Balthazar, doth live;
And, well entreated in the court of Spain,
Humbly commends him to your majesty.
These eyes beheld, and these my followers,
With these, the letters of the King's commends,[18]

Gives him letters.

Are happy witnesses of his highness' health.

The KING *looks on the letters, and proceeds.*

Vice. "Thy son doth live, your tribute is received,
Thy peace is made, and we are satisfied. 71
The rest resolve upon as things proposed
For both our honors and thy benefit."

Amb. These are his highness' farther articles.

He gives him more letters.

Vice. Accursèd wretch, to intimate these ills
Against the life and reputation
Of noble Alexandro!—Come, my lord,
Let him unbind thee that is bound to death,
To make a quital[19] for thy discontent.

They unbind him.

Alex. Dread lord, in kindness[20] you could do no
less, 80
Upon report of such a damnèd fact;[21]
But thus we see our innocence hath saved
The hopeless life which thou, Villuppo, sought
By thy suggestions to have massacred.

Vice. Say, false Villuppo! wherefore didst thou thus
Falsely betray Lord Alexandro's life?
Him whom thou know'st that no unkindness[22] else,
But even the slaughter of our dearest son,
Could once have moved us to have misconceived?

Alex. Say, treacherous Villuppo, tell the King, 90
Wherein hath Alexandro used thee ill?

Vill. Rent with remembrance of so foul a deed,
My guilty soul submits me to thy doom;
For, not for Alexandro's injuries,
But for reward, and hope to be preferred,[23]
Thus have I shamelessly hazarded his life.

Vice. Which, villain, shall be ransomed with thy
death,
And not so mean[24] a torment as we here
Devised for him, who thou said'st slew our son,
But with the bitterest torments and extremes 100
That may be yet invented for thine end.

ALEXANDRO *seems to entreat.*

Entreat me not. Go take the traitor hence.

Exit VILLUPPO [*guarded*].

And, Alexandro, let us honor thee
With public notice of thy loyalty.

To end those things articulated²⁵ here
By our great lord, the mighty King of Spain,
We with our council will deliberate.
Come, Alexandro, keep us company.

Exeunt.

[III.ii]

Enter HIERONIMO.

Hier. O eyes, no eyes, but fountains fraught with
 tears;
O life, no life, but lively¹ form of death;
O world, no world, but mass of public wrongs,
Confused and filled with murder and misdeeds;
O sacred heavens! if this unhallowed deed,
If this inhuman and barbarous attempt,
If this incomparable murder thus
Of mine, but now no more my son,
Shall unrevealed and unrevengèd pass,
How should we term your dealings to be just, 10
If you unjustly deal with those that in your justice
 trust?
The night, sad secretary² to my moans,
With direful visions wake³ my vexèd soul,
And with the wounds of my distressful son
Solicit me for notice of his death.
The ugly fiends do sally forth of hell,
And frame my steps to unfrequented paths,
And fear⁴ my heart with fierce inflamèd thoughts.
The cloudy day my discontents records,
Early begins to register my dreams 20
And drive me forth to seek the murderer.
Eyes, life, world, heavens, hell, night, and day,
See, search, show, send, some man, some mean, that
 may—

A letter falleth.

What's here? A letter? Tush, it is not so!
A letter written to Hieronimo!
"For want of ink, receive this bloody writ. *Red ink.*⁵
Me hath my hapless brother hid from thee.
Revenge thyself on Balthazar and him,
For these were they that murderèd thy son.
Hieronimo, revenge Horatio's death, 30
And better fare than Bel-imperia doth."
What means this unexpected miracle?
My son slain by Lorenzo and the prince!
What cause had they Horatio to malign?⁶
Or what might move thee, Bel-imperia,
To accuse thy brother, had he been the mean?⁷
Hieronimo, beware, thou art betrayed,
And to entrap thy life this train⁸ is laid.
Advise thee therefore, be not credulous:
This is devisèd to endanger thee, 40
That thou by this Lorenzo shouldst accuse,
And he, for thy dishonor done, should draw
Thy life in question⁹ and thy name in hate.
Dear was the life of my belovèd son,
And of his death behoves me be revenged;
Then hazard not thine own, Hieronimo,

But live t'effect thy resolution.
I therefore will by circumstances¹⁰ try
What I can gather to confirm this writ,
And, heark'ning near the Duke of Castile's house, 50
Close, if I can, with Bel-imperia,
To listen more, but nothing to bewray.

Enter PEDRINGANO.

Now, Pedringano!
 Ped. Now, Hieronimo!
 Hier. Where's thy lady?
 Ped. I know not; here's my lord.

Enter LORENZO.

 Lor. How now, who's this? Hieronimo?
 Hier. My lord.
 Ped. He asketh for my Lady Bel-imperia.
 Lor. What to do, Hieronimo? The duke my father
 hath
Upon some disgrace awhile removed her hence,
But if be aught I may inform her of,
Tell me, Hieronimo, and I'll let her know it. 60
 Hier. Nay, nay, my lord, I thank you, it shall not
 need;
I had a suit unto her, but too late,
And her disgrace makes me unfortunate.
 Lor. Why so, Hieronimo? Use me.
 Hier. Oh, no, my lord, I dare not; it must not be.
I humbly thank your lordship.

[SECOND ADDITION]¹¹

[*Hier.* Who, you, my lord?
I reserve your favor for a greater honor;
This is a very toy, my lord, a toy.¹²
 Lor. All's one,¹³ Hieronimo, acquaint me with it.
 Hier. I' faith, my lord, it is an idle thing; 70
I must confess I ha' been too slack, too tardy,
Too remiss unto your honor.
 Lor. How now, Hieronimo?
 Hier. In troth, my lord, it is a thing of nothing,
The murder of a son, or so—
A thing of nothing, my lord.]

[END OF SECOND ADDITION]

 Lor. Why then, farewell.
 Hier. My grief no heart, my thoughts no tongue
 can tell.

Exit.

²⁵ *articulated:* set forth in articles.
III.ii.
 ¹ *lively:* lifelike. ² *secretary:* confidant.
 ³ *wake:* singular for plural, probably attracted by "moans"
in preceeding line. ⁴ *fear:* frighten.
 ⁵ *Red ink:* an author's or prompter's instructions for the
representation of blood(?). ⁶ *malign:* hate.
 ⁷ *mean:* means. ⁸ *train:* trap. ⁹ *question:* hazard.
 ¹⁰ *circumstances:* circumstantial evidence.
 ¹¹ *Second Addition:* This replaces Hieronimo's speech, ll.
65–66. ¹² *toy:* trifle. ¹³ *All's one:* It doesn't matter.

Lor. Come hither, Pedringano; seest thou this?
Ped. My lord, I see it, and suspect it too.
Lor. This is that damnèd villain Serberine,
That hath, I fear, revealed Horatio's death. 80
Ped. My lord, he could not, 'twas so lately done,
And since, he hath not left my company.
Lor. Admit he have not, his condition's [14] such,
As fear or flattering words may make him false.
I know his humor, and therewith repent
That e'er I used him in this enterprise.
But, Pedringano, to prevent [15] the worst,
And 'cause I know thee secret as my soul,
Here, for thy further satisfaction, take thou this,

Gives him more gold.

And hearken to me. Thus it is devised: 90
This night thou must (and prithee so resolve)
Meet Serberine at Saint Luigi's Park—
Thou know'st 'tis here hard by behind the house.
There take thy stand, and see thou strike him sure,
For die he must, if we do mean to live.
Ped. But how shall Serberine be there, my lord?
Lor. Let me alone; [16] I'll send to him to meet
The prince and me, where thou must do this deed.
Ped. It shall be done, my lord, it shall be done,
And I'll go arm myself to meet him there. 100
Lor. When things shall alter, as I hope they will,
Then shalt thou mount [17] for this; thou know'st my
 mind.

Exit PEDRINGANO.

Che le Ieron! [18]

Enter Page.

Page. My lord?
Lor. Go, sirrah, to Serberine,
And bid him forthwith meet the prince and me
At Saint Luigi's Park, behind the house—
This evening, boy!
Page. I go, my lord.
Lor. But, sirrah, let the hour be eight o'clock.
Bid him not fail.
Page. I fly, my lord.

Exit.

Lor. Now to confirm the complot [19] thou hast cast [20]
Of all these practices, I'll spread the watch, 110

Upon precise commandment from the King,
Strongly to guard the place where Pedringano
This night shall murder hapless Serberine.
Thus must we work that will [21] avoid distrust;
Thus must we practice to prevent mishap,
And thus one ill another must expulse. [22]
This sly inquiry of Hieronimo
For Bel-imperia breeds suspicion,
And this suspicion bodes a further ill.
As for myself, I know my secret fault, [23] 120
And so do they, but I have dealt for [24] them.
They that for coin their souls endangerèd,
To save my life, for coin shall venture theirs:
And better it's that base companions [25] die,
Than by their life to hazard our good haps. [26]
Nor shall they live, for me to fear their faith.
I'll trust myself, myself shall be my friend,
For die they shall:
Slaves are ordainèd to no other end.

Exit.

[III.iii]

Enter PEDRINGANO *with a pistol.*

Ped. Now, Pedringano, bid thy pistol hold; [1]
And hold on, Fortune! once more favor me,
Give but success to mine attempting spirit,
And let me shift for making of mine aim! [2]
Here is the gold; this is the gold proposed.
It is no dream that I adventure for,
But Pedringano is possessed thereof.
And he that would not strain his conscience
For him that thus his liberal purse hath stretched,
Unworthy such a favor may he fail, 10
And, wishing, want, when such as I prevail.
As for the fear of apprehension,
I know, if need should be, my noble lord
Will stand between me and ensuing harms;
Besides, this place is free from all suspect. [3]
Here therefore will I stay and take my stand.

Enter the Watch.

1. I wonder much to what intent it is
That we are thus expressly charged to watch.
2. 'Tis by commandment in the King's own name.
3. But we were never wont to watch and ward [4] 20
So near the duke his brother's house before.
2. Content yourself; stand close; [5] there's somewhat
 in't.

Enter SERBERINE.

Serb. Here, Serberine, attend and stay thy pace,
For here did Don Lorenzo's page appoint
That thou by his command shouldst meet with him.
How fit a place, if one were so disposed, [6]
Methinks this corner is to close with one.
Ped. Here comes the bird that I must seize upon.
Now, Pedringano, or never, play the man!
Serb. I wonder that his lordship stays so long, 30
Or wherefore should he send for me so late?

[14] *condition's:* nature's. [15] *prevent:* anticipate.
[16] *Let me alone:* Leave it to me.
[17] *mount:* be promoted, or be hanged; a pun like the one
Lorenzo made at II. iv. 61.
[18] *Che le Ieron:* incomprehensible expression, perhaps a
corruption of the Page's name.
[19] *complot:* plot. [20] *cast:* devised.
[21] *will:* would. [22] *expulse:* expel.
[23] *fault:* offense. [24] *dealt for:* taken care of.
[25] *base companions:* fellows of low rank.
[26] *haps:* chances.
III.iii.
[1] *hold:* perform its function.
[2] *let . . . aim:* leave aiming the pistol to me.
[3] *suspect:* suspicion. [4] *watch and ward:* keep guard.
[5] *close:* hidden. [6] *disposed:* situated.

Ped. For this, Serberine, and thou shalt ha't.

Shoots the dag.[7]

So, there he lies, my promise is performed.

The Watch.

1. Hark, gentlemen, this is a pistol shot.
2. And here's one slain, stay the murderer.
Ped. Now, by the sorrow of the souls in hell,

He strives with the Watch.

Who first lays hand on me, I'll be his priest.[8]
3. Sirrah, confess, and therein play the priest,
Why hast thou thus unkindly[9] killed the man?
Ped. Why? Because he walked abroad so late.
3. Come, sir, you had been better kept your bed,
Than have committed this misdeed so late. 40
2. Come, to the marshal's with the murderer!
1. On to Hieronimo's! Help me here
To bring the murdered body with us too.
Ped. Hieronimo! Carry me before whom you will.
Whate'er he be, I'll answer him and you;
And do your worst, for I defy you all.

Exeunt.

[III.iv]

Enter LORENZO *and* BALTHAZAR.

Balth. How now, my lord, what makes you rise so
 soon?
Lor. Fear of preventing our mishaps too late.
Balth. What mischief is it that we not mistrust?[1]
Lor. Our greatest ills we least mistrust, my lord,
And inexpected harms do hurt us most.
Balth. Why, tell me Don Lorenzo, tell me, man,
If aught concerns our honor and your own.
Lor. Nor you nor me, my lord, but both in one,
For I suspect, and the presumption's[2] great,
That by those base confederates in our fault 10
Touching the death of Don Horatio,
We are betrayed to old Hieronimo.
Balth. Betrayed, Lorenzo? Tush, it cannot be.
Lor. A guilty conscience, urgèd with the thought
Of former evils, easily cannot err;
I am persuaded, and dissuade me not,
That all's revealèd to Hieronimo.
And therefore know that I have cast it thus—

[*Enter* Page.]

But here's the page. How now, what news with thee?
Page. My lord, Serberine is slain. 20
Balth. Who? Serberine, my man?
Page. Your highness' man, my lord.
Lor. Speak, page, who murdered him?
Page. He that is apprehended for the fact.
Lor. Who?
Page. Pedringano.
Balth. Is Serberine slain, that loved his lord so well?
Injurious villain, murderer of his friend!
Lor. Hath Pedringano murdered Serberine?

My lord, let me entreat you to take the pains 30
To exasperate[3] and hasten his[4] revenge
With your complaints unto my lord the King.
This their dissension breeds a greater doubt.
Balth. Assure thee, Don Lorenzo, he shall die,
Or else his highness hardly shall deny.[5]
Meanwhile, I'll haste the marshal-sessions:
For die he shall for this his damnèd deed.

Exit BALTHAZAR.

Lor. Why so, this fits our former policy,[6]
And thus experience bids the wise to deal.
I lay the plot, he prosecutes the point, 40
I set the trap, he breaks the worthless twigs
And sees not that wherewith the bird was limed.
Thus hopeful men, that mean to hold their own,
Must look like fowlers to their dearest friends.
He runs to kill whom I have holp[7] to catch,
And no man knows it was my reaching[8] fatch.[9]
'Tis hard to trust unto a multitude,
Or anyone, in mine opinion,
When men themselves their secrets will reveal.

Enter a Messenger *with a letter.*

Boy! 50
Page. My lord.
Lor. What's he?
Mes. I have a letter to your lordship.
Lor. From whence?
Mes. From Pedringano that's
 imprisoned.
Lor. So, he is in prison then?
Mes. Ay, my good lord.
Lor. What would he with us? He writes us here
To stand good lord[10] and help him in distress.
Tell him I have his letters, know his mind,
And what we may, let him assure him of.
Fellow, begone; my boy shall follow thee.

Exit Messenger.

This works like wax; yet once more try thy wits. 60
Boy, go convey this purse to Pedringano;
Thou know'st the prison; closely[11] give it him,
And be advised that none be there about.
Bid him be merry still, but secret;
And though the marshal-sessions be today,
Bid him not doubt of his delivery.
Tell him his pardon is already signed,
And thereon bid him boldly be resolved;
For were he ready to be turnèd off[12]
(As 'tis my will the uttermost be tried),[13] 70

[7] *dag:* pistol.
[8] *be his priest:* help him to the next world, kill him (proverbial). [9] *unkindly:* unnaturally.
III.iv.
[1] *mistrust:* suspect. [2] *presumption's:* probability's.
[3] *exasperate:* make harsh. [4] *his:* upon him.
[5] *hardly shall deny:* shall show hardness in denying me.
[6] *policy:* scheme, stratagem; the method of the "Machiavellian" villain. [7] *holp:* helped.
[8] *reaching:* far-reaching. [9] *fatch:* stratagem.
[10] *stand good lord:* act the part of patron.
[11] *closely:* secretly. [12] *turnèd off:* hanged.
[13] *the . . . tried:* no stone should be left unturned.

Thou with his pardon shalt attend him still.
Show him this box, tell him his pardon's in't,
But open't not, and if[14] thou lov'st thy life,
But let him wisely keep his hopes unknown;
He shall not want while Don Lorenzo lives.
Away!
 Page. I go, my lord, I run.
 Lor. But, sirrah, see that this be cleanly[15] done.
 Exit Page.
Now stands our fortune on a tickle[16] point,
And now or never ends Lorenzo's doubts.
One only thing is uneffected yet, 80
And that's to see the executioner.
But to what end? I list not[17] trust the air
With utterance of our pretense[18] therein,
For fear the privy[19] whisp'ring of the wind
Convey our words amongst unfriendly ears,
That lie to open to advantages.
E quel che voglio io, nessun lo sa.
Intendo io; quel mi basterà.[20]
 Exit.

[III.v]

Enter Boy *with the box.*

 Page. My master hath forbidden me to look in this
box, and by my troth 'tis likely, if he had not warned
me, I should not have had so much idle time; for we
men's-kind[1] in our minority are like women in their
uncertainty: that they are most forbidden, they will
soonest attempt; so I now. By my bare honesty, here's
nothing but the bare empty box. Were it not sin against
secrecy, I would say it were a piece of gentlemanlike
knavery. I must go to Pedringano, and tell him his
pardon is in this box; nay, I would have sworn it, 10
had I not seen the contrary. I cannot choose but smile
to think how the villain will flout the gallows, scorn the
audience, and descant on the hangman, and all pre-
suming of his pardon from hence. Will 't not be an odd
jest for me to stand and grace every jest he makes,
pointing my finger at this box, as who would say,
"Mock on, here's thy warrant." Is't not a scurvy jest
that a man should jest himself to death? Alas, poor

[14] *and if:* if. [15] *cleanly:* adroitly.
[16] *tickle:* delicately balanced. [17] *list not:* do not want to.
[18] *pretense:* intention.
[19] *privy:* possessing knowledge of our secrets.
[20] *It.:* And what I want; no one knows, I know; that will
be enough for me.

III.v.
[1] *men's-kind:* menfolk.

III.vi.
[1] *Deputy:* Assistant to a knight marshal.
[2] *regard:* consider.
[3] *here:* indicates a gesture—to his head, his heart, or the
bloody kercher(?). [4] *gear:* business.
[5] *approved:* proved.
[6] *habit:* The hangman was entitled to his victim's clothes.
[7] *boot:* profit.

Pedringano, I am in a sort sorry for thee, but if I should
be hanged with thee, I cannot weep. 20
 Exit.

[III.vi]

Enter HIERONIMO *and the* Deputy.[1]

 Hier. Thus must we toil in other men's extremes,
That know not how to remedy our own,
And do them justice, when unjustly we,
For all our wrongs, can compass no redress.
But shall I never live to see the day
That I may come, by justice of the heavens,
To know the cause that may my cares allay?
This toils my body, this consumeth age,
That only I to all men just must be,
And neither gods nor men be just to me. 10
 Dep. Worthy Hieronimo, your office asks
A care to punish such as do transgress.
 Hier. So is't my duty to regard[2] his death
Who, when he lived, deserved my dearest blood.
But come, for that we came for, let's begin.
For here[3] lies that which bids me to be gone.

Enter Officers, Boy, *and* PEDRINGANO,
with a letter in his hand, bound.

 Dep. Bring forth the prisoner, for the court is set.
 Ped. Gramercy, boy, but it was time to come,
For I had written to my lord anew
A nearer matter that concerneth him, 20
For fear his lordship had forgotten me;
But sith he hath remembered me so well—
Come, come, come on, when shall we to this gear?[4]
 Hier. Stand forth, thou monster, murderer of men,
And here, for satisfaction of the world,
Confess thy folly and repent thy fault,
For there's thy place of execution.
 Ped. This is short work: well, to your marshalship
First I confess, nor fear I death therefore,
I am the man, 'twas I slew Serberine. 30
But, sir, then you think this shall be the place
Where we shall satisfy you for this gear?
 Dep. Ay, Pedringano.
 Ped. Now I think not so.
 Hier. Peace, impudent, for thou shalt find it so;
For blood with blood shall, while I sit as judge,
Be satisfied, and the law discharged;
And though myself cannot receive the like,
Yet, will I see that others have their right.
Dispatch! the fault's approved[5] and confessed,
And by our law he is condemned to die. 40
 Hangman. Come on, sir, are you ready?
 Ped. To do what, my fine, officious knave?
 Hangm. To go to this gear.
 Ped. O sir, you are too forward; thou wouldst fain
furnish me with a halter, to disfurnish me of my habit,[6]
so I should go out of this gear, my raiment, into that
gear, the rope; but hangman, now I spy your knavery,
I'll not change without boot,[7] that's flat.
 Hangm. Come, sir.

Ped. So then, I must up? 50

Hangm. No remedy.

Ped. Yes, but there shall be for my coming down.

Hangm. Indeed, here's a remedy for that.

Ped. How? Be turned off?

Hangm. Ay, truly; come, are you ready? I pray sir, dispatch; the day goes away.

Ped. What, do you hang by the hour? If you do, I may chance to break your old custom.

Hangm. Faith, you have reason, for I am like to break your young neck. 60

Ped. Dost thou mock me, hangman? Pray God I be not preserved to break your knave's pate for this!

Hangm. Alas, sir, you are a foot too low to reach it, and I hope you will never grow so high while I am in the office.

Ped. Sirrah, dost see yonder boy with the box in his hand?

Hangm. What, he that points to it with his finger?

Ped. Ay, that companion.

Hangm. I know him not, but what of him? 70

Ped. Dost thou think to live till his old doublet[8] will make thee a new truss?[9]

Hangm. Ay, and many a fair year after, to truss up many an honester man than either thou or he.

Ped. What hath he in his box, as thou think'st?

Hangm. Faith, I cannot tell, nor I care not greatly. Methinks you should rather hearken to your soul's health.

Ped. Why, sirrah hangman? I take it, that that is good for the body is likewise good for the soul; and it may be, in that box is balm for both. 81

Hangm. Well, thou art even the merriest piece of man's flesh that e'er groaned at my office door.

Ped. Is your roguery become an office, with a knave's name?

Hangm. Ay, and that shall all they witness that see you seal it with a thief's name.

Ped. I prithee request this good company to pray with me.

Hangm. Ay, marry sir, this is a good motion:[10] my masters, you see here's a good fellow. 91

Ped. Nay, nay, now I remember me; let them alone till some other time, for now I have no great need.

Hier. I have not seen a wretch so impudent!
Oh, monstrous times, where murder's set so light,
And where the soul, that should be shrined in heaven,
Solely delights in interdicted things,
Still wand'ring in the thorny passages
That intercepts itself of[11] happiness.
Murder, oh, bloody monster—God forbid 100
A fault so foul should scape unpunished.
Dispatch, and see this execution done.—
This makes me to remember thee, my son.

 Exit HIERONIMO.

Ped. Nay, soft, no haste.

Dep. Why, wherefore stay you? Have you hope of life?

Ped. Why, ay.

Hangm. As how?

Ped. Why, rascal, by my pardon from the King.

Hangm. Stand[12] you on that? Then you shall off with this.

 He turns him off.

Dep. So, executioner; convey him hence, 110
But let his body be unburièd.
Let not the earth be chokèd or infect
With that which heaven contemns and men neglect.

 Exeunt.

[III.vii]

Enter HIERONIMO.

Hier. Where shall I run to breathe abroad my woes,
My woes, whose weight hath wearièd the earth?
Or mine exclaims, that have surcharged the air
With ceaseless plaints for my deceasèd son?
The blust'ring winds, conspiring with my words,
At my lament have moved the leaveless trees,
Disrobed the meadows of their flowered green,
Made mountains marsh with spring-tides of my tears,
And broken through the brazen gates of hell.
Yet still tormented is my tortured soul 10
With broken sighs and restless passions,
That wingèd mount, and, hovering in the air,
Beat at the windows of the brightest heavens,
Soliciting for justice and revenge;
But they are placed in those empyreal[1] heights
Where, countermured[2] with walls of diamond,
I find the place impregnable, and they
Resist my woes, and give my words no way.

Enter Hangman *with a letter.*

Hangm. O lord, sir, God bless you, sir, the man, sir, Petergade, sir, he that was so full of merry conceits—[3]

Hier. Well, what of him? 21

Hangm. O lord, sir, he went the wrong way, the fellow had a fair commission to the contrary. Sir, here is his passport; I pray you sir, we have done him wrong.

Hier. I warrant thee, give it me.

Hangm. You will stand between the gallows and me?

Hier. Ay, ay.

Hangm. I thank your lord worship.

 Exit Hangman.

Hier. And yet, though somewhat nearer me concerns,
I will, to ease the grief that I sustain, 31
Take truce with sorrow while I read on this.
"My lord, I writ as mine extremes required,
That you would labor my delivery;

[8] *doublet:* waistcoat.

[9] *truss:* here, close fitting jacket; in l. 73, punningly, "hang." [10] *motion:* proposal.

[11] *intercepts . . . of:* cuts itself off from.

[12] *Stand:* Depend.

III.vii.

[1] *empyreal:* of the highest heaven, the sphere of fire.

[2] *countermured:* doubly walled.

[3] *conceits:* farfetched turns of phrase.

If you neglect, my life is desperate,
And in my death I shall reveal the troth.
You know, my lord, I slew him for your sake,
And as confederate with the prince and you,
Won by rewards and hopeful promises,
I holp to murder Don Horatio, too." 40
Holp he to murder mine Horatio?
And actors in th' accursèd tragedy
Wast thou, Lorenzo, Balthazar and thou,
Of whom my son, my son, deserved so well?
What have I heard, what have mine eyes beheld?
O sacred heavens, may it come to pass
That such a monstrous and detested deed,
So closely smothered, and so long concealed,
Shall thus by this be vengèd or revealed?
Now see I what I durst not then suspect, 50
That Bel-imperia's letter was not feigned,
Nor feignèd she, though falsely they have wronged
Both her, myself, Horatio and themselves.
Now may I make compare, 'twixt hers and this,
Of every accident; I ne'er could find
Till now, and now I feelingly perceive,
They did what heaven unpunished would not leave.
O false Lorenzo, are these thy flattering looks?
Is this the honor that thou didst my son?
And Balthazar, bane to thy soul and me, 60
Was this the ransom he reserved thee for?
Woe to the cause of these constrainèd wars,
Woe to thy baseness and captivity,
Woe to thy birth, thy body and thy soul,
Thy cursèd father, and thy conquered self!
And banned[4] with bitter execrations be
The day and place where he did pity thee!
But wherefore waste I mine unfruitful words,
When naught but blood will satisfy my woes?
I will go plain me[5] to my lord the King, 70
And cry aloud for justice through the court,
Wearing the flints with these my withered feet,
And either purchase justice by entreats,
Or tire them all with my revenging threats.

 Exit.

[III.viii]

 Enter ISABELLA *and her* Maid.

 Isab. So that you say this herb will purge the eye,
And this the head?
Ah, but none of them will purge the heart;

 [4] *banned:* cursed. [5] *plain me:* complain.

III.viii.
 [1] *recure:* cure. [2] *whipstalk:* whipstock.
 [3] *humors:* moods, fancies. [4] *greet:* acclaim.
 [5] *mirror:* paragon.

III.ix.
 [1] *notice:* information.
 [2] *apply . . . time:* adapt myself to things as they are.

III.x.
 [1] *resolution:* firmness.

No, there's no medicine left for my disease,
Nor any physic to recure[1] the dead.

 She runs lunatic.

Horatio! oh, where's Horatio?
 Maid. Good madam, affright not thus yourself
With outrage for your son Horatio;
He sleeps in quiet in the Elysian fields.
 Isab. Why, did I not give you gowns and goodly
 things, 10
Bought you a whistle and a whipstalk[2] too,
To be revengèd on their villainies?
 Maid. Madam, these humors[3] do torment my soul.
 Isab. My soul?—Poor soul, thou talks of things
Thou know'st not what—my soul hath silver wings,
That mount me up unto the highest heavens,
To heaven! Ay, there sits my Horatio,
Backed with a troop of fiery cherubins,
Dancing about his newly healèd wounds,
Singing sweet hymns and chanting heavenly notes, 20
Rare harmony to greet[4] his innocence,
That died, ay, died, a mirror[5] in our days.
But say, where shall I find the men, the murderers,
That slew Horatio? Whither shall I run
To find them out that murderèd my son?

 Exeunt.

[III.ix]

 BEL-IMPERIA *at a window.*

 Bel. What means this outrage that is offered me?
Why am I thus sequestered from the court?
No notice?[1] Shall I not know the cause
Of this my secret and suspicious ills?
Accursèd brother, unkind murderer,
Why bends thou thus thy mind to martyr me?
Hieronimo, why writ I of thy wrongs,
Or why art thou so slack in thy revenge?
Andrea, O Andrea, that thou sawest
Me for thy friend Horatio handled thus, 10
And him for me thus causeless murderèd.
Well, force perforce, I must constrain myself
To patience, and apply me to the time,[2]
Till heaven, as I have hoped, shall set me free.

 Enter CHRISTOPHIL.

 Chris. Come, Madam Bel-imperia, this may not be.
 Exeunt.

[III.x]

 Enter LORENZO, BALTHAZAR, *and the* Page.

 Lor. Boy, talk no further; thus far things go well.
Thou art assurèd that thou sawest him dead?
 Page. Or else, my lord, I live not.
 Lor. That's enough.
As for his resolution[1] in his end,
Leave that to him with whom he sojourns now.
Here, take my ring, and give it Christophil,

And bid him let my sister be enlarged,
And bring her hither straight.

Exit Page.

This that I did was for a policy
To smooth [2] and keep the murder secret, 10
Which, as a nine-days' wonder [3] being o'er-blown,
My gentle sister will I now enlarge.
 Balth. And time, Lorenzo, for my lord the duke,
You heard, inquired for her yesternight.
 Lor. Why, and, my lord, I hope you heard me say
Sufficient reason why she kept away;
But that's all one. My lord, you love her?
 Balth. Ay.
 Lor. Then in your love beware, deal cunningly,
Salve [4] all suspicions, only soothe me up; [5]
And if she hap to stand on terms [6] with us, 20
As for her sweetheart, and concealment so,
Jest with her gently; under feignèd jest
Are things concealed that else would breed unrest.
But here she comes.

Enter BEL-IMPERIA.

 Now, sister—
 Bel. Sister? No,
Thou art no brother, but an enemy;
Else wouldst thou not have used thy sister so:
First, to affright me with thy weapons drawn,
And with extremes [7] abuse my company; [8]
And then to hurry me, like whirlwind's rage,
Amidst a crew of thy confederates, 30
And clap me up where none might come at me,
Nor I at any to reveal my wrongs.
What madding fury did possess thy wits?
Or wherein is't that I offended thee?
 Lor. Advise you better, Bel-imperia,
For I have done you no disparagement, [9]
Unless, by more discretion than deserved,
I sought to save your honor and mine own.
 Bel. Mine honor! Why Lorenzo, wherein is't
That I neglect my reputation so, 40
As you, or any, need to rescue it?
 Lor. His highness and my father were resolved
To come confer with old Hieronimo,
Concerning certain matters of estate
That by the viceroy was determinèd. [10]
 Bel. And wherein was mine honor touched in that?
 Balth. Have patience, Bel-imperia; hear the rest.
 Lor. Me next in sight [11] as messenger they sent,
To give him notice that they were so nigh.
Now when I came, consorted [12] with the prince, 50
And unexpected in an arbor there
Found Bel-imperia with Horatio—
 Bel. How then?
 Lor. Why then, remembering that old disgrace
Which you for Don Andrea had endured,
And now were likely longer to sustain,
By being found so meanly accompanied,
Thought rather, for I knew no readier mean,
To thrust Horatio forth [13] my father's way.
 Balth. And carry you obscurely somewhere else, 60
Lest that his highness should have found you there.

 Bel. Even so, my lord? And you are witness
That this is true which he entreateth [14] of?
You, gentle brother, forgèd this for my sake,
And you, my lord, were made his instrument!
A work of worth, worthy the noting too!
But what's the cause that you concealed me since?
 Lor. Your melancholy, sister, since the news
Of your first favorite Don Andrea's death,
My father's old wrath hath exasperate. 70
 Balth. And better was't for you, being in disgrace,
To absent yourself and give his fury place.
 Bel. But why had I no notice of his ire?
 Lor. That were to add more fuel to your fire,
Who burnt like Aetna for Andrea's loss.
 Bel. Hath not my father then inquired for me?
 Lor. Sister, he hath, and thus excused I thee.

 He whispereth in her ear.

But Bel-imperia, see the gentle prince;
Look on thy love, behold young Balthazar,
Whose passions by thy presence are increased, 80
And in whose melancholy thou mayst see
Thy hate, his love; thy flight, his following thee.
 Bel. Brother, you are become an orator—
I know not, I, by what experience—
Too politic for me, past all compare,
Since last I saw you; but content yourself,
The prince is meditating higher things.
 Balth. 'Tis of thy beauty, then, that conquers kings;
Of those thy tresses, Ariadne's twines, [15]
Wherewith my liberty thou hast surprised; 90
Of that thine ivory front, [16] my sorrow's map,
Wherein I see no haven to rest my hope.
 Bel. To love, and fear, and both at once, my lord,
In my conceit, are things of more import
Than women's wits are to be busied with.
 Balth. 'Tis I that love.
 Bel. Whom?
 Balth. Bel-imperia.
 Bel. But I that fear.
 Balth. Whom?
 Bel. Bel-imperia.
 Lor. Fear yourself?
 Bel. Ay, brother.
 Lor. How?
 Bel. As those
That what they love are loath and fear to lose.

 [2] *smooth:* hush up, gloss over.
 [3] *nine-days' wonder:* event of temporary interest.
 [4] *Salve:* Smooth over.
 [5] *soothe me up:* confirm what I say.
 [6] *stand on terms:* haggle over conditions.
 [7] *extremes:* extreme measures.
 [8] *company:* companion (Horatio).
 [9] *disparagement:* humiliation.
 [10] *estate ... determined:* property that the viceroy had
given up. [11] *next in sight:* nearest person in view.
 [12] *consorted with:* accompanied by. [13] *forth:* out of.
 [14] *entreateth:* talks.
 [15] *Ariadne's twines:* perhaps a confusion between the
thread (twine) with which Ariadne guided Theseus through
the labyrinth and the nets with which Arachne, the weaver-
spider, trapped people. [16] *front:* forehead,

Balth. Then, fair, let Balthazar your keeper be. 100
Bel. No, Balthazar doth fear as well as we:
Et tremulo metui pavidum junxere timorem,
 Et vanum stolidae proditionis opus.[17]

 Exit.

 Lor. Nay, and you argue things so cunningly,
We'll go continue this discourse at court.
 Balth. Led by the loadstar of her heavenly looks,
Wends poor oppressèd Balthazar,
As o'er the mountains walks the wanderer,
Incertain to effect[18] his pilgrimage.

 Exeunt.

[III.xi]

Enter two Portingales, *and* HIERONIMO *meets them.*

 1. By your leave, sir.

[THIRD ADDITION]

[*Hier.* 'Tis neither as you think, nor as you think,
Nor as you think: you're wide all.
These slippers are not mine, they were my son Horatio's.
My son! and what's a son? A thing begot
Within a pair of minutes, thereabout;
A lump bred up in darkness, and doth serve
To ballace[1] these light creatures we call women;
And at nine moneths'[2] end, creeps forth to light.
What is there yet in a son 10
To make a father dote, rave, or run mad?
Being born, it pouts, cries, and breeds teeth.
What is there yet in a son? He must be fed,
Be taught to go,[3] and speak. Ay, or yet?
Why might not a man love a calf as well?
Or melt in passion o'er a frisking kid
As for a son? Methinks a young bacon
Or a fine little smooth horse-colt
Should move a man as much as doth a son;
For one of these in very little time 20
Will grow to some good use, whereas a son,
The more he grows in stature and in years,
The more unsquared, unbeveled he appears,
Reckons his parents among the rank of fools,
Strikes care upon their heads with his mad riots,[4]
Makes them look old before they meet with age.
This is a son.
And what a loss were this, considered truly?
Oh, but my Horatio
Grew out of reach of these insatiate humors; 30

[17] *L.:* And they [I] joined frightened alarm to trembling fear—a vain work of stupid betrayal (an obscure passage made more difficult by textual problems).
[18] *Incertain to effect:* Uncertain that he will achieve.
III.xi.
 [1] *ballace:* ballast.
 [2] *moneths':* metrical extension of "months'."
 [3] *go:* walk. [4] *riots:* riotous behavior.
 [5] *next:* nearest. [6] *He:* i.e., Hieronimo.
 [7] *path . . . side:* the path that leads to the deepest hell.
 [8] *humors:* Melancholy, or black bile, is one of the four humors or fluids that make up the human temperament.
 [9] *uphold:* continue in.

He loved his loving parents,
He was my comfort, and his mother's joy,
The very arm that did hold up our house;
Our hopes were storèd up in him;
None but a damnèd murderer could hate him.
He had not seen the back of nineteen year,
When his strong arm unhorsed the proud Prince
 Balthazar,
And his great mind, too full of honor,
Took him unto mercy,
That valiant but ignoble Portingale. 40
Well, heaven is heaven still,
And there is Nemesis and Furies,
And things called whips,
And they sometimes do meet with murderers.
They do not always scape; that's some comfort.
Ay, ay, ay, and then times steals on,
And steals, and steals, till violence leaps forth
Like thunder wrapped in a ball of fire,
And so doth bring confusion to them all.]

[END OF THIRD ADDITION]

 Hier. Good leave have you; nay, I pray you go, 50
For I'll leave you, if you can leave me so.
 2. Pray you, which is the next[5] way to my lord the
 duke's?
 Hier. The next way from me.
 1. To his house, we mean.
 Hier. Oh, hard by, 'tis yon house that you see.
 2. You could not tell us if his son were there?
 Hier. Who, my lord Lorenzo?
 1. Ay, sir.

 He[6] *goeth in at one door and comes out at another.*

 Hier. Oh, forbear,
For other talk for us far fitter were.
But if you be importunate to know
The way to him, and where to find him out,
Then list to me, and I'll resolve your doubt. 60
There is a path upon your left-hand side,[7]
That leadeth from a guilty conscience
Unto a forest of distrust and fear,
A darksome place and dangerous to pass.
There shall you meet with melancholy thoughts,
Whose baleful humors[8] if you but uphold,[9]
It will conduct you to despair and death;
Whose rocky cliffs when you have once beheld,
Within a hugy dale of lasting night,
That, kindled with the world's iniquities, 70
Doth cast up filthy and detested fumes—
Nor far from thence, where murderers have built
A habitation for their cursèd souls,
There, in a brazen caldron fixed by Jove
In his fel! wrath upon a sulfur flame,
Yourselves shall find Lorenzo bathing him
In boiling lead and blood of innocents.
 1. Ha, ha, ha!
 Hier. Ha, ha, ha!
Why, ha, ha, ha! Farewell, good, ha, ha, ha!

 Exit.

2. Doubtless this man is passing lunatic, 80
Or imperfection of his age doth make him dote.
Come, let's away to seek my lord the duke.

 [Exeunt.]

[III.xii]

Enter HIERONIMO *with a poniard in one hand, and
a rope in the other.*

 Hier. Now sir, perhaps I come and see the King,
The King sees me, and fain would hear my suit.
Why, is not this a strange and seld-seen[1] thing,
That standers-by with toys[2] should strike me mute?
Go to, I see their shifts,[3] and say no more.
Hieronimo, 'tis time for thee to trudge.[4]
Down by the dale that flows with purple gore,
Standeth a fiery tower; there sits a judge
Upon a seat of steel and molten brass,
And 'twixt his teeth he holds a firebrand, 10
That leads unto the lake where hell doth stand.
Away, Hieronimo, to him be gone;
He'll do thee justice for Horatio's death.
Turn down this path, thou shalt be with him straight,
Or this,[5] and then thou need'st not take thy breath.
This way, or that way? Soft and fair, not so;
For if I hang or kill myself, let's know
Who will revenge Horatio's murder then?
No, no! fie, no! pardon me, I'll none of that.

 He flings away the dagger and halter.

This way I'll take, and this way comes the King, 20

 He takes them up again.

And here I'll have a fling at him, that's flat;
And, Balthazar, I'll be with thee to bring,[6]
And thee, Lorenzo! Here's the King—nay, stay;
And here, ay here, there goes the hare away.[7]

 Enter KING, AMBASSADOR, CASTILE, *and*
 LORENZO.

 King. Now show, ambassador, what our viceroy
 saith.
Hath he received the articles we sent?
 Hier. Justice, oh, justice to Hieronimo!
 Lor. Back! seest thou not the King is busy?
 Hier. Oh, is he so?
 King. Who is he that interrupts our business? 30
 Hier. Not I. Hieronimo, beware: go by,[8] go by.
 Amb. Renownèd King, he hath received and read
Thy kingly proffers, and thy promised league,
And, as a man extremely overjoyed
To hear his son so princely entertained,
Whose death he had so solemnly bewailed,
This, for thy further satisfaction
And kingly love, he kindly lets thee know:
First, for the marriage of his princely son
With Bel-imperia, thy belovèd niece, 40
The news are more delightful to his soul,
Than myrrh or incense to the offended heavens.
In person therefore will be come himself,

To see the marriage rites solemnizèd,
And, in the presence of the court of Spain,
To knit a sure, inexplicable[9] band
Of kingly love, and everlasting league,
Betwixt the crowns of Spain and Portingale.
There will he give his crown to Balthazar,
And make a queen of Bel-imperia. 50
 King. Brother, how like you this our viceroy's love?
 Cast. No doubt, my lord, it is an argument
Of honorable care to keep his friend,
And wondrous zeal to Balthazar his son:
Nor am I least indebted to his grace,
That bends his liking to my daughter thus.
 Amb. Now last, dread lord, here hath his highness
 sent
(Although he send not that his son return)
His ransom due to Don Horatio.
 Hier. Horatio? Who calls Horatio? 60
 King. And well remembered, thank his majesty.
Here, see it given to Horatio.
 Hier. Justice, oh, justice, justice, gentle King!
 King. Who is that? Hieronimo?
 Hier. Justice, oh, justice! Oh, my son, my son,
My son, whom naught can ransom or redeem!
 Lor. Hieronimo, you are not well-advised.
 Hier. Away, Lorenzo, hinder me no more,
For thou hast made me bankrupt of my bliss.
Give me my son! You shall not ransom him. 70
Away! I'll rip the bowels of the earth,

 He diggeth with his dagger.

And ferry over to th'Elysian plains,
And bring my son to show his deadly wounds.
Stand from about me!
I'll make a pickaxe of my poniard,
And here surrender up my marshalship;
For I'll go marshal up the fiends in hell,
To be avengèd on you all for this.
 King. What means this outrage?
Will none of you restrain his fury? 80
 Hier. Nay, soft and fair; you shall not need to strive,
Needs must he go that the devils drive.

 Exit.

 King. What accident hath happed[10] Hieronimo?
I have not seen him to demean[11] him so.
 Lor. My gracious lord, he is with extreme pride,
Conceived of young Horatio his son,
And covetous of having to himself
The ransom of the young Prince Balthazar,
Distract, and in a manner lunatic.
 King. Believe me, nephew, we are sorry for't; 90
This is the love that fathers bears their sons.

III.xii.
 [1] *seld-seen:* seldom seen.
 [2] *toys:* triflings, trivial affairs. [3] *shifts:* tricks.
 [4] *trudge:* get moving.
 [5] *this . . . this:* the poniard, the rope.
 [6] *be . . . bring:* get even with you.
 [7] *there . . . away:* the quarry escapes.
 [8] *go by:* get out of the way, be careful.
 [9] *inexplicable:* that cannot be untied.
 [10] *happed:* happened to. [11] *demean:* behave.

But gentle brother, go give to him this gold,
The prince's ransom. Let him have his due,
For what he hath Horatio shall not want;
Haply Hieronimo hath need thereof.
 Lor. But if he be thus helplessly distract,
'Tis requisite his office be resigned,
And given to one of more discretion.
 King. We shall increase his melancholy so.
'Tis best that we see further in it first: 100
Till when, ourself will not exempt the place.[12]
And, brother, now bring in the ambassador,
That he may be a witness of the match
'Twixt Balthazar and Bel-imperia,
And that we may prefix[13] a certain time,
Wherein the marriage shall be solemnized,
That we may have thy lord the viceroy here.
 Amb. Therein your highness highly shall content
His majesty, that longs to hear from hence. 109
 King. On then, and hear you, lord ambassador.
 Exeunt.

[III.xiiA]

[FOURTH ADDITION][1]

[*Enter* JAQUES *and* PEDRO.

Jaq. I wonder, Pedro, why our master thus
At midnight sends us with our torches' light,
When man and bird and beast are all at rest,
Save those that watch for rape and bloody murder?
 Pedro. O Jaques, know thou that our master's mind
Is much distraught since his Horatio died,
And, now his agèd years should sleep in rest,
His heart in quiet, like a desperate man,
Grows lunatic and childish for his son.
Sometimes, as he doth at his table sit, 10
He speaks as if Horatio stood by him,
Then starting in a rage, falls on the earth,
Cries out, "Horatio! Where is my Horatio?"
So that with extreme grief and cutting sorrow,
There is not left in him one inch of man.
See where he comes.

Enter HIERONIMO.

 Hier. I pry through every crevice of each wall,
Look on each tree, and search through every brake,[2]
Beat at the bushes, stamp our grandam[3] earth,
Dive in the water, and stare up to heaven, 20
Yet cannot I behold my son Horatio.
How now? Who's there? Sprites? Sprites?

[12] A hopelessly corrupt line, probably meaning that the King will not take Hieronimo's position from him.
[13] *prefix:* fix in advance.

III.xiiA.
 [1] *Fourth Addition:* See headnote, p. 167.
 [2] *brake:* thicket. [3] *grandam:* grandmother.
 [4] *burn daylight:* waste time.
 [5] *Hecate:* a goddess of the moon, earth, and infernal regions, associated with witchcraft. Her name is here pronounced disyllabically. [6] *aglets:* metallic ornaments.
 [7] *set:* planted.

 Pedro. We are your servants that attend you, sir.
 Hier. What make you with your torches in the dark?
 Pedro. You bid us light them, and attend you here.
 Hier. No, no, you are deceived; not I, you are
 deceived:
Was I so mad to bid you light your torches now?
Light me your torches at the mid of noon,
Whenas the sun-god rides in all his glory; 29
Light me your torches then.
 Pedro. Then we burn daylight.[4]
 Hier. Let it be burned; Night is a murderous slut
That would not have her treasons to be seen;
And yonder pale-faced Hecate[5] there, the moon,
Doth give consent to that is done in darkness;
And all those stars that gaze upon her face
Are aglets[6] on her sleeve, pins on her train;
And those that should be powerful and divine,
Do sleep in darkness when they most should shine.
 Pedro. Provoke them not, fair sir, with tempting
 words.
The heavens are gracious, and your miseries 40
And sorrow makes you speak you know not what.
 Hier. Villain, thou liest, and thou doest naught
But tell me I am mad; thou liest, I am not mad.
I know thee to be Pedro, and he Jaques.
I'll prove it to thee, and were I mad, how could I?
Where was she that same night when my Horatio
Was murdered? She should have shone; search thou
 the book.
Had the moon shone, in my boy's face there was a kind
 of grace,
That I know—nay, I do know—had the murderer seen
 him,
His weapon would have fallen and cut the earth, 50
Had he been framed of naught but blood and death.
Alack, when mischief doth it knows not what,
What shall we say to mischief?

Enter ISABELLA.

 Isab. Dear Hieronimo, come in a-doors;
Oh, seek not means so to increase thy sorrow.
 Hier. Indeed, Isabella, we do nothing here,
I do not cry, ask Pedro,—and ask Jaques—
Not I indeed; we are very merry, very merry.
 Isab. How? Be merry here, be merry here?
Is not this the place, and this the very tree, 60
Where my Horatio died, where he was murdered?
 Hier. Was—do not say what; let her weep it out.
This was the tree, I set[7] it of a kernel,
And when our hot Spain could not let it grow,
But that the infant and the human sap
Began to wither, duly twice a morning
Would I be sprinkling it with fountain water.
At last it grew, and grew, and bore and bore,
Till at the length
It grew a gallows, and did bear our son. 70
It bore thy fruit and mine.—O wicked, wicked plant.
 One knocks within at the door.
See who knocks there.
 Pedro. It is a painter, sir.

Hier. Bid him come in, and paint some comfort,
For surely there's none lives but painted comfort:
Let him come in. One knows not what may chance;
God's will, that I should set this tree!—but even so
Masters ungrateful servants rear from naught,[8]
And then they hate them that did bring them up.

Enter the Painter.

Paint. God bless you, sir.
Hier. Wherefore? Why, thou scornful villain, 80
How, where, or by what means should I be blessed?
Isab. What wouldst thou have, good fellow?
Paint. Justice, madam.
Hier. O ambitious beggar, wouldst thou have that
That lives not in the world?
Why all the undelvèd[9] mines cannot buy
An ounce of justice, 'tis a jewel so inestimable.
I tell thee,
God hath engrossed[10] all justice in his hands,
And there is none but what comes from Him. 90
Paint. Oh, then I see
That God must right me for my murdered son.
Hier. How, was thy son murdered?
Paint. Ay, sir; no man did hold a son so dear.
Hier. What, not as thine? That's a lie
As massy[11] as the earth. I had a son,
Whose least unvalued hair did weigh
A thousand of thy sons: and he was murdered.
Paint. Alas, sir, I had no more but he.
Hier. Nor I, nor I; but this same one of mine 100
Was worth a legion. But all is one.
Pedro, Jaques, go in-a-doors; Isabella go;
And this good fellow here and I
Will range this hideous orchard up and down,
Like to two lions reavèd[12] of their young.
Go in a-doors, I say.
 Exeunt [PEDRO, JAQUES, ISABELLA].

The Painter *and he sits down.*

Come, let's talk wisely now. Was thy son murdered?
Paint. Ay, sir.
Hier. So was mine. How dost take it? Art thou not
sometimes mad? Is there no tricks[13] that comes before
thine eyes? 111
Paint. O lord, yes, sir.
Hier. Art a painter? Canst paint me a tear, or a
wound, a groan, or a sigh? Canst paint me such a tree
as this?
Paint. Sir, I am sure you have heard of my painting;
my name's Bazardo.
Hier. Bazardo! afore God, an excellent fellow!
Look you sir, do you see, I'd have you paint me in my
gallery, in your oil colors matted,[14] and draw me 120
five years younger than I am—do you see, sir, let five
years go, let them go—like the marshal of Spain; my
wife Isabella standing by me, with a speaking look to my
son Horatio, which should intend to this or some such
like purpose: "God bless thee, my sweet son"; and my
hand leaning upon his head, thus sir; do you see? May
it be done?
Paint. Very well, sir.

Hier. Nay, I pray mark me, sir. Then sir, would I
have you paint me this tree, this very tree. Canst paint
a doleful cry? 131
Paint. Seemingly, sir.
Hier. Nay, it should cry; but all is one. Well sir,
paint me a youth, run through and through with
villains' swords, hanging upon this tree. Canst thou
draw a murderer?
Paint. I'll warrant you, sir; I have the pattern of the
most notorious villains that ever lived in all Spain.
Hier. Oh, let them be worse, worse; stretch thine art,
and let their beards be of Judas his own color,[15] 140
and let their eyebrows jutty[16] over; in any case observe
that. Then sir, after some violent noise, bring me forth
in my shirt, and my gown under mine arm, with my
torch in my hand, and my sword reared up thus—and
these words:

What noise is this? Who calls Hieronimo?

May it be done?
Paint. Yea, sir.
Hier. Well, sir, then bring me forth, bring me
through alley[17] and alley, still with a distracted coun-
tenance going along, and let my hair heave up my 150
nightcap. Let the clouds scowl, make the moon dark,
the stars extinct, the winds blowing, the bells tolling,
the owl shrieking, the toads croaking, the minutes
jarring,[18] and the clock striking twelve. And then at last,
sir, starting, behold a man hanging, and tottering and
tottering, as you know the wind will wave a man, and I
with a trice[19] to cut him down. And looking upon him
by the advantage of my torch, find it to be my son
Horatio. There you may show a passion, there you may
may show a passion. Draw me like old Priam of 160
Troy, crying, "The house is a-fire, the house is a-fire,
as the torch over my head." Make me curse, make me
rave, make me cry, make me mad, make me well again,
make me curse hell, invocate[20] heaven, and in the end,
leave me in a trance—and so forth.
Paint. And is this the end?
Hier. Oh, no, there is no end; the end is death and
madness. As I am never better than when I am mad,
then methinks I am a brave fellow, then I do wonders;
but reason abuseth[21] me, and there's the tor- 170
ment, there's the hell. At the last, sir, bring me to one of
the murderers; were he as strong as Hector, thus would
I tear and drag him up and down.

He beats the Painter *in, then comes out again
with a book in his hand.*]

[END OF FOURTH ADDITION]

8 *One . . . naught:* You can't tell what will happen. God
wanted me to plant this tree [but my son was hanged on it];
in just the same way, masters bring up ungrateful servants
from a low position . . .
9 *undelvèd:* not yet dug. 10 *engrossed:* monopolized.
11 *massy:* massive, solid. 12 *reaved:* robbed, reft.
13 *tricks:* illusions. 14 *matted:* dulled.
15 *of . . . color:* red. 16 *jutty:* jut.
17 *alley:* garden-walk. 18 *jarring:* ticking.
19 *with a trice:* in a trice. 20 *invocate:* invoke.
21 *abuseth:* deceives.

[III.xiii]

Enter HIERONIMO *with a book in his hand.*

 Hier. Vindicta mihi![1]
Ay, heaven will be revenged of every ill,
Nor will they suffer murder unrepaid.
Then stay, Hieronimo, attend their will;
For mortal men may not appoint their time.
Per scelus semper tutum est sceleribus iter.[2]
Strike, and strike home, where wrong is offered thee,
For evils unto ills conductors be,
And death's the worst of[3] resolution;
For he that thinks with patience to contend 10
To quiet life, his life shall easily end.
Fata si miseros juvant, habes salutem;
Fata si vitam negant, habes sepulchrum.[4]
If destiny thy miseries do ease,
Then hast thou health, and happy shalt thou be.
If destiny deny thee life, Hieronimo,
Yet shalt thou be assurèd of a tomb;
If neither, yet let this thy comfort be,
Heaven covereth him that hath no burial.
And to conclude, I will revenge his death! 20
But how? Not as the vulgar[5] wits of men,
With open, but inevitable[6] ills,
As by a secret, yet a certain mean.[7]
Which under kindship[8] will be cloakèd best.
Wise men will take their opportunity,
Closely and safely fitting things to time;
But in extremes advantage hath no time,[9]
And therefore all times fit not for revenge.
Thus therefore will I rest me in unrest,
Dissembling quiet in unquietness, 30
Not seeming that I know their villainies,
That my simplicity may make them think
That ignorantly I will let all slip;
For ignorance, I wot, and well they know,

III.xiii.
 [1] *L.:* Though the passages Hieronimo quotes in the rest of this speech suggest that the book he is reading is by Seneca, he quotes here the biblical "Vengeance is mine, I will repay, saith the Lord" (Romans 12:19).
 [2] *L.:* The safe way for crime is always through crimes.
 [3] *the worst of:* the worst that can result from.
 [4] The Latin is translated in the following lines.
 [5] *vulgar:* common.
 [6] *open . . . inevitable:* i.e., common men expect vengeance to take the obvious form of the direct consequences demanded by simple justice.
 [7] *mean:* course of action. [8] *kindship:* kindness.
 [9] *in . . . time:* in desperate circumstances there is no time to wait for opportunity ("advantage").
 [10] *L.:* Is a useless remedy for ills.
 [11] *cap . . . courtesy:* doffing cap in respect.
 [12] *coil . . . keep:* disturbance . . . make.
 [13] *sort:* group. [14] *and:* if. [15] *actions:* petitions.
 [16] *corregidor:* advocate (properly, magistrate).
 [17] *action . . . case:* an action for which, because it did not fall into the standard jurisdiction of the Common Pleas, a special writ was needed stating the particular circumstances of the plea.
 [18] *L.:* a writ to eject a tenant before the expiration of his lease. [19] *band:* bond.
 [20] *silly:* helpless, unsophisticated, pitiable, of humble rank.
 [21] *Corsic:* of Corsica.

Remedium malorum iners est.[10]
Nor aught avails it me to menace them,
Who, as a wintry storm upon a plain,
Will bear me down with their nobility.
No, no, Hieronimo, thou must enjoin
Thine eyes to observation, and thy tongue 40
To milder speeches than thy spirit affords,
Thy heart to patience, and thy hands to rest,
Thy cap to courtesy[11] and thy knee to bow,
Till to revenge thou know, when, where, and how.

 A noise within.

How now, what noise? What coil is that you keep?[12]

 Enter a Servant.

 Serv. Here are a sort[13] of poor petitioners,
That are importunate, and[14] it shall please you sir,
That you should plead their cases to the King.
 Hier. That I should plead their several actions?[15]
Why, let them enter, and let me see them. 50

 Enter three Citizens *and an* Old Man.

 1. So I tell you this, for learning and for law,
There's not any advocate in Spain
That can prevail, or will take half the pain
That he will, in pursuit of equity.
 Hier. Come near, you men that thus importune me.
[*Aside*] Now must I bear a face of gravity,
For thus I used, before my marshalship,
To plead in causes as corregidor.—[16]
Come on sirs, what's the matter?
 2. Sir, an action.
 Hier. Of battery?
 1. Mine of debt.
 Hier. Give place. 60
 2. No, sir, mine is an action of the case.[17]
 3. Mine an *ejectione firmae*[18] by a lease.
 Hier. Content you sirs, are you determinèd
That I should plead your several actions?
 1. Ay sir, and here's my declaration.
 2. And here is my band.[19]
 3. And here is my lease.

 They give him papers.

 Hier. But wherefore stands yon silly[20] man so mute,
With mournful eyes and hands to heaven upreared?
Come hither, father, let me know thy cause. 69
 Senex. O worthy sir, my cause but slightly known
May move the hearts of warlike Myrmidons
And melt the Corsic[21] rocks with ruthful tears.
 Hier. Say, father, tell me what's thy suit?
 Senex. No, sir, could my woes
Give way unto my most distressful words,
Then should I not in paper, as you see,
With ink bewray what blood began in me.
 Hier. What's here? "The humble supplication
Of Don Bazulto for his murdered son."
 Senex. Ay, sir.
 Hier. No, sir, it was my murdered son, 80
Oh, my son, my son, oh, my son Horatio!
But mine, or thine, Bazulto, be content.

Here, take my handkercher and wipe thine eyes,
Whiles wretched I in thy mishaps may see
The lively portrait of my dying self.

He draweth out a bloody napkin.

Oh, no, not this; Horatio, this was thine;
And when I dyed it in thy dearest blood,
This was a token 'twixt thy soul and me
That of thy death revengèd I should be.
But here, take this, and this—what, my purse?— 90
Ay this and that, and all of them are thine,
For all as one are our extremities.
 1. Oh, see the kindness of Hieronimo!
 2. This gentleness shows him a gentleman.
 Hier. See, see, oh, see thy shame, Hieronimo,
See here a loving father to his son!
Behold the sorrows and the sad laments
That he delivereth for his son's decease!
If love's effects so strives in lesser things,
If love enforce such moods in meaner wits, 100
If love express such power in poor estates:
Hieronimo, whenas a raging sea,
Tossed with the wind and tide, o'erturneth then
The upper billows, course of waves to keep,
Whilst lesser waters labor in the deep.[22]
Then shamest thou not, Hieronimo, to neglect
The sweet revenge of thy Horatio?
Though on this earth justice will not be found,
I'll down to hell, and in this passion
Knock at the dismal gates of Pluto's court, 110
Getting by force, as once Alcides[23] did,
A troop of Furies and tormenting hags
To torture Don Lorenzo and the rest.
Yet lest the triple-headed porter[24] should
Deny my passage to the slimy strond,
The Thracian poet[25] thou shalt counterfeit.
Come on, old father, be my Orpheus,
And if thou canst[26] no notes upon the harp,
Then sound the burden of thy sore heart's grief,
Till we do gain that Proserpine may grant 120
Revenge on them that murderèd my son.
Then will I rent[27] and tear them thus and thus,
Shivering their limbs in pieces with my teeth.

Tear the papers.

 1. O sir, my declaration!
 Exit HIERONIMO *and they after.*
 2. Save my bond!

Enter HIERONIMO.

Save my bond!
 3. Alas, my lease! it cost me ten pound,
And you, my lord, have torn the same.
 Hier. That cannot be; I gave it never a wound;
Shew me one drop of blood fall from the same. 130
How is it possible I should slay it, then?
Tush, no; run after, catch me if you can.
 Exeunt all but the Old Man.

BAZULTO *remains till* HIERONIMO *enters again,
who, staring him in the face, speaks.*

 Hier. And art thou come, Horatio, from the depth,
To ask for justice in this upper earth?
To tell thy father thou art unrevenged,
To wring more tears from Isabella's eyes,
Whose lights are dimmed with over-long laments?
Go back my son, complain to Aeacus,
For here's no justice; gentle boy, be gone,
For justice is exilèd from the earth. 140
Hieronimo will bear thee company.
Thy mother cries on righteous Rhadamanth
For just revenge against the murderers.
 Senex. Alas, my lord, whence springs this troubled
 speech?
 Hier. But let me look on my Horatio.
Sweet boy, how art thou changed in death's black shade!
Had Proserpine no pity on thy youth?
But suffered thy fair crimson-colored spring
With withered winter to be blasted thus? 150
Horatio, thou art older than thy father.
Ah, ruthless fate, that favor[28] thus transforms!
 Senex. Ah, my good lord, I am not your young son.
 Hier. What, not my son? Thou, then, a Fury art,
Sent from the empty kingdom of black night
To summon me to make appearance
Before grim Minos and just Rhadamanth,
To plague Hieronimo that is remiss
And seeks not vengeance for Horatio's death.
 Senex. I am a grievèd man, and not a ghost,
That came for justice for my murdered son. 160
 Hier. Ay, now I know thee, now thou nam'st thy son,
Thou art the lively image of my grief;
Within thy face, my sorrows I may see.
Thy eyes are gummed with tears, thy cheeks are wan,
Thy forehead troubled, and thy mutt'ring lips
Murmur sad words abruptly broken off
By force of windy sighs thy spirit breathes;
And all this sorrow riseth for thy son;
And selfsame sorrow feel I for my son.
Come in, old man, thou shalt to Isabel;
Lean on my arm. I thee, thou me shalt stay,[29] 170
And thou, and I, and she, will sing a song,
Three parts in one, but all of discord framed.—
Talk not of cords, but let now be gone,
For with a cord Horatio was slain.

 Exeunt.

[III.xiv]

Enter KING *of Spain, the* DUKE, VICEROY, *and*
LORENZO, BALTHAZAR, DON PEDRO, *and*
BEL-IMPERIA.

 King. Go, brother, it is the Duke of Castile's cause;
Salute the viceroy in our name.
 Cast. I go.

[22] *Hieronimo . . . deep:* an obscure passage not satisfactorily
emended; the point is that Bazulto's grief puts Hieronimo to
shame for not having moved to revenge.
[23] *Alcides:* Hercules. [24] *triple-headed porter:* Cerberus.
[25] *Thracian poet:* Orpheus. [26] *canst:* knowest.
[27] *rent:* rend. [28] *favor:* countenance.
[29] *stay:* support.

Vice. Go forth, Don Pedro, for thy nephew's sake,
And greet the Duke of Castile.
 Pedro. It shall be so.
 King. And now to meet these Portuguese;
For as we now are, so sometime were these,
Kings and commanders of the western Indies.[1]
Welcome, brave viceroy, to the court of Spain,
And welcome, all his honorable train.
'Tis not unknown to us, for why you come, 10
Or have so kingly crossed the seas.[2]
Sufficeth it, in this we note the troth
And more than common love you lend to us.
So is it that mine honorable niece
(For it beseems us now that it be known)
Already is betrothed to Balthazar;
And by appointment and our condescent[3]
Tomorrow are they to be marrièd.
To this intent we entertain thyself,
Thy followers, their pleasure, and our peace. 20
Speak, men of Portingale, shall it be so?
If ay, say so; if not, say flatly no.
 Vice. Renownèd King, I come not as thou think'st,
With doubtful followers, unresolvèd men,
But such as have upon thine articles
Confirmed thy motion and contented me.
Know, sovereign, I come to solemnize
The marriage of thy belovèd niece,
Fair Bel-imperia, with my Balthazar—
With thee, my son, whom sith I live to see, 30
Here take my crown; I give it her and thee;
And let me live a solitary life,
In ceaseless prayers,
To think how strangely heaven hath thee preserved.
 King. See, brother, see, how nature strives in him!
Come, worthy viceroy, and accompany
Thy friend with thine extremities;[4]
A place more private fits this princely mood.
 Vice. Or[5] here or where you highness thinks it good.
 Exeunt all but CASTILE *and* LORENZO.
 Cast. Nat, stay, Lorenzo, let me talk with you. 40
Seest thou this entertainment of these kings?
 Lor. I do, my lord, and joy to see the same.
 Cast. And knowest thou why this meeting is?
 Lor. For her, my lord, whom Balthazar doth love,
And to confirm their promised marriage.
 Cast. She is thy sister?
 Lor. Who, Bel-imperia?
Ay, my gracious lord, and this is the day
That I have longed so happily to see.
 Cast. Thou wouldst be loath that any fault of thine
Should intercept[6] her in her happiness. 50

 Lor. Heavens will not let Lorenzo err[7] so much.
 Cast. Why then, Lorenzo, listen to my words:
It is suspected, and reported too,
That thou, Lorenzo, wrong'st Hieronimo,
And in his suits towards his majesty
Still keep'st him back, and seeks to cross his suit.
 Lor. That I, my lord—?
 Cast. I tell thee son, myself have heard it said,
When to my sorrow I have been ashamed 60
To answer for thee, though thou art my son.
Lorenzo, know'st thou not the common love
And kindness that Hieronimo hath won
By his deserts within the court of Spain?
Or seest thou not the King my brother's care
In his behalf, and to procure his health?
Lorenzo, shouldst thou thwart his passions,
And he exclaim against thee to the King,
What honor were't in this assembly,
Or what a scandal were't among the kings
To hear Hieronimo exclaim on thee? 70
Tell me, and look thou tell me truly too,
Whence grows the ground of this report in court?
 Lor. My lord, it lies not in Lorenzo's power
To stop the vulgar, liberal of[8] their tongues;
A small advantage[9] makes a water-breach,[10]
And no man lives that long contenteth all.
 Cast. Myself have seen thee busy to keep back
Him and his supplications from the King.
 Lor. Yourself, my lord, hath seen his passions,
That ill beseemed the presence of a king, 80
And for[11] I pitied him in his distress,
I held him thence with kind and courteous words,
As free from malice to Hieronimo
As to my soul, my lord.
 Cast. Hieronimo, my son, mistakes thee then.
 Lor. My gracious father, believe me so he doth.
But what's a silly[12] man, distract in mind,
To think upon the murder of his son?
Alas, how easy is it for him to err!
But for his satisfaction and the world's, 90
'Twere good, my lord, that Hieronimo and I
Were reconciled, if he misconster[13] me.
 Cast. Lorenzo, thou hast said; it shall be so.
Go one of you and call Hieronimo.

 Enter BALTHAZAR *and* BEL-IMPERIA.

 Balth. Come, Bel-imperia, Balthazar's content,
My sorrow's ease, and sovereign of my bliss,
Sith heaven hath ordained thee to be mine;
Disperse those clouds and melancholy looks,
And clear them up with those thy sun-bright eyes
Wherein my hope and heaven's fair beauty lies. 100
 Bel. My looks, my lord, are fitting for my love,
Which, new begun, can show no brighter yet.
 Balth. New-kindled flames should burn as morning
sun.
 Bel. But not too fast, lest heat and all be done.
I see my lord my father.
 Balth. Truce, my love,
I will go salute him.
 Cast. Welcome, Balthazar,

[1] *For . . . Indies:* a historical inaccuracy.
[2] *Or . . . seas:* a geographical inaccuracy.
[3] *condescent:* consent.
[4] *extremities:* extreme emotions.
[5] *Or:* Either. [6] *intercept:* interrupt, obstruct.
[7] *err:* go astray. [8] *liberal of:* free with.
[9] *advantage:* occasion, opportunity.
[10] *water-breach:* a break through which waters may flood.
[11] *for:* because. [12] *silly:* feeble-minded.
[13] *misconster:* misconstrue.

Welcome, brave prince, the pledge of Castile's peace;
And welcome Bel-imperia. How now, girl?
Why com'st thou sadly to salute us thus?
Content thyself, for I am satisfied. 110
It is not now as when Andrea lived;
We have forgotten and forgiven that,
And thou art gracèd with a happier love.
But Balthazar, here comes Hieronimo;
I'll have a word with him.

Enter HIERONIMO *and a* Servant.

Hier. And where's the duke?
Serv. Yonder.
Hier. Even so.
What new device have they devisèd, trow?[14]
Pocas palabras[15] mild as a lamb!
Is't I will be revenged? No, I am not the man.
Cast. Welcome, Hieronimo. 120
Lor. Welcome, Hieronimo.
Balth. Welcome, Hieronimo.
Hier. My lords, I thank you for Horatio.
Cast. Hieronimo, the reason that I sent
To speak with you, is this.
Hier. What, so short?
Then I'll be gone, I thank you for't.
Cast. Nay, stay, Hieronimo! Go call him, son.
Lor. Hieronimo, my father craves a word with you.
Hier. With me, sir? Why, my lord, I thought you
 had done.
Lor. No. [*Aside*] Would he had.—
Cast. Hieronimo, I hear
You find yourself aggrievèd at my son 131
Because you have not access unto the King,
And say 'tis he that intercepts your suits.
Hier. Why, is not this a miserable thing, my lord?
Cast. Hieronimo, I hope you have no cause,
And would be loath that one of your deserts
Should once have reason to suspect my son,
Considering how I think of you myself.
Hier. Your son Lorenzo? Whom, my noble lord?
The hope of Spain, mine honorable friend? 140
Grant me the combat of them, if they dare.

 Draws out his sword.

I'll meet him face to face to tell me so.
These be the scandalous reports of such
As love not me, and hate my lord too much.
Should I suspect Lorenzo would prevent[16]
Or cross my suit, that loved my son so well?
My lord, I am ashamed it should be said.
Lor. Hieronimo, I never gave you cause.
Hier. My good lord, I know you did not.
Cast. There then pause;[17]
And for the satisfaction of the world, 150
Hieronimo, frequent my homely[18] house,
The Duke of Castile, Cyprian's ancient seat,
And when thou wilt, use me, my son, and it;
But here, before Prince Balthazar and me,
Embrace each other, and be perfect friends.
Hier. Ay, marry my lord, and shall.
Friends, quoth he? See, I'll be friends with you all—

Specially with you, my lovely lord;
For divers causes it is fit for us
That we be friends; the world is suspicious, 160
And men may think what we imagine not.
Balth. Why, this is friendly done, Hieronimo.
Lor. And I hope that old grudges are forgot.
Hier. What else? It were a shame it should not be so.
Cast. Come on, Hieronimo, at my request;
Let us entreat your company today.
 Exeunt [all but HIERONIMO].
Hier. Your lordship's to command.—Pha! keep
 your way.
Chi mi fa più carezze che non suole,
Tradito mi ha, o tradir mi vuole.[19]

 Exit.

[III.xv]

Ghost [*of* ANDREA] *and* REVENGE.

Andr. Awake, Erichtho![1] Cerberus, awake!
Solicit Pluto, gentle Proserpine!
To combat, Acheron and Erebus!
For ne'er by Styx and Phlegethon in hell
Nor ferried Charon to the fiery lakes
Such fearful sights as poor Andrea sees![2]
Revenge, awake!
Rev. Awake? For why?
Andr. Awake, Revenge, for thou art ill-advised 10
To sleep away what[3] thou art warned to watch!
Rev. Content thyself, and do not trouble me.
Andr. Awake, Revenge, if love, as love hath had,
Have yet the power or prevalence[4] in hell!
Hieronimo with Lorenzo is joined in league
And intercepts our passage to revenge.
Awake, Revenge, or we are woe-begone!
Rev. Thus worldlings ground what they have dreamed
 upon.[5]
Content thyself, Andrea; though I sleep,
Yet is my mood[6] soliciting their souls. 20
Suffice thee that poor Hieronimo
Cannot forget his son Horatio.
Nor dies Revenge, although he sleep awhile;
For in unquiet, quietness is feigned,
And slumb'ring is a common worldly wile.
Behold, Andrea, for an instance, how

[14] *trow:* do you think.
[15] *Sp.:* few words.
[16] *prevent:* forestall, anticipate.
[17] *pause:* cease.
[18] *homely:* hospitable.
[19] *It.:* He who caresses me more than usual has betrayed
me or will betray me.

III.xv.
[1] *Erichtho:* a Thessalian sorceress.
[2] *Solicit ... sees:* corrupt text; suggested emendations
have included the possibility that a line is missing between
the third and fourth lines and alternately the substitution of
"O'er-ferried" for "Nor ferried."
[3] *what:* that is, the time.
[4] *prevalence:* the fact or action of prevailing.
[5] *ground ... upon:* build or base their beliefs on their
dreams. [6] *mood:* anger (or possibly thought).

Revenge hath slept, and then imagine thou
What 'tis to be subject to destiny.

Enter a Dumb Show.

Andr. Awake, Revenge, reveal this mystery.
Rev. The two first, the nuptial torches bore, 30
As brightly burning as the mid-day's sun;
But after them doth Hymen hie as fast,
Clothed in sable, and a saffron robe,
And blows them out and quencheth them with blood,
As discontent that things continue so.
Andr. Sufficeth me; thy meaning's understood,
And thanks to thee and those infernal powers
That will not tolerate a lover's woe.
Rest thee, for I will sit to see the rest.
Rev. Then argue not, for thou hast thy request. 40

ACT FOUR

SCENE ONE

Enter BEL-IMPERIA *and* HIERONIMO.

Bel. Is this the love thou bear'st Horatio?
Is this the kindness that thou counterfeits?
Are these the fruits of thine incessant tears?
Hieronimo, are these thy passions,
Thy protestations and thy deep laments,
That thou wert wont to weary men withal?
O unkind father, O deceitful world!
With what excuses canst thou show thyself,
From this dishonor and the hate of men,[1]
Thus to neglect the loss and life of him 10
Whom both my letters and thine own belief
Assures thee to be causeless slaughterèd.
Hieronimo, for shame, Hieronimo,
Be not a history to aftertimes
Of such ingratitude unto thy son.
Unhappy mothers of such children then,
But monstrous fathers, to forget so soon
The death of those whom they with care and cost
Have tendered[2] so, thus careless should be lost.
Myself, a stranger in respect of[3] thee, 20
So loved his life, as still I wish their deaths,
Nor shall his death be unrevenged by me,
Although I bear it out for fashion's sake;[4]
For here I swear, in sight of heaven and earth,
Shouldst thou neglect the love thou shouldst retain

And give it over and devise no more,
Myself should send their hateful souls to hell,
That wrought his downfall with extremest death.
 Hier. But may it be that Bel-imperia
Vows such revenge as she hath deigned to say? 30
Why then, I see that heaven applies our drift,[5]
And all the saints do sit soliciting
For vengeance on those cursèd murderers.
Madam, 'tis true, and now I find it so,
I found a letter, written in your name,
And in that letter, how Horatio died.
Pardon, oh, pardon, Bel-imperia,
My fear and care[6] in not believing it,
Nor think I thoughtless think upon a mean
To let his death be unrevenged at full, 40
And here I vow (so you but give consent,
And will conceal my resolution)
I will ere long determine of their deaths,
That causeless thus have murderèd my son.
 Bel. Hieronimo, I will consent, conceal,
And aught that many effect for thine avail,
Join with thee to revenge Horatio's death.
 Hier. On then; whatsoever I devise,
Let me entreat you grace[7] my practices;
For why,[8] the plot's already in mine head. 50
Here they are.

Enter BALTHAZAR *and* LORENZO.

Balth. How now, Hieronimo?
What, courting Bel-imperia?
 Hier. Ay, my lord,
Such courting as, I promise you,
She hath my heart, but you, my lord, have hers.
 Lor. But now, Hieronimo, or never,
We are to entreat your help.
 Hier. My help?
 Hier. Why, my good lords, assure yourselves of me,
For you have given me cause;
Ay, by my faith have you.
 Balth. It pleasèd you
At the entertainment of the ambassador 60
To grace[9] the King so much as with a show.
Now, were your study so well furnishèd,
As for the passing of the first night's sport
To entertain my father with the like,
Or any such-like pleasing motion,
Assure yourself it would content them well.
 Hier. Is this all?
 Balth. Ay, this is all.
 Hier. Why then I'll fit you,[10] say no more.
When I was young, I gave my mind 70
And plied myself to fruitless poetry;
Which, though it profit the professor naught,
Yet is it passing[11] pleasing to the world.
 Lor. And how for that?
 Hier. Marry, my good lord, thus—
And yet methinks you are too quick with us—
When in Toledo there I studied,
It was my chance to write a tragedy—
See here, my lords—

 He shows them a book.

IV.i.
 [1] The first nine lines are preceded in the quartos by "With what dishonor and the hate of men," a hodgepodge of fragments of the eighth and ninth lines apparently substituted by a careless compositor for a line now lost.
 [2] *tendered:* cherished. [3] *in . . . of:* compared to.
 [4] *bear . . . sake:* pretend to accept the situation for the sake of appearances.
 [5] *applies . . . drift:* supports our intention, or guides our course. [6] *care:* caution. [7] *grace:* support, favor.
 [8] *For why:* Because. [9] *grace:* honor.
 [10] *I'll fit you:* I'll provide you with what you need; or, I'll give you the punishment you deserve.
 [11] *passing:* extremely.

Which, long forgot, I found this other day.
Now would your lordships favor me so much 80
As but to grace me with your acting it—
I mean each one of you to play a part—
Assure you it will prove most passing strange
And wondrous plausible [12] to that assembly.
 Balth. What, would you have us play a tragedy?
 Hier. Why, Nero thought it no disparagement,
And kings and emperors have ta'en delight
To make experience [13] of their wits in plays!
 Lor. Nay, be not angry, good Hieronimo;
The prince but asked a question. 90
 Balth. In faith, Hieronimo, and [14] you be in earnest,
I'll make one.
 Lor. And I another.
 Hier. Now, my good lord, could you entreat
Your sister Bel-imperia to make one?
For what's a play without a woman in it?
 Bel. Little entreaty shall serve me, Hieronimo,
For I must needs be employèd in your play.
 Hier. Why, this is well; I tell you, lordings,
It was determined to have been acted 100
By gentlemen and scholars too,
Such as could tell what to speak.
 Balth. And now it shall be played by princes and
 courtiers,
Such as can tell how to speak,
If, as it is our country manner, [15]
You will but let us know the argument.
 Hier. That I shall I roundly. [16] The chronicles of
 Spain
Record this written of a knight of Rhodes: [17]
He was betrothed and wedded at the length
To one Perseda, an Italian dame, 110
Whose beauty ravished all that her beheld,
Especially the soul of Soliman, [18]
Who at the marriage was the chiefest guest.
By sundry means sought Soliman to win
Perseda's love, and could not gain the same.
Then gan he break his passions to a friend,
One of his bashaws [19] whom he held full dear;
Her had this bashaw long solicited,
And saw was she not otherwise to be won
But by her husband's death, this knight of Rhodes, 120
Whom presently by treachery he slew.
She, stirred with an exceeding hate therefore,
As cause of this slew Soliman,
And to escape the bashaw's tyranny
Did stab herself; and this the tragedy.
 Lor. Oh, excellent!
 Bel. But say, Hieronimo,
What then became of him that was the bashaw?
 Hier. Marry thus, movèd with remorse of his
 misdeeds,
Ran to a mountain top and hung himself.
 Balth. But which of us is to perform that part? 130
 Hier. Oh, that will I, my lords, make no doubt of it;
I'll play the murderer, I warrant you,
For I already have conceited [20] that.
 Balth. And what shall I?
 Hier. Great Soliman, the Turkish emperor.

 Lor. And I?
 Hier. Erastus, the knight of Rhodes.
 Bel. And I?
 Hier. Perseda, chaste and resolute.
And here, my lords, are several abstracts drawn, 140
For each of you to note your parts,
And act it as occasion's offered you.
You must provide a Turkish cap,
A black mustachio and a fauchion; [21]

 Gives a paper to BALTHAZAR.

You with a cross like to a knight of Rhodes;

 Gives another to LORENZO.

And madam, you must attire yourself

 He giveth BEL-IMPERIA *another.*

Like Phoebe, Flora, or the Huntress, [22]
Which to your discretion shall seem best.
And as for me, my lords, I'll look to one,
And with the ransom that the viceroy sent 150
So furnish and perform this tragedy,
As all the world shall say Hieronimo
Was liberal in gracing of it so.
 Balth. Hieronimo, methinks a comedy were better.
 Hier. A comedy?
Fie, comedies are fit for common wits;
But to present a kingly troop withal,
Give me a stately-written tragedy,
Tragedia cothurnata, [23] fitting kings,
Containing matter, and not common things. 160
My lords, all this must be performèd
As fitting for the first night's reveling.
The Italian tragedians were so sharp of wit,
That in one hour's meditation
They would perform anything in action. [24]
 Lor. And well it may, [25] for I have seen the like
In Paris, 'mongst the French tragedians.
 Hier. In Paris? Mass, [26] and well rememberèd!
There's one thing more that rests for us to do.
 Balth. What's that, Hieronimo? Forget not anything.
 Hier. Each one of us must act his part 171
In unknown languages,
That it may breed the more variety.
As you, my lord, in Latin, I in Greek,
You in Italian, and for because I know
That Bel-imperia hath practisèd the French,
In courtly French shall all her phrases be.
 Bel. You mean to try my cunning then, Hieronimo.

[12] *plausible:* deserving of applause.
[13] *experience:* trial. [14] *and:* if.
[15] *our . . . manner:* the manner of our country.
[16] *roundly:* directly. [17] *knight of Rhodes:* knight templar.
[18] *Soliman:* Sultan of the Turkish Empire, 1520–66.
[19] *bashaws:* pashas.
[20] *conceited:* formed the idea of.
[21] *fauchion:* falchion, a broad, curved sword.
[22] *Huntress:* Diana.
[23] *L.:* Buskined (i.e., high and stately) tragedy.
[24] *The . . . action:* an allusion to the traditionally improvised *commedia dell' arte.*
[25] *may:* may be so. [26] *Mass:* By the Mass.

Balth. But this will be a mere confusion,
And hardly[27] shall we all be understood. 180
 Hier. It must be so, for the conclusion
Shall prove the invention[28] and all was good:
And I myself, in an oration,
And with a strange and wondrous show besides,
That I will have there behind a curtain,
Assure yourself shall make the matter known.
And all shall be concluded in one scene,
For there's no pleasure ta'en in tediousness.
 Balth. [*Aside to* LORENZO] How like you this?
 Lor. Why thus, my lord, 190
We must resolve to soothe his humors up.[29]
 Balth. On then, Hieronimo, farewell till soon.
 Hier. You'll ply[30] this gear?
 Lor. I warrant you.
 Exeunt all but HIERONIMO.
 Hier. Why, so!
Now shall I see the fall of Babylon,[31]
Wrought by the heavens in this confusion.
And if the world like not this tragedy,
Hard is the hap of old Hieronimo.
 Exit.

[IV.ii]

Enter ISABELLA *with a weapon.*

 Isab. Tell me no more! Oh, monstrous homicides!
Since neither piety nor pity moves
The King to justice or compassion,
I will revenge myself upon this place
Where thus they murdered my beloved son.

 She cuts down the arbor.

Down with these branches and these loathsome boughs
Of this unfortunate and fatal pine;
Down with them, Isabella, rent them up
And burn the roots from whence the rest is sprung.
I will not leave a root, a stalk, a tree, 10
A bough, a branch, a blossom, nor a leaf,
No, not an herb within this garden plot—
Accursèd complot of my misery.
Fruitless for ever may this garden be,
Barren the earth, and blissless whosoever
Imagines not to keep it unmanured![1]
An eastern wind commixed with noisome airs
Shall blast the plants and the young saplings;
The earth with serpents shall be pesterèd,
And passengers,[2] for fear to be infect, 20

[27] *hardly:* with difficulty.
[28] *invention:* devising and treatment of the subject.
[29] *soothe . . . up:* indulge him in his whims.
[30] *ply:* proceed with.
[31] *fall of Babylon:* referring either to Revelation 18 or to the tower of Babel.

IV.ii.
[1] *unmanured:* uncultivated. [2] *passengers:* travelers.
[3] *cited:* summoned. [4] *hold excused:* make excuses for.

IV.iii.
[1] *knocks up:* probably, hangs up hastily.
[2] *title:* title-board. [3] *recompt:* recount.

Shall stand aloof, and, looking at it, tell,
"There, murdered, died the son of Isabel."
Ay, here he died, and here I him embrace.
See where his ghost solicits with his wounds
Revenge on her that should revenge his death.
Hieronimo, make haste to see thy son,
For sorrow and despair hath cited[3] me
To hear Horatio plead with Rhadamanth;
Make haste, Hieronimo, to hold excused[4]
Thy negligence in pursuit of their deaths, 30
Whose hateful wrath bereaved him of his breath.
Ah, nay, thou dost delay their deaths,
Forgives the murderers of thy noble son,
And none but I bestir me—to no end!
And as I curse this tree from further fruit,
So shall my womb be cursèd for his sake,
And with this weapon will I wound the breast,

 She stabs herself

The hapless breast, that gave Horatio suck.
 [*Exit.*]

[IV.iii]

Enter HIERONIMO; *he knocks up*[1] *the curtain.*
Enter the DUKE *of* CASTILE.

 Cast. How now, Hieronimo, where's your fellows,
That you take all this pain?
 Hier. O sir, it is for the author's credit
To look that all things may go well.
But good my lord, let me entreat your grace
To give the King the copy of the play;
This is the argument of what we show.
 Cast. I will, Hieronimo.
 Hier. One thing more, my good lord.
 Cast. What's that? 10
 Hier. Let me entreat your grace,
That when the train are passed into the gallery
You would vouchsafe to throw me down the key.
 Cast. I will, Hieronimo.
 Exit CASTILE.
 Hier. What, are you ready, Balthazar?
Bring a chair and a cushion for the King.

Enter BALTHAZAR *with a chair.*

Well done, Balthazar, hang up the title:[2]—
Our scene is Rhodes;—what, is your beard on?
 Balth. Half on, the other is in my hand.
 Hier. Dispatch for shame; are you so long? 20
 Exit BALTHAZAR.
Bethink thyself, Hieronimo,
Recall thy wits, recompt[3] thy former wrongs
Thou hast received by murder of thy son,
And lastly, not least, how Isabel,
Once his mother and thy dearest wife,
All woe-begone for him, hath slain herself.
Behoves thee then, Hieronimo, to be revenged.
The plot is laid of dire revenge.
On then, Hieronimo, pursue revenge,
For nothing wants but acting of revenge. 30
 Exit HIERONIMO.

[IV.iv]

Enter Spanish KING, VICEROY, *the* DUKE *of*
CASTILE, *and their train.*

King. Now, viceroy, shall we see the tragedy
Of Soliman the Turkish emperor,
Performed of pleasure by your son the prince,
My nephew, Don Lorenzo, and my niece.
 Vice. Who, Bel-imperia?
 King. Ay, and Hieronimo our marshal,
At whose request they deign to do't themselves.
These be our pastimes in the court of Spain.
Here, brother, you shall be the book-keeper;[1]
This is the argument of that they show. 10

He giveth him a book,

Gentlemen, this play of HIERONIMO *in sundry languages,
was thought good to be set down in English more largely,
for the easier understanding to every public reader.*

Enter BALTHAZAR, BEL-IMPERIA, *and*
HIERONIMO.

Balth. Bashaw, that Rhodes is ours, yield heavens the
 honor,
*And holy Mahomet, our sacred prophet;
And be thou graced with every excellence
That Soliman can give, or thou desire.
But thy desert in conquering Rhodes is less
Than in reserving this fair Christian nymph,
Perseda, blissful lamp of excellence,
Whose eyes compel, like powerful adamant,
The warlike heart of Soliman to wait.*
 King. See, viceroy, that is Balthazar your son 20
That represents the Emperor Soliman;
How well he acts his amorous passion.
 Vice. Ay, Bel-imperia hath taught him that.
 Cast. That's because his mind runs all on Bel-imperia.
 Hier. Whatever joy earth yields betide your majesty.
 Balth. Earth yields no joy without Perseda's love.
 Hier. Let then Perseda on your grace attend.
 *Balth. She shall not wait on me, but I on her.
Drawn by the influence of her lights, I yield.
But let my friend, the Rhodian knight, come forth,* 30
*Erasto, dearer than my life to me,
That he may see Perseda, my beloved.*

Enter ERASTO.

King. Here comes Lorenzo; look upon the plot,[2]
And tell me, brother, what part plays he?
 Bel. Ah, my Erasto, welcome to Perseda.
 *Lor. Thrice happy is Erasto that thou liv'st;
Rhodes' loss is nothing to Erasto's joy.
Sith his Perseda lives, his life survives.*
 *Balth. Ah, bashaw, here is love between Erasto
And fair Perseda, sovereign of my soul.* 40
 *Hier. Remove Erasto, mighty Soliman,
And then Perseda will be quickly won.*
 *Balth. Erasto is my friend, and while he lives
Perseda will remove her love.*
 Hier. Let not Erasto live to grieve great Soliman.

 Balth. Dear is Erasto in our princely eye.
 Hier. But if he be your rival, let him die.
 *Balth. Why, let him die, so love commandeth me.
Yet grieve I that Erasto should so die.*
 Hier. Erasto, Soliman saluteth thee, 50
*And lets thee wit[3] by me his highness' will,
Which is, thou shouldst be thus employed.*

Stab him.

 Bel. *Ay me,
Erasto! see, Soliman, Erasto's slain!*
 *Balth. Yet liveth Soliman to comfort thee.
Fair queen of beauty, let not favor die,
But with a gracious eye behold his grief,
That with Perseda's beauty is increased,
If by Perseda grief be not released.*
 *Bel. Tyrant, desist soliciting vain suits,
Relentless are mine ears to thy laments,* 60
*As thy butcher is pitiless and base,
Which seized on my Erasto, harmless knight,
Yet by thy power thou thinkest to command,
And to thy power Perseda doth obey;
But were she able, thus she would revenge
Thy treacheries on thee, ignoble prince;*

Stab him.

And on herself she would be thus revenged.

Stab herself.

 King. Well said,[4] old marshal, this was bravely done!
 Hier. But Bel-imperia plays Perseda well.
 Vice. Were this in earnest, Bel-imperia, 70
You would be better to my son than so.
 King. But now what follows for Hieronimo?
 Hier. Marry, this follows for Hieronimo:
Here break we off our sundry languages,
And thus conclude I in our vulgar tongue.
Haply you think, but bootless are your thoughts,
That this is fabulously[5] counterfeit,
And that we do as all tragedians do:
To die today, for fashioning our scene,
The death of Ajax, or some Roman peer, 80
And in a minute starting up again,
Revive to please tomorrow's audience.
No, princes, know I am Hieronimo,
The hopeless father of a hapless son,
Whose tongue is tuned to tell his latest tale,
Not to excuse gross errors in the play.
I see your looks urge instance[6] of these words;
Behold the reason urging me to this.

Shows his dead son.

See here my show, look on this spectacle.
Here lay my hope, and here my hope hath end; 90
Here lay my heart, and here my heart was slain;

IV.iv.
 [1] *book-keeper:* prompter.
 [2] *plot:* schematic outline of a play, held by the prompter,
indicating the assignment of parts and the speech and prop
cues. [3] *wit:* know. [4] *Well said:* Well done.
 [5] *fabulously:* as in a fiction. [6] *instance:* evidence.

Here lay my treasure, here my treasure lost;
Here lay my bliss, and here my bliss bereft;
But hope, heart, treasure, joy and bliss,
All fled, failed, died, yea, all decayed with this.
From forth these wounds came breath that gave me life;
They murdered me that made these fatal marks.
The cause was love, whence grew this mortal hate,
The hate, Lorenzo and young Balthazar,
The love, my son to Bel-imperia. 100
But night, the coverer of accursèd crimes,
With pitchy silence hushed these traitors' harms
And lent them leave, for thy had sorted[7] leisure
To take advantage in my garden plot
Upon my son, my dear Horatio.
There merciless they butchered up my boy,
In black dark night, to pale, dim, cruel death.
He shrieks; I heard, and yet methinks I hear,
His dismal outcry echo in the air.
With soonest speed I hasted to the noise, 110
Where hanging on a tree I found my son,
Through-girt[8] with wounds, and slaughtered as you
 see.
And grieved I, think you, at this spectacle?
Speak, Portuguese, whose loss resembles mine;
If thou canst weep upon thy Balthazar,
'Tis like I wailed for my Horatio.
And you, my lord, whose reconcilèd son
Marched in a net,[9] and thought himself unseen,
And rated me for brainsick lunacy,
With "God amend that mad Hieronimo!"— 120
How can you brook our play's catastrophe?
And here behold this bloody handkercher,
Which at Horatio's death I weeping dipped
Within the river of his bleeding wounds.
It[10] as propitious, see, I have reserved,
And never hath it left my bloody heart,
Soliciting remembrance of my vow
With these, oh, these accursèd murderers,
Which now performed, my heart is satisfied.
And to this end the bashaw I became 130
That might revenge me on Lorenzo's life,
Who therefore was appointed to the part
And was to represent the knight of Rhodes,
That I might kill him more conveniently.
So, viceroy, was this Balthazar, thy son,
That Soliman which Bel-imperia
In person of Perseda murderèd:
Solely appointed to that tragic part,
That she might slay him that offended her.
Poor Bel-imperia missed her part in this, 140
For though the story saith she should have died,
Yet I of kindness, and of care of her,
Did otherwise determine of her end;
But love of him whom they did hate too much
Did urge her resolution to be such.

And, princes, now behold Hieronimo,
Author and actor in this tragedy,
Bearing his latest fortune in his fist;
And will as resolute conclude his part
As any of the actors gone before.
And gentles, thus I end my play; 150
Urge no more words, I have no more to say.

He runs to hang himself.

 King. O hearken, viceroy! Hold, Hieronimo!
Brother, my nephew and thy son are slain!
 Vice. We are betrayed! My Balthazar is slain!
Break ope the doors, run, save Hieronimo!

[*They break in and hold* HIERONIMO.]

Hieronimo, do but inform the King of these events,
Upon mine honor thou shalt have no harm.
 Hier. Viceroy, I will not trust thee with my life,
Which I this day have offered to my son. 160
Accursèd wretch,
Why stayest thou him that was resolved to die?
 King. Speak, traitor; damnèd, bloody murderer,
 speak!
For now I have thee I will make thee speak:
Why hast thou done this undeserving deed?
 Vice. Why has thou murderèd my Balthazar?
 Cast. Why hast thou butchered both my children
 thus?
 Hier. Oh, good words!
As dear to me was my Horatio
As yours, or yours, or yours, my lord, to you 170
My guiltless son was by Lorenzo slain,
And by Lorenzo and that Balthazar
Am I at last revengèd thoroughly,
Upon whose souls may heavens be yet avenged
With greater far than these afflictions.
 Cast. But who were thy confederates in this?
 Vice. That was thy daughter Bel-imperia,
For by her hand my Balthazar was slain;
I saw her stab him.
 King. Why speak'st thou not?
 Hier. What lesser liberty can kings afford 180
Than harmless silence? Then afford it me.
Sufficeth I may not, nor I will not tell thee.
 King. Fetch forth the tortures.
Traitor as thou art, I'll make thee tell.
 Hier. Indeed,
Thou may'st torment me, as his wretched son
Hath done in murdering my Horatio,
But never shalt thou force me to reveal
The thing which I have vowed inviolate.
And therefore, in despite of all thy threats,
Pleased with their deaths, and eased with their revenge,
First take my tongue, and afterwards my heart. 191

He bites out his tongue.

[FIFTH ADDITION][11]

[*Hier.* But are you sure they are dead?
Cast. Ay, slave, too sure.

[7] *sorted:* chosen. [8] *Through-girt:* Pierced.
[9] *Marched in a net:* Acted deceitfully while pretending
innocence. [10] *It.:* object of "reserved."
[11] *Fifth Addition:* This passage substitutes for the lines of
the original text numbered 168–191 in the present edition,
incorporating a few of the original lines.

Hier. What, and yours too?

Vice. Ay, all are dead, not one of them survive.

Hier. Nay, then I care not, come, and we shall be
friends.
Let us lay our heads together;
See, here's a goodly noose will hold them all.

Vice. O damnèd devil, how secure [12] he is.

Hier. Secure? Why dost thou wonder at it?
I tell thee, viceroy, this day I have seen revenge, 200
And in that sight am grown a prouder monarch
Than ever sat under the crown of Spain.
Had I as many lives as there be stars,
As many heavens to go to as those lives,
I'd give them all, ay, and my soul to boot,
But I would see thee ride in this red pool.

Cast. Speak, who were thy confederates in this?

Vice. That was thy daughter Bel-imperia,
For by her hand my Balthazar was slain;
I saw her stab him.

Hier. O good words! 210
As dear to me was my Horatio,
As yours, or yours, or yours, my lord, to you.
My guiltless son was by Lorenzo slain,
And by Lorenzo and that Balthazar
Am I at last revengèd thoroughly,
Upon whose souls may heavens be yet revenged
With greater far than these afflictions.
Methinks since I grew inward [13] with revenge,
I cannot look with scorn enough on death.

King. What, dost thou mock us, slave? Bring
tortures forth! 220

Hier. Do, do, do, and meantime I'll torture you.
You had a son, as I take it; and your son
Should ha'been married to your daughter. Ha, was't
not so?
You had a son, too; he was my liege's nephew.
He was proud and politic; had he lived,
He might ha'come to wear the crown of Spain.
I think 'twas so: 'twas I that killèd him;
Look you, this same hand, 'twas it that stabbed
His heart—do you see this hand?—
For one Horatio, if you ever knew him, 230
A youth, one that they hanged up in his father's garden,
One that did force your valiant son to yield,
While your more valiant son did take him prisoner.

Vice. Be deaf, my senses, I can hear no more.

King. Fall, heaven, and cover us with thy sad ruins.

Cast. Roll all the world within thy pitchy cloud.

Hier. Now do I applaud what I have acted.
 Nunc iners cadat manus. [14]
Now to express the rupture of my part,
First take my tongue, and afterward my heart. 240

 He bites out his tongue.]

[END OF FIFTH ADDITION]

King. Oh, monstrous resolution of a wretch!
See, viceroy, he hath bitten forth his tongue
Rather than to reveal what we required.

Cast. Yet can he write.

King. And if in this he satisfy us not,
We will devise th' extremest kind of death
That ever was invented for a wretch.

 Then he makes signs for a knife to mend his pen.

Cast. Oh, he would have a knife to mend his pen.

Vice. Here, and advise thee that thou write the troth.

King. Look to my brother! Save Hieronimo. 250

 He with a knife stabs the DUKE *and himself.*

What age hath ever heard such monstrous deeds?
My brother, and the whole succeeding hope
That Spain expected after my decease!
Go bear his body hence, that we may mourn
The loss of our belovèd brother's death,
That he may be entombed whate'er befall.
I am the next, the nearest, last of all.

Vice. And thou, Don Pedro, do the like for us.
Take up our hapless son, untimely slain,
Set me with him, and he with woeful me, 260
Upon the mainmast of a ship unmanned,
And let the wind and tide haul me along
To Scylla's barking and untamèd gulf,
Or to the loathsome pool of Acheron,
To weep my want for my sweet Balthazar.
Spain hath no refuge for a Portingale.

 The trumpets sound a dead march, the KING *of* Spain
 mourning after his brother's body, and the KING *of*
 Portingale *bearing the body of his son.*

[IV.v]

Ghost [*of* ANDREA] *and* REVENGE.

Andr. Ay, now my hopes have end in their effects,
When blood and sorrow finish my desires:
Horatio murdered in his father's bower,
Vile Serberine by Pedringano slain,
False Pedringano hanged by quaint [1] device,
Fair Isabella by herself misdone,
Prince Balthazar by Bel-imperia stabbed,
The Duke of Castile and his wicked son
Both done to death by old Hieronimo,
My Bel-imperia fallen as Dido fell, 10
And good Hieronimo slain by himself:
Ay, these were spectacles to please my soul.
Now will I beg at lovely Proserpine,
That by the virtue of her princely doom
I may consort my friends in pleasing sort,
And on my foes work just and sharp revenge.
I'll lead my friend Horatio through those fields
Where never-dying wars are still inured [2]:
I'll lead fair Isabella to that train [3]
Where pity weeps but never feeleth pain; 20
I'll lead my Bel-imperia to those joys

[12] *secure:* self-confident. [13] *inward:* intimate.
[14] *L.:* Now let my hand fall idle.

IV.v.
 [1] *quaint:* ingenious. [2] *inured:* practiced.
 [3] *train:* way of life.

That vestal virgins and fair queens possess;
I'll lead Hieronimo where Orpheus plays,
Adding sweet pleasure to eternal days.
But say, Revenge, for thou must help or none,
Against the rest how shall my hate be shown?
 Rev. This hand shall hale them down to deepest hell,
Where none but furies, bugs[4] and tortures dwell.
 Andr. Then, sweet Revenge, do this at my request,
Let me be judge, and doom them to unrest. 30
Let loose poor Tityus[5] from the vulture's gripe,
And let Don Cyprian supply his room.[6]
Place Don Lorenzo on Ixion's wheel,
And let the lover's[7] endless pains surcease[8]
(Juno forgets old wrath and grants him ease);
Hang Balthazar about Chimaera's[9] neck,

And let him there bewail his bloody love,
Repining at our joys that are above.
Let Serberine go roll the fatal stone,
And take from Sisyphus[10] his endless moan. 40
False Pedringano, for his treachery,
Let him be dragged through boiling Acheron,
And there live, dying still in endless flames,
Blaspheming gods and all their holy names.
 Rev. Then haste we down to meet thy friends and
 foes,
To place thy friends in ease, the rest in woes;
For here though death hath end[11] their misery,
I'll there begin their endless tragedy.

 Exeunt.

[F I N I S]

 [4] *bugs:* bugbears.
 [5] *Tityus:* condemned to have two vultures tear at his liver in hell as punishment for assaulting Leto (a crime like that for which Ixion was punished).
 [6] *supply his room:* take his place.
 [7] *the lover:* Ixion (see note 19 to I.i.66).
 [8] *surcease:* end.
 [9] *Chimaera's:* Chimaera was a triple-bodied, fire-breathing monster.
 [10] *Sisyphus:* punished in Hades by having eternally to roll a rock up a hill from the top of which it always rolls down again. His crime seems to be connected with his having offended Zeus by telling Aesopus where Zeus had taken Aesopus's daughter. [11] *end:* ended.

Christopher Marlowe

[1564–1593]

TAMBURLAINE THE GREAT, PART I

CHRISTOPHER MARLOWE was born the same year as Shakespeare. His father, a prosperous shoemaker, sent him to the King's School in his native city of Canterbury, subsequently to Corpus Christi College, Cambridge, which granted him the B.A. in 1584, the M.A.—with prodding from the Privy Council—in 1587. The intervention of the Crown hints at the role of secret government agent he is supposed to have played in the last half dozen years of his brief career. Just what he was about in these years has never been established in circumstantial ways, despite the assiduous biographical labors of Leslie Hotson and other scholars. Perhaps he is to be seen as participating with Sir Walter Raleigh, the mathematician Thomas Harriot, and Henry Percy, the Wizard Earl of Northumberland, in a "School of Night" dedicated to atheistical, in any case arcane, speculation. But really there is no conclusive proof for the existence of such a school.

It is true, on the other hand, that Marlowe was execrated in his own time and later as a blasphemer, and that his annotations of a manuscript in the possession of his former roommate Thomas Kyd, in which he comments in scurrile ways on the character and divinity of Christ, brought about his arrest for heretical opinion in 1593. He was never brought to trial. At the end of May, while drinking at Madame Bull's tavern in Deptford, below London on the Thames, he was stabbed through the eye by a government employee named Ingram Frizar. The reasons for this murder remain obscure.

Marlowe left behind him seven plays, chiefly though not exclusively the fruit of his connection with the Earl of Nottingham's Men, known later as the Admiral's Men, one of the two most celebrated of Elizabethan acting companies. These plays, which revolutionized English drama, are the two parts of TAMBURLAINE (1587), THE JEW OF MALTA (about 1590), DOCTOR FAUSTUS (1592), EDWARD II (1591–92), *The Massacre at Paris* (printed about 1593 in a version that is almost certainly garbled and incomplete), and the tragedy of *Dido, Queen of Carthage* (printed in 1594 and written in collaboration with Thomas Nashe). Otherwise Marlowe survives in his translations of Ovid's love poems, the *Amores* (published about 1597), and the first book of Lucan's gory epic poem, the *Pharsalia* (published in 1600); in the short lyric—to which Raleigh wrote a mordant rejoinder—"The Passionate Shepherd to His Love" (printed in 1599); and in *Hero and Leander*, an unfinished paraphrase in couplets of the story of a famous pair of star-crossed lovers by the Greek poet Musaeus. Marlowe's *Hero and Leander* is sometimes deeply moving, often lubricious, witty, and comic. It

was completed by George Chapman and published with Chapman's continuation in 1598. The frequently reiterated conjectures that Marlowe had a hand in the writing of some of Shakespeare's earlier plays, such as *Titus Andronicus* and the three parts of *Henry VI*, remain conjectural.

Because Robert Greene, in preface to a work of 1588, refers to "that atheist *Tamburlan*," it is reasonable to date the play—perhaps both parts of it—not later than that year. If one allows time for composition and dissemination, then 1587, when Marlowe left Cambridge, seems a likely date for the writing of the play. Though Marlowe is not named unequivocally as author until the Restoration period, internal evidence—the strong and unmistakable marks of his greatness (and weakness) as playwright and poet—puts the issue beyond doubt.

The theatrical entrepreneur Philip Henslowe records in his diary fifteen performances of Part I and seven of Part II between the late summer of 1594 and the fall of 1595, evidence of extraordinary popularity. This evidence is supplemented by references to TAMBURLAINE by many of the major writers of the age, including Shakespeare, Jonson, Peele, Nashe, Dekker, Marston, Beaumont and Fletcher, Massinger, and Ford. Thomas Heywood, in a prologue (1633) to THE JEW OF MALTA, indicates that the role of Tamburlaine was played first by Edward Alleyn, the famous tragedian of the Lord Admiral's Men.

In the Stationers' Register for August 14, 1590, occurs the entry: "Richard Jones The two comical discourses of Tamburlaine the Scythian shepherd." Jones, if he in fact was the printer—and not Thomas Orwin, as some scholars have suggested—appears to have been in doubt as to the nature of the text he was preparing. The title page of the first edition, a blackletter octavo of 1590, speaks of "two Tragical Discourses." Confusion is compounded by a preface to the "Gentlemen Readers," in which the printer announces that he has omitted "some fond and frivolous gestures" as "far unmeet for the matter." It is possible, then, that what Marlowe wrote originally mingled burlesque comedy with tragedy in the way of the later version of DOCTOR FAUSTUS. See, for a vestige of this hypothetical original, the puerile discourse between Tamburlaine and Mycetes (II.iv).

The octavo of 1590 is extant in two copies, which differ only slightly from one another. Subsequent edions in octavo, reprinting the first edition and collecting both parts in one volume, appeared in 1593 and 1597. In 1605 and 1606, Parts I and II were issued in separate volumes. Differences among these various editions are

insignificant; the indicated copy text is therefore the first edition of 1590.

Throughout the sixteenth century numerous European writers, fascinated by the historical Tamerlane, Mongol conqueror and military genius (1336–1405), conspired to aggrandize his importance and blacken his character until he became identified in the popular imagination as "the scourge of God." This is the half-fabulous personage whom Marlowe inherited and whose legend he made immortal. His principal sources are the sixteenth-century historians Pedro Mexia, a Spaniard (as translated into English by George Whetstone in 1586), and Petrus Perodinus, an Italian writing in Latin (1553) and consulted presumably in the original. Mythological reference depends, as often, on Ovid's *Metamorphoses*. Much of the resonant topographical detail comes from the geographer Abraham Ortelius, whose atlases entitled *Theatrum Orbis Terrarum* were published in 1570. In one signal particular, Marlowe augments his sources: the character of Zenocrate is his own invention.

TAMBURLAINE is partly what T. S. Eliot called it: "pretty simple huffe-snuffe bombast." See, for corroboration, the description of "Boreas' boisterous blasts"

(II.iv). Its blank verse is often notably unsubtle, more sonorous than specific, marred by resort to rhyme or by the use of tautologies or unnecessary verbiage, essentially a means of eking out the iambic pentameter line. It is not difficult to lineate Marlowe's verse in this play, in contrast to the more crowded and nervous verse of his successors, for he is not much given to distributing —breaking up—single lines of pentameter between or among speakers. Here he is excessively regular. THE JEW OF MALTA, only a little later in time, shows how far he progressed in handling dramatic verse, and how quickly. When, however, all critical caveats have been uttered, any just critic will come down on the side of praise. We remember Marlowe, not least in his beginnings, as the triumphant contriver of the mighty line. His lapses are obvious. His achievement as a poet, no doubt more lyric than dramatic, is still occasion for wonderment. Shakespeare and the others—conspicuously Jonson, Chapman, and Webster—modify this achievement and give to blank verse the bent of their own genius, informed by a greater sophistication that is the yield of greater practice. They do not render the achievement obsolete.

R. A. F.

Tamburlaine the Great, Part I

TO THE GENTLEMEN READERS AND OTHERS THAT
TAKE PLEASURE IN READING HISTORIES

GENTLEMEN and courteous readers whosoever, I have here published in print for your sakes the two tragical discourses of the Scythian[1] shepherd Tamburlaine, that became so great a conqueror and so mighty a monarch. My hope is that they will be now no less acceptable unto you to read after your serious affairs and studies than they have been (lately) delightful for many of you to see when the same were showed in London upon stages. I have (purposely) omitted and left out some fond and frivolous gestures,[2] digressing 10 (and in my poor opinion) far unmeet[3] for the matter, which I thought might seem more tedious unto the wise than any way else to be regarded, though (haply)[4] they have been of[5] some vain, conceited[6] fondlings greatly gaped at, what times they were showed upon the stage in their graced deformities. Nevertheless now to be mixtured in print with such matter of worth, it would prove a great disgrace to so honorable and stately a history. Great folly were it in me to commend unto your wisdoms either the eloquence of the author that 20 writ them or the worthiness of the matter itself; I therefore leave unto your learned censures[7] both the one and the other and myself the poor printer of them unto your most courteous and favorable protection, which if you vouchsafe to accept, you shall evermore bind me to employ what travail and service I can to the advancing and pleasuring of your excellent degree.

Yours, most humble at commandment,
R. J., Printer.[8]

DRAMATIS PERSONÆ[1]

MYCETES, King of Persia
COSROE, his brother
ORTYGIUS ⎱
CENEUS ⎰
MEANDER ⎬ Persian Lords
MENAPHON ⎰
THERIDAMAS ⎱
TAMBURLAINE, a Scythian shepherd
TECHELLES ⎱ his followers
USUMCASANE ⎰
BAJAZETH, Emperor of the Turks
KING of ARABIA
KING of FEZ (Fesse)
KING of MOROCCUS

KING of ARGIER[2]
SOLDAN[3] of EGYPT
GOVERNOR of DAMASCUS
AGYDAS ⎱ Median Lords
MAGNETES ⎰
CAPOLIN, an Egyptian
PHILEMUS, a messenger.
ZENOCRATE, Daughter of the Soldan of Egypt
ANIPPE, her Maid
ZABINA, wife of Bajazeth
EBEA, her maid
Virgins of Damascus
Bassoes, Lords, Citizens, Moors, Soldiers, and Attendants

TO THE GENTLEMEN READERS
 [1] *Scythian:* Scythia was located by the sixteenth-century geographer Abraham Ortelius, whose maps Marlowe consulted, on the northern shore of the Black Sea.
 [2] *I . . . gestures:* The comic business to which the printer alludes may represent Marlowe's own work or the interpolations of actors. In any case, it does not survive.
 [3] *unmeet:* unsuitable. [4] *haply:* perhaps. [5] *of:* by.
 [6] *conceited:* puffed up by witless imagination.
 [7] *censures:* judgments.
 [8] *R. J., Printer:* Richard Jones worked as printer and bookseller between (roughly) 1564 and 1602.

DRAMATIS PERSONÆ
 [1] *Dramatis Personæ:* Adapted from the nineteenth-century editor Dyce; not given in the original text.
 [2] *Argier:* Algeria. [3] *Soldan:* Sultan.

THE PROLOGUE

From jigging veins of rhyming mother wits,[1]
And such conceits[2] as clownage keeps in pay,
We'll lead you to the stately tent of war,
Where you shall hear the Scythian Tamburlaine

Threatening the world with high astounding terms,
And scourging kingdoms with his conquering sword.
View but his picture in this tragic glass,
And then applaud his fortunes as you please.

ACT ONE

SCENE ONE

[*Enter*] MYCETES, COSROE, MEANDER,
THERIDAMAS, ORTYGIUS, CENEUS, MENAPHON,
with others.

Myc. Brother Cosroe, I find myself aggrieved,
Yet insufficient[1] to express the same,
For it requires a great and thundering speech:
Good brother, tell the cause unto my lords;
I know you have a better wit[2] than I.
Cos. Unhappy Persia, that in former age
Hast been the seat of mighty conquerors,
That, in their prowess and their policies,
Have triumphed over Afric and the bounds
Of Europe, where the sun dares scarce appear 10
For freezing meteors[3] and congealèd cold,
Now to be ruled and governed by a man
At whose birthday Cynthia with Saturn joined,
And Jove, the sun, and Mercury denied
To shed their influence in his fickle brain![4]
Now Turks and Tartars shake their swords at thee,
Meaning to mangle all thy provinces.
Myc. Brother, I see your meaning well enough,
And through your planets I perceive you think
I am not wise enough to be a king. 20
But I refer me to my noblemen
That know my wit, and can be witnesses.
I might command you to be slain for this.
Meander, might I not?
Meand. Not for so small a fault, my sovereign lord.
Myc. I mean it not, but yet I know I might;
Yet live; yea live. Mycetes wills it so.
Meander, thou, my faithful counselor,
Declare the cause of my conceivèd[5] grief,
Which is, God knows, about that Tamburlaine, 30
That, like a fox in midst of harvest time,
Doth prey upon my flocks of passengers,[6]
And, as I hear, doth mean to pull my plumes.
Therefore 'tis good and meet[7] for to be wise.
Meand. Oft have I heard your majesty complain
Of Tamburlaine, that sturdy Scythian thief,
That robs your merchants of Persepolis[8]
Trading by land unto the Western Isles,[9]
And in your confines[10] with his lawless train
Daily commits incivil[11] outrages, 40
Hoping (misled by dreaming[12] prophecies)
To reign in Asia, and with barbarous arms
To make himself the monarch of the East.
But ere he march in Asia, or display

His vagrant ensign[13] in the Persian fields,
Your grace hath taken order[14] by Theridamas,
Charged[15] with a thousand horse, to apprehend
And bring him captive to your highness' throne.
Myc. Full true thou speak'st, and like thyself, my
 lord,
Whom I may term a Damon[16] for thy love: 50
Therefore 'tis best, if so it like[17] you all,
To send my thousand horse incontinent[18]
To apprehend that paltry Scythian.
How like you this, my honorable lords?
Is it not a kingly resolution?
Cos. It cannot choose,[19] because it comes from you.
Myc. Then hear thy charge, valiant Theridamus,
The chiefest captain of Mycetes' host,
The hope of Persia, and the very legs
Whereon our state doth lean as on a staff, 60
That holds us up, and foils our neighbor foes
Thou shalt be leader of this thousand horse,
Whose foaming gall[20] with rage and high disdain
Have sworn the death of wicked Tamburlaine.
Go frowning forth; but come thou smiling home,
As did Sir[21] Paris with the Grecian dame.[22]
Return with speed—time passeth swift away;
Our life is frail, and we may die today.

THE PROLOGUE
 [1] *jigging. . . wits:* clumsy verses of "old-fashioned" play-
wrights like Kyd and Thomas Preston.
 [2] *conceits:* here "foolish antics."

I.i.
 [1] *insufficient:* inadequate. [2] *wit:* rational faculty.
 [3] *meteors:* used generically for atmospheric disturbances
such as snowstorms.
 [4] *At . . . brain:* Because Cynthia, the proverbially un-
stable moon, and Saturn, whose "influence" was understood
by astrologers to make for dullness or torpor, were in "con-
junction" when Mycetes was born, he partakes of the un-
fortunate character of these planets, rather than the regality
and brightness of the sun and the quickness of Mercury.
 [5] *conceivèd:* that which takes hold of or affects.
 [6] *passengers:* traders and travelers.
 [7] *meet:* fitting. [8] *Persepolis:* ancient capital of Persia.
 [9] *Western Isles:* Great Britain. [10] *confines:* territories.
 [11] *incivil:* violent. [12] *dreaming:* i.e., wide of the mark.
 [13] *vagrant ensign:* wandering banner or flag.
 [14] *taken order:* provided. [15] *Charged:* Entrusted.
 [16] *Damon:* proverbial for his friendship with Pythias.
 [17] *like:* please. [18] *incontinent:* at once.
 [19] *choose:* i.e., but be.
 [20] *gall:* bile; by transference, "asperity."
 [21] *Sir:* in Elizabethan usage, applied conventionally to
notable historical persons.
 [22] *Grecian dame:* Helen of Troy, stolen by Paris from her
husband, Menelaus.

Ther. Before the moon renew her borrowed [23]
 light,
Doubt not, my lord and gracious sovereign, 70
But Tamburlaine and the Tartarian [24] rout, [25]
Shall either perish by our warlike hands,
Or plead for mercy at your highness' feet.
 Myc. Go, stout Theridamas, thy words are swords,
And with thy looks thou conquerest all thy foes.
I long to see thee back return from thence,
That I may view these milk-white steeds of mine
All loaden with the heads of killèd men,
And from their knees even to their hoofs below
Besmeared with blood that makes a dainty show. 80
 Ther. Then now, my lord, I humbly take my leave.
 Myc. Theridamas, farewell ten thousand times.
 [*Exit* THERIDAMAS.]
Ah, Menaphon, why stayest thou thus behind,
When other men press forward for renown?
Go, Menaphon, go into Scythia,
And foot by foot follow Theridamas.
 Cos. Nay, pray you let him stay; a greater [task] [26]
Fits Menaphon than warring with a thief:
Create him Prorex [27] of all Africa,
That he may win the Babylonians' hearts 90
Which will revolt from Persian government,
Unless they have a wiser king than you.
 Myc. "Unless they have a wiser king than you."
These are his words, Meander, set them down.
 Cos. And add this to them—that all Asia
Laments to see the folly of their King.
 Myc. Well, here I swear by this my royal seat—
 Cos. You may do well to kiss it then.
 Myc. Embossed [28] with silk as best beseems [29] my
 state,
To be revenged for these contemptuous words. 100
Oh, where is duty and allegiance now?
Fled to the Caspian or the Ocean main?
What, shall I call thee brother?—no, a foe,
Monster of nature!—Shame unto thy stock

That darest presume thy sovereign for to mock!
Meander, come: I am abused, Meander.
 Exit [with MEANDER].

 Manent [30] COSROE and MENAPHON.

 Men. How now, my lord? What, mated [31] and
 amazed
To hear the King thus threaten like himself!
 Cos. Ah, Menaphon, I pass not [32] for his threats.
The plot is laid by Persian noblemen 110
And captains of the Median garrisons
To crown me Emperor of Asia.
But this it is that doth excruciate
The very substance of my vexèd soul—
To see our neighbors that were wont [33] to quake
And tremble at the Persian monarch's name,
Now sits and laughs [34] our regiment [35] to scorn;
And that which might resolve [36] me into tears,
Men from the farthest equinoctial [37] line
Have swarmed in troops into the Eastern India, 120
Lading [38] their ships with gold and precious stones,
And made their spoils from all our provinces.
 Men. This should entreat [39] your highness to rejoice,
Since fortune gives you opportunity
To gain the title of a conqueror
By curing of this maimèd empery. [40]
Afric and Europe bordering on your land,
And continent to [41] your dominions,
How easily may you, with a mighty host,
Pass into Graecia, as did Cyrus [42] once, 130
And cause them to withdraw their forces home,
Lest you subdue the pride of Christendom!

 [*Trumpet within.*]

 Cos. But, Menaphon, what means this trumpet's
 sound?
 Men. Behold, my lord, Ortygius and the rest
Bringing the crown to make you Emperor!

 Enter ORTYGIUS *and* CENEUS, *bearing a crown,*
 with others.

 Orty. Magnificent and mighty Prince Cosroe,
We, in the name of other Persian states [43]
And commons [44] of this mighty monarchy,
Present thee with th' imperial diadem.
 Cen. The warlike soldiers and the gentlemen, 140
That heretofore have filled Persepolis
With Afric captains taken in the field,
Whose ransom made them march in coats of gold,
With costly jewels hanging at their ears,
And shining stones upon their lofty crests,
Now living idle in the wallèd towns,
Wanting both pay and martial discipline,
Begin in troops to threaten civil war,
And openly exclaim against the King.
Therefore, to stop all sudden mutinies, 150
We will invest your highness Emperor,
Whereat the soldiers will conceive more joy
Than did the Macedonians at the spoil
Of great Darius and his wealthy host. [45]
 Cos. Well, since I see the state of Persia droop

[23] *borrowed:* as from the sun.
[24] *Tartarian:* essentially synonymous with "Scythian," though the medieval Tartar or Mongol Empire extended over much of northern and central Asia.
[25] *rout:* rabble.
[26] *task:* The last word in this line, supplied by the nineteenth-century editor G. Robinson, is omitted in the earliest editions.
[27] *Prorex:* Viceroy.
[28] *Embossed:* Padded.
[29] *beseems:* befits.
[30] *Manent:* Remain.
[31] *mated:* confounded.
[32] *pass not:* care not.
[33] *wont:* accustomed.
[34] *sits and laughs:* governed by the substantive "neighbors," construed grammatically as singular.
[35] *regiment:* government.
[36] *resolve:* dissolve.
[37] *equinoctial:* equatorial.
[38] *Lading:* Loading.
[39] *entreat:* impel.
[40] *empery:* sovereignty.
[41] *continent to:* like "bordering on," above.
[42] *Cyrus:* founder of the Persian Empire and conqueror of the Greek cities of Asia Minor.
[43] *states:* potentates, men of high estate.
[44] *commons:* common people.
[45] *Than . . . host:* comparison is to the victory of Alexander the Great over Darius of Persia at the battle of Issus, 333 B.C.

And languish in my brother's government,
I willingly receive th' imperial crown,
And vow to wear it for my country's good,
In spite of them shall malice[46] my estate.

 Orty. And, in assurance of desired success, 160
We here do crown thee Monarch of the East,
Emperor of Asia and of Persia,
Great Lord of Media and Armenia,
Duke of Africa and Albania,
Mesopotamia and of Parthia,
East India and the late-discovered isles,
Chief Lord of all the wide, vast Euxine sea,
And of the ever-raging Caspian lake.[47]
Long live Cosroe, mighty Emperor!

 Cos. And Jove may[48] never let me longer live 170
Than I may seek to gratify[49] your love,
And cause the soldiers that thus honor me
To triumph over many provinces!
By whose desires of discipline in arms
I doubt not shortly but to reign sole king,
And with the army of Theridamas,
Whither we presently[50] will fly, my lords,
To rest secure against my brother's force.

 Orty. We knew, my lord, before we brought the
 crown,
Intending your investion[51] so near 180
The residence of your despisèd brother,
The lords would not be too exasperate[52]
To injure or suppress your worthy title.
Or, if they would, there are in readiness
Ten thousand horse to carry you from hence,
In spite of all suspected enemies.

 Cos. I know it well, my lord, and thank you all.

 Orty. Sound up the trumpets, then. God save the
 King!

 Exeunt.

I.ii

 [*Enter*] TAMBURLAINE *leading* ZENOCRATE,
 [*followed by*] TECHELLES, USUMCASANE,
 AGYDAS, MAGNETES], *others* Lords *and* Soldiers,
 loaden with treasure.

 Tamb. Come, lady, let not this appall your thoughts;
The jewels and the treasure we have ta'en
Shall be reserved,[1] and you in better state[2]
Than if you were arrived in Syria,
Even in the circle of your father's arms,
The mighty Soldan of Egyptia.

 Zeno. Ah, shepherd! pity my distressèd plight!
(If, as thou seem'st, thou art so mean[3] a man)
And seek not to enrich thy followers
By lawless rapine from a silly[4] maid, 10
Who traveling with these Median lords
To Memphis, from my uncle's country of Media,
Where all my youth I have been governèd,
Have passed the army of the mighty Turk,
Bearing his privy signet and his hand[5]
To safe[6] conduct us thorough[7] Africa.

 Mag. And since we have arrived in Scythia,
Besides rich presents from the puissant Cham,

We have his highness' letters to command
Aid and assistance, if we stand in need. 20

 Tamb. But now you see these letters and commands
Are countermanded by a greater man;
And through my provinces you must expect
Letters of conduct from my mightiness,
If you intend to keep your treasure safe.
But since I love to live at liberty,
As easily may you get the Soldan's crown
As any prizes out of my precinct.[8]
For they are friends that help to wean[9] my state
Till men and kingdoms help to strengthen it, 30
And must maintain my life exempt from servitude.
But, tell me, madam, is your grace betrothed?

 Zeno. I am—my lord—for so you do import.

 Tamb. I am a lord, for so my deeds shall prove,
And yet a shepherd by my parentage.
But, lady, this fair face and heavenly hue
Must grace his bed that conquers Asia,
And means to be a terror to the world,
Measuring the limits of his empery
By east and west, as Phoebus doth his course.[10] 40
Lie here ye weeds[11] that I disdain to wear!
This complete armor and this curtle-ax[12]
Are adjuncts more beseeming[13] Tamburlaine.
And, madam, whatsoever you esteem
Of this success[14] and loss unvaluèd,[15]
Both may invest you Empress of the East.
And these that seem but silly[16] country swains
May have the leading of so great an host,
As with their weight shall make the mountains quake,
Even as when windy exhalations, 50
Fighting for passage, tilt within the earth.[17]

 Tech. As princely lions, when they rouse themselves,
Stretching their paws, and threatening herds of beasts,
So in his armor looketh Tamburlaine.
Methinks I see kings kneeling at his feet,
And he with frowning brows and fiery looks,
Spurning their crowns from off their captive heads.

 Usum. And making thee and me, Techelles, kings,
That even to death will follow Tamburlaine.

 Tamb. Nobly resolved, sweet friends and followers!
These lords perhaps do scorn our estimates, 61

46 *shall malice:* who shall grudge.
47 *Emperor . . . lake:* Marlowe is following Ortelius but, as often, more for resonance than specificity.
48 *And Jove may:* And may Jove.
49 *gratify:* recompense. 50 *presently:* immediately.
51 *investion:* investiture; pronounced as four syllables.
52 *exasperate:* exasperated.

I.ii.
1 *reserved:* kept back. 2 *better state:* i.e., statelier.
3 *mean:* of low estate. 4 *silly:* innocent, helpless.
5 *privy . . . hand:* document sealed and signed by the ruler himself.
6 *safe:* as adverb. 7 *thorough:* through.
8 *precinct:* dominion. 9 *wean:* develop.
10 *Measuring . . . course:* Tamburlaine will control all the world on which the sun shines.
11 *weeds:* clothing. 12 *curtle-ax:* short curved sword.
13 *beseeming:* befitting. 14 *success:* result.
15 *unvaluèd:* invaluable. 16 *silly:* here "lowly."
17 *Even . . . earth:* like earthquakes.

And think we prattle with distempered [18] spirits.
But since they measure our deserts so mean,
That in conceit [19] bear empires on our spears,
Affecting thoughts coequal with the clouds,
They shall be kept our forcèd followers,
Till with their eyes they view us emperors.
 Zeno. The gods, defenders of the innocent,
Will never prosper your intended drifts, [20]
That thus oppress poor friendless passengers. 70
Therefore at least admit us liberty,
Even as thou hopest to be eternizèd, [21]
By living Asia's mighty Emperor.
 Agyd. I hope our ladies' treasure and our own,
May serve for ransom to [22] our liberties:
Return our mules and empty camels back,
That we may travel into Syria,
Where her betrothèd Lord Alcidamas,
Expects th' arrival of her highness' person.
 Mag. And wheresoever we repose ourselves, 80
We will report but [23] well of Tamburlaine.
 Tamb. Disdains Zenocrate to live with me?
Or you, my lords, to be my followers?
Think you I weigh this treasure more than you?
Not all the gold in India's wealthy arms
Shall buy the meanest soldier in my train.
Zenocrate, lovelier than the love of Jove,
Brighter than is the silver Rhodope, [24]
Fairer than whitest snow on Scythian hills,
Thy person is more worth to Tamburlaine 90
Than the possession of the Persian crown,
Which gracious stars have promised at my birth.
A hundred Tartars shall attend on thee,
Mounted on steeds swifter than Pegasus. [25]
Thy garments shall be made of Median silk,
Enchased [26] with precious jewels of mine own,
More rich and valurous [27] than Zenocrate's.
With milk-white harts upon an ivory sled,
Thou shalt be drawn amidst the frozen pools,
And scale the icy mountains' lofty tops, 100
Which with thy beauty will be soon resolved. [28]
My martial prizes with five hundred men,
Won on the fifty-headed [29] Volga's waves,
Shall all we offer to Zenocrate,
And then myself to fair Zenocrate.

 [18] *distempered:* sick (with foolish expectation).
 [19] *conceit:* imagination. [20] *drifts:* designs.
 [21] *eternizèd:* immortalized. [22] *to:* for.
 [23] *but:* only.
 [24] *silver Rhodope:* snow-capped mountains of Thrace;
"silver" also because of their mines.
 [25] *Pegasus:* the winged horse of Greek antiquity.
 [26] *Enchased:* Adorned. [27] *valurous:* valuable.
 [28] *resolved:* thawed.
 [29] *fifty-headed:* reference is to the sources of the river;
by transference, to its tributaries.
 [30] *Soft ye:* scornfully—"Just a moment."
 [31] *exceeding brave:* exceedingly splendid.
 [32] *top:* so in O4; most editors prefer "foot," the reading of
the first three editions.
 [33] *alarum:* attack. [34] *mails:* baggage.
 [35] *lanch:* lance, cut. [36] *bide:* abide, confront.
 [37] *brunt:* assault.
 [38] *furniture:* furnishings, accouterments.

 Tech. What now!—in love?
 Tamb. Techelles, women must be flatterèd.
But this is she with whom I am in love.

 Enter a Soldier.

 Sold. News! news!
 Tamb. How now—what's the matter? 110
 Sold. A thousand Persian horsemen are at hand,
Sent from the King to overcome us all.
 Tamb. How now, my lords of Egypt, and Zenocrate!
Now must your jewels be restored again,
And I, that triumphed so, be overcome.
How say you, lordings, is not this your hope?
 Agyd. We hope yourself will willingly restore them.
 Tamb. Such hope, such fortune, have the thousand
 horse.
Soft ye, [30] my lords, and sweet Zenocrate!
You must be forcèd from me ere you go. 120
A thousand horsemen! We five hundred foot!
An odds too great for us to stand against.
But are they rich?—and is their armor good?
 Sold. Their plumèd helms are wrought with beaten
 gold,
Their swords enameled, and about their necks
Hangs massy chains of gold, down to the waist,
In every part exceeding brave [31] and rich.
 Tamb. Then shall we fight courageously with them?
Or look you I should play the orator?
 Tech. No: cowards and faint-hearted runaways 130
Look for orations when the foe is near.
Our swords shall play the orators for us.
 Usum. Come! let us meet them at the mountain top, [32]
And with a sudden and an hot alarum, [33]
Drive all their horses headlong down the hill.
 Tech. Come, let us march!
 Tamb. Stay, Techelles! ask a parley first.

 The Soldiers *enter.*

Open the mails, [34] yet guard the treasure sure;
Lay out our golden wedges to the view,
That their reflections may amaze the Persians. 140
And look we friendly on them when they come;
But if they offer word or violence,
We'll fight five hundred men at arms to one,
Before we part with our possession.
And 'gainst the general we will lift our swords,
And either lanch [35] his greedy thirsting throat,
Or take him prisoner, and his chain shall serve
For manacles, till he be ransomed home.
 Tech. I hear them come; shall we encounter them?
 Tamb. Keep all your standings and not stir a foot,
Myself will bide [36] the danger of the brunt. [37] 151

 Enter THERIDAMAS *with others.*

 Ther. Where is this Scythian Tamburlaine?
 Tamb. Whom seekest thou, Persian? I am
 Tamburlaine.
 Ther. Tamburlaine!—
A Scythian shepherd so embellishèd
With nature's pride and richest furniture! [38]
His looks do menace heaven and dare the gods.

His fiery eyes are fixed upon the earth,
As if he now devised some stratagem,
Or meant to pierce Avernus'[39] darksome vaults 160
To pull the triple-headed dog[40] from hell.
 Tamb. Noble and mild this Persian seems to be,
If outward habit judge the inward man.
 Tech. His deep affections[41] make him passionate.
 Tamb. With what a majesty he rears his looks!
In thee, thou valiant man of Persia,
I see the folly of thy Emperor.
Art thou but captain of a thousand horse,
That by charàcters graven in thy brows,
And by thy martial face and stout aspèct,[42] 170
Deserv'st to have the leading of an host?
Forsake thy King, and do but join with me,
And we will triumph over all the world.
I hold the fates bound fast in iron chains,
And with my hand turn fortune's wheel about:
And sooner shall the sun fall from his sphere[43]
Than Tamburlaine be slain or overcome.
Draw forth thy sword, thou mighty man at arms,
Intending but to raze[44] my charmèd skin,
And Jove himself will stretch his hand from heaven
To ward the blow and shield me safe from harm. 181
See how he rains down heaps of gold in showers,
As if he meant to give my soldiers pay!
And as a sure and grounded argument,
That I shall be the monarch of the East,
He sends this Soldan's daughter rich and brave,
To be my Queen and portly Emperess.[45]
If thou wilt stay with me, renownèd[46] man,
And lead thy thousand horse with my condùct,[47]
Besides thy share of this Egyptian prize, 190
Those thousand horse shall sweat with martial spoil
Of conquered kingdoms and of cities sacked.
Both we will walk upon the lofty clifts,[48]
And Christian merchants[49] that with Russian stems[50]
Plough up huge furrows in the Caspian Sea,
Shall vail[51] to us, as lords of all the lake.
Both we will reign as consuls of the earth,
And mighty kings shall be our senators.
Jove sometimes maskèd in a shepherd's weed,[52]
And by those steps that[53] he hath scaled the heavens
May we become immortal like the gods. 201
Join with me now in this my mean estate,
(I call it mean because, being yet obscure,
The nations far removed admire me not,)
And when my name and honor shall be spread
As far as Boreas[54] claps his brazen wings,
Or fair Böotes[55] sends his cheerful light,
Then shalt thou be competitor[56] with me,
And sit with Tamburlaine in all his majesty.
 Ther. Not Hermes, prolocutor[57] to the gods, 210
Could use persuasions more pathetical.[58]
 Tamb. Nor are Apollo's oracles[59] more true,
Than thou shalt find my vaunts substantial.
 Tech. We are his friends, and if the Persian King
Should offer present[60] dukedoms to our state,[61]
We think it loss to make exchange for that[62]
We are assured of by our friend's success.
 Usum. And kingdoms at the least we all expect,

Besides the honor in assurèd conquests,
Where kings shall crouch unto our conquering
 swords 220
And hosts of soldiers stand amazed at us;
When with their fearful[63] tongues they shall confess,
These are the men that all the world admires.
 Ther. What strong enchantments tice[64] my yielding
 soul!
Are these resolvèd noble Scythians![65]
But shall I prove a traitor to my King?
 Tamb. No, but the trusty friend of Tamburlaine.
 Ther. Won with thy words, and conquered with thy
 looks,
I yield myself, my men, and horse to thee,
To be partaker of thy good or ill, 230
As long as life maintains Theridamas.
 Tamb. Theridamas, my friend, take here my hand,
Which is as much as if I swore by heaven,
And called the gods to witness of my vow.
Thus shall my heart be still[66] combined with thine
Until our bodies turn to elements,[67]
And both our souls aspire[68] celestial thrones.
Techelles and Casane, welcome him!
 Tech. Welcome, renownèd Persian, to us all!
 Usum. Long may Theridamas remain with us! 240
 Tamb. These are my friends, in whom I more
 rejoice
Than doth the King of Persia in his crown,
And by the love of Pylades[69] and Orestes,
Whose statues we adore in Scythia,
Thyself and them shall never part from me

[39] *Avernus':* entrance to the underworld.
[40] *triple-headed dog:* Cerberus, who guarded the entrance to Hades, and whose abduction was one of the twelve labors assigned to Hercules, to whom Tamburlaine is inferentially compared.
[41] *affections:* feelings. [42] *stout aspèct:* bold looks.
[43] *sphere:* orbit, transparent but solid, like a circular tube girdling the earth.
[44] *raze:* graze. [45] *portly Emperess:* stately Empress.
[46] *renownèd:* renowned.
[47] *with my condùct:* under my generalship.
[48] *clifts:* cliffs. [49] *merchants:* merchantmen.
[50] *stems:* prows.
[51] *vail:* lower their topsails out of respect.
[52] *sometimes . . . weed:* in former times disguised himself in shepherd's clothing.
[53] *that:* by which. [54] *Boreas:* the North Wind.
[55] *Böotes:* the Bear, a northern constellation.
[56] *competitor:* comrade.
[57] *prolocutor:* spokesman or herald.
[58] *pathetical:* moving.
[59] *Apollo's oracles:* prophecies of the "oracular" god.
[60] *present:* immediate. [61] *to our state:* for our position.
[62] *that:* that which. [63] *fearful:* full of fear.
[64] *tice:* entice.
[65] *Are . . . Scythians!:* presumably a statement expressing admiration, and making easier sense if read "These are," etc. Editors conjecture "Ah" or "As" for "Are."
[66] *still:* always.
[67] *elements:* Medieval physiology constituted the universe and everything in it of the four elements of earth, air, fire, and water—to which the body returns as it decays.
[68] *aspire:* ascend to.
[69] *Pylades:* who helped his friend Orestes avenge the murder of the latter's father by Clytemnestra.

Before I crown you kings of Asia.
Make much of them, gentle Theridamas,
And they will never leave thee till the death.
 Ther. Nor thee nor them, thrice noble Tamburlaine,
Shall want my heart to be with gladness pierced,[70] 250
To do you honor and security.[71]
 Tamb. A thousand thanks, worthy Theridamas.
And now fair madam, and my noble lords,
If you will willingly remain with me
You shall have honors as your merits be;
Or else you shall be forced with slavery.
 Agyd. We yield unto thee, happy Tamburlaine.
 Tamb. For you then, madam, I am out of doubt.
 Zeno. I must be pleased perforce.[72] Wretched
 Zenocrate!
 Exeunt.

ACT TWO

SCENE I

[*Enter*] COSROE, MENAPHON, ORTYGIUS, *and*
 CENEUS, *with other* Soldiers.

 Cos. Thus far are we towards Theridamas,
And valiant Tamburlaine, the man of fame,
The man that in the forehead of his fortune
Bears figures of[1] renown and miracle.
But tell me, that[2] hast seen him, Menaphon,
What stature wields he, and what personage?
 Men. Of stature tall, and straightly fashionèd,
Like his desire lift[3] upwards and divine;
So large of limbs, his joints so strongly knit,

Such breadth of shoulders as might mainly[4] bear 10
Old Atlas'[5] burthen; 'twixt his manly pitch,[6]
A pearl,[7] more worth than all the world, is placed,
Wherein by curious[8] sovereignty of art
Are fixed his piercing instruments of sight,
Whose fiery circles bear encompassèd
A heaven of heavenly bodies in their spheres,
That guides his steps and actions to the throne,[9]
Where honor sits invested royally:
Pale of complexion, wrought in him with passion,
Thirsting with sovereignty and love of arms; 20
His lofty brows in folds[10] do figure death,
And in their smoothness amity and life;
About them hangs a knot of amber hair,
Wrappèd in curls, as fierce Achilles' was,
On which the breath of heaven delights to play,
Making it dance with wanton[11] majesty.
His arms and fingers, long, and snowy[12]
Betokening valor and excess of strength—
In every part proportioned like the man
Should[13] make the world subdued to Tamburlaine. 30
 Cos. Well hast thou portrayed in thy terms of life[14]
The face and personage of a wondrous man;
Nature doth strive with fortune and his stars[15]
To make him famous in accomplished worth;
And well his merits show him to be made
His fortune's master and the king of men,
That could persuade at such a sudden pinch,
With reasons of his valor and his life,
A thousand sworn and overmatching foes. 39
Then, when our powers in points of swords are joined,
And closed in compass[16] of the killing bullet,
Though strait the passage and the port[17] be made
That leads to palace of my brother's life,
Proud is his fortune if we pierce it not.
And when the princely Persian diadem
Shall overweigh his weary witless head,
And fall like mellowed fruit with shakes of death,
In fair Persia noble Tamburlaine.
Shall be my regent and remain as king.
 Orty. In happy hour we have set the crown 50
Upon your kingly head that seeks our honor,
In joining with the man ordained by heaven,
To further every action to the best.
 Cen. He that with shepherds and a little spoil
Durst, in disdain of wrong and tyranny,
Defend his freedom 'gainst a monarchy,
What will he do supported by a king,
Leading a troop of gentlemen and lords,
And stuffed[18] with treasure for his highest thoughts!
 Cos. And such shall wait on worthy Tamburlaine.
Our army will be forty thousand strong, 61
When Tamburlaine and brave Theridamas
Have met us by the river Araris;
And all conjoined to meet the witless King,
That now is marching near to Parthia,[19]
And with unwilling soldiers faintly armed,
To seek revenge on me and Tamburlaine,
To whom, sweet Menaphon, direct me straight.
 Men. I will, my lord.
 Exeunt.

 [70] *Nor . . . pierced:* Neither to thee nor them shall my gladdened heart be found wanting.
 [71] *security:* i.e., defend you.
 [72] *perforce:* of necessity.

II.i.
 [1] *figures of:* signs of destiny betokening.
 [2] *that:* thou who. [3] *lift:* lifted.
 [4] *mainly:* mightily (though not so glossed by OED until the mid-seventeenth century.)
 [5] *Atlas:* Atlas was the Titan who carried the heavens and stars on his shoulders.
 [6] *pitch:* points (i.e., width) of his shoulders.
 [7] *pearl:* presumably his head.
 [8] *curious:* cunning (in workmanship).
 [9] *instruments . . . throne:* The universe of stars enclosed within his eyes are influential (astrologically) in enabling his achievements. [10] *folds:* furrows.
 [11] *wanton:* frolicsome.
 [12] *snowy:* the reading of the first three octavos. O4 reads "snowy-white" (better metrically). Most editors emend to "sinewy." [13] *Should:* Who should.
 [14] *of life:* lively.
 [15] *Nature . . . stars:* A competition of the three great powers—physical endowment, chance, and astrological influence—is envisaged in Tamburlaine. [16] *compass:* reach.
 [17] *port:* gate; see Matthew vii, 14.
 [18] *stuffed:* furnished (the modern pejorative connotation does not obtain).
 [19] *Araris . . . Parthia:* sound more than sense; the geography is vague and not especially to the purpose.

II.ii

[*Enter*] MYCETES, MEANDER, *with other* Lords
and Soldiers.

Myc. Come, my Meander, let us to this gear.[1]
I tell you true, my heart is swoln with wrath
On[2] this same thievish villain, Tamburlaine,
And of that false Cosroe, my traitorous brother.
Would it not grieve a king to be so abused[3]
And have a thousand horsemen ta'en away?
And, which is worse, to have his diadem
Sought for by such scald[4] knaves as love him not?
I think it would; well then, by heavens I swear,
Aurora[5] shall not peep out of her doors, 10
But I will have Cosroe by the head,
And kill proud Tamburlaine with point of sword.
Tell you the rest, Meander: I have said.
 Meand. Then having passed Armenian deserts now
And pitched our tents under the Georgian hills,
Whose tops are covered with Tartarian thieves,
That lie in ambush, waiting for a prey,
What should we do but bid them battle straight,[6]
And rid the world of those detested troops?[7]
Lest, if we let them linger here awhile, 20
They gather strength by power of fresh supplies.
This country swarms with vile outrageous[8] men
That live by rapine and by lawless spoil,
Fit soldiers for the wicked Tamburlaine.
And he that could with gifts and promises
Inveigle him that led a thousand horse,
And make him false[9] his faith unto his King,
Will quickly win such as are like himself.
Therefore cheer up your minds; prepare to fight.
He that can take or slaughter Tamburlaine 30
Shall rule the province of Albania.
Who[10] brings that traitor's head, Theridamas,
Shall have a government in Media,
Beside[11] the spoil of him and all his train.
But if Cosroe (as our spials[12] say,
And as we know) remains with Tamburlaine,
His highness' pleasure is that he should live,
And be reclaimed with princely lenity.[13]
 Spy. An hundred horsemen of my company
Scouting abroad upon these champion[14] plains 40
Have viewed the army of the Scythians,
Which make report it far exceeds the King's.
 Meand. Suppose they be in number infinite,
Yet being void of martial discipline,
All running headlong after greedy spoils,
And more regarding gain than victory,
Like to the cruel brothers of the earth,
Sprung of the teeth of dragons venomous,[15]
Their careless[16] swords shall lanch their fellows'
 throats,
And make us triumph in their overthrow. 50
 Myc. Was there such brethren, sweet Meander, say,
That sprung of teeth of dragons venomous?
 Meand. So poets say, my lord.
 Myc. And 'tis a pretty toy[17] to be a poet.
Well, well, Meander, thou art deeply read,
And having thee, I have a jewel sure.

Go on, my lord, and give your charge, I say;
Thy wit[18] will make us conquerors today.
 Meand. Then, noble soldiers, to entrap these
 thieves,
That live confounded[19] in disordered troops, 60
If wealth or riches may prevail with them,
We have our camels laden all with gold,
Which you that be but common soldiers
Shall fling in every corner of the field;
And while the base-born Tartars take it up,
You, fighting more for honor than for gold,
Shall massacre those greedy-minded slaves;
And when their scattered army is subdued,
And you march on their slaughtered carcasses,
Share equally the gold that bought their lives, 70
And live like gentlemen in Persia.
Strike up the drum, and march courageously!
Fortune herself doth sit upon our crests.
 Myc. He tells you true, my masters: so he does.
Drums, why sound ye not, when Meander speaks?
 Exeunt.

II.iii

[*Enter*] COSROE, TAMBURLAINE, THERIDAMAS,
TECHELLES, USUMCASANE, ORTYGIUS,
with others.

 Cos. Now, worthy Tamburlaine, have I reposed
In thy approvèd[1] fortunes all my hope.
What think'st thou, man, shall come of our attempts?
For even as from assurèd oracle,
I take thy doom[2] for satisfaction.[3]
 Tamb. And so mistake you not a whit, my lord.
For fates and oracles [of][4] heaven have sworn
To royalize[5] the deeds of Tamburlaine,
And make them blest that share in his attempts.
And doubt you not but, if you favor me, 10
And let my fortunes and my valor sway[6]

II.ii
 [1] *gear:* business.
 [2] *On:* By, at. So with "of" in following line.
 [3] *abused:* deceived. [4] *scald:* beggarly.
 [5] *Aurora:* goddess of the dawn. [6] *straight:* at once.
 [7] *troops:* with suggestion of "swarms."
 [8] *outrageous:* fierce. [9] *false:* betray.
 [10] *Who:* He who. [11] *Beside:* Besides.
 [12] *spials:* espials, scouts. [13] *lenity:* mercy.
 [14] *champion:* like "plains"; open country.
 [15] *Like . . . venomous:* Cadmus, having killed the dragon
that guarded the well of Ares, sowed its teeth in the earth.
From these teeth armed men sprang up, killing each other.
The five who survived helped Cadmus found the city of
Thebes.
 [16] *careless:* indifferent, striking without regard to the ob-
ject. [17] *toy:* trifling amusement.
 [18] *wit:* intelligence. [19] *confounded:* huddled up.

II.iii
 [1] *approvèd:* tested. [2] *doom:* judgment.
 [3] *satisfaction:* absolute truth.
 [4] *of:* omitted in early editions; added by Robinson.
 [5] *royalize:* render famous.
 [6] *sway:* attain (i.e., command).

To some direction in your martial deeds,
The world will strive with hosts of men at arms,
To swarm unto the ensign [7] I support.
The host of Xerxes, which by fame is said
To drink the mighty Parthian Araris,[8]
Was but a handful to that [9] we will have.
Our quivering lances, shaking in the air,
And bullets, like Jove's dreadful thunderbolts,
Enrolled in flames and fiery smoldering mists, 20
Shall threat the gods more than Cyclopian [10] wars:
And with our sun-bright armor as we march,
We'll chase the stars from heaven and dim their eyes
That stand and muse at our admirèd [11] arms.
 Ther. You see, my lord, what working [12] words he
 hath.
But when you see his actions stop [13] his speech,
Your speech will stay [14] or so extol his worth
As I shall be commended and excused
For turning my poor charge to his direction.
And these his two renownèd friends, my lord, 30
Would make one thrust [15] and strive to be retained
In such a great degree of amity.
 Tech. With duty and with amity we yield
Our utmost service to the fair Cosroe.
 Cos. Which I esteem as portion of my crown.
Usumcasane and Techelles both,
When she that rules in Rhamnis' [16] golden gates,
And makes a passage for all prosperous arms,
Shall make me solely Emperor of Asia,
Then shall your meeds [17] and valors be advanced 40
To rooms [18] of honor and nobility.
 Tamb. Then haste, Cosroe, to be king alone,
That I with these, my friends, and all my men
May triumph in our long-expected fate.
The King, your brother, is now hard at hand;
Meet with the fool, and rid your royal shoulders

Of such a burden as outweighs the sands
And all the craggy rocks of Caspia.[19]

 [Enter a Messenger.]

 Mes. My lord, we have discovered the enemy
Ready to charge you with a mighty army. 50
 Cos. Come, Tamburlaine, now whet thy wingèd
 sword
And lift thy lofty arm into the clouds,
That it may reach the King of Persia's crown,
And set it safe on my victorious head.
 Tamb. See where it is, the keenest curtle-ax
That e'er made passage thorough Persian arms.
These are the wings shall make it fly as swift
As doth the lightning or the breath of heaven,
And kill as sure as it swiftly flies.
 Cos. Thy words assure me of kind [20] success. 60
Go, valiant soldier, go before and charge
The fainting army of that foolish King.
 Tamb. Usumcasane and Techelles, come!
We are enough to scare the enemy,
And more than needs to make an emperor.

 [Exeunt.]

[II.iv]

 To the battle and MYCETES *comes out alone with his*
 crown in his hand, offering [1] *to hide it.*

 Myc. Accursed be he that first invented war!
They knew not, ah, they knew not, simple men,
How those [2] were hit by pelting cannon shot
Stand staggering like a quivering aspen leaf
Fearing the force of Boreas' [3] boisterous blasts.
In what a lamentable case [4] were I
If nature had not given me wisdom's lore,
For kings are clouts [5] that every man shoots at,
Our crown the pin [6] that thousands seek to cleave; [7]
Therefore in policy [8] I think it good 10
To hide it close; [9] a goodly stratagem,
And far from any man that is a fool.
So shall I not be known; or if I be,
They cannot take away my crown from me.
Here will I hide it in this simple hole.

 Enter TAMBURLAINE.

 Tamb. What, fearful coward, straggling from the
 camp,
When kings themselves are present in the field?
 Myc. Thou liest.
 Tamb. Base villain! darest thou give [me]
 the lie? [10]
 Myc. Away; I am the King; go; touch me not.
Thou break'st the law of arms unless thou kneel 20
And cry me "Mercy, noble King."
 Tamb. Are you the witty [11] King of Persia?
 Myc. Ay, marry [12] am I: have you any suit to me?
 Tamb. I would entreat you speak but three wise
 words.
 Myc. So I can when I see my time.
 Tamb. Is this your crown?

 [7] *ensign:* banner.
 [8] *The . . . Araris:* King Xerxes of Persia, defeated in his
invasion of Greece in 480 B.C., led a force so huge as sup-
posedly to have drunk a river dry.
 [9] *that:* that which.
 [10] *Cyclopian:* alluding to the insurrection of the Titans
(here identified with the one-eyed Cyclops) against Jove.
 [11] *admirèd:* wondered at. [12] *working:* moving.
 [13] *stop:* intermit (and so verify in physical fact). Most
editors emend to "top."
 [14] *stay:* break off—"You will be mute."
 [15] *thrust:* Some editions follow O4—"thirst."
 [16] *Rhamnis':* The temple of Nemesis was located in Rham-
nus in Attica. [17] *meeds:* deserts.
 [18] *rooms:* stations. [19] *Caspia:* the Caspian Sea.
 [20] *kind:* rightful.

II.iv.
 [1] *offering:* attempting. [2] *those:* those who.
 [3] *Boreas:* the North Wind. [4] *case:* situation.
 [5] *clouts:* center of the target (in archery).
 [6] *pin:* that fastens the center to the target.
 [7] *cleave:* split. [8] *policy:* craft.
 [9] *close:* secretly.
 [10] *give . . . lie:* accuse me to my face of lying—a mortal
insult. The word "me," omitted in the Octavo, was added in
the 1605 Quarto.
 [11] *witty:* quick-witted (sarcastic here).
 [12] *Ay, marry:* emphatic ejaculation—"Most certainly."

Myc. Ay, didst thou ever see a fairer?
Tamb. You will not sell it, will ye?
Myc. Such another word and I will have thee
 executed.
Come give it me! 30
 Tamb. No; I took it prisoner.
 Myc. You lie; I gave it you.
 Tamb. Then 'tis mine.
 Myc. No; I mean I let you keep it.
 Tamb. Well; I mean you shall have it again.
Here; take it for a while: I lend it thee,
'Till I may see thee hemmed with armèd men.
Then shalt thou see me pull it from thy head:
Thou art no match for mighty Tamburlaine.
 [*Exit* TAMBURLAINE.]
 Myc. O gods! Is this Tamburlaine the thief? 40
I marvel much he stole it not away.

 Sound trumpets to the battle and he runs in.

[II.v]

 [*Enter*] COSROE, TAMBURLAINE, THERIDAMAS,
 MENAPHON, MEANDER, ORTYGIUS,
 TECHELLES, USUMCASANE, *with others.*

 Tamb. Hold thee, Cosroe! wear two imperial crowns.
Think thee invested now as royally,
Even by the mighty hand of Tamburlaine,
As if as many kings as could encompass thee
With greatest pomp had crowned thee emperor.
 Cos. So do I, thrice renownèd man at arms,
And none shall keep the crown but Tamburlaine.
Thee do I make my regent of Persia,
And general lieutenant of my armies.
Meander, you that were our brother's guide, 10
And chiefest counselor in all his acts,
Since he is yielded to the stroke of war,
On your submission we with thanks excuse,
And give you equal place in our affairs.
 Meand. Most happy Emperor, in humblest terms
I vow my service to your majesty,
With utmost virtue of my faith and duty.
 Cos. Thanks, good Meander. Then, Cosroe, reign,
And govern Persia in her former pomp!
Now send embassage to thy neighbor kings, 20
And let them know the Persian King is changed
From one that knew not what a king should do
To one that can command what 'longs[1] thereto.
And now we will to fair Persepolis,
With twenty thousand expert[2] soldiers.
The lords and captains of my brother's camp
With little slaughter take Meander's course,
And gladly yield them to my gracious rule.
Ortygius and Menaphon, my trusty friends,
Now will I gratify your former good,[3] 30
And grace your calling with a greater sway.
 Orty. And as we ever aimed at your behoof,[4]
And sought your state[5] all honor it deserved,
So will we with our powers and our lives
Endeavor to preserve and prosper it.
 Cos. I will not thank thee, sweet Ortygius;

Better replies[6] shall prove my purposes.
And now, Lord Tamburlaine, my brother's camp
I leave to thee and to Theridamas,
To follow me to fair Persepolis. 40
Then will we march to all those Indian mines
My witless brother to the Christians lost,
And ransom them with fame and usury.[7]
And till thou overtake me ,Tamburlaine
(Staying to order all the scattered troops),
Farewell, Lord Regent and his happy friends!
I long to sit upon my brother's throne.
 Meand. Your majesty shall shortly have your wish,
And ride in triumph through Persepolis.
 Exeunt. Manent TAMBURLAINE, TECHELLES,
 THERIDAMAS, *and* USUMCASANE.
 Tamb. "And ride in triumph through Persepolis!"
Is it not brave[8] to be a king, Techelles? 51
Usumcasane and Theridamas,
Is it not passing[9] brave to be a king,
And ride in triumph through Persepolis?
 Tech. Oh, my lord, 'tis sweet and full of pomp.
 Usum. To be a king is half to be a god.
 Ther. A god is not so glorious as a king.
I think the pleasure they enjoy in Heaven,
Cannot compare with kingly joys in[10] earth.
To wear a crown enchased with pearl and gold, 60
Whose virtues[11] carry with it life and death;
To ask and have, command and be obeyed;
When looks breed love, with looks to gain the prize,
Such power attractive shines in princes' eyes!
 Tamb. Why say, Theridamas, wilt thou be a king?
 Ther. Nay, though I praise it, I can live without it.
 Tamb. What says my other friends? Will you be
 kings?
 Tech. I, if I could, with all my heart, my lord.
 Tamb. Why, that's well said, Techelles; so would I,
And so would you, my masters, would you not? 70
 Usum. What then, my lord?
 Tamb. Why then, Casane, shall we wish for aught
The world affords in greatest novelty,
And rest attemptless, faint and destitute?
Methinks we should not. I am strongly moved,[12]
That if I should desire the Persian crown,
I could attain it with a wondrous ease.
And would not all our soldiers soon consent,
If we should aim at such a dignity?
 Ther. I know they would with our persuasions. 80
 Tamb. Why then, Theridamas, I'll first assay[13]
To get the Persian kingdom to myself;
Then thou for Parthia; they for Scythia and Media;
And, if I prosper, all shall be as sure

II.v.
[1] *'longs:* belongs. [2] *expert:* proved.
[3] *gratify . . . good:* recompense the service you have done
me. [4] *behoof:* benefit.
[5] *sought your state:* sought for your position.
[6] *Better replies:* i.e., than words.
[7] *usury:* financial profit. [8] *brave:* splendid.
[9] *passing:* exceedingly. [10] *in:* on.
[11] *virtues:* powers. [12] *moved:* persuaded.
[13] *assay:* attempt.

As if the Turk, the Pope, Afric and Greece,
Came creeping to us with their crowns apace.[14]
 Tech. Then shall we send to this triumphing King,
And bid him battle for his novel[15] crown?
 Usum. Nay, quickly then, before his room[16] be hot.
 Tamb. 'Twill prove a pretty jest, in faith, my friends.
 Ther. A jest to charge on twenty thousand men! 91
I judge the purchase[17] more important far.
 Tamb. Judge by thyself, Theridamas, not me;
For presently Techelles here shall haste
To bid him battle ere he pass too far,
And lose[18] more labor than the gain will quite.[19]
Then shalt thou see this Scythian Tamburlaine,
Make but a jest to win the Persian crown.
Techelles, take a thousand horse with thee,
And bid him turn him back to war with us, 100
That only made him king to make us sport.
We will not steal upon him cowardly,
But give him warning and more warriors.
Haste thee, Techelles, we will follow thee.
What saith Theridamas?
 Ther. Go on for me.[20]

 Exeunt.

II.vi

 [*Enter*] COSROE, MEANDER, ORTYGIUS,
 MENAPHON, *with other* Soldiers.

 Cos. What means this devilish shepherd to aspire
With such a giantly[1] presumption,
To cast up hills against the face of heaven,[2]
And dare the force of angry Jupiter?
But as he thrust them underneath the hills,
And pressed out fire from their burning jaws,[3]
So will I send this monstrous slave to hell,
Where flames shall ever feed upon his soul.

[14] *apace:* swiftly (which makes an oxymoron with "creeping"). [15] *novel:* newly gained.
[16] *room:* place he occupies—throne.
[17] *purchase:* undertaking. [18] *lose:* we lose.
[19] *quite:* requite. [20] *for me:* as far as I am concerned.

II.vi.
[1] *giantly:* like the Titans who warred on Jove.
[2] *To . . . heaven:* The Titans heaped Pelion on Ossa, to prosecute their war.
[3] *But . . . jaws:* The Titans in defeat were buried under volcanoes like Etna; hence, "burning."
[4] *doubtlessly:* without misgiving. [5] *of:* on.
[6] *by ambitious:* proclaim his ambition.
[7] *mold or mettle:* earth ("stuff") or disposition.
[8] *meet encountering:* proper for addressing ourselves to battle.
[9] *Resolve:* Decompose (at death into the elements from which we sprang).
[10] *resembled . . . life:* alike in pledging ourselves to meet the same fate. [11] *dated:* limited.

II.vii.
[1] *uncouth:* unaccustomed. [2] *artier:* artery.
[3] *the . . . Ops:* Jupiter, the son of Saturn and Ops, displaced his father as ruler of heaven.
[4] *empyreal:* imperial; also, the outermost sphere of the Ptolemaic universe, wherein God dwelt.
[5] *manage arms:* wage war. [6] *framed:* composed.
[7] *elements:* earth, air, fire, water. [8] *regiment:* rule.

 Meand. Some powers divine, or else infernal, mixed
Their angry seeds at his conception; 10
For he was never sprung of human race,
Since with the spirit of his fearful pride,
He dares so doubtlessly[4] resolve of[5] rule,
And by profession be ambitious.[6]
 Orty. What god, or fiend, or spirit of the earth,
Or monster turnèd to a manly shape,
Or of what mold or mettle[7] he be made,
What star or fate soever govern him,
Let us put on our meet encountering[8] minds
And in detesting such a devilish thief, 20
In love of honor and defense of right,
Be armed against the hate of such a foe,
Whether from earth, or hell, or heaven, he grow.
 Cos. Nobly resolved, my good Ortygius.
And since we all have sucked one wholesome air,
And with the same proportion of elements
Resolve,[9] I hope we are resembled,
Vowing our loves to equal death and life.[10]
Let's cheer our soldiers to encounter him,
That grievous image of ingratitude. 30
That fiery thirster after sovereignty,
And burn him in the fury of that flame,
That none can quench but blood and empery.
Resolve, my lords and loving soldiers, now
To save your King and country from decay.
Then strike up, drum; and all the stars that make
The loathsome circle of my dated[11] life,
Direct my weapon to his barbarous heart,
That thus opposeth him against the gods,
And scorn the powers that govern Persia. 40
 [*Exeunt.*]

[II.vii]

 Enter to the battle, and after the battle enter
COSROE, *wounded,* THERIDAMAS, TAMBURLAINE,
 TECHELLES, USUMCASANE, *with others.*

 Cos. Barbarous and bloody Tamburlaine,
Thus to deprive me of my crown and life!
Treacherous and false Theridamas,
Even at the morning of my happy state,
Scarce being seated in my royal throne,
To work my downfall and untimely end!
An uncouth[1] pain torments my grievèd soul,
And death arrests the organ of my voice,
Who, entering at the breach thy sword hath made,
Sacks every vein and artier[2] of my heart. 10
Bloody and insatiate Tamburlaine!
 Tamb. The thirst of reign and sweetness of a crown
That caused the eldest son of heavenly Ops,[3]
To thrust his doting father from his chair,
And place himself in the empyreal[4] heaven,
Moved me to manage arms[5] against his state.
What better precedent than mighty Jove?
Nature that framed[6] us of four elements,[7]
Warring within our breasts for regiment,[8]
Doth teach us all to have aspiring minds: 20
Our souls, whose faculties can comprehend
The wondrous architecture of the world,

And measure every wandering planet's course,
Still climbing after knowledge infinite,
And always moving as the restless spheres,[9]
Wills us to wear [10] ourselves, and never rest,
Until we reach the ripest fruit of all,
That perfect bliss and sole felicity,
The sweet fruition of an earthly crown.
 Ther. And that made me to join with Tamburlaine:
For he is gross and like the massy earth 31
That moves not upwards, nor by princely deeds
Doth mean to soar above the highest sort.
 Tech. And that made us the friends of Tamburlaine,
To lift our swords against the Persian King.
 Usum. For as when Jove did thrust old Saturn down,
Neptune and Dis [11] gained each of them a crown,
So do we hope to reign in Asia,
If Tamburlaine be placed in Persia.
 Cos. The strangest men that ever nature made! 40
I know not how to take their tyrannies.
My bloodless body waxeth chill and cold,[12]
And with my blood my life slides through my wound;
My soul begins to take her flight to hell,
And summons all my senses to depart.
The heat and moisture, which did feed each other,
For want of nourishment to feed them both,
Is dry and cold; and now doth ghastly death,
With greedy tallents [13] gripe my bleeding heart,
And like a harpy [14] tires [15] on my life. 50
Theridamas and Tamburlaine, I die;
And fearful vengeance light upon you both!

 [COSROE *dies.*] TAMBURLAINE [16] *takes the crown*
 and puts it on.

 Tamb. Not all the curses which the Furies breathe,
Shall make me leave so rich a prize as this.
Theridamas, Techelles, and the rest,
Who think you now is King of Persia?
 All. Tamburlaine! Tamburlaine!
 Tamb. Though Mars himself, the angry god of arms,
And all the earthly potentates conspire
To dispossess me of this diadem, 60
Yet will I wear it in despite of them,
As great commander of this eastern world,
If you but say that Tamburlaine shall reign.
 All. Long live Tamburlaine and reign in Asia!
 Tamb. So now it is more surer on my head,
Than if the gods had held a parliament,
And all pronounced me King of Persia.

 [*Exeunt.*]

 Finis Actus 2.

ACT THREE

SCENE ONE

[*Enter*] BAJAZETH, *the* KINGS of FEZ, MOROCCO,
 and ARGIER, *with others, in great pomp.*

 Baj. Great Kings of Barbary [1] and my portly
 bassoes,[2]
We hear the Tartars and the eastern thieves,

Under the conduct of one Tamburlaine,
Presume a bickering [3] with your Emperor,
And thinks to rouse us from our deadful siege
Of the famous Grecian Constantinople.
You know our army is invincible;
As many circumcisèd Turks we have,
And warlike bands of Christians renièd,[4]
As hath the ocean or the Terrene [5] sea 10
Small drops of water when the moon begins
To join in one her semicircled horns.[6]
Yet would we not be braved [7] with foreign power,
Nor raise our siege before the Grecians yield,
Or breathless lie before the city walls.
 K. of Fez. Renowmèd Emperor and mighty general,
What if you sent the bassoes of your guard
To charge him to remain in Asia,
Or else to threaten death and deadly arms
As from the mouth of mighty Bajazeth? 20
 Baj. Hie thee,[8] my basso, fast to Persia,
Tell him thy lord, the Turkish Emperor,
Dread lord of Afric, Europe, and Asia,
Grest King and conqueror of Graecia,
The ocean, Terrene, and the coal-black sea,[9]
The high and highest monarch of the world
Wills and commands (for say not I entreat),
Not once to set his foot in Africa,
Or spread his colors [10] in Graecia,
Lest he incur the fury of my wrath. 30
Tell him I am content to take a truce,
Because I hear he bears a valiant mind.
But if, presuming on his silly [11] power,
He be so mad to manage arms with me,
Then stay thou with him; say, I bid thee so.
And if, before the sun have measured heaven
With triple circuit, thou regreet [12] us not,
We mean to take his morning's next arise
For messenger he will not be reclaimed,[13]
And mean to fetch thee in despite him. 40

 [9] *spheres:* which encircled the earth and carried the
planets and stars. [10] *wear:* use.
 [11] *Neptune and Dis:* Jove's brothers: Neptune, who gained
sovereignty over the sea, and Dis (Pluto) who became ruler of
the underworld.
 [12] *My . . . cold:* As the blood, associated with the element
of air and fruitful of moisture and heat, leaves the body,
coldness and dryness, appropriate to the melancholic "hu-
mor" and associated with the element of earth, begin to pre-
dominate. [13] *tallents:* tallons, claws.
 [14] *harpy:* birdlike monster with a woman's face.
 [15] *tires:* seizes (as the falcon seizes and tears its prey). The
verb is disyllabic. [16] *Tamburlaine:* O1–4 read "He."

III.i.
 [1] *Barbary:* North Africa.
 [2] *bassoes:* important officers—pashas.
 [3] *bickering:* skirmishing. [4] *renièd:* apostate.
 [5] *Terrene:* Mediterranean.
 [6] *when . . . horns:* i.e., when the moon is full, the tides
are at their height. [7] *braved:* challenged.
 [8] *Hie thee:* Get thee gone.
 [9] *coal-black sea:* Black Sea. [10] *colors:* banners.
 [11] *silly:* untrained; hence, "weak."
 [12] *regreet:* welcome.
 [13] *reclaimed:* brought to his senses.

Bas. Most great and puissant monarch of the earth,
Your basso will accomplish your behest,[14]
And show your pleasure to the Persian,
As fits the legate of the stately Turk.

Exit BASSO.

K. of Arg. They say he is the King of Persia;
But, if he dare attempt to stir your siege,
'Twere requisite he should be ten times more,
For all flesh quakes at your magnificence.

Baj. True, Argier; and tremble at my looks.

K. of Mor. The spring is hindered by your
 smothering host, 50
For neither rain can fall upon the earth,
Nor sun reflex[15] his virtuous beams thereon,
The ground is mantled[16] with such multitudes.

Baj. All this is true as holy Mahomet;
And all the trees are blasted with our breaths.

K. of Fez. What thinks your greatness best to be
 achieved
In pursuit of the city's overthrow?

Baj. I will the captive pioners[17] of Argier
Cut off the water that by leaden pipes
Runs to the city from the mountain Carnon. 60
Two thousand horse shall forage up and down,
That no relief or succor come by land:
And all the sea my galleys countermand.[18]
Then shall our footmen lie within the trench,
And with their cannons mouthed like Orcus' gulf,[19]
Batter the walls, and we will enter in;
And thus the Grecians shall be conquerèd.

Exeunt.

III.ii

[*Enter*] AGYDAS, ZENOCRATE, ANIPPE, *with others.*

Agyd. Madam Zenocrate, may I presume
To know the cause of these unquiet fits,
That work such trouble to your wonted[1] rest?
'Tis more than pity such a heavenly face
Should by heart's sorrow wax so wan and pale,

When your offensive rape[2] by Tamburlaine,
(Which of your whole displeasures should be most),
Hath seemed to be digested[3] long ago.

Zeno. Although it be digested long ago,
As his exceeding favors have deserved, 10
And might content the Queen of heaven,[4] as well
As it hath changed my first conceived disdain,
Yet since[5] a farther[6] passion feeds my thoughts
With ceaseless and disconsolate conceits,[7]
Which dyes my look so lifeless as they are,
And might, if my extremes had full events,[8]
Make me the ghastly counterfeit[9] of death.

Agyd. Eternal heaven sooner be dissolved,
And all that pierceth Phoebe's silver eye,[10]
Before such hap[11] fall to Zenocrate! 20

Zeno. Ah, life and soul, still hover in his breast
And leave my body senseless as the earth.
Or else unite you[12] to his life and soul,
That I may live and die with Tamburlaine!

Enter TAMBURLAINE *with* TECHELLES *and others.*

Agyd. With Tamburlaine! Ah, fair Zenocrate,
Let not a man so vile and barbarous,
That holds you from your father in despite,[13]
And keeps you from the honors of a queen
(Being supposed his worthless concubine),
Be honored with your love but for necessity. 30
So[14] now the mighty Soldan hears of you,
Your highness needs not doubt but in short time
He will with Tamburlaine's destruction
Redeem you from this deadly servitude.

Zeno. Leave to wound me with these words,
And speak of Tamburlaine as he deserves.
The entertainment we have had of him
Is far from villany[15] or servitude,
And might in noble minds be counted princely.

Agyd. How can you fancy[16] one that looks so fierce,
Only disposed to martial stratagems? 41
Who, when he shall embrace you in his arms,
Will tell how many thousand men he slew;
And when you look for amorous discourse,
Will rattle forth his facts[17] of war and blood,
Too harsh a subject for your dainty ears.

Zeno. As looks the sun through Nilus'[18] flowing
 stream,
Or when the Morning[19] holds him in her arms,
So looks my lordly love, fair Tamburlaine;
His talk much sweeter than the Muses' song 50
They sung for honor 'gainst Pierides;[20]
Or when Minerva did with Neptune strive:[21]
And higher would I rear my estimate
Than Juno, sister to the highest god,[22]
If I were matched with mighty Tamburlaine.

Agyd. Yet be not so inconstant in your love;
But let the young Arabian live in hope
After your rescue to enjoy his choice.
You see, though first the King of Persia,
Being a shepherd, seemed to love you much, 60
Now in his majesty he leaves those looks,
Those words of favor, and those comfortings,
And gives no more than common courtesies.

[14] *behest:* command. [15] *reflex:* reflects.
[16] *mantled:* covered. [17] *pioners:* sappers, diggers.
[18] *countermand:* control.
[19] *Orcus' gulf:* mouth of Hades.

III.ii.
[1] *wonted:* accustomed. [2] *rape:* seizure.
[3] *digested:* assimilated. [4] *Queen of heaven:* Juno.
[5] *since:* since then. [6] *farther:* greater.
[7] *conceits:* imaginings. [8] *events:* issues, results.
[9] *counterfeit:* semblance.
[10] *all . . . eye:* everything the moon looks on.
[11] *hap:* chance. [12] *you:* i.e., her life and soul.
[13] *despite:* defiance. [14] *So:* Provided that.
[15] *villany:* discourtesy. [16] *fancy:* love.
[17] *facts:* feats. [18] *Nilus':* Nile's.
[19] *Morning:* personified—Aurora.
[20] *Pierides:* The nine daughters of Pierus, attempting un-
successfully to compete with the nine Muses in poetry and
other arts. were transformed (as Ovid relates in *Metamor-
phoses,* V. 302ff.) into birds.
[21] *strive:* for the government of Athens (Minerva is Ath-
ena). [22] *Juno . . . god:* spouse and sister of Jove.

Zeno. Thence rise the tears that so distain [23] my
 cheeks,
Fearing [24] his love through my unworthiness.

 TAMBURLAINE *goes to her and takes her away*
 lovingly by the hand, looking wrathfully
 on AGYDAS.

Agyd. Betrayed by fortune and suspicious [25] love,
Threatened with frowning wrath and jealousy,
Surprised with fear of hideous revenge,
I stand aghast; but most astonièd [26]
To see his choler shut in secret thoughts, 70
And wrapped in silence of his angry soul.
Upon his brows was portrayed ugly death,
And in his eyes the furies of his heart
That shine as comets, [27] menacing revenge,
And casts a pale complexion on his cheeks.
As when the seaman sees the Hyades [28]
Gather an army of Cimmerian [29] clouds
(Auster and Aquilon [30] with wingèd steeds,
All sweating, tilt [31] about the watery heavens,
With shivering spears enforcing thunder claps, 80
And from their shields strike flames of lightning),
All fearful folds his sails and sounds the main, [32]
Lifting his prayers to the heavens for aid
Against the terror of the winds and waves,
So fares Agydas for the late felt frowns,
That sent a tempest to my daunted thoughts,
And makes my soul divine her overthrow.

 Enter TECHELLES *with a naked dagger* [*followed by*
 USUMCASANE].

Tech. See you, Agydas, how the King salutes you?
He bids you prophesy what it imports.
Agyd. I prophesied before, and now I prove [33] 90
The killing frowns of jealousy and love.
He needed not with words confirm my fear,
For words are vain where working tools present
The naked action of my threatened end.
It says, Agydas, thou shalt surely die,
And of extremities elect the least;
More honor and less pain it may procure
To die by this resolvèd hand of thine,
Then stay [34] the torments he and heaven have sworn.
Then haste, Agydas, and prevent the plagues 100
Which thy prolongèd fates may draw on thee.
Go, wander, free from fear of tyrant's rage,
Removèd from the torments and the hell
Wherewith he may excruciate thy soul,
And let Agydas by Agydas die,
And with this stab slumber eternally.

 [*Stabs himself.*]

Tech. Usumcasane, see how right the man
Hath hit the meaning of my lord, the King.
Usum. 'Faith, and Techelles, it was manly done;
And since he was so wise and honorable, 110
Let us afford him now the bearing hence,
And crave his triple-worthy burial.
Tech. Agreed, Casane; we will honor him.
 [*Exeunt bearing out the body.*]

III.iii

 [*Enter*] TAMBURLAINE, TECHELLES,
 USUMCASANE, THERIDAMAS, BASSO,
 ZENOCRATE, *with others.*

Tamb. Basso, by this [1] thy lord and master knows
I mean to meet him in Bithynia:
See how he comes! tush, Turks are full of brags,
And menace more than they can well perform.
He meet me in the field, and fetch thee hence!
Alas! poor Turk! his fortune is too weak
T' encounter with the strength of Tamburlaine.
View well my camp, and speak indifferently; [2]
Do not my captains and my soldiers look
As if they meant to conquer Africa? 10
Bas. Your men are valiant, but their number few,
And cannot terrify his mighty host,
My lord, the great commander of the world,
Besides fifteen contributory [3] kings,
Hath now in arms ten thousand janissaries, [4]
Mounted on lusty Mauritanian [5] steeds,
Brought to the war by men of Tripoli;
Two hundred thousand footmen that have served
In two set battles fought in Graecia;
And for the expedition [6] of this war, 20
If he think good, can from his garrisons
Withdraw as many more to follow him.
Tech. The more he brings the greater is the spoil.
For when they perish by our warlike hands,
We mean to set our footmen on their steeds,
And rifle all those those stately janisars. [7]
Tamb. But will those kings accompany your lord?
Bas. Such as his highness please; but some must
 stay
To rule the provinces he late [8] subdued.
Tamb. Then fight courageously: their crowns are
 yours; 30
This hand shall set them on your conquering heads,
That made me Emperor of Asia.
Usum. Let him bring millions infinite of men,
Unpeopling Western Africa and Greece,
Yet we assure us of the victory.
Ther. Even he that in a trice vanquished two kings,
More mighty than the Turkish Emperor,

[23] *distain:* stain. [24] *Fearing:* Lest I lose.
[25] *suspicious:* jealous.
[26] *astonièd:* astonished, cast down.
[27] *comets:* omens of disaster.
[28] *Hyades:* seven stars that, rising with the sun, were
thought to foretell rain. [29] *Cimmerian:* black.
[30] *Auster and Aquilon:* South and North winds, identified
with rain. [31] *tilt:* contest.
[32] *sounds the main:* fathoms the depth of the sea.
[33] *prove:* discover. [34] *stay:* await.
III.iii.
[1] *this:* i.e., time. [2] *indifferently:* impartially.
[3] *contributory:* owing allegiance.
[4] *janissaries:* Turkish soldiers.
[5] *Mauritanian:* in northwest Africa, famous for its horses.
[6] *expedition:* expediting.
[7] *rifle . . . janisars:* plunder . . . janissaries.
[8] *late:* recently.

Shall rouse[9] him out of Europe, and pursue
His scattered army till they yield or die.
 Tamb. Well said, Theridamas; speak in that mood:
For *will* and *shall* best fitteth Tamburlaine, 41
Whose smiling stars give him assurèd hope
Of martial triumph ere he meet his foes.
I that am termed the scourge and wrath of God,
The only fear[10] and terror of the world,
Will first subdue the Turk, and then enlarge[11]
Those Christian captives, which you keep as slaves,
Burdening their bodies with your heavy chains,
And feeding them with thin and slender fare,
That naked row about the Terrene sea, 50
And when they chance to breathe and rest a space,
Are punished with bastones[12] so grievously,
That they lie panting on the galley's side,
And strive for life at every stroke they give.
These are the cruel pirates of Argier,
That damnèd train,[13] the scum of Africa,
Inhabited with straggling runagates,[14]
That make quick havoc of the Christian blood;
But as I live that town shall curse the time
That Tamburlaine set foot in Africa. 60

 Enter BAJAZETH *with his* Bassoes *and contributory*
 KINGS[*and* ZABINA *and* EBEA].

 Baj. Bassoes and janissaries of my guard,
Attend upon the person of your lord,
The greatest potentate of Africa.
 Tamb. Techelles, and the rest, prepare your swords;
I mean t' encounter with that Bajazeth.
 Baj. Kings of Fez, Moroccus, and Argier,
He calls me Bajazeth, whom you call lord!
Note the presumption of this Scythian slave!
I tell thee, villain, those that lead my horse,
Have to their names titles of dignity, 70
And dar'st thou bluntly call me Bajazeth?
 Tamb. And know thou, Turk, that those which lead
 my horse,
Shall lead thee captive thorough[15] Africa;
And dar'st thou bluntly call me Tamburlaine?
 Baj. By Mahomet my kinsman's sepulcher,
And by the holy Alcaron[16] I swear,
He shall be made a chaste and lustless eunuch,
And in my sarell[17] tend my concubines;
And all his captains that thus stoutly[18] stand,

Shall draw the chariot of my Emperess, 80
Whom I have brought to see their overthrow.
 Tamb. By this my sword, that conquered Persia,
Thy fall shall make me famous through the world.
I will not tell thee how I'll handle thee,
But every common soldier of my camp
Shall smile to see thy miserable state.
 K. of Fez. What means the mighty Turkish Emperor,
To talk with one so base as Tamburlaine?
 K. of Mor. Ye Moors and valiant men of Barbary,
How can ye suffer[19] these indignities? 90
 K. of Arg. Leave words, and let them feel your lances'
 points
Which glided through the bowels of the Greeks.
 Baj. Well said, my stout contributory Kings:
Your threefold army and my hugy[20] host
Shall swallow up these base-born Persians.
 Tech. Puissant, renowmed, and mighty Tamburlaine,
Why stay we thus prolonging all their lives?
 Ther. I long to see those crowns won by our swords,
That we may rule as Kings of Africa. 99
 Usum. What coward would not fight for such a prize?
 Tamb. Fight all courageously, and be you kings;
I speak it, and my words are oracles.
 Baj. Zabina, mother of three braver boys
Than Hercules, that in his infancy
Did pash the jaws of serpents venomous;[21]
Whose hands are made to gripe a warlike lance,
Their shoulders broad for complete armor fit,
Their limbs more large, and of a bigger size,
Than all the brats ysprung[22] from Typhon's[23] loins;
Who, when they come unto their father's age, 110
Will batter turrets with their manly fists;—
Sit here upon this royal chair of state,
And on thy head wear my imperial crown,
Until I bring this sturdy Tamburlaine,
And all his captains bound in captive chains.
 Zab. Such good success[24] happens to Bajazeth!
 Tamb. Zenocrate, the loveliest maid alive,
Fairer than rocks of pearl and precious stone,
The only paragon[25] of Tamburlaine,
Whose eyes are brighter than the lamps of heaven, 120
And speech more pleasant than sweet harmony!
That with thy looks canst clear the darkened sky,
And calm the rage of thundering Jupiter,
Sit down by her, adornèd with my crown,
As if thou wert the Empress of the world.
Stir not, Zenocrate, until thou see
Me march victoriously with all my men,
Triumphing over him and these his kings,
Which I will bring as vassals to thy feet;
Till then take thou my crown, vaunt[26] of my worth,
And manage[27] words with her, as we will arms. 131
 Zeno. And may my love, the King of Persia,
Return with victory and free from wound!
 Baj. Now shalt thou feel the force of Turkish arms,
Which lately made all Europe quake for fear.
I have of Turks, Arabians, Moors, and Jews,
Enough to cover all Bithynia.
Let thousands die; their slaughtered carcasses
Shall serve for walls and bulwarks to the rest,

 [9] *rouse:* drive. [10] *fear:* thing feared.
 [11] *enlarge:* free. [12] *bastones:* sticks, cudgels.
 [13] *train:* troop.
 [14] *runagates:* deserters; more generally, "scum."
 [15] *thorough:* through. [16] *Alcaron:* Koran.
 [17] *sarell:* seraglio. [18] *stoutly:* proudly.
 [19] *suffer:* endure. [20] *hugy:* huge.
 [21] *Hercules . . . venomous:* The "pashing" or crushing of
pair of serpents by the infant Hercules was familiar to
Marlowe from Ovid's *Metamorphoses,* IX. 67.
 [22] *ysprung:* sprung.
 [23] *Typhon's:* The hundred-headed monster whose brood
included Cerberus and the Sphinx.
 [24] *success:* issue (not necessarily "successful").
 [25] *paragon:* mate. [26] *vaunt:* boast.
 [27] *manage:* fight in.

And as the heads of Hydra,[28] so my power, 140
Subdued, shall stand as mighty as before.
If they should yield their necks unto the sword,
Thy soldiers' arms could not endure to strike
So many blows as I have heads for thee.
Thou knowest not, foolish, hardy Tamburlaine,
What 'tis to meet me in the open field,
That leave no ground for thee to march upon.
 Tamb. Our conquering swords shall marshal[29] us the way
We use to march upon the slaughtered foe,
Trampling their bowels with our horses' hoofs; 150
Brave horses bred on th' white Tartarian hills;
My camp is like to Julius Caesar's host,
That never fought but had the victory;
Nor in Pharsalia[30] was there such hot war,
As these, my followers, willingly would have.
Legions of spirits fleeting[31] in the air
Direct our bullets and our weapons' points,
And make our strokes to wound the senseless lure,[32]
And when she sees our bloody colors spread,
Then Victory begins to take her flight, 160
Resting herself upon my milk-white tent.
But come, my lords, to weapons let us fall;
The field is ours, the Turk, his wife and all.
 Exit with his followers.
 Baj. Come, Kings and Bassoes, let us glut our swords,
That thirst to drink the feeble Persians' blood.
 Exit with his followers.
 Zab. Base concubine, must thou be placed by me,
That am the Empress of the mighty Turk?
 Zeno. Disdainful Turkess and unreverend boss![33]
Call'st thou me concubine, that am betrothed
Unto the great and mighty Tamburlaine? 170
 Zab. To Tamburlaine, the great Tartarian thief!
 Zeno. Thou will repent these lavish[34] words of thine,
When thy great basso-master and thyself
Must plead for mercy at his kingly feet,
And sue to me to be your advocates.[35]
 Zab. And sue to thee!—I tell thee, shameless girl,
Thou shalt be laundress to my waiting maid!
How lik'st thou her, Ebea?—Will she serve?
 Ebea. Madam, she thinks perhaps she is too fine,
But I shall turn her into other weeds,[36] 180
And make her dainty fingers fall to work.
 Zeno. Hear'st thou, Anippe, how thy drudge doth talk?
And how my slave, her mistress, menaceth?
Both for their sauciness shall be employed
To dress[37] the common soldiers' meat and drink,
For we will scorn they should come near ourselves.
 Anip. Yet sometimes let your highness send for them
To do the work my chambermaid disdains.
 They sound to the battle within and stay.
 Zeno. Ye gods and powers that govern Persia,
And made my lordly love her worthy King, 190
Now strengthen him against the Turkish Bajazeth,

And let his foes, like flocks of fearful roes
Pursued by hunters, fly his angry looks,
That I may see him issue conqueror!
 Zab. Now, Mahomet, solicit God himself,
And make him rain down murdering shot from heaven
To dash the Scythians' brains, and strike them dead,
That dare to manage arms with him
That offered jewels to thy sacred shrine,
When first he warred against the Christians! 200
 To the battle again.

 Zeno. By this the Turks lie weltering in their blood,
And Tamburlaine is Lord of Africa.
 Zab. Thou art deceived. I hear the trumpets sound,
As when my Emperor overthrew the Greeks,
And led them captive into Africa.
Straight will I use thee as thy pride deserves—
Prepare thyself to live and die my slave.
 Zeno. If Mahomet should come from heaven and swear
My royal lord is slain or conquerèd,
Yet should he not persuade me otherwise 210
But that he lives and will be conqueror.

 BAJAZETH *flies and he*[38] *pursues him. The battle*
 short and they enter. BAJAZETH *is overcome.*

 Tamb. Now, King of bassoes, who is conqueror?
 Baj. Thou, by the fortune of this damnèd soil.[39]
 Tamb. Where are your stout contributory Kings?

 Enter TECHELLES, THERIDAMAS, *and*
 USUMCASANE.

 Tech. We have their crowns—their bodies strow the field.
 Tamb. Each man a crown!—Why kingly fought, i' faith.
Deliver them into my treasury.
 Zeno. Now let me offer to my gracious lord
His royal crown again so highly won.
 Tamb. Nay, take the crown from her, Zenocrate,
And crown me Emperor of Africa. 221
 Zab. No, Tamburlaine: though now thou gat[40] the best,
Thou shalt not yet be Lord of Africa.
 Ther. Give her the crown, Turkess: you were best.

 He takes it from her, and gives it ZENOCRATE.

[28] *Hydra:* another many-headed monster of the brood of Typhon, and able to grow heads in place of each one struck off by Hercules. [29] *marshal:* lead.
[30] *Pharsalia:* where Caesar defeated Pompey. Among Marlowe's writings is a blank verse translation of part of Lucan's *Pharsalia*. [31] *fleeting:* floating (hovering).
[32] *lure:* Bajazeth's army, seen derisively as "lured" or "decoyed" unwittingly to its destruction. Many modern editors find the passage corrupt and emend "lure" to "light" or "air." [33] *unreverend boss:* impudent fat woman.
[34] *lavish:* loose. [35] *advocates:* pleaders.
[36] *weeds:* garments. [37] *dress:* prepare.
[38] *he:* i.e., Tamburlaine.
[39] *soil:* soiling, moral stain. Most editors emend to "foil"— defeat. [40] *gat:* have got.

Zab. Injurious villains! thieves! runagates![41]
How dare you thus abuse my majesty?
　Ther. Here, madam, you are Empress; she is none.
　Tamb. Not now, Theridamas; her time is past.
The pillars that have bolstered up those terms[42]
Are fallen in clusters at my conquering feet. 230
　Zab. Though he be prisoner, he may be ransomed.
　Tamb. Not all the world shall ransom Bajazeth.
　Baj. Ah, fair Zabina! we have lost the field.
And never had the Turkish Emperor
So great a foil[43] by any foreign foe.
Now will the Christian miscreants[44] be glad,
Ringing with joy their superstitious bells,
And making bonfires for my overthrow.
But, ere I die, those foul idolaters
Shall make me bonfires with their filthy bones. 240
For though the glory of this day be lost,
Afric and Greece have garrisons enough
To make me sovereign of the earth again.
　Tamb. Those wallèd garrisons will I subdue,
And write myself great Lord of Africa.
So from the East unto the furthest West
Shall Tamburlaine extend his puissant arm.
The galleys and those pilling brigandines,[45]
That yearly sail to the Venetian gulf,
And hover in the straits for Christians' wreck, 250
Shall lie at anchor in the isle Asant,[46]
Until the Persian fleet and men of war,
Sailing along the oriental sea,
Have fetched about[47] the Indian continent,
Even from Persepolis to Mexico,
And thence unto the straits of Jubaltèr;[48]
Where they shall meet and join their force in one
Keeping in awe the bay of Portingale,[49]
And all the ocean by the British shore;
And by this means I'll win the world at last. 260
　Baj. Yet set a ransom on me, Tamburlaine.
　Tamb. What, think'st thou Tamburlaine esteems thy
　　gold?
I'll make the Kings of India, ere I die,
Offer their mines to sue for peace to me,
And dig for treasure to appease my wrath.
Come, bind them both, and one lead in the Turk;
The Turkess let my love's maid lead away.

They bind them.

[41] *runagates:* renegades.
[42] *terms:* termini; statues or busts, supported by a pillar from which the figure appears to derive. [43] *foil:* defeat.
[44] *miscreants:* unbelievers.
[45] *pilling brigandines:* plundering vessels.
[46] *Asant:* Zante, off western Greece.
[47] *fetched about:* sailed around. [48] *Jubaltèr:* Gibraltar.
[49] *Portingale:* Biscay, off Portugal.
IV.i.
[1] *basilisks:* cannons.
[2] *monstrous as Gorgon:* abnormal, preternaturally powerful as Demogorgon, a divinity of hell.
[3] *wanton:* frolicsome.
[4] *bills:* obsolete weapons varying in form from a concave blade with a long wooden handle to a concave ax with a spike at the back and its shaft ending in a spearhead.
[5] *countervail:* equal in number.
[6] *expedition:* celerity.

Baj. Ah, villains!—dare you touch my sacred arms?
O Mahomet!—O sleepy Mahomet!
　Zab. O cursèd Mahomet, that makes us thus 270
The slaves to Scythians rude and barbarous!
　Tamb. Come, bring them in; and for this happy
　　conquest,
Triumph and solemnize a martial feast.

Exeunt.

Finis Actus Tertii.

ACT FOUR

SCENE ONE

[*Enter the*] SOLDAN of EGYPT *with three or four*
Lords, CAPOLIN, Lords.

　Sold. Awake, ye men of Memphis!—hear the clang
Of Scythian trumpets!—hear the basilisks,[1]
That, roaring, shake Damascus' turrets down!
The rogue of Volga holds Zenocrate,
The Soldan's daughter, for his concubine,
And with a troop of thieves and vagabonds
Hath spread his colors to our high disgrace,
While you, faint-hearted, base Egyptians,
Lie slumbering on the flowery banks of Nile,
As crocodiles that unaffrighted rest, 10
While thundering cannons rattle on their skins.
　Mess. Nay, mighty Soldan, did your greatness see
The frowning looks of fiery Tamburlaine,
That with his terror and imperious eyes,
Commands the hearts of his associates,
It might amaze your royal majesty.
　Sold. Villain, I tell thee, were that Tamburlaine
As monstrous as Gorgon[2] prince of hell,
The Soldan would not start a foot from him.
But speak, what power hath he?
　Mess.　　　　　　Mighty lord, 20
Three hundred thousand men in armor clad,
Upon their prancing steeds disdainfully,
With wanton[3] paces trampling on the ground:
Five hundred thousand footmen threatening shot,
Shaking their swords, their spears, and iron bills,[4]
Environing their standard round, that stood
As bristle-pointed as a thorny wood;
Their warlike engines and munition
Exceed the forces of their martial men.
　Sold. Nay, could their numbers countervail[5] the
　　stars, 30
Or ever-drizzling drops of April showers,
Or withered leaves that autumn shaketh down,
Yet would the Soldan by his conquering power
So scatter and consume them in his rage,
That not a man should live to rue their fall.
　Capo. So might your highness, had you time to sort
Your fighting men, and raise your royal host;
But Tamburlaine, by expedition,[6]
Advantage takes of your unreadiness.
　Sold. Let him take all the advantages he can. 40
Were all the world conspired to fight for him,

Nay, were he devil, as he is no man,
Yet in revenge of fair Zenocrate,
Whom he detaineth in despite of us,
This arm should send him down to Erebus,[7]
To shroud his shame in darkness of the night.

 Mess. Pleaseth your mightiness to understand,
His resolution far exceedeth all.
The first day when he pitcheth down his tents,
White is their hue, and on his silver crest, 50
A snowy feather spangled white he bears,
To signify the mildness of his mind,
That, satiate with spoil, refuseth blood.
But when Aurora[8] mounts the second time
As red as scarlet is his furniture;[9]
Then must his kindled wrath be quenched with blood,
Not sparing any that can manage[10] arms;
But if these threats move not submission,
Black are his colors, black pavilion;
His spear, his shield, his horse, his armor, plumes, 60
And jetty feathers, menace death and hell!
Without respect of sex, degree,[11] or age,
He razeth[12] all his foes with fire and sword.

 Sold. Merciless villain!—peasant, ignorant
Of lawful arms or martial discipline!
Pillage and murder are his usual trades.
The slave usurps the glorious name of war.
See, Capolin, the fair Arabian King,
That hath been disappointed by this slave
Of my fair daughter, and his princely love, 70
May have fresh warning to go war with[13] us,
And be revenged for her disparagement.[14]

 [Exeunt.]

IV.ii

 [Enter] TAMBURLAINE, TECHELLES,
THERIDAMAS, USUMCASANE, ZENOCRATE,
ANIPPE, *two* Moors *drawing* BAJAZETH *in his cage,
and his wife following him.*

 Tamb. Bring out my footstool.

 They take him out of the cage.

 Baj. Ye holy priests of heavenly Mahomet,
That, sacrificing, slice and cut your flesh,
Staining his altars with your purple blood;
Make heaven to frown and every fixèd star
To suck up poison from the moorish fens,[1]
And pour it in this glorious[2] tyrant's throat!

 Tamb. The chiefest God, first mover of that sphere,[3]
Enchased[4] with thousands[5] ever-shining lamps,
Will sooner burn the glorious frame of heaven, 10
Than it should so conspire my overthrow.
But, villain! thou that wishest this to me,
Fall prostrate on the low disdainful earth,
And be the footstool of great Tamburlaine,
That I may rise into my royal throne.

 Baj. First shalt thou rip my bowels with thy sword,
And sacrifice my soul to death and hell,
Before I yield to such a slavery.

 Tamb. Base villain, vassal, slave to Tamburlaine!

Unworthy to embrace or touch the ground 20
That bears the honor of my royal weight;
Stoop, villain, stoop!—Stoop! for so he bids
That may command thee piecemeal to be torn,
Or scattered like the lofty cedar trees
Struck with the voice of thundering Jupiter.

 Baj. Then, as I look down to the damnèd fiends,
Fiends, look on me! and thou, dread god of hell,
With ebon scepter strike this hateful earth,
And make it swallow both of us at once!

 He gets upon him to his chair.

 Tamb. Now clear the triple region[6] of the air, 30
And let the majesty of heaven behold
Their scourge and terror tread on emperors.
Smile, stars, that reigned at my nativity,
And dim the brightness of their neighbor lamps!
Disdain to borrow light of Cynthia![7]
For I, the chiefest lamp of all the earth,
First rising in the east with mild aspèct,
But fixèd now in the meridian line,[8]
Will send up fire to your turning spheres,
And cause the sun to borrow light of you. 40
My sword struck fire from his coat of steel,
Even in Bithynia, when I took this Turk;
As when a fiery exhalation,
Wrapped in the bowels of a freezing cloud,
Fighting for passage, makes the welkin crack,
And casts a flash of lightning to the earth.[9]
But ere I march to wealthy Persia,
Or leave Damascus and the Egyptian fields,
As was the fame of Clymene's brain-sick son,[10]
That almost brent[11] the axletree[12] of heaven, 50

 [7] *Erebus:* the dark vestibule of Hades.
 [8] *Aurora:* goddess of the dawn.
 [9] *furniture:* furnishings, equipment.
 [10] *manage:* wield. [11] *degree:* station.
 [12] *razeth:* exterminates. [13] *with:* allied with.
 [14] *disparagement:* disgrace.

IV.ii.
 [1] *star . . . fens:* vapors were supposedly drawn off from the earth by the planets.
 [2] *glorious:* boastful (like the *miles gloriosus*).
 [3] *sphere:* the *primum mobile*, which, impelled by God as prime mover, carried all the stars in their circular course about the earth. [4] *Enchased:* Adorned.
 [5] *thousands:* thousands of.
 [6] *triple region:* Ascending spheres of air, water, and fire—which Tamburlaine wants "cleared" or made perspicuous so that God may look down on him—were thought to enclose the earth. [7] *Cynthia:* the moon.
 [8] *For . . . line:* Tamburlaine, identifying himself with the sun, has reached the high noon or "meridian line" of his fortunes—and unlike the sun is "fixed" and not about to decline.
 [9] *As . . . earth:* Comparison is to the earthly vapors, sometimes compounded of more solid matter, which, drawn off by the sun, reverberate within the clouds, causing thunder in the sky ("welkin"), or, bursting through the clouds, issue in lightning.
 [10] *Clymene's . . . son:* Phaëthon, whose mother married the sun-god Apollo, and who was destroyed for his mad attempt to drive his father's chariot about the earth. Ovid tells the story in *Metamorphoses,* I. 750*ff,* and II. 1–366.
 [11] *brent:* burned.
 [12] *axletree:* the pole on which the spheres revolved.

So shall our swords, our lances, and our shot
Fill all the air with fiery meteors:
Then when the sky shall wax as red as blood
It shall be said I made it red myself,
To make me think of nought but blood and war.

 Zab. Unworthy King, that by thy cruelty
Unlawfully usurp'st the Persian seat,
Dar'st thou that never saw an emperor,
Before thou met my husband in the field,
Being thy captive, thus abuse his state,[13] 60
Keeping his kingly body in a cage,
That roofs of gold and sun-bright palaces
Should have prepared to entertain his grace?
And treading him beneath thy loathsome feet,
Whose feet the Kings of Africa have kissed.

 Tech. You must devise some torment worse, my
 lord,
To make these captives rein their lavish tongues,[14]

 Tamb. Zenocrate, look better to your slave.

 Zeno. She is my handmaid's slave, and she shall
 look
That these abuses flow not from her tongue: 70
Chide her, Anippe.

 Anip. Let these be warnings for you then, my slave,
How you abuse the person of the King;
Or else I swear to have you whipped, stark naked.

 Baj. Great Tamburlaine, great in my overthrow,
Ambitious pride shall make thee fall as low,
For treading on the back of Bajazeth,
That should be horsèd on four mighty kings.

 Tamb. Thy names, and titles, and thy dignities
Are fled from Bajazeth and remain with me, 80
That will maintain it against a world of kings.
Put him in again.

 [*They put him back into the cage.*]

 Baj. Is this a place for mighty Bajazeth?
Confusion light on him that helps thee thus!

 [13] *state:* high station.
 [14] *rein . . . tongues:* curb their loose talk.
 [15] *Plato's wondrous years:* According to Plato in the *Tim-
aeus,* the perfect year occurred when all the seven known
planets resumed the same relative position they had held at
the beginning of the *magnus annus*—perhaps thousands of
years before.
 [16] *Pyramides:* pyramids; generically, "monuments" (four
syllables).
 [17] *Memphian:* Reference is to Memphis, the ancient Egyp-
tian capital. [18] *stature:* statue.
 [19] *bird:* Ibis, the sacred bird of Egypt.
 [20] *mask:* dress themselves.
 [21] *all the rest:* i.e., will be spared too.
 [22] *streamers:* banners.
 [23] *country's:* i.e., Damascus is of my country.

IV.iii.
 [1] *as . . . boar:* like the famous hero (of whom Ovid tells in
Metamorphoses, VIII. 270*ff*) who, "environed" with men of
southern Greece (Argolis), killed the boar of Calydon.
 [2] *Or . . . fields:* Ovid again (*Metamorphoses,* VII. 762*ff*) is
Marlowe's authority for the story of the hunter whose dog
and spear never missed their target—in this case, a beast sent
by the Greek divinity Themis to ravage the territory of Boeo-
tia ("Aonian") in central Greece.
 [3] *five . . . heads:* the size of Tamburlaine's army.

 Tamb. There, whiles he lives, shall Bajazeth be kept;
And, where I go, be thus in triumph drawn;
And thou, his wife, shalt feed him with the scraps
My servitors shall bring thee from my board;
For he that gives him other food than this,
Shall sit by him and starve to death himself; 90
This is my mind and I will have it so.
Not all the kings and emperors of the earth,
If they would lay their crowns before my feet,
Shall ransom him, or take him from this cage.
The ages that shall talk of Tamburlaine,
Even from this day to Plato's wondrous year,[15]
Shall talk how I have handled Bajazeth;
These Moors, that drew him from Bithynia
To fair Damascus, where we now remain,
Shall lead him with us whereso'er we go. 100
Techelles, and my loving followers,
Now may we see Damascus' lofty towers,
Like to the shadows of Pyramides,[16]
That with their beauties graced the Memphian[17]
 fields:
The golden stature[18] of their feathered bird[19]
That spreads her wings upon the city walls
Shall not defend it from our battering shot.
The townsmen mask[20] in silk and cloth of gold,
And every house is as a treasury:
The men, the treasure, and the town is ours. 110

 Ther. Your tents of white now pitched before the
 gates,
And gentle flags of amity displayed,
I doubt not but the governor will yield,
Offering Damascus to your majesty.

 Tamb. So shall he have his life and all the rest:[21]
But if he stay until the bloody flag
Be once advanced on my vermilion tent,
He dies, and those that kept us out so long.
And when they see me march in black array,
With mournful streamers[22] hanging down their heads,
Were in that city all the world contained, 121
Not one should 'scape, but perish by our swords.

 Zeno. Yet would you have some pity for my sake,
Because it is my country's,[23] and my father's.

 Tamb. Not for the world, Zenocrate, if I have
 sworn.
Come; bring in the Turk.

 Exeunt.

IV.iii

[*Enter the*] SOLDAN, KING of ARABIA, CAPOLIN,
 with streaming colors, and Soldiers.

 Sold. Methinks we march as Meleager did,
Environèd with brave Argolian knights,
To chase the savage Calydonian boar,[1]
Or Cephalus with lusty Theban youths
Against the wolf that angry Themis sent
To waste and spoil the sweet Aonian fields.[2]
A monster of five hundred thousand heads,[3]
Compact of rapine, piracy, and spoil,
The scum of men, the hate and scourge of God,

Raves in Egyptia and annoyeth[4] us. 10
My lord, it is the bloody Tamburlaine,
A sturdy felon and a base-bred thief,
By murder raisèd to the Persian crown,
That dares control us in our territories.
To tame the pride of this presumptuous beast,
Join your Arabians with the Soldan's power,
Let us unite our royal bands in one,
And hasten to remove Damascus' siege.
It is a blemish to the majesty
And high estate of mighty emperors, 20
That such a base usurping vagabond
Should brave a king, or wear a princely crown.
 K. of Arab. Renowmèd Soldan, have ye lately heard
The overthrow of mighty Bajazeth
About the confines[5] of Bithynia?
The slavery wherewith he persecutes
The noble Turk and his great Emperess?
 Sold. I have, and sorrow for his bad success.[6]
But noble Lord of great Arabia,
Be so persuaded that the Soldan is 30
No more dismayed with tidings of his fall,
Than in the haven when the pilot stands,
And views a stranger's ship rent in the winds,
And shiverèd against a craggy rock.
Yet in compassion to his wretched state,
A sacred vow to heaven and him I make,
Confirming it with Ibis'[7] holy name.
That Tamburlaine shall rue the day, the hour,
Wherein he wrought such ignominious wrong
Unto the hallowed person of a prince, 40
Or kept the fair Zenocrate so long
As concubine, I fear, to feed his lust.
 K. of Arab. Let grief and fury hasten on revenge;
Let Tamburlaine for his offenses feel
Such plagues as heaven and we can pour on him.
I long to break my spear upon his crest,
And prove[8] the weight of his victorious arm;
For fame, I fear, hath been too prodigal[9]
In sounding through the world his partial[10] praise.
 Sold. Capolin, hast thou surveyed our powers? 50
 Capol. Great Emperors of Egypt and Arabia,
The number of your hosts united is
A hundred and fifty thousand horse;
Two hundred thousand foot, brave men at arms,
Courageous, and full of hardiness.
As frolic[11] as the hunters in the chase
Of savage beasts amid the desert woods.
 K. of Arab. My mind presageth fortunate success;
And Tamburlaine, my spirit doth foresee
The utter ruin of thy men and thee. 60
 Sold. Then rear your standards; let your sounding
 drums
Direct our soldiers to Damascus' walls.
Now, Tamburlaine, the mighty Soldan comes,
And leads with him the great Arabian King,
To dim thy baseness and obscurity,
Famous for nothing but for theft and spoil;
To raze and scatter thy inglorious crew
Of Scythians and slavish Persians.
 Exeunt.

IV.iv

The banquet, and to it cometh TAMBURLAINE
all in scarlet, THERIDAMAS, TECHELLES,
 USUMCASANE, *the Turk with others.*

 Tamb. Now hang our bloody colors by Damascus,
Reflexing hues of blood upon their heads,
While they walk quivering on their city walls,
Half dead for fear before they feel my wrath,
Then let us freely banquet and carouse
Full bowls of wine unto the god of war
That means to fill your helmets full of gold,
And make Damascus spoils as rich to you,
As was to Jason Colchos' golden fleece.[1]
And now, Bajazeth, hast thou any stomach?[2] 10
 Baj. Ay, such a stomach, cruel Tamburlaine, as I
could willingly feed upon thy blood-raw heart.
 Tamb. Nay, thine own is easier to come by; pluck out
that and 'twill serve thee and thy wife. Well, Zenocrate,
Techelles, and the rest, fall to your victuals.[3]
 Baj. Fall to, and never may your meat digest!
Ye Furies, that can mask invisible,[4]
Dive to the bottom of Avernus' pool,
And in your hands bring hellish poison up
And squeeze it in the cup of Tamburlaine! 20
Or, wingèd snakes of Lerna,[5] cast your stings,
And leave your venoms in this tyrant's dish!
 Zab. And may this banquet prove as ominous
As Progne's[6] to the adulterous Thracian King,
That fed upon the substance of his child.
 Zeno. My lord, how can you suffer these
Outrageous curses by these slaves of yours?
 Tamb. To let them see, divine Zenocrate,
I glory in the curses of my foes
Having the power from the imperial heaven 30
To turn them all upon their proper[7] heads.
 Tech. I pray you give them leave, madam; this speech
is a goodly refreshing to them.
 Ther. But if his highness would let them be fed, it
would do them more good.
 Tamb. Sirrah, why fall you not to?—are you so
daintily brought up, you cannot eat your own flesh?
 Baj. First, legions of devils shall tear thee in pieces.
 Usum. Villain, knowest thou to whom thou speak-
est? 40

[4] *annoyeth:* injures. [5] *confines:* boundaries.
[6] *success:* fortune.
[7] *Ibis':* of the "feathered bird" sacred to the Egyptians.
[8] *prove:* test. [9] *prodigal:* lavish.
[10] *partial:* biased. [11] *frolic:* lively.
IV.iv.
[1] *Jason . . . fleece:* The expedition of the Argonauts that
Jason led to Colchis is recounted by Ovid, *Metamorphoses,*
VII. 1ff. [2] *stomach:* i.e., for food; also, "pride."
[3] *Ay . . . victuals:* The lapsing into prose here and subse-
quently suggests textual corruption.
[4] *mask invisible:* put on invisibility.
[5] *Lerna:* where Hercules killed the Hydra and tipped his
arrows with its poison.
[6] *Progne's:* For the story of Procne, who, in revenge for
the rape of her sister Philomel, tricked Tereus, King of
Thrace, into eating their child, Itys, *see Metamorphoses,* VI.
565. [7] *proper:* own.

Tamb. Oh, let him alone. Here; eat, sir; take it from my sword's point, or I'll thrust it to thy heart.

He takes it and stamps upon it.

Ther. He stamps it under his feet, my lord.

Tamb. Take it up, villain, and eat it; or I will make thee slice the brawns[8] of thy arms into carbonadoes[9] and eat them.

Usum. Nay, 'twere better he killed his wife, and then she shall be sure not to be starved, and he be provided for a month's victual beforehand. 49

Tamb. Here is my dagger: dispatch her while she is fat, for if she live but a while longer, she will fall into a consumption with fretting, and then she will not be worth the eating.

Ther. Dost thou think that Mahomet will suffer[10] this?

Tech. 'Tis like he will when he cannot let[11] it.

Tamb. Go to;[12] fall to your meat.—What, not a bit! Belike[13] he hath not been watered[14] today. Give him some drink. 59

They give him water to drink, and he flings it on the ground.

Tamb. Fast, and welcome, sir, while[15] hunger make you eat. How now, Zenocrate, doth not the Turk and his wife make a goodly show at a banquet?

Zeno. Yes, my lord.

Ther. Methinks 'tis a great deal better than a consort of music.[16]

Tamb. Yet music would do well to cheer up Zenocrate. Pray thee, tell, why thou art so sad?—If thou wilt have a song, the Turk shall strain his voice. But why is it?

Zeno. My lord, to see my father's town besieged, The country wasted where myself was born, 71 How can it but afflict my very soul? If any love remain in you, my lord, Or if my love unto your majesty May merit favor at your highness' hands, Then raise your siege from fair Damascus' walls, And with my father take a friendly truce,

Tamb. Zenocrate, were Egypt Jove's own land,

Yet would I with my sword make Jove to stoop. I will confute those blind geographers 80 That make a triple region[17] in the world, Excluding regions which I mean to trace, And with this pen[18] reduce them to[19] a map, Calling the provinces, cities, and towns, After my name and thine, Zenocrate. Here at Damascus will I make the point That shall begin the perpendicular;[20] And would'st thou have me buy thy father's love With such a loss? Tell me, Zenocrate.

Zeno. Honor still wait on happy Tamburlaine; 90 Yet give me leave to plead for him, my lord.

Tamb. Content thyself: his person shall be safe, And all the friends of fair Zenocrate, If with their lives they will be pleased to yield, Or may be forced to make me Emperor; For Egypt and Arabia must be mine.— Feed, you slave; thou may'st think thyself happy to be fed from my trencher.[21]

Baj. My empty stomach full of idle heat, Draws bloody humors from my feeble parts, 100 Preserving life by hasting cruel death. My veins are pale; my sinews hard and dry; My joints benumbed; unless I eat, I die.

Zab. Eat, Bajazeth. Let us live in spite of them, looking[22] some happy power[23] will pity and enlarge[24] us.

Tamb. Here, Turk; wilt thou have a clean trencher?

Baj. Ay, tyrant, and more meat.

Tamb. Soft,[25] sir; you must be dieted; too much eating will make you surfeit.

Ther. So it would, my lord, 'specially having so small a walk and so little exercise. 111

Enter a second course of crowns.

Tamb. Theridamas, Techelles, and Casane, here are the cates[26] you desire to finger, are they not?

Ther. Ay, my lord: but none save kings must feed with these.

Tech. 'Tis enough for us to see them, and for Tamburlaine only to enjoy them.

Tamb. Well; here is now to the Soldan of Egypt, the King of Arabia, and the Governor of Damascus. Now take these three crowns, and pledge me, my con- 120 tributory Kings. I crown you here, Theridamas, King of Argier; Techelles, King of Fesse, and Usumcasane, King of Moroccus. How say you to this, Turk? These are not your contributory Kings.

Baj. Nor shall they long be thine, I warrant them.

Tamb. Kings of Argier, Moroccus, and of Fesse, You that have marched with happy Tamburlaine As far as from the frozen place[27] of heaven, Unto the watery morning's ruddy bower, And thence by land unto the torrid zone, 130 Deserve these titles I endow you with, By valor and by magnanimity. Your births shall be no blemish to your fame, For virtue[28] is the fount whence honor springs, And they[29] are worthy she investeth kings.

Ther. And since your highness hath so well vouchsafed,[30]

8 *brawns:* muscles. 9 *carbonadoes:* rashers of meat.
10 *suffer:* endure. 11 *let:* hinder.
12 *Go to:* an impatient expostulation.
13 *Belike:* Perhaps.
14 *watered:* given drink (like cattle). 15 *while:* until.
16 *consort of music:* band of musicians.
17 *triple region:* Europe, Asia, Africa—the known world.
18 *pen:* his sword.
19 *reduce them to:* express or record them on.
20 *perpendicular:* the meridian whence longitude will be calculated; Damascus is to figure in cartography as the center of the world. 21 *trencher:* wooden dish.
22 *looking:* anticipating.
23 *happy power:* i.e., conferring happiness.
24 *enlarge:* free. 25 *Soft:* Pause.
26 *cates:* delicacies.
27 *place:* many editors emend to "plage" (shore).
28 *virtue:* native endowment as opposed to lowly rank or birth. 29 *they:* they who.
30 *vouchsafed:* permitted.

If we deserve them not with higher meeds [31]
Than erst [32] our states and actions have retained, [33]
Take them away again and make us slaves.

Tamb. Well said, Theridamas. When holy fates 140
Shall 'stablish me in strong Egyptia,
We mean to travel to th' antarctic pole,
Conquering the people underneath our feet, [34]
And be renowmed as never emperors were.
Zenocrate, I will not crown thee yet,
Until with greater honor I be graced.

[*Exeunt.*]

Finis Actus Quarti.

ACT FIVE

Scene One

[*Enter*] *the* Governor *of* Damascus, *with three or
four* Citizens, *and four* Virgins, *with branches of
laurel in their hands.*

Gov. Still doth this man, or rather god of war,
Batter our walls and beat our turrets down;
And to resist with longer stubborness
Or hope of rescue from the Soldan's power,
Were but to bring our willful overthrow,
And make us desperate of our threatened lives.
We see his tents have now been alterèd
With terrors to the last and cruelest hue.
His coal-black colors everywhere advanced,
Threaten our city with a general spoil; 10
And if we should with common rites of arms
Offer our safeties to his clemency,
I fear the custom, proper [1] to his sword,
Which he observes as parcel [2] of his frame,
Intending so to terrify the world,
By any innovation or remorse [3]
Will never be dispensed with till our deaths.
Therefore, for these our harmless virgins' sakes,
Whose honors and whose lives rely on him,
Let us have hope that their unspotted prayers, 20
Their blubbered [4] cheeks, and hearty, [5] humble moans,
Will melt his fury into some remorse,
And use us like a loving conqueror.

1 Virg. If humble suits or imprecations [6]
(Uttered with tears of wretchedness and blood
Shed from the heads and hearts of all our sex,
Some made your wives and some your children),
Might have entreated your obdurate breasts
To entertain some care of our securities [7]
Whiles only danger beat upon our walls, 30
These more than dangerous warrants [8] of our death
Had never been erected as they be,
Nor you depend on such weak helps as we.

Gov. Well, lovely virgins, think our country's care,
Our love of honor, loath to be enthralled
To foreign powers and rough imperious yokes,
Would not with too much cowardice or fear,
Before all hope of rescue were denied,
Submit yourselves and us to servitude.

Therefore in that your safeties and our now, 40
Your honors, liberties, and lives were weighed
In equal care and balance with our own,
Endure as we the malice of our stars,
The wrath of Tamburlaine and power of wars;
Or be the means the overweighing [9] heavens
Have kept to qualify [10] these hot extremes,
And bring us pardon in your cheerful looks.

2 Virg. Then here before the majesty of heaven
And holy patrons of Egyptia,
With knees and hearts submissive we entreat 50
Grace to our words and pity to our looks,
That this device may prove propitious,
And through the eyes and ears of Tamburlaine
Convey events [11] of mercy to his heart;
Grant that these signs of victory [12] we yield
May bind the temples of his conquering head,
To hide the folded furrows of his brows,
And shadow his displeasèd countenance
With happy looks of ruth and lenity.
Leave us, my lord, and loving countrymen. 60
What simple virgins may persuade, we will.

Gov. Farewell, sweet virgins, on whose safe return
Depends our city, liberty, and lives.

Exeunt [Governor *and* Citizens; *the* Virgins *remain*].

[*Enter*] Tamburlaine, Techelles,
Theridamas, Usumcasane, *with others.*
Tamburlaine *all in black and very melancholy.* [13]

Tamb. What, are the turtles frayed [14] out of their
nests?
Alas, poor fools! must you be first shall feel
The sworn destruction of Damascus?
They know my custom; could they not as well
Have sent ye out, when first my milk-white flags,
Through which sweet Mercy threw her gentle beams,
Reflexing them on your disdainful eyes, 70
As now, when fury and incensèd hate
Flings slaughtering terror from my coal-black tents,
And tells for truth submissions comes too late?

1 Virg. Most happy King and Emperor of the
earth,
Image of honor and nobility,
For whom the powers divine have made the world,
And on whose throne the holy Graces [15] sit;
In whose sweet person is comprised the sum

[31] *meeds:* deservings. [32] *erst:* before.
[33] *retained:* displayed.
[34] *underneath our feet:* in the southern hemisphere.

V.i.
[1] *proper:* peculiar. [2] *parcel:* part and parcel.
[3] *innovation or remorse:* change or pity.
[4] *blubbered:* tear-stained. [5] *hearty:* i.e., from the heart.
[6] *imprecations:* prayers. [7] *securities:* safety.
[8] *warrants:* Tamburlaine's black banners.
[9] *overweighing:* preponderating, deciding.
[10] *qualify:* make more temperate. [11] *events:* issues.
[12] *signs of victory:* laurel boughs.
[13] *melancholy:* At this point in the octavo text, a new scene
begins. [14] *turtles frayed:* turtledoves frightened.
[15] *Graces:* the three daughters of Jove, whose "gracious"
office the Virgin imputes wistfully to Tamburlaine.

Of nature's skill and heavenly majesty;
Pity our plights! O pity poor Damascus! 80
Pity old age, within whose silver hairs
Honor and reverence evermore have reigned!
Pity the marriage bed, where many a lord,
In prime and glory of his loving joy,
Embraceth now with tears of ruth and blood
The jealous [16] body of his fearful wife,
Whose cheeks and hearts so punished with conceit,[17]
To think thy puissant, never-stayèd [18] arm,
Will part their bodies, and prevent their souls
From heavens of comfort yet their age might bear, 90
Now wax all pale and withered to the death,
As well for grief our ruthless [19] governor
Have thus refused the mercy of thy hand
(Whose scepter angels kiss and furies dread),
As for their liberties, their loves, or lives!
Oh, then for these, and such as we ourselves,
For us, our infants, and for all our bloods,[20]
That never nourished thought against thy rule,
Pity, O pity, sacred Emperor,
The prostrate service of this wretched town, 100
And take in sign thereof this gilded wreath,
Whereto each man of rule hath given his hand,
And wished, as worthy subjects, happy means
To be investers of thy royal brows
Even with the true Egyptian diadem!
 Tamb. Virgins, in vain you labor to prevent
That which mine honor swears shall be performed.
Behold my sword! what see you at the point?
 1 Virg. Nothing but fear, and fatal steel, my lord.
 Tamb. Your fearful minds are thick and misty then;
For there sits Death; there sits imperious Death 111
Keeping his circuit [21] by the slicing edge.
But I am pleased you shall not see him there;
He now is seated on my horsemen's spears,
And on their points his fleshless [22] body feeds.
Techelles, straight go charge a few of them
To charge these dames, and show my servant, Death,
Sitting in scarlet on their armèd spears.

Virgins. O pity us!
 Tamb. Away with them, I say, and show them
 Death. 120

 They take them away.

I will not spare these proud Egyptians,
Nor change my martial observations [23]
For all the wealth of Gihon's [24] golden waves,
Or for the love of Venus, would she leave
The angry god of arms [25] and lie with me.
They have refused the offer of their lives,
And know my customs are as peremptory
As wrathful planets, death, or destiny.

 Enter TECHELLES.

What, have your horsemen shown the virgins Death?
 Tech. They have, my lord, and on Damascus' walls
Have hoisted up their slaughtered carcasses. 131
 Tamb. A sight as baneful to their souls, I think,
As are Thessalian [26] drugs or mithridate.[27]
But go, my lords, put the rest to the sword.

 Exeunt.

Ah, fair Zenocrate!—divine Zenocrate!—
Fair is too foul an epithet for thee,
That in thy passion [28] for thy country's love,
And fear to see thy kingly father's harm,
With hair disheveled wip'st thy watery cheeks;
And, like to Flora [29] in her morning's pride, 140
Shaking her silver tresses in the air,
Rain'st on the earth resolvèd [30] pearl in showers,
And sprinklest sapphires on thy shining face,
Where Beauty, mother to the Muses, sits
And comments volumes with her ivory pen,
Taking instructions from thy flowing eyes;
Eyes, when that Ebena [31] steps to heaven,
In silence of thy solemn evening's walk,
Making the mantle of the richest night,
The moon, the planets, and the meteors, light; 150
There angels in their crystal armors fight
A doubtful battle with my tempted thoughts [32]
For Egypt's freedom, and the Soldan's life;
His life that so consumes Zenocrate,
Whose sorrows lay more siege unto my soul,
Than all my army to Damascus' walls:
And neither Persia's sovereign, nor the Turk
Troubled my senses with conceit of foil [33]
So much by much as doth Zenocrate.
What is beauty, saith my sufferings, then? 160
If all the pens that ever poets held
Had fed the feeling of their masters' thoughts,
And every sweetness that inspired their hearts,
Their minds, and muses on admirèd themes;
If all the heavenly quintessence [34] they still [35]
From their immortal flowers of poesy,
Wherein, as in a mirror, we perceive
The highest reaches of a human wit; [36]
If these had made one poem's period, [37]
And all combined in beauty's worthiness, 170
Yet should there hover in their restless heads
One thought, one grace, one wonder, at the least,
Which into words no virtue can digest.[38]

[16] *jealous:* suspecting the events coming on.
[17] *punished with conceit:* tortured with imagination.
[18] *stayèd:* held back. [19] *ruthless:* devoid of pity.
[20] *bloods:* lives. [21] *Keeping his circuit:* i.e., as a judge.
[22] *fleshless:* skeletal. [23] *observations:* observances.
[24] *Gihon's:* one of the rivers of Eden.
[25] *god of arms:* Mars.
[26] *Thessalian:* Ovid and Lucan, among others, identify Thessaly with witchcraft. [27] *mithridate:* i.e., poison.
[28] *passion:* sorrow. [29] *Flora:* goddess of flowers.
[30] *resolvèd:* melted (to tears).
[31] *Ebena:* an unknown mythological deity, perhaps invented by Marlowe to personify the coming of darkness ("ebony" or black.)
[32] *Eyes ... thoughts:* Zenocrate's eyes are described as illuminating the planets and other celestial bodies and as contending with Tamburlaine's ambition.
[33] *conceit of foil:* conception of defeat.
[34] *quintessence:* literally, "fifth essence," a sovereign quality supposed to inhere in all matter and the goal of the alchemist's labors. [35] *still:* distill.
[36] *wit:* rational faculty.
[37] *one poem's period:* i.e., a poetic integer.
[38] *virtue can digest:* power can express.

But how unseemly is it for my sex,
My discipline of arms and chivalry,
My nature, and the terror of my name,
To harbor thoughts effeminate and faint!
Save only that in beauty's just applause,
With whose instinct the soul of man is touched;
And every warrior that is rapt with love 180
Of fame, of valor, and of victory,
Must needs have beauty beat on his conceits:
I thus conceiving and subduing both,
That which hath stopped the tempest of the gods,
Even from the fiery-spangled veil of heaven,
To feel the lovely warmth of shepherds' flames,
And march in cottages of strowèd weeds,
Shall give the world to note, for all my birth,
That virtue solely is the sum of glory,
And fashions men with true nobility.39— 190
Who's within there?

Enter two or three.

Hath Bajazeth been fed today?
 Atten. Ay, my lord.
 Tamb. Bring him forth; and let us know if the town
be ransacked.

 [*Exeunt* Attendants.]

Enter TECHELLES, THERIDAMAS, USUMCASANE,
 and others.

 Tech. The town is ours, my lord, and fresh supply
Of conquest and of spoil is offered us.
 Tamb. That's well, Techelles; what's the news?
 Tech. The Soldan and the Arabian King together,
March on us with such eager violence, 200
As if there were no way but one40 with us.
 Tamb. No more there is not, I warrant thee,
 Techelles.41

 They bring in the Turk.

 Ther. We know the victory is ours, my lord;
But let us save the reverend Soldan's life,
For fair Zenocrate that so laments his state.
 Tamb. That will we chiefly see unto, Theridamas,
For sweet Zenocrate, whose worthiness
Deserves a conquest over every heart.
And now, my footstool, if I lose the field,
You hope of liberty and restitution? 210
Here let him stay, my masters, from the tents,
Till we have made us ready for the field.
Pray for us, Bajazeth; we are going.

 Exeunt.

 Baj. Go, never to return with victory.
Millions of men encompass thee about,
And gore thy body with as many wounds!
Sharp, forkèd arrows light upon thy horse!
Furies from the black Cocytus'42 lake,
Break up the earth, and with their firebrands
Enforce thee run upon the baneful43 pikes! 220
Volleys of shot pierce through thy charmèd skin,
And every bullet dipped in poisoned drugs!
Or, roaring cannons sever all thy joints,
Making thee mount as high as eagles soar!

 Zab. Let all the swords and lances in the field
Stick in his breast as in their proper rooms!44
At every pore let blood come dropping forth,
That lingering pains may massacre his heart,
And madness send his damnèd soul to hell!
 Baj. Ah, fair Zabina! we may curse his power; 230
The heavens may frown, the earth for anger quake:
But such a star hath influence in his sword,
As rules the skies and countermands the gods
More than Cimmerian Styx45 or destiny;
And then shall we in this detested guise,
With shame, with hunger, and with horror aye,
Griping our bowels with retorquèd46 thoughts
And have no hope to end our ecstasies.47
 Zab. Then is there left no Mahomet, no God,
No fiend, no fortune, nor no hope of end 240
To our infàmous monstrous slaveries.
Gape earth, and let the fiends infernal view
A hell as hopeless and as full of fear
As are the blasted banks of Erebus,
Where shaking ghosts with ever-howling groans
Hover about the ugly ferryman,48
To get a passage to Elysian!49
Why should we live? Oh, wretches, beggars, slaves!
Why live we, Bajazeth, and build up nests
So high within the region of the air 250
By living long in this oppression,
That all the world will see and laugh to scorn
The former triumphs of our mightiness
In this obscure infernal servitude?
 Baj. O life, more loathsome to my vexèd thoughts
Than noisome parbreak50 of the Stygian51 snakes,
Which fills the nooks of hell with standing52 air,
Infecting all the ghosts with cureless griefs!53
O dreary engines54 of my loathèd sight,
That see my crown, my honor, and my name 260
Thrust under yoke and thraldom of a thief,
Why feed ye still on day's accursèd beams
And sink not quite into my tortured soul?
You see my wife, my Queen, and Emperess,

 39 *Save . . . nobility:* The long speech, marked by ana-coluthon or incompleted sentences and often said to be textually corrupt, may be paraphrased: I would be justly indicted of effeminacy except that every truly noble man is stirred by beauty. I, who have been stirred and yet kept my manliness despite the solicitings of beauty—which has restrained the wrath of the gods and caused them to sojourn on earth in humble dwellings (a reminiscence perhaps of Ovid's tale of Baucis and Philemon)—shall show the world that, whatever my lowly origins, real eminence depends not on birth but wholly on native capacity.
 40 *but one:* i.e., to die.
 41 *No . . . Techelles:* presumably uttered satirically.
 42 *Cocytus':* river of Hades. 43 *baneful:* deathly.
 44 *as . . . rooms:* i.e., where they should be.
 45 *Styx:* chief river of Hades.
 46 *retorquèd:* driven back on themselves.
 47 *ecstasies:* maddened feelings.
 48 *ferryman:* Charon, who ferried passengers across the rivers of Hades.
 49 *Elysian:* Elysium, the abode of the blessed, located in Hades. 50 *noisome parbreak:* stinking vomit.
 51 *Stygian:* of Styx. 52 *standing:* hence, "stagnant."
 53 *griefs:* sickness. 54 *engines:* instruments.

Brought up and proppèd by the hand of fame,
Queen of fifteen contributory Queens,
Now thrown to rooms of black abjection,[55]
Smearèd with blots of basest drudgery,
And villeiness [56] to shame, disdain, and misery.
Accursèd Bajazeth, whose words of ruth, 270
That would with pity cheer Zabina's heart,
And make our souls resolve [57] in ceaseless tears;
Sharp hunger bites upon, and gripes the root,
From whence the issues of my thoughts do break;
O poor Zabina! O my Queen! my Queen!
Fetch me some water for my burning breast,
To cool and comfort me with longer date,
That in the shortened sequel of my life
I may pour forth my soul into thine arms
With words of love, whose moaning intercourse 280
Hath hitherto been stayed with wrath and hate
Of our expressless [58] banned [59] inflictions.
 Zab. Sweet Bajazeth, I will prolong thy life,
As long as any blood or spark of breath
Can quench or cool the torments of my grief.
 She goes out.
 Baj. Now, Bajazeth, abridge thy baneful days,
And beat thy brains out of thy conquered head,
Since other means are all forbidden me,
That may be ministers of my decay.[60]
O highest lamp of ever-living Jove, 290
Accursèd day! infected with my griefs,
Hide now thy stainèd face in endless night,
And shut the windows of the lightsome heavens!
Let ugly Darkness with her rusty coach,
Engirt with tempests, wrapped in pitchy clouds,
Smother the earth with never-fading mists!
And let her horses from their nostrils breathe
Rebellious winds and dreadful thunderclaps,
That in this terror Tamburlaine may live,
And my pined [61] soul, resolved in liquid air, 300
May still excruciate his tormented thoughts!
Then let the stony dart of senseless cold
Pierce through the center of my withered heart,
And make a passage for my loathèd life!

 He brains himself against the cage.

 Enter ZABINA.

 Zab. What do mine eyes behold? My husband dead!
His skull all riven in twain! his brains dashed out,—
The brains of Bajazeth, my lord and sovereign:
O Bajazeth, my husband and my lord!
O Bajazeth! O Turk! O Emperor! 309
Give him his liquor? Not I. Bring milk and fire, and my
blood I bring him again.—Tear me in pieces—give me
the sword with a ball of wild-fire upon it.—Down with
him! Down with him!—Go to my child! Away! Away!
away!—Ah, save that infant! save him, save him!—I,

even I, speak to her.—The sun was down—streamers
white, red, black—here, here, here!—Fling the meat in
his face—Tamburlaine, Tamburlaine!—Let the soldiers
be buried.—Hell! Death, Tamburlaine, Hell! Make
ready my coach, my chair, my jewels.—I come! I come!
I come! 320

 She runs against the cage and brains herself.

 [*Enter*] ZENOCRATE *with* ANIPPE.

 Zeno. Wretched Zenocrate! that liv'st to see
Damascus' walls dyed with Egyptians' blood,
Thy father's subjects and thy countrymen;
The streets strowed with dissevered joints of men,
And wounded bodies gasping yet for life:
But most accursed, to see the sun-bright troop
Of heavenly virgins and unspotted maids,
Whose looks might make the angry god of arms
To break his sword and mildly treat of love,
On horsemen's lances to be hoisted up 330
And guiltlessly endure a cruel death:
For every fell and stout [62] Tartarian steed,
That stamped on others with their thundering hoofs,
When all their riders charged their quivering spears,
Began to check [63] the ground and rein themselves,
Gazing upon the beauty of their looks.
Ah Tamburlaine! wert thou the cause of this
That term'st Zenocrate thy dearest love?
Whose lives were dearer to Zenocrate
Than her own life, or aught save thine own love. 340
But see another bloody spectacle!
Ah, wretched eyes, the enemies of my heart,
How are ye glutted with these grievous objects,
And tell my soul more tales of bleeding ruth!
See, see, Anippe, if they breathe or no.
 Anippe. No breath, nor sense, nor motion in them
 both.
Ah, madam! this their slavery hath enforced,
And ruthless cruelty of Tamburlaine.
 Zeno. Earth, cast up fountains from thy entrails,
And wet thy cheeks for their untimely deaths! 350
Shake with their weight in sign of fear and grief!
Blush, heaven, that gave them honor at their birth
And let them die a death so barbarous!
Those that are proud of fickle empery
And place their chiefest good in earthly pomp,
Behold the Turk and his great Emperess!
Ah, Tamburlaine! my love! sweet Tamburlaine!
That fight'st for scepters and for slippery crowns,
Behold the Turk and his great Emperess!
Thou, that in conduct of [64] thy happy stars 360
Sleep'st every night with conquests on thy brows,
And yet would'st shun the wavering turns of war,
In fear and feeling of the like distress,
Behold the Turk and his great Emperess!
Ah, mighty Jove and holy Mahomet,
Pardon my love!—O pardon his contempt
Of earthly fortune and respect [65] of pity,
And let not conquest, ruthlessly pursued,
Be equally against his life incensed
In this great Turk and hapless Emperess! 370

55 *abjection:* degradation. 56 *villeiness:* slave.
57 *resolve:* dissolve. 58 *expressless:* inexpressible.
59 *banned:* fettered; also, "cursed." 60 *decay:* death.
61 *pined:* pained. 62 *fell and stout:* cruel and strong.
63 *check:* stamp. 64 *in conduct of:* governed by.
65 *respect:* i.e., lack of respect.

And pardon me that was not moved with ruth
To see them live so long in misery!
Ah, what may chance to thee, Zenocrate?
 Anippe. Madam, content yourself, and be resolved
Your love hath Fortune so at his command,
That she shall stay and turn her wheel no more,
As long as life maintains his mighty arm
That fights for honor to adorn your head.

 Enter [PHILEMUS] *a* Messenger.

 Zeno. What other heavy news now brings Philemus?
 Phil. Madam, your father, and the Arabian King,
The first affecter [66] of your excellence, 381
Comes now, as Turnus [67] 'gainst Aeneas did,
Armèd with lance into the Egyptian fields,
Ready for battle 'gainst my lord, the King.
 Zeno. Now shame and duty, love and fear present
A thousand sorrows to my martyred soul.
Whom should I wish the fatal victory
When my poor pleasures are divided thus
And racked by duty from my cursèd heart?
My father and my first-betrothèd love 390
Must fight against my life and present love;
Wherein the change I use [68] condemns my faith,
And makes my deeds infàmous through the world.
But as the gods, to end the Trojan's toil,
Prevented Turnus of Lavinia
And fatally enriched Aeneas' love,
So for a final issue to my griefs,
To pacify my country and my love,
Must Tamburlaine by their resistless powers
With virtue of a gentle victory, 400
Conclude a league of honor to my hope;
Then, as the powers divine have preordained,
With happy safety of my father's life
Send like defense of fair Arabia.

 They sound to the battle. And TAMBURLAINE
 enjoys the victory. After, ARABIA *enters, wounded.*

 K. of Arab. What cursèd power guides the
 murdering hands
Of this infàmous tyrant's soldiers,
That no escape may save their enemies,
Nor fortune keep themselves from victory?
Lie down, Arabia, wounded to the death,
And let Zenocrate's fair eyes behold 410
That, as for her thou bear'st these wretched arms,
Even so for her thou diest in these arms,
Leaving thy blood for witness of thy love.
 Zeno. Too dear a witness for such love, my lord,
Behold Zenocrate! the cursèd object,
Whose fortunes never masterèd her griefs;
Behold her wounded, in conceit, [69] for thee,
As much as thy fair body is for me.
 K. of Arab. Then shall I die with full contented
 heart,
Having beheld divine Zenocrate, 420
Whose sight with joy would take away my life
As now it bringeth sweetness to my wound,
If I had not been wounded as I am.
Ah! that the deadly pangs I suffer now,

Would lend an hour's license to my tongue,
To make discourse of some sweet accidents
Have [70] chanced thy merits in this worthless bondage;
And that I might be privy to the state
Of thy deserved contentment, and thy love.
But, making now a virtue of thy sight, 430
To drive all sorrow from my fainting soul,
Since death denies me further cause of joy,
Deprived of care, my heart with comfort dies,
Since thy desirèd hand shall close mine eyes.

 [*He dies.*]

 Enter TAMBURLAINE, *leading the* SOLDAN,
 TECHELLES, THERIDAMAS, USUMCASANE,
 with others.

 Tamb. Come, happy father of Zenocrate,
A title higher than thy Soldan's name.
Though my right hand have thus enthrallèd thee,
Thy princely daughter here shall set thee free;
She that hath calmed the fury of my sword,
Which had ere this been bathed in streams of blood
As vast and deep as Eúphrates or Nile. 441
 Zeno. Oh, sight thrice welcome to my joyful soul,
To see the King, my father, issue safe
From dangerous battle of [71] my conquering love!
 Sold. Well met, my only dear Zenocrate,
Though with the loss of Egypt and my crown.
 Tamb. 'Twas I, my lord, that gat the victory,
And therefore grieve not at your overthrow,
Since I shall render all into your hands,
And add more strength to your dominions 450
Than ever yet confirmed [72] the Egyptian crown.
The god of war resigns his room [73] to me,
Meaning to make me general of the world:
Jove, viewing me in arms, looks pale and wan,
Fearing my power should pull him from his throne.
Where'er I come the Fatal Sisters sweat,
And grisly Death, by running to and fro
To do their ceaseless homage to my sword;
And here in Afric, where it seldom rains,
Since I arrived with my triumphant host, 460
Have swelling clouds, drawn from wide-gasping
 wounds,
Been oft resolved in bloody purple showers,
A meteor that might terrify the earth,
And make it quake at every drop it drinks.
Millions of souls sit on the banks of Styx
Waiting the back return of Charon's boat;
Hell and Elysian swarm with ghosts of men,
That I have sent from sundry foughten fields,
To spread my fame through hell and up to heaven.
And see, my lord, a sight of strange import, 470
Emperors and kings lie breathless at my feet:
The Turk and his great Empress, as it seems,

 [66] *affecter:* admirer.
 [67] *Turnus:* Virgil in *Aeneid,* VII, tells of the strife of Tur-
nus and Aeneas. Aeneas had married Lavinia, Turnus's be-
trothed. [68] *use:* practice.
 [69] *conceit:* (sympathizing) imagination.
 [70] *Have:* That have. [71] *of:* against.
 [72] *confirmed:* secured. [73] *room:* place.

Left to themselves while we were at the fight,
Have desperately dispatched their slavish lives.
With them Arabia, too, hath left his life:
All sights of power to grace my victory;
And such are objects fit for Tamburlaine;
Wherein, as in a mirror, may be seen
His honor, that consists in shedding blood,
When men presume to manage arms with him. 480

Sold. Mighty hath God and Mahomet made thy hand,
Renowmèd Tamburlaine! to whom all kings
Of force must yield their crowns and emperies;
And I am pleased with this my overthrow,
If, as beseems a person of thy state,
Thou hast with honor used Zenocrate.

Tamb. Her state and person want no pomp, you see;
And for all blot of foul inchastity,
I record[74] heaven her heavenly self is clear.[75]
Then let me find no further time to grace 490
Her princely temples with the Persian crown.
But here these Kings that on my fortunes wait,
And have been crowned for provèd worthiness,
Even by his hand that shall establish them,
Shall now, adjoining all their hands with mine,
Invest her the Queen of Persia.
What saith the noble Soldan and Zenocrate!

Sold. I yield with thanks and protestations
Of endless honor to thee for her love.

Tamb. Then doubt I not but fair Zenocrate 500
Will soon consent to satisfy us both.

Zeno. Else should I much forget myself, my lord.

Ther. Then let us set the crown upon her head,
That long hath lingered for so high a seat.

Tech. My hand is ready to perform the deed;
For now her marriage-time shall work[76] us rest.

Usum. And here's the crown, my lord; help set it on.

Tamb. Then sit thou down, divine Zenocrate;
And here we crown thee Queen of Persia,
And all the kingdoms and dominions 510
That late the power of Tamburlaine subdued.
As Juno, when the giants were suppressed,
That darted mountains at her brother Jove,
So looks my love, shadowing[77] in her brows
Triumphs and trophies for my victories;
Or, as Latona's daughter,[78] bent to arms,
Adding more courage to my conquering mind.
To gratify thee, sweet Zenocrate,
Egyptians, Moors, and men of Asia,
From Barbary unto the western Indie, 520
Shall pay a yearly tribute to thy sire:
And from the bounds of Afric to the banks
Of Ganges shall his mighty arm extend.
And now, my lords and loving followers,
That purchased[79] kingdoms by your martial deeds,
Cast off your armor, put on scarlet robes,
Mount up your royal places of estate,
Environèd with troops of noblemen,
And there make laws to rule your provinces.
Hang up your weapons on Alcides' post,[80] 530
For Tamburlaine takes truce with all the world.
Thy first-betrothèd love, Arabia,
Shall we with honor, as beseems, entomb
With this great Turk and his fair Emperess.
Then, after all these solemn exequies,
We will our celebrated rites of marriage solemnize.

Finis Actus quinti & ultimi luius primae partis.[81]

[74] *record:* summon as witness. [75] *clear:* unspotted.
[76] *work:* make for. [77] *shadowing:* figuring forth.
[78] *Latona's daughter:* Artemis (Diana), goddess of the hunt. [79] *purchased:* achieved.
[80] *Alcides' post:* Hercules' door-post.
[81] *Finis . . . partis:* The end of Act V and of this first part.

Christopher Marlowe

TAMBURLAINE THE GREAT, PART II

IN CARRYING forward his chronicle history of the adventures of Tamburlaine, Marlowe is indebted largely, as for the materials of Part I, to the geographer Ortelius and the historians Pedro Mexia and Petrus Perondinus. Fresh material comes from the writings of two widely popular Frenchmen of the later sixteenth century, François de Belleforest (*Cosmographie Universelle*, 1575) and the homilist Pierre de la Primaudaye (*French Academy*, 1577, translated into English 1586). Seneca, the premier model for earlier Elizabethan drama, appears briefly in the reminiscence of the death of Hippolytus (V.iii). Once again, Virgil's *Aeneid* and Ovid's *Metamorphoses*, staple sources of English poets and playwrights of the Renaissance, furnish details. Though Marlowe's equipment as a scholar was presumably considerable, he does not hesitate to borrow from Ovid—like Shakespeare a little later—by way of Arthur Golding's pedestrian translation of 1567.

The narratives of travelers to the East, such as that of Haytoun the Armenian (accessible in a French translation of 1501), were probably consulted; and, more certainly, the Hungarian history of Antonius Bonfinius (1543) and the *Turcicorum Chronicorum* (1578) of the German historian Philippus Lonicerus, who recapitulates in two volumes the traditional accounts of previous writers. In his acute rendering of Tamburlaine's military tactics (III.ii), Marlowe is following a manuscript version of Paul Ive's *Practise of Fortification* (1589).

These manifold borrowings do not, however, afford enough dramatic material for the making of another play, or not one which can stand alone, for most of what is notable in the life of Tamburlaine had already been exploited in Part I. It is reasonable to suppose that when Marlowe began the story of Tamburlaine he did not intend to write a sequel. Perhaps the popularity of the first play indicated its continuation (comparison is inevitable with Shakespeare's continuation of the story of Prince Hal and his cronies in 2 *Henry IV*), or perhaps

Marlowe's imagination was sufficiently quickened by the work he had begun to incline him to postpone the death of the hero—the point at which conventional tragedy ends—and to use it as the culminating episode of a subsequent play. In any case, once the writing of a second part had been determined, fresh inventiveness was incumbent on the playwright. Marlowe copes or seeks to cope with the challenge by levying on romance. From Lydgate's fifteenth-century *Troy Book* he takes the non-Homeric episode of the braving of Achilles by Hector in the Grecian camp (III.v). Spenser's romantic epic is utilized more than once: necessarily in manuscript, for *The Faerie Queene* did not begin to appear until 1590. Ariosto's *Orlando Furioso*, the most influential romance of the Renaissance, evidently inspires the dramatic account of the foiling of Theridamas by Olympia (IV.ii)—though whether Marlowe is reading in manuscript the English of Sir John Harington (1591) or remembering the original Italian is moot.

If the latter, it is tempting to assume that, unlike almost all his contemporaries, he was acquainted at first hand with Dante, whose *Divine Comedy* remained untranslated in English, perhaps from religious hostility, until the nineteenth century. Incidental details, such as the description of the Underworld (in II.iv and III.ii), suggest the *Inferno*. Collateral evidence of Marlowe's familiarity with the Italian poet is supplied by the famous passage in Part I beginning "If all the pens that ever poets held" (V.ii). Here conceivably, as Professor Clifford Leech has argued, Marlowe is echoing consciously and ironically Dante's description in the *Paradiso* (XXIII, 55–60) of Beatrice's smile. But the lines from Dante are themselves a version of a well-known classical *topos*, occurring as early as Homer and doubtless retaining currency in the commonplace books of the Renaissance. And so the conjectural association of the two great poets, however attractive, must remain unproved. R. A. F.

Tamburlaine the Great, Part II

DRAMATIS PERSONÆ[1]

TAMBURLAINE, King of Persia
CALYPHAS ⎫
AMYRAS ⎬ his sons
CELEBINUS ⎭
THERIDAMAS, King of Argier[2]
TECHELLES, King of Fez (Fesse)
USUMCASANE, King of Moroccus
ORCANES, King of Natolia[3]
KING OF JERUSALEM
KING OF TREBIZON
KING OF SORIA[4]
KING OF AMASIA
GAZELLUS, Viceroy of Byron
URIBASSA
SIGISMUND, King of Hungary

FREDERICK ⎫
BALDWIN ⎬ Lords of Buda and Bohemia
CALLAPINE, son of BAJAZETH
ALMEDA, his keeper
PERDICAS, servant to CALYPHAS
GOVERNOR OF BABYLON
MAXIMUS
CAPTAIN OF BALSERA[5]
His son
Physicians
Another Captain
Lords, Citizens, Soldiers, Messengers, Attendants
ZENOCRATE, wife of TAMBURLAINE
OLYMPIA, wife of the Captain of Balsera
Turkish Concubines

THE PROLOGUE

THE general welcomes Tamburlaine received,
When he arrivèd last upon our stage,
Hath made our poet pen his Second Part,
Where death cuts off the progress of his pomp,
And murderous fates throws all his triumphs down.

But what became of fair Zenocrate,
And with how many cities' sacrifice
He celebrated her said[1] funeral,
Himself in presence shall unfold at large.

The Second Part of the Bloody Conquests of Mighty Tamburlaine. With his impassionate fury for the death of his lady and love, fair Zenocrate, his form of exhortation and discipline to his three sons, and the manner of his own death.

ACT ONE

SCENE ONE

[*Enter*] ORCANES, *King of Natolia*, GAZELLUS, *Viceroy of Byron*, URIBASSA, *and their train, with drums and trumpets.*

Orc. Egregious[1] viceroys of these eastern parts,
Placed by the issue[2] of great Bajazeth,
And sacred lord, the mighty Callapine,
Who lives in Egypt, prisoner to that slave
Which kept his father in an iron cage,
Now have we marched from fair Natolia
Two hundred leagues, and on Danubius' banks
Our warlike host, in còmplete armor, rest,

Where Sigismund, the King of Hungary,
Should meet our person to conclude a truce. 10
What! shall we parle[3] with the Christian?
Or cross the stream, and meet him in the field?
 Gaz. King of Natolia, let us treat of peace;
We are all glutted with the Christians' blood,
And have a greater foe to fight against,—
Proud Tamburlaine, that, now in Asia,
Near Guyron's head doth set his conquering feet,
And means to fire Turkey as he goes.
'Gainst him, my lord, you must address your power.

DRAMATIS PERSONÆ
 [1] *Dramatis Personæ:* Not in octavos; added by the nineteenth-century editor Dyce. [2] *Argier:* Algeria.
 [3] *Natolia:* Asia Minor. [4] *Soria:* Syria.
 [5] *Balsera:* Basra.

THE PROLOGUE
 [1] *said:* so O1–4; most editors emend to "sad."

I.i.
 [1] *Egregious:* Set apart; hence, "distinguished."
 [2] *issue:* offspring. [3] *parle:* parley.

Uri. Besides, King Sigismund hath brought from
　　Christendom　　　　　　　　　　　　　　　　20
More than his camp of stout Hungarians,
Sclavonians,[4] Almains,[5] Rutters,[6] Muffs,[7] and Danes,
That with the halberd,[8] lance, and murdering ax,
Will hazard that[9] we might with surety hold.

　Orc. Though from the shortest northern parallel,[10]
Vast Gruntland[11] compassed with the frozen sea,
Inhabited with tall and sturdy men,
Giants as big as hugy Polypheme,[12]
Millions of soldiers cut the arctic line,[13]
Bringing the strength of Europe to these arms,　　30
Our Turkey blades shall glide through all their throats,
And make this champion mead[14] a bloody fen.
Danubius' stream, that runs to Trebizon,
Shall carry, wrapped within his scarlet waves,
As martial presents to our friends at home,
The slaughtered bodies of these Christians.
The Terrene main,[15] wherein Danubius falls,
Shall, by this battle, be the Bloody Sea.[16]
The wandering sailors of proud Italy　　　　　39
Shall meet those Christians, fleeting[17] with the tide,
Beating in heaps against their argosies,[18]
And make fair Europe, mounted on her bull,[19]
Trapped[20] with the wealth and riches of the world,
Alight, and wear a woeful mourning weed.[21]

　Gaz. Yet, stout Orcanes, Prorex[22] of the world,
Since Tamburlaine hath mustered all his men,
Marching from Cairo northward with his camp
To Alexandria, and the frontier towns,

[4] *Sclavonians:* Slavs.　　　[5] *Almains:* Germans.
[6] *Rutters:* Troopers.　　　[7] *Muffs:* Germans or Swiss.
[8] *halberd:* spear tipped with an axhead.
[9] *hazard that:* jeopardize that which.
[10] *shortest northern parallel:* smallest circle of latitude to the north; hence, "farthest north."
[11] *Gruntland:* Greenland.
[12] *Polypheme:* the one-eyed giant blinded by Ulysses, and of whom Ovid writes in *Metamorphoses*, XIII and XIV.
[13] *cut . . . line:* descend from the Arctic Circle.
[14] *champion mead:* meadow land.
[15] *Terrene main:* Mediterranean.
[16] *Danubius . . . Sea:* The waters of the Danube, rising from two mouths, are seen as carrying the dead bodies of Christian soldiers "home" to Trebizond as trophies and, also, away to southern Europe, to frighten the enemy.
[17] *fleeting:* floating.
[18] *argosies:* large merchant ships.
[19] *Europe . . . bull:* The story of Europa, to whom Jove came in the shape of a bull, is related by Ovid in *Metamorphoses*, II and VI.
[20] *Trapped:* Adorned, as with trappings.
[21] *weed:* costume.　　　[22] *Prorex:* Viceroy.
[23] *intends:* intends against.　　　[24] *Fear:* Fright.
[25] *oriental plage:* eastern strand.
[26] *Lantchidol:* that part of the Indian Ocean between Java and New Holland.
[27] *Cancer's tropic:* the Canary Islands, where the meridian line forms a juncture with the tropic of Cancer.
[28] *Amazonia under Capricorn:* the "Amazonian region" in Africa and all the lands below the tropic of Capricorn.
[29] *Archipelago:* the Mediterranean islands.
[30] *trumpets:* new scene begins here in Octavo.
[31] *axletree:* the pole on which the earth and spheres were understood to turn.　　[32] *blink-eyed:* shutting, as with fright.
[33] *Austric:* Austrian.　　　[34] *princely fowl:* the eagle.

Meaning to make a conquest of our land,
'Tis requisite to parle for a peace　　　　　50
With Sigismund the King of Hungary,
And save our forces for the hot assaults
Proud Tamburlaine intends[23] Natolia.

　Orc. Viceroy of Byron, wisely hast thou said.
My realm, the center of our empery,
Once lost, all Turkey would be overthrown,
And for that cause the Christians shall have peace.
Sclavonians, Almains, Rutters, Muffs, and Danes,
Fear[24] not Orcanes, but great Tamburlaine;
Nor he, but fortune, that hath made him great.　　60
We have revolted Grecians, Albanese,
Cicilians, Jews, Arabians, Turks, and Moors,
Natolians, Sorians, black Egyptians,
Illyrians, Thracians, and Bithynians,
Enough to swallow forceless Sigismund,
Yet scarce enough t'encounter Tamburlaine.
He brings a world of people to the field,
From Scythia to the oriental plage[25]
Of India, where raging Lantchidol[26]
Beats on the regions with his boisterous blows,　　70
That never seaman yet discoverèd,
All Asia is in arms with Tamburlaine,
Even from the midst of fiery Cancer's tropic,[27]
To Amazonia under Capricorn,[28]
And thence as far as Archipelago,[29]
All Afric is in arms with Tamburlaine;
Therefore, viceroy, the Christians must have peace.

　[*Enter*] SIGISMUND, FREDERICK, BALDWIN, *and
　　their train, with drums and trumpets.*[30]

　Sig. Orcanes, as our legates promised thee,
We, with our peers, have crossed Danubius' stream,
To treat of friendly peace or deadly war.　　80
Take which thou wilt, for as the Romans used,
I here present thee with a naked sword;
Wilt thou have war, then shake this blade at me;
If peace, restore it to my hands again,
And I will sheath it, to confirm the same.

　Orc. Stay, Sigismund! forget'st thou I am he
That with the cannon shook Vienna walls,
And made it dance upon the continent,
As when the massy substance of the earth
Quivers about the axletree[31] of heaven?　　90
Forget'st thou that I sent a shower of darts,
Mingled with powdered shot and feathered steel,
So thick upon the blink-eyed[32] burghers' heads,
That thou thyself, then County Palatine,
The King of Boheme, and the Austric[33] Duke,
Sent heralds out, which basely on their knees
In all your names desired a truce of me?
Forget'st thou, that to have me raise my siege,
Wagons of gold were set before my tent,
Stamped with the princely fowl,[34] that in her wings,
Carries the fearful thunderbolts of Jove?　　101
How canst thou think of this, and offer war?

　Sig. Vienna was besieged, and I was there,
Then county palatine, but now a king,
And what we did was in extremity.
But now, Orcanes, view my royal host,

That hides these plains, and seems as vast and wide
As doth the desert of Arabia
To those that stand on Bagdet's³⁵ lofty tower;
Or as the ocean to the traveler 110
That rests upon the snowy Apennines;
And tell me whether I should stoop so low,
Or treat of peace with the Natolian King.
 Gaz. King of Natolia and of Hungary,
We came from Turkey to confirm a league,
And not to dare each other to the field.
A friendly parle might become ye both.
 Fred. And we from Europe, to the same intent,
Which if your general refuse or scorn,
Our tents are pitched, our men stand in array, 120
Ready to charge you ere you stir your feet.
 Orc. So prest³⁶ are we; but yet, if Sigismund
Speak as a friend, and stand not upon terms,³⁷
Here is his sword,—let peace be ratified
On these conditions, specified before,
Drawn with advice of our ambassadors.
 Sig. Then here I sheathe it, and give thee my hand,
Never to draw it out, or manage³⁸ arms
Against thyself or thy confederates,
But whilst I live will be at truce with thee. 130
 Orc. But, Sigismund, confirm it with an oath,
And swear in sight of heaven and by the Christ.
 Sig. By Him that made the world and saved my soul,
The Son of God and issue of a maid,
Sweet Jesus Christ, I solemnly protest
And vow to keep this peace inviolable.
 Orc. By sacred Mahomet, the friend of God,
Whose holy Alcaron³⁹ remains with us,
Whose glorious body, when he left the world,
Closed in a coffin mounted up the air, 140
And hung on stately Mecca's temple roof,
I swear to keep this truce inviolable.
Of whose conditions and our solemn oaths,
Signed with our hands, each shall retain a scroll
As memorable witness of our league.
Now, Sigismund, if any Christian king
Encroach upon the confines of thy realm,
Send word Orcanes of Natolia
Confirmed this league beyond Danubius' stream,
And they will, trembling, sound a quick retreat; 150
So am I feared among all nations.
 Sig. If any heathen potentate or king
Invade Natolia, Sigismund will send
A hundred thousand horse trained to the war,
And backed by stout lanceres of Germany,
The strength and sinews of the imperial seat.
 Orc. I thank thee, Sigismund; but, when I war,
All Asia Minor, Africa, and Greece,
Follow my standard and my thundering drums.
Come, let us go and banquet in our tents; 160
I will dispatch chief⁴⁰ of my army hence
To fair Natolia and to Trebizon,
To stay⁴¹ my coming 'gainst proud Tamburlaine.
Friend Sigismund, and peers of Hungary,
Come, banquet and carouse with us a while,
And then depart we to our territories.
 Exeunt.

[I.ii]

 [*Enter*] CALLAPINE *with* ALMEDA, *his* keeper.

 Call. Sweet Almeda, pity the ruthful plight
Of Callapine, the son of Bajazeth,
Born to be monarch of the western world,¹
Yet here detained by cruel Tamburlaine.
 Alm. My lord, I pity it, and with my heart
Wish your release; but he whose wrath is death,
My sovereign lord, renowmèd Tamburlaine,
Forbids you further liberty than this.
 Call. Ah, were I now but half so eloquent
To paint in words what I'll perform in deeds, 10
I know thou would'st depart from hence with me.
 Alm. Not for all Afric: therefore move² me not.
 Call. Yet hear me speak, my gentle Almeda.
 Alm. No speech to that end, by your favor, sir.
 Call. By Cario³ runs—
 Alm. No talk of running, I tell you, sir.
 Call. A little further, gentle Almeda.
 Alm. Well, sir, what of this?
 Call. By Cario runs to Alexandria bay
Darote's⁴ streams, wherein at anchor lies 20
A Turkish galley of my royal fleet,
Waiting my coming to the river side,
Hoping by some means I shall be released,
Which, when I come aboard, will hoist up sail,
And soon put forth into the Terrene sea,
Where, 'twixt the isles of Cyprus and of Crete
We quickly may in Turkish seas arrive.
Then shalt thou see a hundred kings and more,
Upon their knees, all bid me welcome home.
Amongst so many crowns of burnished gold, 30
Choose which thou wilt, all are at thy command;
A thousand galleys, manned with Christian slaves,
I freely give thee, which shall cut the Straits,
And bring armadoes⁵ from the coasts of Spain
Fraughted⁶ with gold of rich America;
The Grecian virgins shall attend on thee,
Skilful in music and in amorous lays,
As fair as was Pygmalion's ivory girl⁷
Or lovely Io metamorphosèd.⁸
With naked negroes shall thy coach be drawn, 40
And as thou rid'st in triumph through the streets,
The pavement underneath thy chariot wheels

³⁵ *Bagdet's:* Baghdad's. ³⁶ *prest:* ready.
³⁷ *stand . . . terms:* demand special conditions.
³⁸ *manage:* wield. ³⁹ *Alcaron:* Koran.
⁴⁰ *chief:* most. ⁴¹ *stay:* await.

I.ii.
 ¹ *western world:* Turkish Empire (west of Asia).
 ² *move:* importune. ³ *Cario:* Cairo.
 ⁴ *Darote's:* referring to a town on the Nile.
 ⁵ *armadoes:* properly, "warships"; here, "fleets of ships."
 ⁶ *Fraughted:* Loaded.
 ⁷ *Pygmalion's ivory girl:* The account of the statue made
by Pygmalion and given life by Venus perhaps depends on
Ovid, *Metamorphoses,* X. 243*ff.*
 ⁸ *Io metamorphosèd:* The metamorphosis of Io, whom
Jove loved, to a heifer is related by Ovid, *Metamorphoses,* I.
588*ff.*

With Turkey carpets shall be coverèd,
And cloth of arras[9] hung about the walls,
Fit objects for thy princely eye to pierce.
A hundred bassoes,[10] clothed in crimson silk,
Shall ride before thee on Barbarian[11] steeds;
And when thou goest, a golden canopy
Enchased[12] with precious stones, which shine as bright
As that fair veil that covers all the world,　　　　50
When Phoebus,[13] leaping from the hemisphere,
Descendeth downward to the Antipodes,
And more than this—for all I cannot tell.
　　Alm. How far hence lies the galley, say you?
　　Call. Sweet Almeda, scarce half a league from hence.
　　Alm. But need[14] we not be spied going aboard?
　　Call. Betwixt the hollow hanging of a hill,
And crookèd bending of a craggy rock,
The sails wrapped up, the mast and tacklings down,
She lies so close[15] that none can find her out.　　　　60
　　Alm. I like that well: but tell me, my lord, if I
should let you go, would you be as good as your word?
Shall I be made a king for my labor?
　　Call. As I am Callapine the Emperor,
And by the hand of Mahomet I swear
Thou shalt be crowned a king, and be my mate.[16]
　　Alm. Then here I swear, as I am Almeda,
Your keeper under Tamburlaine the Great
(For that's the style[17] and title I have yet),
Although he sent a thousand armèd men　　　　70
To intercept this haughty[18] enterprise,
Yet would I venture to conduct your grace,
And die before I brought you back again.
　　Call. Thanks, gentle Almeda; then let us haste,
Lest time be past, and lingering let[19] us both.
　　Alm. When you will, my lord; I am ready.
　　Call. Even straight;[20] and farewell, cursèd
　　　Tamburlaine.
Now go I to revenge my father's death.

　　　　　　　　　　　　　　　　　　　Exeunt.

　　[9] *cloth of arras:* rich tapestry (originally from Arras,
France).　　　　[10] *bassoes:* Turkish pashas.
　　[11] *Barbarian:* from Barbary, famous for its horses.
　　[12] *Enchased:* Adorned.
　　[13] *Phoebus:* the sun, seen here as setting and veiling the
world in darkness.　　　　[14] *need:* shall.
　　[15] *close:* hidden.　　　　[16] *mate:* equal.
　　[17] *style:* tautologous—"title."
　　[18] *haughty:* mettlesome, bold.　　　[19] *let:* hinder.
　　[20] *straight:* now.

I.iii.
　　[1] *Larissa:* coastal town south of Gaza.
　　[2] *scathe:* injury.　　　[3] *amorous:* i.e., effeminate.
　　[4] *Water and air:* The former, moist and cold, is associated
with the phlegmatic humor; the latter, moist and hot, with
the sanguine humor. What is missing in Tamburlaine's sons
are the tempering qualities of firmness and fierceness, asso-
ciated with earth (bile) and fire (choler).
　　[5] *Bewrays:* Makes apparent.　　　[6] *list:* desire.
　　[7] *tilting:* aiming (with his lance).　　[8] *tainted:* touched.
　　[9] *curvet:* leap (off the hind legs while the forelegs were
raised).　　　　[10] *of proof:* tested.
　　[11] *harmless:* suffering no harm.　　[12] *virtue:* power.

[I.iii]

　　[Enter] TAMBURLAINE, *with* ZENOCRATE, *and
　　his three sons,* CALYPHUS, AMYRAS, *and*
　　CELEBINUS, *with drums and trumpets.*

　　Tamb. Now, bright Zenocrate, the world's fair eye,
Whose beams illuminate the lamps of heaven,
Whose cheerful looks do clear the cloudy air,
And clothe it in a crystal livery;
Now rest thee here on fair Larissa[1] plains,
Where Egypt and the Turkish empire parts,
Between thy sons, that shall be emperors,
And every one commander of a world.
　　Zeno. Sweet Tamburlaine, when wilt thou leave
　　　these arms,
And save thy sacred person free from scathe,[2]　　10
And dangerous chances of the wrathful war?
　　Tamb. When heaven shall cease to move on both the
　　　poles,
And when the ground, whereon my soldiers march,
Shall rise aloft and touch the hornèd moon,
And not before, my sweet Zenocrate.
Sit up, and rest thee like a lovely queen;
So, now she sits in pomp and majesty,
When these, my sons, more precious in mine eyes,
Than all the wealthy kingdoms I subdued,
Placed by her side, look on their mother's face.　　20
But yet methinks their looks are amorous,[3]
Not martial as the sons of Tamburlaine:
Water and air,[4] being symbolized in one,
Argue their want of courage and of wit;
Their hair as white as milk and soft as down,
Which should be like the quills of porcupines,
As black as jet and hard as iron or steel,
Bewrays[5] they are too dainty for the wars;
Their fingers made to quaver on a lute,
Their arms to hang about a lady's neck,　　　　30
Their legs to dance and caper in the air,
Would make me think them bastards, not my sons,
But that I know they issued from thy womb,
That never looked on man but Tamburlaine.
　　Zeno. My gracious lord, they have their mother's
　　　looks,
But when they list,[6] their conquering father's heart.
This lovely boy, the youngest of the three,
Not long ago bestrid a Scythian steed,
Trotting the ring, and tilting[7] at a glove,
Which when he tainted[8] with his slender rod,　　40
He reined him straight and made him so curvet,[9]
As I cried out for fear he should have fallen.
　　Tamb. Well done, my boy, thou shalt have shield and
　　　lance,
Armor of proof,[10] horse, helm, and curtle-ax,
And I will teach thee how to charge thy foe,
And harmless[11] run among the deadly pikes.
If thou wilt love the wars and follow me,
Thou shalt be made a king and reign with me,
Keeping in iron cages emperors.
If thou exceed thy elder brothers' worth　　　　50
And shine in còmplete virtue[12] more than they,
Thou shalt be king before them, and thy seed

Shall issue crownèd from their mother's womb.

 Cel. Yes, father: you shall see me, if I live,
Have under me as many kings as you,
And march with such a multitude of men,
As all the world shall tremble at their view.

 Tamb. These words assure me, boy, thou art my son.
When I am old and cannot manage arms,
Be thou the scourge and terror of the world. 60

 Amy. Why may not I, my lord, as well as he,
Be termed the scourge and terror of the world?

 Tamb. Be all a scourge and terror to the world,
Or else you are not sons of Tamburlaine.

 Caly. But while my brothers follow arms, my lord,
Let me accompany my gracious mother;
They are enough to conquer all the world,
And you have won enough for me to keep.

 Tamb. Bastardly boy, sprung from some coward's
 loins,
And not the issue of great Tamburlaine; 70
Of all the provinces I have subdued,
Thou shalt not have a foot unless thou bear
A mind courageous and invincible:
For he shall wear the crown of Persia
Whose head hath deepest scars, whose breast most
 wounds,
Which being wroth[13] sends lightning from his eyes,
And in the furrows of his frowning brows
Harbors revenge, war, death, and cruelty;
For in a field, whose superficies[14]
Is covered with a liquid purple veil 80
And sprinkled with the brains of slaughtered men,
My royal chair of state shall be advanced;
And he that means to place himself therein,
Must armèd wade up to the chin in blood.

 Zeno. My lord, such speeches to our princely sons
Dismays their minds before they come to prove[15]
The wounding troubles angry war affords.

 Cel. No, madam, these are speeches fit for us,
For if his chair were in a sea of blood
I would prepare a ship and sail to it, 90
Ere I would lose the title of a king.

 Amy. And I would strive to swim through pools of
 blood,
Or make a bridge of murdered carcasses,
Whose arches should be framed with bones of Turks,
Ere I would lose the title of a king.

 Tamb. Well, lovely boys, you shall be emperors both,
Stretching your conquering arms from east to west;
And, sirrah, if you mean to wear a crown,
When we shall meet the Turkish deputy
And all his viceroys, snatch it from his head, 100
And cleave his pericranion[16] with thy sword.

 Caly. If any man will hold him, I will strike
And cleave him to the channel[17] with my sword.

 Tamb. Hold him, and cleave him too, or I'll cleave
 thee,
For we will march against them presently.
Theridamas, Techelles, and Casane
Promised to meet me on Larissa plains
With hosts apiece against this Turkish crew;
For I have sworn by sacred Mahomet

To make it parcel of my empery;[18] 110
The trumpets sound, Zenocrate; they come.

 Enter THERIDAMAS *and his train, with drums
and trumpets.*[19]

 Tamb. Welcome, Theridamas, King of Argier.

 Ther. My lord, the great and mighty Tamburlaine,
Arch-monarch of the world, I offer here
My crown, myself, and all the power I have,
In all affection at thy kingly feet.

 Tamb. Thanks, good Theridamas.

 Ther. Under my colors march ten thousand Greeks;
And of Argier and Afric's frontier towns
Twice twenty thousand valiant men-at-arms, 120
All which have sworn to sack Natolia.
Five hundred brigandines[20] are under sail,
Meet[21] for your service on the sea, my lord,
That, launching from Argier to Tripoli,
Will quickly ride before Natolia,
And batter down the castles on the shore.

 Tamb. Well said, Argier; receive thy crown again.

 Enter TECHELLES *and* USUMCASANE *together.*

 Tamb. Kings of Moroccus and of Fesse, welcome.

 Usum. Magnificent and peerless Tamburlaine!
I and my neighbor King of Fesse have brought 130
To aid thee in this Turkish expedition,
A hundred thousand expert soldiers:
From Azamor[22] to Tunis near the sea
Is Barbary unpeopled for thy sake,
And all the men in armor under me,
Which with my crown I gladly offer thee.

 Tamb. Thanks, King of Moroccus, take your crown
 again.

 Tech. And, mighty Tamburlaine, our earthly god,
Whose looks make this inferior world to quake,
I here present thee with the crown of Fesse, 140
And with an host of Moors trained to the war,
Whose coal-black faces make their foes retire,
And quake for fear, as if infernal Jove[23]
Meaning to aid thee in these Turkish arms,
Should pierce the black circumference of hell
With ugly Furies bearing fiery flags,
And millions of his strong tormenting spirits.
From strong Tesella unto Biledull[24]
All Barbary is unpeopled for thy sake.

 Tamb. Thanks, King of Fesse; take here thy crown
 again. 150
Your presence, loving friends, and fellow kings,
Makes me to surfeit in conceiving[25] joy.

[13] *Which being wroth:* Who being angry.
[14] *superficies:* surface (Robinson's emendation; O1–4 read "superfluities"). [15] *prove:* experience.
[16] *pericranion:* skull. [17] *channel:* collarbone.
[18] *parcel . . . empery:* part of my domain.
[19] *trumpets:* octavo begins new scene here, and again below, on the entrance of Techelles and Usumcasane, though place remains the same. [20] *brigandines:* small vessels.
[21] *Meet:* Fit. [22] *Azamor:* coastal town in Morocco.
[23] *infernal Jove:* here, Pluto, the ruler of Hades.
[24] *Tesella . . . Biledull:* in North Africa.
[25] *conceiving:* fancying.

If all the crystal gates of Jove's high court
Were opened wide, and I might enter in
To see the state and majesty of heaven,
It could not more delight me than your sight.
Now will we banquet on these plains awhile,
And after march to Turkey with our camp,
In number more than are the drops that fall,
When Boreas rents[26] a thousand swelling clouds; 160
And proud Orcanes of Natolia
With all his viceroys shall be so afraid,
That, though the stones, as at Deucalion's flood,[27]
Were turned to men, he should be overcome.
Such lavish[28] will I make of Turkish blood,
That Jove shall send his wingèd messenger[29]
To bid me sheathe my sword and leave the field;
The sun, unable to sustain the sight,
Shall hide his head in Thetis'[30] watery lap,
And leave his steeds to fair Böotes'[31] charge; 170
For half the world shall perish in this fight.
But now, my friends, let me examine ye;
How have ye spent your absent time from me?
 Usum. My lord, our men of Barbary have marched
Four hundred miles with armor on their backs,
And lain in leaguer[32] fifteen months and more;
For, since we left you at the Soldan's court,
We have subdued the southern Guallatia,[33]
And all the land unto the coast of Spain;
We kept the narrow Strait of Gibraltar, 180
And made Canaria[34] call us kings and lords;
Yet never did they recreate[35] themselves,
Or cease one day from war and hot alarms,
And therefore let them rest awhile, my lord.
 Tamb. They shall, Casane, and 'tis time i' faith.
 Tech. And I have marched along the river Nile
To Machda,[36] where the mighty Christian priest,

Called John the Great,[37] sits in a milk-white robe,
Whose triple miter I did take by force,
And made him swear obedience to my crown, 190
From thence unto Cazates[38] did I march,
Where Amazonians met me in the field,
With whom, being women, I vouchsafed a league,
And with my power did march to Zanzibar,
The western part of Afric, where I viewed
The Ethiopian sea,[39] rivers, and lakes,
But neither man nor child in all the land;
Therefore I took my course to Manico,
Where unresisted, I removed my camp;
And by the coast of Byather, at last 200
I came to Cubar, where the negroes dwell,
And conquering that, made haste to Nubia.
There, having sacked Borno, the kingly seat,
I took the King and led him bound in chains
Unto Damasco, where I stayed before.
 Tamb. Well done, Techelles. What saith
 Theridamas?
 Ther. I left the confines and the bounds of Afric
And I made a voyage into Europe,
Where by the river Tyros[40] I subdued
Stoka, Podolia, and Codemia; 210
Thence crossed the sea and came to Oblia
And Nigra Sylva, where the devils dance,
Which in despite of them, I set on fire.
From thence I crossed the gulf called by the name
Mare Majore of the inhabitants.
Yet shall my soldiers make no period,
Until Natolia kneel before your feet.
 Tamb. Then will we triumph, banquet and carouse;
Cooks shall have pensions to provide us cates,[41]
And glut us with the dainties of the world; 220
Lachryma Christi[42] and Calabrian wines
Shall common soldiers drink in quaffing bowls,
Ay, liquid gold, when we have conquered him,
Mingled with coral and with oriental pearl.
Come, let us banquet and carouse the whiles.

 Exeunt.

 Finis Actus primi.

[26] *Boreas rents:* the North Wind tears.
[27] *Deucalion's flood:* Ovid in *Metamorphoses*, I. 318ff, tells of the rebirth of men and women from the stones cast by Deucalion and his wife Pyrrha after a deluge like that of Noah. [28] *lavish:* spilling.
[29] *wingèd messenger:* Mercury.
[30] *Thetis:* a sea-goddess; hence, the sea.
[31] *Böotes:* Arcturus the Bear, a northern constellation.
[32] *leaguer:* camp (especially if in state of siege).
[33] *Guallatia:* in the Sahara.
[34] *Canaria:* the Canary Islands.
[35] *recreate:* indulge in recreation.
[36] *Machda:* Abyssinian town on a tributary of the Nile.
[37] *John the Great:* Prester John, a legendary ruler of Abyssinia.
[38] *Cazates:* near the supposed source of the Nile. Marlowe in this passage is following closely Ortelius's *Theatrum Orbis Terrarum.*
[39] *Ethiopian sea:* between western Africa and South America.
[40] *Tyros:* the Dniester. The place names that follow refer generally to the northwest shore of the Black Sea ("Mare Majore"). [41] *cates:* delicacies.
[42] *Lachryma Christi:* sweet wine from southern Italy.
[43] *oriental:* lustrous (appropriate to the east).

II.i.
[1] *Buda:* the right half of the now consolidated Budapest.
[2] *motion:* emotion.
[3] *Zula:* located by sixteenth-century cartographers north of the Danube. [4] *Varna:* Bulgarian port.
[5] *resteth:* remains.

ACT TWO

SCENE ONE

[Enter] SIGISMUND, FREDERICK, BALDWIN,
 with their train.

 Sig. Now say, my lords of Buda[1] and Bohemia,
What motion[2] is it that inflames your thoughts,
And stirs your valors to such sudden arms?
 Fred. Your majesty remembers, I am sure,
What cruel slaughter of our Christian bloods
These heathenish Turks and pagans lately made,
Betwixt the city Zula[3] and Danubius;
How through the midst of Varna[4] and Bulgaria,
And almost to the very walls of Rome,
They have, not long since, massacred our camp. 10
It resteth[5] now, then, that your majesty
Take all advantages of time and power,

And work revenge upon these infidels.
Your highness knows, for Tamburlaine's repair,[6]
That strikes a terror to all Turkish hearts,
Natolia hath dismissed the greatest part
Of all his army, pitched against our power,
Betwixt Cutheia and Orminius' mount,
And sent them marching up to Belgasar,
Acantha, Antioch, and Cæsarea, 20
To aid the Kings of Soria, and Jerusalem.[7]
Now then, my lord, advantage take hereof,
And issue suddenly upon the rest;
That in the fortune of their overthrow,
We may discourage all the pagan troop,
That dare attempt to war with Christians.
 Sig. But calls not then, your grace, to memory
The league we lately made with King Orcanes,
Confirmed by oath and articles of peace,
And calling Christ for record of our truths? 30
This should be treachery and violence
Against the grace of our profession.
 Bald. No whit, my lord, for with such infidels,
In whom no faith nor true religion rests,
We are not bound to those accomplishments[8]
The holy laws of Christendom enjoin;
But as the faith, which they profanely plight,[9]
Is not by necessary policy
To be esteemed assurance for ourselves,
So what we vow to them should not infringe 40
Our liberty of arms and victory.
 Sig. Though I confess the oaths they undertake
Breed little strength to our security,
Yet those infirmities that thus defame
Their faiths, their honors, and their religion,
Should not give us presumption to the like.
Our faiths are sound, and must be consummate,[10]
Religious, righteous, and inviolate.
 Fred. Assure your grace 'tis superstition
To stand so strictly on dispensive[11] faith; 50
And should we lose the opportunity
That God hath given to venge our Christians' death,
And scourge their foul blasphèmous paganism,
As fell to Saul,[12] to Balaam,[13] and the rest,
That would not kill and curse at God's command,
So surely will the vengeance of the Highest,
And jealous anger of His fearful arm,
Be poured with rigor on our sinful heads,
If we neglect this offered victory.
 Sig. Then arm, my lords, and issue suddenly, 60
Giving commandment to our general host,
With expedition[14] to assail the pagan,
And take the victory our God hath given.

 Exeunt.

II.ii

 Enter ORCANES, GAZELLUS, URIBASSA, *with
 their train.*

 Orc. Gazellus, Uribassa, and the rest,
Now will we march from proud Orminius' mount,
To fair Natolia, where our neighbor kings
Expect[1] our power and our royal presence,

To encounter with the cruel Tamburlaine,
That nigh Larissa sways a mighty host,
And with the thunder of his martial tools
Makes earthquakes in the hearts of men and heaven.
 Gaz. And now come we to make his sinews shake
With greater power than erst[2] his pride hath felt. 10
An hundred kings, by scores, will bid him arms,[3]
And hundred thousands subjects to each score,
Which, if a shower of wounding thunderbolts
Should break out of the bowels of the clouds,
And fall as thick as hail upon our heads,
In partial[4] aid of that proud Scythian,
Yet should our courages and steelèd crests,
And numbers, more than infinite, of men,
Be able to withstand and conquer him.
 Uri. Methinks I see how glad the Christian King 20
Is made, for joy of your admitted truce,
That could not but before be terrified
With unacquainted power of our host.

 Enter a Messenger.

 Mess. Arm, dread sovereign, and my noble lords!
The treacherous army of the Christians,
Taking advantage of your slender power,
Comes marching on us, and determines straight
To bid us battle for our dearest lives.
 Orc. Traitors! villains! damnèd Christians!
Have I not here the articles of peace, 30
And solemn covenants we have both confirmed,
He by his Christ, and I by Mahomet?
 Gaz. Hell and confusion light upon their heads,
That with such treason seek our overthrow,
And cares so little for their prophet, Christ!
 Orc. Can there be such deceit in Christians,
Or treason in the fleshly heart of man,
Whose shape is figure of the highest God!
Then, if there be a Christ, as Christians say,
But in their deeds deny him for their Christ, 40
If he be son to everliving Jove,
And hath the power of his outstretchèd arm,
If he be jealous of his name and honor,
As is our holy prophet, Mahomet,
Take here these papers as our sacrifice
And witness of thy servant's perjury.
Open, thou shining veil of Cynthia,[5]
And make a passage from the empyreal heaven,

 [6] *repair:* advent.
 [7] *Betwixt . . . Jerusalem:* Place names (in Asia Minor)
come from Ortelius.
 [8] *accomplishments:* honoring of promises.
 [9] *plight:* pledge.
 [10] *consummate:* fulfilled (Dyce's emendation; O1–4 read
"consinuate").
 [11] *dispensive:* which may be waived or "dispensed."
 [12] *Saul:* who disobeyed God's injunction to kill Agag (I
Samuel 15).
 [13] *Balaam:* The unwilling prophet of Numbers 22ff, who
—despite Marlowe's reading—was obedient to God in
failing to curse the children of Israel.
 [14] *expedition:* speed.
II.ii
 [1] *Expect:* Await. [2] *erst:* formerly. [3] *arms:* fight.
 [4] *partial:* partisan. [5] *Cynthia:* the moon.

That He that sits on high and never sleeps,
Nor in one place is circumscriptible, 50
But everywhere fills every continent
With strange infusion of his sacred vigor,
May in His endless power and purity,
Behold and venge this traitor's perjury!
Thou Christ, that are esteemed omnipotent,
If thou wilt prove thyself a perfect God,
Worthy the worship of all faithful hearts,
Be now revenged upon this traitor's soul,
And make the power I have left behind
(Too little to defend our guiltless lives) 60
Sufficient to discomfort and confound
The trustless force of those false Christians.
To arms, my lords! On Christ still let us cry!
If there be Christ, we shall have victory.

[*Exeunt.*]

[II.iii]

Sound to the battle, and SIGISMUND *comes out wounded.*

Sig. Discomfited is all the Christian host,
And God hath thundered vengeance from on high,
For my accursed and hateful perjury.
O just and dreadful punisher of sin,
Let the dishonor of the pains I feel,
In this my mortal well-deservèd wound,
End all my penance in my sudden death!
And let this death, wherein to sin I die,
Conceive a second life in endless mercy!

[*He dies.*]

Enter ORCANES, GAZELLUS, URIBASSA, *with others.*

Orc. Now lie the Christians bathing in their bloods,
And Christ or Mahomet hath been my friend. 11
Gaz. See here the perjured traitor Hungary,
Bloody and breathless for his villainy.
Orc. Now shall his barbarous body be a prey
To beasts and fowls, and all the winds shall breathe
Through shady leaves of every senseless[1] tree
Murmurs and hisses for his heinous sin.

Now scalds his soul in the Tartarian[2] streams,
And feeds upon the baneful[3] tree of hell,
That Zoacum,[4] that fruit of bitterness, 20
That in the midst of fire is ingraffed,[5]
Yet flourisheth as Flora[6] in her pride,
With apples like the heads of damnèd fiends.
The devils there, in chains of quenchless flame,
Shall lead his soul through Orcus'[7] burning gulf,
From pain to pain, whose change shall never end.
What say'st thou yet, Gazellus, to his foil,[8]
Which we referred to justice of his Christ,
And to his power, which here appears as full
As rays of Cynthia to the clearest sight? 30
Gaz. 'Tis but the fortune of the wars, my lord,
Whose power is often proved a miracle.
Orc. Yet in my thoughts shall Christ be honorèd,
Not doing Mahomet an injury,
Whose power had share in this our victory.
And since this miscreant[9] hath disgraced his faith,
And died a traitor both to heaven and earth,
We will[10] both watch and ward shall keep his trunk[11]
Amidst these plains for fowls to prey upon.
Go, Uribassa, give it straight[12] in charge. 40
Uri. I will, my lord.

Exit URIBASSA.

Orc. And now, Gazellus, let us haste and meet
Our army,[13] and our brothers of Jerusalem,
Of Soria, Trebizon, and Amasia,
And happily, with full Natolian bowls
Of Greekish wine, now let us celebrate
Our happy conquest and his angry[14] fate.

Exeunt.

[II.iv]

The arras[1] is drawn, and ZENOCRATE *lies in her bed of state,* TAMBURLAINE *sitting by her; three* Physicians *about her bed, tempering potions;* THERIDAMAS, TECHELLES, USUMCASANE, *and the three* Sons.

Tamb. Black is the beauty of the brightest day;
The golden ball of heaven's eternal fire,
That danced with glory on the silver waves,
Now wants the fuel that inflamed[2] his beams;
And all with faintness, and for foul disgrace,
He binds his temples with a frowning cloud,
Ready to darken earth with endless night.
Zenocrate, that gave him light and life,
Whose eyes shot fire from their ivory bowers
And tempered[3] every soul with lively heat, 10
Now by the malice of the angry skies,
Whose jealousy admits no second mate,
Draws in the comfort of her latest breath,
All dazzled with the hellish mists of death.
Now walk the angels on the walls of heaven,
As sentinels to warn the immortal souls
To entertain divine Zenocrate.
Apollo, Cynthia, and the ceaseless lamps
That gently looked upon this loathsome earth,
Shine downward now no more, but deck the heavens,
To entertain divine Zenocrate. 21

II.iii.
[1] *senseless:* without feeling.
[2] *Tartarian:* of Tartarus, the region of the underworld where sinners were punished. [3] *baneful:* poisonous.
[4] *Zoacum:* described in the Koran and familiar to Marlowe from the *Chronicorum Turcorum* of Philippus Lonicerus, 1578. [5] *ingraffed:* planted.
[6] *Flora:* goddess of flowers. [7] *Orcus':* Hades'.
[8] *foil:* disgrace.
[9] *miscreant:* infidel; more generally, "villain."
[10] *will:* command that.
[11] *watch . . . trunk:* shall see to it that his body remains.
[12] *straight:* immediately.
[13] *army:* i.e., the rest of the army, sent against Tamburlaine. [14] *angry:* sharp.

II.iv.
[1] *arras:* curtain, before the "inner stage."
[2] *inflamed:* fueled.
[3] *tempered:* here, "strengthened," as opposed to "tempering," meaning "mixing," in stage direction above.

The crystal springs, whose taste illuminates
Refinèd eyes with an eternal sight,
Like trièd [4] silver, run through Paradise,
To entertain divine Zenocrate.
The cherubins and holy seraphins,
That sing and play before the King of Kings,
Use all their voices and their instruments
To entertain divine Zenocrate.
And in this sweet and curious [5] harmony, 30
The God that tunes this music to our souls,
Holds out His hand in highest majesty
To entertain divine Zenocrate.
Then let some holy trance convey my thoughts
Up to the palace of th' empyreal heaven,
That this my life may be as short to me
As are the days of sweet Zenocrate.
Physicians, will no physic do her good?
 Phys. My lord, your majesty shall soon perceive.
And if she pass this fit, the worst is past. 40
 Tamb. Tell me, how fares my fair Zenocrate?
 Zeno. I fare, my lord, as other empresses,
That, when this frail and transitory flesh
Hath sucked the measure of that vital air
That feeds the body with his dated [6] health,
Wanes with enforced and necessary change.
 Tamb. May never such a change transform my love,
In whose sweet being I repose my life,
Whose heavenly presence, beautified with health,
Gives light to Phoebus [7] and the fixèd stars! 50
Whose absence makes the sun and moon as dark
As when, opposed in one diameter,
Their spheres are mounted on the serpent's head,
Or else descended to his winding train. [8]
Live still, my love, and so conserve my life,
Or, dying, be the author of my death!
 Zeno. Live still, my lord! Oh, let my sovereign live
And sooner let the fiery element [9]
Dissolve and make your kingdom in the sky,
Than this base earth should shroud your majesty. 60
For should I but suspect your death by mine,
The comfort of my future happiness,
And hope to meet your highness in the heavens,
Turned to despair, would break my wretched breast,
And fury would confound my present rest.
But let me die, my love; yet let me die;
With love and patience let your true love die!
Your grief and fury hurts my second life.
Yet let me kiss my lord before I die,
And let me die with kissing of my lord. 70
But since my life is lengthened yet a while,
Let me take leave of these my loving sons,
And of my lords, whose true nobility
Have merited my latest memory.
Sweet sons, farewell! In death resemble me,
And in your lives your father's excellency.
Some music, and my fit will cease, my lord.

They call music.

 Tamb. Proud fury, and intolerable fit,
That dares torment the body of my love,
And scourge the scourge of the immortal God: 80

Now are those spheres, [10] where Cupid used to sit,
Wounding the world with wonder and with love,
Sadly supplied with pale and ghastly death,
Whose darts do pierce the center of my soul.
Her sacred beauty hath enchanted heaven,
And had she lived before the siege of Troy,
Helen (whose beauty summoned Greece to arms,
And drew a thousand ships to Tenedos) [11]
Had not been named in Homer's Iliads,
Her name had been in every line he wrote. 90
Or had those wanton poets, for whose birth
Old Rome was proud, but gazed a while on her,
Nor Lesbia nor Corinna [12] had been named;
Zenocrate had been the argument [13]
Of every epigram or elegy.

 The music sounds and she dies.

What! is she dead? Techelles, draw thy sword
And wound the earth, that it may cleave in twain,
And we descend into the infernal vaults,
To hale the Fatal Sisters [14] by the hair,
And throw them in the triple moat [15] of hell, 100
For taking hence my fair Zenocrate.
Casane and Theridamas, to arms!
Raise cavalieros [16] higher than the clouds,
And with the cannon break the frame of heaven;
Batter the shining palace of the sun,
And shiver all the starry firmament,
For amorous Jove hath snatched my love from hence,
Meaning to make her stately Queen of heaven.
What God soever holds thee in his arms,
Giving thee nectar and ambrosia, 110
Behold me here, divine Zenocrate,
Raving, impatient, desperate, and mad,
Breaking my steelèd lance, with which I burst
The rusty beams of Janus' temple-doors, [17]
Letting out death and tyrannizing war,
To march with me under this bloody flag!
And if thou pitiest Tamburlaine the Great,
Come down from heaven, and live with me again!
 Ther. Ah, good my lord, be patient; she is dead,
And all this raging cannot make her live. 120

 [4] *trièd:* tested; i.e., "purged" (of dross).
 [5] *curious:* intricate. [6] *dated:* allotted.
 [7] *Phoebus:* the sun.
 [8] *Whose . . . train:* The moon is in eclipse because the earth has moved into the "diameter" that connects it to the sun; concurrently, sun, moon, and earth are in a line in the zodiacal constellation Scorpio ("serpent")—whether in the head or tail ("train")—which produces the same result.
 [9] *fiery element:* sphere of fire that encloses the earth.
 [10] *spheres:* her eyes.
 [11] *Tenedos:* literally, an island near Troy; by extension, Troy itself.
 [12] *Lesbia nor Corinna:* celebrated in the "wanton" poetry of Catullus, Horace, and Ovid. [13] *argument:* theme.
 [14] *Fatal Sisters:* Clotho, Lachesis, and Atropos, the divinities who presided over birth and death.
 [15] *triple moat:* following Virgil, *Aeneid,* VI. 548*ff.* and—just conceivably—Dante, *Inferno,* VIII. 74; XVIII. 1*ff.*
 [16] *cavalieros:* elevated cannons.
 [17] *Janus' temple doors:* Janus was the god or numen of doors; the gates of his temple in Rome stood open in war, were closed in peace.

If words might serve, our voice hath rent the air;
If tears, our eyes have watered all the earth;
If grief, our murdered hearts have strained forth blood;
Nothing prevails, for she is dead, my lord.
 Tamb. "For she is dead!" Thy words do pierce my
 soul!
Ah, sweet Theridamas! say so no more;
Though she be dead, yet let me think she lives,
And feed my mind that dies for want of her.
Where'er her soul be, thou [18] shalt stay with me,
Embalmed with cassia, amber greece, and myrrh, [19]
Not lapped in lead, but in a sheet of gold, 131
And till I die thou shalt not be interred.
Then in as rich a tomb as Mausolus' [20]
We both will rest and have one epitaph
Writ in as many several [21] languages
As I have conquered kingdoms with my sword.
This cursèd town will I consume with fire,
Because this place bereaved me of my love.
The houses, burned, will look as if they mourned;
And here will I set up her statue, [22] 140
And march about it with my mourning camp
Drooping and pining for Zenocrate.

 The arras is drawn.

ACT THREE

SCENE ONE

Enter the Kings of TREBIZON *and* SORIA, *one
bringing a sword and another a scepter; next* NATOLIA
and JERUSALEM *with the imperial crown; after*
CALLAPINE; *and, after him, other* Lords [*and*
ALMEDA]. ORCANES *and* JERUSALEM *crown him,
and the other* [1] *give him the scepter.*

 Orc. Callapinus Cyricelibes, otherwise Cybelius, son
and successive heir to the late mighty Emperor, Baja-
zeth, by the aid of God and his friend Mahomet,
Emperor of Natolia, Jerusalem, Trebizon, Soria,
Amasia, Thracia, Illyria, Carmonia, and all the hundred
and thirty kingdoms late contributory to his mighty
father. Long live Callapinus, Emperor of Turkey!
 Call. Thrice worthy Kings of Natolia, and the rest,

[18] *thou:* addressing the body.
[19] *cassia, amber greece, and myrrh:* perfume, the first from
a fragrant plant, the second (ambergris) from the intestines of
a diseased sperm whale, the third from gum-resin.
[20] *Mausolus:* King of Caria, whose famous "mausoleum"
was erected by his widow. [21] *several:* separate.
[22] *statue:* the reading of O3,4; O1,2 read "stature."
III.i.
 [1] *other:* others.
 [2] *As ... infamies:* When we are victorious, our royal
names will be erased from the shameful record in which
Bajazeth's fall has entered them.
 [3] *surcharged:* filled to overflowing. [4] *it:* i.e., pity.
 [5] *Some ... Christian:* alluding to the rear guard that
defeated Sigismund. [6] *enow:* enough.
 [7] *Scalonian's:* Ascalon's. [8] *ensigns:* banners.
 [9] *Mare Major sea:* Black Sea. [10] *battle:* army.

I will requite your royal gratitudes
With all the benefits my empire yields; 10
And were the sinews of the imperial seat
So knit and strengthened as when Bajazeth
My royal lord and father filled the throne,
Whose cursèd fate hath so dismembered it,
Then should you see this thief of Scythia,
This proud, usurping King of Persia,
Do us such honor and supremacy,
Bearing the vengeance of our father's wrongs,
As all the world should blot our dignities
Out of the book of base-born infamies. [2] 20
And now I doubt not but your royal cares
Hath so provided for this cursèd foe,
That, since the heir of mighty Bajazeth
(An emperor so honored for his virtues)
Revives the spirits of true Turkish hearts,
In grievous memory of his father's shame,
We shall not need to nourish any doubt,
But that proud fortune, who hath followed long
The martial sword of mighty Tamburlaine,
Will now retain her old inconstancy, 30
And raise our honors to as high a pitch,
In this our strong and fortunate encounter;
For so hath heaven provided my escape,
From all the cruelty my soul sustained,
By this my friendly keeper's happy means,
That Jove, surcharged [3] with pity of our wrongs,
Will pour it [4] down in showers on our heads,
Scourging the pride of cursèd Tamburlaine.
 Orc. I have a hundred thousand men in arms;
Some, that in conquest of the perjured Christian, [5] 40
Being a handful to a mighty host,
Think them in number yet sufficient
To drink the river Nile or Euphrates,
And for their power enow [6] to win the world.
 K. of Jer. And I as many from Jerusalem,
Judaea, Gaza, and Scalonian's [7] bounds,
That on Mount Sinai with their ensigns [8] spread,
Look like the parti-colored clouds of heaven
That show fair weather to the neighbor morn.
 K. of Treb. And I as many bring from Trebizon, 50
Chio, Famastro, and Amasia,
All bordering on the Mare Major sea, [9]
Riso, Sancina, and the bordering towns
That touch the end of famous Euphrates,
Whose courages are kindled with the flames
The cursèd Scythian sets on all their towns,
And vow to burn the villain's cruel heart.
 K. of Sor. From Soria with seventy thousand strong
Ta'en from Aleppo, Soldino, Tripoli,
And so on to my city of Damasco, 60
I march to meet and aid my neighbor kings;
All which will join against this Tamburlaine,
And bring him captive to your highness' feet.
 Orc. Our battle [10] then in martial manner pitched,
According to our ancient use, shall bear
The figure of the semicircled moon,
Whose horns shall sprinkle through the tainted air
The poisoned brains of this proud Scythian.
 Call. Well then, my noble lords, for this my friend

That freed me from the bondage of my foe, 70
I think it requisite and honorable,
To keep my promise and to make him king,
That is a gentleman, I know, at least.
 Alm. That's no matter, sir, for being a king; for
Tamburlaine came up of nothing.
 K. of Jer. Your majesty may choose some 'pointed
 time,
Performing all your promise to the full;
'Tis nought for your majesty to give a kingdom.
 Call. Then will I shortly keep my promise, Almeda.
 Alm. Why, I thank your majesty. 80
 Exeunt.

III.ii

[Enter] TAMBURLAINE *with* USUMCASANE *and his
three sons; four bearing the hearse of* ZENOCRATE;
*and the drums sounding a doleful march; the town
burning.*

 Tamb. So burn the turrets of this cursèd town,
Flame to the highest region of the air,
And kindle heaps of exhalations,
That, being fiery meteors, may presage
Death and destruction to the inhabitants!
Over my zenith hang a blazing star,
That may endure till heaven be dissolved,
Fed with the fresh supply of earthly dregs,
Threatening a death and famine to this land! [1]
Flying dragons, lightning, fearful thunderclaps, 10
Singe these fair plains and make them seem as black
As is the island where the Furies mask, [2]
Compassed with Lethe, Styx, and Phlegethon,
Because my dear Zenocrate is dead.
 Caly. This pillar, placed in memory of her,
Where in Arabian, Hebrew, Greek, is writ:
*This town, being burnt by Tamburlaine the Great,
Forbids the world to build it up again.*
 Amy. And here this mournful streamer [3] shall be
 placed,
Wrought with the Persian and Egyptian arms, 20
To signify she was a princess born,
And wife unto the Monarch of the East.
 Cel. And here this table [4] as a register
Of all her virtues and perfections.
 Tamb. And here the picture of Zenocrate,
To show her beauty which the world admired;
Sweet picture of divine Zenocrate,
That, hanging here, will draw the gods from heaven,
And cause the stars fixed in the southern arc
(Whose lovely faces never any viewed 30
That have not passed the center's latitude),
As pilgrims, travel to our hemisphere, [5]
Only to gaze upon Zenocrate.
Thou shalt not beautify Larissa plains,
But keep within the circle of mine arms.
At every town and castle I besiege,
Thou shalt be set upon my royal tent;
And when I meet an army in the field,
Those looks will shed such influence in my camp
As if Bellona, goddess of the war, 40

Threw naked swords and sulfur balls of fire [6]
Upon the heads of all our enemies.
And now, my lords, advance your spears again.
Sorrow no more, my sweet Casane, now;
Boys, leave to mourn! this town shall ever mourn,
Being burned to cinders for your mother's death.
 Caly. If I had wept a sea of tears for her,
It would not ease the sorrow I sustain.
 Amy. As is that town, so is my heart consumed
With grief and sorrow for my mother's death. 50
 Cel. My mother's death hath mortified [7] my mind,
And sorrow stops the passage of my speech.
 Tamb. But now, my boys, leave off and list to me,
That mean to teach you rudiments of war;
I'll have you learn to sleep upon the ground,
March in your armor thorough [8] watery fens,
Sustain the scorching heat and freezing cold,
Hunger and thirst, right adjuncts of the war,
And after this to scale a castle wall,
Besiege a fort, to undermine a town, 60
And make whole cities caper in the air.
Then next the way to fortify your men;
In champion [9] grounds, what figure [10] serves you best,
For which the quinque-angle [11] form is meet,
Because the corners there may fall more flat
Whereas [12] the fort may fittest be assailed,
And sharpest where the assault is desperate.
The ditches must be deep; the counterscarps [13]
Narrow and steep; the walls made high and broad;
The bulwarks and the rampires [14] large and strong, 70
With cavalieros and thick counterforts, [15]
And room within to lodge six thousand men.
It must have privy [16] ditches, countermines, [17]
And secret issuings to defend the ditch;
It must have high argins and covered ways, [18]
To keep the bulwark fronts from battery,
And parapets to hide the musketers;
Casemates [19] to place the great artillery;
And store of ordnance, that from every flank
May scour the outward curtains [20] of the fort, 80

III.ii.
 [1] *Flame . . . land:* Fire from the burning town, ascending
to the outer limits of the air that environs the earth, will
ignite meteors or comets, which, like the similarly kindled
star over the head of Tamburlaine, figure as omens of dire
events coming on. [2] *mask:* hide (being invisible).
 [3] *streamer:* pennant. [4] *table:* tablet.
 [5] *And . . . hemisphere:* The southern constellations will,
like votaries, cross the equator to the northern latitudes
("our hemisphere"). [6] *sulfur . . . fire:* incendiary bombs.
 [7] *mortified:* deadened, benumbed.
 [8] *thorough:* through. [9] *champion:* meadow.
 [10] *figure:* i.e., kind of fortification.
 [11] *quinque-angle:* five-pointed or starred.
 [12] *Whereas:* Where.
 [13] *counterscarps:* walls of the ditch facing the fort.
 [14] *rampires:* ramparts. [15] *counterforts:* buttresses.
 [16] *privy:* hidden.
 [17] *countermines:* underground tunnels to detect and counter
the enemy's attempts at undermining.
 [18] *argins and covered ways:* earthworks and protected
roads between them and the walls of the ditch nearest the
besiegers. [19] *Casemates:* Chambers in the ramparts.
 [20] *curtains:* walls joining the towers.

Dismount the cannon of the adverse part,
Murder the foe, and save the walls from breach.
When this is learned for service on the land,
By plain and easy demonstration
I'll teach you how to make the water mount,
That you may dry-foot march through lakes and pools,
Deep rivers, havens, creeks, and little seas,
And make a fortress in the raging waves,
Fenced with the concave of a monstrous rock,
Invincible by nature of the place. 90
When this is done then are ye soldiers,
And worthy sons of Tamburlaine the Great.
 Caly. My lord, but this is dangerous to be done;
We may be slain or wounded ere we learn.
 Tamb. Villain! Art thou the son of Tamburlaine,
And fear'st to die, or with a curtle-ax
To hew thy flesh, and make a gaping wound?
Hast thou beheld a peal of ordnance[21] strike
A ring of pikes,[22] mingled with shot and horse,[23]
Whose shattered limbs, being tossed as high as heaven,
Hang in the air as thick as sunny motes,[24] 101
And canst thou, coward, stand in fear of death?
Hast thou not seen my horsemen charge the foe,
Shot through the arms, cut overthwart[25] the hands,
Dyeing their lances with their streaming blood,
And yet at night carouse within my tent,
Filling their empty veins with airy wine,
That, being concocted,[26] turns to crimson blood,
And wilt thou shun the field for fear of wounds?
View me, thy father, that hath conquered kings, 110
And, with his horse, marched round about the earth,
Quite void of scars, and clear from any wound,
That by the wars lost not a dram of blood,
And see him lance his flesh to teach you all.

 He cuts his arm.

A wound is nothing, be it ne'er so deep;
Blood is the god of war's rich livery.[27]
Now look I like a soldier, and this wound
As great a grace and majesty to me,
As if a chair of gold, enamellèd,
Enchased[28] with diamonds, sapphires, rubies, 120
And fairest pearl of wealthy India,
Were mounted here under a canopy,
And I sat down clothed with the massy robe,
That late adorned the Afric potentate,[29]
Whom I brought bound unto Damascus' walls.
Come, boys, and with your fingers search my wound,

[21] *peal of ordnance:* cannon shot. [22] *pikes:* pikemen.
[23] *shot and horse:* foot soldiers and cavalry (though perhaps the point is to the "mingling" or "shattering" caused by the discharge of cannon).
[24] *motes:* dust particles. [25] *overthwart:* across.
[26] *concocted:* assimilated (the wine "making" new blood).
[27] *livery:* appointed uniform. [28] *Enchased:* Adorned.
[29] *Afric potentate:* Bajazeth, renowned for his triumphs in Africa. [30] *bravely:* boldly.
[31] *at a bay:* at a stand, like a fox run down by dogs.
III.iii.
[1] *hold:* fortress.
[2] *Minions, falc'nets, and sakers:* small pieces of ordnance.

And in my blood wash all your hands at once,
While I sit smiling to behold the sight.
Now, my boys, what think you of a wound?
 Caly. I know not what I should think of it; methinks
't is a pitiful sight. 131
 Cel. 'Tis nothing: give me a wound, father.
 Amy. And me another, my lord.
 Tamb. Come, sirrah, give me your arm.
 Cel. Here, father, cut it bravely,[30] as you did your
own.
 Tamb. It shall suffice thou dar'st abide a wound;
My boy, thou shalt not lose a drop of blood
Before we meet the army of the Turk:
But then run desperate through the thickest throngs,
Dreadless of blows, of bloody wounds, and death; 140
And let the burning of Larissa walls,
My speech of war, and this my wound you see,
Teach you, my boys, to bear courageous minds,
Fit for the followers of great Tamburlaine!
Usumcasane, now come let us march
Towards Techelles and Theridamas,
That we have sent before to fire the towns,
The towers and cities of these hateful Turks,
And hunt that coward, faint-heart runaway,
With that accursèd traitor Almeda, 150
Till fire and sword have found them at a bay.[31]
 Usum. I long to pierce his bowels with my sword,
That hath betrayed my gracious sovereign,—
That cursed and damnèd traitor Almeda.
 Tamb. Then let us see if coward Callapine
Dare levy arms against our puissance,
That we may tread upon his captive neck,
And treble all his father's slaveries.

 Exeunt.

III.iii

[Enter] Techelles, Theridamas, *and their train.*

 Ther. Thus have we marched northward from
 Tamburlaine,
Unto the frontier point of Soria;
And this is Balsera, their chiefest hold,[1]
Wherein is all the treasure of the land.
 Tech. Then let us bring our light artillery,
Minions, falc'nets, and sakers[2] to the trench,
Filling the ditches with the walls' wide breach,
And enter in to seize upon the gold.
How say ye, soldiers? Shall we not?
 Sold. Yes, my lord, yes; come, let's about it. 10
 Ther. But stay awhile; summon a parle, drum.
It may be they will yield it quietly,
Knowing two Kings, the friends to Tamburlaine,
Stand at the walls with such a mighty power.

 Summon the battle.

[Enter] Captain *with* [Olympia] *his* Wife *and*
 [*his*] Son.

 Capt. What require you, my masters?
 Ther. Captain, that thou yield up thy hold to us.

Capt. To you! Why, do you think me weary of it?
Tech. Nay, captain, thou art weary of thy life,
If thou withstand the friends of Tamburlaine!
　Ther. These pioners[3] of Argier in Africa,　　20
Even in the cannon's face, shall raise a hill
Of earth and faggots higher than thy fort,
And over thy argins and covered ways
Shall play upon the bulwarks of thy hold
Volleys of ordnance, till the breach be made
That with his ruin fills up all the trench,
And when we enter in, not heaven itself
Shall ransom thee, thy wife, and family.
　Tech. Captain, these Moors shall cut the leaden
　　pipes
That bring fresh water to thy men and thee,　　30
And lie in trench before thy castle walls,
That no supply of victual shall come in,
Nor any issue forth but they shall die;
And, therefore, captain, yield it quietly.
　Capt. Were you, that are the friends of Tamburlaine,
Brothers of holy Mahomet himself,
I would not yield it; therefore do your worst.
Raise mounts, batter, intrench, and undermine,
Cut off the water, all convoys that can,
Yet I am resolute, and so farewell.　　40
　　　[CAPTAIN, OLYMPIA, *and their* Son *exeunt.*]
　Ther. Pioners, away! and where I stuck the stake,
Intrench with those dimensions I prescribed,
Cast up the earth towards the castle wall,
Which, till it may defend you, labor low,
And few or none shall perish by their shot.
　Pio. We will, my lord.
　　　　　　　　　　　　　Exeunt [Pioners].
　Tech. A hundred horse shall scout about the plains
To spy what force comes to relieve the hold.
Both we, Theridamas, will intrench our men,
And with the Jacob's staff[4] measure the height　　50
And distance of the castle from the trench
That we may know if our artillery
Will carry full pointblank unto their walls.
　Ther. Then see the bringing of our ordnance
Along the trench into the battery,[5]
Where we will have gabions[6] of six feet broad
To save our cannoneers from musket shot.
Betwixt which shall our ordnance thunder forth,
And with the breach's fall, smoke, fire, and dust,
The crack, the echo, and the soldier's cry,　　60
Make deaf the ear and dim the crystal sky.
　Tech. Trumpets and drums, alarum[7] presently;[8]
And, soldiers, play the men; the hold is yours.
　　　　　　　　　　　　　　　[*Exeunt.*]

[III.iv]

Enter the CAPTAIN *with* [OLYMPIA,] *his* Wife
and [*his*] Son.

　Olymp. Come, good my lord, and let us haste from
　　hence
Along the cave that leads beyond the foe;
No hope is left to save this conquered hold.

Capt. A deadly bullet, gliding through my side,
Lies heavy on my heart; I cannot live.
I feel my liver pierced, and all my veins,
That there begin and nourish every part,
Mangled and torn, and all my entrails bathed
In blood that straineth from the orifex.[1]
Farewell, sweet wife! sweet son, farewell! I die.　　10
　Olymp. Death, whither art thou gone, that both we
　　live?
Come back again, sweet Death, and strike us both!
One minute end our days! and one sepùlcher
Contain our bodies! Death, why com'st thou not?
Well, this[2] must be the messenger for thee.
Now, ugly Death, stretch out thy sable wings,
And carry both our souls where his remains.
Tell me, sweet boy, art thou content to die?
These barbarous Scythians, full of cruelty,
And Moors, in whom was never pity found,　　20
Will hew us piecemeal, put us to the wheel,
Or else invent some torture worse than that;
Therefore die by thy loving mother's hand,
Who gently now will lance thy ivory throat,
And quickly rid thee both of pain and life.
　Son. Mother, dispatch me, or I'll kill myself;
For think you I can live and see him dead?
Give me your knife, good mother, or strike home:
The Scythians shall not tyrannize on me:
Sweet mother, strike, that I may meet my father.　　30
　　　　　　　　　　　　　　She stabs him.
　Olymp. Ah, sacred Mahomet, if this be sin,
Entreat a pardon of the God of heaven,
And purge my soul before it come to thee.

　　Enter THERIDAMAS, TECHELLES, *and all
　　　　　their train.*

　Ther. How now, madam, what are you doing?
　Olymp. Killing myself, as I have done my son,
Whose body, with his father's, I have burned,
Lest cruel Scythians should dismember him.
　Tech. 'Twas bravely done, and, like a soldier's
　　wife.
Thou shalt with us to Tamburlaine the Great,
Who, when he hears how resolute thou art,　　40
Will match thee with a viceroy or a king.
　Olymp. My lord deceased was dearer unto me
Than any viceroy, king, or emperor;
And for his sake here will I end my days.
　Ther. But, lady, go with us to Tamburlaine,
And thou shalt see a man, greater than Mahomet,

[3] *pioners:* trench diggers, sappers.
[4] *Jacob's staff:* mathematical instrument for gauging heights and distances.
[5] *battery:* where the guns are mounted.
[6] *gabions:* wickerwork receptacles that when filled with earth provided a protective shield, like sandbags. O1-4 read "galions." [7] *alarum:* sound alarm.
[8] *presently:* at once.

III.iv.
[1] *orifex:* orifice.　　　[2] *this:* Olympia draws a dagger.

In whose high looks is much more majesty
Than from the concave superficies [3]
Of Jove's vast palace, the empyreal orb,
Unto the shining bower where Cynthia [4] sits, 50
Like lovely Thetis, [5] in a crystal robe;
That treadeth fortune underneath his feet,
And makes the mighty god of arms his slave;
On whom Death and the Fatal Sisters wait
With naked swords and scarlet liveries:
Before whom, mounted on a lion's back,
Rhamnusia [6] bears a helmet full of blood,
And strows the way with brains of slaughtered men;
By whose proud side the ugly Furies run,
Hearkening when he shall bid them plague the world;
Over whose zenith, [7] clothed in windy air, 61
And eagle's wings joined to her feathered breast,
Fame hovereth, sounding of her golden trump,
That to the adverse poles of that straight line,
Which measureth the glorious frame of heaven, [8]
The name of mighty Tamburlaine is spread,
And him, fair lady, shall thy eyes behold.
Come!
 Olymp. Take pity of a lady's ruthful [9] tears,
That humbly craves upon her knees to stay 70
And cast her body in the burning flame,
That feeds upon her son's and husband's flesh.
 Tech. Madam, sooner shall fire consume us both,
Than scorch a face so beautiful as this,
In frame [10] of which nature hath showed more skill
Than when she gave eternal chaos form,
Drawing from it the shining lamps of heaven.
 Ther. Madam, I am so far in love with you,
That you must go with us—no remedy.
 Olymp. Then carry me, I care not, where you will,
And let the end of this my fatal journey 81
Be likewise end to my accursèd life.
 Tech. No, madam, but the beginning of your joy:
Come willingly therefore.
 Ther. Soldiers, now let us meet the general,
Who by this time is at Natolia,
Ready to charge the army of the Turk.
The gold, the silver, and the pearl ye got,
Rifling this fort, divide in equal shares:
This lady shall have twice as much again 90
Out of the coffers of our treasury.
 Exeunt.

[3] *concave superficies:* hollow and overarching surface.
[4] *Cynthia:* the moon, the innermost of the eight spheres that Jove's fixed and "empyreal" concavity encloses.
[5] *Thetis:* the ocean goddess.
[6] *Rhamnusia:* Nemesis (after her temple at Rhamnus in Attica). [7] *zenith:* head.
[8] *adverse . . . heaven:* the celestial diameter on which the spheres revolved. [9] *ruthful:* pitiful.
[10] *frame:* framing.

III.v.
[1] *Phrygia:* in Asia Minor.
[2] *Semiramis:* wife of Ninus and rebuilder of the metropolis of Babylon. [3] *Asia the Less:* Asia Minor.
[4] *Naturalized:* Admitted to citizenship.
[5] *Halla:* near Aleppo.

[III.v]

[*Enter*] CALLAPINE, ORCANES, JERUSALEM,
 TREBIZON, SORIA, ALMEDA, *with their trains.*
 [*Enter a* Messenger.]

 Mess. Renownèd Emperor, mighty Callapine,
God's great lieutenant over all the world!
Here at Aleppo, with an host of men,
Lies Tamburlaine, this King of Persia,
In number more than are the quivering leaves
Of Ida's forest, where your Highness' hounds,
With open cry, pursue the wounded stag,
Who means to girt Natolia's walls with siege,
Fire the town, and overrun the land.
 Call. My royal army is as great as his, 10
That, from the bounds of Phrygia [1] to the sea
Which washeth Cyprus with his brinish waves,
Covers the hills, the valleys, and the plains.
Viceroys and Peers of Turkey, play the men!
Whet all your swords, to mangle Tamburlaine,
His sons, his captains, and his followers;
By Mahomet! not one of them shall live;
The field wherein this battle shall be fought
For ever term the Persians' sepulcher,
In memory of this our victory! 20
 Orc. Now, he that calls himself the scourge of
 Jove,
The emperor of the world, and earthly god,
Shall end the warlike progress he intends,
And travel headlong to the lake of hell,
Where legions of devils, knowing he must die
Here, in Natolia, by your Highness' hands,
All brandishing their brands of quenchless fire,
Stretching their monstrous paws, grin with their teeth
And guard the gates to entertain his soul.
 Call. Tell me, viceroys, the number of your men,
And what our army royal is esteemed. 31
 K. of Jer. From Palestina and Jerusalem,
Of Hebrews threescore thousand fighting men
Are come since last we showed your majesty.
 Orc. So from Arabia Desert, and the bounds
Of that sweet land, whose brave metropolis
Re-edified the fair Semiramis, [2]—
Came forty thousand warlike foot and horse,
Since last we numbered to your Majesty.
 K. of Treb. From Trebizon, in Asia the Less, [3]— 40
Naturalized [4] Turks and stout Bithynians
Came to my bands, full fifty thousand more
That, fighting, know not what retreat doth mean,
Nor e'er return but with the victory,
Since last we numbered to your majesty.
 K. of Sor. Of Sorians from Halla [5] is repaired,
And neighbor cities of your highness' land,
Ten thousand horse, and thirty thousand foot,
Since last we numbered to your majesty;
So that the royal army is esteemed 50
Six hundred thousand valiant fighting men.
 Call. Then welcome, Tamburlaine, unto thy death.
Come, puissant viceroys, let us to the field,
The Persians' sepulcher, and sacrifice
Mountains of breathless men to Mahomet,

Who now, with Jove, opens the firmament
To see the slaughter of our enemies.

 [*Enter*] TAMBURLAINE *with his three* Sons,
 USUMCASANE, *with other.*[6]

 Tamb. How now, Casane? See a knot of kings,
Sitting as if they were a-telling riddles.
 Usum. My lord, your presence makes them pale and
 wan. 60
Poor souls! they look as if their death were near.
 Tamb. And so he[7] is, Casane; I am here;
But yet I'll save their lives, and make them slaves.
Ye petty Kings of Turkey, I am come,
As Hector did into the Grecian camp,
To overdare the pride of Graecia,
And set his warlike person to the view
Of fierce Achilles, rival of his fame.
I do you honor in the simile;
For if I should, as Hector did Achilles, 70
The worthiest knight that ever brandished sword,
Challenge in combat any of you all,
I see how fearfully ye would refuse,
And fly my glove[8] as from a scorpion.
 Orc. Now thou art fearful of thy army's strength,
Thou would'st with overmatch of person fight;
But, shepherd's issue, base-born Tamburlaine,
Think of thy end! this sword shall lance thy throat.
 Tamb. Villain! the shepherd's issue, at whose birth
Heaven did afford a gracious aspèct,[9] 80
And joined those stars that shall be opposite
Even till the dissolution of the world,
And never meant to make a conqueror
So famous as is mighty Tamburlaine,
Shall so torment thee and that Callapine,
That, like a roguish runaway, suborned
That villain there, that slave, that Turkish dog,
To false[10] his service to his sovereign,
As ye shall curse the birth of Tamburlaine.
 Call. Rail not, proud Scythian! I shall now revenge
My father's vile abuses,[11] and mine own. 91
 K. of Jer. By Mahomet! he shall be tied in chains,
Rowing with Christians in a brigandine
About the Grecian isles to rob and spoil,
And turn him to his ancient trade again:
Methinks the slave should make a lusty[12] thief.
 Call. Nay, when the battle ends, all we will meet,
And sit in council to invent some pain
That most may vex his body and his soul. 99
 Tamb. Sirrah Callapine! I'll hang a clog[13] about
your neck for[14] running away again; you shall not
trouble me thus to come and fetch you;
But as for you, viceroys, you shall have bits,
And, harnessed like my horses, draw my coach;
And when ye stay,[15] be lashed with whips of wire.
I'll have you learn to feed on provender[16]
And in a stable lie upon the planks.
 Orc. But, Tamburlaine, first thou shalt kneel to us,
And humbly crave a pardon for thy life.
 K. of Treb. The common soldiers of our mighty
 host 110
Shall bring thee bound unto the general's tent.

 K. of Sor. And all have jointly sworn thy cruel death,
Or bind thee in eternal torments' wrath.
 Tamb. Well, sirs, diet yourselves; you know I shall
have occasion shortly to journey you.[17]
 Cel. See, father,
How Almeda the jailor looks upon us.
 Tamb. Villain! traitor! damnèd fugitive!
I'll make thee wish the earth had swallowed thee,
See'st thou not death within my wrathful looks? 120
Go, villain, cast thee headlong from a rock,
Or rip thy bowels, and rend out thy heart
T' appease my wrath! or else I'll torture thee,
Searing thy hateful flesh with burning irons
And drops of scalding lead, while all thy joints
Be racked and beat asunder with the wheel
For, if thou livest, not any element
Shall shroud thee from the wrath of Tamburlaine.
 Call. Well, in despite of thee he shall be King.
Come, Almeda; receive this crown of me, 130
I here invest thee King of Ariadan
Bordering on Mare Roso,[18] near to Mecca.
 Orc. What! Take it, man.
 Alm. Good my Lord, let me take it.[19]
 Call. Dost thou ask him leave? Here; take it.
 Tamb. Go to, sirrah, take your crown, and make up
the half dozen. So, sirrah, now you are a king, you
must give arms.[20]
 Orc. So he shall, and wear thy head in his scutcheon.
 Tamb. No; let him hang a bunch of keys on 140
his standard to put him in remembrance he was a jailor,
that when I take him, I may knock out his brains with
them, and lock you in the stable, when you shall come
sweating from my chariot.
 K. of Treb. Away; let us to the field, that the villain
may be slain.
 Tamb. Sirrah, prepare whips and bring my chariot to
my tent, for as soon as the battle is done, I'll ride in
triumph through the camp.

Enter THERIDAMAS, TECHELLES, *and their train.*

How now, ye petty Kings? Lo, here are bugs[21] 150
Will make the hair stand upright on your heads,
And cast[22] your crowns in slavery at their feet.
Welcome, Theridamas and Techelles, both!
See ye this rout, and know ye this same King?
 Ther. Ay, my lord; he was Callapine's keeper.

 [6] *other:* others. [7] *he:* i.e., their death.
 [8] *glove:* gage, thrown down as a challenge.
 [9] *aspèct:* At Tamburlaine's birth, the relative positions of
the reigning stars were extraordinarily favorable, in "con-
junction" then, forever after in "opposition."
 [10] *false:* betray. [11] *abuses:* i.e., visited on him.
 [12] *lusty:* potent (all senses).
 [13] *clog:* any encumbrance like a thick piece of wood.
 [14] *for:* i.e., to prevent your. [15] *stay:* stop.
 [16] *provender:* grain, appropriate to horses.
 [17] *journey you:* force you to go on a journey.
 [18] *Mare Roso:* the Red Sea.
 [19] *Good . . . it:* Almeda addresses Tamburlaine.
 [20] *arms:* used punningly, of martial prowess, but also of
the heraldic marks or "scutcheon" that denoted the gentle-
man. [21] *bugs:* bugbears.
 [22] *cast:* make you cast.

Tamb. Well, now you see he is a king; look to him,
Theridamas, when we are fighting, lest he hide his
crown as the foolish King of Persia did.[23]

K. of Sor. No, Tamburlaine; he shall not be put to
that exigent, I warrant thee. 160

Tamb. You know not, sir—
But now, my followers and my loving friends,
Fight as you ever did, like conquerors,
The glory of this happy day is yours.
My stern aspèct shall make fair victory,
Hovering betwixt our armies, light on me
Loaden with laurel wreaths to crown us all.

Tech. I smile to think how, when this field is fought
And rich Natolia ours, our men shall sweat
With carrying pearl and treasure on their backs. 170

Tamb. You shall be princes all, immediately;
Come, fight, ye Turks, or yield us victory.

Orc. No; we will meet thee, slavish Tamburlaine.

Exeunt.

ACT FOUR

SCENE ONE

Alarms. AMYRAS *and* CELEBINUS *issues from the
tent where* CALYPHAS *sits asleep.*

Amy. Now in their glories shine the golden crowns
Of these proud Turks, much like so many suns
That half dismay the majesty of heaven.
Now, brother, follow we our father's sword,
That flies with fury swifter than our thoughts,
And cuts down armies with his conquering wings.

Cel. Call forth our lazy brother from the tent,
For if my father miss him in the field,
Wrath, kindled in the furnace of his breast,
Will send a deadly lightning to his heart. 10

Amy. Brother, ho! what given so much to sleep!
You cannot leave it, when our enemies' drums
And rattling cannons thunder in our ears
Our proper[1] ruin and our father's foil?[2]

Cal. Away, ye fools! my father needs not me,
Nor you in faith, but that you will be thought
More childish-valorous than manly-wise.
If half our camp should sit and sleep with me,
My father were enough to scare the foe.
You do dishonor to his majesty, 20
To think our helps will do him any good.

Amy. What, dar'st thou then be absent from the
field,
Knowing my father hates thy cowardice,
And oft hath warned thee to be still in field,

When he himself amidst the thickest troops
Beats down our foes, to flesh our taintless swords![3]

Cal. I know, sir, what it is to kill a man;
It works remorse of conscience in me;
I take no pleasure to be murderous,
Nor care for blood when wine will quench my thirst.

Cel. O cowardly boy! fie! for shame come forth! 31
Thou dost dishonor manhood and thy house.

Cal. Go, go, tall[4] stripling, fight you for us both,
And take my other toward[5] brother here,
For person like to prove a second Mars.
'Twill please my mind as well to hear both you
Have won a heap of honor in the field
And left your slender carcasses behind,
As if I lay with you for company.

Amy. You will not go them? 40

Cal. You say true.

Amy. Were all the lofty mounts of Zona Mundi[6]
That fill the midst of farthest Tartary
Turned into pearl and proffered for my stay,
I would not bide[7] the fury of my father,
When, made a victor in these haughty arms,
He comes and finds his sons have had no shares
In all the honors he proposed for us.

Cal. Take you the honor, I will take my ease;
My wisdom shall excuse my cowardice. 50
I go into the field before I need![8]

Alarm, and AMYRAS *and* CELEBINUS *run in.*

The bullets fly at random where they list;
And should I go and kill a thousand men,
I were as soon rewarded with a shot,
And sooner far than he that never fights;
And should I go and do nor harm nor good,
I might have harm which all the good I have,
Joined with my father's crown, would never cure.
I'll to cards. Perdicas!

[Enter PERDICAS.]

Perd. Here, my lord. 60

Cal. Come, thou and I will go to cards to drive away
the time.

Perd. Content, my lord; but what shall we play for?

Cal. Who shall kiss the fairest of the Turk's con-
cubines first, when my father hath conquered them.

Perd. Agreed, i' faith.

They play.

Cal. They say I am a coward, Perdicas, and I fear as
little their taratantaras,[9] their swords or their cannons,
as I do a naked lady in a net of gold, and, for fear I
should be afraid, would put it off and come to bed with
me. 71

Perd. Such a fear, my lord, would never make ye
retire.

Cal. I would my father would let me be put in the
front of such a battle once to try my valor.

Alarm.

What a coil[10] they keep! I believe there will be some
hurt done anon amongst them.

[23] *lest . . . did:* recalling Part I, II.iv.

IV.i.

[1] *proper:* own—proper to us. [2] *foil:* overthrow.
[3] *flesh . . . swords:* approve in combat our swords, as yet
unstained. [4] *tall:* brave (ironically).
[5] *toward:* towardly, promising.
[6] *Zona Mundi:* Ural Mountains. [7] *bide:* await.
[8] *I . . . need!:* i.e., Not likely!
[9] *taratantaras:* bugle calls. [10] *coil:* hubbub.

Enter TAMBURLAINE, THERIDAMAS, TECHELLES,
USUMCASANE, AMYRAS, CELEBINUS, *leading the*
TURKISH KINGS.

Tamb. See now, ye slaves, my children stoops[11]
your pride,
And leads your glories sheeplike to the sword.
Bring them, my boys, and tell me if the wars 80
Be not a life that may illustrate[12] gods,
And tickle not your spirits with desire
Still to be trained in arms and chivalry?
Amy. Shall we let go these Kings again, my lord,
To gather greater numbers 'gainst our power,
That they may say it is not chance doth this,
But matchless strength and magnanimity?
Tamb. No, no, Amyras; tempt not fortune so:
Cherish thy valor still with fresh supplies,
And glut it not with stale and daunted foes. 90
But where's this coward villain, not my son,
But traitor to my name and majesty?

He goes in and brings him out.

Image of sloth and picture of a slave,
The obloquy and scorn of my renown!
How may my heart, thus fired with mine eyes,
Wounded with shame and killed with discontent,
Shroud[13] any thought may hold my striving hands
From martial justice on thy wretched soul?
Ther. Yet pardon him, I pray your majesty.
Tech. Let all of us entreat your highness' pardon.
Tamb. Stand up, ye base, unworthy soldiers! 101
Know ye not yet the argument of arms?[14]
Amy. Good my lord, let him be forgiven for once,
And we will force him to the field hereafter.
Tamb. Stand up, my boys, and I will teach ye arms,
And what the jealousy[15] of wars must do.
O Samarcanda, where I breathèd first
And joyed[16] the fire of this martial flesh,
Blush, blush, fair city, at thine honor's foil,[17]
And shame of nature, which Jaertis'[18] stream, 110
Embracing thee with deepest of his love,
Can never wash from thy distainèd[19] brows!
Here, Jove, receive his fainting soul again;
A form not meet to give that subject essence
Whose matter is the flesh of Tamburlaine;
Wherein an incorporeal spirit moves,
Made of the mold whereof thyself consists,[20]
Which makes me valiant, proud, ambitious,
Ready to levy power against thy throne,
That I might move the turning spheres of heaven! 120
For earth and all this airy region
Cannot contain the state of Tamburlaine.
By Mahomet! thy mighty friend, I swear,
In sending to my issue such a soul,
Created of the massy dregs of earth,
The scum and tartar[21] of the elements,
Wherein was neither courage, strength, or wit,[22]
But folly, sloth, and damnèd idleness.
Thou hast procured a greater enemy
Than he that darted mountains at thy head, 130
Shaking the burden mighty Atlas[23] bears;

Whereat thou trembling hid'st thee in the air,
Clothed with a pitchy cloud for[24] being seen:
And now, ye cankered curs of Asia,
That will not see the strength of Tamburlaine,
Although it shine as brightly as the sun;
Now you shall feel the strength of Tamburlaine,
And, by the state of his supremacy,

[*Stabs* CALYPHAS.]

Approve[25] the difference 'twixt himself and you.
Orc. Thou show'st the difference 'twixt ourselves
and thee, 140
In this thy barbarous damnèd tyranny.
K. of Jer. Thy victories are grown so violent,
That shortly heaven, filled with the meteors[26]
Of blood and fire thy tyrannies have made,
Will pour down blood and fire on thy head,
Whose scalding drops will pierce thy seething brains,
And, with our bloods, revenge our bloods on thee.
Tamb. Villains! these terrors and these tyrannies
(If tyrannies war's justice ye repute)
I execute, enjoined me from above, 150
To scourge the pride as such as heaven abhors;
Nor am I made arch-monarch of the world,
Crowned and invested by the hand of Jove
For deeds of bounty or nobility;
But since I exercise a greater name,
The scourge of God, and terror of the world,
I must apply myself to fit those terms,
In war, in blood, in death, in cruelty,
And plague such peasants[27] as resist in[28] me,
The power of heaven's eternal majesty. 160
Theridamas, Techelles, and Casane,
Ransack the tents and the pavilions
Of these proud Turks, and take their concubines,
Making them bury this effeminate brat,
For not a common soldier shall defile
His manly fingers with so faint[29] a boy.
Then bring those Turkish harlots to my tent,
And I'll dispose them as it likes[30] me best;
Meanwhile, take him in.
Sold. We will, my lord. 170

[*Exeunt with the body of* CALYPHAS.]

[11] *stoops:* make to stoop.
[12] *illustrate:* beautify, as with light. [13] *Shroud:* Hide.
[14] *argument of arms:* proper course of military life.
[15] *jealousy:* zeal. [16] *joyed:* delighted in.
[17] *foil:* disgrace.
[18] *Jaertis':* Jaxartes' (which flows into the Caspian Sea).
[19] *distainèd:* soiled with disgrace.
[20] *Here . . . consists:* Take back the spirit ("form") of
Calyphas, which is unworthy to be the immortal part
("essence") of a material body derived from Tamburlaine,
in whom moves a spirit like Jove's.
[21] *tartar:* like dregs of wine.
[22] *wit:* the reasonable faculty.
[23] *Atlas:* who bore the heavens on his shoulders.
[24] *for:* i.e., for fear of. [25] *Approve:* Attest.
[26] *meteors:* any prodigious "exhalation" in the heavens.
[27] *peasants:* base fellows.
[28] *resist in:* O1–4 read "resisting." [29] *faint:* cowardly.
[30] *likes:* pleases.

K. of Jer. O damnèd monster! Nay, a fiend of hell,
Whose cruelties are not so harsh as thine,
Nor yet imposed with such a bitter hate!

Orc. Revenge it, Rhadamanth and Aeacus,[31]
And let your hates, extended in his pains,
Excel the hate wherewith he pains our souls.

K. of Treb. May never day give virtue[32] to his eyes,
Whose sight, composed of fury and of fire,
Doth send such stern affections[33] to his heart.

K. of Sor. May never spirit, vein, or artier,[34] feed
The cursèd substance of that cruel heart! 181
But, wanting moisture and remorseful[35] blood,
Dry up with anger, and consume with heat.

Tamb. Well, bark, ye dogs! I'll bridle all your
 tongues,
And bind them close with bits of burnished steel,
Down to the channels of your hateful throats;
And, with the pains my rigor shall inflict,
I'll make ye roar, that earth may echo forth
The far-resounding torments ye sustain:
As when an herd of lusty Cimbrian[36] bulls 190
Run mourning round about the females' miss,[37]
And, stung with fury of their following,[38]
Fill all the air with troublous bellowing;
I will, with engines never exercised,
Conquer, sack, and utterly consume
Your cities and your golden palaces;
And, with the flames that beat against the clouds,
Incense[39] the heavens, and make the stars to melt,
As if they were the tears of Mahomet,
For hot consumption of his country's pride; 200
And, till by vision or by speech I hear
Immortal Jove say "Cease, my Tamburlaine,"
I will persist, a terror to the world,
Making the meteors that, like armèd men,
Are seen to march upon the towers of heaven,
Run tilting[40] round about the firmament,
And break their burning lances in the air,
For honor of my wondrous victories.
Come, bring them in to our pavilion.

 Exeunt.

[IV.ii]

Olympia *alone.*

Olymp. Distressed Olympia, whose weeping eyes
Since thy arrival here beheld no sun,
But closed within the compass of a tent

[31] *Rhadamanth and Aeacus:* judges in Hades.
[32] *virtue:* power. [33] *affections:* feelings.
[34] *artier:* artery. [35] *remorseful:* pitiful.
[36] *Cimbrian:* Celtic. [37] *miss:* loss.
[38] *their following:* following of them.
[39] *Incense:* Fire. [40] *tilting:* as in a tournament.

IV.ii.
[1] *drift:* purpose.
[2] *close:* hidden; but referring also to her incarceration.
[3] *affections:* feelings.
[4] *Cynthia's:* referring to the controlling of the tides by the
moon.

Hath stained thy cheeks, and made thee look like death,
Devise some means to rid thee of thy life,
Rather than yield to his detested suit,
Whose drift[1] is only to dishonor thee;
And since this earth, dewed with thy brinish tears,
Affords no herbs whose taste may poison thee,
Nor yet this air, beat often with thy sighs, 10
Contagious smells and vapors to infect thee,
Nor thy close[2] cave a sword to murder thee;
Let this invention be the instrument.

Enter Theridamas.

Ther. Well met, Olympia; I sought thee in my tent,
But when I saw the place obscure and dark,
Which with thy beauty thou wast wont to light,
Enraged, I ran about the fields for thee,
Supposing amorous Jove had sent his son,
The wingèd Hermes, to convey thee hence;
But now I find thee, and that fear is past. 20
Tell me, Olympia, wilt thou grant my suit?

Olymp. My lord and husband's death, with my
 sweet son's,
With whom I buried all affections[3]
Save grief and sorrow, which torment my heart,
Forbids my mind to entertain a thought
That tends to love, but meditate on death,
A fitter subject for a pensive soul.

Ther. Olympia, pity him, in whom thy looks
Have greater operation and more force
Than Cynthia's[4] in the watery wilderness, 30
For with thy view my joys are at the full,
And ebb again as thou departest from me.

Olymp. Ah, pity me, my lord! and draw your sword
Making a passage for my troubled soul,
Which beats against this prison to get out,
And meet my husband and my loving son.

Ther. Nothing but still thy husband and thy son!
Leave this, my love, and listen more to me.
Thou shalt be stately Queen of fair Argier;
And clothed in costly cloth of massy gold, 40
Upon the marble turrets of my court
Sit like to Venus in her chair of state,
Commanding all thy princely eye desires;
And I will cast off arms and sit with thee,
Spending my life in sweet discourse of love.

Olymp. No such discourse is pleasant in mine ears,
But that where every period ends with death,
And every line begins with death again.
I cannot love, to be an emperess.

Ther. Nay, lady, then, if nothing will prevail, 50
I'll use some other means to make you yield:
Such is the sudden fury of my love,
I must and will be pleased, and you shall yield.
Come to the tent again.

Olymp. Stay, good my lord; and, will you save my
 honor,
I'll give your grace a present of such price,
As all the world cannot afford the like.

Ther. What is it?

Olymp. An ointment which a cunning alchemist,
Distillèd from the purest balsamum 60

And simplest extracts of all minerals,[5]
In which the essential form of marble stone,
Tempered by science metaphysical,[6]
And spells of magic from the mouths of spirits,
With which if you but 'noint your tender skin,
Nor pistols, sword, nor lance, can pierce your flesh.
 Ther. Why, madam, think you to mock me thus
 palpably?
 Olymp. To prove it, I will 'noint my naked throat,
Which, when you stab, look on your weapon's point,
And you shall see't rebated[7] with the blow. 70
 Ther. Why gave you not your husband some of it,
If you loved him, and it so precious?
 Olymp. My purpose was, my lord, to spend it so.
But was prevented by his sudden end;
And for a present, easy proof hereof,
That I dissemble not, try it on me.
 Ther. I will, Olympia, and will keep it for
The richest present of this eastern world.

 She 'noints her throat.

 Olymp. Now stab, my lord, and mark your weapon's
 point,
That will be blunted if the blow be great. 80
 Ther. Here then, Olympia.

 [Stabs her.]

What, have I slain her! Villain, stab thyself;
Cut off this arm that murderèd thy love,
In whom the learnèd rabbis[8] of this age
Might find as many wondrous miracles
As in the theoria[9] of the world.
Now hell is fairer than Elysian;
A great lamp than that bright eye of heaven,
From whence the stars do borrow all their light,
Wanders about the black circumference; 90
And now the damnèd souls are free from pain,
For every Fury gazeth on her looks;
Infernal Dis is courting of my love,
Inventing masks[10] and stately shows for her,
Opening the doors of his rich treasury
To entertain this queen of chastity;
Whose body shall be tombed with all the pomp
The treasure of my kingdom may afford.
 Exit, taking her away.

IV.iii

TAMBURLAINE, *drawn in his chariot by* TREBIZON
and SORIA, *with bits in their mouths, reins in his left
hand, in his right hand a whip with which he scourgeth
them;* TECHELLES, THERIDAMAS, USUMCASANE,
AMYRAS, CELEBINUS, NATOLIA *and* JERUSALEM,
led by with five or six common Soldiers.

 Tamb. Holla, ye pampered jades of Asia!
What! can ye draw but twenty miles a day,
And have so proud a chariot at your heels,
And such a coachman as great Tamburlaine,
But from Asphaltis, where I conquered you,
To Byron[1] here, where thus I honor you!

The horse that guide the golden eye of heaven,
And blow the morning from their nosterils,[2]
Making their fiery gait above the clouds,
Are not so honored in their governor,[3] 10
As you, ye slaves, in mighty Tamburlaine.
The headstrong jades of Thrace Alcides[4] tamed,
That King Aegeus fed with human flesh,
And made so wanton that they knew their strengths,
Were not subdued with valor more divine
Than you by this unconquered arm of mine.
To make you fierce, and fit my appetite,
You shall be fed with flesh as raw as blood,
And drink in pails the strongest muscadel;
If you can live with it, then live, and draw 20
My chariot swifter than the racking[5] clouds;
If not, then die like beasts, and fit for naught
But perches for the black and fatal ravens.
Thus am I right[6] the scourge of highest Jove;
And see the figure[7] of my dignity
By which I hold my name and majesty!
 Amy. Let me have coach, my lord, that I may ride,
And thus be drawn with these two idle Kings.
 Tamb. Thy youth forbids such ease, my kingly boy;
They shall tomorrow draw my chariot, 30
While these their fellow Kings may be refreshed.
 Orc. O thou[8] that sway'st the region under earth,
And art a king as absolute as Jove,
Come as thou didst in fruitful Sicily,
Surveying all the glories of the land,
And as thou took'st the fair Proserpina,
Joying[9] the fruit of Ceres' garden-plot,
For love, for honor, and to make her Queen,
So for just hate, for shame, and to subdue
This proud contemner[10] of thy dreadful power, 40
Come once in fury and survey his pride,
Haling him headlong to the lowest hell.
 Ther. Your majesty must get some bits for these,
To bridle their contemptuous, cursing tongues,
That, like unruly, never-broken jades,
Break through the hedges[11] of their hateful mouths,
And pass their fixèd bounds exceedingly.
 Tech. Nay, we will break the hedges of their mouths,

 [5] *simplest . . . minerals:* the elemental or constituent parts
("essential form").
 [6] *science metaphysical:* occult lore, black magic.
 [7] *rebated:* blunted.
 [8] *rabbis:* generically—"scholars."
 [9] *theoria:* contemplation(?).
 [10] *masks:* courtly entertainments.

IV.iii.
 [1] *Asphaltis . . . Byron:* respectively, bituminous lake and
town near Babylon. [2] *nosterils:* nostrils.
 [3] *governor:* driver.
 [4] *Alcides:* Hercules, among whose labors was the sub-
duing of the cannibalistic horses of the Thracian King
Aegeus (or Diomedes). [5] *racking:* scudding.
 [6] *right:* indeed. [7] *figure:* very image.
 [8] *thou:* Pluto or Dis, whose rape of Proserpina ("which
cost her mother Ceres all that pain") is recounted by Ovid,
Metamorphoses, V. 385*ff*. [9] *Joying:* Enjoying.
 [10] *contemner:* one who eschews or disdains.
 [11] *hedges:* teeth.

And pull their kicking colts [12] out of their pastures.
 Usum. Your majesty already hath devised 50
A mean,[13] as fit as may be, to restrain
These coltish coach-horse tongues from blasphemy.
 Cel. How like you that, sir King? Why speak you
 not?
 K. of Jer. Ah, cruel brat, sprung from a tyrant's
 loins!
How like his cursèd father he begins
To practice taunts and bitter tyrannies!
 Tamb. Ay, Turk, I tell thee, this same boy is he
That must, advanced in higher pomp than this,
Rifle the kingdoms I shall leave unsacked,
If Jove, esteeming me too good for earth, 60
Raise me to match the fair Aldeboran,[14]
Above the threefold astracism [15] of heaven,
Before I conquer all the triple world.[16]
Now, fetch me out the Turkish concubines;
I will prefer [17] them for the funeral
They have bestowed on my abortive son.

 The Concubines *are brought in.*

Where are my common soldiers now, that fought
So lion-like upon Asphaltis' plains?
 Sold. Here, my lord.
 Tamb. Hold ye, tall [18] soldiers, take ye queens
 apiece— 70
I mean such queens [19] as were kings' concubines—
Take them; divide them, and their jewels too,
And let them equally serve all your turns.[20]
 Sold. We thank your majesty.
 Tamb. Brawl not, I warn you, for your lechery:
For every man that so offends shall die.
 Orc. Injurious tyrant, wilt thou so defame
The hateful fortunes of thy victory,
To exercise upon such guiltless dames
The violence of thy common soldiers' lust? 80
 Tamb. Live continent [21] then, ye slaves, and meet
 not me
With troops of harlots at your slothful heels.
 Con. O pity us, my lord, and save our honors.
 Tamb. Are ye not gone, ye villains, with your spoils?

 They run away with the ladies.

 K. of Jer. O merciless, infernal cruelty!
 Tamb. Save your honors! 'Twere but time indeed,
Lost long before ye knew what honor meant.
 Ther. It seems they meant to conquer us, my lord,
And make us jesting pageants for their trulls.[22]
 Tamb. And now themselves shall make our
 pageants, 90
And common soldiers jest with all their trulls.
Let them take pleasure soundly in their spoils,
Till we prepare our march to Babylon,
Whither we next make expedition.
 Tech. Let us not be idle then, my lord,
But presently [23] be prest [24] to conquer it.
 Tamb. We will, Techelles. Forward then, ye jades.
Now crouch, ye Kings of greatest Asia,
And tremble when ye hear this scourge will come
That whips down cities and controlleth crowns, 100
Adding their wealth and treasure to my store.
The Euxine sea, north to Natolia;
The Terrene, west; the Caspian, north-north-east;
And on the south, Sinus Arabicus,[25]
Shall all be loaden with the martial spoils
We will convey with us to Persia.
Then shall my native city, Samarcanda,
And crystal waves of fresh Jaertis' stream,
The pride and beauty of her princely seat,
Be famous through the furthest continents, 110
For there my palace-royal shall be placed,
Whose shining turrets shall dismay the heavens,
And cast the fame of Ilion's [26] tower to hell.
Thorough the streets with troops of conquered kings,
I'll ride in golden armor like the sun;
And in my helm a triple plume shall spring,
Spangled with diamonds, dancing in the air,
To note me emperor of the threefold world,
Like to an almond tree y-mounted high
Upon the lofty and celestial mount 120
Of ever-green Selinus [27] quaintly decked
With blooms more white than Erycina's [28] brows,
Whose tender blossoms tremble every one,
At every little breath that thorough heaven is blown.[29]
Then in my coach, like Saturn's royal son [30]
Mounted, his shining chariot gilt with fire,
And drawn with princely eagles through the path
Paved with bright crystal and enchased with stars,
When all the gods stand gazing at his pomp,
So will I ride through Samarcanda streets, 130
Until my soul, dissevered from this flesh,
Shall mount the milk-white way, and meet him there.
To Babylon, my lords; to Babylon!

 Exeunt.

 Finis Actus Quarti.

[12] *colts:* tongues. [13] *mean:* method.
[14] *Aldeboran:* bright star in the eye of the constellation Taurus.
[15] *astracism:* asterism or zodiacal constellation, "threefold" perhaps as it is made up of three stars, or as Marlowe's mind is on the three spheres encircling the earth, and the three known continents that comprise it.
[16] *triple world:* Europe, Africa, Asia.
[17] *prefer:* advance in dignity. [18] *tall:* brave.
[19] *queens:* with pun on "queans" (whores).
[20] *turns:* "the best turn in bed." [21] *continent:* chaste.
[22] *jesting . . . trulls:* mocking shows for their whores.
[23] *presently:* immediately. [24] *prest:* ready.
[25] *Sinus Arabicus:* the Red Sea. [26] *Ilion's:* Troy's.
[27] *Selinus:* Sicilian town.
[28] *Erycina's:* Venus's (after her temple on Mount Eryx in Sicily).
[29] *Like . . . blown:* borrowed with slight variation from Spenser, *Faerie Queene*, Book I, Canto vii. The last line is an alexandrine. [30] *son:* Jupiter.

ACT FIVE

SCENE ONE

Enter the GOVERNOR *of* BABYLON *upon the walls
with others.*

 Gov. What saith Maximus?
 Max. My lord, the breach the enemy hath made

Gives such assurance of our overthrow
That little hope is left to save our lives,
Or hold our city from the conqueror's hands.
Then hang out flags, my lord, of humble truce,
And satisfy the people's general prayers,
That Tamburlaine's intolerable wrath
May be suppressed by our submission.
 Gov. Villain, respects thou more thy slavish life 10
Than honor of thy country or thy name?
Are not my life and state as dear to me,
The city, and my native country's weal,
As anything of price with thy conceit?[1]
Have we not hope, for all our battered walls,
To live secure and keep his forces out,
When this our famous lake of Limnasphaltis
Makes walls afresh with everything that falls[2]
Into the liquid substance of his stream,
More strong than are the gates of death or hell? 20
What faintness[3] should dismay our courages
When we are thus defensed against our foes,
And have no terror but his threatening looks.

 Enter another, kneeling to the GOVERNOR.

 Cit. My lord, if ever you did deed of ruth,
And now will work a refuge for our lives,
Offer submission, hang up flags of truce,
That Tamburlaine may pity our distress,
And use us like a loving conqueror.
Though this be held his last day's dreadful siege,
Wherein he spareth neither man nor child, 30
Yet are there Christians of Georgia here,
Whose state he ever pitied and relieved,
Will get his pardon if your grace would send.
 Gov. How is my soul environèd,
And this eternized[4] city, Babylon,
Filled with a pack of faint-heart fugitives
That thus entreat their shame and servitude!

 [*Enter another* Citizen.]

 2 Cit. My lord, if ever you will win our hearts,
Yield up the town, save our wives and children;
For I will cast myself from off these walls 40
Or die some death of quickest violence
Before I bide the wrath of Tamburlaine.
 Gov. Villains, cowards, traitors to our state!
Fall to the earth and pierce the pit of hell,
That legions of tormenting spirits may vex
Your slavish bosoms with continual pains!
I care not, nor the town will never yield,
As long as any life is in my breast.

 Enter THERIDAMAS *and* TECHELLES, *with other*
 Soldiers.

 Ther. Thou desperate Governor of Babylon,
To save thy life, and us a little labor, 50
Yield speedily the city to our hands,
Or else be sure thou shalt be forced with pains,
More exquisite than ever traitor felt.
 Gov. Tyrant! I turn the traitor in thy throat,
And will defend it in despite of thee.
Call up the soldiers to defend these walls!

 Tech. Yield, foolish governor; we offer more
Than ever yet we did to such proud slaves
As durst resist us till our third day's siege.
Thou seest us prest[5] to give the last assault, 60
And that shall bide no more regard of parley.[6]
 Gov. Assault and spare not; we will never yield.

 Alarms: and they scale the walls.

 Enter TAMBURLAINE, *with* USUMCASANE,
 AMYRAS, CELEBINUS, *and others; with the two*
 spare Kings.

 Tamb. The stately buildings of fair Babylon,
Whose lofty pillars, higher than the clouds,
Were wont to guide the seaman in the deep,
Being carried thither by the cannon's force,
Now fill the mouth of Limnasphaltis' lake
And make a bridge unto the battered walls.
Where Belus, Ninus, and great Alexander[7]
Have rode in triumph, triumphs Tamburlaine, 70
Whose chariot wheels have burst[8] the Assyrians' bones,
Drawn with[9] these Kings on heaps of carcasses.
Now in the place where fair Semiramis,
Courted by kings and peers of Asia,
Hath trod the measures,[10] do my soldiers march;
And in the streets, where brave[11] Assyrian dames
Have rid in pomp like rich Saturnia,[12]
With furious words and frowning visages
My horsemen brandish their unruly blades.

 Enter THERIDAMAS *and* TECHELLES, *bringing the*
 GOVERNOR *of* BABYLON.

Who have ye there, my lords? 80
 Ther. The sturdy Governor of Babylon,
That made us all the labor for the town,
And used such slender reckoning of your majesty.
 Tamb. Go, bind the villain; he shall hang in chains
Upon the ruins of this conquered town.
Sirrah, the view of our vermilion tents,
Which threatened more than if the region
Next underneath the element of fire
Were full of comets[13] and of blazing stars,
Whose flaming trains should reach down to the earth,
Could not affright you; no, nor I myself, 91
The wrathful messenger of mighty Jove,
That with his sword hath quailed[14] all earthly kings,
Could not persuade you to submission,
But still the ports[15] were shut; villain! I say,

V.i.
 [1] *As . . . conceit:* As any precious thing you can think of.
 [2] *Makes . . . falls:* alluding to the fabulous properties of
this bituminous lake. [3] *faintness:* timidity.
 [4] *eternized:* eternally famous. [5] *prest:* ready.
 [6] *bide . . . parley:* wait on no more talk.
 [7] *Belus, Ninus . . . Alexander:* Belus was the founder of
Babylon, Ninus the founder of Nineveh and husband of
Semiramis, who built Babylon's walls; Alexander the Great
conquered the city in 331 B.C. [8] *burst:* broken.
 [9] *with:* by. [10] *measures:* steps in a stately dance.
 [11] *brave:* resplendent. [12] *Saturnia:* Juno.
 [13] *comets:* i.e., as portents of disaster.
 [14] *quailed:* quelled. [15] *ports:* gates.

Should I but touch the rusty gates of hell,
The triple-headed Cerberus would howl
And make black Jove [16] to crouch and kneel to me;
But I have sent volleys of shot to you,
Yet could not enter till the breach was made. 100
 Gov. Nor, if my body could have stopped the
 breach,
Should'st thou have entered, cruel Tamburlaine.
'Tis not thy bloody tents can make me yield,
Nor yet thyself, the anger of the Highest,
For though thy cannon shook the city walls,
My heart did never quake, or courage faint.
 Tamb. Well, now I'll make it quake; go draw him up,
Hang him in chains upon the city walls,
And let my soldiers shoot the slave to death.
 Gov. Vile monster! born of some infernal hag, 110
And sent from hell to tyrannize on earth,
Do all thy worst; nor death, nor Tamburlaine,
Torture, nor pain, can daunt my dreadless mind.
 Tamb. Up with him, then; his body shall be scarred.
 Gov. But, Tamburlaine, in Limnasphaltis' lake
There lies more gold than Babylon is worth,
Which when the city was besieged, I hid.
Save but my life and I will give it thee.
 Tamb. Then for all your valor you would save your
 life?
Whereabout lies it? 120
 Gov. Under a hollow bank, right opposite
Against the western gate of Babylon.
 Tamb. Go thither, some of you, and take his gold;—
The rest—forward with execution!
Away with him hence, let him speak no more.
I think I make your courage something quail.
When this is done, we'll march from Babylon,
And make our greatest haste to Persia.
These jades are broken-winded and half tired.
Unharness them, and let me have fresh horse. 130
So, now their best is done to honor me,
Take them and hang them both up presently.
 K. of Treb. Vile tyrant! barbarous bloody
 Tamburlaine!
 Tamb. Take them away, Theridamas; see them
 dispatched.
 Ther. I will, my lord.
 [*Exit with the* KINGS *of* TREBIZON *and* SORIA.]
 Tamb. Come, Asian viceroys; to your tasks awhile,
And take such fortune as your fellows felt.
 Orc. First let thy Scythian horse tear both our
 limbs,
Rather than we should draw thy chariot,
And like base slaves abject [17] our princely minds 140
To vile and ignominious servitude.
 K. of Jer. Rather lend me thy weapon, Tamburlaine,
That I may sheathe it in this breast of mine.
A thousand deaths could not torment our hearts
More than the thought of this doth vex our souls.

 Amy. They will talk still, my lord, if you do not
 bridle them.
 Tamb. Bridle them, and let me to my coach.

 They bridle them. [*The* GOVERNOR *is seen hanging
 in chains on the walls.*]

 [*Re-enter* THERIDAMAS.]

 Amy. See now, my lord, how brave [18] the captain
 hangs.
 Tamb. 'Tis brave indeed, my boy; well done.
Shoot first, my lord, and then the rest shall follow.
 Ther. Then have at him to begin withal. [19] 151

 THERIDAMAS *shoots.*

 Gov. Yet save my life, and let this wound appease
The mortal fury of great Tamburlaine.
 Tamb. No, though Asphaltis' lake were liquid gold.
And offered me as ransom for thy life,
Yet should'st thou die. Shoot at him all at once.

 They shoot.

So now he hangs like Bagdet's [20] governor,
Having as many bullets in his flesh
As there be breaches in her battered wall.
Go now, and bind the burghers hand and foot, 160
And cast them headlong in the city's lake.
Tartars and Persians shall inhabit there,
And to command the city, I will build
A citadel that all Africa,
Which hath been subject to the Persian King,
Shall pay me tribute for in Babylon.
 Tech. What shall be done with their wives and
 children, my lord?
 Tamb. Techelles, drown them all, man, woman, and
 child.
Leave not a Babylonian in the town.
 Tech. I will about it straight. Come, soldiers. 170
 Exit.
 Tamb. Now, Casane, where's the Turkish Alcoran,
And all the heaps of superstitious books
Found in the temples of that Mahomet,
Whom I have thought a god? They shall be burnt.
 Usum. Here they are, my lord.
 Tamb. Well said; let there be a fire presently.
In vain, I see, men worship Mahomet:
My sword hath sent millions of Turks to hell,
Slain all his priests, his kinsmen, and his friends,
And yet I live untouched by Mahomet. 180
There is a God, full of revenging wrath,
From whom the thunder and the lightning breaks,
Whose scourge I am, and Him will I obey:
So, Casane, fling them in the fire.
Now, Mahomet, if thou have any power,
Come down thyself and work a miracle:
Thou art not worthy to be worshippèd,
That suffers flame of fire to burn the writ
Wherein the sum of thy religion rests.
Why send'st thou not a furious whirlwind down 190
To blow thy Alcoran up to thy throne,
Where men report thou sit'st by God himself?

[16] *black Jove:* Pluto. [17] *abject:* abase.
[18] *brave:* splendidly.
[19] *begin withal:* make a beginning.
[20] *Bagdet's:* Baghdad's.

Or vengeance on the head of Tamburlaine
That shakes his sword against thy majesty,
And spurns the abstracts of thy foolish laws.
Well, soldiers, Mahomet remains in hell;
He cannot hear the voice of Tamburlaine;
Seek out another Godhead to adore,
The God that sits in heaven, if any God;
For he is God alone, and none but he. 200

[*Re-enter* TECHELLES.]

Tech. I have fulfilled your highness' will, my lord.
Thousands of men, drowned in Asphaltis' lake,
Have make the waters swell above the banks,
And fishes, fed by human carcasses,
Amazed, swim up and down upon the waves,
As when they swallow assafoetida,[21]
Which makes them fleet[22] aloft and gasp for air.
Tamb. Well then, my friendly lords, what now
 remains,
But that we leave sufficient garrison,
And presently depart to Persia 210
To triumph after all our victories?
Ther. Ay, good my lord; let us in haste to Persia,
And let this captain be removed[23] the walls
To some high hill about the city here.
Tamb. Let it be so; about it, soldiers;
But stay; I feel myself distempered[24] suddenly.
Tech. What is it dares distemper Tamburlaine?
Tamb. Something, Techelles; but I know not what—
But forth, ye vassals! whatsoe'er it be,
Sickness or death can never conquer me. 220
 Exeunt.

V.ii

Enter CALLAPINE, AMASIA, [*a* Captain], *with
drums and trumpets.*

Call. King of Amasia, now our mighty host
Marcheth in Asia Major where the streams
Of Euphrates and Tigris swiftly runs,
And here may we behold great Babylon
Circled about with Limnasphaltis' lake,
Where Tamburlaine with all his army lies,
Which being faint and weary with the siege,
We may lie ready to encounter him
Before his host be full from Babylon,
And so revenge our latest grievous loss, 10
If God or Mahomet send any aid.
K. of Am. Doubt not, my lord, but we shall conquer
 him.
The monster that hath drunk a sea of blood,
And yet gapes still for more to quench his thirst,
Our Turkish swords shall headlong send to hell,
And that vile carcass drawn by warlike kings
The fowls shall eat; for never sepulcher
Shall grace this base-born tyrant Tamburlaine.
Call. When I record[1] my parents' slavish life,
Their cruel death, mine own captivity, 20
My viceroy's bondage under Tamburlaine,
Methinks I could sustain a thousand deaths

To be revenged of all his villainy.
Ah, sacred Mahomet! thou that hast seen
Millions of Turks perish by Tamburlaine,
Kingdoms made waste, brave cities sacked and burnt,
And but one host is left to honor thee,
Aid thy obedient servant, Callapine,
And make him after all these overthrows
To triumph over cursèd Tamburlaine. 30
K. of Am. Fear not, my lord; I see great Mahomet
Clothèd in purple clouds, and on his head
A chaplet brighter than Apollo's crown,
Marching about the air with armèd men
To join with you against this Tamburlaine.
Capt. Renownèd General, mighty Callapine,
Though God himself and holy Mahomet
Should come in person to resist your power,
Yet might your mighty host encounter all,
And pull proud Tamburlaine upon his knees 40
To sue for mercy at your Highness' feet.
Call. Captain, the force of Tamburlaine is great,
His fortune greater, and the victories
Wherewith he hath so sore dismayed the world
Are greatest to discourage all our drifts.[2]
Yet when the pride of Cynthia is at full,
She wanes again, and so shall his, I hope;
For we have here the chief selected men
Of twenty several[3] kingdoms at the least;
Nor ploughman, priest, nor merchant, stays at home;
All Turkey is in arms with Callapine; 51
And never will we sunder camps and arms
Before himself or his be conquerèd.
This is the time that must eternize[4] me
For conquering the tyrant of the world.
Come, soldiers, let us lie in wait for him,
And if we find him absent from his camp,
Or[5] that it be rejoined again at full,
Assail it and be sure of victory.
 Exeunt.

V.iii

[*Enter*] THERIDAMAS, TECHELLES, USUMCASANE.

Ther. Weep, heavens, and vanish into liquid tears!
Fall, stars that govern his nativity,
And summon all the shining lamps of heaven
To cast their bootless[1] fires to the earth,
And shed their feeble influence in the air;
Muffle your beauties with eternal clouds,
For Hell and Darkness pitch their pitchy tents,
And Death with armies of Cimmerian[2] spirits

21 *assafoetida:* a medicinal gum. 22 *fleet:* float.
23 *removed:* removed from. 24 *distempered:* sick.

V.ii
1 *record:* remember. 2 *drifts:* intents.
3 *several:* separate. 4 *eternize:* immortalize.
5 *Or:* Ere.

V.iii
1 *bootless:* remediless.
2 *Cimmerian:* black, as of the underworld.

Gives battle 'gainst the heart of Tamburlaine!
Now in defiance of that wonted love 10
Your sacred virtues poured upon his throne
And made his state an honor to the heavens,
These cowards invisible assail his soul,
And threaten conquest on our sovereign;
But if he die your glories are disgraced;
Earth droops and says that hell in heaven is placed.
 Tech. O then, ye powers that sway eternal seats
And guide this massy substance of the earth,
If you retain desert of holiness [3]
As your supreme estates [4] instruct our thoughts, 20
Be not inconstant, careless of your fame,
Bear not the burden of your enemies' joys,
Triumphing in his fall whom you advanced,
But as his birth, life, health, and majesty
Were strangely blessed and governèd by heaven,
So honor, heaven, till heaven dissolvèd be,
His birth, his life, his health, and majesty!
 Usum. Blush, heaven, to lose the honor of thy name!
To see thy footstool set upon thy head!
And let no baseness in thy haughty breast 30
Sustain a shame of such inexcellence, [5]
To see the devils mount in angels' thrones,
And angels dive into the pools of hell!
And though they [6] think their painful date is out,
And that their power is puissant [7] as Jove's,
Which makes them manage arms against thy state,
Yet make them feel the strength of Tamburlaine,
Thy instrument and note [8] of majesty,
Is greater far than they can thus subdue:
For if he die thy glory is disgraced; 40
Earth droops and says that hell in heaven is placed.

[*Enter* TAMBURLAINE *drawn in his chariot by the*
captive Kings, AMYRAS *and* CELEBINUS, *and*
Physicians.]

 Tamb. What daring god torments my body thus,
And seeks to conquer mighty Tamburlaine?
Shall sickness prove me now to be a man,
That have been termed the terror of the world?
Techelles and the rest, come, take your swords,
And threaten him whose hand afflicts my soul.
Come, let us march against the powers of heaven,
And set black streamers in the firmament,

To signify the slaughter of the gods. 50
Ah, friends, what shall I do? I cannot stand.
Come carry me to war against the gods
That thus envy the health of Tamburlaine.
 Ther. Ah, good my lord, leave these impatient
 words,
Which add much danger to your malady.
 Tamb. Why, shall I sit and languish in this pain?
No, strike the drums, and in revenge of this,
Come, let us charge [9] our spears and pierce his [10] breast
Whose shoulders bear the axis of the world,
That, if I perish, heaven and earth may fade. 60
Theridamas, haste to the court of Jove,
Will him to send Apollo [11] hither straight,
To cure me, or I'll fetch him down myself.
 Tech. Sit still, my gracious lord; this grief [12] will
 cease,
And cannot last, it is so violent.
 Tamb. Not last, Techelles? No! for I shall die.
See, where my slave, the ugly monster, Death,
Shaking and quivering, pale and wan for fear,
Stands aiming at me with his murdering dart,
Who flies away at every glance I give, 70
And, when I look away, comes stealing on.
Villain, away, and hie thee to the field!
I and mine army come to load thy bark
With souls of thousand mangled carcasses.
Look, where he goes; but see, he comes again,
Because I stay. [13] Techelles, let us march
And weary Death with bearing souls to hell.
 1 Phys. Pleaseth your majesty to drink this
 potion,
Which will abate the fury of your fit,
And cause some milder spirits govern you. 80
 Tamb. Tell me what think you of my sickness now?
 1 Phys. I viewed your urine, and the hypostasis [14]
Thick and obscure, doth make your danger great.
Your veins are full of accidental [15] heat,
Whereby the moisture of your blood is dried.
The humidum and calor, [16] which some hold
Is not a parcel [17] of the elements,
But of a substance more divine and pure,
Is almost clean extinguishèd and spent;
Which, being the cause of life, imports your death. 90
Besides, my lord, this day is critical, [18]
Dangerous to those whose crisis is as yours;
Your artiers, [19] which alongst the veins convey
The lively spirits which the heart engenders,
Are parched and void of spirit, that the soul,
Wanting those organons [20] by which it moves
Cannot endure, by argument of art.
Yet, if your majesty may escape this day,
No doubt but you shall soon recover all. [21]
 Tamb. Then will I comfort all my vital parts, 100
And live, in spite of death, above a day.

 Alarm within.

[*Enter* Messenger.]

 Mess. My lord, young Callapine, that lately fled
your majesty, hath now gathered a fresh army, and

[3] *retain . . . holiness:* still merit the worship we pay you.
[4] *estates:* states, authorities.
[5] *Sustain . . . inexcellence:* Endure such ignominy.
[6] *they:* i.e., the devils.
[7] *puissant:* here, trisyllabic.
[8] *note:* distinguishing mark.
[9] *charge:* level, as in preparation for charging.
[10] *his:* i.e., Atlas's.
[11] *Apollo:* in his character of healer or physician.
[12] *grief:* fit. [13] *stay:* forbear to die.
[14] *hypostasis:* deposit (O1–4 read "Hipostates").
[15] *accidental:* excessive.
[16] *humidum and calor:* radical moisture and natural heat
that in combination engender those "spirits" that make us
man. [17] *parcel:* part.
[18] *critical:* because of the unfavorable position of the stars.
[19] *artiers:* arteries. [20] *organons:* instruments.
[21] *all:* fully.

hearing[22] your absence in the field, offers to set upon us presently.[23]

 Tamb. See, my physicians now, how Jove hath sent
A present medicine to recure my pain.[24]
My looks shall make them fly, and might I follow,
There should not one of all the villain's power
Live to give offer of another fight. 110

 Usum. I joy, my lord, your highness is so strong,
That can endure[25] so well your royal presence,[26]
Which only[27] will dismay the enemy.

 Tamb. I know it will, Casane. Draw, you slaves;
In spite of death, I will go show my face.

 Alarm. TAMBURLAINE *goes in and comes out again*
with all the rest.

Thus are the villains, cowards fled for fear,
Like summer's vapors vanished[28] by the sun;
And could I but awhile pursue the field,
That Callapine should be my slave again.
But I perceive my martial strength is spent. 120
In vain I strive and rail against those powers
That mean to invest me in a higher throne,
As much too high for this disdainful earth.
Give me a map; then let me see how much
Is left for me to conquer all the world,
That these, my boys, may finish all my wants.

 One brings a map.

Here I began to march towards Persia,
Along Armenia and the Caspian Sea,
And thence unto Bithynia, where I took
The Turk and his great Empress prisoners. 130
Thence marched I into Egypt and Arabia,
And here, not far from Alexandria,
Whereas[29] the Terrene and the Red Sea meet,
Being distant less than full a hundred leagues,
I meant to cut a channel[30] to them both,
That men might quickly sail to India.
From thence to Nubia near Borno lake,
And so along the Ethiopian sea,
Cutting the tropic line of Capricorn,
I conquered all as far as Zanzibar. 140
Then, by the northern part of Africa,
I came at last to Graecia, and from thence
To Asia, where I stay against my will;
Which is from Scythia, where I first began,
Backward and forwards near five thousand leagues.
Look here, my boys; see what a world of ground
Lies westward from the midst of Cancer's line,
Unto the rising of this earthly globe;
Whereas the sun, declining from our sight,
Begins the day with our Antipodes![31] 150
And shall I die, and this unconquerèd?
Lo, here, my sons, are all the golden mines,
Inestimable drugs and precious stones,
More worth than Asia and the world beside;
And from the Antarctic Pole eastward behold
As much more land, which never was descried,
Wherein are rocks of pearl that shine as bright
As all the lamps that beautify the sky!
And shall I die, and this unconquerèd?

Here, lovely boys; what death forbids my life, 160
That let your lives command in spite of death.

 Amy. Alas, my lord, how should our bleeding
 hearts,
Wounded and broken with your highness' grief,[32]
Retain a thought of joy or spark of life?
Your soul gives essence to our wretched subjects,
Whose matter is incorporate in your flesh.[33]

 Cel. Your pains do pierce our souls; no hope survives
For by your life we entertain[34] our lives.

 Tamb. But, sons, this subject, not of force enough
To hold the fiery spirit it contains, 170
Must part, imparting his impressions[35]
By equal portions into both your breasts;
My flesh, divided in your precious shapes,
Shall still retain my spirit, though I die,
And live in all your seeds immortally.
Then now remove me, that I may resign
My place and proper[36] title to my son.
First, take my scourge and my imperial crown
And mount my royal chariot of estate,
That I may see thee crowned before I die. 180
Help me, my lords, to make my last remove.

 Ther. A woeful change, my lord, that daunts our
 thoughts,
More than the ruin of our proper souls!

 Tamb. Sit up, my son, and let me see how well
Thou wilt become thy father's majesty.

 They crown him.

 Amy. With what a flinty bosom should I joy
The breath of life and burden of my soul,
If not resolved into resolvèd pains,
My body's mortifièd lineaments
Should exercise the motions of my heart, 190
Pierced with the joy of any dignity![37]
O father! if the unrelenting ears
Of death and hell be shut against my prayers
And that the spiteful influence of heaven
Deny my soul fruition of her joy;
How should I step, or stir my hateful feet
Against the inward powers of my heart,
Leading a life that only strives to die,
And plead in vain unpleasing sovereignty?

 [22] *hearing:* hearing of. [23] *presently:* immediately.
 [24] *recure my pain:* make me whole.
 [25] *endure:* support, in contrast to "dismay," below.
 [26] *That . . . presence:* modifying "I," above.
 [27] *only:* alone. [28] *vanished:* made to vanish.
 [29] *Whereas:* Where.
 [30] *channel:* Tamburlaine anticipates the Suez Canal, a project that the Venetian Republic sought unsuccessfully to initiate at the beginning of the sixteenth century.
 [31] *Antipodes:* the western hemisphere.
 [32] *grief:* pain.
 [33] *Your . . . flesh:* The sons of Tamburlaine are flesh of his flesh and animated by the same spirit.
 [34] *entertain:* support.
 [35] *his impressions:* the power of the spirit.
 [36] *proper:* peculiar to himself.
 [37] *With . . . dignity:* How callous should I be if I could live happily, if my body did not dissolve in pain but rather took pleasure in earthly rewards.

Tamb. Let not thy love exceed thine honor, son,
Nor bar thy mind that magnanimity[38] 201
That nobly must admit necessity.
Sit up, my boy, and with those silken reins
Bridle the steelèd stomachs[39] of those jades.

Ther. My lord, you must obey his majesty,
Since fate commands and proud necessity.

Amy. Heavens witness me with what a broken heart
And damnèd spirit I ascend this seat,
And send my soul, before my father die,
His anguish and his burning agony! 210

Tamb. Now fetch the hearse[40] of fair Zenocrate;
Let it be placed by this my fatal chair,
And serve as parcel[41] of my funeral.

Usum. Then feels your majesty no sovereign ease,
Nor may our hearts, all drowned in tears of blood,
Joy[42] any hope of your recovery?

Tamb. Casane, no; the monarch of the earth,
And eyeless monster that torments my soul,
Cannot behold the tears ye shed for me,
And therefore still augments his cruelty. 220

Tech. Then let some god oppose his holy power
Against the wrath and tyranny of Death,
That his tear-thirsty and unquenchèd hate
May be upon himself reverberate!

They bring in the hearse.

Tamb. Now eyes enjoy your latest benefit,
And when my soul hath virtue of your sight,[43]
Pierce through the coffin and the sheet of gold,
And glut your longings with a heaven of joy.

So reign, my son; scourge and control those slaves,
Guiding thy chariot with thy father's hand. 230
As precious is the charge thou undertakest
As that which Clymene's[44] brain-sick son did guide,
When wandering Phoebe's[45] ivory cheeks were
 scorched,
And all the earth, like Etna, breathing fire;
Be warned by him, then; learn with awful[46] eye
To sway a throne as dangerous as his;
For if thy body thrive not full of thoughts
As pure and fiery as Phyteus'[47] beams,
The nature of these proud rebelling jades
Will take occasion by the slenderest hair, 240
And draw thee piecemeal like Hippolytus,[48]
Through rocks more steep and sharp than Caspian
 clifts.[49]
The nature of thy chariot will not bear
A guide of baser temper than myself,
More than heaven's coach the pride of Phaëthon.
Farewell, my boys; my dearest friends farewell!
My body feels, my soul doth weep to see
Your sweet desires deprived my company,
For Tamburlaine, the scourge of God, must die.

[He dies.]

Amy. Meet heaven and earth, and here let all things
 end, 250
For earth hath spent the pride of all her fruit,
And heaven consumed his choicest living fire.
Let earth and heaven his timeless[50] death deplore,
For both their worths will equal him no more.

F I N I S

[38] *magnanimity:* greatness of spirit.
[39] *steelèd stomachs:* hardened pride.
[40] *hearse:* coffin. [41] *parcel:* part.
[42] *Joy:* Enjoy.
[43] *when . . . sight:* When Tamburlaine's soul is freed from his body, which is felt as obscuring finer perception, he will be able to see the spirit of Zenocrate.
[44] *Clymene's:* mother of Phaëthon, who stole the chariot of the sun and was destroyed by Jove lest he burn the earth. (Reading follows O2.) [45] *Phoebe's:* the moon's.
[46] *awful:* full of (proper) awe; also, "inspiring awe."
[47] *Phyteus':* Pythius'—Apollo, so called after the fabulous serpent Python that he had slain.
[48] *Hippolytus:* son of Theseus; killed by a bull sent from the sea because of the mistaken jealousy of his father.
[49] *clifts:* cliffs. [50] *timeless:* untimely.

Christopher Marlowe

THE JEW OF MALTA

THE DIARY of Philip Henslowe, which is among our most valuable sources for the theatrical activity of Marlowe and his successors, records receipts for performances at Henslowe's theaters of THE JEW OF MALTA in the five-year period between the winter of 1592 and the fall of 1597. Henslowe's first entry is dated February 26, 1592: before that time the play was written. Composition must follow 1588 because, in the prologue spoken by Machiavelli, mention is made of the death of the Duke of Guise (December 23, 1588), the notorious leader of the Catholic party in France and the protagonist of Marlowe's *Massacre at Paris*. A likely guess is that Marlowe wrote THE JEW OF MALTA in 1590.

The play was entered in the Stationers' Register in 1594; whether it was printed at that time is moot. The first extant edition, from which the present text derives, is that of the Quarto of 1633 (entered S. R. 1632), which survives in more than thirty copies. Printing is careless and is possibly based on a not too scrupulous examination of Marlowe's manuscript. Previous editors have sometimes fragmented the play by dividing it into a plethora of scenes. In this text the scene shifts only as necessary.

THE JEW OF MALTA remained popular throughout the seventeenth century. Henslowe's initial entries list thirty-six performances, a considerable run. Interest was no doubt stimulated by the arrest and execution in 1594 of Queen Elizabeth's Jewish physician, Dr. Roderigo Lopez, at whose unlucky fate Shakespeare glances in *The Merchant of Venice*. Evidence of continuing interest is provided by a ballad entry of 1594, advertising "the murderous life and terrible death of the rich Jew of Malta," as also by the refurbishing of the play seven years later (for which Henslowe duly records payments). Additional evidence suggests performances of THE JEW OF MALTA by English actors on the Continent in the first decade of the seventeenth century and as late as 1626. For the revival of 1632, the dramatist Thomas Heywood contributed prologues and epilogues.

No single source for Marlowe's play is known. It is clear, however, that the playwright is indebted to the traditional image of the Jew as Vice or Devil, an image he fuses with the equally popular misconception of the character of Niccolò Machiavelli, a controversial figure throughout the period, execrated by most Elizabethans as a monster, though sneakingly admired by many. *The Prince*, Machiavelli's most famous work, was not published in English in Marlowe's lifetime. But versions and perversions of it were widely available. The most influential of these is the *Contre Machiavel* (1576) of Innocent Gentillet, whom Barabas seems to remember in his musings on the "policy" appropriate to a scoundrel like himself (V.ii). When Machiavelli soliloquizes at the beginning of the play, he is borrowing perhaps from a Latin poem by Spenser's friend, Gabriel Harvey.

Other details come from contemporary business: the celebrated careers of sixteenth-century Jews, the attack on Malta by the Turks in 1565. Ovid's *Metamorphoses* continues to assist Marlowe's invention; Terence and possibly Virgil are levied on briefly. The prime source of reminiscence is, however, the Bible. Barabas takes his name from the criminal whom the Jews chose to be spared instead of Christ. The language of Marlowe's hero-villain, like that of the professed Christians who are his antagonists, is replete with deliberately incongruous reference to Genesis and Exodus, Numbers, Deuteronomy, Chronicles, Proverbs, the books of Job and Ezekiel, the writings of the Evangelists. That the Devil should quote Scripture is an important part of Marlowe's gleeful purpose. In THE JEW OF MALTA, as in each of his plays, he seems desirous of scandalizing his contemporaries, as he can. The wicked Jew performs up to expectation, but he is scarcely contrasted in his wickedness with the Christians. Their perfidy is no less than his. Perhaps their hypocrisy is greater. Compare, in III.iii, the jesting of Ithamore at the sexual dalliance of the nuns and friars, whose vows, which commit them to a celibate life, are evidently made to be broken. Opportunity abounds for the making of farcical satire in the disparity between profession and practice. Marlowe as always is quick to exploit the opportunity. That is not as his intention is therapeutic. *Èpater le bourgeois*: Voltaire's famous phrase expresses the governing intention.

R. A. F.

The Jew of Malta

[THE EPISTLE DEDICATORY]

TO MY WORTHY FRIEND,
MASTER THOMAS HAMMON[1]
OF GRAY'S INN,[2] ETC.

THIS play, composed by so worthy an author as Master Marlowe, and the part of the Jew presented by so unimitable an actor as Master Alleyn,[3] being in this later age commended to the stage: as I ushered[4] it unto the Court,[5] and presented it to the Cock-pit,[6] with these Prologues and Epilogues here inserted, so now, being newly brought to the press, I was loath it should be published without the ornament of an Epistle; making choice of you unto whom to devote[7] it; than whom (of all those gentlemen and acquaintance, 10 within the compass of my long knowledge) there is none more able to tax[8] ignorance, or attribute right to merit. Sir, you have been pleased to grace some of mine own works with your courteous patronage; I hope this will not be the worse accepted, because commended by me; over whom, none can claim more power or privilege than yourself. I had no better a new year's gift[9] to present you with; receive it therefore as a continuance of that inviolable obligement, by which he rests still engaged; who, as he ever hath, shall always remain, 20

Tuissimus,[10]

THO. HEYWOOD.

THE PROLOGUE SPOKEN AT COURT

GRACIOUS and great,[1] that we so boldly dare
('Mongst other plays that now in fashion are)
To present this, writ many years agone,
And in that age thought second unto none,
We humbly crave your pardon. We pursue[2]
The story of a rich and famous Jew
Who lived in Malta: you shall find him still,[3]
In all his projects, a sound[4] Machevill;
And that's his character. He that hath past
So many censures,[5] is now come at last 10
To have your princely ears: grace you him; then
You crown the action, and renown the pen.

THE PROLOGUE TO THE STAGE
AT THE COCK-PIT

WE know not how our play may pass this stage,
But by the best of poets* in that age *Marlowe
The Malta-Jew had being and was made;
And he, then by the best of actors† played. †Alleyn
In *Hero and Leander,*[1] one did gain
A lasting memory; in Tamburlaine,
This Jew, with others many, th' other wan[2]
The attribute of peerless, being a man
Whom we may rank with (doing no one wrong)
Proteus[3] for shapes, and Roscius[4] for a tongue, 10
So could he speak, so vary; nor is't hate
To merit[5] in him‡ who doth personate ‡Perkins[6]
Our Jew this day; nor is it his ambition
To exceed or equal, being of condition[7]
More modest: this is all that he intends
(And that too, at the urgence of some friends),
To prove[8] his best, and, if none here gainsay[9] it,
The part he hath studied, and intends to play it.

THE EPISTLE DEDICATORY
[1] *Thomas Hammon:* Heywood's patron, to whom two plays by that dramatist are dedicated.
[2] *Gray's Inn:* one of the Inns of Court or London law schools.
[3] *Alleyn:* Edward Alleyn (1566–1626), the leading actor of the Admiral's Men, created the roles of Tamburlaine and Faustus, as well as that of Barabas. [4] *ushered:* introduced.
[5] *Court:* presumably the royal palace at Whitehall, in which a small theater was housed; though conceivably the reference is to another royal residence such as Hampton Court.
[6] *Cock-pit:* Private theater in Drury Lane, also known as the Phoenix. [7] *devote:* dedicate. [8] *tax:* censure.
[9] *new year's gift:* evidently the play had been acted, in any case printed, just before New Year's Day, 1633.
[10] *L.:* Yours (superlative).

THE PROLOGUE SPOKEN AT COURT
[1] *Gracious and great:* the King and Queen.
[2] *pursue:* i.e., enact. [3] *still:* always.
[4] *sound:* through and through. [5] *censures:* judgments.

DRAMATIS PERSONÆ[1]

FERNEZE, Governor of Malta
LODOWICK, his son
SELIM CALYMATH, son of the Grand Seignior
MARTIN DEL BOSCO, Vice-Admiral of Spain
MATHIAS, a gentleman
BARABAS, a wealthy Jew
ITHAMORE, BARABAS' slave
JACOMO, ⎫
BARNARDINE. ⎭ Friars
PILIA-BORZA, a Bully
Two Merchants

Three Jews
Knights, Bassoes, Officers, Guard, Messengers, Slaves,
 Carpenters

KATHERINE, mother of MATHIAS
ABIGAIL, Daughter of BARABAS
BELLAMIRA, a courtesan
Abbess
Two Nuns
MACHIAVEL, Speaker of the Prologue

[THE PROLOGUE]

[*Enter*] MACHIAVEL.

Mach. Albeit the world think Machiavel is dead,
Yet was his soul but flown beyond the Alps,[1]

And now the Guise[2] is dead, is come from France,
To view this land, and frolic with his friends.
To some perhaps my name is odious,
But such as love me guard me from their tongues;[3]
And let them know that I am Machiavel,
And weigh not[4] men, and therefore not men's words.
Admired[5] I am of those that hate me most.
Though some speak openly against my books, 10
Yet will they read me, and thereby attain
To Peter's chair:[6] and when they cast me off,
Are poisoned by my climbing followers.
I count religion but a childish toy,[7]
And hold there is no sin but ignorance.
Birds of the air[8] will tell murders past!
I am ashamed to hear such fooleries.
Many will talk of title to a crown:
What right had Caesar to the empire?
Might first made kings, and laws were then most sure
When, like the Draco's,[9] they were writ in blood. 21
Hence comes it that a strong-built citadel
Commands much more than letters can import;
Which maxim had but Phalaris[10] observed,
H'had never bellowed, in a brazen bull,
Of great ones' envy. Of the poor petty wights[11]
Let me be envied and not pitièd!
But wither am I bound? I come not, I,
To read a lecture here in Britain,
But to present the tragedy of a Jew, 30
Who smiles to see how full his bags are crammed,
Which money was not got without my means.
I crave but this—grace[12] him as he deserves,
And let him not be entertained the worse
Because he favors[13] me.
 [*Exit.*]

THE PROLOGUE TO THE STAGE
 [1] *Hero and Leander:* Marlowe's famous erotic narrative poem, left unfinished at his death, completed by George Chapman and published in 1598. [2] *wan:* won.
 [3] *Proteus:* Greek sea-god who could change his shape at will—like an actor who can play many parts.
 [4] *Roscius:* most famous of Roman comic actors.
 [5] *hate . . . merit:* i.e., no derogation of Perkins is intended.
 [6] *Perkins:* Richard Perkins, a famous actor of the period.
 [7] *condition:* character. [8] *prove:* try.
 [9] *gainsay:* oppose.

DRAMATIS PERSONÆ
 [1] *Dramatis Personae:* Adapted from the eighteenth-century editor Isaac Reed; not given in the original quarto.

THE PROLOGUE
 [1] *Yet . . . Alps:* The spirit of Machiavelli, leaving Italy, has been infused into a Frenchman's body.
 [2] *Guise:* Henry of Lorraine, third Duke of Guise (of whom Marlowe had written in *The Massacre at Paris*), organized the St. Bartholomew's Massacre of the Huguenots in 1572 and was himself assassinated in 1588. He figures here as a type of the Machiavel.
 [3] *guard . . . tongues:* protect me from the slanders of my enemies. [4] *weigh not:* am indifferent to.
 [5] *Admired:* Wondered at.
 [6] *Peter's chair:* the papacy. [7] *toy:* trifle.
 [8] *Birds of the air:* Like the cranes of Ibycus, who, in Greek legend, were responsible for the detection of murder.
 [9] *Draco's:* regarding the rigorous or "draconian" lawgiver of Athens.
 [10] *Phalaris:* Sicilian tyrant who made a brazen bull in which his victims were roasted alive and in which (like Barabas) he himself ultimately died. [11] *wights:* people.
 [12] *grace:* honor. [13] *favors:* looks like, is partisan to.

ACT ONE

SCENE ONE

Enter BARABAS *in his counting-house, with heaps of gold before him.*

Bar. So that of thus much that return was made:
And of the third part of the Persian ships,
There was the venture summed and satisfied.[1]
As for those Saenites,[2] and the men of Uz,[3]
That bought my Spanish oils and wines of Greece,
Here have I pursed[4] their paltry silverlings.[5]
Fie; what a trouble 'tis to count this trash.
Well fare the Arabians, who so richly pay
The things they traffic[6] for with wedge of gold,[7]
Whereof a man may easily in a day 10
Tell[8] that which may maintain him all his life.
The needy groom[9] that never fingered groat,[10]
Would make a miracle of thus much coin:
But he whose steel-barred coffers are crammed full,
And all his lifetime hath been tired,
Wearying his fingers' ends with telling it,
Would in his age be loath to labor so,
And for a pound to sweat himself to death.
Give me the merchants of the Indian mines,
That trade in metal of the purest mold; 20
The wealthy Moor, that in the eastern rocks
Without control[11] can pick his riches up,
And in his house heap pearl like pibble-stones,
Receive them free, and sell them by the weight;
Bags of fiery opals, sapphires, amethysts,
Jacinths, hard topaz, grass-green emeralds,
Beauteous rubies, sparkling diamonds,
And seld-seen[12] costly stones of so great price,
As one of them indifferently rated,[13]
And of a carat[14] of this quantity, 30
May serve in peril of calamity
To ransom great kings from captivity.
This is the ware wherein consists my wealth;
And thus, methinks, should men of judgment frame
Their means of traffic from the vulgar trade,[15]
And as their wealth increaseth, so enclose
Infinite riches in a little room.
But now how stands the wind?
Into what corner peers my halcyon's[16] bill?
Ha! to the east? Yes: see, how stands the vanes? 40
East and by south: why then I hope my ships
I sent for Egypt and the bordering isles
Are gotten up by Nilus' winding banks:
Mine argosy[17] from Alexandria,
Loaden with spice and silks, now under sail,
Are smoothly gliding down by Candy[18] shore
To Malta, through our Mediterranean sea.
But who comes here?

Enter a Merchant.

How now?
Merch. Barabas, thy ships are safe,
Riding in Malta road:[19] and all the merchants 50
With other merchandise are safe arrived,
And have sent me to know whether yourself
Will come and custom[20] them.
 Bar. The ships are safe, thou says't, and richly fraught.[21]
Merch. They are.
 Bar. Why then go bid them come ashore,
And bring with them their bills of entry:[22]
I hope our credit in the custom-house
Will serve as well as[23] I were present there.
Go send 'em threescore camels, thirty mules,
And twenty wagons to bring up the ware. 60
But art thou master in a ship of mine,
And is thy credit enough for that?
 Merch. The very custom barely[24] comes to more
Than many merchants of the town are worth,
And therefore far exceeds my credit, sir.
 Bar. Go tell 'em the Jew of Malta sent thee, man:
Tush! who amongst 'em knows not Barabas?
 Merch. I go.
 Bar. So then, there's somewhat come.
Sirrah,[25] which of my ships art thou master of? 70
 Merch. Of the Speranza, sir.
 Bar. And saw'st thou not
Mine Argosy at Alexandria?
Thou could'st not come from Egypt, or by Caire,[26]
But at the entry there into the sea,
Where Nilus pays his tribute to the main;
Thou needs must sail by Alexandria.
 Merch. I neither saw them, nor inquired of them:
But this we heard some of our seamen say,
They wondered how you durst with so much wealth
Trust such a crazèd[27] vessel, and so far. 80
 Bar. Tush, they are wise![28] I know her and her strength.
But go, go thou thy ways, discharge[29] thy ship,

I.i.
[1] *summed and satisfied:* completed and paid in full.
[2] *Saenites:* poor nomadic people. The original Quarto reads "Samintes." [3] *men of Uz:* wealthy Arabians.
[4] *pursed:* pursed up.
[5] *silverlings:* shekels. Q reads "silverbings."
[6] *traffic:* seek to buy. [7] *wedge of gold:* ingots.
[8] *Tell:* Count. [9] *groom:* servant.
[10] *groat:* small coin worth fourpence; i.e., practically valueless.
[11] *control:* hindrance. [12] *seld-seen:* seldom seen.
[13] *indifferently rated:* impartially assessed.
[14] *carat:* measure of weight for precious stones. Original reads "carrect."
[15] *frame . . . trade:* direct their commerce away from petty dealings, protect their dealings from petty investors.
[16] *halcyon's:* kingfisher's (alluding to the belief that the dead body of the bird, hung up by the bill, acted as a weathervane to point out in what quarter the wind was blowing). Here Barabas presumably comes from his counting house (the inner stage) to look up at his "vanes" outside (on the main stage).
[17] *argosy:* large merchant ships. [18] *Candy:* Crete.
[19] *road:* sheltered haven where ships may lie at anchor.
[20] *custom:* clear through customs.
[21] *fraught:* laden. [22] *entry:* trisyllabic.
[23] *as:* as if. [24] *very custom barely:* custom duty alone.
[25] *Sirrah:* mode of address used to an inferior.
[26] *Caire:* Cairo. [27] *crazèd:* defective.
[28] *they are wise:* said sardonically.
[29] *discharge:* unload.

And bid my factor[30] bring his loading[31] in.

[*Exit* Merchant.]

And yet I wonder at this Argosy.

Enter a second Merchant.

2 Merch. Thine Argosy from Alexandria,
Know, Barabas, doth ride in Malta road,
Laden with riches, and exceeding[32] store
Of Persian silks, of gold, and orient[33] pearl.

Bar. How chance you came not with those other
 ships
That sailed by Egypt?

2 Merch. Sir, we saw 'em not. 90

Bar. Belike[34] they coasted round by Candy shore
About their oils, or other businesses.
But 'twas ill done of you to come so far
Without the aid or conduct of their ships.

2 Merch. Sir, we were wafted[35] by a Spanish fleet,
That never left us till within a league,[36]
That had the galleys of the Turk in chase.

Bar. Oh!—they were going up to Sicily.—Well, go,
And bid the merchants and my men dispatch
And come ashore, and see the fraught[37] discharged.

2 Merch. I go. 101

Exit.

Bar. Thus trowls[38] our fortune in by land and sea,
And thus are we on every side enriched:
These are the blessings promised to the Jews,
And herein was old Abram's[39] happiness:
What more may heaven do for earthly man
Than thus to pour out plenty in their laps,

Ripping the bowels of the earth for them,
Making the sea their servants, and the winds
To drive their substance with successful[40] blasts? 110
Who hateth me but for my happiness?
Or who is honored now but for his wealth?
Rather had I a Jew be hated thus,
Than pitied in a Christian poverty:
For I can see no fruits in all their faith,
But malice, falsehood, and excessive pride,
Which methinks fits not their profession.[41]
Haply[42] some hapless[43] man hath conscience,
And for his conscience lives in beggary.
They say we are a scattered nation: 120
I cannot tell, but we have scambled[44] up
More wealth by far than those that brag of faith.
There's Kirriah Jairim,[45] the great Jew of Greece,
Obed in Bairseth,[46] Nones[47] in Portugal,
Myself in Malta, some in Italy,
Many in France, and wealthy every one;
Ay, wealthier far than any Christian.
I must confess we come not to be kings;
That's not our fault: alas, our number's few,
And crowns come either by succession, 130
Or urged[48] by force; and nothing violent,
Oft have I heard tell, can be permanent.
Give us a peaceful rule, make Christians kings,
That thirst so much for principality.[49]
I have no charge,[50] nor many children,[51]
But one sole daughter, whom I hold as dear
As Agamemnon did his Iphigen:[52]
And all I have is hers. But who comes here?

Enter three Jews.

1 Jew. Tush, tell me not; 'twas done of policy.[53]

2 Jew. Come, therefore, let us go to Barabas, 140
For he can counsel best in these affairs;
And here he comes.

Bar. Why, how now, countrymen!
Why flock you thus to me in multitudes?
What accident's betided to the Jews?

1 Jew. A fleet of warlike galleys, Barabas,
Are come from Turkey, and lie in our road:
And they[54] this day sit in the council-house
To entertain them and their embassy.

Bar. Why, let 'em come, so they come not to war;
Or let 'em war, so we be conquerors— 150
[*Aside.*] Nay, let 'em combat, conquer, and kill all!
So they spare me, my daughter, and my wealth.

1 Jew. Were it for confirmation of a league,[55]
They would not come in warlike manner thus.

2 Jew. I fear their coming will afflict us all.

Bar. Fond[56] men! what dream you of their
 multitudes?
What need they treat of peace that are in league?
The Turks and those of Malta are in league.
Tut, tut, there is some other matter in't.

1 Jew. Why, Barabas, they come for peace or war.

Bar. Haply for neither, but to pass along 161
Towards Venice by the Adriatic Sea;
With whom they have attempted[57] many times,
But never could effect their strategem.

[30] *factor:* agent. [31] *loading:* bill of lading.
[32] *exceeding:* exceedingly great.
[33] *orient:* of the east; hence especially lustrous.
[34] *Belike:* Probably. [35] *wafted:* conducted.
[36] *league:* nautical measurement, approximating three miles. [37] *fraught:* cargo.
[38] *trowls:* comes in abundantly like a flowing stream.
[39] *Abram's:* For the promised blessings and the happiness of Abraham, see Genesis 15 and 17.
[40] *successful:* making for success.
[41] *profession:* the religion they profess.
[42] *Haply:* perhaps. [43] *hapless:* wretched.
[44] *scambled:* scrambled.
[45] *Kirriah Jairim:* Marlowe is mistaking a reference to a place name in I Chronicles 2 for a personal name.
[46] *Obed in Bairseth:* the father of Jesse (whose provenance remains unidentified) is recalled from the same source.
[47] *Nones:* conflating the Portuguese Jew, Dr. Hector Nunez, resident in London, and the beautiful Portuguese Jewess, Maria Nuñes, who was favored by Queen Elizabeth.
[48] *urged:* achieved. [49] *principality:* rule.
[50] *charge:* responsibility. [51] *children:* trisyllabic.
[52] *Iphigen:* Agamemnon, having offended the goddess Artemis on his way to Troy, was prevented from sailing farther until he had sacrificed his daughter Iphigenia. Euripides dramatizes the story in *Iphigenia in Aulis*, a manuscript translation of which (by Lady Lumley, *d.* 1577) was available in Marlowe's lifetime.
[53] *policy:* statecraft (used pejoratively, as appropriate to a Machiavellian.)
[54] *they:* the governor of Malta and his council.
[55] *Were . . . league:* If they were coming to ratify an alliance. [56] *Fond:* Foolish.
[57] *With . . . attempted:* Against whom they have launched (surprise) attacks.

3 Jew. And very wisely said. It may be so.

2 Jew. But there's a meeting in the senate-house,
And all the Jews in Malta must be there.

Bar. Umh! all the Jews in Malta must be there?
Ay, like enough, why then let every man
Provide him,[58] and be there for fashion-sake.[59] 170
If anything shall there concern our state,[60]
Assure yourselves I'll look—[*Aside*] unto myself.

1 Jew. I know you will. Well, brethren, let us go.

2 Jew. Let's take our leaves. Farewell, good
Barabas.

Bar. Farewell, Zaareth; farewell, Temainte.[61]
 [*Exeunt* Jews.]

And, Barabas, now search this secret out;
Summon thy senses, call thy wits together:
These silly[62] men mistake the matter clean.[63]
Long to the Turk did Malta còntribute;
Which tribute, all in policy I fear, 180
The Turks have let increase to such a sum
As all the wealth of Malta cannot pay;
And now by that advantage thinks belike
To seize upon the town: ay, that he seeks.
Howe'er the world go, I'll make sure for one,
And seek in time to intercept[64] the worst,
Warily guarding that which I ha' got.
Ego mihimet sum semper proximus.[65]
Why, let 'em enter, let 'em take the town. 190
 [*Exit.*]

[I.ii]

Enter [FERNEZE,] Governors of Malta, Knights
[*and* Officers] *met by* Bassoes[1] *of the Turk ;*
CALYMATH.

Fern. Now, bassoes, what demand you at our
hands?

1 Bas. Know, Knights of Malta,[2] that we came
from Rhodes,
From Cyprus, Candy, and those other isles
That lie betwixt the Mediterranean seas.[3]

Fern. What's Cyprus, Candy, and those other isles
To us, or Malta? What at our hands demand ye?

Cal. The ten years' tribute that remains unpaid.

Fern. Alas! my lord, the sum is over-great,
I hope your highness will consider us.

Cal. I wish, grave[4] governors, 'twere in my power
To favor you, but 'tis my father's cause, 11
Wherein I may not, nay, I dare not dally.

Fern. Then give us leave,[5] great Selim Calymath.

Cal. Stand all aside, and let the knights determine,
And send to keep our galleys under sail,
For happily[6] we shall not tarry here;
Now, governors, how are you resolved?

Fern. Thus: since your hard conditions are such
That you will needs[7] have ten years' tribute past,
We may have time to make collection 20
Amongst the inhabitants of Malta for't.

1 Bas. That's more than is in our commission.

Cal. What, Callapine! a little courtesy.

Let's know their time, perhaps it is not long;
And 'tis more kingly to obtain by peace
Than to enforce conditions by constraint.
What respite[8] ask you, governors?

Fern. But a month.

Cal. We grant a month, but see you keep your
promise.
Now launch our galleys back again to sea,
Where we'll attend[9] the respite you have ta'en, 30
And for the money send our messenger.
Farewell, great governors and brave Knights of Malta.

Fern. And all good fortunes wait on Calymath!
 [*Exeunt.*]

Go on and call those Jews of Malta hither:
Were they not summoned to appear today?

Off. They were, my lord, and here they come.

Enter BARABAS *and three* Jews.

1 Knight. Have you determined what to say to
them?

Fern. Yes, give me leave:—and, Hebrews, now come
near.
From the Emperor of Turkey is arrived
Great Selim Calymath, his highness's son, 40
To levy of us ten years' tribute past;
Now then, here know that it concerneth us—

Bar. Then, good my lord, to keep your quiet still,
Your lordship shall do well to let them have it.

Fern. Soft, Barabas, there's more 'longs[10] to 't than
so.
To what this ten years' tribute will amount,
That we have cast,[11] but cannot compass[12] it
By reason of the wars that robbed our store;
And therefore are we to request your aid.

Bar. Alas, my lord, we are no soldiers: 50
And what's our aid against so great a prince?

1 Knight. Tut, Jew, we know thou art no soldier;
Thou art a merchant and a moneyed man,
And 'tis thy money, Barabas, we seek.

Bar. How, my lord! my money?

Fern. Thine and the rest.

[58] *Provide him:* Get himself ready.
[59] *for fashion-sake:* as a formality. [60] *state:* condition.
[61] *Temainte:* Marlowe is perhaps remembering Eliphaz
the Temanite in Job 11:2.
[62] *silly:* innocent (in the sense of "foolish").
[63] *clean:* altogether. [64] *intercept:* forestall.
[65] *L.:* Misquoted from Terence's *Andria* IV.i.12: "I am
ever nearer (friend) to myself."

I.ii.
[1] *Bassoes:* Bashaws, pashas; important Turkish fun-
tionaries.
[2] *Knights of Malta:* The headquarters of the Knights of
St. John of Jerusalem were moved to Malta from Rhodes on
the capture of that island by the Turks in the sixteenth
century.
[3] *seas:* referring to the Adriatic, Aegean, etc.
[4] *grave:* honored.
[5] *give us leave:* allow us to confer privately.
[6] *happily:* perhaps. [7] *needs:* of necessity.
[8] *respite:* delay. [9] *attend:* wait on.
[10] *'longs:* belongs. [11] *cast:* reckoned.
[12] *compass:* encompass, satisfy.

For, to be short, amongst you't must be had.

1 Jew. Alas, my lord, the most of us are poor.

Fern. Then let the rich increase your portions.

Bar. Are strangers [13] with your tribute to be taxed?

2 Knight. Have strangers leave with us to get their
 wealth? 60

Then let them with us còntribute.

Bar. How! equally?

Fern. No, Jew, like infidels.

For through our sufferance of your hateful lives,

Who stand accursèd in the sight of heaven,

These taxes and afflictions are befall'n,

And therefore thus we are determinèd.

Read there the articles of our decrees.

Officer [*Reading*] "First, the tribute-money of the
Turks shall all be levied amongst the Jews, and each of
them to pay one half of his estate." 70

Bar. [*Aside.*] How, half his estate? I hope you mean
not mine.

Fern. Read on.

Off. [*Reading*] "Secondly, he that denies [14] to pay
shall straight [15] become a Christian."

Bar. [*Aside*]. How! [16] a Christian? Hum, what's here
to do?

Off. [*Reading.*] "Lastly, he that denies this shall
absolutely lose all he has."

The three Jews. O my lord, we will give half. 80

Bar. O earth-mettled [17] villains, and no Hebrews
 born!

And will you basely thus submit yourselves

To leave your goods to their arbitrament! [18]

Fern. Why, Barabas, wilt thou be christèned?

Bar. No, governor, I will be no convertite. [19]

Fern. Then pay thy half.

Bar. Why, know you what you did by this device?

Half of my substance is a city's wealth.

Governor, it was not got so easily;

Nor will I part so slightly therewithal. 90

Fern. Sir, half is the penalty of our decree,

Either pay that, or we will seize on all.

Bar. Corpo di Dio! [20] stay! you shall have half;

[13] *strangers:* foreigners.
[14] *denies:* refuses.
[15] *straight:* at once.
[16] *How!:* What!
[17] *earth-mettled:* base, as being inspirited of earth.
[18] *arbitrament:* absolute judgment.
[19] *convertite:* convert.
[20] *It.:* Body of God!
[21] *And . . . recalled:* At this point presumably Officers exeunt to seize on Barabas's goods.
[22] *ground:* basis.
[23] *particularly:* in particular.
[24] *save:* prevent.
[25] *private:* i.e., one.
[26] *And . . . man:* Following John 11:50.
[27] *multiply:* increase my wealth.
[28] *If . . . head:* Following Matthew 27:25.
[29] *in general:* "as opposed to the individual."
[30] *The . . . live:* conflating homiletic sayings in Proverbs, Job, Ezekiel.
[31] *profession:* religious creed; but also his profession of usurer.
[32] *exclaims:* outcries.
[33] *of the other:* from the other Jews.
[34] *Then . . . residue:* The quarto gives this line to the Officers, but it is clearly Ferneze who is announcing his intention to "dispose" of Barabas's goods, and to seize on the moiety remaining to his brethren.
[35] *profession:* (Christian) faith.

Let me be used but as my brethren are.

Fern. No, Jew, thou hast denied the articles,

And now it cannot be recalled. [21]

Bar. Will you then steal my goods?

Is theft the ground [22] of your religion?

Fern. No, Jew, we take particularly [23] thine

To save [24] the ruin of a multitude: 100

And better one want for the common good

Than many perish for a private [25] man: [26]

Yet, Barabas, we will not banish thee,

But here in Malta, where thou gott'st thy wealth,

Live still; and, if thou canst, get more.

Bar. Christians, what or how can I multiply? [27]

Of naught is nothing made.

1 Knight. From naught at first thou cam'st to little
 wealth,

From little unto more, from more to most:

If your first curse fall heavy on thy head, [28] 110

And make thee poor and scorned of all the world,

'Tis not our fault, but thy inherent sin.

Bar. What, bring you Scripture to confirm your
 wrongs?

Preach me not out of my possessions.

Some Jews are wicked, as all Christians are:

But say the tribe that I descended of

Were all in general [29] cast away for sin,

Shall I be tried by their transgression?

The man that dealeth righteously shall live: [30]

And which of you can charge me otherwise? 120

Fern. Out, wretched Barabas!

Shams't thou not thus to justify thyself

As if we knew not thy profession? [31]

If thou rely upon thy righteousness,

Be patient and thy riches will increase.

Excess of wealth is cause of covetousness:

And covetousness, oh, 'tis a monstrous sin.

Bar. Ay, but theft is worse: tush! take not from me
 then,

For that is theft! and if you rob me thus,

I must be forced to steal and compass more. 130

1 Knight. Grave governors, list not to his exclaims. [32]

Convert his mansion to a nunnery;

His house will harbor many holy nuns.

Fern. It shall be so.

Enter Officers.

 Now, officers, have you done?

Off. Ay, my lord, we have seized upon the goods

And wares of Barabas, which being valued,

Amount to more than all the wealth in Malta.

And of the other [33] we have seizèd half.

Fern. Then we'll take order for the residue. [34]

Bar. Well then, my lord, say, are you satisfied? 140

You have my goods, my money, and my wealth,

My ships, my store, and all that I enjoyed;

And, having all, you can request no more;

Unless your unrelenting flinty hearts

Suppress all pity in your stony breasts,

And now shall move you to bereave my life.

Fern. No, Barabas, to stain our hands with blood

Is far from us and our profession. [35]

Bar. Why, I esteem the injury far less
To take the lives of miserable men 150
Than be the causers of their misery.
You have my wealth, the labor of my life,
The comfort of mine age, my children's hope,
And therefore ne'er distinguish [36] of the wrong.
 Fern. Content thee, Barabas, thou has naught but
 right.
 Bar. Your èxtreme right does me exceeding wrong:
But take it to you, i' the devil's name.
 Fern. Come, let us in, and gather of [37] these goods
The money for this tribute of the Turk.
 1 Knight. 'Tis necessary that be looked unto: 160
For if we break our day, [38] we break the league,
And that will prove but simple policy. [39]
 Exeunt [*all except* BARABAS *and the* Jews].
 Bar. Ay, policy! that's their profession,
And not simplicity, as they suggest.
The plagues of Egypt, and the curse of heaven,
Earth's barrenness, and all men's hatred
Inflict upon them, thou great *Primus Motor!* [40]
And here upon my knees, striking the earth,
I ban [41] their souls to everlasting pains
And èxtreme tortures of the fiery deep, 170
That thus have dealt with me in my distress.
 1 Jew. O yet be patient, gentle Barabas.
 Bar. O silly brethren, born to see this day;
Why stand you thus unmoved with my laments?
Why weep you not to think upon my wrongs?
Why pine not I, and die in this distress?
 1 Jew. Why, Barabas, as hardly [42] can we brook
The cruel handling of ourselves in this;
Thou seest they have taken half our goods.
 Bar. Why did you yield to their extortion? 180
You were a multitude, and I but one:
And of me only have they taken all.
 1 Jew. Yet, brother Barabas, remember Job.
 Bar. What tell you me of Job? I wot [43] his wealth
Was written thus: he had seven thousand sheep,
Three thousand camels, and two hundred yoke
Of laboring oxen, and five hundred
She-asses: but for every one of those,
Had they been valued at indifferent [44] rate,
I had at home, and in mine argosy, 190
And other ships that came from Egypt last, [45]
As much as would have bought his beasts and him,
And yet have kept enough to live upon:
So that not he, but I may curse the day,
Thy fatal birthday, forlorn Barabas;
And henceforth wish for an eternal night,
That clouds of darkness may enclose my flesh,
And hide these èxtreme sorrows from mine eyes:
For only I have toiled to inherit here
The months of vanity and loss of time, 200
And painful nights, have been appointed me.
 2 Jew. Good Barabas, be patient.
 Bar. Ay, ay pray, leave me in my patience. You, that
Were ne'er possessed of wealth, are pleased with want;
But give him liberty at least to mourn,
That in a field amidst his enemies
Doth see his soldiers slain, himself disarmed,

And knows no means of his recovery:
Ay, let me sorrow for this sudden chance; [46]
'Tis in the trouble of my spirit I speak; 210
Great injuries are not so soon forgot.
 1 Jew. Come, let us leave him; in his ireful mood
Our words will but increase his ecstasy. [47]
 2 Jew. On, then; but trust me 'tis a misery
To see a man in such affliction.—
Farewell, Barabas!
 Exeunt.
 Bar. Ay, fare you well.
See the simplicity of these base slaves,
Who, for [48] the villains have no wit [49] themselves,
Think me to be a senseless lump of clay
That will with every water wash to dirt: 220
No, Barabas is born to better chance, [50]
And framed of finer mold than common men,
That measure naught but by the present time.
A reaching thought [51] will search his deepest wits,
And cast [52] with cunning for the time to come:
For evils are apt to happen every day.—

 Enter ABIGAIL, *the Jew's daughter.*

But whither wends my beauteous Abigail?
Oh! what has made my lovely daughter sad?
What, woman! moan not for a little loss:
Thy father hath enough in store for thee. 230
 Abig. Not for myself, but agèd Barabas:
Father, for thee lamenteth Abigail:
But I will learn to leave these fruitless tears,
And, urged thereto with my afflictions,
With fierce exclaims run to the senate house,
And in the senate reprehend them all,
And rent [53] their hearts with tearing of my hair,
Till they reduce [54] the wrongs done to my father.
 Bar. No, Abigail, things past recovery
Are hardly cured with exclamations. 240
Be silent, daughter, sufferance [55] breeds ease
And time may yield us an occasion
Which [56] on the sudden [57] cannot serve the turn.
Besides, my girl, think me not all so fond [58]
As negligently to forgo so much

[36] *distinguish:* in the sense of making casuistical or specious distinctions. [37] *of:* from.
[38] *break our day:* fail to keep the time stipulated for payment.
[39] *simple policy:* foolish management of state business; in contrast to "policy" as suggesting Machiavellian deceit in the line that follows, and "simplicity" as suggesting forthright behavior.
[40] *L.:* God, who turns the crank that moves all things.
[41] *ban:* curse.
[42] *as hardly:* with just as much difficulty.
[43] *wot:* know. [44] *indifferent:* inconsiderable.
[45] *last:* lately. [46] *chance:* misfortune.
[47] *ecstasy:* madness. [48] *for:* because.
[49] *wit:* here, the rational faculty.
[50] *chance:* fortune (used impartially).
[51] *reaching thought:* provident (also, "ambitious") thinker. [52] *cast:* prepare. [53] *rent:* rend.
[54] *reduce:* diminish; also, "repair."
[55] *sufferance:* endurance.
[56] *Which:* modifying "time."
[57] *on the sudden:* now. [58] *fond:* foolish.

Without provision for thyself and me,
Ten thousand portagues,[59] besides great pearls,
Rich costly jewels, and stones infinite,
Fearing the worst of this before it fell,
I closely[60] hid.
 Abig. Where, father?
 Bar. In my house, my girl.
 Abig. Then shall they ne'er be seen of Barabas: 251
For they have seized upon thy house and wares.
 Bar. But they will give me leave once more, I trow,[61]
To go into my house.
 Abig. That may they not:
For there I left the governor placing nuns.
Displacing me; and of thy house they mean
To make a nunnery, where none but their own sect[62]
Must enter in; men generally[63] barred.
 Bar. My gold! my gold! and all my wealth is gone!
You partial heavens, have I deserved this plague? 260
What, will you thus oppose me, luckless[64] stars,
To make me desperate in my poverty?
And knowing me impatient in distress,
Think me so mad as I will hang myself,
That I may vanish o'er the earth in air,
And leave no memory that e'er I was?
No, I will live; nor loathe I this my life:
And, since you leave me in the ocean thus
To sink or swim, and put me to my shifts,[65]
I'll rouse my senses and awake myself. 270
Daughter! I have it: thou perceiv'st the plight
Wherein these Christians have oppressèd me:
Be ruled by me, for in extremity
We ought to make bar of no policy,[66]
 Abig. Father, whate'er it be to injure them
That have so manifestly wrongèd us,
What will not Abigail attempt?
 Bar. Why, so;
Then thus, thou tolds't me they have turned my house
Into a nunnery, and some nuns are there?
 Abig. I did.
 Bar. Then, Abigail, there must my girl 280

Entreat the abbess to be entertained.[67]
 Abig. How, as a nun?
 Bar. Ay, daughter, for religion
Hides many mischiefs from suspicion.
 Abig. Ay, but, father, they will suspect me there.
 Bar. Let 'em suspect; but be thou so precise[68]
As they may think it done of holiness.
Entreat 'em fair,[69] and give them friendly speech,
And seem to them as if thy sins were great,
Till thou hast gotten to be entertained.[70]
 Abig. Thus, father, shall I much dissemble.
 Bar. Tush!
As good dissemble that thou never mean'st, 291
As first mean truth and then dissemble it,—
A counterfeit[71] profession[72] is better
Than unseen[73] hypocrisy.
 Abig. Well, father, say [that] I be entertained,
What then shall follow?
 Bar. This shall follow then;
There have I hid, close underneath the plank
That runs along the upper-chamber floor,
The gold and jewels which I kept for thee.
But here they come; be cunning, Abigail. 300
 Abig. Then, father, go with me.
 Bar. No, Abigail, in this
It is not necessary I be seen:[74]
For I will seem offended with thee for't:
Be close,[75] my girl, for this must fetch my gold.[76]

Enter three Friars [JACOMO *and* BARNARDINE
among them] and two Nuns [*one the* Abbess].

F. Jac. Sisters,
We now are almost at the new-made nunnery.
 Abb.[77] The better; for we love not to be seen:
'Tis thirty winters long since some of us
Did stray so far amongst the multitude.
 F. Jac. But, madam, this house 310
And waters of this new made nunnery
Will much delight you.
 Abb. It may be so; but who comes here?
 Abig. Grave Abbess, and you, happy virgins'
 guide,[78]
Pity the state of a distressèd maid.
 Abb. What art thou, daughter?
 Abig. The hopeless daughter of a hapless Jew,
The Jew of Malta, wretched Barabas;
Sometimes[79] the owner of a goodly house,
Which they have now turned to a nunnery. 320
 Abb. Well, daughter, say, what is thy suit with us?
 Abig. Fearing the afflictions which my father feels
Proceed from sin, or want of faith in us,
I'd pass away my life in penitence,
And be a novice in your nunnery,
To make atonement for my laboring[80] soul.
 F. Jac. No doubt, brother, but this proceedeth of the
 spirit.
 F. Barn. Ay, and of a moving[81] spirit too, brother;
 but come,
Let us entreat she may be entertained.
 Abb. Well, daughter, we admit you for a nun. 330
 Abig. First let me as a novice learn to frame

[59] *portagues:* Portuguese gold coins.
[60] *closely:* secretly. [61] *trow:* suppose.
[62] *sect:* sex. ..[63] *generally:* i.e., all of them.
[64] *luckless:* i.e., to me.
[65] *put . . . shifts:* bring me to extremity; with collateral
sense of "put me on my mettle."
[66] *policy:* stratagem. [67] *entertained:* i.e., for a nun.
[68] *precise:* scrupulous in a pejorative sense—"puritanical."
[69] *fair:* as by offering "friendly speech."
[70] *entertained:* admitted to service.
[71] *counterfeit:* false.
[72] *profession:* promise (four syllables).
[73] *unseen:* undetected. (If the text is correct, Barabas is
saying, "Better to dissemble from the first than, like the
precisians, to be hypocritical in ways unperceived by them-
selves.")
[74] *It . . . seen:* i.e., It *is* necessary that I be not seen.
[75] *close:* secretive.
[76] *gold:* With the end of the speech, Barabas and Abigail
presumably move to the rear of the stage or behind a pillar.
[77] *Abbess:* referred to impartially in the quarto as "Nun."
[78] *guide:* father confessor. [79] *Sometimes:* Formerly.
[80] *laboring:* struggling (against wickedness).
[81] *moving:* presumably "sexually moving" (the discourse
of the Friars is intended for comedy).

My solitary life to your strait [82] laws,
And let me lodge where I was wont to lie,
I do not doubt, by your divine precèpts
And mine own industry, but to profit much.
 Bar. [*Aside*] As much, I hope, as all I hid is worth.
 Abb. Come, daughter, follow us.
 [BARABAS *comes forward.*]
 Bar. Why, how now,
 Abigail,
What makest thou [83] amongst these hateful Christians?
 F. Jac. Hinder her not, thou man of little faith,
For she has mortified [84] herself.
 Bar. How! mortified? 340
 F. Jac. And is admitted to the sisterhood.
 Bar. Child of perdition, and thy father's shame!
What wilt thou do amongst these hateful fiends?
I charge thee on my blessing that thou leave
These devils, and their damnèd heresy.
 Abig. Father, give me—
 Bar. Nay, back, Abigail,
[*Whispers to her.*] And think upon the jewels and the
 gold;
The board is markèd thus that covers it.
 [*Makes a cross.*]
Away, accursèd, from thy father's sight. 349
 F. Jac. Barabas, although thou art in misbelief,[85]
And wilt not see thine own afflictions,
Yet let thy daughter be no longer blind.
 Bar. Blind friar, I reck not thy persuasions.[86]
—The board is markèd thus that covers it.—
 [*Makes a cross*]
For I had rather die than see her thus.
Wilt thou forsake me too in my distress,
Seducèd daughter? [*Aside to her*] Go, forget not—
Becomes it Jews to be so credulous?
[*Aside to her*] Tomorrow early I'll be at the door.
No, come not at me; if thou wilt be damned, 360
Forget me, see me not, and so be gone.
[*Aside to her*] Farewell, remember tomorrow morning.—
Out, out, thou wretch!
 [*Exeunt.*]

Enter MATHIAS.

 Math. Who's this? Fair Abigail, the rich Jew's
 daughter,
Become a nun! her father's sudden fall
Has humbled her and brought her down to this:
Tut, she were fitter for a tale of love
Than to be tired out with orisons:[87]
And better would she far become a bed,
Embracèd in a friendly lover's arms, 370
Than rise at midnight to a solemn mass.

Enter LODOWICK.

 Lod. Why, how now, Don Mathias! in a dump?[88]
 Math. Believe me, noble Lodowick, I have seen
The strangest sight, in my opinion,
That ever I beheld.
 Lod. What was't, I prithee?
 Math. A fair young maid, scarce fourteen years of
 age,

The sweetest flower in Cytherea's [89] field,
Cropped from the pleasures of the fruitful earth,
And strangely metamorphised nun.
 Lod. But say, what was she?
 Math. Why, the rich Jew's
 daughter. 380
 Lod. What, Barabas, whose goods were lately seized?
Is she so fair?
 Math. And matchless beautiful;
As, had you seen her, 'twould have moved your heart,
Though countermined [90] with walls of brass, to love,
Or at the least to pity.
 Lod. And if she be so fair as you report,
'Twere time well spent to go and visit her:
How say you, shall we?
 Math. I must and will, sir; there's no remedy.
 Lod. And so will I too, or it shall go hard.[91] 390
Farewell, Mathias.
 Math. Farewell, Lodowick.
 Exeunt.

ACT TWO

SCENE ONE

Enter BARABAS *with a light.*[1]

 Bar. Thus, like the sad presaging [2] raven, that tolls [3]
The sick man's passport [4] in her hollow beak,
And in the shadow of the silent night
Doth shake contagion from her sable wings;
Vexed and tormented runs poor Barabas
With fatal curses towards these Christians.
The incertain pleasures of swift-footed time
Have ta'en their flight, and left me in despair;
And of my former riches rests [5] no more
But bare remembrance, like a soldier's scar, 10
That has no further comfort for his maim.[6]
O Thou, that with a fiery pillar led'st
The sons of Israel through the dismal shades,
Light Abraham's offspring; and direct the hand
Of Abigail this night; or let the day
Turn to eternal darkness after this!
No sleep can fasten on my watchful [7] eyes,

[82] *strait:* strict.
[83] *What makest thou:* What are you doing.
[84] *mortified:* died to the world by entering the nunnery.
[85] *in misbelief:* not a Christian.
[86] *reck . . . persuasions:* care not for your arguments.
[87] *orisons:* prayers (in the middle of the night).
[88] *dump:* melancholy fit. [89] *Cytherea's:* Venus's.
[90] *countermined:* i.e., doubly protected.
[91] *or . . . hard:* unless I am prevented by great obstacles.

II.i.
[1] *light:* indicative of night. Barabas—as the subsequent entrance of Abigail on the balcony instructs us—stands before the nunnery, formerly his own dwelling.
[2] *presaging:* foreboding.
[3] *tolls:* sounds, announces (like the fatal bellman).
[4] *passport:* i.e., to the land of death.
[5] *rests:* remains.
[6] *maim:* injury, which only the scar (ironically) redresses.
[7] *watchful:* sleepless.

Nor quiet enter my distempered[8] thoughts,
Till I have answer of my Abigail.

Enter ABIGAIL *above.*

Abig. Now have I happily espied a time 20
To search the plank my father did appoint;[9]
And here behold, unseen, where I have found
The gold, the pearls, and jewels, which he hid.
Bar. Now I remember those old women's words,
Who in my wealth[10] would tell me winter's tales,[11]
And speak of spirits and ghosts that glide by night
About the place where treasure hath been hid:
And now methinks that I am one of those:
For whilst I live, here lives my soul's sole hope,
And, when I die, here shall my spirit walk. 30
Abig. Now that my father's fortune were so good
As but to be about this happy place;
'Tis not so happy: yet when we parted last,
He said he would attend[12] me in the morn.
Then, gentle sleep, where'er his body rests,
Give charge to Morpheus[13] that he may dream
A golden dream, and of the sudden walk,[14]
Come, and receive the treasure I have found.
Bar. *Bueno para todos mi ganado no era:*[15]
As good go on as sit so sadly thus. 40
But stay, what star shines yonder in the east?
The lodestar[16] of my life, if Abigail.
Who's there?
Abig. Who's that?
Bar. Peace, Abigail, 'tis I.
Abig. Then, father, here receive thy happiness.
Bar. Hast thou't?

[ABIGAIL *throws down bags.*]

Abig. Here. Hast thou't?
There's more, and more, and more.
Bar. O my girl,

8 *distempered:* agitated.
9 *appoint:* designate. 10 *wealth:* days of wealth.
11 *winter's tales:* old wives' tales, fairy stories.
12 *attend:* wait on.
13 *Morpheus:* God of dreams (following Ovid, *Metamorphoses*, XI. 623ff).
14 *walk:* wake.
15 *Sp.:* Dyce's emendation of the corrupt original: "My wealth, good for everybody else, is no good to me."
16 *lodestar:* guiding star (pole-star).
17 *practice thy enlargement:* devise thy release.
18 *Phoebus:* the sun. 19 *for:* instead of.
20 *Sp.:* Dyce's emendation: "Beautiful pleasure of money."

II.ii.
1 *entreat:* treat. 2 *fraught:* cargo.
3 *late:* recently.
4 *vailed:* lowered our sails in token of submission.
5 *Turkish:* original reads "Spanish."
6 *luffed and tacked:* hauled on the wind (to gain headway) and went about into (original reads: "left and tooke").
7 *fired:* set afire.
8 *tributary league:* alliance, founded on payment of tribute.
9 *it:* the league.
10 *Christian:* denoting the former headquarters of the Knights of the Order of the Hospital of St. John of Jerusalem.
11 *stated:* placed.

My gold, my fortune, my felicity!
Strength to my soul, death to mine enemy!
Welcome the first beginner of my bliss! 50
O Abigail, Abigail, that I had thee here too!
Then my desires were fully satisfied:
But I will practice thy enlargement[17] thence:
O girl! O gold! O beauty! O my bliss!

Hugs his bags.

Abig. Father, it draweth towards midnight now,
And 'bout this time the nuns begin to wake;
To shun suspicion, therefore, let us part.
Bar. Farewell, my joy, and by my fingers take
A kiss from him that sends it from his soul.
Now Phoebus[18] ope the eyelids of the day, 60
And for[19] the raven wake the morning lark,
That I may hover with her in the air;
Singing o'er these, as she does o'er her young.
Hermoso placer de los dineros.[20]

Exeunt.

[II.ii]

Enter FERNEZE, MARTIN DEL BOSCO, *the* Knights.

Fern. Now, captain, tell us whither thou art bound?
Whence is thy ship that anchors in the road?
And why thou cam'st ashore without our leave?
Bosc. Governor of Malta, hither am I bound;
My ship, the Flying Dragon, is of Spain,
And so am I: del Bosco is my name;
Vice-admiral unto the Catholic King.
1 Knight. 'Tis true, my lord, therefore entreat[1]
him well.
Bosc. Our fraught[2] is Grecians, Turks, and Afric
Moors,
For late[3] upon the coast of Corsica, 10
Because we vailed[4] not to the Turkish[5] fleet,
Their creeping galleys had us in the chase:
But suddenly the wind began to rise,
And then we luffed and tacked,[6] and fought at ease:
Some have we fired,[7] and many have we sunk;
But one amongst the rest became our prize:
The captain's slain, the rest remain our slaves,
Of whom we would make sale in Malta here.
Fern. Martin del Bosco, I have heard of thee;
Welcome to Malta, and to all of us; 20
But to admit a sale of these thy Turks
We may not, nay, we dare not give consent
By reason of a tributary league.[8]
1 Knight. Del Bosco, as thou lovest and honor'st us,
Persuade our governor against the Turk;
This truce we have is but in hope of gold,
And with that sum he craves might we wage war.
Bosc. Will Knights of Malta be in league with
Turks,
And buy it[9] basely too for sums of gold?
My lord, remember that, to Europe's shame, 30
The Christian[10] Isle of Rhodes, from whence you came,
Was lately lost, and you were stated[11] here
To be at deadly enmity with Turks.
Fern. Captain, we know it, but our force is small.

Bosc. What is the sum that Calymath requires?
Fern. A hundred thousand crowns.
Bosc. My lord and king hath title to this isle,
And he means quickly to expel you hence;
Therefore be ruled by me, and keep the gold;
I'll write unto his majesty for aid, 40
And not depart until I see you free.
Fern. On this condition shall thy Turks be sold:
Go, officers, and set them straight in show.[12]
 [*Exeunt* Officers.]
Bosco, thou shalt be Malta's general;
We and our warlike knights will follow thee
Against these barb'rous misbelieving Turks.
Bosc. So shall you imitate those you succeed:
For when their hideous force environed Rhodes,[13]
Small though the number was that kept the town,
They fought it out, and not a man survived 50
To bring the hapless[14] news to Christendom.
Fern. So will we fight it out; come, let's away.
Proud daring Calymath, instead of gold,
We'll send thee bullets wrapped in smoke and fire:
Claim tribute where thou wilt, we are resolved,
Honor is bought with blood and not with gold.
 Exeunt.

[II.iii]

Enter Officers *with* [ITHAMORE *and other*] Slaves.

1 Off. This is the market-place, here let 'em stand:
Fear not their sale, for they'll be quickly bought.
2 Off. Every one's price is written on his back,
And so much must they yield or not be sold.
1 Off. Here comes the Jew; had not his goods been
 seized,
He'd give us present money[1] for them all.

Enter BARABAS.

Bar. In spite of these swine-eating Christians,
Unchosen nation, never circumcised,
Such as (poor villains[2]) were ne'er thought upon
Till Titus and Vespasian[3] conquered us, 10
Am I become as wealthy as I was:
They hoped my daughter would ha' been a nun;
But she's at home, and I have bought a house
As great and fair as is the governor's;
And there in spite of Malta will I dwell,
Having Ferneze's hand,[4] whose heart I'll have;
Ay, and his son's too, or it shall go hard.
I am not of the tribe of Levi,[5] I,
That can so soon forget an injury.
We Jews can fawn like spaniels when we please: 20
And when we grin we bite, yet are our looks
As innocent and harmless as a lamb's.
I learned in Florence[6] how to kiss my hand,
Heave up my shoulders when they call me dog,
And duck as low as any barefoot friar;
Hoping to see them starve upon a stall,[7]
Or else be gathered for[8] in our synagogue,
That, when the offering-basin comes to me,
Even for charity I may spit into't.

Here comes Don Lodowick, the governor's son, 30
One that I love for his good father's sake.

Enter LODOWICK.

Lod. I hear the wealthy Jew walkèd this way;
I'll seek him out, and so insinuate,[9]
That I may have a sight of Abigail;
For Don Mathias tells me she is fair.
Bar. [*Aside*]. Now will I show myself
To have more of the serpent than the dove;
That is—more knave than fool.
Lod. Yond' walks the Jew; now for fair Abigail.
Bar. [*Aside*] Ay, ay, no doubt but she's at your
 command. 40
Lod. Barabas, thou know'st I am the governor's son.
Bar. I would you were his father, too, sir;
That's all the harm I wish you. [*Aside*] The slave looks
Like a hog's-cheek new singed.[10]
Lod. Whither walk'st thou, Barabas?
Bar. No farther: 'tis a custom held with us,
That when we speak with Gentiles like to you,
We turn into the air to purge ourselves:
For unto us the promise[11] doth belong. 49
Lod. Well, Barabas, canst help me to a diamond?
Bar. O, sir, your father had my diamonds.
Yet I have one left that will serve your turn.
[*Aside*] I mean my daughter: but ere he shall have her
I'll sacrifice her on a pile of wood.
I ha' the poison of the city[12] for him,
And the white leprosy.[13]
Lod. What sparkle does it give without a foil?[14]
Bar. The diamond that I talk of ne'er was foiled.[15]
[*Aside*] But when he touches it, it will be foiled—[16]
Lord Lodowick, it sparkles bright and fair. 60
Lod. Is it square or pointed, pray let me know.
Bar. Pointed[17] it is, good sir. [*Aside*] But not for you.
Lod. I like it much the better.
Bar. So do I too.

[12] *set . . . show:* display them at once.
[13] *For . . . Rhodes:* alluding to the siege of Rhodes by the
Turks in 1522 and the expulsion of the Knights (whose fate
was not so harsh as Marlowe suggests).
[14] *hapless:* wretched.
II.iii.
 [1] *present money:* cash. [2] *villains:* low fellows.
 [3] *Titus and Vespasian:* Successive emperors of Rome, who
achieved the conquest of Jerusalem in A.D. 70.
 [4] *hand:* agreement.
 [5] *tribe of Levi:* the priestly tribe.
 [6] *Florence:* the home of Machiavelli.
 [7] *stall:* bench before a storefront where goods were set
for sale.
 [8] *gathered for:* a collection be taken for.
 [9] *insinuate:* work myself into his favor.
 [10] *Like . . . singed:* Lodowick is fresh from the barber's.
 [11] *promise:* denoting the Chosen People.
 [12] *poison of the city:* This presumably virulent potion has
not been identified.
 [13] *white leprosy:* so called from the repulsive white scales
that formed on the skin.
 [14] *foil:* setting; metal leaf placed beneath a jewel to en-
hance its luster.
 [15] *foiled:* set off or presented. [16] *foiled:* defiled.
 [17] *Pointed:* punning on "appointed."

Lod. How shows it by night?

Bar. Outshines Cynthia's [18] rays.

[*Aside*] You'll like it better far a' nights than days.

Lod. And what's the price?

Bar. [*Aside*] Your life an if you have it.—O my lord,

We will not jar [19] about the price; come to my house

And I will give't your honor. [*Aside*] With a vengeance.

Lod. No, Barabas, I will deserve it first. 71

Bar. Good sir,

Your father has deserved it at my hands,

Who, of mere charity and Christian ruth, [20]

To bring me to religious purity,

And as it were in catechizing sort, [21]

To make me mindful of my mortal sins,

Against my will, and whether I would or no,

Seized all I had, and thrust me out a' doors,

And made my house a place for nuns most chaste. 80

Lod. No doubt your soul shall reap the fruit of it.

Bar. Ay, but, my lord, the harvest is far off.

And yet I know the prayers of those nuns

And holy friars, having money for their pains,

Are wondrous. [*Aside*] And indeed do no man good—

And seeing they are not idle, but still doing, [22]

'Tis likely they in time may reap some fruit,

I mean in fullness of perfection. [23]

Lod. Good Barabas, glance not at our holy nuns.

Bar. No, but I do it through a burning [24] zeal. 90

[*Aside*] Hoping ere long to set the house afire;

For though they do a while increase and multiply,

I'll have a saying [25] to that nunnery.—

As for the diamond, sir, I told you of,

Come home and there's no price shall make us part,

Even for your honorable father's sake.

[*Aside*] It shall go hard but I will see your death.—

But now I must be gone to buy a slave.

[18] *Cynthia's:* the moon's. [19] *jar:* dispute.

[20] *ruth:* pity.

[21] *in . . . sort:* in the manner of one who is proffering religious instruction. The irony here and in what follows is heavy enough. [22] *doing:* fornicating.

[23] *fullness of perfection:* The secondary sense— "when they are ready to give birth"—is emphasized, as Lodowick realizes.

[24] *burning:* punning on the fire he contemplates.

[25] *a saying:* something to say.

[26] *trick for:* way of stealing.

[27] *And if:* intensive—"If." [28] *plates:* silver coins.

[29] *So . . . purged:* Provided that he is spared from hanging by official sanction—because those days when cases are brought to trial are mostly fatal to thieves, who are likely at such times to be put to their purgation (hanged).

[30] *philosopher's stone:* which turned other metals to gold and silver. [31] *and:* if.

[32] *shaver:* contemptuously, as of tonsured clerics; with possible secondary reference to shaving or clipping coins.

[33] *Lady Vanity:* allegorical character in the morality plays.

[34] *serve:* Barabas in the next line takes this profession of service to mean "play a trick on."

[35] *passing:* exceedingly. [36] *stone:* fourteen pounds.

[37] *chops:* chaps, fat face. [38] *mark:* put your mark on.

[39] *mark:* remark.

[40] *Enter . . . Katherine:* Original reads "Mater," as also in speech prefixes.

[41] *stay:* break off (our talk).

[42] *mistrust:* suspect.

Lod. And, Barabas, I'll bear thee company.

Bar. Come then—here's the market-place. 100

What's the price of this slave? Two hundred crowns!

Do the Turks weigh so much?

1 Off. Sir, that's his price.

Bar. What, can he steal that you demand so much?

Belike he has some new trick for [26] a purse;

And if [27] he has, he is worth three hundred plates, [28]

So that, being bought, the town-seal might be got

To keep for his lifetime from the gallows:

The sessions day is critical to thieves,

And few or none 'scape but by being purged. [29]

Lod. Ratest thou this Moor but at two hundred plates? 110

1 Off. No more, my Lord.

Bar. Why should this Turk be dearer than that Moor?

1 Off. Because he is young and has more qualities.

Bar. What, hast the philosopher's stone? [30] And [31] thou hast break my head with it, I'll forgive thee.

Slave. No, sir; I can cut and shave.

Bar. Let me see, sirrah, are you not an old shaver? [32]

Slave. Alas, sir! I am a very youth.

Bar. A youth? I'll buy you, and marry you to Lady Vanity, [33] if you do well. 120

Slave. I will serve [34] you, sir.

Bar. Some wicked trick or other. It may be, under color of shaving, thou'lt cut my throat for my goods. Tell me, hast thou thy health well?

Slave. Ay, passing [35] well.

Bar. So much the worse; I must have one that's sickly, and be but for sparing victuals: 'tis not a stone [36] of beef a day will maintain you in these chops; [37] let me see one that's somewhat leaner.

1 Off. Here's a leaner, how like you him? 130

Bar. Where wast thou born?

Itha. In Thrace; brought up in Arabia.

Bar. So much the better, thou art for my turn.

An hundred crowns? I'll have him; there's the coin.

1 Off. Then mark [38] him, sir, and take him hence.

Bar. [*Aside*] Ay, mark [39] him, you were best, for this is he

That by my help shall do much villainy.—

My lord, farewell: Come, sirrah, you are mine.

As for the diamond, it shall be yours;

I pray, sir, be no stranger at my house, 140

All that I have shall be at your command.

Enter MATHIAS [*and his*] *mother* [KATHERINE]. [40]

Math. What makes the Jew and Lodowick so private?

[*Aside*] I fear me 'tis about fair Abigail.

Bar. Yonder comes Don Mathias, let us stay; [41]

[*Exit* LODOWICK.]

He loves my daughter, and she holds him dear:

But I have sworn to frustrate both their hopes,

And be revenged upon the governor.

Kath. This Moor is comeliest, is he not? Speak, son.

Math. No, this is the better, mother; view this well.

Bar. Seem not to know me here before your mother,

Lest she mistrust [42] the match that is in hand: 151

When you have brought[43] her home, come to my house;
Think of me as thy father; son, farewell.
 Math. But wherefore talked Don Lodowick with
 you?
 Bar. Tush! man, we talked of diamonds, not of
 Abigail.
 Kath. Tell me, Mathias, is not that the Jew?
 Bar. As for the comment on the Maccabees,[44]
I have it, sir, and 'tis at your command.
 Math. Yes, madam, and my talk with him was
About the borrowing of a book or two. 160
 Kath. Converse not with him, he is cast off from
 heaven.
Thou has thy crowns, fellow; come, let's away.
 Math. Sirrah, Jew, remember the book.
 Bar. Marry will I, sir.
 Exeunt [MATHIAS *and his* Mother.]
 Off. Come, I have made reasonable market; let's
 away.
 [*Exeunt* Officers *with* Slaves.]
 Bar. Now let me know thy name, and therewithal
Thy birth, condition, and profession.
 Itha. Faith, sir, my birth is but mean:[45] my name's
Ithamore,[46] my profession what you please.
 Bar. Hast thou no trade? Then listen to my words,
And I will teach thee that shall stick by thee: 171
First be thou void of these affections:[47]
Compassion, love, vain hope, and heartless[48] fear,
Be moved at nothing, see thou pity none,
But to thyself smile when the Christians moan.
 Itha. O brave! master, I worship your nose[49] for this.
 Bar. As for myself, I walk abroad a' nights
And kill sick people groaning under walls:
Sometimes I go about and poison wells;
And now and then, to cherish[50] Christian thieves, 180
I am content to lose some of my crowns,
That I may, walking in my gallery,[51]
See 'em go pinioned[52] along by my door.
Being young, I studied physic,[53] and began
To practice first upon the Italian;
There I enriched the priests with burials,
And always kept the sexton's arms in ure[54]
With digging graves and ringing dead men's knells:
And after that was I an engineer,[55]
And in the wars 'twixt France and Germany, 190
Under pretense of helping Charles the Fifth,[56]
Slew friends and enemy with my stratagems.
Then after that was I an usurer,[57]
And with extorting, cozening,[58] forfeiting,
And tricks belonging unto brokery,[59]
I filled the jails with bankrupts[60] in a year,
And with young orphans planted[61] hospitals,
And every moon made some or other mad,
And now and then one hang himself for grief,
Pinning upon his breast a long great scroll 200
How I with[62] interest tormented him.
But mark how I am blessed for plaguing them;
I have as much coin as will buy the town.
But tell me now, how hast thou spent thy time?
 Itha. 'Faith, master,
In setting Christian villages on fire,

Chaining of eunuchs, binding galley-slaves.
One time I was an hostler[63] in an inn,
And in the night-time secretly would I steal
To travelers' chambers, and there cut their throats:
Once at Jerusalem, where the pilgrims kneeled, 211
I strewèd powder on the marble stones,
And therewithal their knees would rankle[64] so,
That I have laughed a-good[65] to see the cripples
Go limping home to Christendom on stilts.[66]
 Bar. Why this is something: make account[67] of me
As of thy fellow; we are villains both:
Both circumcisèd, we hate Christians both:
Be true and secret, thou shalt want no gold.
But stand aside, here comes Don Lodowick. 220

 Enter LODOWICK.

 Lod. O Barabas, well met;
Where is the diamond you told me of?
 Bar. I have it for you, sir; please you walk in with
 me.
What ho, Abigail! open the door, I say.

 Enter ABIGAIL.

 Abig. In good time,[68] father; here are letters come
From Ormus,[69] and the post[70] stays here within.
 Bar. Give me the letters. [*Aside*] Daughter, do you
 hear,
Entertain Lodowick, the governor's son,
With all the courtesy you can afford,[71]
Provided that you keep your maidenhead. 230
Use him as if he were a Philistine,
Dissemble, swear, protest, vow to love him,
He is not of the seed of Abraham.—
I am a little busy, sir, pray pardon me.
Abigail, bid him welcome for my sake.
 Abig. For your sake and his own he's welcome hither.
 Bar. [*Aside*] Daughter, a word more; kiss him;
 speak him fair,[72]
And like a cunning Jew so cast about,[73]
That ye be both made sure[74] ere you come out. 239

 [43] *brought:* accompanied.
 [44] *comment . . . Maccabees:* Barabas, inventing talk about a
commentary on these Apocryphal books of the Bible, hopes
to put Katherine off the scent.
 [45] *mean:* low, undistinguished.
 [46] *Ithamore:* Marlowe finds the name in Numbers.
 [47] *affections:* emotions. [48] *heartless:* cowardly.
 [49] *nose:* huge, as denoting the stage Jew.
 [50] *cherish:* embolden. [51] *gallery:* balcony.
 [52] *pinioned:* fettered. [53] *physic:* medicine.
 [54] *ure:* use. [55] *engineer:* builder of military engines.
 [56] *Charles the Fifth:* 1500–1558, Holy Roman Emperor
and King of Spain.
 [57] *usurer:* moneylender. [58] *cozening:* cheating.
 [59] *brokery:* broker's business (pejorative implication).
 [60] *bankrupts:* Q reads "bankrouts".
 [61] *planted:* furnished. [62] *with:* by demanding.
 [63] *hostler:* stable keeper. [64] *rankle:* fester.
 [65] *a-good:* heartily. [66] *stilts:* crutches.
 [67] *make account:* think.
 [68] *In good time:* You've come at the right time.
 [69] *Ormus:* On the Persian Gulf, celebrated for its trading
in luxuries. [70] *post:* messenger. [71] *afford:* manage.
 [72] *speak him fair:* speak to him courteously.
 [73] *cast about:* devise. [74] *made sure:* affianced.

Abig. [*Aside*] O father! Don Mathias is my love;
Bar. [*Aside*] I know it: yet I say, make love to him;
Do, it is requisite it should be so.
Nay, on my life, it is my factor's [75] hand.
But go you in, I'll think upon the account.—[76]
 [*Exeunt* ABIGAIL *and* LODOWICK *into the house.*]
The account is made, for Lodowick dies.
My factor sends me word a merchant's fled
That owes me for a hundred tun [77] of wine:
I weigh it thus much; [78] I have wealth enough.
For now by this has he kissed Abigail;
And she vows love to him, and he to her. 250
As sure as heaven rained manna for the Jews,
So sure shall he and Don Mathias die:
His father was [79] my chiefest enemy.

 Enter MATHIAS.

Whither goes Don Mathias? Stay awhile.
 Math. Whither, but to my fair love Abigail?
 Bar. Thou know'st, and heaven can witness it is
 true,
That I intend my daughter shall be thine.
 Math. Ay, Barabas, or else thou wrong'st me much.
 Bar. Oh, heaven forbid I should have such a thought.
Pardon me though I weep: the governor's son 260
Will, whether I will or no, have Abigail:
He sends her letters, bracelets, jewels, rings.
 Math. Does she receive them?
 Bar. She? No, Mathias, no, but sends them back,
And when he comes, she locks herself up fast; [80]
Yet through the keyhole will he talk to her,
While she runs to the window looking out,
When you should come and hale him from the door.
 Math. O treacherous Lodowick!
 Bar. Even now as I came home, he slipped me in, [81]
And I am sure he is with Abigail. 271
 Math. I'll rouse [82] him thence.
 Bar. Not for all Malta, therefore sheathe your
 sword;
If you love me, no quarrels in my house;
But steal you in, and seem to see him not;
I'll give him such a warning ere he goes
As he shall have small hopes of Abigail.
Away, for here they come.

 Enter LODOWICK [*and*] ABIGAIL.

[75] *factor's*: agent's. [76] *account*: financial reckoning.
[77] *tun*: barrel.
[78] *I . . . much*: Presumably Barabas snaps his fingers.
[79] *was*: has been. [80] *fast*: securely.
[81] *slipped me in*: The pronoun is gratuitous.
[82] *rouse*: drive, as a hunted animal is driven from its lair.
[83] *happily*: haply, perhaps. [84] *silly*: slight.
[85] *hold my mind*: keep silent.
[86] *cross*: coin stamped with a cross.
[87] *posies*: mottoes. [88] *ring*: edge.
[89] *Jebusite*: member of a tribe of Canaanites driven from Jerusalem by King David.
[90] *Messias*: Messiah.
[91] *gentle*: a double pun; "gentle" is "gentile" and also (as substantive) "maggot."
[92] *plight . . . me*: make a (binding) promise to marry me.
[93] *Stay*: Stop. [94] *guise*: manner.

 Math. What, hand in hand! I cannot suffer this.
 Bar. Mathias, as thou lovest me, not a word. 280
 Math. Well, let it pass, another time shall serve.
 Exit.
 Lod. Barabas, is not that the widow's son?
 Bar. Ay, and take heed, for he hath sworn your
 death.
 Lod. My death? What, is the base-born peasant
 mad?
 Bar. No, no, but happily [83] he stands in fear
Of that which you, I think, ne'er dream upon,
My daughter here, a paltry silly [84] girl.
 Lod. Why, loves she Don Mathias?
 Bar. Doth she not with her smiling answer you?
 Abig. [*Aside*] He has my heart; I smile against my
 will. 290
 Lod. Barabas, thou know'st I've loved thy daughter
 long.
 Bar. And so has she done you, even from a child.
 Lod. And now I can no longer hold my mind. [85]
 Bar. Nor I the affection that I bear to you,
 Lod. This is thy diamond, tell me shall I have it?
 Bar. Win it, and wear it, it is yet unsoiled.
Oh! but I know your lordship would disdain
To marry with the daughter of a Jew;
And yet I'll give her many a golden cross [86]
With Christian posies [87] round about the ring. [88] 300
 Lod. 'Tis not thy wealth, but her that I esteem.
Yet crave I thy consent.
 Bar. And mine you have, yet let me talk to her.
[*Aside*] This offspring of Cain, this Jebusite, [89]
That never tasted of the Passover,
Nor e'er shall see the land of Canaan,
Nor our Messias [90] that is yet to come;
This gentle [91] maggot, Lodowick, I mean,
Must be deluded: let him have thy hand,
But keep thy heart till Don Mathias comes. 310
 Abig. [*Aside*] What, shall I be betrothed to
 Lodowick?
 Bar. [*Aside*] It's no sin to deceive a Christian;
For they themselves hold it a principle
Faith is not to be held with heretics;
But all are heretics that are not Jews;
This follows well, and therefore, daughter, fear not.—
I have entreated her, and she will grant.
 Lod. Then, gentle Abigail, plight thy faith to me. [92]
 Abig. I cannot choose, seeing my father bids. 319
[*Aside*] Nothing but death shall part my love and me.
 Lod. Now have I that for which my soul hath longed.
 Bar. [*Aside*] So have not I, but yet I hope I shall.
 Abig. [*Aside*] O wretched Abigail, what hast thou
 done?
 Lod. Why on the sudden is your color changed?
 Abig. I know not, but farewell, I must be gone.
 Bar. Stay [93] her, but let her not speak one word
 more.
 Lod. Mute o' the sudden! here's a sudden change.
 Bar. Oh, muse not at it, 'tis the Hebrews' guise, [94]
That maidens new betrothed should weep awhile:
Trouble her not; sweet Lodowick, depart: 330
She is thy wife, and thou shalt be mine heir.

Lod. Oh, is't the custom? Then I am resolved:[95]
But rather[96] let the brightsome heavens be dim,
And nature's beauty choke with stifling clouds,
Than my fair Abigail should frown on me.—
There comes the villain, now I'll be revenged.

Enter MATHIAS.

Bar. Be quiet, Lodowick, it is enough
That I have made thee sure to Abigail.
　Lod. Well, let him go.

Exit.

Bar. Well, but for me, as you went in at doors　340
You had been stabbed, but not a word on't now;
Here must no speeches pass, nor swords be drawn.
　Math. Suffer me, Barabas, but to follow him.
　Bar. No; so shall I, if any hurt be done,
Be made an accessary[97] of your deeds;
Revenge it on him when you meet him next.
　Math. For this I'll have his heart.
　Bar. Do so; lo, here I give thee Abigail.
　Math. What greater gift can poor Mathias have?
Shall Lodowick rob me of so fair a love?　350
My life is not so dear as Abigail.
　Bar. My heart misgives me,[98] that, to cross[99] your love,
He's with your mother: therefore after him.
　Math. What, is he gone unto my mother?
　Bar. Nay, if you will, stay till she comes herself.
　Math. I cannot stay; for if my mother come,
She'll die with grief.

Exit.

Abig. I cannot take my leave of him for tears:
Father, why have you thus incensed them both?　359
　Bar. What's that to thee?
　Abig.　　　　　　I'll make 'em friends again.
　Bar. You'll make 'em friends!
Are there not Jews enow[100] in Malta,
But thou must dote upon a Christian?
　Abig. I will have Don Mathias; he is my love.
　Bar. Yes, you shall have him: go put her in.
　Itha. Ay, I'll put her in.

[Puts ABIGAIL *in.]*

Bar. Now tell me, Ithamore, how lik'st thou this?
　Itha. Faith, master, I think by this
You purchase[101] both their lives; is it not so?　369
　Bar. True; and it shall be cunningly performed.
　Itha. O master, that I might have a hand in this.
　Bar. Ay, so thou shalt, 'tis thou must do the deed:
Take this, and bear it to Mathias straight,[102]
And tell him that it comes from Lodowick.
　Itha. 'Tis poisoned, is it not?
　Bar. No, no, and yet it might be done that way:
It is a challenge feigned from Lodowick.
　Itha. Fear not; I will so set his heart afire,
That he shall verily think it comes from him.
　Bar. I cannot choose but like thy readiness:[103]　380
Yet be not rash, but do it cunningly.
　Itha. As I behave myself in this, employ me hereafter.
　Bar. Away then.

[Exit ITHAMORE.*]*

So, now will I go in to Lodowick,
And, like a cunning spirit, feign some lie
Till I have set 'em both at enmity.

Exit.

ACT THREE

SCENE ONE

Enter [BELLAMIRA,] *a Courtesan.*[1]

Bell. Since this town was besieged, my gain grows
　cold:[2]
The time has been that, but for one bare night,
A hundred ducats have been freely given:
But now against my will I must be chaste;
And yet I know my beauty doth not fail.
From Venice merchants, and from Padua[3]
Were wont to come rare-witted gentlemen,
Scholars I mean, learnèd and liberal;[4]
And now, save Pilia-Borza,[5] comes there none,
And he is very seldom from[6] my house;　10
And here he comes.

Enter PILIA-BORZA.

Pilia. Hold thee,[7] wench, there's something for thee
　to spend.
　Bell. 'Tis silver. I disdain it.
　Pilia. Ay, but the Jew has gold,
And I will have it, or it shall go hard.
　Bell. Tell me, how cam'st thou by this?
　Pilia. 'Faith, walking the back lanes, through the
gardens, I chanced to cast mine eye up to the Jew's
counting-house, where I saw some bags of money, and
in the night I clambered up with my hooks,[8] and,　20
as I was taking my choice, I heard a rumbling in the
house; so I took only this, and run my way: but here's
the Jew's man.

Enter ITHAMORE.

Bell. Hide the bag.
　Pilia. Look not towards him, let's away; zoons,[9]
what a looking[10] thou keep'st; thou'lt betray 's anon.

　　　　[Exeunt BELLAMIRA *and* PILIA-BORZA.*]*
　Itha. O the sweetest face that ever I beheld! I know

95 *resolved:* satisfied.
96 *rather:* for "rathe" in original.
97 *accessary:* accent on first syllable.
98 *My . . . me:* I have a foreboding of evil business.
99 *cross:* thwart.　　　　　　　100 *enow:* enough.
101 *purchase:* compass.
102 *straight:* at once. Barabas presumably hands Ithamore
a letter.　　　　　　　103 *readiness:* alacrity.

III.i.
1 *Courtesan:* Expensive prostitute.
2 *my . . . cold:* i.e., my earnings have decreased.
3 *Venice . . . Padua:* trading port and center of learning,
respectively.　　　　　　4 *liberal:* free spending.
5 *Pilia-Borza:* The name suggests a cutpurse or pick-
pocket.
6 *from:* away from.　　　7 *Hold thee:* Here! take it!
8 *hooks:* for grappling.
9 *zoons:* zounds ("God's wounds!").
10 *looking:* fixed stare, which serves to give them away.

she is a courtesan by her attire: [11] now would I give a
hundred of the Jew's crowns that I had such a concu-
bine. 30
Well, I have delivered the challenge in such sort,
As meet they will, and fighting die; brave sport.

Exit.

[III.ii]

Enter MATHIAS, [*reading*].

Math. This [1] is the place; now Abigail shall see
Whether Mathias holds her dear or no.

Enter LODOWICK, *reading.*

What, dares the villain write in such base terms? [2]
Lod. I did it; and revenge it if thou darest.

[*They*] *fight.*

Enter BARABAS *above.*

Bar. Oh! bravely fought; and yet they thrust not
 home.
Now, Lodowick! now, Mathias! So—

[*Both fall.*]

So now they have showed themselve to be tall [3] fellows.
 [*Cries*] *within.* Part 'em, part 'em.
Bar. Ay, part 'em now they are dead. Farewell, fare-
well. 10

Exit.

Enter [FERNEZE, KATHERINE, [4] *and* Attendants.]

Fern. What sight is this! my Lodowick slain!
These arms of mine shall be thy sepulcher,
Kath. Who is this? My son Mathias slain!
Fern. O Lodowick! had'st thou perished by the Turk,
Wretched Ferneze might have 'venged thy death.
Kath. Thy son slew mine, and I'll revenge his death.
Fern. Look, Katherine, look! Thy son gave mine
 these wounds.

Kath. Oh, leave [5] to grieve me, I am grieved enough.
Fern. Oh! that my sighs could turn to lively [6] breath;
And these my tears to blood, that he might live. 20
Kath. Who made them enemies?
Fern. I know not, and that grieves me most of all.
Kath. My son loved thine.
Fern. And so did Lodowick him.
Kath. Lend me that weapon that did kill my son,
And it shall murder me.
Fern. Nay, madam, stay; that weapon was my son's,
And on that rather should Ferneze die.
Kath. Hold, let's inquire the causers of their deaths,
That we may 'venge their blood upon their heads.
Fern. Then take them up, [7] and let them be interred
Within one sacred monument of stone; 31
Upon which altar I will offer up
My daily sacrifice of sighs and tears,
And with my prayers pierce impartial [8] heavens,
Till they [reveal] [9] the causers of our smarts, [10]
Which [11] forced their hands divide united hearts:
Come, Katherine, our losses equal are,
Then of true grief let us take equal share.

Exeunt.

[III.iii]

Enter ITHAMORE.

Itha. Why, was there ever seen such villainy,
So neatly plotted, and so well performed?
Both held in hand, [1] and flatly [2] both beguiled?

Enter ABIGAIL.

Abig. Why, how now, Ithamore, why laugh'st thou
so?
Itha. O mistress, ha! ha! ha!
Abig. Why, what ail'st thou?
Itha. O my master!
Abig. Ha! 9
Itha. O mistress! I have the bravest, [3] gravest, secret,
subtle, bottle-nosed [4] knave to [5] my master, that ever
gentleman had.
Abig. Say, knave, why rail'st upon [6] my father thus?
Itha. Oh, my master has the bravest policy.
Abig. Wherein?
Itha. Why, know you not?
Abig. Why, no.
Itha. Know you not of Mathias' and Don Lodo-
wick's [7] disaster?
Abig. No, what was it? 20
Itha. Why, the devil invented a challenge, my mas-
ter writ it, and I carried it, first to Lodowick, and *im-
primis* [8] to Mathias.
And then they met, and, as the story says,
In doleful wise they ended both their days.
Abig. And was my father furtherer of their deaths?
Itha. Am I Ithamore?
Abig. Yes.
Itha. So sure did your father write, and I carry the
challenge. 30
Abig. Well, Ithamore, let me request thee this,
Go to the new-made nunnery, and inquire

[11] *attire:* loose-bodied and flowing gown, the uniform of
the courtesan.
III.ii.
 [1] *This:* the common mode in the Elizabethan drama of
denoting the setting of a scene—here, a public street, before
the house of Barabas.
 [2] There is some textual confusion here. Some modern
editors think a line or two may have dropped out.
 [3] *tall:* brave (ironically).
 [4] *Ferneze, Katherine:* Q reads "governor, Mater."
 [5] *leave:* cease. [6] *lively:* life-giving.
 [7] *Then . . . up:* Here the bodies are removed—necessarily,
because no curtain depended from the front stage.
 [8] *impartial:* indifferent, and hence, by extension,
"partial(?)." [9] *reveal:* Dyce's addition.
 [10] *smarts:* injuries. [11] *Which:* The unknown "causers."
III.iii.
 [1] *held in hand:* kept in false expectation.
 [3] *flatly:* completely. [3] *bravest:* best, most cunning.
 [4] *bottle-nosed:* The stage Jew, like the devil in the moral-
ity plays, is recognized by a large nose.
 [5] *to:* for. [6] *upon:* against.
 [7] *Mathias' . . . Lodowick's:* Q reads "Mathia . . . Lodo-
wick."
 [8] *L.:* first. Ithamore, like low comic characters in
Shakespeare, misuses difficult terms.

For any of the friars of Saint Jacques,[9]
And say, I pray them come and speak with me.
 Itha. I pray, mistress, will you answer me to one
question?
 Abig. Well, sirrah, what is't?
 Itha. A very feeling[10] one: have not the nuns fine
sport with the friars now and then?
 Abig. Go to, sirrah sauce,[11] is this your question?
Get ye gone. 41
 Itha. I will, forsooth, mistress.
 Exit.

 Abig. Hard-hearted father, unkind Barabas!
Was this the pursuit[12] of thy policy!
To make me show them favor severally,[13]
That by my favor they should both be slain?
Admit thou lovedst not Lodowick for his sin,[14]
Yet Don Mathias ne'er offended thee:
But thou wert set upon extreme[15] revenge,
Because the prior[16] dispossessed thee once, 50
And could'st not 'venge it, but upon his son,
Nor on his son, but by Mathias' means;
Nor on Mathias, but by murdering me.
But I perceive there is no love on earth,
Pity in Jews, nor piety in Turks.
But here comes cursèd Ithamore, with the friar.

 Enter ITHAMORE [*and*] Friar [JACOMO].

 F. Jac. Virgo, salve.[17]
 Itha. When![18] duck you![19]
 Abig. Welcome, grave friar; Ithamore, begone.
 Exit [ITHAMORE.]
Know, holy sir, I am bold to solicit thee. 60
 F. Jac. Wherein?
 Abig. To get me be admitted for a nun.
 F. Jac. Why, Abigail, it is not yet long since
That I did labor[20] thy admission,
And then thou did'st not like that holy life.
 Abig. Then were my thoughts so frail and uncon-
 firmed,[21]
And I was chained to follies of the world:
But now experience, purchasèd with grief,
Has made me see the difference of things.
My sinful soul, alas, hath paced too long 70
The fatal labyrinth of misbelief,
Far from the Son[22] that gives eternal life.
 F. Jac. Who taught thee this?
 Abig. The abbess of the
 house,
Whose zealous admonition[23] I embrace:[24]
Oh, therefore, Jacomo, let me be one,
Although unworthy, of that sisterhood.
 F. Jac. Abigail, I will, but see thou change no more,
For that will be most heavy[25] to thy soul.
 Abig. That was my father's fault.
 F. Jac. Thy father's! how?
 Abig. Nay, you shall pardon me. [*Aside*] O Barabas,
Though thou deservest hardly[26] at my hands, 81
Yet never shall these lips bewray[27] thy life.
 F. Jac. Come, shall we go?
 Abig. My duty waits on you.
 Exeunt.

[III.iv]

 Enter BARABAS, *reading a letter.*

 Bar. What, Abigail become a nun again!
False and unkind;[1] what, hast thou lost thy father?
And all unknown, and unconstrained of me,
Art thou again got to the nunnery?
Now here she writes, and wills[2] me to repent.
Repentance! *Spurca!*[3] what pretendeth[4] this?
I fear she knows—'tis so—of my device[5]
In Don Mathias' and Lodowick's deaths:
If so, 'tis time that it be seen into:[6]
For she that varies from me in belief 10
Gives great presumption[7] that she loves me not;
Or loving, doth dislike of something done.—
But who comes here?

 [*Enter* ITHAMORE.]

 O Ithamore, come near;
Come near, my love; come near, thy master's life,
My trusty servant, nay, my second self:
For I have now no hope but even in thee,
And on that hope my happiness is built.
When saw'st thou Abigail?
 Itha. Today.
 Bar. With whom?
 Itha. A friar.
 Bar. A friar! false villain, he hath done the deed. 20
 Itha. How,[8] sir?
 Bar. Why, made mine Abigail a nun.
 Itha. That's no lie, for she sent me for him.
 Bar. O unhappy day!
False, credulous, inconstant Abigail!
But let 'em go: Ithamore, from hence
Ne'er shall she grieve me more with her disgrace;
Ne'er shall she live to inherit aught of mine,
Be blessed of me, nor come within my gates,
But perish underneath my bitter curse,
Like Cain by Adam for his brother's death. 30
 Itha. O master!

 [9] *Jacques:* Dominicans or Jacobin friars, after their Paris
church of St. Jaques. Q reads "Jaynes."
 [10] *feeling:* earnest, with a pun on erotic "feeling."
 [11] *sirrah sauce:* impudence.
 [12] *pursuit:* direction, drift. [13] *severally:* separately.
 [14] *sin:* because of his parentage; or perhaps a compositor's
error for "sire," which comes down to the same thing.
 [15] *extreme:* utmost.
 [16] *prior:* chief magistrate, governor.
 [17] *L.:* Young woman, God save you.
 [18] *When!:* exclamation of impatience, like "How!"
 [19] *duck you!:* make a bow! [20] *labor:* labor for.
 [21] *unconfirmed:* not yet firm.
 [22] *Son:* punning also on "sun."
 [23] *admonition:* counsel.
 [24] *embrace:* accept joyfully. [25] *heavy:* grievous.
 [26] *hardly:* grievously.
 [27] *bewray:* betray to execution.

III.iv.
 [1] *unkind:* unnatural. [2] *wills:* entreats.
 [3] *L.:* Filthy! [4] *pretendeth:* meaneth.
 [5] *device:* trick. [6] *seen into:* looked to.
 [7] *presumption:* grounds for supposing. [8] *How:* What.

Bar. Ithamore, entreat not for her, I am moved,[9]
And she is hateful to my soul and me:
And 'less[10] thou yield to this that I entreat,
I cannot think but that thou hat'st my life.
 Itha. Who, I, master? Why, I'll run to some rock,
And throw myself headlong into the sea;
Why, I'll do anything for your sweet sake.
 Bar. O trusty Ithamore, no servant, but my friend:
I here adopt thee for mine only heir, 40
All that I have is thine when I am dead,
And whilst I live use half;[11] spend as myself;
Here take my keys, I'll give 'em thee anon:[12]
Go buy thee garments: but thou shalt not want:
Only know this, that thus thou art to do:
But first go fetch me in the pot of rice
That for our supper stands upon the fire.
 Itha. [*Aside*] I hold[13] my head, my master's hungry.
—I go, sir.

Exit.

 Bar. Thus every villain ambles[14] after wealth, 50
Although he ne'er be richer than in hope:
But, husht!

Enter ITHAMORE *with the pot.*

 Itha. Here 'tis, master.
 Bar. Well said, Ithamore.
What, has thou brought the ladle with thee too?
 Itha. Yes, sir, the proverb says he that eats with the
devil had need of a long spoon. I have brought you a
ladle.
 Bar. Very well, Ithamore, then now be secret;
And for thy sake ,whom I so dearly love,
Now shalt thou see the death of Abigail,
That thou may'st freely live to be my heir. 60
 Itha. Why, master, will you poison her with a mess[15]
of rice porridge? That will preserve life, make her

round and plump, and batten[16] more than you are
aware.
 Bar. Ay, but, Ithamore, seest thou this?
It is a precious powder that I bought
Of an Italian in Ancona,[17] once,
Whose operation is to bind,[18] infect,
And poison deeply, yet not appear
In forty hours after it is ta'en. 70
 Itha. How master?
 Bar. Thus, Ithamore.
This even they use[19] in Malta here,—'tis called
Saint Jacques' Even,—and then I say they use
To send their alms unto the nunneries:
Among the rest bear this, and set it there;
There's a dark entry where they take it in,
Where they must neither see the messenger,
Nor make inquiry who hath sent it them.
 Itha. How so? 80
 Bar. Belike there is some ceremony in't.
There, Ithamore, must thou go place this plot!
Stay, let me spice it first.
 Itha, Pray do, and let me help you, master. Pray let
me taste first.
 Bar. Prithee do. What say'st thou now?
 Itha. Troth, master, I'm loath such a pot of pottage[20]
should be spoiled.
 Bar. Peace, Ithamore, 'tis better so than spared.[21]
Assure thyself thou shalt have broth by the eye.[22] 90
My purse, my coffer, and my self is thine.

[Puts in poison.]

 Itha. Well, master, I go.
 Bar. Stay, first let me stir it, Ithamore.
As fatal be it to her as the draught
Of which great Alexander[23] drunk and died:
And with her let it work like Borgia's[24] wine,
Whereof his sire, the Pope, was poisonèd.
In few,[25] the blood of Hydra,[26] Lerna's bane:[27]
The juice of hebon,[28] and Cocytus'[29] breath,
And all the poisons of the Stygian pool[30] 100
Break from the fiery kingdom; and in this
Vomit your venom and envenom her
That like a fiend hath left her father thus.
 Itha. What a blessing has he given't! was ever pot of
rice porridge so sauced! What shall I do with it?
 Bar. O my sweet Ithamore, go set it down,
And come again so soon as thou hast done,
For I have other business for thee.
 Itha. Here's a drench[31] to poison a whole stable of
Flanders mares: I'll carry 't to the nuns with a powder.[32]
 Bar. And the horse pestilence to boot;[33] away! 111
 Itha. I am gone.
Pay me my wages, for my work is done.

Exit [with the pot].

 Bar. I'll pay thee with a vengeance, Ithamore.

Exit.

[III.v]

Enter FERNEZE, [MARTIN DEL] BOSCO, Knights,
 [*and*] Basso.

 Fern. Welcome, great basso;[1] how fares Calymath?
What wind drives you thus into Malta road?

[9] *moved:* angered. [10] *'less:* unless. Q reads "least."
[11] *half:* Q reads "helfe."
[12] *anon:* soon. Barabas is promising more than he pays.
[13] *hold:* wager. [14] *ambles:* trots easily, like a horse.
[15] *mess:* serving. [16] *batten:* grow fat.
[17] *Ancona:* where Portuguese Jews found asylum.
[18] *bind:* constipate. [19] *use:* are accustomed to.
[20] *pottage:* soup. [21] *spared:* not used.
[22] *by the eye:* abundantly.
[23] *Alexander:* who, according to one tradition, died after
much drinking at a feast; to another. after having been
poisoned by his teacher, Aristotle.
[24] *Borgia's:* Caesar Borgia (with whom Machiavelli was
popularly associated as counselor) was supposed to have
poisoned his father, Pope Alexander VI.
[25] *In few:* In brief.
[26] *Hydra:* nine-headed monster whom Hercules slew as
one of his labors.
[27] *Lerna's bane:* poison (metaphorically) to the marshy
country where it lived.
[28] *hebon:* perhaps the yew, considered to be poisonous.
[29] *Cocytus':* alluding to a river in Hades.
[30] *Stygian pool:* formed by the river Styx, which girdled
the Underworld; identified subsequently with a poisonous
well in Arcadia.
[31] *drench:* medicinal dose, appropriate to horses.
[32] *powder:* the poison with which the porridge is spiced.
[33] *to boot:* in addition.
III.v.
[1] *basso:* Q reads "Bashaws."

Bas. The wind that bloweth all the world besides,—
Desire of gold.
 Fern. Desire of gold, great sir?
That's to be gotten in the Western Ind:
In Malta are no golden minerals.
 Bas. To you of Malta thus saith Calymath:
The time you took for respite is at hand,
For the performance of your promise passed,
And for the tribute-money I am sent. 10
 Fern. Basso, in brief, 'shalt have no tribute here,
Nor shall the heathens live upon our spoil:
First will we raze the city walls ourselves,
Lay waste the island, hew the temples down,
And, shipping off our goods to Sicily,
Open an entrance for the wasteful[2] sea,
Whose billows beating the resistless[3] banks,
Shall overflow with their refluence.[4]
 Bas. Well, governor, since thou hast broke the
 league
By flat denial of the promised tribute, 20
Talk not of razing down your city walls,
You shall not need trouble yourselves so far,
For Selim Calymath shall come himself,
And with brass bullets batter down your towers,
And turn proud Malta to a wilderness
For these intolerable wrongs of yours;
And so farewell.
 Fern. Farewell.
 [Exit Basso.]
And now, you men of Malta, look about,
And let's provide to welcome Calymath: 30
Close your portcullis, charge your basilisks,[5]
And as you profitably[6] take up arms,
So now courageously encounter them;
For by this answer, broken is the league,
And naught is to be looked for now but wars,
And naught to us more welcome is than wars.
 Exeunt.

[III.vi]

 Enter Friar JACOMO *and* Friar BARNARDINE.[1]

F. Jac. O brother, brother, all the nuns are sick,
And physic[2] will not help them: they must die.
 F. Barn. The abbess sent for me to be confessed.
Oh, what a sad confession will there be!
 F. Jac. And so did fair Maria send for me:
I'll to her lodging: hereabouts she lies.
 Exit

 Enter ABIGAIL.

 F. Barn. What, all dead, save only Abigail?
 Abig. And I shall die too, for I feel death coming.
Where is the friar that conversed with me?
 F. Barn. Oh, he is gone to see the other nuns. 10
 Abig. I sent for him, but seeing you are come,
Be you my ghostly father:[3] and first know,
That in this house I lived religiously,
Chaste, and devout, much sorrowing for my sins;
But ere I came—
 F. Barn. What then?

 Abig. I did offend high heaven so grievously,
As I am almost desperate for my sins:
And one offense torments me more than all.
You knew Mathias and Don Lodowick? 20
 F. Barn. Yes, what of them?
 Abig. My father did contract[4] me to 'em both:
First to Don Lodowick; him I never loved;
Mathias was the man that I held dear,
And for his sake did I become a nun.
 F. Barn. So, say how was their end?
 Abig. Both, jealous of my love, envied[5] each other,
And by my father's practice,[6] which is there
Set down at large,[7] the gallants were both slain.

 [Gives a written paper.]

 F.Barn. Oh, monstrous villainy! 30
 Abig. To work[8] my peace, this I confess to thee;
Reveal it not, for then my father dies.
 F. Barn. Know that confession must not be revealed,
The canon law forbids it, and the priest
That makes it known, being degraded[9] first,
Shall be condemned, and then sent to the fire.
 Abig. So I have heard; pray, therefore, keep it close.[10]
Death seizeth on my heart: ah gentle friar,
Convert my father that he may be saved,
And witness that I die a Christian. 40
 [Dies]
 F. Barn. Ay, and a virgin too; that grieves me most:
But I must to the Jew and exclaim on[11] him,
And make him stand in fear of me.

 [Re-enter Friar JACOMO.][12]

 F. Jac. O brother, all the nuns are dead, let's bury
 them.
 F. Barn. First help to bury this,[13] then go with me
And help me to exclaim against[14] the Jew
 F. Jac. Why, what has he done?
 F. Barn. A thing that makes me tremble to unfold.
 F. Jac. What, has he crucified a child?[15]
 F. Barn. No, but a worse thing: 'twas told me in
 shrift,[16] 50
Thou know'st 'tis death and if it be revealed.
Come, let's away.
 Exeunt.

 [2] *wasteful:* i.e., which lays waste.
 [3] *resistless:* incapable of resistance.
 [4] *refluence:* flowing back.
 [5] *basilisks:* large brass cannons, resembling the fabulous
serpent called the basilisk.
 [6] *profitably:* for your own profit.
III.vi.
 [1] *Enter . . . Barnardine:* Q reads "Enter two Fryars and
Abigail."
 [2] *physic:* medicine. [3] *ghostly father:* confessor.
 [4] *contract:* betroth. [5] *envied:* hated.
 [6] *practice:* scheming. [7] *at large:* in full.
 [8] *work:* achieve. [9] *degraded:* unfrocked.
 [10] *close:* secret. [11] *exclaim on:* accuse.
 [12] *Re-enter . . . Jacomo:* Q reads "Enter 1 Friar."
 [13] *this:* Abigail. [14] *exclaim against:* complain of.
 [15] *crucified a child:* as Jews were alleged to do, especially
by governors in need of money.
 [16] *shrift:* confession.

ACT FOUR

SCENE ONE

Enter BARABAS[*and*] ITHAMORE. *Bells within.*

Bar. There is no music to [1] a Christian's knell:
How sweet the bells ring now the nuns are dead,
That sound at other times like tinkers' pans!
I was afraid the poison had not wrought: [2]
Or, though it wrought, it would have done no good,
For every year they swell, [3] and yet they live;
Now all are dead, not one remains alive.
Itha. That's brave, [4] master, but think you it will not
be known?
Bar. How can it, if we two be secret? 10
Itha. For my part fear you not.
Bar. I'd cut thy throat if I did.
Itha. And reason too.
But here's a royal [5] monastery hard by;
Good master, let me poison all the monks.
Bar. Thou shalt not need, for now the nuns are dead
They'll die with grief.
Itha. Do you not sorrow for your daughter's death?
Bar. No, but I grieve because she lived so long.
An Hebrew born, and would become a Christian!
Cazzo, diabolo. [6] 20

Enter the two Friars[JACOMO *and* BARNARDINE].

Itha. Look, look, master, here come two religious
caterpillars. [7]
Bar. I smelt 'em ere they came.
Itha. God-a-mercy, nose! Come, let's begone.
F. Barn. Stay, wicked Jew, repent, I say, and stay.
F. Jac. Thou hast offended, therefore must be
damned.
Bar. I fear they know we sent the poisoned broth.
Itha. And so do I, master; therefore speak 'em fair.
F. Barn. Barabas, thou hast—
F. Jac. Ay, that thou hast— 30
Bar. True, I have money, what though I have?
F. Barn. Thou art a—
F. Jac. Ay, that thou art, a—
Bar. What needs all this? I know I am a Jew.
F. Barn. Thy daughter—

F. Jac. Ay, thy daughter—
Bar. Oh, speak not of her! then I die with grief.
F. Barn. Remember that—
F. Jac. Ay, remember that—
Bar. I must needs say that I have been a great usurer.
F. Barn. Thou has committed— 41
Bar. Fornication—but that was in another country;
And besides, the wench is dead.
F. Barn. Ay, but, Barabas,
Remember Mathias and Don Lodowick.
Bar. Why, what of them?
F. Barn. I will not say that by a forged challenge
they met.
Bar. [*Aside*] She has confessed, and we are both
undone.
My bosom inmates! [8] but I must dissemble.—
O holy friars, the burden of my sins 50
Lie heavy on my soul; then pray you tell me,
Is't not too late now to turn Christian?
I have been zealous in the Jewish faith,
Hard-hearted to the poor, a covetous wretch,
That would for lucre's sake have sold my soul.
A hundred for a hundred [9] I have ta'en;
And now for store of wealth may I compare
With all the Jews of Malta; but what is wealth?
I am a Jew, and therefore am I lost.
Would penance serve for this my sin, 60
I could afford to whip myself to death—
Itha. And so could I; but penance will not serve.
Bar. To fast, to pray, and wear a shirt of hair,
And on my knees creep to Jerusalem.
Cellars of wine, and sollars [10] full of wheat,
Warehouses stuffed with spices and with drugs, [11]
Whole chests of gold, in bullion, and in coin,
Besides I know not how much weight in pearl,
Orient [12] and round, have I within my house;
At Alexandria, merchandise unsold: 70
But yesterday two ships went from this town,
Their voyage will be worth ten thousand crowns.
In Florence, Venice, Antwerp, London, Sèville,
Frankfort, Lubeck, Moscow, and where not,
Have I debts owing; and in most of these,
Great sums of money lying in the banco; [13]
All this I'll give to some religious house.
So [14] I may be baptized, and live therein.
F. Jac. O good Barabas, come to our house. 79
F. Barn. Oh, no, good Barabas, come to our house.
And Barabas, you know—
Bar. I know that I have highly sinned.
You shall convert me, you shall have all my wealth.
F. Jac. O Barabas, their laws are strict.
Bar. I know they are, and I will be with you.
F. Barn. They wear no shirts, and they go barefoot
too.
Bar. Then 'tis not for me; and I am resolved
You shall confess me, and have all my goods.
F. Jac. Good Barabas, come to me.
Bar. You see I answer him, and yet he stays; 90
Rid [15] him away, and go you home with me.
F. Jac. I'll be with you tonight.
Bar. Come to my house at one o'clock this night.

IV.i.

[1] *to:* comparable to. [2] *wrought:* worked.
[3] *swell:* i.e., with child. [4] *brave:* fine.
[5] *royal:* like "brave" above.
[6] *It.:* Q's "Catho diabola" is presumably meant to
suggest a contemptuous oath like "What the devil!"
"Cazzo" is Italian vulgar argot for "prick."
[7] *caterpillars:* called so because they are parasitic on
society.
[8] *bosom inmates:* i.e., the friars are now partakers of my
inmost secrets.
[9] *hundred . . . hundred:* Barabas the usurer has charged
interest at the rate of one hundred per cent.
[10] *sollars:* lofts used as granaries.
[11] *drugs:* used generically for chemicals, pharmaceuticals,
etc.
[12] *Orient:* from the East, and generally meaning "lust-
rous." [13] *banco:* commercial bank.
[14] *So:* if. [15] *Rid:* remove.

F. Jac. You hear your answer, and you may be gone.

F. Barn. Why, go get you away.

F. Jac. I will not go for [16] thee.

F. Barn. Not! then I'll make thee go.

F. Jac. How, dost call me rogue? [17]

[They] fight.

Itha. Part 'em, master, part 'em.

Bar. This is mere frailty, brethren; be content. 100
[*Aside*] Friar Barnardine, go you with Ithamore:
You know my mind, let me alone [18] with him.

F. Jac. Why does he go to thy house? Let him be gone. [19]

Bar. I'll give him something and so stop his mouth.

Exit [ITHAMORE *with* Friar BARNARDINE].
I never heard of any man but he
Maligned the order of the Jacobins: [20]
But do you think that I believe his words?
Why, brother, you converted Abigail;
And I am bound in charity to requite it,
And so I will. O Jacomo, fail not, but come. 110

F. Jac. But, Barabas, who shall be your godfathers?
For presently you shall be shrived. [21]

Bar. Marry, the Turk [22] shall be one of my godfathers,
But not a word to any of your covent. [23]

F. Jac. I warrant [24] thee, Barabas.

Exit.

Bar. So, now the fear is past, and I am safe,
For he that shrived her is within my house;
What if I murdered him ere Jacomo comes?
Now I have such a plot for both their lives
As never Jew nor Christian knew the like: 120
One turned [25] my daughter; therefore he shall die;
The other knows enough to have my life,
Therefore 'tis not requisite he should live. [26]
But are not both these wise men to suppose
That I will leave my house, my goods, and all,
To fast and be well whipped? I'll none of that.
Now Friar Barnardine I come to you,
I'll feast you, lodge you, give you fair words,
And after that, I and my trusty Turk—
No more, but so: [27] it must and shall be done. 130

Enter ITHAMORE.

Ithamore, tell me, is the friar asleep?

Itha. Yes; and I know not what the reason is:
Do what I can he will not strip himself,
Nor go to bed, but sleeps in his own clothes;
I fear me he mistrusts what we intend.

Bar. No, 'tis an order which the friars use: [28]
Yet, if he knew our meanings, could he 'scape?

Itha. No, none can hear him, cry he ne'er so loud.

Bar. Why, true; therefore did I place him there:
The other chambers open towards the street. 140

Itha. You loiter, master; wherefore stay we thus?
Oh, how I long to see him shake his heels. [29]

Bar. Come on, sirrah.
Off with your girdle, [30] make a handsome noose.
Friar, awake! [31]

F. Barn. What, do you mean to strangle me?

Itha. Yes, 'cause you use to confess. [32]

Bar. Blame not us but the proverb, Confess and be hanged; pull hard!

F. Barn. What, will you save [33] my life? 149

Bar. Pull hard, I say; you would have had my goods.

Itha. Ay, and our lives too, therefore pull amain. [34]

[They strangle him.]

'Tis neatly done, sir, here's no print [35] at all.

Bar. Then is it as it should be; take him up.

Itha. Nay, master, be ruled by me a little. [36] So,
let him lean upon his staff; excellent! he stands as if he
were begging of bacon.

Bar. Who would not think but that this friar lived?
What time a' night is't now, sweet Ithamore?

Itha. Towards one.

Bar. Then will not Jacomo be long from hence. 160

[Exeunt.]

Enter [Friar] JACOMO.

F. Jac. This is the hour wherein I shall proceed; [37]
Oh, happy hour wherein I shall convert
An infidel, and bring his gold into our treasury!
But soft, [38] is not this Barnardine? It is;
And, understanding I should come this way,
Stands here a' purpose, meaning me some wrong,
And intercept [39] my going to the Jew.—
Barnardine!
Wilt thou not speak? Thou think'st I see thee not;
Away, I'd wish thee, and let me go by: 170
No, wilt thou not? Nay, then, I'll force my way;
And see, a staff stands ready for the purpose:
As thou lik'st that, stop me another time.

Strike[s] him, he falls.

Enter BARABAS [*and* ITHAMORE].

Bar. Why, how now, Jacomo, what hast thou done?

F. Jac. Why, stricken him that would have struck at me.

[16] *for:* because of.

[17] *rogue:* Jacomo has perhaps misheard Barnardine's "go."

[18] *let me alone:* leave it to me (to deal).

[19] *You . . . gone:* Q assigns these two lines to Ithamore.

[20] *Jacobins:* Dominicans.

[21] *shrived:* confessed and then baptized.

[22] *Turk:* Ithamore. [23] *covent:* convent.

[24] *warrant:* assure. [25] *turned:* converted.

[26] *Therefore . . . live:* an ironic understatement meaning "It is requisite he should not live."

[27] *No . . . so:* common Elizabethan expression signifying "So be it" or "That's that."

[28] *order . . . use:* custom . . . follow.

[29] *shake his heels:* as when he is hanged. [30] *girdle:* belt.

[31] *awake:* Presumably at this point Barabas parts the curtains of the inner stage to reveal Barnardine asleep.

[32] *'cause . . . confess:* because you are accustomed to hear (and reveal) confessions.

[33] *save:* commonly emended to "have."

[34] *amain:* strongly.

[35] *print:* mark on his neck from the belt.

[36] *Nay . . . little:* Ithamore accompanies his words by dragging the Friar from the inner stage and propping him on his staff against one of the pillars that supported the "heavens" or partial roof above the main stage.

[37] *proceed:* succeed. [38] *soft:* wait.

[39] *intercept:* to intercept.

Bar. Who is it? Barnardine! now out, alas,⁴⁰ he is slain!

Itha. Ay, master, he's slain; look how his brains drop out on's⁴¹ nose.

F. Jac. Good sirs, I have done't, but nobody knows it but you two—I may escape. 181

Bar. So might my man and I hang with you for company.

Itha. No, let us bear him to the magistrates.

F. Jac. Good Barbaras, let me go.

Bar. No, pardon me; the law must have his course. I must be forced to give in evidence That bring importuned by this Barnardine To be a Christian, I shut him out, And there he sat: now I, to keep my word, 190 And give my goods and substance to your house, Was up thus early; with intent to go Unto your friary, because you stayed.⁴²

Itha. Fie upon 'em master; will you turn Christian when holy friars turn devils and murder one another?

Bar. No, for this example I'll remain a Jew: Heaven bless me! what, a friar a murderer? When shall you see a Jew commit the like?

Itha. Why, a Turk could ha' done no more.

Bar. Tomorrow is the sessions:⁴³ you shall to it. 200 Come, Ithamore, let's help to take him hence.

F. Jac. Villains, I am a sacred person; touch me not.

Bar. The law shall touch⁴⁴ you, we'll but lead you, we:

'Las, I could weep at your calamity! Take in the staff too, for that must be shown: Law wills that each particular⁴⁵ be known.

 Exeunt.

[IV.ii]

Enter BELLAMIRA *and* PILIA-BORZA.

Bell. Pilia-Borza, did'st thou meet with Ithamore?
Pilia. I did.

⁴⁰ *out, alas:* expressive of horror. ⁴¹ *on's:* of his.
⁴² *stayed:* delayed to come.
⁴³ *sessions:* when the court sits. ⁴⁴ *touch:* accuse.
⁴⁵ *particular:* bit of evidence.

IV.ii.
¹ *saluted:* addressed. ² *tall:* splendid.
³ *non-plus:* state of perplexity.
⁴ *critical:* fault-finding.
⁵ *freehold:* where Pilia-Borza spends his time; literally, a property held for life.
⁶ *neck-verse:* Latin verse, generally from the beginning of the 51st Psalm, given to a criminal to see whether he could read it and hence claim his freedom from punishment or "benefit of clergy." ⁷ *of:* on at.
⁸ *hempen:* appropriate to the hangman's rope; also, "common." ⁹ *L.:* You today, me tomorrow.
¹⁰ *exercise:* ceremony (ironically).
¹¹ *tippet:* noose; literally, a clergyman's scarf.
¹² *cure to serve:* parish to minister to.
¹³ *muschatoes:* mustachios.
¹⁴ *Turk of tenpence:* of no value; "tenpenny" was a familiar term of contempt. ¹⁵ *hale:* pull.
¹⁶ *clean:* completely (with a pun to contrast with "foully").
¹⁷ *out . . . way:* bewildered. ¹⁸ *discharged:* unloaded.
¹⁹ *And:* If.

Bell. And did'st thou deliver my letter?
Pilia. I did.
Bell. And what think'st thou? Will he come?
Pilia. I think so, but yet I cannot tell; for at the reading of the letter he looked like a man of another world.
Bell. Why so? 9
Pilia. That such a base slave as he should be saluted¹ by such a tall² man as I am, from such a beautiful dame as you.
Bell. And what said he?
Pilia. Not a wise word, only gave me a nod, as who should say, "Is it even so?" And so I left him, being driven to a non-plus³ at the critical⁴ aspect of my terrible countenance.
Bell. And where didst meet him?
Pilia. Upon mine own freehold,⁵ within forty foot of the gallows, conning his neck-verse,⁶ I take it, 20 looking of⁷ a friar's execution, whom I saluted with an old hempen⁸ proverb, *Hodie tibi, cras mihi,*⁹ and so I left him to the mercy of the hangman: but the exercise¹⁰ being done, see where he comes.

Enter ITHAMORE.

Itha. I never knew a man take his death so patiently as this friar; he was ready to leap off ere the halter was about his neck; and when the hangman had put on his hempen tippet,¹¹ he made such haste to his prayers, as if he had had another cure to serve.¹² Well, go whither he will, I'll be none of his followers in haste: and, now 30 I think on't, going to the execution, a fellow met me with a muschatoes¹³ like a raven's wing, and a dagger with a hilt like a warming-pan, and he gave me a letter from one Madam Bellamira, saluting me in such sort as if he had meant to make clean my boots with his lips; the effect was, that I should come to her house. I wonder what the reason is; it may be she sees more in me than I can find in myself: for she writes further that she loves me ever since she saw me, and who would not requite such love? Here's her house, and here she comes, 40 and now would I were gone; I am not worthy to look upon her.

Pilia. This is the gentleman you writ to.

Itha. [*Aside*] Gentleman! he flouts me; what gentry can be in a poor Turk of tenpence?¹⁴ I'll be gone.

Bell. Is't not a sweet-faced youth, Pilia?

Itha. [*Aside*] Again, "sweet youth!"—Did not you, sir, bring the sweet youth a letter?

Pilia. I did, sir, and from this gentlewoman, who, as myself, and the rest of the family, stand or fall at your service. 51

Bell. Though woman's modesty should hale¹⁵ me back, I can withhold no longer; welcome, sweet love.

Itha. [*Aside*] Now am I clean,¹⁶ or rather foully out of the way.¹⁷

Bell. Whither so soon?

Itha. [*Aside*] I'll go steal some money from my master to make me handsome.—Pray pardon me, I must go and see a ship discharged.¹⁸

Bell. Canst thou be so unkind to leave me thus? 60
Pilia. And¹⁹ ye did but know how she loves you, sir.

Itha. Nay, I care not how much she loves me—
Sweet Bellamira, would I had my master's wealth for
thy sake!

Pilia. And you can have it, sir, and if you please.

Itha. If 'twere above ground, I could and would have
it; but he hides and buries it up, as partridges do their
eggs, under the earth.

Pilia. And is't not possible to find it out?

Itha. By no means possible. 70

Bell. [*Aside to* PILIA-BORZA.] What shall we do with
this base villain then?

Pilia. [*Aside to her.*] Let me alone; do you but speak
him fair.—20
But you know some secrets of the Jew,
Which, if they were revealed ,would do him harm.

Itha. Ay, and such as—Go to,21 no more! I'll make
him send me half he has, and glad he 'scapes so too. Pen
and ink! I'll write unto him; we'll have money straight.22

Pilia. Send for a hundred crowns at least. 80

Itha. Ten hundred thousand crowns. [*He writes.*]
"Master Barabas."

Pilia. Write not so submissively, but threatening
him.

Itha. [*Writes*] "Sirrah Barabas, send me a hundred
crowns."

Pilia. Put in two hundred at least.

Itha. [*Writes*] "I charge thee send me three hundred
by this bearer, and this shall be your warrant: if you
do not—no more, but so."

Pilia. Tell him you will confess. 90

Itha. [*Writes*] "Otherwise I'll confess all."—Vanish,
and return in a twinkle.23

Pilia. Let me alone; I'll use him in his kind.24

 [*Exit* PILIA-BORZA *with the letter.*]

Itha. Hang him, Jew!

Bell. Now, gentle Ithamore, lie in my lap.—
Where are my maids? Provide a running25 banquet;
Send to the merchant, bid him bring me silks,
Shall Ithamore, my love, go in such rags?

Itha. And bid the jeweller come hither too.

Bell. I have no husband, sweet; I'll marry thee. 100

Itha. Content:26 but we will leave this paltry land,
And sail from hence to Greece, to lovely Greece.
I'll be thy Jason,27 thou my golden fleece;
Where painted carpets28 o'er the meads29 are hurled,
And Bacchus' vineyards o'erspread the world;
Where woods and forests go in goodly green,
I'll be Adonis,30 thou shalt be love's queen.
The meads, the orchards, and the primrose lanes,
Instead of sedge31 and reed, bear sugar canes:
Thou in those groves, by Dis32 above, 110
Shalt live with me and be my love.

Bell. Whither will I not go with gentle Ithamore?

Enter PILIA-BORZA.

Itha. How now! hast thou the gold?

Pilia. Yes.

Itha. But came it freely? Did the cow give down33
her milk freely?

Pilia. At reading of the letter, he stared and stamped
and turned aside. I took him by the beard,34 and looked

upon him thus; told him he were best to send it; then
he hugged and embraced me. 120

Itha. Rather for fear than love.

Pilia. Then, like a Jew, he laughed and jeered, and
told me he loved me for your sake, and said what a
faithful servant you had been.

Itha. The more villain he to keep me thus; here's
goodly 'parel,35 is there not?

Pilia. To conclude, he gave me ten crowns.36

Itha. But ten? I'll not leave him worth a gray groat.37
Give me a ream38 of paper; we'll have a kingdom of
gold for't. 130

Pilia. Write for five hundred crowns.

Itha. [*Writes*] "Sirrah Jew, as you love your life send
me five hundred crowns, and give the bearer one
hundred.—"Tell him I must have 't.

Pilia. I warrant your worship shall have 't.

Itha. And if he ask why I demand so much, tell him
I scorn to write a line under a hundred crowns.

Pilia You'd make a rich poet, sir, I am gone.

 [*Exit.*]

Itha. Take thou the money; spend it for my sake.

Bell. 'Tis not thy money, but thyself I weigh;39 140
Thus Bellamira esteems of gold.

 [*Throws it aside.*]
But thus of thee.

 Kisses him.

Itha. That kiss again! she runs division of40 my lips.
What an eye she casts on me! It twinkles41 like a star.

Bell. Come, my dear love, let's in and sleep to-
gether.

Itha. Oh, that ten thousand nights were put in one,
that we might sleep seven years together afore we wake!

Bell. Come, amorous wag,42 first banquet, and then
sleep. 150
 [*Exeunt.*]

[IV.iii]

Enter BARABAS, *reading a letter.*

Bar. "Barabas, send me three hundred crowns.—"
Plain Barabas! Oh, that wicked courtesan!
He was not wont to call me Barabas.
"Or else I will confess": ay, there it goes:

20 *speak him fair:* "sweet-talk" him.
21 *Go to:* exclamation, like "Come!"
22 *straight:* immediately.
23 *in a twinkle:* a phrase from conjuring.
24 *in his kind:* according to his nature (and deserts).
25 *running:* hastily prepared. 26 *Content:* Agreed.
27 *Jason:* who recovered the golden fleece.
28 *painted carpets:* i.e., flowers. 29 *meads:* meadows.
30 *Adonis:* beloved by Venus, the Queen of Love.
31 *sedge:* coarse grass.
32 *Dis:* Pluto, god of the Underworld; hardly "above."
33 *give down:* let flow.
34 *took . . . beard:* a deadly insult (Q reads "sterd").
35 *'parel:* apparel. 36 *ten crowns:* as a tip.
37 *gray groat:* proverbial for something of no value.
38 *ream:* pronounced the same as "realm" and hence
making a pun with "kingdom." 39 *weigh:* value.
40 *runs division of:* plays a musical passage on.
41 *twinkles:* winks. 42 *wag:* term of endearment.

But, if I get him, *coupe de gorge*[1] for that.
He sent a shaggy tottered[2] staring[3] slave,
That when he speaks draws out his grisly[4] beard,
And winds it twice or thrice about his ear;
Whose face has been a grindstone for men's swords;
His hands are hacked, some fingers cut quite off; 10
Who, when he speaks, grunts like a hog, and looks
Like one that is employed in catzerie[5]
And crossbiting,[6]—such a rogue
As is the husband to a hundred whores:[7]
And I by him must send three hundred crowns!
Well, my hope is, he will not stay there still;[8]
And when he comes: Oh, that he were but here!

Enter PILIA-BORZA.

Pilia. Jew, I must have more gold.
Bar. Why, want'st[9] thou any of thy tale?[10]
Pilia. No; but three hundred will not serve his turn.
Bar. Not serve his turn, sir? 21
Pilia. No sir; and, therefore, I must have five hundred more.
Bar. I'll rather—
Pilia. Oh, good words, sir, and send it you were best! see, there's his letter.
Bar. Might he not as well come as send? Pray bid him come and fetch it; what he writes for you, ye shall have straight.
Pilia. Ay, and the rest too, or else— 30
Bar. [*Aside*]. I must make this villain away.[12]
Please you dine with me, sir. [*Aside*] And you shall be most heartily poisoned.
Pilia. No, God-a-mercy. Shall I have these crowns?
Bar. I cannot do it, I have lost my keys.
Pilia. Oh, if that be all, I can pick ope your locks.
Bar. Or climb up to my countinghouse window: you know my meaning.
Pilia. I know enough, and therefore talk not to me of your countinghouse. The gold! or know, Jew, it is in my power to hang thee. 41
Bar. [*Aside*] I am betrayed.—
'Tis not five hundred crowns that I esteem,

I am not moved[13] at that: this angers me,
That he, who knows I love him as myself,
Should write in this imperious vein. Why, sir,
You know I have no child, and unto whom
Should I leave all but unto Ithamore?
Pilia. Here's many words, but no crowns: the crowns!
Bar. Commend me to him, sir, most humbly, 50
And unto your good mistress, as unknown.[14]
Pilia. Speak, shall I have 'em, sir?
Bar. Sir, here they are.
[*Aside*] Oh, that I should part with so much gold!—
Here, take 'em, fellow, with as good a will
[*Aside*] As I would see thee hanged.—Oh, love stops my breath:
Never loved man servant as I do Ithamore!
Pilia. I know it, sir.
Bar. Pray, when, sir, shall I see you at my house?
Pilia. Soon enough, to your cost, sir. Fare you well.
Exit.
Bar. Nay, to thine own cost, villain, if thou com'st!
Was ever Jew tormented as I am? 62
To have a shag-rag[15] knave to come,—
Three hundred crowns,—and then five hundred crowns!
Well, I must seek a means to rid 'em all,
And presently;[16] for in his villainy
He will tell all he knows, and I shall die for't.
I have it:
I will in some disguise go see the slave,
And how the villain revels with my gold. 70
Exit.

[IV.iv]

Enter Courtesan [BELLAMIRA], ITHAMORE, *and* PILIA-BORZA.

Bell. I'll pledge thee, love, and therefore drink it off.
Itha. [*Whispers*] Say'st thou me[1] so? have at it; and do you hear?
Bell. Go to, it shall be so.
Itha. Of[2] that condition I will drink it up. Here's to thee!
Bell. Nay, I'll have all or none.[3]
Itha. There, if thou lov'st me do not leave a drop.
Bell. Love thee! fill me three glasses.
Itha. Three and fifty dozen, I'll pledge thee.
Pilia. Knavely[4] spoke, and like a knight-at-arms.
Itha. Hey, *Rivo Castiliano!*[5] a man's a man! 11
Bell. Now to the Jew.
Itha. Ha! to the Jew, and send me money you were best.
Pilia. What would'st thou do if he should send thee none?
Itha. Do nothing; but I know what I know; he's a murderer.
Bell. I had not thought he had been so brave a man.
Itha. You knew Mathias and the governor's son; he and I killed 'em both, and yet never touched 'em. 21
Pilia. Oh, bravely done.
Itha. I carried the broth that poisoned the nuns; and he and I, snickle hand too fast,[6] strangled a friar.

[1] *Fr.:* I'll cut his throat. [2] *tottered:* tattered.
[3] *staring:* as if wild. [4] *grisly:* horrible, gray.
[5] *catzerie:* presumably some obscene business, connected with *cazzo* in IV.i. Compare the Italian cant phrase: "Cazz' a voi." Alternatively read "cazzeria."
[6] *crossbiting:* cheating.
[7] *husband . . . whores:* alluding to the "crossbiting" practice of compromising a man with a prostitute, whose pretended husband then came forward.
[8] *still:* forever. [9] *want'st:* lack'st.
[10] *tale:* reckoning. [11] *serve his turn:* i.e., suffice.
[12] *make . . . away:* i.e., kill. [13] *moved:* angered.
[14] *as unknown:* as yet not known to me.
[15] *shag-rag:* ragged. [16] *presently:* immediately.
IV.iv.
[1] *me:* to me. [2] *Of:* On.
[3] *Nay . . . none:* Q gives this line to Pilia-Borza.
[4] *Knavely:* Like a knave.
[5] *It.:* a Bacchanalian summons, the exact meaning of which is doubtful.
[6] *snickle . . . fast:* phrase is of uncertain meaning and perhaps textually corrupt; "snickle" means noose or snare.

Bell. You two alone?

Itha. We two; and 'twas never known, nor never shall be for me.[7]

Pilia. [*Aside to* BELLAMIRA] This shall with me unto the governor.

Bell. [*Aside to* PILIA-BORZA] And fit it should: but first let's ha' more gold,— 31
Come, gentle Ithamore, lie[8] in my lap.

Itha. Love me little, love me long; let music rumble Whilst I in thy incony[9] lap do tumble.

Enter BARABAS, *with a lute, disguised.*

Bell. A French musician! come, let's hear your skill.

Bar. Must tuna my lute for sound, twang, twang, first.

Itha. Wilt drink, Frenchman? Here's to thee with a—Pox[10] on this drunken hiccup!

Bar. Gramercy,[11] monsieur. 39

Bell. Prithee, Pilia-Borza, bid the fiddler give me the posy[12] in his hat there.

Pilia. Sirrah, you must give my mistress your posy.

Bar. *A votre commandement, madame.*[13]

Bell. How sweet, my Ithamore, the flowers smell!

Itha. Like thy breath, sweetheart; no violet like 'em.

Pilia. Foh! methinks they stink like a hollyhock.

Bar. [*Aside*] So, now I am revenged upon 'em all. The scent thereof was death; I poisoned it.

Itha. Play, fiddler, or I'll cut your cat's guts into chitterlings.[14] 50

Bar. *Pardona moy,*[15] be no in tune yet; so now, now all be in.

Itha. Give him a crown, and fill[16] me out more wine.

Pilia. There's two crowns for thee; play.

Bar. [*Aside*] How liberally the villain gives me mine own gold!

Pilia. Methinks he fingers[17] very well.

Bar. [*Aside*] So did you when you stole my gold.

Pilia. How swift he runs![18]

Bar. [*Aside*] You run swifter when you threw my gold out of my window. 61

Bell. Musician, hast been in Malta long?

Bar. Two, three, four month, madame.

Itha. Dost not know a Jew, one Barabas?

Bar. Very mush; mounsier, you no be his man?[19]

Pilia. His man?

Itha. I scorn the peasant; tell him so.

Bar. [*Aside*] He knows it already.

Itha. 'Tis a strange thing of that Jew, he lives upon pickled grasshoppers and sauced mushrooms. 70

Bar. [*Aside*] What a slave's this? The governor feeds not as I do.

Itha. He never put on clean shirt since he was circumcised.

Bar. [*Aside*] O rascal! I change myself twice a day.

Itha. The hat he wears, Judas left under the elder[20] when he hanged himself.

Bar. [*Aside*] 'Twas sent me for a present from the Great Cham.[21] 79

Pilia. A masty[22] slave he is;—Whither now, fiddler?

Bar. *Pardona moy, mounsier,* we be no well

 Exit.

Pilia. Farewell, fiddler! One letter more to the Jew.

Bell. Prithee, sweet love, one more, and write it sharp.[23]

Itha. No, I'll send by word of mouth now—Bid him deliver thee a thousand crowns, by the same token, that the nuns loved rice, that Friar Barnardine slept in his own clothes; any of 'em will do it.

Pilia. Let me alone to urge it, now I know the meaning. 90

Itha. The meaning has a meaning. Come, lets' in. To undo a Jew is charity, and not sin.

 Exeunt.

ACT FIVE

SCENE ONE

Enter Governor [FERNEZE], Knights, MARTIN DEL BOSCO, [*and* Officers].

Fern. Now, gentlemen, betake you to your arms, And see that Malta be well fortified; And it behoves you to be resolute; For Calymath, having hovered here so long, Will win the town, or die before the walls.

1 Knight. And die he shall, for we will never yield.

Enter Courtesan [BELLAMIRA] *and* PILIA-BORZA.

Bell. Oh, bring us to the governor.

Fern. Away with her! she is a courtesan.

Bell. Whate'er I am, yet, governor, hear me speak, I bring thee news by whom thy son was slain: 10
Mathias did it not; it was the Jew.

Pilia. Who, besides the slaughter of these gentlemen, Poisoned his own daughter and the nuns, Strangled a friar and I know not what Mischief besides.

Fern. Had we but proof of this—

Bell. Strong proof, my lord; his man's now at my lodging,
That was his agent; he'll confess it all.

Fern. Go fetch him straight.

 [*Exeunt* Officers.]
 I always feared that Jew.

Enter [Officers *with*] BARABAS *and* ITHAMORE.

Bar. I'll go alone; dogs! do not hale[1] me thus.

[7] *for me:* if I have anything to do with it.

[8] *lie:* with a pun on sexual intercourse.

[9] *incony:* pretty.

[10] *Pox:* Damnation; literally, veneral disease.

[11] *Gramercy:* Thanks. [12] *posy:* bouquet of flowers.

[13] *Fr.:* At your command, madam.

[14] *cat's . . . chitterlings:* lute strings into pig's intestines (a delicacy).

[15] *Fr. (corrupt):* Pardon me. [16] *fill:* pour.

[17] *fingers:* plays on the lute with his fingers (as opposed to the sense of "stole" in the aside that follows).

[18] *runs:* executes a melodic passage. [19] *man:* servant.

[20] *elder:* on which Judas is supposed to have hanged himself. [21] *Great Cham:* Mongol Emperor.

[22] *masty:* burly, like a mastiff; or like a swine, from the food or "mast" on which it fattens. [23] *sharp:* sharply.

V.i.

[1] *hale:* drag.

Itha. Nor me neither, I cannot outrun you, con-
stable:—Oh, my belly! 21
 Bar. [*Aside*] One dram of powder more had made all
 sure;
What a damned slave[2] was I!
 Fern. Make fires, heat irons, let the rack[3] be fetched.
 1 Knight. Nay, stay, my lord; 't may be he will
 confess.
 Bar. Confess! what mean you, lords? Who should
 confess?
 Fern. Thou and thy Turk; 'twas you that slew my
 son.
 Itha. Guilty, my lord, I confess. Your son and
Mathias were both contracted unto Abigail; [he] forged
a counterfeit challenge. 30
 Bar. Who carried that challenge?
 Itha. I carried it, I confess; but who writ it? Marry,[4]
even he that strangled Barnardine, poisoned the nuns
and his own daughter.
 Fern. Away with him! his sight is death to me.
 Bar. For what, you men of Malta? Hear me speak:
She is a courtesan, and he[5] a thief,
And he my bondman.[6] Let me have law,
For none of this can prejudice my life.
 Fern. Once more, away with him; you shall have law.
 Bar. Devils, do your worst! I live in spite of you. 41
As these have spoke, so be it to their souls!
[*Aside*] I hope the poisoned flowers will work anon.[7]
 [*Exeunt* Officers *with* BARABAS *and* ITHAMORE,
 BELLAMIRA *and* PILIA-BORZA.]

 Enter KATHERINE.

 Kath. Was my Mathias murdered by the Jew?
Ferneze, 'twas thy son that murdered him.
 Fern. Be patient, gentle madam, it was he;
He forged the daring challenge made them fight.
 Kath. Where is the Jew? Where is that murderer?
 Fern. In prison till the law has passed on him.

 Enter Officer.

 1 Off. My lord, the courtesan and her man are
 dead: 50
So is the Turk and Barabas the Jew.

² *damned slave:* i.e., fool.
³ *rack:* instrument of torture on which the body was
stretched.
⁴ *Marry:* for emphasis—"Why." ⁵ *he:* Pilia-Borza.
⁶ *bondman:* serf. ⁷ *anon:* immediately.
⁸ *Exeunt:* The stage direction in Q leaves us in doubt as
to what happens next. Either Barabas is carried off, or he is
thrown (gingerly) over the "walls" or left—as if thrown—
on the floor of the stage. In any case, when he awakes, he is
alone and outside the city. ⁹ *well fare:* farewell.
¹⁰ *sleepy:* Barabas has drugged himself to induce a death-
like sleep.
¹¹ *Bassoes:* so called by Q in Act I, but in Acts III and
V they become "bashaws" in Q. ¹² *spy:* reveal.
¹³ *poppy . . . mandrake:* both sleep-inducing.
¹⁴ *belike:* probably.
¹⁵ *truce:* so Q; the word is sometimes emended to "sluice,"
meaning drainage ditch. ¹⁶ *common channels:* gutters.
¹⁷ *vault:* sewer. ¹⁸ *presently:* at once.
V.ii.
¹ *vail:* let fall.

 Fern. Dead!
 1 Off. Dead, my lord, and here they bring his
 body.
 Bosco. This sudden death of his is very strange.

 [*Re-enter* Officers *carrying* BARABAS *as dead.*]

 Fern. Wonder not at it, sir, the heavens are just;
Their deaths were like their lives, then think not of 'em
Since they are dead, let them be burièd;
For the Jew's body, throw that o'er the walls,
To be a prey for vultures and wild beasts.—
So now away, and fortify the town. 60
 Exeunt.[8]
 Bar. What, all alone? Well fare,[9] sleepy[10] drink.
I'll be revenged on this accursèd town;
For by my means Calymath shall enter in
I'll help to slay their children and their wives,
To fire the churches, pull their houses down—
Take my goods too, and seize upon my lands.
I hope to see the governor a slave,
And, rowing in a galley, whipped to death.

 Enter CALYMATH, Bassoes,[11] *and* Turks.

 Caly. Whom have we there, a spy?
 Bar. Yes, my good lord, one that can spy[12] a place
Where you may enter, and surprise the town. 71
My name is Barabas: I am a Jew.
 Caly. Art thou that Jew whose goods we heard were
 sold
For tribute money?
 Bar. The very same, my lord:
And since that time they have hired a slave, my man,
To accuse me of a thousand villanies:
I was imprisonèd, but 'scaped their hands.
 Caly. Did'st break prison?
 Bar. No, no;
I drank of poppy and cold mandrake[13] juice: 80
And being asleep, belike[14] they thought me dead,
And threw me o'er the walls: so, or how else,
The Jew is here, and rests as your command.
 Caly. 'Twas bravely done, but tell me, Barabas,
Canst thou, as thou reportest, make Malta ours?
 Bar. Fear not, my lord, for here against the truce[15]
The rock is hollow, and of purpose digged,
To make a passage for the running streams
And common channels[16] of the city.
Now, whilst you give assault unto the walls, 90
I'll lead five hundred soldiers through the vault,[17]
And rise with them i' the middle of the town,
Open the gates for you to enter in;
And by this means the city is your own.
 Caly. If this be true, I'll make thee governor.
 Bar. And if it be not true, then let me die.
 Caly. Thou'st doomed thyself. Assault it presently.[18]
 Exeunt.

[V.ii]

 Alarms. Enter Turks, BARABAS, [*with*] Governor
 [FERNEZE] *and* Knights *prisoners.*

 Caly. Now vail[1] your pride, you captive Christians,

And kneel for mercy to your conquering foe:
Now where's the hope you had of haughty Spain?
Ferneze, speak, had it not been much better
T'[have] kept thy promise than be thus surprised?
 Fern. What should I say? We are captives and must
yield.
 Caly. Ay, villains, you must yield, and under
Turkish yokes.
Shall groaning bear the burden of our ire;
And, Barabas, as erst[2] we promised thee,
For thy desert we make thee governor; 10
Use them at thy discretion.
 Bar. Thanks, my lord.
 Fern. Oh, fatal day, to fall into the hands
Of such a traitor and unhallowed Jew!
What greater misery could heaven inflict?
 Caly. 'Tis our command: and Barabas, we give
To guard thy person these our Janizaries:[3]
Entreat[4] them well, as we have usèd thee.
And now, brave bassoes, come, we'll walk about
The ruined town, and see the wrack[5] we made:—
Farewell, brave Jew; farewell, great Barabas! 20
 Bar. May all good fortune follow Calymath!
 Exeunt [CALYMATH *and* Bassoes.]
And now, as entrance[6] to our safety,
To prison with the governor and these
Captains, his consorts[7] and confederates.
 Fern. O villain! heaven will be revenged on thee.
 Exeunt.
 Bar. Away! no more; let him not trouble me.
Thus hast thou gotten, by thy policy,
No simple[8] place, no small authority,
I now am Governor of Malta; true,—
But Malta hates me, and, in hating me, 30
My life's in danger, and what boots[9] it thee,
Poor Barabas, to be the governor,
Whenas[10] thy life shall be at their command?
No, Barabas, this must be looked into;[11]
And since by wrong thou got'st authority,
Maintain it bravely by firm policy,
At least unprofitably[12] lose it not;
For he that liveth in authority,
And neither gets him friends, nor fills[13] his bags,
Lives like the ass that Aesop speaketh of, 40
That labors with a load of bread and wine,
And leaves it off[14] to snap on thistle tops:
But Barabas will be more circumspect.
Begin betimes;[15] Occasion's bald behind;[16]
Slip[17] not thine opportunity, for fear too late
Thou seek'st for much, but canst not compass it.—
Within here!

 Enter Governor [FERNEZE] *with a* Guard.

 Fern. My lord?
 Bar. Ay, "lord"; thus slaves will learn.
Now, Governor;—stand by there, wait within. 50
 [*Exeunt* Guard.]
This is the reason that I sent for thee;
Thou seest thy life and Malta's happiness
Are at my arbitrament;[18] and Barabas
At his discretion may dispose of both;

Now tell me, governor, and plainly too,
What think'st thou shall become of it and thee?
 Fern. This, Barabas; since things are in thy power,
I see no reason but of Malta's wrack,
Nor hope of thee but èxtreme cruelty;
Nor fear I death, nor will I flatter thee. 60
 Bar. Governor, good words;[19] be not so furious.
'Tis not thy life which can avail me aught;
Yet[20] you do live, and live for me[21] you shall:
And, as for Malta's ruin, think you not
'Twere slender[22] policy for Barabas
To dispossess himself of such a place?
For sith,[23] as once you said, within this isle,
In Malta here, that I have got my goods,
And in this city still[24] have had success,
And now at length am grown your governor, 70
Yourselves shall see it shall not be forgot;
For, as a friend not known but in distress,
I'll rear up Malta, now remediless.[25]
 Fern. Will Barabas recover Malta's loss?
Will Barabas be good to Christians?
 Bar. What wilt thou give me, governor, to procure
A dissolution of the slavish bands[26]
Wherein the Turk hath yoked your land and you?
What will you give me if I render you
The life of Calymath, surprise his men, 80
And in an outhouse[27] of the city shut
His soldiers, till I have consumed 'em all with fire?
What will you give him that procureth this?
 Fern. Do but bring this to pass which thou
pretendest,[28]
Deal truly with us as thou intimatest,
And I will send amongst the citizens,
And by my letters privately[29] procure
Great sums of money for thy recompense:
Nay more, do this, and live thou governor still.
 Bar. Nay, do thou this, Ferneze, and be free; 90
Governor, I enlarge[30] thee; live with me,
Go walk about the city, see thy friends:
Tush, send not letters to 'em, go thyself,
And let me see what money thou canst make;
Here is my hand that I'll set Malta free:
And thus we cast[31] it: to a solemn feast

 [2] *erst:* formerly.
 [3] *Janizaries:* Turkish foot soldiers who constituted the Sultan's guard and the chief part of the army.
 [4] *Entreat:* Treat. [5] *wrack:* destruction.
 [6] *entrance:* prelude (i.e., making sure).
 [7] *consorts:* fellows. [8] *simple:* slight.
 [9] *boots:* avails. [10] *Whenas:* Since.
 [11] *looked into:* scanned, scrutinized.
 [12] *unprofitably:* without some profit.
 [13] *fills:* i.e., with money.
 [14] *leaves it off:* forbears to enjoy it. [15] *betimes:* quickly.
 [16] *Occasion's bald behind:* Occasion or Opportunity, so depicted by tradition, must be seized by the forelock.
 [17] *Slip:* Omit. [18] *arbitrament:* disposal.
 [19] *good words:* i.e., not so hot. [20] *Yet:* Still.
 [21] *for me:* so long as it's up to me. [22] *slender:* foolish.
 [23] *sith:* since. [24] *still:* continually.
 [25] *remindless:* cast down and without hope of remedy.
 [26] *bands:* bonds. [27] *outhouse:* building outside.
 [28] *pretendest:* settest forth. [29] *privately:* secretly.
 [30] *enlarge:* free. [31] *cast:* plot.

I will invite young Selim Calymath,
Where be thou present only to perform
One strategem that I'll impart to thee,
Wherein no danger shall betide[32] thy life,　　　　　100
And I will warrant Malta free for ever.
　Fern. Here is my hand; believe me, Barabas,
I will be there, and do as thou desirest.
When is the time?
　Bar.　　　　　Governor, presently:
For Calymath, when he hath viewed the town,
Will take his leave and sail toward Ottoman.[33]
　Fern. Then will I, Barabas, about[34] this coin,
And bring it with me to thee in the evening.
　Bar. Do so, but fail not; now farewell, Ferneze!—
　　　　　　　　　　　　　　　　[*Exit* FERNEZE.]
And thus far roundly[35] goes the business:　　　110
Thus loving neither, will I live with both,
Making a profit of my policy;
And he from whom my most advantage comes
Shall be my friend.
This is the life we Jews are used[36] to lead;
And reason[37] too, for Christians do the like,
Well, now about effecting this device;
First surprise great Selim's soldiers,
And then to make provision for the feast,
That at one instant all things may be done:　　　120
My policy detests prevention:[38]
To what event[39] my secret purpose drives,
I know; and they shall witness[40] with their lives.
　　　　　　　　　　　　　　　　　　　Exit.

[V.iii]

　　　Enter CALYMATH *and* Bassoes.

　Caly. Thus have we viewed the city, seen the sack,[1]
And caused the ruins to be new-repaired,
Which with our bombards' shot and basilisk[2]
We rent in sunder at our entry:
And now[3] I see the situation,
And how secure this conquered island stands

[32] *betide:* befall.　　　　　　[33] *Ottoman:* Turkey.
[34] *about:* set about the business of.
[35] *roundly:* successfully.　　　[36] *used:* accustomed.
[37] *reason:* reasonably.
[38] *prevention:* being frustrated or forestalled.
[39] *event:* end.　　　　　　　[40] *witness:* bear witness.

V.iii.
　[1] *sack:* plundering.
　[2] *bombards' . . . basilisk:* large cannons' (throwing stone shot) . . . smaller gun (firing iron shot).
　[3] *now:* now that.
　[4] *countermined:* i.e., defended.　[5] *Calabria:* in Italy.
　[6] *Dionysius:* Tyrant of Syracuse in the fourth century B.C. Q makes this line follow the next.
　[7] *Ottoman:* the Sultan.　　　[8] *train:* retinue.
　[9] *lately:* recently.　　　　　[10] *store:* reserve.
[11] *indifferently:* impartially.　[12] *Except:* Unless.
[13] *meditate:* consider.　　　　[14] *grace:* carry.

V.iv.
　[1] *culverin:* cannon, smaller than a basilisk.
　[2] *linstock:* stick that held the match.
　[3] *happily:* perhaps.　　　　[4] *thralls:* slaves.
　[5] *adventure:* venture.

Environed with the Mediterranean Sea,
Strong-countermined[4] with other petty isles;
And, toward Calabria,[5] backed by Sicily
(When Syracusian Dionysius[6] reigned),　　　10
Two lofty turrets that command the town;
I wonder how it could be conquered thus.

　　　Enter a Messenger.

　Mess. From Barabas, Malta's governor, I bring
A message unto mighty Calymath;
Hearing his sovereign was bound for sea,
To sail to Turkey, to great Ottoman,[7]
He humbly would entreat your majesty.
To come and see his homely citadel,
And banquet with him ere thou leav'st the isle.
　Caly. To banquet with him in his citadel?　　　20
I fear me, messenger, to feast my train[8]
Within a town of war so lately[9] pillaged,
Will be too costly and too troublesome:
Yet would I gladly visit Barabas,
For well has Barabas deserved of us.
　Mess. Selim, for that, thus saith the governor,
That he hath in store[10] a pearl so big,
So precious, and withal so orient,
As, be it valued but indifferently,[11]
The price thereof will serve to entertain　　　30
Selim and all his soldiers for a month;
Therefore he humbly would entreat your highness
Not to depart till he has feasted you.
　Caly. I cannot feast my men in Malta-walls,
Except[12] he place his table in the streets.
　Mess. Know, Selim, that there is a monastery
Which standeth as an outhouse to the town:
There will he banquet them; but thee at home,
With all thy bassoes and brave followers.
　Caly. Well, tell the governor we grant his suit,　　　40
We'll in this summer evening feast with him.
　Mess. I shall, my lord.
　　　　　　　　　　　　　　　　　　　Exit.
　Caly. And now, bold bassoes, let us to our tents,
And meditate[13] how we may grace[14] us best
To solemnize our governor's great feast.
　　　　　　　　　　　　　　　　　　　Exeunt.

[V.iv]

　Enter Governor [FERNEZE], Knights, [*and*
　　　　　MARTIN] DEL BOSCO.

　Fern. In this, my countrymen, be ruled by me,
Have special care that no man sally forth
Till you shall hear a culverin[1] discharged
By him that bears the linstock,[2] kindled thus;
Then issue out and come to rescue me,
For happily[3] I shall be in distress,
Or you releasèd of this servitude.
　1 Knight. Rather than thus to live as Turkish
　　　thralls,[4]
What will we not adventure?[5]
　Fern.　　　　　　　On then, begone.
　Knights. Farewell, grave governor!　　　10
　　　　　　　　　　　　　　　　　　　Exeunt.

[V.v]

Enter [BARABAS] with a hammer, above,[1] very busy;
[and Carpenters].

Bar. How stand the cords? How hang these hinges?
Fast?
Are all the cranes and pulleys sure?
1 Carp. All fast.
Bar. Leave nothing loose, all leveled[2] to my mind.
Why now I see that you have art indeed.
There, carpenters, divide that gold amongst you:

[*Gives money.*]

Go swill in bowls of sack and muscadine![3]
Down to the cellar, taste of all my wines.
1 Carp. We shall, my lord, and thank you.
 Exeunt.
Bar. And, if you like them, drink your fill and die:[4]
For so[5] I live, perish may all the world! 10
Now Selim Calymath return me word
That thou wilt come, and I am satisfied.

Enter Messenger.

Now, sirrah, what, will he come?
Mess. He will; and has commanded all his men
To come ashore, and march through Malta streets,
That thou may'st feast them in thy citadel.
Bar. Then now are all things as my wish would have
'em,
There wanteth nothing but the governor's pelf,[6]
And see, he brings it.

Enter Governor [FERNEZE].

 Now, governor, the sum.
Fern. With free consent, a hundred thousand pounds
Bar. Pounds say'st thou, governor? well, since it is
no more, 21
I'll satisfy myself with that; nay, keep it still,
For if I keep not promise, trust not me.
And, governor, now partake[7] my policy:
First, for his army; they are sent before,[8]
Entered the monastry, and underneath
In several places are field-pieces pitched,[9]
Bombards, whole barrels full of gunpowder
That on the sudden shall dissever it,[10]
And batter all the stones about their ears, 30
Whence none can possibly escape alive.
Now as for Calymath and his consorts,
Here have I made a dainty[11] gallery,
The floor whereof, this cable being cut,
Doth fall asunder; so that it doth sink
Into a deep pit past recovery.

[*Hands down a knife.*]

Here, hold that knife, and when thou seest he comes,
And with his bassoes shall be blithely set,[12]
A warning-piece[13] shall be shot off from the tower,
To give thee knowledge when to cut the cord 40
And fire the house; say, will not this be brave?
Fern. Oh, excellent! here, hold thee,[14] Barabas
I trust thy word, take what I promised thee.

Bar. No, governor, I'll satisfy thee first,
Thou shalt not live in doubt of anything.
Stand close,[15] for here they come.

[FERNEZE *retires.*]
 Why, is not this
A kingly kind of trade, to purchase towns
By treachery and sell 'em by deceit?
Now tell me, worldings,[16] underneath the sun[17]
If greater falsehood ever has been done? 50

Enter CALYMATH *and* Bassoes.

Caly. Come, my companion bassoes; see, I pray,
How busy Barabas is there above
To entertain us in his gallery;
Let us salute[18] him. Save[19] thee, Barabas!
Bar. Welcome, great Calymath!
Fern. [*Aside*] How the slave jeers at him.
Bar. Will 't please thee, mighty Selim Calymath,
To ascend our homely stairs?
Caly. Ay, Barabas;—
Come, bassoes,
Fern. Stay, Calymath!
For I will show thee greater courtesy 60
Than Barabas would have afforded thee.
Knight [*Within*] Sound a charge[20] there!

A charge [*sounded within*] *cable cut* [*by* FERNEZE;
the floor of the gallery gives way, and BARABAS
falls into] *a caldron, discovered* [*below*].

[*Enter* MARTIN DEL BOSCO *and* Knights.]

Caly. How now! what means this?
Bar. Help, help me! Christians, help!
Fern. See, Calymath, this was devised for thee!
Caly. Treason! treason! bassoes, fly!
Fern. No, Selim, do not fly;
See his end first, and fly then if thou canst.
Bar. O help me, Selim! help me, Christians!
Governor, why stand you all so pitiless? 70
Fern. Should I in pity of thy plaints or thee,
Accursèd Barabas, base Jew, relent?
No, thus I'll see thy treachery repaid,
But wish thou hadst behaved thee otherwise.

V.v.
 [1] *above:* Barabas is busy on the upper stage or balcony, seeing to the trap that will lead to the caldron on the inner stage or alcove directly below him.
 [2] *leveled:* done according.
 [3] *sack and mascadine:* fortified wine (like sherry) and strong sweet wine.
 [4] *die:* Barabas has poisoned the wine to be rid of the witnesses. [5] *so:* long as. [6] *pelf:* money.
 [7] *partake:* partake of. [8] *before:* on ahead.
 [9] *field-pieces pitched:* light cannon placed.
 [10] *dissever it:* blow up the monastery.
 [11] *dainty:* expressive of Barabas's delight in his craft.
 [12] *blithely set:* merrily seated.
 [13] *warning-piece:* signal gun.
 [14] *here, hold thee:* Ferneze either is adjuring Barabas to keep to his purpose or is attempting to give him the money.
 [15] *close:* hidden.
 [16] *worldings:* addressing kindred spirits in the audience.
 [17] *sun:* Q reads "summe." [18] *salute:* greet.
 [19] *Save:* God save. [20] *charge:* trumpet signal.

Bar. You will not help me then?
Fern. No, villain, no.
Bar. And, villains, know you cannot help me now.—
Then, Barabas, breathe forth thy latest[21] fate,
And in the fury of thy torments strive
To end thy life with resolution.[22] 80
Know, governor, 'twas I that slew thy son;
I framed[23] the challenge that did make them meet;
Know, Calymath, I aimed[24] thy overthrow,
And had I but escaped this stratagem,
I would have brought confusion[25] on you all,
Damned Christians! dogs! and Turkish infidels!
But now begins the extremity of heat
To pinch me with intolerable pangs;
Die, life! fly, soul! tongue, curse thy fill, and die!

 [*Dies.*]

Caly. Tell me, you Christians, what doth this
 portend? 90
Fern. This train he laid[26] to have entrapped thy life;
Now, Selim, note the unhallowed deed of Jews:
Thus he determined to have handled thee,
But I have rather chose to save thy life.
Caly. Was this the banquet he prepared for us?
Let's hence, lest further mischief be pretended.[27]
Fern. Nay, Selim, stay; for since we have thee here,
We will not let thee part so suddenly:
Besides, if we should let thee go, all's one,[28]
For with thy galleys could'st thou not get hence, 100

Without fresh[29] men to rig and furnish[30] them.
Caly. Tush, Governor, take thou no care for that,[31]
My men are all aboard,
And do attend[32] my coming there by this.[33]
Fern. Why, heard'st thou not the trumpet sound a
 charge?
Caly. Yes, what of that?
Fern. Why then the house was
 fired.
Blown up, and all thy soldiers massacred.
Caly. Oh, monstrous treason!
Fern. A Jew's courtesy:
For he that did by treason work[34] our fall,
By treason hath delivered thee to us: 110
Know, therefore, till thy father hath made good
The ruins done to Malta and to us,
Thou canst not part; for Malta shall be freed,
Or Selim ne'er return to Ottoman.
Caly. Nay, rather, Christians, let me go to Turkey,
In person there to meditate[35] your peace;
To keep me here will not advantage[36] you.
Fern. Content thee, Calymath, here thou must stay,
And alive in Malta prisoner; for come call the world
To rescue thee, so will we guard us now, 120
As sooner shall they drink the ocean dry
Than conquer Malta, or endanger us.
So march away, and let due praise be given
Neither to fate nor fortune, but to heaven.

 [*Exeunt.*]

EPILOGUE SPOKEN AT COURT

IT IS our fear (dread[1] Sovereign) we have been
Too tedious; neither can't be less than sin
To wrong your princely patience: if we have
(Thus[2] low dejected), we your pardon crave:
And, if aught here offend your ear or sight,
We only act, and speak, what others write.

[21] *latest:* last. [22] *resolution:* courage.
[23] *framed:* devised. [24] *aimed:* aimed at.
[25] *confusion:* destruction.
[26] *train he laid:* scheme he concocted.
[27] *pretended:* intended.
[28] *all's one:* it wouldn't matter.
[29] *fresh:* new (the other being dead).
[30] *furnish:* fit out (for sailing).
[31] *take . . . that:* don't worry about that.
[32] *attend:* await. [33] *by this:* by this time.
[34] *work:* achieve.
[35] *meditate:* plan: some editors emend to "mediate."
[36] *advantage:* be advantageous to.

EPILOGUE SPOKEN AT COURT
[1] *dread:* inspiring awe.
[2] *Thus:* At this point the actors bow.

EPILOGUE TO THE STAGE

[AT THE COCK-PIT]

IN GRAVING,[1] with Pygmalion[2] to contend,
Or painting, with Apelles,[3] doubtless the end
Must be disgrace: our actor did not so,
He only aimed to go, but not outgo.[4]

Nor think that this day any prize was played;[5]
Here were no bets at all, no wagers laid:[6]
All the ambition that his mind doth swell,
Is but hear from you (by me) 'twas well.

FINIS

EPILOGUE TO THE STAGE
 [1] *graving:* sculpturing.
 [2] *Pygmalion:* fabulous artist and King of Cyprus, whose statue of Galatea, with whom he fell in love, was brought to life by Aphrodite.
 [3] *Apelles:* most famous Greek painter of antiquity, patronized by Alexander.
 [4] *go . . . outgo:* do well . . . overgo, excel.
 [5] *prize was played:* match (as of fencing) was contested.
 [6] *wagers laid:* Betting on the relative excellence of Elizabethan actors was apparently common.

Christopher Marlowe

DOCTOR FAUSTUS

O F ALL the famous plays of the Renaissance, Marlowe's DOCTOR FAUSTUS is the most difficult textually; hence the comprehensiveness of this discussion.

The only ascertainable source of DOCTOR FAUSTUS is P. F.'s English translation and amplification, in 1592, of the very popular German *Historia von D. Johann Fausten* of 1587. The entering of this work in the Stationers' Register (18 December 1592) provides the *terminus a quo* for Marlowe's play, unless Marlowe had access to a manuscript version of the "history." Because the anonymous *Taming of a Shrew*, a play (not by Shakespeare) published in 1594 and probably acted in 1592 and 1593, quotes or follows DOCTOR FAUSTUS in some half dozen passages, it is plausible to date the composition of DOCTOR FAUSTUS in 1592.

A number of editors argue, however, for an earlier dating. They adduce in evidence a ballad entry on the "life and death of Doctor Faustus" (Stationers' Register, 28 February 1588/9), and the currency of Robert Greene's FRIAR BACON AND FRIAR BUNGAY, not a new play when produced in 1591–92. If Greene's historical romance was written to capitalize on Marlowe's somewhat similar play, the latter would of course require an earlier dating. But the relationship is wholly conjectural; and relative maturity of style is as telling an argument as any for assigning DOCTOR FAUSTUS to the early 1590s. Such topical allusions as the play affords—it glances, for example, at the death of Dr. Roderigo Lopez, the ill-starred physician to Queen Elizabeth who was executed in 1594—are too vague to be helpful, unless as an unnecessary *terminus ad quem*.

On 30 September 1594, the first recorded performance of the play, probably a revival, was noted in his diary by Philip Henslowe, who lists more than two dozen performances in the mid-1590s at his own theater, the Rose, with the celebrated tragedian Edward Alleyn in the title role. The first entry in the Stationers' Register (7 January 1600/01) postdates Marlowe's death, as does the publication of the First Quarto (of which only the Bodleian copy survives) in 1604. The title page advertises the play as having "been acted by the . . . Earl of Nottingham his servants," a mutable company that became subsequently the Lord Admiral's Men (22 October 1597) and, on the accession of King James, Prince Henry's Men (so called for the heir apparent) in early 1604.

As the acting company was in flux, so was the play. Additions were grafted to it in 1602—this on the evidence of Henslowe's diary, which, on 22 November 1602, records payments to William Birde and Samuel

Rowley, who went back to P. F.'s *English Faust Book* for fresh material. What these persons considered fresh, and what they imparted to Marlowe's original version, may be gathered perhaps from two conflicting stage directions (both from II.i.). In the quarto of 1604, which follows the recension by Henslowe's hired hands, we read (apropos the diligence of Mephistophilis, who has gone off at Faustus' bidding to fetch the hero a wife): "Enter a divell drest like a woman, with fier workes." Just before and after this direction we get a passage of puerile dialogue, peculiar to Q1604. In the quarto of 1616, the dialogue disappears and the stage direction is laconic: "He fetches in a woman devill."

No doubt it is dangerous to build a hypothetically canonical text on an editor's sense of what is puerile (or not). Certainly the quarto of 1616 has its aesthetically inferior aspects. Some readers may feel that it is conclusively inferior to its predecessor. Though most editors since Greg have indicated their preference for Q1616, the question of priority remains unresolved, and in fact some recent editorial sentiment inclines strongly to Q1604. It is worth emphasizing, therefore, that one ought not to impute to an editor absolute taste or acumen. As it happens, evidence independent of aesthetic or intuitive judgment is available, and seems to give warrant for preferring, by and large, the readings of Q1616, which is the basis of the text given here.

The story of the text is presumably as follows. Q1604, a poorly printed edition, was based on a memorial version of the play's original production, a thesis originated by Kirschbaum, accepted by Greg, and now reconfirmed by Fredson Bowers. This text was reproduced with few changes in editions of 1609 and 1611. Editors conjecture that for the quarto of 1616 (extant only in the British Museum), another manuscript, in some respects apparently closer to Marlowe's version, furnished the copy. In his edition, roughly 550 lines appear for the first time—deriving mostly, though not entirely, from P.F.'s *English Faust Book*—content is varied as against Q1604 and its successors, and scenes are changed, even added. Perhaps these variations and additions reflect Marlowe's intention, perhaps not. The assumption here is that they do.

Some students of the text, while denying Rowley any part in the comic scenes of Q1604, argue for his authorship or partial authorship not only of the additional scenes in Q1616 but also of that quarto's version of the comic material. It is unlikely, so the argument runs, that the publisher of Q1604, having entered the play in the Stationers' Register would have acquired a text with the Birde-Rowley additions (which are characterized

as major because of the relatively large payment) between 1601 and 1604, particularly if the revised play was popular.

In one respect the edition of 1604 is clearly superior or "Marlovian," because, with the increasing intolerance of the Jacobean period, Q1616 was subject to excisions by the state censor, who cut whatever he conceived as blasphemous. See, for example, the discussion between Faustus and Mephistophilis in II.ii, in which Faustus struggles unsuccessfully to repent, and the greatest speech in the play: the hero's last soliloquy. These excisions on religious grounds have been returned to the text.

Q1616 was followed by a quarto of 1619, which, though promising on its title page "new Additions," reprints its predecessor with only minor changes. The same comment holds for the quartos of 1620, 1624, and 1631.

The present text follows Q1616 (clarified occasionally by reading from subsequent quartos). Q1604 is preferred if it offers material not yet subject to censorship, or is superior metrically or in a particular reading. Superiority in the latter case is very narrowly construed and not dependent on editorial feeling. Here and there the compositor of Q1616 has inadvertently dropped a line found in Q1604 or, from simple carelessness, repeated a phrase. In such instances, Q1604 takes priority. In other instances, though it expands on or differs from Q1616, priority is denied. The hypothetically amusing scene (I.iv) between Wagner and the Clown—to give a single illustration—is assumed to be faithful to the tinkering of Birde and Rowley in 1602, and is omitted. Readers who wish to compare the two quartos at length should consult the editions of F. S. Boas (1932) and C. F. Tucker Brooke (1910) or should refer to W. W. Greg, *Marlowe's "Doctor Faustus" 1604–1616: Parallel Texts* (1950). Fredson Bowers in *The Complete Works of Christopher Marlowe* (1973) offers an authoritative discussion of the textual problem.

Editorial emendations are admitted only if the readings of the quartos are obviously corrupt. Emendations and variants are not cited in footnotes unless signal or controversial: it seems gratuitous in an edition of this kind to note that the Bad Angel of the play is called "Evil Angel" in 1604 and "Spirit" in 1616.

Because DOCTOR FAUSTUS is shorter than Marlowe's other major plays, it is likely not only that what Marlowe actually wrote has been distorted in printing and by revision but also that some of his work has been cut and lost forever. Despite the vexed and perhaps truncated character of the play, it has held the stage consistently from the time of its initial performance, though often in farcical perversions. In our own time, its appeal has quickened strongly. That is not surprising, for this tragedy, more than any other of Marlowe's, more than most of the tragedies that survive from the Renaissance, seems to speak to the pessimism that modern man finds necessary or congenial. A tragic protagonist like Macbeth is damned as he declines to restrain the cursed thoughts that nature gives way to in repose. There is at least the suggestion that an alternative ending to this story is potential. Marlowe does not allow of this suggestion in DOCTOR FAUSTUS. His protagonist, unlike Shakespeare's, repents at last. As that is so, perhaps he ought to be saved. But the repentance is unavailing. That is not precisely because it comes too late. In the Christian scheme—as presented, for example, by Dante in the *Purgatorio*—a remorseful tear at the latest hour is sufficient. In the iron scheme of Marlowe's imagining, repentance and obduracy are equally off the point. The contention of the good and evil angels for the soul of the hero, though theatrically engrossing, is more histrionic than real.

R. A. F.

Doctor Faustus

DRAMATIS PERSONÆ

THE CHORUS
DOCTOR FAUSTUS
WAGNER, *his servant*
VALDES ⎫
CORNELIUS ⎭ *friends to Faustus*
THREE SCHOLARS
AN OLD MAN

THE POPE
RAYMOND, *King of Hungary*
BRUNO
TWO CARDINALS
ARCHBISHOP OF RHEIMS
CARDINAL OF LORRAINE
CHARLES, *Emperor of Germany*
MARTINO ⎫
FREDERICK ⎬ *Gentlemen of his Court*
BENVOLIO ⎭
A KNIGHT
DUKE OF SAXONY
DUKE OF ANHOLT
DUCHESS OF ANHOLT
BISHOPS, MONKS, FRIARS, SOLDIERS,
 and ATTENDANTS

CLOWN
ROBIN, *an ostler*
DICK
RALPH
A VINTNER
A HORSE-COURSER
A CARTER
HOSTESS

GOOD ANGEL
BAD ANGEL
EVIL ANGEL
MEPHISTOPHILIS
LUCIFER
BELZEBUB
DEVILS
THE SEVEN DEADLY SINS
ALEXANDER THE GREAT ⎫
PARAMOUR OF ALEXANDER ⎬ *Spirits*
DARIUS ⎪
HELEN ⎪
TWO CUPIDS ⎭

[ACT ONE]

[PROLOGUE]

Enter Chorus.

Chor. Not marching in fields of Thrasimen,[1]
Where Mars did mate the warlike Carthagens;[2]
Nor sporting in the dalliance of love,
In courts of kings, where state is overturned;
Nor in the pomp of proud audacious deeds,
Intends our Muse to vaunt his heavenly verse:
Only this, Gentles—we must now perform
The form of Faustus' fortunes, good or bad:
And now to patient judgments we appeal,
And speak for Faustus in his infancy. 10
Now is he born, of parents base of stock,
In Germany, within a town called Rhodes.[3]
At riper years, to Wittenberg he went,
Whereas[4] his kinsmen chiefly brought him up.
So much he profits in divinity,
The fruitful plot of scholarism graced,[5]
That shortly he was graced[6] with Doctor's name,
Excelling all and sweetly can dispute
In the heavenly matters of theology;
Till swoln with cunning,[7] of a self-conceit, 20
His waxen wings[8] did mount above his reach,
And melting, heavens conspired his overthrow;
For, falling to a devilish exercise,
And glutted now with learning's golden gifts,
He surfeits upon cursèd necromancy;
Nothing so sweet as magic is to him,
Which he prefers before his chiefest bliss:
And this the man that in his study sits.

 Exit.

I. PROLOGUE

[1] *Thrasimen:* Lake Trasimene was the site of a great victory over the Romans by Hannibal in 217 B.C.
[2] *mate . . . Carthagens:* ally himself with the Carthaginians (Hannibal's party)(?).
[3] *Rhodes:* Perhaps Roda in the Duchy of Saxe-Altenburg.
[4] *Whereas:* Where.
[5] *plot . . . graced:* garden . . . adorned (by him).
[6] *graced:* technical term from Marlowe's Cambridge and signifying the right of a candidate to proceed to his degree.
[7] *cunning:* knowledge.
[8] *waxen wings:* like those which betrayed Icarus to his death.

[SCENE ONE]

Enter FAUSTUS *in his study.*

Faust. Settle thy studies, Faustus, and begin
To sound the depth of that thou wilt profess:[1]
Having commenced,[2] be a divine in show,[3]
Yet level[4] at the end of every art,
And live and die in Aristotle's works.[5]
Sweet Analytics, 'tis thou has ravished me!
Bene disserere est finis logices.[6]
Is, to dispute[7] well, logic's chiefest end?
Affords this art no greater miracle?
Then read no more; thou hast attained that end. 10
A greater subject fitteth Faustus' wit:
Bid ὂν χαὶ μὴ ὂν[8] farewell; and Galen[9] come;
Seeing, *Ubi desinit philosophus ibi incipit medicus,*[10]
Be a physician, Faustus; heap up gold,
And be eternized for some wondrous cure!
Summum bonum medicinae sanitas,
The end of physic is our body's health.
Why, Faustus, hast thou not attained that end?
Is not thy common talk sound aphorisms?[11]
Are not thy bills[12] hung up as monuments, 20
Whereby whole cities have escaped the plague,
And thousand desperate maladies been cured?
Yet art thou still but Faustus, and a man.
Couldst thou make men to live eternally,
Or, being dead, raise them to life again,
Then this profession were to be esteemed.
Physic, farewell! Where is Justinian?
[*Reads*] " *Si una eademque res legatur duobus
Alter rem, alter valorem rei,*" *etc.*[13]
A petty case of paltry legacies! 30
[*Reads*] " *Exhaereditare filium non potest pater nisi*"[14]—
Such is the subject of the Institute,
And universal body of the law.
This study fits a mercenary drudge,
Who aims at nothing but external trash;
Too servile and illiberal for me.
When all is done, divinity is best:
Jeromè's Bible,[15] Faustus; view it well.
[*Reads*] " *Stipendium peccati mors est.*"[16]—Ha!
" *Stipendium,*" *etc.*
The reward of sin is death: that's hard. 40
[*Reads*]" *Si peccasse negamus, fallimur
Et nulla est in nobis veritas.*"[17]—
If we say that we have no sin,
We deceive ourselves, and there is no truth in us.
Why, then, belike we must sin,
And so consequently die:
Ay, we must die an everlasting death.
What doctrine call you this, *Che sera, sera:*
What will be, shall be? Divinity, adieu!
These metaphysics of magicians 50
And necromantic books are heavenly;
Lines, circles, letters, and characters;
Ay, these are those that Faustus most desires.
Oh, what a world of profit and delight,
Of power, of honor, and omnipotence,
Is promised to the studious artisan![18]
All things that move between the quiet poles

Shall be at my command: emperors and kings
Are but obeyed in their several[19] provinces,
Nor can they raise the wind, or rend the clouds; 60
But his dominion that exceeds in this
Stretcheth as far as doth the mind of man;
A sound magician is a demi-god:
Here, tire my brains to get[20] a deity!

Enter WAGNER.

Wagner, commend me to my dearest friends,
The German Valdes and Cornelius;
Request them earnestly to visit me.
Wag. I will, sir.
 Exit.
Faust. Their conference[21] will be a greater help to
 me
Than all my labors, plod I ne'er so fast. 70

Enter the Good Angel *and* Bad Angel.

Good Ang. O Faustus, lay that damnèd book aside,
And gaze not on it, lest it tempt thy soul,
And heap God's heavy wrath upon thy head!
Read, read the Scriptures:—that is blasphemy.
Bad Ang. Go forward, Faustus, in that famous art
Wherein all Nature's treasure is contained:
Be thou on earth as Jove is in the sky,
Lord and commander of these elements.
 Exeunt Angels.
Faust. How am I glutted with conceit[22] of this!
Shall I make spirits fetch me what I please, 80
Resolve me of[23] all ambiguities,
Perform what desperate enterprise I will?
I'll have them fly to India[24] for gold,

I.i.
 [1] *profess:* be an adept in.
 [2] *commenced:* another technical term from Cambridge—proceeded to a degree (in theology).
 [3] *in show:* in appearance. [4] *level:* aim.
 [5] *Aristotle's works:* which dominated the study of logic in sixteenth-century universities.
 [6] *L.:* This axiom, translated in the next line, reflects not Aristotle but his chief opponent in Marlowe's time, Peter Ramus.
 [7] *dispute:* engage in a disputation according to the principles of logic.
 [8] *Gk.:* Aristotle's "being and not being" (emended from the garbled transliterating of Q1604—"Oncaymaeon").
 [9] *Galen:* chief authority on medicine to the Middle Ages.
 [10] *L.:* adapting Aristotle (as the next quotation does, also)—"Where the philosopher leaves off, the physician begins."
 [11] *aphorisms:* like those of the Greek physician Hippocrates (fifth century B.C.); medical memoranda.
 [12] *bills:* prescriptions.
 [13] *L.:* Garbling Justinian's *Institutes* on Roman law (as the next quotation does)—"If the same thing is willed to two persons, let one have the thing and the other the value of the thing."
 [14] *L.:* A father is not able to disinherit his son unless.
 [15] *Jeromè's Bible:* the so-called Vulgate.
 [16] *L.:* Epistle to the Romans 6:23.
 [17] *L.:* I Epistle of St. John 1:8.
 [18] *artisan:* practitioner of the higher arts.
 [19] *several:* particular. [20] *get:* beget.
 [21] *conference:* talk, conferring.
 [22] *conceit:* imagination (of achieving).
 [23] *Resolve me of:* Satisfy me regarding.
 [24] *India:* presumably the West Indies.

Ransack the ocean for orient[25] pearl,
And search all corners of the new found world
For pleasant fruits and princely delicates;[26]
I'll have them read me strange philosophy,
And tell the secrets of all foreign kings;
I'll have them wall all Germany with brass,[27]
And make swift Rhine circle fair Wittenberg. 90
I'll have them fill the public schools[28] with skill,[29]
Wherewith the students shall be bravely clad;
I'll levy soldiers with the coin they bring,
And chase the Prince of Parma[30] from our land,
And reign sole king of all the Provinces;[31]
Yea, stranger engines for the brunt of war,
Than was the fiery keel at Antwerp bridge,[32]
I'll make my servile spirits to invent.

Enter VALDES *and* CORNELIUS.

Come, German Valdes and Cornelius,
And make me blest with your sage conference! 100
Valdes, sweet Valdes, and Cornelius,
Know that your words have won me at the last
To practise magic and concealèd arts:

Yet not your words only, but mine own fantasy,
That will receive no object; for my head
But ruminates on necromantic skill.[33]
Philosophy is odious and obscure;
Both law and physics are for petty wits;
Divinity is basest of the three,
Unpleasant, harsh, contemptible, and vile: 110
'Tis magic, magic, that hath ravished me.
Then, gentle friends, aid me in this attempt,
And I, that have with subtle syllogisms
Gravelled[34] the pastors of the German church,
And made the flowering pride of Wittenberg
Swarm to my problems[35] as the infernal spirits
On sweet Musaeus[36] when he came to hell,
Will be as cunning as Agrippa[37] was,
Whose shadows made all Europe honor him.
 Vald. Faustus, these books, thy wit, and our
 experience 120
Shall make all nations to canònize us.
As Indian Moors[38] obey their Spanish lords,
So shall the spirits of every element
Be always serviceable to us three;
Like lions shall they guard us when we please;
Like Almaine rutters[39] with their horsemen's staves,
Or Lapland giants, trotting by our sides;
Sometimes like women, or unwedded maids,
Shadowing[40] more beauty in their airy[41] brows
Than has the white breasts of the queen of love: 130
From Venice shall they drag huge argosies,[42]
And from America the golden fleece[43]
That yearly stuffs old Philip's[44] treasury;
If learned Faustus will be resolute.
 Faust. Valdes, as resolute am I in this
As thou to live: therefore object it not.[45]
 Corn. The miracles that magic will perform
Will make thee vow to study nothing else.
He that is grounded in astrology,
Enriched with tongues,[46] well seen in[47] minerals, 140
Hath all the principles magic doth require;
Then doubt not, Faustus, but to be renowned,
And more frequented for this mystery
Than heretofore the Delphian oracle.
The spirits tell me they can dry the sea,
And fetch the treasure of all foreign wrecks,
Yea, all the wealth that our forefathers hid
Within the massy entrails of the earth:
Then tell me, Faustus, what shall we three want?[48]
 Faust. Nothing, Cornelius. Oh, this cheers my soul!
Come, show me some demonstrations magical, 151
That I may conjure in some bushy grove,
And have these joys in full possession.
 Vald. Then haste thee to some solitary grove,
And bear wise Bacon's and Albanus'[49] works,
The Hebrew Psalter, and New Testament;[50]
And whatsoever else is requisite
We will inform thee ere our conference cease.
 Corn. Valdes, first let him know the words of art;
And then, all other ceremonies learned, 160
Faustus may try his cunning by himself.
 Vald. First I'll instruct thee in the rudiments,
And then wilt thou be perfecter than I.

[25] *orient:* lustrous. [26] *delicates:* delicacies.
[27] *wall . . . brass:* Friar Bacon, the "white" magician in Robert Greene's play, intended to do the same for England.
[28] *public schools:* lecture rooms of the University.
[29] *skill:* often emended to "silk" (affluence, not characteristic of scholars).
[30] *Parma:* Governor General of the Spanish Netherlands from 1579 to 1592, and hence one of the topical references involved (not very helpfully) in dating the play.
[31] *Provinces:* i.e., of the Netherlands.
[32] *fiery . . . bridge:* On April 4, 1585 the Netherlands employed a fireship to demolish the bridge Parma had built across the river Scheldt to complete his blockade of Antwerp.
[33] *Yet . . . skill:* It is not simply the persuasion of his friends that has won Faustus to magic but his own wayward "fantasy" (the part of the mind that receives sense impressions and synthesizes them), which declines to work on any sense impression, so preoccupied is he with necromancy.
[34] *Gravelled:* Disconcerted.
[35] *problems:* intellectual demonstrations.
[36] *Musaeus:* Virgil locates this semimythological Greek poet in the Underworld in *Aeneid*, VI. 666*ff.* But it is worth recalling also that another Musaeus (fifth century A.D.) wrote a poem on Hero and Leander.
[37] *Agrippa:* Henry Cornelius Agrippa of Nettlesheim, a sixteenth-century physician, was part propagandist of science (hence in the popular imagination a mage who could call up the shades of the dead, "shadows") and part hysterical moralist.
[38] *Moors:* generically, dark-skinned persons; here, American Indians. [39] *Almaine rutters:* German horsemen.
[40] *Shadowing:* Harboring. [41] *airy:* ethereal, heavenly.
[42] *argosies:* large merchant vessels.
[43] *golden fleece:* the fabulous prize of Jason, the leader of the Argonauts, and hence emblematic of riches.
[44] *Philip's:* King Philip of Spain died in 1598; hence Q1614 revises Q1604 and gives the verb in the past tense, "stuffed." [45] *object it not:* don't make that a condition.
[46] *tongues:* languages.
[47] *seen in:* versed in (the properties of). [48] *want:* lack.
[49] *Bacon's and Albanus':* Roger Bacon, the thirteenth-century Franciscan, was a celebrated scientist (hence magician); Albanus (frequently emended to "Albertus" for the thirteenth-century Dominican philosopher, Albertus Magnus) may signify Pietro d'Albano, an alchemist of the thirteenth century, or a German saint (Alban) venerated at Cologne.
[50] *Psalter . . . Testament:* each used in conjuring spirits.

Faust. Then come and dine with me, and, after meat,
We'll canvass every quiddity[51] thereof;
For, ere I sleep, I'll try what I can do:
This night I'll conjure, though I die therefore.

Exeunt omnes.

[I.ii]

Enter Two Scholars.

1 Schol. I wonder what's become of Faustus, that
was wont to make our schools ring with *sic probo*.[1]

Enter WAGNER.

2 Schol. That shall we presently[2] know; here
comes his boy.

1 Schol. How now, sirrah! where's thy master?

Wag. God in heaven knows.

2 Schol. Why, dost not thou know, then?

Wag. Yes, I know; but that follows not.

1 Schol. Go to, sirrah! leave your jesting, and tell
us where he is. 10

Wag. That follows not by force of argument, which
you, being Licentiates,[3] should stand upon; therefore,
acknowledge your error, and be attentive.[4]

2 Schol. Then you will not tell us?

Wag. You are deceived, for I will tell you: yet, if you
were not dunces, you would never ask me such a
question; for is he not *corpus naturale?* And is not that
mobile?[5] Then wherefore should you ask me such a
question? But that I am by nature phlegmatic, slow to
wrath, and prone to lechery (to love, I would say), 20
it were not for you to come within forty foot of the place
of execution,[6] although I do not doubt but to see you
both hanged the next sessions.[7] Thus having triumphed
over you, I will set my countenance like a precisian,[8]
and begin to speak thus:—Truly, my dear brethren,
my master is within at dinner,[9] with Valdes and Corne-
lius, as this wine, if it could speak, would inform your
worships: and so, the Lord bless you, preserve you,
and keep you, my dear brethren.

Exit.

1 Schol. O Faustus. Then I fear that which I have
long suspected, 31
That thou art fallen into that damnèd art
For which they two are infamous through the world.

2 Schol. Were he a stranger, not allied to me,
The danger of his soul would make me mourn.
But, come, let us go and inform the Rector,[10]
It may be his grave counsel may reclaim him.

1 Schol. I fear me nothing will reclaim him now!

2 Schol. Yet let us see what we can do.

Exeunt.

[I.iii]

Thunder. Enter LUCIFER *and four* Devils, FAUSTUS
to them with this speech.

Faust. Now that the gloomy shadow of the night,
Longing to view Orion's drizzling look,[1]
Leaps from the antarctic world unto the sky,
And dims the welkin[2] with her pitchy[3] breath,

Faustus, begin thine incantations,
And try if devils will obey thy hest,[4]
Seeing thou has prayed and sacrificed to them.
Within this circle is Jehovah's name,
Forward and backward anagrammatized;[5]
Th' abbreviated names of holy saints, 10
Figures of every adjunct[6] to the heavens,
And characters[7] of signs[8] and erring[9] stars,
By which the spirits are enforced to rise:
Then fear not, Faustus, to be resolute,
And try the utmost magic can perform.

Thunder.

*Sint mihi Dii Acherontis propitii! Valeat numen triplex
Jehovae! Ignis, aeris, aquae, terrae spiritus, salvete!
Orientis princeps, Belzebub, inferni ardentis monarcha, et
Demogorgon, propitiamus vos, ut appareat et surgat
Mephistophilis.*[10] [Enter] Dragon [above.] *Quod* 20
tumeraris;[11] *per Jehovam Gehennam, et consecratam
aquam quam nunc spargo, signum crucis quod nunc facio,
et per vota nostra, ipse nunc surgat nobis dicatus Me-
phistophilis!*[12]

Enter a Devil.

I charge thee to return, and change thy shape;
Thou art too ugly to attend on me:

[51] *canvass every quiddity:* examine every essential element
(a Scholastic term).

I.ii.

 [1] *L.:* thus I prove (a term from Scholastic debate).

 [2] *presently:* immediately.

 [3] *Licentiates:* scholars licensed to proceed to a Master's or
a Doctor's degree.

 [4] *attentive:* At this point there follows in Q1604 only a
four-line exchange among Wagner and the Scholars. It is a
good illustration of what most editors take to be the inter-
polations in 1602 of Birde and Rowley.

 [5] *L.:* The scholastic term for the subject matter of physics
is "*Corpus naturale seu mobile*"; Wagner is parading his
learning. [6] *place of execution:* dining room.

 [7] *sessions:* when the court sits. [8] *precisian:* puritan.

 [9] *within at dinner:* With these words, Wagner gives the
scene; we are before Faustus' house.

 [10] *Rector:* Head of the university.

I.iii.

 [1] *Orion's drizzling look:* Echoing Virgil, *Aeneid*, I. 535.
When the constellation Orion set at the beginning of Novem-
ber, storm and rain ensued. [2] *welkin:* heaven.

 [3] *pitchy:* black. [4] *hest:* command.

 [5] *anagrammatized:* transposed to form another word.

 [6] *adjunct:* The heavenly bodies are represented as being
joined to the solid firmament of the sky.

 [7] *characters:* symbols.

 [8] *signs:* the figures of the zodiac.

 [9] *erring:* wandering: not fixed.

 [10] *L.:* May the gods of Acheron be favorable to me!
Away with the triple deity (? i.e., Trinity) of Jehovah! Hail,
spirits of fire, air, water, earth! Prince of the East, Belzebub,
monarch of burning hell, and Demogorgon, we ask you that
Mephistophilis may appear and rise.

 [11] *L.:* Not intelligible as it stands, and perhaps represent-
ing a corruption of a phrase beginning "*Quod tu me*"
Editors often emend to "*Quid tu moraris?*" ("Why do you
linger?"), which makes good sense.

 [12] *L.:* By Jehovah, hell, and the holy water that I now
sprinkle, and by the sign of the Cross that I now make, and
by our vows, may Mephistophilis himself now rise to serve us.

Go, and return an old Franciscan friar;
That holy shape becomes a devil best.

Exit Devil.

I see there's virtue in my heavenly words:[13]
Who would not be proficient in this art? 30
How pliant is this Mephistophilis,
Full of obedience and humility!
Such is the force of magic and my spells:
Now, Faustus, thou art conjuror laureate,[14]
That canst command great Mephistophilis.
Quin regis, Mephistophilis, fratris imagine![15]

Enter MEPHISTOPHILIS.

Meph. Now, Faustus, what would'st thou have me
 do?
Faust. I charge thee wait upon me whilst I live,
To do whatever Faustus shall command,
Be it to make the moon drop from her sphere 40
Or the ocean to overwhelm the world.
Meph. I am a servant to great Lucifer,
And may not follow thee without his leave;
No more than he commands must we perform.
Faust. Did not he charge thee to appear to me?
Meph. No, I came now hither of mine own accord.
Faust. Did not my conjuring raise thee? Speak.
Meph. That was the cause, but yet *per accidens,*[16]
For, when we hear one rack[17] the name of God,
Abjure the Scriptures and his Savior Christ, 50
We fly, in hope to get his glorious soul;
Nor will we come, unless he use such means
Whereby he is in danger to be damned.
Therefore the shortest cut for conjuring
Is stoutly to abjure the Trinity,
And pray devoutly to the prince of hell.
Faust. So Faustus hath
Already done; and holds this principle,
There is no chief but only Belzebub;
To whom Faustus doth dedicate himself. 60
This word "damnation" terrifies not me,
For I confound hell in Elysium:[18]
My ghost be with the old[19] philosophers!
But, leaving these vain trifles of men's souls,
Tell me what is that Lucifer thy lord?
Meph. Arch-regent and commander of all spirits.
Faust. Was not that Lucifer an angel once?
Meph. Yes, Faustus, and most dearly loved of God.

Faust. How comes it then that he is prince of devils?
Meph. Oh, by aspiring pride and insolence; 70
For which God threw him from the face of heaven.
Faust. And what are you that live with Lucifer?
Meph. Unhappy spirits that fell with Lucifer,
Conspired against our God with Lucifer,
And are forever damned with Lucifer.
Faust. Where are you damned?
Meph. In hell.
Faust. How comes it then thou art out of hell?
Meph. Why this is hell, nor am I out of it:
Think'st thou that I, that saw the face of God,
And tasted the eternal joys of heaven, 80
Am not tormented with ten thousand hells,
In being deprived of everlasting bliss?
O Faustus, leave these frivolous demands,
Which strikes a terror to my fainting soul!
Faust. What, is great Mephistophilis so passionate[20]
For being deprived of the joys of heaven?
Learn thou of Faustus manly fortitude,
And scorn those joys thou never shalt possess.
Go bear these tidings to great Lucifer:
Seeing Faustus hath incurred eternal death 90
By desperate thoughts against Jove's deity,
Say, he surrenders up to him his soul,
So he will spare him four-and-twenty years,
Letting him live in all voluptuousness;
Having thee ever to attend on me,
To give me whatsoever I shall ask,
To tell me whatsoever I demand,
To slay mine enemies, and to aid my friends,
And always be obedient to my will.
Go, and return to mighty Lucifer, 100
And meet me in my study at midnight,
And then resolve me of thy master's mind.
Meph. I will, Faustus.

Exit.

Faust. Had I as many souls as there be stars,
I'd give them all for Mephistophilis.
By him I'll be great emperor of the world.
And make a bridge thorough[21] the moving air,
To pass the ocean with a band of men;
I'll join the hills that bind[22] the Afric shore,
And make that country continent to[23] Spain, 110
And both contributory to my crown:
The Emperor shall not live but by my leave,
Nor any potentate of Germany.
Now that I have obtained what I desired,
I'll live in speculation[24] of this art,
Till Mephistophilis return again.

Exit.

[13] *heavenly words:* Scriptural invocations used in conjuring.
[14] *conjuror laureate:* like "poet laureate."
[15] *L.:* Nay but you rule, Mephistophilis, in the likeness of a friar. Editors often emend "*regis*" to "*redis*" ("you return").
[16] *L.:* incidentally (another formulaic term from scholasticism).
[17] *rack:* torture, as by anagrammatizing or transposing letters.
[18] *confound . . . Elysium:* make no distinction between hell and heaven. [19] *old:* i.e., pre-Christian.
[20] *passionate:* stirred by passion.
[21] *thorough:* through. [22] *bind:* bind in.
[23] *continent to:* bordering on.
[24] *speculation:* contemplative study.
I.iv.
[1] *comings in:* income.

[I.iv]

Enter WAGNER *and the* Clown.

Wag. Come hither, sirrah boy.
Clown. Boy! Oh, disgrace to my person. Zounds, boy in your face! You have seen many boys with beards, I am sure.
Wag. Sirrah, hast thou no comings in?[1]

Clown. Yes, and goings out too, you may see, sir.

Wag. Alas, poor slave! see how poverty jests in his nakedness! I know the villain's out of service, and so hungry that I know he would give his soul to the devil for a shoulder of mutton, though it were blood-raw. 10

Clown. Not so, neither. By'r lady, I had need to have it well roasted, and good sauce to it, if I pay so dear, I can tell you.

Wag. Sirrah, wilt thou be my man and wait on me, and I will make thee go like *Qui mihi discipulus?*[2]

Clown. What, in verse?

Wag. No, slave; in beaten[3] silk and staves-acre.[4]

Clown. Staves-acre! that's good to kill vermin. Then, belike, if I serve you, I shall be lousy. 19

Wag. Why, so thou shalt be, whether thou do'st it or no. For sirrah, if thou dost not presently bind thyself to me for seven years, I'll turn all the lice about thee into familiars,[5] and make them tear thee in pieces.

Clown. Nay, sir, you may save yourself a labor, for they are as familiar with me as if they had paid for their meat and drink, I can tell you.

Wag. Well, sirrah, leave your jesting and take these guilders.[6]

Clown. Yes, marry, sir, and I thank you too. 29

Wag. So, now thou art to be at an hour's warning, whensoever and wheresoever the devil shall fetch thee.

Clown. Here, take your guilders again, I'll none of 'em.

Wag. Not I, thou art pressed,[7] for I will presently raise up two devils to carry thee away—Banio, Belcher!

Clown. Belcher! and[8] Belcher come here, I'll belch him. I am not afraid of a devil.

Enter two Devils.

Wag. How now, sir, will you serve me now?

Clown. Ay, good Wagner, take away the devil then.

Wag. Spirits, away! Now, sirrah, follow me. 40
[*Exeunt* Devils.]

Clown. I will, sir, but hark you, master, will you teach me this conjuring occupation?

Wag. Ay, sirrah, I'll teach thee to turn thyself to a dog, or a cat, or a mouse, or a rat, or any thing.

Clown. A dog, or a cat, or a mouse, or a rat, O brave Wagner!

Wag. Villain, call me Master Wagner, and see that you walk attentively and let your right eye be always diametrally[9] fixed upon my left heel, that thou may'st *quasi vestigias nostras insistere.*[10] 50

Clown. Well, sir, I warrant you.

Exeunt.

[ACT TWO]

[SCENE ONE]

Enter FAUSTUS *in his study.*

Faust. Now, Faustus, must
Thou needs be damned, and canst thou not be saved.
What boots it, then, to think on God or heaven?
Away with such vain fancies, and despair;

Despair in God, and trust in Belzebub:
Now go not backward; Faustus, be resolute:
Why waver'st thou? Oh, something soundeth in mine ear,
"Abjure this magic, turn to God again!"
Ay, and Faustus will turn to God again.
To God? He loves thee not; 10
The God thou serv'st is thine own appetite,
Wherein is fixed the love of Belzebub:
To him I'll build an altar and a church,
And offer lukewarm blood of new-born babes.

Enter Good Angel and Evil [Angel].

Bad Ang. Go forward, Faustus, in that famous art.
Good Ang. Sweet Faustus, leave that execrable art.
Faust. Contrition, prayer, repentance—what of these?
Good Ang. Oh, they are means to bring thee unto heaven!
Bad Ang. Rather illusions, fruits of lunacy,
That make them foolish that do use them most. 20
Good Ang. Sweet Faustus, think of heaven and heavenly things.
Bad Ang. No, Faustus; think of honor and of wealth.
Exeunt [Angels].
Faust. Wealth! why, the signiory of Embden[1] shall be mine.
When Mephistophilis shall stand by me,
What God can hurt me? Faustus, thou art safe:
Cast no more doubts—Mephistophilis, come!
And bring glad tidings from great Lucifer;
Is't not midnight?—come, Mephistophilis,
Veni,[2] *veni, Mephistophile!*

Enter MEPHISTOPHILIS.

Now tell me what saith Lucifer, thy lord? 30
Meph. That I shall wait on Faustus while he lives,
So he will buy my service with his soul.
Faust. Already Faustus hath hazarded that for thee.
Meph. But now thou must bequeath it solemnly,
And write a deed of gift with thine own blood;
For that security craves Lucifer.
If thou deny it, I must back to hell.
Faust. Stay, Mephistophilis, tell me what good
Will my soul do thy lord?
Meph. Enlarge his kingdom.
Faust. Is that the reason why he tempts us thus? 40
Meph. *Solamen miseris socios habuisse doloris.*[3]

[2] *L.:* You who are my students.
[3] *beaten:* embroidered.
[4] *staves-acre:* the plant larkspur.
[5] *familiars:* demons haunting a particular person.
[6] *guilders:* Dutch coins.
[7] *pressed:* enlisted in my service, by having taken the "press-money." [8] *and:* if.
[9] *diametrally:* in a straight line.
[10] *L.:* as if to walk in our tracks.

II.i.
[1] *signiory of Embden:* The important mercantile town of Emden in East Friesland had considerable trade relations with England in Marlowe's time. [2] *L.:* Come.
[3] *L.:* Misery loves company.

Faust. Why, have you any pain that torture others?
Meph. As great as have the human souls of men.
But tell me, Faustus, shall I have thy soul?
And I will be thy slave, and wait on thee,
And give thee more then thou hast wit to ask.
Faust. Ay, Mephistophilis, I'll give it him.[4]
Meph. Then, Faustus, stab thy arm courageously,
And bind[5] thy soul, that at some certain day
Great Lucifer may claim it as his own; 50
And then be thou as great as Lucifer.

[FAUSTUS *stabs his arm.*]

Faust. Lo, Mephistophilis, for love of thee,
I cut mine arm, and with my proper[6] blood
Assure[7] my soul to be great Lucifer's,
Chief lord and regent of perpetual night!
View here this blood that trickles from mine arm,
And let it be propitious for my wish.
Meph. But, Faustus,
Write it in manner of a deed of gift.
Faust. Ay, so I do. [*Writes*] But, Mephistophilis, 60
My blood congeals, and I can write no more.
Meph. I'll fetch thee fire to dissolve it straight.
 Exit.

Faust. What might the staying[8] of my blood
 portend?
Is it unwilling I should write this bill?
Why streams it not, that I may write afresh?
Faustus gives to thee his soul: oh, there it stayed!
Why shouldst thou not? Is not thy soul thine own?
Then write again, *Faustus gives to thee his soul.*

Enter MEPHISTOPHILIS *with the chafer[9] of fire.*

Meph. See, Faustus, here is fire, set it[10] on.
Faust. So, now the blood begins to clear again; 70
Now will I make an end immediately.

[*Writes.*]

Meph. [*Aside*] What will not I do to obtain his soul?
Faust. Consummatum est,[11] this bill is ended,
And Faustus hath bequeathed his soul to Lucifer.
But what is this inscription on mine arm?
Homo, fuge![12] whither should I fly?
If unto God, he'll throw me down to hell.
My senses are deceived; here's nothing writ:
Oh, yes, I see it plain; even here is writ,
Homo, fuge! yet shall not Faustus fly. 80
Meph. [*Aside*] I'll fetch him somewhat to delight his
 mind.
 Exit.

Enter Devils, *giving crowns and rich apparel to*
FAUSTUS. *They dance, and then depart.*

Enter MEPHISTOPHILIS.

Faust. What means this show? Speak,
 Mephistophilis.
Meph. Nothing, Faustus, but to delight thy mind,
And let thee see what magic can perform.
Faust. But may I raise such spirits when I please?
Meph. Ay, Faustus, and do greater things than these.
Faust. Then there's enough for a thousand souls.
Here, Mephistophilis, receive this scroll,
A deed of gift of body and of soul:
But yet conditionally that thou perform 90
All articles prescribed between us both.
Meph. Faustus, I swear by hell and Lucifer
To effect all promises between us both.
Faust. Then hear me read it, Mephistophilis.

On these conditions following.
First, that Faustus may be a spirit in form and substance.
Secondly, that Mephistophilis shall be his servant, and be
 by him commanded.
Thirdly, that Mephistophilis shall do for him, and bring
 him whatsoever. 100
Fourthly, that he shall be in his chamber or house invisible.
Lastly, that he shall appear to the said John Faustus at
 all times, in what form or shape soever he please.
I, John Faustus, of Wittenberg, Doctor, by these presents,
 do give both body and soul to Lucifer Prince of the East,
 and his minister Mephistophilis: and furthermore grant
 unto them that, four and twenty years being expired, and
 these articles above written being inviolate, full power to
 fetch or carry the said John Faustus, body and soul,
 flesh, blood, or goods, into their habitation wheresoever.
 By me, John Faustus.

Meph. Speak, Faustus, do you deliver this as your
 deed? 112
Faust. Ay, take it, and the devil give thee good of it!
Meph. So, now, Faustus, ask me what thou wilt.
Faust. First I will question with thee about hell.
Tell me, where is the place that men call hell?
Meph. Under the heavens.
Faust. Ay, so are all things else, but whereabouts?
Meph. Within the bowels of these elements,
Where we are tortured and remain forever: 120
Hell hath no limits, nor is circumscribed
In one self[13] place; but where we are is hell,
And where hell is, there must we ever be:
And, to be short, when all the world dissolves,
And every creature shall be purified,
All places shall be hell that is not heaven.
Faust. I think hell's a fable.
Meph. Ay, think so, till experience change thy mind.
Faust. Why, dost thou think that Faustus shall be
 damned?
Meph. Ay, of necessity, for here's the scroll 130
In which thou hast given thy soul to Lucifer.
Faust. Ay, and body too: but what of that?
Think'st thou that Faustus is so fond[14] to imagine
That, after this life, there is any pain?
No, these are trifles and mere old wives' tales.
Meph. But I am an instance to prove the contrary;
For I tell thee I am damned, and now in hell.

[4] *him*: Lucifer. [5] *bind*: give a bond for.
[6] *proper*: own. [7] *Assure*: Pledge.
[8] *staying*: failing to flow (congealing).
[9] *chafer*: vessel (used for heating). [10] *it*: the blood.
[11] *L.*: It is finished (echoing Christ on the Cross: John
29 :30). [12] *L.*: Man, fly. [13] *self*: same.
[14] *fond*: foolish.

Faust. Nay, and this be hell, I'll willingly be damned:
What! sleeping, eating, walking, and disputing!
But, leaving off this, let me have a wife, 140
The fairest maid in Germany, for I
Am wanton and lascivious
And cannot live without a wife.
 Meph. Well, Faustus, thou shalt have a wife.

 He fetches in a Woman Devil.

 Faust. What sight is this?
 Meph. Now, Faustus, wilt thou have a wife?
 Faust. Here's a hot whore indeed! No, I'll no wife.
 Meph. Marriage is but a ceremonial toy:
And if thou lovest me, think no more of it.
I'll cut thee out the fairest courtesans,[15] 150
And bring them every morning to thy bed:
She whom thine eye shall like, thy heart shall have,
Were she as chaste as was Penelope,[16]
As wise as Saba,[17] or as beautiful
As was bright Lucifer before his fall.
Here, take this book, and peruse it well:
The iterating[18] of these lines brings gold;
The framing of this circle on the ground
Brings thunder, whirlwinds, storm, and lightning;
Pronounce this thrice devoutly to thyself, 160
And men in harness[19] shall appear to thee,
Ready to execute what thou command'st.
 Faust. Thanks, Mephistophilis, for this sweet book.
This will I keep as chary[20] as my life.

 Exeunt.[21]

[II.ii]

 Enter FAUSTUS *in his study and* MEPHISTOPHILIS.

 Faust. When I behold the heavens, then I repent,
And curse thee, wicked Mephistophilis,
Because thou hast deprived me of those joys.
 Meph. 'Twas thine own seeking, Faustus, thank
 thyself.
But think'st thou heaven is such a glorious thing?
I tell thee, Faustus, it is not half so fair
As thou, or any man that breathes on earth.
 Faust. How provest thou that?
 Meph. 'Twas made for man; then he's more
 excellent.
 Faust. If heaven was made for man, 'twas made for
 me: 10
I will renounce this magic and repent.

 Enter the two Angels.

 Good Ang. Faustus, repent; yet[1] God will pity thee.
 Bad Ang. Thou art a spirit;[2] God cannot pity thee.
 Faust. Who buzzeth in mine ears, I am a spirit?
Be I a devil, yet God may pity me;
Yea, God will pity me, if I repent.
 Bad Ang. Ay, but Faustus never shall repent.
 Exeunt Angels.
 Faust. My heart is hardened, I cannot repent:
Scarce can I name salvation, faith, or heaven,
But fearful echoes thunders in mine ears, 20

"Faustus, thou art damned!" Then swords, and knives
Poison, guns, halters, and envenomed[3] steel
Are laid before me to dispatch myself;
And long ere this I should have done the deed,
Had not sweet pleasure conquered deep despair.
Have not I made blind Homer sing to me
Of Alexander's[4] love and Oenon's death?
And hath not he,[5] that built the walls of Thebes,
With ravishing sound of his melodious harp,
Made music with my Mephistophilis? 30
Why should I die, then, or basely despair?
I am resolved; Faustus shall not repent.
Come, Mephistophilis, let us dispute again,
And reason of[6] divine astrology.
Speak, are there many heavens above the moon?
Are all celestial bodies but one globe,
As is the substance of this centric earth?[7]
 Meph. As are the elements, such are the heavens,
Even from the moon unto the imperial orb,
Mutually folded in each other's spheres, 40
And jointly move upon one axletree,
Whose terminè is termed the world's wide pole;
Nor are the names of Saturn, Mars, or Jupiter
Feigned, but are erring stars.[8]
 Faust. But have they all
One motion, both *situ et tempore?*[9]

[15] *courtesans:* elegant prostitutes.
[16] *Penelope:* whose long faithfulness to her absent husband, Ulysses, made her the type of the chaste wife.
[17] *Saba:* Sheba, Solomon's queen, was proverbial for her wisdom. [18] *iterating:* repeating. [19] *harness:* armor.
[20] *chary:* carefully.
[21] *Exeunt:* Q1604 carries the scene forward with further talk between Faustus and Mephistophilis. Q1616 follows the stage direction with a brief appearance on stage of Wagner, "solus." Because what Wagner says abridges the speech of the Chorus that functions as Prologue to Act III, his lines are omitted here. Editors conjecture that he figured at this point in a lost comic scene, especially because, when the action begins again, we meet Faustus and Mephistophilis in the same setting. Evidently time has passed and some action has ensued.

II.ii.
[1] *yet:* even now. [2] *spirit:* devil.
[3] *envenomed:* tipped with poison.
[4] *Alexander's:* Paris's (the lover of Oenone, who committed suicide after his death). [5] *he:* Amphion.
[6] *reason of:* discourse about.
[7] *Are . . . earth:* Is the universe really constituted of layers of spheres (nine is the number subsequently assigned), one above another? Do all the apparently separate heavenly bodies actually compose a single globe, like the earth (which in the old astronomy is understood to be at the center of the universe)?
[8] *As . . . stars:* Just as the four elements are distinct and yet combine with one another, so the various spheres, ascending from the moon to the heaven imperial (highest of all), are distinct. In this they are like the heavenly bodies, also distinct and yet connected to the axletree or pole (described as a boundary or farthest limit) on which the universe turns, and moving or wandering (hence "erring stars") in each other's spheres. We are right, then, to give the planets individual names.
[9] *L.:* in position and in time (in the direction in which they move and in the duration of their movement around the earth).

Meph. All move from east to west in four and twenty hours upon the poles of the world; but differ in their motions upon the poles of the zodiac.[10]

Faust. These slender questions Wagner can decide: Hath Mephistophilis no greater skill? 50
Who knows not the double motion of the planets? That the first is finished in a natural day; The second thus: Saturn in 30 years; Jupiter in 12; Mars in 4; the Sun, Venus, and Mercury in a year; the Moon in 28 days.[11] These are freshmen's questions. But, tell me, hath every sphere a dominion or intelligentia?[12]

Meph. Ay.

Faust. How many heavens or spheres are there? 59

Meph. Nine; the seven planets, the firmament,[13] and the imperial heaven.

Faust. But is there not *coelum igneum, et cristallinum?*[14]

Meph. No, Faustus, they be but fables.

Faust. Resolve[15] me then in this one question: why are not conjunctions, oppositions, aspects,[16] eclipses, all at one time, but in some years we have more, in some less?

Meph. Per inaequalum motum respectu totius.[17]

Faust. Well, I am answered. Now tell me who made the world. 71

Meph. I will not.

Faust. Sweet Mephistophilis, tell me.

Meph. Move me not, Faustus.

Faust. Villain, have not I bound thee to tell me any thing?

Meph. Ay, that is not against our kingdom. This is: thou art damned; think thou of hell.

Faust. Think, Faustus, upon God that made the world. 80

Meph. Remember this.

 Exit.

Faust. Ay, go, accursèd spirit, to ugly hell! 'Tis thou hast damned distressèd Faustus' soul. Is't not too late?

Enter the two Angels.

Bad Ang. Too late.

Good Ang. Never too late, if Faustus will repent.

Bad Ang. If thou repent, devils will tear thee in pieces.

Good Ang. Repent, and they shall never raze[18] thy skin. 90

 Exeunt Angels.

Faust. O Christ, my Savior, my Savior, Help to save distressèd Faustus' soul!

Enter LUCIFER, BELZEBUB, *and* MEPHISTOPHILIS.

Luc. Christ cannot save thy soul, for he is just: There's none but I have interest in[19] the same.

Faust. Oh, what art thou that looks't so terribly?

Luc. I am Lucifer, And this is my companion prince in hell.

Faust. O Faustus, they are come to fetch thy soul!

Belz. We are come to tell thee thou dost injure us.

Luc. Thou call'st on Christ, contrary to thy promise.

Belz. Thou shouldst not think on God. 101

Luc. Think on the devil.

Belz. And his dam too.

Faust. Nor[20] will I henceforth: pardon me in this, And Faustus vows never to look to heaven, Never to name God, or to pray to him, To burn his Scriptures, slay his ministers, And make my spirits pull his churches down.

Luc. So shalt thou show thyself an obedient servant, And we will highly gratify thee for it. 110

Belz. Faustus, we are come from hell in person to show thee some pastime: sit down, and thou shalt behold the Seven Deadly Sins appear to thee in their own proper shapes and likeness.

Faust. That sight will be as pleasing unto me As Paradise was to Adam, the first day Of his creation.

Luc. Talk not of paradise or creation; but mark the show. Go, Mephistophilis, fetch them in. 119

Enter the Seven Deadly Sins.

Belz. Now, Faustus, question them of their names and dispositions.

Faust. That shall I soon. What are thou, the first?

Pride. I am Pride. I disdain to have any parents. I am like to Ovid's flea;[21] I can creep into every corner of a wench; sometimes, like a periwig,[22] I sit upon her brow; next, like a necklace, I hang about her neck; then, like a fan of feathers, I kiss her lips, and then, turning myself to a wrought smock[23] do what I list. But, fie, what a smell is here! I'll not speak another word, unless the ground be perfumed, and covered with cloth of arras.[24] 131

[10] *All . . . zodiac:* The duration of their movement around the earth is the same for each planet (twenty-four hours), but the time it takes them to revolve around the common axletree is different in each case. (Their movement, as Faustus goes on to say, is "double.")

[11] *Saturn . . . days:* Faustus has got it right for Saturn and Jupiter (in their revolution not around the earth but the sun); he overestimates in the case of Mars, Venus, and Mercury.

[12] *dominion or intelligentia:* ruling spirit or angel.

[13] *firmament:* abode of the fixed (as opposed to "erring") stars.

[14] *L.:* sphere of fire and the crystalline sphere. The latter, in the Ptolemaic system, is above the firmament; the former is conceived as a belt or "element" encircling the earth (which was bounded also by elements of air and water).

[15] *Resolve:* Enlighten.

[16] *conjunctions, oppositions, aspects:* The first denotes the apparent proximity of two heavenly bodies, the second their extreme divergence, the third any other relative position for the two.

[17] *L.:* Because of their unequal motion with respect to the whole. In other words, the heavenly bodies move at different speeds within the universe.

[18] *raze:* graze, touch the surface of.

[19] *interest in:* a legal claim on.

[20] *Nor:* responding to the injunction not to think on God.

[21] *Ovid's flea:* A Latin "Song of the Flea," probably written in the Middle Ages, was attributed to Ovid.

[22] *periwig:* wig.

[23] *wrought smock:* embroidered undergarment.

[24] *cloth of arras:* tapestry, from Arras in Flanders.

Faust. Thou art a proud knave, indeed! what art thou, the second?

Covet. I am Covetousness, begotten of an old churl in a leather bag: and might I now obtain my wish, this house, you and all, should turn to gold, that I might lock you safe into my chest. Oh, my sweet gold!

Faust. And what art thou, the third?

Envy. I am Envy, begotten of a chimney-sweeper and an oyster-wife.[25] I cannot read, and therefore 140 wish all books burned. I am lean with seeing others eat. Oh, that there would come a famine over all the world, that all might die and I live alone! then thou should'st see how fat I'd be. But must thou sit, and I stand? Come down, with a vengeance!

Faust. Out, envious wretch!—But what art thou, the fourth?

Wrath. I am Wrath, I had neither father nor mother: I leaped out of a lion's mouth when I was scarce an hour old; and ever since have run up and down the 150 world with these case of rapiers, wounding myself when I could get none to fight withal.[26] I was born in hell; and look to it, for some[27] of you shall[28] be my father.

Faust. And what are thou, the fifth?

Glut. I am Gluttony, My parents are all dead, and the devil a penny they have left me, but[29] a small pension, and that buys me thirty meals a day and ten bevers[30]—a small trifle to suffice nature. I come of a royal pedigree! my father was a Gammon of Bacon, and my mother was a Hogshead of Claret wine; 160 my godfathers were these, Peter Pickled-herring[31] and Martin Martlemas-beef.[32] But my godmother, oh, she was an ancient gentlewoman, her name was Margery March-beer.[33] Now, Faustus, thou hast heard all my progeny;[34] wilt thou bid me to supper?

Faust. Not I.

Glut. Then the devil choke thee.

Faust. Choke thyself, glutton!—What art thou, the sixth? 169

Sloth. Heigh ho! I am Sloth. I was begotten on a sunny bank, where I have lain ever since; and you have done me great injury to bring me from thence: let me be carried thither again by Gluttony and Lechery. Heigh ho! I'll not speak a word more for a king's ransom.

Faust. And what are you, Mistress Minx, the seventh and last.

Lechery. Who, I, sir? I am one that loves an inch of raw mutton[35] better than an ell[36] of fried stockfish,[37] and the first letter of my name begins with Lechery.

Luc. Away, to hell, away, on Piper![38] 181

Exeunt the Seven Sins.

Faust. Oh, how this sight doth delight my soul!

Luc. But, Faustus, in hell is all manner of delight.

Faust. Oh, might I see hell, and return again safe, how happy were I then!

Luc. Faustus, thou shalt. At midnight I will send for thee.

Meanwhile peruse this book and view it throughly[39] And thou shalt turn thyself into what shape thou wilt.

Faust. Thanks, mighty Lucifer!
This will I keep as chary as my life. 190

Luc. Now, Faustus, farewell.

Faust. Farewell, great Lucifer. Come, Mephistophilis.

Exeunt omnes several ways.[40]

[II.iii]

Enter the Clown [ROBIN *with a book.*]

Robin. What, Dick, look to the horses there,[1] till I come again. I have gotten one of Doctor Faustus' conjuring books, and now we'll have such knavery, as't passes.[2]

Enter DICK.

Dick. What, Robin, you must come away and walk the horses.

Robin. I walk the horses? I scorn't, faith', I have other matters in hand, let the horses walk themselves and[3] they will. [*Reads*] *A per se;*[4] *a, t. h. e. the; o per se; o deny orgon, gorgon.*[5] Keep further from me, O thou illiterate and unlearned hostler. 11

Dick. 'Snails,[6] what hast thou got there? A book? Why, thou canst not tell ne'er a word on't.

Robin. That thou shalt see presently. Keep out of the circle, I say, lest I send you into the ostry[7] with a vengeance.

Dick. That's like, 'faith: you had best leave your foolery, for an[8] any master come, he'll conjure you, 'faith. 19

Robin. My master conjure me? I'll tell thee what, an my master come here, I'll clap as fair a pair of horns on's head as e'er thou sawest in thy life.

Dick. Thou need'st not do that, for my mistress hath done it.

Robin. Ay, there be of us here that have waded as deep into matters[9] as other men, if they were disposed to talk.

[25] *chimney-sweeper . . . oyster-wife:* suggesting dirt and fishy smells. [26] *withal:* with.
[27] *some:* one (of the devils on stage). [28] *shall:* must.
[29] *but:* only. [30] *bevers:* snacks.
[31] *Pickled-herring:* cant for "buffoon."
[32] *Martin Martlemas-beef:* November 11 (Martinmas) was the time for hanging up beef that had been salted for the winter. [33] *March-beer:* choice ale made in March.
[34] *progeny:* ancestry. [35] *mutton:* cant for "prostitute."
[36] *ell:* i.e., more than a yard.
[37] *fried stockfish:* dried codfish.
[38] *Piper:* addressing a musician on stage, who leads off the procession of the Sins. [39] *throughly:* thoroughly.
[40] *Exeunt . . . ways:* What follows in Q1616 is omitted in Q1604, which offers a different version later in the play.

II.iii.
[1] *look . . . there:* The reference to horses places the scene; we are in an innyard.
[2] *as't passes:* as beats everything. [3] *and:* if.
[4] *A per se: A* by itself; i.e., a unique thing (Robin's mock attempt at conjuring).
[5] *o . . . gorgon:* for Demogorgon, whom Faustus had invoked. [6] *'Snails:* God's nails. [7] *ostry:* inn.
[8] *an:* and; i.e., if.
[9] *matters:* a euphemism for sexual business; here, the woman herself.

Dick. A plague take you, I thought you did not sneak up and down after her for nothing. But I prithee tell me in good sadness,[10] Robin, is that a conjuring book? 31

Robin. Do but speak what thou't have me to do, and I'll do't: If thou't dance naked, put off thy clothes, and I'll conjure thee about presently: or if thou't go but to the tavern with me, I'll give thee white wine, red wine, claret wine, sack, muscadine, malmesey, and whippincrust,[11] hold belly, hold, and we'll not pay one penny for it.

Dick. Oh, brave, prithee let's to it presently, for I am as dry as a dog. 40

Robin. Come then, let's away.

Exeunt.

[ACT THREE]

[PROLOGUE]

Enter the Chorus.

Chor. Learned Faustus,
To find the secrets of astronomy
Graven in the book of Jove's high firmament,
Did mount him up to scale Olympus' top,
Where sitting in a chariot burning bright,
Drawn by the strength of yokèd dragons' necks,
He views the clouds, the planets, and the stars,
The tropic zones, and quarters of the sky,
From the bright circle of the hornèd moon,
E'en to the height of *Primum Mobile:* [1] 10
And whirling round with this circumference,
Within the concave compass of the pole;
From east to west his dragons swiftly glide,
And in eight days did bring him home again.

[10] *sadness:* seriousness.

[11] *muscadine, malmesey, and whippincrust:* The first and second are strong sweet wines, the third perhaps a corruption for "hippocras," a spice-flavored wine.

III. PROLOGUE

[1] *Primum Mobile:* The axle of the heavens, by which God moves all the concentric spheres. [2] *subtle:* rarefied.

III.i.

[1] *Trier:* Treves, on the river Mosel.

[2] *entrenchèd lakes:* i.e., a moat.

[3] *coasting:* passing along the side of.

[4] *straight forth:* running from one end of the town to another in a straight line.

[5] *Quarters . . . equivalents:* Divides in four equal parts. This line, occurring in Q1604 but not in Q1616, is an instance in which the earlier edition is more ample than the later for reasons that have nothing to do with the interposing of the censor.

[6] *Maro's:* Virgil's (buried at Naples in 19 B.C.).

[7] *The . . . space:* This prodigious feat reflects Virgil's reputation in the Middle Ages as a necromancer.

[8] *temple:* St. Mark's in Venice. [9] *curious:* intricate.

[10] *erst:* formerly.

[11] *privy-chamber:* another instance in which dialogue sets the scene. [12] *All's one:* It doesn't matter.

[13] *lean:* arch.

[14] *castle:* The Castello di Sant' Angelo, built A.D. 135 by Emperor Hadrian as his mausoleum but not, despite Mephistophilis, on the bridge itself.

Not long he stayed within his quiet house,
To rest his bones after his weary toil,
But new exploits do hale him out again,
And mounted then upon a dragon's back,
That with his wings did part the subtle[2] air,
He now is gone to prove cosmography, 20
That measures coasts, and kingdoms of the earth:
And, as I guess, will first arrive at Rome,
To see the Pope and manner of his court,
And take some part of holy Peter's feast,
The which this day is highly solemnized.

Exit.

[SCENE ONE]

Enter FAUSTUS *and* MEPHISTOPHILIS.

Faust. Having now, my good Mephistophilis,
Passed with delight the stately town of Trier,[1]
Environed round with airy mountain tops,
With walls of flint, and deep entrenchèd lakes,[2]
Not to be won by our conquering prince;
From Paris next, coasting[3] the realm of France,
We saw the river Maine fall into Rhine,
Whose banks are set with groves of fruitful vines;
Then up to Naples, rich Campania,
Whose buildings fair and gorgeous to the eye, 10
The streets straight forth,[4] and paved with finest brick,
Quarters the town in four equivalents;[5]
There saw we learned Maro's[6] golden tomb
The way he cut, an English mile in length
Thorough a rock of stone, in one night's space;[7]
From thence to Venice, Padua, and the East,
In one of which a sumptuous temple[8] stands,
That threats the stars with her aspiring top,
Whose frame is paved with sundry colored stones,
And roofed aloft with curious[9] work in gold. 20
Thus hitherto hath Faustus spent his time:
But tell me now, what resting place is this?
Hast thou, as erst[10] I did command,
Conducted me within the walls of Rome?

Meph. I have, my Faustus, and for proof thereof
This is the goodly palace of the Pope;
And cause we are no common guests
I choose his privy-chamber[11] for our use.

Faust. I hope his Holiness will bid us welcome.

Meph. All's one,[12] for we'll be bold with his venison.
But now, my Faustus, that thou may'st perceive 31
What Rome contains for to delight thine eyes,
Know that this city stands upon seven hills
That underprop the groundwork of the same:
Just through the midst runs flowing Tiber's stream,
With winding banks that cut it in two parts;
Over the which four stately bridges lean,[13]
That make safe passage to each part of Rome:
Upon the bridge called Ponte Angelo
Erected is a castle[14] passing strong, 40
Where thou shalt see such store of ordinance,
As that the double cannons, forged of brass,
Do match the number of the days contained
Within the compass of one complete year:

Beside the gates, and high pyramides,[15]
That Julius Caesar brought from Africa.
 Faust. Now, by the kingdoms of infernal rule,
Of Styx, of Acheron, and the fiery lake
Of ever-burning Phlegethon,[16] I swear
That I do long to see the mounuments 50
And situation of bright splendent[17] Rome:
Come therefore, let's away.
 Meph. Nay, stay, my Faustus; I know you'd see the
 Pope
And take some part of holy Peter's feast,
The which, in state and high solemnity,
This day is held through Rome and Italy,
In honor of the Pope's triumphant victory.
 Faust. Sweet Mephistophilis, thou pleasest me.
Whilst I am here on earth, let me be cloyed[18]
With all things that delight the heart of man. 60
My four-and-twenty years of liberty
I'll spend in pleasure and in dalliance,
That Faustus' name, whilst this bright frame doth
 stand,
May be admired through the furthest land.
 Meph. 'Tis well said, Faustus; come then, stand by
 me
And thou shalt see them come immediately.
 Faust. Nay, stay, my gentle Mephistophilis,
And grant me my request, and then I go.
Thou know'st within the compass of eight days
We viewed the face of heaven, of earth and hell. 70
So high our dragons soared into the air,
That looking down, the earth appeared to me
No bigger than my hand in quantity.
There did we view the kingdom of the world,
And what might please mine eye, I there beheld.
Then in this show let me an actor be,
That this proud Pope may Faustus' cunning see.
 Meph. Let it be so, my Faustus, but first stay,
And view their triumphs,[19] as they pass this way.
And then devise what best contents thy mind 80
By cunning in thine art to cross the Pope,
Or dash the pride of this solemnity;
To make his monks and abbots stand like apes,
And point like antics[20] at his triple crown:
To beat the beads about the friars' pates,
Or clap huge horns upon the Cardinals' heads;
Or any villainy thou canst devise,
And I'll perform it, Faustus: Hark! they come:
This day shall make thee be admired[21] in Rome.

Enter the Cardinals *and* Bishops, *some bearing crosiers,*[22]
 some the pillars,[23] Monks *and* Friars *singing their*
 procession.[24] *Then the* POPE, *and* RAYMOND, KING
 OF HUNGARY *with* BRUNO[25] *led in chains.*

 Pope. Cast down our footstool.
 Ray. Saxon Bruno, stoop,
Whilst on thy back his Holiness ascends 91
Saint Peter's chair and state[26] pontifical.
 Bruno. Proud Lucifer, that state belongs to me:
But thus I fall to Peter, not to thee.
 Pope. To me and Peter shalt thou grovelling lie,
And crouch before the Papal dignity;

Sound trumpets, then, for thus Saint Peter's heir,
From Bruno's back, ascends Saint Peter's chair.

 A flourish[27] *while he ascends.*

Thus, as the gods creep on with feet of wool,
Long ere with iron hands they punish men, 100
So shall our sleeping vengeance now arise,
And smite with death thy hated enterprise.
Lord Cardinals of France and Padua,
Go forthwith to our holy Consistory,[28]
And read amongst the Statutes Decretal,[29]
What, by the holy Council held at Trent,[30]
The sacred synod[31] hath decreed for him
That doth assume the Papal government
Without election, and a true consent:
Away, and bring us word with speed. 110
 1 Card. We go, my lord.
 Exeunt Cardinals.
 Pope. Lord Raymond.
 Faust. Go, haste thee, gentle Mephistophilis,
Follow the Cardinals to the Consistory;
And as they turn their superstitious books,
Strike them with sloth, and drowsy idleness;
And make them sleep so sound, that in their shapes
Thyself and I may parley with this Pope,
This proud confronter of the Emperor:
And in despite of all his Holiness 120
Restore this Bruno to his liberty,
And bear him to the States of Germany.
 Meph. Faustus, I go.
 Faust. Dispatch it soon,
The Pope shall curse that Faustus came to Rome.
 Exeunt FAUSTUS *and* MEPHISTOPHILIS.
 Bruno. Pope Adrian,[32] let me have right of law,
I was elected by the Emperor.
 Pope. We will depose the Emperor for that deed,
And curse the people that submit to him;
Both he and thou shalt stand excommunicate, 130
And interdict from Church's privilege

 [15] *pyramides:* obelisks.
 [16] *Styx . . . Acheron . . . Phlegethon:* rivers of the under-world. [17] *bright splendent:* resplendent.
 [18] *cloyed:* sated, stuffed.
 [19] *triumphs:* spectacular entertainments.
 [20] *antics:* fools, madmen. [21] *admired:* wondered at.
 [22] *crosiers:* bishops' staffs, shaped like shepherds' crooks.
 [23] *pillars:* emblems of office, perhaps (as in medieval painting) figuring the pillar against which Christ was scourged, and used in England in the sixteenth century in lieu of the mace. [24] *procession:* processional chant, litany.
 [25] *Raymond . . . Bruno:* Neither has been identified. It is plausible to see Marlowe as capitalizing on the fame of the Italian philosopher Giordano Bruno, who had traveled in England and who was burned in Rome a few years after the writing of the play. [26] *state:* estate, office.
 [27] *flourish:* fanfare of trumpets.
 [28] *Consistory:* Ecclesiastical Senate.
 [29] *Statutes Decretal:* which incorporated Papal rulings on doctrine and church law.
 [30] *Trent:* The Council of Trent, 1545–63, was called in response to the Protestant Reformation.
 [31] *synod:* ecclesiastical council.
 [32] *Adrian:* Pope Adrian VI (1522–23) was contemporary with the historical Faustus.

And all society of holy men:
He grows too proud in his authority,
Lifting his lofty head above the clouds,
And like a steeple over-peers the Church:
But we'll pull down his haughty insolence.
And as Pope Alexander, our progenitor,[33]
Trod on the neck of German Frederick,[34]
Adding this golden sentence to our praise:—
"That Peter's heirs should tread on Emperors, 140
And walk upon the dreadful adder's back,
Treading the lion and the dragon down,
And fearless spurn the killing basilisk:[35]
So will we quell that haughty schismatic;[36]
And by authority apostolical[37]
Depose him from his regal government.
 Bruno. Pope Julius swore to princely Sigismond,[38]
For him, and the succeeding Popes of Rome,
To hold the Emperors their lawful lords.
 Pope. Pope Julius did abuse the Church's rites, 150
And therefore none of his decrees can stand.
Is not all power on earth bestowed on us?
And therefore, though we would, we cannot err.
Behold this silver belt, whereto is fixed
Seven golden keys[39] fast sealed with seven seals
In token of our sevenfold power from Heaven,
To bind or loose, lock fast, condemn, or judge,
Resign,[40] or seal, or whatso pleaseath us.
Then he and thou, and all the world shall stoop,
Or be assurèd of our dreadful curse, 160
To light as heavy as the pains of hell.

 Enter F a u s t u s *and* M e p h i s t o p h i l i s *like the Cardinals.*

 Meph. Now tell me, Faustus, are we not fitted[41] well?
 Faust. Yes, Mephistophilis, and two such Cardinals
Ne'er served a holy Pope as we shall do.
But whilst they sleep within the Consistory,
Let us salute his reverend Fatherhood.
 Ray. Behold, my Lord, the Cardinals are returned.
 Pope. Welcome, grave Fathers, answer presently,
What have our holy Council there decreed,

Concerning Bruno and the Emperor, 170
In quittance of[42] of their late conspiracy
Against our state and Papal dignity?
 Faust. Most sacred Patron of the Church of Rome,
By full consent of all the synod
Of priests and prelates, it is thus decreed:
That Bruno and the German Emperor
Be held as Lollards[43] and bold schismatics
And proud disturbers of the Church's peace.
And if that Bruno, by his own assent,
Without enforcement of[44] the German peers, 180
Did seek to wear the triple diadem,
And by your death to climb Saint Peter's chair,
The Statutes Decretal have thus decreed,
He shall be straight condemned of heresy,
And on a pile of fagots burned to death.
 Pope. It is enough: Here, take him to your charge,
And bear him straight to Ponte Angelo,
And in the strongest tower enclose him fast;
Tomorrow, sitting in our Consistory
With all our College of grave Cardinals, 190
We will determine of his life or death.
Here, take his triple crown along with you,
And leave it in the Church's treasury.
Make haste again, my good Lord Cardinals,
And take our blessing apostolical.
 Meph. So, so; was never devil thus blessed before.
 Faust. Away, sweet Mephistophilis, be gone,
The Cardinals will be plagued for this anon.
 Exeunt F a u s t u s *and* M e p h i s t o p h i l i s *[with* B r u n o].
 Pope. Go presently and bring a banquet forth,
That we may solemnize Saint Peter's feast, 200
And with Lord Raymond, King of Hungary,
Drink to our late and happy victory.
 Exeunt.

[III.ii]

 A Sennet[1] *while the banquet is brought in; and then enter* F a u s t u s *and* M e p h i s t o p h i l i s *in their own shapes.*

 Meph. Now, Faustus, come, prepare thyself for mirth:
The sleepy Cardinals are hard at hand
To censure[2] Bruno, that is posted hence,
And on a proud-paced steed, as swift as thought,
Flies o'er the Alps to fruitful Germany,
There to salute the woeful Emperor.
 Faust. The Pope will curse them for their sloth today,
That slept both Bruno and his crown away:
But now, that Faustus may delight his mind,
And by their folly make some merriment, 10
Sweet Mephistophilis, so charm me here
That I may walk invisible to all,
And do whate'er I please, unseen of any.
 Meph. Faustus, thou shalt, then kneel down presently:

[33] *progenitor:* ancestor.
[34] *Alexander . . . Frederick:* Pope Alexander III (1159–81) forced the German Emperor Frederick Barbarossa to stoop before him.
[35] *basilisk:* a monster supposedly able to kill with a look.
[36] *schismatic:* maker of schisms or divisions in the Church.
[37] *apostolical:* derived from the Apostles.
[38] *Julius . . . Sigismond:* sonorous names more than historical sense here; the Pope and Emperor do not overlap in time.
[39] *keys:* in token of the sevenfold power bestowed from heaven and enumerated below. Original reads "seals"—a careless printer's anticipation of what follows.
[40] *Resign:* Unseal(?). [41] *fitted:* dressed.
[42] *quittance of:* requital for.
[43] *Lollards:* heretics (followers of the fourteenth-century English reformer, Wyclif; but the reference is generic).
[44] *enforcement of:* compulsion from.

III.ii.
[1] *Sennet:* trumpet signal.
[2] *censure:* pass judgment on.

Whilst on thy head I lay my hand,
And charm thee with this magic wand.
First, wear this girdle,[3] then appear
Invisible to all are here:
The Planets seven, the gloomy air,
Hell and the Furies' forkèd hair, 20
Pluto's blue fire, and Hecate's tree,[4]
With magic spells so compass thee.
That no eye may thy body see.
So, Faustus, now for all their holiness,
Do what thou wilt, thou shalt not be discerned.
 Faust. Thanks, Mephistophilis; now, friars, take
 heed,
Lest Faustus make your shaven crowns to bleed.
 Meph. Faustus, no more: see where the Cardinals
 come.

Enter POPE *and all the* Lords. *Enter the* Cardinals
with a book.

 Pope. Welcome, Lord Cardinals: come, sit down.
Lord Raymond, take your seat. Friars, attend, 30
And see that all things be in readiness,
As best beseems this solemn festival.
 1 Card. First, may it please your sacred Holiness
To view the sentence of the reverend synod,
Concerning Bruno and the Emperor?
 Pope. What needs this question? Did I not tell you,
Tomorrow we would sit i' the Consistory,
And there determine of his punishment?
You brought us word even now, it was decreed
That Bruno and the cursèd Emperor 40
Were by the holy Council both condemned
For loathèd Lollards and base schismatics:
Then wherefore would you have me view that book?
 1 Card. Your Grace mistakes, you gave us no
 such charge.
 Ray. Deny it not, we all are witnesses
That Bruno here was late delivered[5] you,
With his rich triple crown to be reserved[6]
And put into the Church's treasury.
 Both Card. By holy Paul, we saw them not.
 Pope. By Peter, you shall die, 50
Unless you bring them forth immediately:
Hale them to prison, lade their limbs with gyves:[7]
False prelates, for this hateful treachery,
Cursed be your souls to hellish misery.
 [*Exeunt* Attendants *with the two* Cardinals.]
 Faust. So, they are safe: now, Faustus, to the feast,
The Pope had never such a frolic[8] guest.
 Pope. Lord Archbishop of Rheims,[9] sit down with
 us.
 Arch. I thank your Holiness.
 Faust. Fall to, the devil choke you an you spare.
 Pope. How now? Who's that which spake?—Friars,
 look about. 60
 Friar. Here's nobody, if it like[10] your Holiness.
 Pope. Lord Raymond, pray fall to, I am beholding
To the Bishop of Milan for this so rare a present.
 Faust. I thank you, sir.
 [*Snatches the dish.*]

 Pope. How now? who's that which snatched the meat
 from me?
Villains, why speak you not?—
My good Lord Archbishop, here's a most dainty dish,
Was sent me from a Cardinal in France.
 Faust. I'll have that too.

 [*Snatches the dish.*]

 Pope. What Lollards do attend our Holiness, 70
That we receive such great indignity?
Fetch me some wine.
 Faust. Ay, pray do, for Faustus is a-dry.
 Pope. Lord Raymond, I drink unto your grace.
 Faust. I pledge your grace.

 [*Snatches the cup.*]

 Pope. My wine gone too?—Ye lubbers,[11] look about
And find the man that doth this villainy,
Or by our sanctitude, you all shall die.
I pray, my lords, have patience at this
Troublesome banquet. 80
 Arch. Please it your Holiness, I think it be
Some ghost crept out of Purgatory, and now
Is come unto your Holiness for his pardon.
 Pope. It may be so:
Go then command our priests to sing a dirge.
To lay the fury of this same troublesome ghost.
 [*Exit an* Attendant.]
Once again, my lord, fall to.

 The POPE *crosseth himself.*

 Faust. How now?
Must every bit be spiced with a cross?
Nay then, take that. 90

 [*Strikes the* POPE.[12]]

 Pope. Oh, I am slain, help me, my lords;
Oh, come and help to bear my body hence:
Damned be his soul forever for this deed!
 Exeunt the POPE *and his train.*
 Meph. Now, Faustus, what will you do now, for I
can tell you you'll be cursed with bell, book, and
candle.[13]
 Faust. Bell, book, and candle,—candle, book, and
 bell,—

[3] *girdle:* belt, cincture.
[4] *tree:* perhaps a misprint for "three" (alluding to the triple divinity of the goddess associated with the Underworld). [5] *delivered:* delivered to.
[6] *reserved:* preserved.
[7] *lade ... gyves:* load ... fetters.
[8] *frolic:* frolicsome.
[9] *Archbishop of Rheims:* The title had been held in the sixteenth century by three members of the House of Guise, which furnished the infamous hero of Marlowe's play *The Massacre at Paris.* [10] *like:* please.
[11] *lubbers:* louts.
[12] *Strikes the* Pope: The stage direction from Q1604 is worth preserving: "Cross again, and Faustus hits him a box of the ear, and they all run away."
[13] *bell, book, and candle:* The office of excommunication concludes with the tolling of the bell, closing of the book, and snuffing of the candle.

Forward and backward, to curse Faustus to hell!
Anon you shall hear a hog grunt, a calf bleat, and an ass
 bray,
Because it is St. Peter's holy day. 100

Enter the Friars *with bell, book, and candle for the
Dirge.*

1 Friar. Come, brethren, let's about our business
with good devotion.
 Sing this.
*Cursed be he that stole his Holiness' meat from the table!
 Maledicat Dominus!* [14]
*Cursed be he that struck his Holiness a blow on the face!
 Maledicat Dominus!*
Cursed be he that took [15] *Fair Sandelo a blow on the pate!
 Maledicat Dominus!* 110
*Cursed be he that disturbeth our holy dirge! Maledicat
 Dominus!*
*Cursed be he that took away his Holiness' wine! Maledicat
 Dominus!*
Et omnes Sancti [16] *Amen!*

[MEPHISTOPHILIS *and* FAUSTUS] *beat the* Friars,
 fling fireworks among them; and exeunt.

[III.iii]

Enter Clown [ROBIN] *and* DICK, *with a cup.*

Dick. Sirrah Robin, we were best look that your devil
can answer the stealing of this same cup, for the vintner's
boy follows us at the hard [1] heels.
Robin. 'Tis no matter! let him come; an he follow us
I'll so conjure him as he was never conjured in his life,
I warrant him. Let me see the cup.

Enter Vintner.

Dick. Here 'tis. Yonder he comes. Now, Robin, now
or never show thy cunning.
Vint. Oh, are you here? I am glad I have found you,
you are a couple of fine companions; [2] pray, where's the
cup you stole from the tavern? 11
Robin. How, how? We steal a cup? Take heed what
you say; we look not like cup-stealers, I can tell you.

[14] *L.:* Let God curse him.
[15] *took:* struck (the reading of Q1616, which is inadvertently repeating "struck" from the line before).
[16] *L.:* And all the saints (i.e., curse him).
III.iii.
 [1] *hard:* very (intensive). [2] *companions:* base fellows.
 [3] *outface . . . matter:* try to brave the matter out with me.
 [4] *beyond us both:* out of our hands.
 [5] *Ay . . . tell:* an impudent rejoinder—"That'll be the
day!" [6] *villains':* peasants'. [7] *shrewd:* hard.
 [8] *to:* for. [9] *tester:* sixpence. [10] *with:* the aid of.
 [11] *amain:* at full speed.
IV. PROLOGUE
 [1] *Chorus:* This speech, omitted in Q1616, occurs in Q1604
after the excommunication ceremony (in this text, the close of
III.ii). That it ought to follow the scene between the Clowns
and the Vintner (III.iii) is suggested by the reference Mephistophilis makes in that scene to his traveling with Faustus.
Now, as IV opens, these particular travels have been concluded and Faustus is said to have returned home.

Vint. Never deny 't, for I know you have it, and I'll
search you.
Robin. Search me? Ay, and spare not. [*Aside to*
DICK] Hold the cup, Dick. Come, come, search me,
search me!

[Vintner *searches him.*]

Vint. [*To* DICK] Come on, sirrah, let me search you
now! 20
Dick. Ay, ay, do! [*Aside to* ROBIN] Hold the cup,
Robin—I fear not your searching; we scorn to steal
your cups, I can tell you.

[Vintner *searches him.*]

Vint. Never outface me for the matter, [3] for, sure, the
cup is between you two.
Robin. Nay, there you lie, 'tis beyond us both. [4]
Vint. A plague take you! I thought 'twas your
knavery to take it away; come, give it me again.
Robin. Ay, much; when? Can you tell? [5] Dick, make
me a circle, and stand close at my back, and stir 30
not for thy life. Vintner, you shall have your cup anon.
Say nothing, Dick. [*Reads*] *O per se, o Demogorgon,
Belcher and Mephistophilis!*

Enter MEPHISTOPHILIS.

Meph. You princely legions of infernal rule,
How am I vexèd by these villains' [6] charms!
From Constantinople have they brought me now
Only for pleasure of these damnèd slaves.
 [*Exit* Vintner.]
Robin. By Lady, sir, you have had a shrewd [7]
journey of it. Will it please you to take a shoulder of
mutton to [8] supper, and a tester [9] in your purse, and go
back again? 41
Dick. Ay, ay. I pray you heartily, sir, for we called
you but in jest, I promise you.
Meph. To purge the rashness of this cursèd deed,
First be thou turnèd to this ugly shape,
For apish deeds transformèd to an ape.
Robin. Oh, brave! an ape! I pray, sir, let me have the
carrying of him about to show some tricks.
Meph. And so thou shalt: be thou transformed to a
dog, and carry him upon thy back. Away, be gone! 50
Robin. A dog! that's excellent; let the maids look well
to their porridge-pots, for I'll into the kitchen presently.
Come, Dick, come.
 Exeunt the Two Clowns.
Meph. Now with [10] the flames of ever-burning fire,
I'll wing myself, and forthwith fly amain [11]
Unto my Faustus, to the Great Turk's Court.
 Exit.

[ACT FOUR]

[PROLOGUE]
Enter Chorus. [1]

Chor. When Faustus had with pleasure ta'en the view
Of rarest things, and royal courts of kings,
He stayed his course, and so returnèd home;



Where such as bear his absence but with grief,
I mean his friends and near'st companions,
Did gratulate[2] his safety with kind words,
And in their conference[3] of what befell,
Touching his journey through the world and air,
They put forth questions of astrology,
Which Faustus answered with such learned skill 10
As they admired and wondered at his wit.
Now is his fame spread forth in every land:
Amongst the rest the Emperor is one,
Carolus the Fifth,[4] at whose palace now
Faustus is feasted 'mongst his noblemen.
What there he did, in trial of[5] his art,
I leave untold; your eyes shall see performed.

Exit.

[SCENE ONE]

The Emperor's Court at Innsbruck.

Enter MARTINO, *and* FREDERICK *at several[1] doors.*

Mart. What ho, officers, gentlemen,
Hie to the presence[2] to attend the Emperor,[3]
Good Frederick, see the rooms be voided straight,[4]
His majesty is coming to the hall;
Go back, and see the state[5] in readiness.
Fred. But where is Bruno, our elected Pope,
That on a fury's back came post[6] from Rome?
Will not his grace consort[7] the Emperor?
Mart. Oh, yes, and with him comes the German
conjuror,
The learned Faustus, fame of Wittenberg, 10
The wonder of the world for magic art;
And he intends to show great Carolus
The race of all his stout[8] progenitors;
And bring in presence of his majesty
The royal shapes and warlike semblances
Of Alexander and his beauteous paramour.
Fred. Where is Benvolio?
Mart. Fast asleep, I warrant you,
He took his rouse[9] with stoups[10] of Rhenish wine
So kindly yesternight to Bruno's health, 20
That all this day the sluggard keeps his bed.
Fred. See, see, his window's ope, we'll call to him.
Mart. What ho, Benvolio!

Enter BENVOLIO *above, at a window, in his
nightcap; buttoning.[11]*

Benv. What a[12] devil ail you two?
Mart. Speak softly, sir, lest the devil hear you:
For Faustus at the court is late arrived,
And at his heels a thousand furies wait,
To accomplish whatsoever the Doctor please,
Benv. What of this?
Mart. Come, leave thy chamber first, and thou shalt
see 30
This conjuror perform such rare exploits,
Before the Pope[13] and royal Emperor,
As never yet was seen in Germany.

Benv. Has not the Pope enough of conjuring yet?
He was upon the devil's back late enough;
And if he be so far in love with him,
I would he would post with him to Rome again.
Fred. Speak, wilt thou come and see this sport?
Benv. Not I.
Mart. Wilt thou stand in thy window, and see it
then? 40
Benv. Ay, an I fall not asleep i' th' meantime.
Mart. The Emperor is at hand, who comes to see
What wonders by black spells may compassed[14] be.
Benv. Well, go you attend the Emperor: I am content
for this once to thrust my head out at a window; for
they say, if a man be drunk overnight the devil cannot
hurt him in the morning; if that be true, I have a charm
in my head shall control him as well as the conjuror,
I warrant you.

Exit.

A Sennet. CHARLES, *the* GERMAN EMPEROR,
BRUNO, SAXONY, FAUSTUS, MEPHISTOPHILIS,
FREDERICK, MARTINO, *and* Attendants.

Emp. Wonder of men, renowned magician, 50
Thrice-learnèd Faustus, welcome to our court.
This deed of thine, in setting Bruno free
From his and our professèd[15] enemy,
Shall add more excellence unto thine art,
Than if by powerful necromantic spells,
Thou couldst command the world's obedience:
For ever be beloved of Carolus,
And if this Bruno thou hast late redeemed[16]
In peace possess the triple diadem,
And sit in Peter's chair, despite of chance, 60
Thou shalt be famous through all Italy,
And honored of the German Emperor.
Faust. These gracious words, most royal Carolus,
Shall make poor Faustus to his utmost power,
Both love and serve the German Emperor,
And lay his life at holy Bruno's feet.
For proof whereof, if so your grace be pleased,
The Doctor stands prepared by power of art
To cast his magic charms, that shall pierce through
The ebon[17] gates of ever-burning hell, 70
And hale the stubborn Furies from their caves,
To compass whatsoe'er your grace commands.
Benv. [*Above*] 'Blood, he speaks terribly: but for all

[2] *gratulate:* express joy at. [3] *conference:* discussion.
[4] *Carolus the Fifth:* King of Spain and Holy Roman
Emperor from 1519 to 1556.
[5] *in trial of:* by way of experiment in.

IV.i.
[1] *several:* separate. [2] *presence:* royal chamber.
[3] *Emperor:* The scene has shifted to the Emperor's court
in Germany. [4] *voided straight:* emptied immediately.
[5] *see the state:* see that the throne is. [6] *post:* with speed.
[7] *consort:* accompany. [8] *stout:* brave, hardy.
[9] *took his rouse:* drank deep. [10] *stoups:* tankards.
[11] *buttoning:* i.e., himself up. [12] *a:* the.
[13] *Pope:* Bruno. [14] *compassed:* achieved.
[15] *professèd:* avowed. [16] *redeemed:* freed.
[17] *ebon:* black.

that I do not greatly believe him: he looks as like a conjuror as the Pope [18] to a costermonger. [19]

Emp. Then, Faustus, as thou late didst promise us,
We would behold that famous conqueror,
Great Alexander, and his paramour [20]
In their true shapes and state majestical,
That we may wonder at their excellence. 80

Faust. Your majesty shall see them presently.
Mephistophilis away.
And with a solemn noise of trumpets' sound
Present before this royal Emperor
Great Alexander and his beauteous paramour.

Meph. Faustus, I will.

Benv. Well, Master Doctor, an your devils come not away quickly, you shall have me asleep presently: zounds, I could eat myself for anger, to think I have been such an ass all this while to stand gaping after the devil's governor, and can see nothing. 91

Faust. I'll make you feel something anon, if my art fail me not.—
My lord, I must forewarn your majesty,
That when my spirits present the royal shapes
Of Alexander and his paramour,
Your grace demand no questions of the King,
But in dumb silence let them come and go.

Emp. Be it as Faustus please, we are content. 99

Benv. Ay, ay, and I am content too; and thou bring Alexander and his paramour before the Emperor, I'll be Actaeon [21] and turn myself to a stag.

Faust. And I'll play Diana, and send you the horns presently.

Sennet. Enter at one door the EMPEROR ALEXANDER, *at the other* DARIUS; *they meet,* DARIUS *is thrown down,* ALEXANDER *kills him; takes off his crown, and offering to go out, his paramour meets him, he embraceth her, and sets* DARIUS' *crown upon her head; and coming back, both salute the* EMPEROR, *who, leaving his state, offers to embrace them, which,* FAUSTUS *seeing, suddenly stays him. Then trumpets cease, and music sounds.*

My gracious lord, you do forget yourself,
These are but shadows, not substantial.

Emp. Oh, pardon me, my thoughts are so ravished
With sight of this renownèd Emperor,
That in mine arms I would have compassed [22] him.
But, Faustus, since I may not speak to them, 110
To satisfy my longing thoughts at full,
Let me tell thee: I have heard it said,
That this fair lady whilst she lived on earth,

Had on her neck a little wart, or mole;
How may I prove that saying to be true?

Faust. Your majesty may boldly go and see.

Emp. Faustus, I see it plain,
And in this sight thou better pleasest me,
Than if I gained another monarchy.

Faust. Away, be gone! 120
 Exit show.
See, see, my gracious lord, what strange beast is yon,
that thrusts his head out at window?

Emp. Oh, wondrous sight: see, Duke of Saxony,
Two spreading horns most strangely fastened
Upon the head of young Benvolio.

Sax. What, is he asleep, or dead?

Faust. He sleeps, my lord, but dreams not of his
 horns.

Emp. This sport is excellent; we'll call and wake him.
What ho, Benvolio.

Benv. A plague upon you, let me sleep awhile. 130

Emp. I blame thee not to sleep much, having such a
head of thine own.

Sax. Look up, Benvolio, 'tis the Emperor calls.

Benv. The Emperor? Where?—Oh, zounds, my
head!

Emp. Nay, and thy horns hold, 'tis no matter for thy
head, for that's armed sufficiently.

Faust. Why, how now, Sir Knight, what, hanged by
the horns? This is most horrible: fie, fie, pull in your
head for shame, let not all the world wonder at you.

Benv. Zounds, Doctor, is this your villainy? 141

Faust. Oh, say not so, sir: the Doctor has no skill,
No art, no cunning, to present these lords,
Or bring before this royal Emperor
The mighty monarch, warlike Alexander.
If Faustus do it, you are straight resolved
In bold Actaeon's shape to turn a stag.
And therefore, my lord, so please your majesty,
I'll raise a kennel of hounds, shall hunt him so,
As all his footmanship shall scarce prevail 150
To keep his carcass from their bloody fangs.
Ho, Belimote, Argiron, Asterote.

Benv. Hold, hold! Zounds, he'll raise up a kennel of
devils, I think, anon: good, my lord, entreat for me:
'sblood, I am never [23] able to endure these torments.

Emp. Then, good Master Doctor,
Let me entreat you to remove his horns,
He has done penance now sufficiently. 158

Faust. My gracious lord, not so much for injury done
to me, as to delight your majesty with some mirth, hath
Faustus justly requited this injurious [24] knight, which
being all I desire, I am content to remove his horns.
Mephistophilis, transform him.

[MEPHISTOPHILIS *removes the horns.*]

and hereafter, sir, look you speak well of scholars.

Benv. Speak well of ye? 'Sblood, and scholars be
such cuckold-makers to clap horns of [25] honest men's
heads o' this order, [26] I'll ne'er trust smooth faces and
small ruffs, [27] more. But an I be not revenged for this,
would I might be turned to a gaping oyster, and drink
nothing but salt water. 170

[18] *Pope:* i.e., Bruno.
[19] *costermonger:* literally, appleseller (term of abuse).
[20] *paramour:* in this context, "consort," "queen."
[21] *Actaeon:* famous hunter who, for looking on Diana naked, was transformed to a stag and torn to pieces by his own hounds. [22] *compassed:* enfolded.
[23] *am never:* shall never be. [24] *injurious:* insulting.
[25] *of:* on. [26] *o' this order:* in this way.
[27] *smooth . . . ruffs:* beardless scholars in academic attire.

Emp. Come, Faustus, while the Emperor lives,
In recompense of this thy high desert,
Thou shalt command the state of Germany,
And live beloved of mighty Carolus.

<div align="right">*Exeunt omnes.*[28]</div>

[IV.ii]

<div align="center">*Enter* BENVOLIO, MARTINO, FREDERICK,
and Soldiers.</div>

Mart. Nay, sweet Benvolio, let us sway thy thoughts
From this attempt against the conjuror.

Benv. Away, you love me not, to urge me thus.
Shall I let slip so great an injury,
When every servile groom[1] jests at my wrongs,
And in their rustic gambols[2] proudly say,
"Benvolio's head was graced with horns today?"
Oh, may these eyelids never close again,
Till with my sword I have that conjuror slain.
If you will aid me in this enterprise, 10
Then draw your weapons, and be resolute:
If not, depart: here will Benvolio die,
But Faustus' death shall quit[3] my infamy.

Fred. Nay, we will stay with thee, betide[4] what may,
And kill that Doctor if he comes this way.

Benv. Then, gentle Frederick, hie thee to the grove,[5]
And place our servants and our followers
Close[6] in an ambush there behind the trees.
By this (I know) the conjuror is near;
I saw him kneel and kiss the Emperor's hand, 20
And take his leave laden with rich rewards.
Then, soldiers, boldly fight; if Faustus die,
Take you the wealth, leave us the victory.

Fred. Come, soldiers, follow me unto the grove;
Who kills him shall have gold and endless love.

<div align="right">*Exit* FREDERICK *with the* Soldiers.</div>

Benv. My head is lighter than it was by[7] th' horns,
But yet my heart's more ponderous than my head,
And pants until I see that conjuror dead.

Mart. Where shall we place ourselves, Benvolio?

Benv. Here will we stay to bide the first assault. 30
Oh, were that damnèd hell-hound but in place,[8]
Thou soon shouldst see me quit my foul disgrace.

<div align="center">*Enter* FREDERICK.</div>

Fred. Close, close, the conjuror is at hand,
And all alone comes walking in his gown;
Be ready then, and strike the peasant down.

Benv. Mine be that honor then: now, sword, strike
home,
For horns he gave I'll have his head anon.

<div align="center">*Enter* FAUSTUS *with the false head.*</div>

Mart. See, see, he comes.

Benv. No words: this blow ends
all,
Hell take his soul, his body thus must fall.

<div align="center">[*Stabs* FAUSTUS, *who falls.*]</div>

Faust. Oh! 40
Fred. Groan you, Master Doctor?

Benv. Break may his heart with groans: dear
Frederick, see,
Thus will I end his griefs immediately.

Mart. Strike with a willing hand.

<div align="center">[BENVOLIO *strikes off* FAUSTUS' *false head.*]</div>

<div align="right">His head is off.</div>

Benv. The devil's dead, the Furies[9] now may laugh.

Fred. Was this that stern aspèct, that awful frown,
Made[10] the grim monarch[11] of infernal spirits
Tremble and quake at his commanding charms?

Mart. Was this that damnèd head, whose heart[12]
conspired[13]
Benvolio's shame before the Emperor? 50

Benv. Ay, that's the head, and here the body lies,
Justly rewarded for his villainies.

Fred. Come let's devise how we may add more
shame
To the black scandal of his hated name.

Benv. First, on his head, in quittance of my wrongs,
I'll nail huge forkèd horns, and let them hang
Within the window where he yoked[14] me first,
That all the world may see my just revenge.

Mart. What use shall we put his beard to?

Benv. We'll sell it to a chimney-sweeper; it will wear
out ten birchen brooms, I warrant you. 61

Fred. What shall his eyes do?

Benv. We'll put out his eyes, and they shall serve for
buttons to his lips, to keep his tongue from catching
cold.

Mart. An excellent policy: and now, sirs, having
divided him, what shall the body do?

<div align="right">[FAUSTUS *rises.*]</div>

Benv. Zounds, the devil's alive again.

Fred. Give him his head, for God's sake.

Faust. Nay, keep it: Faustus will have heads and
hands, 70
Ay, all your hearts to recompense this deed.
Knew you not, traitors, I was limited[15]
For four-and-twenty years to breathe on earth?

[28] *Exeunt omnes:* In Q1604, after the exit of the Emperor, Faustus speaks six lines that "sound" authentic. That is not sufficient reason to include them in the text; but it is sufficient reason, perhaps, to give them in a footnote:
> Now, Mephistophilis, the restless course
> That time doth run, with calm and silent foot
> Shortening my days and thread of vital life,
> Calls for the payment of my latest years:
> Therefore, sweet Mephistophilis, let us
> Make haste to Wittenberg.

IV.ii.
[1] *groom:* base fellow. [2] *gambols:* frolics.
[3] *quit:* requite. [4] *betide:* happen.
[5] *grove:* The scene, then, is near a grove outside the city.
[6] *Close:* Hidden. [7] *by:* for the absence of.
[8] *in place:* at hand.
[9] *Furies:* Tisiphone, Alecto, and Megaera, avenging deities who punished criminality in this world and after death. [10] *Made.* That made.
[11] *monarch:* Pluto, god of the Underworld.
[12] *heart:* frequently emended to "art."
[13] *conspired:* plotted.
[14] *yoked:* held fast, as with a yoke.
[15] *limited:* given a fixed period.

And had you cut my body with your swords,
Or hewed this flesh and bones as small as sand,
Yet in a minute had my spirit returned,
And I had breathed a [16] man made free from harm.
But wherefore do I dally my revenge?
Asteroth, Belimoth, Mephistophilis,

Enter MEPHISTOPHILIS *and other* Devils.

Go, horse these traitors on your fiery backs, 80
And mount aloft with them as high as heaven,
Thence pitch them headlong to the lowest hell:
Yet, stay, the world shall see their misery,
And hell shall after plague their treachery.
Go, Belimoth, and take this caitiff hence,
And hurl him in some lake of mud and dirt:
Take thou this other, drag him through the woods,
Amongst the pricking thorns, and sharpest briers,
Whilst with my gentle Mephistophilis,
This traitor flies unto some steepy [17] rock, 90
That, rolling down, may break the villain's bones,
As he intended to dismember me.
Fly hence, dispatch [18] my charge immediately.
 Fred. Pity us, gentle Faustus, save our lives!
 Faust. Away!
 Fred. He must needs go that the devil drives. [19]
 Exeunt Spirits *with the* Knights.

Enter the ambushed [20] Soldiers.

 1 Sold. Come, sirs, prepare yourselves in readiness,
Make haste to help these noble gentlemen,
I heard them parley with the conjuror.
 2 Sold. See where he comes, dispatch, and kill the
 slave. 100
 Faust. What's here? An ambush to betray my life:
Then, Faustus, try thy skill: base peasants, stand:
For lo! these trees remove [21] at my command,
And stand as bulwarks 'twixt yourselves and me,
To shield me from your hated treachery:
Yet to encounter this your weak attempt,
Behold an army comes incontinent. [22]

FAUSTUS *strikes the door,* [23] *and enter a devil playing*
on a drum, after him another bearing an ensign; [24]

[16] *a:* as a. [17] *steepy:* precipitous.
[18] *dispatch:* carry out.
[19] *He . . . drives:* proverbial—"There's nothing for it."
[20] *ambushed:* i.e., hidden in ambush.
[21] *remove:* uproot themselves and move to another place.
[22] *incontinent:* hastily.
[23] *door:* stage door, which Faustus strikes to cue those
who are about to come on. [24] *ensign:* flag.
[25] *divers:* several others. [26] *several:* separate.
[27] *we . . . kill:* we are not hunters (playing on "haunted"
above) who will kill you because of your horns.
[28] *sped:* done for. [29] *joining:* adjoining.
[30] *obscure:* obscurely. [31] *Sith:* Since.

IV.iii.
 [1] *Horse-courser:* Horse-dealer.
 [2] *Mephistophilis:* Because he does not speak during the
scene, most editors dispense with his presence. One can see
him, however, as observing the proceedings with a speaking
silence. [3] *stand with:* haggle.
 [4] *will . . . waters:* will he not be ready for anything?

and divers [25] *with weapons,* MEPHISTOPHILIS
with fireworks; they set upon the Soldiers, *and*
drive them out. [*Exit* FAUSTUS.]

Enter at several [26] *doors* BENVOLIO, FREDERICK,
and MARTINO, *their heads and faces bloody, and*
besmeared with mud and dirt, all having horns
on their heads.

 Mart. What ho, Benvolio!
 Benv. Here, what, Frederick, ho! 109
 Fred. Oh, help me, gentle friend; where is Martino?
 Mart. Dear Frederick, here,
Half smothered in a lake of mud and dirt,
Through which the furies dragged me by the heels.
 Fred. Martino, see Benvolio's horns again.
 Mart. Oh, misery, how now, Benvolio?
 Benv. Defend me, heaven, shall I be haunted still?
 Mart. Nay, fear not, man; we have no power to kill. [27]
 Benv. My friends transformèd thus! Oh, hellish
 spite,
Your heads are all set with horns.
 Fred. You hit it right:
It is your own you mean, feel on your head. 120
 Benv. 'Zounds, horns again!
 Mart. Nay, chafe not, man, we all are sped. [28]
 Benv. What devil attends this damned magician,
That, spite of spite, our wrongs are doubled?
 Fred. What may we do, that we may hide our shames?
 Benv. If we should follow him to work revenge,
He'd join long asses' ears to these huge horns,
And make us laughing-stocks to all the world.
 Mart. What shall we then do, dear Benvolio? 129
 Benv. I have a castle joining [29] near these woods,
And thither we'll repair and live obscure, [30]
Till time shall alter these our brutish shapes:
Sith [31] black disgrace hath thus eclipsed our fame,
We'll rather die with grief than live with shame.
 Exeunt omnes.

[IV.iii]

Enter FAUSTUS *and the* Horse-courser, [1] *and*
MEPHISTOPHILIS. [2]

 Horse-c. I beseech your worship, accept of these forty
dollars.
 Faust. Friend, thou canst not buy so good a horse
for so small a price. I have no great need to sell him,
but if thou likest him for ten dollars more take him,
because I see thou hast a good mind to him.
 Horse-c. I beseech you, sir, accept of this; I am a very
poor man and have lost very much of late by horseflesh,
and this bargain will set me up again. 9
 Faust. Well, I will not stand with [3] thee, give me the
money.

[Horse-courser *gives* FAUSTUS *the money.*]

Now, sirrah, I must tell you that you may ride him o'er
hedge and ditch, and spare him not; but, do you hear?
In any case ride him not into the water.
 Horse-c. How, sir, not into the water? Why, will he
not drink of all waters? [4]

Faust. Yes, he will drink of all waters, but ride him not into the water; o'er hedge and ditch, or where thou wilt, but not into the water. Go, bid the ostler deliver him unto you, and remember what I say. 20

Horse-c. I warrant you, sir. Oh, joyful day, now am I a made man for ever.

Exit.

Faust. What art thou, Faustus, but a man condemned
 to die?
Thy fatal[5] time draws to a final end,
Despair doth drive distrust into my thoughts.
Confound[6] these passions with a quiet sleep.
Tush! Christ did call the thief upon the Cross;
Then rest thee, Faustus, quiet in conceit.[7]

He sits to sleep.

Enter the Horse-courser *wet.*

Horse-c. Oh, what a cozening[8] Doctor was this? I was riding my horse into the water, thinking some 30 hidden mystery had been in the horse. I had nothing under me but a little straw, and had much ado to escape drowning. Well, I'll go rouse him and make him give me my forty dollars again. Ho, sirrah Doctor, you cozening scab![9] Master Doctor, awake and rise, and give me my money again, for your horse is turned to a bottle[10] of hay, Master Doctor.

[He pulls off his leg.]

Alas! I am undone, what shall I do? I have pulled off his leg. 39

Faust. Oh, help, help, the villain hath murdered me.

Horse-c. Murder, or not murder, now he has but one leg, I'll outrun him, and cast this leg into some ditch or other.

[Runs out.]

Faust. Stop him, stop him, stop him!—ha, ha, ha. Faustus hath his leg again, and the horse-courser a bundle of hay for his forty dollars.

Enter WAGNER.

How now, Wagner, what news with thee?

Wag. If it please you, the Duke of Anholt doth earnestly entreat your company, and hath sent some of his men to attend you with provision fit for your 50 journey.

Faust. The Duke of Anholt's an honorable gentleman, and one to whom I must be no niggard[11] of my cunning. Come away!

Exeunt.

[IV.iv]

Enter Clown [ROBIN], DICK, Horse-courser,
and a Carter.

Cart. Come, my masters, I'll bring you to the best beer in Europe. What ho, hostess!—where be these whores?[1]

Enter Hostess.

Host. How now, what lack you? What, my old guesse,[2] welcome.

Robin. Sirrah Dick, dost thou know why I stand so mute?

Dick. No, Robin, why is't?

Robin. I am eighteenpence on the score,[3] but say nothing, see if she have forgotten me. 10

Host. Who's this, that stands so solemnly by himself? what, my old guest?

Robin. O hostess, how do you? I hope my score stands still.[4]

Host. Ay, there's no doubt of that, for methinks you make no haste to wipe it out.

Dick. Why, hostess, I say, fetch us some beer.

Host. You shall presently:[5] look up into th' hall there, ho![6] 19

Exit.

Dick. Come sirs, what shall we do now till mine hostess comes?

Cart. Marry, sir, I'll tell you the bravest tale how a conjuror served me; you know Doctor Fauster?

Horse-c. Ay, a plague take him, here's some on's[7] have cause to know him; did he conjure thee too?

Cart. I'll tell you how he served me: As I was going to Wittenberg t'other day, with a load of hay, he met me, and asked me what he should give me for as much hay as he could eat; now, sir, I, thinking that a little would serve his turn, bade him take as much as he 30 would for three farthings; so he presently gave me my money, and fell to eating; and, as I am a cursen[8] man, he never left eating, till he had eat up all my load of hay.

All. Oh, monstrous, eat a whole load of hay!

Robin. Yes, yes, that may be; for I have heard of one that has eat a load of logs.

Horse-c. Now, sirs, you shall hear how villainously he served[9] me: I went to him yesterday to buy a horse of him, and he would by no means sell him under forty dollars; so, sir, because I knew him to be such a 40 horse as would run over hedge and ditch and never tire, I gave him his money. So when I had my horse, Doctor Fauster bade me ride him night and day, and spare him no time; but, quoth he, in any case, ride him not into the water. Now, sir, I, thinking the horse had had some rare quality that he would not have me know of, what did I but rid him into a great river, and when I came just in the midst, my horse vanished away, and I sat straddling upon a bottle of hay.

All. Oh, brave Doctor! 50

Horse-c. But you shall hear how bravely I served him

5 *fatal:* allotted.
7 *conceit:* thought.
9 *scab:* scurvy fellow.
11 *be . . . niggard:* not be sparing.

6 *Confound:* Allay.
8 *cozening:* cheating.
10 *bottle:* bundle.

IV.iv.
1 *where . . . whores:* Addressed to the company; the Hostess and her staff are whores. The scene, it is clear, is an inn. 2 *guesse:* guests.
3 *on the score:* on the tick: in debt to the Hostess.
4 *stands still:* doesn't increase; is permitted to stand or remain. 5 *shall presently:* shall have it at once.
6 *look . . . ho:* be lively (spoken to the servants).
7 *on's:* of us. 8 *cursen:* Christian.
9 *served:* dealt with.

for it; I went me[10] home to his house, and there I found him asleep; I kept a hallooing and whooping in his ears, but all could not wake him: I seeing that, took him by the leg, and never rested pulling, till I had pulled me his leg quite off, and now 'tis at home in mine hostry.[11]

Robin.[12] And has the Doctor but one leg then? That's excellent, for one of his devils turned me into the likeness of an ape's face.

Cart. Some more drinks, hostess. 60

Robin. Hark you, we'll into another room and drink a while, and then we'll go seek out the Doctor.

 Exeunt omnes.

[IV.v]

 Enter the DUKE OF ANHOLT, *his* Duchess,
 FAUSTUS, *and* MEPHISTOPHILIS.

Duke. Thanks, Master Doctor, for these pleasant sights. Nor know I how sufficiently to recompense your great deserts in erecting that enchanted castle in the air, the sight whereof so delighted me,
As nothing in the world could please me more.

Faust. I do think myself, my good lord, highly recompensed in that it pleaseth your grace to think but well of that which Faustus hath performed. But gracious lady, it may be that you have taken no pleasure in those sights; therefore, I pray you tell me, what is 10
the thing you most desire to have; be it in the world, it shall be yours. I have heard that great-bellied women do long for things are[1] rare and dainty.

Duch. True, Master Doctor, and since I find you so kind, I will make known unto you what my heart desires to have; and were it now summer, as it is January, a dead time of the winter, I would request no better meat than a dish of ripe grapes.

Faust. This is but a small matter. Go, Mephistophilis, away! 20

 Exit MEPHISTOPHILIS.
Madam, I will do more than this for your content.

Enter MEPHISTOPHILIS *again with the grapes.*

Here now taste ye these; they should be good,
For they come from a far country, I can tell you.

Duke. This makes me wonder more than all the rest
That at this time of the year, when every tree
Is barren of his fruit, from whence you had
These ripe grapes.

Faust. Please it your grace the year is divided into

two circles over the whole world, so that when it is winter with us, in the contrary circle it is likewise 30 summer with them, as in India, Saba[2] and such countries that lie far east, where they have fruit twice a year. From whence, by means of a swift spirit that I have, I had these grapes brought, as you see.

Duch. And trust me, they are the sweetest grapes that e'er I tasted.

 The Clowns *bounce*[3] *at the gate within.*

Duke. What rude disturbers have we at the gate?
Go pacify their fury, set it ope,
And then demand of them what they would have. 39

 They knock again, and call out to talk with FAUSTUS.

Serv. Why, how now, masters, what a coil[4] is there? What is the reason you disturb the Duke?

Dick. We have no reason for it, therefore a fig for him.[5]

Serv. Why, saucy varlets, dare you be so bold?

Horse-c. I hope, sir, we have wit enough to be more bold than welcome.

Serv. It appears so, pray be bold elsewhere,
And trouble not the Duke.

Duke. What would they have?

Serv. They all cry out to speak with Doctor Faustus.

Cart. Ay, and we will speak with him. 51

Duke. Will you sir? Commit[6] the rascals.

Dick. Commit with us! he were as good commit with his father as commit with us.

Faust. I do beseech your grace let them come in,
They are good subject for a merriment.

Duke. Do as thou wilt, Faustus, I give thee leave.

Faust. I thank your grace.

 Enter the Clown [ROBIN], DICK, CARTER, *and*
 Horse-courser.

Why, how now, my good friends?
'Faith you are too outrageous,[7] but come near, 60
I have procured your pardons: welcome all.

Robin. Nay, sir, we will be welcome for our money, and we will pay for what we take. What ho, give's half a dozen of beer here, and be hanged.

Faust. Nay, hark you, can you tell me where you are?[8]

Cart. Ay, marry can I; we are under heaven.

Serv. Ay, but, sir sauce-box,[9] know you in what place? 69

Horce-c. Ay, ay, the house is good enough to drink in: Zouns, fill us some beer, or we'll break all the barrels in the house, and dash out all your brains with your bottles.

Faust. Be not so furious: come, you shall have beer. My lord, beseech you give me leave a while,
I'll gage[10] my credit, 'twill content your grace.

Duke. With all my heart, kind Doctor, please thyself;
Our servants and our court's at thy command.

Faust. I humbly thank your grace: then fetch some beer. 79

Horse-c. Ay, marry, there spake a Doctor indeed, and, 'faith, I'll drink a health to thy wooden leg for that word.

[10] *me:* The reflexive (here and below) is common in Elizabethan English and gratuitous. [11] *hostry:* hostelry.
[12] *Robin:* Editors often give this speech to Dick, who had been so transformed, rather than to "Clown" (i.e., Robin) as in the original.

IV.v.
[1] *are:* that are. [2] *Saba:* Sheba.
[3] *bounce:* bang. [4] *coil:* commotion.
[5] *fig for him:* Dick makes a contemptuous gesture, biting his thumb or thrusting it between two of his fingers.
[6] *Commit:* Imprison; and giving rise to the pun on sexual intercourse in the next line. [7] *outrageous:* violent.
[8] *where you are:* i.e., in the ducal court.
[9] *sauce-box:* impudence. [10] *gage:* pledge as security.

Faust. My wooden leg! what dost thou mean by that?

Cart. Ha, ha, ha, dost hear him, Dick? He has forgot his leg.

Horse-c. Ay, ay, he does not stand much upon[11] that.

Faust. No, 'faith not much upon a wooden leg.

Cart. Good Lord, that flesh and blood should be so frail with your worship. Do not you remember a horse-courser you sold a horse to? 91

Faust. Yes, I remember I sold one a horse.

Cart. And do you remember you bid he should not ride him into the water?

Faust. Yes, I do very well remember that.

Cart. And do you remember nothing of your leg?

Faust. No, in good sooth.

Cart. Then, I pray, remember your courtesy.

Faust. I thank you, sir.

Cart. 'Tis not so much worth; I pray you tell me one thing. 101

Faust. What's that?

Cart. Be both your legs bedfellows every night together?

Faust. Wouldst thou make a Colossus[12] of me, that thou askest me such questions?

Cart. No, truly, sir: I would make nothing[13] of you, but I would fain know that.

Enter Hostess *with drink.*

Faust. Then I assure thee certainly they are.

Cart. I thank you, I am fully satisfied. 110

Faust. But wherefore dost thou ask?

Cart. For nothing, sir: but methinks you should have a wooden bedfellow of one of 'em.

Horse-c. Why, do you hear, sir, did not I pull off one of your legs when you were asleep?

Faust. But I have it again, now I am awake: look you here, sir.

All. Oh, horrible, had the Doctor three legs?

Cart. Do you remember, sir, how you cozened me and ate up my load of—— 120

FAUSTUS *charms him dumb.*

Dick. Do you remember how you made me wear an ape's——

Horse-c. You whoreson conjuring scab, do you remember how you cozened me with a ho——

Robin. Ha' you forgotten me? You think to carry it away[14] with your *hey-pass* and *re-pass,*[15] do you remember the dogs' fa——

Exeunt Clowns.

Host. Who pays for the ale? Hear you, Master Doctor, now you have sent away my guesse, I pray who shall pay me for my a—— 130

Exit Hostess.

Lady. My lord,
We are much beholding to this learned man.

Duke. So are we, madam, which we will recompense
With all the love and kindness that we may.
His artful sport drives all sad thoughts away.

Exeunt.

[ACT FIVE]

[SCENE ONE]

Thunder and lightning. Enter Devils *with covered dishes.* MEPHISTOPHILIS *leads them into* FAUSTUS' *study. Then enter* WAGNER.

Wag. I think my master means to die shortly,
He has made his will, and given me his wealth,
His house, his goods, and store of golden plate,
Besides two thousand ducats ready coined.
I wonder what he means; if death were nigh
He would not frolic thus. He's now at supper
With the scholars, where there's such belly-cheer
As Wagner in his life ne'er saw the like.
And see where they come, belike the feast is done. 9

Exit.

Enter FAUSTUS, MEPHISTOPHILIS, *and two or three* Scholars.

1 Schol. Master Faustus, since our conference[1] about fair ladies, which was the beautifullest in all the world, we have determined with ourselves that Helen of Greece was the admirablest lady that ever lived: therefore, Master Doctor, if you will do us so much favor as to let us see that peerless dame of Greece, whom all the world admires for majesty, we should think ourselves much beholding unto you.

Faust. Gentlemen,
For that[2] I know your friendship is unfeigned,
It is not Faustus' custom to deny 20
The just request of those that wish him well,
You shall behold that peerless dame of Greece,
No otherwise for pomp or majesty
Than when Sir Paris crossed the seas with her,
And brought the spoils[3] to rich Dardania.[4]
Be silent, then, for danger is in words.

[*Music sound,* MEPHISTOPHILIS *brings in* HELEN, *she passeth over the stage.*

2 Schol. Was this fair Helen, whose admired worth
Made Greece with ten years' wars afflict poor Troy?
Too simple is my wit to tell her praise,
Whom all the world admires for majesty. 30

3 Schol. No marvel though the angry Greeks pursued[5]
With ten years' war the rape of such a queen,
Whose heavenly beauty passeth all compare.

[11] *stand much upon:* in the obvious sense; but meaning also "make much of."

[12] *Colossus:* which stood with legs astride (hence not "bedfellows") at the entrance to the harbor of Rhodes.

[13] *make nothing:* in the obvious sense, and also "make light." [14] *away:* off.

[15] *hey-pass ... re-pass:* exclamations used by conjurors and jugglers.

V.i.

[1] *conference:* discussion. [2] *For that:* Because.

[3] *spoils:* destruction. [4] *Dardania:* Troy.

[5] *pursued:* revenged. (The dialogue and assigning of speeches in this scene conflate the editions of 1604 and 1616.)

1 Schol. Now we have seen the pride of nature's
 work,
And only paragon of excellence,
We'll take our leaves; and for this blessèd sight
Happy and blessed be Faustus evermore!
 Faust. Gentlemen, farewell: the same wish I to you.
 Exeunt Scholars.

 Enter an Old Man.

 Old Man. O gentle Faustus, leave this damnèd art,
This magic, that will charm thy soul to hell, 40
And quite bereave thee of salvation.
Though thou hast now offended like a man,
Do not persèver in it like a devil;
Yet, yet, thou hast an amiable[6] soul,
If sin by custom grow not into nature:
Then, Faustus, will repentance come too late,
Then thou art banished from the sight of heaven;
No mortal can express the pains of hell.
It may be this my exhortation
Seems harsh and all unpleasant; let it not, 50
For gentle son, I speak it not in wrath,
Or envy of[7] thee, but in tender love,
And pity of thy future misery.
And so have hope, that this my kind rebuke,
Checking[8] thy body, may amend thy soul.
Break heart, drop blood, and mingle it with tears,
Tears falling from repentant heaviness
Of thy most vile and loathsome filthiness,
The stench whereof corrupts the inward soul
With such flagitious crimes of heinous[9] sins 60
As no commiseration may expel,
But mercy, Faustus, of thy Savior sweet,
Whose blood alone must wash away thy guilt.
 Faust. Where art thou, Faustus? Wretch, what hast
 thou done?
Damned art thou, Faustus, damned; despair and die!

 MEPHISTOPHILIS *gives him a dagger.*

Hell claims his right, and with a roaring voice
Says, "Faustus, come; thine hour is almost come,"
And Faustus now will come to do thee right.
 Old Man. Oh, stay, good Faustus, stay thy desperate
 steps!
I see an angel hover o'er thy head, 70
And, with a vial full of precious grace,
Offers to pour the same into thy soul:
Then call for mercy, and avoid despair.
 Faust. O friend, I feel
Thy words to comfort my distressèd soul!
Leave me a while to ponder on my sins.

 [6] *amiable:* worthy of (divine) love.
 [7] *envy of:* animosity toward. [8] *Checking:* Reproving.
 [9] *flagitious . . . heinous:* flagrant . . . hateful.
 [10] *Revolt:* i.e., from God. [11] *drift:* purpose.
 [12] *topless:* lofty (the tops being too high to be visible).
 [13] *Menelaus:* husband of Helen and type of the cuckold;
hence, "weak."
 [14] *wound . . . heel:* as Paris, the lover of Helen, did.
 [15] *Semele:* to whom her lover Jupiter appeared as the god
of thunder, consuming her with his flames.

 Old Man. Faustus, I leave thee; but with grief of
 heart,
Fearing the enemy of thy hapless soul.
 Exit.
 Faust. Accursèd Faustus, where is mercy now?
I do repent; and yet I do despair: 80
Hell strives with grace for conquest in my breast:
What shall I do to shun the snares of death?
 Meph. Thou traitor, Faustus, I arrest thy soul
For disobedience to my sovereign lord:
Revolt,[10] or I'll in piecemeal tear thy flesh.
 Faust. I do repent I e'er offended him.
Sweet Mephistophilis, entreat thy lord
To pardon my unjust presumption,
And with my blood again I will confirm
The former vow I made to Lucifer. 90
 Meph. Do it, then, Faustus, with unfeignèd heart,
Lest greater dangers do attend thy drift.[11]

 [FAUSTUS *stabs his arm, and writes on a paper*
 with his blood.]

 Faust. Torment, sweet friend, that base and agèd
 man,
That durst dissuade me from thy Lucifer,
With greatest torments that our hell affords.
 Meph. His faith is great; I cannot touch his soul;
But what I may afflict his body with
I will attempt, which is but little worth.
 Faust. One thing, good servant, let me crave of thee,
To glut the longing of my heart's desire,— 100
That I may have unto my paramour
That heavenly Helen which I saw of late,
Whose sweet embraces may extinguish clean
Those thoughts that do dissuade me from my vow,
And keep my oath I made to Lucifer.
 Meph. This, or what else, my Faustus shall desire,
Shall be performed in twinkling of an eye.

 Enter HELEN *again, passing over between two* Cupids.

 Faust. Was this the face that launched a thousand
 ships,
And burnt the topless[12] towers of Ilium?—
Sweet Helen, make me immortal with a kiss.— 110
 Kisses her.
Her lips suck forth my soul: see where it flies!—
Come, Helen, come, give me my soul again.
Here will I dwell, for heaven is in these lips,
And all is dross that is not Helena.

 Enter Old Man.

I will be Paris, and for love of thee,
Instead of Troy, shall Wittenberg be sacked;
And will combat with weak Menelaus,[13]
And wear thy colors on my plumèd crest:
Yea, I will wound Achilles in the heel,[14]
And then return to Helen for a kiss. 120
Oh, thou art fairer than the evening's air
Clad in the beauty of a thousand stars;
Brighter art thou than flaming Jupiter
When he appeared to hapless Semele;[15]

More lovely than the monarch of the sky
In wanton Arethusa's azured arms;[16]
And none but thou shalt be my paramour!
 Exeunt [FAUSTUS, HELEN, *and* Cupids].
Old Man. Accursèd Faustus, miserable man,
That from thy soul exclud'st the grace of heaven,
And fliest the throne of His tribunal-seat! 130

Enter the Devils.

Satan begins to sift[17] me with his pride:[18]
As in this furnace God shall try my faith,
My faith, vile hell, shall triumph over thee.
Ambitious fiends, see how the heavens smiles
At your repulse, and laughs your state[19] to scorn!
Hence, hell! for hence I fly unto my God.
 Exeunt.

Thunder. Enter LUCIFER, BELZEBUB, *and* MEPHISTOPHILIS.

Luc. Thus from infernal Dis[20] do we ascend
To view the subject of our monarchy,
Those souls which sin seals[21] the black sons of hell,
'Mong which as chief, Faustus, we come to thee, 140
Bringing with us lasting damnation
To wait upon thy soul: the time is come
Which makes it forfeit.
Meph. And this gloomy night,
Here in this room will wretched Faustus be.
Belz. And here we'll stay,
To mark[22] him how he doth demean[23] himself.
Meph. How should he, but in desperate lunacy?
Fond[24] worldling, now his heart-blood dries with
 grief,
His conscience kills it, and his laboring brain
Begets a world of idle fantasies 150
To over-reach the Devil; but all in vain,
His store of pleasures must be sauced[25] with pain.
He and his servant, Wagner, are at hand.
Both come from drawing[26] Faustus' latest[27] will.
See where they come!

Enter FAUSTUS and WAGNER.

Faust. Say, Wagner, thou hast perused my will,
How dost thou like it?
Wag. Sir, so wondrous well,
As in all humble duty, I do yield
My life and lasting service for your love.

Enter the Scholars.

Faust. Gramercies,[28] Wagner. Welcome, gentlemen.
 [*Exit* WAGNER.]
1 Schol. Now, worthy Faustus, methinks your looks
 are changed. 161
Faust. Oh, gentlemen!
2 Schol. What ails Faustus?
Faust. Ah, my sweet chamber-fellow,[29] had I lived
with thee, then had I lived still! but now must die
eternally. Look, sirs, comes he not? Comes he not?
1 Schol. O my dear Faustus, what imports this fear?
2 Schol. Is all our pleasure turned to melancholy?
3 Schol. He is not well with being over-solitary.

2 Schol. If it be so, we'll have physicians 170
And Faustus shall be cured.
3 Schol. 'Tis but a surfeit,[30] sir; fear nothing.
Faust. A surfeit of deadly sin, that hath damned both
body and soul.
2 Schol. Yet, Faustus, look up to heaven; remember
God's mercies are infinite.
Faust. But Faustus' offense can ne'er be pardoned:
the serpent that tempted Eve may be saved, but not
Faustus. Oh, gentlemen, hear me with patience, and
tremble not at my speeches! Though my heart 180
pant and quiver to remember that I have been a student
here these thirty years, oh, would I had never seen
Wittenberg, never read book! and what wonders I have
done, all Germany can witness, yea, all the world; for
which Faustus hath lost both Germany and the world;
yea, heaven itself, heaven, the seat of God, the throne of
the blessed, the kingdom of joy; and must remain in hell
for ever—hell, oh, hell for ever! Sweet friends, what
shall become of Faustus, being in hell for ever?
2 Schol. Yet, Faustus, call on God. 190
Faust. On God, whom Faustus hath abjured! on
God, whom Faustus hath blasphemed! Oh, my God, I
would weep! but the devil draws in my tears. Gush
forth blood, instead of tears! yea, life and soul—Oh, he
stays my tongue! I would lift up my hands; but see,
they hold 'em, they hold 'em!
All. Who, Faustus?
Faust. Why, Lucifer and Mephistophilis. Oh, gentle-
men, I gave them my soul for my cunning!
All. Oh, God forbid! 200
Faust. God forbade it, indeed; but Faustus hath
done it: for the vain pleasure of four and twenty years
hath Faustus lost eternal joy and felicity. I writ them a
bill with mine own blood: the date is expired; this is the
time, and he will fetch me.
1 Schol. Why did not Faustus tell us of this before,
that divines might have prayed for thee?
Faust. Oft have I thought to have done so; but the
Devil threatened to tear me in pieces, if I named God;
to fetch me, body and soul, if I once gave ear to 210
divinity: and now 'tis too late. Gentlemen, away, lest
you perish with me.
2 Schol. Oh, what may we do to save Faustus?
Faust. Talk not of me, but save yourselves, and de-
part.
3 Schol. God will strengthen me; I will stay with
Faustus.

[16] *Arethusa's azured arms:* The arms of this Nereid are
sky blue in token of the fountain in which she dwelt. Her
relation to the "monarch of the sky" is not recorded else-
where. [17] *sift:* try (a reminiscence of Luke 22:31).
[18] *pride:* power. [19] *state:* dignity, power.
[20] *Dis:* properly, the ruler of the Underworld; here, the
region. [21] *seals:* marks irrevocably as.
[22] *mark:* note. [23] *demean:* conduct.
[24] *Fond:* Foolish.
[25] *sauced:* paid for (and also in our sense of mixed with
something sharp). [26] *drawing:* drawing up.
[27] *latest:* last. [28] *Gramercies:* Thanks.
[29] *chamber-fellow:* student with whom one shared the same
room. [30] *surfeit:* disorder as from too much eating.

1 Schol. Tempt not God, sweet friend; but let us into the next room, and pray for him. 219

Faust. Ay, pray for me, pray for me; and what noise soever you hear, come not unto me, for nothing can rescue me.

2 Schol. Pray thou, and we will pray that God may have mercy upon thee.

Faust. Gentlemen, farewell: if I live till morning, I'll visit you; if not, Faustus is gone to hell.

All. Faustus, farewell.

 Exeunt Scholars.

Meph.[31] Ay, Faustus, now thou hast no hope of heaven;
Therefore despair, think only upon hell,
For that must be thy mansion, there to dwell. 230

Faust. O thou bewitching fiend, 'twas thy temptation
Hath robbed me of eternal happiness.

Meph. I do confess it, Faustus, and rejoice;
'Twas I, that when thou wert i' the way to heaven,
Dammed up thy passage; when thou took'st the book,
To view the Scriptures, then I turned the leaves,
And led thine eye.—
What, weep'st thou? 'Tis too late, despair, farewell!
Fools that will laugh on earth must weep in hell.

 Exit.

Enter the Good Angel *and the* Bad Angel *at several doors.*

Good Ang. Oh, Faustus, if thou hadst given ear to me, 240
Innumerable joys had followed thee.
But thou didst love the world.

Bad Ang. Gave ear to me,
And now must taste hell's pains perpetually.

Good Ang. Oh, what will all thy riches, pleasures, pomps,
Avail thee now?

Bad Ang. Nothing but vex thee more,
To want in hell, that had on earth such store.

Music while the throne[32] *descends.*

Good Ang. Oh, thou hast lost celestial happiness,
Pleasures unspeakable, bliss without end.
Hadst thou affected[33] sweet divinity,
Hell, or the devil, had had no power on thee.
Hadst thou kept on that way, Faustus, behold 250
In what replendent glory thou hadst sat
In yonder throne, like those bright shining saints,[34]
And triumphed over hell: that hast thou lost:
And now, poor soul, must thy good angel leave thee,

 [*The throne ascends.*]

The jaws of hell are open to receive thee.

 Exit.

 Hell is discovered.[35]

Bad. Ang. Now, Faustus, let thine eyes with horror stare
Into that vast perpetual torture-house.
There are the Furies tossing damnèd souls
On burning forks; their bodies boil in lead: 260
There are live quarters broiling on the coals,
That ne'er can die: this ever-burning chair
Is for o'er-tortured souls to rest them in;
These that are fed with sops of flaming fire,
Were gluttons and loved only delicates,[36]
And laughed to see the poor starve at their gates:
But yet all these are nothing; thou shalt see
Ten thousand tortures that more horrid be.

Faust. Oh, I have seen enough to torture me.

Bad Ang. Nay, thou must feel them, taste the smart of all: 270
He that loves pleasure, must for pleasure fall:
And so I leave thee, Faustus, till anon;
Then wilt thou tumble in confusion.

 Exit.

 The clock strikes eleven.

Faust. Oh, Faustus,
Now hast thou but one bare hour to live,
And then thou must be damned perpetually!
Stand still, you ever moving spheres of heaven,
That time may cease, and midnight never come;
Fair nature's eye, rise, rise, again, and make
Perpetual day; or let this hour be but 280
A year, a month, a week, a natural day,
That Faustus may repent and save his soul!
O lente, lente currite, noctis equi![37]
The stars move still, time runs, the clock will strike,
The devil will come, and Faustus must be damned.
Oh, I'll leap up to my God!—Who pulls me down?—
See, see, where Christ's blood streams in the firmament!
One drop would save my soul, half a drop: oh, my Christ!—
Ah, rend not my heart for naming of my Christ!
Yet will I call on him: Oh, spare me, Lucifer!— 290
Where is it[38] now? 'Tis gone: and see, where God
Stretcheth out his arm, and bends his ireful brows!
Mountains and hills, come, come, and fall on me,
And hide me from the heavy wrath of God!
No, no!
Then will I headlong run into the earth:
Earth, gape! Oh, no, it will not harbor me!
You stars that reigned at my nativity,
Whose influence[39] hath allotted death and hell,
Now draw up Faustus, like a foggy mist, 300
Into the entrails of yon laboring[40] cloud
That, when you[41] vomit forth into the air,

[31] *Meph.:* Who at this point comes forward.
[32] *throne:* let down from the "heavens" above the stage by cords and pulleys. [33] *affected:* cultivated.
[34] *saints:* presumably brightly dressed actors occupied the throne.
[35] *discovered:* as by drawing back a curtain to reveal a "Hell-mouth" or, less ambitiously, a painted cloth.
[36] *delicates:* delicacies.
[37] *L.:* Adapting Ovid's *Amores,* I. xiii. 40: "O run slowly, slowly, horses of the night!" [38] *it:* Christ's blood.
[39] *influence:* the decisive power over men imputed by astrology to the stars.
[40] *laboring:* working; contorted, contracting and expanding as with pain in the entrails. [41] *you:* the cloud.

My limbs may issue from your smoky mouths,
So that my soul may but ascend to heaven!

The watch strikes.

Oh, half the hour is past! 'twill all be passed anon.
O God,
If Thou wilt not have mercy on my soul,
Yet for Christ's sake, whose blood hath ransomed me,
Impose some end to my incessant pain;
Let Faustus live in hell a thousand years, 310
A hundred thousand, and at last be saved!
No end is limited [42] to damnèd souls!
Why wert thou not a creature wanting soul?
Or why is this immortal that thou hast?
Ah, Pythagoras' *metempsychosis*, [43] were that true,
This soul should fly from me, and I be changed
Unto some brutish beast! all beasts are happy,
For, when they die,
Their souls are soon dissolved in [44] elements;
But mine must live still to be plagued in hell. 320
Cursed be the parents that engendered me!
No, Faustus, curse thyself, curse Lucifer
That hath deprived thee of the joys of heaven.

The clock strikes twelve.

It strikes, it strikes! Now, body, turn to air,
Or Lucifer will bear thee quick [45] to hell!
O soul, be changed into small water-drops,
And fall into the ocean, ne'er be found!

Thunder and enter the Devils.

My God, my God, look not so fierce on me!
Adders and serpents, let me breathe a while!
Ugly hell, gape not! come not, Lucifer! 330
I'll burn my books!—Oh, Mephistophilis!

Exeunt with him.

Enter the Scholars.

1 Schol. Come, gentlemen, let us go visit Faustus,
For such a dreadful night was never seen,
Since first the world's creation did begin.
Such fearful shrieks and cries were never heard:
Pray heaven the Doctor have escaped the danger.
 2 Schol. Oh, help us heaven! see, here are Faustus'
limbs,
All torn asunder by the hand of death.
 3 Schol. The devils whom Faustus served have torn
him thus:
For 'twixt the hours of twelve and one, methought 340
I heard him shriek and call aloud for help:
At which self [46] time the house seemed all on fire,
With dreadful horror of these damnèd fiends.
 2 Schol. Well, gentlemen, though Faustus' end be
such
As every Christian heart laments to think on,
Yet for [47] he was a scholar, once admired
For wondrous knowledge in our German schools,
We'll give his mangled limbs due burial;
And all the students, clothed in mourning black,
Shall wait upon [48] his heavy [49] funeral. 350

Exeunt.

[EPILOGUE]

Enter Chorus.

Chor. Cut is the branch that might have grown full
straight,
And burnèd is Apollo's [1] laurel bough,
That sometime grew within this learned man.
Faustus is gone: regard [2] his hellish fall,

Whose fiendful [3] fortune may exhort the wise,
Only to wonder [4] at unlawful things,
Whose deepness doth entice such forward wits
To practice more than heavenly power permits.

Exit.

Terminat hora diem; terminat Author opus. [5]

F I N I S

[42] *limited:* appointed.
[43] *Pythagoras' metempsychosis:* alluding to the belief of the Greek philosopher in the transmigration of souls.
[44] *in:* into. [45] *quick:* alive.
[46] *self:* same. [47] *for:* because.
[48] *wait upon:* attend. [49] *heavy:* sorrowful.

EPILOGUE
[1] *Apollo's:* alluding to his patronage of learning.
[2] *regard:* The injunction that follows is often denied to Marlowe on the grounds that it is too positive.
[3] *fiendful:* devilish.
[4] *Only to wonder:* To be satisfied with wondering.
[5] *L.:* The hour ends the day; the author ends his work.

Christopher Marlowe

EDWARD II

THE TEXT of EDWARD II that serves as copy for this edition is essentially the earliest extant edition of the play, an octavo printed in 1594. Two copies survive, the first in the Zentralbibliothek, Zurich; the second in the Landesbibliothek, Cassel, Germany. Though these two copies differ in minor ways—a few corrections have been made in the process of printing—they are for practical purposes virtually identical.

A second edition, in quarto, and printed by Richard Bradocke for William Jones, appeared in 1598. Four copies exist: two in the British Museum, one in the Bodleian Library, one in the Dyce collection, South Kensington. A second quarto, also extant in the British Museum and the Dyce collection, was published by Roger Barnes in 1612; a third by Henry Bell (to whom the copyright had passed) in 1622. Bell's quarto preserves two different states. The first, like its predecessors, records on the title page performances by the Earl of Pembroke's servants; the second reads "*As it was publickely Acted by the late Queens Maiesties Seruants at the Red Bull in S. Johns streete.*"

Previous editors generally assert that these early editions were printed one from another. We would conjecture only that the third quarto reprints the second, because the same variants from the octavo and the first quarto occur in each. The text in every case is relatively good.

There exists also, in the Dyce collection, an imperfect copy of the first quarto of 1598, in which the first two leaves are lacking and are supplied in manuscript, written in a neat Italian hand. The title page of these manuscript leaves is dated 1593 and differs in wording from that of the 1598 quarto, which it completes. Patent misreadings, and variations between the manuscript and the octavo, and the manuscript and the first quarto, beget the conclusion or supposition that the unknown scribe was copying faithfully a carelessly printed edition of 1593, an edition that no longer survives except in this fragmentary version, and that was worked up in haste to capitalize on Marlowe's sensational death, on May 30, 1593.

EDWARD II was entered in the Stationers' Register on 6 July 1593 (Arber, *S.R.*, II, 299ᵛ). Composition is to be assigned, presumably, to the period 1591–92. (Here, the evidence is sketchy and has been subject to different and even antithetical interpretations.) Pembroke's company, which is said to have acted the play sundry times, is first noticed as a performing entity at Leicester in the last months of 1592. Parallels from other plays suggest to some editors that EDWARD II

was written in the previous year. Marlowe levies (apparently) on Peele's *Edward I*, an earlier play, and on the second and third parts of Shakespeare's *Henry VI*, which, as Greene's deathbed attack on Shakespeare attests, were in existence by 1592. But Marlowe in turn furnished hints to the author or authors of two other plays, entered in the Stationers' Register in the spring and fall of 1592. These plays are ARDEN OF FEVERSHAM and *Solyman and Perseda*, each of which has been attributed to Thomas Kyd, with whom Marlowe was sharing a chamber early in 1591. Editors have conjectured that Kyd read at that time, and borrowed from, the holograph of EDWARD II. Such conjectures are, however, not really crucial to the dating of the play. One may assert with confidence, on the basis of style alone, that EDWARD II is a work of Marlowe's maturity, insofar as he can be said to have attained it.

Marlowe's source is, substantially, the *Chronicles of England* by Raphael Holinshed, as printed first in 1577, or in the second edition of 1586. Whether the play was popular in its own time is moot. Following its initial performance by Pembroke's company, it was revived at the Red Bull by Queen Anne's men, early in the seventeenth century.

EDWARD II is generally described as the best example of the genre of chronicle history, excluding only the plays of Shakespeare. The description is valid, and for two reasons. First and more obviously, Marlowe, having arrived at the summit of his powers, brings to the writing of the play a gift for expressing whimsy, poignance, and terror that, in isolated but sufficiently numerous passages, has never been surpassed. The final agony of the hero ranks with the greatest and most memorable scenes in the annals of English drama. But to emphasize the quality of any one scene is not enough. For the second reason that validates the particular praise accorded this play is its character as a total work of theater. In the two parts of TAMBURLAINE, even in the much greater tragedy of DOCTOR FAUSTUS, Marlowe is writing episodic drama. Such unity as he communicates is linear or chronological. Events succeed one another "as the waves make toward the pebbled shore." In EDWARD II, the succession of events is, at least in part, not simply chronological but causal. The hero dies, not *post hoc* or after much titillating incident, like Barabas, but *propter hoc*: on account of what has happened before. Marlowe, attempting to convey the sense of a veritable progression, is not only preeminent in the making of chronicle history. He transcends the genre.

R. A. F.

Edward II

DRAMATIS PERSONÆ

KING EDWARD THE SECOND
PRINCE EDWARD, his Son, afterwards King Edward the Third
EDMUND, EARL OF KENT, brother of King Edward the Second
PIERCE OF GAVESTON, EARL OF CORNWALL
GUY, EARL OF WARWICK
EARL OF LANCASTER
EARL OF PEMBROKE
EARL OF ARUNDEL
EARL OF LEICESTER
BERKELEY
LORD MORTIMER senior
LORD MORTIMER junior, his nephew
HUGH SPENCER senior
HUGH SPENCER junior, his Son
ARCHBISHOP OF CANTERBURY
BISHOP OF COVENTRY

BISHOP OF WINCHESTER
BALDOCK, a clerk
BEAUMONT, a follower of the King
TRUSSEL
GURNEY } followers of Mortimer junior
MATREVIS
LIGHTBORN, a murderer
SIR JOHN OF HAINAULT
LEVUNE, a Frenchman
RICE AP HOWEL
Abbot, Monks, Herald, Lords, Three Poor Men, James (servant to Pembroke), Mower, the King's Champion, Mayor of Bristol, Messengers, Soldiers, Horse-boy, and Attendants
QUEEN ISABELLA, wife of King Edward the Second
NIECE TO KING EDWARD THE SECOND, daughter of the Duke of Gloucester
Ladies

ACT ONE

SCENE ONE

Enter GAVESTON, *reading on a letter that was brought him from the King.*

Gav. "My father is deceased. Come, Gaveston,
And share the kingdom with thy dearest friend."
Ah, words that make me surfeit with delight!
What greater bliss can hap to Gaveston
Than live and be the favorite of a king?
Sweet prince, I come; these, these thy amorous lines
Might have enforced me to have swum from France,[1]
And, like Leander,[2] gasped upon the sand,
So thou wouldst smile, and take me in thy arms.
The sight of London to my exiled eyes 10
Is as Elysium to a new-come soul;
Not that I love the city, or the men,
But that it harbors him I hold so dear,
The King, upon whose bosom let me die,[3]
And with the world be still at enmity.
What need the arctic people love starlight,
To whom the sun shines both by day and night?
Farewell base stooping to the lordly peers.
My knee shall bow to none but to the King.
As for the multitude that are but sparks, 20
Raked up in embers of their poverty—
Tanti![4] I'll fawn[5] first on the wind
That glanceth at my lips, and flieth away.
But how now, what are these?

Enter three Poor Men.

Men. Such as desire your worship's service.
Gav. What canst thou do?
1 Man. I can ride.
Gav. But I have no horses. What art thou?
2 Man. A traveler.
Gav. Let me see—thou wouldst do well 30
To wait at my trencher and tell me lies at dinner-time;
And as I like your discoursing, I'll have you.
And what art thou?
3 Man. A soldier, that hath served against the Scot.
Gav. Why, there are hospitals[6] for such as you;
I have no war, and therefore, sir, be gone.
3 Man. Farewell, and perish by a soldier's hand,
That wouldst reward them with an hospital.
Gav. Ay, ay, these words of his move me as much
As if a goose should play the porpintine,[7] 40
And dart her plumes, thinking to pierce my breast.
But yet it is no pain to speak men fair;

I.i.
 [1] *France:* Gaveston had been banished to France by Edward I.
 [2] *Leander:* who drowns in the story of Hero and Leander.
 [3] *die:* faint with joy. [4] *It:* So much for that.
 [5] *fawn:* emended from "fanne" of MS and original editions.
 [6] *hospitals:* for the aged and indigent rather than the sick.
 [7] *porpintine:* Pliny (trans. Holland, VIII, XXXV) ascribes to the porcupine the ability to dart its plumes or quills.

[*Aside*] I'll flatter these and make them live in hope.
You know that I came lately out of France,
And yet I have not viewed my lord the King.
If I speed well, I'll entertain you all.
 All. We thank your worship.
 Gav. I have some business, leave me to myself.
 All. We will wait here about the court.
 Exeunt.
 Gav. Do; these are not men for me: 50
I must have wanton [8] poets, pleasant wits,
Musicians, that with touching of a string
May draw the pliant King which way I please.
Music and poetry is his delight;
Therefore I'll have Italian masks [9] by night,
Sweet speeches, comedies, and pleasing shows;
And in the day, when he shall walk abroad,
Like sylvan nymphs my pages shall be clad;
My men, like satyrs grazing [10] on the lawns,
Shall with their goat-feet dance an antic hay. [11] 60
Sometime a lovely boy in Dian's shape,
With hair that gilds the water as it glides,
Crownets [12] of pearl about his naked arms,
And in his sportful hands an olive-tree,
To hide those parts which men delight to see,
Shall bathe him in a spring; and there, hard by,
One like Actaeon [13] peeping through the grove,
Shall by the angry goddess be transformed,
And running in the likeness of an hart
By yelping hounds pulled down, and seem to die— 70
Such things as these best please his majesty,
My lord. [14] Here comes the King and the nobles
From the parliament. I'll stand aside.
 [*Retires.*]

Enter the KING, LANCASTER, MORTIMER *senior,*
MORTIMER *junior,* EDMUND, *Earl of Kent,* GUY,
 Earl of Warwick, etc.

 King. Lancaster!
 Lanc. My lord.
 Gav. [*Aside*] That Earl of Lancaster do I abhor.
 King. Will you not grant me this? [*Aside*] In spite of
 them
I'll have my will; and these two Mortimers, [15]
That cross me thus, shall know I am displeased. 79
 Mort. Sen. If you love us, my lord, hate Gaveston.
 Gav. [*Aside*] That villain Mortimer: I'll be his death.
 Mort. Jun. Mine uncle here, this earl, and I myself,

 [8] *wanton:* amorous.
 [9] *Italian masks:* The provenance of the mask was under-
stood by Elizabethans to be Italian.
 [10] *grazing:* like beasts; but also tending cattle while they
feed. [11] *hay:* rural dance.
 [12] *Crownets:* Coronets; by transference, bracelets.
 [13] *Actaeon:* See Ovid, *Metamorphoses,* III. 155*ff.*
 [14] *lord:* followed by a comma in original editions.
 [15] *these two Mortimers:* who, in historical fact, were
innocent of opposition to Gaveston.
 [16] *to the proof:* to the point; irrefutably.
 [17] *Braved:* Challenged.
 [18] *Cousin:* used to signalize any distant relationship.
 [19] *wanton:* ungovernable.
 [20] *glozing:* given to talking smoothly and speciously.
 [21] *bandy:* give and take blows (metaphor from tennis).

Were sworn to your father at his death,
That he should ne'er return into the realm:
And know, my lord, ere I will break my oath,
This sword of mine, that should offend your foes,
Shall sleep within the scabbard at thy need,
And underneath thy banners march who will,
For Mortimer will hang his armor up.
 Gav. [*Aside*] *Mort Dieu!* 90
 King. Well, Mortimer, I'll make thee rue these
 words.
Beseems it thee to contradict thy King?
Frownst thou thereat, aspiring Lancaster?
The sword shall plane the furrows of thy brows,
And hew these knees that now are grown so stiff.
I will have Gaveston; and you shall know
What danger 'tis to stand against your King.
 Gav. [*Aside*] Well done, Ned!
 Lanc. My lord, why do you thus incense your peers,
That naturally would love and honor you 100
But for that base and obscure Gaveston?
Four earldoms have I, besides Lancaster,
Derby, Salisbury, Lincoln, Leicester;
These will I sell, to give my soldiers pay,
Ere Gaveston shall stay within the realm;
Therefore, if he be come, expel him straight.
 Kent. Barons and earls, your pride hath made me
 mute;
But now I'll speak, and to the proof, [16] I hope.
I do remember, in my father's days,
Lord Percy of the north, being highly moved, 110
Braved [17] Mowbery in presence of the King;
For which, had not his highness loved him well,
He should have lost his head; but with his look
The undaunted spirit of Percy was appeased,
And Mowbery and he were reconciled:
Yet dare you brave the King unto his face.
Brother, revenge it, and let these their heads
Preach upon poles, for trespass of their tongues.
 War. Oh, our heads!
 King. Ay, yours; and therefore I would wish you
 grant— 120
 War. Bridle thy anger, gentle Mortimer.
 Mort. Jun. I cannot, nor I will not; I must speak.
Cousin, [18] our hands I hope shall fence our heads.
And strike off his that makes you threaten us.
Come, uncle, let us leave the brain-sick King,
And henceforth parley with our naked swords.
 Mort. Sen. Wiltshire hath men enough to save our
 heads.
 War. All Warwickshire will love him for my sake.
 Lanc. And northward Gaveston hath many friends.
Adieu, my lord; and either change your mind, 130
Or look to see the throne, where you should sit,
To float in blood, and at thy wanton [19] head,
The glozing [20] head of thy base minion thrown.
 Exeunt Nobles.
 King. I cannot brook these haughty menaces;
Am I a king, and must be overruled?
Brother, display my ensigns in the field;
I'll bandy [21] with the barons and the earls,
And either die, or live with Gaveston.

Gav. I can no longer keep me from my lord.
King. What, Gaveston! welcome!—Kiss not my
 hand, 140
Embrace me, Gaveston, as I do thee.
Why shouldst thou kneel? Knowest thou not who I am?
Thy friend, thyself, another Gaveston!
Not Hylas [22] was more mourned of Hercules,
Than thou hast been of me since thy exile. [23]
 Gav. And since I went from hence, no soul in hell
Hath felt more torment than poor Gaveston.
 King. I know it. Brother, welcome home, my friend.
Now let the treacherous Mortimers conspire,
And that high-minded [24] Earl of Lancaster: 150
I have my wish, in that I joy [25] thy sight; [26]
And sooner shall the sea o'erwhelm my land
Than bear the ship that shall transport thee hence.
I here create thee Lord High Chamberlain, [27]
Chief Secretary to the state and me,
Earl of Cornwall, King and Lord of Man.
 Gav. My lord, these titles far exceed my worth.
 Kent. Brother, the least of these may well suffice
For one of greater birth than Gaveston.
 King. Cease, brother, for I cannot brook these
 words. 160
Thy worth, sweet friend, is far above my gifts,
Therefore, to equal it, receive my heart;
If for these dignities thou be envied, [28]
I'll give thee more; for, but to honor thee,
Is Edward pleased with kingly regiment. [29]
Fearst [30] thou thy person? Thou shalt have a guard:
Wantst thou gold? Go to my treasury:
Wouldst thou be loved and feared? Receive my seal;
Save or condemn, and in our name command
Whatso thy mind affects, or fancy likes. 170
 Gav. It shall suffice me to enjoy your love,
Which, whiles I have, I think myself as great

 Enter the BISHOP OF COVENTRY.

As Caesar riding in the Roman street
With captive kings at his triumphant car.
 King. Whither goes my lord of Coventry so fast?
 Cov. To celebrate your father's exequies.
But is that wicked Gaveston returned?
 King. Ay, priest, and lives to be revenged on thee,
That wert the only cause of his exile. [31] 179
 Gav. 'Tis true; and but for reverence of these robes,
Thou shouldst not plod one foot beyond this place.
 Cov. I did no more than I was bound to do;
And, Gaveston, unless thou be reclaimed,
As then I did incense the parliament,
So will I now and thou shalt back to France.
 Gav. Saving your reverence, [32] you must pardon me.
 King. Throw off his golden miter, rend his stole,
And in the channel [33] christen him anew.
 Kent. Ah, brother, lay not violent hands on him!
For he'll complain unto the see of Rome. 190
 Gav. Let him complain unto the see of hell;
I'll be revenged on him for my exile. [34]
 King. No, spare his life, but seize upon his goods:
Be thou lord bishop and receive his rents,
And make him serve thee as thy chaplain:

I give him thee—here, use him as thou wilt.
 Gav. He shall to prison, and there die in bolts.
 King. Ay, to the Tower, the Fleet, or where thou
 wilt.
 Cov. For this offense, be thou accurst of God!
 King. Who's there? Convey this priest to the Tower.
 Cov. True, true. [35] 201
 King. But in the meantime, Gaveston, away,
And take possession of his house and goods.
Come, follow me, and thou shalt have my guard
To see it done, and bring thee safe again.
 Gav. What should a priest do with so fair a house?
A prison may beseem his holiness.

 [Exeunt.]

[I.ii]

 Enter both the MORTIMERS, WARWICK, *and*
 LANCASTER.

 War. 'Tis true, the bishop is in the Tower,
And goods and body given to Gaveston.
 Lan. What! will they tyrannize upon the Church?
Ah, wicked King! accursèd Gaveston!
This ground, which is corrupted with their steps,
Shall be their timeless [1] sepulcher, or mine.
 Mort. Jun. Well, let that peevish [2] Frenchman guard
 him sure;
Unless his breast be sword-proof he shall die.
 Mort. Sen. How now! why droops the Earl of
 Lancaster?
 Mort. Jun. Wherefore is Guy of Warwick
 discontent? 10
 Lanc. That villain Gaveston is made an earl.
 Mort. Sen. An earl!
 War. Ay, and besides Lord Chamberlain of the
 realm,
And Secretary, too, and Lord of Man.
 Mort. Sen. We may not, nor we will not suffer this.
 Mort. Jun. Why post we not from hence to levy men?
 Lanc. "My Lord of Cornwall," now at every word!
And happy is the man whom he vouchsafes,

[22] *Hylas:* On the expedition of the Argonauts in search of
the Golden Fleece, Hylas, whom Hercules had brought with
him, was drawn down into a well by admiring Naiads, and
never seen again.
[23] *exile:* accent on second syllable.
[24] *high-minded:* arrogant. [25] *joy:* enjoy.
[26] *I . . . sight:* See *Arden of Feversham,* xiv. 1. 346, for
repetition of this line.
[27] *Lord High Chamberlain:* Following Holinshed's account
edition of 1577.
[28] *envied:* accent on second syllable. [29] *regiment:* rule.
[30] *Fearst:* Fearest for.
[31] *exile:* accent on second syllable.
[32] *Saving your reverence:* mocking apology, to introduce
an offensive remark.
[33] *channel:* gutter of the street; an open drain.
[34] *exile:* accent on second syllable.
[35] *True, true:* uttered sarcastically, as a comment on the
equivocal sense of "Convey" (to steal), in the previous line.
I.ii.
 [1] *timeless:* untimely, premature.
 [2] *peevish:* senseless, foolish.

For vailing[3] of his bonnet, one good look.
Thus, arm in arm, the King and he doth march: 20
Nay more, the guard upon his lordship waits;
And all the court begins to flatter him.
 War. Thus leaning on the shoulder of the King,
He nods, and scorns, and smiles at those that pass.
 Mort. Sen. Doth no man take exceptions at[4] the
 slave?
 Lanc. All stomach[5] him, but none dare speak a word.
 Mort. Jun. Ah, that bewrays[6] their baseness,
 Lancaster!
Were all the earls and barons of my mind,
We'll hale him from the bosom of the King,
And at the court-gate hang the peasant up, 30
Who, swoln with venom of ambitious pride,
Will be the ruin of the realm and us.

Enter the [ARCH]BISHOP OF CANTERBURY [*and an*
Attendant]

 War. Here comes my lord of Canterbury's grace.
 Lanc. His countenance bewrays he is displeased.
 Cant. First were his sacred garments rent and torn,
Then laid thy violent hands upon him; next
Himself imprisoned, and his goods asseized:[7]
This certify[8] the Pope; away, take horse.
 [*Exit* Attendant.]
 Lanc. My lord, will you take arms against the King?
 Cant. What need I? God himself is up in arms 40
When violence is offered to the church.
 Mort. Jun. Then will you join with us, that be his
 peers,[9]
To banish or behead that Gaveston?
 Cant. What else, my lords? For it concerns me
 near;
The bishopric of Coventry is his.

Enter the QUEEN.

 Mort. Jun. Madam, whither walks your majesty so
 fast?
 Queen. Unto the forest,[10] gentle Mortimer,
To live in grief and baleful discontent;
For now my lord the King regards me not,
But dotes upon the love of Gaveston. 50
He claps[11] his cheeks, and hangs about his neck,
Smiles in his face, and whispers in his ears;
And when I come, he frowns, as who should say,

 [3] *vailing:* lowering, doffing, in courtesy.
 [4] *exceptions at:* exceptions to.
 [5] *stomach:* are angry at.
 [6] *bewrays:* betrays (as also at *l.* 34).
 [7] *asseized:* seized, legally expropriated.
 [8] *certify:* certify to. [9] *his peers:* the King's peers.
 [10] *forest:* wilderness. [11] *claps:* pats fondly.
 [12] *exile:* accent on second syllable (not noted hereafter).
 [13] *Cant.:* Early editions give speech to Mortimer junior.
 [14] *Lambeth:* the Archbishop's manor.
I.iii.
 [1] *redoubted:* feared (spoken sarcastically).
 [2] *towards Lambeth:* whither the Archbishop had invited
them (I. ii. 78).
I.iv.
 [1] *declined:* turned aside.
 [2] *sits here:* i.e., close to the King.

Go whither thou wilt, seeing I have Gaveston.
 Mort. Sen. Is it not strange, that he is thus
 bewitched?
 Mort. Jun. Madam, return unto the court again;
That sly inveigling Frenchman we'll exile,[12]
Or lose our lives; and yet, ere that day come,
The King shall lose his crown, for we have power,
And courage too, to be revenged at full. 60
 Cant. But yet lift not your swords against the King.
 Lanc. No; but we'll lift Gaveston from hence.
 War. And war must be the means, or he'll stay still.
 Queen. Then let him stay; for rather than my lord
Shall be oppressed by civil mutinies,
I will endure a melancholy life,
And let him frolic with his minion.
 Cant. My lords, to ease all this, but hear me speak:
We and the rest that are his counselors
Will meet, and with a general consent, 70
Confirm his banishment with our hands and seals.
 Lanc. What we confirm the King will frustrate.
 Mort. Jun. Then may we lawfully revolt from him.
 War. But say, my lord, where shall this meeting be?
 Cant. At the New Temple.
 Mort. Jun. Content.
 Cant.[13] And, in the meantime, I'll entreat you all
To cross to Lambeth,[14] and there stay with me.
 Lanc. Come then, let's away.
 Mort. Jun. Madam, farewell. 80
 Queen. Farewell, sweet Mortimer; and for my sake,
Forbear to levy arms against the King.
 Mort. Jun. Ay, if words will serve; if not, I must.
 [*Exeunt.*]

[I.iii]

Enter GAVESTON *and the* EARL OF KENT.

 Gav. Edmund, the mighty Prince of Lancaster,
That hath more earldoms than an ass can bear,
And both the Mortimers, two goodly men,
With Guy of Warwick, that redoubted[1] knight,
Are gone towards Lambeth.[2] There let them remain.
 Exeunt.

[I.iv]

Enter Nobles [LANCASTER, WARWICK, PEMBROKE,
MORTIMER senior, MORTIMER junior, *the*
ARCHBISHOP OF CANTERBURY, *and* Attendants].

 Lanc. Here is the form of Gaveston's exile:
May it please your lordship to subscribe your name.
 Cant. Give me the paper.
 Lanc. Quick, quick, my lord; I long to write my
 name.
 War. But I long more to see him banished hence.
 Mort. Jun. The name of Mortimer shall fright the
 King,
Unless he be declined[1] from that base peasant.

Enter the KING *and* GAVESTON [*and* KENT].

 King. What? Are you moved that Gaveston sits
 here?[2]

It is our pleasure; we will have it so.

 Lanc. Your grace doth well to place him by your
 side, 10
For nowhere else the new earl is so safe.

 Mort. Sen. What man of noble birth can brook this
 sight?
Quam male conveniunt![3]
See what a scornful look the peasant casts.

 Pem. Can kingly lions fawn on creeping ants?

 War. Ignoble vassal, that like Phaëton[4]
Aspirst unto the guidance of the sun.

 Mort. Jun. Their downfall is at hand, their forces
 down:
We will not thus be faced and over-peered.[5]

 King. Lay hands on that traitor Mortimer! 20

 Mort. Sen. Lay hands on that traitor Gaveston!

 Kent. Is this the duty that you owe your King?

 War. We know our duties, let him know his peers.

 King. Whither will you bear him? Stay, or ye shall
 die.

 Mort. Sen. We are no traitors; therefore threaten not

 Gav. No, threaten not, my lord, but pay them
 home!
Were I a king—

 Mort. Jun. Thou villain,[6] wherefore talks thou of a
 king,
That hardly art a gentleman by birth?

 King. Were he a peasant, being my minion,[7] 30
I'll make the proudest of you stoop to him.

 Lanc. My lord, you may not thus disparage[8] us.
Away, I say, with hateful Gaveston!

 Mort. Sen. And with the Earl of Kent that favors
 him.

 [*Attendants* remove KENT *and* GAVESTON.]

 King. Nay, then lay violent hands upon your King,
Here, Mortimer, sit thou in Edward's throne:
Warwick and Lancaster, wear you my crown:
Was ever king thus over-ruled as I?

 Lanc. Learn then to rule us better, and the realm.

 Mort. Jun. What we have done, our heart-blood
 shall maintain. 40

 War. Think you that we can brook this upstart[9]
 pride?

 King. Anger and wrathful fury stops my speech.

 Cant. Why are you moved? Be patient, my lord,
And see what we, your counselors, have done.

 Mort. Jun. My lords, now let us all be resolute,
And either have our wills, or lose our lives.

 King. Meet you for this, proud overdaring peers?
Ere my sweet Gaveston shall part from me,
This Isle shall fleet[10] upon the Ocean,
And wander to the unfrequented Inde.[11] 50

 Cant. You know that I am legate to the Pope;
On your allegiance to the see of Rome,
Subscribe as we have done to his exile.

 Mort. Jun. Curse[12] him, if he refuse; and then may
 we
Depose him and elect another king.

 King. Ay, there it goes: but yet I will not yield:
Curse me, depose me, do the worst you can.

 Lanc. Then linger not, my lord, but do it straight.

 Cant. Remember how the bishop was abused:
Either banish him that was the cause thereof, 60
Or I will presently discharge these lords
Of duty and allegiance due to thee.

 King. It boots me not to threat; I must speak fair:
The legate of the Pope will be obeyed.
My lord, you shall be Chancellor of the realm;
Thou, Lancaster, High Admiral of our fleet;
Young Mortimer and his uncle shall be earls;
And you, Lord Warwick, President of the North;
And thou of Wales. If this content you not,
Make several kingdoms of this monarchy, 70
And share it equally amongst you all,
So I may have some nook or corner left,
To frolic with my dearest Gaveston.

 Cant. Nothing shall alter us: we are resolved.

 Lanc. Come, come, subscribe.

 Mort. Jun. Why should you love him whom the
 world hates so?

 King. Because he loves me more than all the world.
Ah, none but rude[13] and savage-minded men
Would seek the ruin of my Gaveston;
You that be noble-born should pity him. 80

 War. You that are princely-born should shake him
 off:
For shame subscribe, and let the lown[14] depart.

 Mort. Sen. Urge him, my lord.

 Cant. Are you content to banish him the realm?

 King. I see I must, and therefore am content:
Instead of ink I'll write it with my tears.

 [*Subscribes.*]

 Mort. Jun. The King is love-sick for his minion.

 King. 'Tis done, and now, accursèd hand, fall off!

 Lanc. Give it me; I'll have it published in the streets.

 Mort. Jun. I'll see him presently dispatched
 away. 90

 Cant. Now is my heart at ease.

 War. And so is mine.

 Pem. This will be good news to the common sort.

 Mort. Sen. Be it or no, he shall not linger here.

 Exeunt Nobles.

 King. How fast they run to banish him I love.
They would not stir, were it to do me good.
Why should a king be subject to a priest?
Proud Rome, that hatchest such imperial grooms,[15]

 [3] *L.:* After Ovid, *Metamorphoses*, II. 846: "*Majestas et amor conveniunt non bene, nec morantur in una sede.*" "Dignity and love do not agree well, nor tarry together in one seat."

 [4] *Phaëton:* In *Metamorphoses*, I. 755*ff.*, Phaëton, unable to control the chariot of his father, Helios, is killed by a bolt of lightning hurled by Zeus, and falls into the river Eridanus (Po).

 [5] *faced and over-peered:* bullied and looked down on (with pun on "peer" as substantive).

 [6] *villain:* as in the modern sense, but also "serf" or "peasant." [7] *minion:* favorite.

 [8] *disparage:* degrade. [9] *upstart:* used as an adjective.

 [10] *fleet:* float. [11] *Inde:* India.

 [12] *Curse:* Excommunicate. [13] *rude:* barbarous.

 [14] *lown:* peasant. [15] *grooms:* servants.

For these thy superstitious taper-lights,
Wherewith thy antichristian churches blaze,
I'll fire thy crazèd [16] buildings, and enforce 100
The papal towers to kiss the lowly ground. [17]
With slaughtered priests may Tiber's channel swell,
And banks raised higher with their sepulchers.
As for the peers, that back the clergy thus,
If I be King, not one of them shall live.

Enter GAVESTON.

Gav. My lord, I hear it whispered everywhere,
That I am banished, and must fly the land.
King. 'Tis true, sweet Gaveston—Oh! were it false!
The legate of the Pope will have it so,
And thou must hence, or I shall be deposed. 110
But I will reign to be revenged of them;
And therefore, sweet friend, take it patiently.
Live where thou wilt, I'll send thee gold enough;
And long thou shalt not stay, or if thou dost,
I'll come to thee; my love shall ne'er decline.
Gav. Is all my hope turned to this hell of grief?
King. Rend not my heart with thy too-piercing
 words:
Thou from this land, I from myself am banished.
Gav. To go from hence grieves not poor Gaveston;
But to forsake you, in whose gracious looks 120
The blessedness of Gaveston remains:
For nowhere else seeks he felicity.
King. And only this torments my wretched soul,
That, whether I will or no, thou must depart.
Be Governor of Ireland in my stead,
And there abide till fortune call thee home.
Here take my picture, and let me wear thine;

[*They exchange pictures.*]

Oh, might I keep thee here as I do this,
Happy were I: but now most miserable.
Gav. 'Tis something to be pitied of a king. 130
King. Thou shalt not hence; I'll hide thee, Gaveston.
Gav. I shall be found, and then 'twill grieve me more.
King. Kind words and mutual talk makes our grief
greater:
Therefore, with dumb embracement, let us part—
Stay, Gaveston, I cannot leave thee thus.
Gav. For every look, my lord drops down a tear:
Seeing I must go, do not renew my sorrow.
King. The time is little that thou hast to stay,
And therefore give me leave to look my fill:
But come, sweet friend, I'll bear thee on thy way. 140

Gav. The peers will frown.
King. I pass [18] not for their anger. Come, let's go.
Oh, that we might as well return as go.

Enter QUEEN ISABELLA. [19]

Queen. Whither goes my lord?
King. Fawn not on me, French strumpet; get thee
 gone.
Queen. On whom but on my husband should I fawn?
Gav. On Mortimer, with whom, ungentle Queen—
I say no more, judge you the rest, my lord.
Queen. In saying this, thou wrongst me, Gaveston;
Is't not enough that thou corrupts my lord, 150
And art a bawd to his affections,
But thou must call mine honor thus in question?
Gav. I mean not so; your grace must pardon me.
King. Thou art too familiar with that Mortimer,
And by thy means is Gaveston exiled;
But I would wish thee reconcile the lords,
Or thou shalt ne'er be reconciled to me.
Queen. Your highness knows it lies not in my power.
King. Away then; touch me not. Come, Gaveston.
Queen. Villain! 'tis you that robbst me of my lord.
Gav. Madam, 'tis you that rob me of my lord. 161
King. Speak not unto her; let her droop and pine.
Queen. Wherein, my lord, have I deserved these
 words?
Witness the tears that Isabella sheds,
Witness this heart, that, sighing for thee, breaks
How dear my lord is to poor Isabel.
King. And witness heaven how dear thou art to me.
There weep: for till my Gaveston be repealed,
Assure thyself thou com'st not in my sight.

 Exeunt EDWARD *and* GAVESTON.
Queen. O miserable and distressèd Queen! 170
Would, when I left sweet France and was embarked,
That charming Circes, [20] walking on the waves,
Had changed my shape, or at the marriage-day
The cup of Hymen had been full of poison,
Or with those arms that twined about my neck
I had been stifled, and not lived to see
The King my lord thus to abandon me.
Like frantic Juno will I fill the earth
With ghastly murmur of my sighs and cries;
For never doted Jove on Ganymed [21] 180
So much as he on cursèd Gaveston:
But that will more exasperate his wrath;
I must entreat him, I must speak him fair;
And be a means to call home Gaveston:
And yet he'll ever dote on Gaveston;
And so am I forever miserable.

Enter the Nobles *to the* QUEEN.

Lanc. Look where the sister of the King of France
Sits wringing of her hands, and beats her breast!
War. The King, I fear, hath ill intreated [22] her.
Pem. Hard is the heart that injures such a saint. 190
Mort. Jun. I know 'tis long of [23] Gaveston she weeps.
Mort. Sen. Why? He is gone.
Mort. Jun. Madam, how fares
 your grace?

[16] *crazèd:* ruined.
[17] *I'll fire . . . ground:* Cf. Marlowe in *The Massacre at Paris,* xxi. 64–65: "I'll fire his crazed buildings, and enforce / The papal towers to kiss the lowly earth."
[18] *pass:* care.
[19] *Enter . . . Isabella:* Early editions bring on Edmund with the Queen.
[20] *Circes:* Marlowe uses as a nominative singular in *Dido,* IV. iv. 2. Ovid, *Metamorphoses,* XIV. 48*ff,* describes Circe walking on the waves.
[21] *Ganymed:* Ovid, *Metamorphoses,* X. 155–61, tells of Jove's love for Ganymede. [22] *intreated:* treated.
[23] *long of:* on account of.

Queen. Ah, Mortimer! now breaks the King's hate
forth,
And he confesseth that he loves me not.

Mort. Jun. Cry quittance, madam, then; and love
not him.

Queen. No, rather will I die a thousand deaths:
And yet I love in vain; he'll ne'er love me.

Lanc. Fear ye not, madam; now his minion's gone,
His wanton humor will be quickly left.

Queen. Oh, never, Lancaster! I am enjoined 200
To sue unto you all for his repeal;
This wills my lord, and this must I perform
Or else be banished from his highness' presence.

Lanc. For his repeal, madam! he comes not back,
Unless the sea cast up his shipwracked body.

War. And to behold so sweet a sight as that,
There's none here but would run his horse to death.

Mort. Jun. But, madam, would you have us call him
home?

Queen. Ay, Mortimer, for till he be restored,
The angry King hath banished me the court; 210
And therefore, as thou lovest and tendrest[24] me,
Be thou my advocate unto these peers.

Mort. Jun. What, would ye have me plead for
Gaveston?

Mort. Sen. Plead for him he that will, I am resolved.

Lanc. And so am I, my lord: dissuade the Queen.

Queen. O Lancaster, let him dissuade the King,
For 'tis against my will he should return.

War. Then speak not for him, let the peasant go.

Queen. 'Tis for myself I speak, and not for him.

Pem. No speaking will prevail,[25] and therefore
cease. 220

Mort. Jun. Fair Queen, forbear to angle for the fish
Which, being caught, strikes him that takes it dead;
I mean that vile torpedo,[26] Gaveston,
That now, I hope, floats on the Irish seas.

Queen. Sweet Mortimer, sit down by me awhile,
And I will tell thee reasons of such weight
As thou wilt soon subscribe to his repeal.

Mort. Jun. It is impossible; but speak your mind.

Queen. Then thus, but none shall hear it but
ourselves.

[*Talks to* MORTIMER junior *apart.*]

Lanc. My lords, albeit the Queen win Mortimer,
Will you be resolute and hold with me? 231

Mort. Sen. Not I, against my nephew.

Pem. Fear not, the Queen's words cannot alter him.

War. No? Do but mark how earnestly she pleads.

Lan. And see how coldly his looks make denial.

War. She smiles; now for my life his mind is
changed.

Lanc. I'll rather lose his friendship, I, than grant.

Mort. Jun. Well, of necessity it must be so.
My Lords, that I abhor base Gaveston,
I hope your honors make no question, 240
And therefore, though I plead for his repeal,
'Tis not for his sake, but for our avail;
Nay for the realm's behoof, and for the King's.

Lanc. Fie, Mortimer, dishonor not thyself!

Can this be true, 'twas good to banish him?
And is this true, to call him home again?
Such reasons make white black, and dark night day.

Mort. Jun. My Lord of Lancaster, mark the
respect.[27]

Lanc. In no respect can contraries be true.

Queen. Yet, good my lord, hear what he can
allege. 250

War. All that he speaks is nothing; we are resolved.

Mort. Jun. Do you not wish that Gaveston were
dead?

Pem. I would he were.

Mort. Jun. Why then, my lord, give me but leave to
speak.

Mort. Sen. But, nephew, do not play the sophister.[28]

Mort. Jun. This which I urge is of[29] a burning zeal
To mend the King, and do our country good.
Know you not Gaveston hath store of gold,
Which may in Ireland purchase him such friends
As he will front the mightiest of us all? 260
And whereas he shall live and be beloved,
'Tis hard for us to work his overthrow.

War. Mark you but that, my Lord of Lancaster.

Mort. Jun. But were he here, detested as he is,
How easily might some base slave be suborned
To greet his lordship with a poniard,
And none so much as blame the murderer,
But rather praise him for that brave attempt,
And in the chronicle enroll his name
For purging of the realm of such a plague. 270

Pem. He saith true.

Lanc. Ay, but how chance[30] this was not done
before?

Mort. Jun. Because, my lords, it was not thought
upon.
Nay, more, when he shall know it lies in us
To banish him and then to call him home,
'Twill make him vail[31] the top-flag of his pride,
And fear to offend the meanest nobleman.

Mort. Sen. But how if he do not, nephew?

Mort. Jun. Then may we with some color[32] rise in
arms;
For howsoever we have borne it out, 280
'Tis treason to be up against the King;
So we shall have the people of[33] our side,
Which for his father's sake lean to the King,
But cannot brook a night-grown mushrump,[34]
Such a one as my Lord of Cornwall is,
Should bear us down of the nobility.
And when the commons and the nobles join,
'Tis not the King can buckler[35] Gaveston;
We'll pull him from the strongest hold[36] he hath.

[24] *tendrest:* carest for. [25] *prevail:* avail.
[26] *torpedo:* electric ray or cramp fish.
[27] *respect:* special consideration.
[28] *play the sophister:* make use of specious arguments.
[29] *is of:* comes of. [30] *how chance:* how chances it.
[31] *vail:* lower. [32] *color:* pretext. [33] *of:* on.
[34] *mushrump:* mushroom. [35] *buckler:* shield, protect.
[36] *hold:* place of refuge.

My lords, if to perform this I be slack, 290
Think me as base a groom [37] as Gaveston.
 Lanc. On that condition, Lancster will grant.
 War. And so will Pembroke and I.
 Mort. Sen. And I.
 Mort. Jun. In this I count me highly gratified,
And Mortimer will rest at your command.
 Queen. And when this favor Isabel forgets,
Then let her live abandoned and forlorn.
But see, in happy time, my lord the King,
Having brought the Earl of Cornwall on his way,
Is new returned; this news will glad him much; 300
Yet not so much as me; I love him more
Than he can Gaveston; would he loved me
But half so much, then were I treble-blessed!

 Enter KING EDWARD *mourning.*

 King. He's gone, and for his absence thus I mourn.
Did never sorrow go so near my heart
As doth the want of my sweet Gaveston;
And could my crown's revenue [38] bring him back,
I would freely give it to his enemies,
And think I gained, having bought so dear a friend.
 Queen. Hark, how he harps upon his minion. 310
 King. My heart is as an anvil unto sorrow,
Which beats upon it like the Cyclops' hammers, [39]
And with the noise turns up my giddy brain,
And makes me frantic for my Gaveston.
Ah, had some bloodless Fury [40] rose from hell,
And with my kingly scepter struck me dead,
When I was forced to leave my Gaveston.
 Lanc. Diablo! What passions call you these?
 Queen. My gracious lord, I come to bring you news.
 King. That you have parlèd with your Mortimer.
 Queen. That Gaveston, my lord, shall be
 repealed. 321
 King. Repealed! the news is too sweet to be true.
 Queen. But will you love me, if you find it so?
 King. If it be so, what will not Edward do?
 Queen. For Gaveston, but not for Isabel.
 King. For thee, fair queen, if thou lovest Gaveston;
I'll hang a golden tongue [41] about thy neck,
Seeing thou hast pleaded with so good success. [42]
 Queen. No other jewels hang about my neck 329
Than these, [43] my lord; nor let me have more wealth
Than I may fetch from this rich treasury:
Oh, how a kiss revives poor Isabel!

 King. Once more receive my hand, and let this be
A second marriage 'twixt thyself and me.
 Queen. And may it prove more happy than the first.
My gentle lord, bespeak these nobles fair,
That wait attendance for a gracious look,
And on their knees salute your majesty.
 King. Courageous Lancaster, embrace thy King.
And, as gross vapors perish by the sun, 340
Even so let hatred with thy sovereign's smile.
Live thou with me as my companion.
 Lanc. This salutation overjoys my heart.
 King. Warwick shall be my chiefest counselor:
These silver hairs will more adorn my court
Than gaudy silks, or rich embroidery.
Chide me, sweet Warwick, if I go astray.
 War. Slay me, my lord, when I offend your grace.
 King. In solemn triumphs, and in public show,
Pembroke shall bear the sword before the King. 350
 Pem. And with this sword Pembroke will fight for
 you.
 King. But wherefore walks young Mortimer aside?
Be thou commander of our royal fleet;
Or, if that lofty office like [44] thee not,
I make thee here Lord Marshal of the realm.
 Mort. Jun. My lord, I'll marshal so your enemies,
As England shall be quiet, and you safe.
 King. And as for you, Lord Mortimer of Chirke,
Whose great achievements in our foreign war
Deserves no common place, nor mean reward; 360
Be you the general of the levied troops,
That now are ready to assail the Scots.
 Mort. Sen. In this your grace hath highly honored
 me,
For with my nature war doth best agree.
 Queen. Now is the King of England rich and strong,
Having the love of his renownèd peers.
 King. Ay, Isabel, ne'er was my heart so light.
Clerk of the Crown, direct our warrant forth
For Gaveston to Ireland:

 [*Enter* BEAUMONT *with warrant.*]

 Beaumont, fly
As fast as Iris or Jove's Mercury. [45] 370
 Beau. It shall be done, my gracious lord.
 [*Exit.*]
 King. Lord Mortimer, we leave you to your charge.
Now let us in, and feast it royally.
Against [46] our friend the Earl of Cornwall comes,
We'll have a general tilt and tournament;
And then his marriage [47] shall be solemnized.
For wot you not that I have made him sure [48]
Unto our cousin, [49] the Earl of Gloucester's heir?
 Lanc. Such news we hear, my lord.
 King. That day, if not for him, yet for my sake, 380
Who in the triumph [50] will be challenger,
Spare for no cost; we will requite your love.
 War. In this or aught your highness shall command
 us.
 King. Thanks, gentle Warwick: come, let's in and
 revel.
 Exeunt. Manent MORTIMERS.

[37] *groom:* slave. [38] *revenue:* accent on second syllable.
[39] *cyclops' hammers:* Virgil (*Georgics,* IV. 170 *ff;* and *Aeneid,* VIII. 418 *ff*) makes the Cyclops assistants to Vulcan.
[40] *bloodless Fury:* The retributive goddesses or Furies dwelt in Tartarus, and as such are to be described as lifeless or pale as death.
[41] *golden tongue:* OED records use as jewelry in the sixteenth century. [42] *success:* result (whether good or bad).
[43] *these:* Edward's arms. [44] *like:* please.
[45] *Iris . . . Mercury:* Iris was Juno's messenger, as Mercury was Jove's.
[46] *Against:* Anticipating the time when.
[47] *his marriage:* Stow's *Annals* for 1309 record Gaveston's marriage on his return from Ireland.
[48] *made him sure:* bethrothed him. [49] *cousin:* niece.
[50] *triumph:* tournament.

Mort. Sen. Nephew, I must to Scotland; thou
 stayest here
Leave now to oppose thyself against the King.
Thou seest by nature he is mild and calm,
And, seeing his mind so dotes of Gaveston,
Let him without controlment have his will.
The mightiest kings have had their minions: 390
Great Alexander loved Hephestion;
The conquering Hercules [51] for Hylas wept;
And for Patroclus stern Achilles drooped.
And not kings only, but the wisest men:
The Roman Tully loved Octavius; [52]
Grave Socrates, wild Alcibiades.
Then let his grace, whose youth is flexible,
And promiseth as much as we can wish,
Freely enjoy that vain, lighted-headed earl;
For riper years will wean him from such toys. [53] 400
 Mort. Jun. Uncle, his wanton humor grieves not me;
But this I scorn, that one so basely born
Should by his sovereign's favor grow so pert,
And riot it with the treasure of the realm,
While soldiers mutiny for want of pay.
He wears a lord's revenue [54] on his back, [55]
And, Midas-like, [56] he jets [57] it in the court,
With base outlandish cullions [58] at his heels,
Whose proud fantastic liveries make such show,
As if that Proteus, [59] god of shapes, appeared 410
I have not seen a dapper Jack [60] so brisk;
He wears a short Italian [61] hooded cloak,
Larded [62] with pearl, and, in his Tuscan cap,
A jewel [63] of more value than the crown.
Whiles other [64] walk below, the King and he
From out a window laugh at such as we,
And flout our train, and jest at our attire.
Uncle, 'tis this that makes me impatient.
 Mort. Sen. But, nephew, now you see the King is
 changed. 419
 Mort. Jun. Then so am I, and live to do him service:
But while I have a sword, a hand, a heart,
I will not yield to any such upstart.
You throw my mind; come, uncle, let's away.

 Exeunt.

ACT TWO

SCENE ONE

Enter SPENCER [junior] *and* BALDOCK.

Bald. Spencer,
Seeing that our lord th' Earl of Gloucester's dead, [1]
Which of the nobles dost thou mean to serve?
 Spenc. Jun. Not Mortimer, nor any of his side;
Because the King and he are enemies.
Baldock, learn this of me, a factious lord
Shall hardly do himself good, much less us;
But he that hath the favor of a king,
May with one word advance us while we live:
The liberal Earl of Cornwall is the man 10
On whose good fortune Spencer's hope depends.
 Bald. What, mean you then to be his follower?

Spenc. Jun. No, his companion; for he loves me well,
And would have once preferred [2] me to the King.
 Bald. But he is banished; there's small hope of him.
 Spenc. Jun. Ay, for a while; but, Baldock, mark the
 end.
A friend of mine told me in secrecy
That he's repealed, and sent for back again;
And even now a post came from the court
With letters to our lady [3] from the King; 20
And as she reads she smiled, which makes me think
It is about her lover Gaveston.
 Bald. 'Tis like enough; for since he was exiled
She neither walks abroad, nor comes in sight.
But I had thought the match had been broke off,
And that his banishment had changed her mind.
 Spenc. Jun. Our lady's first love is not wavering;
My life for thine she will have Gaveston.
 Bald. Then hope I by her means to be preferred,
Having read unto her since she was a child. 30
 Spenc. Jun. Then, Baldock, you must cast the
 scholar off,
And learn to court it like a gentleman.
'Tis not a black coat [4] and a little band, [5]
A velvet-capped [6] cloak, faced before with serge, [7]
And smelling to a nosegay all the day,
Or holding of a napkin in your hand,
Or saying a long grace at a table's end, [8]
Or making low legs [9] to a nobleman,
Or looking downward with your eyelids close,
And saying, "Truly, an't [10] may please your honor,"
Can get you any favor with great men; 41
You must be proud, bold, pleasant, resolute,
And now and then stab, as occasion serves.

[51] *Hercules:* Early editions read "Hector."
[52] *Tully . . . Octavius:* Marlowe is apparently alone in conjecturing a special relationship between these two.
[53] *toys:* slight things, trinkets.
[54] *revenue:* accent on second syllable.
[55] *He . . . back:* Cf. Shakespeare, *2 Henry VI*, I. iii. 83; "She bears a duke's revenues on her back."
[56] *Midas-like:* Midas turned all he touched to gold.
[57] *jets:* struts. [58] *outlandish cullions:* low foreigners.
[59] *Proteus:* sea-god, capable of infinite metamorphoses.
[60] *dapper Jack:* smart or spruce fellow (pejorative).
[61] *Italian:* the mark of affectation.
[62] *Larded:* Adorned.
[63] *jewel:* to secure a feather in the cap.
[64] *other:* others (grammatically acceptable).

II.i.
[1] *Gloucester's dead:* Marlowe associates Spencer and Baldock by positing a nonexistent dependence on Gloucester, whom Gaveston actually preceded in death.
[2] *preferred:* recommended.
[3] *our lady:* Margaret, the betrothed of Gaveston and daughter of Gloucester, whom Spencer and Baldock are supposed to serve.
[4] *black coat:* traditional garb of the student.
[5] *band:* binding around the collar, which extended slightly over the coat as a trimming; to be contrasted with the more extravagant ruff or broad band of the courtier.
[6] *capped:* trimmed covered.
[7] *serge:* cheap material, and hence denoting the poor scholar.
[8] *table's end:* the bottom of the board, reserved for inferior persons. [9] *making low legs:* bowing low.
[10] *an't:* an (if)it.

Bald. Spencer, thou knowest I hate such formal
 toys,[11]
And use them but of mere hypocrisy.
Mine old lord while he lived was so precise,[12]
That he would take exceptions at [13] my buttons,
And being like pin's heads, blame me for the bigness;
Which made me curate-like in mine attire,
Though inwardly licentious enough, 50
And apt for any kind of villainy.
I am none of these common pedants, I,
That cannot speak without *propterea quod.*[14]
 Spenc. Jun. But one of those that saith,
 quandoquidem,[15]
And hath a special gift to form a verb.[16]
 Bald. Leave off this jesting, here my lady comes.

 Enter the LADY [MARGARET].

 Lady M. The grief for his exile was not so much,
As is the joy of his returning home.
This letter came from my sweet Gaveston:
What needst thou, love, thus to excuse thyself? 60
I know thou couldst not come and visit me:
[*Reads*] "I will not long be from thee, though I die."—
This argues the entire love of my lord;
[*Reads*] "When I forsake thee, death seize on my
 heart"—
But rest thee here where Gaveston shall sleep.

 [*Placing the letter in her bosom.*]

Now to the letter of my lord the King.
He wills me to repair unto the court,
And meet my Gaveston. Why do I stay,
Seeing that he talks thus of my marriage-day?
Who's there? Baldock! 70
See that my coach [17] be ready, I must hence.
 Bald. It shall be done, madam.
 Lady M. And meet me at the park-pale presently.
 Exit [BALDOCK.]
Spencer, stay you and bear me company,
For I have joyful news to tell thee of;
My lord of Cornwall is a-coming over,
And will be at the court as soon as we.

[11] *toys:* trifles.
[12] *precise:* rigid, as of a precisian or Puritan.
[13] *take exceptions at:* object to.
[14] L.: because (any Latin tag).
[15] L.: because, seeing that. Perhaps Spencer is sneering at Baldock, or perhaps the alternative expression is understood as more elegant.
[16] *form a verb:* The meaning is, perhaps, to palter, equivocate.
[17] *coach:* appropriate to Marlowe's England, rather than that of Edward II. [18] *sort:* fall.
II.ii.
 [1] *King of France:* Marlowe's invention.
 [2] *device:* painting on a shield, with appropriate motto, as at *l.* 20.
 [3] L.: Equally at length. The canker at last is equal in height to the tree.
 [4] *Pliny reports:* Earlier editors repudiate this ascription.
 [5] L.: On all sides is death.
 [6] *jesses:* leather or silken straps, attached to the legs of a trained hawk. Early editions read "gresses."
 [7] *Britainy:* Britain.

Spenc. Jun. I knew the King would have him home
 again.
 Lady M. If all things sort [18] out as I hope they will,
Thy service, Spencer, shall be thought upon. 80
 Spenc. Jun. I humbly thank your ladyship.
 Lady M. Come, lead the way; I long till I am there.
 [*Exeunt.*]

[II.ii]

 Enter [KING] EDWARD, *the* QUEEN, LANCASTER,
 MORTIMER [junior], WARWICK, PEMBROKE,
 KENT, Attendants.

 King. The wind is good, I wonder why he stays;
I fear me he is wrecked upon the sea.
 Queen. Look, Lancaster, how passionate he is,
And still his mind runs on his minion.
 Lanc. My lord,—
 King. How now! what news? Is Gaveston arrived?
 Mort. Jun. Nothing but Gaveston! what means your
 grace?
You have matters of more weight to think upon;
The King of France [1] sets foot in Normandy.
 King. A trifle! we'll expel him when we please. 10
But tell me, Mortimer, what's thy device [2]
Against the stately triumph we decreed?
 Mort. Jun. A homely one, my lord, not worth the
 telling.
 King. Prithee let me know it.
 Mort. Jun. But seeing you are so desirous, thus it is:
A lofty cedar-tree, fair flourishing,
On whose top-branches kingly eagles perch,
And by the bark a canker creeps me up,
And gets unto the highest bough of all:
The motto, *Aeque tandem.*[3] 20
 King. And what is yours, my Lord of Lancaster?
 Lanc. My lord, mine's more obscure than
 Mortimer's.
Pliny reports [4] there is a flying fish
Which all the other fishes deadly hate,
And therefore, being pursued, it takes the air:
No sooner is it up, but there's a fowl
That seizeth it; this fish, my lord, I bear,
The motto this: *Undique mors est.*[5]
 King. Proud Mortimer! ungentle Lancaster!
Is this the love you bear your sovereign? 30
Is this the fruit your reconcilement bears?
Can you in words make show of amity,
And in your shields display your rancorous minds?
What call you this but private libeling
Against the Earl of Cornwall and my brother?
 Queen. Sweet husband, be content, they all love you.
 King. They love me not that hate my Gaveston,
I am that cedar, shake me not too much;
And you the eagles; soar ye ne'er so high,
I have the jesses [6] that will pull you down; 40
And *Aeque tandem* shall that canker cry
Unto the proudest peer of Britainy.[7]
Though thou comparest him to a flying fish,
And threatenest death whether he rise or fall,

'Tis not the hugest monster of the sea,
Nor foulest harpy [8] that shall swallow him.
　Mort. Jun. If in his absence thus he favors him,
What will he do whenas [9] he shall be present?
　Lanc. That shall we see; look where his lordship
　　comes.

Enter GAVESTON.

　King. My Gaveston! 　　　　　　　　　50
Welcome to Tynemouth, welcome to thy friend!
Thy absence made me droop and pine away;
For, as the lovers of fair Danaë, [10]
When she was locked up in a brazen tower,
Desired her more, and waxed outrageous,
So did it sure with me: and now thy sight
Is sweeter far than was thy parting hence
Bitter and irksome to my sobbing heart.
　Gav. Sweet lord and King, your speech preventeth [11]
　　mine,
Yet have I words left to express my joy: 　　60
The shepherd nipped with biting winter's rage
Frolics not more to see the painted [12] spring,
Than I do to behold your majesty.
　King. Will none of you salute my Gaveston?
　Lanc. Salute him? Yes; welcome Lord Chamberlain.
　Mort. Jun. Welcome is the good Earl of Cornwall.
　War. Welcome, Lord Governor of the Isle of Man.
　Pem. Welcome, Master Secretary.
　Kent. Brother, do you hear them?
　King. Still will these earls and barons use me thus?
　Gav. My lord, I cannot brook these injuries. 　71
　Queen. Ay me, poor soul, when these begin to jar.
　King. Return it to their throats, I'll be thy warrant.
　Gav. Base, leaden earls, that glory in your birth,
Go sit at home and eat your tenant's beef;
And come not here to scoff at Gaveston,
Whose mounting thoughts did never creep so low
As to bestow a look on such as you.
　Lanc. Yet I disdain not to do this for you.

[Draws his sword.]

　King. Treason, treason! where's the traitor? 　80
　Pem. Here! here! King: [13] convey hence Gaveston.
They'll murder him.
　Gav. The life of thee shall salve this foul disgrace.
　Mort. Jun. Villain, thy life, unless I miss mine aim.

[Wounds GAVESTON.]

　Queen. Ah, furious Mortimer, what hast thou done?
　Mort. Jun. No more than I would answer, were he
　　slain.

[Exit GAVESTON with Attendants.]

　King. Yes, more than thou canst answer, though he
　　live;
Dear shall you both aby [14] this riotous deed.
Out of my presence, come not near the court.
　Mort. Jun. I'll not be barred the court for
　　Gaveston. 　　　　　　　　　90
　Lanc. We'll hale him by the ears unto the block.
　King. Look to your own heads; his is sure enough.
　War. Look to your own crown, if you back him thus.

　Kent. Warwick, these words do ill beseem thy years.
　King. Nay, all of them conspire to cross me thus;
But if I live, I'll tread upon their heads
That think with high looks thus to tread me down.
Come, Edmund, let's away and levy men,
'Tis war that must abate these barons' pride. 　99

Exit the KING, [QUEEN ISABELLA, and KENT.]

　War. Let's to our castles, for the King is moved.
　Mort. Jun. Moved may he be, and perish in his
　　wrath!
　Lanc. Cousin, it [15] is no dealing with him now,
He means to make us stoop by force of arms:
And therefore let us jointly here protest [16]
To prosecute [17] that Gaveston to the death.
　Mort. Jun. By heaven, the abject villain shall not
　　live.
　War. I'll have his blood, or die in seeking it.
　Pem. The like oath Pembroke takes.
　Lanc. And so doth Lancaster.
Now send our heralds to defy the King; 　　110
And make the people swear to put him down.

Enter a Post.

　Mort. Jun. Letters: from whence?
　Mess. 　　　　　　　　　From Scotland,
　　my lord.
　Lanc. Why, how now, cousin, how fares all our
　　friends?
　Mort. Jun. My uncle's taken prisoner [18] by the Scots.
　Lanc. We'll have him ransomed, man; be of good
　　cheer.
　Mort. Jun. They rate his ransom at five thousand
　　pound.
Who should defray the money but the King,
Seeing he is taken prisoner in his wars?
I'll to the King.
　Lanc. Do, cousin, and I'll bear thee company. 　120
　War. Meantime, my Lord of Pembroke and
　　myself
Will to Newcastle here, and gather head. [19]
　Mort. Jun. About it then, and we will follow you.
　Lanc. Be resolute and full of secrecy.
　War. I warrant you.

[Exeunt all but MORTIMER and LANCASTER.]

　Mort. Jun. Cousin, and if he will not ransom him,
I'll thunder such a peal into his ears,
As never subject did unto his King.
　Lanc. Content, I'll bear my part. Holla! who's
　　there?

[8] *harpy:* winged bird with woman's head.
[9] *whenas:* when.
[10] *Danaë:* mother of Perseus by Zeus, who, in the form of a golden shower, visited her in the brazen tower where she had been imprisoned by her father, Acrisius.
[11] *preventeth:* anticipates. 　　[12] *painted:* with flowers.
[13] *King:* Most editors read as a speech heading and give the rest of the line to Edward.
[14] *aby:* pay the penalty for. 　　　　[15] *it:* there.
[16] *protest:* vow. 　　　　[17] *prosecute:* follow.
[18] *My uncle's taken prisoner:* Marlowe's invention.
[19] *gather head:* muster forces.

[*Enter* Guard].

Mort. Jun. Ay, marry, such a guard as this doth well.
Lanc. Lead on the way.
Guard. Whither will your lordships?
Mort. Jun. Whither else but to the King? 132
Guard. His highness is disposed to be alone.
Lanc. Why, so he may, but we will speak to him.
Guard. You may not in, my lord.
Mort. Jun. May we not?

[*Enter the* KING *and* KENT.]

King. How now!—What noise is this?
Who have we there, is't you?

 [*Going.*]

Mort. Jun. Nay, stay, my lord, I come to bring you
 news;
Mine uncle's taken prisoner by the Scots.
King. Then ransom him. 140
Lanc. 'Twas in your wars; you should ransom him.
Mort. Jun. And you shall ransom him, or else—
Kent. What, Mortimer! You will not threaten him?
King. Quiet yourself, you shall have the broad seal,[20]
To gather for him throughout the realm.
Lanc. Your minion Gaveston hath taught you this.
Mort. Jun. My lord, the family of the Mortimers
Are not so poor, but, would they sell their land,
Would levy men enough to anger you.
We never beg, but use such prayers as these. 150
King. Shall I still be haunted[21] thus?
Mort. Jun. Nay, now you are here alone, I'll speak
 my mind.
Lanc. And so will I, and then, my lord, farewell.

[20] *broad seal:* warrant under the Great Seal for collecting money for a particular purpose.
[21] *haunted:* followed.
[22] *Oneyl:* Not mentioned in Marlowe's chronicle sources. Historically, the O'Neills were famous for their protracted struggle against English rule. Marlowe is using the name as representative of any Irish rebel chief.
[23] *English pale:* Small pacified area around Dublin.
[24] *The . . . pale:* The whole passage is closely paralleled in *First Part of the Contention,* ix. 133 (Q1594). Cf. Shakespeare, *2 Henry VI,* III. i. 310–11: "The uncivil Kerns of Ireland are in arms / And temper clay with blood of Englishmen."
[25] *made road:* raided.
[26] *haughty Dane:* The assertion that the Danes controlled the English Channel ("narrow seas") in Edward's time is unhistorical. The line is closely paralleled in *2 Henry VI,* I. i. 239. [27] *sort:* crew.
[28] *Libels:* Slanderous pamphlets.
[29] *labels:* slips of parchment for affixing a seal to a document. [30] *fleering:* gibing.
[31] *jig:* mocking song, taken by Marlowe from Fabyan's *Chronicle.*
[32] *lemans:* lovers. [33] *weeneth:* thinketh.
[34] *rombelow:* rumblelow; meaningless combination of syllables serving as a refrain. So *OED.* But see the early sixteenth-century play, *Hickscorner,* in which the hero announces, "I have been in Gene and in Cowe, /Also in the land of Rumbelow, Three mile out of Hell."
[35] *Wigmore shall fly:* Wigmore Castle shall be sold.
[36] *purchase:* win. [37] *cockerels:* young cocks.

Mort. Jun. The idle triumphs, masks, lascivious
 shows,
And prodigal gifts bestowed on Gaveston,
Have drawn thy treasure dry, and made thee weak,
The murmuring commons overstretchèd hath.
Lanc. Look for rebellion, look to be deposed;
Thy garrisons are beaten out of France,
And, lame and poor, lie groaning at the gates. 160
The wild Oneyl,[22] with swarms of Irish kerns,
Lives uncontrolled within the English pale.[23,24]
Unto the walls of York the Scots made road,[25]
And unresisted drove away rich spoils.
Mort. Jun. The haughty Dane[26] commands the
 narrow seas,
While in the harbor ride thy ships unrigged.
Lanc. What foreign prince sends thee ambassadors?
Mort. Jun. Who loves thee, but a sort[27] of flatterers?
Lanc. Thy gentle Queen, sole sister to Valois,
Complains that thou hast left her all forlorn. 170
Mort. Jun. Thy court is naked, being bereft of those
That makes a king seem glorious to the world;
I mean the peers, whom thou shouldst dearly love:
Libels[28] are cast again thee in the street:
Ballads and rhymes made of thy overthrow.
Lanc. The Northern borderers seeing their houses
 burnt,
Their wives and children slain, run up and down,
Cursing the name of thee and Gaveston.
Mort. Jun. When wert thou in the field with banner
 spread?
But once, and then thy soldiers marched like players,
With garish robes, not armor, and thyself, 181
Bedaubed with gold, rode laughing at the rest,
Nodding and shaking of thy spangled crest,
Where women's favors hung like labels[29] down.
Lanc. And thereof came it that the fleering[30] Scots
To England's high disgrace, have made this jig;[31]
"Maids of England, sore may you mourn,
For your lemans[32] you have lost at Bannocksbourn,
With a heave and a ho!
What weeneth[33] the King of England, 190
So soon to have won Scotland?—
With a rombelow."[34]
Mort. Jun. Wigmore shall fly[35] to set my uncle free.
Lanc. And when 'tis gone, our swords shall
 purchase[36] more.
If ye be moved, revenge it as you can;
Look next to see us with our ensigns spread.
 Exeunt Nobles.
King. My swelling heart for very anger breaks.
How oft have I been baited by these peers?
And dare not be revenged, for their power is great.
Yet, shall the crowing of these cockerels[37] 200
Affright a lion? Edward, unfold thy paws,
And let their lives' blood slake thy fury's hunger.
If I be cruel and grow tyrannous,
Now let them thank themselves, and rue too late.
Kent. My lord, I see your love to Gaveston
Will be the ruin of the realm and you,
For now the wrathful nobles threaten wars,
And therefore, brother, banish him forever.

King. Art thou an enemy to my Gaveston?
Kent. Ay, and it grieves me that I favored him. 210
King. Traitor, begone![38] whine thou with
 Mortimer.
Kent. So will I, rather than with Gaveston.
King. Out of my sight, and trouble me no more.
Kent. No marvel though thou scorn thy noble peers,
When I thy brother am rejected thus.
King. Away!

 Exit KENT.

Poor Gaveston, that hast no friend but me,
Do what they can, we'll live in Tynemouth here,
And, so I walk with him about the walls,
What care I though the earls begirt us round? 220
Here comes she that's cause of all these jars.

 Enter the QUEEN [*with* LADY MARGARET, *the*
 KING'S NIECE, *two* Ladies, GAVESTON],
 BALDOCK *and* SPENCER [junior].

Queen. My lord, 'tis thought the earls are up in
 arms.
King. Ay, and 'tis likewise thought you favor him.[39]
Queen. Thus do you still suspect me without cause?
Lady M. Sweet uncle, speak more kindly to the
 Queen.
Gav. My lord, dissemble with her, speak her fair.
King. Pardon me, sweet, I forgot myself.
Queen. Your pardon is quickly got of Isabel.
King. The younger Mortimer is grown so brave,[40]
That to my face he threatens civil wars. 230
Gav. Why do you not commit him to the Tower?
King. I dare not, for the people love him well.
Gav. Why, then we'll have him privily made away.
King. Would Lancaster and he had both caroused
A bowl of poison to each other's health.
But let them go, and tell me what are these.
Lady M. Two of my father's servants while he lived;
May't please your grace to entertain them now?
King. Tell me, where wast thou born? What is thine
 arms?[41]
Bald. My name is Baldock, and my gentry 240
I fetched from Oxford, not from heraldry.
King. The fitter art thou, Baldock, for my turn.
Wait on me, and I'll see thou shalt not want.
Bald. I humbly thank your majesty.
King. Knowest thou him, Gaveston?
Gav. Ay, my lord;
His name is Spencer, he is well allied;
For my sake, let him wait upon your grace;
Scarce shall you find a man of more desert.
King. Then, Spencer, wait upon me; for his sake
I'll grace thee with a higher style ere long. 250
Spenc. Jun. No greater titles happen unto me,
Than to be favored of your majesty.
King. Cousin,[42] this day shall be your marriage-
 feast.
And, Gaveston, think that I love thee well,
To wed thee to our niece, the only heir
Unto the Earl of Gloucester late deceased.[43]
Gav. I know, my lord, many will stomach[44] me,
But I respect neither their love nor hate.

King. The headstrong barons shall not limit me;
He that I list to favor shall be great. 260
Come, let's away; and when the marriage ends,
Have at the rebels, and their complices.

 Exeunt omnes.

[II.iii]

 Enter LANCASTER, MORTIMER [junior],
 WARWICK, PEMBROKE, KENT.

Kent. My lords, of[1] love to this our native land
I come to join with you and leave the King;
And in your quarrel and the realm's behoof[2]
Will be the first that shall adventure[3] life.
Lanc. I fear me you are sent of policy,[4]
To undermine us with a show of love.
War. He is your brother, therefore have we cause
To cast[5] the worst, and doubt of your revolt.
Kent. Mine honor shall be hostage of my truth:
If that will not suffice, farewell, my lords. 10
Mort. Jun. Stay, Edmund; never was Plantagenet
False of his word, and therefore trust we thee.
Pemb. But what's the reason you should leave him
 now?
Kent. I have informed the Earl of Lancaster.
Lanc. And it sufficeth. Now, my lords, know this,
That Gaveston is secretly arrived,[6]
And here in Tynemouth frolics with the King.
Let us with these our followers scale the walls,
And suddenly surprise them unawares. 19
Mort. Jun. I'll give the onset.[7]
War. And I'll follow thee.
Mort. Jun. This tottered[8] ensign of my ancestors,
Which swept the desert shore of that dead sea
Whereof we got the name of Mortimer,[9]
Will I advance upon this castle's walls.
Drums, strike alarum, raise them from their sport,
And ring aloud the knell of Gaveston.
Lanc. None be so hardy as to touch the King;
But neither spare you Gaveston nor his friends.

 Exeunt.

[II.iv]

 Enter the KING *and* SPENCER [junior].

King. Oh, tell me, Spencer, where is Gaveston?
Spenc. Jun. I fear me he is slain, my gracious lord.
King. No, here he comes; now let them spoil and
 kill.

[38] *Traitor, begone!:* Kent's initial allegiance to Edward and his desertion at this point are Marlowe's invention.
[39] *him:* Mortimer. [40] *brave:* presumptuous.
[41] *arms:* coat of arms. [42] *Cousin:* Niece.
[43] *late deceased:* Marlowe compressing events; Gloucester had died in 1295. [44] *stomach:* resent.
II.iii.
[1] *of:* from. [2] *behoof:* benefit. [3] *adventure:* hazard.
[4] *of policy:* as a stratagem. [5] *cast:* anticipate.
[6] *Gaveston . . . arrived:* gratuitous information.
[7] *onset:* beginning. [8] *tottered:* tattered.
[9] *name of Mortimer:* popular etymology; the Mortimers were from Mortemer in Normandy.

[*Enter the* QUEEN, *the* LADY MARGARET,
GAVESTON, *and* Nobles.]

Fly, fly, my lords, the earls have got the hold;[1]
Take shipping and away to Scarborough;[2]
Spencer and I will post away by land.
 Gav. Oh, stay, my lord, they will not injure you.
 King. I will not trust them, Gaveston; away.
 Gav. Farewell, my lord.
 King. Lady, farewell. 10
 Lady M. Farewell, sweet uncle, till we meet again.
 King. Farewell, sweet Gaveston, and farewell, niece.
 Queen. No farewell to poor Isabel thy Queen?
 King. Yes, yes, for Mortimer, your lover's sake.
 Queen. Heavens can witness I love none but you:
 Exeunt omnes, manet ISABELLA.
From my embracements thus he breaks away.
Oh, that mine arms could close this isle about,
That I might pull him to me where I would;
Or that these tears, that drizzle from mine eyes,
Had power to mollify his stony heart, 20
That when I had him we might never part.

 Enter the Barons.

 Alarums [*within*].

 Lanc. I wonder how he scaped?
 Mort. Jun. Who's this? The Queen!
 Queen. Ay, Mortimer, the miserable Queen,
Whose pining heart her inward sighs have blasted,
And body with continual mourning wasted;
These hands are tired with haling of my lord
From Gaveston, from wicked Gaveston,
And all in vain; for, when I speak him fair,
He turns away, and smiles upon his minion.
 Mort. Jun. Cease to lament, and tell us where's the
 King? 30
 Queen. What would you with the King? Is't him
 you seek?
 Lanc. No, madam, but that cursèd Gaveston.
Far be it from the thought of Lancaster
To offer violence to his sovereign.
We would but rid the realm of Gaveston:
Tell us where he remains, and he shall die.
 Queen. He's gone by water unto Scarborough;
Pursue him quickly, and he cannot scape;
The king hath left him, and his train is small.
 War. Forslow[3] no time; sweet Lancaster, let's
 march. 40
 Mort. Jun. How comes it that the King and he is
 parted?
 Queen. That this your army, going several ways,
Might be of lesser force: and with the power

That he intendeth presently[4] to raise,
Be easily suppressed; and therefore be gone.
 Mort. Jun. Here in the river rides a Flemish hoy;[5]
Let's all aboard, and follow him amain.[6]
 Lanc. The wind that bears him hence will fill our
 sails:
Come, come aboard, 'tis but an hour's sailing.
 Mort. Jun. Madam, stay you within this castle
 here. 50
 Queen. No, Mortimer, I'll to my lord the King.
 Mort. Jun. Nay, rather sail with us to Scarborough.
 Queen. You know the King is so suspicious,
As if he hear I have but talked with you,
Mine honor will be called in question;
And therefore, gentle Mortimer, be gone.
 Mort. Jun. Madam, I cannot stay to answer you,
But think of Mortimer as he deserves.
 [*Exeunt all but the* QUEEN.]
 Queen. So well hast thou deserved, sweet Mortimer,
As Isabel could live with thee for ever. 60
In vain I look for love at Edward's hand,
Whose eyes are fixed on none but Gaveston,
Yet once more I'll importune him with prayers:
If he be strange and not regard my words,
My son and I will over into France,
And to the King my brother there complain,
How Gaveston hath robbed me of his love:
But yet I hope my sorrows will have end,
And Gaveston this blessèd day be slain.
 [*Exit.*]

[II.v]

 Enter GAVESTON, *pursued.*

 Gav. Yet, lusty lords, I have escaped your hands,
Your threats, your larums, and your hot pursuits;
And though divorcèd from King Edward's eyes,
Yet liveth Pierce of Gaveston unsurprised,
Breathing, in hope (*malgrado*[1] all your beards,
That muster rebels thus against your King),
To see his royal sovereign once again.

 Enter the Nobles [*with* JAMES, *and other*
 Attendants of PEMBROKE].

 War. Upon him, soldiers, take away his weapons.
 Mort. Jun. Thou proud disturber of thy country's
 peace,
Corrupter of thy King, cause of these broils, 10
Base flatterer, yield! and were it not for shame,
Shame and dishonor to a soldier's name,
Upon my weapon's point here shouldst thou fall,
And welter in thy gore.
 Lanc. Monster of men!
That, like the Greekish strumpet,[2] trained[3] to arms
And bloody wars so many valiant knights;
Look for no other fortune, wretch, than death.
King Edward is not here to buckler[4] thee.
 War. Lancaster, why talkst thou to the slave?
Go, soldiers, take him hence, for, by my sword, 20
His head shall off: Gaveston, short warning
Shall serve thy turn: it is our country's cause

II.iv.
 [1] *hold:* stronghold.
 [2] *Scarborough:* Following Holinshed.
 [3] *Forslow:* Waste. [4] *presently:* immediately.
 [5] *hoy:* small sloop-rigged vessel.
 [6] *amain:* with full speed.
II.v.
 [1] *It.:* in spite of. [2] *Greekish strumpet:* Helen of Troy.
 [3] *trained:* enticed. [4] *buckler:* defend.

That here severely we will execute
Upon thy person. Hang him at a bough.
 Gav. My lord!—
 War. Soldiers, have him away;
But for thou wert the favorite of a king,
Thou shalt have so much honor at our hands.[5]
 Gav. I thank you all, my lords: then I perceive,
That heading is one, and hanging is the other, 30
And death is all.

<p style="text-align:center">*Enter* EARL OF ARUNDEL.</p>

 Lanc. How now, my Lord of Arundel?
 Arun. My lords, King Edward greets you all by me.
 War. Arundel, say your message.
 Arun. His majesty,
Hearing that you had taken Gaveston,
Entreateth you by me, yet but he may
See him before he dies; for why,[6] he says,
And send you word, he knows that die he shall;
And if you gratify his grace so far,
He will be mindful of the courtesy. 40
 War. How now?
 Gav. Renowmèd[7] Edward, how thy name
Revives poor Gaveston.
 War. No, it needeth not;
Arundel, we will gratify the King
In other matters; he must pardon us in this.
Soldiers, away with him.
 Gav. Why, my Lord of Warwick,
Will not these delays beget my hopes?[8]
I know it, lords, it is this life you aim at;
Yet grant King Edward this.
 Mort. Jun. Shalt thou appoint
What we shall grant? Soldiers, away with him: 50
Thus we'll gratify the King,
We'll send his head by thee; let him bestow
His tears on that, for that is all he gets
Of Gaveston, or else his senseless trunk.
 Lanc. Not so, my lord, lest he bestow more cost
In burying him than he hath ever earned.
 Arun. My lords, it is his majesty's request,
And in the honor of a king he swears,
He will but talk with him, and send him back.
 War. When, can you tell? Arundel, no; we wot,[9] 60
He that the care of realm remits,[10]
And drives his nobles to these exigents
For Gaveston, will, if he seize[11] him once,
Violate any promise to possess him.
 Arun. Then if you will not trust his grace in keep,[12]
My lords, I will be pledge for his return.
 Mort. Jun. It is honorable in thee to offer this;
But for[13] we know thou art a noble gentleman,
We will not wrong thee so, to make away
A true man for a thief. 70
 Gav. How mean'st thou, Mortimer? That is over-base.
 Mort. Jun. Away, base groom, robber of king's renowm.[14]
Question with thy companions and thy mates.
 Pem. My Lord Mortimer, and you, my lords, each one,

To gratify the King's request therein,
Touching the sending of this Gaveston,
Because his majesty so earnestly
Desires to see the man before his death,
I will upon mine honor undertake
To carry him, and bring him back again; 80
Provided this, that you my Lord of Arundel
Will join with me.
 War. Pembroke, what wilt thou do?
Cause yet more bloodshed: is it not enough
That we have taken him, but must we now
Leave him on "had I wist,"[15] and let him go?
 Pem. My lords, I will not over-woo your honors,
But if you dare trust Pembroke with the prisoner,
Upon mine oath, I will return him back.
 Arun. My Lord of Lancaster, what say you in this?
 Lanc. Why, I say, let him go on Pembroke's word.
 Pem. And you, Lord Mortimer? 91
 Mort. Jun. How say you, my Lord of Warwick?
 War. Nay, do your pleasures; I know how 'twill prove.
 Pem. Then give him me.
 Gav. Sweet sovereign, yet I come
To see thee ere I die.
 War. [*Aside*] Yet not perhaps,
If Warwick's wit and policy prevail.
 Mort. Jun. My Lord of Pembroke, we deliver him you;
Return him on your honor. Sound, away!

<p style="text-align:right">*Exeunt.*[16] *Manent* PEMBROKE, GAVESTON,
[ARUNDEL, JAMES], *and* Pembroke's Men,
four soldiers.</p>

 Pem. My lord, you shall go with me.
My house is not far hence, out of the way 100
A little, but our men shall go along.
We that have pretty wenches to our wives,
Sir, must not come so near and balk[17] their lips.
 Arun. 'Tis very kindly spoke, my Lord of Pembroke;
Your honor hath an adamant[18] of power
To draw a prince.
 Pem. So, my lord. Come hither, James:

[5] *But . . . hands:* Gaveston, because of his eminence, will be executed by the ax, like a gentleman, rather than by hanging, like a common felon. [6] *for why:* because.
[7] *Renowmèd:* Renowned (common spelling in Elizabethan English.)
[8] *Will . . . hopes:* Question uttered sarcastically; Gaveston understands that he has no hope. [9] *wot:* know.
[10] *remits:* abandons.
[11] *seize:* have possession of (most editors emend to "sees").
[12] *in keep:* in custody. [13] *for:* because.
[14] *renowm:* renown.
[15] *"had I wist":* had I but known (proverbial expression for repentance that comes too late).
[16] *Exeunt:* Early editions introduce in this stage direction Lord Matrevis, who, subsequently, is confused with Arundel (III. ii, IV. iii). W. W. Greg, in his edition of *Edward II*, suggests that the same actor played the parts of Matrevis and Arundel, making for the confusion here and later, and that the octavo edition was printed from a playhouse manuscript that had undergone revision for the stage.
[17] *balk:* refuse, disappoint.
[18] *adamant:* magnet, lodestone.

I do commit this Gaveston to thee,
Be thou this night his keeper; in the morning
We will discharge thee of thy charge: be gone.
 Gav. Unhappy Gaveston, whither goest thou
 now? 110
 [*Exit* PEMBROKE *with his* Men.]
 Horse-Boy. My lord, we'll quickly be at Cobham.[19]
 Exeunt.

ACT THREE

SCENE ONE

Enter GAVESTON *mourning,* [JAMES], *and the*
Earl of Pembroke's Men.

 Gav. O treacherous Warwick, thus to wrong thy
 friend.
 James. I see it is your life these arms pursue.
 Gav. Weaponless must I fall, and die in bands?[1]
Oh, must this day be period of my life?
Center[2] of all my bliss! An[3] ye be men,
Speed to the King.

Enter WARWICK *and his company.*

 War. My Lord of Pembroke's men,
Strive you no longer; I will have that Gaveston.
 James. Your lordship doth dishonor to yourself,
And wrong our lord, your honorable friend.
 War. No, James, it is my country's cause I follow.
Go, take the villain; soldiers, come away. 11
We'll make quick work. Commend me to your master,
My friend, and tell him that I watched it well.
Come, let thy shadow[4] parley with King Edward.
 Gav. Treacherous earl, shall I not see the King?
 War. The King of heaven perhaps, no other king.
Away!

 [*Exeunt* WARWICK *and his* Men, *with*
 GAVESTON.]
 James. Come, fellows, it booted not for us to strive,
We will in haste go certify[5] our lord.
 Exeunt.

[19] *Cobham:* Kentish village, remote in fact from the place where these events are supposedly occurring.

III.i.
 [1] *bands:* bonds.
 [2] *Center:* Generally explained as in apposition to "day" (above), but the general sense may be that life is blissful.
 [3] *An:* If. [4] *shadow:* ghost. [5] *certify:* inform.

III.ii.
 [1] *Longshanks':* Edward I, so called from the length of his legs. [2] *braves:* taunts, insults.
 [3] *magnanimity:* haughty courage.
 [4] *counterbuft:* beaten so as to recoil.
 [5] *preachments:* sermons. [6] *steel it:* strike with steel.
 [7] *poll their tops:* cut off their heads (as trees are polled).
 [8] *haught:* lofty.
 [9] *affection:* will; whatever they affect or desire.
 [10] *awed:* overawed.
 [11] *Brown bills:* Halberds bronzed to prevent rust.
 [12] *targeteers:* foot soldiers armed with a target.
 [13] *an:* if.

[III.ii]

Enter KING EDWARD *and* SPENCER [junior,
 BALDOCK, *and* Nobles *of the King's side, and*
 Soldiers] *with drums and fifes.*

 King. I long to hear an answer from the barons
Touching my friend, my dearest Gaveston.
Ah, Spencer, not the riches of my realm
Can ransom him; ah, he is marked to die.
I know the malice of the younger Mortimer,
Warwick I know is rough, and Lancaster
Inexorable, and I shall never see
My lovely Pierce, my Gaveston again!
The barons overbear me with their pride.
 Spenc. Jun. Were I King Edward, England's
 sovereign, 10
Son to the lovely Eleanor of Spain,
Great Edward Longshanks'[1] issue, would I bear
These braves,[2] this rage, and suffer uncontrolled
These barons thus to beard me in my land,
In mine own realm? My lord, pardon my speech:
Did you retain your father's magnanimity,[3]
Did you regard the honor of your name,
You would not suffer thus your majesty
Be counterbuft[4] of your nobility.
Strike off their heads, and let them preach on poles. 20
No doubt, such lessons they will teach the rest,
As by their preachments[5] they will profit much,
And learn obedience to their lawful King.
 King. Yea, gentle Spencer, we have been too mild,
Too kind to them; but now have drawn our sword,
And if they send me not my Gaveston,
We'll steel it[6] on their crest, and poll their tops.[7]
 Bald. This haught[8] resolve becomes your majesty,
Not to be tied to their affection,[9]
As though your highness were a schoolboy still, 30
And must be awed[10] and governed like a child.

 Enter HUGH SPENCER, *an old man, father to the*
 young SPENCER, *with his truncheon and* Soldiers.

 Spenc. Sen. Long live my sovereign, the noble
 Edward,
In peace triumphant, fortunate in wars!
 King. Welcome, old man, comest thou in Edward's
 aid?
Then tell thy Prince of whence, and what thou art.
 Spenc. Sen. Lo, with a band of bowmen and of pikes,
Brown bills[11] and targeteers,[12] four hundred strong,
Sworn to defend King Edward's royal right,
I come in person to your majesty,
Spencer, the father of Hugh Spencer there, 40
Bound to your highness everlastingly,
For favors done, in him, unto us all.
 King. Thy father, Spencer?
 Spenc. Jun. True, an[13] it like your
 grace,
That pours, in lieu of all your goodness shown,
His life, my lord, before your princely feet.
 King. Welcome ten thousand times, old man, again.
Spencer, this love, this kindness to thy King,
Argues thy noble mind and disposition.

Spencer, I here create thee Earl of Wiltshire,[14]
And daily will enrich thee with our favor, 50
That, as the sunshine, shall reflect o'er thee.
Beside, the more to manifest our love,
Because we hear Lord Bruce doth sell[15] his land,
And that the Mortimers are in hand[16] withal,
Thou shalt have crowns of us t' outbid the barons:
And, Spencer, spare them not, but lay it on.
Soldiers, a largess, and thrice welcome all.
 Spenc. Jun. My lord, here comes the Queen.

Enter the QUEEN, *and her son* [PRINCE EDWARD],
 and LEVUNE, *a Frenchman.*

King. Madam,
 what news?
Queen. News of dishonor, lord, and discontent.
Our friend Levune, faithful and full of trust, 60
Informeth us, by letters and by words,
That Lord Valois our brother, King of France,
Because your highness hath been slack in homage,
Hath seizèd Normandy[17] into his hands.
These be the letters, this the messenger.
 King. Welcome, Levune. Tush, Sib,[18] if this be all,
Valois and I will soon be friends again.
But to my Gaveston; shall I never see,
Never behold thee now? Madam, in this matter,
We will employ you[19] and your little son; 70
You shall go parley with the King of France.
Boy, see you bear you bravely to the King,
And do your message with a majesty.
 Prince. Commit not to my youth things of more
 weight
Than fits a prince so young as I to bear,
And fear not, lord and father, heaven's great beams
On Atlas' shoulder shall not lie more safe,
Than shall your charge committed to my trust.
 Queen. Ah, boy! this towardness makes thy mother
 fear
Thou art not marked to many days on earth. 80
 King. Madam, we will that you with speed be
 shipped,
And this our son; Levune shall follow you
With all the haste we can dispatch him hence.
Choose of our lords to bear you company;
And go in peace, leave us in wars at home.
 Queen. Unnatural wars, where subjects brave their
 King;
God end them once![20] my lord, I take my leave,
To make my preparation for France.
 [*Exit with* PRINCE EDWARD.]

 Enter [ARUNDEL].

 King. What, Lord Arundel, dost thou come alone?
 Arun. Yea, my good lord, for Gaveston is dead. 90
 King. Ah, traitors! have they put my friend to death?
Tell me, Arundel, died he ere thou camest,
Or didst thou see my friend to take his death?
 Arun. Neither, my lord; for as he was surprised,
Begirt with weapons and with enemies round,
I did your highness' message to them all;
Demanding him of them, entreating rather,

And said, upon the honor of my name,
That I would undertake to carry him
Unto your highness, and to bring him back. 100
 King. And tell me, would the rebels deny me that?
 Spenc. Jun. Proud recreants.
 King. Yea, Spencer, traitors all.
 Arun. I found them at the first inexorable;
The Earl of Warwick would not bide the hearing,
Mortimer hardly; Pembroke and Lancaster
Spake least: and when they flatly had denied,
Refusing to receive me[21] pledge for him,
The Earl of Pembroke mildly thus bespake;
"My lords, because our sovereign sends for him,
And promiseth he shall be safe returned, 110
I will this undertake, to have him hence,
And see him re-delivered to your hands."
 King. Well, and how fortunes that he came not?
 Spenc. Jun. Some treason, or some villainy, was
 cause.
 Arun. The Earl of Warwick seized him on his way;
For being delivered unto Pembroke's men,
Their lord rode home thinking his prisoner safe;
But ere he came, Warwick in ambush lay,
And bare him to his death; and in a trench
Strake off his head, and marched unto the camp. 120
 Spenc. Jun. A bloody part, flatly against law of arms.
 King. Oh, shall I speak, or shall I sigh and die!
 Spenc. Jun. My lord, refer your vengeance to the
 sword
Upon these barons; hearten up your men;
Let them not unrevenged murder your friends!
Advance your standard, Edward, in the field,
And march to fire them[22] from their starting holes.

 [*The* KING *kneels.*]

 King. By earth, the common mother of us all,
By heaven, and all the moving orbs thereof,
By this right hand, and by my father's sword, 130
And all the honors longing[23] to my crown,
I will have heads, and lives for him, as many
As I have manors, castles, towns, and towers.

 [*Rises.*]

Treacherous Warwick! traitorous Mortimer!
If I be England's King, in lakes of gore
Your headless trunks, your bodies will I trail,
That you may drink your fill, and quaff in blood,
And stain my royal standard with the same,
That so my bloody colors may suggest
Remembrance of revenge immortally 140
On your accursèd traitorous progeny,
You villains, that have slain my Gaveston.

[14] *Earl of Wiltshire:* Marlowe's invention.
[15] *Lord Bruce doth sell:* Following Holinshed.
[16] *in hand:* in process (the phrase occurs in Holinshed's
account).
[17] *seizèd Normandy:* Holinshed assigns the seizure to parts
of Aquitaine. [18] *Sib:* Kinswoman; wife.
[19] *We will employ you:* Following Holinshed.
[20] *once:* once and for all. [21] *receive me:* allow me to.
[22] *fire them:* smoke them out of their holes or places of
refuge, like hunted animals. [23] *longing:* belonging.

And in this place of honor and of trust,
Spencer, sweet Spencer, I adopt thee here:
And merely of our love we do create thee
Earl of Gloucester, and Lord Chamberlain,
Despite of times, despite of enemies.

 Spenc. Jun. My lord, here's a messenger from the
 barons
Desires access unto your majesty.

 King. Admit him near. 150

 Enter the Herald *from the* Barons, *with his*
 coat of arms.

 Her. Long live King Edward, England's lawful
 lord.

 King. So wish not they, I wis,[24] that sent thee hither.
Thou comst from Mortimer and his complices,
A ranker rout of rebels never was.
Well, say thy message.

 Her. The barons up in arms by me salute
Your highness with long life and happiness;
And bid me say, as plainer[25] to your grace,
That if without effusion[26] of blood
You will[27] this grief have ease and remedy, 160
That from your princely person you remove
This Spencer, as a putrifying branch,
That deads[28] the royal vine, whose golden leaves
Empale your princely head, your diadem,
Whose brightness such pernicious upstarts dim,
Say they; and lovingly advise your grace,
To cherish virtue and nobility,
And have old servitors in high esteem,
And shake off smooth dissembling flatterers:
This granted, they, their honors, and their lives, 170
And to your highness vowed and consecrate.

 Spenc. Jun. Ah, traitors! will they still display their
 pride?

 King. Away, tarry no answer, but be gone.
Rebels, will they appoint their sovereign
His sports, his pleasures, and his company?
Yet, ere thou go, see how I do divorce

 [*Embraces* SPENCER]

Spencer from me. Now get thee to thy lords,
And tell them I will come to chastise them

 [24] *I wis:* originally "ywis" ("certainly"); here, cor-
rupted to mean "I know." [25] *plainer:* complainant.
 [26] *effusion:* pronounced as four syllables.
 [27] *will:* will that. [28] *deads:* kills.

III.iii.
 [1] *Why . . . lords:* Marlowe, compressing history, declines
to record the ups and downs of Edward's previous en-
counters with the barons, and brings him abruptly to the
decisive battle of Boroughbridge in 1322.
 [2] *retire:* as substantive. [3] *L.:* with the rest.
 [4] *Thou'd:* Originals read "Th'ad"; most editors emend
to "They'd." [5] *betimes:* early.
 [6] *them:* originals read "thee." [7] *trains:* stratagems.
 [8] *trow:* think.
 [9] *huge heaps of stones:* Cf. Marlowe's translation of Lucan,
ll. 25*f:* "'That rampires fallen down, huge heaps of stone / Lie
in our towns, that houses are abandon'd."
 [10] *St. George:* not adopted as England's patron saint until
the reign of Edward III.

For murdering Gaveston; hie thee, get thee gone.
Edward with fire and sword follows at thy heels. 180

 [*Exit* Herald.]

My lord, perceive you how these rebels swell?
Soldiers, good hearts, defend your sovereign's right,
For now, even now, we march to make them stoop.
Away!

 Exeunt. Alarums, excursions, a great fight,
 and a retreat [*sounded, within.*]

[III.iii]

 Enter the KING, SPENCER senior, SPENCER
 junior, *and the* Noblemen *of the King's side.*

 King. Why do we sound retreat? Upon them,
 lords![1]
This day I shall pour vengeance with my sword
On those proud rebels that are up in arms,
And do confront and countermand their King.

 Spenc. Jun. I doubt it not, my lord, right will
 prevail.

 Spenc. Sen. 'Tis not amiss, my liege, for either part
To breathe awhile; our men, with sweat and dust
All choked well near, begin to faint for heat;
And this retire[2] refresheth horse and man.

 Spenc. Jun. Here come the rebels. 10

 Enter the Barons, MORTIMER [junior], LANCASTER,
 WARWICK, PEMBROKE, *cum caeteris.*[3]

 Mort. Jun. Look, Lancaster, yonder is Edward
Among his flatterers.

 Lanc. And there let him be
Till he pay dearly for their company.

 War. And shall, or Warwick's sword shall smite in
 vain.

 King. What, rebels, do you shrink and sound
 retreat?

 Mort. Jun. No, Edward, no, thy flatterers faint and
 fly.

 Lanc. Thou'd[4] best betimes[5] forsake them,[6] and
 their trains,[7]
For they'll betray thee, traitors as they are.

 Spenc. Jun. Traitor on thy face, rebellious
 Lancaster!

 Pem. Away, base upstart, bravest thou nobles
 thus? 20

 Spenc. Sen. A noble attempt, and honorable deed,
Is it not, trow[8] ye, to assemble aid,
And levy arms against your lawful King?

 King. For which ere long their heads shall satisfy,
T' appease the wrath of their offended King.

 Mort. Jun. Then, Edward, thou wilt fight it to the
 last,
And rather bathe thy sword in subjects' blood,
Than banish that pernicious company.

 King. Ay, traitors all, rather than thus be braved,
Make England's civil towns huge heaps of stones,[9] 30
And ploughs to go about our palace-gates.

 War. A desperate and unnatural resolution.
Alarum! to the fight! St. George[10] for England,
And the barons' right.

King. Saint George for England, and King Edward's right.

[*Alarums. Exeunt the two parties severally.*]

Enter EDWARD [*and his followers*], *with the* Barons [*and* KENT,] *captives.*

King. Now, lusty lords, now, not by chance of war,
But justice of the quarrel and the cause,
Vailed[11] is your pride; methinks you hang the heads,
But we'll advance them, traitors; now 'tis time
To be avenged on you for all your braves, 40
And for the murder of my dearest friend,
To whom right well you knew our soul was knit,
Good Pierce of Gaveston, my sweet favorite.
Ah, rebels, recreants, you made him away!
 Kent. Brother, in regard of thee, and of thy land,
Did they remove that flatterer from thy throne.
 King. So, sir, you have spoke; away, avoid our presence.

[*Exit* KENT.]

Accursed wretches, was't in regard of us,
When we had sent our messenger to request
He might be spared to come to speak with us, 50
And Pembroke undertook for his return,
That thou, proud Warwick, watched the prisoner,[12]
Poor Pierce, and headed him against law of arms?
For which thy head shall overlook the rest,
As much as thou in rage outwentst the rest.
 War. Tyrant, I scorn thy threats and menaces;
'Tis but temporal[13] that thou canst inflict.
 Lanc. The worst is death, and better die to live
Than live in infamy under such a king.
 King. Away with them, my Lord of Winchester.[14]
These lusty leaders, Warwick and Lancaster, 61
I charge you roundly—off with both their heads.
Away!
 War. Farewell, vain world.
 Lanc. Sweet Mortimer, farewell
 Mort. Jun. England, unkind to thy nobility,
Groan for this grief, behold how thou art maimed.
 King. Go, take that haughty Mortimer to the Tower,
There see him safe bestowed; and for the rest,
Do speedy execution on them all.
Begone! 70
 Mort. Jun. What, Mortimer! can ragged[15] stony walls
Immure thy virtue that aspires to heaven?
No, Edward, England's scourge, it may not be;
Mortimer's hope surmounts his fortune far,

[*The captive* Barons *are led off.*]

 King. Sound drums and trumpets! march with me, my friends,
Edward this day hath crowned him king anew:
 Exit. Manent SPENCER *filius*,[16] LEVUNE, *and* BALDOCK.
 Spenc. Jun. Levune, the trust that we repose in thee,
Begets the quiet of King Edward's land.
Therefore begone in haste, and with advice
Bestow[17] that treasure on the lords of France, 80
That therewith all enchanted, like the guard

That suffered Jove to pass in showers of gold
To Danaë,[18] all aid may be denied
To Isabel, the Queen, that now in France
Makes friends, to cross the seas with her young son,
And step into his father's regiment.[19]
 Lev. That's it these barons and the subtle Queen
Long levied[20] at.
 Bald. Yea, but, Levune, thou seest
These barons lay their heads on blocks together;
What they intend, the hangman frustrates clean. 90
 Lev. Have you no doubts, my lords, I'll clap so close[21]
Among the lords of France with England's gold,
That Isabel shall make her plaints in vain,
And France shall be obdurate with her tears.
 Spenc. Jun. Then make for France amain;[22]
 Levune, away.
Proclaim King Edward's wars and victories.

Exeunt omnes.

ACT FOUR

SCENE ONE

Enter KENT.

 Kent. Fair blows the wind for France; blow, gentle gale,
Till Edmund be arrived for England's good.
Nature, yield to my country's cause in this.
A brother, no, a butcher of thy friends,
Proud Edward, dost thou banish me[1] thy presence:
But I'll to France, and cheer the wrongèd Queen,
And certify what Edward's looseness is.
Unnatural king, to slaughter noble men
And cherish flatterers. Mortimer, I stay[2]
Thy sweet escape: stand gracious, gloomy night, 10
To his device.

Enter MORTIMER [*junior,*] *disguised.*

 Mort. Jun. Holla! who walketh there?
Is't you, my lord?
 Kent. Mortimer, 'tis I;
But hath thy potion[3] wrought so happily?

[11] *Vailed:* Fallen.
[12] *watched the prisoner:* echoing Warwick's own words, at III. i. 13. In fact, three years separate Gaveston's death and Warwick's retribution, and seven years the death of Warwick and the battle of Boroughbridge.
[13] *temporal:* bodily punishment.
[14] *Lord of Winchester:* Spencer senior.
[15] *ragged:* rough, jagged. [16] *L.:* son, junior.
[17] *Bestow that treasure:* Marlowe follows Holinshed's account of the Spencers' bribing of the French, to frustrate the designs of Queen Isabella.
[18] *Danaë:* See II. ii. 53. [19] *regiment:* royal authority.
[20] *levied:* OED notes confusion with "leveled" (which most editors prefer) from 1618.
[21] *clap so close:* bribe so securely and secretly. Originals read "claps." [22] *amain:* with full speed.

IV.i.
[1] *banish me:* Marlowe's invention. [2] *stay:* await.
[3] *potion:* Following Holinshed, who reports that Mortimer escaped from prison by drugging his keepers' drink.

Mort. Jun. It hath, my lord; the warders all asleep,
I thank them, gave me leave to pass in peace.
But hath your grace got shipping unto France?
 Kent. Fear it not.

 Exeunt.

[IV.ii]

 Enter the QUEEN *and her son* [PRINCE EDWARD.]

Queen. Ah, boy, our friends do fail us all in
 France:
The lords are cruel, and the King unkind;[1]
What shall we do?
 Prince. Madam, return to England,
And please my father well, and then a fig
For all my uncle's friendship here in France.
I warrant you, I'll win his highness quickly;
'A loves me better than a thousand Spencers.
 Queen. Ah, boy, thou art deceived, at least in this,
To think that we can yet be tuned together; 10
No, no, we jar too far. Unkind Valois,
Unhappy Isabel, when France rejects,
Whither, oh, whither dost thou bend thy steps?

 Enter SIR JOHN OF HAINAULT.

Sir J. Madam, what cheer?
Queen. Ah, good Sir John of
 Hainault,
Never so cheerless, nor so far distressed.
Sir J. I hear, sweet lady, of the King's unkindness;
But droop not, madam; noble minds contemn[2]
Despair: will your grace with me to Hainault,
And there stay[3] time's advantage with your son?
How say you, my lord, will you go with your friends,
And shake off[4] all our fortunes equally? 21
 Prince. So pleaseth the Queen, my mother, me it
 likes;
The King of England, nor the court of France,
Shall have me from my gracious mother's side,
Till I be strong enough to break a staff;
And then have at the proudest[5] Spencer's head.
 Sir J. Well said, my lord.
 Queen. Oh, my sweet heart, how do I moan thy
 wrongs,
Yet triumph in the hope of thee, my joy.
Ah, sweet Sir John, even to the utmost verge 30

Of Europe, or the shore of Tanaïs,[6]
Will we with thee to Hainault, so we will;
The marquis[7] is a noble gentleman;
His grace, I dare presume, will welcome me.
But who are these?

 Enter KENT *and* MORTIMER [junior].

Kent. Madam, long may you live,
Much happier than your friends in England do.
 Queen. Lord Edmund and Lord Mortimer alive!
Welcome to France; the news was here, my lord,
That you were dead, or very near your death.
 Mort. Jun. Lady, the last was truest of the twain:
But Mortimer, reserved for better hap, 41
Hath shaken off the thralldom of the Tower,
And lives t' advance your standard, good my lord.
 Prince. How mean you? And the King, my father,
 lives!
No, my Lord Mortimer, not I, I trow.
 Queen. Not, son! why not? I would it were no
 worse.[8]
But, gentle lords, friendless we are in France.
 Mort. Jun. Monsieur le Grand, a noble friend of
 yours,
Told us, at our arrival, all the news—
How hard the nobles, how unkind the King 50
Hath showed himself; but, madam, right makes room
Where weapons want; and, though a many[9] friends
Are made away, as Warwick, Lancaster,
And others of our party and faction;
Yet have we friends, assure your grace, in England
Would cast up caps, and clap their hands for joy,
To see us there appointed[10] for our foes.
 Kent. Would all were well, and Edward well
 reclaimed,
For England's honor, peace, and quietness.
 Mort. Jun. But by the sword, my lord, it must be
 deserved;[11] 60
The King will ne'er forsake his flatterers.
 Sir J. My lords of England, sith[12] the ungentle
 King
Of France refuseth to give aid of arms
To this distressèd Queen his sister here,
Go you with her to Hainault; doubt ye not,
We will find comfort, money, men and friends
Ere long, to bid the English King a base.[13]
How say, young prince, what think you of the match?
 Prince. I think King Edward will outrun us all.
 Queen. Nay, son, not so; and you must not
 discourage 70
Your friends, that are so forward in your aid.
 Kent. Sir John of Hainault, pardon us, I pray;
These comforts that you give our woeful Queen
Bind us in kindness all at your command.
 Queen. Yea, gentle brothers; and the God of
 heaven
Prosper your happy motion, good Sir John.
 Mort. Jun. This noble gentleman, forward in arms,
Was born, I see, to be our anchor-hold.
Sir John of Hainault, be it thy renown,
That England's Queen, and nobles in distress, 80

IV.ii.
 [1] *the king unkind:* Following Holinshed.
 [2] *contemn:* shun. [3] *stay:* wait on.
 [4] *shake off:* cast off (our hopes in France).
 [5] *proudest:* exceeding proud.
 [6] *Tanaïs:* the Don, commonly taken by the Elizabethans as dividing Europe from Asia.
 [7] *marquis:* William, Count of Hainault, brother of Sir John.
 [8] *would it were no worse:* would that our situation were compromised only by Mortimer's offer.
 [9] *many:* as substantive—"many (of)."
 [10] *appointed:* made ready.
 [11] *deserved:* earned. OED first lists in this sense in 1628.
 [12] *sith:* since.
 [13] *bid . . . a base:* challenge the player to leave his "home" and so risk being caught, as in the game of prisoner's base.

Have been by thee restored and comforted.
 Sir J. Madam, along, and you, my lord, with me,
That England's peers may Hainault's welcome see.
 [Exeunt.]

[IV.iii]

 Enter the KING, ARUNDEL,[1] *the* SPENCERS, *with others.*

 King. Thus after many threats of wrathful war,
Triumpheth England's Edward with his friends;
And triumph, Edward, with his friends uncontrolled.
My Lord of Gloucester, do you hear the news?
 Spenc. Jun. What news, my lord?
 King. Why, man, they say there is great execution
Done through the realm; my Lord of Arundel,
You have the note, have you not?
 Arun. From the lieutenant of the Tower, my lord.
 King. I pray let us see it.

 [Takes the note.]

 What have we there?— 10
Read it, Spencer.—

 [Hands it to] SPENCER [junior,] [*who*]
 reads their names.[2]

[*Spenc. Jun.* "The Lord William Tuchet, the Lord William fitz William, the Lord Warren de Lisle, the Lord Henry Bradborne, and the Lord William Chenie —barons—with John Page, an esquire, were drawn and hanged at Pomfret. And then shortly after, Roger Lord Clifford, John Lord Mowbray, and Sir Gosein d'Eevill—barons—were drawn and hanged at York. At Bristow in like manner were executed Sir Henry de Willington and Sir Henry Montford, baronets. And at Gloucester, the Lord John Gifford and Sir William Elmebridge, knight. And at London, the Lord Henry Teies, baron. At Winchelsea, Sir Thomas Culpepper, knight. At Windsor, the Lord Francis de Aldham, baron. And at Canterbury, the Lord Bartholomew de Badelismere and the Lord Bartholomew de Ashbornham, barons. Also at Cardiff, in Wales, Sir William Fleming, knight, was executed. Divers were executed in their counties, as Sir Thomas Mandit and others."]
 [*King.*] Why, so; they barked apace a month ago:
Now, on my life, they'll neither bark nor bite.
Now, sirs, the news from France? Gloucester, I trow
The lords of France love England's gold so well
As Isabel gets no aid from thence.
What now remains? Have you proclaimed, my lord,
Reward for them can bring in Mortimer?
 Spenc. Jun. My lord, we have; and if he be in England,
'A will be had ere long, I doubt it not. 20
 King. If, dost thou say? Spencer, as true as death,
He is in England's ground; our portmasters
Are not so careless of their King's command.

 Enter a Post.

How now, what news with thee? from whence come these?

 Post. Letters, my lord, and tidings forth of France;
To you, my Lord of Gloucester, from Levune.

 [Gives letters to SPENCER junior.]

 King. Read.
 Spenc. Jun. reads the letter.
 "My duty to your Honor premised,[3] etc. I have, according to instructions in that behalf, dealt with the King of France his lords, and effected, that the 30 Queen, all discontented and discomforted, is gone: whither, if you ask, with Sir John of Hainault, brother to the Marquis, into Flanders. With them are gone Lord Edmund, and the Lord Mortimer, having in their company divers of your nation, and others; and, as constant report goeth, they intend to give King Edward battle in England, sooner than he can look for them. This is all the news of import.
 Your honor's in all service, LEVUNE."
 King. Ah, villains, hath that Mortimer escaped? 40
With him is Edmund gone associate?[4]
And will Sir John of Hainault lead the round?[5]
Welcome, a God's name, madam, and your son;
England shall welcome you and all your rout.
Gallop apace,[6] bright Phoebus, through the sky,
And dusky night, in rusty iron car,
Between you both shorten the time, I pray,
That I may see that most desired day,
When we may meet these traitors in the field.
Ah, nothing grieves me, but my little boy 50
Is thus misled to countenance their ills.
Come, friends, to Bristow, there to make us strong;
And, winds, as equal[7] be to bring them in,
As you injurious were to bear them forth.
 [Exeunt.]

[IV.iv]

 Enter the QUEEN, PRINCE EDWARD, KENT, MORTIMER [junior], *and* SIR JOHN OF HAINAULT.

 Queen. Now, lords, our loving friends and countrymen,
Welcome to England all, with prosperous winds.
Our kindest friends in Belgia[1] have we left,
To cope[2] with friends at home; a heavy case
When force to force is knit, and sword and glaive[3]

IV.iii.
 [1] *Arundel:* Originals read "Matrevis."
 [2] *their names:* The play as printed provides no list of names, although such a list is necessary both to the sense and the action. Therefore, following the example of Kirschbaum's edition, we have added the list printed in Marlowe's principal source, Holinshed's *Chronicles.*
 [3] *premised:* stated by way of introduction.
 [4] *associate:* as associate. [5] *round:* dance.
 [6] *Gallop apace,* etc.: Shakespeare perhaps is remembering this passage in *Romeo and Juliet,* III. ii. 1–4.
 [7] *equal:* adequate.

IV.iv.
 [1] *Belgia:* The Netherlands.
 [2] *cope:* encounter, in friendly ways.
 [3] *glaive:* lance or bill.

In civil broils makes kin and countrymen
Slaughter themselves in others, and their sides
With their own weapons gored. But what's the help?
Misgoverned kings are cause of all this wrack;[4]
And, Edward, thou art one among them all, 10
Whose looseness hath betrayed thy land to spoil,
And made the channels[5] overflow with blood
Of thine own people; patron shouldst thou be,
But thou—
 Mort. Jun. Nay, madam, if you be a warrior,
Ye must not grow so passionate in speeches.
Lords, sith[6] that we are by sufferance of heaven
Arrived, and armèd in this prince's right,
Here for our country's cause swear we to him
All homage, fealty, and forwardness; 20
And for the open wrongs and injuries
Edward hath done to us, his Queen and land,
We come in arms to wreck it[7] with the swords;
That England's Queen in peace may repossess
Her dignities and honor: and withal
We may remove these flatterers from the King,
That havocs[8] England's wealth and treasury.
 Sir J. Sound trumpets, my lord, and forward let
 us march.
Edward will think we come to flatter him.
 Kent. I would he never had been flattered more. 30
 [Exeunt.]

[IV.v]

Enter the KING, BALDOCK, *and* SPENCER junior,
flying about the stage.

 Spenc. Jun. Fly, fly, my lord, the Queen is over-
 strong;
Her friends do multiply,[1] and yours do fail.
Shape we our course to Ireland, there to breathe.
 King. What, was I born to fly and run away,
And leave the Mortimers conquerors behind?
Give me my horse, and let's r'enforce[2] our troops:
And in this bed of honor die with fame.
 Bald. Oh, no, my lord, this princely resolution
Fits not the time; away, we are pursued.
 [Exeunt.]

Enter KENT *alone, with a sword and target.*

 [4] *wrack:* disaster.
 [5] *channels;* drainage and sewage gutters at the side of the
road. [6] *sith:* since.
 [7] *wreck it:* wrack, work destruction.
 [8] *havocs:* makes havoc with.
IV.v.
 [1] *Her friends do multiply:* Holinshed records the growing
strength of the Queen's party.
 [2] *r'enforce:* restore the strength of.
 [3] *Vile:* original "Vilde". [4] *unkind:* unnatural.
 [5] *Bristow . . . Is false:* Following Holinshed, who records
the complicity of the townsfolk with the Queen.
 [6] *for suspect:* since suspicion has already arisen.
 [7] *Lord Warden:* Following Holinshed.
 [8] *infortunate:* unfortunate.
 [9] *betimes:* at an early time.

 Kent. This way he fled, but I am come too late. 10
Edward, alas, my heart relents for thee.
Proud traitor, Mortimer, why dost thou chase
Thy lawful King, thy sovereign, with thy sword?
Vile[3] wretch, and why hast thou, of all unkind,[4]
Borne arms against thy brother and thy King?
Rain showers of vengeance on my cursèd head,
Thou God, to whom in justice it belongs
To punish this unnatural revolt.
Edward, this Mortimer aims at they life.
Oh, fly him, then! But, Edmund, calm this rage, 20
Dissemble, or thou diest; for Mortimer
And Isabel do kiss, while they conspire:
And yet she bears a face of love forsooth.
Fie on that love that hatcheth death and hate.
Edmund, away. Bristow to Longshanks' blood
Is false;[5] be not found single for suspect:[6]
Proud Mortimer pries near into thy walks.

Enter the QUEEN, PRINCE EDWARD, MORTIMER
 junior, *and* SIR JOHN OF HAINAULT.

 Queen. Successful battles gives the God of kings
To them that fight in right and fear his wrath.
Since then successfully we have prevailed, 30
Thanks be heaven's great architect, and you.
Ere farther we proceed, my noble lords,
We here create our well-belovèd son,
Of love and care unto his royal person,
Lord Warden[7] of the realm, and sith the fates
Have made his father so infortunate,[8]
Deal you, my lords, in this, my loving lords,
As to your wisdoms fittest seems in all.
 Kent. Madam, without offense, if I may ask,
How will you deal with Edward in his fall? 40
 Prince. Tell me, good uncle, what Edward do you
 mean?
 Kent. Nephew, your father: I dare not call him
 King.
 Mort. Jun. My Lord of Kent, what needs these
 questions?
'Tis not in her controlment, nor in ours,
But as the realm and parliament shall please,
So shall your brother be disposèd of.
[Aside to the QUEEN*]* I like not this relenting mood in
 Edmund.
Madam, 'tis good to look to him betimes.[9]
 Queen. My lord, the Mayor of Bristow knows our
 mind.
 Mort. Jun. Yea, madam, and they scape not easily
That fled the field.
 Queen. Baldock is with the King. 51
A goodly chancellor, is he not, my lord?
 Sir J. So are the Spencers, the father and the son.
 Kent. This, Edward, is the ruin of the realm.

Enter RICE AP HOWELL, *and the* Mayor of
 Bristow, *with* SPENCER senior, *prisoner, and*
 Attendants.

 Rice. God save Queen Isabel, and her princely son.
Madam, the mayor and citizens of Bristow,
In sign of love and duty to this presence,

Present by me this traitor to the state,
Spencer, the father to that wanton Spencer,
That, like the lawless Catiline [10] of Rome, 60
Revelled in England's wealth and treasury.
 Queen. We thank you all.
 Mort. Jun. Your loving care in this
Deserveth princely favors and rewards.
But where's the King and the other Spencer fled?
 Rice. Spencer the son, created Earl of Gloucester,
Is with that smooth-tongued scholar Baldock gone,
And shipped but late for Ireland with the King.
 Mort. Jun, Some whirlwind fetch them back or sink
 them all:—
They shall be started thence, I doubt it not.
 Prince. Shall I not see the King my father yet? 70
 Kent. [*Aside*] Unhappy is Edward, chased from
 England's bounds.
 Sir J. Madam, what resteth, [11] why stand ye in a
 muse?
 Queen. I rue my lord's ill-fortune; but alas,
Care of my country called me to this war.
 Mort. Jun. Madam, have done with care and sad
 complaint;
Your King hath wronged your country and himself,
And we must seek to right it as we may.
Meanwhile, have hence this rebel to the block.
Your lordship cannot privilege your head.
 Spenc. Sen. Rebel is he that fights against his
 Prince; 80
So fought not they that fought in Edward's right.
 Mort. Jun. Take him away, he prates;
 [*Exeunt* Attendants *with* SPENCER senior.]
 You, Rice ap
 Howell, [12]
Shall do good service to her majesty,
Being of countenance [13] in your country here,
To follow these rebellious runagates. [14]
We in meanwhile, madam, must take advice,
How Baldock, Spencer, and their complices,
May in their fall be followed to their end.
 Exeunt omnes.

[IV.vi]

 Enter the Abbot, Monks, *the* KING, SPENCER
 [junior], *and* BALDOCK [*the three latter disguised*].

 Abbot. Have you no doubt, my lord; have you no
 fear;
As silent and as careful will we be,
To keep your royal person safe with us,
Free from suspèct, [1] and fell invasion
Of such as have your majesty in chase,
Yourself, and those your chosen company,
As danger of this stormy time requires.
 King. Father, thy face should harbor no deceit. [2]
Oh, hadst thou ever been a king, thy heart,
Pierced deeply with [a] sense of my distress, 10
Could not but take compassion of my state.
Stately and proud, in riches and in train,
Whilom [3] I was powerful, and full of pomp:
But what is he whom rule and empery [4]

Have not in life or death made miserable?
Come, Spencer; come, Baldock, come, sit down by me;
Make trial now of that philosophy,
That in our famous nurseries of arts
Thou suckedst from Plato and from Aristotle.
Father, this life contemplative is heaven. 20
Oh, that I might this life in quiet lead.
But we, alas, are chased; and you, my friends,
Your lives and my dishonor they pursue,
Yet, gentle monks, for treasure, gold nor fee,
Do you betray us and our company.
 Monks. Your grace may sit secure, if none but we
Do wot [5] of your abode.
 Spenc. Jun. Not one alive; but shrewdly [6] I suspect
A gloomy fellow in a mead below.
'A gave a long look after us, my lord; 30
And all the land I know is up in arms,
Arms that pursue our lives with deadly hate.
 Bald. We were embarked for Ireland, wretched we,
With awkward winds and sore tempests driven
To fall on shore, and here to pine in fear
Of Mortimer and his confederates.
 King. Mortimer, who talks of Mortimer?
Who wounds me with the name of Mortimer,
That bloody man? Good father, on thy lap
Lay I this head, laden with mickle [7] care, 40
Oh, might I never open these eyes again,
Never again lift up this drooping head,
Oh, never more lift up this dying heart!
 Spenc. Jun. Look up, my lord. Baldock, this
 drowsiness
Betides [8] no good; here even we are betrayed.

 Enter, with Welsh hooks, [9] RICE AP HOWELL,
 a Mower, *and* LEICESTER.

 Mower. Upon my life, those be the men ye seek.
 Rice. Fellow, enough. My lord, I pray be short,
A fair [10] commission warrants what we do.
 Leic. The Queen's commission, urged by Mortimer.
What cannot gallant Mortimer with the Queen? 50
Alas, see where he sits, and hopes unseen
T' escape their hands that seek to reave [11] his life.
Too true it is, *Quem dies vidit veniens superbum,*
Hunc dies vidit fugiens jacentem. [12]

 [10] *Catiline:* sonority more than sense; there is no parti-
cular point in invoking the Roman rebel here.
 [11] *resteth:* remains to be done.
 [12] *Rice ap Howell:* Holinshed records his role in tracking
down and apprehending the King.
 [13] *countenance:* importance. [14] *runagates:* runaways.
IV.vi.
 [1] *suspèct:* suspicion.
 [2] *thy . . . deceit:* Cf. *Soliman and Perseda,* III. i. 72:
"This face of thine should harbor no deceit."
 [3] *Whilom:* Formerly. [4] *empery:* empire.
 [5] *wot:* know. [6] *shrewdly:* very much.
 [7] *mickle:* much. [8] *Betides:* Augers, promises.
 [9] *Welsh hooks:* bill hooks distinguished by a crosspiece
below the blade. [10] *fair:* legitimate. [11] *reave:* rob.
 [12] *L.:* Quoting Seneca *Thyestes,* 613–14. Cf. Jonson's
translation in *Sejanus,* V. 902–3: "For whom the morning
saw so great and high, / Thus low and little 'fore the even
doth lie."

But, Leicester, leave to grow so passionate.
Spencer and Baldock, by no other names,[13]
I arrest you of high treason here.
Stand not on titles, but obey th' arrest;
'Tis in the name of Isabel the Queen.
My lord, why droop you thus? 60
 King. O day! the last of all my bliss on earth,
Center[14] of all misfortune! O my stars!
Why do you lour[15] unkindly on a king?
Comes Leicester, then, in Isabella's name
To take my life, my company from me?
Here, man, rip up this panting breast of mine,
And take my heart in rescue of my friends!
 Rice. Away with them.
 Spenc. Jun. It may become thee yet
To let us take our farewell of his grace.
 Abbot. My heart with pity earns[16] to see this sight,
A king to bear these words and proud commands. 71
 King. Spencer, ah, sweet Spencer, thus then must
 we part.
 Spenc. Jun. We must, my lord, so will the angry
 heavens.
 King. Nay, so will hell and cruel Mortimer;
The gentle heavens have not to do in this.
 Bald. My lord, it is in vain to grieve or storm.
Here humbly of your grace we take our leaves;
Our lots are cast; I fear me, so is thine.
 King. In heaven we may, in earth never shall we
 meet:
And, Leicester, say, what shall become of us? 80
 Leic. Your majesty must go to Killingworth.[17]
 King. Must! 'tis somewhat hard, when kings must
 go.
 Leic. Here is a litter ready for your grace,
That waits your pleasure, and the day grows old.
 Rice. As good be gone, as stay and be benighted.
 King. A litter hast thou? Lay me in a hearse,
And to the gates of hell convey me hence;
Let Pluto's bells ring out my fatal knell,
And hags howl for my death at Charon's[18] shore,

For friends hath Edward none but these and these, 90
And these must die under a tyrant's sword.
 Rice. My lord, be going; care not for these,
For we shall see them shorter by the heads.
 King. Well, that shall be,[19] shall be: part we must.
Sweet Spencer, gentle Baldock, part we must.
Hence feignèd weeds! unfeignèd are my woes;

 [Throws off his disguise.]

Father, farewell. Leicester, thou stayest for me,
And go I must. Life, farewell, with my friends.
 Exeunt the KING *and* LEICESTER.[20]
 Spenc. Jun. Oh, is he gone? Is noble Edward gone?
Parted from hence? Never to see us more? 100
Rent,[21] sphere of heaven, and, fire, forsake thy orb,
Earth, melt to air! gone is my sovereign,
Gone, gone, alas, never to make return.
 Bald. Spencer, I see our souls are fleeted[22] hence;
We are deprived the sunshine of our life:
Make for a new life, man; throw up thy eyes
And heart and hand to heaven's immortal throne,
Pay nature's debt with cheerful countenance;
Reduce we all our lessons unto this,
To die, sweet Spencer, therefore live we all; 110
Spencer, all live to die, and rise to fall.
 Rice. Come, come, keep these preachments till you
come to the place appointed. You, and such as you are,
have made wise work in England; will your lordships
away?
 Mower. Your worship, I trust, will remember me?
 Rice. Remember thee, fellow! what else? Follow me
to the town.

 [Exeunt.]

ACT FIVE

SCENE ONE

Enter the KING, LEICESTER, *the* BISHOP OF
WINCHESTER [,*and* TRUSSEL[1]].

 Leic. Be patient, good my lord, cease to lament,
Imagine Killingworth Castle were your court,
And that you lay for pleasure here a space,
Not of compulsion or necessity.
 King. Leicester, if gentle words might comfort me,
Thy speeches long ago had eased my sorrows;
For kind and loving hast thou always been.
The griefs of private men are soon allayed,
But not of kings. The forest deer, being struck,
Runs to an herb[2] that closeth up the wounds; 10
But, when the imperial lion's flesh is gored,
He rends and tears it with his wrathful paw,
Highly[3] scorning that the lowly earth
Should drink his blood, mounts up into the air.
And so it fares with me, whose dauntless mind
The ambitious Mortimer would seek to curb,
And that unnatural Queen, false Isabel,
That thus hath pent and mewed me in a prison;
For such outrageous passions cloy my soul,
As with the wings of rancor and disdain 20

[13] *by . . . names:* without reciting either's title or full name.
[14] *Center:* echoing Gaveston at III. i. 5.
[15] *lour:* look gloomily. [16] *earns:* grieves.
[17] *Killingworth:* Kenilworth. Holinshed employs the same spelling as Marlowe, in his second edition of 1586.
[18] *Charon's:* alluding to the ferryman who carried the shades of the dead across the rivers of the lower world.
[19] *that shall be:* So *Faustus,* I. i. 48: "What doctrine call you this, *Che sera, sera,* / What will be, shall be?"
[20] *Leicester:* who succeeded in 1324 to the title of his deceased brother Thomas, Earl of Lancaster.
[21] *Rent:* Rend. [22] *fleeted:* drifting. See I. iv. 49.
V.i.
[1] *Winchester . . . Trussel:* The name of the ecclesiastic, whose see is unspecified in the text, is inferred from Holinshed's account. Trussel is presumably the Sir William Trussel who appears in Fabyan's *Chronicle* (1533), sig. OOiiiiv, as one of the commissioners, and whom Holinshed represents as renouncing the King in the name of the parliament. The two speeches allotted to Trussel in this scene are prefixed only with the heading *Tru.*
[2] *Runs to an herb:* The wounded deer is supposed to be cured by application of the herb dittany.
[3] *Highly:* Most editors emend by prefacing with "And."

Full often am I soaring up to heaven,
To plain me [4] to the gods against them both.
But when I call to mind I am a king,
Methinks I should revenge me of the wrongs
That Mortimer and Isabel have done.
But what are kings, when regiment [5] is gone,
But perfect shadows in a sunshine day?
My nobles rule, I bear the name of king;
I wear the crown, but am controlled by them,
By Mortimer, and my unconstant Queen, 30
Who spots my nuptial bed with infamy;
Whilst I am lodged within this cave of care,
Where sorrow at my elbow still attends,
To company my heart with sad laments,
That bleeds within me for this strange exchange.
But tell me, must I now resign my crown,
To make usurping Mortimer a king?
 Winch. Your grace mistakes; it is for England's
 good,
And princely Edward's right we crave the crown.
 King. No, 'tis for Mortimer, not Edward's head; 40
For he's a lamb, encompassèd by wolves,
Which in a moment will abridge his life.
But if proud Mortimer do wear this crown,
Heavens turn it to a blaze of quenchless fire;
Or, like the snaky wreath of Tisiphon, [6]
Engirt the temples of his hateful head;
So shall not England's vines be perishèd,
But Edward's name survives, though Edward dies.
 Leic. My lord, why waste you thus the time away?
They stay [7] your answer; will you yield your crown?
 King. Ah, Leicester, weigh how hardly I can brook
To lose my crown and kingdom without cause; 52
To give ambitious Mortimer my right,
That like a mountain overwhelms my bliss,
In which extreme my mind here murdered is.
But what the heavens appoint, I must obey!
Here, take my crown; the life of Edward too;

 [Taking off the crown.]

Two kings in England cannot reign at once.
But stay awhile, let me be King till night,
That I may gaze upon this glittering crown; 60
So shall my eyes receive their last content,
My head, the latest honor due to it,
And jointly both yield up their wishèd right.
Continue ever thou celestial sun;
Let never silent night possess this clime:
Stand still you watches of the element; [8,9]
All times and seasons, rest you at a stay,
That Edward may be still fair England's King.
But day's bright beams doth vanish fast away,
And needs I must resign my wishèd crown. 70
Inhuman creatures, nursed with tiger's milk,
Why gape you for your sovereign's overthrow?
My diadem I mean, and guiltless life.
See, monsters, see, I'll wear my crown again!

 [He puts on the crown.]

What, fear you not the fury of your King?
But, hapless Edward, thou art fondly [10] led;

They pass [11] not for thy frowns as late they did,
But seek to make a new-elected king;
Which fills my mind with strange despairing thoughts,
Which thoughts are martyrèd with endless torments,
And in this torment comfort find I none, 81
But that I feel the crown upon my head,
And therefore let me wear it yet awhile.
 Trus. My lord, the parliament must have present [12]
 news,
And therefore say, will you resign or no?

 The KING *rageth.*

 King. I'll not resign; not whilst I live.
Traitors, be gone! and join you with Mortimer!
Elect, conspire, install, do what you will,
Their blood and yours shall seal these treacheries! 89
 Winch. This answer we'll return, and so farewell.
 Leic. Call them again, my lord, and speak them
 fair;
For if they go, the prince shall lose his right.
 King. Call thou them back, I have no power to
 speak.
 Leic. My lord, the King is willing to resign.
 Winch. If he be not, let him choose.
 King. Oh, would I might! but heavens and earth
 conspire
To make me miserable. Here receive my crown;
Receive it? No, these innocent hands of mine
Shall not be guilty of so foul a crime.
He of you all that most desires my blood, 100
And will be called the murderer of a king,
Take it. What, are you moved? Pity you me?
Then send for unrelenting Mortimer,
And Isabel, whose eyes, being turned to steel,
Will sooner sparkle fire than shed a tear.
Yet stay, for rather than I will look on them,
Here, here!

 [Gives the crown.]

 Now, sweet God of heaven,
Make me despise this transitory pomp,
And sit for aye enthronizèd [13] in heaven.
Come, death, and with thy fingers close my eyes, 110
Or if I live, let me forget myself.

 Enter BERKELEY. [14]

 Berk. My lord—
 King. Call me not lord; away—out of my sight:
Ah, pardon me: grief makes me lunatic.
Let not that Mortimer protect [15] my son;
More safety is there in a tiger's jaws,

[4] *plain me:* complain. [5] *regiment:* rule.
[6] *Tisiphon:* one of the three Furies, who punished evil-
doers in this world and after death. [7] *stay:* wait on.
[8] *Stand . . . element:* Cf. *Faustus,* V. i. 277: "Stand still
you ever-moving spheres of heaven." [9] *element:* sky.
[10] *fondly:* foolishly (by himself). [11] *pass:* care.
[12] *present:* immediate. [13] *enthronizèd:* enthroned.
[14] *Berkeley:* Originals read (here and for the balance of
the scene) "Bartley." Most editions omit the direction and
give the ensuing speech to Winchester.
[15] *protect:* be protector to.

Than his embracements. Bear this to the Queen,
Wet with my tears, and dried again with sighs;

[Gives a handkerchief.]

If with the sight thereof she be not moved,
Return it back and dip it in my blood. 120
Commend me to my son, and bid him rule
Better than I. Yet how have I transgressed,
Unless it be with too much clemency?

 Trus. And thus most humbly do we take our leave.
 [Exeunt the BISHOP OF WINCHESTER
 and TRUSSEL.]

 King. Farewell; I know the next news that they
 bring
Will be my death; and welcome shall it be;
To wretched men death is felicity.

 [Enter Post.]

 Leic. Another post. What news brings he?
 King. Such news as I expect: come, Berkeley, come,
And tell thy message to my naked breast. 130
 Berk. My lord, think not a thought so villainous
Can harbor in a man of noble birth.
To do your highness service and devoir,[16]
And save you from your foes, Berkeley would die.
 Leic. My lord, the council of the Queen commands
That I resign[17] my charge.
 King. And who must keep me now? Must you, my
 lord?
 Berk. Ay, my most gracious lord, so 'tis decreed.

 [The KING *takes the paper.]*

 King. By Mortimer, whose name is written here.
Well may I rent[18] his name that rends my heart! 140

 [Tears it.]

This poor revenge hath something eased my mind.
So may his limbs be torn, as is this paper.
Hear me, immortal Jove, and grant it too.
 Berk. Your grace must hence with me to Berkeley[19]
 straight.
 King. Whither you will; all places are alike,
And every earth is fit for burial.
 Leic. Favor him, my lord, as much as lieth in you.
 Berk. Even so betide[20] my soul as I use him.
 King. Mine enemy hath pitied my estate,

[16] *devoir:* duty.
[17] *That I resign:* Following Holinshed, who records
that the Queen replaced Leicester as favoring her husband
too much. [18] *rent:* rend.
[19] *Berkeley:* the castle. [20] *betide:* befall.

V.ii.
[1] *slip:* escape.
[2] *gripe . . . griped:* seize . . . seized (with suggestion in
latter of "afflicted"). [3] *imports:* concerns.
 [4] *behoof:* benefit. [5] *Whenas:* When.
 [6] *let me alone:* leave it to me (as at *l.* 37).
 [7] *ere:* Originals read "or."
 [8] *letter:* announcing the resignation of the King.
 [9] *Edmund laid a plot:* Following Holinshed.
 [10] *Berkeley is so pitiful:* Following Holinshed.
 [11] *dash:* confound (as also at *l.* 78). [12] *drift:* plot.

And that's the cause that I am now removed. 150
 Berk. And thinks your grace that Berkeley will be
 cruel?
 King. I know not; but of this am I assured,
That death ends all, and I can die but once.
Leicester, farewell.
 Leic. Not yet, my lord; I'll bear you on your way.
 Exeunt omnes.

[V.ii]

 Enter MORTIMER [junior] *and* QUEEN ISABEL.

 Mort. Jun. Fair Isabel, now have we our desire;
The proud corrupters of the light-brained King
Have done their homage to the lofty gallows,
And he himself lies in captivity.
Be ruled by me, and we will rule the realm.
In any case take heed of childish fear,
For now we hold an old wolf by the ears,
That, if he slip,[1] will seize upon us both,
And gripe the sorer, being griped[2] himself.
Think therefore, madam, that imports[3] us much 10
To erect your son with all the speed we may,
And that I be protector over him;
For our behoof[4] will bear the greater sway
Whenas[5] a king's name shall be under writ.
 Queen. Sweet Mortimer, the life of Isabel,
Be thou persuaded that I love thee well,
And therefore, so the prince my son be safe,
Whom I esteem as dear as these mine eyes,
Conclude against his father what thou wilt,
And I myself will willingly subscribe. 20
 Mort. Jun. First would I hear news that he were
 deposed,
And then let me alone[6] to handle him.

 Enter Messenger.

Letters! from whence?
 Mess. From Killingworth, my lord.
 Queen. How fares my lord the King?
 Mess. In health, madam, but full of pensiveness.
 Queen. Alas, poor soul, would I could ease his grief.

[Enter the BISHOP OF WINCHESTER *with the crown.]*

Thanks, gentle Winchester. *[To the* Messenger] Sirrah,
 be gone.
 [Exit Messenger.]
 Winch. The king hath willingly resigned his crown.
 Queen. Oh, happy news! send for the prince, my son.
 Winch. Further, ere[7] this letter[8] was sealed,
 Lord Berkeley came, 30
So that he now is gone from Killingworth;
And we have heard that Edmund laid a plot[9]
To set his brother free; no more but so.
The Lord of Berkeley is so pitiful[10]
As Leicester that had charge of him before.
 Queen. Then let some other be his guardian.
 Mort. Jun. Let me alone, here is the privy seal.
Who's there? *[To* Attendants *within]* Call hither
 Gurney and Matrevis.
To dash[11] the heavy-headed Edmund's drift,[12]

Berkeley shall be discharged, the King removed, 40
And none but we shall know where he lieth.
 Queen. But, Mortimer, as long as he survives,
What safety rests for us, or for my son?
 Mort. Jun. Speak, shall he presently be dispatched
 and die?
 Queen. I would he were, so it were not by my
 means.

 Enter MATREVIS *and* GURNEY.

 Mort. Jun. Enough.
Matrevis, write a letter presently [13]
Unto the Lord of Berkeley from ourself
That he resign the King to thee and Gurney;
And when 'tis done, we will subscribe our name. 50
 Mat. It shall be done, my lord.
 Mort. Jun. Gurney.
 Gurney. My lord.
 Mort. Jun. As thou intendest to rise by Mortimer,
Who now makes Fortune's wheel turn as he please,
Seek all the means thou canst to make him droop,
And neither give him kind word nor good look.
 Gurney. I warrant you, my lord.
 Mort. Jun. And this above the rest: because we hear
That Edmund casts [14] to work his liberty,
Remove him still [15] from place to place by night,
Till at the last he come to Killingworth, 60
And then from thence to Berkeley back again; [16]
And by the way, to make him fret the more,
Speak curstly [17] to him; and in any case
Let no man comfort him if he chance to weep,
But amplify his grief with bitter words.
 Mat. Fear not, my lord, we'll do as you command.
 Mort. Jun. So now away; post thitherwards
 amain. [18]
 Queen. Whither goes this letter? To my lord the
 King?
Commend me humbly [19] to his majesty,
And tell him that I labor all in vain 70
To ease his grief, and work his liberty;
And bear him this [20] as witness of my love.
 Mat. I will, madam.
 Exeunt MATREVIS *and* GURNEY.
 Manent ISABEL *and* MORTIMER.
 Mort. Jun. Finely dissembled. Do so still, sweet
 Queen.
Here comes the young prince with the Earl of Kent.

 Enter the young PRINCE [EDWARD], *and the*
 EARL OF KENT *talking with him.*

 Queen. Something he whispers in his childish ears.
 Mort. Jun. If we have such access unto the prince,
Our plots and stratagems will soon be dashed.
 Queen. Use Edmund friendly as if all were well.
 Mort. Jun. How fares my honorable Lord of
 Kent? 80
 Kent. In health, sweet Mortimer: how fares your
 grace?
 Queen. Well, if my lord your brother were
 enlarged. [21]
 Kent. I hear of late he hath deposed himself.

 Queen. The more my grief.
 Mort. Jun. And mine.
 Kent. [*Aside*] Ah, they do dissemble.
 Queen. Sweet son, come hither, I must talk with
 thee.
 Mort. Jun. Thou being his uncle, and the next of
 blood,
Do look to be Protector over the Prince.
 Kent. Not I, my lord; who should protect the son,
But she that gave him life? I mean the Queen. 91
 Prince. Mother, persuade me not to wear the
 crown:
Let him be King. I am too young to reign.
 Queen. But be content, seeing it his highness'
 pleasure. [22]
 Prince. Let me but see him first, and then I will.
 Kent. Ay, do, sweet nephew.
 Queen. Brother, you know it is impossible.
 Prince. Why, is he dead?
 Queen. No, God forbid.
 Kent. I would those words proceeded from your
 heart. 100
 Mort. Jun. Inconstant Edmund, dost thou favor
 him,
That wast a cause of his imprisonment?
 Kent. The more cause have I now to make amends.
 Mort. Jun. I tell thee, 'tis not meet that one so false
Should come about the person of a prince.
My lord, he hath betrayed the King his brother,
And therefore trust him not.
 Prince. But he repents, and sorrows for it now.
 Queen. Come, son, and go with this gentle lord
 and me.
 Prince. With you I will, but not with Mortimer. 110
 Mort. Jun. Why, youngling, 'sdainst thou so of
 Mortimer?
Then I will carry thee by force away.
 Prince. Help, uncle Kent, Mortimer will wrong me.
 Queen. Brother Edmund, strive not; we are his
 friends;
Isabel is nearer than the Earl of Kent.
 Kent. Sister, Edward is my charge; redeem him.
 Queen. Edward is my son, and I will keep him.
 Kent. Mortimer shall know that he hath wronged
 me.
Hence will I haste to Killingworth Castle,
And rescue agèd [23] Edward from his foes, 120
To be revenged on Mortimer and thee.

 Exeunt omnes.

[13] *presently:* immediately. [14] *casts:* schemes.
[15] *still:* continually.
[16] *Remove . . . again:* Following Holinshed.
[17] *curstly:* harshly. [18] *amain:* with full speed.
[19] *Commend me humbly:* Following Holinshed's account of
the Queen's duplicity.
[20] *this:* message. Most editors append the gratuitous
direction "Gives a ring." [21] *enlarged:* freed.
[22] *his highness' pleasure:* Holinshed records the reluctance
of the Prince to assume the crown until the King had conferred
the title on him.
[23] *agèd:* Marlowe makes Edward's physical decline co-
incident with his loss of power.

[V.iii]

Enter MATREVIS *and* GURNEY [*and* Soldiers,]
with the KING.

Mat. My lord, be not pensive, we are your friends;
Men are ordained to live in misery,
Therefore come: dalliance dangereth [1] our lives.
 King. Friends, whither must unhappy Edward go?
Will hateful Mortimer appoint [2] no rest?
Must I be vexèd like the nightly bird, [3]
Whose sight is loathsome to all wingèd fowls?
When will the fury of his mind assuage?
When will his heart be satisfied with blood?
If mine will serve, unbowel straight this breast, 10
And give my heart to Isabel and him;
It is the chiefest mark they level at.
 Gurney. Not so, my liege, the Queen hath given
 this charge
To keep your grace in safety;
Your passions make your dolors [4] to increase.
 King. This usage makes my misery increase.
But can my air of life [5] continue long
When all my senses are annoyed [6] with stench? [7]
Within a dungeon England's King is kept,
Where I am starved for want of sustenance. 20
My daily diet is heart-breaking sobs,
That almost rents the closet of my heart;
Thus lives old Edward not relieved by any,
And so must die, though pitièd by many.
Oh, water, gentle friends, to cool my thirst,
And clear my body from foul excrements. [8]
 Mat. Here's channel water, [9] as our charge is given;
Sit down, for we'll be barbers to your grace.
 King. Traitors, away! what, will you murder me,
Or choke your sovereign with puddle water? 30
 Gurney. No; but wash your face, and shave away
 your beard,
Lest you be known and so be rescuèd.
 Mat. Why strive you thus? Your labor is in vain.
 King. The wren may strive against the lion's
 strength,
But all in vain: so vainly do I strive
To seek for mercy at a tyrant's hand.

 They wash him with puddle water, and shave his
 beard away.

V.iii.
 [1] *dalliance dangereth:* delay endangers (OED cites first use of verb in this sense 1663). [2] *appoint:* fix a time for.
 [3] *nightly bird:* night bird, owl. [4] *dolors:* sorrows.
 [5] *air of life:* breath of life. [6] *annoyed:* injured.
 [7] *stench:* Holinshed records the immuring of the King in "a chamber over a foule filthie dungeon . . . to make an ende of him, wyth the abhominable stinche."
 [8] *excrements:* originally, anything external to the body.
 [9] *channel water:* Following Stow's account (*Annals,* edition of 1606), as also in the shaving of the beard.
 [10] *Enter Kent:* Kent's attempt to rescue the King is Marlowe's expansion of Holinshed's "secret plot."
 [11] *gripe:* "grip," but also "afflict."

V.iv.
 [1] *This letter:* Following Holinshed.
 [2] *Unpointed:* Without punctuation.

Immortal powers! that knows the painful cares
That waits upon my distressèd soul,
Oh, level all your looks upon these daring men,
That wrongs their liege and sovereign, England's
 King. 40
O Gaveston, it is for thee that I am wronged,
For me, both thou and both the Spencers died!
And for your sakes a thousand wrongs I'll take.
The Spencers' ghosts, wherever they remain,
Wish well to mine; then tush, for them I'll die.
 Mat. 'Twixt theirs and yours shall be no enmity.
Come, come away; now put the torches out,
We'll enter in by darkness to Killingworth.

Enter KENT.[10]

 Gurney. How now, who comes there? 49
 Mat. Guard the King sure: it is the Earl of Kent.
 King. O gentle brother, help to rescue me.
 Mat. Keep them asunder; thrust in the King.
 Kent. Soldiers, let me but talk to him one word.
 Gurney. Lay hands upon the Earl for this assault.
 Kent. Lay down your weapons, traitors; yield the
 King.
 Mat. Edmund, yield thou thyself, or thou shalt die.
 Kent. Base villains, wherefore do you gripe [11] me
 thus?
 Gurney. Bind him and so convey him to the court.
 Kent. Where is the court but here? Here is the King;
And I will visit him; why stay you me? 60
 Mat. The court is where Lord Mortimer remains;
Thither shall your honor go; and so farewell.
 Exeunt MATREVIS *and* GURNEY, *with the* KING.
 Manent KENT *and the* Soldiers.
 Kent. Oh, miserable is that commonweal,
Where lords keep courts, and kings are locked in
 prison!
 Sold. Wherefore stay we? On, sirs, to the court.
 Kent. Ay, lead me whither you will, even to my
 death,
Seeing that my brother cannot be released.
 Exeunt omnes.

[V.iv]

Enter MORTIMER [junior] *alone.*

 Mort. Jun. The King must die, or Mortimer goes
 down;
The commons now begin to pity him:
Yet he that is the cause of Edward's death,
Is sure to pay for it when his son is of age;
And therefore will I do it cunningly.
This letter, [1] written by a friend of ours,
Contains his death, yet bids them save his life.
[*Reads*] "*Edwardum occidere nolite timere bonum est:*
Fear not to kill the King, 'tis good he die."
But read it thus, and that's another sense: 10
"*Edwardum occidere nolite timere bonum est:*
Kill not the King, 'tis good to fear the worst."
Unpointed [2] as it is, thus shall it go,
That, being dead, if it chance to be found,

Matrevis and the rest may bear the blame,
And we be quit[3] that caused it to be done.
Within this room is locked the messenger
That shall convey it, and perform the rest:
And by a secret token that he bears,
Shall he be murdered when the deed is done. 20
Lightborn, come forth!

[Enter LIGHTBORN.]

Art thou as resolute as thou wast?
 Light. What else, my lord? And far more resolute.
 Mort. Jun. And hast thou cast[4] how to accomplish
 it?
 Light. Ay, ay, and none shall know which way he
 died.
 Mort. Jun. But at his looks, Lightborn, thou wilt
 relent.
 Light. Relent! ha, ha! I use much[5] to relent.
 Mort. Jun. Well, do it bravely, and be secret.
 Light. You shall not need to give instructions;
'Tis not the first time I have killed a man. 30
I learned in Naples how to poison flowers;
To strangle with a lawn[6] thrust through the throat;
To pierce the windpipe with a needle's point;
Or whilst one is asleep, to take a quill
And blow a little powder in his ears:
Or open his mouth and pour quicksilver down.
But yet I have a braver way than these.
 Mort. Jun. What's that?
 Light. Nay, you shall pardon me; none shall know
 my tricks.
 Mort. Jun. I care not how it is, so it be not spied. 40
Deliver this to Gurney and Matrevis.

[Gives letter.]

At every ten miles' end thou hast a horse.
Take this;

[Gives money]

 away, and never see me more.
 Light. No.
 Mort. Jun. No,
Unless thou bring me news of Edward's death.
 Light. That will I quickly do. Farewell, my lord.

[Exit.]

 Mort. Jun. The prince I rule, the Queen do I
 command,
And with a lowly congé[7] to the ground,
The proudest lords salute me as I pass; 50
I seal, I cancel, I do what I will.
Feared am I more than loved;—let me be feared,
And when I frown, make all the court look pale.
I view the prince with Aristarchus'[8] eyes,
Whose looks were as a breeching[9] to a boy.
They thrust upon me the protectorship,
And sue to me for that that I desire.
While at the council-table, grave enough,
And not unlike a bashful[10] Puritan,
First I complain of imbecility,[11] 60
Saying it is *onus quam gravissimum;*[12]
Till, being interrupted by my friends,

Suscepi that *provinciam*[13] as they term it;
And to conclude, I am Protector now.
Now is all sure: the Queen and Mortimer
Shall rule the realm, the King; and none rule us.
Mine enemies will I plague, my friends advance;
And what I list command who dare control?
Major sum quam cui possit fortuna nocere.[14]
And that this be the coronation-day, 70
It pleaseth me, and Isabel the Queen.

[Trumpets within.]

The trumpets sound, I must go take my place.

Enter the young KING, [*the* ARCH]BISHOP[OF
CANTERBURY], Champion, Nobles, [*and the*] QUEEN.

 Cant. Long live King Edward, by the grace of God,
King of England and Lord of Ireland.
 Champ. If any Christian, Heathen, Turk, or Jew,
Dare but affirm that Edward's not true King,
And will avouch[15] his saying with the sword,
I am the champion that will combat him.
 Mort. Jun. None comes, sound trumpets.

[Trumpets sound.]

 K. Edw. III. Champion,
 here's to thee.[16] 79
 Queen. Lord Mortimer, now take him to your charge.

Enter Soldiers, *with* KENT *prisoner.*

 Mort. Jun. What traitor have we there with blades
 and bills?
 Sold. Edmund, the Earl of Kent.
 K. Edw III. What hath he done?
 Sold. 'A would have taken the King away perforce,
As we were bringing him to Killingworth.
 Mort. Jun. Did you attempt his rescue, Edmund?
 Speak.
 Kent. Mortimer, I did; he is our King,
And thou compellest this prince to wear the crown.
 Mort. Jun. Strike off his head! he shall have
 martial law.[17] 88
 Kent. Strike off my head! base traitor, I defy thee.
 K. Edw. III. My lord, he is my uncle, and shall live.
 Mort. Jun. My lord, he is your enemy, and shall die.
 Kent. Stay, villains!
 K. Edw. III. Sweet mother, if I cannot pardon him,

[3] *quit:* cleared. [4] *cast:* calculated.
[5] *I use much:* It is my custom (ironically).
[6] *lawn:* piece of linen.
[7] *congé:* bow, usually at leavetaking.
[8] *Aristarchus':* the most famous grammarian and school-master of the pre-Christian era, and hence a notably severe or censorious man. [9] *breeching:* flogging.
[10] *bashful:* "modest"; in context, "hypocritically modest."
[11] *imbecility:* weakness. [12] *L.:* a very heavy burden.
[13] *L.:* undertook the task (charge of a province).
[14] *L.:* I am greater than one whom Fortune is able to harm (slightly modified from Ovid, *Metamorphoses,* VI. 195).
[15] *avouch:* support.
[16] *here's to thee:* The King drinks (like Claudius in *Hamlet*), or perhaps gives a purse.
[17] *martial law:* Kent was tried and condemned by parliament. Marlowe is aggrandizing Mortimer's role as despot.

Entreat my lord protector for his life.
 Queen. Son, be content; I dare not speak a word.
 K. Edw. III. Nor I, and yet methinks I should
 command;
But, seeing I cannot, I'll entreat for him.
My lord, if you will let my uncle live,
I will requite it when I come to age.
 Mort. Jun. 'Tis for your highness' good, and for
 the realm's. 100
How often shall I bid you bear him hence?
 Kent. Art thou King? Must I die at thy command?
 Mort. Jun. At our command. Once more away with
 him.
 Kent. Let me but stay and speak; I will not go.
Either my brother or his son is King,
And none of both them thirst for Edmund's blood:
And therefore, soldiers, whither will you hale me?

 They hale KENT *away, and carry him to be beheaded.*

 K. Edw. III. What safety may I look for at his hands,
If that my uncle shall be murdered thus?
 Queen. Fear not, sweet boy; I'll guard thee from
 thy foes; 110
Had Edmund lived he would have sought thy death.
Come, son, we'll ride a-hunting in the park.
 K. Edw. III. And shall my uncle Edmund ride with
 us?
 Queen. He is a traitor; think not on him; come.
 Exeunt omnes.

[V.v]

 Enter MATREVIS *and* GURNEY.

 Mat. Gurney, I wonder the King dies not,
Being in a vault [1] up to the knees in water,
To which the channels of the castle run,
From whence a damp continually ariseth,
That were enough to poison any man,
Much more a king brought up so tenderly.
 Gurney. And so do I, Matrevis: yesternight
I opened but the door to throw him meat,
And I was almost stifled with the savor. [2]
 Mat. He hath a body able to endure 10
More than we can inflict: and therefore now
Let us assail his mind another while.
 Gurney. Send for him out thence, and I will anger
 him.

V.v.
 [1] *vault:* In Holinshed's account, the vault or dungeon is
below the room in which Edward is confined. Marlowe
engrosses the horror. [2] *savor:* (foul) smell.
 [3] *conster:* interpret. [4] *for the nonce:* on purpose.
 [5] *L.:* He dies. [6] *lake:* pit, dungeon.
 [7] *spit:* So Holinshed: "with heavie feather beddes, (or a
table as some write) being cast upon him, they kept him
downe, and withall put into his fundament an horne, and
through the same they thrust up into his bodie a hote spitte
. . . the which passing up into his intrayles, and being rolled
to and fro, burnt the same, but so as no appearance of any
wounde or hurt outwardly might bee once perceyved."
 [8] *gear:* business.

 Mat. But stay, who's this?

 Enter LIGHTBORN.

 Light. My Lord Protector greets you.

 [*Gives letter.*]

 Gurney. What's here? I know not how to conster [3] it.
 Mat. Gurney, it was left unpointed for the nonce; [4]
"*Edwardum occidere nolite timere,*"
That's his meaning.
 Light. Know you this token? I must have the King.

 [*Gives token.*]

 Mat. Ay, stay awhile, thou shalt have answer
 straight. 20
 [*Aside*] This villain's sent to make away the King.
 Gurney. [*Aside*] I thought as much.
 Mat. [*Aside*] And when the
 murder's done,
See how he must be handled for his labor.
Pereat iste! [5] Let him have the King.
What else? Here is the key, this is the lake, [6]
Do as you are commanded by my lord.
 Light. I know what I must do. Get you away.
Yet be not far off, I shall need your help;
See that in the next room I have a fire,
And get me a spit, [7] and let it be red-hot. 30
 Mat. Very well.
 Gurney. Need you anything besides?
 Light. What else? A table and a feather-bed.
 Gurney. That's all?
 Light. Ay, ay; so, when I call you, bring it in.
 Mat. Fear not you that.
 Gurney. Here's a light, to go into the dungeon.

 [*Gives a light, and then exit with* MATREVIS.]

 Light. So now
Must I about this gear; [8] ne'er was there any
So finely handled as this King shall be.
Foh, here's a place indeed, with all my heart. 40
 King. Who's there? What light is that? Wherefore
 comes thou?
 Light. To comfort you, and bring you joyful news.
 King. Small comfort finds poor Edward in thy looks.
Villain, I know thou comst to murder me.
 Light. To murder you, my most gracious lord!
Far is it from my heart to do you harm.
The Queen sent me to see how you were used,
For she relents at this your misery:
And what eyes can refrain from shedding tears,
To see a king in this most piteous state? 50
 King. Weepst thou already? List awhile to me
And then thy heart, were it as Gurney's is,
Or as Matrevis', hewn from the Caucasus,
Yet will it melt, ere I have done my tale.
This dungeon where they keep me is the sink
Wherein the filth of all the castle falls.
 Light. Oh, villains!
 King. And there in mire and puddle have I stood
This ten days' space; and, lest that I should sleep,
One plays continually upon a drum. 60

They give me bread and water, being a king;
So that, for want of sleep and sustenance,
My mind's distempered, and my body's numbed,
And whether I have limbs or no I know not.
Oh, would my blood dropped out from every vein,
As doth this water from my tattered robes.
Tell Isabel, the Queen, I looked not thus,
When for her sake I ran at tilt in France,[9]
And there unhorsed the duke of Clerémont.
 Light. Oh, speak no more, my lord; this breaks
 my heart. 70
Lie on this bed, and rest yourself awhile.
 King. These looks of thine can harbor naught but
 death:
I see my tragedy written in thy brows.
Yet stay awhile; forbear thy bloody hand,
And let me see the stroke before it comes,
That even[10] then when I shall lose my life,
My mind may be more steadfast on my God.
 Light. What means your highness to mistrust me
 thus?
 King. What means thou to dissemble with me thus?
 Light. These hands were never stained with
 innocent blood, 80
Nor shall they now be tainted with a king's.
 King. Forgive my thought for having such a thought.
One jewel have I left; receive thou this.

 [Giving jewel.]

Still fear I, and I know not what's the cause,
But every joint shakes as I give it thee.
Oh, if thou harborst murder in they heart,
Let this gift change thy mind, and save thy soul.
Know that I am a king; Oh, at that name
I feel a hell of grief! where is my crown?
Gone, gone, and do I remain alive? 90
 Light. You're overwatched, my lord; lie down and
 rest.
 King. But that grief keeps me waking, I should
 sleep;
For not these ten days have these eyes' lids closed.
Now as I speak they fall, and yet with fear
Open again. Oh, wherefore sits thou here?
 Light. If you mistrust me, I'll be gone, my lord.
 King. No, no, for if thou meanst to murder me,
Thou wilt return again, and therefore stay.

 [Sleeps.]

 Light. He sleeps.

 [The KING *awakes.]*

 King. Oh, let me not die, yet stay, oh, stay a
 while! 100
 Light. How now, my lord?
 King. Something still buzzeth in mine ears,
And tells me if I sleep I never wake;
This fear is that which makes me tremble thus;
And therefore tell me, wherefore art thou come?
 Light. To rid thee of thy life. Matrevis, come!

 [Enter MATREVIS *and* GURNEY.]

 King. I am too weak and feeble to resist:
Assist me, sweet God, and receive my soul!
 Light. Run for the table.
 King. Oh, spare me, or dispatch me in a trice.[11] 110

 [MATREVIS *brings in a table.*]

 Light. So, lay the table down, and stamp on it,
But not too hard, lest that you bruise his body.

 [KING EDWARD *is murdered.*]

 Mat. I fear me that this cry[12] will raise the town,
And therefore let us take horse and away.
 Light. Tell me, sirs, was it not bravely done?
 Gurney. Excellent well: take this for thy reward.

 Then GURNEY *stabs* LIGHTBORN [, *who dies*].

Come, let us cast the body in the moat,
And bear the King's to Mortimer our lord:
Away!

 Exeunt omnes [*with the bodies*].

[V.vi]

 Enter MORTIMER [junior] *and* MATREVIS.

 Mort. Jun. Is't done, Matrevis, and the murderer
 dead?
 Mat. Ay, my good lord; I would it were undone.
 Mort. Jun. Matrevis, if thou now growest penitent
I'll be thy ghostly father;[1] therefore choose,
Whether thou wilt be secret in this,
Or else die by the hand of Mortimer.
 Mat. Gurney, my lord, is fled, and will, I fear,
Betray us both; therefore let me fly.
 Mort. Jun. Fly to the savages.
 Mat. I humbly thank your honor. 10
 [Exit.]
 Mort. Jun. As for myself, I stand as Jove's huge
 tree,[2]
And others are but shrubs compared to me.
All tremble at my name, and I fear none;
Let's see who dare impeach me for his death.

 Enter the QUEEN.

 Queen. Ah, Mortimer, the King my son hath news
His father's dead, and we have murdered him!

 [9] *Tell Isabel . . . France:* Cf. *First Part of the Contention,*
iii. 59ff, and *2 Henry VI,* I. iii. 50–2: "I tell thee, Pole, when in
the city Tours / Thou ran'st a tilt in honour of my love, / And
stol'st away the ladies' hearts of France."
 [10] *That even:* Emending "That and even" of original
editions. [11] *in a trice:* quickly.
 [12] *this cry:* Holinshed, records that "His crie did move
many within the castell and towne of Berkeley to com-
passion."
V.vi.
 [1] *ghostly father:* confessor (Mortimer will shrive Matrevis
befor executing him). Holinshed, records the banishing of
Matrevis and Gurney, and the subsequent beheading of the
latter, whose "betrayal" of Mortimer (V. vi. 45) is Marlowe's
invention. [2] *Jove's huge tree:* the oak.

Mort. Jun. What if we have? The King is yet a
child.

Queen. Ay, ay, but he tears his hair, and wrings his
hands,

And vows to be revenged upon us both.

Into the council-chamber he is gone, 20

To crave the aid and succor of his peers.

Ay me, see where he comes, and they with him;

Now, Mortimer, begins our tragedy.

Enter KING [EDWARD THE THIRD], *with the*
Lords [*and* Attendants].

1 Lord. Fear not, my lord, know that you are a
King.

K. Edw. III. Villain!—

Mort. Jun. How now, my lord?

K. Edw. III. Think not that I am frightened with
thy words.

My father's murdered through thy treachery;

And thou shalt die,[3] and on his mournful hearse

Thy hateful and accursèd head shall lie, 30

To witness to the world that by thy means

His kingly body was too soon interred.

Queen. Weep not, sweet son.

K. Edw. III. Forbid not me to weep, he was my
father;

And had you loved him half so well as I,

You could not bear his death thus patiently.

But you, I fear, conspired with Mortimer.

1 Lord. Why speak you not unto my lord the
King?

Mort. Jun. Because I think[4] scorn to be accused.

Who is the man dare say I murdered him? 40

K. Edw. III. Traitor, in me my loving father speaks,

And plainly saith, 'twas thou that murdredst him.

Mort. Jun. But hath your grace no other proof
than this?

K. Edw. III. Yes, if this be the hand of Mortimer.

[*Showing letter.*]

Mort. Jun. [*Aside*] False Gurney hath betrayed me
and himself.

Queen. [*Aside*] I feared as much; murder cannot be
hid.

Mort. Jun. 'Tis my hand;[5] what gather you by
this?

K. Edw. III. That thither thou didst send a
murderer.

Mort. Jun. What murderer? Bring forth the man I
sent.

K. Edw. III. Ah, Mortimer, thou knowest that he
is slain; 50

And so shalt thou be too. Why stays he here?

Bring him unto a hurdle,[6] drag him forth;

Hang him, I say, and set his quarters[7] up;

But bring his head back presently[8] to me.

Queen. For my sake, sweet son, pity Mortimer.

Mort. Jun. Madam, entreat not, I will rather die,

Than sue for life unto a paltry boy.

K. Edw. III. Hence with the traitor, with the
murderer!

Mort. Jun. Base Fortune, now I see, that in thy
wheel

There is a point, to which when men aspire, 60

They tumble headlong down: that point I touched,

And, seeing there was no place to mount up higher,

Why should I grieve at my declining fall?

Farewell, fair Queen; weep not for Mortimer,

That scorns the world, and, as a traveler,

Goes to discover countries yet unknown.

K. Edw. III. What! suffer you the traitor to delay?

[MORTIMER junior *is taken away by* 1 Lord *and*
Attendants.]

Queen. As thou receivedst thy life from me,

Spill not the blood of gentle Mortimer!

K. Edw. III. This argues that you spilt my father's
blood, 70

Else would you not entreat for Mortimer.

Queen. I spill his blood? No.

K. Edw. III. Ay, madam, you; for so the rumor runs.

Queen. That rumor is untrue; for loving thee

Is this report raised on poor Isabel.

K. Edw. III. I do not think her so unnatural.

2 Lord. My lord, I fear me it will prove too true.

K. Edw. III. Mother, you are suspected for his
death,

And therefore we commit you to the Tower[9]

Till further trial may be made thereof; 80

If you be guilty, though I be your son,

Think not to find me slack or pitiful.

Queen. Nay, to my death, for too long have I lived,

Whenas[10] my son thinks to abridge my days.

K. Edw. III. Away with her, her words enforce
these tears,

And I shall pity her if she speak again.

Queen. Shall I not mourn for my belovèd lord,

And with the rest accompany him to his grave?

2 Lord. Thus, madam, 'tis the King's will you shall
hence.

Queen. He hath forgotten me; stay, I am his
mother. 90

2 Lord. That boots[11] not; therefore, gentle madam,
go.

Queen. Then come, sweet death, and rid me of this
grief.

[*Exit.*]

[*Re-enter* 1 Lord, *with the head of* MORTIMER
junior.]

1 Lord. My Lord, here is the head of Mortimer.

[3] *die:* Marlowe compressing history; three years elapse
between Edward's murder and the execution of Mortimer.
[4] *think:* think it.
[5] *my hand:* At V. iv. 6, the letter is said by Mortimer to
be "written by a friend of ours."
[6] *hurdle:* carriage bearing criminals to execution.
[7] *quarters:* Mortimer is to be hanged and "quartered"
or cut up into parts. [8] *presently:* immediately.
[9] *to the Tower:* Marlowe's heightening of the punishment
of the Queen, who was merely debarred from travel.
[10] *Whenas:* When. [11] *boots:* avails.

K. Edw. III. Go fetch my father's hearse, where it
 shall lie;
And bring my funeral robes.

 [*Exeunt* Attendants.]
 Accursèd head,
Could I have ruled thee then, as I do now,
Thou hadst not hatched this monstrous treachery!
Here comes the hearse; help me to mourn, my lords.

 [*Re-enter* Attendants *with the hearse and
 funeral robes*].
Sweet father, here unto thy murdered ghost
I offer up this wicked traitor's head; 100
And let these tears, distilling from mine eyes,
Be witness of my grief and innocency.
 [*Exeunt.*]

 F I N I S

Robert Greene

[1558–1592]

FRIAR BACON AND FRIAR BUNGAY

GREENE'S life was as rich and fascinating a phenomenon as any of the literary legacy he has left us, as Virginia Woolf perceived in making him a central figure in her brilliant novel *Orlando*. He lived it swiftly and intensely, and he wrote about it in a series of fictions and homiletic autobiographical pamphlets that made him as vivid a man as any of his period. The son of a Norwich saddler, he was educated at St. John's College, Cambridge, where he earned the B.A. in 1578 and the M.A. in 1583, years in which university students were notorious for their rowdiness and academic study offered little to attract them away from it; between the awarding of the two degrees he traveled in Italy, Spain, France, Germany, Poland, and Denmark, drinking too much and indulging in dissipations he was later to report with horror. He alternated between periods of debauchery and of religious conversion, attracted one day by the sermon of a Cambridge preacher and the next by the renewal of old and unfortunate friendships, marrying a respectable young woman and, her dowry spent, throwing her out with their child. Both he and his enemies had their own reasons for exaggerating the sordidness of his life, but there is no denying the luridness of the figure he cut in London during the 1580s: constantly in debt, allied with a notorious hoodlum named Cutting Ball, who ended his life on the gallows and whose sister became Greene's mistress and mother of his son Fortunatus, hanging around the worst districts of the city, forever changing residences, in pawnshops and taverns and only by the grace of Ball's gang saved from debtors' prison, longhaired, redbearded, and elegantly dressed. In 1592 Greene fell ill after a supper with Thomas Nashe and a few others at which, his detractor Gabriel Harvey reports, he overindulged in Rhenish wine and pickled herring, and after a month of lonely misery, ignored by his friends except for a shoemaker and his wife who took him in, and in a frenzy of remorse, he died on September 3. Despite the note of envy that recurs in his autobiographical writings, of Marlowe and later of Shakespeare and others, Greene seems to have been a likeable and generous man whose vices hurt him more than they did those of his acquaintances lucky enough not to be members of his family.

During his last decade Greene wrote constantly. His immediate motivation was doubtless the money he always needed. But he wrote with the vigor and color of a talented professional, and his work appealed to a wide audience in one of the great periods of English literature. The writings include pamphlets exposing the ways of the London underworld, prose romances—most notably *Pandosto*, source of *The Winter's Tale*—which were the day's equivalent of the novel, lyric poetry, and plays. His career as dramatist began with *Alphonsus, King of Aragon*, an imitation of TAMBURLAINE probably written in 1587, and produced, in addition to the two plays included in this volume, *Orlando Furioso* (c. 1591), a romantic play loosely based on elements of Ariosto's Italian epic, and *James the Fourth* (c. 1591), a lively mixture of Scottish pseudo-history, fantasy, and comedy reminiscent of FRIAR BACON AND FRIAR BUNGAY. A number of plays have been attributed to Greene with varying degrees of plausibility, the most likely being *George a Greene, the Pinner of Wakefield*, which has some of the rustic charm and ebullience of his best plays.

FRIAR BACON AND FRIAR BUNGAY was probably written in 1589–90, though any date before his death in 1592 is plausible. It was performed a number of times by Lord Strange's Men at the Rose in 1592 and 1593, but may have had earlier performances, and it continued to hold the stage for a number of years. Though the play was printed three times before the closing of the theaters, the 1594 Quarto (Q1), of which only four copies survive, is the only authoritative script and the basis of the present text. The major source was a prose romance of the mid-sixteenth century, *The Famous History of Friar Bacon*, of which the earliest extant edition dates from 1627. Holinshed's *Chronicles* and other works dealing with history and with magic supplied some additional materials.

Little in Greene's life might lead one to expect FRIAR BACON AND FRIAR BUNGAY. The romanticized and nostalgic view of rural England, of course, is precisely the kind of thing such a man might have created to attract an audience who lived in the largest and most squalid and congested metropolis, outside of Paris, in all of Europe. But the play is more than an urban audience's pipe dream. A comic hymn to the virtues of English life at court, in the university, and in the countryside, it deals in each instance with a theme familiar in much Renaissance literature: the question of role and identity, of what one can properly do with one's powers, of life's capacity to satisfy one's ambitions without disaster. In each of the play's actions the principal characters come to terms with the limits of their being, and in their reconciliations they glorify the life of England. Greene's cheerful nationalism typifies the optimism of much literature in the years following the victory over the Spanish Armada; a decade later it

would be a note thoroughly out of fashion. Equally characteristic of the period is the ambivalent fascination with magic, evident too in DOCTOR FAUSTUS; William Empson has some interesting things to say on this subject in the course of a suggestive essay on Greene's play in *Some Versions of Pastoral*, and Wayne Shumaker provides much useful background in *The Occult Sciences in the Renaissance*. FRIAR BACON AND FRIAR BUNGAY is a mature comedy, an achievement that shows that the University Wits had, by the beginning of Shakespeare's career, integrated the elements of earlier drama into a free and imaginative new kind of theater; thus Miles is our old friend the Vice transformed, and the skillfully arranged multiple plot brings a new smoothness and elegance to an old convention. After such a play *A Midsummer Night's Dream* and *As You Like It* are, if not really predictable, at least not isolated and inexplicable anomalies. N. R.

Friar Bacon and Friar Bungay

DRAMATIS PERSONÆ

KING HENRY THE THIRD
EDWARD, PRINCE OF WALES, *his son*
EMPEROR OF GERMANY
KING OF CASTILE
DUKE OF SAXONY
LACY, *Earl of Lincoln* ⎫
WARREN, *Earl of Sussex* ⎬ *Edward's friends*
ERMSBY, *a Gentleman* ⎭
RAFE SIMNELL, *the King's fool*
FRIAR BACON
MILES, *his poor scholar*
FRIAR BUNGAY
JACQUES VANDERMAST, *a German magician*
BURDEN ⎫
MASON ⎬ *Oxford doctors*
CLEMENT ⎭
LAMBERT ⎫
SERLSBY ⎬ *country squires*
TWO SCHOLARS, *their sons*
THE KEEPER OF FRESSINGFIELD

HIS FRIEND
THOMAS ⎫
RICHARD ⎬ *rustics*
A CONSTABLE
A POST, *serving Lacy*

LORDS, GENTLEMEN, SERVANTS, *attending King*
 Henry's court
COUNTRY CLOWNS *at Harleston Fair*

ELEANOR, *daughter to the King of Castile*
MARGARET, *the Keeper's daughter, called the Fair Maid*
 of Fressingfield
JOAN, *a country wench*
HOSTESS OF THE BELL, *at Henley*

TWO DEVILS
THE VOICE OF BACON'S BRAZEN HEAD
A SPIRIT IN THE SHAPE OF HERCULES

[i]

Enter [PRINCE EDWARD], *malcontented; with* LACY,
Earl of Lincoln; JOHN WARREN, *Earl of Sussex;*
and ERMSBY, *Gentleman;* RAFE SIMNELL, *the*
King's fool; [*other lords and gentlemen*].

Lacy. Why looks my lord like to a troubled sky
When heaven's bright shine is shadowed with a fog?
Alate[1] we ran the deer, and through the lawns
Stripped[2] with our nags the lofty frolic[3] bucks
That scudded 'fore the teasers[4] like the wind.
Ne'er was the deer of merry Fressingfield[5]
So lustily pulled down by jolly mates,
Nor shared the farmers such fat venison,
So frankly dealt,[6] this hundred years before;
Nor have I seen my lord more frolic in the chase, 10
And now changed to a melancholy dump.[7]
 War. After the prince got to the keeper's lodge
And had been jocund in the house a while,
Tossing[8] of ale and milk in country cans,
Whether it was the country's sweet content,
Or else the bonny damsel filled[9] us drink,
That seemed so stately in her stammel[10] red,
Or that a qualm did cross his stomach then,
But straight he fell into his passions.
 Erm. Sirrah Rafe, what say you to your master? 20
Shall he thus all amort[11] live malcontent?
 Rafe. Hearest thou, Ned? Nay, look if he will speak
to me.

Edw. What sayst thou to me, fool?
Rafe. I prithee tell me, Ned, art thou in love with
the keeper's daughter?
Edw. How if I be, what then?
Rafe. Why then, sirrah, I'll teach thee how to deceive
love.
Edw. How, Rafe? 30
Rafe. Marry, sirrah Ned, thou shalt put on my cap
and my coat and my dagger,[12] and I will put on thy
clothes and thy sword, and so thou shalt be my fool.
Edw. And what of this?
Rafe. Why, so thou shalt beguile Love, for Love is
such a proud scab[13] that he will never meddle with
fools nor children. Is not Rafe's counsel good, Ned?
Edw. Tell me, Ned Lacy, didst thou mark the maid,
How lively in her country weeds[14] she looked?
A bonnier wench all Suffolk cannot yield. 40
All Suffolk! Nay, all England holds none such.

i.

[1] *Alate:* Lately. [2] *Stripped:* Outstripped.
[3] *frolic:* merry, joyous.
[4] *teasers:* deerhounds trained to rouse the game.
[5] *Fressingfield:* a Suffolk village south of Norwich.
[6] *frankly dealt:* freely distributed.
[7] *dump:* fit of abstraction or depression.
[8] *Tossing:* Drinking. [9] *filled:* who filled.
[10] *stammel:* coarse woolen cloth, usually red, for making
petticoats. [11] *all amort:* dejected (French *à la mort*).
[12] *cap . . . coat . . . dagger:* parts of the costume worn by
clowns. [13] *scab:* scoundrel. [14] *weeds:* clothes.

Rafe. Sirrah Will Ermsby, Ned is deceived.

Erm. Why, Rafe?

Rafe. He says all England hath no such, and I say, and I'll stand to it, there is one better in Warwickshire.

War. How provest thou that, Rafe?

Rafe. Why, is not the abbot a learned man and hath read many books, and thinkest thou he hath not more learning than thou to choose a bonny wench? Yes, I warrant thee, by his whole grammar. 50

Erm. A good reason, Rafe.

Edw. I tell thee, Lacy, that her sparkling eyes
Do lighten forth sweet love's alluring fire;
And in her tresses she doth fold the looks
Of such as gaze upon her golden hair;
Her bashful [15] white mixed with the morning's red
Luna [16] doth boast upon her love cheeks;
Her front [17] is beauty's table,[18] where she [19] paints
The glories of her gorgeous excellence;
Her teeth are shelves of precious margarites [20] 60
Richly enclosed with ruddy coral cleeves.[21]
Tush, Lacy, she is beauty's over-match,
If thou survey'st her curious imagery.[22]

Lacy. I grant, my lord, the damsel is as fair
As simple Suffolk's homely [23] towns can yield;
But in the court be quainter [24] dames than she,
Whose faces are enriched with honor's taint,[25]
Whose beauties stand upon the stage of fame
And vaunt their trophies in the courts of Love.[26]

Edw. Ah, Ned, but hadst thou watched her as
 myself, 70
And seen the secret [27] beauties of the maid,
Their courtly coyness [28] were but foolery.

Erm. Why, how watched you her, my lord?

Edw. When as [29] she swept like Venus through the
 house,
And in her shape fast folded up my thoughts,
Into the milkhouse went I with the maid,
And there amongst the cream bowls she did shine
As Pallas 'mongst her princely huswifery.[30]
She turned her smock over her lily arms
And dived them into milk to run [31] her cheese; 80
But, whiter than the milk, her crystal skin,
Checked with lines of azure, made her blush,
That art or nature durst bring for compare.[32]
Ermsby, if thou hadst seen, as I did note it well,
How beauty played the huswife, how this girl,
Like Lucrece, laid her fingers to the work,
Thou would'st with Tarquin [33] hazard Rome and all
To win the lovely maid of Fressingfield.

Rafe. Sirrah Ned, wouldst fain have her?

Edw. Ay, Rafe. 90

Rafe. Why, Ned, I have laid the plot in my head thou [34] shalt have her already.

Edw. I'll give thee a new coat, and [35] learn [36] me that.

Rafe. Why, sirrah Ned, we'll ride to Oxford to Friar Bacon. Oh, he is a brave [37] scholar, sirrah; they say he is a brave nigromancer,[38] that he can make women of devils, and he can juggle cats into costermongers.[39]

Edw. And how then, Rafe?

Rafe. Marry, sirrah, thou shalt go to him, and because thy father Harry shall not miss thee, he shall 100

turn me into thee; and I'll to the court and I'll prince it out, and he shall make thee either a silken purse, full of gold, or else a fine wrought smock.

Edw. But how shall I have the maid?

Rafe. Marry, sirrah, if thou beest a silken purse full of gold, then on Sundays she'll hang thee by her side, and you must not say a word. Now, sir, when she comes into a great press of people, for fear of the cutpurse, on a sudden she'll swap [40] thee into her plackerd;[41] then, sirrah, being there, you may plead for yourself. 110

Erm. Excellent policy!

Edw. But how if I be a wrought smock?

Rafe. Then she'll put thee into her chest and lay thee into lavender, and upon some good day she'll put thee on, and at night when you go to bed, then being turned from a smock to a man, you may make up the match.

Lacy. Wonderfully wisely counseled, Rafe.

Edw. Rafe shall have a new coat.

Rafe. God thank you when I have it on my back, Ned.

Edw. Lacy, the fool hath laid a perfect plot; 120
For why [42] our country Margaret is so coy.
And stands so much upon her honest points,[43]
That marriage or no market with the maid,
Ermsby, it must be nigromantic spells
And charms of art [44] that must enchain her love,
Or else shall Edward never win the girl.
Therefore, my wags, we'll horse us in the morn,
And post to Oxford to this jolly friar.
Bacon shall by his magic do this deed. 129

War. Content, my lord; and that's a speedy way
To wean these headstrong puppies from the teat.

Edw. I am unknown, not taken for the prince;
They only deem us [45] frolic courtiers
That revel thus among our liege's game;
Therefore I have devised a policy.
Lacy, thou know'st next Friday is Saint James',[46]

[15] *bashful:* modest. [16] *Luna:* goddess of the moon.
[17] *front:* forehead. [18] *table:* tablet for painting.
[19] *she:* i.e., Beauty. [20] *margarites:* pearls.
[21] *cleeves:* cliffs.
[22] *curious imagery:* beautifully wrought form.
[23] *homely:* humble. [24] *quainter:* more exquisite.
[25] *taint:* tint.
[26] *courts of love:* chivalric courts that adjudicated disputes over matters of love. [27] *secret:* not publicly displayed.
[28] *coyness:* reserve. [29] *When as:* When.
[30] *Pallas . . . huswifery:* Pallas Athene was sometimes worshipped as goddess of the domestic arts of weaving and spinning. [31] *run:* cause to coagulate.
[32] *made . . . compare:* would have put to shame any woman who had been made eligible for comparison either by natural beauty or by cosmetics.
[33] *Lucrece . . . Tarquin:* the familiar story of the chaste Roman wife who killed herself after being raped by Sextus Tarquin, son of the last Etruscan king of Rome.
[34] *head thou:* head how thou. [35] *and:* if.
[36] *learn:* teach. [37] *brave:* splendid.
[38] *nigromancer:* necromancer.
[39] *costermongers:* applesellers. [40] *swap:* move quickly.
[41] *plackerd:* placket, slit at the top of a skirt or petticoat.
[42] *For why:* Because.
[43] *honest points:* chaste principles.
[44] *art:* the art of magic. [45] *only deem us:* deem us only.
[46] *Saint James':* St. James's day, July 25.

And then the country flocks to Harleston[47] fair;
Then will the keeper's daughter frolic there,
And over-shine the troop of all the maids
That come to see and to be seen that day. 140
Haunt thee disguised among the country swains;
Feign th'art a farmer's son not far from thence;
Espy her loves, and who she liketh best;
Cote[48] him, and court her to control[49] the clown.[50]
Say that the courtier 'tired all in green,
That helped her handsomely to run her cheese
And filled her father's lodge with venison,
Commends him,[51] and sends fairings[52] to herself.
Buy something worthy of her parentage,
Not worth her beauty, for, Lacy, then the fair 150
Affords no jewel fitting for the maid.
And when thou talkest of me, note if she blush;
Oh, then she loves; but if her cheeks wax pale,
Disdain it is. Lacy, send[53] how she fares,
And spare no time nor cost to win her loves.
 Lacy. I will, my lord, so execute this charge
As if that Lacy were in love with her.
 Edw. Send letters speedily to Oxford of the news.
 Rafe. And, sirrah Lacy, buy me a thousand thousand
million of fine bells. 160
 Lacy. What wilt thou do with them, Rafe?
 Rafe. Marry, every time that Ned sighs for the
keeper's daughter, I'll tie a bell about him; and so
within three or four days I will send word to his father
Harry that his son and my master Ned is become love's
morris-dance.[54]
 Edw. Well, Lacy, look with care unto thy charge,
And I will haste to Oxford to the friar,

That he by art, and thou by secret gifts,
Mayst make me lord of merry Fressingfield. 170
 Lacy. God send your honor your heart's desire.
 Exeunt.

[ii]

Enter FRIAR BACON *with* MILES, *his poor scholar,*[1]
 with books under his arm; with them BURDEN,
 MASON, CLEMENT, *three doctors.*

 Bacon. Miles, where are you?
 Miles. Hic sum, dostissime et reverendissime doctor.[2]
 Bacon. Attulisti nos libros meos de necromantia?[3]
 Miles. Ecce quam bonum et quam jocundum, habitares
libros in unum.[4]
 Bacon. Now, masters of our academic state,
That rule in Oxford, viceroys in your place,
Whose heads contain maps of the liberal arts,
Spending your time in depth of learnèd skill,
Why flock you thus to Bacon's secret cell, 10
A friar newly stalled[5] in Brazen-nose?[6]
Say what's your mind, that I may make reply.
 Burd. Bacon, we hear that[7] long we have suspect,
That thou art read in magic's mystery;
In pyromancy[8] to divine by flames;
To tell[9] by hydromantic[10] ebbs and tides;
By aeromancy[11] to discover doubts,[12]
To plain out questions, as Apollo[13] did.
 Bacon. Well, Master Burden, what of all this? 19
 Miles. Marry, sir, he doth but fulfill by rehearsing of
these names the fable of the fox and the grapes: that
which is above us pertains nothing to us.
 Burd. I tell thee, Bacon, Oxford makes report,
Nay, England, and the court of Henry says
Th'art making of a brazen head by art
Which shall unfold strange doubts and aphorisms[14]
And read a lecture in philosophy,
And by the help of devils and ghastly fiends,
Thou mean'st, ere many years or days be past,
To compass England with a wall of brass. 30
 Bacon. And what of this?
 Miles. What of this, master? Why, he doth speak
mystically,[15] for he knows if your skill fail to make a
brazen head, yet Mother Waters'[16] strong ale will fit
his turn to make him have a copper[17] nose.
 Clem. Bacon, we come not grieving at thy skill,
But joying that our academy yields
A man supposed the wonder of the world;
For if thy cunning work these miracles,
England and Europe shall admire[18] thy fame, 40
And Oxford shall in characters of brass
And statues such as were built up in Rome
Eternize Friar Bacon for his art.
 Mas. Then, gentle friar, tell us thy intent.
 Bacon. Seeing you come as friends unto the friar,
Resolve you,[19] doctors: Bacon can by books
Make storming Boreas[20] thunder from his cave
And dim fair Luna to a dark eclipse.
The great arch-ruler, potentate of hell,
Trembles, when Bacon bids him or his fiends 50

Bow to the force of his pentageron.[21]
What art can work, the frolic friar knows;
And therefore will I turn my magic books
And strain out nigromancy to the deep.
I have contrived and framed a head of brass
(I made Belcephon[22] hammer out the stuff),
And that by art shall read philosophy;
And I will strengthen England by my skill,
That if ten Caesars lived and reigned in Rome,
With all the legions Europe doth contain, 60
They should not touch a grass of English ground.
The work that Ninus reared at Babylon,
The brazen walls framed by Semiramis,
Carved out like to the portal of the sun,
Shall not be such as rings the English strand[23]
From Dover to the market place of Rye.
 Burd. Is this possible?
 Miles. I'll bring ye two or three witnesses.
 Burd. What be those?
 Miles. Marry, sir, three or four as honest devils and
good companions as any be in hell. 71
 Mas. No doubt but magic may do much in this,
For he that reads but mathematic[24] rules
Shall find conclusions that avail to work
Wonders that pass the common sense[25] of men.
 Burd. But Bacon roves[26] a bow beyond his reach,
And tells of more than magic can perform,
Thinking to get a fame by fooleries.
Have I not passed as far in state of schools,[27]
And read of many secrets? Yet to think 80
That heads of brass can utter any voice,
Or more, to tell of deep philosophy—
This is a fable Aesop had forgot.
 Bacon. Burden, thou wrong'st me in detracting thus;
Bacon loves not to stuff himself with lies.
But tell me 'fore these doctors, if thou dare,
Of certain questions I shall move to thee.
 Burd. I will; ask what thou can.
 Miles. Marry, sir, he'll straight be on your pick-
pack[28] to know whether the feminine or the masculine
gender be most worthy. 91
 Bacon. Were you not yesterday, Master Burden, at
Henley[29] upon the Thames?
 Burd. I was; what then?
 Bacon. What book studied you thereon all night?
 Burd. I? None at all; I read not there a line.
 Bacon. Then, doctors, Friar Bacon's art knows
naught.
 Clem. What say you to this, Master Burden? Doth
he not touch you? 100
 Burd. I pass not of[30] his frivolous speeches.
 Miles. Nay, Master Burden, my master, ere he hath
done with you, will turn you from a doctor to a dunce,
and shake you so small that he will leave no more learn-
ing in you than is in Balaam's ass.[31]
 Bacon. Masters, for that learned Burden's skill is
 deep,
And sore he doubts of Bacon's cabalism,[32]
I'll show you why he haunts to Henley oft:
Not, doctors, for to taste the fragrant air,
But there to spend the night in alchemy, 110

To multiply with secret spells of art.
Thus private steals he learning from us all.
To prove my sayings true, I'll show you straight
The book he keeps at Henley for himself.
 Miles. Nay, now my master goes to conjuration; take
heed.
 Bacon. Masters, stand still; fear not. I'll show you
but his book.
 [*Here he conjures.*]
Per omnes deos infernales, Belcephon.[33]

 Enter a Woman *with a shoulder of mutton on a spit,
 and a* Devil.

 Miles. Oh, master, cease your conjuration or you spoil
all, for here's a she-devil come with a shoulder of 120
mutton on a spit. You have marred the devil's supper;
but no doubt he thinks our college fare is slender, and
so hath sent you his cook with a shoulder of mutton to
make it exceed.[34]
 Host. Oh, where am I, or what's become of me?
 Bacon. What art thou?
 Host. Hostess at Henley, mistress of the Bell.
 Bacon. How camest thou here?
 Host. As I was in the kitchen 'mongst the maids,
Spitting the meat against[35] supper for my guess,[36]
A motion[37] moved me to look forth of door. 131
No sooner had I pried[38] into the yard,
But straight a whirlwind hoisted me from thence
And mounted me aloft unto the clouds.
As in a trance, I thought nor feared naught,
Nor know I where or whither I was ta'en,
Nor where I am, nor what these persons be.
 Bacon. No? Know you not Master Burden?
 Host. Oh, yes, good sir, he is my daily guest.
What, Master Burden, 'twas but yesternight 140
That you and I at Henley played at cards.
 Burd. I know not what we did; a pox of all conjuring
 friars!
 Clem. Now, jolly friar, tell us, is this the book
That Burden is so careful to look on?
 Bacon. It is; but, Burden, tell me now,
Thinkest thou that Bacon's nigromantic skill
Cannot perform his head and wall of brass,
When he can fetch thine hostess in such post?[39]
 Miles. I'll warrant you, master, if Master Burden

[21] *pentageron:* pentagonon, five-pointed mystical symbol credited with magical powers, including that of holding off witches and ghosts.
[22] *Belcephon:* unidentified in occult literature.
[23] *strand:* coast.
[24] *mathematic:* astrological or astronomical.
[25] *sense:* perception.
[26] *roves:* shoots at a mark (technical term of archery).
[27] *state of schools:* academic honors.
[28] *pick-pack:* pick-a-back (i.e., riding piggyback).
[29] *Henley:* a town between Oxford and London.
[30] *pass not of:* care not for.
[31] *Balaam's ass:* see Numbers xxii:22–34.
[32] *cabalism:* esoteric art.
[33] *L.:* By all the infernal gods, Belcephon.
[34] *exceed:* surpass. [35] *against:* in expectation of.
[36] *guess:* guests (obsolete form).
[37] *motion:* impulse. [38] *pried:* peered. [39] *post:* speed.

could conjure as well as you, he would have his book
every night from Henley to study on at Oxford. 151

Mas. Burden, what, are you mated [40] by this frolic
 friar?
Look how he droops; his guilty conscience
Drives him to bash [41] and makes his hostess blush.

Bacon. Well, mistress, for I will not have you missed,
You shall to Henley to cheer up your guests
'Fore supper 'gin. Burden, bid her adieu,
Say farewell to your hostess 'fore she goes.
Sirrah, away, and set her safe at home.

Host. Master Burden, when shall we see you at
 Henley? 160

 Exeunt Hostess *and the* Devil.

Burd. The devil take thee and Henley too.

Miles. Master, shall I make a good motion? [42]

Bacon. What's that?

Miles. Marry, sir, now that my hostess is gone to
provide supper, conjure up another spirit, and send
Doctor Burden flying after.

Bacon. Thus, rulers of our academic state,
You have seen the friar frame his art by proof;
And as the college callèd Brazen-nose
Is under him, and he the master there, 170
So surely shall this head of brass be framed,
And yield forth strange and uncouth [43] aphorisms;
And hell and Hecate shall fail the friar,
But I will circle England round with brass.

Miles. So be it, *et nunc et semper.* [44] Amen.

 Exeunt omnes.

[iii]

Enter MARGARET, *the fair Maid of Fressingfield,
with* THOMAS, [RICHARD,] *and* JOAN, *and other
 clowns;* LACY, *disguised in country apparel.*

Thom. By my troth, Margaret, here's a weather is
able to make a man call his father whoreson. If this
weather hold, we shall have hay good cheap, [1] and butter
and cheese at Harleston will bear no price.

Marg. Thomas, maids, when they come to see the fair,
Count not to make a cope [2] for dearth of hay.
When we have turned our butter to the salt,
And set our cheese safely upon the racks,
Then let our fathers price it as they please.
We country sluts [3] of merry Fressingfield 10
Come to buy needless naughts [4] to make us fine,
And look that young men should be frank [5] this day,

[40] *mated:* confounded. [41] *bash:* loss of self-confidence.
[42] *motion:* proposal. [43] *uncouth:* unknown.
[44] *L.:* both now and forever.

iii.
[1] *good cheap:* at a low price. [2] *cope:* bargain.
[3] *sluts:* girls. [4] *naughts:* trifles. [5] *frank:* generous.
[6] *chapmen:* merchants. [7] *soothe ... up:* cajole.
[8] *scoff's:* jest's. [9] *broad before:* unsubtle.
[10] *Beccles:* Suffolk market town near Harleston.
[11] *by:* nearby. [12] *quaint:* over-refined.
[13] *forget yourself:* are mistaken (some editors assign this
sentence to Lacy). [14] *Goodman:* master of a household.
[15] *jade:* nag. [16] *hilding:* worthless wretch.
[17] *gray:* conventional color worn by shepherds in pastoral
literature.

And court us with such fairings as they can.
Phoebus is blithe, and frolic looks from heaven
As when he courted lovely Semele,
Swearing the pedlars shall have empty packs,
If that fair weather may make chapmen [6] buy.

Lacy. But, lovely Peggy, Semele is dead,
And therefore Phoebus from his palace pries,
And, seeing such a sweet and seemly saint, 20
Shows all his glories for to court yourself.

Marg. This is a fairing, gentle sir, indeed,
To soothe me up [7] with such smooth flattery;
But learn of me, your scoff's [8] too broad before. [9]
Well, Joan, our beauties must abide their jests;
We serve the turn in jolly Fressingfield.

Joan. Margaret, a farmer's daughter for a farmer's
 son.
I warrant you the meanest of us both
Shall have a mate to lead us from the church.
But, Thomas, what's the news? What, in a dump? 30
Give me your hand, we are near a pedlar's shop;
Out with your purse; we must have fairings now.

Thom. Faith, Joan, and shall. I'll bestow a fairing on
you, and then we will to the tavern and snap off a pint
of wine or two.

All this while LACY *whispers* MARGARET *in the ear.*

Marg. Whence are you, sir? Of Suffolk? For your
 terms
Are finer than the common sort of men.

Lacy. Faith, lovely girl, I am of Beccles [10] by, [11]
Your neighbor not above six miles from hence,
A farmer's son that never was so quaint [12] 40
But that he could do courtesy to such dames.
But trust me, Margaret, I am sent in charge
From him that reveled in your father's house,
And filled his lodge with cheer and venison,
'Tired in green. He sent you this rich purse,
His token that he helped you run your cheese,
And in the milkhouse chatted with yourself.

Marg. To me? You forget yourself. [13]

Lacy. Women are often weak in memory.

Marg. Oh, pardon, sir, I call to mind the man. 50
'Twere little manners to refuse his gift,
And yet I hope he sends it not for love;
For we have little leisure to debate of that.

Joan. What, Margaret, blush not; maids must have
 their loves.

Thom. Nay, by the Mass, she looks pale as if she
 were angry.

Rich. Sirrah, are you of Beccles? I pray, how doth
Goodman [14] Cob? My father bought a horse of him.
I'll tell you, Marget, 'a were good to be a gentleman's
jade, [15] for of all things the foul hilding [16] could not
abide a dungcart. 60

Marg. [*Aside*] How different is this farmer from the
 rest
That erst as yet hath pleased my wand'ring sight.
His words are witty, quickened with a smile,
His courtesy gentle, smelling of the court;
Facile and debonair in all his deeds,
Proportional as was Paris, when, in gray, [17]

He courted Oenon[18] in the vale by Troy.
Great lords have come and pleaded for my love—
Who but the keeper's lass of Fressingfield?
And yet methinks this farmer's jolly[19] son 70
Passeth the proudest[20] that hath pleased mine eye.
But, Peg, disclose not that thou art in love,
And show as yet no sign of love to him,
Although thou well wouldst wish him for thy love;
Keep that to thee, till time doth serve thy turn
To show the grief wherein thy heart doth burn.
Come, Joan and Thomas, shall we to the fair?
You, Beccles man, will not forsake us now?
 Lacy. Not whilst I may have such quaint girls as you.
 Marg. Well, if you chance to come by Fressingfield,
Make but a step into the keeper's lodge, 81
And such poor fare as woodmen can afford—
Butter and cheese, cream, and fat venison—
You shall have store, and welcome therewithal.
 Lacy. Gramercies,[21] Peggy; look for me ere long.
 Exeunt omnes.

[iv]

Enter [KING] HENRY THE THIRD; *the* EMPEROR
[of Germany]; *the* KING of Castile; ELEANOR,
his daughter; JACQUES VANDERMAST, *a German*
[scientist].

 Hen. Great men of Europe, monarchs of the west,
Ringed with the walls of old Oceanus,[1]
Whose lofty surge is like the battlements
That compassed high-built Babel in with towers,
Welcome, my lords, welcome, brave western kings,
To England's shore, whose promontory cleeves
Shows[2] Albion[3] is another little world.
Welcome says English Henry to you all;
Chiefly unto the lovely Eleanor,
Who dared for Edward's sake cut through the seas, 10
And venture as Agenor's damsel[4] through the deep,
To get the love of Henry's wanton[5] son.
 Cast. England's rich monarch, brave Plantagenet,
The Pyren Mounts[6] swelling above the clouds,
That ward the wealthy Castile in with walls,
Could not detain the beauteous Eleanor;
But, hearing of the fame of Edward's youth,
She dared to brook Neptunus' haughty pride
And bide the brunt of froward Aeolus.
Then may fair England welcome her the more. 20
 Ele. After that English Henry, by his lords,
Had sent Prince Edward's lovely[7] counterfeit,[8]
A present to the Castile Eleanor,
The comely portrait of so brave a man,
The virtuous fame discoursèd of his deeds,
Edward's courageous resolution
Done at the Holy Land 'fore Damas'[9] walls,
Led both mine eye and thoughts in equal links
To like so of the English monarch's son
That I attempted perils for his sake. 30
 Emp. Where is the prince, my lord?
 Hen. He posted down, not long since, from the court
To Suffolk side,[10] to merry Fremingham,[11]
To sport himself amongst my fallow deer;

From thence, by packets sent to Hampton House,[12]
We hear the prince is ridden with his lords
To Oxford, in the academy there
To hear dispute amongst the learned men.
But we will send forth letters for my son,
To will him come from Oxford to the court. 40
 Emp. Nay, rather, Henry, let us, as we be,
Ride for to visit Oxford with our train.
Fain would I see your universities
And what learned men your academy yields.
From Hapsburg have I brought a learned clerk
To hold dispute with English orators.
This doctor, surnamed Jacques Vandermast,
A German born, passed into[13] Padua,
To Florence, and to fair Bologna,
To Paris, Rheims, and stately Orleans, 50
And, talking there with men of art, put down
The chiefest of them all in aphorisms,
In magic, and the mathematic rules.
Now let us, Henry, try him in your schools.
 Hen. He shall, my lord; this motion likes me well.
We'll progress[14] straight to Oxford with our trains,
And see what men our academy brings.
And, wonder[15] Vandermast, welcome to me;
In Oxford shalt thou find a jolly friar
Called Friar Bacon, England's only flower. 60
Set him but nonplus in his magic spells,
And make him yield in mathematic rules,
And for thy glory I will bind thy brows
Not with a poet's garland made of bays,
But with a coronet of choicest gold.
Whilst[16] then we fit to Oxford with our troops,
Let's in and banquet in our English court.
 [*Exeunt.*]

[v]

Enter RAFE SIMNELL *in Edward's apparel;*
EDWARD, WARREN, ERMSBY, *disguised.*

 Rafe. Where be these vagabond knaves, that they
attend no better on their master?

 [18] *Oenon:* Oenone, nymph who lived on Mount Ida near
Troy; Paris's love before Helen.
 [19] *jolly:* fresh, high-spirited.
 [20] *proudest:* finest looking. [21] *Gramercies:* Thanks.
iv.
 [1] *Oceanus:* mythical river thought by the Greeks to en-
circle the earth.
 [2] *Shows:* singular form for plural subject, frequent in
Elizabethan English.
 [3] *Albion:* England; i.e., the island is like a miniature
Europe.
 [4] *Agenor's damsel:* Europa, daughter of Agenor, King of
Tyre, was carried across the sea on the back of a bull into
which Jupiter had transformed himself.
 [5] *wanton:* amorous. [6] *Pyren Mounts:* Pyrenees.
 [7] *lovely:* lovable. [8] *counterfeit:* portrait.
 [9] *Damas':* Damascus'. [10] *side:* border.
 [11] *Fremingham:* the quarto's spelling of a Suffolk market
village properly called Framlingham, though pronounced
"Fromingham" by local people.
 [12] *Hampton House:* to be built in the reign of Henry VIII.
 [13] *passed into:* traveled through.
 [14] *progress:* journey in state. [15] *wonder:* wondrous.
 [16] *Whilst:* Until.

Edw. If it please your honor, we are all ready at an inch.[1]

Rafe. Sirrah Ned, I'll have no more post horse to ride on. I'll have another fetch.[2]

Erm. I pray you, how is that, my lord?

Rafe. Marry, sir, I'll send to the Isle of Ely[3] for four of five dozen of geese, and I'll have them tied six and six together with whipcord. Now upon their backs 10 will I have a fair field-bed with a canopy; and so, when it is my pleasure, I'll flee[4] into what place I please. This will be easy.

War. Your honor hath said well; but shall we to Brazen-nose College before we pull off our boots?

Erm. Warren, well motionèd; we will to the friar Before we revel it within the town. Rafe, see you keep your countenance[5] like a prince.

Rafe. Wherefore have I such a company of cutting[6] knaves to wait upon me, but to keep and defend 20 my countenance against all mine enemies? Have you not good swords and bucklers?

Enter BACON *and* MILES.

Erm. Stay, who comes here?

War. Some scholar; and we'll ask him where Friar Bacon is.

Bacon. Why, thou arrant dunce, shall I never make thee good scholar? Doth not all the town cry out and say, Friar Bacon's subsizar[7] is the greatest blockhead in all Oxford? Why, thou canst not speak one word of true Latin. 30

Miles. No, sir? Yes; what is this else? *Ego sum tuus homo,* "I am your man." I warrant you, sir, as good Tully's[8] phrase as any is in Oxford.

Bacon. Come on, sirrah, what part of speech is *Ego?*

Miles. *Ego,* that is "I"; marry, *nomen substantivo.*

Bacon. How prove you that?

Miles. Why, sir, let him prove himself and 'a will: "I" can be heard, felt, and understood.

Bacon. Oh, gross dunce!

Here beat him.

Edw. Come, let us break off this dispute between these two. Sirrah, where is Brazen-nose College? 41

Miles. Not far from Coppersmiths' Hall.[9]

Edw. What, dost thou mock me?

Miles. Not I, sir; but what would you at Brazen-nose?

Erm. Marry, we would speak with Friar Bacon.

Miles. Whose men be you?

Erm. Marry, scholar, here's our master.

Rafe. Sirrah, I am the master of these good fellows; mayst thou not know me to be a lord by my re- 50 parel?[10]

Miles. Then here's good game for the hawk, for here's the master fool and a covey of coxcombs;[11] one wise man, I think, would spring[12] you all.

Edw. Gog's[13] wounds! Warren, kill him.

War. Why, Ned, I think the devil be in my sheath; I cannot get out my dagger.

Erm. Nor I mine. 'Swones,[14] Ned, I think I am bewitched.

Miles. A company of scabs. The proudest of you all draw your weapon, if he can. [*Aside*] See how boldly I speak, now my master is by. 62

Edw. I strive in vain; but if my sword be shut And conjured fast by magic in my sheath, Villain, here is my fist.

Strike him a box on the ear.

Miles. Oh, I beseech you, conjure his hands, too, that he may not lift his arms to his head, for he is light-fingered.[15]

Rafe. Ned, strike him. I'll warrant thee by mine honor. 70

Bacon. What means the English prince to wrong my man?

Edw. To whom speakest thou?

Bacon. To thee.

Edw. Who art thou?

Bacon. Could you not judge when all your swords grew fast
That Friar Bacon was not far from hence?
Edward, King Henry's son, and Prince of Wales,
Thy fool disguised cannot conceal thyself.
I know both Ermsby and the Sussex earl, 80
Else Friar Bacon had but little skill.
Thou comest in post from merry Fressingfield,
Fast-fancied[16] to the keeper's bonny lass,
To crave some succor of the jolly friar;
And Lacy, Earl of Lincoln, hast thou left
To 'treat[17] fair Margaret to allow thy loves;
But friends are men, and love can baffle lords.
The earl both woos and courts her for himself.

War. Ned, this is strange; the friar knoweth all.

Erm. Apollo could not utter more than this. 90

Edw. I stand amazed to hear this jolly friar
Tell even the very secrets of my thoughts.
But, learned Bacon, since thou knowest the cause
Why I did post so fast from Fressingfield,
Help, friar, at a pinch,[18] that I may have
The love of lovely Margaret to myself,
And, as I am true Prince of Wales, I'll give
Living and lands to strength[19] thy college state.[20]

War. Good friar, help the prince in this.

v.

[1] *at an inch:* on a moment's notice. [2] *fetch:* trick.
[3] *Isle of Ely:* a hilly area of Cambridgeshire rising above fens noted for the fish and geese bred there. [4] *flee:* fly.
[5] *keep your countenance:* hold your expression.
[6] *cutting:* swaggering.
[7] *subsizar:* Cambridge term for a student who received free room and board in exchange for tuition.
[8] *Tully's:* Cicero's; Miles's pedantic conversation parodies both pseudo-scholarly affectation and commonplace instruction in grammar.
[9] *Coppersmith's Hall:* perhaps a joking allusion to a tavern (cf. ii. 35). [10] *reparel:* error for "apparel."
[11] *coxcombs:* the caps, standard accessories of the fool, worn by the disguised prince and his companions.
[12] *spring:* to cause (birds) to rise from cover.
[13] *Gog's:* God's. [14] *'Swones:* By God's wounds.
[15] *light-fingered:* regular term used of pickpockets.
[16] *Fast-fancied:* Tied by love. [17] *'treat:* entreat.
[18] *at a pinch:* in a time of need. [19] *strength:* strengthen.
[20] *college state:* the estate of the college.

Rafe. Why, servant Ned, will not the friar do it?
Were not my sword glued to my scabbard by 101
conjuration, I would cut off his head, and make him
do it by force.

Miles. In faith, my lord, your manhood and your
sword is all alike; they are so fast conjured that we shall
never see them.

Erm. What, doctor, in a dump? Tush, help the
prince,
And thou shalt see how liberal he will prove.

Bacon. Crave not such actions greater dumps than
these?
I will, my lord, strain out my magic spells; 110
For this day comes the earl to Fressingfield,
And 'fore that night shuts in the day with dark,
They'll be betrothèd each to other fast.
But come with me; we'll to my study straight,
And in a glass prospective²¹ I will show
What's done this day in merry Fressingfield.

Edw. Gramercies, Bacon; I will quite²² thy pain.

Bacon. But send your train, my lord, into the town;
My scholar shall go bring them to their inn.
Meanwhile we'll see the knavery of the earl. 120

Edw. Warren, leave me; and, Ermsby, take the fool;
Let him be master, and go revel it
Till I and Friar Bacon talk awhile.

War. We will, my lord.

Rafe. Faith Ned, and I'll lord it out till thou comest.
I'll be Prince of Wales over all the blackpots²³ in
Oxford.

Exeunt [all except BACON *and* EDWARD].

[vi]

BACON *and* EDWARD *goes into the study.*¹

Bacon. Now, frolic Edward, welcome to my cell.
Here tempers² Friar Bacon many toys,
And holds this place his consistory court,³
Wherein the devils plead⁴ homage to his words.
Within this glass prospective thou shalt see
This day what's done in merry Fressingfield
'Twixt lovely Peggy and the Lincoln earl.

Edw. Friar, thou glad'st me. Now shall Edward try
How Lacy meaneth to his sovereign lord.

Bacon. Stand there and look directly in the glass. 10

Enter MARGARET *and* FRIAR BUNGAY.

What sees my lord?

Edw. I see the keeper's lovely lass appear
As bright-sun⁵ as the paramour of Mars,⁶
Only attended⁷ by a jolly friar.

Bacon. Sit still, and keep the crystal in your eye.

Marg. But tell me, Friar Bungay, is it true
That this fair courteous country swain,
Who says his father is a farmer nigh,
Can be Lord Lacy, Earl of Lincolnshire?

Bung. Peggy, 'tis true, 'tis Lacy, for my life, 20
Or else mine art and cunning both doth fail,
Left by Prince Edward to procure his loves;
For he in green that holp you run your cheese
Is son to Henry, and the Prince of Wales.

Marg. Be what he will, his lure is but for lust.
But did Lord Lacy like poor Margaret,
Or would he deign to wed a country lass,
Friar, I would his humble handmaid be,
And, for great wealth, quite⁸ him with courtesy.

Bung. Why, Margaret, dost thou love him? 30

Marg. His personage, like the pride of vaunting
Troy,
Might well avouch to shadow⁹ Helen's scape;¹⁰
His wit is quick, and ready in conceit,¹¹
As Greece afforded in her chiefest prime;
Courteous, ah, friar, full of pleasing smiles.
Trust me, I love too much to tell thee more;
Suffice to me he is England's paramour.

Bung. Hath not each eye that viewed thy pleasing face
Surnamèd thee Fair Maid of Fressingfield?

Marg. Yes, Bungay, and would God the lovely earl
Had that in *esse*¹² that so many sought. 41

Bung. Fear not, the friar will not be behind
To show his cunning to entangle love.

Edw. I think the friar courts the bonny wench.
Bacon, methinks he is a lusty churl.

Bacon. Now look, my lord.

Enter LACY.

Edw. Gog's wound's, Bacon, here comes Lacy!

Bacon. Sit still, my lord, and mark the comedy.

Bung. Here's Lacy. Margaret, step aside awhile.

Lacy. Daphne, the damsel that caught Phoebus fast,
And locked him in the brightness of her looks, 51
Was not so beauteous in Apollo's eyes¹³
As is fair Margaret to the Lincoln earl.
Recant thee, Lacy, thou art put in trust.
Edward, thy sovereign's son, hath chosen thee,
A secret¹⁴ friend, to court her for himself,
And darest thou wrong thy prince with treachery?
Lacy, love makes no exception of a friend,
Nor deems it of a prince but as a man.
Honor bids thee control him in his lust; 60
His wooing is not for to wed the girl,
But to entrap her and beguile the lass.
Lacy, thou lovest; then brook not such abuse,

²¹ *glass prospective:* magic glass that reflects what is in the future or at a distance.
²² *quite:* requite.
²³ *blackpots:* leather jugs for ale or wine.

vi.
¹ *study:* simply another area of the stage, not a localized inner stage. ² *tempers:* mixes, or fashions by heating.
³ *consistory court:* a secular or ecclesiastical tribunal.
⁴ *pleads:* Though changed to "plead" in the second quarto, this is an acceptable Elizabethan plural.
⁵ *bright-sun:* emended by most modern editors to "bright-some." ⁶ *paramour of Mars:* Venus.
⁷ *Only attended:* Attended only. ⁸ *quite:* requite.
⁹ *shadow:* conceal or foreshadow (a rather obscure passage).
¹⁰ *His . . . scape:* His appearance, like Paris's (pride of Troy), would be enough to excuse Helen's transgression.
¹¹ *conceit:* metaphor. ¹² *L.:* actuality.
¹³ *Daphne . . . Apollos' eyes:* Ovid's tale of Apollo's pursuit of Daphne until she was transformed into a laurel tree.
¹⁴ *secret:* confidential.

But wed her, and abide thy prince's frown,
For better die, than see her live disgraced.
 Marg. Come, friar, I will shake him from his dumps
How cheer you, sir? A penny for your thought.
You're early up; pray God it be the near.[15]
What, come from Beccles in a morn so soon?
 Lacy. Thus watchful[16] are such men as live in love,
Whose eyes brook broken slumbers for their sleep. 71
I tell thee, Peggy, since last Harleston fair
My mind hath felt a heap of passions.
 Marg. A trusty man, that court it for your friend.
Woo you still for the courtier all in green?
I marvel that he sues not for himself.
 Lacy. Peggy, I pleaded first to get your grace for
 him,
But when mine eyes surveyed your beauteous looks,
Love, like a wag,[17] straight dived into my heart,
And there did shrine the idea[18] of yourself. 80
Pity me, though I be a farmer's son,
And measure not my riches but my love.
 Marg. You are very hasty; for, to garden well,
Seeds must have time to sprout before they spring;
Love ought to creep as doth the dial's[19] shade,
For timely[20] ripe is rotten too too[21] soon.
 Bung. Deus hic;[22] room for a merry friar.
What, youth of Beccles, with the keeper's lass?
'Tis well. But, tell me, hear you any news?
 Marg. No, friar. What news? 90
 Bung. Hear you not how the pursevants[23] do post
With proclamations through each country town?
 Lacy. For what, gentle friar? Tell the news.
 Bung. Dwellst thou in Beccles and hear'st not of
these news?
Lacy, the Earl of Lincoln, is late fled
From Windsor court, disguisèd like a swain,
And lurks about the country here unknown.
Henry suspects him of some treachery,
And therefore doth proclaim in every way
That who can take the Lincoln earl shall have, 100
Paid in the exchequer, twenty thousand crowns.
 Lacy. The Earl of Lincoln! Friar, thou art mad.
It was some other; thou mistak'st the man.
The Earl of Lincoln! Why, it cannot be.
 Marg. Yes, very well, my lord, for you are he.
The keeper's daughter took you prisoner.
Lord Lacy, yield; I'll be your jailer once.
 Edw. How familiar they be, Bacon.

 Bacon. Sit still, and mark the sequel of their loves.
 Lacy. Then am I double prisoner to thyself. 110
Peggy, I yield. But are these news in jest?
 Marg. In jest with you, but earnest unto me;
For why these wrongs do wring me at the heart.
Ah, how these earls and noble men of birth
Flatter and feign to forge poor women's ill.
 Lacy. Believe me, lass, I am[24] the Lincoln earl
I not deny; but, 'tirèd thus in rags,
I lived disguised to win fair Peggy's love.
 Marg. What love is there where wedding ends not
 love?
 Lacy. I meant, fair girl, to make thee Lacy's wife.
 Marg. I little think that earls will stoop so low. 121
 Lacy. Say, shall I make thee countess ere I sleep?
 Marg. Handmaid unto the earl, so please himself;
A wife in name, but servant in obedience.
 Lacy. The Lincoln countess, for it shall be so.
I'll plight the bands,[25] and seal it with a kiss.
 Edw. Gog's wounds, Bacon, they kiss! I'll stab them!
 Bacon. Oh, hold your hands, my lord, it is the glass!
 Edw. Choler to see the traitors 'gree so well
Made me think the shadows substances. 130
 Bacon. 'Twere a long poinard,[26] my lord, to reach
 between
Oxford and Fressingfield. But sit still and see more.
 Bung. Well, Lord of Lincoln, if your loves be knit,
And that your tongues and thoughts do both agree,
To avoid ensuing jars,[27] I'll hamper up[28] the match.
I'll take my portace[29] forth and wed you here;
Then go to bed and seal up your desires.
 Lacy. Friar, content. Peggy, how like you this?
 Marg. What likes my lord is pleasing unto me.
 Bung. Then handfast[30] hand, and I will to my book.
 Bacon. What sees my lord now? 141
 Edw. Bacon, I see the lovers hand in hand,
The friar ready with his portace there
To wed them both; then am I quite undone.
Bacon, help now, if e'er thy magic served;
Help, Bacon; stop the marriage now,
If devils or nigromancy may suffice,
And I will give thee forty thousand crowns.
 Bacon. Fear not, my lord, I'll stop the jolly friar
For[31] mumbling up his orisons this day. 150
 Lacy. Why speak'st not, Bungay? Friar, to thy book.

BUNGAY *is mute, crying,* "Hud, hud."

 Marg. How lookst thou, friar, as a man distraught?
Reft of thy senses, Bungay? Show by signs,
If thou be dumb, what passions[32] holdeth thee.
 Lacy. He's dumb indeed. Bacon hath with his devils
Enchanted him, or else some strange disease
Or apoplexy hath possessed his lungs.
But, Peggy, what he cannot with his book,
We'll 'twixt us both unite it up in heart.
 Marg. Else let me die, my lord, a miscreant. 160
 Edw. Why stands Friar Bungay so amazed?[33]
 Bacon. I have struck him dumb, my lord; and if
 your honor please,
I'll fetch this Bungay straightway from Fressingfield,
And he shall dine with us in Oxford here.

Edw. Bacon, do that, and thou contentest me.
Lacy. Of courtesy, Margaret, let us lead the friar
Unto thy father's lodge, to comfort him
With broths, to bring him from this hapless trance.
Marg. Or else, my lord, we were passing[34] unkind
To leave the friar so in his distress.— 170

Enter a Devil, *and carry* [*off*] BUNGAY *on his back.*

Oh, help, my lord, a devil! a devil, my lord!
Look how he carries Bungay on his back!
Let's hence, for Bacon's spirits be abroad.
 Exeunt.

Edw. Bacon, I laugh to see the jolly friar
Mounted upon the devil, and how the earl
Flees with his bonny lass for fear.
As soon as Bungay is at Brazen-nose,
And I have chatted with the merry friar,
I will in post hie me to Fressingfield
And quite these wrongs on Lacy ere it be long. 180
Bacon. So be it, my lord. But let us to our dinner;
For ere we have taken our repast awhile,
We shall have Bungay brought to Brazen-nose.
 Exeunt.

[vii]

Enter three doctors, BURDEN, MASON, CLEMENT.

Mas. Now that we are gathered in the Regent House,[1]
It fits us talk about the King's repair;[2]
For he, trooped with[3] all the western kings
That lie alongst the Dansig seas by east,
North by the clime of frosty Germany,
The Almain[4] monarch, and the Saxon duke,
Castile, and lovely Eleanor with him,
Have in their jests[5] resolved for Oxford town.
Burd. We must lay plots of stately tragedies,
Strange[6] comic shows, such as proud Roscius[7] 10
Vaunted before the Roman emperors,
To welcome all the western potentates.
Clem. But more, the King by letters hath foretold
That Frederick, the Almain emperor,
Hath brought with him a German of esteem,
Whose surname is Don Jacques Vandermast,
Skillful in magic and those secret arts.
Mas. Then must we all make suit unto the friar,
To Friar Bacon, that he vouch[8] this task,
And undertake to countervail in skill 20
The German; else there's none in Oxford can
Match and dispute with learned Vandermast.
Burd. Bacon, if he will hold the German play,[9]
We'll teach him what an English friar can do.
The devil, I think, dare not dispute with him.
Clem. Indeed, mas[10] doctor, he pleasured you
In that he brought your hostess with her spit
From Henley, posting unto Brazen-nose.
Burd. A vengeance on the friar for his pains;
But, leaving that, let's hie to Bacon straight 30
To see if he will take this task in hand.
Clem. Stay, what rumor[11] is this? The town is up in
 a mutiny.
What hurly-burly is this?

Enter a Constable, *with* RAFE, WARREN, ERMSBY,
and MILES.

Cons. Nay, masters, if you were ne'er so good, you
shall before the doctors to answer your misdemeanor.
Burd. What's the matter, fellow?
Cons. Marry, sir, here's a company of rufflers[12] that
drinking in the tavern have made a great brawl, and
almost killed the vintner.
Miles. *Salve,*[13] Doctor Burden. This lubberly lur-
den,[14] 41
Ill-shaped and ill-facèd, disdained and disgracèd,
What he tell unto *vobis, mentitur de nobis.*[15]
Burd. Who is the master and chief of this crew?
Miles. *Ecce asinum mundi, fugura rotundi,*[16]
Neat,[17] sheat,[18] and fine, as brisk as a cup of wine.
Burd. What are you?
Rafe. I am, father doctor, as a man would say, the
bellwether of this company. These are my lords, and I
the Prince of Wales. 50
Clem. Are you Edward, the King's son?
Rafe. Sirrah Miles, bring hither the tapster that drew
the wine, and I warrant when they see how soundly I
have broke his head, they'll say 'twas done by no less
man than a prince.
Mas. I cannot believe that this is the Prince of Wales.
War. And why so, sir?
Mas. For they say the prince is a brave[19] and a wise
gentleman.
War. Why, and think'st thou, doctor, that is is not so
Dar'st thou detract and derogate from him, 61
Being so lovely and so brave a youth?
Erm. Whose face, shining with many a sugared smile,
Bewrays that he is bred of princely race?
Miles. And yet, master doctor, to speak like a
 proctor,
And tell unto you what is veriment[20] and true,
To cease of this quarrel, look but on his apparel;
Then mark but my talis,[21] he is great Prince of Wales,
The chief of our *gregis,*[22] and *filius regis.*[23] 69
Then 'ware what is done, for he is Henry's white[24] son.
Rafe. Doctors, whose doting nightcaps are not cap-
able of my ingenious dignity, know that I am Edward

[34] *passing:* exceedingly.

vii.
[1] *Regent House:* meeting place for governing board of a
university faculty. [2] *repair:* visit.
[3] *trooped with:* attended by. [4] *Almain:* German.
[5] *jests:* gests, itinerary of a royal progress.
[6] *Strange:* Exotic.
[7] *Roscius:* famous Roman actor of comic and tragic parts.
[8] *vouch:* think fit to.
[9] *hold . . . play:* keep him occupied (as in fencing).
[10] *Mas:* jocular shortening of "Master."
[11] *rumor:* clamor, noise.
[12] *rufflers:* swaggering fellows, blustering bullies.
[13] *L.:* Hail. [14] *lubberly lurden:* loutish dullard.
[15] *L.:* you, he lies about us.
[16] *L.:* Behold the jackass of the world, round in shape
("*fugura*" = *figura*"). [17] *Neat:* Undiluted.
[18] *sheat:* nimble(?).
[19] *brave:* handsome, splendidly dressed.
[20] *veriment:* truth. [21] *talis:* tales.
[22] *L.:* flock, band. [23] *L.:* king's son. [24] *white:* dear.

Plantagenet, whom if you displease, will make a ship
that shall hold all your colleges, and so carry away the
Niniversity[25] with a fair wind to the Bankside in South-
wark.[26] How say'st thou, Ned Warren, shall I not do it?

War. Yes, my good lord; and if it please your lord-
ship, I will gather up all your old pantofles,[27] and with
the cork make you a pinnace[28] of five hundred ton, that
shall serve the turn marvelous well, my lord. 80

Erm. And I, my lord, will have pioners[29] to under-
mine the town, that the very gardens and orchards be
carried away for your summer walks.

Miles. And I with *scientia* and great *diligentia*
Will conjure and charm to keep you from harm;
That *utrum horum mavis*,[30] your very great *navis*,[31]
Like Bartlet's ship,[32] from Oxford do skip,
With colleges and schools full loaden with fools.
Quid dices ad hoc,[33] worshipful *domine* Dawcock?[34]

Clem. Why, hare-brained courtiers, are you drunk or
mad, 90
To taunt us up with such scurrility?
Deem you us men of base and light[35] esteem,
To bring us such a fop for Henry's son?
Call out the beadles and convey them hence,
Straight to Bocardo;[36] let the roisters[37] lie
Close clapped in bolts, until their wits be tame.

Erms. Why, shall we to prison, my lord?

Rafe. What say'st, Miles, shall I honor the prison
with my presence?

Miles. No, no; out with your blades, and hamper[38]
these jades; 100
Have a flirt[39] and a crash, now play revel-dash,
And teach these *sacerdos*[40] that the Bocardos,
Like peasants and elves, are meet for themselves.[41]

Mas. To the prison with them, constable.

War. Well, doctors, seeing I have sported me
With laughing at these mad and merry wags,
Know that Prince Edward is at Brazen-nose,

And this, attirèd like the Prince of Wales,
Is Rafe, King Henry's only loved fool;
I, Earl of Sussex; and this, Ermsby, 110
One of the privy chamber to the King,
Who, while the prince with Friar Bacon stays,
Have reveled it in Oxford as you see.

Mas. My lord, pardon us: we knew not what you
were;
But courtiers may make greater scapes[42] than these.
Will't please your honor dine with me today?

War. I will, master doctor, and satisfy the vintner
for his hurt; only I must desire you to imagine him[43]
all this forenoon the Prince of Wales.

Mas. I will, sir. 120

Rafe. And upon that, I will lead the way; only I will
have Miles go before me, because I have heard Henry
say that wisdom must go before majesty.

Exeunt omnes.

[viii]

Enter PRINCE EDWARD *with his poniard in his
hand,* LACY *and* MARGARET.

Edw. Lacy, thou canst not shroud thy trait'rous
thoughts,
Nor cover as did Cassius[1] all his wiles;
For Edward hath an eye that looks as far
As Lynceus[2] from the shores of Grecia.
Did not I sit in Oxford by the friar,
And see thee court the maid of Fressingfield,
Sealing thy flattering fancies with a kiss?
Did not proud Bungay draw his portace forth
And, joining hand in hand, had married you,
If Friar Bacon had not struck[3] him dumb 10
And mounted him upon a spirit's back,
That we might chat at Oxford with the friar?
Traitor, what answer'st? Is not all this true?

Lacy. Truth all, my lord, and thus I make reply.
At Harleston Fair, there courting for your grace,
When as mine eyes surveyed her curious[4] shape,
And drew the beauteous glory of her looks
To dive into the center of my heart,
Love taught me that your honor did but jest,
That princes were in fancy but as men, 20
How that the lovely maid of Fressingfield
Was fitter to be Lacy's wedded wife
Than concubine unto the Prince of Wales.

Edw. Injurious Lacy, did I love thee more
That Alexander his Hephestion?[5]
Did I unfold the passions of my love
And lock them in the closet of thy thoughts?
Wert thou to Edward second to himself,
Sole friend, and partner of his secret loves?
And could a glance of fading beauty break 30
Th' enchainèd fetters of such private friends?
Base coward, false, and too effeminate
To be corival with a prince in thoughts!
From Oxford have I posted since I dined
To quite a traitor 'fore that Edward sleep.

Marg. 'Twas I, my lord, not Lacy stepped awry;
For oft he sued and courted for yourself,

[25] *Niniversity:* compound of "ninny" (fool) and "uni-
versity."

[26] *Bankside in Southwark:* area, on the south bank of the
Thames, where some of the principal London theaters were
located, including the Rose, at which this play was frequently
performed.

[27] *pantofles:* slippers, often made higher by the addition of
an inner cork sole.

[28] *pinnace:* small two-masted schooner-rigged vessel.

[29] *pioners:* trench-diggers, miners.

[30] *L.:* whichever of these you prefer. [31] *L.:* ship.

[32] *Bartlet's ship: The Ship of Fools*, Barclay's translation
of Brandt's satirical *Narrenschiff*.

[33] *L.:* What do you say to this?

[34] *domine Dawcock:* Master Simpleton.

[35] *light:* frivolous.

[36] *Bocardo:* prison in the old north gate of Oxford.

[37] *roisters:* rioters. [38] *hamper:* beat.

[39] *flirt:* sharp sudden blow. [40] *L.:* priests.

[41] *meet for themselves:* good enough for the likes of them.

[42] *scapes:* escapades. [43] *him:* Rafe.

viii.

[1] *cover . . . Cassius:* i.e., in concealing the conspiracy
against Caesar.

[2] *Lynceus:* one of the Argonauts, noted for his keen eye-
sight. [3] *stroke:* struck. [4] *curious:* rare.

[5] *Hephestion:* closest friend of Alexander the Great,
mourned with notorious extravagance.

And still[6] wooed for the courtier all in green;
But I, whom fancy made but over-fond,
Pleaded myself with looks as if I loved. 40
I fed mine eye with gazing on his face,
And, still bewitched, loved Lacy with my looks.
My heart with sighs, mine eyes pleaded with tears,
My face held pity and content at once,
And more I could not cipher out by signs[7]
But that I loved Lord Lacy with my heart.
Then, worthy Edward, measure with thy mind
If women's favors will not force men fall,
If beauty and if darts of piercing love
Is not of force to bury thoughts of friends. 50
　Edw. I tell thee, Peggy, I will have thy loves.
Edward or none shall conquer Margaret.
In frigates bottomed with rich Sethin[8] planks,
Topped with the lofty firs of Lebanon,
Stemmed and incased with burnished ivory,
And overlaid with plates of Persian wealth,
Like Thetis[9] shalt thou wanton[10] on the waves,
And draw the dolphins to thy lovely eyes,
To dance lavoltas[11] in the purple streams.
Sirens, with harps and silver psalteries, 60
Shall wait with music at thy frigate's stem
And entertain fair Margaret with their lays.
England and England's wealth shall wait on thee;
Britain shall bend unto her prince's love
And do due homage to thine excellence,
If thou wilt be but Edward's Margaret.
　Marg. Pardon, my lord. If Jove's great royalty
Sent me such presents as to Danaë,[12]
If Phoebus, 'tired in Latona's[13] weeds,
Come courting from the beauty of his lodge, 70
The dulcet tunes of frolic Mercury,
Not all the wealth heaven's treasury affords,
Should make me leave Lord Lacy or his love.
　Edw. I have learned at Oxford, then, this point of
　　schools:
Ablata causa, tollitur effectus.[14]
Lacy, the cause that Margaret cannot love
Nor fix her liking on the English prince,
Take him away, and then the effects will fail.
Villain, prepare thyself; for I will bathe
My poinard in the bosom of an earl. 80
　Lacy. Rather than live and miss fair Margaret's love,
Prince Edward, stop not at the fatal doom,[15]
But stab it home; end both my loves and life.
　Marg. Brave Prince of Wales, honored for royal
　　deeds,
'Twere sin to stain fair Venus' courts with blood.
Love's conquests ends, my lord, in courtesy;
Spare Lacy, gentle Edward; let me die,
For so both you and he do cease your loves.
　Edw. Lacy shall die as traitor to his lord.
　Lacy. I have deserved it; Edward, act it well. 90
　Marg. What hopes the prince to gain by Lacy's
　　death?
　Edw. To end the loves 'twixt him and Margaret.
　Marg. Why, thinks King Henry's son that
　　Margaret's love
Hangs in the uncertain balance of proud time,

That death shall make a discord of our thoughts?
No; stab the earl, and 'fore the morning sun
Shall vaunt him[16] thrice over the lofty east,
Margaret will meet her Lacy in the heavens.
　Lacy. If aught betides to lovely Margaret
That wrongs or wrings her honor from content, 100
Europe's rich wealth nor England's monarchy
Should not allure Lacy to overlive.
Then Edward, short[17] my life and end her loves.
　Marg. Rid[18] me, and keep a friend worth many
　　loves.
　Lacy. Nay, Edward, keep a love worth many friends.
　Marg. And if thy mind be such as fame hath blazed,[19]
Then, princely Edward, let us both abide[20]
The fatal resolution of thy rage;
Banish thou fancy and embrace revenge,
And in one tomb knit both our carcasses, 110
Whose hearts were linkèd in one perfect love.
　Edw. [*Aside*] Edward, art thou that famous Prince of
　　Wales
Who at Damasco beat the Saracens,
And brought'st home triumph on thy lance's point,
And shall thy plumes be pulled by Venus down?
Is it princely to dissever lover's leagues,
To part such friends as glory in their loves?
Leave, Ned, and make a virtue of this fault,
And further Peg and Lacy in their loves.
So in subduing fancy's passion, 120
Conquering thyself, thou get'st the richest spoil.—
Lacy, rise up. Fair Peggy, here's my hand.
The Prince of Wales hath conquered all his thoughts,
And all his loves he yields unto the earl.
Lacy, enjoy the maid of Fressingfield;
Make her thy Lincoln countess at the church,
And Ned, as he is true Plantagenet,
Will give her to thee frankly for thy wife.
　Lacy. Humbly I take her of my sovereign,
As if that Edward gave me England's right, 130
And riched me with the Albion diadem.
　Marg. And doth the English prince mean true?
Will he vouchsafe to cease his former loves,
And yield the title of a country maid
Unto Lord Lacy?
　Edw. I will, fair Peggy, as I am true lord.
　Marg. Then, lordly sir, whose conquest is as great,
In conquering love, as Caesar's victories,
Margaret, as mild and humble in her thoughts
As was Aspasia[21] unto Cyrus' self, 140

[6] *still:* always.
[7] *cipher out by signs:* communicate by facial or bodily
expression.
[8] *Sethin:* Shittim, Biblical name for acacia wood.
[9] *Thetis:* sea-nymph, mother of Achilles.
[10] *wanton:* play.　　　[11] *lavoltas:* lively, intricate dance.
[12] *Jove's . . . Danaë:* shut in a bronze chamber, Danaë
was visited by the god in a shower of gold.
[13] *Latona's:* referring to mother of Phoebus Apollo.
[14] *L.:* When the cause is removed, the effect is removed.
[15] *doom:* sentence.　　　　　[16] *him:* himself.
[17] *short:* shorten.　　　　[18] *Rid:* Get rid of, kill.
[19] *blazed:* proclaimed.　　　[20] *abide:* suffer.
[21] *Aspasia:* Cyrus's favorite concubine.

Yields thanks, and, next Lord Lacy, doth enshrine
Edward the second secret [22] in her heart.
 Edw. Gramercy, Peggy. Now that vows are passed, [23]
And that your loves are not to be revolt, [24]
Once, Lacy, friends again, come, we will post
To Oxford; for this day the King is there,
And brings for Edward Castile Eleanor.
Peggy, I must go see and view my wife;
I pray God I like her as I lovèd thee.
Beside, Lord Lincoln, we shall hear dispute 150
'Twixt Friar Bacon and learned Vandermast.
Peggy, we'll leave you for a week or two.
 Marg. As it please Lord Lacy; but love's foolish
 looks
Think footsteps miles and minutes to be hours.
 Lacy. I'll hasten, Peggy, to make short return.
But, please your honor, go unto the lodge;
We shall have butter, cheese, and venison;
And yesterday I brought for Margaret
A lusty bottle of neat claret wine.
Thus can we feast and entertain your grace. 160
 Edw. 'Tis cheer, Lord Lacy, for an emperor,
If he respect the person and the place.
Come, let us in; for I will all this night
Ride post until I come to Bacon's cell.
 Exeunt.

[ix]

Enter HENRY, EMPEROR, [DUKE of SAXONY,]
CASTILE, ELEANOR, VANDERMAST, BUNGAY,
 [*other* Lords *and* Attendants].

 Emp. Trust me, Plantagenet, these Oxford schools
Are richly seated near the river side;
The mountains full of fat and fallow deer,
The battling [1] pastures laid [2] with kine and flocks,
The town gorgeous with high-built colleges,
And scholars seemly in their grave attire,
Learned in searching [3] principles of art.
What is thy judgment, Jacques Vandermast?

 [22] *second secret:* next most intimate.
 [23] *passed:* exchanged. [24] *revolt:* overturned.

ix.
 [1] *battling:* battening, nourishing. [2] *laid:* laden.
 [3] *searching:* searching out.
 [4] *Oxenford:* old form of the name.
 [5] *Charm:* Overcome by magic.
 [6] *doubtful:* perplexing.
 [7] *Hermes:* Hermes Trismegistus, name given to author(s)
of influential neoplatonic writings and to Egyptian god
Thoth, who was associated with the Greek god Hermes and
thought to be author of all mystical doctrine.
 [8] *Melchie:* Malchus Porphyry, another neoplatonist.
 [9] *Pythagoras:* mathematician and philosopher important
in development of cabalism.
 [10] *the . . . essence:* the four elements.
 [11] *terra . . . rest:* earth is considered a point in comparison
to the others. [12] *compass:* sizes.
 [13] *demones:* spirits (trisyllabic). [14] *calls:* summons.
 [15] *L:* sons of the earth. [16] *massy:* heavy.
 [17] *under Luna's continent:* in the sublunary sphere, closest
to earth.

 Van. That lordly are the buildings of the town,
Spacious the rooms and full of pleasant walks; 10
But for the doctors, how that they be learned,
It may be meanly, for aught I can hear.
 Bung. I tell thee, German, Hapsburg holds none
 such,
None read so deep as Oxenford [4] contains.
There are within our academic state
Men that may lecture it in Germany
To all the doctors of your Belgic schools.
 Hen. Stand to him, Bungay. Charm [5] this
 Vandermast,
And I will use thee as a royal king.
 Van. Wherein darest thou dispute with me? 20
 Bung. In what a doctor and a friar can.
 Van. Before rich Europe's worthies put thou forth
The doubtful [6] question unto Vandermast.
 Bung. Let it be this: whether the spirits of pyro-
mancy or geomancy be most predominant in magic?
 Van. I say, of pyromancy.
 Bung. And I, of geomancy.
 Van. The cabalists that write of magic spells,
As Hermes, [7] Melchie, [8] and Pythagoras, [9]
Affirm that 'mongst the quadruplicity 30
Of elemental essence, [10] *terra* is but thought
To be a *punctum* squarèd to the rest; [11]
And that the compass [12] of ascending elements
Exceed in bigness as they do in height;
Judging the concave circle of the sun
To hold the rest in his circumference.
If, then, as Hermes says, the fire be great'st,
Purest, and only giveth shapes to spirits,
Then must these demones [13] that haunt that place
Be every way superior to the rest. 40
 Bung. I reason not of elemental shapes,
Nor tell I of the concave latitudes,
Noting their essence nor their quality,
But of the spirits that pyromancy calls, [14]
And of the vigor of the geomantic fiends.
I tell thee, German, magic haunts the grounds,
And those strange necromantic spells,
That work such shows and wondering in the world,
Are acted by those geomantic spirits
That Hermes calleth *terrae filii.* [15] 50
The fiery spirits are but transparent shades
That lightly pass as heralds to bear news;
But earthly fiends, closed in the lowest deep,
Dissever mountains, if they be but charged,
Being more gross and massy [16] in their power.
 Van. Rather these earthly geomantic spirits
Are dull and like the place where they remain;
For, when proud Lucifer fell from the heavens,
The spirits and angels that did sin with him
Retained their local essence as their faults, 60
All subject under Luna's continent. [17]
They which offended less hang in the fire,
And second faults did rest within the air;
But Lucifer and his proud-hearted fiends
Were thrown into the center of the earth,
Having less understanding than the rest,
As having greater sin and lesser grace.

Therefore such gross and earthly spirits do serve
For jugglers, witches, and vile [18] sorcerers;
Whereas the pyromantic genii 70
Are mighty, swift, and of far-reaching power.
But grant that geomancy hath most force;
Bungay, to please these mighty potentates,
Prove by some instance what thy art can do.

Bung. I will.

Emp. Now, English Harry, here begins the game;
We shall see sport between these learned men.

Van. What wilt thou do?

Bung. Show thee the tree leaved with refinèd gold,
Whereon the fearful [19] dragon held his seat, 80
That watched the garden called Hesperides,
Subdued and won by conquering Hercules.

Van. Well done.

Here BUNGAY *conjures, and the tree appears with
the dragon shooting fire.*

Hen. What say you, royal lordings, to my friar?
Hath he not done a point of cunning skill?

Van. Each scholar in the necromantic spells
Can do as much as Bungay hath performed.
But as Alcmena's [20] bastard razed this tree,
So will I raise him up as when he lived,
And cause him pull the dragon from his seat, 90
And tear the branches piecemeal from the root.
Hercules, *prodi*, [21] *prodi*, Hercules!

HERCULES *appears in his lion's skin.*

Herc. Quis me vult? [22]

Van. Jove's bastard son, thou Libyan Hercules,
Pull off the sprigs from off the Hesperian tree,
As once thou didst to win the golden fruit.

Herc. Fiat. [23]

Here he begins to break the branches.

Van. Now, Bungay, if thou canst by magic charm
The fiend appearing like great Hercules
From pulling down the branches of the tree, 100
Then art thou worthy to be counted learned.

Bung. I cannot.

Van. Cease, Hercules, until I give thee charge.
Mighty commander of this English isle,
Henry, come from the stout Plantagenets,
Bungay is learned enough to be a friar,
But to compare with Jacques Vandermast,
Oxford and Cambridge must go seek their cells
To find a man to match him in his art.
I have given nonplus to the Paduans, 110
To them of Sien, Florence, and Bologna,
Rheims, Louvain, and fair Rotherdam,
Frankford, Lutrech, [24] and Orleans;
And now must Henry, if he do me right,
Crown me with laurel, as they all have done.

Enter BACON.

Bacon. All hail to this royal company,
That sit to hear and see this strange dispute.
Bungay, how stand'st thou as a man amazed?
What, hath the German acted [25] more than thou?

Van. What art thou that questions thus? 120

Bacon. Men call me Bacon.

Van. Lordly thou lookest, as if that thou wert
learned;
Thy countenance, as if science held her seat
Between the circlèd arches of thy brows.

Hen. Now, monarchs, hath the German found his
match.

Emp. Bestir thee, Jacques, take not now the foil, [26]
Lest thou dost lose what foretime thou didst gain.

Van. Bacon, wilt thou dispute?

Bacon. No, unless he were more learned than
Vandermast;
For yet, tell me; what hast thou done? 130

Van. Raised Hercules to ruinate that tree
That Bungay mounted by his magic spells.

Bacon. Set Hercules to work.

Van. Now, Hercules, I charge thee to thy task.
Pull off the golden branches from the root.

Herc. I dare not. Seest thou not great Bacon here,
Whose frown doth act more than thy magic can?

Van. By all the thrones and dominations,
Virtues, powers, and mighty hierarchies, [27]
I charge thee to obey to Vandermast. 140

Herc. Bacon, that bridles headstrong Belcephon,
And rules Asmenoth, guider of the north,
Binds me from yielding unto Vandermast.

Hen. How now, Vandermast, have you met with
your match?

Van. Never before was't known to Vandermast
That man held devils in such obedient awe.
Bacon doth more than art, or else I fail.

Emp. Why, Vandermast, art thou overcome?
Bacon, dispute with him and try his skill.

Bacon. I come not, monarchs, for to hold dispute
With such a novice as is Vandermast. 151
I come to have your royalties to dine
With Friar Bacon here in Brazen-nose;
And for this German troubles but the place,
And holds this audience with a long suspense,
I'll send him to his academy hence.
Thou, Hercules, whom Vandermast did raise,
Transport the German unto Hapsburg straight,
That he may learn by travail, [28] 'gainst the spring,
More secret dooms [29] and aphorisms of art. 160
Vanish the tree and thou away with him.

Exit the Spirit *with* VANDERMAST *and the tree.*

Emp. Why Bacon, whither dost thou send him?

Bacon. To Hapsburg; there your highness at return
Shall find the German in his study safe.

Hen. Bacon, thou hast honored England with thy
skill,
And made fair Oxford famous by thine art;

18 *vile:* vild in Q. 19 *fearful:* frightening.
20 *Alcmena's:* referring to Hercules's mother.
21 *L.:* come forth. 22 *L.:* Who wishes me?
23 *L.:* Let it be done. 24 *Lutrech:* Utrecht(?).
25 *acted:* performed. 26 *foil:* defeat.
27 *thrones . . . hierarchies:* categories of devils arranged by
power.
28 *travail:* travel, labor (pun). 29 *dooms:* rules.

I will be English Henry to thyself.
But tell me, shall we dine with thee today?
 Bacon. With me, my lord; and while I fit my
 cheer,[30]
See where Prince Edward comes to welcome you, 170
Gracious as the morning star of heaven.
 Exit.

 Enter EDWARD, LACY, WARREN, ERMSBY.

 Emp. Is this Prince Edward, Henry's royal son?
How martial is the figure[31] of his face,
Yet lovely and beset with amorets.[32]
 Hen. Ned, where hast thou been?
 Edw. At Fremingham, my lord, to try your bucks
If they could 'scape the teasers or the toil;[33]
But hearing of these lordly potentates
Landed and progressed up to Oxford town,
I posted to give entertain to them— 180
Chief, to the Almain monarch; next to him,
And joint[34] with him, Castile and Saxony,
Are welcome as they may be to the English court.
Thus for the men. But see, Venus appears,
Or one that over-matcheth Venus in her shape.
Sweet Eleanor, beauty's high-swelling pride,
Rich nature's glory and her wealth at once,
Fair of all fairs, welcome to Albion;
Welcome to me, and welcome to thine own,
If that thou deign'st the welcome from myself. 190
 Ele. Martial Plantagenet, Henry's high-minded son,
The mark that Eleanor did count her aim,
I liked thee 'fore I saw thee; now, I love,
And so as in so short a time I may;
Yet so as time shall never break that so,
And therefore so accept of Eleanor.
 Cast. Fear not, my lord, this couple will agree,
If love may creep into their wanton eyes;
And therefore, Edward, I accept thee here,
Without suspense as my adopted son. 200
 Hen. Let me that joy in these consorting greets,[35]
And glory in these honors done to Ned,
Yield thanks for all these favors to my son,
And rest a true Plantagenet to all.

 Enter MILES *with a cloth and trenchers and salt.*

 Miles. Salvete, omnes, reges,[36] that govern your
 greges,[37]
In Saxony and Spain, in England and in Almain;

30 *cheer:* refreshments. 31 *figure:* features.
32 *amorets:* love-kindling looks. 33 *toil:* net.
34 *joint:* equally.
35 *consorting greets:* harmonious greetings.
36 *L.:* Hail, all you kings. 37 *L.:* people.
38 *rable:* rabble. 39 *sewer:* servant who sets the table.
40 *skills:* does it matter. 41 *sleights:* tricks.
42 *twopenny chop:* chopped meat in broth(?).
43 *L.:* your noble grace. 44 *L.:* beast.
45 *admire:* wonder. 46 *cates:* delicacies.
47 *use to:* are used to. 48 *drugs:* spices.
49 *carvels:* small, fast Portuguese ships.
50 *'gyptian courtesan:* Cleopatra.
51 *countermatch:* rival (i.e., Antony).
52 *Kandy:* Ceylonese district briefly occupied by Portu-
guese in sixteenth century.

For all this frolic rable[38] must I cover thee, table,
With trenchers, salt, and cloth, and then look for your
 broth.
 Emp. What pleasant fellow is this? 209
 Hen. 'Tis, my lord, Doctor Bacon's poor scholar.
 Miles [*Aside*] My master hath made me sewer[39] of
these great lords, and God knows I am as serviceable at
a table as a sow is under an apple tree. 'Tis no matter;
their cheer shall not be great, and therefore what skills[40]
where the salt stand, before or behind?
 [*Exit.*]
 Cast. These scholars knows more skill in axioms,
How to use quips and sleights[41] of sophistry,
Than for to cover courtly for a king.

 Enter MILES *with a mess of pottage and broth,*
 and after him, BACON.

 Miles. Spill, sir? Why, do you think I never carried
twopenny chop[42] before in my life? 220
By your leave, *nobile decus,*[43] for here comes Doctor
 Bacon's *pecus,*[44]
Being in his full age, to carry a mess of pottage.
 Bacon. Lordings, admire[45] not if your cheer be this,
For we must keep our academic fare.
No riot where philosophy doth reign;
And therefore, Henry, place these potentates,
And bid them fall unto their frugal cates.[46]
 Emp. Presumptuous friar, what scoff'st thou at a
 king?
What, dost thou taunt us with their peasants' fare,
And give us cates fit for country swains? 230
Henry, proceeds this jest of thy consent,
To twit us with such a pittance of such price?
Tell me, and Frederick will not grieve thee long.
 Hen. By Henry's honor and the royal faith
The English monarch beareth to his friend,
I knew not of the friar's feeble fare;
Nor am I pleased he entertains you thus.
 Bacon. Content thee, Frederick, for I showed the
 cates
To let thee see how scholars use to[47] feed,
How little meat refines our English wits. 240
Miles, take away, and let it be thy dinner.
 Miles. Marry, sir, I will. This day shall be a festival
 day with me,
For I shall exceed in the highest degree.
 Exit MILES.
 Bacon. I tell thee, monarch, all the German peers
Could not afford thy entertainment such,
So royal and so full of majesty,
As Bacon will present to Frederick.
The basest waiter that attends thy cups
Shall be in honors greater than thyself;
And for thy cates, rich Alexandria drugs,[48] 250
Fetched by carvels[49] from Egypt's richest straits,
Found in the wealthy strond of Africa,
Shall royalize the table of my king.
Wines richer than the 'gyptian courtesan[50]
Quaffed to Augustus' kingly countermatch[51]
Shall be caroused in English Henry's feasts;
Kandy[52] shall yield the richest of her canes;

Persia, down her Volga by canoes,
Send down the secrets of her spicery;
The Afric dates, mirabolans[53] of Spain,　　　　　260
Conserves and suckets[54] from Tiberias,
Cates from Judea, choicer than the lamp[55]
That fired Rome with sparks of gluttony,
Shall beautify the board for Frederick;
And therefore grudge not at a friar's feast.

　　　　　　　　　　　　　　　　　[*Exeunt.*]

[x]

　　Enter two gentlemen, LAMBERT *and* SERLSBY,
　　　　　　　with the Keeper.

　Lam. Come, frolic keeper of our liege's game,
Whose table spread hath ever venison
And jacks[1] of wine to welcome passengers,
Know I am in love with jolly Margaret,
That over-shines our damsels as the moon
Dark'neth the brightest sparkles of the night.
In Laxfield[2] here my land and living lies;
I'll make thy daughter jointer[3] of it all,
So thou consent to give her to my wife;
And I can spend five hundred marks a year.　　10
　Serl. I am the lands-lord, keeper, of thy holds;[4]
By copy[5] all thy living lies in me;
Laxfield did never see me raise my due.[6]
I will enfeoff[7] fair Margaret in all,
So she will take her to a lusty squire.
　Keep. Now, courteous gentles, if the keeper's girl
Hath pleased the liking fancy of you both,
And with her beauty hath subdued your thoughts,
'Tis doubtful[8] to decide the question.
It joys me that such men of great esteem　　20
Should lay their liking on this base estate,
And that her state should grow so fortunate
To be a wife to meaner men than you.
But sith[9] such squires will stoop to keeper's fee,[10]
I will, to avoid displeasure of you both,
Call Margaret forth, and she shall make her choice.

　　　　　　　　　　　　　　　　　Exit.

　Lam. Content, keeper, send her unto us.
Why, Serlsby, is thy wife so lately dead,
Are all thy loves so lightly passed over,
As thou canst wed before the year be out?　　30
　Serl. I live not, Lambert, to content the dead;
Nor was I wedded but for life to her.
The grave ends and begins a married state.

　　　　　Enter MARGARET.

　Lam. Peggy, the lovely flower of all towns,
Suffolk's fair Helen and rich England's star,
Whose beauty tempered with her huswifery
Makes England talk of merry Fressingfield!
　Serl. I cannot trick it up with poesies,
Nor paint my passions with comparisons,[11]
Nor tell a tale of Phoebus and his loves;　　40
But this believe me: Laxfield here is mine,
Of ancient rent seven hundred pounds a year,
And, if thou canst but love a country squire,
I will enfeoff thee, Margaret, in all.

I cannot flatter; try me, if thou please.
　Marg. Brave neighboring squires, the stay[12] of
　　Suffolk's clime,[13]
A keeper's daughter is too base in 'gree[14]
To match with men accompted[15] of such worth.
But might I not displease, I would reply.　　49
　Lam. Say, Peggy. Naught shall make us discontent.
　Marg. Then, gentles, note that love hath little
　　stay,[16]
Nor can the flames that Venus sets on fire
Be kindled but by fancy's motion.
Then pardon, gentles, if a maid's reply
Be doubtful, while I have debated with myself,
Who or of whom love shall constrain me like.
　Serl. Let it be me; and trust me, Margaret,
The meads environed with the silver streams,
Whose battling pastures fatt'neth all my flocks,
Yielding forth fleeces stapled[17] with such wool　60
As Lempster[18] cannot yield more finer stuff,
And forty kine with fair and burnished heads,
With strouting[19] dugs that paggle[20] to the ground,
Shall serve thy dairy if thou wed with me.
　Lam. Let pass the country wealth, as flocks and kine,
And lands that wave with Ceres'[21] golden sheaves,
Filling my barns with plenty of the fields;
But, Peggy, if thou wed thyself to me,
Thou shalt have garments of embrodered[22] silk,
Lawns,[23] and rich networks for thy head-attire.　70
Costly shall be thy fair 'abiliments,
If thou wilt be but Lambert's loving wife.
　Marg. Content you, gentles. You have proffered fair,
And more than fits a country maid's degree.
But give me leave to counsel me[24] a time;
For fancy blooms not at the first assault.
Give me but ten days respite, and I will reply
Which or to whom myself affectionates.[25]
　Serl. Lambert, I tell thee thou art importunate;
Such beauty fits not such a base esquire.　　80
It is for Serlsby to have Margaret.
　Lam. Think'st thou with wealth to over-reach me?

　[53] *mirobolans:* dried fruit.　　　[54] *suckets:* sweetmeats.
　[55] *lamp:* obscure passage, possibly due to textual corruption; "*lamp*" may be error for lamprey, an eellike fish favored in Roman feasting.

x.
　[1] *jacks:* pitchers.
　[2] *Laxfield:* Suffolk village a few miles northeast of Framlingham.　　　　　　　　　[3] *jointer:* joint possessor.
　[4] *holds:* holdings.
　[5] *copy:* copyhold tenure, a legal agreement.
　[6] *due:* rents.　　　　[7] *enfeoff:* write over in possession.
　[8] *doubtful:* difficult.　　　　　　　　[9] *sith:* since.
　[10] *fee:* estate.　　　[11] *comparisons:* similes.
　[12] *stay:* support.　　　　　[13] *clime:* region.
　[14] *'gree:* degree.　　　[15] *accompted:* accounted.
　[16] *stay:* constancy.　　　[17] *stapled:* of long, fine fibers.
　[18] *Lempster:* Leominster, Herefordshire village famous for wool.　　　　　　　　[19] *strouting:* swelling.
　[20] *paggle:* hang down.
　[21] *Ceres:* referring to the goddess of grain.
　[22] *embrodered:* embroidered.
　[23] *Lawns:* a kind of fine linen.
　[24] *counsel me:* take counsel with myself.
　[25] *myself affectionates:* I feel affection for.

Serlsby, I scorn to brook thy country braves.[26]
I dare thee, coward, to maintain this wrong
At dint [27] of rapier, single in the field.
 Serl. I'll answer, Lambert, what I have avouched.
Margaret, farewell; another time shall serve.
 Exit SERLSBY.
 Lam. I'll follow. Peggy, farewell to thyself;
Listen how well I'll answer for thy love.
 Exit LAMBERT.
 Marg. How Fortune tempers lucky haps [28] with
 frowns, 90
And wrongs me with the sweets of my delight.
Love is my bliss; and love is now my bale.
Shall I be Helen in my froward [29] fates,
As I am Helen in my matchless hue,
And set rich Suffolk with my face afire?
If lovely Lacy were but with his Peggy,
The cloudy darkness of his bitter frown
Would check the pride of these aspiring squires.
Before the term of ten days be expirèd,
When as they look for answer of their loves, 100
My lord will come to merry Fressingfield
And end their fancies and their follies both;
Till when, Peggy, be blithe and of good cheer.

 Enter a Post *with a letter and a bag of gold.*

 Post. Fair lovely damsel, which way leads this path?
How might I post me unto Fressingfield?
Which footpath leadeth to the keeper's lodge?
 Marg. Your way is ready [30] and this path is right.
Myself do dwell hereby in Fressingfield,
And, if the keeper be the man you seek,
I am his daughter. May I know the cause? 110
 Post. Lovely and once beloved of my lord—
No marvel if his eye was lodged so low,
When brighter beauty is not in the heavens—
The Lincoln earl hath sent you letters here,
And with them, just [31] an hundred pounds in gold.
Sweet bonny wench, read them and make reply.
 Marg. The scrolls that Jove sent Danaë,
Wrapped in rich closures of fine burnished gold,
Were not more welcome than these lines to me.
Tell me, whilst that I do unrip the seals, 120
Lives Lacy well? How fares my lovely lord?
 Post. Well, if that wealth may make men to live well.

 The letter, and MARGARET *reads it.*

"The blooms of the almond tree grow in a night, and
vanish in a morn; the flies *haemerae*,[32] fair Peggy, take
life with the sun, and die with the dew; fancy, that
slippeth in with a gaze, goeth out with a wink; and too

timely [33] loves have ever the shortest length. I write
this as thy grief, and my folly, who at Fressingfield
loved that which time hath taught me to be but mean
dainties. Eyes are dissemblers, and fancy is but 130
queasy. Therefore know, Margaret, I have chosen a
Spanish lady to be my wife, chief waiting woman to
the Princess Eleanor: a lady fair, and no less fair than
thyself, honorable and wealthy. In that I forsake thee,
I leave thee to thine own liking; and for thy dowry I
have sent thee an hundred pounds, and ever assure thee
of my favor, which shall avail thee and thine much.
Farewell.

 Not thine nor his own,
 Edward Lacy"

Fond [34] Ate,[35] doomer of bad-boding fates, 140
That wraps proud Fortune in thy snaky locks,
Didst thou enchant my birthday with such stars
As lightened mischief from their infancy?
If heavens had vowed, if stars had made decree,
To show on me their froward influence,
If Lacy had but loved, heavens, hell, and all,
Could not have wronged the patience of my mind.
 Post. It grieves me, damsel, but the earl is forced
To love the lady by the King's command.
 Marg. The wealth combined within the English
 shelves,[36] 150
Europe's commander, nor the English King
Should not have moved the love of Peggy from her lord.
 Post. What answer shall I return to my lord?
 Marg. First, for thou cam'st from Lacy whom I
 loved—
Ah, give me leave to sigh at every thought!—
Take thou, my friend, the hundred pound he sent;
For Margaret's resolution craves no dower.
The world shall be to her as vanity;
Wealth, trash; love, hate; pleasure, despair.
For I will straight to stately Framingham, 160
And in the abbey there be shorn a nun,
And yield my loves and liberty to God.
Fellow, I give thee this, not for the news,
For those be hateful unto Margaret,
But for th'art Lacy's man, once Margaret's love.
 Post. What I have heard, what passions I have seen,
I'll make report of them unto the earl.
 Exit Post.
 Marg. Say that she joys his fancies be at rest,
And prays that his misfortune may be hers.
 Exit.

[xi]

Enter FRIAR BACON *drawing the curtains with a white
stick,[1] a book in his hand, and a lamp lighted by him, and
the* Brazen Head; *and* MILES, *with weapons by him.*

 Bacon. Miles, where are you?
 Miles. Here, sir.
 Bacon. How chance you tarry so long?
 Miles. Think you that the watching of the brazen
head craves [2] no furniture? [3] I warrant you, sir, I have
so armed myself that if all your devils come I will not
fear them an inch.

[26] *braves:* boasts. [27] *at dint:* by force.
[28] *haps:* events. [29] *froward:* untoward.
[30] *ready:* directly before you. [31] *just:* exactly.
[32] *Gk.:* ephemerae, insects that live only for a day.
[33] *timely:* hasty. [34] *Fond:* Mad.
[35] *Ate:* personification of infatuation, destructive passion
(Greek). [36] *shelves:* cliffs.
xi.
[1] *white stick:* magic wand. [2] *craves:* needs.
[3] *furniture:* equipment.

Bacon. Miles, thou know'st that I have divèd into
 hell
And sought the darkest palaces of fiends;
That with my magic spells great Belcephon 10
Hath left his lodge and kneelèd at my cell;
The rafters of the earth rent from the poles,
And three-formed Luna hid her silver looks,
Trembling upon her concave continent,
When Bacon read upon his magic book.
With seven years' tossing nig romantic charms,
Poring upon dark Hecat's principles,
I have framed out a monstrous head of brass,
That, by th' enchanting forces of the devil,
Shall tell out strange and uncouth aphorisms, 20
And girt fair England with a wall of brass.
Bungay and I have watched these threescore days,
And now our vital spirits crave some rest.
If Argus[4] lived, and had his hundred eyes,
They could not overwatch Phobeter's[5] night.
Now, Miles, in thee rests Friar Bacon's weal;[6]
The honor and renown of all his life
Hangs in the watching of this brazen head.
Therefore, I charge thee by the immortal God,
That holds the souls of men within his fist, 30
This night thou watch; for, ere the morning star
Sends out his glorious glister on the north,
The head will speak. Then, Miles, upon thy life,
Wake me; for then by magic art I'll work
To end my seven years' task with excellence.
If that a wink but shut thy watchful eye,
Then farewell Bacon's glory and his fame.
Draw close the curtains, Miles. Now, for thy life,
Be watchful, and— 39

Here he falleth asleep.

Miles. So. I thought you would talk yourself asleep
anon; and 'tis no marvel, for Bungay on the days and
he on the nights have watched just these ten-and-fifty
days. Now this is the night, and 'tis my task and no
more. Now, Jesus bless me, what a goodly head it is;
and a nose! you talk of *nos autem glorificare*,[7] but here's
a nose that I warrant may be called *nos autem popelare*
for the people of the parish. Well, I am furnished with
weapons. Now, sir, I will set me down by a post, and
make it as good as a watchman to wake me if I chance
to slumber. I thought, Goodman Head, I would call
you out of your memento.[8] 51

Sit down and knock your head.

Passion a' God, I have almost broke my pate! Up,
Miles, to your task; take your brown bill[9] in your hand;
here's some of your master's hobgoblins abroad.

With this a great noise. The Head *speaks.*

Head. Time is.
Miles. Time is? Why, Master Brazen-head, have
you such a capital nose, and answer you with syllables,
"Time is"? Is this all my master's cunning, to spend
seven years' study about "Time is"? Well, sir, it may
be we shall have some better orations of it anon. 60
Well, I'll watch you as narrowly as ever you were

watched, and I'll play with you as the nightingale with
the slowworm: I'll set a prick against my breast.[10]

[Places the point of the halberd against his breast].

Now, rest there, Miles.

[Falls asleep.]

Lord have mercy upon me, I have almost killed myself!

[Noise again.]

Up, Miles; list how they rumble.
Head. Time was.
Miles. Well, Friar Bacon, you spent your seven
years' study well, that can make your head speak but two
words at once. "Time was." Yea, marry, time was 70
when my master was a wise man, but that was before he
began to make the brazen head. You shall lie, while
your arse ache and your head speak no better. Well, I
will watch, and walk up and down, and be a peripate-
tian[11] and a philosopher of Aristotle's stamp.

[Noise again.]

What, a fresh noise? Take thy pistols in hand, Miles.

Here the Head *speaks; and a lightning flasheth forth,
and a hand appears that breaketh down the* Head
with a hammer.

Head. Time is past.
Miles. Master, master, up! Hell's broken loose; your
head speaks, and there's such a thunder and lightning
that I warrant all Oxford is up in arms. Out of your 80
bed, and take a brown bill in your hand. The latter
day[12] is come.
Bacon. Miles, I come. Oh, passing warily watched;
Bacon will make thee next himself in love.
When spake the head?
Miles. When spake the head! Did not you say that
he should tell strange principles of philosophy? Why,
sir, it speaks but two words at a time.
Bacon. Why, villain, hath it spoken oft? 89
Miles. Oft? Ay, marry, hath it, thrice. But in all
those three times it hath uttered but seven words.
Bacon. As how?
Miles. Marry, sir, the first time he said, "Time is."
As if Fabius Cumentator[13] should have pronounced a
sentence, he said, "Time was." And the third time,

[4] *Argus:* monster set to watch over Io, who was threatened
by Jupiter.
[5] *Phobeter's:* Phobeter, like Morpheus, one of the three
sons of Sleep. [6] *weal:* welfare.
[7] *L.:* nonsensical pun on a liturgical phrase.
[8] *memento:* Miles uses the word improperly to mean
revery, "brown study." [9] *brown bill:* pike.
[10] *nightingale . . . breast:* for fear of the serpent ("slow-
worm"), the nightingale was sometimes thought to lean his
breast against a thorn all night; his lamentation was a by-
product.
[11] *peripatetian:* Aristotle's method of teaching while walk-
ing gave his disciples the name *peripatetics.*
[12] *latter day:* Judgment Day.
[13] *Cumentator:* for Cunctator, surname of Fabius Maximus,
Roman dictator at the time of Hannibal.

with thunder and lightning, as in great choler, he said,
"Time is past."

Bacon. 'Tis past indeed. Ah, villain, time is past;
My life, my fame, my glory, all are past.
Bacon, the turrets of thy hope are ruined down; 100
Thy seven years' study lieth in the dust;
Thy brazen head lies broken through a slave
That watched, and would not when the head did will.
What said the head first?

Miles. Even, sir, "Time is."

Bacon. Villain, if thou hadst called to Bacon then,
If thou hadst watched, and waked the sleepy friar,
The brazen head had uttered aphorisms,
And England had been circled round with brass.
But proud Astmeroth, ruler of the north, 110
And Demogorgon, master of the fates,
Grudge that a mortal man should work so much.
Hell trembled at my deep, commanding spells;
Fiends frowned to see a man their over-match.
Bacon might boast more than a man might boast,
But now the braves of Bacon hath an end;
Europe's conceit of Bacon hath an end;
His seven years' practice sorteth[14] to ill end;
And, villain, sith my glory hath an end,
I will appoint thee fatal to some end.[15] 120
Villain, avoid;[16] get thee from Bacon's sight.
Vagrant, go roam and range about the world,
And perish as a vagabond on earth.

Miles. Why then, sir, you forbid me your service.

Bacon. My service, villain, with a fatal curse
That direful plagues and mischief fall on thee.

Miles. 'Tis no matter. I am against[17] you with the
old proverb, "The more the fox is cursed,[18] the better
he fares." God be with you, sir. I'll take but a book
in my hand, a wide-sleeve gown on my back, and 130
a crowned cap[19] on my head, and see if I can want[20]
promotion.

[*Exit.*]

Bacon. Some fiend or ghost haunt on thy weary steps,
Until they do transport thee quick[21] to hell;
For Bacon shall have never merry day,
To lose the fame and honor of his head.

Exit.

[xii]

Enter EMPEROR, CASTILE, HENRY, ELEANOR,
EDWARD, LACY, RAFE, [*and* Attendants].

Emp. Now, lovely prince, the prince of Albion's
wealth,
How fares the Lady Eleanor and you?
What, have you courted and found Castile fit

To answer England in equivalence?
Will't be a match 'twixt bonny Nell and thee?

Edw. Should Paris enter in the courts of Greece
And not lie fettered in fair Helen's looks?
Or Phoebus 'scape those piercing amorets
That Daphne glancèd at his deity?
Can Edward then sit by a flame and freeze, 10
Whose heat puts Helen and fair Daphne down?
Now, monarchs, ask the lady if we 'gree.

Hen. What, madam, hath my son found grace or no?

Ele. Seeing, my lord, his lovely counterfeit,
And hearing how his mind and shape agreed,
I come not, trooped with all this warlike train,
Doubting of love, but so affectionate
As Edward hath in England what he won in Spain.

Cast. A match, my lord; these wantons needs must
love.
Men must have wives and women will be wed. 20
Let's haste the day to honor up the rites.

Rafe. Sirrah Harry, shall Ned marry Nell?

Hen. Ay, Rafe; how then?

Rafe. Marry, Harry, follow my counsel. Send for
Friar Bacon to marry them, for he'll so conjure him and
her with his nigromancy, that they shall love together
like pig and lamb whilst they live.

Cast. But hear'st thou, Rafe, art thou content to have
Eleanor to thy lady?

Rafe. Ay, so she will promise me two things. 30

Cast. What's that, Rafe?

Rafe. That she will never scold with Ned, nor fight
with me. Sirrah Harry, I have put her down with a
thing unpossible.

Hen. What's that, Rafe?

Rafe. Why, Harry, didst thou ever see that a woman
could both hold her tongue and her hands? No. But
when egg-pies grows on apple trees, then will thy gray
mare prove a bagpiper. 39

Emp. What says the Lord of Castile and the Earl of
Lincoln, that they are in such earnest and secret talk?

Cast. I stand, my lord, amazèd at his talk,
How he discourseth of the constancy
Of one surnamed, for beauty's excellence,
The Fair Maid of merry Fressingfield.

Hen. 'Tis true, my lord, 'tis wondrous for to hear;
Her beauty passing Mars's paramour,
Her virgin's right[1] as rich as Vesta's was.
Lacy and Ned hath told me miracles. 49

Cast. What says Lord Lacy? Shall she be his wife?

Lacy. Or else Lord Lacy is unfit to live.
May it please you highness give me leave to post
To Fressingfield, I'll fetch the bonny girl,
And prove in true appearance at the court
What I have vouchèd often with my tongue.

Hen. Lacy, go to the querry[2] of my stable
And take such coursers as shall fit thy turn.
Hie thee to Fressingfield and bring home the lass;
And for her fame flies through the English coast,
If it may please the Lady Eleanor, 60
One day shall match your excellence and her.

Ele. We Castile ladies are not very coy.[3]
Your highness may command a greater boon;

[14] *sorteth:* comes.
[15] *fatal . . . end:* emended by some editors to "to some
fatal end." [16] *avoid:* go away.
[17] *against:* ready for.
[18] *cursed:* with a pun on "coursed," pursued.
[19] *crowned cap:* scholar's cap.
[20] *want:* lack. [21] *quick:* alive.
xii.
[1] *virgin's right:* right to use the name *virgin.*
[2] *querry:* equerry, officer in charge of royal stables.
[3] *coy:* standoffish.

And glad were I to grace the Lincoln earl
With being partner of his marriage day.

 Edw. Gramercy, Nell; for I do love the lord
As he that's second to myself in love.

 Rafe. You love her? Madam Nell, never believe him
you though he swears he loves you.

 Ele. Why, Rafe? 70

 Rafe. Why, his love is like unto a tapster's glass that
is broken with every touch; for he loved the Fair Maid
of Fressingfield once, out of all ho.[4] Nay, Ned, never
wink upon me; I care not, I.

 Hen. Rafe tells all; you shall have a good secretary of
him.

But, Lacy, haste thee post[5] to Fressingfield,
For ere thou hast fitted all things for her state,
The solemn marriage day will be at hand.

 Lacy. I go, my lord. 80
 Exit LACY.

 Emp. How shall we pass this day, my lord?

 Hen. To horse, my lord. The day is passing fair;
We'll fly the partridge or go rouse the deer.
Follow, my lords; you shall not want for sport.
 Exeunt.

[xiii]

Enter FRIAR BACON *with* FRIAR BUNGAY *to his cell.*

 Bung. What means the friar that frolicked it of late
To sit as melancholy in his cell
As if he had neither lost nor won today?

 Bacon. Ah, Bungay, my brazen head is spoiled,
My glory gone, my seven years' study lost.
The fame of Bacon, bruited through the world,
Shall end and perish with this deep disgrace.

 Bung. Bacon hath built foundation on his fame
So surely on the wings of true report,
With acting strange and uncouth miracles, 10
As this cannot infringe what he deserves.

 Bacon. Bungay, sit down; for by prospective skill
I find this day shall fall out ominous.
Some deadly act shall 'tide me ere I sleep,
But what and wherein little can I guess.

 Bung. My mind is heavy, whatso'er shall hap.

Enter two Scholars, *sons to* LAMBERT *and* SERLSBY.
Knock.

 Bacon. Who's that knocks?

 Bung. Two scholars that desires to speak with you.

 Bacon. Bid them come in. Now, my youths, what
 would you have?

 1 Scho. Sir, we are Suffolk men and neighboring
 friends, 20
Our fathers, in their countries, lusty squires;
Their lands adjoin. In Crackfield[1] mine doth dwell,
And his in Laxfield. We are college mates,
Sworn brothers, as our fathers lives as friends.

 Bacon. To what end is all this?

 2 Scho. Hearing your worship kept within your cell
A glass prospective wherein men might see
Whatso their thoughts or hearts' desire could wish,
We come to know how that our fathers fare.

 Bacon. My glass is free for every honest man. 30

Sit down and you shall see ere long
How or in what state your friendly fathers lives.
Meanwhile, tell me your names.

 1 Scho. Mine Lambert.

 2 Scho. And mine Serlsby.

 Bacon. Bungay, I smell there will be a tragedy.

Enter LAMBERT *and* SERLSBY, *with rapiers
and daggers.*

 Lamb. Serlsby, thou hast kept thine hour like a man.
Th'art worthy of the title of a squire
That durst, for proof of thy affection,
And for thy mistress' favor, prize[2] thy blood. 40
Thou know'st what words did pass at Fressingfield,
Such shameless braves as manhood cannot brook;
Ay, for I scorn to bear such piercing taunts,
Prepare thee, Serlsby; one of us will die.

 Serl. Thou see'st I single thee the field,
And what I spake, I'll maintain with my sword.
Stand on thy guard; I cannot scold it out.
And if thou kill me, think I have a son,
That lives in Oxford, in the Broadgates Hall,[3]
Who will revenge his father's blood with blood. 50

 Lamb. And, Serlsby, I have there a lusty boy
That dares at weapon buckle with thy son,
And lives in Broadgates too, as well as thine.
But draw thy rapier, for we'll have a bout.

 Bacon. Now, lusty younkers,[4] look within the glass,
And tell me if you can discern your sires.

 1 Scho. Serlsby, 'tis hard; thy father offers wrong,
To combat with thy father in the field.

 2 Scho. Lambert, thou liest; my father's in the abuse,
And thou shalt find it, if my father harm.[5] 60

 Bung. How goes it, sirs?

 1 Scho. Our fathers are in combat hard by
 Fressingfield.

 Bacon. Sit still, my friends, and see the event.[6]

 Lamb. Why stand'st thou, Serlsby? Doubt'st thou
 of thy life?
A veney,[7] man; fair Margaret craves so much.

 Serl. Then this, for her!

 1 Scho. Ah, well thrust.

 2 Scho. But mark the ward.[8]

 They fight and kill each other.

 Lamb. Oh, I am slain!

 Serl. And I; Lord have mercy on me. 70

 1 Scho. My father slain! Serlsby, ward that.

 2 Scho. And so is mine. Lambert, I'll quite thee
 well.

 The two Scholars *stab one another* [*and die*].

 [4] *out . . . ho:* beyond all calling (perhaps from hunting).
 [5] *post:* fast.
xiii.
 [1] *Crackfield:* Cratfield, village nine miles from Framling-
ham. [2] *prize:* stake.
 [3] *Broadgates Hall:* now part of Pembroke College.
 [4] *younkers:* young gentlemen.
 [5] *harm:* come to harm. [6] *event:* outcome.
 [7] *veney:* bout (fencing term, from French *venue*).
 [8] *ward:* parry.

Bung. Oh, strange stratagem.[9]
Bacon. See, friar, where the fathers both lie dead.
Bacon, thy magic doth effect this massacre.
This glass prospective worketh many woes;
And therefore, seeing these brave, lusty brutes,[10]
These friendly youths did perish by thine art,
End all thy magic and thine art at once.
The poniard that did end the fatal[11] lives 80
Shall break the cause efficiat[12] of their woes.
So fade the glass, and end with it the shows
That nigromancy did infuse the crystal with.
 He breaks the glass.
Bung. What means learned Bacon thus to break his
 glass?
Bacon. I tell thee, Bungay, it repents me sore
That ever Bacon meddled in this art.
The hours I have spent in pyromantic spells,
The fearful tossing in the latest night
Of papers full of nigromantic charms,
Conjuring and adjuring devils and fiends, 90
With stole and albe[13] and strange pentagonon,
The wresting of the holy name of God,
As Sother,[14] Eloim, and Adonai,[15]
Alpha,[16] Manoth,[17] and Tetragrammaton,
With praying to the five-fold powers[18] of heaven,
Are instances that Bacon must be damned
For using devils to countervail[19] his God.
Yet, Bacon, cheer thee; drown not in despair.
Sins have their salves. Repentance can do much.
Think Mercy sits where Justice holds her seat, 100
And from those wounds those bloody Jews did pierce,
Which by thy magic oft did bleed afresh,
From thence for thee the dew of mercy drops
To wash the wrath of high Jehovah's ire,
And make thee as a new-born babe from sin.
Bungay, I'll spend the remnant of my life
In pure devotion, praying to my God
That he would save what Bacon vainly lost.
 Exit [*with* BUNGAY].

[xiv]

Enter MARGARET *in nun's apparel;* Keeper, *her*
 father; and their Friend.

Keep. Margaret, be not so headstrong in these vows.
Oh, bury not such beauty in a cell,

[9] *stratagem:* deed of blood or violence.
[10] *brutes:* Britons(?), bloods(?). [11] *fatal:* ill-fated.
[12] *efficiat:* efficient.
[13] *stole and alb:* ecclesiastical vestments.
[14] *Sother:* Savior.
[15] *Eloim . . . Adonai:* Hebrew substitutions for the Tetragrammaton, unpronounceable four-consonant name of God represented by expanded name *Jehovah.*
[16] *Alpha:* first letter of Greek alphabet, used similarly.
[17] *Manoth:* unexplained, perhaps Greene's erroneous version of a magical name of God.
[18] *five-fold powers:* at the points of his pentagonon Bacon has inscribed five names of God.
[19] *countervail:* avail against.
xiv.
[1] *engine:* instrument.
[2] *mutton:* prostitute, unchaste woman (cant term).

That England hath held famous for the hue.
Thy father's hair, like to the silver blooms
That beautify the shrubs of Africa,
Shall fall before the dated time of death,
Thus to forgo his lovely Margaret.
 Marg. Ah, father, when the harmony of heaven
Soundeth the measures of a lively faith,
The vain illusions of this flattering world 10
Seems odious to the thoughts of Margaret.
I lovèd once; Lord Lacy was my love;
And now I hate myself for that I loved,
And doted more on him than on my God.
For this, I scourge myself with sharp repents.
But now, the touch of such aspiring sins
Tells me all love is lust but love of heavens,
That beauty used for love is vanity.
The world contains naught but alluring baits,
Pride, flattery, and inconstant thoughts. 20
To shun the pricks of death I leave the world,
And vow to meditate on heavenly bliss,
To live in Fremingham a holy nun,
Holy and pure in conscience and in deed;
And for to wish all maids to learn of me
To seek heaven's joy before earth's vanity.
 Friend. And will you then, Margaret, be shorn a nun,
and so leave us all?
 Marg. Now, farewell, world, the engine[1] of all
 woe.
Farewell to friends and father; welcome, Christ. 30
Adieu to dainty robes; this base attire
Better befits an humble mind to God
Than all the show of rich 'abiliments.
Love, oh, love, and, with fond love, farewell,
Sweet Lacy, whom I lovèd once so dear;
Ever be well, but never in my thoughts,
Lest I offend to think on Lacy's love.
But even to that, as to the rest, farewell.

Enter LACY, WARREN, ERMSBY, *booted and spurred.*

Lacy. Come on, my wags, we're near the keeper's
 lodge.
Here have I oft walked in the wat'ry meads, 40
And chatted with my lovely Margaret.
 War. Sirrah Ned, is not this the keeper?
 Lacy. 'Tis the same.
 Erm. The old lecher hath gotten holy mutton[2] to
him. A nun, my lord.
 Lacy. Keeper, how farest thou? Holla, man, what
 cheer?
How doth Peggy, thy daughter and my love?
 Keep. Ah, good my lord, oh, woe is me for Peg!
She where she stands, clad in her nun's attire,
Ready for to be shorn in Framingham. 50
She leaves the world because she left your love.
Oh, good my lord, persuade her if you can.
 Lacy. Why, how now, Margaret; what, a
 malcontent?
A nun? What holy father taught you this,
To task yourself to such a tedious life
As die a maid? 'Twere injury to me
To smother up such beauty in a cell.

Marg. Lord Lacy, thinking of thy former miss,[3]
How fond[4] the prime of wanton years were spent
In love—oh, fie upon that fond conceit,　　　60
Whose hap and essence hangeth in the eye—
I leave both love and love's content at once,
Betaking me to Him that is true love,
And leaving all the world for love of Him.

Lacy. Whence, Peggy, comes this metamorphosis?
What, shorn a nun? And I have from the court
Posted with courses to convey thee hence
To Windsor, where our marriage shall be kept.
Thy wedding robes are in the tailors' hands.
Come, Peggy, leave these peremptory vows.　　70

Marg. Did not my lord resign his interest,
And make divorce 'twixt Margaret and him?

Lacy. 'Twas but to try sweet Peggy's constancy.
But will fair Margaret leave her love and lord?

Marg. Is not heaven's joy before earth's fading
　　bliss,
And life above sweeter than life in love?

Lacy. Why, then Margaret will be shorn a nun?

Marg. Margaret hath made a vow which may not be
　　revoked.

War. We cannot stay, my lord; and if she be so
　　strict,
Our leisure grants us not to woo afresh.　　80

Erm. Choose you, fair damsel; yet the choice is
　　yours.
Either a solemn nunnery or the court;
God or Lord Lacy. Which contents you best,
To be a nun, or else Lord Lacy's wife?

Lacy. A good motion. Peggy, your answer must be
　　short.

Marg. The flesh is frail. My lord doth know it well,
That when he comes with his enchanting face,
Whatso'er betide, I cannot say him nay.
Off goes the habit of a maiden's heart;
And, seeing Fortune will, fair Fremingham,　　90
And all the show of holy nuns, farewell.
Lacy for me, if he will be my lord.

Lacy. Peggy, thy lord, thy love, thy husband.
Trust me, by truth of knighthood, that the King
Stays for to marry matchless Eleanor
Until I bring thee richly to the court,
That one day may both marry her and thee.
How sayst thou, keeper? Art thou glad of this?

Keep. As if the English King had given
The park and deer of Fressingfield to me.　　100

Erm. I pray thee, my Lord of Sussex, why art thou in
a brown study?

War. To see the nature of women, that be they never
so near God, yet they love to die[5] in a man's arms.

Lacy. What have you fit for breakfast? We have hied
And posted all this night to Fressingfield.

Marg. Butter and cheese and humbles[6] of a deer,
Such as poor keepers have within their lodge.

Lacy. And not a bottle of wine?

Marg. We'll find one for my lord.　　110

Lacy. Come, Sussex, let's in; we shall have more,
For she speaks least to hold her promise sure.

　　　　　　　　　Exeunt.

[xv]

Enter a DEVIL *to seek* MILES.

Dev. How restless are the ghosts of hellish spirits
When every charmer[1] with his magic spells
Calls us from nine-fold trenchèd Phlegethon,[2]
To scud and over-scour the earth in post
Upon the speedy wings of swiftest winds.
Now Bacon hath raised me from the darkest deep
To search about the world for Miles his man,
For Miles, and to torment his lazy bones
For careless watching of his brazen head.
See where he comes. Oh, he is mine.　　10

Enter MILES *with a gown and a cornercap.*[3]

Miles. A scholar, quoth you? Marry, sir, I would I
had been made a bottlemaker when I was made a
scholar; for I can get neither to be a deacon, reader, nor
schoolmaster; no, not the clerk of a parish. Some call
me dunce; another saith my head is as full of Latin as
an egg's full of oatmeal. Thus I am tormented that the
devil and Friar Bacon haunts me. Good Lord, here's
one of my master's devils. I'll go speak to him. What,
Master Plutus,[4] how cheer you?

Dev. Dost thou know me?　　20

Miles. Know you, sir? Why, are not you one of my
master's devils that were wont to come to my master,
Doctor Bacon, at Brazen-nose?

Dev. Yes, marry, am I.

Miles. Good Lord, Master Plutus, I have seen you a
thousand times at my master's, and yet I had never the
manners to make you drink. But, sir, I am glad to see
how conformable you are to the statute.[5] I warrant you
he's as yeomanly a man as you shall see; mark you,
masters, here's a plain, honest man, without welt　30
or guard.[6] But I pray you, sir, do you come lately from
hell?

Dev. Ay, marry; how then?

Miles. Faith, 'tis a place I have desired long to see.
Have you not good tippling houses there? May not a
man have a lusty fire there, a pot of good ale, a pair[7] of
cards, a swinging[8] piece of chalk,[9] and a brown toast
that will clap a white waistcoat[10] on a cup of good
drink?

Dev. All this you may have there.　　40

Miles. You are for me, friend, and I am for you. But
I pray you, may I not have an office there?

　[3] *miss:* error.　　　　　　　[4] *fond:* foolishly.
　[5] *die:* with standard pun, experience orgasm.
　[6] *humbles:* liver, kidneys, and other inner organs.

xv.
　[1] *charmer:* magician.
　[2] *Phlegethon:* Q1 "Blegiton"; one of the rivers of the
Underworld.
　[3] *gown . . . cornercap:* academic costume.
　[4] *Plutus:* god of wealth, Miles's blunder for "Pluto."
　[5] *statute:* restricting dress elaborate beyond one's station.
　[6] *welt or guard:* terms for decorative facing of a garment.
　[7] *pair:* pack.　　　　　　　[8] *swinging:* large.
　[9] *chalk:* for calculating the bill.
　[10] *white waistcoat:* head.

Dev. Yes, a thousand. What wouldst thou be?

Miles. By my troth, sir, in a place where I may profit myself. I know hell is a hot place, and men are marvelous dry, and much drink is spent there. I would be a tapster.

Dev. Thou shalt.

Miles. There's nothing lets[11] me from going with you, but that 'tis a long journey, and I have never a horse. 51

Dev. Thou shalt ride on my back.

Miles. Now surely here's a courteous devil, that for to pleasure his friend will not stick to make a jade of himself. But I pray you, goodman friend, let me move a question to you.

Dev. What's that?

Miles. I pray you, whether is your pace a trot or an amble?

Dev. An amble. 60

Miles. 'Tis well. But take heed it be not a trot. But 'tis no matter; I'll prevent it.

Dev. What dost?

Miles. Marry, friend, I put on my spurs; for if I find your pace either a trot or else uneasy, I'll put you to a false gallop;[12] I'll make you feel the benefit of my spurs.

Dev. Get up upon my back.

Miles. Oh, Lord, here's even a goodly marvel, when a man rides to hell on the devil's back.

 Exeunt roaring.

[xvi]

Enter the EMPEROR *with a pointless sword;*[1] *next, the* KING *of* CASTILE, *carrying a sword with a point;*[2] LACY, *carrying the globe;*[3] ED[WARD]; WARR[EN], *carrying a rod*[4] *of gold with a dove on it;* ERMSBY, *with a crown and scepter;* [PRINCESS ELEANOR], *with the* FAIR MAID *of Fressingfield on her left hand;* HENRY, BACON, *with other* Lords *Attending.*

Edw. Great potentates, earth's miracles for state,
Think that Prince Edward humbles[5] at your feet,
And, for these favors, on his martial sword
He vows perpetual homage to yourselves,
Yielding these honors unto Eleanor.

Hen. Gramercies, lordlings. Old Plantagenet,
That rules and sways the Albion diadem,

[11] *lets:* prevents. [12] *false gallop:* canter.
xvi.
 [1] *pointless sword:* sword of mercy.
 [2] *sword . . . point:* sword of justice. [3] *globe:* royal orb.
 [4] *rod:* rod of equity. [5] *humbles:* humbles himself.
 [6] *images:* i.e., the three goddesses of whom Paris judged one most beautiful.
 [7] *Brute . . . Troynovant:* Brute, descendant of Aeneas, was fancied to have built London as a New Troy as his great-grandfather did Rome. [8] *Phoebus' flower:* sunflower.
 [9] *careless:* unafraid.
 [10] *hellitropian:* heliotrope, sunflower. [11] *vail:* lower.
 [12] *Diana's rose:* the Tudor rose of the Virgin Queen Elizabeth. [13] *mystical:* allegorical.
 [14] *Gihon:* Biblical (Genesis ii:12) name of the river Oxus.
 [15] *swift:* Q1 first.

With tears discovers these conceivèd joys,
And vows requital, if his men-at-arms,
The wealth of England, or due honors done 10
To Eleanor, may quite his favorites.
But all this while, what say you to the dames,
That shine like to the crystal lamps of heaven?

Emp. If but a third were added to these two,
They did surpass those gorgeous images[6]
That gloried Ida with rich beauty's wealth.

Marg. 'Tis I, my lords, who humbly on my knee
Must yield her orisons to mighty Jove,
For lifting up his handmaid to this state,
Brought from her homely cottage to the court, 20
And graced with kings, princes, and emperors;
To whom, next to the noble Lincoln earl,
I vow obedience and such humble love
As may a handmaid to such mighty men.

Ele. Thou martial man that wears the Almain crown,
And you the western potentates of might,
The Albion princess, English Edward's wife,
Proud that the lovely star of Fressingfield,
Fair Margaret, countess to the Lincoln earl,
Attends on Eleanor—gramercies, lord, for her— 30
'Tis I give thanks for Margaret to you all,
And rest, for her, due bounden to yourselves.

Hen. Seeing the marriage is solemnizèd,
Let's march in triumph to the royal feast.
But why stands Friar Bacon here so mute?

Bacon. Repentant for the follies of my youth,
That magic's secret mysteries misled,
And joyful that this royal marriage
Portends such bliss unto this matchless realm.

Hen. Why, Bacon, what strange event shall happen
 to this land? 40
Or what shall grow from Edward and his Queen?

Bacon. I find by deep prescience of mine art,
Which once I tempered in my secret cell,
That here where Brute did build his Troynovant,[7]
From forth the royal garden of a king
Shall flourish out so rich and fair a bud
Whose brightness shall deface proud Phoebus' flower,[8]
And overshadow Albion with her leaves.
Till then Mars shall be master of the field;
But then the stormy threats of wars shall cease. 50
The horse shall stamp as careless[9] of the pike;
Drums shall be turned to timbrels of delight;
With wealthy favors plenty shall enrich
The strand that gladded wand'ring Brute to see,
And peace from heaven shall harbor in these leaves
That gorgeous beautifies this matchless flower.
Apollo's hellitropian[10] then shall stoop,
And Venus' hyacinth shall vail[11] her top;
Juno shall shut her gilliflowers up,
And Pallas' bay shall bash her brightest green; 60
Cere's carnation, in consort with those,
Shall stoop and wonder at Diana's rose.[12]

Hen. This prophecy is mystical.[13]
But, glorious commanders of Europa's love,
That makes fair England like that wealthy isle
Circled with Gihon[14] and swift[15] Euphrates,
In royalizing Henry's Albion

With presence of your princely mightiness,
Let's march. The tables all are spread,
And viands such as England's wealth affords
Are ready set to furnish out the boards.
You shall have welcome, mighty potentates;

70

It rests [16] to furnish up this royal feast.
Only your hearts be frolic, for the time
Craves that we taste of naught but jouissance. [17]
Thus glories England over all the west.

Exeunt omnes.

Finis Friar Bacon, made by Robert Greene,
Master of Arts.
Omne tulit punctum qui miscuit utile dulci. [18]

[16] *rest:* remains. [17] *jouissance:* pleasure.
[18] *L.:* He wins every vote who combines the useful with the pleasurable.

Thomas Lodge

[1558–1625]

Robert Greene

[1558–1592]

A LOOKING GLASS FOR LONDON AND ENGLAND

THOMAS LODGE shares so many of Robert Greene's most notable personal vices and literary virtues (see introduction to FRIAR BACON AND FRIAR BUNGAY) that, at least in retrospect, collaboration between the two men seems almost inevitable. Greene's contemporary, he was of respectable birth, the son, in fact, of a man who was for a time Lord Mayor of London. Like Greene he discovered that a prestigious education, at the Merchant Taylors' School and at Lincoln's Inn, where he studied law, led him nowhere, and he chose to depend on his talent at writing. Like Greene he tried his hand at everything—sonnets and other verse, pamphlets, polemic in defense of literature, drama, prose romance; his most famous tale, *Rosalynde*, is the source of *As You Like It*. He participated in expeditions, one of which took him as far as South America. In a more enduring escape from the penury of life as a writer he studied medicine at Avignon and Oxford at the turn of the century, and though the Roman Catholicism he adopted must have cost him a large practice he remained active as a physician until his death in 1625; during that period even his writing turned sober, and the scholarly historian of his maturity is a far cry from the prodigal scapegrace who shared the life of the University Wits. The only extant play certainly and exclusively Lodge's is *The Wounds of Civil War*, a Roman history written *c.* 1588, but he has been suggested, not implausibly if without convincing evidence, as author of a good many unascribed plays, including *The True Chronicle History of King Leir* (comic source of Shakespeare's tragedy) and MUCEDORUS.

Lodge and Greene probably collaborated on A LOOKING GLASS while the former was in London between voyages to the Canaries and South America. The play was revived for four performances by Lord Strange's Men (Henslowe's company) several months before Greene's death in 1592, and though it seems to have ended its stage life at that point another kind of popularity is suggested by four reprints of the 1594 Quarto between 1598 and 1617, as well as by a number of quotations in the 1600 anthology *England's Parnassus*. The present text is the first modern-spelling edition and the only edition systematically based on the authoritative First Quarto (referred to in the notes as Q). Act and scene numbers have been added.

The play's popularity is not hard to explain despite the frequent flatfootedness of the verse, simplicity of characterization, and moralistic sentimentality of some of the plotting. Though the first response of the modern reader may be to the apparent naiveté of the play, Lodge and Greene write as true University Wits, sophisticatedly combining a number of inherited dramatic modes with imitations of the newest vogues, so that the piece has the appearance of a spectacular résumé of the state of the theater in 1590. Thus the story of the conversion of Nineveh by the Hebrew prophets, akin to a play in one of the old mystery cycles, is juxtaposed with a presentation of Rasni's despotism reminiscent of the atmosphere of such foreign histories as TAMBURLAINE, with a clown plot—replete with devil—that harks back to the vice episodes of the moralities, with a prodigal son play in the action of Radagon and Clesiphon; exotic Assyria is montaged with London taverns; the kaleidoscopic form is rationalized to romantic comedy at the end as the repentant king makes plans to marry his paramour; and elaborate stage machinery is demanded for lightning that burns up Remilia, a flame from the earth that swallows up Radagon, and a serpent that eats the vine that shelters Jonas. A LOOKING GLASS is traditional both in its elements and in the thematic parallelism it so carefully establishes among them, but ambitiously novel in the disparateness of the material it harmonizes. And it glances, like so many plays of the period, knowingly at the theater of its own day: the Usurer's speech at the beginning of V.ii may or may not be an imitation of Faustus' final soliloquy (if Marlowe's play was not yet in existence in 1590, a moot question, the lines could have been modified in the 1594 text), but in III.iii Lodge and Greene explicitly parody the style of Lyly.

The source of the main action is the Book of Jonah, which the authors used in the Bishops' Bible translation; other materials are drawn from elsewhere in the Bible and from Lodge's *Alarum Against Usurers* (1584). But the combination of materials that lends the play much of its interest is the achievement of its coauthors, so much so that it is virtually impossible to assign separate authorship of the various parts.

N. R.

A Looking Glass for London and England

DRAMATIS PERSONÆ

RASNI, *King of Nineveh or of Assyria*
King of CILICIA
King of CRETE
King of PAPHLAGONIA
RADAGON, *a courtier, son of Alcon*
REMILIA, *sister to Rasni*
ALVIDA, *wife of Paphlagonia*
An angel
OSEAS,[1] *the prophet, as Chorus*
A Smith
ADAM, *a clown, his man*
Two Ruffians[2]
A Usurer
THRASIBULUS, *a young gentleman*
ALCON, *a poor man*
Magi (also called Soothsayers and Sages)
A Lawyer

A Judge
A Lord
JONAS,[3] *the prophet*
A Master Mariner
A Sailor
A Merchant of Tharsus
SAMIA, *wife of Alcon*
CLESIPHON, *their son*
The Smith's wife
Governor of Joppa
Priest of the Sun
A man disguised as a devil
An Evil Angel
Ladies
Two Searchers
Lords, Ladies, Ruffians, Sailors,
 Merchants

ACT ONE

SCENE ONE

Enters RASNI, King of Nineveh, *with three* Kings of
CILICIA, CRETE, *and* PAPHLAGONIA, *from the
overthrow of* JEROBOAM,[1] King of Jerusalem.

Ras. So pace ye on, triumphant warriors;
Make Venus' leman,[2] armed in all his pomp,
Bash[3] at the brightness of your hardy looks,
For you, the viceroys, are the cavaliers
That wait on Rasni's royal mightiness.
Boast, petty Kings, and glory in your fates,
That stars have made your fortunes climb so high
To give attend[4] on Rasni's excellence.
Am I not he that rules great Nineveh,
Rounded with Lycus'[5] silver flowing streams, 10
Whose city large diametri[6] contains,
Even three days' journey's length from wall to wall,
Two hundred gates carved out of burnished brass,
As glorious as the portal of the sun,
And, for to deck heaven's battlements with pride,
Six hundred towers that topless touch the clouds?
This city is the footstool of your King;
A hundred lords do honor at my feet;
My scepter straineth[7] both the parallels;
And now, t' enlarge the highness of my power, 20
I have made Judea's monarch flee the field,
And beat proud Jeroboam from his holds,
Winning from Kadesh[8] to Samaria.[9]
Great Jewry's God, that foiled stout[10] Benhadab,[11]
Could not rebate[12] the strength that Rasni brought;
For, be he God in heaven, yet, viceroys, know:
Rasni is God on earth, and none but he.
Cil. If lovely shape, feature by nature's skill
Passing in beauty fair Endymion's[13]
That Luna[14] wrapped within her snowy breasts, 30

DRAMATIS PERSONÆ
[1] *Oseas:* Hosea, called "Osee" in the Bishops' Bible.
[2] *Ruffians:* swaggering bullies.
[3] *Jonas:* Vulgate and Bishops' Bible form of "Jonah."

I.i.
[1] *Jeroboam:* King of Israel, actually overthrown by
Abijah, King of Judah.
[2] *leman:* sweetheart; in this case, Mars.
[3] *Bash:* be abashed. [4] *attend:* attendance.
[5] *Lycus:* Lycus is named in the Bishops' Bible gloss as
the river by which Nineveh is situated.
[6] *diametri:* diameters.
[7] *straineth:* controls, draws together.
[8] *Kadesh:* on the southeastern frontier of Judah.
[9] *Samaria:* Kingdom in northern Palestine between the
River Jordan and the Mediterranean. [10] *stout:* tough.
[11] *Benhadab:* unrevised Vulgate form of "Benhadad,"
name of several kings of Damascus. [12] *rebate:* diminish.
[13] *Endymion's:* referring to the beautiful young man in
Greek myth said to have been loved by the moon.
[14] *Luna:* moon.

Or that sweet boy[15] that wrought bright Venus' bane,[16]
Transformed into a purple hyacinth,
If beauty nonpareil in excellence
May make a king match with the gods in gree,[17]
Rasni is God on earth, and none but he.
 Cre. If martial looks, wrapped in a cloud of wars,
More fierce than Mavors[18] lighteneth from his eyes,
Sparkling[19] revenge and dire disparagement;[20]
If doughty deeds more haught[21] than any done,
Sealed with the smile of fortune and of fate, 40
Matchless to manage lance and curtal-ax;[22]
If such high actions, graced with victories,
Make a king match with the gods in gree,
Rasni is God on earth, and none but he.
 Paph. If Pallas'[23] wealth—
 Ras. Viceroys, enough! Peace, Paphlagon, no more.
See where my sister, fair Remilia,
Fairer than was the virgin Danaë[24]
That waits on Venus with a golden show,
She that hath stolen the wealth of Rasni's looks 50
And tied his thoughts within her lovely locks,
She that is loved and love unto your King,
See where she comes to gratulate my fame.

 Enters RADAGON *with* REMILIA, *Sister to* RASNI;
 ALVIDA, *Wife to* PAPHLAGON; *and other* Ladies
 bring[ing] a *globe seated in a ship.*

 Rem. Victorious Monarch, second unto Jove,
Mars upon earth and Neptune on the seas,
Whose frown strows[25] all the ocean with a calm,
Whose smile draws Flora[26] to display her pride,
Whose eye holds wanton Venus at a gaze,
Rasni, the regent of great Nineveh,
For thou hast foiled proud Jeroboam's force 60
And, like the mustering breath of Aeolus[27]
That overturns the pines of Lebanon,
Hast scattered Jewry and her upstart grooms,
Winning from Kadesh to Samaria,

Remilia greets thee with a kind salute
And, for a present to thy mightiness,
Gives thee a globe folded within a ship,
As king on earth and lord of all the seas,
With such a welcome unto Nineveh
As may thy sister's humble love afford. 70
 Ras. Sister—the title fits not thy degree;
A higher state of honor shall be thine.
The lovely trull[28] that Mercury entrapped
Within the curious pleasure of his tongue,[29]
And she that bashed the sun-god with her eyes,
Fair Semele,[30] the choice of Venus' maids,
Were not so beauteous as Remilia.
Then, sweeting,[31] "sister" shall not serve the turn,
But Rasni's wife, his leman, and his love,
Thou shalt like Juno wed thyself to Jove 80
And fold me in the riches of thy fair;[32]
Remilia shall be Rasni's paramour.
For why, if I be Mars for warlike deeds
And thou bright Venus for thy clear aspect,
Why should not from our loins issue a son
That might be lord of royal sovereignty?
Of twenty worlds, if twenty worlds might be?
What sayest, Remilia, art thou Rasni's wife?
 Rem. My heart doth swell with favor of thy thoughts;
The love of Rasni maketh me as proud 90
As Juno when she wore heaven's diadem.
Thy sister born was for thy wife by love.
Had I the riches nature locketh up
To deck her darling beauty when she smiles,
Rasni should prank[33] him in the pride of all.
 Ras. Remilia's love is far more either prized
Than Jeroboam's or the world's subdue.
Lordings, I'll have my weddings sumptuous,
Made glorious with the treasures of the world.
I'll fetch from Albia[34] shelves of margarites[35] 100
And strip the Indies of their diamonds,
And Tyre[36] shall yield me tribute of her gold
To make Remilia's wedding glorious.
I'll send for all the damsel[37] queens that live
Within the reach of Rasni's government
To wait as handmaids on Remilia,
That her attendant train may pass[38] the troop
That gloried Venus at her wedding day.
 Cre. Oh, my lord, not sister to thy love!
'Tis incest and too foul a fact[39] for kings. 110
Nature allows no limits to such lust.
 Ras. Presumptuous viceroy, dar'st thou check thy
 lord
Or twit him with the laws that nature 'lows?
Is not great Rasni above nature's reach,
God upon earth, and all his will is law?
 Rad. Doth not the brightness of his majesty
Shadow his deeds from being counted faults?
 Ras. Well hast thou answered with him, Radagon;
I like thee for thy learned sophistry.
But thou of Crete that countercheck'st thy King 120
Pack[40] hence in exile; give Radagon thy crown.
Be thou vicegerent of his royalty,
And fail me not in what my thoughts may please,
For from a beggar have I brought thee up

[15] *boy:* confusion of Hyacinth, Spartan boy killed by Apollo and transformed into a hyacinth, and Adonis, who spurned Venus' love, and was killed by a boar and changed into an anemone; neither "wrought . . . Venus' bane."
[16] *bane:* destruction. [17] *gree:* agree.
[18] *Mavors:* Mars. [19] *Sparkling:* Emitting.
[20] *disparagement:* detraction. [21] *haught:* high.
[22] *curtal-ax:* short broad cutting sword, cutlass.
[23] *Pallas'* Pallas is another name for Athena.
[24] *Danaë:* Q "Dania," not readily decipherable. *Danaë* was a virgin raped by Zeus, who appeared in a shower of gold (for which "golden show" of *l.* 49 is a misprint?), but did not wait on Venus; "Diana" makes no sense.
[25] *strows:* levels.
[26] *Flora:* Italian goddess of flowering or blossoming plants.
[27] *Aeolus:* Greek god of the winds.
[28] *trull:* girl, prostitute.
[29] *trull . . . tongue:* a pseudo-mythological allusion.
[30] *Semele:* daughter of Cadmus and beloved of Zeus, here apparently confused with sea-nymph Clytie, loved by Apollo. [31] *sweeting:* darling.
[32] *fair:* beauty. [33] *prank:* dress splendidly.
[34] *Albia:* Albion, England. [35] *margarites:* pearls.
[36] *Tyre:* Phoenician seaport.
[37] *damsel:* young unmarried woman of gentle birth.
[38] *pass:* surpass. [39] *fact:* evil deed.
[40] *Pack:* Get out.

And graced thee with the honor of a crown.—
Ye quondam⁴¹ king, what, feed ye on delays?
 Cre. Better no king than viceroy under him
That hath no virtue to maintain his crown.

 [Exit.]

 Ras. Remilia, what fair dames be those that wait
Attendant on thy matchless royalty? 130
 Rem. 'Tis Alvida, the fair wife to the King of
 Paphlagonia.
 Ras. Trust me, she is fair. Th' hast, Paphlagon, a
 jewel
To fold thee in so bright a sweeting's arms.
 Rad. Like you her, my lord?
 Ras. What if I do, Radagon?
 Rad. Why then, she is yours, my lord; for marriage
Makes no exception where Rasni doth command.
 Paph. Ill dost thou counsel him to fancy wives.
 Rad. Wife or not wife, what so he likes is his.
 Ras. Well answered, Radagon; thou art for me; 140
Feed thou mine humor, and be still a king.
Lords, go in triumph of my happy loves,
And, for to feast us after all our broils,⁴²
Frolic and revel it in Nineveh.
Whatsoever befitteth your conceited⁴³ thoughts,
Or good or ill, love or not love, my boys,
In love or what may satisfy your lust,
Act it, my lords, for no man dare say no.
*Divisum imperium cum Iove nunc teneo.*⁴⁴

 Exeunt.

[I.ii]

 Enters, brought in by an Angel, OSEAS *the Prophet,
 and set down over the stage in a throne.*¹

 Ang. Amaze not, man of God, if in the spirit
Th'art brought from Jewry unto Nineveh;
So was Elias² wrapped within a storm
And set upon Mount Carmel³ by the Lord;
For thou hast preached long to the stubborn Jews,
Whose flinty hearts have felt no sweet remorse,
But, lightly valuing all the threats of God,
Have still persevered in their wickedness.
Lo, I have brought thee unto Nineveh,
The rich and royal city of the world, 10
Pampered in wealth and overgrown with pride,
As Sodom and Gomorrah⁴ full of sin.
The Lord looks down and cannot see one good,
Not one that covets to obey his will,
But wicked all, from cradle to the crutch.
Note then, Oseas, all their grievous sins,
And see the wrath of God that pays revenge;
And when the ripeness of their sin is full
And thou hast written all their wicked thoughts,⁵
I'll carry thee to Jewry back again 20
And seat thee in the great Jerusalem.
There shalt thou publish in her open streets
That God sends down his hateful wrath for sin
On such as never neard his prophets speak;
Much more will he inflict, a world of plagues,
On such as hear the sweetness of his voice

And yet obey not what his prophets speak.
Sit thee, Oseas, pondering in the spirit
The mightiness of these fond⁶ people's sins.
 Os. The will of the Lord be done. 30

 Exit Angel.

 Enters [ADAM], *the* Clown, *and his crew of* Ruffians
 to go to drink.

 1 Ruff. Come on, smith, thou shalt be one of the
crew, because thou knowest where the best ale in the
town is.
 Adam. Come on! in faith, my colts, I have left my
master striking of a heat⁷ and stole away because I
would keep you company.
 1 Ruff. Why, what, shall we have this paltry smith
with us?
 Adam. "Paltry smith!" why, you incarnative⁸ knave,
what are you that you speak petty treason against the
smith's trade? 41
 1 Ruff. Why, slave, I am a gentleman of Nineveh.
 Adam. A gentleman! good sir, I remember you well,
and all your progenitors. Your father bare office in our
town, and honest man he was, and in great discredit in
the parish, for they bestowed two squires' livings⁹ on
him. The one was on working-days, and then he kept
the town stage, and on holidays they made him the
sexton's man, for he whipped dogs out of the church.
Alas, sir, your father—why, sir, methinks I see the 50
gentleman still. A proper youth he was, faith, aged
some forty and ten, his beard rat's color, half black,
half white; his nose was in the highest degree of noses,
it was *nose autem glorificam*,¹⁰ so set with rubies that
after his death it should have been nailed up in Copper-
smith's Hall¹¹ for a monument. Well, sir, I was be-
holding to your good father, for he was the first man
that ever instructed me in the mystery¹² of a pot of ale.
 2 Ruff. Well said, smith; that crossed him over the
thumbs.¹³ 60
 1 Ruff. Villain, were it not that we go to be merry,
my rapier should presently quit¹⁴ thy opprobrious
terms.
 Adam. O Peter, Peter, put up thy sword, I prithee,

⁴¹ *quondam:* former. ⁴² *broils:* battles.
⁴³ *conceited:* fanciful.
⁴⁴ *L.:* I now share an empire with Jove.
I.ii.
 ¹ Oseas remains above the stage until the end of Act IV,
Scene v. ² *Elias:* Elijah.
 ³ *Mount Carmel:* in Palestine.
 ⁴ *Sodom and Gomorrah:* biblical "cities of the plain"
destroyed for their sinfulness.
 ⁵ *thoughts:* Qq "through." ⁶ *fond:* foolish.
 ⁷ *of a heat:* some heated metal.
 ⁸ *incarnative:* fleshbreeding, Adam's error for "incarn-
ate" (i.e., arrant). ⁹ *two . . . livings:* two men's jobs.
 ¹⁰ *nose . . . glorificam:* nonsensical pun on liturgical phrase,
in which the Latin is unintentionally garbled; cf. *Friar Bacon
and Friar Bungay.*
 ¹¹ *Coppersmith's Hall:* because of the redness of the
drinker's nose; possibly a tavern; the same joke occurs in
Friar Bacon and Friar Bungay, v.42.
 ¹² *mystery:* occupation, professsion; also the modern sense.
 ¹³ *crossed . . . thumbs:* punished, reproved.
 ¹⁴ *quit:* repay; get rid of.

heartily into thy scabbard; hold in thy rapier, for though I have not a long reacher,[15] I have a short hitter.[16] Nay then, gentlemen, stay me, for my choler begins to rise against him, for mark the words "a paltry smith." Oh, horrible sentence,[17] thou hast in these words, I will stand to it, libelled against all 70 the sound horses, whole horses, coursers, curtals,[18] jades, cuts,[19] hackneys, and mares; whereupon, my friend, in their defense I give thee this curse: thou shalt not be worth a horse of thine own this seven year.

1 Ruff. I prithee, smith, is your occupation so excellent?

Adam. "A paltry smith"! why, I'll stand to it,[20] a smith is lord of the four elements, for our iron is made of the earth, our bellows blows out air, our floor holds fire, and our forge water. Nay, sir, we read in the Chronicles that there was a god[21] of our occupation. 81

1 Ruff. Ay, but he was a cuckold.

Adam. That was the reason, sir, he called your father cousin. "Paltry smith"! why, in this one word thou hast defaced their worshipful occupation.

1 Ruff. As how?

Adam. Marry, sir, I will stand to it that a smith in his kind is a physician, a surgeon, and a barber. For let a horse take a cold or be troubled with the botts[22] and we straight give him a potion or a purgation in such 90 physical manner that he mends straight. If he have outward diseases, as the spavin, splent,[23] ringbone,[24] windgall,[25] or fashion,[26] or, sir, a galled[27] back, we let him blood and clap a plaster to him with a pestilence that mends him with a very vengeance. Now if his mane grow out of order, and he have any rebellious hairs, we straight to our shears and trim him with what cut it please us, pick his ears, and make him neat. Marry, indeed, sir, we are slovens for one thing: we

never use any muskballs[28] to wash him with, and 100 the reason is, sir, because he can woo without kissing.

1 Ruff. Well, sirrah, leave off these praises of a smith and bring us to the best ale in the town.

Adam. Now, sir, I have a feat above all the smiths in Nineveh, for, sir, I am a philosopher that can dispute of the nature of ale. For mark you, sir, a pot of ale consists of four parts, *imprimis*[29] the ale,[30] the toast,[31] the ginger, and the nutmeg.

1 Ruff. Excellent. 109

Adam. The ale is a restorative, bread is a binder—mark you, sir, two excellent points in physic.[32] The ginger, oh, ware of that, the philosophers have written of the nature of ginger, 'tis expulsive in two degrees. You shall hear the sentence of Galen:[33] "It will make a man belch, cough, and fart, and is a great comfort to the heart"—a proper posy,[34] I promise you. But now to the noble virtue of the nutmeg. It is, saith one ballad—I think an English Roman was the author —an underlayer[35] to the brains, for when the ale gives a buffet to the head, oh, the nutmeg, that keeps 120 him for a while in temper.[36] Thus you see the description of the virtue of a pot of ale. Now, sir, to put my physical precepts in practice follow me; but afore I step any further—

1 Ruff. What's the matter now?

Adam. Why, seeing I have provided the ale, who is the purveyor for the wenches? For, masters, take this of me, a cup of ale without a wench, why, alas, 'tis like an egg without salt or a red[37] herring without mustard.

1 Ruff. Lead us to the ale; we'll have wenches enough, I warrant thee. 131

[*Exeunt all but* OSEAS.]

Os. Iniquity seek out companions still,
And mortal men are armèd to do ill.
London, look on, this matter nips thee near;
Leave off thy riot, pride, and sumptuous cheer.
Spend less at board and spare not at the door,[38]
But aid the infant and relieve the poor,
Else, seeking mercy, being merciless,
Thou be adjudged to endless heaviness.

[I.iii]

Enters the Usurer, [THRASIBULUS] *a* Young
Gentleman, *and* [ALCON] *a* Poor Man.

Usu. Come on. I am every day troubled with these needy companions. What news with you? What wind brings you hither?

Thras. Sir, I hope, how far soever you make off,[1] you remember too well for me that this is the day wherein I should pay you money that I took up of you a-late in a commodity.[2]

Alc. And, sir, sirreverence of[3] your manhood and gentry, I have brought home such money as you lent me. 10

Usu. You, young gentleman, is my money ready?

Thras. Truly, sir, this time was so short, the commodity so bad, and the promise of friends so broken, that I could not provide it against the day, wherefore I

15 *reacher:* sword. 16 *hitter:* dagger.

17 *sentence:* opinion, saying.

18 *curtals:* horse with short or docked tails.

19 *cuts:* laboring horses.

20 *stand to it:* defend the proposition.

21 *god:* i.e., Hephaestus (Vulcan).

22 *botts:* horse disease caused by maggot larvae.

23 *spavin, splent:* maladies caused by bony tumors in various parts of the leg.

24 *ringbone:* disease caused by deposit of bony matter on the pastern-bones. 25 *windgall:* soft tumor on the leg.

26 *fashion:* farcy, horse disease akin to glanders.

27 *galled:* afflicted with painful swellings.

28 *muskballs:* balls of soap scented with a powerful perfume. 29 *L.:* in the first place.

30 *ale:* mulled ale.

31 *toast:* piece of bread browned at the fire and put in a beverage. 32 *physic:* medicine.

33 *Galen:* Greek physician and writer on medicine, *c.* 130–200 A.D.

34 *posy:* short motto, usually in verse, often inscribed in rings, etc. 35 *underlayer:* base, support.

36 *temper:* healthy condition. 37 *red:* smoked.

38 *spare . . . door:* be charitable to calling beggars.

I.iii.

1 *make if off:* are going.

2 *commodity:* a parcel of goods sold on credit by a usurer to a needy person, who could raise cash by reselling them at a lower price (often to the usurer).

3 *sirreverence of:* with all respect for.

am come to entreat you to stand my friend and to favor me with a longer time, and I will make you sufficient consideration.

Usu. Is the wind in that door? If thou hast my money, so it is; I will not defer a day, an hour, a minute, but take the forfeit of the bond. 20

Thras. I pray you, sir, consider that my loss was great by the commodity I took up. You know, sir, I borrowed of you forty pounds, whereof I had ten pounds in money and thirty pounds in lute strings, which when I came to sell again I could get but five pounds for them; so had I, sir, but fifteen pounds for my forty. In consideration of this ill bargain I pray you sir, give me a month longer.

Usu. I answered thee afore not a minute: what have I to do how thy bargain proved? I have thy hand 30 set to my book that thou receivedst forty pounds of me in money.

Thras. Ay, sir, it was your device, that, to color[4] the statute,[5] but your conscience knows what I had.

Alc. Friend, thou speakest Hebrew to him when thou talkest to him of conscience, for he hath as much conscience about the forfeit of an obligation as my blind mare, God bless her, hath over a manger of oats.

Thras. Then there is no favor, sir?

Usu. Come tomorrow to me and see how I will use thee. 41

Thras. No, courteous caterpillar,[6] know that I have made extreme shift[7] rather than I would fall into the hands of such a ravening panther, and therefore here is thy money, and deliver me the recognizance[8] of my lands.

Usu. What a spite is this! hath sped of[9] his crowns. If he had missed but one half hour, what a goodly farm had I gotten for forty pounds. Well, 'tis my cursed fortune. Oh, have I no shift to make him forfeit his recognizance? 51

Thras. Come, sir, will you dispatch and tell your money?

Strikes four o'clock.

Usu. Stay—what is this, o'clock four? Let me see: to be paid between the hours of three and four in the afternoon; this goes right for me. You, sir, hear you not the clock? And have you not a counterpain[10] of your obligation? The hour is past; it was to be paid between three and four, and now the clock hath stroken four. I will receive none; I'll stand to the forfeit of the recognizance. 61

Thras. Why, sir, I hope you do but jest. Why, 'tis but four, and will you for a minute take forfeit of my bond? If it were so, sir, I was here before four.

Usu. Why didst thou not tender thy money then? If I offer thee injury, take the law of me. Complain to the judge. I will receive no money.

Alc. Well, sir, I hope you will stand my good master for my cow. I borrowed thirty shillings on her, and for that I have paid you eighteen pence a week, and 70 for her meat[11] you have had her milk, and I tell you, sir, she gives a goodly sup.[12] Now, sir, here is your money.

Usu. Hang, beggarly knave, comest to me for a cow? Did I not bind her bought and sold for a penny, and was not thy day to have paid yesterday? Thou getst no cow at my hand.

Alc. No cow, sir! Alas, that word "no cow" goes as cold to my heart as a draught of small[13] drink in a frosty morning. No cow, sir! Why, alas, alas, 80 master usurer, what shall become of me, my wife, and my poor child?

Usu. Thou getst no cow of me, knave. I cannot stand prating with you; I must be gone.

Alc. Nay, but hear you, master usurer. No cow! Why, sir, here's your thirty shillings. I have paid you eighteen pence a week, and therefore there is reason I should have my cow.

Usu. What pratest thou? Have I not answered thee thy day is broken? 90

Alc. Why, sir, alas, my cow is a commonwealth to me, for first, sir, she allows me, my wife, and son for to banquet ourselves withal—butter, cheese, whey, curds, cream, sod[14] milk, raw milk, sour milk, sweet milk, and buttermilk. Besides, sir, she saved me every year a penny in almanacs, for she was as good to me as a prognostication. If she had but set up her tail and have galloped about the mead, my little boy was able to say, "Oh, father, there will be a storm"; her very tail was a calendar to me, and now to lose my cow—alas, master usurer, take pity upon me. 101

Usu. I have other matters to talk on. Farewell, fellows.

Thras. Why, but, thou courteous churl, wilt thou not receive thy money and deliver me my recognizance?

Usu. I'll deliver thee none. If I have wronged thee, seek thy mends at the law.

[Exit.]

Thras. And so I will, insatiable peasant.

Alc. And, sir, rather than I will put up this word "no cow," I will lay my wife's best gown to pawn. 110 I tell you, sir, when the slave uttered this word "no cow," it struck to my heart, for my wife shall never have one so fit for her turn again; for indeed, sir, she is a woman that hath her twiddling strings[15] broke.

Thras. What meanest thou by that, fellow?

Alc. Marry, sir, sirreverence of your manhood, she breaks wind behind; and indeed, sir, when she sat milking of her cow and let a fart, my other cows would start at the noise and kick down the milk and away, but

[4] *color:* misrepresent.

[5] *statute:* bond by which creditor had the power of holding debtor's lands in case of default.

[6] *caterpillar:* rapacious person, one who preys on commonwealth.

[7] *shift:* ingenious device for effecting purpose.

[8] *recognizance:* property pledged as surety for performance of obligation required by debt and forfeited by neglect of it. [9] *sped of:* succeeded in getting.

[10] *counterpain:* corresponding part of a pair of deeds.

[11] *meat:* feed. [12] *sup:* sip.

[13] *small:* of low alcoholic strength.

[14] *sod:* boiled.

[15] *twiddling strings:* twattling (i.e., talking) strings, vulgar expression for anal sphincter.

this cow, sir—the gentlest cow—my wife might　120
blow whilst she burst. And having such good condi-
tions, shall the usurer come upon me with "no cow"?
Nay, sir, before I pocket up this word "no cow," my
wife's gown goes to the lawyer; why, alas, sir, 'tis as
ill a word to me as "no crown" to a king.

Thras. Well, fellow, go with me, and I'll help thee to
a lawyer.

Alc. Marry and I will, sir. "No cow!" Well, the
world goes hard.

　　　　　　　　　　　　　　　　　　　　Exeunt.

Os. Where hateful usury　　　　　　　　　130
Is counted husbandry;[16]
Where merciless men rob the poor,
And the needy are thrust out of door;
Where gain is held for conscience,
And men's pleasures is[17] all on pence;
Where young gentlemen forfeit their lands,
Through riot, into the usurer's hands;
Where poverty is despised and pity banished
And mercy indeed utterly vanished;
Where men esteem more of money than of God:　140
Let that land look to feel his wrathful rod,
For there is no sin more odious in his sight
Than where usury defrauds the poor of his right.
London, take heed, these sins abound in thee;
The poor complain, the widows wrongèd be.
The gentlemen by subtlety are spoiled;[18]
The ploughmen lose the crop for which they toiled.
Sin reigns in thee, O London, every hour;
Repent and tempt not thus the heavenly power.

ACT TWO

SCENE ONE

Enters REMILIA, *with a train of* Ladies, *in all royalty.*[1]

Rem. Fair Queens, yet handmaids unto Rasni's love,
Tell me, is not my state as glorious
As Juno's pomp when, 'tired with heaven's despoil,
Clad in her vestments, spotted all with stars,
She crossed the silver path unto her Jove?
Is not Remilia far more beauteous,
Riched with the pride of nature's excellence,
Than Venus in the brightest of her shine?
My hairs, surpass they not Apollo's locks?
Are not my tresses curlèd with such art　　　　10

[16] *husbandry:* thrift.
[17] *is:* not uncommon after plural noun.
[18] *spoiled:* despoiled.

II.i.
[1] *in . . . royalty:* regally dressed.
[2] *Aurora:* goddess of the dawn.
[3] *beauties . . . ball:* Paris presided over a beauty contest on
Mount Ida among Hera (Juno), Aphrodite (Venus), and
Athena (Minerva) for the prize of a golden apple.
[4] *trammels:* plaits, braids, fishing nets.
[5] *curious:* ingenious, artistic.
[6] *coy it:* act coyly.　　　[7] *trick . . . trim:* neatly, elegantly.
[8] *play . . . wanton:* behave with restrained lewdness.
[9] *hardly:* with difficulty.　　　[10] *unkind:* unnatural.
[11] *quite:* stop.　　　[12] *traced:* passed, trod.

As love delights to hide him in their fair?
Doth not mine eye shine like the morning lamp
That tells Aurora[2] when her love will come?
Have I not stol'n the beauty of the heavens
And placed it on the feature of my face?
Can any goddess make compare with me,
Or match her with the fair Remilia?

Alv. The beauties that proud Paris saw from Troy,
Must'ring in Ida for the golden ball,[3]
Were not so gorgeous as Remilia.　　　　　20

Rem. I have tricked my trammels[4] up with richest
　balm,
And made my perfumes of the purest myrrh.
The precious drugs that Egypt's wealth affords,
The costly paintings fetched from curious[5] Tyre,
Have mended in my face what nature missed.
Am I not the earth's wonder in my looks?

Alv. The wonder of the earth and pride of heaven.

Rem. Look, Alvida, a hair stands not amiss,
For women's locks are trammels of conceit
Which do entangle love for all his wiles.　　　30

Alv. Madam, unless you coy it[6] trick and trim,[7]
And play the civil wanton[8] ere you yield,
Smiting disdain of pleasures with your tongue,
Patting your princely Rasni on the cheek
When he presumes to kiss without consent,
You mar the market. Beauty naught avails;
You must be proud, for pleasures hardly[9] got
Are sweet if once attained.

Rem.　　　　　　　　　Fair Alvida,
Thy counsel makes Remilia passing wise.
Suppose that thou wert Rasni's mightiness,　40
And I, Remilia, prince of excellence.

Alv. I would be master then of love and thee.

Rem. Of love and me. Proud and disdainful King,
Dar'st thou presume to touch a deity
Before she grace thee with a yielding smile?

Alv. Tut, my Remilia, be not thou so coy;
Say nay and take it.

Rem.　　　　　　　Careless and unkind,[10]
Talks Rasni to Remilia in such sort
As if I did enjoy a human form?
Look on thy love, behold mine eyes divine;　50
And dar'st thou twit me with a woman's fault?
Ah, Rasni, thou art rash to judge of me.
I tell thee Flora oft hath wooed my lips
To lend a rose to beautify her spring;
The sea-nymphs fetch their lilies from my cheeks.
Then thou unkind, and hereon would I weep.

Alv. And here would Alvida resign her charge,
For were I but in thought th' Assyrian King,
I needs must quite[11] thy tears with kisses sweet,
And crave a pardon with a friendly touch.　60
You know it, madam, though I teach it not—
The touch, I mean; you smile when as you think it.

Rem. How am I pleased to hear thy pretty prate
According to the humor of my mind.
Ah, nymphs, who fairer than Remilia?
The gentle winds have wooed me with their sighs,
The frowning air hath cleared when I did smile;
And when I traced[12] upon the tender grass,

Love, that makes warm the center of the earth,
Lift up his crest to kiss Remilia's foot. 70
Juno still entertains her amorous Jove
With new delights for fear he look on me;
The phoenix'[13] feathers are become my fan,
For I am beauty's phoenix in this world.
Shut close these curtains straight and shadow me
For fear Apollo spy me in his walks,
And scorn all eyes to see Remilia's eyes.
Nymphs, eunuchs, sing, for Mavors draweth nigh.
Hide me in closure, let him long to look,
For were a goddess fairer than am I, 80
I'll scale the heavens to pull her from the place.

They draw the curtains, and music plays.

Alv. Believe me, though she say that she is fairest,
I think my penny silver[14] by her leave.

Enter RASNI *with* [RADAGON *and*] *his* Lords *in pomp, who make a ward about him, with the* Magi *in great pomp.*

Ras. Magi, for love of Rasni, by your art,
By magic frame an arbor out of hand
For fair Remilia to disport her in.
Meanwhile I will bethink me on further pomp.

Exit.

The Magi *with their rods beat the ground, and from under the same riseth a brave arbor; the* King *returneth in another suit while the trumpets sound.*

Ras. Blessèd be ye, man of art that grace me thus,
And blessèd be this day where Hymen[15] hies
To join in union pride of heaven and earth. 90

Lightning and thunder wherewith REMILIA *is stroken.*

What wondrous threatening noise is this I hear?
What flashing lightnings trouble our delights?
When I draw near Remilia's royal tent
I waking dream of sorrow and mishap.
Rad. Dread not, O King, at ordinary chance.
These are but common exhalations
Drawn from the earth, in substance hot and dry
Or moist and thick, or meteors combust,[16]
Matters and causes incident to time,
Enkindled in the fiery region first. 100
Tut, be not now a Roman augurer;
Approach the tent, look on Remilia.
Ras. Thou hast confirmed my doubts, kind Radagon.
Now ope the folds where Queen of favor sits,
Carrying a net within her curlèd locks
Wherein the graces are entangled oft.
Ope like th' imperial gates where Phoebus[17] sits
When as he means to woo his Clitia.[18]
Nocturnal cares, ye blemishers of bliss,
Cloud not mine eyes whilst I behold her face.— 110
Remilia, my delight.—She answereth not.

He draws the curtains and finds her stroken with thunder, black.

How pale? As if bereaved in fatal meeds;
The balmy breath hath left her bosom quite;

My Hesperus[19] by cloudy death is blent.[20]
Villains, away, fetch syrups of the Inde,[21]
Fetch balsamo,[22] the kind preserve of life,
Fetch wine of Greece, fetch oils, fetch herbs, fetch all
To fetch her life, or I will faint and die.

They bring in all these and offer; naught prevails.

Herbs, oils of Inde, alas, there naught prevails.
Shut are the day-bright eyes that made me see, 120
Locked are the gems of joy in dens of death.
Yet triumph I on fate, and he on her.
Malicious mistress[23] of inconstancy,
Damned be thy name that hast obscured my joy.
Kings, viceroys, princes, rear a royal tomb
For my Remilia; bear her from my sight,
Whilst I in tears weep for Remilia.

They bear her out.

Rad. What maketh Rasni moody? Loss of one?
As if no more were left so fair as she?
Behold a dainty minion[24] for the nonce, 130
Fair Alvida, the Paphlagonian Queen;
Woo her, and leave this weeping for the dead.
Ras. What, woo my subject's wife that honoreth me?
Rad. Tut, kings this *meum tuum*[25] should not know.
Is she not fair? Is not her husband hence?
Hold, take her at the hands of Radagon,
A pretty peat[26] to drive your mourn away.
Ras. She smiles on me; I see she is mine own.
Wilt thou be Rasni's royal paramour?
Rad. She blushing yields consent, make no dispute;
The King is sad and must be gladded straight. 141
Let Paphlagonian King go mourn meanwhile.

He thrusts the King *out, and so they exeunt.*

Os. Pride hath his judgment. London, look about.
'Tis not enough in show to be devout.
A fury now from heaven to lands unknown
Hath made the prophet speak, not to his own.
Fly, wantons, fly this pride and vain attire,
The seals to set your tender hearts on fire.
Be faithful in the promise you have passed,
Else God will plague and punish at the last 150
When lust is hid in shroud of wretched life,
When craft doth dwell in bed of married wife,
Mark but the prophets, we that shortly shows,
After death expect for many woes.[27]

[13] *phoenix':* The phoenix was a legendary bird, the only one of its kind, said to live hundreds of years, burn itself on a funeral pyre, and rise from its ashes to live another cycle.
[14] *think . . . silver:* i.e., I think I am as beautiful, have a high opinion of myself (proverbial).
[15] *Hymen:* Greek god of marriage.
[16] *meteors combust:* lightning. Radagon's explanation bases natural phenomena on combinations of the four elements—air, fire, earth, and water. [17] *Phoebus:* Apollo.
[18] *Clitia:* sea-nymph, daughter of Oceanus, beloved of Apollo. [19] *Hesperus:* evening star.
[20] *blent:* destroyed. [21] *Inde:* India.
[22] *balsamo:* balsam, an aromatic medicine.
[23] *mistress:* i.e., fortune. [24] *minion:* paramour.
[25] *L.:* mine [and] thine; i.e., property rights.
[26] *peat:* pet. [27] *Mark . . . woes:* Text is corrupt.

[II.ii]

Enters [ALCON] *the* Poor Man *and* [THRASIBULUS] *the* Gentleman *with their* Lawyer.

Thras. I need not, sir, discourse unto you the duty of lawyers in tendering the right cause of their clients nor the conscience you are tied unto by higher command. Therefore, suffice the usurer hath done me wrong, you know the case, and, good sir, I have strained myself to give you your fees.

Law. Sir, if I should any way neglect so manifest a truth, I were to be accused of open perjury, for the case is evident. 9

Alc. And truly, sir, for my case, if you help me not for my matter, why, sir, I and my wife are quite undone. I want my mess[1] of milk when I go to my work, and my boy his bread and butter when he goes to school. Master Lawyer, pity me, for surely, sir, I was fain to lay my wife's best gown to pawn for your fees. When I looked upon it, sir, and saw how handsomely it was daubed with statute lace,[2] and what a fair mockado[3] cape it had, and then thought how handsomely it became my wife—truly, sir, my heart is made of butter, it melts at the least persecution—I fell on weeping; 20 but when I thought on the words the usurer gave me, "no cow," then, sir, I would have stripped her into her smock, but I would make him deliver my cow ere I had done. Therefore, good master lawyer, stand my friend.

Law. Trust me, father, I will do for thee as much as for myself.

Alc. Are you married, sir?

Law. Ay, marry[4] am I, father.

Alc. Then God's benison[5] light on you and your good wife, and send her that she be never troubled with my wife's disease. 31

Law. Why, what's thy wife's disease?

Alc. Truly, sir, she hath two open faults and one privy fault. Sir, the first is, she is too eloquent for a poor man, and hath her words of art, for she will call me a rascal, rogue, runagate,[6] varlet, vagabond, slave, knave. Why, alas, sir, and these be but holiday terms, but if you heard her working-day words, in faith, sir, they be rattlers like thunder, sir, for after the dew follows a storm, for then am I sure either to be 40 well buffeted, my face scratched, or my head broken; and therefore, good master lawyer, on my knees I ask it, let me not go home again to my wife with this word "no cow," for then she will exercise her two faults upon me with all extremity.

Law. Fear not, man. But what is thy wife's privy fault?

Alc. Truly, sir, that's a thing of nothing. Alas, she indeed, sirreverence of your mastership, doth use to break wind in her sleep. Oh, sir, here comes the judge and the old caitiff[7] the usurer. 51

Enters the Judge, *the* Usurer, *and his* Attendants.

Usu. Sir, here is forty angels[8] for you, and if at any time you want a hundred pound or two, 'tis ready at your command, or the feeding of three or four fat bullocks; whereas these needy slaves can reward you with nothing but a cap and a knee,[9] and therefore I pray you, sir, favor my case.

Judge. Fear not, sir, I'll do what I can for you.

Usu. What, master lawyer, what make you here, mine adversary for these clients? 60

Law. So it chanceth now, sir.

Usu. I know you know the old proverb, "He is not wise that is not wise for himself." I would not be disgraced in this action; therefore, here is twenty angels. Say nothing in the matter, and what you say, say to no purpose, for the judge is my friend.

Law. Let me alone, I'll fit your purpose.

Judge. Come, where are these fellows that are the plaintiffs? What can they say against this honest citizen, our neighbor, a man of good report amongst all men. 70

Alc. Truly, master judge, he is a man much spoken of. Marry, every man's cries are against him, and especially we, and therefore I think we have brought our lawyer to touch him with as much law as will fetch his lands and my cow, with a pestilence.

Thras. Sir, I am the other plaintiff, and this is my counselor. I beseech your honor be favorable to me in equity.

Judge. O Signor Mizaldo, what can you say in this gentleman's behalf? 80

Law. Faith, sir, as yet little good. Sir, tell your own case to the judge, for I have so many matters in my head that I have almost forgotten it.

Thras. Is the wind in that door? Why, then, my lord, thus: I took up of this cursed usurer, for so I may well term him, a commodity of forty pounds, whereof I received ten pounds and thirty pound in lute strings, whereof I could by great friendship[10] make but five pounds. For the assurance of this bad commodity I bound him my land in recognizance. I came at 90 my day and tendered him his money, and he would not take it; for the redress of my open wrong I crave but justice.

Judge. What say you to this, sir?

Usu. That first, he had no lute strings of me, for, look you, sir, I have his own hand to my book for the receipt of forty pound.

Thras. That was, sir, but a device of him to color[11] the statute. 99

Judge. Well, he hath thine own hand, and we can crave no more in law. But now, sir, he says his money was tendered at the day and hour.

Usu. This is manifest contrary, sir, and on that I will depose, for here is the obligation, "to be paid

between three and four in the afternoon," and the clock struck four before he offered it, and the words be "between three and four," therefore to be tendered before four.

Thras. Sir, I was there before four, and he held me with brabbling [12] until the clock struck, and 110 then for the breach of a minute he refused my money and kept the recognizance of my land for so small a trifle. Good Signor Mizaldo, speak what is law. You have your fee, you have heard what the case is, and therefore do me justice and right. I am a young gentleman and speak for my patrimony.

Law. Faith, sir, the case is altered. You told me it before in another manner. The law goes quite against you, and therefore you must plead to the judge for favor. 120

Thras. Oh, execrable bribery.

Alc. Faith, sir judge, I pray you let me be the gentleman's counselor, for I can say thus much in his defense, that the usurer's clock is the swiftest clock in all the town. 'Tis, sir, like a woman's tongue: it goes ever half an hour before the time; for when we were gone from him, other clocks in the town struck four.

Judge. Hold thy prating, fellow; and you, young gentleman, this is my ward. [13] Look better another time both to your bargains and to the payments, for I 130 must give flat sentence against you, that for default of tendering the money between the hours you have forfeited your recognizance, and he to have the land.

Thras. [*Aside*] Oh, unspeakable injustice!

Alc. [*Aside*] Oh, monstrous, miserable, moth-eaten judge!

Judge. Now you, fellow, what have you to say for your matter?

Alc. Master lawyer, I laid my wife's gown to pawn for your fees; I pray you to this gear. [14] 140

Law. Alas, poor man, thy matter is out of my head, and therefore I pray thee tell it thyself.

Alc. I hold my cap to a noble [15] that the usurer hath given him some gold, and he, chawing it in his mouth, hath got the toothache that he cannot speak,

Judge. Well, sirrah, I must be short, and therefore say on.

Alc. Master judge, I borrowed of this man thirty shillings, for which I left him in pawn my good cow. The bargain was he should have eighteen pence 150 a week and the cow's milk for usury. Now, sir, as soon as I had gotten the money, I brought it to him, and broke [16] but a day, and for that he refused his money and keeps my cow, sir.

Judge. Why, thou hast given sentence against thyself, for in breaking thy day thou hast lost thy cow.

Alc. Master lawyer, now for my ten shillings.

Law. Faith, poor man, thy case is so bad I shall but speak against thee.

Alc. 'Twere good, then, I should have my ten shillings again. 161

Law. 'Tis my fee, fellow, for coming. Wouldst thee have me come for nothing?

Alc. Why, then, am I like to go home not only with no cow, but no gown; this gear goes hard.

Judge. Well, you have heard what favor I can show you; I must do justice. Come, Master Mizaldo; and you, sir, go home with me to dinner.

Alc. Why, but master judge, no cow, and master lawyer, no gown;
Then must I clean run out of the town. 170
How cheer you, gentleman? You cry "no lands," too; the judge hath made you a knight for a gentleman, hath dubbed you Sir John Lackland.

Thras. Oh, miserable time wherein gold is above God.

Alc. Fear not, man, I have yet a fetch [17] to get thy lands and my cow again, for I have a son in the court that is either a king or a king's fellow, and to him will I go and complain on the judge and the usurer both.

Thras. And I will go with thee and entreat him for my case. 181

Alc. But how shall I go home to my wife, when I shall have nothing to say unto her but "no cow"? Alas, sir, my wife's faults will fall upon me.

Thras. Fear not. Let's go; I'll quiet her; shalt see.
[*Exeunt.*]

Os. Fly, judges, fly corruption in your court.
The Judge of truth hath made your judgment short.
Look so to judge that at the latter day
You be not judged with those that wend astray.
Who passeth judgment for his private gain, 190
He well may judge; he is adjudged to pain.

[II.iii]

Enters [ADAM] *the* Clown *and all his* Crew *drunk.*

Adam. Farewell, gentle tapster. Masters, as good ale as was ever tapped; look to your feet, for the ale is strong. Well, farewell, gentle tapster.

1 Ruff. Why, sirrah slave, by heaven's maker, thinkest thou the wench love thee best because she laughed on thee? Give me but such another word, and I will throw the pot at thy head.

Adam. Spill no drink! spill no drink! the ale is good. I'll tell you what: ale is ale; and so I'll commend me to you [1] with hearty commendations. Farewell, gentle tapster. 11

2 Ruff. Why, wherefore, peasant, scorn'st thou that the wench should love me? Look but on her, and I'll thrust my dagger in thy bosom.

1 Ruff. Well, sirrah, well; th'art as th'art, and so I'll take thee.

2 Ruff. Why, what am I?

1 Ruff. Why, what thou wilt, a slave.

2 Ruff. Then take that, villain, and learn how thou use me another time. 20

[*Stabs him.*]

[12] *brabbling:* quarreling noisily.
[13] *ward:* place over which I have authority.
[14] *gear:* business.
[15] *noble:* gold coin, predecessor of the angel.
[16] *broke:* i.e., the contract. [17] *fetch:* stratagem.
II.iii.
[1] *commend . . . you:* present my kind regards.

1 Ruff. Oh, I am slain.

[*Dies.*]

2 Ruff. That's all one to me; I care not. Now will I in to my wench and call for a fresh pot.

[*Exit.*]

Adam. Nay, but hear ye, take me with ye,[2] for the ale is ale. Cut a fresh toast, tapster; fill me a pot. Here is money; I am no beggar. I'll follow thee as long as the ale lasts.

Here he falls over the dead man.[3]

A pestilence on the blocks[4] for me, for I might have had a fall. Well, if we shall have no ale I'll sit me down; and so farewell, gentle tapster. 30

Enters the King, ALVIDA, King of CILICIA, *with other* Attendant[s].

Ras. What slaughtered wretch lies bleeding here his last?
So near the royal palace of the King?
Search out if any one be hiding nigh
That can discourse the manner of his death.
Seat thee, fair Alvida, the fair of fairs;
Let not the object[5] once offend thine eyes.

Lord. Here's one sits here asleep, my lord.

Ras. Wake him and make inquiry of this thing.

Lord. Sirrah! you! hearest thou, fellow?

Adam. If you will fill a fresh pot, here's a penny, or else farewell, gentle tapster. 41

Lord. He is drunk, my lord.

Ras. We'll sport with him that Alvida may laugh.

Lord. Sirrah, thou, fellow, thou must come to the King.

Adam. I will not do a stroke of work today, for the ale is good ale, and you can ask but a penny for a pot, no more by the statute.

Lord. Villain, here's the King. Thou must come to him. 50

Adam. The King come to an alehouse! Tapster, fill me three pots. Where's the King? Is this he? Give me your hand, sir; as good ale as ever was tapped you shall drink while your skin crack.[6]

Ras. But hearest thou, fellow? Who killed this man?

Adam. I'll tell you, sir, if you did taste of the ale, all Nineveh hath not such a cup of ale; it flowers[7] in the cup, sir. By my troth, I spent eleven pence beside three races[8] of ginger.

Ras. Answer me, knave, to my question. How came this man slain? 61

Adam. Slain! Why, ale is strong ale, 'tis huffcap;[9] I warrant you 'twill make a man well. Tapster, ho! for

the King a cup of ale and a fresh toast. Here's two races more.

Alv. Why, good fellow, the King talks not of drink; he would have thee tell him how this man came dead.

Adam. Dead! Nay, I think I am alive yet, and will drink a full pot ere night; but, hear ye, if ye be the wench that filled us drink, why so, do your office 70 and give us a fresh pot, or if you be the tapster's wife, why so, wash the glass clean.

Alv. He is so drunk, my lord, there's no talking with him.

Adam. Drunk! nay, then, wench, I am not drunk; th'art a shitten quean[10] to call me drunk. I tell thee I am not drunk; I am a smith, I.

Enters the Smith, [ADAM] *the* Clown's *Master.*

Lord. Sir, here comes one perhaps that can tell.

Smith. God save you, master.

Ras. Smith, canst thou tell me how this man came dead? 81

Smith. May it please your highness, my man here and a crew of them went to the alehouse and came out so drunk that one of them killed another, and now, sir, I am fain to leave my shop and come to fetch him home.

Ras. Some of you carry away the dead body. Drunken men must have their fits; and, sirrah smith, hence with thy man.

Smith. Sirrah, you, rise, come go with me.

Adam. If we shall have a pot of ale, let's have it; here's money; hold, tapster, take my purse. 91

Smith. Come then with me. The pot stands full in the house.

Adam. I am for you. Let's go; th'art an honest tapster. We'll drink six pots ere we part.

Exeunt [ADAM *and* Smith].

Ras. Beauteous, more bright than beauty in mine eyes,
Tell me, fair sweeting, wants thou anything
Contained within the threefold circle of the world
That may make Alvida live full content?

Alv. Nothing, my lord, for all my thoughts are pleased 100
When as mine eye surfeits with Rasni's sight.

Enters the King of PAPHLAGONIA, *malcontent.*

Ras. Look how thy husband haunts our royal courts,
How still his sight breeds melancholy storms.
O Alvida, I am passing passionate,
And vexed with wrath and anger to the death.
Mars, when he held fair Venus on his knee
And saw the limping smith[11] come from his forge,
Had not more deeper furrows in his brow
Than Rasni hath to see this Paphlagon.

Alv. Content thee, sweet, I'll salve thy sorrow straight; 110
Rest but the ease of all thy thoughts on me,
And if I make not Rasni blithe again,
Then say that women's fancies[12] have no shifts.

Paph. Sham'st thou not, Rasni, though thou beest a king,
To shroud adultery in thy royal seat?

[2] *take . . . ye:* i.e., I'll go along with that.
[3] *Here . . . man:* Q has this stage direction two lines later.
[4] *blocks:* i.e., stumbling blocks. [5] *object:* Q "otrict."
[6] *crack:* i.e., is dry. [7] *flowers:* foams.
[8] *races:* roots. [9] *huffcap:* strong and heady.
[10] *quean:* prostitute.
[11] *smith:* i.e., Vulcan, husband of Venus.
[12] *fancies:* powers of invention.

Art thou arch-ruler of great Nineveh,
Who shouldst excel in virtue as in state,
And wrongst thy friend by keeping back his wife?
Have not I battled in thy troops full oft
'Gainst Egypt, Jewry, and proud Babylon, 120
Spending my blood to purchase thy renown,
And is the guerdon [13] of my chivalry
Ended in this abusing of my wife?
Restore her me, or I will from thy courts
And make discourse of thy adulterous deeds.

Ras. Why, take her, Paphlagon; exclaim not, man,
For I do prize mine honor more than love.
Fair Alvida, go with thy husband home.

Alv. How dare I go, shamed with so deep misdeed?
Revenge will broil within my husband's breast, 130
And when he hath me in the court at home,
Then Alvida shall feel revenge for all.

Ras. What saist thou, King of Paphlagon, to this?
Thou hearest the doubt thy wife doth stand upon.
If she hath done amiss it is my fault;
I prithee pardon and forget it all.

Paph. If that I meant not, Rasni, to forgive
And quite forget the follies that are past,
I would not vouch [14] her presence in my courts;
But she shall be my Queen, my love, my life, 140
And Alvida unto her Paphlagon,
And loved, and more beloved than before.

Ras. What saist thou, Alvida, to this?

Alv. That will he swear it to my lord the King,
And in a full carouse of Greekish wine
Drink down the malice of his deep revenge,
I will go home and love him new again.

Ras. What answers Paphlagon?

Paph. That what she hath requested I will do.

Alv. Go, damosel, [and] fetch me that sweet wine
That stands within thy closet on the shelf. 151
Pour it into a standing bowl of gold,
But on thy life taste not before the King.
Make haste. Why is great Rasni melancholy thus?
If promise be not kept, hate all for me.
Here is the wine, my lord. First make him swear.

Paph. By Nineveh's great gods and Nineveh's great
 King,
My thoughts shall never be to wrong my wife;
And thereon here's a full carouse to her.

Alv. And thereon, Rasni, here's a kiss for thee. 160
Now mayst thou freely fold [15] thine Alvida.

Paph. Oh, I am dead—obstructions of my breath—
The poison is of wondrous sharp effect.
Cursed be all adult'rous queens, say I,
And cursing so poor Paphlagon doth die.

 [Dies.]

Alv. Now, have I not salved the sorrows of my lord?
Have I not rid a rival of thy love's?
What saist thou, Rasni, to thy paramour?

Ras. That for this deed I'll deck my Alvida
In sendal [16] and in costly gossampine, [17] 170
Bordered with pearl and India diamond;
I'll cause great Aeol perfume all his winds
With richest myrrh and curious [18] ambergris.

Come, lovely minion, paragon for fair, [19]
Come follow me, sweet goddess of mine eye,
And taste the pleasures Rasni will provide.

 Exeunt.

Os. Where whoredom reigns, there murder follows
 fast,
As falling leaves before the winter blast.
A wicked life trained up in endless crime
Hath no regard unto the latter time, 180
When lechers shall be punished for their lust,
When princes plagued because they are unjust.
Foresee in time: the warning bell doth toll;
Subdue the flesh by prayer to save the soul.
London, behold the cause of other's wrack,
And see the sword of justice at thy back.
Defer not off; tomorrow is too late;
By night He comes perhaps to judge thy state.

ACT THREE

SCENE ONE

Enter Jonas *solus.*

Jon. From forth the depth of my imprisoned soul
Steal you, my sighs, testify my pain,
Convey on wings of mine immortal tone
My zealous prayers unto the starry throne.
Ah, merciful and just, thou dreadful God,
Where is thine arm to lay revengeful strokes
Upon the heads of our rebellious race?
Lo, Israel, once that flourished like the vine,
Is barren laid, the beautiful increase
Is wholly blent, and irreligious zeal 10
Encampeth there where virtue was enthroned.
Alas the while, the widow wants relief;
The fatherless is wronged by naked need;
Devotion sleeps in cinders of contempt;
Hypocrisy infects the holy priest.
Aye me for this, woe me for these misdeeds;
Alone I walk to think upon the world,
And sigh to see thy prophets so contemned,
Alas contemned by cursèd Israel.
Yet, Jonas, rest content, 'tis Israel's sin 20
That causeth this; then muse thereon,
But pray amends, and mend thy own amiss.

An Angel *appeareth to* Jonas.

Ang. Amithai's [1] son, I charge thee muse no more.
I AM hath power to pardon and correct;
To thee pertains to do the Lord's command.
Go, girt [2] thy loins, and haste thee quickly hence
To Nineveh, that mighty city; wend,

[13] *guerdon:* prize. [14] *vouch:* allow. [15] *fold:* embrace.
[16] *sendal:* thin, rich, silken material.
[17] *gossampine:* cloth made of a cotton-like fiber.
[18] *curious:* exquisite. [19] *for fair:* in beauty.
III.i.
 [1] *Amithai's:* Bishops' Bible form of "Amittai's."
 [2] *girt:* gird.

And say this message from the Lord of hosts;
Preach unto them these tidings from thy God:
"Behold, thy wickedness hath tempted me 30
And piercèd through the ninefold orbs of heaven.
Repent, or else thy judgment is at hand."

This said, the Angel *vanisheth.*

Jon. Prostrate I lie before the Lord of hosts,
With humble ears intending his behest.
Ah, honored be Jehovah's great command.
Then Jonas must to Nineveh repair,
Commanded as the prophet of the Lord.
Great dangers on this journey do await,
But dangers none where heavens direct the course.
What should I deem? [3] I see, yea, sighing see, 40
How Israel sins yet knows the way of truth,
And thereby grows the byword of the world;
How then should God in judgment be so strict
'Gainst those who never heard or knew his power,
To threaten utter ruin of them all?
Should I report this judgment of my God,
I should incite them more to follow sin,
And publish to the world my country's blame.
It may not be, my conscience tells me no.
Ah, Jonas, wilt thou prove rebellious then? 50
Consider, ere thou fall, what error is.
My mind misgives; to Joppa [4] will I flee,
And for a while to Tharsus [5] shape my course,
Until the Lord unfret [6] his angry brows.

Enter certain Merchants of Tharsus, *a* Master,
and some Sailors.

Mast. Come on, brave merchants, now the wind
 doth serve,
And swiftly blows a gale at west southwest.
Our yards [7] a cross, [8] our anchors on the pike [9]—
What, shall we hence and take this merry gale?
Merch. Sailors, convey our budgets [10] straight aboard
And we will recompense your pains at last. 60
If once in safety we may Tharsus see,
Master, we'll feast these merry mates and thee.
Mast. Meanwhile, content yourselves with silly [11]
 cates. [12]
Our beds are boards, our feasts are full of mirth;

We use no pomp, we are the lords of sea.
When princes sweat in care, we swink [13] of [14] glee.
Orion's shoulders and the pointers [15] serve
To be our lodestars in the lingering night;
The beauties of Arcturus we behold;
And though the sailor is no bookman held, 70
He knows more art than ever bookmen read.
 Sail. By heavens, well said; in honor of our trade,
Let's see the proudest scholar stir [16] his course
Or shift [17] his tides as silly [18] sailors do;
Then will we yield them praise, else never none.
 Merch. Well spoken, fellow, in thine own behalf;
But let us hence; wind tarries none, you wot, [19]
And tide and time let slip is hardly [20] got.
 Mast. March to the haven, [21] merchants; I follow
 you.
 Jon. Now doth occasion further my desires; 80
I find companions fit to aid my flight.
Stay, sir, I pray, and hear a word or two.
 Mast. Say on, good friend, but briefly, if you please;
My passengers by this time are aboard.
 Jon. Whither pretend [22] you to embark yourselves?
 Mast. To Tharsus, sir, and here in Joppa haven
Our ship is pressed [23] and ready to depart.
 Jon. May I have passage for my money, then?
 Mast. What not for money? Pay ten silverlings;
You are a welcome guest if so you please. 90
 Jon. Hold, take thy hire; I follow thee, my friend.
 Mast. Where is your budget? Let me bear it, sir.
 Jon. To one in peace who sail as I do now, [24]
Put trust in Him who succoreth every want.

 Exeunt.

 Os. When prophets new inspired presume to force
And tie the power of heaven to their conceits;
When fear, promotion, [25] pride, or simony, [26]
Ambition, subtle craft their thoughts disguise,
Woe to the flock whereas [27] the shepherds foul.
For lo, the Lord at unawares [28] shall plague 100
The careless guide because his flocks do stray.
The ax already to the tree is set;
Beware to tempt the Lord, ye men of art.

[III.ii]

Enter ALCON, THRASIBULUS, SAMIA,
CLESIPHON, *a lad.*

Cles. Mother, some meat or else I die for want.
Sam. Ah, little boy, how glad thy mother would
Supply thy wants, but naked need denies;
Thy father's slender portion in this world
By usury and false deceit is lost.
No charity within this city bides;
All for themselves, and none to help the poor.
 Cles. Father, shall Clesiphon have no relief?
 Alc. Faith, my boy, I must be flat with thee: we
must feed on proverbs now. As necessity hath no 10
law, a churl's feast is better than none at all, for other
remedies have we none except thy brother Radagon
help us.
 Sam. Is this thy slender care to help our child?

 [3] *deem:* think.
 [4] *Joppa:* ancient name of Jaffa, Palestinian seaport.
 [5] *Tharsus:* i.e., Tarshish, ancient country said to have
been in southern Spain, perhaps confused with Tarsus,
Acts 22:24. [6] *unfret:* clear.
 [7] *yards:* yardarms.
 [8] *a cross:* set up on the mast to take the sail.
 [9] *pike:* projecting beam on which anchor is hoisted.
 [10] *budgets:* leather pouches. [11] *silly:* simple.
 [12] *cates:* food. [13] *swink:* labor. [14] *of:* in.
 [15] *pointers:* two stars in Ursa Major, a straight line through
which points to the North Star. [16] *stir:* steer.
 [17] *shift:* record variations of. [18] *silly:* lowly.
 [19] *wot:* know. [20] *hardly:* at a high price.
 [21] *haven:* port. [22] *pretend:* undertake, venture.
 [23] *pressed:* prepared. [24] *To . . . now:* Text is corrupt.
 [25] *promotion:* desire of preferment.
 [26] *simony:* profiting by sale of ecclesiastical office.
 [27] *whereas:* where. [28] *unawares:* when he is unaware.

Hath nature armed thee to no more remorse?
Ah, cruel man, unkind and pitiless,
Come, Clesiphon, my boy, I'll beg for thee.

 Cles. Oh, how my mother's mourning moveth me.

 Alc. Nay, you shall pay me interest for getting[1] the
boy, wife, before you carry him hence. Alas, 20
woman, what can Alcon do more? I'll pluck the belly
out of my heart[2] for thee, sweet Samia; be not so
waspish.

 Sam. Ah, silly man, I know thy want is great,
And foolish I, to crave where nothing is.
Haste, Alcon, haste, make haste unto our son,
Who, since he is in favor of the King,
May help this hapless gentleman and us
For to regain our goods from tyrants' hands.

 Thras. Have patience, Samia, wait your weal from
 heaven. 30
The gods have raised your son; I hope for this
To succor innocents in their distress.

<div align="center">Enters RADAGON solus.</div>

Lo where he comes from the imperial court.
Go, let us prostrate us before his feet.

 Alc. Nay, by my troth, I'll never ask my son blessing,
che[3] trow,[4] cha[5] taught him his lesson to know his
father. What, son Radagon, yfaith, boy, how dost
thee?

 Rad. Villain, disturb me not; I cannot stay. 39

 Alc. Tut, son, I'll help you of that disease quickly,
for I can hold thee. Ask thy mother, knave, what
cunning I have to ease a woman when a qualm of kind-
ness come too near her stomach. Let me but clasp mine
arms about her body and say my prayers in her bosom,
and she shall be healed presently.

 Rad. Traitor unto my princely majesty,
How dar'st thou lay thy hands upon a king?

 Sam. No traitor, Radagon, but true is he.
What, hath promotion bleared thus thine eye
To scorn thy father when he visits thee? 50
Alas, my son, behold with ruthful[6] eyes,
Thy parents robbed of all their worldly weal
By subtle means of usury and guile.
The judge's ears are deaf and shut up close,
All mercy sleeps; then be thou in these plunges[7]
A patron to thy mother in her pains.
Behold thy brother almost dead for food;
Oh, succor us that first did succor thee.

 Rad. What, succor me? False callet,[8] hence, avaunt!
Old dotard, pack, move not my patience; 60
I know you not; kings never look so low.

 Sam. You know us not! O Radagon, you know
That knowing us you know your parents then;
Thou knowst this womb first brought thee forth to
 light;
I know these paps did foster thee, my son.

 Alc. And I know he hath had many a piece of bread
and cheese at my hands, as proud as he is; that know I.

 Thras. I wait no hope of succors in this place,
Where children hold their fathers in disgrace.

 Rad. Dare you enforce the furrows of revenge 70
Within the brows of royal Radagon?

Villain, avaunt; hence, beggars, with your brats.
Marshal, why whip you not these rogues away
That thus disturb our royal majesty?

 Cles. Mother, I see it is a wondrous thing
From base estate for to become a king;
For why, methink my mother in these fits
Hath got a kingdom and hath lost his wits.

 Rad. Yet more contempt before my royalty? 79
Slaves, fetch out tortures worse than Tityus'[9] plagues,
And tear their tongues from their blasphemous heads.

 Thras. I'll get me gone, though woebegone with
 grief.
No hope remains; come, Alcon, let us wend.

 Rad. 'Twere best you did, for fear you catch your
 bane.

 Sam. Nay, traitor, I will haunt thee to the death;
Ungracious son, untoward and perverse,
I'll fill the heavens with echoes of thy pride,
And ring in every ear thy small regard,
That dost despise thy parents in their wants;
And, breathing forth my soul before thy wants, 90
My curses still[10] shall haunt thy hateful head;
And, being dead, my ghost shall thee pursue.

<div align="center">Enter RASNI, King of Assyria, attended on by his
Soothsayers and Kings.</div>

 Ras. How now, what mean these outcries in our
 court,
Where naught should sound but harmonies of heaven?
What maketh Radagon so passionate?

 Sam. Justice, O King, justice against my son.

 Ras. Thy son! what son?

 Sam. This cursèd Radagon.

 Rad. Dread monarch, this is but a lunacy
Which grief and want hath brought the woman to.
What, doth this passion hold you every moon? 100

 Sam. Oh, politic in sin and wickedness,
Too impudent for to delude thy prince!
O Rasni, this same womb first brought him forth.
This is his father, worn with care and age;
This is his brother, poor unhappy lad,
And I his mother, though contemned by him.
With tedious toil we got our little good,
And brought him up to school with mickle[11] charge.
Lord, how we enjoyed to see his towardness,[12]
And to ourselves we oft in silence said, 110
"This youth when we are old may succor us."
But now, preferred and lifted up by thee,
We quite destroyed by cursèd usury,
He scorneth me, his father, and this child.

 Cles. He plays the serpent right, described in Aesop's
 tale,

III.ii.
 [1] *getting:* begetting. [2] *heart:* bosom.
 [3] *che:* I (rustic). [4] *trow:* declare.
 [5] *cha:* I have. [6] *ruthful:* pitying.
 [7] *plunges:* straits. [8] *callet:* strumpet.
 [9] *Tityus':* referring to the giant son of Earth, punished
by vultures tearing his liver. [10] *still:* ever.
 [11] *mickle:* much.
 [12] *towardness:* aptness and willingness to learn, good dis-
position.

That sought the foster's [13] death that lately gave him
 life.

Alc. Nay, and please your majestyship, for proof he
was my child, search the parish book; the clerk will
swear it, his godfathers and godmothers can witness it;
it cost me forty pence in ale and cakes on the 120
wives at his christening. Hence, proud King, thou shalt
never more have my blessing.

He takes him apart.

Ras. Say sooth [14] in secret, Radagon,
Is this thy father?
 Rad. Mighty King, he is;
I blushing tell it to your majesty.
 Ras. Why dost thou then contemn him and his
 friends?
 Rad. Because he is a base and abject swain,
My mother and her brat both beggarly,
Unmeet to be allied unto a king.
Should I, that look on Rasni's countenance 130
And march amidst his royal equipage,
Embase myself to speak to such as they?
'Twere impious so to impair the love
That mighty Rasni bears to Radagon.
I would your Grace would quit them from your sight
That dare presume to look on Jove's compare.
 Ras. I like thy pride, I praise thy policy; [15]
Such should they be that wait upon my court.
Let me alone to answer, Radagon.
Villains, seditious traitors as you be, 140
That scandalize the honor of a king,
Depart my court, you stales [16] of impudence,
Unless you would be parted from your limbs;
So base for to entitle fatherhood
To Rasni's friend, to Rasni's favorite?
 Rad. Hence, begging scold, hence, caitiff clogged
 with years.
On pain of death revisit not the court.
Was I conceived by such a scurvy trull,
Or brought to light by such a lump of dirt?
Go, losel, [17] trot it to the cart and spade; 150
Thou art unmeet to look upon a king,
Much less to be the father of a king.
 Alc. You may see, wife, what a goodly piece of work
you have made. Have I taught you arsmetry, [18] as
additiori multiplicatorum, the rule of three, and all for
the begetting of a boy and to be banished for my labor?
Oh, pitiful hearing. Come, Clesiphon, follow me.
 Cles. Brother, beware, I oft have heard it told,
That sons who do their fathers scorn shall beg when
 they be old.

Ex[eunt] ALCON, CLESIPHON.

 Rad. Hence, bastard boy, for fear you taste the whip.
 Sam. O all you heavens and you eternal powers 161
That sway the sword of justice in your hands,

If mother's curses for her son's contempt
May fill the balance of your fury full,
Pour down the tempest of your direful plagues
Upon the head of cursèd Radagon.

*Upon this prayer she departeth, and a flame of fire
appeareth from beneath, and* RADAGON *is swallowed.*

So you are just. Now triumph, Samia.

Exit SAMIA.

 Ras. What exorcising charm or hateful hag
Hath ravishèd the pride of my delight?
What tortuous planets or malevolent, 170
Conspiring power, repining [19] destiny,
Hath made the concave of the earth unclose
And shut in ruptures lovely Radagon?
If I be lord commander of the clouds,
King of the earth, and sovereign of the seas,
What daring Saturn from his fiery den
Doth dart these furious flames amidst my court?
What greater than th' Assyrian satrapos? [20]
It may not be, and yet I fear there is,
That hath bereft me of my Radagon. 180
 Sooth. Monarch and Potentate of all our provinces,
Muse not so much upon this accident,
Which is indeed nothing miraculous.
The hill [21] of Sicily, dread sovereign,
Sometime on sudden doth evacuate
Whole flakes of fire, and spews out from below
The smoky brands that Vulcan's bellows drive;
Whether by winds enclosèd in the earth
Or fracture of the earth by river's force,
Such chances as was this are often seen, 190
Whole cities sunk, whole countries drownèd quite.
Then muse not at the loss of Radagon,
But frolic with the dalliance of your love.
Let cloths of purple set with studs of gold,
Embellishèd with all the pride of earth,
Be spread for Alvida to sit upon.
Then thou, like Mars courting the Queen of Love,
Mayst drive away this melancholy fit.
 Ras. The proof is good and philosophical;
And more, thy counsel plausible and sweet. 200
Come, lords, though Rasni wants his Radagon,
Earth will repay him many Radagons,
And Alvida with pleasant looks revive
The heart that droops for want of Radagon.

Exeunt.

 Os. When disobedience reigneth in the child,
And princes' ears by flattery be beguiled;
When laws do pass by favor, not by truth;
When falsehood swarmeth both in old and youth;
When gold is made a god to wrong the poor,
And charity exiled from rich men's door; 210
When men by wit do labor to disprove
The plagues for sin sent down by God above;
When great men's ears are stopped to good advice
And apt to hear those tales that feed their vice;
Woe to the land, for from the east shall rise
A lamb of peace, the scourge of vanities,
The judge of truth, the patron of the just,
Who soon will lay presumption in the dust,

[13] *foster's:* forester's. [14] *sooth:* truth.
[15] *policy:* scheming.
[16] *stales:* deceivers, lowlife. [17] *losel:* worthless wretch.
[18] *arsmetry:* corruption of "arithmetic."
[19] *repining:* discontent, grudging.
[20] *satrapos:* satrap, tyrant. [21] *hill:* Mount Etna.

And give the humble poor their hearts' desire,
And doom the worldlings to eternal fire. 220
Repent you, all that hear, for fear of plagues.
O London, this and more doth swarm in thee.
Repent, repent, for why[22] the Lord doth see.
With trembling pray, and mend what is amiss;
The sword of justice drawn already is.

[III.iii]

Enter [ADAM] *the* Clown *and the* Smith's Wife.

Adam. Why, but hear you, mistress, you know a
woman's eyes are like a pair of pattens,[1] fit to save shoe
leather in summer and to keep away the cold in winter;
so you may like your husband with the one eye, be-
cause you are married, and me with the other, because
I am your man. Alas, alas, think mistress, what a thing
love is; why, it is like to an hostry-fagot[2] that, once
set on fire, is as hardly quenched as the bird crocodile[3]
driven out of her nest. 9
Wife. Why, Adam, cannot a woman wink but she
must sleep? And can she not love but she must cry it
out at the cross?[4] Know, Adam, I love thee as myself
now that we are together in secret.
Adam. Mistress, these words of yours are like to a
foxtail placed in a gentlewoman's fan, which as it is
light, so it giveth life.[5] Oh, these words are as sweet as a
lily;[6] whereupon, offering a borachio[7] of kisses to your
unseemly personage, I entertain you upon further
acquaintance.

[*They embrace.*]

Wife. Alas, my husband comes. 20
Adam. Strike up the drum, and say no words but
mum.
Smith. Sirrah you, and you, huswife, well taken
together. I have long suspected you, and now I am glad
I have found you together.
Adam. Truly, sir, and I am glad that I may do you
any way pleasure, either in helping you or my mistress.
Smith. Boy, hear, and, knave, you shall know it
straight. I will have you both before the magistrate and
there have you surely punished. 30
Adam. Why, then, master, you are jealous?
Smith. Jealous, knave! how can I be but jealous to
see you ever familiar together? Thou art not only
content to drink away my goods, but to abuse my wife.
Adam. Two good qualities, drunkenness and lech-
ery; but, master, are you jealous?
Smith. Ay, knave, and thou shalt know it ere I pass,
for I will beswinge[8] thee while this rope will hold.

[*Beats him.*]

Wife. My good husband, abuse him not, for he
never proffered you any wrong. 40
Adam. Why, suppose, master, I have offended you,
is it lawful for the master to beat the servant for all
offenses?
Smith. Ay, marry, it is, knave.
Adam. Then, master, will I prove by logic that,

seeing all sins are to receive correction, the master is to
be corrected of[9] the man, and, sir, I pray you, what
greater sin is than jealousy? 'Tis like a mad dog that for
anger bites himself. Therefore, that I may do my duty
to you, good master, and to make a white[10] son of 50
you, I will so beswinge jealousy out of you as you shall
love me the better while you live.

[*Beats him.*]

Smith. What, beat thy master, knave?
Adam. What, beat thy man, knave? And ay, master,
and double beat you, because you are a man of credit
and therefore have at you[11] the fairest for forty pence.
Smith. Alas, wife, help, help, my man kills me.
Wife. Nay, even as you have baked, so brew. Jealousy
must be driven out by extremities.
Adam. And that will I do, mistress. 60
Smith. Hold thy hand, Adam, and not only I forgive
and forget all, but I will give thee a good farm to live on.
Adam. Begone, peasant, out of the compass of my
further wrath, for I am a corrector of vice, and at
night I will bring home my mistress.
Smith. Even when you please, good Adam.
Adam. When I please—mark the words, 'tis a lease
parole,[12] to have and to hold. Thou shalt be mine for
ever, and so let's go to the alehouse.

Exeunt.

Os. Where servants gainst masters do rebel, 70
The commonweal may be accounted hell.
For if the feet the head shall hold in scorn,
The city's state will fall and be forlorn.
This error, London, waiteth on thy state.
Servants, amend, and masters, leave to hate.
Let love abound and virtue reign in all,
So God will hold his hand that threat'neth thrall.[13]

ACT FOUR

SCENE ONE

Enter the Merchants of Tharsus, *the* Master of the
Ship, *some* Sailors *wet from the sea; with them the*
Governor of Joppa.

Gov. What strange encounters met you on the sea
That thus your bark is battered by the floods
And you return thus sea-wrecked as I see?

[22] *for why:* because.

III.iii.
 [1] *pattens:* overshoes consisting of wooden soles strapped
to the feet.
 [2] *hostry-fagot:* bundle of sticks used to ignite fire in an
inn. [3] *bird crocodile:* Lylyesque nonsense.
 [4] *cross:* market cross.
 [5] *foxtail . . . life:* more Lylyesque nonsense.
 [6] *lily:* Adam's unwitting pun acknowledges the parody
of Lyly. [7] *borachio:* leather wine-bottle.
 [8] *beswinge:* beat soundly. [9] *of:* by.
 [10] *white:* fine, favorite. [11] *have . . . you:* beat you.
 [12] *parole:* by word of mouth (not in writing).
 [13] *thrall:* oppression, misery.

Merch. Most mighty Governor, the chance is strange,
The tidings full of wonder and amaze,
Which better than we our master can report.
 Gov. Master, discourse us all the accident.
 Mast. The fair Triones [1] with their glimmering light
Smiled at the foot of clear Boötes' [2] Wain, [3]
And in the north, distinguishing the hours, 10
The lodestar of our course dispersed his clear,
When to the seas with blitheful western blasts
We sailed amain [4] and let the bowling [5] fly.
Scarce had we gone ten leagues from sight of land
But lo, an host of black and sable clouds
Gan to eclipse Lucina's [6] silver face,
And with a hurling [7] noise from forth the south
A gust of wind did rear the billows up.
Then scantled [8] we our sails with speedy hands
And took our drabblers [9] from our bonnets straight 20
And severèd our bonnets from the courses; [10]
Our topsails up, we truss our spritsails in.
But vainly strive they that resist the heavens,
For lo, the waves incense them more and more,
Mounting with hideous roarings from the depth.
Our bark is battered by encount'ring storms,
And well nigh stemmed [11] by breaking of the floods.
The steersman pale and careful holds his helm
Wherein the trust of life and safety lay,
Till all at once (a mortal tale to tell) 30
Our sails were split by Bisa's [12] bitter blast,
Our rudder broke, and we bereft of hope.
There might you see, with pale and ghastly looks,
The dead in thought, and doleful merchants lifts
Their eyes and hands unto their country's gods.
The goods we cast in bowels of the sea,
A sacrifice to suage proud Neptune's ire.
Only alone a man of Israel,
A passenger, did under hatches lie
And slept secure when we for succor prayed. 40
Him I awoke and said, "Why slumberest thou?
Arise and pray, and call upon thy God;
He will perhaps in pity look on us."
Then cast we lots to know by whose amiss
Our mischief came, according to the guise;
And lo, the lot did unto Jonas fall,
The Israelite of whom I told you last.

Then question we his country and his name,
Who answered us, "I am an Hebrew born,
Who feared the Lord of heaven who made the sea, 50
And fled from him, for which we all are plagued.
So, to assuage the fury of my God,
Take me and cast my carcass in the sea;
Then shall this stormy wind and billow cease."
The heavens they know, the Hebrew's God can tell
How loath we were to execute his will;
But when no oars nor labor might suffice,
We heaved the hapless Jonas overboard.
So ceased the storm and calmèd all the sea,
And we by strength of oars recovered shore. 60
 Gov. A wondrous chance of mighty consequence!
 Merch. Ah, honored be the God that wrought the
 same,
For we have vowed that saw his wondrous works
To cast away profanèd paganism
And count the Hebrew's God the only God;
To Him this offering of the purest gold,
This myrrh and cassia [13] freely I do yield.
 Mast. And on his altars fume these Turkey clothes;
This gossampine and gold I'll sacrifice.
 Sail. To him my heart and thoughts I will addict;
Then suffer us, most mighty Governor, 71
Within your temples to do sacrifice.
 Gov. You men of Tharsus, follow me,
Who sacrifice unto the God of heaven,
And welcome, friends, to Joppa's Governor.

 Exeunt; a sacrifice.

 Os. If warnèd once the ethnics [14] thus repent,
And at the first their error do lament,
What senseless beasts devoured in their sin
Are they whom long persuasions cannot win.
Beware, ye western cities where the word 80
Is daily preachèd both at church and board,
Where majesty the gospel doth maintain,
Where preachers for your good themselves do pain,
To dally long and still protract the time.
Presume not far, delay not to amend;
Who suffereth long will punish in the end.
Cast thy account, O London, in this case;
Then judge what cause thou hast to call for grace.

IV.i.
 [1] *Triones:* seven principal stars in Ursa Major.
 [2] *Boötes:* the oxdriver, constellation containing Arcturus.
 [3] *Wain:* Charles' Wain, or Ursa Major, imagined as a wagon driver by Boötes. [4] *amain:* at full speed.
 [5] *bowling:* bowline.
 [6] *Lucina's:* referring to a moon-goddess, daughter of Juno.
 [7] *hurling:* violently rushing.
 [8] *scantled:* shortened, reefed.
 [9] *drabblers:* extra canvas laced to bottom of sail's bonnet to give it greater depth.
 [10] *courses:* sails attached to the lower yards.
 [11] *stemmed:* rammed, dashed.
 [12] *Bisa's:* Bisa is a Latinized form of Bise, the north wind.
 [13] *cassia:* a fragrant shrub. [14] *ethnics:* pagans.

IV.ii.
 [1] *rears:* Elizabethan usage permits the singular verb form with a plural subject. [2] *stress:* straining.

[IV.ii]

[*Enter*] JONAS the Prophet *cast out of the whale's*
 belly upon the stage.

 Jon. Lord of the light, thou maker of the world,
Behold, thy hands of mercy rears [1] me up;
Lo, from the hideous bowels of this fish
Thou hast returned me to the wishèd air.
Lo, here apparent witness of thy power,
The proud Leviathan that scours the seas
And from his nostrils showers out stormy floods,
Whose back resists the tempest of the wind,
Whose presence makes the scaly troops to shake,
With humble stress [2] of his broad opened chaps 10
Hath lent me harbor in the raging floods.

Thus, though my sin hath drawn me down to death,
Thy mercy hath restorèd me to life.
Bow ye, my knees, and you my bashful eyes
Weep so for grief as ³ you to water would.
In trouble, Lord, I callèd unto Thee
Out of the belly of the deepest hell;
I cried, and Thou didst hear my voice, O God.
'Tis Thou hadst cast me down into the deep;
The seas and floods did compass me about; 20
I thought I had been cast from out Thy sight;
The weeds were wrapped about my wretched head;
I went unto the bottom of the hills.
But Thou, O Lord my God, hast brought me up.
On Thee I thought whenas my soul did faint;
My prayers did prease ⁴ before Thy mercy seat.
Then will I pay my vows unto the Lord,
For why salvation cometh from His throne.

The Angel *appeareth.*

Ang. Jonas, arise, get thee to Nineveh,
And preach to them the preachings that I bade; 30
Haste thee to see the will of heaven performed.

Depart Angel.

Jon. Jehovah, I am pressed to do thy will.
What coast is this, and where am I arrived?
Behold sweet Lycus streaming in his bounds,
Bearing the walls of haughty Nineveh,
Whereas three hundred towns do tempt the heaven.
Fair are thy walls, pride of Assyria,
But lo, thy sins have piercèd through the clouds.
Here will I enter boldly, since I know
My God commands, whose power no power resists. 40
Exit.

Os. You prophets, learn by Jonas how to live;
Repent your sins whilst he doth warning give.
Who knows his master's will and doth it not
Shall suffer many stripes, full well I wot.

[IV.iii]

Enter ALVIDA *in rich attire with the* King of
CILICIA, *her* Ladies.

Alv. Ladies, go sit you down amidst this bower
And let the eunuchs play you all asleep;
Put garlands made of roses on your heads,
And play the wantons whilst I talk a while.
Lady. Thou beautiful of all the world, we will.

Enter the bowers.

Alv. King of Cilicia, kind and courteous,
Like to thyself because a lovely king,
Come lay thee down upon thy mistress' knee,
And I will sing and talk of love to thee.
Cil. Most gracious paragon of excellence, 10
It fits not such an abject prince as I
To talk with Rasni's paramour and love.
Alv. To talk, sweet friend? Who would not talk with thee?
Oh, be not coy; art thou not only fair?

Come twine thine arms about this snow-white neck,
A love-nest for the great Assyrian King.
Blushing I tell thee, fair Cilician Prince,
None but thyself can merit such a grace.
Cil. Madam, I hope you mean not for to mock me.
Alv. No, King, fair King, my meaning is to yoke
thee. 20
Hear me but sing of love; then by my sighs,
My tears, my glancing looks, my changèd cheer,
Thou shalt perceive how I do hold thee dear.
Cil. Sing, madam, if you please, but love in jest.
Alv. Nay, I will love, and sigh at every rest.

SONG

Beauty, alas, where wast thou born
Thus to hold thyself in scorn?
Whenas beauty kissed to woo thee,
Thou by beauty dost undo me.
Heigho, despise me not. 30

I and thou in sooth are one,
Fair art thou, aye, fairer none.
Wanton ¹ thou, and wilt thou, wanton,²
Yield a cruel heart to plant ³ on?
Do me right and do me reason;
Cruelty is cursèd treason.
Heigho I love, heigho I love,
Heigho, and yet he eyes me not.

Cil. Madam, your song is passing passionate.
Alv. And wilt thou not then pity my estate? 40
Cil. Ask love of them who pity may impart.
Alv. I ask of thee, sweet; thou hast stole my heart.
Cil. Your love is fixèd on a greater king.
Alv. Tut, woman's love, it is a fickle thing.
I love my Rasni for my dignity.
I love Cilician King for his sweet eye.
I love my Rasni since he rules the world,
But more I love this kingly little world.

Embrace him.

How sweet he looks! Oh, were I Cynthia's ⁴ fere ⁵
And thou Endymion,⁶ I should hold thee dear; 50
Thus should mine arms be spread about thy neck.

Embrace his neck.

Thus would I kiss my love at every beck.

Kiss.

Thus would I sigh to see thee sweetly sleep;
And if thou wakest not soon, thus would I weep,
And thus, and thus, and thus; thus much I love thee.

Kiss him.

³ *as:* as if. ⁴ *prease:* press.
IV.iii.
¹ *wanton:* lustful. ² *wanton:* a term of endearment.
³ *plant:* text corrupt; pant(?).
⁴ *Cynthia's:* referring to the goddess of the moon.
⁵ *fere:* companion.
⁶ *Endymion:* mortal beloved of the moon.

Cil. For all these vows, beshrew[7] me if I prove you;
My faith unto my King shall not be falsed.
 Alv. Good Lord, how men are coy when they are
 craved!
 Cil. Madam, behold our King approacheth nigh.
 Alv. Thou art Endymion, then, no more. Heigho,
 for him I die. 60

Faints. Point at the King of CILICIA.

Enter RASNI *with his* Kings *and* Lords.

Ras. What ails the center of my happiness,
Whereon depends the heaven of my delight?
Thine eyes the motors[8] to command my world,
Thy hands the axis to maintain my world,
Thy smiles the prime and springtide of my world,
Thy frowns the winter to afflict my world;
Thou queen of me, I king of all the world.
 Alv. Ah, feeble eyes, lift up and look on him.

She riseth as out of a trance.

Is Rasni here? Then droop no more, poor heart.
Oh, how I fainted when I wanted thee. 70

Embrace him.

How fain am I; now I may look on thee.
How glorious is my Rasni, how divine!
Eunuchs play hymns to praise his deity;
He is my Jove, and I his Juno am.
 Ras. Sun-bright as the eye of summer's day
Whenas he suits his pennons[9] all in gold
To woo his Leda[10] in a swanlike shape;
Seemly as Galatea[11] for thy white;
Rose-colored, lily, lovely, wanton, kind,
Be thou the labyrinth[12] to tangle love 80
Whilst I command the crown from Venus' crest
And pull Orion's[13] girdle from his loins,
Enchased with carbuncles and diamonds
To beautify fair Alvida, my love.
Play, eunuchs, sing in honor of her name;
Yet look not, slaves, upon her wooing eyne,
For she is fair Lucina to your King,
But fierce Medusa[14] to your baser eye.

[7] *beshrew:* devil take. [8] *motors:* movers.
[9] *pennons:* wings.
[10] *Leda:* mother of Helen of Troy by Zeus, who approached her in the shape of a swan.
[11] *Galatea:* statue of a maiden brought to life by Aphrodite in response to prayers of the sculptor Pygmalion, who had fallen in love with his own work.
[12] *labyrinth:* building made by Daedalus for King Minos of Crete from which no one could escape and in which the Minotaur lived until Theseus killed him with the help of Ariadne, who loved Theseus.
[13] *Orion's:* referring to the giant hunter killed by Artemis and made a constellation.
[14] *Medusa:* ugly monster in Greek mythology whose gaze transformed victims to stone. [15] *blend:* disturb.
[16] *Cephalus:* lover of dawn-goddess Eos.
[17] *addites:* Latin *adyta*, innermost secret part or sanctuary of temple. [18] *vae:* a threatening of woe.
[19] *distain:* stain. [20] *Morpheus:* god of sleep.
[21] *retrograde:* apparently moving in direction contrary to the order of the signs.

 Alv. What, if I slept, where should my pillow be?
 Ras. Within my bosom, nymph, not on my
 knee. 90
Sleep like the smiling purity of heaven
When mildest wind is loath to blend[15] the peace.
Meanwhile thy balm shall from thy breath arise,
And while these closures of thy lamps be shut
My soul may have his peace from fancy's war.
This is my morn, and I her Cephalus.[16]
Wake not too soon, sweet nymph; my love is won.
Caitiffs, why stay your strains? why tempt you me?

Enter the Priest of the Sun, [Sages] *with the miters
on their heads, carrying fire in their hands.*

 Priest. All hail unto th' Assyrian deity.
 Ras. Priests, why presume you to disturb my peace?
 Priest. Rasni, the destinies disturb thy peace. 101
Behold, amidst the addites[17] of our gods,
Our mighty gods, the patrons of our war,
The ghosts of dead men howling walk about,
Crying "vae,[18] vae, woe to this city, woe!"
The statues of our gods are thrown down,
And streams of blood our altars do distain.[19]
 Alv. Alas, my lord, what tidings do I hear?
Shall I be slain?

She starteth.

 Ras. Who tempteth Alvida?
Go, break me up the brazen doors of dreams, 110
And bind me cursèd Morpheus[20] in a chain,
And fetter all the fancies of the night
Because they do disturb my Alvida.

A hand from out a cloud threateneth a burning sword.

 Cil. Behold, dread prince, a burning sword from
 heaven,
Which by a threat'ning arm is brandishèd.
 Ras. What, am I threatened then amidst my throne?
Sages? You, Magi? Speak: what meaneth this?
 Sages. These are but clammy exhalations,
Or retrograde[21] conjunctions of the stars,
Or oppositions of the greater lights, 120
Or radiations finding matter fit
That in the starry sphere enkindled be,
Matters betokening dangers to thy foes
But peace and honor to my lord the King.
 Ras. Then frolic, viceroys, kings, and potentates;
Drive all vain fancies from your feeble minds.
Priests, go and pray whilst I prepare my feast
Where Alvida and I, in pearl and gold,
Will quaff unto our nobles richest wine
In spite of fortune, fate, or destiny. 130

Exeunt.

 Os. Woe to the trains of women's foolish lust,
In wedlock rights that yield but little trust,
That vow to one yet common be to all.
Take warning, wantons, pride will have a fall.
Woe to the land where warnings profit naught,
Who say that nature God's decrees hath wrought,
Who build one fate and leave the cornerstone,
The God of gods, sweet Christ, the only one.

If such escapes, O London, reign in thee,
Repent, for why each sin shall punished be. 140
Repent, amend, repent; the hour is nigh;
Defer not time; who knows when he shall die?

[IV.iv]

Enters one clad in devil's attire alone

Dev. Longer lives a merry man than a sad, and be-
cause I mean to make myself pleasant[1] this night, I
have put myself into this attire, to make a clown afraid
that passeth this way; for of late there have appeared
many strange apparitions to the great fear and terror of
the citizens. Oh, here my young master comes.

Enters ADAM *and his* Mistress.

Adam. Fear not, mistress, I'll bring you safe home;
if my master frown, then will I stamp and stare, and if
all be not well then, why then tomorrow morn put out
mine eyes clean with forty pound. 10
Wife. Oh, but Adam, I am afraid to walk so late
because of the spirits that appear in the city.
Adam. What, are you afraid of spirits, armed as I am
with ale and nutmegs? Turn me loose to all the devils
in hell.
Wife. Alas, Adam! Adam! the devil! the devil!
Adam. The devil, mistress! fly you for your safe-
guard; [*Exit* Wife.] Let me alone, the devil and I will
deal well enough. If he have any honesty at all in him,
I'll either win him with a smooth tale or else with a
toast and a cup of ale. 21

The Devil *sings here.*

Dev. Oh, oh, oh, oh, fain would I be
If that my kingdom fulfilled I might see.
Oh, oh, oh, oh.
Adam. Surely this is a merry devil, and I believe he
is one of Lucifer's minstrels; hath a sweet voice; now
surely, he may sing to a pair of tongs[2] and a bagpipe.
Dev. Oh, thou art he that I seek for.
Adam. Spritus santus,[3] away from me, Satan; I have
nothing to do with thee. 30
Dev. O villain, thou art mine.
Adam. Nominus patrus,[4] I bless me from thee, and I
conjure thee to tell me who thou art.
Dev. I am the spirit of the dead man that was slain.
in thy company when we were drunk together at the ale.
Adam. By my troth, sir, I cry you mercy; your face
is so changed that I had quite forgotten you. Well,
master devil, we have tossed over many a pot of ale
together.
Dev. And therefore must thou go with me to hell. 40
Adam. I have a policy to shift him, for I know he
comes out of a hot place, and I know myself the smith
and the devil have a dry tooth in his head; therefore
will I leave him asleep and run my way.
Dev. Come. Art thou ready?
Adam. Faith, sir, my old friend and now goodman
devil, you know, you and I have been tossing many a

good cup of ale; your nose is grown very rich. What say
you? Will you take a pot of ale now at my hands? Hell
is like a smith's forge, full of water and yet ever a-
thirst. 51
Dev. No ale, villain; spirits cannot drink. Come, get
up on my back that I may carry thee.
Adam. You know I am a smith, sir; let me look
whether you be well shod or no, for if you want a shoe,
a remove, or the clinching[5] of a nail, I am at your
command.
Dev. Thou hast never a shoe fit for me.
Adam. Why, sir, we shoe horned beasts as well as
you. O good Lord, let me sit down and laugh— 60
hath never a cloven foot! A devil, quoth he; I'll use
spritus santus nor *nominus patrus* no more to him, I
warrant you. I'll do more good upon him with my
cudgel. Now will I sit me down and become justice of
peace to the devil.
Dev. Come, art thou ready?
Adam. I am ready, and with this cudgel will I con-
jure thee.

[*Beats him.*]

Dev. Oh, hold thy hand! thou kill'st me, thou kill'st
me! 70
[*Exit.*]
Adam. Then may I count myself, I think, a tall[6]
man that am able to kill a devil. Now who dare deal
with me in the parish, or what wench in Nineveh will
not love me, when they say, "There goes he that beat
the devil"?

[*Exit.*]

[IV.v]

Enters THRASIBULUS.

Thras. Loathèd is the life that now enforced I lead;
But since necessity will have it so
(Necessity it doth command the gods),
Through every coast and corner now I pry
To pilfer what I can to buy me meat.
Here have I got a cloak not over old
Which will afford some little sustenance.
Now will I to the broking usurer
To make exchange of ware for ready coin.

[*Enter* ALCON, SAMIA, *and* CLESIPHON.]

Alc. Wife, bid the trumpets sound. A prize, a prize!
Mark the posy;[1] I cut this from a new married 11

IV.iv.
 [1] *make . . . pleasant:* amuse myself.
 [2] *tongs:* instrument in burlesque music.
 [3] *Spritus santus:* Adam's blunder for Latin *Spiritus
sanctus,* "Holy Spirit."
 [4] *Nominus patrus:* blunder for *Nomine patri,* "In the
name of the Father."
 [5] *clinching:* fixing securely. [6] *tall:* brave.
IV.v.
 [1] *posy:* inscription (on the purse he has stolen).

wife, by the help of a horn thumb[2] and a knife. Six shillings, four pence.

Sam. The better luck ours; but what have we here? Cast[3] apparel. Come away, man, the usurer is near; this is dead[4] ware; let it not bide on our hands.

Thras. Here are my partners in my poverty, Enforced to seek their fortunes as I do. Alas, that few men should possess the wealth, And many souls be forced to beg or steal. 20 Alcon, well met!

 Alc. Fellow beggar, whither now?

 Thras. To the usurer to get gold on commodity.

 Alc. And I to the same place to get a vent for my villainy. See where the old crust comes. Let us salute him. God speed, sir; may a man abuse your patience upon a pawn?

[*Enter* Usurer.]

Usu. Friend, let me see it.

Alc. Ecce signum,[5] a fair doublet and hose, new bought out of the pilferer's shop; a handsome cloak.

Usu. How were they gotten? 30

Thras. How catch the fishermen fish? Master, take them as you think them worth; we leave all to your conscience.

Usu. Honest men, toward men, good men, my friends, like to prove good members, use me, command me; I will maintain your credits. There's money; now spend not your time in idleness. Bring me commodity;[6] I have crowns for you; there is two shillings for thee, and, sir, shillings for thee. 39

Alc. A bargain! Now, Samia, have at it for a new smock. Come, let us to the spring of the best liquor; whilst this lasts, tril-lil.

Usu. Good fellows, proper fellows, my companions, farewell; I have a pot for you.

Sam. If he could spare it.

Enters to them JONAS.

Jon. Repent, ye men of Nineveh, repent. The day of horror and of torment comes, When greedy hearts shall glutted be with fire, Whenas corruptions veiled shall be unmasked, When briberies shall be repaid with bane, 50 When whoredoms shall be recompensed in hell, When riot shall with rigor be rewarded, Whenas neglect of truth, contempt of God, Disdain of poor men, fatherless and sick, Shall be rewarded with a bitter plague. Repent, ye men of Nineveh, repent. The Lord hath spoke, and I do cry it out: There are as yet but forty days remaining, And then shall Nineveh be overthrown. Repent, ye men of Nineveh, repent. 60

There are as yet but forty days remaining, And then shall Nineveh be overthrown.

 Exit.

Usu. Confused in thought, oh, whither shall I wend.

 Exit.

Thras. My conscience cries that I have done amiss.

 Exit.

Alc. O God of heaven, gainst thee have I offended.

 Exit.

Sam. Ashamed of my misdeeds, where shall I hide me?

 Exit.

Cles. Father, methinks this word "repent" is good; He that punisheth disobedience Doth hold a scourge for every privy fault. 69

 Exit.

Os. Look, London, look; with inward eyes behold What lessons the events do here unfold. Sin, grown to pride, to misery is thrall; The warning bell is rung; beware to fall. Ye worldly men whom wealth doth lift on high, Beware and fear, for worldly men must die. The time shall come where least suspect remains; The sword shall light upon the wisest brains; The head that deems to overtop the sky Shall perish in his human policy. Lo, I have said, when I have said the truth, 80 When will is law, when folly guideth youth, When show of zeal is pranked[7] in robes of zeal, When ministers poll[8] the pride of commonweal, When law is made a labyrinth of strife, When honor yields him friend to wicked life, When princes hear by others' ears their folly, When usury is most accounted holy: If these shall hap, as would to God they might not, The plague is near; I speak although I write not.

Enters the Angel.

Ang. Oseas. 90

Os. Lord.

Ang. Now hath thine eyes perused these heinous sins, Hateful unto the mighty Lord of hosts. The time is come; their sins are waxen ripe, And though the Lord forewarns, yet they repent not. Custom of sin hath hardened all their hearts. Now comes revenge, armed with mighty plagues, To punish all that live in Nineveh, For God is just as he is merciful And doubtless plagues all such as scorn repent. 100 Thou shalt not see the desolation That falls unto these cursèd Ninevites, But shalt return to great Jerusalem And preach unto the people of thy God What mighty plagues are incident to sin Unless repentance mitigate his ire. Wrapped in the spirit as thou wert hither brought, I'll seat thee in Judea's provinces; Fear not, Oseas, then, to preach the word.

Os. The will of the Lord be done. 110

 OSEAS *taken away.*

 [2] *horn thumb:* pickpocket's thimble used in cutting purses with a knife. [3] *Cast:* Cast off. [4] *dead:* unsaleable.
 [5] *L.:* Behold the sign. [6] *commodity:* goods.
 [7] *pranked:* tricked out. [8] *poll:* plunder.

ACT FIVE

SCENE ONE

Enters RASNI *with his* Viceroys, ALVIDA *and her*
Ladies, *to a banquet.*

Ras. So, viceroys, you have pleased me passing well;
These curious cates [1] are gracious in mine eye,
But these borachios of the richest wine
Make me to think how blithesome we will be.
Seat thee, fair Juno, in the royal throne,
And I will serve thee but to see thy face,
That, feeding on the beauty of thy looks,
My stomach and mine eyes may both be filled.
Come, lordings, seat you, fellow mates at feast,
And frolic, wags; this is a day of glee; 10
This banquet is for brightsome Alvida.
I'll have them skink [2] my standing bowls with wine,
And no man drink but quaff a whole carouse
Unto the health of beauteous Alvida;
For whoso riseth from this feast not drunk,
As I am Rasni, Nineveh's great king,
Shall die the death as traitor to myself
For that [3] he scorns the health of Alvida.
 Cil. That will I never do, my lord;
Therefore with favor, fortune to your grace, 20
Carouse unto the health of Alvida.
 Ras. Gramercy, lording; here I take thy pledge,
And Crete, to thee a bowl of Greekish wine
Here to the health of Alvida.
 Cre. Let come, my lord; Jack Skinker, fill it full,
A pledge unto the health of heavenly Alvida.
 Ras. Vassals attendant on our royal feasts,
Drink you, I say, unto my lover's health;
Let none that is in Rasni's royal court
Go this night safe and sober to his bed. 30

Enters [ADAM] *the* Clown.

Adam. This way he is, and here will I speak with him.
Lord. Fellow, wither pressest thou?
Adam. I press nobody, sir; I am going to speak with
a friend of mine.
Lord. Why, slave, here is none but the King and his
viceroys.
Adam. The King! marry, sir, he is the man I would
speak withal. [4]
Lord. Why, call'st him a friend of thine?
Adam. Aye, marry do I, sir, for if he be not my
friend, I'll make him my friend ere he and I pass. 41
Lord. Away, vassal, be gone; thou speak unto the
King!
Adam. Aye, marry will I, sir; and if [5] he were a king
of velvet, [6] I will talk to him.
Ras. What's the matter there? What noise is that?
Adam. A boon, my liege; a boon, my liege.
Ras. What is it that great Rasni will not grant
This day unto the meanest of his land
In honor of his beauteous Alvida? 50
Come hither, swain. What is it that thou cravest?
Adam. Faith, sir, nothing but to speak a few sen-
tences to your worship.

Ras. Say, what is it?
Adam. I am sure, sir, you have heard of the spirits
that walk in the city here.
Ras. Ay, what of that?
Adam. Truly, sir, I have an oration to tell you of one
of them, and this it is.
Alv. Why goest not forward with thy tale? 60
Adam. Faith, mistress, I feel an imperfection in my
voice, a disease that often troubles me, but, alas, easily
mended; a cup of ale or a cup of wine will serve the
turn.
Alv. Fill him a bowl, and let him want no drink.
Adam. Oh, what a precious word was that "and let
him want no drink." Well, sir, now I'll tell you forth
my tale. Sir, as I was coming along the port rivel [7] of
Nineveh, there appeared to me a great devil, and as hard
favored a devil as ever I saw; nay, sir, he was a 70
cuckoldly devil, for he had horns on his head. This
devil, mark you now, presseth upon me, and, sir,
indeed, I charged him with my pikestaff, but when that
would not serve I came upon him with *spritus santus*—
why, it had been able to have put Lucifer out of his
wits. When I saw my charm would not serve, I was in
such a perplexity that six pennyworth of juniper would
not have made the place sweet again.
Alv. Why, fellow, wert thou so afraid? 79
Adam. Oh, mistress, had you been there and seen,
his very sight had made you shift a clean smock. I
promise you, though I were a man and counted a tall
fellow, yet my laundress called me slovenly knave the
next day.
Ras. A pleasant slave. Forward, sirrah, on with thy
tale.
Adam. Faith, sir, but I remember a word that my
mistress your bedfellow spoke.
Ras. What was that, fellow? 89
Adam. O sir, a word of comfort, a precious word:
"and let him want no drink."
Ras. Her word is law; and thou shalt want no drink.
Adam. Then, sir, this devil came upon me and
would not be persuaded, but he would needs carry me
to hell. I proffered him a cup of ale, thinking because
he came out of so hot a place that he was thirsty, but
the devil was not dry, and therefore the more sorry was
I. Well, there was no remedy but I must with him to
hell, and at last I cast mine eye aside. If you knew
what I spied, you would laugh, sir; I looked from 100
top to toe, and he had no cloven feet. Then I ruffled up
my hair and set my cap on the one side and, sir, grew to
be a justice of peace to the devil. At last, in a great
fume, as I am very choleric, and sometime so hot in my
fustian fumes [8] that no man can abide within twenty
yards of me, I start up and so bombasted [9] the devil
that, sir, he cried out and ran away.

V.i.
[1] *cates:* delicacies. [2] *skink:* pour, fill.
[3] *For that:* Because. [4] *withal:* with.
[5] *and if:* if. [6] *king of velvet:* stuffed dummy.
[7] *port rivel:* landing place.
[8] *fustian fumes:* great displays of anger.
[9] *bombasted:* denounced in grandiose language.

Alv. This pleasant knave hath made me laugh my
 fill.
Rasni, now Alvida begins her quaff
And drinks a full carouse unto her King. 110
 Ras. A pledge, my love, as hardy as great Jove
Drunk when his Juno heaved a bowl to him.
Frolic, my lords; let all the standards[10] walk.
Ply it till every man hath ta'en his load.
How now, sirrah? How cheer? We have no words of
 you.
 Adam. Truly, sir, I was in a brown study about my
mistress.
 Alv. About me? For what?
 Adam. Truly, mistress, to think what a golden sen-
tence you did speak; all the philosophers in the 120
world could not have said more: "What, come, let him
want no drink." Oh, wise speech.
 Alv. Villains, why skink you not unto this fellow?
He makes me blithe and merry in my thoughts.
Heard you not that the King hath given command
That all be drunk this day within his court
In quaffing to the health of Alvida?

 Enters JONAS.

 Jon. Repent, repent, ye men of Nineveh, repent.
The Lord hath spoken, and I do cry it out:
There are as yet but forty days remaining, 130
And then shall Nineveh be overthrown.
Repent, ye men of Nineveh, repent.
 Ras. What fellow is this that thus disturbs our feasts
With outcries and alarums to repent?
 Adam. O sir, 'tis one goodman Jonas that is come
from Jericho, and surely I think he hath seen some
spirit by the way and is fallen out of his wits, for he
never leaves crying night nor day. My master heard
him, and he shut up his shop, gave me my indenture,
and he and his wife do nothing but fast and pray. 140
 Jon. Repent, ye men of Nineveh, repent.
 Ras. Come hither, fellow. What art and from whence
comest thou?
 Jon. Rasni, I am a prophet of the Lord,
Sent hither by the mighty God of hosts
To cry destruction to the Ninevites.
O Nineveh, thou harlot of the world,
I raise thy neighbors round about thy bounds
To come and see thy filthiness and sin.
Thus saith the Lord, the mighty God of hosts: 150
Your King loves chambering[11] and wantonness;
Whoredom and murder do distain his court;
He favoreth courteous and drunken men.
Behold, therefore, all like a strumpet soul.
Thou shalt be judged and punished for thy crime;
The foe shall pierce the gates with iron ramps;[12]
The fire shall quite consume thee from above;
The houses shall be burnt, the infants slain;
And women shall behold their husbands die.
Thine eldest sister is Samaria, 160

[10] *standards:* standard-bearers; i.e., servants to pour.
[11] *chambering:* sexual indulgence.
[12] *ramps:* battering rams. [13] *overborne:* overwhelmed.

And Sodom on thy right hand seated is.
Repent, ye men of Nineveh, repent.
The Lord hath spoke, and I do cry it out.
There are as yet but forty days remaining,
And then shall Nineveh be overthrown.
 Exit offered.
 Ras. Stay, prophet, stay.
 Jon. Disturb not Him that sent me;
Let me perform the message of the Lord.
 Exit.
 Ras. My soul is buried in the hell of thoughts.
Ah Alvida, I look on thee with shame. 170
My lords on sudden fix their eyes on ground
As if dismayed to look upon the heavens.
Hence, Magi, who have flattered me in sin.
 Exit his sages.
Horror of mind, disturbance of my soul
Makes me aghast for Nineveh's mishap.
Lords, see proclaimed, yea see it straight proclaimed
That man and beast, the woman and her child,
For forty days in sack and ashes fast;
Perhaps the Lord will yield and pity us.
Bear hence these wretched blandishments of sin, 180
And bring me sackcloth to attire your King.
Away with pomp; my soul is full of woe.
In pity look on Nineveh, O God.
 Exit a Man.
 Alv. Assailed with shame, with horror overborne,[13]
To sorrows sold, all guilty of our sin,
Come, ladies, come, let us prepare to pray.
Alas, how dare we look on heavenly light
That have despised the maker of the same?
How may we hope for mercy from above
That still despise the warnings from above? 190
Woe's me, my conscience is a heavy foe.
O patron of the poor, oppressed with sin,
Look, look on me that now for pity crave,
Assailed with shame, with horror overborne,
To sorrow sold, all guilty of our sin.
Come, ladies, come, let us prepare to pray.
 Exeunt.

[V.ii]

 Enter the Usurer *solus, with a halter in one hand,*
 a dagger in the other.

 Usu. Groaning in conscience, burdened with my
 crimes,
The hell of sorrow haunts me up and down.
Tread where I list, methinks the bleeding ghosts
Of those whom my corruption brought to naught
Do serve for stumbling blocks before my steps.
The fatherless and widow wronged by me,
The poor oppressèd by my usury,
Methinks I see their hands reared up to heaven
To cry for vengeance of my covetousness.
Whereso I walk, all sigh and shun my way. 10
Thus am I made a monster of the world.
Hell gapes for me, heaven will not hold my soul.
You mountains, shroud me from the God of truth.

Methinks I see Him sit to judge the earth.
See how He blots me out of the book of life.
Oh, burthen more than Etna [1] that I bear!
Cover me, hills, and shroud me from the Lord;
Swallow me, Lycus, shield me from the Lord.
In life no peace; each murmuring that I hear,
Methinks the sentence of damnation sounds; 20
Die reprobate, and hie thee hence to hell.

The Evil Angel *tempteth him, offering the knife*
and rope.

What fiend is this that tempts me to the death?
What, is my death the harbor of my rest?
Then let me die. What second charge is this?
Methinks I hear a voice amidst mine ears
That bids me stay and tells me that the Lord
Is merciful to those that do repent.
May I repent? O thou, my doubtful soul,
Thou may'st repent; the Judge is merciful.
Hence, tools of wrath, stales [2] of temptation, 30
For I will pray and sigh unto the Lord.
In sackcloth will I sigh, and fasting pray:
O Lord, in rigor look not on my sins.

He sits him down in sackcloth, his hands and eyes
reared to heaven.

Enters ALVIDA *with her* Ladies *with dispersed locks.*

Alv. Come, mournful dames, lay off your broidered
 locks,
And on your shoulders spread dispersèd hairs.
Let voice of music cease where sorrow dwells.
Clothed in sackcloths, sigh your sins with me.
Bemoan your pride, bewail your lawless lusts,
With fasting mortify your pampered loins.
Oh, think upon the horror of your sins. 40
Think, think with me, the burden of your blames.
Woe to thy pomp, false beauty, fading flower,
Blasted by age, by sickness, and by death;
Woe to our painted cheeks, our curious oils,
Our rich array that fostered us in sin;
Woe to our idle thoughts that wound our souls.
Oh, would to God all nations might receive
A good example by our grievous fall.
 Ladies. You that are planted there where pleasure
 dwells
And think your pomp as great as Nineveh's 50
May fall for sin as Nineveh doth now.
 Alv. Mourn, mourn; let moan be all your melody,
And pray with me, and I will pray for all:
O Lord of heaven, forgive us our misdeeds.
 Ladies. O Lord of heaven, forgive us our misdeeds.
 Usu. O Lord of heaven, forgive me my misdeeds.

Enter RASNI, *the* King of Assyria, *with his* Nobles
in sackcloth.

 Cil. Be not so overcome with grief, O King,
Lest you endanger life by sorrowing so.
 Ras. King of Cilicia, should I cease my grief
Where as my swarming sins afflict my soul? 60
Vain man, know, this my burden greater is

Than every private subject in my land.
My life hath been a lodestar unto them
To guide them in the labyrinth of blame.
Thus I have taught them for to do amiss.
Then must I weep, my friend, for their amiss;
The fall of Nineveh is wrought by me.
I have maintained this city in her shame;
I have contemned the warnings from above;
I have upholden incest, rape, and spoil. 70
'Tis I that wrought the sin, must weep the sin.
Oh, had I tears like to the silver streams
That from the Alpine mountains sweetly stream,
Or had I sighs, the treasures of remorse,
As plentiful as Aeolus hath blasts;
I then would tempt the heavens with my laments
And pierce the throne of mercy by my sighs.
 Cil. Heavens are propitious unto faithful prayers.
 Ras. But after our repent we must lament,
Lest that a worser mischief doth befall. 80
Oh, pray, perhaps the Lord will pity us.
O God of truth, both merciful and just,
Behold repentant men with piteous eyes;
We wail the life that we have led before.
Oh, pardon, Lord, oh, pity Nineveh.
 Omnes. Oh, pardon, Lord, oh, pity Nineveh.
 Ras. Let not the infants dallying on the teat
For fathers' sins in judgment be oppressed.
 Cil. Let not the painful mothers big with child,
The innocents, be punished for our sin. 90
 Ras. Oh, pardon, Lord, oh, pity Nineveh.
 Omnes. Oh, pardon, Lord, oh, pity Nineveh.
 Ras. O Lord of heaven, the virgins weep to thee.
The covetous man is sorry for his sin.
The prince and poor all pray before Thy throne;
And wilt Thou then be wroth with Nineveh?
 Cil. Give truce to prayer, O King, and rest a space.
 Ras. Give truce to prayers when times require no
 truce?
No, princes, no. Let all our subjects hie
Unto our temples, where on humbled knees 100
I will expect [3] some mercy from above.

Enter the temple omnes.

[V.iii]

Enter JONAS *solus.*

 Jon. This is the day wherein the Lord hath said
That Nineveh shall quite be overthrown.
This is the day of horror and mishap,
Fatal unto the cursèd Ninevites.
These stately towers shall in thy watery bounds,
Swift flowing Lycus, find their burials;
These palaces, the pride of Assur's kings,
Shall be the bowers of desolation,
Where as the solitary bird shall sing,
And tigers train their young ones to their nest. 10

V.ii.
 [1] *Etna:* The eruptions of the Sicilian volcano were said
to be caused by a giant buried beneath.
 [2] *stales:* decoys. [3] *expect:* await.

O all ye nations bounded by the west,
Ye happy isles where prophets do abound,
Ye cities famous in the western world,
Make Nineveh a precedent for you.
Leave lewd desires, leave covetous delights,
Fly usury, let whoredom be exiled,
Lest you with Nineveh be overthrown.
Lo, how the sun's enflamèd torch prevails,
Scorching the parchèd furrows of the earth.
Here will I sit me down and fix mine eye 20
Upon the ruins of yon wretched town;
And lo, a pleasant shade, a spreading vine
To shelter Jonas in this sunny heat.
What means my God? The day is done and spent.
Lord, shall my prophecy be brought to naught?
When falls the fire? When will the Judge be wroth?
I pray the Lord remember what I said
When I was yet within my country land.
Jehovah is too merciful, I fear.
Oh, let me fly before a prophet fault, 30
For Thou art merciful, the Lord my God,
Full of compassion and of sufferance,
And dost repent in taking punishment.
Why stays Thy hand? O Lord, first take my life
Before my prophecy be brought to naught.
Ah, He is wroth; behold the gladsome vine
That did defend me from the sunny heat
Is withered quite, and swallowed by a serpent.

A serpent devoureth the vine.

Now furious Phlegon [1] triumphs on my brows,
And heat prevails, and I am faint in heart. 40

Enters the Angel.

Ang. Art thou so angry, Jonas? tell my why?
Jon. Jehovah, I with burning heat am plunged,
And shadowed only by a silly [2] vine.
Behold, a serpent hath devoured it;
And lo, the sun, incensed by eastern wind,
Afflicts me with canicular aspect. [3]
Would God that I might die, for well I wot
'Twere better I were dead than rest alive.
Ang. Jonas, art thou so angry for the vine?
Jon. Yea, I am angry to the death, my God. 50
Ang. Thou hast compassion, Jonas, on a vine
On which thou never labor didst bestow;
Thou never gav'st it life or power to grow,
But suddenly it sprung, and suddenly died.
And should not I have great compassion
On Nineveh, the city of the world,
Wherein there are a hundred thousand souls
And twenty thousand infants that ne [4] wot

The right hand from the left, beside much cattle?
O Jonas, look into their temples now, 60
And see the true contrition of their King,
The subjects' tears, the sinners' true remorse.
Then from the Lord proclaim a mercy day,
For He is pitiful as He is just.
Exit Angelus.
Jon. I go, my God, to finish thy command.
Oh, who can tell the wonders of my God,
Or talk his praises with a fervent tongue?
He bringeth down to hell and lifts to heaven.
He draws the yoke of bondage from the just,
And looks upon the heathen with piteous eyes. 70
To Him all praise and honor be ascribed.
Oh, who can tell the wonders of my God?
He makes the infant to proclaim his truth,
The ass to speak to save the prophet's life,
The earth and sea to yield increase for man.
Who can describe the compass of his power,
Or testify in terms his endless might?
My ravished sprite, [5] oh, whither dost thou wend?
Go and proclaim the mercy of my God.
Relieve the careful [6] hearted Ninevites. 80
And as thou wert the messenger of death,
Go bring glad tidings of recovered grace.
[*Exit.*]

[V.iv]

Enters ADAM *solus, with a bottle of beer in one slop* [1]
and a great piece of beef in another.

Adam. Well, goodman Jonas, I would you had never come from Jewry to this country; you have made me look like a lean rib of roast beef, or like the picture of Lent painted upon a red herring's cob. [2] Alas, masters, we are commanded by the proclamation to fast and pray; by my troth, I could prettily: so, so; away with praying; but for fasting, why, 'tis so contrary to my nature that I had rather suffer a short hanging than a long fasting. Mark me, the words be these: "Thou shalt take no manner of food for so many days." I 10 had as leave he should have said, "Thou shalt hang thyself for so many days." And yet, in faith, I need not find fault with the proclamation, for I have a buttery and a pantry and a kitchen about me; for proof, *ecce signum:* this right slop is my pantry—behold a manchet; [3] this place is my kitchen—for lo, a piece of beef. Oh, let me repeat that sweet word again—"For lo, a piece of beef." This is my buttery, for see, see, my friends, to my great joy, a bottle of beer. Thus, alas, I make shift to wear out this fasting. I drive away 20 the time, but there go searchers about to seek if any man breaks the King's command. Oh, here they be; in with your victuals, Adam.

Enters two Searchers.

1 Sear. How duly the men of Nineveh keep the proclamation! how are they armed to repentance! We have searched through the whole city and have not as yet found one that breaks the fast.

V.iii.
 [1] *Phlegon:* one of the four horses of the sun in Greek myth. [2] *silly:* helpless.
 [3] *canicular aspect:* i.e., with the heat of the dog-days in mid-August. [4] *ne:* do not.
 [5] *sprite:* spirit. [6] *careful:* full of care.
V.iv.
 [1] *slop:* one leg of a pair of wide, baggy breeches.
 [2] *cob:* head. [3] *manchet:* fine white bread.

2 Sear. The sign of the more grace. But stay, here sits one methinks at his prayers; let us see who it is.

1 Sear. 'Tis Adam, the smith's man. How now, Adam? 31

Adam. Trouble me not; thou shalt take no manner of food, but fast and pray.

1 Sear. How devoutly he sits at his orisons.[4] But stay, methinks I feel a smell of some meat or bread about him.

2 Sear. So thinks me too. You, sirrah, what victuals have you about you?

Adam. Victuals! oh, horrible blasphemy! hinder me not of my prayer, nor drive me not into a choler. 40 Victuals! why, heardst thou not the sentence, "Thou shalt take no food, but fast and pray?"

2 Sear. Truth, so it should be, but methinks I smell meat about thee.

Adam. About me, my friends; these words are actions in the case, "about me"; no, no—hang those gluttons that cannot fast and pray.

1 Sear. Well, for all your words, we must search you. 49

Adam. Search me! take heed what you do; my hose are my castles; 'tis burglary if you break ope a slop; no officer must lift up an iron hatch; take heed—my slops are iron.

[They search him.]

2 Sear. Oh, villain! see how he hath gotten victuals, bread, beef, and beer, where the King commanded upon pain of death none should eat for so many days, no, not the sucking infant.

Adam. Alas, sir, this is nothing but a *modicum non nocet ut medicus daret;*[5] why, sir, a bit to comfort my stomach. 60

1 Sear. Villain, thou shalt be hanged for it.

Adam. These are your words, "I shall be hanged for it," but first answer me to this question: how many days have to fast still?

2 Sear. Five days.

Adam. Five days! a long time. Then must I be hanged?

1 Sear. Ay, marry must thou.

Adam. I am your man; I am for you, sir, for I had rather be hanged than abide so long a fast. What, 70 five days! Come, I'll untruss. Is your halter and the gallows, the ladder, and all such furniture in readiness?

1 Sear. I warrant thee, shalt want none of these.

Adam. But hear you, must I be hanged?

1 Sear. Ay, marry.

Adam. And for eating of meat! then, friends, know ye by these presents, I will eat up all my meat and drink up all my drink, for it shall never be said I was hanged with an empty stomach. 79

1 Sear. Come away, knave; wilt thou stand feeding now?

Adam. If you be so hasty, hang yourself an hour while I come to you, for surely I will eat up my meat.

2 Sear. Come, let's draw him away perforce.[6]

Adam. You say there is five days yet to fast? These are your words?

2 Sear. Ay, sir.

Adam. I am for you; come, let's away, and yet let me be put in the Chronicles.

[Exeunt.]

[V.v]

Enter JONAS, RASNI, ALVIDA, Kings of CILICIA, [*and*] Others, *royally attended*.

Jon. Come, careful King, cast off thy mournful weeds;
Exchange thy cloudy looks to smoothèd smiles.
Thy tears have pierced the piteous throne of grace,
Thy sighs, like incense pleasing to the Lord,
Have been peace-offerings for thy former pride.
Rejoice and praise His name that gave thee peace.
And ye, fair nymphs, ye lovely Ninevites,
Since you have wept and fasted for the Lord,
Ye graciously have tempered his revenge;
Beware henceforth to tempt him any more; 10
Let not the niceness of your beauteous looks
Ingraft in you a high, presuming mind,
For those that climb He casteth to the ground,
And they that humble be He lifts aloft.

Ras. Lowly I bend with awful bent of eye
Before the dread Jehovah, God of hosts,
Despising all profane device of man;
Those lustful lures that whilom[1] led awry
My wanton eyes shall wound my heart no more;
And she whose youth in dalliance I abused 20
Shall now at last become my wedlock mate.
Fair Alvida, look not so woebegone;
If for thy sin thy sorrow do exceed,
Blessed be thou; come, with a holy hand
Let's knit a knot to salve our former shame.

Alv. With blushing looks betokening my remorse
I lowly yield, my King, to thy behest,
So as this man of God shall think it good.

Jon. Woman, amends may never come too late,
The[2] * * * * * * * 30
A will to practice goodness virtuous.
The God of heaven, when sinners do repent,
Doth more rejoice than in ten thousand just.

Ras. Then witness, holy prophet, our accord.

Alv. Plight in the presence of the Lord thy God.

Jon. Blest may you be, like to the flowering sheaves
That play with gentle winds in summertide;
Like olive branches let your children spread,
And as the pines in lofty Lebanon
Or as the kids that feed on Sepher[3] plains, 40
So be the seed and offspring of your loins.

[4] *orisons:* prayers.
[5] *L.:* a little bit doesn't hurt, as the doctor allows.
[6] *perforce:* by force.

V.v.
[1] *whilom:* formerly. [2] *The:* Rest of the line is missing.
[3] *Sepher:* Vulgate version of "Shapher," a mountain(?) Q "Lepher."

Enters the Usurer, [THRASIBULUS *the*] Gentleman,
and ALCON.

Usu. Come forth, my friends whom wittingly I
 wronged,
Before this man of God receive your due.
Before our King I mean to make my peace.
Jonas, behold, in sign of my remorse
I here restore into these poor men's hands
Their goods which I unjustly have detained,
And may the heavens so pardon my misdeeds
As I am penitent for my offense.

Thras. And what through want from others I
 purloined 50
Behold, O King, I proffer fore thy throne
To be restored to such as owe the same.

Jon. A virtuous deed, pleasing to God and man;
Would God all cities drownèd in like shame
Would take example of these Ninevites.

Ras. Such be the fruits of Nineveh's repent,
And such forever may our dealings be
That He that called us home in height of sin
May smile to see our hearty penitence.
Viceroys, proclaim a fast unto the Lord; 60
Let Israel's God be honored in our land;
Let all occasion of corruption die,
For who shall fault therein shall suffer death.
Bear witness, God, of my unfainèd zeal.
Come, holy man, as thou shalt counsel me,
My court and city shall reformèd be.

 Exeunt [*all but* JONAS.]

Jon. Wend on in peace and prosecute this course.
You islanders on whom the milder air
Doth sweetly breathe the balm of kind increase,
Whose lands are fattened with the dew of heaven 70
And made more fruitful than Actean[4] plains;
You whom delicious pleasures dandle soft,
Whose eyes are blinded with security,
Unmask yourselves, cast error clean aside.
O London, maiden of the mistress isle,
Wrapped in the folds and swathing clouts[5] of shame,
In thee more sins than Nineveh contains:
Contempt of God, despite of reverend age,
Neglect of law, desire to wrong the poor,
Corruption, whoredom, drunkenness, and pride. 80
Swoll'n are thy brows with impudence and shame.
O proud, adulterous glory of the west,
Thy neighbor burns, yet dost thou fear no fire.
The preachers cry, yet dost thou stop thine ears.
The larum[6] rings, yet sleepest thou secure.
London, awake, for fear the Lord do frown.
I set a looking glass before thine eyes;
Oh, turn, oh, turn with weeping to the Lord,
And think the prayers and virtues of thy Queen
Defers the plague which otherwise would fall. 90
Repent, O London, lest for thine offense
Thy shepherd fail, whom mighty God preserve
That she may bide the pillar of his Church
Against the storms of Romish Antichrist.
The hand of mercy overshade her head,
And let all faithful subjects say "Amen."

 [*Exit.*]

F I N I S

[4] *Actean:* of Asia Minor.
[5] *swathing clouts:* swaddling clothes. [6] *larum:* alarm.

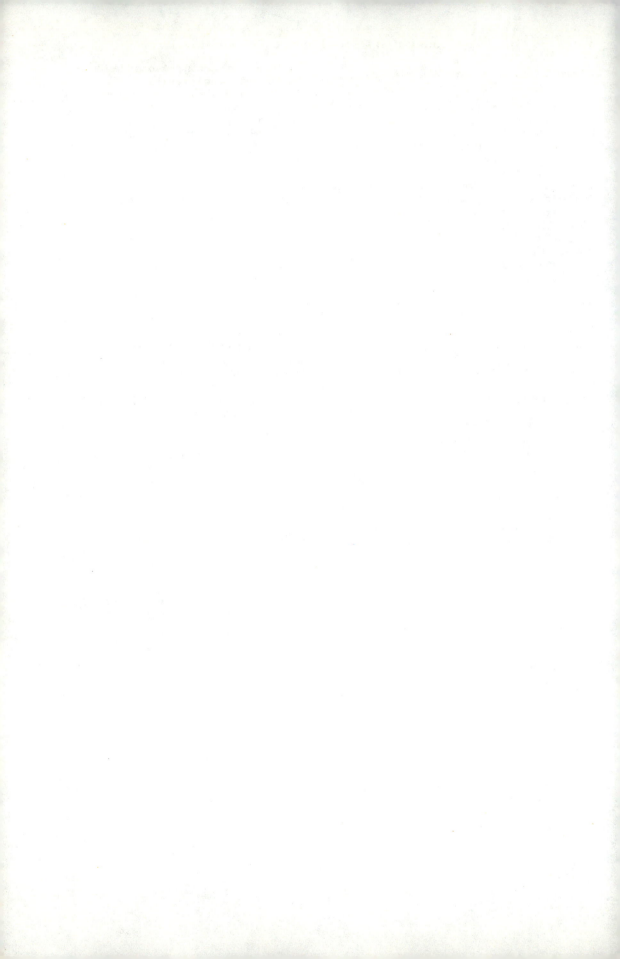

Anonymous

ARDEN OF FEVERSHAM

ARDEN OF FEVERSHAM is the first surviving example in English of the domestic tragedy, a popular form that Shakespeare and Webster metamorphosed and transcended in dramatizing the familial relationships of *Othello* and THE DUCHESS OF MALFI. Thomas Heywood, in A WOMAN KILLED WITH KINDNESS and again in *The English Traveller*, tried his hand at domestic tragedy, but Heywood's work is off the main line in that the stories he tells are of his own invention. Characteristically the form is indebted to historical fact. The protagonists whose unhappy annals it records are not necessarily humble but they do not fetch their being from men of royal siege. That is true of *A Yorkshire Tragedy* and *A Warning for Fair Women*—two anonymous plays, the latter of which is influenced by ARDEN—as also of Dekker, Ford, and Rowley's *Witch of Edmonton* and George Wilkins' *Miseries of Enforced Marriage*. Philip Henslowe, the theatrical entrepreneur, records payment to Jonson and Dekker for a *Lamentable Tragedy of the Page of Plymouth*, presumably another essay in the same kind.

If Jonson participated in the writing of domestic tragedy, he did so, no doubt, on the assumption that he was undertaking hack work for money. That assumption is by no means implicit in ARDEN OF FEVERSHAM, a play sufficiently meritorious as to have been attributed, in the eighteenth century and after, to Shakespeare. No evidence supports the attribution and one can say conclusively that Shakespeare did not write the play. But it is interesting to ask why it was fathered on him. Style is one answer. The blank verse in which ARDEN is cast is sometimes eked-out doggerel and often extremely rough, really not verse at all, and hence indicating for this text frequent conversion to prose, as in the speeches of Black Will in Scene ii. Sometimes, however, the blank verse line, at once relaxed and crowded, suggests a mature and practiced writer. Compare, for instance, Arden's speech at the beginning of Scene iv. It is the work of a writer of consequence. So with other passages in the play.

The identity of the writer remains mysterious. Thomas Kyd and Christopher Marlowe have been proposed, each without any basis but conjecture. The influence of Marlowe's EDWARD II is perceptible; so is that of the Roman dramatist Seneca and his French follower Garnier.

ARDEN OF FEVERSHAM was entered in the Stationers' Register on April 3, 1592, and printed anonymously in quarto for the publisher Edward White in the same year. (Quartos following in 1599 and 1633 correct the first edition in some particulars; such corrections are made silently here.) The title page advertises the play as a moral fable. It is the "lamentable and true tragedy of Master Arden of Feversham in Kent, who was most wickedly murdered by the means of his disloyal and wanton wife, who for the love she bare to one Mosby hired two desperate ruffians, Black Will and Shakebag, to kill him." Then comes the ostensible point: "Wherein is showed the great malice and dissimulation of a wicked woman, the unsatiable desire of filthy lust, and the shameful end of all murderers."

The strongly asserted moral bias of Elizabethan domestic tragedy occasioned its revival in the sentimental theater of the eighteenth century. Aaron Hill in *The Fatal Extravagance* rewrote *A Yorkshire Tragedy*, and Benjamin Victor A WOMAN KILLED WITH KINDNESS. George Lillo, the high priest of sentimentalism, sought in his version of ARDEN OF FEVERSHAM (published posthumously in 1762) to wring more tears and caveats from the play.

But ARDEN is much more than a lugubrious and cautionary tale. Though Holinshed's *Chronicle* (edition of 1577) furnished most of the historical background—a notorious murder occurring on February 15, 1551—the unknown playwright was not satisfied merely to recapitulate or to sermonize. Plot and character are strengthened, under his hand. He introduces Arden's friend Franklin; the journey of the luckless Bradshaw, whose execution for no cause provides a nice mordant touch of which Lillo would certainly have been incapable; the providential episode of the apprentice and his stall; the rivalry of the servant Michael and the painter Clarke; and the grimly comic business of the Ferryman in the fog. Both Mosby the murderer and Arden the hero are ambiguous figures, more equivocal than in the source—one regenerate *in posse*, the other tainted but not blackened. Each is indebted less to melodrama than to life.

Given the manifest power of the play, it is plausible to assign it a date closer to that of publication than to the appearance of the chronicle account fifteen years earlier. In 1592 Shakespeare was already impinging on his time. There are passages in ARDEN OF FEVERSHAM not unworthy of the author of 2 and 3 *Henry VI*. That is more than faint praise. R. A. F.

Arden of Feversham

DRAMATIS PERSONÆ

THOMAS ARDEN
FRANKLIN, *his friend*
MOSBY
CLARKE, *a painter*
BRADSHAW, *a goldsmith*
ADAM FOWLE, *landlord of the Flower-de-Luce*
MICHAEL, *Arden's servant*
RICHARD GREENE, *a tenant*

RICHARD REEDE, *a sailor*
BLACK WILL ⎫ *murderers*
SHAKEBAG ⎭
LORD CHEINY
MAYOR OF FEVERSHAM
ALICE, *Arden's wife*
SUSAN, *Mosby's sister and Alice's servingmaid*
Servants, a Sailor, the Watch, a Prentice, a Ferryman

[i]

Enter ARDEN *and* FRANKLIN.

Frank. Arden, cheer up thy spirits and droop no
 more.
My gracious lord the Duke of Somerset
Hath freely given to thee and to thy heirs,
By letters patents [1] from his majesty,
All the lands of the Abbey of Feversham.
Here are the deeds sealed and subscribed
With his name and the King's.
Read them, and leave this melancholy mood.
Ard. Franklin, thy love prolongs my weary life. 10
And but for thee how odious were this life
That shows me nothing but torments my soul,
And those foul objects that offend mine eyes,
Which makes me wish that for [2] this veil of heaven
The earth hung over my head and covered me.
Love letters passed twixt Mosby and my wife,
And they have privy [3] meetings in the town.
Nay, on his finger did I espy a ring
Which at our marriage day the priest put on.
Can any grief be half so great as this?
Frank. Comfort thyself, sweet friend; it is not
 strange 20
That women will be false and wavering.
Ard. Ay, but to dote on such a one as he
Is monstrous, Franklin, and intolerable.
Frank. Why, what is he?
Ard. A botcher,[4] and no better at the first,[5]
Who by base brokage [6] getting some small stock,
Crept into service of a nobleman,
And by his servile flattery and fawning
Is now become the steward of his house,
And bravely jets it [7] in his silken gown. 30
Frank. No nobleman will countenance such a
 peasant!
Ard. Yes, the Lord Clifford, he that loves not me.
But through his favor let not him [8] grow proud,
For were he by the lord protector backed,
He should not make me to be pointed at.

I am by birth a gentleman of blood,
And that injurious ribald [9] that attempts
To violate my dear wife's chastity—
For dear I hold her love, as dear as heaven—
Shall on the bed which he thinks to defile 40
See his disseevered joints and sinews torn,
Whilst on the planchers [10] pants his weary body,
Smeared in the channels of his lustful blood.
Frank. Be patient, gentle friend, and learn of me
To ease thy grief and save her chastity.
Entreat [11] her fair; sweet words are fittest engines [12]
To raze the flint walls of a woman's breast.
In any case, be not too jealous,
Nor make no question of her love to thee;
But as securely,[13] presently [14] take horse, 50
And lie [15] with me at London all this term.[16]
For women when they may will not,
But being kept back, straight grow outrageous.
Ard. Though this abhors [17] from reason, yet I'll try
 it,
And call her forth, and presently take leave.
How, Alice!

Here enters ALICE.

Al. Husband, what mean you to get up so early?
Summer nights are short, and yet you rise ere day.
Had I been 'wake you had not rise [18] so soon.
Ard. Sweet love, thou knowest that we two,
 Ovid-like, 60

i.
 [1] *letters patents:* which conferred title.
 [2] *for:* instead of. [3] *privy:* secret.
 [4] *botcher:* tailor, mender of old clothes.
 [5] *at the first:* from the beginning (he has always been of
low estate). [6] *base brokage:* pandering.
 [7] *bravely jets it:* swaggers splendidly. [8] *him:* Mosby.
 [9] *ribald:* low fellow.
 [10] *planchers:* planks (of the floor). [11] *Entreat:* Treat.
 [12] *engines:* of war, like battering rams.
 [13] *as securely:* as if confident. [14] *presently:* immediately.
 [15] *lie:* live. [16] *term:* while the law courts were sitting.
 [17] *abhors:* is at variance. [18] *rise:* risen.

Have often chid the morning when it 'gan to peep,
And often wished that dark night's purblind [19] steeds
Would pull her by the purple mantle back
And cast her in the ocean to her love.
But this night, sweet Alice, thou hast killed my heart;
I heard thee call on Mosby in thy sleep.
 Al. 'Tis like I was asleep when I named him,
For being awake he comes not in my thoughts.
 Ard. Ay, but you started up, and suddenly
Instead of him caught me about the neck. 70
 Al. Instead of him? Why, who was there but you?
And where but one is how can I mistake?
 Frank. Arden, leave [20] to urge her over-far.
 Ard. Nay, love, there is no credit in a dream.
Let it suffice I know thou lovest me well.
 Al. Now I remember whereupon it came.
Had we no talk of Mosby yesternight?
 Frank. Mistress Alice, I heard you name him once or
 twice.
 Al. And thereof came it, and therefore blame not me.
 Ard. I know it did, and therefore let it pass. 80
I must to London, sweet Alice, presently.
 Al. But tell me, do you mean to stay there long?
 Ard. No longer there till my affairs be done.
 Frank. He will not stay above a month at most.
 Al. A month? Ay me! sweet Arden, come again
Within a day or two or else I die.
 Ard. I cannot long be from thee, gentle Alice.
Whilst Michael fetch our horses from the field
Franklin and I will down unto the quay,
For I have certain goods there to unload. 90
Meanwhile prepare our breakfast, gentle Alice,
For yet ere noon we'll take horse and away.
 Exeunt ARDEN *and* FRANKLIN.
 Al. Ere noon he means to take horse and away.
Sweet news is this. Oh, that some airy spirit
Would, in the shape and likeness of a horse,
Gallop with Arden across the ocean
And throw him from his back into the waves.
Sweet Mosby is the man that hath my heart,
And he [21] usurps it, having nought but this,
That I am tied to him by marriage. 100
Love is a god, and marriage is but words,
And therefore Mosby's title is the best.
Tush! whether it be or no he shall be mine,
In spite of him, of Hymen, [22] and of rites.

 Here enters ADAM *of the Flower-de-Luce.*

And here comes Adam of the Flower-de-Luce.
I hope he brings me tidings of my love.
How now, Adam, what is the news with you?
Be not afraid, my husband is now from home.

 Adam. He whom you wot [23] of, Mosby, Mistress
 Alice,
Is come to town and sends you word by me 110
In any case you may not visit him.
 Al. Not visit him?
 Adam. No, nor take no knowledge of his being here.
 Al. But tell me, is he angry or displeased?
 Adam. Should seem so, for he is wondrous sad.
 Al. Were he as mad as raving Hercules
I'll see him. Ay, and were thy house of force, [24]
These hands of mine should raze it to the ground,
Unless that thou wouldst bring me to my love.
 Adam. Nay, and [25] you be so impatient I'll be gone.
 Al. Stay, Adam, stay; thou wert wont to be my
 friend. 121
Ask Mosby how I have incurred his wrath.
Bear him from me these pair of silver dice
With which we played for kisses many a time,
And when I lost I won and so did he—
Such winning and such losing Jove send me!
And bid him, if his love do not decline,
To come this morning but along [26] my door,
And as a stranger but salute me there.
This may he do without suspect or fear. 130
 Adam. I'll tell him what you say, and so farewell.
 Exit ADAM.
 Al. Do, and one day I'll make amends for all.
I know he loves me well but dares not come
Because my husband is so jealous,
And these my marrow [27]-prying neighbors blab,
Hinder our meetings when we would confer.
But if I live that block [28] shall be removed,
And, Mosby, thou that comes to me by stealth,
Shalt neither fear the biting speech of men
Nor Arden's looks. As surely shall he die 140
As I abhor him and love only thee.

 Here enters MICHAEL.

How now, Michael, whither are you going?
 Mich. To fetch my master's nag. I hope you'll think
 on me.
 Al. Ay, but Michael, see you keep your oath,
And be as secret as you are resolute.
 Mich. I'll see he shall not live above a week.
 Al. On that condition, Michael, here is my hand:
None shall have Mosby's sister but thyself.
 Mich. I understand the painter here hard by
Hath made report that he and Sue is sure. [29] 150
 Al. There's no such matter, Michael; believe it not.
 Mich. But he hath sent a dagger sticking in a heart,
With a verse or two stolen from a painted cloth, [30]
The which I hear the wench keeps in her chest.
Well, let her keep it; I shall find a fellow
That can both write and read and make rhyme too,
And if I do—well, I say no more.
I'll send from London such a taunting letter
As [31] [she] shall eat the heart he sent with salt,
And fling the dagger at the painter's head. 160
 Al. What needs all this? I say that Susan's thine.
 Mich. Why, then, I say that I will kill my master,
Or anything that you will have me do.

[19] *purblind:* here, "totally blind." [20] *leave:* cease.
[21] *he:* Arden. [22] *Hymen:* the marriage-god.
[23] *wot:* know. [24] *of force:* fortified.
[25] *and:* if. [26] *along:* as if passing.
[27] *marrow:* retained here as a more vivid reading than the expected "narrow" of subsequent editions.
[28] *block:* hindrance. [29] *sure:* betrothed.
[30] *painted cloth:* with which rooms were hung in Elizabethan houses. [31] *As:* That.

Al. But Michael, see you do it cunningly.

Mich. Why, say I should be took, I'll ne'er confess
That you know anything, and Susan being a maid [32]
May beg me from the gallows of the sheriff.

Al. Trust not to that, Michael.

Mich. You cannot tell me, I have seen it, I.
But, mistress, tell her, whether I live or die, 170
I'll make her more worth than twenty painters can,
For I will rid mine elder brother away, [33]
And then the farm of Bolton is mine own.
Who would not venture upon house and land,
When he may have it for a right-down [34] blow?

Here enters MOSBY.

Al. Yonder comes Mosby. Michael, get thee gone,
And let not him nor any know thy drifts. [35]

Exit MICHAEL.

Mosby, my love!

Mos. Away, I say, and talk not to me now.

Al. A word or two, sweetheart, and then I will. 180
'Tis yet but early days, [36] thou needest not fear.

Mos. Where is your husband?

Al. 'Tis now high water, and he is at the quay.

Mos. There let him be; henceforward know me not.

Al. Is this the end of all thy solemn oaths?
Is this the fruit thy reconcilement buds?
Have I for this given thee so many favors,
Incurred my husband's hate, and, out alas!
Made shipwreck of mine honor for thy sake? 189
And dost thou say "henceforward know me not"?
Remember when I locked thee in my closet, [37]
What were thy words and mine? Did we not both
Decree to murder Arden in the night?
The heavens can witness, and the world can tell,
Before I saw that falsehood look of thine,
'Fore I was tangled with thy ticing [38] speech,
Arden to me was dearer than my soul—
And shall be still. Base peasant, get thee gone,
And boast not of thy conquest over me,
Gotten by witchcraft and mere [39] sorcery. 200
For what hast thou to countenance [40] my love,
Being descended of a noble house
And matched already with a gentleman
Whose servant thou mayst be? And so farewell.

Mos. Ungentle and unkind Alice, now I see
That which I ever feared and find too true:
A woman's love is as the lightning flame,
Which even in bursting forth consumes itself.
To try thy constancy have I been strange. [41]
Would I had never tried but lived in hope. 210

Al. What needs thou try me whom thou never found
false?

Mos. Yet pardon me for love is jealous.

Al. So list [42] the sailor to the mermaid's song,
So looks the traveler to the basilisk. [43]
I am content for to be reconciled,
And that I know will be mine overthrow.

Mos. Thine overthrow? First let the world dissolve.

Al. Nay, Mosby, let me still enjoy thy love,
And happen what will, I am resolute.
My saving husband hoards up bags of gold 220

To make our children rich, and now is he
Gone to unload the goods that shall be thine,
And he and Franklin will to London straight.

Mos. To London, Alice? If thou'lt be ruled by me,
We'll make him sure enough 'fore coming there.

Al. Ah, would we could!

Mos. I happened on a painter yesternight,
The only [44] cunning man of Christendom,
For he can temper poison with his oil
That whoso looks upon the work he draws 230
Shall, with the beams that issue from his sight,
Suck venom to his breast and slay himself.
Sweet Alice, he shall draw thy counterfeit, [45]
That Arden may by gazing on it perish.

Al. Ay, but Mosby, that is dangerous,
For thou, or I, or any other else,
Coming into the chamber where it hangs, may die.

Mos. Ay, but we'll have it covered with a cloth
And hung up in the study for himself.

Al. It may not be, for when the picture's drawn 240
Arden I know will come and show it me.

Mos. Fear not, we'll have that shall serve the turn.
This is the painter's house. I'll call him forth.

Al. But Mosby, I'll have no such picture, I.

Mos. I pray thee leave it to my discretion.
How, Clarke!

Here enters CLARKE.

Oh, you are an honest man of your word, you served me
well.

Clar. Why, sir, I'll do it for you at any time,
Provided as you have given your word
I may have Susan Mosby to my wife. 250
For as sharp-witted poets, whose sweet verse
Make heavenly gods break off their nectar draughts
And lay their ears down to the lowly earth,
Use humble promise to their sacred muse,
So we that are the poets' favorites
Must have a love. Ay, love is the painter's muse,
That makes him frame a speaking countenance,
A weeping eye that witnesses heart's grief.
Then tell me, Master Mosby, shall I have her?

Al. 'Tis pity but [46] he should; he'll use her well.

Mos. Clarke, here's my hand; my sister shall be
thine. 261

Clar. Then, brother, to requite this courtesy,
You shall command my life, my skill, and all.

Al. Ah, that thou couldst be secret!

Mos. Fear him not; leave; I have talked sufficient.

Clar. You know not me that ask such questions.
Let it suffice, I know you love him well

[32] *maid:* and hence able, in popular belief, to save a con-
demned man from hanging.
[33] *rid . . . away:* get rid of, murder.
[34] *right-down:* downright. [35] *drifts:* intentions.
[36] *early days:* early in the day. [37] *closet:* private chamber.
[38] *ticing:* enticing. [39] *mere:* absolute.
[40] *countenance:* make a proper case for.
[41] *strange:* aloof. [42] *list:* listens.
[43] *basilisk:* whose looks could kill. [44] *only:* most.
[45] *counterfeit:* likeness. [46] *but:* unless.

And fain would have your husband made away,
Wherein, trust me, you show a noble mind,
That rather than you'll live with him you hate, 270
You'll venture life, and die with him you love.
The like will I do for my Susan's sake.
 Al. Yet nothing could enforce me to the deed
But Mosby's love. Might I without control[47]
Enjoy thee still, then Arden should not die;
But seeing I cannot, therefore let him die.
 Mos. Enough, sweet Alice, thy kind words makes me
 melt.
[*To* CLARKE] Your trick of poisoned pictures we
 dislike;
Some other poison would do better far.
 Al. Ay, such as might be put into his broth, 280
And yet in taste not to be found at all.
 Clar. I know your mind, and here I have it for you.
Put but a dram of this into his drink,
Or any kind of broth that he shall eat,
And he shall die within an hour after.
 Al. As I am a gentlewoman, Clarke, next day
Thou and Susan shall be married.
 Mos. And I'll make her dowry more than I'll talk of,
 Clarke.
 Clar. Yonder's your husband. Mosby, I'll be gone.

Here enters ARDEN *and* FRANKLIN [*and* MICHAEL].

 Al. In good time,[48] see where my husband comes.
Master Mosby, ask him the question yourself. 291
 Exit CLARKE.
 Mos. Master Arden, being at London yesternight,
The Abbey lands whereof you are now possessed
Were offered me on some occasion
By Greene, one of Sir Antony Ager's men.
I pray you, sir, tell me, are not the lands yours?
Hath any other interest herein?
 Ard. Mosby, that question we'll decide anon.[49]
Alice, make ready my breakfast; I must hence.
 Exit ALICE.
As for the lands, Mosby, they are mine, 300
By letters patents from his majesty.
But I must have a mandate[50] for my wife;
They say you seek to rob me of her love.
Villain, what makes thou in her company?
She's no companion for so base a groom.[51]
 Mos. Arden, I thought not on her, I came to thee;
But rather than I pocket up[52] this wrong—

[47] *control:* restraint. [48] *In good time:* At the right time.
[49] *anon:* now. [50] *mandate:* legal command.
[51] *groom:* servant, "customer."
[52] *pocket up:* accept without protest.
[53] *statute . . . artificers:* law disallows the wearing of swords
by handicraftsmen.
[54] *warrant that:* have warrant for what.
[55] *bodkin:* stiletto; or perhaps derisively "pin to fasten up
the hair." Here, and in succeeding lines, Arden is playing on
Mosby's tailoring heritage.
[56] *Spanish needle:* presumably uttered in contempt, given
the popular conception of things Spanish.
[57] *velvet drudge:* liveried servant.
[58] *misswollen:* mistakenly agitated.
[59] *late:* recently, just now. [60] *eschew:* avoid.
[61] *bruit:* report.

 Frank. What will you do, sir?
 Mos. Revenge it on the proudest of you both.

 Then ARDEN *draws forth* MOSBY'*s sword.*

 Ard. So, sirrah, you may not wear a sword; 310
The statute makes against artificers;[53]
I warrant that[54] I do. Now use your bodkin,[55]
Your Spanish needle,[56] and your pressing iron,
For this shall go with me. And mark my words,
You goodman botcher, 'tis to you I speak:
The next time that I take thee near my house,
Instead of legs, I'll make thee crawl on stumps.
 Mos. Ah, Master Arden, you have injured me;
I do appeal to God and to the world.
 Frank. Why, canst thou deny thou wert a botcher
 once? 320
 Mos. Measure me what I am, not what I was.
 Ard. Why, what art thou now but a velvet drudge,[57]
A cheating steward, and a base-minded peasant?
 Mos. Arden, now thou hast belched and vomited
The rancorous venom of thy misswollen[58] heart,
Hear me but speak. As I intend to live
With God and his elected saints in heaven,
I never meant more to solicit her,
And that she knows and all the world shall see.
I loved her once; sweet Arden, pardon me. 330
I could not choose, her beauty fired my heart.
But time hath quenched these over-raging coals;
And, Arden, though I now frequent thy house,
'Tis for my sister's sake, her waiting-maid,
And not for hers. Mayest thou enjoy her long;
Hell-fire and wrathful vengeance light on me
If I dishonor her or injure thee.
 Ard. Mosby, with these thy protestations
The deadly hatred of my heart is appeased,
And thou and I'll be friends if this prove true. 340
As for the base terms I gave thee late,[59]
Forget them, Mosby; I had cause to speak
When all the knights and gentlemen of Kent
Make common table-talk of her and thee.
 Mos. Who lives that is not touched with slanderous
 tongues?
 Frank. Then, Mosby, to eschew[60] the speech of men,
Upon whose general bruit[61] all honor hangs,
Forbear his house.
 Ard. Forbear it? Nay, rather frequent it more;
The world shall see that I distrust her not. 350
To warn him on the sudden from my house
Were to confirm the rumor that is grown.
 Mos. By my faith, sir, you say true.
And therefore will I sojourn here awhile,
Until our enemies have talked their fill.
And then I hope they'll cease and at last confess
How causeless they have injured her and me.
 Ard. And I will lie at London all this term
To let them see how light I weigh their words.

 Here enters ALICE.

 Al. Husband, sit down, your breakfast will be cold.
 Ard. Come, Master Mosby, will you sit with us?
 Mos. I cannot eat, but I'll sit for company. 362

Ard. Sirrah Michael, see our horse be ready.
 [*Exit* MICHAEL *and re-enter.*]
Al. Husband, why pause ye, why eat you not?
Ard. I am not well; there's something in this broth
That is not wholesome. Didst thou make it, Alice?
Al. I did, and that's the cause it likes[62] not you.

Then she throws down the broth on the ground.

There's nothing that I do can please your taste.
You were best to say I would have poisoned you.
I cannot speak or cast aside my eye 370
But he imagines I have stepped awry.
Here's he that you cast in my teeth so oft;
Now will I be convinced[63] or purge myself.
I charge thee speak to this mistrustful man,
Thou that wouldst see me hang, thou, Mosby, thou.
What favor hast thou had more than a kiss
At coming or departing from the town?
Mos. You wrong yourself and me, to cast these
 doubts;
Your loving husband is not jealous.
Ard. Why, gentle Mistress Alice, cannot I be ill 380
But you'll accuse yourself?
Franklin, thou hast a box of mithridate;[64]
I'll take a little to prevent the worst.
Frank. Do so, and let us presently take horse.
My life for yours, ye shall do well enough.
Al. Give me a spoon; I'll eat of it myself.
Would it were full of poison to the brim!
Then should my cares and troubles have an end.
Was ever silly[65] woman so tormented?
Ard. Be patient, sweet love, I mistrust not thee. 390
Al. God will revenge it, Arden, if thou dost,
For never woman loved her husband better
Than I do thee.
Ard. I know it, sweet Alice; cease to complain,
Lest that in tears I answer thee again.
Frank. Come, leave this dallying and let us away.
Al. Forbear to wound me with that bitter word.
Arden shall go to London in my arms.
Ard. Loath am I to depart, yet I must go.
Al. Wilt thou to London then, and leave me here?
Ah, if thou love me, gentle Arden, stay. 401
Yet if thy business be of great import
Go if thou wilt; I'll bear it as I may.
But write from London to me every week,
Nay, every day, and stay no longer there
Than thou must needs, lest that I die for sorrow.
Ard. I'll write unto thee every other tide,
And so farewell, sweet Alice, till we meet next.
Al. Farewell, husband, seeing you'll have it so.
And, Master Franklin, seeing you take him hence, 410
In hope you'll hasten him home I'll give you this.

And then she kisseth him.

Frank. And if he stay, the fault shall not be mine.
Mosby, farewell, and see you keep your oath.
Mos. I hope he is not jealous of me now.
Ard. No, Mosby, no. Hereafter think of me
As of your dearest friend. And so farewell.
 Exeunt ARDEN, FRANKLIN, *and* MICHAEL.

Al. I am glad he is gone; he was about to stay.
But did you mark me then how I brake off?
Mos. Ay, Alice, and it was cunningly performed.
But what a villain is this painter Clarke! 420
Al. Was it not a goodly poison that he gave!
Why, he's as well now as he was before.
It should have been some fine confection
That might have given the broth some dainty taste.
This powder was too gross and populous.[66]
Mos. But had he eaten but three spoonfuls more
Then had he died and our love continued.
Al. Why, so it shall, Mosby, albeit he live.
Mos. It is unpossible, for I have sworn
Never hereafter to solicit thee, 430
Or whilst he lives once more importune thee.
Al. Thou shalt not need; I will importune thee.
What, shall an oath make thee forsake my love?
As if I have not sworn as much myself,
And given my hand unto him in the church!
Tush, Mosby, oaths are words, and words is wind,
And wind is mutable. Then I conclude,
'Tis childishness to stand upon an oath.
Mos. Well proved, Mistress Alice, yet by your leave
I'll keep mine unbroken whilst he lives. 440
Al. Ay, do, and spare not. His time is but short,
For if thou beest as resolute as I,
We'll have him murdered as he walks the streets.
In London many alehouse ruffians keep,[67]
Which, as I hear, will murder men for gold.
They shall be soundly fee'd to pay him home.[68]

Here enters GREENE.

Mos. Alice, what's he that comes yonder; knowest
 thou him?
Al. Mosby, be gone; I hope 'tis one that comes
To put in practice our intended drifts.
 Exit MOSBY.

Gre. Mistress Arden, you are well met. 450
I am sorry that your husband is from home,
Whenas[69] my purposed journey was to him.
Yet all my labor is not spent in vain,
For I suppose that you can full discourse,
And flat resolve[70] me of the thing I seek.
Al. What is it, Master Greene? If that I may
Or can with safety, I will answer you.
Gre. I heard your husband hath the grant of late,
Confirmed by letters patents from the King,
Of all the lands of the Abbey of Feversham, 460
Generally intitled,[71] so that all former grants
Are cut off,[72] whereof I myself had one;
But now my interest by that is void.
This is all, Mistress Arden, is it true nor no?
Al. True, Master Greene, the lands are his in state,[73]
And whatsoever leases were before

62 *likes:* pleases. 63 *convinced:* convicted.
64 *mithridate:* antidote against poison.
65 *silly:* innocent. 66 *populous:* thick, coarse.
67 *keep:* live. 68 *pay him home:* do his business.
69 *Whenas:* Since. 70 *flat resolve:* completely satisfy.
71 *intitled:* deeded. 72 *cut off:* nullified.
73 *in state:* legally.

Are void for term of Master Arden's life.
He hath the grant under the Chancery [74] seal.

 Gre. Pardon me, Mistress Arden, I must speak,
For I am touched.[75] Your husband doth me wrong
To wring me from the little land I have. 471
My living is my life; only that
Resteth remainder of my portion.
Desire of wealth is endless in his mind
And he is greedy-gaping still [76] for gain.
Nor cares he though young gentlemen do beg,
So [77] he may scrape and hoard up in his pouch.
But, seeing he hath taken my lands, I'll value life
As careless as he is careful for to get;
And tell him this from me: I'll be revenged, 480
And so as he shall wish the Abbey lands
Had rested still within their former state.

 Al. Alas, poor gentleman, I pity you,
And woe is me that any man should want.
God knows, 'tis not my fault. But wonder not
Though he be hard to others when to me—
Ah, Master Greene, God knows how I am used.

 Gre. Why, Mistress Arden, can the crabbèd [78] churl
Use you unkindly? Respects he not your birth,
Your honorable friends, nor what you brought? [79] 490
Why, all Kent knows your parentage and what you are.

 Al. Ah, Master Greene, be it spoken in secret here,
I never live good day with him alone.
When he is at home, then have I froward [80] looks,
Hard words and blows, to mend [81] the match withal.
And though I might content as good a man,
Yet doth he keep in every corner trulls,[82]
And weary with his trugs [83] at home,
Then rides he straight to London; there, forsooth,
He revels it among such filthy ones 500
As counsels him to make away his wife.
Thus live I daily in continual fear,
In sorrow, so despairing of redress
As every day I wish with hearty prayer
That he or I were taken forth the world.

 Gre. Now trust me, Mistress Alice, it grieveth me
So fair a creature should be so abused.
Why, who would have thought the civil sir so sullen,
He looks so smoothly. Now, fie upon him, churl!
And if he live a day he lives too long. 510
But frolic, woman, I shall be the man
Shall set you free from all this discontent.
And if the churl deny my interest [84]
And will not yield my lease into my hand,
I'll pay him home, whatever hap to me.

 Al. But speak you as you think?

 Gre. Ay, God's my witness, I mean plain dealing,
For I had rather die than lose my land.

 Al. Then, Master Greene, be counselèd by me:
Endanger not yourself for such a churl, 520
But hire some cutter [85] for to cut him short,
And here's ten pound to wager [86] them withal.
When he is dead you shall have twenty more,
And the lands whereof my husband is possessed
Shall be entitled as they were before.

 Gre. Will you keep promise with me?

 Al. Or count me false and perjured whilst I live.

 Gre. Then here's my hand, I'll have him so
 dispatched.
I'll up to London straight; I'll thither post,
And never rest till I have compassed it. 530
Till then, farewell.

 Al. Good fortune follow all your forward thoughts.
 Exit GREENE.
And whosoever doth attempt the deed,
A happy hand I wish, and so farewell.
All this goes well. Mosby, I long for thee
To let thee know all that I have contrived.

 Here enters MOSBY *and* CLARKE.

 Mos. How now, Alice, what's the news?

 Al. Such as will content thee well, sweetheart.

 Mos. Well, let them pass awhile, and tell me, Alice,
How have you dealt and tempered with [87] my sister?
What, will she have my neighbor Clarke or no? 541

 Al. What, Master Mosby? Let him woo himself.
Think you that maids look not for fair words?
Go to her, Clarke, she's all alone within;
Michael, my man, is clean out of her books.

 Clar. I thank you, Mistress Arden, I will in,
And if fair Susan and I can make a gree,[88]
You shall command me to the uttermost,
As far as either goods or life may stretch.
 Exit CLARKE.

 Mos. Now, Alice, let's hear thy news. 550

 Al. They be so good that I must laugh for joy
Before I can begin to tell my tale.

 Mos. Let's hear, then, that I may laugh for company.

 Al. This morning Master Greene, Dick Greene I
 mean,
From whom my husband had the Abbey land,
Came hither railing for to know the truth,
Whether my husband had the lands by grant.
I told him all, whereat he stormed amain,[89]
And swore he would cry quittance [90] with the churl,
And if he did deny his interest 560
Stab him whatsoever did befall himself.
Whenas [91] I saw his choler thus to rise,
I whetted on the gentleman with words,
And to conclude, Mosby, at last we grew
To composition [92] for my husband's death.
I gave him ten pound to hire knaves
By some device to make away the churl.
When he is dead he should have twenty more
And repossess his former lands again.
On this we 'greed and he is ridden straight 570
To London to bring his death about.

 [74] *Chancery:* the highest court of justice except for the
House of Lords. [75] *touched:* injured.
 [76] *still:* continually.
 [77] *So:* So long as.
 [78] *crabbèd:* evil-tempered. [79] *brought:* as dowry.
 [80] *froward:* ill-tempered. [81] *mend:* make up.
 [82] *trulls:* wenches. [83] *trugs:* harlots.
 [84] *interest:* right. [85] *cutter:* cutthroat.
 [86] *wager:* pay. [87] *tempered with:* worked on.
 [88] *make a gree:* reach an agreement.
 [89] *amain:* mightily. [90] *cry quittance:* be even.
 [91] *Whenas:* When. [92] *composition:* agreement.

Mos. But call you this good news?

Al. Ay, sweetheart, be they not?

Mos. 'Twere cheerful news to hear the churl were dead,
But trust me, Alice, I take it passing [93] ill
You would be so forgetful of our state,
To make recount of it to every groom.
What! to acquaint each stranger with our drifts,
Chiefly in case of murder! Why, 'tis the way
To make it open unto Arden's self, 580
And bring thyself and me to ruin both.
Forewarned, forearmed: who threats his enemy
Lends him a sword to guard himself withal.

Al. I did it for the best.

Mos. Well, seeing 'tis done, cheerly [94] let it pass.
You know this Greene. Is he not religious?
A man, I guess, of great devotion.

Al. He is.

Mos. Then, sweet Alice, let it pass. I have a drift
Will quiet all, whatever is amiss. 590

Here enters CLARKE *and* SUSAN.

Al. How now, Clarke, have you found me false?
Did I not plead the matter hard for you?

Clar. You did.

Mos. And what? Will't be a match?

Clar. A match, i'faith sir! ay, the day is mine.
The painter lays his colors to the life,
His pencil draws no shadows in his love;
Susan is mine.

Al. You make her blush.

Mos. What, sister, is it Clarke must be the man?

Sus. It resteth in your grant. [95] Some words are past,
And haply [96] we be grown unto a match 602
If you be willing that it shall be so.

Mos. Ah, Master Clarke, it resteth at my grant;
You see my sister's yet at my dispose,
But so you'll grant me one thing I shall ask,
I am content my sister shall be yours.

Clar. What is it, Master Mosby?

Mos. I do remember once in secret talk
You told me how you could compound by art 610
A crucifix impoisoned,
That whoso look upon it should wax blind,
And with the scent be stifled, that ere long
He should die poisoned that did view it well.
I would have you make me such a crucifix,
And then I'll grant my sister shall be yours.

Clar. Though I am loath, because it toucheth life,
Yet rather or I'll leave sweet Susan's love,
I'll do it, and with all the haste I may.
But for whom is it? 620

Al. Leave that to us. Why, Clarke, is it possible
That you should paint and draw it out yourself,
The colors being baleful [97] and impoisoned,
And no ways prejudice [98] yourself withal?

Mos. Well questioned, Alice; Clarke, how answer
you that?

Clar. Very easily; I'll tell you straight
How I do work of these impoisoned drugs.
I fasten on my spectacles so close

As nothing can any way offend my sight;
Then, as I put a leaf within my nose, 630
So put I rhubarb to avoid the smell,
And softly as another [99] work I paint.

Mos. 'Tis very well, but against when [100] shall I have
it?

Clar. Within this ten days.

Mos. 'Twill serve the turn.
Now, Alice, let's in and see what cheer you keep.
I hope now Master Arden is from home,
You'll give me leave to play your husband's part.

Al. Mosby, you know who's master of my heart;
He may well be the master of the house. 640

Exeunt.

[ii]

Here enters GREENE *and* BRADSHAW.

Brad. See you them that comes yonder, Master
Greene?

Gre. Ay, very well. Do you know them?

Here enters BLACK WILL *and* SHAKEBAG.

Brad. The one I know not, but he seems a knave,
Chiefly for bearing the other company;
For such a slave, so vile a rogue as he,
Lives not again upon the earth.
Black Will is his name, I tell you, Master Greene.
At Boulogne he and I were fellow soldiers
Where he played such pranks
As all the camp feared him for his villainy. 10
I warrant you he bears so bad a mind
That for a crown he'll murder any man.

Gre. The fitter is he for my purpose, marry! [1]

B. Will. How now, fellow Bradshaw! Whither away
so early?

Brad. Oh, Will, times are changed; no fellows now,
Though we were once together in the field;
Yet thy friend to do thee any good I can.

B. Will. Why, Bradshaw, was not thou and I fellow
soldiers at Boulogne where I was a corporal and thou
but a base, mercenary groom? No fellows now 20
because you are a goldsmith, and have a little plate in
your shop? You were glad to call me "fellow Will" and
with a cursy [2] to the earth "One snatch, good Cor-
poral" when I stole the half ox from John the victualer,
and domineered [3] with it amongst good fellows in one
night.

Brad. Ay, Will, those days are past with me.

B. Will. Ay, but they be not past with me, for I keep
that same honorable mind still. Good neighbor Brad-
shaw, you are too proud to be my fellow, but were 30

i.
93 *passing:* exceedingly. 94 *cheerly:* cheerfully.
95 *grant:* power to grant. 96 *haply:* it may be.
97 *baleful:* injurious. 98 *prejudice:* injure.
99 *as another:* as with any other.
100 *against when:* by what date.

ii.
1 *marry:* by Mary. 2 *cursy:* curtsy.
3 *domineered:* feasted like a lord.

it not that I see more company coming down the hill,
I would be fellows with you once more, and share
crowns with[4] you, too. But let that pass and tell me
whither you go.

Brad. To London, Will, about a piece of service
Wherein haply thou mayst pleasure me.

B. Will. What is it?

Brad. Of late, Lord Cheiny lost some plate,
Which one did bring and sold it at my shop
Saying he served Sir Antony Cooke. 40
A search was made, the plate was found with me,
And I am bound to answer at the size.[5]
Now Lord Cheiny solemnly vows
If law will serve him he'll hang me for his plate.
Now I am going to London upon hope
To find the fellow. Now, Will, I know
Thou art acquainted with such companions.[6]

B. Will. What manner of man was he?

Brad. A lean-faced, writhen[7] knave,
Hawk-nosed and very hollow-eyed, 50
With mighty furrows in his stormy brows,
Long hair down his shoulders curled;
His chin was bare, but on his upper lip
A mutchado[8] which he wound about his ear.

B. Will. What apparel had he?

Brad. A watchet[9] satin doublet all to-torn
(The inner side did bear the greater show[10]),
A pair of threadbare velvet hose, seam rent,
A worsted stocking rent above the shoe,
A livery cloak, but all the lace was off; 60
'Twas bad, but yet it served to hide the plate.

B. Will. Sirrah Shakebag, canst thou remember since
we trolled the bowl[11] at Sittingburgh, where I broke
the tapster's head of the Lion[12] with a cudgel-stick?

Shak. Ay, very well, Will.

B. Will. Why, it was with the money that the plate
was sold for. Sirrah Bradshaw, what wilt thou give him
that can tell thee who sold thy plate?

Brad. Who, I pray thee, good Will? 69

B. Will. Why, 'twas one Jack Fitten. He's now in
Newgate for stealing a horse, and shall be arraigned the
next size.

Brad. Why then, let Lord Cheiny seek Jack Fitten
forth,
For I'll back and tell him who robbed him of his plate.

This cheers my heart. Master Greene, I'll leave you,
For I must to the Isle of Sheppey with speed.

Gre. Before you go let me entreat you
To carry this letter to Mistress Arden of Feversham
And humbly recommend me to herself. 79

Brad. That will I, Master Greene, and so farewell.
Here, Will, there's a crown for thy good news.
 Exit BRADSHAW.

B. Will. Farewell, Bradshaw; I'll drink no water for
thy sake whilst this lasts. Now, gentleman, shall we
have your company to London?

Gre. Nay, stay, sirs,
A little more; I needs must use your help,
And in a matter of great consequence,
Wherein if you'll be secret and profound,
I'll give you twenty angels[13] for your pains. 89

B. Will. How? Twenty angels? Give my fellow
George Shakebag and me twenty angels, and if thou'lt
have thy own father slain that thou mayest inherit his
land, we'll kill him.

Shak. Ay, thy mother, thy sister, thy brother, or all
thy kin.

Gre. Well, this is it: Arden of Feversham
Hath highly wronged me about the Abbey land,
That no revenge but death will serve the turn.[14]
Will you two kill him? Here's the angels down
And I will lay the platform[15] of his death. 99

B. Will. Plat me no platforms! Give me the money,
I'll stab him as he stands pissing against a wall, but I'll
kill him.

Shak. Where is he?

Gre. He is now at London, in Aldersgate Street.

Shak. He's dead as if he had been condemned by an
Act of Parliament if once Black Will and I swear his
death.

Gre. Here is ten pound, and when he is dead
Ye shall have twenty more. 109

B. Will. My fingers itches to be at the peasant. Ah,
that I might be set a work thus through the year and
that murder would grown to an occupation, that a man
might[16] without danger of law. Zounds![17] I warrant
I should be warden of the company. Come, let us be
going, and we'll bait[18] at Rochester, where I'll give thee
a gallon of sack[19] to handsel[20] the match withal.
 Exeunt.

[4] *share crowns with:* rob (which is made impossible by the "company coming down the hill"). [5] *size:* assizes.
[6] *companions:* rogues. [7] *writhen:* twisted.
[8] *mutchado:* mustache. [9] *watchet:* light blue.
[10] *The . . . show:* More of the lining was visible than the ragged outside.
[11] *trolled the bowl:* passed the drinking cup.
[12] *tapster's . . . Lion:* head of the tapster of the Lion.
[13] *angels:* gold coins.
[14] *serve the turn:* do the business; satisfy me.
[15] *platform:* plan. [16] *might:* might perform.
[17] *Zounds:* God's wounds. [18] *bait:* stop (to eat).
[19] *sack:* white wine.
[20] *to handsel:* as auspicious earnest of.

iii.
[1] *making:* writing. [2] *turtle:* turtledove.
[3] *Paul's:* St. Paul's Cathedral in London.

[iii]

Here enters MICHAEL.

Mich. I have gotten such a letter as will touch the
painter and thus it is:

Here enters ARDEN *and* FRANKLIN *and hears* MICHAEL *read this letter:*

My duty remembered, Mistress Susan, hoping in
God you be in good health, as I, Michael, was at the
making[1] hereof. This is to certify you that, as the
turtle[2] true when she hath lost her mate sitteth alone,
so I, mourning for your absence, do walk up and
down Paul's[3] till one day I fell asleep and lost my

master's pantofles.[4] Ah, Mistress Susan, abolish that
paltry painter, cut him off by the shins with a 10
frowning look of your crabbed countenance, and
think upon Michael who, drunk with the dregs of
your favor, will cleave as fast to your love as a plaster
of pitch to a galled horseback. Thus hoping you will
let my passions penetrate, or rather impetrate[5] mercy
of your meek hands, I end.

Yours, Michael, or else not Michael.

Ard. Why, you paltry knave,
Stand you here loitering, knowing my affairs,
What haste my business craves to send to Kent? 20
Frank. 'Faith, friend Michael, this is very ill,
Knowing your master hath no more but you,
And do ye slack his business for your own?
Ard. Where is the letter, sirrah? Let me see it.

Then he[6] gives him the letter.

See, Master Franklin, here's proper stuff.
Susan my maid, the painter, and my man,
A crew of harlots,[7] all in love, forsooth.
Sirrah, let me hear no more of this,
Nor, for thy life, once write to her a word.

Here enters GREENE, BLACK WILL, *and*
SHAKEBAG.

Wilt thou be married to so base a trull? 30
'Tis Mosby's sister. Come I once at home
I'll rouse her from remaining in my house.
Now, Master Franklin, let us go walk in Paul's.
Come but a turn or two and then away.

Exeunt [ARDEN, FRANKLIN, *and* MICHAEL].
Gre. The first is Arden, and that's his man.
The other is Franklin, Arden's dearest friend.
B. Will. Zounds, I'll kill them all three.
Gre. Nay, sirs, touch not his man in any case,
But stand close and take you fittest standing,
And at his coming forth speed[8] him. 40
To[9] the Nag's Head,[10] there is this coward's haunt.
But now I'll leave you till the deed be done.

Exit GREENE.
Shak. If he be not paid his own ne'er trust Shakebag.
B. Will. Sirrah Shakebag, at his coming forth I'll run
him through and then to the Blackfriars and there take
water[11] and away.
Shak. Why, that's the best; but see thou miss him
not.
B. Will. How can I miss him when I think on the
forty angels I must have more? 50

Here enters a Prentice.

Pren. 'Tis very late; I were best shut up my stall, for
here will be old[12] filching when the press[13] comes forth
of[14] Paul's.

Then lets he down his window and it breaks BLACK
WILL'*s head.*

B. Will. Zounds, draw, Shakebag, draw! I am almost
killed.
Pren. We'll tame you, I warrant.

B. Will. Zounds, I am tame enough already.

Here enters ARDEN, FRANKLIN, *and* MICHAEL.

Ard. What troublesome fray or mutiny is this?
Frank. 'Tis nothing but some brabbling,[15] paltry
fray
Devised to pick men's pockets in the throng. 60
Ard. Is't nothing else? Come, Franklin, let us away.

Exeunt.
B. Will. What mends[16] shall I have for my broken
head?
Pren. Marry, this mends, that if you get you not
away all the sooner, you shall be well beaten and sent to
the Counter.[17]

Exit Prentice.
B. Will. Well, I'll be gone. But look to your signs,
for I'll pull them down all. Shakebag, my broken head
grieves me not so much as[18] by this means Arden hath
escaped. I had a glimpse of him and his companion. 69

Here enters GREENE.

Gre. Why, sirs, Arden's as well as I; I met him and
Franklin going merrily to the ordinary[19] again. What,
dare you not do it?
B. Will. Yes, sir, we dare do it, but were my consent
to give again we would not do it under ten pound more.
I value every drop of my blood at a French crown. I
have had ten pound to steal a dog, and we have no more
here to kill a man. But that a bargain is a bargain and so
forth you should do it yourself.
Gre. I pray thee, how came thy head broke?
B. Will. Why, thou seest it is broke, dost thou not?
Shak. Standing against a stall watching Arden's 81
coming, a boy let down his shop window and broke his
head. Whereupon arose a brawl, and in the tumult
Arden escaped us, and passed by unthought on. But
forbearance is no acquittance; another time we'll do it,
I warrant thee.
Gre. I pray thee, Will, make clean thy bloody brow,
And let us bethink us on some other place
Where Arden may be met with handsomely.
Remember how devoutly thou hast sworn 90
To kill the villain; think upon thine oath.
B. Will. Tush, I have broken five hundred oaths;
But wouldst thou charm me to effect this deed,
Tell me of gold, my resolution's fee;
Say thou seest Mosby kneeling at my knees,
Offering me service for my high attempt;
And sweet Alice Arden with a lap of crowns
Comes with a lowly cursy to the earth,

[4] *pantofles:* slippers. [5] *impetrate:* achieve by entreaty.
[6] *he:* Michael.
[7] *harlots:* generically for persons of no account.
[8] *speed:* despatch. [9] *To:* Let's go to.
[10] *Nag's Head:* a London pub in Covent Garden, which
still survives. [11] *take water:* get a boat on the Thames.
[12] *old:* any amount of. [13] *press:* crowd.
[14] *of:* from. [15] *brabbling:* brawling.
[16] *mends:* amends. [17] *Counter:* a London prison.
[18] *as:* as that.
[19] *ordinary:* tavern; also, the eating place within it.

Saying "Take this but for thy quarterage,[20]
Such yearly tribute will I answer[21] thee." 100
Why, this would steel soft-mettled cowardice,
With which Black Will was never tainted with.
I tell thee, Greene, the forlorn traveler,
Whose lips are glued with summer's parching heat,
Ne'er longed so much to see a running brook
As I to finish Arden's tragedy.
Seest thou this gore that cleaveth to my face?
From hence ne'er will I wash this bloody stain
Till Arden's heart be panting in my hand.
 Gre. Why, that's well said; but what saith Shakebag?
 Shak. I cannot paint my valor out with words; 111
But, give me place and opportunity,
Such mercy as the starven lioness,
When she is dry-sucked of her eager young,
Shows to the prey that next encounters her,
On Arden so much pity would I take.
 Gre. So should it fare with men of firm resolve.
And now, sirs, seeing this accident
Of meeting him in Paul's hath no success,
Let us bethink us on some other place, 120
Whose earth may swallow up this Arden's blood.

Here enters MICHAEL.

See, yonder comes his man, and wot[22] you what,
The foolish knave is in love with Mosby's sister,
And for her sake, whose love he cannot get
Unless Mosby solicit his suit,
The villain hath sworn the slaughter of his master.
We'll question him for he may stead[23] us much.
How now, Michael, whither are you going?
 Mich. My master hath new supped
And I am going to prepare his chamber. 130
 Gre. Where supped Master Arden?
 Mich. At the Nag's Head, at the eighteen-pence
 ordinary.
How now, Master Shakebag! what, Black Will!
God's dear lady, how chance your face is so bloody?
 B. Will. Go to, sirrah; there is a chance in it this
sauciness in you will make you be knocked.
 Mich. Nay, and you be offended I'll be gone.
 Gre. Stay, Michael, you may not 'scape us so.
Michael, I know you love your master well. 139
 Mich. Why, so I do; but wherefore urge you that?
 Gre. Because I think you love your mistress better.
 Mich. So think not I. But say, i' faith, what if I
 should?
 Shak. Come, to the purpose. Michael, we hear
You have a pretty love in Feversham.
 Mich. Why, have I two or three, what's that to thee?

 B. Will. You deal too mildly with the peasant. Thus
 it is:
'Tis known to us you love Mosby's sister;
We know besides that you have ta'en your oath
To further Mosby to your mistress' bed
And kill your master for his sister's sake. 150
Now, sir, a poorer coward than yourself
Was never fostered in the coast of Kent.
How comes it then that such a knave as you
Dare swear a matter of such consequence?
 Gre. Ah, Will—
 B. Will. Tush, give me leave, there's no more but
 this:
Sith[24] thou hast sworn, we dare discover all,
And, hadst thou or shouldst thou utter it,
We have devised a complot under hand[25]—
Whatever shall betide[26] to any of us— 160
To send thee roundly[27] to the devil of hell.
And therefore thus: I am the very man,
Marked in my birth-hour by the destinies,
To give an end to Arden's life on earth;
Thou but a member but to whet the knife
Whose edge must search the closet of his breast.
Thy office is but to appoint the place,
And train[28] thy master to his tragedy;
Mine to perform it when occasion serves.
Then be not nice,[29] but here devise with us 170
How and what way we may conclude his death.
 Shak. So shalt thou purchase Mosby for thy friend
And by his friendship gain his sister's love.
 Gre. So shall thy mistress be thy favorer
And thou disburdened of the oath thou made.
 Mich. Well, gentlemen, I cannot but confess,
Sith you have urged me so apparently,[30]
That I have vowed my Master Arden's death,
And he whose kindly love and liberal hand
Doth challenge nought but good deserts[31] of me 180
I will deliver over to your hands.
This night come to his house at Aldersgate.
The doors I'll leave unlocked against[32] you come.
No sooner shall ye enter through the latch,
Over the threshold to the inner court,
But on your left hand shall you see the stairs
That leads directly to my master's chamber.
There take him and dispose him as ye please.
Now it were good we parted company.
What I have promisèd I will perform. 190
 B. Will. Should you deceive us 'twould go wrong
with you.
 Mich. I will accomplish all I have revealed.
 B. Will. Come, let's go drink. Choler makes me as
dry as a dog.
 Exeunt [BLACK] WILL, GREENE, *and* SHAKEBAG.
 Manet[33] MICHAEL.
 Mich. Thus feeds the lamb securely[34] on the down,
Whilst through the thicket of an arbor brake
The hunger-bitten wolf o'erpries[35] his haunt[36]
And takes advantage to eat him up.
Ah, harmless Arden, how, how hast thou misdone
That thus thy gentle life is leveled[37] at? 201
The many good turns that thou hast done to me

[20] *quarterage:* quarterly payment. [21] *answer:* render.
[22] *wot:* know. [23] *stead:* help. [24] *Sith:* Since.
[25] *complot under hand:* secret plot. [26] *betide:* happen.
[27] *roundly:* directly. [28] *train:* as an animal is decoyed.
[29] *nice:* fastidious. [30] *apparently:* openly.
[31] *deserts:* returns.
[32] *against:* in anticipation of the time when.
[33] *L.:* Remains. [34] *securely:* falsely confident.
[35] *o'erpries:* looks over.
[36] *haunt:* the place the lamb frequents.
[37] *leveled:* aimed.

Now must I quittance[38] with betraying thee.
I, that should take the weapon in my hand,
And buckler[39] thee from ill-intending foes,
Do lead thee with a wicked, fraudful smile,
As unsuspected, to the slaughterhouse.
So have I sworn to Mosby and my mistress;
So have I promised to the slaughtermen.
And should I not deal currently[40] with them 210
Their lawless rage would take revenge on me.
Tush, I will spurn at mercy for this once.
Let pity lodge where feeble women lie;
I am resolved, and Arden needs must die.

 Exit MICHAEL.

[iv]

 Here enters ARDEN *and* FRANKLIN.

Ard. No, Franklin, no. If fear or stormy threats,
If love of me or care of womanhood,
If fear of God or common speech of men,
Who mangle credit with their wounding words
And couch[1] dishonor as dishonor buds,
Might join[2] repentance in her wanton thoughts,
No question then but she would turn the leaf
And sorrow for her dissolution.[3]
But she is rooted in her wickedness,
Perverse and stubborn, not to be reclaimed. 10
Good counsel is to her as rain to weeds,
And reprehension makes her vice to grow
As Hydra's[4] head that perished[5] by decay.
Her faults, methink, are painted in my face
For every searching eye to over-read,
And Mosby's name, a scandal unto mine,
Is deeply trenchèd in my blushing brow.
Ah, Franklin, Franklin, when I think on this
My heart's grief rends my other powers
Worse than the conflict at the hour of death. 20
Frank. Gentle Arden, leave this sad lament.
She will amend, and so your griefs will cease;
Or else she'll die, and so your sorrows end.
If neither of these two do happily fall,[6]
Yet let your comfort be that others bear
Your woes twice doubled all with patience.
Ard. My house is irksome, there I cannot rest.
Frank. Then stay with me in London; go not home.
Ard. Then that base Mosby doth usurp my room
And makes his triumph of my being thence. 30
At home or not at home, where'er I be,
Here, here it lies,

 [*Points to his heart*]

 ah, Franklin, here it lies
That will not out till wretched Arden dies.

 Here enters MICHAEL.

Frank. Forget your griefs awhile; here comes your
 man.
Ard. What o'clock is't, sirrah?
Mich. Almost ten.
Ard. See, see how runs away the weary time.
Come, Master Franklin, shall we go to bed?

 Exeunt ARDEN *and* MICHAEL.
 Manet FRANKLIN.
Frank. I pray you go before; I'll follow you.
Ah, what a hell is fretful jealousy! 40
What pity-moaning[7] words, what deep-fetched sighs,
What grievous groans and overlading woes
Accompanies this gentle gentleman.
Now will he shake his care-oppressèd head,
Then fix his sad eyes on the sullen earth,
Ashamed to gaze upon the open world;
Now will he cast his eyes up towards the heavens,
Looking that ways for redress of wrong.
Sometimes he seeketh to beguile his grief
And tells a story with his careful[8] tongue; 50
Then comes his wife's dishonor in his thoughts
And in the middle cutteth off his tale,
Pouring fresh sorrow on his weary limbs.
So woebegone, so inly charged with woe
Was never any lived and bare it so.

 Here enters MICHAEL.

Mich. My master would desire you come to bed.
Frank. Is he himself already in his bed?

 Exit FRANKLIN.
 Manet MICHAEL.
Mich. He is and fain would have the light away.
Conflicting thoughts encampèd in my breast
Awake me with the echo of their strokes; 60
And I, a judge to censure[9] either side,
Can give to neither wishèd victory.
My master's kindness pleads to me for life
With just demand, and I must grant it him;
My mistress, she hath forced me with an oath,
For Susan's sake, the which I may not break,
For that is nearer than a master's love;
That grim-faced fellow, pitiless Black Will,
And Shakebag, stern in bloody stratagem—
Two rougher ruffians never lived in Kent— 70
Have sworn my death if I infringe my vow,
A dreadful thing to be considered of.
Methinks I see them with their bolstered[10] hair,
Staring and grinning in thy[11] gentle face,
And in their ruthless hands their daggers drawn,
Insulting o'er thee with a peck of oaths,
Whilst thou, submissive, pleading for relief,
Art mangled by their ireful instruments.
Methinks I hear them ask where Michael is,
And pitiless Black Will cries "Stab the slave! 80

[38] *quittance:* repay. [39] *buckler:* defend, as with a shield.
[40] *currently:* honestly.

iv.
 [1] *couch:* gild, embroider. [2] *join:* enjoin.
 [3] *dissolution:* degenerate behavior.
 [4] *Hydra's:* alluding to the many-headed snake of Lerna,
whose heads grew again as fast as they were cut off, and who
was ultimately slain by Hercules.
 [5] *perished:* often emended to "flourished."
 [6] *happily fall:* chance to come to pass.
 [7] *moaning:* frequently emended to "moving."
 [8] *careful:* full of care. [9] *censure:* give judgment on.
 [10] *bolstered:* disheveled. [11] *thy:* Arden's.

The peasant will detect [12] the tragedy."
The wrinkles in his foul, death-threatening face
Gapes open wide, like graves to swallow men.
My death to him is but a merriment,
And he will murder me to make him sport.
He comes, he comes! Ah, Master Franklin, help!
Call up the neighbors or we are but dead!

Here enters FRANKLIN *and* ARDEN.

Frank. What dismal outcry calls me from my rest?
Ard. What hath occasioned such a fearful cry?
Speak, Michael, hath any injured thee? 90
Mich. Nothing, sir, but as I fell asleep
Upon the threshold, leaning [13] to the stairs,
I had a fearful dream that troubled me,
And in my slumber thought I was beset
With murderer thieves that came to rifle me.
My trembling joints witness my inward fear.
I crave your pardons for disturbing you.
Ard. So great a cry for nothing I ne'er heard.
What, are the doors fast locked and all things safe?
Mich. I cannot tell. I think I locked the doors. 100
Ard. I like not this but I'll go see myself.

[*He tries the doors.*]

Ne'er trust me but the doors were all unlocked.
This negligence not half contenteth me.
Get you to bed, and if you love my favor
Let me have no more such pranks as these.
Come, Master Franklin, let us go to bed.
Frank. Ay, by my faith; the air is very cold.
Michael, farewell; I pray thee dream no more.

Exeunt.

[v]

Here enters [BLACK] WILL, GREENE, *and*
SHAKEBAG.

Shak. Black night hath hid the pleasures of the day
And sheeting darkness overhangs the earth,
And with the black fold of her cloudy robe
Obscures us from the eyesight of the world,
In which sweet silence such as we triumph.
The lazy minutes linger on their time,
Loath to give due audit to the hour,
Till in the watch [1] our purpose be complete

And Arden sent to everlasting night.
Greene, get you gone and linger here about, 10
And at some hour hence come to us again,
Where we will give you instance [2] of his death.
Gre. Speed [3] to my wish, whose will soe'er says no; [4]
And so I'll leave you for an hour or two.

Exit GREENE.

B. Will. I tell thee, Shakebag, would this thing were
done;
I am so heavy that I can scarce go.
This drowsiness in me bodes little good.
Shak. How now, Will, become a precisian? [5]
Nay, then, let's go sleep when bugs [6] and fears
Shall kill our courages with their fancy's work. 20
B. Will. Why, Shakebag, thou mistakes me much
And wrongs me too in telling [7] me of fear.
Wert not a serious thing we go about
It should be slipped [8] till I had fought with thee
To let thee know I am no coward, I.
I tell thee, Shakebag, thou abusest me.
Shak. Why, thy speech bewrayed an inly kind of
fear,
And savored of a weak, relenting spirit.
Go forward now in that we have begun,
And afterwards attempt [9] me when thou darest. 30
B. Will. And if I do not, heaven cut me off.
But let that pass, and show me to this house
Where thou shalt see I'll do as much as Shakebag.
Shak. This is the door—but soft, methinks 'tis shut.
The villain Michael hath deceivèd us.
B. Will. Soft, let me see. Shakebag, 'tis shut indeed.
Knock with thy sword; perhaps the slave will hear.
Shak. It will not be; the white-livered peasant
Is gone to bed and laughs us both to scorn.
B. Will. And he shall buy his merriment as dear 40
As ever coistrel [10] bought so little sport.
Ne'er let this sword assist me when I need,
But rust and canker after I have sworn,
If I, the next time that I meet the hind, [11]
Lop not away his leg, his arm or both.
Shak. And let me never draw a sword again,
Nor prosper in the twilight, cockshut light, [12]
When I would fleece the wealthy passenger, [13]
But lie and languish in a loathsome den,
Hated and spit at by the goers-by, 50
And in that death may die unpitièd,
If I the next time that I meet the slave
Cut not the nose from off the coward's face,
And trample on it for this villainy.
B. Will. Come, let's go seek out Greene; I know he'll
swear.
Shak. He were a villain and he would not swear.
'Twould make a peasant swear amongst his boys,
That ne'er durst say before but "yea" and "no,"
To be thus flouted of a coisterel.
B. Will. Shakebag, let's seek out Greene and in the
morning 60
At the alehouse butting [14] Arden's house
Watch the out-coming of that prick-eared [15] cur,
And then let me alone [16] to handle him.

Exeunt.

[12] *detect:* disclose.
[13] *leaning:* describing Michael's posture; or possibly
modifying "threshold."

v.

[1] *watch:* time division of the night.
[2] *instance:* evidence. [3] *Speed:* Success.
[4] *whose . . . no:* no matter who desires.
[5] *precisian:* Puritan. [6] *bugs:* bugbears.
[7] *telling:* accusing. [8] *slipped:* let go by.
[9] *attempt:* try. [10] *coistrel:* base fellow.
[11] *hind:* peasant.
[12] *cockshut light:* when woodcocks (gulls) are snared.
[13] *passenger:* traveler. [14] *butting:* abutting on.
[15] *prick-eared:* with ears erect, like a watchful dog.
[16] *let me alone:* leave it to me.

[vi]

Here enters ARDEN, FRANKLIN, *and* MICHAEL.

Ard. Sirrah, get you back to Billingsgate
And learn what time the tide will serve our turn.
Come to us in Paul's. First go make the bed,
And afterwards go hearken for the flood.[1]

Exit MICHAEL.

Come, Master Franklin, you shall go with me.
This night I dreamed that, being in a park,
A toil was pitched[2] to overthrow the deer,
And I upon a little rising hill
Stood whistly[3] watching for the herd's approach.
Even there, methoughts, a gentle slumber took me, 10
And summoned all my parts to sweet repose.
But in the pleasure of this golden rest
An ill-thewed foster[4] had removed the toil,
And rounded[5] me with that beguiling home[6]
Which late,[7] methought, was pitched to cast[8] the deer.
With that he blew an evil-sounding horn,
And at the noise another herdman came
With fauchon[9] drawn, and bent[10] it at my breast,
Crying aloud, "Thou art the game we seek."
With this I waked and trembled every joint, 20
Like one obscurèd in a little bush
That sees a lion foraging about,
And when the dreadful forest king is gone,
He pries about with timorous suspect[11]
Throughout the thorny casements[12] of the brake,
And will not think his person dangerless,
But quakes and shivers though the cause be gone.
So trust me, Franklin, when I did awake
I stood in doubt whether I waked or no,
Such great impression took this fond[13] surprise. 30
God grant this vision bedeem me any good.[14]

Frank. This fantasy doth rise from Michael's fear
Who being awakèd with the noise he made,
His troubled senses yet could take no rest;
And this, I warrant you, procured your dream.

Ard. It may be so; God frame it to the best;
But oftentimes my dreams presage too true.

Frank. To such as note their nightly fantasies,
Some one in twenty may incur belief.
But use[15] it not; 'tis but a mockery. 40

Ard. Come, Master Franklin, we'll now walk in Paul's,
And dine together at the ordinary,
And by my man's direction draw to the quay,
And with the tide go down to Feversham.
Say, Master Franklin, shall it not be so?

Frank. At your good pleasure, sir; I'll bear you company.

Exeunt.

[vii]

Here enters MICHAEL *at one door. Here enters*
GREENE, [BLACK] WILL, *and* SHAKEBAG *at
another door.*

B. Will. Draw, Shakebag, for here's that villain Michael.[1]

Gre. First, Will, let's hear what he can say.

B. Will. Speak, milksop slave, and never after speak.

Mich. For God's sake, sirs, let me excuse myself,
For here I swear by heaven and earth and all,
I did perform the outmost[1] of my task,
And left the doors unbolted and unlocked.
But see the chance: Franklin and my master
Were very late conferring in the porch,
And Franklin left his napkin[2] where he sat, 10
With certain gold knit in it, as he said.
Being in bed he did bethink himself,
And, coming down, he found the doors unshut.
He locked the gates and brought away the keys,
For which offense my master rated[3] me.
But now I am going to see what flood it is,
For with the tide my master will away,
Where you may front him well on Rainham Down,
A place well fitting such a stratagem.

B. Will. Your excuse hath somewhat mollified my
choler. 20
Why now, Greene, 'tis better now nor[4] e'er it was.

Gre. But, Michael, is this true?

Mich. As true as I report it to be true.

Shak. Then, Michael, this shall be your penance,
To feast us all at the Salutation,
Where we will plat[5] our purpose thoroughly.

Gre. And, Michael, you shall bear no news of this
tide
Because[6] they two may be in Rainham Down
Before your master.

Mich. Why, I'll agree to anything you'll have me,
So you will except of my company.[7] 31

Exeunt.

[viii]

Here enters MOSBY.

Mos. Disturbed thoughts drives me from company
And dries my marrow with their watchfulness.
Continual trouble of my moody brain
Feebles my body by excess of drink
And nips me, as the bitter northeast wind
Doth check the tender blossoms in the spring.

vi.

[1] *flood:* floodtide (which Michael will hear, rather than see, as it pours through the arches of London Bridge).
[2] *toil was pitched:* trap was set. [3] *whistly:* silently.
[4] *ill-thewed foster:* unmannerly forester.
[5] *rounded:* surrounded.
[6] *beguiling home:* deceitful snare. [7] *late:* recently.
[8] *cast:* overthrow. [9] *fauchon:* falchion, a curved sword.
[10] *bent:* aimed. [11] *suspect:* suspicion.
[12] *casements:* windows.
[13] *took this fond:* gave this foolish.
[14] *bedeem . . . good:* OED does not cite the verb; the phrase may mean either "augur me some good" or "bode no evil for me."
[15] *use:* practice.

vii.

[1] *outmost:* utmost. [2] *napkin:* handkerchief.
[3] *rated:* castigated. [4] *nor:* than. [5] *plat:* plot.
[6] *Because:* So that.
[7] *except . . . company:* excuse me from joining you(?).

Well fares the man, howe'er his cates [1] do taste,
That tables [2] not with foul suspicion;
And he but pines amongst his delicates [3]
Whose troubled mind is stuffed with discontent. 10
My golden time was when I had no gold;
Though then I wanted, yet I slept secure;
My daily toil begat me night's repose,
My night's repose made daylight fresh to me.
But since I climbed the top bough of the tree
And sought to build my nest among the clouds,
Each gentlest airy [4] gale doth shake my bed
And makes me dread my downfall to the earth.
But whither doth contemplation carry me?
The way I seek to find, where pleasure dwells, 20
Is hedged behind me that I cannot back
But needs must on, although to danger's gate.
Then, Arden, perish thou by that decree,
For Greene doth ear [5] the land and weed thee up
To make my harvest nothing but pure corn. [6]
And for his pains I'll heave him up [7] awhile,
And after smother him to have his wax.
Such bees as Greene must never live to sting.
Then is there Michael and the painter, too,
Chief actors to Arden's overthrow, 30
Who, when they shall see me sit in Arden's seat,
They will insult upon me for my meed, [8]
Or fright me by detecting of his end.
I'll none of that, for I can cast a bone
To make these curs pluck out each other's throat,
And then am I sole ruler of mine own.
Yet Mistress Arden lives; but she's myself,
And holy church rites makes us two but one.
But what for [9] that I may not trust you, Alice?
You have supplanted Arden for my sake, 40
And will extirpen [10] me to plant another.
'Tis fearful sleeping in a serpent's bed,
And I will cleanly rid my hands of her.

Here enters ALICE [*with a prayerbook*].

But here she comes and I must flatter her.—
How now, Alice! What, sad and passionate? [11]
Make me partaker of thy pensiveness:
Fire divided burns with lesser force.

 Al. But I will dam that fire in my breast
Till by the force thereof my part consume.
Ah, Mosby! 50

 Mos. Such deep pathaires, [12] like to a cannon's burst

Discharged against a ruinated wall,
Breaks my relenting heart in thousand pieces.
Ungentle Alice, thy sorrow is my sore.
Thou knowest it well, and 'tis thy policy
To forge distressful looks to wound a breast
Where lies a heart that dies where thou art sad.
It is not love that loves to anger love.

 Al. It is not love that loves to murder love.

 Mos. How mean you that? 60

 Al. Thou knowest how dearly Arden lovèd me.

 Mos. And then?

 Al. And then conceal the rest, for 'tis too bad,
Lest that my words be carried with the wind,
And published in the world to both our shames.
I pray thee, Mosby, let our springtime wither,
Our harvest else will yield but loathsome weeds.
Forget, I pray thee, what hath past betwixt us,
For now I blush and tremble at the thoughts.

 Mos. What, are you changed? 70

 Al. Ay, to my former happy life again,
From title of an odious strumpet's name
To honest Arden's wife, not Arden's honest [13] wife.
Ha, Mosby, 'tis thou hast rifled me of that,
And made me slanderous to all my kin.
Even in my forehead is thy name engraven,
A mean artificer, that low-born name.
I was bewitched; woe worth [14] the hapless hour,
And all the causes that enchanted me.

 Mos. Nay, if thou ban, [15] let me breathe curses forth,
And if you stand so nicely at your fame [16] 81
Let me repent the credit I have lost.
I have neglected matters of import
That would have stated [17] me above thy state;
Forslowed [18] advantages, and spurned at time.
Ay, Fortune's right hand Mosby hath forsook
To take a wanton giglot [19] by the left.
I left the marriage of an honest maid
Whose dowry would have weighed down all thy wealth,
Whose beauty and demeanor far exceeded thee. 90
This certain good I lost for changing bad,
And wrapped my credit in thy company.
I was bewitched,—that is no theme of thine,
And thou unhallowed hast enchanted me.
But I will break thy spells and exorcisms,
And put another sight upon these eyes
That showed my heart a raven for a dove.
Thou art not fair, I viewed thee not till now;
Thou art not kind, till now I knew thee not.
And now the rain hath beaten off thy gilt 100
Thy worthless copper shows thee counterfeit.
It grieves me not to see how foul thou art
But mads me that ever I thought thee fair.
Go, get thee gone, a copesmate [20] for thy hinds.
I am too good to be thy favorite.

 Al. Ay, now I see, and too soon find it true,
Which often hath been told me by my friends,
That Mosby loves me not but for my wealth,
Which too incredulous I ne'er believed.
Nay, hear me speak, Mosby, a word or two; 110
I'll bite my tongue if it speak bitterly.
Look on me, Mosby, or I'll kill myself;

viii.

[1] *cates:* foods. [2] *tables:* dines.
[3] *delicates:* delicacies.
[4] *gentlest airy:* emending "gentle stary" of original.
[5] *ear:* plough. [6] *corn:* wheat.
[7] *heave him up:* make much of him.
[8] *meed:* reward; although the pronomial adjective suggests "possessions." [9] *for:* of the fact.
[10] *extirpen:* extirpate, root up.
[11] *passionate:* full of emotion.
[12] *pathaires:* sad outbursts. [13] *honest:* chaste.
[14] *worth:* betide. [15] *ban:* curse.
[16] *stand . . . fame:* are so (overly) concerned for your reputation. [17] *stated:* installed.
[18] *Forslowed:* Forfeited by sloth.
[19] *giglot:* worthless wench. [20] *copesmate:* companion.

Nothing shall hide me from thy stormy look.
If thou cry war there is no peace for me;
I will do penance for offending thee,
And burn this prayerbook, where I here use
The holy word that had converted me.
See, Mosby, I will tear away the leaves,
And all the leaves, and in this golden cover
Shall thy sweet phrases and thy letters dwell, 120
And thereon will I chiefly meditate
And hold no other sect [21] but such devotion.
Wilt thou not look? Is all thy love overwhelmed?
Wilt thou not hear? What malice stops thine ears?
Why speaks thou not? What silence ties thy tongue?
Thou hast been sighted [22] as the eagle is,
And heard as quickly as the fearful hare,
And spoke as smoothly as an orator,
When I have bid thee hear, or see, or speak.
And art thou sensible [23] in none of these? 130
Weigh all thy good turns [24] with this little fault
And I deserve not Mosby's muddy looks.
A fount once troubled [25] is not thickened still; [26]
Be clear again, I'll ne'er more trouble thee.
 Mos. Oh, no, I am a base artificer,
My wings are feathered for a lowly flight.
Mosby? Fie, no! not for a thousand pound.
Make love to you? Why, 'tis unpardonable;
We beggars must not breathe where gentles [27] are.
 Al. Sweet Mosby is as gentle as a king, 140
And I too blind to judge him otherwise.
Flowers do sometimes spring in fallow lands,
Weeds in gardens, roses grow on thorns;
So whatsoe'er my Mosby's father was,
Himself [is] valued gentle by his worth.
 Mos. Ah, how you women can insinuate
And clear a trespass with your sweet-set tongue.
I will forget this quarrel, gentle Alice,
Provided I'll be tempted so no more.

Here enters BRADSHAW.

 Al. Then with thy lips seal up this new-made match.
 Mos. Soft, Alice, for here comes somebody. 151
 Al. How now, Bradshaw, what's the news with you?
 Brad. I have little news but here's a letter,
That Master Greene importuned me to give you.
 Al. Go in, Bradshaw; call for a cup of beer.
'Tis almost supper time; thou shalt stay with us.

 Exit [BRADSHAW].

Then she reads the letter. [28]

We have missed of our purpose at London, but shall
perform it by the way. We thank our neighbor Brad-
shaw.

 Yours, Richard Greene.

How likes my love the tenor of this letter? 161
 Mos. Well, were his date complete and expired.
 Al. Ah, would it were; then comes my happy hour.
Till then my bliss is mixed with bitter gall.
Come, let us in to shun suspicion.
 Mos. Ay, to the gates of death to follow thee.

 Exeunt.

[ix]

Here enters GREENE, [BLACK] WILL, *and* SHAKEBAG.

 Shak. Come, Will, see thy tools be in a readiness.
Is not thy powder dank, or will thy flint strike fire?
 B. Will. Then ask me if my nose be on my face,
Or whether my tongue be frozen in my mouth.
Zounds, here's a coil! [1]
You were best swear me on the interrogatories [2]
How many pistols I have took in hand,
Or whether I love the smell of gunpowder,
Or dare abide the noise the dag [3] will make,
Or will not wink at flashing of the fire. 10
I pray thee, Shakebag, let this answer thee,
That I have took more purses in this Down
Than e'er thou handlest pistols in thy life.
 Shak. Ay, haply thou hast picked more in a throng;
But should I brag what booties I have took,
I think the overplus that's more than thine
Would mount to a greater sum of money
Than either thou or all thy kin are worth.
Zounds, I hate them as I hate a toad
That carry a muscado [4] in their tongue, 20
And scarce a hurting weapon in their hand.
 B. Will. Oh, Greene, intolerable!
It is not for mine honor to bear this.
Why, Shakebag, I did serve the King at Boulogne,
And thou canst brag of nothing that thou hast done.
 Shak. Why, so can Jack of Feversham,
That sounded [5] for a fillip on the nose,
When he that gave it him hollaed in his ear,
And he supposed a cannon-bullet hit him.

 Then they fight.

 Gre. I pray you, sirs, list to Aesop's [6] talk: 30
Whilst two stout [7] dogs were striving for a bone,
There comes a cur and stole it from them both.
So while you stand striving on these terms of manhood,
Arden escapes us and deceives us all.
 Shak. Why, he begun.
 B. Will. And thou shalt find I'll end.
I do but slip it until better time.
But if I do forget—

Then he kneels down and holds up his hands to heaven.

[21] *sect:* religious faith.
[22] *sighted:* endowed with sight. [23] *sensible:* capable.
[24] *thy good turns:* i.e., that I have done you.
[25] *fount once troubled:* Original reads "fence of trouble."
[26] *thickened still:* always muddy. [27] *gentles:* gentlefolk.
[28] *letter:* the tenor of which postdates Greene's parting with Bradshaw.

ix.
[1] *coil:* great to-do. [2] *the interrogatories:* oath.
[3] *dag:* pistol.
[4] *muscado:* musket(?). So OED, citing only this instance of the word. Perhaps "volley," suggesting sound, is a likelier meaning. [5] *sounded:* swooned.
[6] *Aesop's:* alluding to the Greek writer of the sixth century B.C., whose fables were widely current in the Renaissance.
[7] *stout:* courageous.

Gre. Well, take your fittest standings, and once more
Lime[8] your twigs to catch this weary[9] bird. 40
I'll leave you, and at your dag's discharge
Make towards, like the longing water-dog
That coucheth[10] till the fowling-piece be off,
Then seizeth on the prey with eager mood.
Ah, might I see him stretching forth his limbs,
As I have seen them beat their wings ere now.
 Shak. Why, that thou shalt see if he come this way.
 Gre. Yes, that he doth, Shakebag, I warrant thee.
But brawl not when I am gone in any case,
But, sirs, be sure to speed him when he comes; 50
And in that hope I'll leave you for an hour.

 Exit GREENE.

Here enters ARDEN, FRANKLIN, *and* MICHAEL.

Mich. 'Twere best that I went back to Rochester.
The horse halts downright;[11] it were not good
He traveled in such pain to Feversham.
Removing of a shoe may haply help it.
 Ard. Well, get you back to Rochester; but, sirrah,
 see ye
Overtake us ere we come to Rainham Down,
For it will be very late ere we get home.
 Mich. [*Aside*] Ay, God he knows, and so doth Will
 and Shakebag,
That thou shalt never go further than that Down; 60
And therefore have I pricked[12] the horse on purpose,
Because I would not view the massacre.

 Exit MICHAEL.

 Ard. Come, Master Franklin, onwards with your
 tale.
 Frank. I assure you, sir, you task me much.
A heavy blood is gathered at my heart,
And on the sudden is my wind so short
As hindereth the passage of my speech.
So fierce a qualm yet ne'er assailed me.
 Ard. Come, Master Franklin, let us go on softly.
The annoyance of the dust or else some meat 70
You ate at dinner cannot brook you.[13]
I have been often so and soon amended.
 Frank. Do you remember where my tale did leave?
 Ard. Ay, where the gentleman did check[14] his wife.
 Frank. She being reprehended for the fact,[15]
Witness produced that took her with the deed,
Her glove brought in which there she left behind,
And many other assurèd arguments,
Her husband asked her whether it were not so.
 Ard. Her answer then? I wonder how she looked,
Having forsworn it with such vehement oaths, 81

And at the instant so approved[16] upon her.
 Frank. First did she cast her eyes down to the earth,
Watching the drops that fell amain from thence;
Then softly draws she forth her handkerchief,
And modestly she wipes her tear-stained face:
Then hemmed she out, to clear her voice should seem,
And with a majesty addressed herself
To encounter all their accusations.—
Pardon me, Master Arden, I can no more; 90
This fighting at my heart makes short my wind.
 Ard. Come, we are almost now at Rainham Down;
Your pretty tale beguiles the weary way.
I would you were in state to tell it out.
 Shak. [*Aside*] Stand close, Will, I hear them coming.

Here enters LORD CHEINY *with his* Men.

 B. Will. [*Aside*] Stand to it, Shakebag, and be
 resolute.
 Lord. Is it so near night as it seems,
Or will this black-faced evening have a shower?

 [*Sees* ARDEN.]

What, Master Arden? You are well met.
I have longed this fortnight's day to speak with you;
You are a stranger, man, in the Isle of Sheppey. 101
 Ard. Your honor's always! bound to do you service.
 Lord. Come you from London and ne'er a man with
 you?
 Ard. My man's coming after,
But here's my honest friend that came along with me.
 Lord. My lord protector's man I take you to be.
 Frank. Ay, my good lord, and highly bound to you.
 Lord. You and your friend come home and sup with
 me.
 Ard. I beseech your honor pardon me;
I have made a promise to a gentleman, 110
My honest friend, to meet him at my house.
The occasion is great, or else would I wait on you.
 Lord. Will you come tomorrow and dine with me
And bring your honest friend along with you?
I have divers[17] matters to talk with you about.
 Ard. Tomorrow we'll wait upon your honor.
 Lord. One of you stay my horse at the top of the hill.

 [*Sees* BLACK WILL.]

What, Black Will! for whose purse wait you?
Thou wilt be hanged in Kent when all is done.
 B. Will. Not hanged, God save your honor. 120
I am your beadsman,[18] bound to pray for you.
 Lord. I think thou ne'er saidest prayer in all thy life.
One of you give him a crown.—
And, sirrah, leave this kind of life.
If thou beest tainted[19] for a penny matter
And come in question,[20] surely thou wilt truss.[21]
Come, Master Arden, let us be going;
Your way and mine lies four mile together.

 Exeunt.

 Manet BLACK WILL *and* SHAKEBAG.

 B. Will. The Devil break all your necks at four miles'
 end!
Zounds, I could kill myself for very anger. 130

 [8] *Lime:* Spread sticky birdlime on.
 [9] *weary:* i.e., to us—"troublesome."
 [10] *coucheth:* lies down.
 [11] *halts downright:* is downright lame.
 [12] *pricked:* cut the foot of.
 [13] *cannot brook you:* you cannot brook (endure).
 [14] *check:* reprove. [15] *fact:* deed.
 [16] *approved:* proved. [17] *divers:* several.
 [18] *beadsman:* one who is paid to pray for another, as by
telling his rosary beads. [19] *tainted:* attainted, accused.
 [20] *come in question:* be brought to trial. [21] *truss:* hang.

His lordship chops me in,[22] even when
My dag was leveled at his heart.
I would his crown were molten down his throat.
 Shak. Arden, thou hast wondrous holy luck.
Did ever man escape as thou hast done?
Well, I'll discharge my pistol at the sky,
For by this bullet Arden might not die.

<div align="center">*Here enters* GREENE.</div>

 Gre. What, is he down? Is he dispatched?
 Shak. Ay, in health towards Feversham to shame us
 all.
 Gre. The devil he is! Why, sirs, how escaped he?
 Shak. When we were ready to shoot 141
Comes my Lord Cheiny to prevent his death.
 Gre. The Lord of Heaven hath preserved him.
 B. Will. Preserved a fig! the Lord Cheiny hath
 preserved him,
And bids him to a feast, to his house at Shorlow.
But by the way once more I'll meet with him,
And if all the Cheinies in the world say no,
I'll have a bullet in his breast tomorrow.
Therefore come, Greene, and let us to Feversham.
 Gre. Ay, and excuse ourselves to Mistress Arden.
Oh, how she'll chafe when she hears of this. 151
 Shak. Why, I'll warrant you she'll think we dare not
 do it.
 B. Will. Why, then let us go, and tell her all the
 matter,
And plot the news[23] to cut him off tomorrow.

<div align="right">*Exeunt.*</div>

[x]

<div align="center">*Here enters* ARDEN *and his* Wife, FRANKLIN,
and MICHAEL.</div>

 Ard. See how the hours, the guardant[1] of heaven's
 gate,
Have by their toil removed the darksome clouds,
That Sol may well deserve[2] the trampled pace[3]
Wherein he wont to guide his golden car.
The season fits; come, Franklin, let's away.
 Al. I thought you did pretend[4] some special hunt
That made you thus cut short the time of rest.
 Ard. It was no chase that made me rise so early,
But as I told thee yesternight, to go
To the Isle of Sheppey, there to dine with my Lord
 Cheiny; 10
For so his honor late commanded me.
 Al. Ay, such kind husbands seldom want excuses.
Home is a wild cat to a wandering wit.
The time hath been—would God it were not past—
That honor's title, nor a lord's command
Could once have drawn you from these arms of mine.
But my deserves[5] or your desires decay,
Or both; yet if true love may seem desert,
I merit still to have thy company.
 Frank. Why, I pray you, sir, let her go along with
 us; 20
I am sure his honor will welcome her,
And us the more for bringing her along.

 Ard. Content. [*To* MICHAEL] Sirrah, saddle your
 mistress' nag.
 Al. No. Begged favor merits little thanks.
If I should go our house would run away
Or else be stolen; therefore I'll stay behind.
 Ard. Nay, see how mistaking you are. I pray thee, go.
 Al. No, no, not now.
 Ard. Then let me leave thee satisfied in this,
That time nor place nor persons alter me, 30
But that I hold thee dearer thàn my life.
 Al. That will be seen by your quick return.
 Ard. And that shall be ere night and if I live.
Farewell, sweet Alice; we mind[6] to sup with thee.

<div align="right">*Exit* ALICE.</div>

 Frank. Come, Michael, are our horses ready?
 Mich. Ay, your horse are ready but I am not ready,
for I have lost my purse with six and thirty shillings in
it, with taking up[7] of my master's nag.
 Frank. Why, I pray you, let us go before,
Whilst he stays behind to seek his purse. 40
 Ard. Go to, sirrah; see you follow us to the Isle of
 Sheppey,
To my Lord Cheiny's, where we mean to dine.

<div align="right">*Exeunt* ARDEN *and* FRANKLIN.
Manet MICHAEL.</div>

 Mich. So, fair weather after you, for before you lies
Black Will and Shakebag, in the broom close,[8] too close
for you. They'll be your ferrymen to long home.[9]

<div align="center">*Here enters the* Painter.</div>

But who is this? The painter, my co-rival, that would
needs win Mistress Susan.
 Clar. How now, Michael, how doth my mistress and
all at home?
 Mich. Who, Susan Mosby? She is your mistress,
too? 51
 Clar. Ay, how doth she, and all the rest?
 Mich. All's well but Susan; she is sick.
 Clar. Sick? Of what disease?
 Mich. Of a great fear.
 Clar. A fear of what?
 Mich. A great fever.
 Clar. A fever? God forbid!
 Mich. Yes, faith, and of a lurdan,[10] too, as big as
yourself. 60
 Clar. Oh, Michael, the spleen[11] prickles you. Go to;
you carry an eye over[12] Mistress Susan.
 Mich. Ay, faith, to keep her from the painter.

x.
 [1] *guardant:* guardian.
 [2] *deserve:* generally emended to "discern."
 [3] *pace:* path. [4] *pretend:* intend.
 [5] *deserves:* deserts. [6] *mind:* intend.
 [7] *taking up:* seeing to the reshoeing(?).
 [8] *broom close:* enclosed field (of furze or gorse).
 [9] *long home:* the grave.
 [10] *lurdan:* clown; fever of idleness.
 [11] *spleen:* seat of anger.
 [12] *carry . . . over:* keep an eye on.

Clar. Why more from a painter than from a serving-creature like yourself?

Mich. Because you painters make but a painting table [13] of a pretty wench and spoil her beauty with blotting.

Clar. What mean you by that? 69

Mich. Why, that you painters paint lambs in the lining of wenches' petticoats, and we servingmen put horns to them to make them become sheep.

Clar. Such another word will cost you a cuff or a knock.

Mich. What, with a dagger made of a pencil? Faith, 'tis too weak, and therefore thou too weak to win Susan.

Clar. Would Susan's love lay upon this stroke.

Then he breaks MICHAEL's *head.*

Here enters MOSBY, GREENE, *and* ALICE.

Al. I'll lay my life, this is for Susan's love.
Stayed you behind your master to this end? 80
Have you no other time to brabble [14] in
But now when serious matters are in hand?
Say, Clarke, has thou done the thing thou promised?

Clar. Ay, here it [15] is; the very touch is death.

Al. Then this, I hope, if all the rest do fail,
Will catch Master Arden,
And make him wise in death that lived a fool.
Why should he thrust his sickle in our corn,
Or what hath he to do with thee, my love,
Or govern me that am to rule myself? 90
Forsooth, for credit sake I must leave thee!
Nay, he must leave [16] to live that we may love,
May live, may love; for what is life but love?
And love shall last as long as life remains,
And life shall end before my love depart.

Mos. Why, what's love without true constancy?
Like to a pillar built of many stones,
Yet neither with good mortar well compact,
Nor cement, to fasten it in the joints,
But that it shakes with every blast of wind, 100
And, being touched, straight falls unto the earth,
And buries all his [17] haughty pride in dust.
No, let out love be rocks of adamant,
Which time nor place nor tempest can asunder. [18]

Gre. Mosby, leave protestations now,
And let us bethink us what we have to do.
Black Will and Shakebag I have placed
In the broom close watching Arden's coming.
Let's to them and see what they have done.

Exeunt.

[xi]

Here enters ARDEN *and* FRANKLIN.

Ard. O ferryman, where art thou?

Here enters the Ferryman.

Fer. Here, here! Go before to the boat,
And I will follow you.

Ard. We have great haste; I pray thee come away.

Fer. Fie, what a mist is here!

Ard. This mist, my friend, is mystical,
Like to a good companion's [1] smoky brain,
That was half-drowned with new ale overnight.

Fer. 'Twere pity but his skull were [2] opened
To make more chimney room. 10

Frank. Friend, what's thy opinion of this mist?

Fer. I think 'tis like to a curst [3] wife in a little house, that never leaves her husband till she have driven him out at [4] doors with a wet pair of eyes. Then looks he as if his house were afire, or some of his friends dead.

Ard. Speaks thou this of thine own experience?

Fer. Perhaps ay, perhaps no: for my wife is as other women are, that is to say, governed by the moon.

Frank. By the moon? How, I pray thee?

Fer. Nay, thereby lies a bargain, and you shall not have it fresh and fasting. [5] 21

Ard. Yes, I pray thee, good ferryman.

Fer. Then for this once let it be midsummer moon; [6] but yet my wife has another moon.

Frank. Another moon?

Fer. Ay, and it hath influences and eclipses.

Ard. Why, then, by this reckoning you sometimes play the man in the moon.

Fer. Ay, but you had not best to meddle with that moon lest I scratch you by the face with my bramble-bush. [7] 31

Ard. I am almost stifled with this fog; come, let's away.

Frank. And, sirrah, as we go let us have some more of your bold yeomanry. [8]

Fer. Nay, by my faith, sir, but flat knavery.

Exeunt.

[xii]

Here enters [BLACK] WILL *at one door and* SHAKEBAG *at another.*

Shak. O Will, where art thou?

B. Will. Here, Shakebag, almost in hell's mouth, [1] where I cannot see my way for smoke.

Shak. I pray thee speak still [2] that we may meet by the sound, for I shall fall into some ditch or other, unless my feet see better than my eyes.

B. Will. Didst thou ever see better weather to run

[13] *table:* picture. [14] *brabble:* quarrel.
[15] *it:* the poisoned crucifix. [16] *leave:* leave off.
[17] *his:* its. [18] *asunder:* sunder.

xi.
[1] *companion's:* drinking partner's.
[2] *but ... were:* if ... were not. [3] *curst:* shrewish.
[4] *at:* of.
[5] *fresh and fasting:* for nothing (picking up "bargain")(?).
[6] *midsummer moon:* a "lunatic" time, as in Shakespeare's play; also, a festive time, hence proper to gratuities like that the ferryman is proffering.
[7] *bramble-bush:* one of the traditional accouterments of the Man in the Moon. The *double entendre* is obviously sexual.
[8] *yeomanry:* honest speech.

xii.
[1] *hell's mouth:* a reminiscence of that permanent feature of the medieval stage. See General Introduction.
[2] *still:* on, continuously.

away with another man's wife, or play with a wench at potfinger.³

9

Shak. No, this were a fine world for chandlers,⁴ if this weather would last; for then a man should never dine nor sup without candlelight. But, sirrah Will, what horses are those that passed?

B. Will. Why, didst thou hear any?

Shak. Ay, that I did.

B. Will. My life for thine, 'twas Arden and his companion, and then all our labor's lost.

Shak. Nay, say not so; for, if it be they, they may haply lose their way as we have done, and then we may chance meet with them.

20

B. Will. Come, let us go on like a couple of blind pilgrims.

Then SHAKEBAG *falls into a ditch.*

Shak. Help, Will, help! I am almost drowned.

Here enters the Ferryman.

Fer. Who's that that calls for help?

B. Will. 'Twas none here, 'twas thou thyself.

Fer. I came to help him that called for help. Why, how now? Who is this that's in the ditch? You are well enough served to go without a guide, such weather as this!

29

B. Will. Sirrah, what companies hath passed your ferry this morning?

Fer. None but a couple of gentlemen that went to dine at my Lord Cheiny's.

B. Will. Shakebag, did I not tell thee as much?

Fer. Why, sir, will you have any letters carried to them?

B. Will. No, sir; get you gone.

Fer. Did you ever see such a mist as this?

B. Will. No, nor such a fool as will rather be hocked⁵ than get his way.

40

Fer. Why, sir, this is no Hock Monday;⁶ you are deceived. What's his name, I pray you, sir?

Shak. His name is Black Will.

Fer. I hope to see him one day hanged upon a hill.

Exit Ferryman.

Shak. See how the sun hath cleared the foggy mist, Now we have missed the mark of our intent.

Here enters GREENE, MOSBY, *and* ALICE.

Mos. Black Will and Shakebag, what make⁷ you here?
What, is the deed done, is Arden dead?

B. Will. What could a blinded man perform in arms?
Saw you not how till now the sky was dark,

50

That neither horse nor man could be discerned?
Yet did we hear their horses as they passed.

Gre. Have they escaped you then and passed the ferry?

Shak. Ay, for a while; but here we two will stay,
And at their coming back meet with them once more.
Zounds, I was ne'er so toiled⁸ in all my life
In following so slight a task as this.

Mos. How camest thou so berayed?⁹

B. Will. With making false footing in the dark;

He needs would follow them without a guide.

60

Al. Here's to pay for a fire and good cheer.
Get you to Feversham, to the Flower-de-Luce,
And rest yourselves until some other time.

Gre. Let me alone; it most concerns my state.

B. Will. Ay, Mistress Arden, this will serve the turn
In case we fall into a second fog.

Exeunt GREENE, BLACK WILL, *and*
SHAKEBAG.

Mos. These knaves will never do it; let's give it over.

Al. First tell me how you like my new device.
Soon, when my husband is returning back,
You and I both marching arm in arm,

70

Like loving friends we'll meet him on the way,
And boldly beard and brave him to his teeth.
When words grow hot and blows begin to rise
I'll call those cutters forth your tenement.¹⁰
Who, in a manner to take up the fray,
Shall wound my husband Hornsby¹¹ to the death.

Mos. Ah, fine device; why, this deserves a kiss.

Exeunt.

[xiii]

Here enters DICK REEDE *and a* Sailor.

Sail. Faith, Dick Reede, it is to little end.¹
His conscience is too liberal² and he too niggardly
To part with anything may do thee good.

Reede. He is coming from Shorlow, as I understand.
Here I'll intercept him, for at his house
He never will vouchsafe to speak with me.
If prayers and fair entreaties will not serve
Or make no battery in his flinty breast
I'll curse the carl³ and see what that will do.

Here enters FRANKLIN, ARDEN, *and* MICHAEL.

See where he comes to further my intent.—

10

Master Arden, I am now bound to the sea.
My coming to you was about the plot of ground
Which wrongfully you detain from me.
Although the rent of it be very small,
Yet will it help my wife and children,
Which here I leave in Feversham, God knows,
Needy and bare. For Christ's sake, let them have it.

Ard. Franklin, hearest thou this fellow speak?
That which he craves I dearly bought of him,
Although the rent of it was ever mine.

20

Sirrah, you that ask these questions,
If with thy clamorous impeaching⁴ tongue
Thou rail on me as I have heard thou dost,

³ *potfinger*: inserting a finger in the "pot." The sexual image is clear enough. ⁴ *chandlers*: candlemakers.
⁵ *hocked*: hamstrung.
⁶ *Hock Monday*: festival falling on the second Monday after Easter. ⁷ *make*: do.
⁸ *toiled*: fatigued. ⁹ *berayed*: muddied.
¹⁰ *tenement*: house. ¹¹ *Hornsby*: Cuckold.
xiii.
¹ *end*: purpose.
² *liberal*: large (in pejorative sense).
³ *carl*: rude fellow. ⁴ *impeaching*: accusing.

I'll lay thee up so close [5] a twelve month's day
As thou shalt neither see the sun nor moon.
Look to it, for as surely as I live,
I'll banish pity if thou use me thus.

Reede. What, wilt thou do me wrong and threat me
 too?

Nay, then, I'll tempt thee, Arden; do thy worst.
God, I beseech thee, show some miracle 30
On thee or thine, in plaguing thee for this.
That plot of ground, which thou detains from me,
I speak it in an agony of spirit,
Be ruinous and fatal unto thee.
Either there be butchered by thy dearest friends,
Or else be brought for men to wonder at,
Or thou or thine miscarry in that place,
Or there run mad and end thy cursèd days.

Frank. Fie, bitter knave, bridle thine envious tongue,
For curses are like arrows shot upright, 40
Which falling down light on the shooter's head.

Reede. Light where they will; were I upon the sea
As oft I have in many a bitter storm,
And saw a dreadful southern flaw [6] at hand,
The pilot quaking at the doubtful [7] storm,
And all the sailors praying on their knees,
Even in that fearful time would I fall down,
And ask of God, whate'er betide of me,
Vengeance on Arden, or some misevent, [8]
To show the world what wrong the carl hath done. 50
This charge I'll leave with my distressful wife;
My children shall be taught such prayers as these.
And thus I go but leave my curse with thee.

 Exeunt REEDE *and the* Sailor.

Ard. It is the railingest knave in Christendom,
And oftentimes the villain will be mad.
It greatly matters not what he says,
But I assure you I ne'er did him wrong.

Frank. I think so, Master Arden.

Ard. Now that our horses are gone home before,
My wife may haply meet me on the way. 60
For God knows she is grown passing kind of late
And greatly changèd from the old humor [9]
Of her wonted frowardness,
And seeks by fair means to redeem old faults.

Frank. Happy the change that alters for the best.
But see in any case you make no speech
Of the cheer [10] we had at my Lord Cheiny's,
Although most bounteous and most liberal.
For that will make her think herself more wronged,
In that we did not carry her along; 70
For sure she grieved that she was left behind.

Ard. Come, Franklin, let us strain to mend our pace
And take her unawares, playing the cook,

 Here enters ALICE *and* MOSBY.

For I believe she'll strive to mend [11] our cheer.

 [5] *lay . . . close:* confine . . . so securely. [6] *flaw:* gust.
 [7] *doubtful:* fearful. [8] *misevent:* mischance.
 [9] *humor:* disposition.
 [10] *Of the cheer:* About the hospitality. [11] *mend:* better.
 [12] *thee:* emended from "thy" of original.
 [13] *sullens:* sulks. [14] *while:* until.

Frank. Why, there's no better creatures in the world
Than women are when they are in good humors.

Ard. Who is that? Mosby? What, so familiar?
Injurious strumpet and thou ribald knave,
Untwine those arms.

Al. Ay, with a sugared kiss let them untwine. 80

Ard. Ah, Mosby! perjured beast! bear this and all!

Mos. And yet no hornèd beast; the horns are thine.

Frank. Oh, monstrous! Nay then, 'tis time to draw.

Al. Help, help, they murder my husband.

 Here enters [BLACK] WILL *and* SHAKEBAG.

Shak. Zounds, who injures Master Mosby?

 [SHAKEBAG *and* MOSBY *are wounded.*]

Help, Will, I am hurt.

Mos. I may thank you, Mistress Arden, for this
 wound.

 Exeunt MOSBY, [BLACK] WILL, *and*
 SHAKEBAG.

Al. Ah, Arden, what folly blinded thee?
Ah, jealous harebrain man, what hast thou done?
When we, to welcome thee, [12] intended sport, 90
Came lovingly to meet thee on thy way,
Thou drewest thy sword, enraged with jealousy,
And hurt thy friends whose thoughts were free from
 harm;
All for a worthless kiss and joining arms,
Both done but merely to try thy patience.
And me unhappy that devised the jest,
Which, though begun in sport, yet ends in blood!

Frank. Marry, God defend me from such a jest!

Al. Couldst thou not see us friendly smile on thee
When we joined arms and when I kissed his cheek?
Hast thou not lately found me over-kind? 101
Didst thou not hear me cry, they murder thee?
Called I not help to set my husband free?
No, ears and all were witched. Ah, me accursed,
To link in liking with a frantic man!
Henceforth I'll be thy slave, no more thy wife;
For with that name I never shall content thee.
If I be merry, thou straightways thinks me light;
If sad, thou sayest the sullens [13] trouble me;
If well attired, thou thinks I will be gadding; 110
If homely, I seem sluttish in thine eye.
Thus am I still, and shall be while [14] I die,
Poor wench, abused by thy misgovernment.

Ard. But is it for truth that neither thou nor he
Intendest malice in your misdemeanor?

Al. The heavens can witness of our harmless
 thoughts.

Ard. Then pardon me, sweet Alice, and forgive this
 fault;
Forget but this and never see the like;
Impose me penance and I will perform it;
For in thy discontent I find a death, 120
A death tormenting more than death itself.

Al. Nay, hadst thou loved me as thou dost pretend,
Thou wouldst have marked the speeches of thy friend,
Who, going wounded from the place, he said
His skin was pierced only through my device.

And if sad sorrow taint thee for this fault
Thou wouldst have followed him and seen him
 dressed,[15]
And cried him mercy whom thou hast misdone;
Ne'er shall my heart be eased till this be done.
 Ard. Content thee, sweet Alice, thou shalt have thy
 will, 130
Whate'er it be. For that I injured thee
And wronged my friend, shame scourgeth my offense.
Come thou thyself and go along with me,
And be a mediator 'twixt us two.
 Frank. Why, Master Arden, know you what you do?
Will you follow him that hath dishonored you?
 Al. Why, canst thou prove I have been disloyal?
 Frank. Why, Mosby taunt[16] your husband with the
 horn.
 Al. Ay, after he had reviled him
By the injurious name of perjured beast. 140
He knew no wrong could spite a jealous man
More than the hateful naming of the horn.
 Frank. Suppose 'tis true, yet it is dangerous
To follow him whom he hath lately hurt.
 Al. A fault confessed is more than half amends:
But men of such ill spirit as yourself
Work crosses and debates 'twixt man and wife.
 Ard. I pray thee, gentle Franklin, hold thy peace;
I know my wife counsels me for the best.
I'll seek out Mosby where his wound is dressed, 150
And salve his hapless quarrel if I may.
 Exeunt ARDEN *and* ALICE.
 Frank. He whom the devil drives must go perforce.
Poor gentleman, how soon he is bewitched,
And yet, because his wife is the instrument,
His friends must not be lavish in their speech.
 Exit FRANKLIN.

[xiv]

Here enters [BLACK] WILL, SHAKEBAG, *and*
GREENE.

 B. Will. Sirrah Greene, when was I so long in killing
a man?
 Gre. I think we shall never do it; let us give it over.
 Shak. Nay, zounds, we'll kill him, though we be
hanged at his door for our labor.
 B. Will. Thou knowest, Greene, that I have lived in
London this twelve years where I have made some go
upon wooden legs for taking the wall on me;[1] divers
with silver[2] noses for saying "There goes Black Will."
I have cracked as many blades as thou hast done nuts.
 Gre. Oh, monstrous lie! 11
 B. Will. Faith, in a manner I have. The bawdy-
houses have paid me tribute; there durst not a whore
set up unless she have agreed with me first for opening
her shop-windows. For a cross word of a tapster I have
pierced one barrel after another with my dagger and
held him by the ears till all his beer hath run out. In
Thames Street a brewer's cart was like to have run over
me; I made no more ado but went to the clerk and cut
all the notches off his tales[3] and beat them about 20
his head. I and my company have taken the constable

from his watch and carried him about the fields on a
colt-staff.[4] I have broken a sergeant's head with his own
mace, and bailed whom I list with my sword and
buckler. All the tenpenny alehouses would stand every
morning with a quart pot in his hand saying "Will it
please your worship drink?" He that had not done so
had been sure to have had his sign pulled down and his
lattice[5] borne away the next night. To conclude, what
have I not done? Yet cannot do this; doubtless, he is
preserved by miracle. 31

Here enters ALICE *and* MICHAEL.

 Gre. Hence, Will; here comes Mistress Arden.
 Al. Ah, gentle Michael, art thou sure they're friends?
 Mich. Why, I saw them when they both shook hands;
When Mosby bled he even wept for sorrow,
And railed on Franklin that was cause of all.
No sooner came the surgeon in at doors,
But my master took to his purse and gave him money,
And, to conclude, sent me to bring you word
That Mosby, Franklin, Bradshaw, Adam Fowle, 40
With divers of his neighbors and his friends,
Will come and sup with you at our house this night.
 Al. Ah, gentle Michael, run thou back again,
And when my husband walks into the fair,
Bid Mosby steal from him and come to me,
And this night shall thou and Susan be made sure.
 Mich. I'll go tell him.
 Al. And as thou goest, tell John cook of our guests,
And bid him lay it on, spare for no cost.
 Exit MICHAEL.
 B. Will. Nay, and there be such cheer, we will bid[6]
ourselves.— 51
Mistress Arden, Dick Greene and I do mean to sup
with you.
 Al. And welcome shall you be. Ah, gentlemen,
How missed you of your purpose yesternight?
 Gre. 'Twas long[7] of Shakebag, that unlucky villain.
 Shak. Thou dost me wrong; I did as much as any.
 B. Will. Nay, then, Mistress Alice, I'll tell you how
it was. When he should have locked with both his hilts,[8]
he in a bravery[9] flourished over his head. With 60
that comes Franklin at him lustily and hurts the slave;
with that he slinks away. Now his way had been to have
come hand and feet, one and two round at his costard.[10]
He like a fool bears his sword point half a yard out of
danger. I lie here for my life.

[*Takes up a position of defense.*]

 [15] *dressed:* treated. [16] *taunt:* did taunt.
xiv.
 [1] *taking . . . me:* pushing me into the gutter.
 [2] *silver:* white, from being beaten(?); or from being treated,
as with nitrate.
 [3] *notches . . . tales:* scorings on the sticks (on which ac-
counts were tallied).
 [4] *colt-staff:* on which tubs were carried.
 [5] *sign . . . lattice:* denoting an alehouse.
 [6] *bid:* invite. [7] *long:* on account.
 [8] *locked . . . hilts:* gone to sword play.
 [9] *bravery:* bravado.
 [10] *round . . . costard:* straight for his head.

If the devil come and he have no more strength than
fence,[11] he shall never beat me from this ward;[12] I'll
stand to it. A buckler in a skillful hand is as good as a
castle; nay, 'tis better than a sconce,[13] for I have tried
it. Mosby, perceiving this,[14] began to faint. With 70
that comes Arden with his arming[15] sword and thrust
him through the shoulder in a trice.

 Al. Ay, but I wonder why you both stood still.

 B. Will. Faith, I was so amazed I could not strike.

 Al. Ah, sirs, had he yesternight been slain,
For every drop of his detested blood,
I would have crammed in angels in thy fist,
And kissed thee too, and hugged thee in my arms.

 B. Will. Patient yourself; we cannot help it now.
Greene and we two will dog him through the fair, 80
And stab him in the crowd, and steal away.

<div align="center">Here enters MOSBY.</div>

 Al. It is unpossible. But here comes he
That will, I hope, invent some surer means.
Sweet Mosby, hide thy arm;[16] it kills my heart.

 Mos. Ay, Mistress Arden, this is your favor.[17]

 Al. Ah, say not so, for when I saw thee hurt
I could have took the weapon thou letst fall
And run at Arden, for I have sworn
That these mine eyes, offended with his sight,
Shall never close till Arden's be shut up. 90
This night[18] I rose and walked about the chamber,
And twice or thrice I thought to have murdered him.

 Mos. What, in the night? Then we had been undone!

 Al. Why, how long shall he live?

 Mos. Faith, Alice, no longer than this night.
Black Will and Shakebag, will you two
Perform the complot that I have laid?

 B. Will. Ay, or else think me as a villain.

 Gre. And rather than you shall want,[19] I'll help
 myself.

 Mos. You, Master Greene, shall single Franklin
 forth 100
And hold him with a long tale of strange news,
That he may not come home till suppertime.
I'll fetch Master Arden home, and we, like friends,
Will play a game or two at tables[20] here.

 Al. But what of all this? How shall he be slain?

 Mos. Why, Black Will and Shakebag, locked within
 the countinghouse,

 [11] *fence:* fencing skill.

 [12] *ward:* the posture of defense he has just taken up.

 [13] *sconce:* small fort.

 [14] *this:* Black Will's skill at fencing(?); Shakebag's
wound(?). [15] *arming:* two-handed.

 [16] *arm:* which has been dressed or bandaged.

 [17] *favor:* lover's token—the bandage.

 [18] *night:* just passed. [19] *want:* be lacking.

 [20] *tables:* backgammon.

 [21] *against:* in expectation of the time when.

 [22] *play . . . harmony:* give . . . money.

 [23] *sine:* seine (net); Q1633 reads "sive" (seive).

 [24] *Tisiphone:* one of the Furies, whose office was to torture
the guilty.

 [25] *Diana:* the goddess of the moon, whose love for the
mortal Endymion is alluded to subsequently.

Shall, at a certain watchword given, rush forth.

 B. Will. What shall the watchword be?

 Mos. "Now I take you"—that shall be the word.
But come not forth before in any case. 110

 B. Will. I warrant you; but who shall lock me in?

 Al. That will I do; thou'st keep the key thyself.

 Mos. Come, Master Greene, go you along with me.
See all things ready, Alice, against[21] we come.

 Al. Take no care for that; send you him home.

<div align="right">Exeunt MOSBY and GREENE.</div>

And if he e'er go forth again, blame me.
Come, Black Will, that in mine eyes art fair;
Next unto Mosby do I honor thee.
Instead of fair words and large promises
My hands shall play you golden harmony.[22] 120
How like you this? Say, will you do it, sirs?

 B. Will. Ay, and that bravely, too. Mark my device;
Place Mosby, being a stranger, in a chair,
And let your husband sit upon a stool,
That I may come behind him cunningly
And with a towel pull him to the ground;
Then stab him till his flesh be as a sine.[23]
That done, bear him behind the Abbey,
That those that find him murdered may suppose
Some slave or other killed him for his gold. 130

 Al. A fine device! you shall have twenty pound,
And when he is dead you shall have forty more.
And lest you might be suspected staying here,
Michael shall saddle you two lusty geldings.
Ride whither you will, to Scotland or to Wales;
I'll see you shall not lack where'er you be.

 B. Will. Such words would make one kill a thousand
 men!
Give me the key; which is the countinghouse?

 Al. Here would I stay and still encourage you
But that I know how resolute you are. 140

 Shak. Tush! You are too faint-hearted; we must do
 it.

 Al. But Mosby will be there, whose very looks
Will add unwonted courage to my thought
And make me the first that shall adventure on him.

 B. Will. Tush, get you gone; 'tis we must do the
 deed.
When this door opens next, look for his death.

<div align="right">[BLACK WILL and SHAKEBAG exeunt.]</div>

 Al. Ah, would he now were here, that it might open.
I shall no more be closed in Arden's arms,
That like the snakes of black Tisiphone[24]
Sting me with their embracings. Mosby's arms 150
Shall compass me, and, were I made a star,
I would have none other spheres but those.
There is no nectar but in Mosby's lips;
Had chaste Diana[25] kissed him, she, like me,
Would grow love-sick, and from her watery bower
Fling down Endymion and snatch him up.
Then blame not me that slay a silly man
Not half so lovely as Endymion.

<div align="center">Here enters MICHAEL.</div>

 Mich. Mistress, my master is coming hard by.

 Al. Who comes with him? 160

Mich. Nobody but Mosby.

Al. That's well, Michael. Fetch in the tables,
And, when thou hast done,
Stand before the countinghouse door.

Mich. Why so?

Al. Black Will is locked within to do the deed.

Mich. What, shall he die tonight?

Al. Ay, Michael.

Mich. But shall not Susan know it?

Al. Yes, for she'll be as secret as ourselves. 170

Mich. That's brave![26] I'll go fetch the tables.

Al. But Michael, hark to me a word or two.
When my husband is come in lock the street door.
He shall be murdered ere the guests come in.

 Exit MICHAEL.

 Here enters ARDEN *and* MOSBY.

Husband, what mean you to bring Mosby home?
Although I wished you to be reconciled,
'Twas more for fear of you than love of him.
Black Will and Greene are his companions,
And they are cutters and may cut you short.
Therefore, I thought it good to make you friends. 180
But wherefore do you bring him hither now?
You have given me my supper[27] with his sight.

Mos. Master Arden, methinks your wife would have
 me gone.

Ard. No, good Master Mosby; women will be
 prating.
Alice, bid him welcome; he and I are friends.

Al. You may enforce me to it if you will,
But I had rather die than bid him welcome.
His company hath purchased me ill friends,
And therefore will I ne'er frequent it more.

Mos. [*Aside*] Oh, how cunningly she can dissemble.

Ard. Now he is here you will not serve me so. 191

Al. I pray you be not angry or displeased;
I'll bid him welcome, seeing you'll have it so.
You are welcome, Master Mosby; will you sit down?

Mos. I know I am welcome to your loving husband;
But, for yourself, you speak not from your heart.

Al. And if I do not, sir, think I have cause.

Mos. Pardon me, Master Arden; I'll away.

Ard. No, good Master Mosby.

Al. We shall have guests enough, though you go
 hence. 200

Mos. I pray you, Master Arden, let me go.

Ard. I pray thee, Mosby, let her prate her fill.

Al. The doors are open, sir; you may be gone.

 [*Re-enter* MICHAEL *with the tables.*]

Mich. [*Aside*] Nay, that's a lie, for I have locked the
 doors.

Ard. Sirrah, fetch me a cup of wine; I'll make them
 friends.

 [*Exit* MICHAEL *and returns with wine.*]

And, gentle Mistress Alice, seeing you are so stout,[28]
You shall begin.[29] Frown not; I'll have it so.

Al. I pray you meddle with that you have to do.

Ard. Why, Alice, how can I do too much for him

Whose life I have endangered without cause? 210

Al. 'Tis true, and seeing 'twas partly through my
 means,
I am content to drink to him for this once.
Here, Master Mosby; and, I pray you, henceforth
Be you as strange to me as I to you.
Your company hath purchased me ill friends,
And I for you, God knows, have undeserved
Been ill spoken of in every place.
Therefore, henceforth frequent my house no more.

Mos. I'll see your husband in despite of you.

Yet, Arden, I protest to thee by heaven, 220
Thou ne'er shalt see me more after this night.
I'll go to Rome rather than be forsworn.

Ard. Tush, I'll have no such vows made in my house.

Al. Yes, I pray you, husband, let him swear;
And on that condition, Mosby, pledge[30] me here.

Mos. Ay, as willingly as I mean to live.

Ard. Come, Alice, is our supper ready yet?

Al. It will by then you have played a game at tables.

Ard. Come, Master Mosby, what shall we play for?

Mos. Three games for a French crown, sir, and[31]
 please you. 230

Ard. Content.

 Then they play at the tables.

B. Will. [*From the countinghouse*] Can he not take
 him yet? What a spite is that!

Al. [*Aside*] Not yet, Will. Take heed he see thee not.

B. Will. [*Aside*] I fear he will spy me as I am coming.

Mich. [*Aside*] To prevent that, creep betwixt my
 legs.

Mos. One ace, or else I lose the game.

 [*Throws the dice.*]

Ard. Marry, sir, there's two for failing.[32]

Mos. Ay, Master Arden, "Now I can take you."

 Then [BLACK WILL] *pulls him down with a towel.*

Ard. Mosby, Michael, Alice, what will you do? 239

B. Will. Nothing but take you up, sir, nothing else.

Mos. There's for the pressing iron you told me of.

 [*Stabs him.*]

Shak. And there's for the ten pound in my sleeve.

 [*Stabs him.*]

Al. What, groans thou? Nay, then, give me the
 weapon.
Take this for hindering Mosby's love and mine.

 [*Stabs him.*]

Mich. Oh, mistress!

B. Will. Ah, that villain will betray us all.

[26] *brave:* splendid.
[27] *given . . . supper:* killed my appetite.
[28] *stout:* stubborn.
[29] *begin:* drink first—pledge Mosby.
[30] *pledge:* drink to. [31] *and:* if it.
[32] *for failing:* if one isn't enough.

Mos. Tush, fear him not; he will be secret.

Mich. Why, dost thou think I will betray myself?

Shak. In Southwark dwells a bonny northern lass,
The widow Chambley; I'll to her house now, 250
And if she will not give me harborough,[33]
I'll make booty of the quean,[34] even to her smock.

B. Will. Shift for yourselves; we two will leave you
 now.

Al. First lay the body in the countinghouse.

 Then they lay the body in the countinghouse.

B. Will. We have our gold; Mistress Alice, adieu;
Mosby, farewell, and, Michael, farewell, too.

 Exeunt [BLACK WILL *and* SHAKEBAG].

 Enter SUSAN.

Sus. Mistress, the guests are at the doors.
Hearken, they knock. What, shall I let them in?

Al. Mosby, go thou and bear them company.

 Exit MOSBY.
And Susan, fetch water and wash away this blood. 260

[*Exit* SUSAN, *returns with water, and washes the floor.*]

Sus. The blood cleaveth to the ground and will not
 out.

Al. But with my nails I'll scrape away the blood.
The more I strive the more the blood appears.

Sus. What's the reason, mistress; can you tell?

Al. Because I blush not at my husband's death.

 Here enters MOSBY.

Mos. How now, what's the matter? Is all well?

Al. Ay, well—if Arden were alive again!
In vain we strive for here his blood remains.

Mos. Why, strew rushes[35] on it, can you not?
This wench doth nothing; fall unto the work. 270

Al. 'Twas thou that made me murder him.

Mos. What of that?

Al. Nay, nothing, Mosby, so it be not known.

Mos. Keep thou it close,[36] and 'tis unpossible.

Al. Ah, but I cannot. Was he not slain by me?
My husband's death torments me at the heart.

Mos. It shall not long torment thee, gentle Alice;
I am thy husband; think no more of him.

 Here enters ADAM FOWLE *and* BRADSHAW.

Brad. How now, Mistress Arden; what ail[37] you
 weep?

Mos. Because her husband is abroad so late. 280
A couple of ruffians threatened him yesternight,
And the poor soul is afraid he should be hurt.

Adam. Is't nothing else? Tush, he'll be here anon.

 Here enters GREENE.

Gre. Now, Mistress Arden, lack you any guests?

[33] *harborough:* harbor.
[34] *make . . . quean:* pillage the whore.
[35] *rushes:* which functioned as carpeting in Elizabethan
dwellings. [36] *close:* secret.
[37] *ail:* ails you that. [38] *link:* torch.

Al. Ah, Master Greene, did you see my husband
lately?

Gre. I saw him walking behind the Abbey even now.

 Here enters FRANKLIN.

Al. I do not like this being out so late.
Master Franklin, where did you leave my husband?

Frank. Believe me, I saw him not since morn- 290
ing. Fear you not, he'll come anon. Meantime, you may
do well to bid his guests sit down.

Al. Ay, so they shall. Master Bradshaw, sit you there;
I pray you be content, I'll have my will. Master Mosby,
sit you in my husband's seat.

Mich. [*Aside*] Susan, shall thou and I wait on them?
Or, and thou sayest the word, let us sit down too.

Sus. [*Aside*] Peace, we have other matters now in
hand. I fear me, Michael, all will be bewrayed. 299

Mich. [*Aside*] Tush, so it be known that I shall
marry thee in the morning I care not though I be
hanged ere night. But to prevent the worst I'll buy some
ratsbane.

Sus. [*Aside*] Why, Michael, wilt thou poison thyself?

Mich. [*Aside*] No, but my mistress, for I fear she'll
tell.

Sus. [*Aside*] Tush, Michael, fear not her, she's wise
enough.

Mos. Sirrah Michael, give's a cup of beer. Mistress
Arden, here's to your husband. 310

Al. My husband!

Frank. What ails you, woman, to cry so suddenly?

Al. Ah, neighbors, a sudden qualm came over my
 heart.
My husband's being forth torments my mind.
I know something's amiss, he is not well;
Or else I should have heard of him ere now.

Mos. [*Aside*] She will undo us through her
 foolishness.

Gre. Fear not, Mistress Arden, he's well enough.

Al. Tell not me; I know he is not well.
He was not wont for to stay thus late. 320
Good Master Franklin, go and seek him forth,
And if you find him send him home to me,
And tell him what a fear he hath put me in.

Frank. I like not this; I pray God all be well.
I'll seek him out and find him if I can.

 Exeunt FRANKLIN, MOSBY, *and* GREENE.

Al. [*Aside*] Michael, how shall I do to rid the rest
 away?

Mich. [*Aside*] Leave that to my charge, let me alone.
'Tis very late, Master Bradshaw,
And there are many false knaves abroad,
And you have many narrow lanes to pass. 330

Brad. Faith, friend Michael, and thou sayest true.
Therefore I pray thee light's forth and lend's a link.[38]

 Exeunt BRADSHAW, ADAM, *and* MICHAEL.

Al. Michael, bring them to the doors but do not stay.
You know I do not love to be alone.
Go, Susan, and bid thy brother come.
But wherefore should he come? Here is naught but
 fear.
Stay, Susan, stay, and help to counsel me.

Sus. Alas, I counsel! Fear frights away my wits.

Then they open the countinghouse door and look upon ARDEN.

Al. See, Susan, where thy quondam[39] master lies,
Sweet Arden, smeared in blood and filthy gore. 340
Sus. My brother, you and I shall rue this deed.
Al. Come, Susan, help to lift this body forth,
And let our salt tears be his obsequies.

[*They bring him out of the countinghouse.*]

Here enters MOSBY *and* GREENE.

Mos. How now, Alice, whither will you bear him?
Al. Sweet Mosby, art thou come? Then weep that will;
I have my wish in that I joy thy sight.
Gre. Well, it hoves[40] us to be circumspect.
Mos. Ay, for Franklin thinks that we have murdered him.
Al. Ay, but he cannot prove it for his life.
We'll spend this night in dalliance and in sport. 350

Here enters MICHAEL.

Mich. Oh, mistress, the Mayor and all the watch
Are coming towards our house with glaives and bills.[41]
Al. Make the door fast; let them not come in.
Mos. Tell me, sweet Alice, how shall I escape?
Al. Out at the back door, over the pile of wood,
And for one night lie at the Flower-de-Luce.
Mos. That is the next[42] way to betray myself.
Gre. Alas, Mistress Arden, the watch will take me here,
And cause suspicion where else would be none.
Al. Why, take that way that Master Mosby doth;
But first convey the body to the fields. 361

Then they bear the body into the fields [*and return*].

Mos. Until tomorrow, sweet Alice, now, farewell,
And see you confess nothing in any case.
Gre. Be resolute, Mistress Alice, betray us not,
But cleave to us as we will stick to you.

Exeunt MOSBY *and* GREENE.

Al. Now let the judge and juries do their worst;
My house is clear and now I fear them not.
Sus. As we went it snowèd all the way,
Which makes me fear our footsteps will be spied.
Al. Peace, fool; the snow will cover them again. 370
Sus. But it had done[43] before we came back again.
Al. Hark, hark, they knock. Go, Michael, let them in.

Here enters the Mayor *and the* Watch.

How now, Master Mayor; have you brought my husband home?
May. I saw him come into your house an hour ago.
Al. You are deceived; it was a Londoner.
May. Mistress Arden, know you not one that is called Black Will?
Al. I know none such. What mean these questions?
May. I have the Council's warrant to apprehend him.

Al. I am glad it is no worse. Why, master mayor,
Think you I harbor any such? 380
May. We are informed that here he is,
And therefore pardon us for we must search.
Al. Ay, search and spare you not, through every room.
Were my husband at home you would not offer this.

Here enters FRANKLIN.

Master Franklin, what mean you come so sad?
Frank. Arden, thy husband and my friend, is slain.
Al. Ah, by whom? Master Franklin, can you tell?
Frank. I know not; but behind the Abbey
There he lies murdered in most piteous case. 389
May. But, Master Franklin, are you sure 'tis he?
Frank. I am too sure. Would God I were deceived.
Al. Find out the murderers; let them be known.
Frank. Ay, so they shall. Come you along with us.
Al. Wherefore?
Frank. Know you this hand towel and this knife?
Sus. [*Aside*] Ah, Michael, through this thy negligence
Thou hast betrayed and undone us all.
Mich. [*Aside*] I was so afraid, I knew not what I did.
I thought I had thrown them both into the well.
Al. It is the pig's blood we had to[44] supper. 400
But wherefore stay you? Find out the murderers.
May. I fear me you'll prove one of them yourself.
Al. I one of them? What mean such questions?
Frank. I fear me he was murdered in this house
And carried to the fields, for from that place
Backwards and forwards may you see
The print of many feet within the snow.
And look about the chamber where we are
And you shall find part of his guiltless blood;
For in his slipshoe[45] did I find some rushes, 410
Which argueth he was murdered in this room.
May. Look in the place where he was wont to sit.
See, see! his blood! it is too manifest.
Al. It is a cup of wine that Michael shed.
Mich. Ay, truly.
Frank. It is his blood which, strumpet, thou hast shed.
But if I live, thou and thy complices,
Which have conspired and wrought his death, shall rue it.
Al. Ah, Master Franklin, God and heaven can tell
I loved him more than all the world beside. 420
But bring me to him; let me see his body.
Frank. Bring that villain and Mosby's sister, too;
And one of you go to the Flower-de-Luce
And seek for Mosby, and apprehend him, too.

Exeunt.

[39] *quondam:* sometime. [40] *hoves:* behooves.
[41] *glaives and bills:* broadswords, or pikes with blade affixed; broadswords, or pikes with spiked ax and spearhead affixed—in general, weapons carried by the watch.
[42] *next:* nearest, best. [43] *done:* stopped.
[44] *to:* for. [45] *slipshoe:* slipper.

[xv]

Here enters SHAKEBAG *solus.*

Shak. The widow Chambley in her husband's days
 I kept;
And now he's dead she is grown so stout [1]
She will not know her old companions.
I came hither thinking to have had
Harbor as I was wont,
And she was ready to thrust me out at doors.
But whether she would or no I got me up,
And as she followed me I spurned her down the stairs
And broke her neck, and cut her tapster's throat;
And now I am going to fling them in the Thames. 10
I have the gold; what care I though it be known?
I'll cross the water and take sanctuary. [2]

 Exit SHAKEBAG.

[xvi]

Here enters the MAYOR, MOSBY, ALICE,
 FRANKLIN, MICHAEL, *and* SUSAN.

May. See, Mistress Arden, where your husband lies.
Confess this foul fault and be penitent.

Al. Arden, sweet husband, what shall I say?
The more I sound his name the more he bleeds. [1]
This blood condemns me and in gushing forth
Speaks as it falls and asks me why I did it.
Forgive me, Arden; I repent me now;
And would my death save thine thou shouldst not die.
Rise up, sweet Arden, and enjoy thy love,
And frown not on me when we meet in heaven. 10
In heaven I love thee though on earth I did not.

May. Say, Mosby, what made thee murder him?

Frank. Study not for [2] an answer, look not down;
His purse and girdle [3] found at thy bed's head
Witness sufficiently thou didst the deed.
It bootless [4] is to swear thou didst it not.

Mos. I [5] hired Black Will and Shakebag, ruffians
 both,
And they and I have done this murderous deed.
But wherefore stay we? Come and bear me hence.

xv.
 [1] *stout:* proved.
 [2] *sanctuary:* technically used of the harbor afforded by a
church, which was supposed to be inviolate, and, as the
Epilogue makes clear, was not.

xvi.
 [1] *bleeds:* Popular belief supposed a corpse to bleed afresh
in the presence of the murderer.
 [2] *Study not for:* Don't try to think up.
 [3] *girdle:* belt. [4] *bootless:* fruitless.
 [5] *I:* In fact, Greene, who disappears from the play except
for a brief mention in the Epilogue, did the hiring.

xvii.
 [1] *hoy:* small coastal vessel.
 [2] *blank . . . adventures:* tilt, whatever the risks involved.

xviii.
 [1] *About:* Because of. [2] *privy to:* acquainted with.
 [3] *sound:* the depth of, as with a plummet.

Frank. Those ruffians shall not escape. I will up to
 London 20
And get the Council's warrant to apprehend them.

 Exeunt.

[xvii]

Here enters [BLACK] WILL.

B. Will. Shakebag, I hear, hath taken sanctuary.
But I am so pursued with hues and cries
For petty robberies that I have done
That I can come unto no sanctuary.
Therefore must I in some oyster-boat
At last be fain to go aboard some hoy, [1]
And so to Flushing. There is no staying here.
At Sittinburgh the watch was like to take me,
And, had I not with my buckler covered my head
And run full blank at all adventures, [2] 10
I am sure I had ne'er gone further than that place,
For the constable had twenty warrants to apprehend
 me,
Besides that I robbed him and his man once at
 Gadshill.
Farewell, England; I'll to Flushing now.

 Exit [BLACK] WILL.

[xviii]

Here enters the MAYOR, MOSBY, ALICE,
 MICHAEL, SUSAN, *and* BRADSHAW.

May. Come, make haste, and bring away the
 prisoners.

Brad. Mistress Arden, you are now going to God.
And I am by the law condemned to die
About [1] a letter I brought from Master Greene.
I pray you, Mistress Arden, speak the truth.
Was I ever privy to [2] your intent or no?

Al. What should I say? You brought me such a
 letter,
But I dare swear thou knewest not the contents.
Leave now to trouble me with wordly things
And let me meditate upon my Savior Christ 10
Whose blood must save me for the blood I shed.

Mos. How long shall I live in this hell of grief?
Convey me from the presence of that strumpet.

Al. Ah, but for thee I had never been strumpet.
What cannot oaths and protestations do
When men have opportunity to woo?
I was too young to sound [3] thy villainies,
But now I find it, and repent too late.

Sus. Ah, gentle brother, wherefore should I die?
I knew not of it till the deed was done. 20

Mos. For thee I mourn more than for myself,
But let it suffice I cannot save thee now.

Mich. And if your brother and my mistress
Had not promised me you in marriage,
I had ne'er given consent to this foul deed.

May. Leave to accuse each other now,
And listen to the sentence I shall give:

Bear Mosby and his sister to London straight [4]
Where they in Smithfield must be executed;
Bear Mistress Arden unto Canterbury 30
Where her sentence is she must be burnt;
Michael and Bradshaw in Feversham must suffer death.
 Al. Let my death make amends for all my sins.
 Mos. Fie upon women! this shall be my song;

But bear me hence for I have lived too long.
 Sus. Seeing no hope on earth in heaven is my hope.
 Mich. Faith, I care not, seeing I die with Susan.
 Brad. My blood be on his head that gave the
 sentence.
 May. To speedy execution with them all.
 Exeunt.

[EPILOGUE]

Here enters FRANKLIN.

 Frank. Thus have you seen the truth of Arden's
 death.
As for the ruffians, Shakebag and Black Will,
The one took sanctuary and being sent for out
Was murdered in Southwark as he passed
To Greenwich where the lord protector lay.
Black Will was burned in Flushing on a stage.[1]
Greene was hanged at Osbridge in Kent.
The painter fled and how he died we know not.

But this above the rest is to be noted:
Arden lay murdered in that plot of ground 10
Which he by force and violence held from Reede;
And in the grass his body's print was seen
Two years and more after the deed was done.
Gentlemen, we hope you'll pardon this naked tragedy
Wherein no filèd [2] points [3] are foisted in
To make it gracious to the ear or eye;
For simple truth is gracious enough,
And needs no other points of glozing [4] stuff.
 [Exit.]

F I N I S

 [4] *straight:* directly.

EPILOGUE
 [1] *stage:* scaffold. [2] *filèd:* polished.
 [3] *points:* literally, lace that held the hose and doublet to-
gether; generically, "niceties." [4] *glozing:* deceiving.

Thomas Nashe

[1567–c. 1600]

SUMMER'S LAST WILL AND TESTAMENT

BRILLIANT, funny, eccentric, contentious, intoxicated with language, addicted to learning and to the appearance of even greater learning, and constantly inventive, Thomas Nashe resembles the other "University Wits" even in his uniqueness. He studied at Cambridge between 1582 and 1586, where he must have known Marlowe, and began his career as a writer in London in the years when Greene, Marlowe, Kyd, and Lodge were emerging as a dazzling generation of high-spirited, uninhibited, and original new writers. A pamphleteer who supported himself by publishing a flood of satirical tracts, he was an innovator as well in prose fiction, and *The Unfortunate Traveller* (1594) is one of the most interesting and attractive tales to appear in England before the beginnings a century later of the modern novel; though Nashe did not do much in verse, Summer's song (1584ff) in the play printed here is one of the famous poems of the Elizabethan period. The best characterization of Nashe's style is that of C. S. Lewis, who, praising his deliberate incorporation of some "cheap-jack and guttersnipe elements" of the earlier prose tradition, notes his idiosyncratic addition of "something quite different: comic ink-horn terms, burlesque rodomontade, gigantic hyperbole, Rabelaisian monstrosity."

Like much else in Nashe, SUMMER'S LAST WILL AND TESTAMENT defies generic classification. It seems to have been written for private performance, either by household servants or by a children's company away from London because of plague (no performance record survives), at the Croydon house of John Whitgift, Archbishop of Canterbury. The special occasion dictates a good deal of topical reference—to details such as the unusual lowness of the Thames, the harvest season in progress, the apparent presence of the Queen, the closing down of the Michaelmas law term in London and the prolonged country residence of the Archbishop's household because of the plague, the names of actors taking various parts, the Archbishop's palaces at Croydon and Lambeth, nearby geographical features (Streatham, Duppa's Hill), and so on—which have served to identify the probable date of writing and performance as October 1592. Such building into the play of reference to particular matters with which its audience might be concerned makes the play resemble private-theater productions written for London performance, and perhaps more importantly the court masque, which shares with SUMMER'S LAST WILL AND TESTAMENT not only a dramatic structure that involves singing and dancing but also a peculiarly intimate relationship between actors and audience, fiction and the real lives of those watching; like the masque, the play is more involved in the symbolic representation of cosmic process than in dramatic plot and characterization. On the other hand, the procession of the seasons, the debate structure, and the pageantry owe much to the popular tradition of the morality play, and, as C. L. Barber points out in his fine discussion of the play in *Shakespeare's Festive Comedy*, to traditional games and social customs and pageantry of just the sorts that Shakespeare would shortly use in his *Midsummer Night's Dream*; and Will Summers, the court jester turned Chorus, is a clown in the best traditions of the public theater.

SUMMER'S LAST WILL AND TESTAMENT is notable for its unique fusion of the quirky personality of its author with pageantry materials steeped in English tradition and with a characteristic Renaissance multivalence of attitude toward the passage of time and the process of mutability. Its debates, and Will Summers' sardonic diatribes, permit Nashe to indulge in the invective of his pamphlets; its educated audience allows him to parade his learning—which, as the notes testify, is often dust thrown in the audience's eyes, because most of the Latin quotations are half-remembered and an extraordinary number of them are immediately derived not from their literary sources but rather from Cornelius Agrippa's *De Incertitudine et Vanitate Omnium Scientiarum et Artium* (1531, translated 1569), a learned attack on magic and many other forms of learning by a truculent writer who had himself written sympathetically about occult science. Aggressive in its rhetoric, its pedantry, and its inclusiveness, it is just the kind of book that would have appealed to Nashe, and he seems to have kept it in front of him as he wrote. The notes identify many sources of quotation and allusion in order to suggest the range of Nashe's very Elizabethan learning and interests. There is no known source for the general scheme of the play.

SUMMER'S LAST WILL AND TESTAMENT was printed in 1600 in quarto (Q). Though it was reprinted a few times in the nineteenth century, its only authoritative edition is the great text by R. B. McKerrow in his monumental *Works of Thomas Nashe*, to which all editors and readers must be indebted. N. R.

Summer's Last Will and Testament

DRAMATIS PERSONÆ

WILL SUMMERS[1]
SUMMER
AUTUMN } with Satyrs
WINTER } and Woodnymphs.
VERTUMNUS[2]
VER,[3] with his Train
SOLSTITIUM,[4] with Shepherds
SOL,[5] with a Noise[6] of Musicians
ORION,[7] with Huntsmen.

HARVEST, with Reapers.
BACCHUS, with his Companions
CHRISTMAS } sons to Winter
BACKWINTER[8] } sons to Winter
Morris Dancers[9] with the Hobbyhorse[10]
Three Clowns
Three Maids
Boy with an Epilogue

Enter WILL SUMMERS, *in his fool's coat but half on, coming out.*

Noctem peccatis et fraudibus objice nubem.[1] There is no such fine time to play the knave in as the night. I am a goose, or a ghost at least; for what with turmoil of getting my fool's apparel, and care of being perfect, I am sure I have not yet supped tonight. Will Summer's ghost I should be, come to present you with Summer's last will and testament. Be it so, if my Cousin Ned[2] will lend me his chain[3] and his fiddle. Other stately-paced Prologues use to attire themselves within;[4] I, that have a toy[5] in my head more than ordinary, and use to go without money, without garters, without girdle, without a hatband,[6] without points[7] to my hose, without a knife to my dinner, and make so much use of this word "without" in every thing, will here dress me without.[8] Dick Huntley[9] cries, "Begin, begin," and all the whole house, "For shame, come away"; when I had my things but now brought me out of the laundry—God forgive me, I did not see my lord before! I'll set a good face on it, as though what I had talked idly all this while were my part. So it is, *boni viri*,[10] that one fool presents another; and I, a fool by nature and by art, do speak to you in the person of the idiot our play-maker. He, like a fop and an ass, must be making himself a public laughingstock, and have no thank for his labor; where other *Magisterii*,[11] whose invention is far more exquisite, are content to sit still and do nothing. I'll show you what a scurvy Prologue he had made me, in an old vein of similitudes: if you be good fellows, give it the hearing, that you may judge of him thereafter. 30

THE PROLOGUE

At the solemn feast of the *Triumviri*[12] in Rome, it was seen and observed that the birds ceased to sing and sat solitary on the housetops by reason of the sight of a painted serpent set openly to view.[13] So fares it with us novices that here betray our imperfections: we, afraid to look on the imaginary serpent of envy, painted in men's affections, have ceased to tune any music of mirth to your ears this twelvemonth, thinking that, as it is the nature of the serpent to hiss, so childhood and ignorance would play the goslings, contemning and 40 condemning what they understood not. Their censures we weigh not, whose senses are not yet unswaddled. The little minutes will be continually striking, though no man regard them; whelps will bark before they can see and strive to bite before they have teeth. Politianus[14] speaketh of a beast who, while he is cut on the table, drinketh and represents the motions and voices of a living creature. Such like foolish beasts are we, who, whilst we are cut, mocked, and flouted at in every man's

DRAMATIS PERSONÆ
[1] *Will Summers:* called Will Summer by Q, Henry VIII's famous jester from *c.* 1525, *d.* 1560.
[2] *Vertumnus:* Etruscan god of the changing year, of the seasons and their productions, and of trade.
[3] *Ver:* Spring. [4] *Solstitium:* Solstice.
[5] *Sol:* Sun. [6] *Noise:* Band.
[7] *Orion:* mythical gigantic hunter, identical with the constellation.
[8] *Backwinter:* a return of winter after its normal time.
[9] *Morris Dancers:* performers of a grotesque dance, fantastically costumed, often to represent characters of the Robin Hood legend, and wearing bells.
[10] *Hobbyhorse:* a morris dancer wearing a wicker figure of a horse attached at the waist and miming a horse's movements.

THE PLAY
[1] *L.:* Cover my sins with night and my deceptions with a cloud; Horace, *Epistles*, I. 16. 62.
[2] *Ned:* probably the name of the fool in the Archbishop's household. [3] *chain:* ensign of office.
[4] *within:* in the tiring house.
[5] *toy:* fancy; possibly a pun on Toy, which may be the name of the actor who played Will Summers (see l. 1093).
[6] *hatband:* Hats without bands were eccentric attire.
[7] *points:* laces. [8] "*without*": on stage.
[9] *Dick Huntley:* probably the prompter.
[10] *L.:* gentlemen. [11] *L.:* Masters.
[12] *L.:* Lepidus, Mark Antony, and Octavius, the three men who shared supreme authority in Rome.
[13] *At . . . view:* An anecdote told by Pliny; Lepidus had a painting of a serpent hung up to silence the birds that kept him awake at night.
[14] *Politianus:* Politian, i.e., Angelo Poliziano, 1454–94, Italian humanist and friend of Lorenzo the Magnificent.

common talk will, notwithstanding, proceed to 50 shame ourselves to make sport. No man pleaseth all; we seek to please one. Didymus[15] wrote four thousand books, or, as some say, six thousand, of the art of Grammar. Our author hopes it may be as lawful for him to write a thousand lines of as light a subject. Socrates, whom the oracle pronounced the wisest man of Greece, sometimes danced; Scipio and Laelius[16] by the seaside, played at pebblestones.[17] *Semel insanivimus omnes.*[18] Every man cannot, with Archimedes,[19] make a heaven of brass, or dig gold out of the iron mines of the law. 60 Such odd trifles as mathematicians' experiments be, artificial flies to hang in the air by themselves, dancing balls, an egg-shell that shall climb up to the top of a spear, fiery breathing gourds,[20] *poeta noster*[21] professeth not to make. *Placeat sibi quisques, licebit.*[22] What's a fool but his bauble?[23] Deep-reaching wits, here is no deep stream for you to angle in. Moralizers, you that wrest a never-meant meaning out of every thing, applying all things to the present time, keep your attention for the common[24] stage; for here are no quips in charac- 70 ters[25] for you to read. Vain glozers[26] gather what you will. Spite, spell backwards what thou canst. As the Parthians fight, flying away, so will we prate and talk, but stand to nothing that we say.

How say you, my masters, do you not laugh at him for a coxcomb? Why he hath made a prologue longer than his play: nay, 'tis no play neither, but a show. I'll be sworn the jig[27] of Rowland's godson[28] is a giant in comparison of it. What can be made of Summer's last will and testament? Such another thing as Gyllian 80 of Brainford's will,[29] where she bequeathed a score of

[15] *Didymus:* Diomedes, fourth-century A.D. author of a three-volume *Art of Grammar.*

[16] *Scipio and Laelius:* Scipio the Younger, destroyer of Carthage in 146 B.C., and his protégé Gaius Laelius; Cicero reports that they gathered shells and pebbles.

[17] *pebblestone:* perhaps a version of "checkstones," a Scots game resembling jacks.

[18] L.: Once we were all mad; Mantuan, *Eclogues,* I. 118.

[19] *Archimedes:* Syracusan mathematician, 287–212 B.C., revered by alchemical writers such as Cornelius Agrippa (1486–1535), source of this claim and of many of the allu- sions in the play. [20] *gourds:* Q "goares."

[21] L.: our poet. [22] L.: May everyone please himself.

[23] *bauble:* stick carried by the fool, with a fantastically carved head with asses' ears at the top. [24] *common:* public.

[25] *quips in characters:* personal allusions in code.

[26] *glozers:* annotators.

[27] *jig:* comic rhymed dialogue sung and danced by actors.

[28] *Rowland's godson:* based on the sixty-seventh tale in Boccaccio's *Decameron,* a popular subject for jigs.

[29] *Gyllian . . . will:* a popular tale; "Brainford" is Brent- ford, a London suburb on the north side of the Thames.

[30] *tittle . . . boy:* meaning unsure; "tittle-tattle" means "nonsense." [31] *God . . . night:* worse luck! too bad!

[32] *Watling Street:* a Roman road in England; London street, site of the drapers' shops; the Milky Way; meaning here unclear. [33] *in cue:* in humor or temper.

[34] L.: at a loss, unable to proceed. [35] *leav'st:* cease.

[36] *green men:* dressed up in green costumes as wild men of the woods.

[37] *"Jowben":* presumably a song, of which no record now remains.

[38] L.: A single night waits for everyone, and the road of death must be walked; Horace, *Odes,* I. 28. 15–16.

farts amongst her friends. Forsooth, because the plague reigns in most places in this latter end of summer, Summer must come in sick; he must call his officers to account, yield his throne to Autumn, make Winter his executor, with tittle tattle Tom boy.[30] God give you good night[31] in Watling Street.[32] I care not what you say now, for I play no more than you hear; and some of that you heard too, by your leave, was extempore. He were as good have let me had the best part, for I'll 90 be revenged on him to the uttermost in this person of *Will Summers,* which I have put on to play the prologue, and mean not to put off 'till the play be done. I'll sit as a Chorus, and flout the actors and him at the end of every scene. I know they will not interrupt me, for fear of marring of all; but look to your cues, my masters, for I intend to play the knave in cue,[33] and put you besides all your parts, if you take not the better heed. Actors, you rogues, come away; clear your throats, blow your noses, and wipe your mouths ere you enter, that 100 you may take no occasion to spit or to cough when you are *non plus.*[34] And this I bar, over and besides, that none of you stroke your beards to make action, play with your codpiece points, or stand fumbling on your buttons, when you know not how to bestow your fin- gers. Serve God, and act cleanly. A fit of mirth, and an old song first, if you will.

Enter SUMMER, *leaning on* AUTUMN'S *and* WINTER'S *shoulders, and attended on with a train of* Satyrs *and* Woodnymphs, *singing* [VERTUMNUS *also following him*].

Fair Summer droops, droop men and beasts therefore; *So fair a summer look for never more:* *All good things vanish less than in a day,* 110 *Peace, plenty, pleasure, suddenly decay.* *Go not yet away, bright soul of the sad year;* *The earth is hell when thou leav'st*[35] *to appear.*

What, shall those flowers that decked thy garland erst, *Upon thy grave be wastefully disperst?* *O trees, consume your sap in sorrow's source;* *Streams turn to tears your tributary course.* *Go not yet hence, bright soul of the sad year;* *The earth is hell when thou leav'st to appear.* 119

The Satyrs *and* Woodnymphs *go out singing and leave* SUMMER *and* WINTER, [*with* VERTUMNUS *and* AUTUMN] *on the stage.*

Will S. A couple of pretty boys if they would wash their faces and were well breeched an hour or two. The rest of the green men[36] have reasonable voices, good to sing catches, or the great "Jowben"[37] by the fire's side in a winter's evening. But let us hear what Summer can say for himself, why he should not be hissed at.

Sum. What pleasure alway lasts? No joy endures: Summer I was; I am not as I was; Harvest and age have whitened my green head; On Autumn now and Winter must I lean. Needs must he fall, whom none but foes uphold, 130 Thus must the happiest man have his black day. *Omnibus una manet nox, et calcanda semel via lethi.*[38]

This month have I lain languishing a-bed,
Looking each hour to yield my life and throne;
And died I had indeed unto the earth,
But that Eliza, England's beauteous Queen,
On whom all seasons prosperously attend,
Forbade the execution of my fate
Until her joyful progress [39] was expired.
For her doth Summer live, and linger here, 140
And wisheth long to live to her content;
But wishes are not had when they wish well.
I must depart, my death-day is set down;
To these two must I leave my wheaten crown.
So unto unthrifts rich men leave their lands,
Who in an hour consume long labor's gains.
True is it that divinest Sidney sung,
"Oh, he is marred that is for others made." [40]
Come near, my friends, for I am near my end.
In presence of this honorable train, 150
Who love me, for [41] I patronize their sports,
Mean I to make my final testament:
But first I'll call my officers to count, [42]
And of the wealth I gave them to dispose,
Known what is left, I may know what to give.
Vertumnus then, that turn'st the year about,
Summon them one by one to answer me.
First Ver, the Spring, unto whose custody
I have committed more than to the rest;
The choice of all my fragrant meads and flowers, 160
And what delights so e'er nature affords.

Vertum. I will, my lord. Ver, lusty Ver, by the name of [43] lusty Ver, come into the court! lose a mark in issues. [44]

Enter VER, *with his train, overlaid with suits of green moss, representing short grass, singing.*

THE SONG

Spring, the sweet spring, is the year's pleasant king;
Then blooms each thing, then maids dance in ring,
Cold doth not sting, the pretty birds do sing,
Cuckow, jug, jug, pu we, to witta woo.

The palm [45] *and may* [46] *make country houses gay,*
Lambs frisk and play, the shepherds pipe all day, 170
And we hear aye, birds tune this merry lay,
Cuckow, jug, jug, pu we, to witta woo.

The fields breathe sweet, the daisies kiss our feet,
Young lovers meet, old wives a-sunning sit;
In every street these tunes our ears do greet,
Cuckow, jug, jug, pu we, to witta woo.
Spring, the sweet spring.

Will S. By my troth, they have voices as clear as crystal: this is a pretty thing, if it be for nothing but to go a-begging with. 180

Sum. Believe me, Ver, but thou art pleasant bent; This humor should [47] import a harmless mind. Know'st thou the reason why I sent for thee?

Ver. No faith, nor care not whether I do or no. If you will dance a galliard, [48] so it is: if not

Falangtado, [49] *Falangtado,*
To wear the black and yellow, [50]
Falangtado, Falangtado,
My mates are gone, I'll follow.

Sum. Nay, stay awhile, we must confer and talk. 190 Ver, call to mind I am thy sovereign lord, And what thou hast, of me thou hast and hold'st. Unto no other end I sent for thee, But to demand a reckoning at thy hands, How well or ill thou hast employed my wealth.

Ver. If that be all, we will not disagree: A clean trencher [51] and a napkin you shall have presently.

Will S. The truth is, this fellow hath been a tapster in his days.

VER *goes in, and fetcheth out the* Hobbyhorse *and the* Morris Dance[rs], *who dance about.*

Sum. How now? is this the reckoning we shall have?

Wint. My lord, he doth abuse you; brook it 201 not.

Aut. Summa totalis, [52] I fear, will prove him but a fool.

Ver. About, about! lively, put your horse to it, rein him harder; jerk him with your wand; sit fast, sit fast, man! fool, hold up your ladle [53] there.

Will S. O brave [54] hall! [55] oh, well said, butcher. Now for the credit of Worcestershire. [56] The finest set of morris dancers that is between this and Streat- 210 ham. Marry, methinks there is one of them danceth like a clothier's horse, [57] with a woolpack on his back. You friend with the hobbyhorse, go not too fast, for fear of wearing out my lord's tile-stones with your hobnails.

Ver. So, so, so; trot the ring twice over and away. May it please my lord, this is the grand capital sum; but there are certain parcels behind, as you shall see.

Sum. Nay, nay, no more; for this is all too much.

Ver. Content yourself; we'll have variety.

Here enter three Clowns *and three* Maids, *singing this song, dancing.*

[39] *progress:* a royal trip through the country; one such, through the midland counties, occurred in autumn 1592.
[40] *"Oh . . . made":* from the eclogues at the end of Book One of the *Arcadia,* published 1590. [41] *for:* because.
[42] *count:* account. [43] *by . . . of:* a courtroom formula.
[44] *lose . . . issues:* be fined a mark for nonattendance.
[45] *palm:* a northern shrub substituted for the true palm on Palm Sunday.
[46] *may:* hawthorne which blooms in May.
[47] *should:* must.
[48] *galliard:* a quick lively dance in triple time.
[49] *Falangtado:* refrain of a popular song.
[50] *black and yellow:* colors of constancy.
[51] *trencher:* wooden plate. [52] *L.:* Sum total.
[53] *ladle:* carried by the Fool or the Hobbyhorse to collect money from the audience; but perhaps an error for "bable," bauble. [54] *brave:* splendid.
[55] *hall:* perhaps Hall, a musician.
[56] *Worcestershire:* Some of the dancers may have come from there in the household of Whitgift, who had been Bishop of Worcester.
[57] *clothier's horse:* clotheshorse, structure on which washed linen is dried.

Trip and go, heave and hoe, 220
Up and down, to and fro ;
From the town to the grove,
Two and two let us rove
A maying, a playing;
Love hath no gainsaying;
So merrily trip and go.

Will S. Beshrew[58] my heart, of a number of ill legs I
never saw worse dancers. How blest are you that the
wenches of the parish do not see you! 229

Sum. Presumptuous Ver, uncivil nurtured boy,
Think'st I will be derided thus of thee?
Is this th' account and reckoning that thou mak'st?

Ver. Troth, my lord, to tell you plain, I can give you
no other account; *nam quae habui perdidi :*[59] what I had
I have spent on good fellows, in these sports you have
seen, which are proper to the spring, and others of like
sort—as giving wenches green gowns,[60] making garlands
for fencers, and tricking up children gay—have I be-
stowed all my flowery treasure and flower of my youth.

Will S. A small matter. I know one spent in less than
a year eight and fifty pounds in mustard; and 241
another that ran in debt, in the space of four or five
year, above fourteen thousand pound in lute-strings
and gray paper.[61]

Sum. Oh, monstrous unthrift! who ere heard the
 like?
The sea's vast throat, in so short tract of time,
Devoureth nor consumeth half so much.
How well might'st thou have lived within thy bounds.

Ver. What talk you to me of living within my
bounds? I tell you none but asses live within 250
their bounds: the silly beasts, if they be put in a pas-
ture that is eaten bare to the very earth, and where there
is nothing to be had but thistles, will rather fall soberly
to those thistles and be hunger-starved, than they will
offer to break their bounds; whereas the lusty courser,[62]
if he be in a barren plot, and spy better grass in some
pasture near adjoining, breaks over hedge and ditch,
and to go,[63] ere he will be pent in and not have his belly
full. Peradventure, the horses[64] lately sworn to be
stolen carried that youthful mind, who, if they had been
asses would have been yet extant. 261

Will S. Thus, we may see, the longer we live the
more we shall learn: I ne'er thought honesty an ass till
this day.

Ver. This world is transitory; it was made of no-
thing, and it must to nothing: wherefore, if we will do
the will of our high creator, whose will it is that it pass
to nothing, we must help to comsume it to nothing. Gold
is more vile than men: men die in thousands and ten
thousands, yea many times in hundred thousands, 270
in one battle. If then the best husband be so liberal
of his best handywork, to what end should we make
much of a glittering excrement, or doubt to spend at a
banquet as many pounds as he spends men at a battle?
Methinks I honor Geta,[65] the Roman Emperor, for a
brave minded fellow; for he commanded a banquet to
be made him of all meats under the sun, which were
served in after the order of the alphabet, and the clerk
of the kitchen, following the last dish, which was two
mile off from the foremost, brought him an index 280
of their several names. Neither did he pingle[66] when it
was set on the board, but for the space of three days and
three nights never rose from the table.

Will S. Oh, intolerable lying villain, that was never
begotten without the consent of a whetstone![67]

Sum. Ungracious man; how fondly he argueth.

Ver. Tell me, I pray, wherefore was gold laid under
our feet in the veins of the earth, but that we should
contemn it, and tread upon it, and so consequently
tread thrift under our feet? It was not known 290
till the iron age, *donec facinus invasit mortales,*[68] as the
poet says; and the Scythians always detested it. I will
prove it that an unthrift, of any, comes nearest a happy
man, in so much as he comes nearest to beggary.
Cicero saith, *summum bonum* consists in *omnium rerum
vacatione,*[69] that it is the chiefest felicity that may be to
rest from all labors. Now who doth so much *vacare a
rebus,*[70] who rests so much, who hath so little to do as
the beggar?

Who can sing so merry a note, 300
 As he that cannot change a groat?

Cui nil est, nil deest :[71] he that hath nothing wants[72]
nothing. On the other side, it is said of the carl,[73] *omnia
habeo, nec quicquam habeo :*[74] I have all things, yet want
every thing. *Multi mihi vitio vertunt quia egeo,* saith
Marcus Cato in Aulus Gellius;[75] *at egeo illis quia ne-
queunt egere ;* many unpraid me, saith he, because I
am poor; but I upbraid them because they cannot live
if they were poor. It is a common proverb, *Divesque
miserque,* a rich man and a miserable: *nam natura* 310
paucis contenta,[76] none so contented as the poor man.

[58] *Beshrew :* Curse.

[59] *L.:* for what I had, I lost; adapted from Terence,
Eunuchus, II. 2. 6.

[60] *giving . . . gowns :* throwing them down on the grass.

[61] *lute . . . paper :* a standard "commodity," goods of low
value sold on credit by a usurer evading the ten per cent limit
on interest to a needy person, who could raise cash by resell-
ing them at a lower price to the usurer and would then owe
the full price. [62] *courser :* horse. [63] *to go :* is off.

[64] *horses :* stolen from sun-god by his son Phaëthon, who
drove too near earth and was destroyed by Zeus.

[65] *Geta :* brother of Caracalla, Emperor A.D. 209–212

[66] *pingle :* eat with little appetite, fuss with one's food.

[67] *whetstone :* traditional prize for lying.

[68] *L.:* when criminality took possession of men.

[69] *L.:* the highest good . . . in freedom from all things;
adapted from Cicero, *De Natura Deorum.* I. 20. 53.

[70] *L.:* be free from things.

[71] *L.:* translated in text; adapted from Terence, *Eunuchus,*
II. 2. 12. [72] *wants :* lacks.

[73] *carl :* country man, often with implications of churlish-
ness and miserliness.

[74] *L.:* This and the following Latin phrases are translated
in text.

[75] *Marcus . . . Gellius :* Aulus Gellius, A.D. 123–165, Ro-
man writer who preserved extracts from earlier writers such
as Marcus Cato, 234–149 B.C., leading Roman republican
administrator and orator.

[76] *L.:* for nature is content with a few things; proverbial.

Admit that the chiefest happiness were not rest or ease, but knowledge, as Herillus, Alcidamas,[77] and many of Socrates' followers affirm; why *paupertas omnes perdocet artes*,[78] poverty instructs a man in all arts; it makes a man hardy and venturous, and therefore is it called of the poets, *paupertas audax*,[79] valiant poverty. It is not so much subject to inordinate desires as wealth or prosperity. *Non habet, unde suum paupertas pascat amorem:*[80] poverty hath not wherewithal to feed 320 lust. All the poets were beggars; all alchemists, and all philosophers are beggars. *Omnia mea mecum porto*,[81] quoth Bias,[82] when he had nothing but bread and cheese in a leathern bag, and two or three books in his bosom. Saint Francis, a holy saint, a[83] never had any money. It is madness to dote upon muck. That young man of Athens Aelianus[84] makes mention of may be an example to us, who doted so extremely on the image of fortune, that when he might not enjoy it he died for sorrow. The earth yields all her fruits together, 330 and why should not we spend them together? I thank heavens on my knees, that have made me an unthrift.

Sum. Oh, vanity itself; oh, wit ill spent!
So study thousands not to mend their lives,
But to maintain the sin they most affect,
To be hell's advocates against their own souls.
Ver, since thou giv'st such praise to beggary
And hath defended it so valiantly,
This be thy penance: thou shalt ne'er appear
Or come abroad, but Lent shall wait on thee; 340
His scarcity may countervail thy waste.
Riot may flourish, but finds want at last.
Take him away that knoweth no good way,
And lead him the next way to woe and want.

 Exit VER.

Thus in the path of knowledge many stray,
And from the means of life fetch their decay.

Will S. Heigh ho. Here is a coil[85] indeed to bring beggars to stocks. I promise you truly I was almost asleep; I thought I had been at a sermon. Well, for this one night's exhortation, I vow, by God's grace, 350 never to be good husband[86] while I live. But what is this to the purpose? *Hur come to Powl*[87] (as the Welshman says) *and hur pay an halfpenny for hur seat, and hur hear the preacher talg, and hur talg very well, by gis;*[88] *but yet a cannot make hur laugh: go to a theater and hear a Queen's Fice*,[89] *and he make hur laugh, and laugh hur belly full.* So we come hither to laugh and be merry, and we hear a filthy beggarly oration in the praise of beggary. It is a beggarly poet that writ it; and that makes him so much commend it, because he knows not 360 how to mend himself. Well, rather than he shall have no employment but lick dishes, I will set him a work myself, to write in praise of the art of stooping, and how there was never any famous thresher, porter, brewer, pioner,[90] or carpenter, that had straight back. Repair to my chamber, poor fellow, when the play is done, and thou shalt see what I will say to thee.

Sum. Vertumnus, call Solstitium. 368
Vertum. Solstitium, come into the court without. Peace there below! make room for Master Solstitium.

Enter SOLSTITIUM, *like an aged hermit, carrying a pair of balances, with an hour-glass in either of them; one hour-glass white, the other black: he is brought in by a number of* Shepherds, *playing upon recorders.*

Solst. All hail to Summer, my dread sovereign lord.
Sum. Welcome, Solstitium; thou art one of them
To whose good husbandry we have referred
Part of those small revenues that we have.
What hast thou gained us? What hast thou brought in?
Solst. Alas, my lord, what gave you me to keep
But a few day's-eyes[91] in my prime of youth?
And those I have converted to white hairs:
I never loved ambitiously to climb
Or thrust my hand too far into the fire. 380
To be in heaven, sure, is a blessèd thing,
But Atlas-like to prop heaven on one's back
Cannot but be more labor than delight.
Such is the state of men in honor placed;
They are gold vessels made for servile uses;
High trees that keep the weather from low houses,
But cannot shield the tempest from themselves.
I love to dwell betwixt the hills and dales;
Neither to be so great to be envied,
Nor yet so poor the world should pity me. 390
Inter utrumque tene, medio tutissimus ibis.[92]
Sum. What dost thou with those balances thou bear'st?
Solst. In them I weigh the day and night alike:
This white glass is the hour-glass of the day,
This black one the just measure of the night.
One more than other holdeth not a grain;
Both serve times just proportion to maintain.
Sum. I like thy moderation wondrous well;
And this thy balance, weighing the white glass
And black, with equal poise and steadfast hand, 400
A pattern is to princes and great men,
How to weigh all estates indifferently;
The spiritualty and temporalty alike:
Neither to be too prodigal of smiles,
Nor too severe in frowning without cause.
If you be wise, you monarchs of the earth,

[77] *Herillus, Alcidamas:* philosophers of the second and fourth centuries A.D., respectively; their names are taken from a passage in Cornelius Agrippa's *De Incertitudine et Vanitate Omnium Scientiarum et Artium*, translated 1569.
[78] *L.:* translated in text; proverbial.
[79] *L.:* bold poverty; Horace, *Epistles*, II. 2. 51.
[80] *L.:* translated in text; Ovid, *Remedia Amoris*, 749.
[81] *L.:* All that is mine I carry with me; Cicero, *Paradoxes*, I. I. 8.
[82] *Bias:* philosopher, one of the seven wise men of ancient Greece. [83] *a:* he; Q "&".
[84] *Aelianus:* Greek rhetorician writing in Rome, A.D. 170–235, cited by Agrippa. [85] *coil:* tumult.
[86] *husband:* thrifty person.
[87] *Powl:* St. Paul's Cathedral.
[88] *by gis:* mild oath, corruption of "Jesus."
[89] *Fice:* Vice, the stock comic character.
[90] *pioner:* ditch-digger, miner. [91] *day's-eyes:* daisies.
[92] *L.:* Hold on between the two; you will go most safely in the middle; Ovid, *Metamorphoses*, II. 137, 140.

Have two such glasses still[93] before your eyes;
Think as you have a white glass running on,
Good days, friends, favor, and all things at beck,
So, this white glass run out, as out it will, 410
The black comes next; your downfall is at hand.
Take this of me, for somewhat I have tried;
A mighty ebb follows a mighty tide.
But say, Solstitium, hadst thou nought besides?
Nought but day's-eyes and fair looks gave I thee?

 Solst. Nothing, my lord, nor aught more did I ask.
 Sum. But hadst thou always kept thee in my sight,
Thy good deserts, though silent, would have asked.
 Solst. Deserts, my lord, of ancient servitors
Are like old sores, which may not be ripped up. 420
Such use these times have got, that none must beg,
But those that have young limbs to lavish fast.
 Sum. I grieve no more regard was had of thee.
A little sooner hadst thou spoke to me,
Thou hadst been heard, but now the time is past:
Death waiteth at the door for thee and me.
Let us go measure out our beds in clay;
Nought but good deeds hence shall we bear away.
Be, as thou wert, best steward of my hours,
And so return unto thy country bowers. 430

Here SOLISTITIUM *goes out with his music,*
as he comes in.

Will S. Fie, fie of honesty, fie! Solstitium is an ass
perdy;[94] this play is a gallimaufry.[95] Fetch me some
drink, somebody. What cheer, what cheer, my hearts?
Are not you thirsty with listening to this dry sport?
What have we to do with scales and hourglasses, ex-
cept we were bakers or clock-keepers? I cannot tell
how other men are addicted, but it is against my pro-
fession to use any scales[96] but such as we play at with
a bowl,[97] or keep any hours, but dinner or supper. It is a
pedantical thing to respect times and seasons. If a 440
man be drinking with good fellows late, he must come
home for fear the gates be shut. When I am in my warm
bed, I must rise to prayers because the bell rings. I like
no such foolish customs. Actors, bring now a black
jack[98] and a rundlet[99] of Rhenish wine, disputing of
the antiquity of red noses. Let the prodigal child[100]
come out in his doublet and hose all greasy, his shirt
hanging forth, and ne'er a penny in his purse, and talk
what a fine thing it is to walk summerly,[101] or sit

[93] *still:* always.
[94] *perdy:* a mild oath (*par dieu,* by God).
[95] *gallimaufry:* a dish made by hashing up odds and ends
of food; a heterogeneous and absurd mixture.
[96] *scales:* kayles, the pins used in a game resembling nine-
pins. [97] *bowl:* ball used in such a game.
[98] *black jack:* large leather jug for beer, etc., coated ex-
ternally with tar. [99] *rundlet:* small barrel.
[100] *prodigal child:* common subject of popular drama.
[101] *summerly:* in a manner befitting summer.
[102] *in . . . proceed:* allusion to the by then proverbial
opening rhyme of the hornbook or school grammar.
[103] *ut . . . sol:* the syllables sung to the notes of the scale.
[104] *big:* truculent, swaggering.
[105] *for . . . respect:* for a consideration.
[106] *Daphne:* turned into a tree to escape the pursuing sun-
god Apollo. [107] *Thetis:* referring to the sea-nymph.

whistling under a hedge and keep hogs. Go 450
forward, in grace and virtue to proceed,[102] but let us
have no more of these grave matters.
 Sum. Vertumnus, will Sol come before us.
 Vert. Sol, *sol, ut, re, me, fa, sol!*[103]
Come to church while the bell toll.

Enter SOL, *very richly attired, with a noise of*
Musicians *before him.*

 Sum. Ay, marry, here comes majesty in pomp,
Resplendent Sol, chief planet of the heavens!
He is our servant, looks he ne'er so big.[104]
 Sol. My liege, what cravest thou at thy vassal's
 hands?
 Sum. Hypocrisy, how it can change his shape! 460
How base is pride from his own dunghill put!
How I have raised thee, Sol, I list not tell,
Out of the ocean of adversity,
To sit in height of honor's glorious heaven,
To be the eyesore of aspiring eyes:
To give the day her life from thy bright looks,
And let nought thrive upon the face of earth,
From which thou shalt withdraw thy powerful smiles.
What hast thou done deserving such high grace?
What industry, or meritorious toil, 470
Canst thou produce to prove my gift well placed?
Some service or some profit I expect:
None is promoted but for some respect.[105]
 Sol. My lord, what needs these terms betwixt us
 two?
Upbraiding ill beseems your bounteous mind:
I do you honor for advancing me.
Why, 'tis a credit for your excellence
To have so great a subject as I am.
This is your glory and magnificence,
That without stooping of your mightiness, 480
Or taking any whit from your high state,
You can make one as mighty as yourself.
 Aut. Oh, arrogance exceeding all belief!
Summer, my lord, this saucy upstart Jack,
That now doth rule the chariot of the sun,
And makes all stars derive their light from him,
Is a most base insinuating slave,
The son of parsimony and disdain;
One that will shine on friends and foes alike,
That under brightest smiles hideth black showers, 490
Whose envious breath doth dry up springs and lakes
And burns the grass, that beasts can get no food.
 Wint. No dunghill hath so vile an excrement,
But with his beams he will forthwith exhale.
The fens and quagmires tithe to him their filth;
Forth purest mines he sucks a gainful dross.
Green ivy-bushes at the vintner's doors
He withers and devoureth all their sap.
 Aut. Lascivious and intemperate he is.
The wrong of Daphne[106] is a well known tale. 500
Each evening he descends to Thetis'[107] lap
The while men think he bathes him in the sea.
Oh, but when he returneth whence he came
Down to the west, then dawns his deity,
Then doubled is the swelling of his looks.

He overloads his car with orient[108] gems,
And reins his fiery horses with rich pearl.
He terms himself the god of poetry,
And setteth wanton songs unto the lute.
 Wint. Let him not talk, for he hath words at will,
And wit to make the baddest matter good. 511
 Sum. Bad words, bad wit! oh, where dwells faith or
 truth?
Ill usury my favors reap from thee,
Usurping Sol, the hate of heaven and earth.
 Sol. If envy unconfuted may accuse,
Then innocence must uncondemnèd die.
The name of martyrdom offense hath gained
When fury stopped a froward[109] judge's ears.
Much I'll not say—much speech much folly shows—
What I have done you gave me leave to do. 520
The excrements you bred, whereon I feed,
To rid the earth of their contagious fumes;
With such gross carriage did I load my beams;
I burned no grass, I dried no springs and lakes,
I sucked no mines, I withered no green boughs,
But when to ripen harvest I was forced
To make my rays more fervent than I wont.
For Daphne's wrongs, and 'scapes in Thetis' lap,
All gods are subject to the like mishap.
Stars daily fall—'tis use[110] is all in all— 530
And men account the fall but nature's course.
Vaunting my jewels hasting to the west,
Or rising early from the gray-eyed morn,
What do I vaunt but your large bountyhood,
And show how liberal a lord I serve?
Music and poetry, my two last crimes,
Are those two exercises of delight,
Wherewith long labors I do weary out.
The dying swan is not forbid to sing:
The waves of Heber played on Orpheus' strings,[111]
When he, sweet music's trophy, was destroyed. 541
And as for poetry, woods' eloquence,
(Dead Phaëthon's three sisters' funeral tears,
That by the gods were to electrum turned,)[112]
Not flint, or rocks of icy cinders framed,
Deny the source of silver-falling streams.
Envy envieth not outcries unrest:[113]
In vain I plead; well is to me a fault,
And these my words seem the slight web of art,
And not to have the taste of sounder truth. 550
Let none but fools be cared for of the wise;
Knowledge[114] own children knowledge most despise.
 Sum. Thou know'st too much to know to keep the
 mean;
He that sees all things oft sees not himself.
The Thames is witness of thy tyranny,
Whose waves thou hast exhaust for winter showers.
The naked channel plains her of thy spite,
That laid'st her entrails unto open sight.
Unprofitably borne to man and beast,
Which like to Nilus yet doth hide his head,[115] 560
Some few years since thou let'st o'erflow these walks,
And in the horserace[116] headlong ran at race,
While in a cloud thou hid'st thy burning face.
Where was thy care to rid contagious filth,

When some men wet-shod, with his waters, drooped?
Others that ate the eels his heat cast up
Sickened and died by them impoisonèd.
Sleep'st or keep'st thou then Admetus' sheep,[117]
Thou driv'st not back these flowings to the deep?
 Sol. The winds, not I, have floods and tides in chase.
Diana, whom our fables call the moon, 571
Only commandeth o'er the raging main;
She leads his wallowing offspring up and down;
She waning, all streams ebb; in the year,[118]
She was eclipsed, when that the Thames was bare.
 Sum. A bare conjecture, builded on perhaps.
In laying thus the blame upon the moon,
Thou imitat'st subtle Pythagoras,[119]
Who, what he would the people should believe,
The same he wrote with blood upon a glass, 580
And turned it opposite 'gainst the new moon;
Whose beams reflecting on it with full force,
Showed all those lines to them that stood behind,
Most plainly writ in circle of the moon;
And then he said, "Not I, but the new moon,
Fair Cynthia, persuades you this and that."
With like collusion shalt thou not blind me;
But for abusing both the moon and me
Long shalt thou be eclipsèd by the moon,
And long in darkness live and see no light. 590
Away with him, his doom hath no reverse!
 Sol. What is eclipsed will one day shine again;
Though winter frowns the spring will ease my pain.
Time from the brow doth wipe out every stain.
 [*Exit* SOL.]
 Will S. I think the sun is not so long in passing
through the twelve signs, as the son of a fool hath been
disputing here about "had I wist."[120] Out of doubt the
poet is bribed of some that have a mess[121] of cream to
eat before my lord go to bed yet, to hold him half 599
the night with riff raff[122] of the rumming of Elinor.[123]

[108] *orient:* brilliant. [109] *froward:* obstinate.
[110] *use:* normal occurrence.
[111] *waves . . . strings:* As Ovid tells (*Metamorphoses*, XI. 50–52), the severed head of Orpheus and his lyre-strings played as they floated in the river Hebrus after his death at the hands of the Maenads.
[112] *Dead . . . turned:* Phaëthon's mourning sisters were turned into amber- (electrum-) dropping trees.
[113] *Dead . . . unrest:* These lines are apparently corrupt.
[114] *Knowledge:* a genitive form.
[115] *Which . . . head:* Textual corruption may be responsible for the difficulty; apparently the Thames is compared to the Nile in respect of the obscurity of its source.
[116] *horserace:* presumably a plot of land by the Thames used for the purpose, though none is recorded.
[117] *Admetus' sheep:* Apollo was punished by Zeus for killing the Cyclops by having to be a serf to the mortal Admetus, husband of Alcestis, who courteously employed him to care for his animals.
[118] *the year:* i.e., the present year.
[119] *Pythagoras:* sixth-century B.C. Greek metaphysician and mathematician revered by writers on alchemy such as C. Agrippa, source of this anecdote. [120] *wist:* known.
[121] *mess:* portion. [122] *riff raff:* nonsense, doggerel.
[123] *rumming of Elinor:* Skelton's *Tunning of Elynour Rumming* is an early sixteenth-century poem about an alewife and her lowlife patrons.

If I can tell what it means, pray God I may never get breakfast more when I am hungry. Troth, I am of opinion he is one of those hieroglyphical [124] writers, that by the figures of beasts, plants, and of stones, express the mind, as we do in A B C; or one that writes under hair, as I have heard of a certain notary, Histiaeus, [125] who following Darius in the Persian wars, and desirous to disclose some secrets of import to his friend Aristagoras, [126] that dwelt afar off, found out this means. He had a servant that had been long sick of a 610 pain in his eyes, whom, under pretense of curing his malady, he shaved from one side of his head to the other, and with a soft pencil wrote upon his scalp, as on parchment, the discourse of his business, the fellow all the while imagining his master had done nothing but noint his head with a feather. After this he kept him secretly in his tent, till his hair was somewhat grown, and then willed him to go to Aristagoras into the country, and bid him shave him, as he had done, and he should have perfect remedy. He did so, Aristagoras 620 shaved him with his own hands, read his friend's letter, and when he had done, washed it out, that no man should perceive it else, and sent him home to buy him a night-cap. If I wist there were any such knavery, or Peter Bales' [127] brachigraphy, [128] under Sol's bushy hair, I would have a barber, my host of the Murrion's [129] head, to be his interpreter, who would whet his razor on his Richmond cap, [130] and give him the terrible cut [131] like himself, but he would come as near as a quart pot to the construction of it. To be sententious, 630 not superfluous, Sol should have been beholding to the barber, and not the beard-master. Is it pride that is shadowed under this two-legged sun, that never came nearer heaven than Dubber's Hill? [132] That pride is not my sin; Sloven's Hall, where I was born, be my record. As for covetousness, intemperance, and exaction, I meet with nothing in a whole year but a cup of wine for such vices to be conversant in. *Pergite porro*, [133] my good children, [134] and multiply the sins of your absurdities

[124] *hieroglyphical*: symbolic.
[125] *Histiaeus*: tyrant of Miletus who assisted Darius, King of Persia, in his punitive campaign against the Scythians in 512 B.C. [126] *Aristagoras*: actually Histiaeus' son-in-law.
[127] *Peter Bales'*: Bales, ?1547–1610, was a stenographer, famed for his calligraphy and his ability to write much in little space; his "knavery" may be the plagiarism in his *The Writing Schoolmaster*.
[128] *brachigraphy*: shorthand, which may have been rediscovered by Bales or by his contemporary Timothy Bright.
[129] *Murrion's*: Blackamoor's.
[130] *Richmond cap*: unexplained allusion.
[131] *terrible cut*: haircut designed to make one frightening to one's enemies.
[132] *Dubber's Hill*: Duppa's Hill, west of Croydon.
[133] *L.*: Go right on.
[134] *my . . . children*: i.e., the child-actors.
[135] *rheum*: mucal discharge, thought to cause disease.
[136] *Urion*: original name of Orion.
[137] *Arion*: a mythological horse with magic powers.
[138] *bandogs*: ferocious chained dogs.
[139] *dog-days*: This sultry period extends from 3 July to 11 August. [140] *meteors*: i.e., *ignis fatuus*.
[141] *arre*: snarl. [142] *warrantize*: corroborate.

till you come to the full measure of the grand hiss, 640
and you shall hear how we will purge rheum [135] with censuring your imperfections.
 Sum. Vertumnus, call Orion.
 Vertum. Orion, Urion, [136] Arion; [137]
My lord thou must look upon.—
Orion, gentleman dog-keeper, huntsman, come into the court; look you bring all hounds, and no bandogs. [138]
Peace there, that we may hear their horns blow.

 Enter ORION *like a hunter, with a horn about his neck, all his* Men *after the same sort halloing, and blowing their horns.*

 Orion. Sirrah, was't thou that called us from our game?
How durst thou, being but a petty god, 650
Disturb me in the entrance of my sports?
 Sum. 'Twas I, Orion, caused thee to be called.
 Orion. 'Tis I, dread lord, that humbly will obey.
 Sum. How haps't thou left'st the heavens to hunt below?
As I remember thou wert Hyreus' son,
Whom of a huntsman Jove chose for a star,
And thou art called the Dog-star, art thou not?
 Aut. Pleaseth your honor, heaven's circumference
Is not enough for him to hunt and range,
But with those venom-breathèd curs he leads, 660
He comes to chase health from our earthly bounds.
Each one of those foul-mouthèd mangy dogs
Governs a day (no dog but hath his day);
And all the days by them so governèd,
The dog-days [139] hight; infectious fosterers
Of meteors [140] from carrion that arise,
And putrified bodies of dead men,
Are they engendered to that ugly shape,
Being nought else but preserved corruption.
'Tis these that in the entrance of their reign 670
The plague and dangerous agues have brought in.
They arre [141] and bark at night against the moon,
For fetching in fresh tides to cleanse the streets.
They vomit flames and blast the ripened fruits;
They are death's messengers unto all those
That sicken while their malice beareth sway.
 Orion. A tedious discourse built on no ground.
A silly fancy, Autumn, hast thou told,
Which no philosophy doth warrantize, [142]
No old receivèd poetry confirms. 680
I will not grace thee by confuting thee;
Yet in a jest (since thou rail'st so 'gainst dogs)
I'll speak a word or two in their defense.
That creature's best that comes most near to men.
That dogs of all come nearest, thus I prove:
First they excel us in all outward sense,
Which no one of experience will deny:
They hear, they smell, they see better than we.
To come to speech, they have it questionless,
Although we understand them not so well. 690
They bark as good old Saxon as may be,
And that in more variety than we:
For they have one voice when they are in chase,
Another when they wrangle for their meat,

Another when we beat them out of doors.
That they have reason, this I will allege:
They choose those things that are most fit for them,
And shun the contrary all that they may.
They know what is for their own diet best,
And seek about for't very carefully. 700
At sight of any whip they run away,
As runs a thief from noise of hue and cry.
Nor live they on the sweat of others' brows,
But have their trades to get their living with,
Hunting and coney-catching,[143] two fine arts.
Yea there be of them, as there be of men,
Of every occupation more or less:
Some carriers, and they fetch; some watermen,
And they will dive and swim when you bid them;
Some butchers, and they worry sheep by night; 710
Some cooks, and they do nothing but turn spits.
Chrysippus[144] holds dogs are logicians,
In that by study and by canvassing,
They can distinguish 'twixt three several things:
As when he cometh where three broad ways meet,
And of those three hath staid at two of them,
By which he guesseth that the game went not,
Without more pause he runneth on the third;
Which, as Chrysippus saith, insinuates,
As if he reasoned thus within himself: 720
Either he went this, that, or yonder way,
But neither that, nor yonder, therefore this,
But whether they logicians be or no,
Cynics they are, for they will snarl and bite;
Right courtiers to flatter and to fawn;
Valiant to set upon their enemies;
Most faithful and most constant to their friends.
Nay, they are wise, as Homer witnesseth,[145]
Who, talking of Ulysses' coming home,
Saith all his household but Argus his dog 730
Had quite forgot him: Ay, and his deep insight,
Nor Pallas'[146] art in altering of his shape,
Nor his base weeds, nor absence twenty years,
Could go beyond, or any way delude.
That dogs physicians are, thus I infer!
They are ne'er sick, but they know their disease,
And find out means to ease them of their grief;
Special good surgeons to cure dangerous wounds;
For struken with a stake into the flesh
This policy they use to get it out: 740
They trail one of their feet upon the ground,
And gnaw the flesh about where the wound is,
Till it be clean drawn out; and then, because
Ulcers and sores kept foul are hardly cured,
They lick and purify it with their tongue,
And well observe Hippocrates' old rule,
The only medicine for the foot is rest;
For if they have the least hurt in their feet,
They bear them up and look they be not stirred.
When humors rise they eat a sovereign herb, 750
Whereby what cloys their stomachs they cast up;
And as some writers of experience tell,
They were the first invented vomiting.
Shamest thou not, Autumn, unadvisedly
To slander such rare creatures as they be?

Sum. We called thee not, Orion, to this end,
To tell a story of dogs' qualities.
With all thy hunting how are we enriched?
What tribute payest thou us for thy high place?
Orion. What tribute should I pay you out of
 nought? 760
Hunters do hunt for pleasure, not for gain.
While dog-days last the harvest safely thrives;
The sun burns hot to finish up fruit's growth;
There is no blood letting to make men weak.[147]
Physicians with their cataposia[148]
[thei]r little[149] elinctoria[150]
Masticatorum[151] and cataplasmata:[152]
Their gargarisms,[153] clysters,[154] and pitched[155]
 cloths,
Their perfumes, syrups, and their triacles,[156]
Refrain to poison the sick patients, 770
And dare not minister 'til I be out.
Then none will bathe, and so are fewer drowned,
All lust is perilsome therefore less used.
In brief the year without me cannot stand.
Summer, I am thy staff and thy right hand.
Sum. A broken staff, a lame right hand I had,
If thou wert all the stay that held me up,
Nihil violentum perpetuum.[157]
No violence that liveth to old age.
Ill governed star, that never bod'st good luck, 780
I banish thee a twelvemonth and a day,
Forth of my presence; come not in my sight,
Nor show thy head so much as in the night.
Orion. I am content; though hunting be not out,
We will go hunt in hell for better hap.
One parting blow, my hearts, unto our friends,
To bid the fields and huntsmen all farewell.
Toss up your bugle horns unto the stars.
Toil findeth ease, peace follows after wars,

Here they go out, blowing their horns, and halloing,
 as they came in.

Will S. Faith, this scene of Orion is right *prandium caninum,*[158] a dog's dinner! which, as it is without 791
wine, so here's a coil about dogs without wit. If I had
thought the ship of fools[159] would have stayed to take in

[143] *coney-catching:* catching rabbits; also deceiving fools.
[144] *Chrysippus:* Stoic philosopher, 280–207 B.C.
[145] *Homer witnesseth: Odyssey,* XVII.
[146] *Pallas':* referring to Pallas Athene, Odysseus' patron goddess.
[147] *There . . . weak:* During periods of extreme weather, like the dog-days, blood-letting was considered inadvisable and not practiced. [148] *cataposia:* pills.
[149] *[thei]r little:* Q "*r. tittle.*"
[150] *elinctoria;* things to be licked.
[151] *Masticatorum:* Things to be chewed.
[152] *cataplasmata:* poultices. [153] *gargarisms:* gargles.
[154] *clysters:* enemas, suppositories.
[155] *pitched:* soaked in pitch. [156] *triacles:* treacles.
[157] *L.:* Nothing violent lasts forever; proverbial.
[158] *L.:* translated in text.
[159] *ship of fools:* Sebastian Brandt's famous satirical book about the deportation of fools to the Land of Fools was published on the Continent in 1494 and in an English adaptation in 1509.

fresh water at the Isle of Dogs,[160] I would have furnished it with a whole kennel of collections to the purpose. I have had a dog myself that would dream and talk in his sleep, turn round like Ned fool,[161] and sleep all night in a porridge-pot. Mark but the skirmish between Sixpence[162] and the fox, and it is miraculous how they overcome one another in honorable courtesy. The 800 fox, though he wears a chain, runs as though he were free; mocking us, as it is a crafty beast, because we, having a lord and master to attend on, run about at our pleasures like masterless men. Young Sixpence, the best page his master hath, plays a little, and retires. I warrant he will not be far out of the way, when his master goes to dinner. Learn of him, you diminutive urchins, how to behave yourselves in your vocation; take not up your standings in a nuttree, when you should be waiting on my lord's trencher. Shoot but a bit at butts;[163] play but a span at points.[164] Whatever you do, *memento mori;* remember to rise betimes in the morning. 812

Sum. Vertumnus, call Harvest.

Vertum. Harvest, by west and by north, by south and southeast,

Show thyself like a beast.

Goodman Harvest, yeoman, come in and say what you can. Room for the scythe and the sickles there.

Enter HARVEST, *with a scythe on his neck, and all his* Reapers *with sickles, and a great black bowl with a posset*[165] *in it, borne before him; they come in singing.*

THE SONG

Merry, merry, merry, cheary, cheary, cheary,
 Troll[166] *the black bowl to me;*
Hey derry, derry, with a poup and a lerry,[167] 820
 I'll troll it again to thee:
Hooky, hooky, we have shorn,
 And we have bound,
And we have brought Harvest
 Home to town.

Sum. Harvest, the baily[168] of my husbandry,
What plenty hast thou heaped into our barns?
I hope thou hast sped[169] well, thou art so blithe.

Harv. Sped well or ill, sir, I drink to you on the same. Is your throat clear to help us to sing "Hooky, hooky?"

Here they all sing after him.

Hooky, hooky, we have shorn, 831
 And we have bound;
And we have brought Harvest
 Home to town.

Aut. Thou Corydon,[170] why answer'st not direct?

Harv. Answer? Why friend, I am no tapster, to say "Anon,[171] anon," sir; but leave you to molest me, goodman tawny-leaves, for fear—as the proverb says, leave is light—so I mow off all your leaves, with my scythe. 840

Wint. Mock not and mow[172] not too long you were best not,

For fear we whet not your scythe upon your pate.

Sum. Since thou art so perverse in answering,
Harvest, hear what complaints are brought to me.
Thou art accusèd by the public voice,
For an engrosser[173] of the common store;
A carl that hast no conscience, nor remorse,
But dost impoverish the fruitful earth
To make thy garners rise up to the heavens.
To whom giv'st thou? Who feedeth at thy board? 850
No alms, but unreasonable gain
Digests[174] what thy huge iron teeth devour:
"Small beer, coarse bread," the hinds and beggars cry,
Whilst thou withholdest both the malt and flour,
And giv'st us bran and water fit for dogs.

Harv. Hooky, hooky! if you were not my lord, I would say you lie. First and foremost, you say I am a grocer. A grocer is a citizen: I am no citizen, therefore no grocer. A hoarder up of grain: that's false; for not so much but my elbows eat wheat[175] every time 860 I lean upon them. A carl: that is as much as to say as a coney-catcher of good fellowship. For that one word you shall pledge me a carouse: eat a spoonful of the curd to allay your choler. My mates and fellows, sing no more "Merry, merry," but weep out a lamentable "Hooky, hooky," and let your sickles cry—

Sick, sick, and very sick.
 And sick and for the time;
For Harvest your master is
 Abused without reason or rime. 870

I have no conscience, I? I'll come nearer to you, and yet I am no scab, nor no louse. Can you make proof wherever I sold away my conscience, or pawned it? Do you know who would buy it, or lend any money upon it? I think I have given you the pose;[176] Blow your nose, Master Constable.[177] But to say that I impoverish the earth, that I rob the man in the moon, that I take a purse on the top of Paul's steeple; by this straw and thread I swear you are no gentleman, no proper man, no honest man, to make me sing "O man in desperation."[178] 881

Sum. I must give credit unto what I hear:
For other than I hear, attract[179] I nought.

Harv. Ay, ay; nought seek, nought have:
An ill husband is the first step to a knave.

[160] *Isle of Dogs:* In 1597, Nashe and Ben Jonson were to be jailed for the excesses of their satirical play *The Isle of Dogs,* now lost. [161] *Ned fool:* probably the household fool.

[162] *Sixpence:* a dog's name. [163] *butts:* archery.

[164] *points:* games of war.

[165] *posset:* a drink of hot milk curdled with ale or wine and spices. [166] *Troll:* Pass.

[167] *poup and a lerry:* nonsense phrase.

[168] *baily:* bailiff, steward. [169] *sped:* succeeded.

[170] *Corydon:* conventional shepherd's name in pastoral poetry.

[171] *Anon:* Right away, the drawer's cry (cf. Francis in 1 *Henry IV*).

[172] *mow:* with pun on another meaning, to make grimaces.

[173] *engrosser:* monopolist. [174] *Disgests:* Digests.

[175] *elbows . . . wheat:* Harvest's costume is adorned with wheat. [176] *pose:* cold in the head; state of perplexity.

[177] *Blow . . . Constable:* meaningless contemptuous expression, like the more common "Blurt, Master Constable."

[178] *"O . . . desperation":* popular song.

[179] *attract:* take in, "swallow."

You object, I feed none at my board: I am sure, if you were a hog, you would never say so; for, sirreverence of their worships, they feed at my stable—table—every day. I keep good hospitality for hens and geese; gleaners are oppressed with heavy burdens of my bounty. They rake me and eat me to the very bones, 891
Till there be nothing left but gravel and stones;
And yet I give no alms, but devour all. They say when a man cannot hear well, you hear with your harvest ears; but if you heard with your harvest ears, that is, with the ears of corn, which my alms-cart scatters, they would tell you that I am the very poor man's box of pity; that there are more holes of liberality open in Harvest's heart than in a sieve or a dustbox.[180] Suppose you were a craftsman, or an artificer, and should come to 900 buy corn of me, you should have bushels of me; not like the baker's loaf, that should weigh but six ounces, but usury for your money, thousands for one. What would you have more? Eat me out of my apparel, if you will, if you suspect me for a miser.

Sum. I credit thee, and think thou wert belied. But tell me hadst thou a good crop this year?

Harv. Hay, God's plenty, which was so sweet, and so good, that when I jerted[181] my whip, and said to my horses but "hay," they would go as they were mad.

Sum. But "hay" alone thou say'st not, but "hay-ree." 911

Harv. I sing "hay-ree," that is, hay and rye; meaning, that they shall have hay and rye, their bellyfulls, if they will draw hard. So we say, "Wa, hay," when they go out of the way; meaning, that they shall want hay, if they will not do as they should do.

Sum. How thrive thy oats, thy barley, and thy wheat?

Harv. My oats grew like a cup of beer, that makes the brewer rich; my rye like a cavalier, that wears a huge feather in his cap, but had no courage in his heart; 920 had a long stalk, a goodly husk, but nothing so great a kernel as it was wont. My barley, even as many a novice, is cross-bitten[182] as soon as ever he peeps out of the shell, so was it frost-bitten in the blade, yet picked up his crumbs again afterward, and bade "Fill pot, hostess," in spite of a dear year. As for my peas and my fetches,[183] they are famous, and not to be spoken of.

Aut. Ay, ay, such country buttoned caps as you, Do want no fetches[184] to undo great towns.

Harv. Will you make good your words that we want no fetches? 931

Wint. Ay, that he shall.

Harvest. Then fetch us a cloakbag[185] to carry away yourself in.

Sum. Plough-swains are blunt, and will taunt bitterly.
Harvest, when all is done, thou art the man;
Thou dost me the best service of them all.
Rest from thy labors till the year renews,
And let the husbandmen sing of thy praise.

Harv. Rest from my labors, and let the husbandmen sing of my praise? Nay, we do not mean to rest so; 941 by your leave, we'll have a largesse amongst you ere we part.

All. A largesse, a largessse, a largesse!

Will S. Is there no man that will give them a hiss for a largesse?[186]

Harv. No, that there is not, goodman Lungis.[187] I see charity waxeth cold, and I think this house be her habitation, for it is not very hot; we were as good even put up our pipes[188] and sing "Merry, merry," for we shall get no money. 951

Here they all go out singing.

Merry, merry, merry, cheary, cheary, cheary:
Troll the black bowl to me.
Hey derry, derry, with a poup and a lerry;
I'll troll it again to thee.

Hooky, hooky, we have shorn
And we have bound,
And we have brought harvest
Home to town.

Will S. Well, go thy ways, thou bundle of straw: I'll give thee this gift; thou shalt be a clown while 961 thou livest. As lusty as they are, they run on the score with George's wife for their posset; and God knows who shall pay goodman Yeomans for his wheat sheaf. They may sing well enough,

Troll the black bowl to me,
Troll the black bowl to me;

for a hundred to one but they will be all drunk ere they go to bed. Yet of a slavering fool, that hath no conceit in[189] any thing but in carrying a wand in his hand 970 with commendation when he runneth by the highwayside, this stripling, Harvest, hath done reasonable well. Oh, that somebody had had the wit to set his thatched suit on fire, and so lighted him out; if I had had but a jet ring on my finger, I might have done with him what I list.[190] I had spoiled him, I had took his apparel prisoner; for it being made of straw, and the nature of jet to draw straw unto it, I would have nailed him to the pommel[191] of my chair till the play were done, and then have carried him to my chamber-door, and laid 980 him at the threshold as a wisp or a piece of mat, to wipe my shoes on every time I come up dirty.

Sum. Vertumnus, call Bacchus.

Vertum. Bacchus, Baccha, Bacchum:[192] God Bacchus, God fat-back,
Baron of double beer and bottle ale,
Come in and show thy nose that is nothing pale;
Back, back there, god barrel-belly may enter.

[180] *dustbox:* box from which fine sand is sprinkled on wet ink, serving as blotter. [181] *jerted:* jerked.
[182] *cross-bitten:* swindled.
[183] *fetches:* form of "vetches," beans.
[184] *fetches:* tricks. [185] *cloakbag:* suitcase.
[186] *a . . . largesse:* a sss for a large S.
[187] *Lungis:* long, slim, awkward fellow; lout.
[188] *put . . . pipes:* conclude. [189] *conceit in:* esteem for.
[190] *list:* liked. [191] *pommel:* ornamental knob.
[192] *Bacchus . . . Bacchum:* declining the name as if it were an adjective.

Enter BACCHUS *riding upon an ass trapped*[193] *in ivy,
himself dressed in vine leaves, and a garland of grapes
on his head; his* Companions *having all jacks*[194]
*in their hands, and ivy garlands on their heads;
they come in singing.*

THE SONG

Monsieur Mingo[195] *for quaffing doth surpass,
In cup, in can, or glass.
God Bacchus, do me right,*[196] 990
*And dub me knight
Domingo.*[197]

Bac. Wherefore didst thou call me, Vertumnus?
Hast any drink to give me? One of you hold my ass
while I light: walk him up and down the hall, till I talk
a word or two.

Sum. What, Bacchus? still *animus in patinis,*[198] no
mind but on the pot?

Bac. Why, Summer, Summer, how wouldst do but
for rain? What is a fair house without water 1000
coming to it? Let me see how a smith can work if he have
not his trough standing by him. What sets an edge on
a knife? The grindstone alone? No, the moist element
poured upon it, which grinds out all gaps, sets a point
upon it, and scours it as bright as the firmament. So I
tell thee, give a soldier wine before he goes to battle, it
grinds out all gaps, it makes him forget all scars and

wounds, and fight in the thickest of his enemies, as
though he were but at foils amongst his fellows. Give a
scholar wine going to his book, or being about to 1010
invent, it sets a new point on his wit, it glazeth it, it
scours it, it gives him acumen. Plato saith, *Vinum esse
fomitem quendam, et incitabilem ingenii virtulisque.*[199]
Aristotle saith, *Nulla est magna scientia absque mixtura
dementiae!*[200] there is no excellent knowledge without
mixture of madness, and what makes a man more mad
in the head than wine? *Qui bene vult ποιεν, debet ante
πινειν.*[201] He that will do well must drink well. *Prome,
prome, potum, prome!*[202] ho, butler, a fresh pot! *Nunc
est libendum, nunc pede libero terra pulsanda;*[203] a pox on
him that leaves his drink behind him. Hey Rendovow.[204]

Sum. It is wine's custom to be full of words. 1022
I pray thee, Bacchus, give us *vicissitudinem loquendi.*[205]

Bac. A fiddlestick! ne'er tell me I am full of words.
Faecundi calices, quem non fecere disertum:[206] *aut epi
aut abi;*[207] either take your drink, or you are an infidel.

Sum. I would about thy vintage question thee.
How thrive thy vines? hadst thou good store of grapes?

Bac. Vinum quasi venenum,[208] wine is poison to a sick
body. A sick body is no sound body; *ergo,* wine is 1030
a pure thing, and is poison to all corruption. Trilill![209]
the hunters' hoop[210] to you. I'll stand to it: Alexander
was a brave man, and yet an arrant drunkard.

Wint. Fie, drunken sot! forget'st thou where thou
 art?
My lord asks thee what vintage thou hast made?

Bac. Our vintage was a vintage, for it did not work
upon the advantage:[211] it came in the vaunt-guard of
Summer,

> And winds and storms met it by the way,
> And made it cry, "Alas, and well-a-day!" 1040

Sum. That was not well; but all miscarried not?

Bac. Faith, shall I tell you no lie? Because you are
my countryman, and so forth; and a good fellow is a
good fellow, though he have never a penny in his
purse. We had but even pot-luck; a little to moisten our
lips and no more. That same Sol is a pagan and a prose-
lyte;[212] he shined so bright all summer, that he burned
more grapes than his beams were worth, were every
beam[213] as big as a weaver's beam. *A fabis abstinen-
dum;*[214] faith, he should have abstained, for what is
flesh and blood without his liquor? 1051

Aut. Thou want'st no liquor, nor no flesh and blood.
I pray thee, may I ask, without offense,
How many tuns of wine hast in thy paunch?
Methinks, that, built like a round church,
Should yet have some of Julius Caesar's wine:
I warrant 'twas not broached this hundred year.

Bac. Hear'st thou, dough-belly! because thou talk'st
and talk'st, and dar'st not drink to me a black jack, wilt
thou give me leave to broach this little kilderkin[215] 1060
of my corpse[216] against thy back? I know thou art
but a micher,[217] and dar'st not stand me. *A vous
monsieur Winter,* a frolic:[218] upsy freese;[219] cross,[220]
ho! *super nagulum.*[221]

[*Knocks the jack upon his thumb.*]

[193] *trapped:* got up, harnessed.
[194] *jacks:* cf. "black jack," 1. 445–6.
[195] *Mingo:* legendary drunkard, perhaps Spanish.
[196] *do me right:* toast me.
[197] *Domingo:* perhaps Don Mingo, a fuller name of Mingo;
perhaps St. Domingo, patron of topers.
[198] *L.:* his mind is on his dinner; Terence, *Eunuchus,*
4. 7. 46.
[199] *L.:* Wine to be a certain kindling and stimulus of wit
and virtue. The general topic is discussed in Plato's *Laws,*
but the source of the words is Aulus Gellius.
[200] *L.:* There is no great science without a mixture of mad-
ness. The translation from Aristotle's *Problems* is derived
from C. Agrippa. [201] *L., Gk.:* translated in text.
[202] *L.:* Bring forth drink.
[203] *L.:* Now is the time for drinking, for lively dancing;
Horace, *Odes,* I. 37. 1–2.
[204] *Rendovow:* probably a drinking term.
[205] *L.:* exchange of speech.
[206] *L.:* Whom does the teeming cup not make eloquent?
[207] *L.:* corrupt form of the proverb "drink or go away."
[208] *L.:* Wine is like poison.
[209] *Trilill:* a cry accompanying drinking.
[210] *hoop:* call; measure of drink.
[211] *work . . . advantage:* take every possible advantage.
[212] *proselyte:* convert to Judaism.
[213] *beam:* cylinder in loom on which warp is wound before
weaving.
[214] *L.:* One should eat no beans (a supposed principle of
Pythagoras). [215] *kilderkin:* cask holding half a barrel.
[216] *corpse:* body. [217] *micher:* petty thief, truant.
[218] *frolic:* humorous verses circulated at a feast.
[219] *upsy freese:* deeply.
[220] *cross:* unexplained term Nashe uses elsewhere in this
context.
[221] *L.:* turn your glass over on your thumbnail to show it
is empty.

Wint. Gramercy,[222] Bacchus, as much as though I
 did.
For this time, thou must pardon me perforce.

Bac. What, give me the disgrace?[223] go to, I say, I
am no Pope to pardon any man. *Ran, ran, tarra:* cold
beer makes good blood.[224] St. George for England!
Somewhat is better than nothing. Let me see, hast 1070
thou done me justice? why so: thou art a king, though
there were no more kings in the cards but the knave.
Summer, wilt thou have a demi-culverin,[225] that shall
cry "hufty tufty,"[226] and make thy cup fly fine meal in
the element?

Sum. No, keep thy drink, I pray thee, to thyself.

Bac. This Pupillonian[227] in the fool's coat shall have
a cast[228] of martins[229] and a whiff.[230] To the health of
Captain Rhinocerotry![231] Look to it; let him have
weight and measure. 1080

Will S. What an ass is this. I cannot drink so much,
though I should burst.

Bac. Fool, do not refuse your moist sustenance:
come, come, dog's head in the pot;[232] do what you are
born to.

Will S. If you will needs make me a drunkard
against my will, so it is; I'll try what burden my belly
is of.

Bac. Crouch, crouch on your knees, fool, when you
pledge god Bacchus. 1090

Here WILL SUMMERS *drinks, and they sing
about him,* BACCHUS *begins.*

All. *Monsieur Mingo for quaffing did surpass*
 In cup, in can, or glass.

Bac. Ho, well shot, a toucher,[233] a toucher!

 For quaffing Toy[234] *doth pass,*
 In cup, in can, or glass.
All. *God Bacchus do him right*
 And dub him knight.

Here he dubs WILL SUMMERS *with the black jack.*

Bac. Rise up Sir Robert Toss-pot.

Sum. No more of this, I hate it to the death. 1100
No such deformer of the soul and sense,
As is this swinish damned-born drunkenness.
Bacchus for thou abusest so earth's fruits,
Imprisoned live in cellars and in vaults.
Let none commit their councils unto thee;
Thy wrath be fatal to thy dearest friends;
Unarmèd run upon thy foemen's swords;
Never fear any plague before it fall;
Dropsies and watery tympanies[235] haunt thee;
Thy lungs with surfeiting be putrified,
To cause thee have an odious stinking breath; 1110
Slaver and drivel like a child at mouth;
Be poor and beggarly in thy old age;
Let thy own kinsmen laugh when thou complain'st,
And many tears gain nothing but blind scoffs.
This is the guerdon[236] due to drunkenness:
Shame, sickness, misery follow excess.

Bac. Now on my honor, Sim Summer, thou art a
bad member, a dunce, a mongrel, to discredit so wor-

shipful an art after this order. Thou hast cursed me and
I will bless thee. Never cap of nipitaty[237] in 1120
London come near thy niggardly habitation! I beseech
the gods of good fellowship thou mayst fall into a con-
sumption with drinking small beer! Every day mayst
thou eat fish, and let it stick in the midst of thy maw
for want of a cup of wine to swim away in. Venison be
venenum[238] to thee: and may that vintner have the
plague in his house that sells thee a drop of claret to
kill the poison of it! As many wounds mayst thou have
as Caesar had in the senate house, and get no white
wine[239] to wash them with; and to conclude, 1130
pine away in melancholy and sorrow before thou hast the
fourth part of a dram of my juice to cheer up thy spirits.

Sum. Hale him away, he barketh like a wolf:
It is his drink, not he, that rails on us.

Bac. Nay soft, brother Summer, back with that
fool.[240] Here is a snuff[241] in the bottom of the jack,
enough to light a man to bed withal;[242] we'll leave no
flocks[243] behind us whatsoever we do.

Sum. Go drag him hence, I say, when I command.

Bac. Since we must needs go, let's go merrily. 1140
Farewell Sir Robert Tosspot. Sing amain, Monsieur
Mingo, whilst I mount up my ass.

Here they go out, singing "Monsieur Mingo," as
they came in.

Will S. Of all gods this Bacchus is the ill-favor'dst
misshapen god that ever I saw. A pox on him! he hath
christened me with a new nickname of Sir Robert
Tosspot, that will not part from me this twelvemonth.
Ned fool's clothes are so perfumed with the beer he
poured on me that there shall not be a Dutchman within
twenty mile, but he'll smell out and claim kindred of
him. What a beastly thing is it to bottle up ale in 1150
a man's belly, when a man must set his guts on a gallon
pot last, only to purchase the alehouse title of a boon
companion. "Carouse; pledge me and[244] you dare!
'Swounds, I'll drink with thee for all that ever thou art
worth!" It is even as two men should strive who should
run farthest into the sea for a wager. Methinks these are
good household terms; "Will it please you to be here

[222] *Gramercy:* Mercy on us.
[223] *give . . . disgrace:* by not toasting him.
[224] *cold . . . blood:* parodying the proverbial "good wine
makes good blood." [225] *demi-culverin:* cannon.
[226] *"hufty-tufty":* Q *"husty-tusty";* swaggering.
[227] *Pupillonian:* perhaps a nonsense word.
[228] *cast:* pair. [229] *martins:* swallows, dupes, or apes.
[230] *whiff:* sip of liquor(?). The entire passage has not been
satisfactorily explained.
[231] *Captain Rhinocerotry:* perhaps alluding ironically to
Will Summers' relative thinness. [232] *dogs' . . . pot:* glutton.
[233] *toucher:* in bowling, a bowl that touches the jack or
mark; with implied pun on "jack."
[234] *Toy:* actor who played Will Summers(?).
[235] *tympanies:* swellings of the bowels, tumors.
[236] *guerdon:* reward. [237] *nipitaty:* strong ale.
[238] *L.:* poison.
[239] *white wine:* sometimes used medicinally.
[240] *fool:* Q *"foote."*
[241] *snuff:* bit of drink left at bottom of cup.
[242] *withal:* with. [243] *flocks:* dregs. [244] *and:* if.

sir? I commend me to you; shall I be so bold as trouble you? Saving your tale I drink to you." And if these were put in practice but a year or two in taverns, wine 1160 would soon fall from six and twenty pound a tun, and be beggar's money a penny a quart, and take up his inn with waste beer in the alms tub. I am a sinner as others: I must not say much of this argument. Every one when he is whole can give advice to them that are sick. My masters, you that be good fellows, get you into corners and sup off your provender closely.[245] Report hath a blister on her tongue; open taverns are tell-tales.
Non peccat quicunque potest peccasse negare.[246]

 Sum. I'll call my servants to account, said I? 1170
A bad account; worse servants no man hath.
Quos credis fidos effuge, tutus eris:[247]
The proverb I have proved to be too true,
Totidem domi hostes habemus quot servos.[248]
And that wise caution of Democritus,[249]
Servus necessaria possessio, non autem dulcis:[250]
No where fidelity and labor dwells.
Hope—young heads count to build on "had I wist";
Conscience but few respect, all hunt for gain;
Except the camel have his provender 1180
Hung at his mouth he will not travel on.
Tiresias to Narcissus promised
Much prosperous hap and many golden days,
If of his beauty he no knowledge took.[251]
Knowledge breeds pride, pride breedeth discontent;
Black discontent, thou urgest to revenge;
Revenge opes not her ears to poor men's prayers.
That dolt destruction is she, without doubt,
That hales her forth and feedeth her with nought.
Simplicity and plainness, you I love! 1190
Hence, double[252] diligence, thou mean'st deceit.
Those that now serpent-like creep on the ground,
And seem to eat the dust, they crouch so low,
If they be disappointed of their prey,
Most traitorously will trace[253] their tails and sting.
Yea, such as, like the lapwing,[254] build their nests
In a man's dung, come up by drudgery,

Will be the first that, like that foolish bird,
Will follow him with yelling and false cries.
Well sung a shepherd,[255] that now sleeps in skies, 1200
"Dumb swans do love, and not vain chattering pies."[256]
In mountains, poets say, Echo is hid,
For her deformity and monstrous shape:
Those mountains are the houses of great lords,
Where Stentor,[257] with his hundred voices, sounds
A hundred trumps at once with rumor filled.
A woman they imagine her to be,
Because that sex keeps nothing close they hear;
And that's the reason magic writers frame
There are more witches women than of men; 1210
For women generally, for the most part,
Of secrets more desirous are[258] than men,
Which having got they have no power to hold.
In these times had Echo's first fathers lived,
No woman but a man she had been feigned;
Though women yet will want no news to prate.
For men, mean men, the scum and dross of all,
Will talk and babble of they know not what,
Upbraid, deprave, and taunt they care not whom.
Surmises pass for sound approvèd truths: 1220
Familiarity and conference,
That were the sinews of societies,
Are now for underminings only used;
And novel wits that love none but themselves,
Think wisdom's height as falsehood slily couched,
Seeking each other to o'erthrow his mate.
O friendship! thy old temple is defaced;
Embracing envy,[259] guileful courtesy,
Hath overgrown fraud-wanting honesty.
Examples live but in the idle schools: 1230
Sinon[260] bears all the sway in princes' courts.
Sickness, be thou my soul's physician;
Bring the apothecary Death with thee.
In earth is hell, true hell felicity,
Comparèd with this world, the den of wolves!
 Aut. My lord, you are too passionate without cause.
 Wint. Grieve not for that which cannot be recalled.
Is it your servant's carelessness you plain?
Tully[261] by one of his own slaves was slain.
The husbandman close in his bosom nursed 1240
A subtle snake, that after wrought his bane.
 Aut. Servos fideles liberalitas facit;[262]
Where, on the contrary, *servitutem:*[263]
Those that attend upon illiberal lords,
Whose covetize[264] yields nought else but fair looks,
Even of those fair looks make their gainful use.
For, as in Ireland and in Denmark both,
Witches for gold will sell a man a wind,
Which, in the corner of a napkin wrapped,
Shall blow him safe unto what coast he will; 1250
So make ill servants sale of their lord's wind,[265]
Which, wrapped up in a piece of parchment,
Blows many a knave forth danger of the law.
 Sum. Enough of this; let me go make my will.
Ah! it is made, although I hold my peace:
These two will share betwixt them what I have.
The surest way to get my will performed
Is to make my executor my heir;

[245] *closely:* secretly.
[246] *L.:* No one sins who can deny he has sinned; slightly misquoted from Ovid, *Amores,* III. 14. 5.
[247] *L.,* Flee those you consider faithful, and you will be safe; Ovid, *Ars Amoris,* I. 752.
[248] *L.:* We have just as many enemies at home as we have servants; proverbial, quoted by C. Agrippa.
[249] *Democritus:* Greek philosopher, fifth century B.C.
[250] *L.:* A servant is a necessary possession but not, however, a sweet one.
[251] *Tiresias . . . took:* Ovid tells the story of the prophet's unheeded warning to the vain boy in *Metamorphoses,* III.
[252] *double:* false. [253] *trace:* raise.
[254] *lapwing:* kind of bird.
[255] *shepherd:* Sir Philip Sidney (d. 1586); line adapted from sonnet 54 of *Astrophel and Stella.* [256] *pies:* magpies.
[257] *Stentor:* Homer (*Iliad,* V. 785–86) tells of this man who could shout as loud as fifty people. [258] *are:* Q "of."
[259] *envy:* Q "every."
[260] *Sinon:* the traitor in the episode of the Trojan horse.
[261] *Tully:* Cicero.
[262] *L.:* Liberality makes faithful servants; Plautus, *Aulularia,* cited by C. Agrippa. [263] *L.:* (makes) servitude.
[264] *covetize:* covetousness. [265] *wind:* favor.

And he, if all be given him, and none else,
Unfallibly will see it well performed. 1260
Lions will feed, though none bid them go to.
Ill grows the tree affordeth ne'er a graft.
Had I some issue to sit in my throne,
My grief would die, death should not hear me groan,
But when, perforce, these must enjoy my wealth,
Which thank me not, but enter 't as a prey,
Bequeathed it is not, but clean cast away.
Autumn, be thou successor of my seat:
Hold, take my crown:—look, how he grasps for it!
Thou shalt not have it yet—but hold it, too; 1270
Why should I keep that needs I must forego?
 Wint. Then, duty laid aside, you do me wrong.
I am more worthy of it far than he:
He hath no skill nor courage for to rule.
A weather-beaten bankrupt ass it is,
That scatters and consumeth all he hath:
Each one do pluck from him without control.
He is nor hot nor cold; a silly soul,
That fain would please each party, if so he might.
He and the Spring are scholar's favorites; 1280
What scholars are, what thriftless kind of men,
Yourself be judge, and judge of him by them.
When Cerberus [266] was headlong drawn from heli,
He voided a black poison from his mouth
Called *Aconitum*, [267] whereof ink was made.
That ink, with reeds first laid on dried barks,
Served men awhile to make rude works withal,
Till Hermes, secretary to the gods,
Or Hermes Trismegistus, [268] as some will,
Weary with graving in blind [269] characters, 1290
And figures of familiar beasts and plants,
Invented letters to write lies withal.
In them he penned the fables of the gods,
The giants' war, and thousand tales besides.
After each nation got these toys in use
There grew up certain drunken parasites, [270]
Termed poets, which, for a meal's meat or two,
Would promise monarchs immortality.
They vomited in verse all that they knew;
Found causes and beginnings of the world; 1300
Fetched pedigrees of mountains and of floods,
From men and women whom the gods transformed.
If any town or city they passed by
Had in compassion, thinking them mad men,
Forborne to whip them or imprison them,
That city was not built by human hands;
'Twas raised by music, like Megara [271] walls;
Apollo, poets' patron, founded it,
Because they found one fitting favor there.
Musaeus, [272] Linus, [273] Homer, Orpheus, 1310
Were of this trade, and thereby won their fame.
 Will S. Fama malum, quo non velocius ullum. [274]
 Wint. Next them a company of ragged knaves,
Sun-bathing beggars, lazy hedge-creepers,
Sleeping face upwards in the fields all night,
Dreamed strange devices of the sun and moon;
And they, like gypsies, wandering up and down,
Told fortunes, juggled, nicknamed all the stars,
And were of idiots termed philosophers.

Such was Pythagoras, the silencer; [275] 1320
Prometheus, [276] Thales, Milesius, [277]
Who would all things of water should be made:
Anaximander, [278] Anaxamines, [279]
That positively said the air was god:
Xenocrates, [280] that said there were eight gods;
And Cratoniates, Alcmeon [281] too,
Who thought the sun and moon and stars were gods.
The poorer sort of them, that could get nought,
Professed, like beggarly Franciscan friars,
And the strict order of the Capuchins, 1330
A voluntary, wretched poverty,
Contempt of gold, thin fare, and lying hard.
Yet he that was most vehement in these,
Diogenes [282] the cynic and the dog,
Was taken coining money in his cell.
 Will S. What an old ass was that. Methinks he
should have coined carrot-roots rather; for, as for
money he had no use for 't except it were to melt, and
solder up holes in his tub withal.
 Wint. It were a whole Olympiad's [283] work to tell
How many devilish, *ergo*, armèd arts, 1341
Sprung all as vices of this idleness:
For even as soldiers not employed in wars,
But living loosely in a quiet state,
Not having wherewithal to maintain pride,
Nay, scarce to find their bellies any food,
Nought but walk melancholy, and devise
How they may cozen [284] merchants, fleece young heirs,
Creep into favor, by betraying men,
Rob churches, beg waste toys, [285] court city dames
Who shall undo their husbands for their sakes; 1351
The baser rabble how to cheat and steal,
And yet be free from penalty of death:
So these word-warriors, lazy star-gazers,
Used to no labor but to louse themselves,

 [266] *Cerberus:* monstrous dog that guarded the entrance to
the Underworld, dragged away by Hercules.
 [267] *Aconitum:* poisonous plant, monkshood or wolfsbane.
 [268] *Hermes Trismegistus:* legendary magician, king, priest,
prophet, and sophist, credited in the Renaissance with the
authorship of a vast body of occult writings and often identi-
fied with the Greek god Hermes. [269] *blind:* obscure.
 [270] *parasites:* men who flatter in order to cadge meals.
 [271] *Megara:* Corinthian city.
 [272] *Musaeus:* mythical singer.
 [273] *Linus:* legendary singer killed for rivaling Apollo, in
one story Hercules' music teacher.
 [274] *L.:* Fame, swiftest of all evils; misquoted from *Aeneid*,
IV. 474.
 [275] *silencer:* Novices in the school of Pythagoras were com-
mitted to a long period of silence.
 [276] *Prometheus:* demigod who stole fire from heaven.
 [277] *Thales Milesius:* Thales of Miletus, one of the Seven
Sages, Greek philosopher and scientist, sixth century B.C.
 [278] *Anaximander:* sixth-century B.C. philosopher and
astronomer. [279] *Anaximines:* pupil of Anaximander.
 [280] *Xenocrates:* fourth-century B.C. disciple of Plato.
 [281] *Cratoniates, Alcmeon:* Alcmeon of Croton, pupil of
Pythagoras, c. 500 B.C.; Nashe seems to think the names indi-
cate two people.
 [282] *Diogenes:* Athenian philosopher, 400–325 B.C., founder
of the Cynic sect, which is named after κύων, the dog, because
of Diogenes' insistence on the need for shamelessness.
 [283] *Olympiad's:* referring to the company of gods.
 [284] *cozen:* cheat. [285] *toys:* trifles.

Had their heads filled with cozening fantasies.
They plotted how to make their poverty
Better esteemed of than high sovereignty,
They thought how they might plant a heaven on earth,
Whereof they would be principal low gods; 1360
That heaven they called contemplation—
As much to say as a most pleasant sloth,
Which better I cannot compare than this,
That if a fellow, licensèd to beg,
Should all his lifetime go from fair to fair,
And buy gape-seed,[286] having no business else,
That contemplation, like an agèd weed,
Engendered thousand sects, and all those sects
Were but as these times, cunning shrouded rogues.
Grammarians some, and wherein differ they 1370
From beggars that profess the pedlar's French?[287]
The poets next, slovenly tattered slaves,
That wander and sell ballads in the streets.
Historiographers others there be,
And they, like lazars[288] by the highway side,
That for a penny or a halfpenny,
Will call each knave a good faced gentleman,
Give honor unto tinkers for good ale,
Prefer a cobbler 'fore the black prince far,
If he bestow but blacking of their shoes: 1380
And as it is the spittle-house's[289] guise
Over their gate to write the founder's names
Or on the outside of their walls at least,
In hope by their examples others moved
Will be more bountiful and liberal;
So in the forefront of their chronicles,
Or *peroratione operis*,[290]
They learning's benefactors reckon up;
Who built this college, who gave that free school,
What king or queen advancèd scholars most, 1390
And in their times what writers flourishèd.
Rich men and magistrates, whilst yet they live,
They flatter palpably, in hope of gain.
Smooth-tonguèd orators, the fourth in place,
Lawyers our commonwealth entitles them,
Mere swashbucklers and ruffianly mates,

That will for twelvepence make a doughty fray,
Set men for straws together by the ears.
Sky-measuring mathematicians,
Gold-breathing alchemists also we have, 1400
Both which are subtle-witted humorists,
That get their meals by telling miracles,
Which they have seen in traveling the skies.
Vain boasters, liars, makeshifts, they are all;
Men that, removèd from their inkhorn terms,[291]
Bring forth no action worthy of their bread.
What should I speak of pale physicians,
Who as Fismenus *non nasutus*[292] was,
Upon a wager that his friends had laid,
Hired to live in a privy a whole year, 1410
So are they hired for lucre and for gain,
All their whole life to smell on excrements.

Will S. Very true, for I have heard it for a proverb
many a time and oft, *hunc os fetidum;*[293] fah! he stinks
like a physician.

Wint. Innumerable monstrous practices
Hath loitering contemplation brought forth more,
Which't were too long particular to recite:
Suffice they all conduce unto this end,
To banish labor, nourish slothfulness, 1420
Pamper up lust, devise newfangled sins,
Nay, I will justify, there is no vice
Which learning and vile knowledge brought not in,
Or in whose praise some learnèd have not wrote.
The art of murder Machiavel hath penned;
Whoredom hath Ovid to uphold her throne,
And Aretine[294] of late in Italy,
Whose *Cortigiana* touched bawds their trade.
Gluttony Epicurus[295] doth defend,
And books of the art of cookery confirm, 1430
Of which Platina[296] hath not writ the least.
Drunkenness of his good behavior
Hath testimonial from where he was born;
That pleasant work *de arte bibendi*,[297]
A drunken Dutchman spewed out few years since.
Nor wanteth sloth (although sloth's plague be want)
His paper pillars for to lean upon.
The praise of nothing pleads his worthiness.
Folly Erasmus sets a flourish on:
For baldness, a bald ass I have forgot, 1440
Patched up a pamphletary periwig.
Slovenry Grobianus[298] magnifieth:
Sodomitry a cardinal commends,
And Aristotle necessary deems.
In brief, all books, divinity except,
Are nought but tables[299] of the devil's laws,
Poison wrapped up in sugared words,
Man's pride, damnation's props, the world's abuse.
Then censure, good my lord, what bookmen are:
If they be pestilent members in a state; 1450
He is unfit to sit at stern of state
That favors such as will o'erthrow his state.
Blest is that government where no art thrives;
Vox populi, vox Dei,
The vulgar's voice it is the voice of God.
Yet Tully saith, *Non est consilium in vulgo, non ratio, non
 discrimen, non differentia :*[300]

[286] *buy gape-seed:* go sightseeing.
[287] *pedlar's French:* cant language of vagabonds.
[288] *lazars:* lepers.
[289] *spittle-house's:* referring to a hospital or charitable institution. [290] *L.:* peroration of the work.
[291] *inkhorn terms:* pedantic expressions.
[292] *Fismenus . . . nasutus:* noseless Fismenus, a fictitious character.
[293] *L.:* he has a stinking mouth (said of the devil).
[294] *Aretine:* Pietro Aretino, 1492–1556, author of a number of works (some bawdy), including a play *La Cortigiana* (*The Courtesan*), which Nashe seems to be confusing with something else.
[295] *Epicurus:* Athenian philosopher, 342/1–271/0 B.C., who did not advocate the excesses attributed to him.
[296] *Platina:* Bartholomaeus Sacchi, fifteenth-century Italian writer.
[297] *L.: The Art of Drinking*, by one V. Obsopaeus, 1536.
[298] *Grobianus:* an imaginary German boor and patron of boors. [299] *tables:* Q "*tales.*"
[300] *L.:* There is no deliberation, reason, discrimination, or difference [*sic;* Cicero wrote *diligentia*, diligence] in the multitude; Cicero, *Pro Gnaio Plancio*, 4. 9.

The vulgar have no learning, wit, nor sense.
Themistocles[301] having spent all his time
In study of philosophy and arts,
And noting well the vanity of them, 1460
Wished, with repentance for his folly passed,
Some would teach him th' art of oblivion,
How to forget the arts that he had learnt.
And Cicero, whom we alleged before,
As saith Valerius,[302] stepping into old age,
Despisèd learning, loathèd eloquence.
Naso,[303] that could speak nothing but pure verse,
And had more wit than words to utter it,
And words as choice as ever poet had,
Cried and exclaimed in bitter agony, 1470
When knowledge had corrupted his chaste mind;
Discite, qui sapitis, non haec quae scimus inertes,
Sed trepidas acies, et fera bella sequi.
You that be wise, and ever mean to thrive,
O study not these toys we sluggards use,
But follow arms, and wait on barbarous wars.
Young men, young boys, beware of schoolmasters;
They will infect you, mar you, blear your eyes;
They seek to lay the curse of God on you,
Namely, confusion of languages, 1480
Wherewith those that the tower of Babel built
Accursèd were in the world's infancy.
Latin, it was the speech of infidels;
Logic hath nought to say in a true cause;
Philosophy is curiosity;
And Socrates was therefore put to death,
Only for he was a philosopher.
Abhor, contemn, despise these damnèd snares.

Will S. Out upon it! who would be a scholar? not I,
I promise you: my mind always gave me this 1490
learning was such a filthy thing, which made me hate it
so as I did. When I should have been at school con-
struing, *Batte, mi fili, mi fili, mi batte,*[304] I was close
under a hedge, or under a barn wall, playing at span-
counter[305] or jack in a box.[306] My master beat me, my
father beat me, my mother gave me bread and butter,
yet all this would not make me a squitterbook.[307] It was
my destiny; I thank her as a most courteous goddess,
that she hath not cast me away upon gibberish. Oh, in
what a mighty vein am I now against horn- 1500
books![308] Here, before all this company, I profess myself
an open enemy to ink and paper. I'll make it good upon
the accidence[309] body that in speech[310] is the devil's
paternoster.[311] Nouns and pronouns, I pronounce you
as traitors to boys' buttocks; syntaxis[312] and pro-
sodia,[313] you are tormentors of wit, and good for noth-
ing but to get a school-master twopence a-week. Hang
copies! Fly out, phrase-books! let pens be turned to pick-
tooths! Bowls, cards, and dice, you are the true liberal
sciences! I'll ne'er be goosequill, gentlemen, while I live.

Sum. Winter, with patience unto my grief, 1511
I have attended thy invective tale.
So much untruth wit never shadowèd:
'Gainst her own bowels thou art's weapons turn'st.
Let none believe thee that will ever thrive.
Words have their course, the wind blows where it lists,
He errs alone in error that persists.

For thou 'gainst Autumn such exceptions tak'st,
I grant his overseer thou shalt be,
His treasurer, protector and his staff; 1520
He shall do nothing without thy consent:
Provide thou for his weal and his content.

Wint. Thanks, gracious lord; so I'll dispose of him
As it shall not repent you of your gift.

Aut. On such conditions no crown will I take.
I challenge Winter for my enemy;
A most insatiate miserable carl,
That to fill up his garners to the brim
Cares not how he endamageth the earth,
What poverty he makes it to endure! 1530
He overbars the crystal streams with ice,
That none but he and his may drink of them;
All for a foul Backwinter he lays up.
Hard craggy ways, and uncouth slippery paths
He frames that passengers may slide and fall.
Who quaketh not that heareth but his name?
Oh, but two sons he hath worse than himself:
Christmas the one, a pinchbeck,[314] cutthroat churl,
That keeps no open house, as he should do,
Delighteth in no game or fellowship, 1540
Loves no good deeds and hateth talk;
But sitteth in a corner turning crabs,[315]
Or coughing o'er a warmèd pot of ale.
Backwinter th' other, that's his none[316] sweet boy,
Who like his father taketh[317] in all points.
An elf it is compact of envious pride,
A miscreant,[318] born for a plague to men;
A monster that devoureth all he meets.
Were but his father dead, so he would reign,
Yea, he would go good-near[319] to deal by him 1550
As Nabuchodonozor's ungracious son,
Evilmerodach, by his father dealt:[320]
Who when his sire was turnèd to an ox
Full greedily snatched up his sovereignty,
And thought himself a king without control.
So it fell out, seven years expired and gone,
Nabuchodonozor came to his shape again,
And dispossessed him of the regiment;[321]
Which my young prince, no little grieving at,
When that his father shortly after died, 1560

[301] *Themistocles:* Athenian statesman, 528–462 B.C.
[302] *Valerius:* Valerius Maximus, Roman historian of the first century A.D.
[303] *Naso: Ovid ... L.* (*lines 1471–72*): translated in text; Ovid, *Amores,* III. 8. 25–26.
[304] *L.:* unidentified tag used in teaching grammar.
[305] *span-counter:* a game in which one player attempts to throw his counter to a point within the distance of a span from another player's. [306] *jack ... box:* gambling game.
[307] *squitterbook:* scribbler. [308] *hornbooks:* primers.
[309] *accidence:* rules of grammar.
[310] *speech:* i.e., grammar. [311] *paternoster:* prayer.
[312] *syntaxis:* syntax. [313] *prosodia:* prosody.
[314] *pinchbeck:* miserly; Q "pinchback."
[315] *crabs:* crabapples. [316] *none:* own.
[317] *like ... taketh:* takes after his father.
[318] *miscreant:* villain. [319] *good-near:* very near.
[320] *As ... dealt:* This story of Nebuchadnezzar's son is not of biblical origin. [321] *regiment:* rule.

Fearing lest he should come from death again,
As he came from an ox to be a man,
Willed that his body, 'spoiled of coverture,
Should be cast forth into the open fields,
For birds and ravens to devour at will;
Thinking if they bare, every one of them,
A bill full of his flesh into their nests,
He would not rise to trouble him in haste.

 Will S. A virtuous son; and I'll lay my life on't he
was a cavalier[322] and a good fellow.[323] 1570

 Wint. Pleaseth your honor, all he says is false.
For my own part I love good husbandry,
But hate dishonorable covetize.
Youth ne'er aspires to virtue's perfect growth,
Till his wild oats be sown; and so the earth
Until his weeds be rotted with my frosts
Is not for any seed or tillage fit.
He must be purgèd that hath surfeited:
The fields have surfeited with summer fruits;
They must be purged, made poor, oppressed with
 snow, 1580
Ere they recover their decayèd pride.
For overbarring of the streams with ice,
Who locks not poison from his children's taste?
When Winter reigns the water is so cold
That it is poison, present death to those
That wash or bathe their limbs in his cold streams.
The slipp'rier that ways are under us,
The better it makes us to heed our steps,
And look ere we presume too rashly on.
If that my sons have misbehaved themselves, 1590
A God's name let them answer't 'fore my lord.

 Aut. Now, I beseech your honor it may be so.

 Sum. With all my heart. Vertumnus, go for them.

 [*Exit* VERTUMNUS.]

 Will S. This same Harry Baker[324] is such a necessary fellow to go on errands as you shall not find in a[325] country. It is pity but he should have another silver arrow, if it be but for crossing the stage with his cap on.

 Sum. To weary out the time until they come,
Sing me some doleful ditty to the lute,
That may complain my near approaching death.

THE SONG

 Adieu; farewell earth's bliss, 1601
 This world uncertain is:
 Fond[326] *are life's lustful joys,*
 Death proves them all but toys.
 None from his darts can fly:
 I am sick, I must die.
 Lord have mercy on us!

 Rich men trust not in wealth;
 Gold cannot buy you health.
 Physic himself must fade: 1610
 All things to end are made.
 The plague full swift goes by.[327]
 I am sick, I must die.
 Lord have mercy on us!

 Beauty is but a flower,
 Which wrinkles will devour:
 Brightness falls from the air;[328]
 Queens have died young and fair.
 Dust hath closed Helen's eye.
 I am sick, I must die. 1620
 Lord have mercy on us!

 Strength stoops unto the grave,
 Worms feed on Hector brave,
 Swords may not fight with fate,
 Earth still holds ope her gate.
 Come, come the bells do cry.
 I am sick, I must die.
 Lord have mercy on us!

 Wit with his wantonness
 Tasteth death's bitterness. 1630
 Hell's executioner
 Hath no ears for to hear
 What vain art can reply.
 I am sick, I must die.
 Lord have mercy on us!

 Haste therefore each degree
 To welcome destiny;
 Heaven is our heritage,
 Earth but a player's stage.
 Mount we unto the sky. 1640
 I am sick, I must die.
 Lord have mercy on us!

 Sum. Beshrew me, but thy song hath moved me.

 Will S. "Lord have mercy on us," how lamentable 'tis!

Enter VERTUMNUS, *with* CHRISTMAS *and* BACKWINTER.

 Vertum. I have dispatched, my lord; I have brought you them you sent me for.

 Will S. What say'st thou? Hast thou made a good batch? I pray thee give me a new loaf![329]

 Sum. Christmas, how chance thou com'st not as the rest, 1650
Accompanied with some music or some song?
A merry carrol would have graced thee well;
Thy ancestors have used it heretofore.

 Chris. Ay, antiquity was the mother of ignorance; this latter world, that sees but with her spectacles, hath spied a pad[330] in those sports more than they could.

 Sum. What, is't against thy conscience for to sing?

 Chris. No, nor to say, by my troth, if I may get a good bargain.

322 *cavalier:* swaggerer.
323 *good fellow:* jovial companion; robber.
324 *Harry Baker:* presumably the actor who played Vertumnus. 325 *a:* i.e., the.
326 *Fond:* Foolish. 327 *by:* Q "*lye.*"
328 *air:* "*hair*" has been suggested as the correct reading, but there is no need for this damaging emendation.
329 *Hast . . . loaf:* punning on Harry Baker's name.
330 *pad:* toad, from "a toad in the straw," a lurking danger.

Sum. Why, thou should'st spend, thou should'st not
 care to get: 1660
Christmas is god of hospitality.

Chris. So will he never be of good husbandry. I may
say to you, there is many an old god that is now grown
out of fashion; so is the god of hospitality.

Sum. What reason can'st thou give he should be left?

Chris. No other reason but that gluttony is a sin, and
too many dunghills are infectious. A man's belly was
not made for a powdering[331] beef tub; to feed the poor
twelve days, and let them starve all the year after, would
but stretch out the guts wider than they should 1670
be, and so make famine a bigger den in their bellies than
he had before. I should kill an ox, and have some such
fellow as Milo[332] to come and eat it up at a mouthful;
or, like the Sybarites,[333] do nothing all one year but bid
guests against the next year. The scraping of trenchers
you think would put a man to no charges. It is not a
hundred pound a-year would serve the scullions in dish-
clouts.[334] My house stands upon vaults; it will fall if
it be overladen with a multitude. Besides, have you
never read of a city that was undermined and de- 1680
stroyed by moles? So, say I keep hospitality, and a whole
fair of beggars bid me to dinner[335] every day, what
with making legs[336] when they thank me at their going
away, and settling their wallets[337] handsomely on their
backs, they would shake as many lice on the ground as
were able to undermine my house and undo me utterly.
It is their prayers would build it again if it were over-
thrown by this vermin, would it? I pray who began
feasting and gourmandize first, but Sardanapalus,[338]
Nero, Heliogabalus, Commodus,[339] tyrants, 1690
whoremasters, unthrifts. Some call them emperors, but
I respect no crowns but crowns in the purse. Any man
may wear a silver crown that hath made a fray in
Smithfield,[340] and lost but a piece of his brain-pan;
and to tell you plain, your golden crowns are little better
in substance, and many times got after the same sort.

Sum. Gross-headed sot! how light he makes of state.

Aut. Who treadeth not on stars when they are fall'n?
Who talketh not of states when they are dead?
A fool conceits[341] no farther than he sees, 1700
He hath no sense of aught but what he feels.

Chris. Ay, ay; such wise men as you come to beg at
such fool's doors as we be.

Aut. Thou shut'st thy door; how should we beg of
 thee?
No alms but thy sink[342] carries from thy house.

Will S. And I can tell you that's as plentiful alms for
the plague as the sheriff's tub[343] to them of Newgate.[344]

Aut. For feasts thou keepest none; cankers thou
 feed'st.
The worms will curse thy flesh another day,
Because it yieldeth them no fatter prey. 1710

Chris. What worms do another day I care not, but
I'll be sworn upon a whole kilderkin of single[345] beer,
I will not have a worm-eaten nose, like a pursuivant,[346]
while I live. Feasts are but puffing up the flesh, the pur-
veyors for diseases; travel, cost, time ill-spent. Oh, it
were a trim thing to send, as the Romans did, round
about the world for provision for one banquet. I must

rig ships to Samos for peacocks; to Paphos for pigeons,
to Austria for oysters; to Phasis for pheasants; to Arabia
for phoenixes; to Meander for swans; to the 1720
Orcades for geese; to Phrygia for woodcocks; to Malta
for cranes; to the Isle of Man for puffins; to Ambracia
for goats; to Tartole for lampreys; to Egypt for dates;
to Spain for chestnuts, and all for one feast.

Will S. Oh, sir, you need not; you may buy them at
London better cheap.[347]

Chris. Liberalitas liberalitate perit;[348] love me a little
and love me long:[349] our feet must have wherewithal to
fend[350] the stones; our backs, walls of wool to keep out
the cold that besiegeth our warm blood; our doors 1730
must have bars, our doublets must have buttons.
Item, for an old sword to scrape the stones before the
door with, three halfpence; for stitching a wooden tank-
ard that was burst.—These water-bearers will empty the
conduit and a man's coffers at once. Not a porter that
brings a man a letter but will have his penny. I am afraid
to keep past one or two servants, lest, hungry knaves,
they should rob me; and those I keep I warrant I do not
pamper up too lusty. I keep them under with red
herring and poor John[351] all the year long. 1740
I have dammed up all my chimneys for fear—though
I burn nothing but small coal—my house should be set
on fire with the smoke. I will not deny, but once in a
dozen year, when there is a great rot of sheep, and I
know not what to do with them, I keep open house for
all the beggars in some of my out-yards: marry they
must bring bread with them; I am no baker.

Will S. As good men as you, and have thought no
scorn to serve their prenticeships on the pillory.

Sum. Winter is this thy son? Hear'st how he talks?

Wint. I am his father, therefore may not speak,
But otherwise I could excuse his fault. 1752

Sum. Christmas, I tell thee plain, thou art a
 snudge,[352]
And were't not that we love thy father well,
Thou should'st have felt what longs[353] to avarice.
It is the honor of nobility
To keep high days and solemn festivals;
Then to set their magnificence to view,
To frolic open with their favorites,

[331] *powdering:* salt.
[332] *Milo:* Milon, Greek athlete, sixth century B.C., said
to have carried a heifer down the racecourse, killed it with a
blow, and eaten it in one day.
[333] *Sybarites:* inhabitants of an ancient city known for its
wealth and luxury. [334] *dishclouts:* dishcloths.
[335] *whole . . . dinner:* ask a whole fair . . . to dinner.
[336] *legs:* bows. [337] *wallets:* pouches.
[338] *Sardanapalus:* King of Assyria, seventh century B.C.
[339] *Nero . . . Commodus:* Roman emperors.
[340] *Smithfield:* meat-market district of London.
[341] *conceits:* imagines. [342] *sink:* sewer.
[343] *sheriff's tub:* tub of food scraps left for the poor.
[344] *Newgate:* London prison. [345] *single:* weak, poor.
[346] *pursuivant:* warrant-officer, messenger.
[347] *better cheap:* at a better price.
[348] *L.:* Liberality dies of liberality.
[349] *love . . . long:* first line of a popular song.
[350] *fend:* Q "feede."
[351] *poor John:* dried fish, eaten by the poor.
[352] *snudge:* miser. [353] *longs:* belongs.

And use their neighbors with all courtesy; 1760
When thou in hugger-mugger [354] spend'st thy wealth.
Amend thy manners, breathe [355] thy rusty gold;
Bounty will win thee love when thou art old.

Will S. Ay, that bounty would I fain meet, to borrow money of; he is fairly blessed nowadays that scapes blows when he begs. *Verba dandi et reddendi* [356] go together in the grammar rule: there is no giving but with condition of restoring.

Ah! *benedicite;* [357]
Well is he hath no necessity 1770
Of gold ne [358] of sustenance:
Slow good hap comes by chance;
Flattery best fares;
Arts are but idle wares;
Fair words want giving hands;
The *lento* [359] begs that hath no lands.
Fie on thee, thou scurvy knave,
That hast nought, and yet goes brave: [360]
A prison be thy deathbed,
Or be hanged all save the head. 1780

Sum. Backwinter, stand forth.

Vertum. Stand forth, stand forth; hold up your head; speak out.

Back. What, should I stand, or whither should I go?

Sum. Autumn accuseth thee of sundry crimes,
Which here thou art to clear or to confess.

Back. With thee, or Autumn, have I nought to do,
I would you were both hangèd, face to face.

Sum. Is this the reverence that thou ow'st to us?

Back. Why not? What art thou? Shalt thou always live?

Aut. It is the veriest dog in Christendom. 1790

Wint. That's, for he barks at such a knave as thou.

Back. Would I could bark the sun out of the sky,
Turn moon and stars to frozen meteors,
And make the ocean a dry land of ice!
With tempest of my breath turn up high trees,
On mountains heap up second mounts of snow,
Which, melted into water, might fall down
As fell the deluge on the former world!
I hate the air, the fire, the spring, the year,
And whatsoe'er brings mankind any good. 1800
Oh, that my looks were lightning to blast fruits!
Would I with thunder presently might die,
So I might speak in thunder to slay men.
Earth, if I cannot injure thee enough,
I'll bite thee with my teeth, I'll scratch thee thus:
I'll beat down the partition with my heels,
Which, as a mud-vault, severs hell and thee.

[354] *hugger-mugger:* secretly.
[355] *breathe:* expose to the air.
[356] *L.:* Verbs of giving and giving back.
[357] *L.:* bless us! [358] *ne:* nor.
[359] *It.:* idle man. [360] *brave:* splendidly dressed.
[361] *envies:* hates.
[362] *L.:* O unheard of wickedness, O voice of those who condemn; untraced quotation.
[363] *Hecuba:* wife of Priam and mother of his fifty sons.
[364] *Hippotades:* Aeolus, god of the winds; Q "Hipporlatos." [365] *'raying:* beraying, dirtying.
[366] *hold . . . well:* to the prompter or "bookholder."

Spirits come up! 'tis I that knock for you;
One that envies [361] the world far more than you.
Come up in millions! millions are too few, 1810
To execute the malice I intend.

Sum. O scelus inauditum, O vox damnatorum! [362]
Not raging Hecuba, [363] whose hollow eyes
Gave suck to fifty sorrows at one time,
That midwife to so many murders was,
Used half the execrations that thou dost.

Back. More I will use, if more I may prevail.
Backwinter comes but seldom forth abroad,
But when he comes he pincheth to the proof.
Winter is mild, his son is rough and stern; 1820
Ovid could well write of my tyranny,
When he was banished to the frozen zone.

Sum. And banished be thou from my fertile bounds.
Winter, imprison him in thy dark cell,
Or with the winds in bellowing caves of brass
Let stern Hippotades [364] lock him up safe,
Ne'er to peep forth, but when thou faint and weak
Want'st him to aid thee in thy regiment.

Back. I will peep forth, thy kingdom to supplant.
My father I will quickly freeze to death, 1830
And then sole monarch will I sit, and think
How I may banish thee as thou dost me.

Wint. I see my downfall written in his brows.
Convey him hence to his assignèd hell!
Fathers are given to love their sons too well.

[*Exit* BACKWINTER.]

Will S. No, by my troth, nor mothers neither: I am sure I could never find it. This Backwinter plays a railing part to no purpose: my small learning finds no reason for it, except as a Backwinter or an after winter is more raging, tempestuous, and violent than 1840 the beginning of winter; so he brings him in stamping and raging as if he were mad, when his father is a jolly, mild, quiet old man and stands still and does nothing.—The court accepts of your meaning. You might have writ in the margin of your playbook: "Let there be a few rushes laid in the place where Backwinter shall tumble, for fear of 'raying [365] his clothes"; or set down, "Enter Backwinter with his boy bringing a brush after him, to take off the dust, if need require." But you will ne'er have any wardrobe wit while you live. 1850 I pray you hold the book well, [366] we be not *non plus* in the latter end of the play.

Sum. This is the last stroke my tongue's clock must strike,
My last will, which I will that you perform.
My crown I have disposed already of.
Item, I give my withered flowers and herbs
Unto dead corpses, for to deck them with.
My shady walks to great men's servitors,
Who in their master's shadows walk secure.
My pleasant open air, and fragrant smells, 1860
To Croydon and the grounds abutting round.
My heat and warmth to toiling laborers,
My long days to bondmen and prisoners,
My short nights to young married souls.
My drought and thirst to drunkards' quenchless throats;
My fruits to Autumn, my adopted heir;

My murmuring springs, musicians of sweet sleep,
To malcontents,[367] with their well-tunèd cares
Channeled in a sweet falling quatorzain,[368]
Do lull their ears asleep, listening themselves. 1870
And finally, O words, now cleanse your course,
Unto Eliza,[369] that most sacred dame,
Whom none but saints and angels ought to name,
All my fair days remaining I bequeath
To wait upon her till she be returned.
Autumn, I charge thee, when that I am dead,
Be prest[370] and serviceable at her beck,
Present her with thy goodliest ripened fruits;
Unclothe no arbors where she ever sate,
Touch not a tree thou think'st she may pass by. 1880
And, Winter, with thy writhen frosty face,
Smooth up thy visage when thou look'st on her;
Thou never look'st on such bright majesty.
A charmèd circle draw about her court,
Wherein warm days may dance, and no cold come:
On seas let winds make war, not vex her rest;
Quiet enclose her bed, thought fly her breast.
Ah, gracious Queen, though summer pine away,
Yet let thy flourishing stand at a stay!
First droop this universal's[371] agèd frame, 1890
Ere any malady thy strength should tame.
Heaven raise up pillars to uphold thy hand;
Peace may have still his temple in thy land.
Lo! I have said; this is the total sum.
Autumn and Winter, on your faithfulness
For the performance I do firmly build.
Farewell, my friends: Summer bids you farewell!
Archers and bowlers, all my followers,
Adieu, and dwell with desolation;
Silence must be your master's mansion. 1900
Slow marching thus descend I to the fiends.
Weep heavens, mourn earth, here Summer ends.

Here the Satyrs *and* Woodnymphs *carry him
out, singing as he came in.*

THE SONG

*Autumn hath all the summer's fruitful treasure;
Gone is our sport, fled is poor Croydon's pleasure!
Short days, sharp days, long nights come on apace;
Ah, who shall hide us from the winter's face?
Cold doth increase, the sickness will not cease,
And here we lie, God knows, with little ease.
 From winter, plague, and pestilence, good Lord,
 deliver us!*

*London doth mourn, Lambeth[372] is quite forlorn; 1910
Trades cry, woe worth[373] that ever they were born!
The want of term[374] is town and city's harm.
Close chambers we do want to keep us warm.
Long banishèd must we live from our friends:
This low-built house[375] will bring us to our ends.
 From winter, plague, and pestilence, good Lord,
 deliver us!*

Will S. How is't, how is't? you that be of the graver
sort, do you think these youths worthy of a *plaudite*[376]

for praying for the Queen, and singing of the litany?
They are poor fellows I must needs say, and 1920
have bestowed great labor in sewing leaves and grass,
and straw, and moss upon cast[377] suits. You may do
well to warm your hands with clapping before you go
to bed, and send them to the tavern with merry hearts.

Enter a little Boy *with an Epilogue.*

Here is a pretty boy comes with an Epilogue, to get
him audacity. I pray you sit still a little and hear him
say his lesson without book. It is a good boy, be not
afraid; turn thy face to my lord. Thou and I will play
at pouch[378] tomorrow morning for a breakfast. Come
and sit on my knee and I'll dance thee, if thou canst not
endure to stand. 1931

THE EPILOGUE

Ulysses, a dwarf and the prolocutor for the Grecians,
gave me leave, that am a pigmy, to do an embassage to
you from the cranes. Gentlemen—for kings are no
better—certain humble animals, called our actors, com-
mend them unto you; who, what offense they have
committed I know not, except it be in purloining some
hours out of time's treasury that might have been better
employed, but by me, the agent for their imperfections,
they humbly crave pardon, if haply some of their 1940
terms have trod awry or their tongues stumbled unwit-
tingly on any man's content. In much corn is some
cockle;[379] in a heap of coin here and there a piece of
copper; wit hath his dregs as well as wine; words their
waste, ink his blots, every speech his parenthesis; poeti-
cal fury, as well crabs as sweetings[380] for his summer
fruits. *Nemo sapit omnibus horis.*[381] Their folly is de-
ceased; their fear is yet living. Nothing can kill an ass
but cold: cold entertainment, discouraging scoffs,
authorized disgraces, may kill a whole litter of 1950
young asses of them here at once, that have traveled
thus far in impudence only in hope to sit a-sunning in
your smile. The Romans dedicated a temple to the fever
quartan[382] thinking it some great god, because it shook
them so; and another to ill fortune in Esquilliis[383] a
mountain in Rome, that it should not plague them at
cards and dice. Your Grace's frowns are to them shaking
fevers; your least disfavors, the greatest ill fortune that
may betide them. They can build no temples but them-

[367] *To malcontents:* Q "To murmuring male-contents."
[368] *quatorzain:* fourteen-line poem, sonnet.
[369] *Eliza:* Queen Elizabeth. [370] *prest:* ready.
[371] *universal's:* universe's.
[372] *Lambeth:* London borough, and the London house of
the Archbishop of Canterbury. [373] *woe worth:* cursed be.
[374] *want of term:* absence of the Michaelmas law term,
exiled from London during a plague season.
[375] *low . . . house:* Croydon's architecture was known for
its lowness. [376] *L.:* round of applause.
[377] *cast:* cast-off (the origin of many theatrical costumes of
the day). [378] *pouch:* a children's game.
[379] *cockle:* weed that grows in grainfields.
[380] *sweetings:* sweet apples.
[381] *L.:* No one is wise all the time; proverbial.
[382] *quartan:* a fever with paroxysms recurring every fourth
day. [383] *Esquilliis:* Esquiline Hill, largest of Rome's seven.

selves, and their best endeavors with all prostrate 1960 reverence they here dedicate and offer up wholly to your service. *Sis bonus, O felixque tuis.*[384] To make the gods merry, the celestial clown Vulcan tuned his polt[385] foot to the measures of Apollo's lute and danced a limping galliard in Jove's starry hall; to make you merry, that are the gods of art, and guides unto heaven, a number of rude Vulcans, unwieldy speakers, hammerheaded clowns—for so it pleaseth them in modesty to name themselves—have set their deformities to view, as it were in a dance, here before you. Bear with their 1970 wants; lull melancholy asleep with their absurdities, and expect hereafter better fruits of their industry. Little creatures often terrify great beasts: the elephant flyeth from a ram; the lion from a cock and from fire; the

crocodile from all sea-fish; the whale from the noise of parched bones. Light toys chase great cares. The great fool Toy hath marred the play. Good night, gentlemen; I go.

Let him be carried away.

Will S. Is't true, jackanapes? Do you serve me so? As sure as this coat is too short for me, all the 1980 points of your hose for this are condemned to my pocket, if you and I e'er play at span-counter more. *Valete,*[386] *Spectatores;* pay for this sport with a *plaudite,* and the next time the wind blows from this corner, we will make you ten times as merry.

Barbarus hic ego sum, quia non intelligor ulli.[387]

FINIS

[384] *L.:* Be good and gracious to your own; Virgil, *Eclogues,* 5. 65. [385] *polt:* club. [386] *L.:* Farewell.
[387] *L.:* I am the barbarian here because I am understood by no one; Ovid, *Tristia,* V. 10. 37.

Anonymous

MUCEDORUS

MUCEDORUS was published in an astonishing seventeen known editions; it was acted before Queen Elizabeth and revived for performance before her successor; it was put on by strolling players in various parts of Oxfordshire during the years when the theaters were closed; there is a record of performance as late as 1654, and its last early edition appeared in 1668, seventy years after its first, when Dryden and Etherege were writing for the stage and most Elizabethan drama was old hat. It has sometimes been suggested that the number of editions reflects rather the play's attractiveness to groups of amateur players than its theatrical success, a suggestion strengthened by the *dramatis personae* broken down according to the doubling of parts. But even if that is the case, there can be no denying the comedy's popularity or the King's Men's willingness to revive it in 1610 "before the King's majesty at Whitehall on Shrove-Sunday night," as the title page of the edition that year testifies. (Whether it was the same company that first performed the play is not known; one would like to know whether Shakespeare played a part.)

To be sure MUCEDORUS is no work of genius, but to say that is a far cry from denigrating its success. The anonymity of its author is a wiser critical judgment than its inclusion among the "Shakespeare apocrypha," plays attributed at one time or another to Shakespeare. For MUCEDORUS is a product of its theater—both the stage and the pit—as much as any of the films of the 1930s that were enjoyed and scorned in their own day and are rediscovered a generation later as enduring art of a certain very entertaining kind, valuable in themselves and as the necessary condition for the greater art of the day. The title of the play in its first edition will suggest some of MUCEDORUS' charms: "A most pleasant comedy of Mucedorus, the king's son of Valencia, and Amadine, the king's daughter of Arragon, with the merry conceits of Mouse. Newly set forth, as it hath been sundry times played in the honorable City of London. Very delectable and full of mirth." The play represents its theater in a multitude of ways: in its mingling of romantic plot, a Vice-like clown, a pastoral shepherd, a primitive wild man, and a bear, classical stichomythia, song, competent and flowing blank verse, racy prose; in its generic freedom in bringing two deaths into a comedy; in its theatrical self-conscious-

ness, reflected by the frame and by the invitation at the end, like that in *Hamlet*, to turn the illusory reality that has just been witnessed into a work of art. If the melodramatic flatness of characters both good and evil is a limiting factor, the naive assumption that the true virtue of a prince makes him attractive to a princess even when he is disguised underlies so profound a Shakespearean romance as *Cymbeline*, and the magical forest in which all comes out right reminds us of other Shakespearean plays—just as the bear would serve the author of *The Winter's Tale*. Certainly Mouse the Clown, noticed on the title page, was the brightest attraction of the piece, with his deafness an amusing twist on the stock gimmick of the clod who willfully and stupidly misunderstands the words he hears. Bremo the wild man is something of a forerunner of Caliban, suggesting the interest of an age of exploration in the phenomenon of natural man while ensuring that the play remains fairy tale. Like Caliban he is not without his own kind of humanity, and in fact his romantic appeal to Amadine is perhaps the best speech in the play. But more than Caliban he resembles the lonely intruders of a later kind of romance, King Kong and the Frankenstein monster, sharing both the sentimentality of their conception, as in his version of "Come live with me and be my love," and the wry attitude of audience and playwright revealed in his campy "Now glut thy greedy guts with lukewarm blood." It is the unabashed combination of naive pleasure in a childish story and sophisticated detachment that makes MUCEDORUS a continuing delight.

The source of the main story is an episode in Sidney's *Arcadia*, but the playwright has drawn only the simplest details from it: the hero's name and disguise, the pursuing bear, the pattern of impeded and achieved love; and it is truer to say that the comedy is based on a whole tradition of romances, many of them staged, than that it springs from a single source. The 1610 edition, "amplified with new additions," is the basis of the present text in part because it is textually better on the whole, in part because the additions make it a better play. In brief, those additions consist of the Prologue, scenes i, ii, xiii, parts of xviii (including the conclusion), and the epilogue address to King James, which substitutes for an encomium to Queen Elizabeth.

N. R.

Mucedorus

DRAMATIS PERSONÆ

Ten persons may easily play it.[1]

THE KING *and* RUMBELO } *for one*
KING VALENCIA } *for one*
MUCEDORUS, *the Prince of Valencia* } *for one*
ANSELMO } *for one*
AMADINE, *the king's daughter of Aragon* } *for one*
SEGASTO, *a nobleman* } *for one*

ENVY; TREMELIO, *a captain;*
 BREMO, *a wild man* } *for one*
COMEDY; *a* Boy; *an* Old Woman;
 ARIENA, *Amadine's maid* } *for one*
COLLIN, *a counselor; a* Messenger } *for one*
MOUSE, *the clown* } *for one*
[A Bear]

THE PROLOGUE

Most sacred majesty, whose great deserts
Thy subject England, nay, the world admires,
Which heaven grant still increase—oh, may your praise,
Multiplying with your hours, your fame still raise;
Embrace your council; love, with faith, them guide,
That both as one bench[1] by each other's side.
So may your life pass on and run so even
That your firm zeal plant you a throne in heaven,
Where smiling angels shall your guardians be
From blemished traitors stained with perjury. 10
And as the night's inferior to the day,
So be all earthly regions to your sway.
Be as the sun to day, the day to night,
For from your beams Europe shall borrow light.
Mirth drown your bosom, fair delight your mind,
And may our pastime your contentment find.

Exit.

[INDUCTION]

Enter COMEDY *joyfully, with a garland of bays on her head.*

Com. Why, so; thus do I hope to please.
Music revives, and mirth is tolerable.
Comedy, play thy part and please;
Make merry them that comes to joy with thee.
Joy, then, good gentles; I hope to make you laugh.
Sound forth Bellona's[1] silver-tunèd strings.
Time fits us well; the day and place is ours.

Enter ENVY, *his arms naked, besmeared with blood.*

Env. Nay, stay, minion; there lies a block.[2]
What, all on mirth? I'll interrupt your tale
And mix your music with a tragic end 10
Com. What monstrous ugly hag is this
That dares control the pleasures of our will?
Vaunt,[3] churlish cur, besmeared with gory blood,
That seem'st to check the blossom of delight,
And stifle[4] the sound of sweet Bellona's breath.
Blush, monster, blush, and post away with shame,
That seekest disturbance of a goddess' deeds.
Env. Post hence thyself, thou counterchecking trull!
I will possess this habit,[5] spite of thee,
And gain the glory of thy wishèd port.[6] 20

I'll thunder music shall appall the nymphs
And make them shiver their clattering strings,
Flying for succor to their dankish[7] caves.

Sound drums within and cry, "Stab! Stab!"

Hearken, thou shalt hear a noise
Shall fill the air with a shrilling sound,
And thunder music to [the]⁸ gods above;
Mars shall himself breathe down
A peerless crown upon brave Envy's head,
And raise his chival⁹ with a lasting fame.
In this brave music Envy takes delight, 30
Where I may see them wallow in their blood,
To spurn at¹⁰ arms and legs quite shivered off
And hear the cries of many thousand slain.
How lik'st thou this, my trull? This sport alone for me!

 Com. Vaunt, bloody cur, nursed up with tiger's sap,
That so dost [seek to]¹¹ quail a woman's mind.
Comedy is mild, gentle, willing for to please,
And seeks to gain the love of all estates,
Delighting in mirth, mixed all with lovely tales,
And bringeth things with treble joy to pass. 40
Thou, bloody, envious disdainer of men's joys,
Whose name is fraught with bloody stratagems,
Delights in nothing but in spoil and death,
Where thou mayst trample in their lukewarm blood,
And grasp their hearts within thy cursèd paws.
Yet vail thy mind;¹² revenge thou not on me;
A silly woman begs it at thy hands.
Give me the leave to utter out my play.
Forbear this place, I humbly crave thee; hence,
And mix not death 'mongst pleasing comedies, 50
That treats naught else but pleasure and delight.
If any spark of human rests in thee,
Forbear, begone, tender¹³ the suit of me.

 Env. Why, so I will; forbearance¹⁴ shall be such
As treble death shall cross thee with despite
And make thee mourn where most thou joyest,
Turning thy mirth into a deadly dole,
Whirling thy pleasures with a peal of death,
And drench thy methods¹⁵ in a sea of blood.
This will I do; thus shall I bear with thee; 60
And, more to vex thee with a deeper spite,
I will with threats of blood begin thy play,
Favoring thee with envy and with hate.

 Com. Then, ugly monster, do thy worst;
I will defend them in despite of thee.
And, though thou think'st with tragic fumes¹⁶
To prave¹⁷ my play unto my deep disgrace.
I force it not;¹⁸ I scorn what thou canst do;
I'll grace it so thyself shall it confess
From tragic stuff to be a pleasant comedy. 70

 Env. Why then, Comedy, send thy actors forth,
And I will cross the first steps of their trade,

⁸ *[the]:* 1598; not in 1610. ⁹ *chival:* horse.
¹⁰ *spurn at:* stumble over.
¹¹ *[seek to]:* 1598; not in 1610.
¹² *vail . . . mind:* intend less.
¹³ *tender:* respond favorably.
¹⁴ *forbearance:* 1598; 1610 "forbear."
¹⁵ *methods:* literary designs, plots.
¹⁶ *fumes:* fits of anger. ¹⁷ *prave:* ruin.
¹⁸ *force . . . not:* don't care. ¹⁹ *maugre:* in spite of.
²⁰ *prove to:* 1598, become; 1610 "prove two."

i.

¹ *coy:* disdainful. ² *Misconster:* Misconstrue.
³ *miss:* absence. ⁴ *gripe:* grasp. ⁵ *suit:* dress.

Making them fear the very dart of death.

 Com. And I'll defend them maugre¹⁹ all thy spite.
So, ugly fiend, farewell, till time shall serve
That we may meet to parle[y] for the best.

 Env. Content, Comedy; I'll go spread my branch,
And scattered blossoms from mine envious tree
Shall prove to²⁰ monsters, spoiling of their joys.

 Ex[eunt.]

[i]

Sound. Enter MUCEDORUS *and* ANSELMO, *his friend.*

 Mu. Anselmo.

 Ans. My lord and friend.

 Mu. True, my Anselmo, both thy lord and friend,
Whose dear affections bosom with my heart
And keep their domination in one orb.

 Ans. Whence ne'er disloyalty shall root it forth,
But faith plant firmer in your choice respect.

 Mu. Much blame were mine if I should other deem,
Nor can coy¹ fortune contrary allow.
But, my Anselmo, loath I am to say 10
I must estrange that friendship.
Misconster² not: 'tis from the realm, not thee;
Though lands part bodies, hearts keep company.
Thou know'st that I imparted often have
Private relations with my royal sire,
Had as concerning beauteous Amadine,
Rich Aragon's bright jewel, whose face some say
That blooming lilies never shone so gay,
Excelling, not excelled. Yet lest report
Does mangle verity, boasting of what is not, 20
Winged with desire, thither I'll straight repair,
And be my fortunes, as my thoughts are, fair.

 Ans. Will you forsake Valencia, leave the court,
Absent you from the eye of sovereignty?
Do not, sweet prince, adventure on that task,
Since danger lurks each where. Be won from it.

 Mu. Desist dissuasion;
My resolution brooks no battery;
Therefore, if thou retain thy wonted form,
Assist what I intend. 30

 Ans. Your miss³ will breed a blemish in the court
And throw a frosty dew upon that beard
Whose front Valencia stoops to.

 Mu. If thou my welfare tender, then no more;
Let love's strong magic charm thy trivial phrase,
Wasted as vainly as to gripe⁴ the sun.
Augment not then more answers; lock thy lips,
Unless thy wisdom suit⁵ me with disguise
According to my purpose.

 Ans. That action craves no counsel, 40
Since what you rightly are will more command
Than best usurpèd shape.

 Mu. Thou still art opposite in disposition.
A more obscure, servile habiliment
Beseems this enterprise.

 Ans. Then like a Florentine or mountebank?

 Mu. 'Tis much too tedious; I dislike thy judgment.
My mind is grafted on an humbler stock.

Ans. Within my closet does there hang a cassock;
Though base the weed is, 't was a shepherd's 50
Which I presented in Lord Julio's masque.
 Mu. That, my Anselmo, and none else but that,
Mask Mucedorus from the vulgar view.
That habit suits my mind; fetch me that weed.
 Exit Anselmo.
Better than kings have not disdained that state,
And much inferior, to obtain their mate.

 Enter Anselmo *with a shepherd's coat.*

So let our respect command thy secrecy.
At once a brief farewell;
Delay to lovers is a second hell.
 Exit Mucedorus.
 Ans. Prosperity forerun thee; awkward chance 60
Never be neighbor to thy wish's venture;
Content and fame advance thee; ever thrive,
And glory thy mortality survive.
 Exit.

[ii]

 Enter Mouse *with a bottle* [1] *of hay.*

 Mouse. Oh, horrible, terrible! Was ever poor gentle-
man so scared out of his seven senses? A bear? Nay,
sure it cannot be a bear, but some devil in a bear's
doublet, for a bear could never have had that agility to
have frighted me. Well, I'll see my father hanged before
I'll serve his horse any more. Well, I'll carry home my
bottle of hay, and for once make my father's horse turn
puritan and observe fasting days, for he gets not a bit.
But soft! this way she followed me; therefore I'll take
the other path; and, because [2] I'll be sure to have 10
an eye on him, I will take hands with some foolish
creditor, [3] and make every step backward.

 As he goes backwards the Bear *comes in and he tumbles
 over her, and runs away and leaves his bottle of hay
 behind him.*

[iii]

 Enter Segasto *running and* Amadine *after him,
 being pursued with a bear.*

 Seg. Oh, fly, madam, fly or else we are but dead.
 Am. Help, Segasto, help! Help, sweet Segasto, or
else I die!
 Seg. Alas, madam, there is no way but flight;
Then haste and save yourself.
 Segasto *runs away.*
 Am. Why, then I die; ah, help me in distress.

 Enter Mucedorus *like a shepherd, with a sword
 drawn and a bear's head in his hand.*

 Mu. Stay, lady, stay, and be no more dismayed.
That cruel beast most merciless and fell,
Which hath bereavèd thousands of their lives,
Affrighted many with his hard pursues,
Prying from place to place to find his prey, 10
Prolonging thus his life by others' death,

His carcass now lies headless, void of breath.
 Am. That foul, deformèd monster, is he dead?
 Mu. Assure yourself thereof: behold his head,
Which, if it please you, lady, to accept,
With willing heart I yield it to your majesty.
 Am. Thanks, worthy shepherd, thanks a thousand
 times.
This gift, assure thyself, contents me more
Than greatest bounty of a mighty prince,
Although he were the monarch of the world. 20
 Mu. Most gracious goddess, more than mortal
 wight—
Your heavenly hue of right imports no less—
Most glad am I in that it was my chance
To undertake this enterprise in hand
Which doth so greatly glad your princely mind.
 Am. No goddess, shepherd, but a mortal wight,
A mortal wight distressèd as thou seest.
My father here is King of Aragon.
I, Amadine, his only daughter am,
And after him sole heir unto the crown. 30
Now whereas it is my father's will
To marry me unto Segasto, one
Whose wealth through father's former usury
Is known to be no less than wonderful,
We both of custom oftentimes did use,
Leaving the court, to walk within the fields
For recreation, especially [in] the spring,
In that it yields great store of rare delights;
And, passing further than our wonted walks,
Scarce entered were within these luckless woods 40
But right before us down a steep-fall hill
A monstrous, ugly bear did hie him fast
To meet us both. I faint to tell the rest,
Good shepherd, but suppose the ghastly looks,
The hideous fears, the thousand hundred woes,
Which at this instant Amadine sustained.
 Mu. Yet, worthy princess, let thy sorrow cease,
And let this sight your former joys revive.
 Am. Believe me, shepherd, so it doth no less.
 Mu. Long may they last unto your heart's content
But tell me, lady, what is become of him 51
Segasto called? What is become of him?
 Am. I know not, I; that know the powers divine;
But God grant this, that sweet Segasto live.
 Mu. Yet hard-hearted he in such a case,
So cowardly to save himself by flight,
And leave so brave a princess to the spoil.
 Am. Well, shepherd, for thy worthy valor tried,
Endangering thyself to set me free,
Unrecompensèd sure thou shalt not be. 60
In court thy courage shall be plainly known;
Throughout the kingdom will I spread thy name,
To thy renown and never-dying fame.
And, that thy courage may be better known,
Bear thou the head of this most monstrous beast
In open sight to every courtier's view.

ii.
 [1] *bottle:* bundle. [2] *because:* so that.
 [3] *foolish creditor:* i.e., afraid to take his eyes off his debtor.

So will the King my father thee reward.
Come, let's away, and guard me to the court.
Mu. With all my heart.

 Exeunt.

[iv]

 Enter SEGASTO *solus.*

Seg. When heaps of harms do hover overhead,
'Tis time as then, some say, to look about,
And of¹ ensuing harms to choose the least.
But hard, yea, hapless, is that wretch's chance,
Luckless his lot and caitiff²-like accursed,
At whose proceedings fortune ever frowns:
Myself I mean, most subject unto thrall,
For I, the more I seek to shun the worst,
The more by proof I find myself accursed.
Erewhiles assaulted with an ugly bear, 10
Fair Amadine in company all alone,
Forthwith by flight I thought to save myself,
Leaving my Amadine unto her shifts,
For death it was for to resist the bear,
And death no less of Amadine's harms to hear.
Accursèd I in ling'ring life thus long!
In living thus, each minute of an hour
Doth pierce my heart with darts of thousand deaths.
If she by flight her fury do escape,
What will she think? 20
Will she not say, yea, flatly to my face,
Accusing me of mere³ disloyalty,
A trusty friend is tried in time of need?
But I, when she in danger was of death
And needed me and cried "Segasto, help!"
I turned my back and quickly ran away.
Unworthy I to bear this vital breath!
But what? What needs these plaints?
If Amadine do live, then happy I;
She will in time forgive and so forget. 30
Amadine is merciful, not Juno like
In harmful heart to harbor hatred long.

Enter MOUSE, *the* Clown, *running, crying* "*Clubs!*"⁴

Mouse. Clubs, prongs, pitchforks, bills!⁵ Oh, help!
A bear, a bear, a bear!
Seg. Still⁶ bears, and nothing else but bears! Tell
me, sirrah, where she is.
Mouse. Oh, sir, she is run down the woods. I saw her
white head and her white belly.
Seg. Thou talkest of wonders, to tell me of white
 bears.
But, sirrah, didst thou ever see any such? 40

Mouse. No, faith, I never saw any such, but I re-
member my father's words: he bade me take heed I was
not caught with a white bear.
Seg. A lamentable tale, no doubt.
Mouse. I tell you what, sir, as I was going afield to
serve my father's great horse, and carried a bottle of
hay upon my head—now do you see, sir—I, fast⁷
hoodwinked⁸ that I could see nothing, I perceiving the
bear coming, I threw my hay into the hedge and ran
away. 50
Seg. What, from nothing?
Mouse. I warrant you, yes, I saw something, for
there was two load of thorns besides my bottle of hay,
and that made three.
Seg. But tell me, sirrah, the bear that thou didst see.
Did she not bear a bucket on her arm?
Mouse. Ha, ha, ha! I never saw bear go a-milking in
all my life. But hark you, sir, I did not look so high as
her arm; I saw nothing but her white head and her
white belly. 60
Seg. But tell me, sirrah, where dost thou dwell?
Mouse. Why, do you not know me?
Seg. Why, no, how should I know thee?
Mouse. Why, then, you know nobody and⁹ you
know not me.¹⁰ I tell you, sir, I am the Goodman Rat's
son of the next parish over the hill.
Seg. Goodman Rat's son? Why, what's thy name?
Mouse. Why, I am very near kin unto him.
Seg. I think so, but what's thy name?
Mouse. My name? I have a very pretty name. I'll
tell you what my name is; my name is Mouse. 71
Seg. What, plain Mouse?
Mouse. Ay, plain Mouse without either welt or
guard.¹¹ But do you hear, sir, I am but a very young
mouse, for my tail is scarce grown out yet; look you
here else.
Seg. But, I pray thee, who gave thee that name?
Mouse. Faith sir, I know not that, but if you would
fain know ask my father's great horse, for he hath been
half a year longer with my father than I have. 80
Seg. [*Aside*] This seems to be a merry fellow.
I care not if I take him home with me;
Mirth is a comfort to a troubled mind;
A merry man a merry master makes.—
How sayst thou, sirrah, wilt thou dwell with me?
Mouse. Nay, soft, sir, two words to a bargain. Pray
you, what occupation are you?
Seg. No occupation; I live upon my lands.
Mouse. Your lands? Away, you are no master for
me. Why, do you think that I am so mad to go seek 90
my living in the lands amongst the stones, briers, and
bushes, and tear my holiday apparel? Not I, by your
leave.
Seg. Why, I do not mean thou shalt.
Mouse. How then?
Seg. Why, thou shalt be my man, and wait upon me
at the court.
Mouse. What's that?
Seg. Where the King lies.
Mouse. What's that same king, a man or a woman?
Seg. A man as thou art. 101

Mouse. As I am? Hark you, sir; pray you, what kin is he to Goodman King of our parish, the churchwarden?

Seg. No kin to him; he is the King of the whole land.

Mouse. King of the land! I never see him.

Seg. If thou wilt dwell with me, thou shalt see him every day.

Mouse. Shall I go home again to be torn in pieces with bears? No, not I. I will go home and put on a clean shirt, and then go drown myself. 110

Seg. Thou shalt not need; if thou wilt dwell with me, thou shalt want nothing.

Mouse. Shall I not? Then here's my hand; I'll dwell with you. And hark you, sir; now you have entertained me, I will tell you what I can do: I can keep my tongue from picking and stealing and my hands from lying and slandering, I warrant you, as well as ever you had man in all your life.

Seg. Now will I to court with sorrowful heart, rounded[12] with doubts.[13] If Amadine do live, then happy I; yea, happy I, if Amadine do live. 121

[*Exeunt.*]

[v]

Enter the KING *with a young* Prince *prisoner, with* AMADINE, TREMELIO, COLLIN *and* Counselors

King. Now, brave lords, our wars are brought to end,
Our foes the foil,[1] and we in safety rest.
It us behooves to use such clemency in peace
As valor in the wars.
It is as great honor to be bountiful at home
As to be conquerors in the field.
Therefore, my lords, the more to my content,
Your liking, and your country's safeguard,
We are disposed in marriage for to give
Our daughter to Lord Segasto here, 10
Who shall succeed the diadem after me,
And reign hereafter as I tofore[2] have done,
Your sole and lawful King of Aragon.
What say you, lordings? Like you of my advice?

Col. An't please your majesty, we do not only allow of your highness' pleasure, but also vow faithfully in what we may to further it.

King. Thanks, good my lords; if long Adrostus live, He will at full requite your courtesies.
Tremelio, in recompense of thy late valor done, 20
Take unto thee the Catalone,[3] a prince,
Lately our prisoner taken in the wars.
Be thou his keeper; his ransom shall be thine;
We'll think of it when leisure shall afford.
Meanwhile, do use him well; his father is a king.

Tre. Thanks to your majesty! His usage shall be such As he thereat shall think no cause to grutch.[4]

Exeunt [TREMELIO *and* Prince].

King. Then march we on to court and rest our
 wearied limbs.
But, Collin, I have a tale in secret kept for thee:
When thou shalt hear a watchword from thy King, 30
Think then some weighty matter is at hand
That highly shall concern our state;

Then, Collin, look thou be not far from me.
And, for the service thou tofore hast done,
Thy truth and valor proved in every point,
I shall with bounties thee enlarge therefor.
So guard us to the court.

Col. Whatso my sovereign doth command me do,
With willing mind I gladly consent.

Exeunt.

[vi]

Enter SEGASTO *and* [MOUSE] *the* Clown, *with weapons about him.*

Seg. Tell me, sirrah, how do you like your weapons?

Mouse. Oh, very well, very well; they keep my sides warm.

Seg. They keep the dogs from your shins very well, do they not?

Mouse. How, keep the dogs from my shins? I would scorn but my shins could keep the dogs from them.

Seg. Well, sirrah, leaving idle talk, tell me dost thou know Captain Tremelio's chamber?

Mouse. Ay, very well; it hath a door. 10

Seg. I think so, for so hath every chamber. But dost thou know the man?

Mouse. Ay, forsooth; he hath a nose on his face.

Seg. Why, so hath everyone.

Mouse. That's more than I know.

Seg. But dost thou remember the captain that was here with the King even now, that brought the young prince prisoner?

Mouse. Oh, very well. 19

Seg. Go unto him and bid him come unto me. Tell him I have a matter in secret to impart to him.

Mouse. I will, master—master, what's his name?

Seg. Why, Captain Tremelio.

Mouse. Oh, the mealman; I know him very well; he brings meal every Saturday. But hark you, master, must I bid him come to you or must you come to him?

Seg. No, sirrah, he must come to me.

Mouse. Hark you, master, how if he be not at home? What shall I do then?

Seg. Why, then leave word with some of his folks. 30

Mouse. Oh, master, if there be nobody within, I will leave word with his dog.

Seg. Why, can his dog speak?

Mouse. I cannot tell; wherefore doth he keep his chamber else?

Seg. To keep out such knaves as thou art.

Mouse. Nay, by Lady; then go yourself.

Seg. You will go, sir, will you not?

Mouse. Yes, marry, will I. Oh, 'tis come to my head; and a[1] be not within, I'll bring his chamber to you. 40

12 *rounded:* surrounded. 13 *doubts:* fears.

v.

1 *foil:* defeated. 2 *tofore:* before.
3 *Catalone:* Catalonian. 4 *grutch:* complain.

vi.

1 *a:* he.

Seg. What, wilt thou pluck down the King's house?

Mouse. Nay, by Lady, I'll know the price of it first. Master, it is such a hard name I have forgotten it again, I pray you, tell me his name.

Seg. I tell thee, Captain Tremelio.

Mouse. Oh, Captain Treble-knave, Captain Treble-knave.

Enter TREMELIO.

Tre. How now, sirrah, dost thou call me?

Mouse. You must come to my master, Captain Treble-knave. 50

Tre. My Lord Segasto, did you send for me?

Seg. I did, Tremelio.—Sirrah, about your business.

Mouse. Ay, marry, what's that? Can you tell?

Seg. No, not well.

Mouse. Marry, then, I can; straight to the kitchen-dresser, to John the cook, and get me a good piece of beef and brewis,[2] and then to the buttery-hatch to Thomas the butler for a jack[3] of beer, and there for an hour I'll so belabor myself. And therefore, I pray you, call me not till you think I have done, I pray you, good master. 61

Exit.

Seg. Well, sir, away.—Tremelio, this it is: thou knowest the valor of Segasto spread through all the kingdom of Aragon, and such as have found triumph and favors, never daunted at any time; but now a shepherd [is] admired at in court for worthiness, and Segasto's honor laid aside. My will, therefore, is this: that thou dost find some means to work the shepherd's death. I know thy strength sufficient to perform my desire, and thy love no otherwise than to revenge my injuries. 71

Tre. It is not the frowns of a shepherd that Tremelio fears. Therefore, account it accomplished, what I take in hand.

Seg. Thanks, good Tremelio, and assure thyself What I promise that will I perform.

Tre. Thanks, good my lord, and in good time see where
He cometh. Stand by a while, and you shall see
Me put in practice your intended drift.[4]

Enter MUCEDORUS.

Have at thee, swain, if that I hit thee right! 80

Mu. Vile coward, so without cause to strike a man! Turn, coward, turn; now strike and do thy worst!

MUCEDORUS *killeth him.*

Seg. Hold, shepherd, hold; spare him, kill him not.
Accursèd villain, tell me what hast thou done?
Ah, Tremelio, trusty Tremelio,

I sorrow for thy death, and, since that thou
Living didst prove faithful to Segasto,
So Segasto now living will honor
The dead corpse of Tremelio with revenge. 89
Bloodthirsty villain, born and bred in merciless murder,
Tell me, how durst thou be so bold as once
To lay thy hands upon the least of mine?
Assure thyself, thou shalt be used according to the law.

Mu. Segasto, cease; these threats are needless.
Accuse not me of murder that have done nothing
But in mine own defense.

Seg. Nay, shepherd, reason not with me.
I'll manifest thy fact[5] unto the King,
Whose doom[6] will be thy death, as thou deserv'st.
What ho, Mouse, come away. 100

Enter MOUSE.

Mouse. Why, how now, what's the matter? I thought you would be calling before I had done.

Seg. Come, help; away with my friend.

Mouse. Why, is he drunk? Cannot he stand on his feet?

Seg. No, he is not drunk; he is slain.

Mouse. Flain?[7] No, by Lady; he is not flain.

Seg. He's killed, I tell thee.

Mouse. What, do you use to kill your friends? I will serve you no longer. 110

Seg. I tell thee, the shepherd killed him.

Mouse. Oh, did a so? But, master, I will have all his apparel if I carry him away?

Seg. Why, so thou shalt.

Mouse. Come, then, I will help. Mass, Master, I think his mother sung "looby"[8] to him, he is so heavy.

Exeunt [SEGASTO *and* MOUSE].

Mu. Behold the fickle state of man, always mutable,
Never at one. Sometimes we feed on fancies
With the sweet of our desires; sometimes again
We feel the heat of extreme miseries. 120
Now am I in favor about the court and country;
Tomorrow those favors will turn to frowns.
Today I live revengèd on my foe;
Tomorrow I die, my foe revenged on me.

Exit.

[vii]

Enter BREMO, *a wild man.*

Bre. No passenger[1] this morning? What, not one?
A chance that seldom doth befall.
What, not one? Then lie thou there,
And rest thyself till I have further need.

[*Puts down his club.*]

Now, Bremo, sith[2] thy leisure so affords—
An endless thing. Who knows not Bremo's strength,
Who like a king commands[3] within these woods?
The bear, the boar, dares not abide my sight,
But haste away to save themselves by flight.
The crystal waters in the bubbling brooks, 10
When I come by, doth swiftly slide away,
And claps themselves in closets under banks,

[2] *brewis:* broth in which beef and vegetables have been cooked. [3] *jack:* leather tankard.
[4] *drift:* plan. [5] *fact:* deed. [6] *doom:* judgment.
[7] *Flain:* Flayed. [8] *looby:* lazy, stupid, hulking lout.
vii.
[1] *passenger:* traveler. [2] *sith:* since.
[3] *commands:* Qq "commander."

Afraid to look bold Bremo in the face.
The agèd oaks at Bremo's breath doth bow,
And all things else are still at my command.
Else, what would I?
Rend them in pieces and pluck them from the earth,
And each way else I would revenge myself.
Why, who comes here with whom I dare not fight?
Who fights with me and doth not die the death? Not
 one. 20
What favor shows this sturdy stick to those
That here within these woods are combatants with me?
Why, death, and nothing else but present death.
With restless rage I wander through these woods;
No creature here but feareth Bremo's force;
Man, woman, child, beast, and bird,
And everything that doth approach my sight
Are forced to fall if Bremo once do frown.
Come, cudgel, come, my partner in my spoils,
For here I see this day it will not be; 30
But, when it falls that I encounter any,
One pat sufficeth for to work my will.
What, comes not one? Then let's begone;
A time will serve when we shall better speed.

 Exit.

[viii]

 Enter the KING, SEGASTO, *the* Shepherd,
 [i.e. MUCEDORUS] *and* [MOUSE] *the*
 Clown, *with others.*

 King. Shepherd, thou hast heard thine accusers;
Murder is laid to thy charge.
What canst thou say? Thou hast deservèd death.
 Mu. Dread sovereign, I must needs confess
I slew this captain in mine own defense,
Not of any malice but by chance;
But mine accuser hath a further meaning.
 Seg. Words will not here prevail;
I seek for justice, and justice craves his death.
 King. Shepherd, thine own confession hath con-
 demned thee. 10
Sirrah, take him away and do him to execution straight.
 Mouse. So he shall, I warrant him. But do you hear,
master King, he is kin to a monkey; his neck is bigger
than his head.
 Seg. Come, sirrah, away with him, and hang him
about the middle.
 Mouse. Yes, forsooth, I warrant you. Come on, sir.
Ah, so like a sheepbiter [1] a looks!

 Enter AMADINE *and a* Boy *with a bear's head.*

 Am. Dread sovereign and well-belovèd sire,
On bended knee I crave the life of this 20
Condemnèd shepherd, which heretofore preserved
The life of thy sometime distressèd daughter.
 King. Preserved the life of my sometime distressèd
 daughter?
How can that be? I never knew the time
Wherein thou wast distressed; I never knew the day
But that I have maintainèd thy estate
As best beseemed the daughter of a king.

I never saw the shepherd until now.
How comes it, then, that he preserved thy life?
 Am. Once walking with Segasto in the woods, 30
Further than our accustomed manner was,
Right before us, down a steep-fall hill,
A monstrous, ugly bear did hie him fast
To meet us both. Now whether this be true,
I refer it to the credit of Segasto.
 Seg. Most true, an't like your majesty.
 King How then?
 Am. The bear, being eager to obtain his prey,
Made forward to us with an open mouth,
As if he meant to swallow us both at once,
The sight whereof did make us both to dread, 40
But specially your daughter Amadine,
Who, for I saw no succor incident
But in Segasto's valor, I grew desperate,
And he most cowardlike began to fly—
Left me distressed to be devoured of him.
How say you, Segasto, is it not true?
 King. His silence verifies it to be true. What then?
 Am. Then I amazed, distressèd, all alone,
Did hie me fast to scape that ugly bear;
But all in vain, forwhy [2] he reachèd after me, 50
And hardly I did oft escape his paws,
Till at the length this shepherd came,
And brought to me his head. Come hither, boy.
Lo, here it is, which I present unto your majesty.
 King. The slaughter of this bear deserves great fame.
 Seg. The slaughter of a man deserves great blame.
 King. Indeed, occasion oftentimes so falls out.
 Seg. Tremelio in the wars, O King, preservèd thee.
 Am. The shepherd in the woods, O King, preservèd
 me.
 Seg. Tremelio fought when many men did yield. 60
 Am. So would the shepherd, had he been in field.
 Mouse. [*Aside*] So would my master, had he not run
 away.
 Seg. Tremelio's force saved thousands from the foe.
 Am. The shepherd's force hath savèd thousands mo. [3]
 Mouse. [*Aside*] Ay, shipsticks, [4] nothing else.
 King. Segasto, cease to accuse the shepherd;
His worthiness deserves a recompense;
All we are bound to do the shepherd good.
Shepherd, whereas it was my sentence thou shouldst
 die,
So shall my sentence stand, for thou shalt die. 70
 Seg. Thanks to your majesty.
 King. But soft, Segasto, not for this offense!
Long mayst thou live, and, when the Sisters [5] shall
 decree
To cut in twain the twisted thread of life,
Then let him die. For this I set him free.—
And for thy valor I will honor thee.

viii.
 [1] *sheepbiter:* sneaky or censorious fellow.
 [2] *forwhy:* because. [3] *mo:* more.
 [4] *shipsticks:* sheep's ticks.
 [5] In classical Greek mythology, the Three Fates, who
spun the thread of human destiny which they could cut off
when they wished.

Mu. Thanks to your majesty.

King. Come, daughter, let us now depart, to honor the worthy valor of the shepherd with our rewards. 79

 Exeunt [*all but* MOUSE *and* SEGASTO].

Mouse. O Master, hear you. You have made a fresh hand now. You would be slow, you! What will you do now? You have lost me a good occupation by the means. Faith, master, now I cannot hang the shepherd, I pray you, let me take the pains to hang you; it is but half an hour's exercise.

Seg. You are still in your knavery, but sith I cannot have his life I will procure his banishment forever. Come on, sirrah.

Mouse. Yes, forsooth, I come—[*To audience.*] Laugh at him, I pray you. 90

 Exeunt.

[ix]

 Enter MUCEDORUS *solus.*

Mu. From Amadine and from her father's court,
With gold and silver and with rich rewards,
Flowing from the banks of golden treasures—
More may I boast and say: but I
Was never shepherd in such dignity.

 Enter the Messenger *and* [MOUSE] *the* Clown.

Mess. All hail, worthy shepherd!

Mouse. All rain, lousy shepherd!

Mu. Welcome, my friends. From whence come you?

Mess. The King and Amadine greet thee well, and after greeting done bids thee depart the court. Shepherd, begone! 11

Mouse. Shepherd! Take law,[1] legs; fly away, shepherd.

Mu. Whose words are these? Came these from
 Amadine?

Mess. Ay, from Amadine.

Mouse. Ay, from Amadine.

Mu. Ah, luckless fortune, worse than Phaëthon's[2]
 tale,
My former bliss is now become my bale.[3]

Mouse. What, wilt thou poison thyself?

Mu. My former heaven is now become my hell. 20

Mouse. The worst alehouse that ever I came in, in all my life.

Mu. What shall I do?

Mouse. Even go hang thyself half an hour.

Mu. Can Amadine so churlishly command
To banish the shepherd from her father's court?

Mess. What should shepherds do in the court?

Mouse. What should shepherds do amongst us? Have we not lords enough on us in the court? 29

Mu. Why, shepherds are men, and kings are no more.

Mess. Shepherds are men, and masters over their flock.

Mouse. That's a lie. Who pays them their wages then?

Mess. Well, you are always interrupting of me, but you were best to look to him, lest you hang for him when he is gone.

 Exit [Messenger].
 The Clown [MOUSE] *sings.*

Mouse. And you shall hang for company,
For leaving me alone. 40

Shepherd, stand forth and hear my sentence: shepherd, begone within three days in pain of my displeasure. Shepherd, begone; shepherd, begone, begone, begone, begone, shepherd, shepherd, shepherd.

 Exit [MOUSE.]

Mu. And must I go? And must I needs depart?
Ye goodly groves, partakers of my songs
In time tofore when fortune did not frown,
Pour forth your plaints and wail awhile with me.
And thou, bright sun, my comfort in the cold,
Hide, hide thy face and leave me comfortless. 50
Ye wholesome herbs and sweet-smelling savors,
Yea, each thing else prolonging life of man,
Change, change your wonted course, that I,
Wanting your aid, in woeful sort may die.

 Enter AMADINE *and* ARIENA, *her maid.*

Am. Ariena, if anybody ask for me,
Make some excuse till I return.

Ari. What and Segasto call?

Am. Do thou the like to him; I mean not to stay
 long.

 Exit [ARIENA].

Mu. This voice so sweet my pining spirits revives.

Am. Shepherd, well met; tell me how thou doest.

Mu. I linger life, yet wish for speedy death. 61

Am. Shepherd, although thy banishment already
Be decreed, and all against my will,
Yet Amadine—

Mu. Ah Amadine, to hear of banishment
Is death, ay, double death to me;
But, since I must depart, one thing I crave.

Am. Say on with all my heart.

Mu. That in absence, either far or near,
You honor me, as servant, with your name. 70

Am. Not so.

Mu. And why?

Am. I honor thee as sovereign of my heart.

Mus. A shepherd and a sovereign? Nothing like.

Am. Yet like enough where there is no dislike.

Mu. Yet great dislike, or else no banishment.

Am. Shepherd, it is only
Segasto that procures thy banishment.

Mu. Unworthy wights are more in jealousy.

Am. Would God they would free thee from
 banishment, 80
Or likewise banish me.

Mu. Amen, say I, to have your company.

Am. Well, shepherd, sith thou suff'rest this for my
 sake,

ix.
[1] *law:* handicap, lead (hunting and racing).
[2] *Phaëthon's:* who was killed by Zeus for mismanaging the chariot of his father, the sun. [3] *bale:* woe, undoing.

With thee in exile also let me live—
On this condition, shepherd, thou canst love.
 Mu. No longer love, no longer let me live.
 Am. Of late I lovèd one indeed; now love
I none but only thee.
 Mu. Thanks, worthy princess.
I burn likewise, yet smother up the blast;
I dare not promise what I may perform. 90
 Am. Well, shepherd, hark what I shall say:
I will return unto my father's court,
There for to provide me of such necessaries
As for my journey I shall think most fit;
This being done, I will return to thee.
Do thou, therefore, appoint the place
Where we may meet.
 Mu. Down in the valley where I slew the bear.
And there doth grow a fair, broad-branchèd beech
That overshades a well; so who comes first 100
Let them abide the happy meeting of us both.
How like you this?
 Am. I like it very well.
 Mu. Now, if you please, you may appoint the time.
 Am. Full three hours hence, God willing, I will
 return.
 Mu. The thanks that Paris gave the Grecian queen
The like doth Mucedorus yield.
 Am. Then, Mucedorus, for three hours farewell.
 Exit.
 Mu. Your departure, lady, breeds a privy[4] pain.
 Exit.

[x]

 Enter SEGASTO *solus.*

 Seg. 'Tis well, Segasto, that thou hast thy will.
Should such a shepherd, such a simple swain
As he, eclipse thy credit famous through
The court? No, ply,[1] Segasto, ply.
Let it not in Aragon be said
A shepherd hath Segasto's honor won.

 Enter MOUSE *the* Clown, *calling his master.*

 Mouse. What ho, master, will you come away?
 Seg. Will you come hither? I pray you, what's the
matter?
 Mouse. Why, is it not past eleven o'clock? 10
 Seg. How then, sir?
 Mouse. I pray you, come away to dinner.
 Seg. I pray you, come hither.
 Mouse. Here's such ado with you. Will you never
come?
 Seg. I pray you, sir, what news of the message I sent
you about?
 Mouse. I tell you all the messes[2] be on the table
already. There wants not so much as a mess of mustard
half an hour ago. 20
 Seg. Come, sir, your mind is all upon your belly;
You have forgotten what I bid you do.
 Mouse. Faith, I know nothing, but you bade me go
to breakfast.

 Seg. Was that all?
 Mouse. Faith, I have forgotten it; the very scent of
the meat hath made me forget[3] it quite.
 Seg. You have forgotten the errand[4] I bid you do?
 Mouse. What arrant? An arrant knave, or an arrant
whore? 30
 Seg. Why, thou knave, did I not bid thee banish the
shepherd?
 Mouse. Oh, the shepherd's bastard.
 Seg. I tell thee, the shepherd's banishment.
 Mouse. I tell you, the shepherd's bastard shall be
well kept. I'll look to it myself. But, I pray you, come
away to dinner.
 Seg. Then you will not tell me whether you have
banished him or no?
 Mouse. Why, I cannot say "banishment," and you
would give me a thousand pounds to say so. 41
 Seg. Why you whoreson[5] slave, have you forgotten
that I sent you and another to drive away the shepherd?
 Mouse. What an ass are you! Here's a stir indeed!
Here's "message," "arrant," "banishment," and I
cannot tell what.
 Seg. I pray you, sir, shall I know whether you have
drove him away?
 Mouse. Faith, I think I have; and you will not
believe me, ask my staff. 50
 Seg. Why, can thy staff tell?
 Mouse. Why, he was with me too.
 Seg. Then happy I that have obtained my will.
 Mouse. And happier I if you would go to dinner.
 Seg. Come, sirrah, follow me.
 Mouse. I warrant you, I will not lose an inch of you
now you are going to dinner.— [*To the audience*] I
promise you, I thought seven year before I could get
him away.
 Exeunt.

[xi]

 Enter AMADINE *solus.*[1]

 Am. God grant my long delay procures no harm
Nor this my tarrying frustrate my pretense.[2]
My Mucedorus surely stays for me,
And thinks me overlong. At length I come
My present[3] promise to perform.
Ah, what a thing is firm, unfeignèd love!
What is it which true love dares not attempt?
My father he may make, but I must match;
Segasto loves, but Amadine must like
Where likes her best; compulsion is a thrall. 10

 [4] *privy:* personal, private.
x.
 [1] *ply:* work. [2] *messes:* dinners.
 [3] *hath . . . forget:* Qq "made me, hath forgot."
 [4] *errand:* Q "arrand" makes the pun clearer.
 [5] *whoreson:* scoundrelly.
xi.
 [1] *solus:* The masculine adjective agrees with the actor
rather than with his role. [2] *pretense:* intention.
 [3] *present:* current.

No, no, the hearty choice is all in all;
The shepherd's virtue Amadine esteems.
But what! methinks my shepherd is not come.
I muse at that; the hour is at hand.
Well, here I'll rest till Mucedorus come.

She sits down.

Enter BREMO, *looking about, hastily takes hold of her.*

Bre. A happy prey! Now, Bremo, feed on flesh.
Dainties, Bremo, dainties, thy hungry paunch to fill!
Now glut thy greedy guts with lukewarm blood.
Come, fight with me; I long to see thee dead. 19
 Am. How can she fight that weapons cannot wield?
 Bre. What, canst not fight? Then lie thee down and
die.
 Am. What, must I die?
 Bre. What need these words? I thirst to suck thy
blood.
 Am. Yet pity me and let me live awhile.
 Bre. No pity I; I'll feed upon thy flesh;
I'll tear thy body piecemeal joint from joint.
 Am. Ah, how I want my shepherd's company.
 Bre. I'll crush thy bones betwixt two oaken trees.
 Am. Haste, shepherd, haste, or else thou com'st too
late. 29
 Bre. I'll cuck the sweetness from thy marrowbones.
 Am. Ah, spare, ah, spare to shed my guiltless blood!
 Bre. With this my bat will I beat out thy brains.
Down, down, I say; prostrate thyself upon the ground.
 Am. Then, Mucedorus, farewell; my hopèd joys,
farewell.
Yea, farewell, life, and welcome, present death.

She kneels.

To thee, O God, I yield my dying ghost.
 Bre. Now, Bremo, play thy part.
How now, what sudden chance is this?
My limbs do tremble and my sinews shake;
My unweakened arms hath lost their former force. 40
Ah, Bremo, Bremo, what a foil⁴ hast thou
That yet at no time [ever]⁵ wast afraid
To dare the greatest gods to fight with thee,

He strikes.

And now wants strength for one downdriving blow!
Ah, how my courage fails when I should strike.
Some new-come spirit, abiding in my breast,
Saith, "Spare her," which never sparèd any.
Shall I spare her, Bremo? Spare her; do not kill.
To it, Bremo, to it! say⁶ again.—
I cannot wield my weapons in my hand; 50
Methinks I should not strike so fair a one.
I think her beauty hath bewitched my force
Or else within me altered nature's course.
Ay, woman, wilt thou live in woods with me?
 Am. Fain would I live, yet loath to live in woods.

⁴ *foil:* disgrace. ⁵ *[ever]:* 1598. ⁶ *say:* essay.
xii.
¹ *world:* great thing. ² *prevented:* anticipated.
³ *expect:* await. ⁴ *doubt:* fear. ⁵ *cap:* arrest.

Bre. Thou shalt not choose; it shall be as I say,
And, therefore, follow me.

Exeunt.

[xii]

Enter MUCEDORUS *solus.*

Mu. It was my will an hour ago and more,
As was my promise, for to make return,
But other business hindered my pretense.
It is a world¹ to see when man appoints
And purposely one certain thing decrees,
How many things may hinder his intent.
What one would wish, the same is farthest off.
But yet th' appointed time cannot be past,
Nor hath her presence yet prevented² me.
Well, here I'll stay and expect³ her coming. 10

They cry within, "Hold him, hold him!"

Mu. Someone or other is pursued, no doubt;
Perhaps some search for me. 'Tis good to doubt⁴ the
worst;
Therefore I'll be gone.

Exit.
Cry within, "Hold him, hold him!"

Enter MOUSE *the* Clown, *with a pot.*

Mouse. Hold him, hold him, hold him! Here's a stir
indeed. Here came hue after the crier; and I was set
close at Mother Nip's house, and there I called for
three pots of ale, as 'tis the manner of us courtiers.
Now, sirrah, I had taken the maidenhead of two of
them. Now as I was lifting up the third to my mouth,
there came, "Hold him, hold him!" Now I could 20
not tell whom to catch hold on, but I am sure I
caught one—perchance a may be in this pot. Well, I'll
see. Mass, I cannot see him yet. Well, I'll look a little
further. Mass, he is a little slave, if a be here. Why,
here's nobody. All this goes well yet; but if the old trot
should come for her pot—ay marry, there's the matter.
But I care not; I'll face her out, and call her old rusty,
dusty, musty, fusty, crusty firebrand, and worse than
all that, and so face her out of her pot. But soft, here
she comes. 30

Enter the Old Woman.

Old W. Come, you knave! Where's my pot, you
knave?
Mouse. Go look your pot; come not to me for your
pot, 'twere good for you.
Old W. Thou liest, thou knave; thou hast my pot.
Mouse. You lie, and you say it. I your pot? I know
what I'll say.
[*Old W.*] Why, what wilt thou say?
Mouse. But say I have him, and thou dar'st.
Old W. Why, thou knave, thou hast not only my pot
but my drink unpaid for. 41
Mouse. You lie like an old—I will not say whore.
Old W. Dost thou call me whore? I'll cap⁵ thee for
my pot.

Mouse. Cap me and thou darest. Search me whether I have it or no.

She searcheth him, and he drinketh over her head and casteth down the pot; she stumbleth at it; then they fall together by the ears; she takes up her pot and goes out.

Enter SEGASTO.

Seg. How now, sirrah, what's the matter?

Mouse. Oh, flies, master, flies.

Seg. Flies? Where are they?

Mouse. Oh, here, master, all about your face. 50

Seg. Why, thou liest, I think thou art mad.

Mouse. Why, master, I have killed a dungcartful at the least.

Seg. Go to, sirrah! Leaving this idle talk, give ear to me.

Mouse. How? Give you one of my ears? Not and you were ten masters.

Seg. Why, sir, I bid you give ear to my words.

Mouse. I tell you I will not be made a curtal[6] for no man's pleasure. 60

Seg. I tell thee, attend what I say. Go thy ways straight and rear[7] the whole town.

Mouse. How? Rear the whole town? Even go yourself; it is more than I can do. Why, do you think I can rear a town, that can scarce rear a pot of ale to my head? I should rear a town, should I not!

Seg. Go to the constable and make a privy[8] search, for the shepherd is run away with the King's daughter.

Mouse. How? Is the shepherd run away with the King's daughter, or is the King's daughter run away with the shepherd? 71

Seg. I cannot tell, but they are both gone together.

Mouse. What a fool is she to run away with the shepherd! Why, I think I am a little handsomer man than the shepherd myself. But tell me, master, must I make a privy search, or search in the privy?

Seg. Why, dost thou think they will be there?

Mouse. I cannot tell.

Seg. Well, then search everywhere; leave no place unsearched for them. 80

Exit.

Mouse. Oh, now am I in office; now will I to that old firebrand's house and will not leave one place unsearched; nay, I'll to the alestand[9] and drink as long as I can stand, and, when I have done, I'll let out all the rest, to see if he be not hid in the barrel. And, if I find him not there, I'll to the cupboard; I'll not leave one corner of her house unsearched. I' faith, ye old crust, I will be with you now.

Exit.

[xiii]

Sound music.

Enter the KING *of* VALENCIA, ANSELMO, RODERIGO, LORD BORACHIUS, *with others.*

King of Val. Enough of music; it but adds to torment;

Delights to vexèd spirits are as dates
Set to a sickly man, which rather cloy than comfort.
Let me entreat you to entreat no more.

Rod. Let your strings sleep; have done there.

Let the music cease.

King of Val. Mirth to a soul disturbed are embers turned,
Which sudden gleam with molestation,
But sooner lose their sight for't;
'Tis gold bestowed upon a rioter,
Which not relieves but murders him. 10
'Tis a drug given to the healthful
Which infects, not cures.
How can a father that hath lost his son,
A prince both wise, virtuous, and valiant,
Take pleasure in the idle acts of time?
No, no; till Mucedorus I shall see again,
All joy is comfortless, all pleasure pain.

Ans. Your son, my lord, is well.

King of Val. I prithee, speak that thrice.

Ans. The prince, your son, is safe. 20

King of Val. Oh, where, Anselmo? Surfeit me with that.

Ans. In Aragon, my liege; and at his parture
Bound my secrecy
By his affectious[1] love, not to disclose it.
But care of him and pity of your age
Makes my tongue blab what my breast vowed concealment.

King of Val. Thou not deceiv'st me?
I ever thought thee what I find thee now,
An upright, loyal man. But what desire,
Or young-fed humor nursed within the brain, 30
Drew him so privately to Aragon?

Ans. A forcing adamant:[2]
Love, mixed with fear and doubtful jealousy,
Whether report gilded a worthless trunk,
Or Amadine deserved her high extolment.

King of Val. See our provision be in readiness;
Collect us followers of the comeliest hue
For our chief guardians; we will thither wend.
The crystal eye of heaven shall not thrice wink,
Nor the green flood six times his shoulders turn, 40
Till we salute the Aragonian King.
Music, speak loudly now; the season's apt,
For former dolors are in pleasure wrapped.

Exeunt omnes.

[xiv]

Enter MUCEDORUS to disguise himself.

Mu. Now, Mucedorus, whither wilt thou go?
Home to thy father to thy native soil,
Or try some long abode within these woods?
Well, I will hence depart and hie me home.

6 *be . . . curtal:* have ears cropped. 7 *rear:* rouse.

8 *privy:* surreptitious. 9*alestand:* bar.

xiii.

1 *affectious:* earnest. 2 *adamant:* magnet.

What, hie me home, said I? That may not be;
In Amadine rests my felicity.
Then, Mucedorus, do as thou didst decree:
Attire thee hermit-like within these groves;
Walk often to the beech and view the well;
Make settles there and seat thyself thereon; 10
And when thou feelest thyself to be athirst
Then drink a hearty draught to Amadine.
No doubt she thinks on thee,
And will one day come pledge thee at this well.
Come, habit, thou art fit for me.

He disguiseth himself.

No shepherd now, a hermit must I be.
Methinks this fits me very well;
Now must I learn to bear a walking staff
And exercise some gravity withal. 19

Enter [MOUSE] *the* Clown.

Mouse. Here's through the woods, and through the
woods, to look out a shepherd and a stray king's
daughter. But soft, who have we here? What art thou?
Mu. I am an hermit.
Mouse. An emmet?[1] I never saw such a big emmet
in all my life before.
Mu. I tell you, sir, I am an hermit, one that leads a
solitary life within these woods.
Mouse. Oh, I know thee now; thou art her that eats
up all the hips and haws; we could not have one piece
of fat bacon for thee all this year. 30
Mu. Thou dost mistake me. But, I pray thee, tell
me who dost thou seek in these woods.
Mouse. What do I seek? For a stray king's daughter
run away with a shepherd.
Mu. A stray king's daughter run away with a shep-
herd! Wherefore, canst thou tell?
Mouse. Yes, that I can. 'Tis this: my master and
Amadine, walking one day abroad, nearer to these
woods than they were used, about what I cannot tell
but towards them comes running a great bear. 40
Now my master, he played the man and ran away, and
Amadine crying after him. Now, sir, comes me a
shepherd and he strikes off the bear's head. Now
whether the bear were dead before or no I cannot tell,
for bring twenty bears before me and bind their hands
and feet, and I'll kill them all. Now, ever since,
Amadine hath been in love with the shepherd, and for
good will she's even run away with the shepherd.
Mu. What manner of man was he? Canst describe
him unto me? 50
Mouse. 'Scribe him? Ay, I warrant you that I can.
A was a little, low, broad, tall, narrow, big, well-
favored fellow; a jerkin of white cloth, and buttons of
the same cloth.
Mu. Thou describest him well, but if I chance to

see any such, pray you, where shall I find you, or
what's your name?
Mouse. My name is called Master Mouse.
Mu. Oh, Master Mouse, I pray you, what office
might you bear in the court? 60
Mouse. Marry, sir, I am a rusher of the stable.
Mu. Oh, usher of the table!
Mouse. Nay, I say "rusher," and I'll prove mine
office good; for look, sir, when any comes from under
the sea or so, and a dog chance to blow his nose back-
ward, then with a whip I give him the good time of the
day, and strew rushes presently.[2] Therefore, I am a
rusher, a high office, I promise ye.
Mu. But where shall I find you in the court? 69
Mouse. Why, where it is best being, either in the
kitchen a-eating or in the buttery drinking. But, if you
come, I will provide for thee a piece of beef and brewis
knuckledeep in fat. Pray you, take pains; remember
Master Mouse.

Exit.

Mu. Ay, sir, I warrant I will not forget you.—
Ah, Amadine, what should become of thee?
Whither shouldst thou go so long unknown?
With watch and ward each passage is beset,
So that she cannot long escape unknown.
Doubtless she hath lost herself within these woods 80
And wand'ring to and fro she seeks the well,
Which yet she cannot find; therefore will I seek her out.

Exit.

[xv]

Enter BREMO *and* AMADINE.

Bre. Amadine, how like you Bremo and his woods?
Am. As like the woods[1] of Bremo's cruelty!
Though I were dumb and could not answer him,
The beasts themselves would with relenting tears
Bewail thy savage and unhuman deeds.
Bre. My love, why dost thou murmur to thyself?
Speak louder, for thy Bremo hears thee not.
Am. My Bremo? No, the shepherd is my love.
Bre. Have I not saved thee from sudden death,
Giving thee leave to live that thou mightst love? 10
And dost thou whet me on to cruelty?
Come, kiss me, sweet, for all my favors past.
Am. I may not, Bremo, and therefore pardon me.
Bre. [*Aside*] See how she flings away from me; I will
follow
And give attend to her.—Deny my love!
Ah, worm of beauty, I will chastise thee.
Come, come, prepare thy head upon the block.
Am. Oh, spare me, Bremo! Love should limit life,
Not to be made a murderer of himself.
If thou wilt glut thy loving heart with blood, 20
Encounter with the lion or the bear,
And like a wolf prey not upon a lamb.
Bre. Why then dost thou repine[2] at me?
If thou wilt love me, thou shalt be my queen;
I will crown thee with a chaplet[3] made of ivory,
And make the rose and lily wait on thee.

xiv.
[1] *emmet:* ant. [2] *presently:* immediately.
xv.
[1] *woods:* probably forest, but may mean madness.
[2] *repine:* complain. [3] *chaplet:* Qq "complet."

I'll rend the burly branches from the oak,[4]
To shadow thee from burning sun.
The trees shall spread themselves where thou dost go,
And, as thy spread, I'll trace[5] along with thee. 30
 Am. [*Aside*] You may, for who but you?
 Bre. Thou shalt be fed with quails and partridges,
With blackbirds, larks, thrushes, and nightingales.
Thy drink shall be goat's milk and crystal water,
Distilled from the fountains and the clearest springs.
And all the dainties that the woods afford
I'll freely give thee to obtain thy love.
 Am. [*Aside*] You may, for who but you?
 Bre. The day I'll spend to recreate my love
With all the pleasures that I can devise, 40
And in the night I'll be thy bedfellow,
And lovingly embrace thee in mine arms.
 Am. [*Aside*] One may; so may not you.
 Bre. The satyrs and the wood-nymphs shall attend
 on thee
And lull thee asleep with music's sound,
And in the morning when thou dost awake,
The lark shall sing good morrow to my queen,
And, whilst he sings, I'll kiss my Amadine.
 Am. [*Aside*] You may, for who but you?
 Bre. When thou art up, the wood lanes shall be
 strewed 50
With violets, cowslips, and sweet marigolds
For thee to trample and to trace upon,
And I will teach thee how to kill the deer,
To chase the hart and how to rouse the roe,
If thou wilt live to love and honor me.
 Am. [*Aside*] You may, for who but you?

 Enter MUCEDORUS.

 Bre. Welcome, sir;
An hour ago I looked for such a guest.
Be merry, wench, we'll have a frolic feast.
Here's flesh enough for to suffice us both.— 60
Say, sirrah, wilt thou fight or dost thou mean to die?
 Mu. I want[6] a weapon; how can I fight?
 Bre. Thou wants a weapon? Why then, thou yield'st
 to die.
 Mu. I say not so; I do not yield to die.
 Bre. Thou shalt not choose. I long to see thee dead.
 Am. Yet spare him, Bremo, spare him!
 Bre. Away, I say; I will not spare him.
 Mu. Yet give me leave to speak.
 Bre. Thou shalt not
 speak.
 Am. Yet give him leave to speak for my sake.
 Bre. Speak on, but be not overlong. 70
 Mu. In time of yore, when men like brutish beasts
Did lead their lives in loathsome cells and woods
And wholly gave themselves to witless will,
A rude, unruly rout, then man to man
Became a present prey; then might prevailed;
The weakest went to walls.
Right was unknown, for wrong was all in all.
As men thus livèd in their great outrage,[7]
Behold, one Orpheus came, as poets tell,
And them from rudeness unto reason brought, 80

Who, led by reason, some forsook the woods.
Instead of caves they built them castles strong;
Cities and towns were founded by them then.
Glad were they, they found such case, and in
The end they grew to perfect amity.
Weighing their former wickedness,
They termed the time wherein they livèd then
A golden age, a goodly golden age.
Now, Bremo, for so I hear thee called,
If men which lived tofore, as thou dost now, 90
Wild in wood, addicted all to spoil,
Returnèd were by worthy Orpheus' means,
Let me like Orpheus cause thee to return
From murder, bloodshed, and like cruelty.
What, should we fight before we have a cause?
No, let's live and love together faithfully.
I'll fight for thee
 Bre. Fight for me or die!
Or[8] fight or else thou diest!
 Am. Hold, Bremo, hold!
 Bre. Away, I say; thou troublest me.
 Am. You promised me to make me your queen. 100
 Bre. I did; I mean no less.
 Am. You promised that I should have my will.
 Bre. I did; I mean no less.
 Am. Then save this hermit's life, for he may save us
 both.
 Bre. At thy request I'll spare him, but never any
after him. Say, hermit, what canst thou do?
 Mu. I'll wait on thee; sometime upon thy queen.
Such service shalt thou shortly have as Bremo never
had.

 Exeunt.

[xvi]

Enter SEGASTO, [MOUSE] *the* Clown, *and* RUMBELO.

 Seg. Come, sirs; what, shall I never have you find
out Amadine and the shepherd?
 Mouse. And I have been through the woods, and
through the woods, and could see nothing but an
emmet.
 Ru. Why, I see a thousand emmets. Thou mean'st a
little one?
 Mouse. Nay, that emmet that I saw was bigger than
thou art. 9
 Ru. Bigger than I?—What a fool have you to your
man; I pray you, master, turn him away.
 Seg. But dost thou hear? Was he not a man?
 Mouse. Think he was, for he said he did lead a salt-
seller's life about the woods.
 Seg. Thou wouldest say a solitary life about the
woods.
 Mouse. I think it was so, indeed.
 Ru. I thought what a fool thou art.

[4] *oak:* 1598; 1610 "oxe." [5] *trace:* walk.
[6] *want:* lack. [7] *outrage:* violence, disorder.
[8] *Or:* Either.

Mouse. Thou art a wise man. Why, he did nothing but sleep since he went. 20

Seg. But tell me, Mouse, how did he go?

Mouse. In a white gown, and a white hat on his head, and a staff in his hand.

Seg. I thought so; it was an hermit that walked a solitary life in the woods. Well, get you to dinner, and after, never leave seeking till you bring some news of them, or I'll hang you both.

 Exit.

Mouse. How now, Rumbelo? What shall we do now?

Ru. Faith, I'll home to dinner, and afterward to sleep. 30

Mouse. Why, then, thou wilt be hanged.

Ru. Faith, I care not, for I know I shall never find them. Well, I'll once more abroad, and, if I cannot find them, I'll never come home again.

Mouse. I tell thee what, Rumbelo, thou shalt go in at one end of the wood and I at the other, and we will meet both together in the midst.

Ru. Content! Let's away to dinner.

 Exeunt.

[xvii]

Enter MUCEDORUS *solus.*

Mu. Unknown to any here within these woods,
With bloody Bremo do I lead my life.
The monster, he doth murder all he meets;
He spareth none, and none doth him escape.
Who would continue, who but only I,
In such a cruel cutthroat's company?
Yet Amadine is there. How can I choose?
Ah, silly soul, how oftentimes she sits
And sighs and calls, "Come, shepherd, come;
Sweet Mucedorus, come and set me free," 10
When Mucedorus peasant[1] stands her by.—
But here she comes.

Enter AMADINE.

What news, fair lady, as you walk these woods?

Am. Ah, hermit, none but bad and such as thou
 knowest.

Mu. How do you like your Bremo and his woods?

Am. Not my Bremo nor his Bremo woods.

Mu. And why not yours? Methinks he loves you
 well.

Am. I like not him; his love to me is nothing worth.

Mu. Lady, in this methinks you offer wrong.
To hate the man that ever loves you best. 20

Am. Ah, hermit, I take no pleasure in his love;
Neither doth Bremo like me best.

Mu. Pardon my boldness, fair lady; sith we both
May safely talk now out of Bremo's sight,
Unfold to me, so if you please, the full discourse:

How, when, and why you came into these woods
And fell into this bloody butcher's hands.

Am. Hermit, I will.
Of late a worthy shepherd I did love—

Mu. A shepherd, lady? Sure, a man unfit 30
To match with you.

Am. Hermit, this is true; and, when we had—

Mu. Stay there; the wild man comes!
Refer[2] the rest until another time.

Enter BREMO.

Bre. What secret tale is this? What whisp'ring have
 we here?
Villain, I charge thee tell thy tale again.

Mu. If needs I must, lo, here it is again;
Whenas we both had lost the sight of thee,
It grieved us both, but specially thy Queen,
Who in thy absence ever fears the worst, 40
Lest some mischance befall your royal grace.
"Shall my sweet Bremo wander through the woods?
Toil to and fro for to redress my want,
Hazard his life, and all to cherish me?
I like not this," quoth she,
And thereupon craved to know of me
If I could teach her handle weapons well.
My answer was I had small skill therein,
But gladsome, mighty King, to learn of thee.
And this was all. 50

Bre. Was't so? None can dislike of this. I'll teach
You both to fight; but first, my Queen, begin.
Here, take this weapon; see how thou canst use it.

Am. This is too big; I cannot wield it in my arm.

Bre. Is't so? We'll have a knotty crabtree staff
For thee—But, sirrah, tell me, what sayest thou?

Mu. With all my heart I willing am to learn.

Bre. Then take my staff and see how thou canst
 wield it.

Mu. First teach me how to hold it in my hand.

Bre. Thou hold'st it well. 60
Look how he doth; thou mayst the sooner learn.

Mu. Next tell me how and when 'tis best to strike.

Bre. 'Tis best to strike when time doth serve;
Tis best to lose no time.

Mu. [*Aside*] Then now or never is my time to strike.

Bre. And, when thou strikest, be sure to hit the
 head.

Mu. The head?

Bre. The very head.

Mu. Then have at thine!

 He strikes him down dead.

So, lie there and die,
A death no doubt according to desert,
Or else a worse as thou deserv'st a worse. 70

Am. It glads my heart this tyrant's death to see.

Mu. Now, lady, it remains in you
To end the tale you lately had begun,
Being interrupted by this wicked wight.[3]
You said you loved a shepherd?

Am. Ay, so I do, and none but only him,
And will do still as long as life shall last.

xvii.
 [1] *peasant:* "present" has been suggested as emendation.
 [2] *Refer:* Put off. [3] *wight:* man.

Mu. But tell me, lady, sith I set you free,
What course of life do you intend to take?
Am. I will disguisèd wander through the world 80
Till I have found him out.
Mu. How if you find your shepherd in these woods?
Am. Ah, none so happy then as Amadine.

He discloseth[4] *himself.*

Mu. In tract of time a man may alter much.
Say, lady, do you know your shepherd well?
Am. My Mucedorus! Hath he set me free?
Mu. He hath set thee free.
Am. And lived so long unknown to Amadine?
Mu. Ay, that's a question whereof you may not be
 resolved.
You know that I am banished from the court? 90
I know likewise each passage is beset
So that we cannot long escape unknown;
Therefore my will is this: that we return
Right through the thickets to the wild man's cave,
And there awhile live on his provision
Until the search and narrow watch be past.
This is my counsel, and I think it best.
Am. I think the very same.
Mu. Come, let's begone.

[MOUSE] *the Clown* [*enters*] *and searcheth, and falls
 over the* Wild Man, *and so carries him away.*

Mouse. Nay, soft, sir; are you here? A botts[5] on you!
I was liked to be hanged for not finding you. We 100
would borrow a certain stray king's daughter of you—
a wench, a wench, sir, we would have.
Mu. A wench of me? I'll make thee eat my sword.
Mouse. O Lord! Nay, and you are so lusty, I'll call
a cooling card[6] for you. Ho, master, master, ay, come
away quickly!

Enter SEG[ASTO].

Seg. What's the matter?
Mouse. Look, master: Amadine and the shepherd;
Oh, brave!
Seg. What, minion, have I found you out? 110
Mouse. Nay, that's a lie; I found her out myself.
Seg. Thou gadding housewife, what cause hadst thou
 to gad abroad,
Whenas thou knowest our wedding day so nigh?
Am. Not so, Segasto; no such thing in hand.
Show your assurance;[7] then I'll answer you
Seg. Thy father's promise my assurance is.
Am. But what he promised he hath not performed.
Seg. It rests in thee for to perform the same.
Am. Not I.
Seg. And why? 120
Am. So is my will, and therefore even so.
Mouse. Master, with a nonny, nonny, no!
Seg. Ah, wicked villain, art thou here?
Mu. What needs these words? We weigh them not.
Seg. We weigh them not? Proud shepherd, I scorn
 thy company.
Mouse. We'll not have a corner of thy company.
Mu. I scorn not thee, nor yet the least of thine.

Mouse. That's a lie; a would have killed me with his
pugsnando.[8] 129
Seg. This stoutness, Amadine, contents me not.
Am. Then seek another that may you better please.
Mu. Well, Amadine, it only rests in thee
Without delay to make thy choice of three:
There stands Segasto; here a shepherd stands;
There stands the third. Now make thy choice.
Mouse. A lord at the least I am.
Am. My choice is made, for I will none but thee.
Seg. A worthy mate, no doubt, for such a wife.
Mu. And, Amadine, why wilt thou none but me?
I cannot keep thee as thy father did; 140
I have no lands for to maintain thy state.
Moreover, if thou mean to be my wife,
Commonly this must be thy use:
To bed at midnight, up at four,
Drudge all day and trudge from place to place,
Whereby our daily victual for to win;
And last of all, which is the worst of all,
No princess then, but plain a shepherd's wife.
Mouse. Then, God gi' you good morrow, goody
 shepherd!
Am. It shall not need; if Amadine do live, 150
Thou shalt be crownèd King of Aragon.
Mouse. Oh, master, laugh! When he's king, then I'll
be a queen!
Mu. Then know that which ne'er tofore was known:
I am no shepherd, no Aragonian I,
But born of royal blood—my father's of
Valencia King, my mother, Queen—who for
Thy sacred sake took this hard task in hand.
Am. Ah, how I joy my fortune is so good!
Seg. Well, now I see Segasto shall not speed;[9] 160
But, Mucedorus, I as much do joy
To see thee here within our court of Aragon
As if a kingdom had befall'n me this time.
I with my heart surrender her to thee,

He gives her to him.

And loose[10] what right to Amadine I have!
Mouse. What barn's door, and born where my father
was constable! A botts on thee! How dost thee?
Mu. Thanks, Segasto; but yet you leveled at the
 crown.
Mouse. Master, bear this and bear all.
Seg. Why so, sir? 170
Mouse. He sees you take a goose by the crown.
Seg. Go to, sir! Away, post you to the King,
Whose heart is fraught with careful doubts,
Glad him up and tell him these good news,
And we will follow as fast as we may.
Mouse. I go, master; I run master!

Exeunt.

4 *discloseth:* Qq " disguiseth."
5 *botts:* parasitic disease of animals.
6 *cooling card:* card that puts down one's opponent.
7 *assurance:* document of betrothal.
8 *pugsnando:* weapon(?), pugnacity(?).
9 *speed:* prosper. 10 *loose:* Qq "looke."

[xviii]

Enter the KING *and* COLLIN.

King. Break, heart, and end my pallid woes!
My Amadine, the comfort of my life:
How can I joy except she were in sight?
Her absence breeds sorrow to my soul
And with a thunder breaks my heart in twain.
Col. Forbear those passions, gentle King,
And you shall see 'twill turn unto the best
And bring your soul to quiet and to joy.
King. Such joy as death, I do assure me that,
And naught but death, unless of her I hear, 10
And that with speed; I cannot sigh thus long.
But what a tumult do I hear within?

They cry within, "*Joy and happiness!*"

Col. I hear a noise of overpassing joy
Within the court; my lord, be of good comfort.
And here comes one in haste.

Enter [MOUSE] *the* Clown *running.*

Mouse. A king! a king! a king!
Col. Why, how now, sirrah? What's the matter?
Mouse. Oh, 'tis news for a king; 'tis worth money.
King. Why, sirrah, thou shalt have silver and gold
if it be good. 20
Mouse. Oh, 'tis good, 'tis good. Amadine—
King. Oh, what of her? Tell me, and I will make thee
a knight.
Mouse. How, a sprite? No, by Lady, I will not be a
sprite. Masters, get you away; if I be a sprite, I shall be
so lean I shall make you all afraid.
Col. Thou sot, the King means to make thee a gentle-
man.
Mouse. Why, I shall want 'parel.
King. Thou shalt want for nothing. 30
Mouse. Then stand away; strike up thyself. Here
they come.

Enter SEGASTO, MUCEDORUS, *and* AMADINE.

Am. My gracious father, pardon thy disloyal daughter.
King. What, do mine eyes behold my daughter
 Amadine?
Rise up, dear daughter, and let these my embracing
 arms
Show some token of thy father's joy,
Which ever since thy departure hath languished in
 sorrow.
Am. Dear father, never were your sorrows
Greater than my griefs,
Never you so desolate as I comfortless; 40
Yet, nevertheless, acknowledging myself
To be the cause of both, on bended knees
I humbly crave your pardon.
King. I'll pardon thee, dear daughter; but, as for
 him—

Am. Ah, father, what of him?
King. As sure as I am King and wear the crown,
I will revenge on that accursèd wretch.
Mu. Yet, worthy prince, work not thy will in
 wrath;
Show favor.
King. Ay, such favor as thou deservest.
Mu. I do deserve the daughter of a king. 50
King. Oh, impudent! A shepherd and so insolent?
Mu. No shepherd I, but a worthy prince.
King. In fair conceit,[1] not princely born.
Mu. Yes, princely born: my father is a king,
My mother a queen, and of Valencia both.
King. What, Mucedorus? Welcome to our court!
What cause hadst thou to come to me disguised?
Mu. No cause to fear; I causèd no offense
But this: desiring thy daughter's virtues for to see,
Disguised myself from out my father's court, 60
Unknown to any. In secret I did rest,
And passèd many troubles near to death;
So hath your daughter my partaker been
As you shall know hereafter more at large,
Desiring you, you will give her to me.
Even as mine own and sovereign of my life;
Then shall I think my travails are well spent.
King. With all my heart, but this—
Segasto claims my promise made tofore,
That he should have her as his only wife, 70
Before my council when we came from war.
Segasto, may I crave thee let it pass.
And give Amadine as wife to Mucedorus?
Seg. With all my heart, were it a far greater thing;
And what I may to furnish up their rites
With pleasing sports and pastimes you shall see.
King. Thanks, good Segasto, I will think of this.
Mu. Thanks, good my lord, and, while I live
Account of me in what I can or may.
Am. And, good Segasto, these great courtesies 80
Shall not be forgot.
Mouse. Why, hark you, master! Bones, what have
you done? What, given away the wench you made me
take such pains for? You are wise indeed! Mass, and I
had known of that, I would have had her myself. Faith,
master, now we may go to breakfast with a woodcock
pie!
Seg. Go, sir; you were best leave this knavery.
King. Come on, my lords, let's now to court,
Where we may finish up the joyfulest day 90
That ever happed to a distressèd king.
Were but thy father, the Valencia lord,
Present in view of this combining knot!

A shout within. Enter a Messenger.

What shout was that?
Mess. My lord, the great Valencia King.
Newly arrived, entreats your presence.
Mu. My father?
King. Preparèd welcomes give him entertainment.
A happier planet never reigned than that
Which governs at this hour. 100
 Sound [*trumpets.*]

 [1] *conceit:* imagination.

Enter the KING *of* VALENCIA, ANSELMO,
RODERIGO, BORACHIUS, *with others; the
King runs and embraces his son.*

King of Val. Rise, honor of my age, food to my rest!
Condemn not, mighty King of Aragon,
My rude behavior, so compelled by nature,
That manners stood unknowledgèd.
 King. What we have to recite would tedious prove
By declaration; therefore, in and feast.
Tomorrow the performance shall explain
What words conceal; till then, drums, speak; bells, ring
Give plausive² welcomes to our brother king.
 Sound drums and trumpets. Exeunt omnes.

[EPILOGUE]

Enter COMEDY *and* ENVY.

 Com. How now, Envy? What, blushest thou already?
Peep forth; hide not thy head with shame,
But with a courage praise a woman's deeds.
Thy threats were vain; thou couldst do me no hurt.
Although thou seemest to cross me with despite,
I overwhelmed, and turnèd upside down thy blocks
And made thyself to stumble at the same.
 Env. Though stumbled, yet not overthrown.
Thou canst not draw my heart to mildness;
Yet must I needs confess thou hast done well, 10
And played thy part with mirth and pleasant glee.
Say all this, yet canst thou not conquer me;
Although this time thou hast got—yet not the conquest
 neither.
A double revenge another time I'll have.
 Com. Envy, spit thy gall;
Plot, work, contrive; create new fallacies;
Teem from thy womb each minute a black traitor,
Whose blood and thoughts have twins' conception;
Study to act deeds yet unchronicled;
Cast native monsters in the molds of men; 20
Case vicious devils under sancted¹ rochets;²
Unhasp the wicket³ where all perjureds roost,
And swarm this ball with treasons. Do thy worst,
Thou canst not, hellhound, cross my steer⁴ tonight,
Nor blind that glory where I wish delight.
 Env. I can, I will.
 Com. Nefarious hag, begin,
And let us tug till one the mast'ry win.
 Env. Comedy, thou art a shallow goose;
I'll overthrow thee in thine own intent,
And make thy fall my comic merriment. 30
 Com. Thy policy wants gravity; thou art

Too weak. Speak, fiend! As how?
 Env. Why, thus:
From my foul study will I hoist a wretch,
A lean and hungry neger⁵ cannibal,
Whose jaws swell to his eyes with chawing malice;
And him I'll make a poet.
 Com. What's that to th' purpose?
 Env. This scrambling raven, with his needy beard,
Will I whet on to write a comedy
Wherein shall be composed dark sentences, 40
Pleasing to factious brains;
And every other where place me a jest
Whose high abuse shall more torment than blows.
Then I myself, quicker than lightning,
Will fly me to a puissant magistrate,
And, waiting with a trencher⁶ at his back,
In midst of jollity, rehearse those galls,
With some additions,
So lately vented in your theater.
He, upon this, cannot but make complaint 50
To your great danger, or at least restraint.
 Com. Ha, ha, ha! I laugh to hear thy folly;
This is a trap for boys, not men, nor such,
Especially desertful in their doings,
Whose staid discretion rules their purposes.
I and my faction do eschew those vices.
But see, oh, see! The weary sun for rest
Hath lain his golden compass to the west,
Where he perpetual bide and ever shine,
As David's offspring, in his happy clime. 60
Stoop, Envy, stoop; bow to the earth with me;
Let's beg our pardons on our bended knee.
 They kneel.
 Env. My power has lost her might; Envy's date's
 expired.
Yon splendent majesty⁷ hath felled my sting,
And I amazèd am.
 Fall down and quake.
 Com. Glorious and wise arch-Caesar on this earth,
At whose appearance Envy's stroken dumb,
And all bad thing cease operation,
Vouchsafe to pardon our unwilling error,
So late presented to your gracious view, 70
And we'll endeavor with excess of pain
To please your senses in a choicer strain.
Thus we commit you to the arms of Night,
Whose spangled carcass would, for your delight,
Strive to excel the Day; be blessèd, then.
Who other wishes, let him never speak.
 Env. Amen!
To fame and honor we commend your rest;
Live still more happy, every hour more blessed.

F I N I S

Thomas Dekker

[*c.* 1572–*c.* 1632]

THE SHOEMAKER'S HOLIDAY, A PLEASANT COMEDY OF THE GENTLE CRAFT

LIKE Heywood, Middleton, and other prolific dramatists of the period, Dekker left little more than his writings to memorialize his life. He was born and raised in London, according to his testimony, but nothing is known about his family, his education, or his early years. By 1597–98 at the latest he was working for the Admiral's Men, and by 1602, according to the diary kept by its manager Philip Henslowe, he had worked on forty-four plays for that company alone (his lifetime total would number more than sixty); in following years the record is thinner, which may indicate either diminished activity in the theater or simply the disappearance of his work. In 1601 he wrote, for Paul's Boys and the Chamberlain's Men and in probable collaboration with John Marston, a play called *Satiromastix*, which hit out bitterly at Ben Jonson, in answer to the latter's satirical *Poetaster*; this exchange of dramatic barbs constituted a major and characteristic part of the teapot tempest known as the war of the theaters. In 1603 Dekker began to publish the long series of pamphlets that include some of the best prose accounts of London life of the period; notable among them are *The Wonderful Year*, *The Gull's Hornbook*, and *English Villainies Discovered by Lantern and Candlelight*. No one but Shakespeare seems to have grown rich in the theater, and he did so by virtue of his part ownership of the company and theater for which he wrote and acted. Dekker's furious rate of composition seems not to have enabled him ever to escape the slums and debtors' prison, where in fact he was committed for nearly seven years in 1612. After his release he wrote a series of plays in collaboration with Ford, but collaboration was nothing new: among others with whom he worked are Webster, Middleton, Day, Massinger, William and Samuel Rowley, Chettle, Drayton, Jonson, and Heywood.

A thoroughly commercial writer, probably regarded as a hack by his contemporaries, who did not say much about him, Dekker was nevertheless a genuinely gifted artist, able to understand and use the conventions of his theater with originality and ease. His first extant plays, *Old Fortunatus* and THE SHOEMAKER'S HOLIDAY, show him the successor to Greene in his mingling of realism and fantasy, his interest in the comic portrayal of the national life, and his ability to turn charming stories into lively drama; but in his later work he wrote satirically in the mode of Marston,

tragicomically in that of Heywood and Beaumont and Fletcher, intricately like Jonson and sentimentally like Massinger. A number of his plays are still a pleasure to read and deserve a turn on the stage, among them preeminently the two parts of *The Honest Whore* (1604, 1605) and, written with Ford and W. Rowley, *The Witch of Edmonton*. In his last years Dekker earned some of his support by writing pageants for civic occasions.

THE SHOEMAKER'S HOLIDAY was written and bought for the Admiral's Men in 1599 and played before the Queen, as an appropriately festive piece, on New Year's Day 1600. As its subtitle acknowledges, it is based on the prose shoemaker tales that Thomas Deloney had published in 1598 as *The Gentle Craft*, and it draws its materials from that source for Eyre, the Rose–Lacy plot, shoemaker lore, and the Saint Hugh legend. Numerous allusions to and borrowings from *Romeo and Juliet*, *Much Ado About Nothing*, and even *2 Henry VI* suggest Shakespeare's influence enough to make one wonder if Simon Eyre owes a few touches to Falstaff. Dekker derived Lacy's name from the similar character in FRIAR BACON AND FRIAR BUNGAY.

The only substantive text is the first quarto of 1600 (Q1), published by Valentine Simmes and apparently authorized. Quarto editions were published in 1610, 1618, 1624, 1646, and 1657, each based on the one before it. Fredson Bowers has made a useful collation of the extant copies of Q1. Dutch is translated as literally as possible, London places are generally identified, and an attempt is made in the notes to follow out some of the elaborate puns of Firke and his master; where the reader suspects a sexual innuendo not remarked on in the notes, he is probably right. The play was not originally divided into acts and scenes, and the divisions followed here are Bowers'.

The contrast between the grubbiness of Dekker's life and the sunny fantasy of THE SHOEMAKER'S HOLIDAY is as vivid as the contrast between Greene's rather similar life and his strikingly similar FRIAR BACON AND FRIAR BUNGAY. Dekker's comedy is not at all an exposé of the harshness of London life; rather it is a celebration of the city's possibilities. If Dekker makes us aware of the realities of war and financial hardship, unemployment, and the infirmities inflicted by time and the sword, he does so in order that his audience may share the triumph of characters who

escape every blow that life can deal: Simon Eyre refuses to grow old, lovers are united despite all obstacles, the shoemakers are given a new social status, and the King must forgive a deserter and preside over a marriage that violates the normal order of things. Like much other romantic comedy—including FRIAR BACON AND FRIAR BUNGAY—THE SHOEMAKER'S HOLIDAY works in two ways. On the one hand it creates a magic world in which those who are protected —unlike the outcast Hammon—can escape the tribulations of the real world implied outside the circle, the world that the audience must feel it is condemned to inhabit; and thus the comedy presents a happy if temporary retreat from reality. On the other hand, it suggests that the real world is not so ferocious after all: flexibility is built into the class structure, kings can bend laws, and even time cannot daunt the likes of Simon Eyre; thus a play can serve meliorist impulses and provide an audience with grounds for an optimism that survives the theatrical experience. There is an undeniable sentimentality about THE SHOEMAKER'S HOLIDAY, an occasional note of pandering to a middle-class audience that antagonizes some readers; but it is no mean feat to have turned a convincingly dramatized London into a version of the forest of Arden.

N. R.

The Shoemaker's Holiday

DRAMATIS PERSONÆ

KING OF ENGLAND[1]
EARL OF LINCOLN (Sir Hugh Lacy)
EARL OF CORNWALL
SIR ROGER OTLEY, Lord Mayor[2] of London
SIMON EYRE, shoemaker and afterward Lord Mayor
ROWLAND LACY, nephew to Lincoln, afterward disguised as Hans Meulter
ASKEW, cousin to Lacy
HAMMON, citizen of London
WARNER, cousin to Hammon
MASTER SCOTT, friend to Otley
HODGE (also called Roger), foreman to Eyre

FIRKE, journeyman to Eyre
RAFE DAMPORT, journeyman to Eyre
LOVELL, servant to the King
DODGER, servant to Lincoln
Dutch Skipper
MARGERY, wife to Eyre
ROSE, daughter to Otley
JANE, wife to Rafe Damport
SYBIL, maid to Rose
Noblemen, Soldiers, Huntsmen, Shoemakers, Apprentices, Servants

[EPISTLE]

To all good Fellows, Professors of the Gentle Craft;[1] of what degree soever

KIND gentlemen and honest boon companions, I present you here with a merry conceited[2] comedy called *The Shoemaker's Holiday*, acted by my Lord Admiral's Players[3] this present Christmas before the Queen's most excellent majesty. For the mirth and pleasant matter, by her majesty graciously accepted, being indeed no way offensive. The Argument of the play I will set down in this Epistle: Sir Hugh Lacy, Earl of Lincoln, had a young gentleman of his own name, his near kinsman, that loved the lord 10 mayor's daughter of London; to prevent and cross which love the earl caused his kinsman to be sent colonel of a company into France; who resigned his place to another gentleman, his friend, and came disguised like a Dutch shoemaker to the house of Simon Eyre in Tower Street, who served the mayor and his household with shoes. The merriments that passed in Eyre's house, his coming to be Mayor of London, Lacy's getting his love, and other accidents;[4] with two merry Three-mens songs. Take all in good worth 20 that is well intended, for nothing is purposed but mirth. Mirth lengtheneth long life; which, with other blessings I heartily wish you. Farewell.

The first Three-men's Song

Oh, the month of May, the merry month of May,
So frolic, so gay, and so green, so green, so green:
Oh, and then did I unto my true love say,
"Sweet Peg, thou shalt be my summer's queen."

Now the nightingale, the pretty nightingale,
The sweetest singer in all the forest's choir,
Entreats thee, sweet Peggy, to hear thy true love's
* tale*
Lo, yonder she sitteth, her breast against a briar.[1]

But, oh, I spy the cuckoo,[2] the cuckoo, the cuckoo.
See where she sitteth; come away, my joy. 10
Come away, I prithee; I do not like the cuckoo
Should sing where my Peggy and I kiss and toy.

Oh, the month of May, the merry month of May,
So frolic, so gay, and so green, so green, so green:
And then did I unto my true love say,
"Sweet Peg, thou shalt be my summer's queen."

DRAMATIS PERSONÆ
 [1] *King of England:* historically Henry VI, though more like Henry V.
 [2] *Lord Mayor:* a commoner, elected annually by the community.
EPISTLE
 [1] *the Gentle Craft:* paradoxical name (gentle = noble) traditionally given to shoemaker's trade.
 [2] *conceited:* cleverly devised.
 [3] *Lord Admiral's Players:* one of the two great theatrical companies of the period.　　　　[4] *accidents:* events.

FIRST THREE-MEN'S SONG
 [1] *breast . . . briar:* a habit said to account for the nightingale's nocturnal singing.
 [2] *cuckoo:* linked by the sound of the name to cuckolding.

The second Three-men's Song

This is to be sung at the latter end.

Cold's the wind, and wet's the rain;
Saint Hugh[1] be our good speed;[2]
Ill is the weather that bringeth no gain,
Nor helps good hearts in need.

Troll[3] the bowl, the jolly, nut-brown bowl,
And here, kind mate, to thee:
Let's sing a dirge for Saint Hugh's soul,
And down it merrily.

Down a-down, hey down a-down, 9
Hey derry derry down a-down, Close with the
Ho, well done, to me let come, tenor boy.
Ring compass gentle joy.

Troll the bowl, the nut-brown bowl, as often as
And here kind etc. there be men to drink.

At last when all have drunk, this verse:

Cold's the wind, and wet's the rain;
Saint Hugh be our good speed;
Ill is the weather that bringeth no gain,
Nor helps good hearts in need.

The Prologue, as it was pronounced before the Queen's Majesty

As wretches in a storm, expecting day,
With trembling hands and eyes cast up to heaven,
Make prayers the anchor of their conquered hopes,
So we, dear goddess, wonder of all eyes,
Your meanest vassals, through mistrust and fear
To sink into the bottom of disgrace
By our imperfect pastimes, prostrate thus
On bended knees, our sails of hope do strike,
Dreading the bitter storms of your dislike.

Since then, unhappy men, our hap is such 10
That to ourselves no help can bring,
But needs must perish, if your saint-like ears,
Locking the temple where all mercy sits,
Refuse the tribute of our begging tongues.
Oh, grant, bright mirror of true chastity,
From those life-breathing stars, your sun-like eyes,
One gracious smile; for your celestial breath
Must send us life, or sentence us to death.

ACT ONE

SCENE ONE

Enter the LORD MAYOR *and
the* EARL OF LINCOLN.

Linc. My lord mayor, you have sundry times
Feasted myself and many courtiers more;
Seldom or never can we be so kind
To make requital[1] of your courtesy.
But, leaving this, I hear my cousin[2] Lacy
Is much affected to your daughter Rose.
 L. Ma. True, my good lord, and she loves him so
well
That I mislike her boldness in the chase.
 Linc. Why, my lord mayor? Think you it then a
shame
To join a Lacy with an Otley's name? 10
 L. Ma. Too mean[3] is my poor girl for his high birth.
Poor citizens must not with courtiers wed,
Who will in silks and gay apparel spend
More in one year than I am worth by far.
Therefore your honor need not doubt[4] my girl.
 Linc. Take heed, my lord; advise you what you do.
A verier unthrift[5] lives not in the world
Than is my cousin. For I'll tell you what:
'Tis now almost a year since he requested
To travel countries for experience. 20

I furnished him with coin, bills of exchange,
Letters of credit, men to wait on him,
Solicited my friends in Italy
Well to respect him. But to see the end:
Scant[6] had he journeyed through half Germany
But all his coin was spent, his men cast off,
His bills embezzled;[7] and my jolly cos,
Ashamed to show his bankrupt presence here,
Became a shoemaker in Wittenberg—
A goodly science[8] for a gentleman 30
Of such descent! Now judge the rest by this:
Suppose your daughter have a thousand pound—
He did consume me more in one half year—
And make him heir to all the wealth you have,
One twelve month's rioting will waste it all.
Then seek, my lord, some honest citizen
To wed your daughter to.
 L. Ma. I thank your lordship.

SECOND THREE-MEN'S SONG
 [1] *Saint Hugh:* legendary prince who, in return for their kindness, made the shoemakers Gentlemen of the Gentle Craft, was martyred, and became patron saint of the trade.
 [2] *speed:* good fortune. [3] *Troll:* Pass round.

I.i.
 [1] *requital:* repayment. [2] *cousin:* nephew.
 [3] *mean:* low. [4] *doubt:* fear.
 [5] *unthrift:* spendthrift. [6] *Scant:* Scarcely.
 [7] *embezzled:* squandered. [8] *science:* skill.

[*Aside*] Well, fox, I understand your subtlety.
As for your nephew, let your lordship's eye
But watch his actions, and you need not fear, 40
For I have sent my daughter far enough.—
And yet your cousin Rowland might do well
Now he hath learned an occupation.
[*Aside*] And yet I scorn to call him son-in-law.
 Linc. Ay, but I have a better trade for him.
I thank his grace, he hath appointed him
Chief colonel of all those companies
Mustered in London and the shires about
To serve his highness in those wars in France.
See where he comes—

 Enter LOVELL, LACY, *and* ASKEW.

 Lovell, what news with you? 50
 Lov. My Lord of Lincoln, 'tis his highness' will
That presently[9] your cousin ship for France
With all his powers.[10] He would not for a million
But they should land at Dieppe within four days.
 Linc. Go certify his grace it shall be done.
 Exit LOVELL.
Now, cousin Lacy. In what forwardness[11]
Are all your companies?
 Lacy. All well prepared.
The men of Hertfordshire lie at Mile End,
Suffolk and Essex train in Tothill Fields,
The Londoners and those of Middlesex, 60
All gallantly prepared in Finsbury,[12]
With frolic[13] spirits long for the parting hour.
 L. Ma. They have their imprest,[14] coats, and
 furniture,[15]
And if it please your cousin Lacy come
To the guildhall, he shall receive his pay;
And twenty pounds besides my brethren.[16]
Will freely give him, to approve[17] our loves
We bear unto my lord your uncle here.
 Lacy. I thank your honor.
 Linc. Thanks, my good lord
 Mayor. 69
 L. Ma. At the Guildhall we will expect your coming.
 Exit.
 Linc. To approve your loves to me? No! subtlety!
Nephew, that twenty pound he doth bestow
For joy to rid you from his daughter Rose.
For, cousins both, now here are none but friends,

I would not have you cast an amorous eye
Upon so mean a project as the love
Of a gay, wanton, painted citizen.
I know this churl, even in the height of scorn,
Doth hate the mixture of his blood with thine.
I pray thee do thou so. Remember, cos, 80
What honorable fortunes wait on thee.
Increase the King's love, which so brightly shines
And gilds thy hopes. I have no heir but thee;
And yet not thee if, with a wayward spirit,
Thou start from the true bias[18] of my love.
 Lacy. My lord, I will—for honor, not desire
Of land or livings, or to be your heir—
So guide my actions in pursuit of France
As shall add glory to the Lacys' name.
 Linc. Cos, for those words here's thirty portagues,[19]
And, nephew Askew, there's a few for you. 91
Fair honor, in her loftiest eminence,
Stays in France for you till you fetch her thence.
Then, nephews, clap swift wings on your designs.
Be gone, be gone; make haste to the Guildhall.
There presently I'll meet you. Do not stay;
Where Honor beckons, Shame attends delay.
 Exit.
 Ask. How gladly would your uncle have you gone!
 Lacy. True, cos, but I'll o'erreach[20] his policies.[21]
I have some serious business for three days, 100
Which nothing but my presence can dispatch.
You therefore, cousin, with the companies,
Shall haste to Dover. There I'll meet with you;
Or, if I stay past my prefixèd time,
Away for France; we'll meet in Normandy.
The twenty pounds my lord mayor gives to me
You shall receive, and these ten portagues,
Part of mine uncle's thirty. Gentle cos,
Have care to our great charge. I know your wisdom
Hath tried itself in higher consequence. 110
 Ask. Cos, all myself am yours. Yet have this care,
To lodge in London with all secrecy.
Our uncle Lincoln hath, besides his own,
Many a jealous eye, that in your face
Stares only to watch means for your disgrace.
 Lacy. Stay, cousin, who be these?

Enter SIMON EYRE, *his* Wife [MARGERY], HODGE,
 FIRKE, JANE, *and* RAFE *with a piece.*[22]

 Eyre. Leave whining, leave whining! Away with this
whimpering, this puling, these blubbering tears, and
these wet eyes! I'll get thy husband discharged, I war-
rant thee, sweet Jane; go to.[23] 120
 Hod. Master, here be the captains.
 Eyre. Peace, Hodge, hushed, ye knave, hushed!
 Firke. Here be the cavaliers and the colonels, master.
 Eyre. Peace, Firke. Peace, my fine Firke. Stand by
with your pishery-pashery,[24] away! I am a man of the
best presence. I'll speak to them and[25] they were popes.
[*To* LACY *and* ASKEW] Gentlemen, captains, colonels,
commanders! Brave men, brave leaders, may it please
you to give me audience. I am Simon Eyre, the mad
shoemaker of Tower Street. This wench with the 130
mealy mouth[26] that will never tire is my wife, I can tell

 [9] *presently:* at once. [10] *powers:* troops.
[11] *forwardness:* readiness.
[12] *Mile End . . . Tothill Fields . . . Finsbury:* training
grounds. [13] *frolic:* merry.
 [14] *imprest:* advance pay. [15] *furniture:* equipment.
 [16] *brethren:* the aldermen. [17] *approve:* demonstrate.
[18] *bias:* tendency (metaphor derived from term for oblique
course run by a bowling ball).
[19] *portagues:* large gold coins worth three or four Eliza-
bethan pounds. [20] *o'erreach:* outdo.
 [21] *policies:* schemes. [22] *piece:* gun.
[23] *go to:* come on!
 [24] *pishery-pashery:* nonsense (a nonce word).
 [25] *and:* although.
[26] *with the mealy mouth:* soft-spoken, given to mince
matters.

you; here's Hodge, my man and my foreman; here's Firke, my fine firking[27] journeyman; and this is blubbered Jane. All we come to be suitors for this honest Rafe. Keep him at home, and, as I am a true shoemaker and a gentleman of the gentle craft, buy spurs yourself, and I'll find ye boots these seven years.

Marg. Seven years, husband?

Eyre. Peace, midriff,[28] peace. I know what I do. Peace. 140

Firke. Truly, Master Cormorant,[29] you shall do God good service to let Rafe and his wife stay together. She's a young, new-married woman; if you take her husband away from here anight, you undo her. She may beg in the day-time, for he's as good a workman at a prick and an awl[30] as any is in our trade.

Jane. Oh, let him stay; else I shall be undone.[31]

Firke. Ay, truly, she shall be laid at one side like a pair of old shoes else, and be occupied[32] for no use.

Lacy. Truly my friends, it lies not in my power. The Londoners are pressed,[33] paid, and set forth 151 By the lord mayor. I cannot change a man.

Hod. Why then, you were as good be a corporal as a colonel if you cannot discharge one good fellow. And I tell you true: I think you do more than you can answer, to press a man within a year and a day of his marriage.

Eyre. Well said, melancholy Hodge. Gramercy,[34] my fine foreman.

Marg. Truly, gentlemen, it were ill done for such as you to stand so stiffly against a poor young wife, 160 considering her case. She is but new married; but let that pass. I pray deal not roughly with her. Her husband is a young man and but newly entered; but let that pass.

Eyre. Away with your pishery-pashery, your pols and your edipols![35] Peace, midriff! Silence, Cicely Bumtrinket; let your head speak!

Firke. Yea, and the horns[36] too, master.

Eyre. Too soon,[37] my fine Firke, too soon. Peace, scoundrels. See you this man, captains? You will 170 not release him—well, let him go. He's a proper shot; let him vanish. Peace. Jane, dry up thy tears; they'll make his powder dankish. Take him, brave men! Hector of Troy was an hackney[38] to him, Hercules and Termagant[39] scoundrels. Prince Arthur's Round Table, by the Lord of Ludgate,[40] ne'er fed such a tall, such a dapper swordsman; by the life of pharaoh, a brave, resolute swordsman! Peace, Jane. I say no more, mad knaves. 179

Firke. See, see Hodge, how my master raves in commendation of Rafe.

Hod. Rafe, thou art a gull,[41] by this hand, and thou goest.[42]

Ask. I am glad, good Master Eyre, it is my hap To meet so resolute a soldier. Trust me, for your report and love to him A common slight regard shall not respect him.[43]

Lacy. Is thy name Rafe?

Rafe. Yes, sir.

Lacy. Give me thy hand. Thou shalt not want,[44] as I am a gentleman. Woman, be patient. God, no doubt, will send 190

Thy husband safe again, but he must go; His country's quarrel says it shall be so.

Hod. Thou art a gull, by my stirrup,[45] if thou dost not go. I will not have thee strike thy gimlet into these weak vessels. Prick thine enemies, Rafe.

Enter DODGER.

Dod. My lord, your uncle on the Tower Hill Stays with the lord mayor and the aldermen, And doth request you, with all speed you may, To hasten thither.

Ask. Cousin, let us go.

Lacy. Dodger, run you before. Tell them we come. This Dodger is mine uncle's parasite,[46] 201

Exit DODGER.

The arrant'st varlet that e'er breathed on earth. He sets more discord in a noble house By one day's broaching of his pickthank[47] tales Than can be salved again in twenty years; And he, I fear, shall go with us to France To pry into our actions.

Ask. Therefore, cos, It shall behove you to be circumspect.

Lacy. Fear not, good cousin. Rafe, hie to your colors.

Exeunt LACY *and* ASKEW.

Rafe. I must, because there is no remedy. 210 But, gentle master and my loving dame, As you have always been a friend to me, So in mine absence think upon my wife.

Jane. Alas, my Rafe.

Marg. She cannot speak for weeping.

Eyre. Peace, you cracked groats,[48] you mustard tokens![49] Disquiet not the brave soldier. Go thy ways, Rafe.

[27] *firking:* firk: move briskly, dance, flaunt, frisk, beat, whip, cheat.

[28] *midriff:* diaphragm, cause of laughter, and therefore in Eyre's vocabulary a term of contempt.

[29] *Cormorant:* with a pun on "coronel."

[30] *prick and an awl:* bawdy puns on the tools of the trade, with awl sounding like "hole."

[31] *undone:* another sexual innuendo.

[32] *occupied:* used in sexual intercourse (see 2 *Henry IV*, II. iv. 140). [33] *pressed:* impressed into military service.

[34] *Gramercy:* Thanks.

[35] *pols . . . edipols:* mild exclamations.

[36] *horns:* i.e., the mark of the cuckold.

[37] *Too soon:* A modern editor suggests Q compositor misunderstood ms "Tawsoone," Welsh for "be quiet," though Eyre's point may simply be that Rafe is too recently married to be cuckolded. [38] *hackney:* hack.

[39] *Termagant:* an imaginary god thought in the middle ages to be worshipped by the Moslems, represented in mystery plays as a blusterer.

[40] *Ludgate:* ancient London gate; the phrase is characteristic Eyre nonsense. [41] *gull:* credulous simpleton.

[42] *goest:* Some editors add "not."

[43] *A . . . him:* He shall have better consideration than his station warrants. [44] *want:* lack.

[45] *stirrup:* strap with which shoemaker holds work in place.

[46] *parasite:* one who lives at the expense of another, generally in exchange for flattery; a stock character in Roman comedy. [47] *pickthank:* flattering.

[48] *groats:* fourpenny bits.

[49] *mustard tokens:* given to purchasers of mustard, entitling them to small refund after accumulation of enough.

Jane. Ay, ay, you bid him go. What shall I do when
he is gone? 220
Firke. Why, be doing with me, or my fellow Hodge;
be not idle.
Eyre. Let me see thy hand, Jane. This fine hand, this
white hand, these pretty fingers must spin, must card,
must work. Work, you bombast[50] cotton[51]-candle-
quean,[52] work for your living, with a pox[53] to you.
Hold thee, Rafe: here's five sixpences for thee. Fight
for the honor of the gentle craft, for the gentlemen
shoemakers, the courageous cordwainers,[54] the flower
of Saint Martin's,[55] the mad knaves of Bedlam,[56] 230
Fleet Street,[57] Tower Street,[58] and Whitechapel.[59]
Crack me the crowns of the French knaves, a pox on
them! Crack them! Fight, by the Lord of Ludgate.
Fight, my boy.
Firke. Here, Rafe, here's three two-pences. Two
carry into France; the third shall wash our souls at
parting, for sorrow is dry. For my sake, firk the *Basa
mon cues.*[60]
Hod. Rafe, I am heavy at parting, but here's a
shilling for thee. God send thee to cram thy 240
slops[61] with French crowns, and thy enemies' bellies
with bullets.
Rafe. I thank you, master, and I thank you all.
Now, gentle wife, my loving, lovely Jane,
Rich men at parting give their wives rich gifts,
Jewels and rings to grace their lily hands.
Thou know'st our trade makes rings for women's heels;
Here, take this pair of shoes cut out by Hodge,
Stitched by my fellow Firke, seamed by myself,
Made up and pinked[62] with letters for thy name. 250
Wear them, my dear Jane, for thy husband's sake,
And every morning, when thou pull'st them on,

Remember me and pray for my return.
Make much of them; for I have made them so,
That I can know them from a thousand mo.[63]

Sound drum. Enter LORD MAYOR, LINCOLN,
LACY, ASKEW, DODGER, *and* Soldiers. *They pass
over the stage.* RAFE *falls in amongst them.* FIRKE *and
the rest cry Farewell, etc., and so exeunt.*

[I.ii]

Enter ROSE *alone, making a garland.*

Rose. Here sit thou down upon this flow'ry bank,
And make a garland for thy Lacy's head.
These pinks, these roses, and these violets,
These blushing gillyflowers, these marigolds,
The fair embroidery of his coronet,
Carry not half such beauty in their cheeks
As the sweet countenance of my Lacy doth.
Oh, my most unkind father! Oh, my stars,
Why loured you so at my nativity
To make me love, yet live robbed of my love? 10
Here as a thief am I imprisonèd
For my dear Lacy's sake, within those walls
Which by my father's cost were builded up
For better purposes. Here must I languish
For him that doth as much lament, I know,

Enter SYBIL.

Mine absence, as for him I pine in woe.
Syb. Good morrow, young mistress. I am sure you
make that garland for me, against[1] I shall be Lady of
the Harvest.[2]
Rose. Sybil, what news at London? 20
Syb. None but good. My lord mayor your father,
and Master Philpot your uncle, and Master Scott your
cousin, and Mistress Frigbottom by Doctors' Com-
mons,[3] do all, by my troth, send you most hearty
commendations.
Rose. Did Lacy send kind greetings to his love?
Syb. Oh, yes, out of cry.[4] By my troth, I scant knew
him. Here 'a wore a scarf and here a scarf, here a bunch
of feathers, and here precious stones and jewels and a
pair of garters. Oh, monstrous! Like one of our 30
yellow silk curtains at home here in Old Ford[5] House,
here in Master Bellymount's chamber. I stood at our
door in Cornhill,[6] looked at him, he at me indeed,
spake to him, but he not to me, not a word. "Marry,
gup,"[7] thought I, "with a wanion."[8] He passed by me
as proud. "Marry, foh! Are you grown humorous?"[9]
thought I, and so shut the door, and in I came.
Rose. Oh, Sybil, how dost thou my Lacy wrong!
My Rowland is as gentle as a lamb.
No dove was ever half so mild as he. 40
Syb. Mild? Yea, as a bushel of stamped crabs.[10] He
looked upon me as sour as verjuice.[11] "Go thy ways!"
thought I. "Thou may'st be much in my gaskins,[12] but
nothing in my netherstocks."[13] This is your fault,
mistress, to love him that loves not you. He thinks
scorn to do as he's done to, but if I were as you, I'd cry
"Go by, Hieronimo, go by."[14]

I'd set mine old debts against my new driblets,[15]
And the hare's foot against the goose giblets,[16]
For if ever I sigh when sleep I should take, 50
Pray God I may lose my maidenhead when I wake.

Rose. Will my love leave me, then, and go to France?

Syb. I know not that, but I am sure I see him stalk
before the soldiers. By my troth, he is a proper man;
but he is proper that proper doth. Let him go snick-
up,[17] young mistress.

Rose. Get thee to London, and learn perfectly
Whether my Lacy go to France or no.
Do this, and I will give thee for thy pains
My cambrick[18] apron and my Romish[19] gloves, 60
My purple stockings and a stomacher.[20]
Say, wilt thou do this, Sybil, for my sake?

Syb. Will I, quoth 'a? At whose suit? By my troth,
yes I'll go—a cambrick apron, gloves, a pair of purple
stockings, and a stomacher! I'll sweat in purple,
mistress, for you! I'll take anything that comes, o' God's
name! Oh, rich—a cambrick apron! Faith then, have at
up tails all;[21] I'll go jiggy-joggy to London and be here
in a trice, young mistress.

 Exit.

Rose. Do so, good Sybil. Meantime, wretched I 70
Will sit and sigh for his lost company.

 Exit.

[I.iii]

Enter ROWLAND LACY *like a Dutch shoemaker.*

Lacy. How many shapes have gods and kings devised
Thereby to compass their desirèd loves?
It is no shame for Rowland Lacy, then,
To clothe his cunning with the gentle craft,
That thus disguised I may unknown possess
The only happy presence of my Rose.
For her I have forsook my charge in France,
Incurred the King's displeasure, and stirred up
Rough hatred in mine uncle Lincoln's breast.
Oh, love, how powerful art thou, that canst change 10
High birth to bareness,[1] and a noble mind
To the mean semblance of a shoemaker!
But thus it must be; for her cruel father,
Hating the single union of our souls,
Hath secretly conveyed my Rose from London,
To bar me of her presence. But I trust
Fortune and this disguise will further me
Once more to view her beauty, gain her sight.
Here in Tower Street, with Eyre the shoemaker,
Mean I awhile to work. I know the trade; 20
I learned it when I was in Wittenberg.
Then cheer thy hoping sprites,[2] be not dismayed;
Thou canst not want, do Fortune what she can.
The gentle craft is living for a man.

 Exit.

[I.iv]

Enter EYRE, *making himself ready.*

Eyre. Where be these boys, these girls, these drabs,[1]
these scoundrels? They wallow in the fat brewis[2] of my
bounty and lick up the crumbs of my table, yet will not
rise to see my walks cleansed. Come out, your powder-
beef[3] queans! What, Nan! what, Madge Mumblecrust!
come out, you fat midriff swagbelly whores, and sweep
me these kennels,[4] that noisome stench offend not the
nose of my neighbors. What, Firke, I say! what, Hodge!
open my shop-windows! what, Firke, I say! 9

Enter FIRKE.

Firke. Oh, master, is't you that speak bandog and
bedlam[5] this morning? I was in a dream and mused
what mad man was got into the street so early. Have
you drunk this morning that your throat is so clear?

Eyre. Ah, well said, Firke! well said, Firke! to work,
my fine knave, to work. Wash thy face, and thou' t be
more blessed.

Firke. Let them wash my face that will eat it. Good
master, send for a souse wife[6] if you'll have my face
cleaner. 19

Enter HODGE.

Eyre. Away, sloven! Avaunt, scoundrel! Good
morrow, Hodge. Good morrow, my fine foreman.

Hod. Oh master, good morrow; y'are an early stirrer.
Here's a fair morning—good morrow, Firke; I could
have slept this hour. Here's a brave[7] day towards![8]

Eyre. Oh, haste to work, my fine foreman. Haste to
work.

Firke. Master, I am dry as dust to hear my fellow
Roger talk of fair weather. Let us pray for good leather,
and let clowns and ploughboys and those that work in
the fields pray for brave days. We work in a dry shop;
what care I if it rain? 31

Enter EYRE's Wife [MARGERY].

Eyre. How now, Dame Margery, can you see to
rise? Trip and go; call up the drabs your maids.

Marg. See to rise? I hope 'tis time enough. 'Tis
early enough for any woman to be seen abroad. I marvel
how many wives in Tower Street are up so soon. God's
me, 'tis not noon! Here's a yawling.[9]

Eyre. Peace, Margery, peace. Where's Cicely Bum-
trinket, your maid? She has a privy fault—she farts in

[15] *driblets:* petty cash.
[16] *And . . . giblets:* i.e., One thing against another (a pro-
verbial expression). [17] *snick-up:* hang.
[18] *cambrick:* white linen. [19] *Romish:* Roman.
[20] *stomacher:* ornamental garment worn under bodice
lacing.
[21] *have . . . all:* let's get going (also the name of a card
game).

I.iii.
 [1] *bareness:* Some modern editors emend to "baseness."
 [2] *sprites:* spirits.

I.iv.
 [1] *drabs:* whores. [2] *brewis:* meat broth.
 [3] *powder-beef:* salted beef. [4] *kennels:* gutters.
 [5] *bandog and bedlam:* furiously and madly (a bandog is a
fierce chained dog; bedlam is Bethlehem Hospital for the
insane).
 [6] *souse wife:* woman who pickles and sells pig's ears and
feet, with pun on souse ("wash"). [7] *brave:* fine.
 [8] *towards:* ahead. [9] *yawling:* howling.

her sleep. Call the quean up. If my men want[10] shoe-thread, I'll swinge[11] her in a stirrup. 41

Firke. Yet that's but a dry beating. Here's still a sign of drought.

Enter LACY *singing.*

Lacy. Der was een bore van Gelderland,
Frolik si byen.
He was als dronk he could nyet stand,
Upsolce se byen.
Tap eens de canneken,
Drinke schone mannekin.[12] 49

Firke. Master, for my life, yonder's a brother of the gentle craft. If he bear not Saint Hugh's bones,[13] I'll forfeit my bones. He's some uplandish[14] workman; hire him, good master, that I may learn some gibble-gabble. 'Twill make us work the faster.

Eyre. Peace, Firke. A hard world! Let him pass, let him vanish. We have journeymen enough. Peace, my fine Firke.

Marg. Nay, nay, y'are best to follow your man's counsel. You shall see what will come on't. We have not men enough but we must entertain every butter-box;[15] but let that pass. 61

Hod. Dame, 'fore God, if my master follow your counsel, he'll consume little beef. He shall be glad of men and he can catch them.

Firke. Ay, that he shall.

Hod. 'Fore God, a proper man, and, I warrant, a fine workman! Master, farewell. Dame, adieu. If such a man as he cannot find work, Hodge is not for you.

Offers to go.

Eyre. Stay, my fine Hodge. 69

Firke. Faith, and your foreman go, dame, you must take a journey to seek a new journeyman. If Roger re-

move, Firke follows. If Saint Hugh's bones be not set a-work, I may prick mine awl in the walls and go play. Fare ye well, master. Goodbye, dame.

Eyre. Tarry, my fine Hodge, my brisk foreman! Stay, Firke. Peace, pudding-broth. By the Lord of Ludgate, I love my men as my life. Peace, you galli-maufry.[16] Hodge, if he want work I'll hire him. One of you, to him—stay, he comes to us.

Lacy. Goeden dach, meester, ende u vro oak.[17] 80

Firke. Nails,[18] if I should speak after[19] him without drinking I should choke. [*To* LACY] And you, friend Oak,[20] are you of the gentle craft?

Lacy. Yaw, yaw. Ik bin den skomawker.[21]

Firke. "Den skomawker," quoth 'a. And hark you, good skomawker, have you all your tools? A good rubbing pin, a good stopper, a good dresser, your four sorts of awls, and your two balls of wax, your paring knife, your hand and thumb-leathers, and good Saint Hugh's bones to smooth up your work? 90

Lacy. Yaw, yaw. Be niet vorveard. Ik hab all de dingen voour mak skoes groot and clean.[22]

Firke. Ha, ha! Good master, hire him; he'll make me laugh so that I shall work more in mirth than I can in earnest.

Eyre. Hear ye, friend. Have ye any skill in the mystery[23] of cordwainers?

Lacy. Ik weet niet wat yow seg. Ich verstaw you niet.[24]

Firke. Why, thus man 100
[*miming a shoemaker at work*].
"Ich verstaw you niet," quoth 'a.

Lacy. Yaw, yaw, yaw. Ich can dat wel doen.[25]

Firke. Yaw, yaw. He speaks yawing like a jackdaw that gapes to be fed with cheese curds. Oh, he'll give a villainous pull at a can of double beer, but Hodge and I have the vantage: we must drink first, because we are the eldest journeymen.

Eyre. What is thy name?

Lacy. Hans. Hans Meulter. 109

Eyre. Give me thy hand; th'art welcome. Hodge, entertain him. Firke, bid him welcome. Come, Hans. Run, wife; bid your maids, your Trullibubs,[26] make ready my fine men's breakfasts. To him, Hodge.

Hod. Hans, th'art welcome. Use thyself friendly,[27] for we are good fellows. If not, thou shalt be fought with, wert thou bigger than a giant.

Firke. Yea, and drunk with, wert thou Gargantua.[28] My master keeps no cowards, I tell thee. Ho, boy! Bring him an heel-block; here's a new journeyman.

Enter Boy.

Lacy. Oh, ich wersto you. Ich moet een halve dossen cans betaelen. Here, boy, nempt dis skilling. Tap eens freelick.[29] 122
Exit Boy.

Eyre. Quick, snipper-snapper, away! Firke, scour thy throat; thou shalt wash it with Castilian liquor. [*To* Boy] Come, my last of the fives.[30]

Enter Boy.

Give me a can. Have to thee, Hans! Here, Hodge!

[10] *want:* lack. [11] *swinge:* thrash.
[12] *Der . . . mannekin:* There was a man of Gelderland, Merry they be. He was so drunk he could not stand, Drunk [?] they be. Clink the cannikin once; Drink, pretty little man.
[13] *Saint Hugh's bones:* the martyr's bones, turned into tools by his shoemaker friends. [14] *uplandish:* provincial.
[15] *butterbox:* Dutchman.
[16] *gallimaufry:* dish made by hashing up odds and ends of meat; hodgepodge.
[17] *Goeden . . . oak:* Good day, sir, and you too, lady.
[18] *Nails:* God's nails. [19] *after:* in his manner.
[20] *Oak:* mocking Lacy's last word ("too").
[21] *Yaw . . . skomawker:* Yes, yes, I'm a shoemaker.
[22] *Yaw . . . clean:* Yes, yes, don't be afraid; I have all the things to make shoes, large and small.
[23] *mystery:* trade.
[24] *Ik . . . niet:* I don't know what you're saying. I don't understand you.
[25] *Yaw . . . doen:* Yes, yes, yes. I can do that well.
[26] *Trullibubs:* animals' entrails, perhaps with pun on trulls ("sluts"). [27] *Use . . . friendly:* Act friendly.
[28] *Gargantua:* probably the folktale hero rather than Rabelais' character.
[29] *Oh . . . freelick:* Oh I understand you. I must pay for a half dozen cans. Here, boy, take this shilling. Drink once gaily.
[30] *last . . . fives:* the last for number five shoes; i.e., a small one.

Drink, you mad Greeks, and work like true Trojans, and pray for Simon Eyre, the shoemaker. Here, Hans, and th'art welcome. 129

Firke. Lo, dame, you would have lost a good fellow that will teach us to laugh. This beer came hopping in well.

Marg. Simon, it is almost seven.

Eyre. Is't so, Dame Clapper-dudgeon?[31] Is't seven a clock and my men's breakfast not ready? Trip and go, you soused conger[32]—away! Come, you mad Hyperboreans.[33] Follow me, Hodge. Follow me, Hans. Come after, my fine Firke. To work, to work a while, and then to breakfast. 139

Exit.

Firke. Soft! Yaw, yaw, good Hans. Though my master have no more wit but to call you afore me, I am not so foolish to go behind you, I being the elder journeyman.

Exeunt.

ACT TWO

SCENE ONE

Hallooing within. Enter WARNER *and* HAMMON, *dressed as hunters.*

Ham. Cousin, beat every brake; the game's not far.
This way with wingèd feet he fled from death,
Whilst the pursuing hounds, scenting his steps
Find out his high way to destruction.
Besides, the miller's boy told me even now
He saw him take soil[1] and he halloed him,
Affirming him so embossed[2]
That long he could not hold.
 War. If it be so,
'Tis best we trace these meadows by Old Ford. 9

A noise of hunters within.

Enter a Boy.

Ham. How now, boy? Where's the deer? Speak, saw'st thou him?

Boy. Oh, yea, I saw him leap through a hedge and then over a ditch, then at my lord mayor's pale;[3] over he skipped me and in he went me, and "Holla" the hunters cried and "There boy, there boy," but there he is, a'mine honesty.

Ham. Boy, God amercy! Cousin, let's away.
I hope we shall find better sport today.

Exeunt.

[II.ii]

Hunting within. Enter ROSE *and* SYBIL.

Rose. Why, Sybil, wilt thou prove a forester?

Syb. Upon some,[1] no! Forester, go by! No, faith, mistress; the deer came running into the barn through the orchard and over the pale. I wot well I looked as pale as a new cheese to see him. But "Whip!" says Goodman Pinclose, up with his flail and our Nick with a prong, and down he fell, and they upon him, and I upon them. By my troth, we had such sport, and in the end we ended him; his throat we cut, flayed him, un-

horned him, and my lord mayor shall eat of him anon when he comes. 11

Horns sound within.

Rose. Hark, hark, the hunters come! Y'are best take heed;
They'll have a saying to you for this deed.

Enter HAMMON, WARNER, Huntsmen, *and* Boy.

Ham. God save you, fair ladies.
Syb. Ladies! Oh, gross![2]
War. Came not a buck this way?
Rose. No, but two does.
Ham. And which way went they? Faith, we'll hunt at those.
Syb. At those? Upon some, no! When, can you tell?
War. Upon some, ay!
Syb. Good Lord!
War. Wounds![3] Then farewell.
Ham. Boy, which way went he?
Boy. This way, sir, he ran.
Ham. This way he ran indeed. Fair mistress Rose,
Our game was lately in your orchard seen. 21
War. Can you advise which way he took his flight?
Syb. Follow your nose, his horns will guide you right.
War. Th'art a mad wench.
Syb. Oh, rich!
Rose. Trust me, not I.
It is not like, the wild forest deer
Would come so near to places of resort.
You are deceived; he fled some other way.
War. Which way, my sugar-candy, can you show?
Syb. Come up, good honeysops. Upon some, no!
Rose. Why do you stay, and not pursue your game?
Syb. I'll hold my life their hunting nags be lame. 31
Ham. A deer more dear is found within this place.
Rose. But not the deer, sir, which you had in chase.
Ham. I chased the deer, but this dear chaseth me.
Rose. The strangest hunting that ever I see.
But where's your park?

She offers to go away.

Ham. 'Tis here—oh, stay!
Rose. Impale[4] me, and then I will not stray.
[*To* SYBIL] They wrangle, wench. We are more kind than they.
Syb. What kind of hart is that, dear heart, you seek?
War. A hart, dear heart.
Syb. Who ever saw the like? 40

[31] *Clapper-dudgeon:* Beggar. [32] *conger:* eel.
[33] *Hyperboreans:* legendary inhabitants of the far north.
II.i.
[1] *soil:* refuge in a muddy place.
[2] *embossed:* exhausted and foaming at the mouth.
[3] *pale:* fence.
II.ii.
[1] *Upon some:* i.e., Upon my word.
[2] *gross:* gross flattery. [3] *Wounds:* God's wounds.
[4] *Impale:* Fence up.

Rose. To lose your heart, is't possible you can?
Ham. My heart is lost.
Rose. Alack, good gentleman!
Ham. This poor lost heart would I wish you might
 find.
Rose. You, by such luck, might prove your hart a
 hind.
Ham. Why, Luck had horns, so have I heard some
 say.
Rose. Now God, and't be His will, send Luck into
 your way.

 Enter LORD MAYOR *and* Servants.

L. Ma. What, Master Hammon! Welcome to Old
 Ford.
Syb. [*To* WARNER] God's pittikins,[5] hands off, sir!
 Here's my lord.
L. Ma. I hear you had ill luck and lost your game.
Ham. 'Tis true, my lord.
L. Ma. I am sorry for the same.
What gentleman is this?
Ham. My brother-in-law. 51
L. Ma. Y'are welcome both. Sith Fortune offers you
Into my hands, you shall not part from hence
Until you have refreshed your wearied limbs.
Go, Sybil, cover the board. You shall be guest
To no good cheer but even a hunter's feast.
Ham. I thank your lordship. [*Aside to* WARNER]
 Cousin, on my life,
For our lost venison, I shall find a wife.
 Exeunt.
L. Ma. In, gentlemen; I'll not be absent long.
This Hammon is a proper gentleman, 60
A citizen by birth, fairly allied.
How fit an husband were he for my girl!
Well, I will in and do the best I can
To match my daughter to this gentleman.
 Exit.

[II.iii]
 Enter LACY [*as* Hans], SKIPPER, HODGE, *and*
 FIRKE.

Skip. Ick sal yow wat seggen, Hans: dis skip dat
comen from Candy is al vol, by Got's sacrament, van
sugar, civet, almonds, cambrick, and all dingen—
towsand, towsand ding. Nempt it, Hans. Nempt it vor

u meester. Daer be de bills van laden. Your meester,
Simon Eyre, sal hae good copen. Wat seggen you,
Hans?[1]
Firke. Wat seggen de reggen de copen, slopen.
Laugh, Hodge, laugh! 9
Lacy. Mine liever broder, Firke, bringt meester
Eyre tot den sign van swannekin.[2] Daer sal yow find dis
skipper end me. Wat seggen yow, broder Firke? Doot
it, Hodge.[3] Come, skipper.
 Exeunt LACY *and* SKIPPER.
Firke. "Bring him," quoth you? Here's no knavery,
to bring my master to buy a ship worth the lading of
two or three hundred thousand pounds! Alas, that's
nothing! A trifle, a bauble, Hodge.
Hod. The truth is, Firke, that the merchant owner of
the ship dares not show his head, and therefore this
skipper that deals for him, for the love he bears to 20
Hans, offers my master Eyre a bargain in the commodi-
ties. He shall have a reasonable day of payment. He
may sell the wares by that time and be an huge gainer
himself.
Firke. Yea, but can my fellow Hans lend my master
twenty porpentines[4] as an earnest penny?[5]
Hod. Portagues, thou wouldst say. Here they be,
Firke. Hark, they jingle in my pocket like Saint Mary
Overy's[6] bells. 29

 Enter EYRE *and his* Wife [MARGERY] [*and a* Boy.]

Firke. Mum! Here comes my dame and my master.
She'll scold, on my life, for loitering this Monday. But
all's one; let them all say what they can, Monday's our
holiday.
Marg. You sing, Sir Sauce, but I beshrew your
 heart;
I fear for this your singing we shall smart.
Firke. Smart for me, dame? Why, dame, why?
Hod. Master, I hope you'll not suffer my dame to
take down your journeyman.
Firke. If she take me down, I'll take her up. Yea,
and take her down too—a button-hole lower. 40
Eyre. Peace, Firke. Not I, Hodge; by the life of
Pharaoh, by the Lord of Ludgate, by this beard, every
hair whereof I value at a king's ransom, she shall not
meddle with you. Peace, you bombast-cotton-candle
quean! away, Queen of Clubs! Quarrel not with my
men, with me and my fine Firke. I'll firk you if you do.
Marg. Yea, yea, man. You may use me as you please;
but let that pass.
Eyre. Let it pass, let it vanish away. Peace! Am I not
Simon Eyre? Are not these my brave men? Brave 50
shoemakers, all gentlemen of the gentle craft. Prince
am I none, yet am I nobly born, as being the sole son of
a shoemaker. Away, rubbish! vanish! melt like kitchen
stuff.[7]
Marg. Yea, yea, 'tis well. I must be called rubbish,
kitchen stuff, for a sort[8] of knaves.
Firke. Nay, dame. You shall not weep and wail in
woe for me. Master, I'll stay no longer. Here's a
venentory[9] of my shop tools. Adieu, master. Hodge,
farewell. 60
Hod. Nay, stay, Firke. Thou shalt not go alone.

 [5] *pittikins:* diminutive of pity (cf. "body" in "Od's
bodkins").
 II.iii.
 [1] *Ick . . . Hans:* I'll tell you what, Hans: this ship that
comes from Candia (Crete) is all full, by God's sacrament,
of sugar, . . . and all things—a thousand . . . things. Take it,
Hans . . . for your master. There are the bills of lading.
Your master . . . shall have a good bargain. What do you say,
Hans?
 [2] *Mine . . . swannekin:* My dear brother, Firke, bring
Master Eyre to the sign of the Swan.
 [3] *Daer . . . Hodge:* There you will find the skipper and
me. . . . Do it, Hodge. [4] *porpentines:* porcupines.
 [5] *earnest penny:* token of more to come.
 [6] *Saint Mary Overy's:* church on the south side of the
Thames. [7] *kitchen stuff:* greasy drippings.
 [8] *sort:* bunch. [9] *venentory:* (mistake for) inventory.

Marg. I pray let them go. There be more maids than Mawkin,[10] more men than Hodge, and more fools than Firke.

Firke. Fools! nails! If I tarry now I would my guts might be turned to shoe-thread!

Hod. And if I stay, I pray God I may be turned to a Turk[11] and set in Finsbury[12] for boys to shoot at. Come, Firke. 69

Eyre. Stay, my fine knaves! You arms of my trade, you pillars of my profession. What, shall a tittle-tattle's words make you forsake Simon Eyre? [*To his* Wife] Avaunt, kitchen-stuff!—Rip, you brown-bread tanni-kin[13] out of my sight! Move me not![14] Have I not ta'en you from selling tripes in Eastcheap[15] and set you in my shop and made you hail-fellow with Simon Eyre the shoemaker? And now do you deal thus with my jour-neymen? Look, you powder-beef quean, on the face of Hodge. Here's a face for a lord. 79

Firke. And here's a face for any lady in Christendom.

Eyre. Rip, you chitterling! Avaunt, boy: bid the tapster of the Boar's Head fill me a dozen cans of beer for my journeymen.

Firke. A dozen cans? Oh, brave! Hodge, now I'll stay.

Eyre. [*Aside to the* Boy] And the knave fills any more than two, he pays for them.—

[*Exit* Boy.]

[*Aloud*] A dozen cans of beer for my journeymen!

[*Enter* Boy *with two cans, and exit.*]

Here, you mad Mesopotamians, wash your livers with this liquor. Where be the odd[16] ten? No more, 90 Madge, no more. Well said. Drink and to work. What work dost thou, Hodge? What work?

Hod. I am making a pair of shoes for Sybil, my lord's maid. I deal with her.

Eyre. Sybil? Fie, defile not thy fine workmanly fingers with the feet of kitchen stuff and basting ladles! Ladies of the court, fine ladies, my lads, commit their feet to our appareling. Put gross work to Hans. Yark[17] and seam, yark and seam! 99

Firke. For yarking and seaming let me alone, an I come to't.

Hod. Well, master, all this is from the bias.[18] Do you remember the ship my fellow Hans told you of? The skipper and he are both drinking at the Swan. Here be the portagues to give earnest. If you go through with it you cannot choose but be a lord at least.

Firke. Nay, dame, if my master prove not a lord and you a lady, hang me.

Marg. Yea, like enough, if you loiter and tipple thus.

Firke. Tipple, dame? No, we have been bargaining with Skellum[19] Skanderbag.[20] Can you Dutch spreaken for a ship of silk Cyprus, laden with sugar-candy? 112

Enter the Boy *with a velvet coat and an alderman's gown.*

Eyre. Peace, Firke. Silence, tittle-tattle. Hodge, I'll go through with it. Here's a ring, and I have sent for a guarded[21] gown and a damask cassock. See where it comes. Look here, Maggy. Help me, Firke. Apparel me,

Hodge. Silk and satin, you mad Philistines! Silk and satin!

[EYRE *is appareled.*]

Firke. Ha ha! My master will be as proud as a dog in a doublet, all in beaten[22] damask and velvet. 120

Eyre. Softly, Firke, for rearing[23] of the nap and wearing threadbare my garments. How dost thou like me, Firke? How do I look, my fine Hodge?

Hod. Why, now you look like yourself, master. I warrant you, there's few in the City but will give you the wall[24] and come upon you with the "Right Worshipful."

Firke. Nails! my master looks like a threadbare cloak new turned and dressed. Lord, lord, to see what good raiment doth! Dame, dame, are you not enamored?

Eyre. How say'st thou, Maggy? Am I not brink? Am I not fine? 132

Marg. Fine? By my troth, sweetheart, very fine. By my troth, I never liked thee so well in my life, sweet heart. But let that pass. I warrant there be many women in the City have not such handsome husbands, but only for their apparel. But let that pass too.

Enter [LACY *as*] Hans *and* SKIPPER.

Lacy. Godden day, mester. Dis be de skipper dat heb de skip van merchandice. De commodity ben good. Nempt it, master, nempt it.[25] 140

Eyre. God-a-mercy, Hans. Welcome, skipper. Where lies this ship of merchandise?

Skip. De skip ben in revere. Dor be van sugar,[26] civet, almonds, cambrick, and a towsand towsand tings. Got's sacrament! Nempt it, mester. Yo sall heb good copen.

Firke. To him, master. Oh, sweet master! Oh, sweet wares: prunes, almonds, sugar-candy, carrot roots, turnips! Oh brave fatting meat! Let not a man buy a nutmeg but yourself. 150

Eyre. Peace, Firke. Come, skipper, I'll go aboard with you. Hans, have you made him drink?

Skip. Yaw, yaw, ic hab veale[27] gedrunk.

[10] *Mawkin:* Malkin, proverbial name for a slatternly kitchen wench.

[11] *Turk:* Targets for shooting practice were often figures of Turks.

[12] *Finsbury:* London training ground for archers.

[13] *tannikin:* diminutive of Anna, nickname for Dutch girls.

[14] *Move me not:* Don't get me angry!

[15] *Eastcheap:* district noted for cooks and butchers.

[16] *odd:* other.

[17] *Yark:* Yerk, shoemaker's term—draw stitches tightly.

[18] *from the bias:* off the point. [19] *Skellum:* Rascal.

[20] *Skanderbag:* scoundrel, cant term derived from name of fifteenth-century Albanian Turk-fighter.

[21] *guarded:* with ornamental borders.

[22] *beaten:* embroidered. [23] *rearing:* raising.

[24] *give you the wall:* give you precedence; the phrase de-rives from the advantage of walking and passing on the wall rather than street side.

[25] *Godden . . . it:* Good day This is the skipper that has the ship of merchandise. The commodity is good. Take it, . . .

[26] *De . . . sugar:* The ship is in the river. There is sugar, . . .

[27] *veale:* much.

Eyre. Come, Hans, follow me. Skipper, thou shalt have my countenance in the City.

 Exeunt [EYRE, SKIPPER, *and* LACY].

Firke. "Yaw, heb veale gedrunk," quoth-a. They may well be called butter-boxes when they drink fat veal, and thick beer too. But come, dame, I hope you'll chide us no more. 159

Marg. No faith, Firke. No perdy,[28] Hodge. I do feel honor creep upon me; and, which is more, a certain rising in my flesh, but let that pass.

Firke. Rising in your flesh do you feel, say you? Ay, you may be with child. But why should not my master feel a rising in his flesh, having a gown and a gold ring on. But you are such a shrew, you'll soon pull him down.

Marg. Ha ha, prithee peace. Thou mak'st my worship laugh. But let that pass. Come, I'll go in. Hodge, prithee go before me. Firke, follow me. 169

Firke. Firke doth follow. Hodge, pass out in state.

 Exeunt.

[II.iv]

Enter LINCOLN *and* DODGER.

Linc. How now, good Dodger? What's the news in
 France?

Dod. My lord, upon the eighteenth day of May
The French and English were prepared to fight.
Each side with eager fury gave the sign
Of a most hot encounter. Five long hours
Both armies fought together. At the length,
The lot of victory fell on our sides.
Twelve thousand of the Frenchmen that day died,
Four thousand English, and no man of name
But Captain Hyam and young Ardington. 10

Linc. Two gallant gentlemen; I knew them well.
But, Dodger, prithee tell me, in this fight
How did my cousin Lacy bear himself?

Dod. My lord, your cousin Lacy was not there.

Linc. Not there?

Dod. No, my good lord.

Linc. Sure thou
 mistakest.
I saw him shipped, and a thousand eyes beside
Were witnesses of the farewells which he gave
When I with weeping eyes bid him adieu.
Dodger, take heed.

Dod. My lord, I am advised
That what I spake is true. To prove it so, 20
His cousin Askew, that supplied his place,
Sent me for him from France, that secretly
He might convey himself hither.

Linc. Is't even so?
Dares he so carelessly venture his life
Upon the indignation of a king?
Hath he despised my love and spurned those favors
Which I with prodigal hand poured on his head?
He shall repent his rashness with his soul.
Since of my love he makes no estimate,
I'll make him wish he had not known my hate. 30
Thou hast no other news?

Dod. None else, my lord.

Linc. None worse I know thou hast. Procure the
 King
To crown his giddy brows with ample honors!
Send him chief colonel, and all my hope
Thus to be dashed! But 'tis in vain to grieve.
One evil cannot a worse relieve.
Upon my life, I have found out his plot!
That old dog Love that fawned upon him so,
Love to that puling girl, his fair-cheeked Rose,
The lord mayor's daughter, hath distracted him, 40
And in the fire of that love's lunacy
Hath he burned up himself, consumed his credit,
Lost the King's love, yea, and I fear, his life,
Only to get a wanton to his wife.
Dodger, it is so.

Dod. I fear so, my good lord.

Linc. It is so. Nay, sure it cannot be!
I am at my wit's end. Dodger—

Dod. Yea, my lord.

Linc. Thou art acquainted with my nephew's haunts.
Spend this gold for thy pains. Go, seek him out.
Watch at my lord mayor's. There, if he live, 50
Dodger, thou shalt be sure to meet with him.
Prithee, be diligent. Lacy, thy name
Lived once in honor, now dead in shame.
Be circumspect.

 Exit.

Dod. I warrant you, my lord.

 Exit.

ACT THREE

SCENE ONE

Enter LORD MAYOR *and* MASTER SCOTT.

L. Ma. Good Master Scott, I have been bold with
 you
To be a witness to a wedding knot
Betwixt young Master Hammon and my daughter.
Oh, stand aside; see where the lovers come.

Enter HAMMON *and* ROSE.

Rose. Can it be possible you love me so?
No, no! Within those eyeballs I espy
Apparent likelihoods of flattery.
Pray now, let go my hand.

Ham. Sweet Mistress Rose,
Misconstrue not my words, nor misconceive
Of my affection, whose devoted soul 10
Swears that I love thee dearer than my heart.

Rose. As dear as your own heart? I judge it right.
Men love their hearts best when th'are out of sight.

Ham. I love you, by this hand.

Rose. Yet hands off now!
If flesh be frail, how weak and frail's your vow.

Ham. Then by my life I swear.

Rose. Then do not brawl.
One quarrel loseth wife and life and all.
Is not your meaning thus?

Ham. In faith, you jest.

[28] *perdy:* by God.

Rose. Love loves to sport; therefore leave love, y'are best.

L. Ma. What? Square[1] they, Master Scott?

Scott. Sir, never doubt; 20
Lovers are quickly in and quickly out.

Ham. Sweet Rose, be not so strange[2] in fancying me.
Nay, never turn aside! Shun not my sight.
I am not grown so fond to fond[3] my love
On any that shall quit[4] it with disdain.
If you will love me, so; if not, farewell.

L. Ma. Why, how now, lovers? Are you both agreed?

Ham. Yes, faith, my lord.

L. Ma. 'Tis well. Give me your hand.
Give me yours, daughter. How now? Both pull back?
What means this, girl?

Rose. I mean to live a maid. 30

Ham. [*Aside*] But not to die one—pause ere that be said.

L. Ma. Will you still cross me? Still be obstinate?

Ham. Nay, chide her not, my lord, for doing well.
If she can live an happy virgin's life
'Tis far more blèssèd than to be a wife.

Rose. Say, sir, I cannot. I have made a vow:
Whoever be my husband, 'tis not you.

L. Ma. Your tongue is quick. But, Master Hammon, know
I bade you welcome to another end.

Ham. What? Would you have me pule and pine and pray 40
With "lovely lady, mistress of my heart,
Pardon your servant," and the rhymer play,
Railing on Cupid and his tyrant dart?
Or shall I undertake some martial spoil,
Wearing your glove at tourney and at tilt,
And tell how many gallants I unhorsed?
Sweet, will this pleasure you?

Rose. Yea. When wilt begin?
What? Love-rhymes, man? Fie on that deadly sin.

L. Ma. If you will have her, I'll make her agree.

Ham. Enforcèd love is worse than hate to me. 50
There is a wench keeps shop in the Old Change.[5]
To her will I. It is not wealth I seek;
I have enough, and will prefer her love
Before the world. My good Lord Mayor, adieu.
Old love for me; I have no luck with new.
 Exit.

L. Ma. Now, mammet![6] You have well behaved yourself!
But you shall curse your coyness[7] if I live.
Who's within there? See you convey your mistress
Straight to th' Old Ford. I'll keep you straight enough.
Fore God, I would have sworn the puling girl 60
Would willingly accepted Hammon's love.
But banish him my thoughts! Go, minion, in!
 Exit ROSE.
Now, tell me, Master Scott, would you have thought
That Master Simon Eyre, the shoemaker,
Had been of wealth to buy such merchandise?

Scott. 'Twas well, my lord, your honor and myself

Grew partners with him. For your bills of lading
Show that Eyre's gains in one commodity
Rise at the least to full three thousand pound,
Besides like gain in other merchandise. 70

L. Ma. Well he shall spend some of his thousands now,
For I have sent for him to the Guildhall.

Enter EYRE.

See where he comes. Good morrow, Master Eyre.

Eyre. Poor Simon Eyre, my lord, your shoemaker.

L. Ma. Well, well, it likes[8] yourself to term you so.

Enter DODGER.

Now, Master Dodger, what's the news with you?

Dod. I'll gladly speak in private to your honor.

L. Ma. You shall, you shall. Master Eyre and Master Scott,
I have some business with this gentleman.
I pray you, let me entreat you to walk before 80
To the Guildhall. I'll follow presently.
Master Eyre, I hope ere noon to call you sheriff.

Eyre. I would not care, my lord, if you might call me
King of Spain. Come, Master Scott.
 Exeunt [EYRE *and* SCOTT.]

L. Ma. Now, Master Dodger, what's the news you bring?

Dod. The Earl of Lincoln by me greets your lordship
And earnestly requests you, if you can,
Inform him where his nephew Lacy keeps.

L. Ma. Is not his nephew Lacy now in France?

Dod. No, I assure your lordship, but disguised 90
Lurks here in London.

L. Ma. London? Is't even so?
It may be, but upon my faith and soul
I know not where he lives or whether he lives.
So tell my Lord of Lincoln. Lurch[9] in London?
Well, Master Dodger, you perhaps may start[10] him.
Be but the means to rid him into France,
I'll give you a dozen angels[11] for your pains:
So much I love his honor, hate his nephew,
And prithee so inform thy lord from me.

Dod. I take my leave.

L. Ma. Farewell, good Master Dodger.
 Exit DODGER.
Lacy in London? I dare pawn my life 101
My daughter knows thereof and for that cause
Denied young Master Hammon in his love.
Well, I am glad I sent her to Old Ford.
God's Lord, 'tis late! To Guildhall I must hie.
I know my brethren stay my company.
 Exit.

III.i.
[1] *Square:* Quarrel. [2] *strange:* reserved.
[3] *so . . . fond:* so foolish as to found. [4] *quit:* requite.
[5] *Old Change:* street at west end of St. Paul's, site of the Old Exchange. [6] *mammet:* puppet.
[7] *coyness:* reserve. [8] *likes:* pleases.
[9] *Lurch:* Lurk. [10] *start:* flush from cover.
[11] *angels:* gold coins.

[III.ii]

Enter FIRKE, EYRE'*s* Wife [MARGERY],
[LACY *as*] Hans, *and* ROGER.

Marg. Thou goest too fast for me, Roger. Oh, Firke!
Firke. Ay, forsooth.
Marg. I pray thee, run, do you hear, run to Guild-
hall and learn if my husband Master Eyre will take that
worshipful vocation of Master Sheriff upon him. Hie
thee, good Firke.
Firke. Take it? Well, I go. And he should not take it,
Firke swears to forswear him. Yes, forsooth, I go to
Guildhall. 9
Marg. Nay, when? Thou art too compendious[1] and
tedious.
Firke. Oh, rare! your excellence is full of eloquence.
[*Aside*] How like a new cart-wheel my dame speaks!
And she looks like an old, musty ale-bottle going to
scalding.[2]
Marg. Nay, when?[3] Thou wilt make me melan-
choly.
Firke. God forbid your worship should fall into that
humor.[4] I run.
 Exit.
Marg. Let me see now, Roger and Hans. 20
Hod. Ay, forsooth, dame—mistress, I should say,
but the old term so sticks to the roof of my mouth I can
hardly lick it off.
Marg. Even what thou wilt, good Roger. Dame is a
fair name for any honest Christian, but let that pass.
How dost thou, Hans?
Lacy. Me tank you, vro.[5]
Marg. Well, Hans and Roger, you see God hath
blest your master, and, perdy, if ever he comes to be
Master Sheriff of London—as we are all mortal— 30
you shall see I will have some odd thing or other in a
corner for you. I will not be your back[6] friend. But let
that pass. Hans, pray thee tie my shoe.
Lacy. Yaw, ic sall, vro.[7]
Marg. Roger, thou knowest the length of my foot.
As it is none of the biggest, so I thank God it is hand-
some enough. Prithee, let me have a pair of shoes made.
Cork, good Roger, wooden heel too.
Hod. You shall. 39
Marg. Art thou acquainted with never a fartingale[8]
maker, nor a French-hood maker? I must enlarge my
bum. Ha ha! How shall I look in a hood, I wonder?
Perdy, oddly, I think.

Hod. [*Aside*] As a cat out of a pillory.—[*To her*] Very
well, I warrant you, mistress.
Marg. Indeed, all flesh is grass. And, Roger, canst
thou tell where I may buy a good hair?[9]
Hod. Yea, forsooth, at the poulterer's in Gracious[10]
Street.
Marg. Thou art an ungracious wag, perdy. I mean a
false hair for my periwig. 51
Hod. Why, mistress, the next time I cut my beard
you shall have the shavings of it—but they are all true
hairs.
Marg. It is very hot. I must get me a fan or else a
mask.
Hod. [*Aside*] So you had need, to hide your wrinkled
face.
Marg. Fie upon it! How costly this world's calling is,
perdy. But that is one of the wonderful works of 60
God: I would not deal with it. Is not Firke come yet?
Hans, be not so sad; let it pass and vanish, as my
husband's worship says.
Lacy. Ic bin vrolick. Lot see yow so.[11]
Hod. Mistress, will you drink[12] a pipe of tobacco?
Marg. Oh, fie upon it, Roger! Perdy, these filthy
tobacco pipes are the most idle, slavering baubles that
ever I felt. Out upon it! God bless us, men look not
like men that use them. 69

Enter RAFE, *being lame.*

Hod. What! Fellow Rafe? Mistress, look here:
Jane's husband! Why, how now? Lame? Hans, make
much of him. He's a brother of our trade, a good work-
man, and a tall[13] soldier.
Lacy. You be welcome, broder.
Marg. Perdy, I knew him not. How dost thou, good
Rafe? I am glad to see thee well.
Rafe. I would God you saw me, dame, as well
As when I went from London into France.
Marg. Trust me, I am sorry, Rafe, to see thee im-
potent. Lord, how the wars have made him sun- 80
burned! The left leg is not well. 'Twas a fair gift of
God the infirmity took not hold a little higher,[14] con-
sidering thou camest from France. But let that pass.
Rafe. I am glad to see you well, and I rejoice
To hear that God hath blessed my master so
Since my departure.
Marg. Yea, truly, Rafe, I thank my maker. But let
that pass.
Hod. And, sirrah Rafe, what news? What news in
France? 90
Rafe. Tell me, good Roger, first, what news in
 England?
How does my Jane? When didst thou see my wife?
Where lives my poor heart? She'll be poor indeed,
Now I want limbs to get whereon to feed.
Hod. Limbs? Hast thou not hands, man? Thou shalt
never see a shoemaker want bread, though he have but
three fingers on a hand.
Rafe. Yet all this while I hear not of my Jane.
Marg. Oh, Rafe! Your wife, perdy, we know not
what's become of her. She was here awhile, and 100
because she was married grew more stately than became

III.ii.
 [1] *compendious:* Margery's error for "comprehensive."
 [2] *scalding:* being cleaned in hot water.
 [3] *when:* exclamation of impatience.
 [4] *humor:* The four humors or fluids that determined
character ("temperament") were thought to be blood,
phlegm, choler (bile), and melancholy (black bile).
 [5] *Me . . . vro:* I thank you, mistress.
 [6] *back:* faithless. [7] *Yaw . . . vro:* Yes, I will, mistress.
 [8] *fartingale:* hooped petticoat.
 [9] *hair:* Hodge puns on "hair"–"hare"; poulterers sold
rabbits. [10] *Gracious:* Gracechurch.
 [11] *Ic . . . so:* I'm merry. Let's see you so.
 [12] *drink:* smoke. [13] *tall:* valiant.
 [14] *higher:* Syphilis was known as "the French disease."

her. I checked her, and so forth. Away she flung. Never
returned, nor said bye nor bah. And Rafe, you know,
"ka me, ka thee." [15] And so, as I tell ye. Roger, is not
Firke come yet?

Hod. No, forsooth.

Marg. And so, indeed, we heard not of her, but I
hear she lives in London; but let that pass. If she had
wanted, she might have opened her case to me or my
husband, or to any of my men. I am sure there's 110
not any of them, perdy, but would have done her good
to his power. Hans, look if Firke be come.

Lacy. Yaw, ic sal, vro. *Exit.*

Marg. And so as I said. But, Rafe, why dost thou
weep? Thou knowest that naked we came out of our
mother's womb, and naked we must return. And there-
fore thank God for all things.

Hod. No, faith. Jane is a stranger here, but, Rafe,
pull up a good heart; I know thou hast one. Thy wife,
man, is in London. One told me he saw her a 120
while ago, very brave and neat. We'll ferret her out,
and London hold her.

Marg. Alas, poor soul, he's overcome with sorrow.
He does but as I do, weep for the loss of any good thing.
But, Rafe, get thee in. Call for some meat and drink.
Thou shalt find me worshipful towards thee.

Rafe. I thank you, dame. Since I want limbs and
lands, I'll to God, my good friends, and to these my
hands. 129
 Exit.

Enter [LACY *as*] Hans *and* FIRKE *running.*

Firke. Run, good Hans. Oh, Hodge! oh, mistress!
Hodge, heave up thine ears. Mistress, smug [16] up your
looks. On with your best apparel. My master is chosen!
My master is called, nay, condemned by the cry of the
country, to be Sheriff of the City for this famous year
now to come and time now being. A great many men in
black gowns were asked for their voices and their hands,
and my master had all their fists about his ears presently,
and they cried "Ay, ay, ay, ay," and so I came away.
Wherefore, without all other grieve,
I do salute you, Mistress Shrieve. [17] 140

Lacy. Yaw. My mester is de groot man, de shrieve.

Hod. Did I not tell you, mistress? Now I may boldly
say "Good morrow to your worship."

Marg. Good morrow, good Roger. I thank you, my
good people all. Firke, hold up thy hand. Here's a three-
penny piece for thy tidings.

Firke. 'Tis but three-half-pence, I think. Yes, 'tis
threepence; I smell the rose. [18]

Hod. But, mistress, be ruled by me, and do not
speak so pulingly. 150

Firke. 'Tis her worship speaks so and not she. No
faith, mistress, speak me in the old key—"To it, Firke!
There, good Firke! Ply your business, Hodge!"
"Hodge!" with a full mouth! "I'll fill your bellies
with good cheer till they cry twang." [19]

Enter SIMON EYRE *wearing a gold chain.*

Lacy. See, mine liever broder. Here compt my
meester.

Marg. Welcome home, Master Shrieve! I pray God
continue you in health and wealth. 159

Eyre. See here, my Maggy. A chain, a gold chain for
Simon Eyre. I shall make thee a lady. Here's a French
hood for thee—on with it, on with it! Dress thy brows
with this flap of a shoulder of mutton [20] to make thee
look lovely. Where be my fine men? Roger, I'll make
over my shop and tools to thee. Firke, thou shalt be the
foreman. Hans, thou shalt have an hundred for twenty. [21]
Be as mad knaves as your master Sim Eyre hath been,
and you shall live to be Sheriffs of London. How dost
thou like me, Margery? Prince am I none, yet am I
princely born. Firke, Hodge, and Hans! 170

All Three. Ay, forsooth. What says your worship,
Master Sheriff?

Eyre. Worship and honor, you Babylonian knaves,
for the gentle craft! But I forget myself. I am bidden
by my Lord Mayor to dinner at Old Ford. He's gone
before, I must after. Come, Madge, on with your
trinkets. Now, my true Trojans, my fine Firke, my
dapper Hodge, my honest Hans. Some device, some
odd crotchets, some morris [22] or such like, for the honor
of the gentle shoemakers. Meet me at Old Ford. You
know my mind. 181
Come, Madge, away!
Shut up the shop, knaves, and make holiday!
 Exeunt [SIMON *and* MISTRESS EYRE.]

Firke. Oh, rare, oh, brave! Come, Hodge. Follow
me, Hans. We'll be with them for a morris dance.
 Exeunt.

[III.iii]

Enter LORD MAYOR, EYRE, *his* Wife [MARGERY],
in a French hood, ROSE, SYBIL, *and other* Servants.

L. Ma. Trust me, you are as welcome to Old Ford
As I myself.

Marg. Truly, I thank your lordship.

L. Ma. Would our bad cheer were worth the thanks
you give.

Eyre. Good cheer, my Lord Mayor, a fine cheer! A
fine house, fine walls, all fine and neat.

L. Ma. Now, by my troth, I'll tell thee, Master Eyre,
It does me good and all my brethren
That such a madcap fellow as thyself 10
Is entered into our society.

Marg. Ay, but, my lord, he must learn now to put
on gravity.

Eyre. Peace, Maggy. A fig for gravity! When I go to
Guildhall in my scarlet gown, I'll look as demurely as a
saint, and speak as gravely as a justice of the peace. But
now I am here at Old Ford, at my good Lord Mayor's
house; let it go by! Vanish, Maggy! I'll be merry. Away
with flip-flap, these fooleries, these gulleries. What,

[15] *ka . . . thee:* you help me and I'll help you.
[16] *smug:* smarten. [17] *Shrieve:* Sheriff.
[18] *rose:* on the threepenny coin.
[19] *cry twang:* i.e., with tightness.
[20] *flap . . . mutton:* wool.
[21] *hundred for twenty:* see II. iii. 25–26.
[22] *morris:* morris dance.

honey? Prince am I none, yet am I princely born.
What says my Lord Mayor? 21

L. Ma. Ha, ha, ha! I had rather than a thousand
pound
I had an heart but half so light as yours.

Eyre. Why, what should I do, my lord? A pound of
care pays not a dram of debt. Hum, let's be merry whiles
we are young. Old age, sack,[1] and sugar[2] will steal upon
us ere we be aware.

L. Ma. It's well done. Mistress Eyre, pray give good
counsel to my daughter. 29

Marg. I hope Mistress Rose will have the grace to
take nothing that's bad.

L. Ma. Pray God she do, for, i'faith, Mistress Eyre,
I would bestow upon that peevish girl
A thousand marks more than I mean to give her
Upon condition she'd be ruled by me.
The ape still crosseth[3] me. There came of late
A proper gentleman, of fair revenues,
Whom gladly I would call son in law.
But my fine cockney[4] would have none of him.
You'll prove a cockscomb for it ere you die. 40
A courtier, or no man, must please your eye.

Eyre. Be ruled, sweet Rose. Th'art ripe for a man.
Marry not with a boy, that has no more hair on his face
than thou hast on thy cheeks. A courtier! wash, go by!
Stand not upon pishery pashery. Those silken fellows
are but painted images, outsides, outsides, Rose; their
inner linings are torn. No, my fine mouse; marry me
with a gentleman grocer, like my Lord Mayor, your
father. A grocer is a sweet trade: plums, plums! Had I a
son or daughter should marry out of the genera- 50
tion and blood of shoemakers, he should pack.[5] What?
The gentle trade is a living for a man through Europe,
through the world.

A noise within of a tabor and a pipe.

L. Ma. What noise is this?

Eyre. Oh, my Lord Mayor, a crew of fellows that for
love of your honor are come hither with a morris dance.
Come in, my Mesopotamians, cheerly!

Enter HODGE, [LACY *as*] Hans, RAFE, FIRKE, *and
other* shoemakers *in a morris. After a little dancing,
the* LORD MAYOR *speaks.*

L. Ma. Master Eyre, are all these shoemakers?

Eyre. All cordwainers,[6] my good Lord Mayor.

Rose. [*Aside*] How like my Lacy looks yond
shoemaker. 60

Lacy. [*Aside*] Oh, that I durst but speak unto my
love!

L. Ma. Sybil, go fetch some wine to make these
drink.
You are all welcome.

All. We thank your lordship.

ROSE *takes a cup of wine and goes to* Hans.

Rose. For his sake whose fair shape thou represent'st,
Good friend, I drink to thee.

Lacy. Ic be dank, good frister.[7]

Marg. I see, Mistress Rose, you do not want judge-
ment. You have drunk to the properest man I keep.

Firke. Here be some have done their parts to be as
proper as he. 71

L. Ma. Well, urgent business calls me back to
London.
Good fellow, first go in and taste our cheer;
And to make merry as you homeward go,
Spend these two angels in beer at Stratford Bow.[8]

Eyre. To these two, my mad lads, Sim Eyre adds
another. Then cheerly, Firke. Tickle it, Hans. And all
for the honor of shoemakers.

All go dancing out.

L. Ma. Come, Master Eyre, let's have your company.

Exeunt EYRE *and* LORD MAYOR.

Rose. Sybil, what shall I do? 80

Syb. Why, what's the matter?

Rose. That Hans the shoemaker is my love Lacy,
Disguised in that attire to find me out.
How should I find the means to speak with him?

Syb. What, mistress, never fear. I dare venture my
maidenhead to nothing—and that's great odds—that
Hans, the Dutchman, when we come to London, shall
not only see and speak with you, but, in spite of all your
father's policies, steal you away and marry you. Will
not this please you? 90

Rose. Do this, and ever be assured of my love.

Syb. Away then, and follow your father to London,
lest your absence cause him to suspect something.
Tomorrow, if my counsel be obeyed,
I'll bind you prentice to the gentle trade.

Exeunt.

[III.iv]

Enter JANE *in a seamster's shop working, and*
HAMMON *muffled[1] at another door. He stands aloof.*

Ham. Yonder's the shop, and there my fair love sits.
She's fair and lovely, but she is not mine.
Oh, would she were! Thrice have I courted her;
Thrice hath my hand been moist'nèd with her hand,
Whilst my poor famished eyes do feed on that
Which made them famish. I am infortunate;
I still love one, yet nobody loves me.
I muse in other men what women see
That I so want! Fine Mistress Rose was coy,
And this too curious[2]—oh, no! She is chaste, 10
And, for she thinks me wanton, she denies
To cheer my cold heart with her sunny eyes.

III.iii.
[1] *sack:* sherry.
[2] *sugar:* i.e., rots the teeth, as sherry works on us, without
our awareness. [3] *crosseth:* obstructs.
[4] *cockney:* Londoner; pampered child, or rascal.
[5] *he ... pack:* I'd send him packing.
[6] *cordwainers:* shoemakers.
[7] *Ic ... frister:* I thank you, miss.
[8] *Stratford Bow:* Stratford-le-Bow, Chaucer's Stratford-
atte-Bowe, a country village beyond Whitechapel.
III.iv.
[1] *muffled:* his face concealed by his clothing.
[2] *curious:* particular.

How prettily she works. Oh, pretty hand!
Oh, happy work! It doth me good to stand
Unseen to see her. Thus I oft have stood
In frosty evenings, a light burning by her,
Enduring biting cold, only to eye her.
One only look hath seemed as rich to me
As a king's crown, such is love's lunacy.
Muffled I'll pass along, and by that try 20
Whether she knows me.
 Jane. Sir, what is't you buy?
What is't you lack?[3] Calico, or lawn?
Fine cambrick shirts, or bands? What will you buy?
 Ham. [*Aside*] That which thou wilt not sell. Faith,
 yet I'll try.—
[*To her*] How do you sell this handkercher?
 Jane. Good cheap.[4]
 Ham. And how these ruffs?
 Jane. Cheap too.
 Ham. And how this
 band?
 Jane. Cheap too.
 Ham. All cheap! How sell you then this
 hand?
 Jane. My hands are not to be sold.
 Ham. To be given then.
Nay, faith, I come to buy.
 Jane. But none knows when.
 Ham. Good sweet, leave work a little while. Let's
 play. 30
 Jane. I cannot live by keeping holiday.
 Ham. I'll pay you for the time which shall be lost.
 Jane. With me you shall not be at so much cost.
 Ham. Look how you wound this cloth. So you wound
 me.
 Jane. It may be so.
 Ham. 'Tis so.
 Jane. What remedy?
 Ham. Nay, faith, you are too coy.
 Jane. Let go my hand.
 Ham. I will do any task at your command.
I would let go this beauty, were I not
Enjoined to disobey you by a power
That controls kings. I love you.
 Jane. So; now part. 40
 Ham. With hands I may, but never with my heart.
In faith, I love you.
 Jane. I believe you do.
 Ham. Shall a true love in me breed hate in you?
 Jane. I hate you not.
 Ham. Then you must love.
 Jane. I do.
What? Are you better now? I love not you.
 Ham. All this I hope is but a woman's fray
That means "Come to me" when she cries "Away."
In earnest, mistress, I do not jest.
A true chaste love hath ent'rèd in my breast.
I love you dearly as I love my life. 50
I love you as a husband loves a wife.
That and no other love my love requires.
Thy wealth, I know, is little; my desires
Thirst not for gold. Sweet beauteous Jane, what's mine

Shall, if thou make myself thine, all be thine.
Say, judge, what is thy sentence? Life, or death?
Mercy or cruelty lies in thy breath.
 Jane. Good sir, I do believe you love me well,
For 'tis a silly conquest, silly pride,
For one like you, I mean a gentleman, 60
To boast that by his love tricks he hath brought
Such and such women to his amorous lure.
I think you do not so; yet many do,
And make it even a very trade to woo.
I could be coy, as many women be,
Feed you with sunshine smiles and wanton looks,
But I detest witchcraft. Say that I
Do constantly believe you constant have—
 Ham. Why dost thou not believe me?
 Jane. I believe you.
But yet, good sir, because I will not grieve you 70
With hopes to taste fruit which will never fall,
In simple truth this is the sum of all:
My husband lives, at least I hope he lives.
Pressed he was to these bitter wars in France;
Bitter they are to me by wanting him.
I have but one heart and that heart's his due.
How can I then bestow the same on you?
Whilst he lives, his I live, be it ne'er so poor,
And rather be his wife than a king's whore.
 Ham. Chaste and dear woman, I will not abuse thee,
Although it cost my life if thou refuse me. 81
Thy husband pressed for France? What was his name?
 Jane. Rafe Damport.
 Ham. Damport. Here's a letter sent
From France to me from a dear friend of mine,
A gentleman of place. Here he doth write
Their names that have been slain in every fight.
 Jane. I hope death's scroll contains not my love's
 name.
 Ham. Cannot you read?
 Jane. I can.
 Ham. Peruse the same.
To my remembrance such a name I read
Amongst the rest. See here.
 Jane. Ay, me! He's dead, 90
He's dead. If this be true, my dear heart's slain.
 Ham. Have patience, dear love.
 Jane. Hence, hence.
 Ham. Nay,
 sweet Jane,
Make not poor sorrow proud with these rich tears.
I mourn thy husband's death because thou mourn'st.
 Jane. That bill is forged. 'Tis signed by forgery.
 Ham. I'll bring thee letters sent besides to many
Carrying the like report. Jane, 'tis too true.
Come, weep not. Mourning, though it rise from love,
Helps not the mournèd, yet hurts them that mourn.
 Jane. For God's sake, leave me.
 Ham. Whither dost thou
 turn? 100
Forget the dead, love them that are alive.

3 *What . . . lack?:* the shopkeeper's cry.
4 *Good cheap:* At a bargain price.

His love is faded; try how mine will thrive.

Jane. 'Tis now no time for me to think on love.

Ham. 'Tis now best time for you to think on love,
Because your love lives not.

Jane. Though he be dead,
My love to him shall not be burièd.
For God's sake, leave me to myself alone.

Ham. 'Twould kill my soul to leave thee drowned in
moan.
Answer me to my suit, and I am gone.
Say to me yea or no.

Jane. No.

Ham. Then farewell. 110
One farewell will not serve—I come again.
Come, dry these wet cheeks. Tell me, faith, sweet Jane,
Yea or no, once more.

Jane. Once more I say no.
Once more be gone, I pray, else will I go.

Ham. Nay, then, I will grow rude. By this white hand
Unless you change that cold "No," here I'll stand,
Till by your hard heart—

Jane. Nay, for God's sake, peace!
My sorrows by your presence more increase.
Not that you thus are present, but all grief
Desires to be alone. Therefore in brief 120
Thus much I say, and saying bid adieu:
If ever I wed man, it shall be you.

Ham. Oh, blessèd voice! Dear Jane, I'll urge no
more.
Thy breath hath made me rich.

Jane. Death makes me poor.
Exeunt.

ACT FOUR

SCENE ONE

Enter HODGE *at his shop board*,[1] RAFE, FIRKE,
[LACY *as*] Hans, *and a* Boy *at work.*

All. [*Singing*] Hey down, a-down, a-down, down
derry.

Hod. Well said, my hearts. Ply your work, today; we
loitered yesterday. To it pell mell that we may live to
be Lord Mayors, or aldermen at least.

Firke. Hey down, a-down derry.

Hod. Well said, i'faith. How say'st thou, Hans?
Doth not Firke tickle it?

Lacy. Yaw, mester. 9

Firke. Not so neither. My organ pipe squeaks this
morning for want of liquoring. Hey down a-down derry!

Lacy. Forware, Firke, tow best un jolly yongster.
Hort I, mester, ic bid yo cut me un pair vampies vor[2]
mester Jeffres' bootes.

Hod. Thou shalt, Hans.

Firke. Master.

Hod. How now, boy?

Firke. Pray, now you are in the cutting vein, cut me
out a pair of counterfeits,[3] or else my work will not pass
current.[4] Hey down a-down. 20

Hod. Tell me, sirs, are my cousin Mistress Priscilla's
shoes done?

Firke. Your cousin? No, master; one of your aunts,[5]
hang her. Let them alone!

Rafe. I am in hand with them. She gave charge that
none but I should do them for her.

Firke. Thou do for her? Then 'twill be a lame doing,
and that she loves not. Rafe, thou mightst have sent her
to me. In faith, I would have yerked and firked your
Priscilla. Hey down a-down derry. This gear will not
hold. 31

Hod. How say you, Firke? Were we not merry at
Old Ford?

Firke. How, merry? Why, our buttocks went jiggy-
joggy like a quagmire. Well, Sir Roger Oatmeal, if I
thought all meal of that nature, I would eat nothing but
bag-puddings.

Rafe. Of all good fortunes, my fellow Hans had the
best. 39

Firke. 'Tis true, because Mistress Rose drank to him.

Hod. Well, well, work apace. They say seven of the
aldermen be dead, or very sick.

Firke. I care not, I'll be none.

Rafe. No, nor I. But then my master Eyre will come
quickly to be Lord Mayor.

Enter SYBIL.

Firke. Whoop! yonder comes Sybil.

Hod. Sybil, welcome, i'faith. And how dost thou,
mad wench?

Firke. Syb whore, welcome to London. 49

Syb. Godamercy, sweet Firke. Good lord, Hodge!
what a delicious shop you have got. You tickle it, i'faith.

Rafe. Godamercy, Sybil, for our good cheer at Old
Ford.

Syb. That you shall have, Rafe.

Firke. Nay, by the Mass, we had tickling cheer,
Sybil. And how the plague dost thou and Mistress Rose?
And my Lord Mayor? (I put the women in first.)

Syb. Well, Godamercy. But God's me, I forget
myself! Where's Hans the Fleming? 59

Firke. Hark, butter-box, now you must yelp out
some spreken.

Lacy. Vat begaie you? Vat vod you, frister?[6]

Syb. Marry, you must come to my young mistress,
to pull on her shoes you made last.

Lacy. Vare ben your edle fro?[7] Vare ben your
mistress?

Syb. Marry, here at our London house in Cornwall.[8]

Firke. Will nobody serve her turn but Hans?

Syb. No, sir. Come, Hans, I stand upon needles.

Hod. Why then, Sybil, take heed of pricking. 70

IV.i.
 [1] *shop board:* counter.
 [2] *Forware . . . vor:* Indeed, Firk, thou art a jolly young-
ster. Hear me, master, I bid you cut me a pair of vamps
for. . . . [3] *counterfeits:* pieces cut to a pattern.
 [4] *current:* as good (coinage).
 [5] *aunts:* (slang) prostitutes.
 [6] *Vat . . . frister:* What do you desire? What would you,
girl? [7] *Vare . . . fro:* Where is your noble lady? . . .
 [8] *Cornwall:* Cornhill.

Syb. For that let me alone; I have a trick in my budget.[9] Come, Hans.

Lacy. Yaw, yaw, ic sall meet yo gane.[10]

Hod. Go, Hans, make haste again. Come, who lacks work?

Exeunt LACY *and* SYBIL.

Firke. I, master, for I lack my breakfast. 'Tis munching time, and past.

Hod. Is't so? Why then, leave work, Rafe. To breakfast. Boy, look to the tools. Come, Rafe, come Firke.

Exeunt.

[IV.ii]

Enter a Serving Man.

Serv. Let me see, now: the sign of the Last in Tower Street. Mass, yonder's the house. What, ho! who's within?

Enter RAFE.

Rafe. Who calls there? What want you, sir?

Serv. Marry, I would have a pair of shoes made for a gentlewoman against tomorrow morning. What, can you do them?

Rafe. Yes, sir, you shall have them; but what length's her foot? 9

Serv. Why, you must make them in all parts like this shoe; but at any hand,[1] fail not to do them, for the gentlewoman is to be married very early in the morning.

Rafe. How? By this shoe must it be made? By this? Are you sure, sir, by this?

Serv. How, "by this am I sure, by this"? Are thou in thy wits? I tell thee I must have a pair of shoes, dost thou mark me? A pair of shoes, two shoes, made by this very shoe, this same shoe, against tomorrow morning by four o'clock. Dost understand me? Canst thou do't?

Rafe. Yes, sir, yes, ay, ay, I can do't. By this 20 shoe, you say. I should know this shoe. Yes, sir, yes, by this shoe. I can do't; four o'clock; well. Whither shall I bring them?

Serv. To the sign of the Golden Ball in Watling Street. Inquire for one Master Hammon, a gentleman, my master.

Rafe. Yea, sir. By this shoe, you say?

Serv. I say Master Hammon at the Golden Ball. He's the bridegroom and those shoes are for his bride.

Rafe. They shall be done, by this shoe. Well, 30 well; Master Hammon at the Golden Shoe—I would say the Golden Ball. Very well, very well. But I pray you, sir, where must Master Hammon be married?

Serv. At Saint Faith's Church under Paul's,[2] but what's that to thee? Prithee, dispatch those shoes, and so farewell.

Exit.

Rafe. By this shoe, said he. How am I amazed At this strange accident! Upon my life, This was the very shoe I gave my wife When I was pressed for France, since when, alas, 40 I never could hear of her. It is the same, And Hammon's bride no other but my Jane.

Enter FIRKE.

Firke. 'Snails, Rafe! Thou hast lost thy part of three pots a countryman of mine gave me to breakfast.

Rafe. I care not; I have found a better thing.

Firke. A thing? Is it a man's thing or a woman's thing?

Rafe. Firke, dost thou know this shoe?

Firke. No, by my troth, neither doth that know me. I have no acquaintance with it, 'tis a mere stranger to me.

Rafe. Why, then, I do: this shoe, I durst be sworn, Once covered the instep of my Jane. 52 This is her size, her breadth; thus trod my love; These true love knots I pricked. I hold my life,[3] By this old shoe I shall find out my wife!

Firke. Ha, ha! Old shoe, that wert new—how a murrain[4] came this ague fit of foolishness upon thee?

Rafe. Thus, Firke: even now here came a serving man. By this show would he have a new pair made Against tomorrow morning for his mistress 60 That's to be married to a gentleman. And why may not this be my sweet Jane?

Firke. And why may'st not thou be my sweet ass? Ha ha!

Rafe. Well, laugh and spare not. But the truth is this: Against tomorrow morning I'll provide A lusty crew of honest shoemakers To watch the going of the bride to church. If she prove Jane, I'll take her in despite From Hammon and the devil, were he by. If it be not my Jane, what remedy? 70 Hereof am I sure: I shall live till I die, Although I never with a woman lie.

Exit.

Firke. Thou lie with a woman to build nothing but Cripplegates![5] Well, God sends fools fortune, and it may be he may light upon his matrimony by such a device. For wedding and hanging goes by destiny.

Exit.

[IV.iii]

Enter [LACY *as*] Hans *and* ROSE *arm in arm.*

Lacy. How happy am I by embracing thee! Oh, I did fear such cross mishaps did reign That I should never see my Rose again.

Rose. Sweet Lacy, since fair opportunity Offers herself to further our escape, Let not too over-fond esteem of me Hinder that happy hour; invent the means, And Rose will follow thee through all the world.

[9] *budget:* pouch. [10] *ic ... gane:* I shall go with you.
IV.ii.
 [1] *at any hand:* in any case.
 [2] *under Paul's:* nearby and on a lower level than St. Paul's Cathedral. [3] *I ... life:* As sure as I'm alive.
 [4] *murrain:* pestilence.
 [5] *Cripplegates:* Cripplegate was the London gate at which cripples begged.

Lacy. Oh, how I surfeit with excess of joy,
Made happy by thy rich perfection. 10
But since thou pay'st sweet interest to my hopes,
Redoubling love on love, let me once more,
Like to a bold-faced debtor, crave of thee
This night to steal abroad, and at Eyre's house,
Who now by death of certain aldermen
Is Mayor of London, and my master once,
Meet thou thy Lacy. Where, in spite of change,
Your father's anger, and mine uncle's hate,
Our happy nuptials will we consummate. 19

Enter SYBIL.

Syb. Oh, God, what will you do, mistress? Shift for
yourself—your father is at hand! He's coming, he's
coming! Master Lacy, hide yourself in my mistress.
For God's sake, shift for yourselves!

Lacy. Your father come, sweet Rose. What shall I do?
Where shall I hide me? How shall I escape?

Rose. A man, and want wit in extremity?
Come, come, be Hans still; play the shoemaker;
Pull on my shoe.

Enter [former] LORD MAYOR.

Lacy. Mass, and that's well remembered.

Syb. Here comes your father. 30

Lacy. Forware, metress, tis un good skow. It sal vel
dute, or ye sall neit betallen.[1]

Rose. Oh God, it pincheth me! [*To* LACY] What
will you do?

Lacy. [*Aside to* ROSE] Your father's presence pinch-
eth, not the shoe.

L. Ma. Well done, fit my daughter well, and she
shall please thee well.

Lacy. Yaw, yaw, ick weit dat well. Forware, tis un
good skoo. Tis gemait van neit's leather, se ever mine
here.[2] 41

Enter a Prentice.

L. Ma. I do believe it. What's the news with you?

Prent. Please you, the Earl of Lincoln at the gate
Is newly lighted and would speak with you.

L. Ma. The Earl of Lincoln come to speak with me?
Well, well, I know his errand. Daughter Rose,
Send hence your shoemaker. Dispatch, have done.
Syb, make things handsome. Sir boy, follow me.
 Exeunt [LORD MAYOR, SYBIL, *and* Prentice.]

Lacy. Mine uncle come! Oh, what may this portend?
Sweet Rose, this of our love threatens an end. 50

Rose. Be not dismayed at this. What e'er befall,
Rose is thine own. To witness I speak truth,
Where thou appoints the place, I'll meet with thee.

I will not fix a day to follow thee,
But presently[3] steal hence. Do not reply;
Love which gave strength to bear my father's hate
Shall now add wings to further our escape.
 Exeunt.

[IV.iv]

Enter [former] LORD MAYOR and LINCOLN.

L. Ma. Believe me, on my credit, I speak truth.
Since first your nephew Lacy went to France
I have not seen him. It seemed strange to me,
When Dodger told me that he stayed behind,
Neglecting the high charge the King imposed.

Linc. Trust me, Sir Roger Otley, I did think
Your counsel had given head to this attempt,
Drawn to it by the love he bears your child.
Here I did hope to find him, in your house.
But now I see mine error and confess 10
My judgment wronged you by conceiving so.

L. Ma. Lodge in my house, say you? Trust me, my
 lord,
I love your nephew Lacy too, too dearly
So much to wrong his honor; and he hath done so
That first gave him advice to stay from France.
To witness I speak truth, I let you know
How careful I have been to keep my daughter
Free from all conference or speech of him.
Not that I scorn your nephew, but in love
I bear your honor, lest your noble blood 20
Should by my mean worth be dishonorèd.

Linc. [*Aside*] How far the churl's tongue wanders
 from his heart.
Well, well, Sir Roger Otley, I believe you,
With more than many thanks for the kind love
So much you seem to bear me. But, my lord,
Let me request your help to seek my nephew,
Whom, if I find, I'll straight embark for France.
So shall your Rose be free, my thoughts at rest,
And much care die which now lies in my breast. 29

Enter SYBIL.

Syb. Oh, Lord, help, for God's sake! My mistress!
oh, my young mistress!

L. Ma. Where is thy mistress? What's become of
her?

Syb. She's gone! She's fled!

L. Ma. Gone! Whither is she fled?

Syb. I know not, forsooth. She's fled out of doors
with Hans, the shoemaker. I saw them scud,[1] scud,
scud, apace, apace.

L. Ma. Which way? What, John! Where be my
men? Which way? 40

Syb. I know not, and it please your worship.

L. Ma. Fled with a shoemaker! Can this be true?

Syb. Oh, Lord, sir, as true as God's in heaven.

Linc. Her love turned shoemaker? I am glad of this.

L. Ma. A Fleming butter-box, a shoemaker?
Will she forget her birth? Requite my care
With such ingratitude? Scorned she young Hammon

IV.iii.
 [1] *Forware . . . betallen:* Indeed, mistress, it is a good shoe.
It will do well, or you shall not pay.
 [2] *Yaw . . . Here:* Yes, yes, I know that well. Indeed, it is a
good shoe. It is made of neat's leather, just look, my lord.
 [3] *presently:* immediately.

IV.iv.
 [1] *scud:* run swiftly.

To love a honnikin,[2] a needy knave?
Well, let her fly; I'll not fly after her.
Let her starve if she will, she's none of mine. 50
 L. Ma. Be not so cruel, sir.

Enter FIRKE *with shoes.*

 Syb. I am glad she's scaped.
 L. Ma. I'll not account of her as of my child.
Was there no better object for her eyes
But a foul drunken lubber, swill-belly,
A shoemaker? That's brave!
 Firke. Yea, forsooth, 'tis a very brave shoe, and as
fit as a pudding.
 L. Ma. How now? What knave is this? From whence
comest thou? 60
 Firke. No knave, sir. I am Firke, the shoemaker,
lusty Roger's chief lusty journeyman, and I come
hither to take up the pretty leg of sweet Mistress Rose;
and thus hoping your worship is in as good health as I
was at the making hereof, I bid you farewell, Yours,
Firke.
 L. Ma. Stay, stay, sir knave.
 Linc. Come hither, shoemaker.
 Firke. 'Tis happy the knave is put before the shoe-
maker, or else I would not have vouchsafed to come
back to you. I am moved, for I stir. 71
 L. Ma. My lord, this villain calls us knaves by craft.
 Firke. Then 'tis the gentle craft, and to call one
knave gently is no harm. Sit your worship merry.
[*Aside to* SYBIL] Syb, your young mistress. I'll so bob[3]
them now my Master Eyre is Lord Mayor of London.
 L. Ma. Tell me, sirrah, whose man are you?
 Firke. I am glad to see your worship so merry. I
have no maw[4] to this gear,[5] no stomach as yet to a red
petticoat. 80

Pointing to SYBIL.

 Linc. He means not, sir, to woo you to his maid,
But only doth demand whose man you are.
 Firke. I sing now to the tune of Rogero;[6] Roger,
my fellow, is now my master.
 Linc. Sirrah, know'st thou one Hans, a shoemaker?
 Firke. Hans, shoemaker? Oh, yes; stay; yes, I have
him! I tell you what—I speak it in secret—: Mistress
Rose and he are by this time; no, not so, but shortly are
to come over one another with "Can you dance the
shaking of the sheets?"[7] It is that Hans—[*Aside*] I'll
so gull[8] these diggers! 91
 L. Ma. Know'st thou then where he is?
 Firke. Yea, forsooth. Yea, marry.
 Linc. Canst thou? In sadness?[9]
 Firke. No, forsooth. No, marry.
 L. Ma. Tell me, good honest fellow, where he is,
And thou shalt see what I'll bestow of thee.
 Firke. Honest fellow? No, sir, not so, sir. My pro-
fession is the gentle craft. I care not for seeing: I love
feeling. Let me feel it here. *Aurium tenus,*[10] ten 100
pieces of gold: *genuum tenus,*[11] ten pieces of silver. And
then Firke is your man on a new pair of stretchers.[12]
 L. Ma. Here is an angel, part of thy reward,
Which I will give thee. Tell me where he is.

 Firke. No, point. Shall I betray my brother? No.
Shall I prove Judas to Hans? No. Shall I cry treason to
my corporation?[13] No. I shall be firked and yerked
then. But give me your angel; your angel shall tell you.
 Linc. Do so, good fellow. 'Tis no hurt to thee.
 Firke. Send simpering Syb away. 110
 L. Ma. Huswife, get you in.

Exit SYBIL.

 Firke. Pitchers have ears, and maids have wide
mouths. But for Hans-prans, upon my word, tomorrow
morning he and young Mistress Rose go to this gear.
They shall be married together, by this rush,[14] or else
turn Firke to a firkin of butter to tan leather[15] withal.
 L. Ma. But art thou sure of this?
 Firke. Am I sure that Paul's steeple is a handful
higher than London Stone?[16] Or that the Pissing Con-
duit[17] leaks nothing but pure Mother Bunch?[18] 120
Am I sure that I am lusty Firke? God's nails! Do you
think I am so base to gull you?
 Linc. Where are they married? Dost thou know the
church?
 Firke. I never go to church, but I know the name of
it. It is a swearing church. Stay a while.—'tis—Ay! by
the Mass—no, no, 'tis—ay, by my faith, that that—'tis
—Ay! by my Faith's Church under Paul's Cross! There
they shall be knit like a pair of stockings in matrimony.
There they'll be incony.[19] 130
 Linc. Upon my life, my nephew Lacy walks
In the disguise of this Dutch shoemaker.
 Firke. Yes, forsooth.
 Linc. Doth he not, honest fellow?
 Firke. No, forsooth. I think Hans is nobody but
Hans, no spirit.
 L. Ma. My mind misgives me now; 'tis so indeed.
 Linc. My cousin speaks the language, knows the
trade. 139
 L. Ma. Let me request your company, my lord.
Your honorable presence may, no doubt,
Refrain their headstrong rashness, when myself
Going alone perchance may be o'erborne.
Shall I request this favor?

 [2] *honnikin:* despicable person(?), Dutchman—a diminu-
tive form suggesting contempt. [3] *bob:* make fools of.
 [4] *maw:* inclination. [5] *gear:* stuff.
 [6] *Rogero:* a popular dance tune.
 [7] *shaking . . . sheets:* an old dance, with the obvious double
entendre. [8] *gull:* fool. [9] *In sadness:* Seriously.
 [10] *L.:* As far as the ears (with a macaronic pun—ten
pieces of gold).
 [11] *L.:* as far as the knees (i.e., for ten pieces he'll go so far).
 [12] *stretchers:* shoe- and truth-stretchers.
 [13] *corporation:* guild.
 [14] *rush:* rush floor covering(?), rush rings worn by bride-
grooms not intending to be restrained by their vows(?), rush
lights(?).
 [15] *butter . . . leather:* fatty substances were sometimes
used to convert pelts to leather, although vegetable material
containing tannin was more commonly used.
 [16] *London Stone:* marked the meeting of the Roman roads.
 [17] *Pissing Conduit:* a conduit near the Royal Exchange;
in 2 *Henry VI,* IV. vi. 1–7, Jack Cade commands that it run
claret wine during his usurpation.
 [18] *Mother Bunch:* ale dispensed by a well-known alewife.
 [19] *incony:* pretty.

Linc. This, or what else.

Firke. Then you must rise betimes, for they mean to fall to their hey pass and repass,[20] pindy pandy, which hand will you have,[21] very early.

L. Ma. My care shall every way equal their haste. This night accept your lodging in my house. The earlier shall we stir, and at Saint Faith's 150 Prevent this giddy, hare-brained nuptial. This traffic of hot love shall yield cold gains. They ban[22] our loves, and we'll forbid their banns.
> *Exit.*

Linc. At Saint Faith's Church, thou say'st?

Firke. Yes, by their troth.

Linc. Be secret on thy life.
> *Exit.*

Firke. Yes, when I kiss your wife! Ha, ha! Here's no craft in the gentle craft. I came hither of purpose with shoes to Sir Roger's worship, whilst Rose, his daughter, be coney-catched[23] by Hans. Soft now! These 160 two gulls will be at Saint Faith's Church tomorrow morning, to take Master Bridegroom and Mistress Bride napping; and they in the meantime shall chop up[24] the matter at the Savoy.[25] But the best sport is: Sir Roger Otley will find my fellow, lame Rafe's wife going to marry a gentleman, and then he'll stop her instead of his daughter. Oh, brave! There will be fine tickling sport. Soft now, what have I to do? Oh, I know now. A mess[26] of shoemakers meet at the Woolsack[27] in Ivy Lane to cozen my gentleman of lame Rafe's wife; that's true. 171

Alack, alack!
Girls, hold out tack![28]
For now smocks for this jumbling
Shall go to wrack.
> *Exit.*

ACT FIVE

SCENE ONE

Enter EYRE, *his* Wife [MARGERY], LACY [*as* Hans], *and* ROSE.

Eyre. This is the morning, then. Say,[1] my bully, my honest Hans, is it not?

[20] *hey . . . repass:* conjuring jargon.
[21] *pindy . . . have:* allusions to handy dandy, a children's game. [22] *ban:* curse.
[23] *coney-catched:* tricked (from coney-catcher, one who catches rabbits or dupes). [24] *chop up:* bargain.
[25] *Savoy:* site of a palace on north bank of Thames, used as a sanctuary; its chapel was used for irregular marriages.
[26] *mess:* party of four. [27] *Woolsack:* a tavern.
[28] *hold out tack:* resist.
V.i.
[1] *Say:* Q "stay." [2] *vah:* expression of contempt.
[3] *Hamborough:* Hamburg (for German[?]).
[4] *marchpane:* marzipan.
[5] *Cappadocians:* from Cappadochio, cant name for stocks or prison, perhaps with punning allusion to apprentices' caps.
[6] *when . . . together:* apprentices had to carry water from the conduit.
[7] *pancake bell:* rung on Shrove Tuesday, signifying the approach of Lent (and its diet); pancakes are still Shrove Tuesday fare in England.

Lacy. This is the morning that must make us two Happy or miserable. Therefore, if you—

Eyre. Away with these if's and and's, Hans, and these et ceteras. By mine honor, Rowland Lacy, none but the King shall wrong thee. Come, fear nothing; am not I Sim Eyre? Is not Sim Eyre Lord Mayor of London? Fear nothing, Rose; let them all say what they can. Dainty, come thou to me. Laughest thou?

Marg. Good my lord, stand her friend in what thing you may. 12

Eyre. Why, my sweet Lady Madgy, think you Simon Eyre can forget his fine Dutch journeyman? No, vah.[2] Fie, I scorn it! It shall never be cast in my teeth that I was unthankful. Lady Madgy, thou hadst never covered thy Saracen's head with this French flap, nor loaden thy bum with this fardingale; 'tis trash, trumpery, vanity. Simon Eyre had never walked in a red petticoat, nor worn a chain of gold, but for my fine journey- 20 man's portagues; and shall I leave him? No! Prince am I none, yet bear a princely mind.

Lacy. My lord, 'tis time for us to part from hence.

Eyre. Lady Madgy, Lady Madgy, take two or three of my piecrust eaters, my buff-jerkin varlets that do walk in black gowns at Simon Eyre's heels, take them, good Lady Madgy. Trip and go, my brown Queen of Perriwigs, with my delicate Rose and my jolly Rowland, to the Savoy. See them linked, countenance the marriage, and, when it is done, cling, cling together, 30 you Hamborough[3] turtle doves. I'll bear you out. Come to Simon Eyre, come dwell with me, Hans. Thou shalt eat minced pies and marchpane,[4] Rose. Away, cricket! trip and go! My Lady Madgy, to the Savoy! Hans, wed and to bed; kiss and away. Go, vanish!

Marg. Farewell, my lord.

Rose. Make haste, sweet love.

Marg. She'd fain the deed were done.

Lacy. Come, my sweet Rose, faster than deer we'll run. 38
> *They go out.*

Eyre. Go, vanish, vanish! Avaunt, I say! By the Lord of Ludgate, it's a mad life to be a lord mayor; it's a stirring life, a fine life, a velvet life, a careful life. Well, Simon Eyre, set a good face on it, in the honor of Saint Hugh. Soft! The King this day comes to dine with me, to see my new buildings. His majesty is welcome; he shall have good cheer, delicate cheer, princely cheer. This day my fellow prentices of London come to dine with me too; they shall have fine cheer, gentlemanlike cheer. I promised the mad Cappadocians,[5] when we all served at the Conduit together,[6] that if ever I came to be Mayor of London I would feast them all, 50 and I'll do't. I'll do't, by the life of Pharaoh! By this beard, Sim Eyre will be no flincher! Besides, I have procured that upon every Shrove Tuesday, at the sound of the pancake bell,[7] my fine dapper Assyrian lads shall clap up their shop windows, and away. This is the day! And this day they shall do't, they shall do't!

Boys, that day are you free. Let masters care,
And prentices shall pray for Simon Eyre.
> *Exit.*

[V.ii]

Enter HODGE, FIRKE, RAFE, *and five or six*
Shoemakers, *all with cudgels or such weapons.*

Hod. Come, Rafe; stand to it, Firke. My masters, as
we are the brave bloods of the shoemakers, heirs
apparent to Saint Hugh, and perpetual benefactors to
all good fellows, thou shalt have no wrong. Were Ham-
mon a king of spades, he should not delve [1] in thy close [2]
without thy sufferance. But tell me, Rafe, art thou sure
'tis thy wife?

Rafe. Am I sure this is Firke? This morning, when I
stroked on her shoes, I looked upon her, and she upon
me, and sighed, asked me if ever I knew one Rafe. 10
"Yes," said I. "For his sake," said she, tears standing
in her eyes, "and for thou art somewhat like him, spend
this piece of gold." I took it. My lame leg and my travel
beyond sea made me unknown. All is one for that; I
know she's mine.

Firke. Did she give thee this gold? Oh glorious,
glittering gold! She's thine own, 'tis thy wife, and she
loves thee; for I'll stand to't, there's no woman will give
gold to any man, but she thinks better of him than she
thinks of them she gives silver to. And for Ham- 20
mon, neither Hammon nor hangman [3] shall wrong me
in London. Is not our old Master Eyre Lord Mayor?
Speak, my hearts.

All. Yes, and Hammon shall know it to his cost.

Enter HAMMON, *his* Man, JANE, *and* Others.

Hod. Peace, my bullies. Yonder they come.

Rafe. Stand to't, my hearts. Firke, let me speak first.

Hod. No, Rafe, let me.—Hammon, whither away
so early?

Ham. Unmannerly, rude slave, what's that to thee?

Firke. To him, sir? Yes, sir, and to me, and 30
others. Good morrow, Jane, how dost thou? Good
Lord, how the world is changed with you, God be
thanked.

Ham. Villains, hands off! How dare you touch my
love?

All the Shoemakers. Villains? Down with them! Cry
clubs [4] for prentices!

Hod. Hold, my hearts. Touch her, Hammon? Yea,
and more than that, we'll carry her away with us. My
masters and gentlemen, never draw your bird-spits. 40
Shoemakers are steel to the back, men every inch of
them, all spirit.

All of Hammon's Side. Well, and what of all this?

Hod. I'll show you. Jane, dost thou know this man?
'Tis Rafe, I can tell thee. Nay, 'tis he in faith, though he
be lamed by the wars. Yet look not strange, but run to
him. Fold him about the neck and kiss him.

Jane. Lives then my husband? Oh, God, let me go,
Let me embrace my Rafe!

Ham. What means my Jane? 49

Jane. Nay, what meant you to tell me he was slain?

Ham. Pardon me, dear love, for being misled.
[*To* RAFE] 'Twas rumored here in London thou wert
dead.

Firke. Thou seest he lives. Lass, go pack home with

him. Now, Master Hammon, where's your mistress,
your wife?

Serv. 'Swounds, master! Fight for her! Will you
thus lose her?

Shoemakers. Down with that creature! clubs! down
with him! 60

Hod. Hold, hold!

Ham. Hold, fool! Sirs, he shall do no wrong.
Will my Jane leave me thus, and break her faith?

Firke. Yea, sir. She must, sir, she shall, sir. What
then? Mend it.

Hod. Hark, fellow Rafe, follow my counsel. Set the
wench in the midst and let her choose her man and let
her be his woman.

Jane. Whom should I choose? Whom should my
 thoughts affect
But him whom heaven hath made to be my love? 70
Thou art my husband, and these humble weeds
Makes thee more beautiful than all his wealth.
Therefore I will but put off his attire,
Returning it into the owner's hand,
And after ever be thy constant wife.

Hod. Not a rag, Jane. The law's on our side. He that
sows in another man's ground forfeits his harvest. Get
thee home, Rafe. Follow him, Jane. He shall not have so
much as a busk-point [5] from thee. 79

Firke. Stand to that, Rafe. The appurtenances are
thine own. Hammon, look not at her.

Serv. Oh, 'swounds, no.

Firke. Bluecoat, [6] be quiet; we'll give you a new
livery else. We'll make Shrove Tuesday Saint George's
Day [7] for you. Look not, Hammon, leer not. I'll firk
you—for thy head now, one glance, one sheep's eye,
anything at her. Touch not a rag, lest I and my brethren
beat you to clouts. [8]

Serv. Come, Master Hammon, there's no striving
 here.

Ham. Good fellows, hear me speak. And honest
 Rafe, 90
Whom I have injured most by loving Jane,
Mark what I offer thee. Here in fair gold
Is twenty pound. I'll give it thee for thy Jane.
If this content thee not, thou shalt have more.

Hod. Sell not thy wife, Rafe. Make her not a whore.

Ham. Say, wilt thou freely cease thy claim in her,
And let her be my wife?

Shoemakers. No, do not, Rafe!

Rafe. Sirrah Hammon. Hammon, dost thou think a
shoemaker is so base to be a bawd to his own wife 100
for commodity? Take thy gold. Choke with it! Were I
not lame, I would make thee eat thy words.

V.ii.

 [1] *delve:* dig. [2] *close:* enclosure.
 [3] *Hammon . . . hangman:* Some editors suggest a three-
way pun including "Haman."
 [4] *clubs:* rallying cry of the apprentices.
 [5] *busk-point:* lace for tying whalebone bodice-stiffening.
 [6] *Bluecoat:* servants' livery; charity children also wore
blue coats, and the term became opprobrious.
 [7] *Saint George's Day:* when servants' contracts ended and
they could seek new employment; Firke threatens to change
his livery today. [8] *clouts:* rags.

Firke. A shoemaker sell his flesh and blood! oh,
indignity!

Hod. Sirrah, take up your pelf and be packing.

Ham. I will not touch one penny. But in lieu
Of that great wrong I offerèd thy Jane,
To Jane and thee I give that twenty pound.
Since I have failed of her, during my life
I vow no woman else shall be my wife.
Farewell, good fellows of the gentle trade. 110
Your morning's mirth my mourning day hath made.

Exeunt [HAMMON *and* Servants.]

Firke. [*To* Servant *going out*] Touch the gold, crea-
ture, if you dare. Y'are best be trudging. Here, Jane,
take thou it. Now let's home, my hearts.

Hod. Stay, who comes here? Jane, on again with thy
mask!

Enter LINCOLN, [*former*] LORD MAYOR, *and*
Servants.

Linc. Yonder's the lying varlet mocked us so.

L. Ma. Come hither, sirrah.

Firke. I, sir? I am sirrah? You mean me, do you not?

Linc. Where is my nephew married? 120

Firke. Is he married? God give him joy, I am glad of
it. They have a fair day and the sign is in a good planet,
Mars in Venus.

L. Ma. Villain! Thou told'st me that my daughter
Rose
This morning should be married at Saint Faith's.
We have watched there these three hours at the least,
Yet see we no such thing.

Firke. Truly, I am sorry for't. A bride's a pretty
thing. 129

Hod. Come, to the purpose. Yonder's the bride and
bridegroom you look for, I hope. Though you be lords,
you are not to bar, by your authority, men from women,
are you?

L. Ma. See, see! My daughter's masked.

Linc. True, and
my nephew,
To hide his guilt, counterfeits him lame.

Firke. Yea truly, God help the poor couple! They are
lame and blind.

L. Ma. I'll ease her blindness.

Linc. I'll his lameness cure.

Firke. [*To the* Shoemakers] Lie down, sirs, and
laugh. My fellow Rafe is taken for Rowland Lacy, and
Jane for Mistress Damask Rose. This is all my knavery.

L. Ma. [*To* JANE] What, have I found you, minion?

Linc. [*To* RAFE] Oh,
base wretch. 141
Nay, hide thy face. The horror of thy guilt
Can hardly be washed off. Where are thy powers?
What battles have you made? Oh, yes, I see
Thou fought'st with shame, and shame hath conquered
thee.
This lameness will not serve.

L. Ma. Unmask yourself.

Linc. Lead home your daughter.

L. Ma. Take your nephew
hence.

Rafe. Hence? 'Swounds, what mean you? Are you
mad? I hope you cannot enforce my wife from me.
Where's Hammon? 150

L. Ma. Your wife?

Linc. What Hammon?

Rafe. Yea, my wife. And therefore, the proudest of
you that lays hands on her first, I'll lay my crutch cross
his pate.

Firke. To him, lame Rafe! Here's brave sport!

Rafe. Rose call you her? Why, her name is Jane.
Look here else. Do you know her now?

[*Unmasks her.*]

Linc. Is this your daughter?

L. Ma. No, nor this your nephew.
My Lord of Lincoln, we are both abused 160
By this base crafty varlet.

Firke. Yea, forsooth, no varlet. Forsooth, no base.
Forsooth, I am but mean.9 Not crafty neither, but of
the gentle craft.

L. Ma. Where is my daughter Rose? Where is my
child?

Linc. Where is my nephew Lacy married?

Firke. Why, here is good laced mutton10 as I
promised you. 169

Linc. Villain! I'll have thee punished for this wrong.

Firke. Punish the journeyman villain, but not the
journeyman shoemaker.

Enter DODGER.

Dod. My lord, I come to bring unwelcome news:
Your nephew Lacy and your daughter Rose
Early this morning wedded at the Savoy,
None being present but the Lady Mayoress.
Besides I learned among the officers
The Lord Mayor vows to stand in their defense
Gainst any that shall seek to cross the match.

Linc. Dares Eyre the shoemaker uphold the deed?

Firke. Yes, sir, shoemakers dare stand in a woman's
quarrel, 181
I warrant you, as deep as another, and deeper too.

Dod. Besides, his grace today dines with the mayor,
Who on his knees humbly intends to fall
And beg a pardon for your nephew's fault.

Linc. But I'll prevent him. Come, Sir Roger Otley.
The King will do us justice in this cause.
Howe'er their hands have made them man and wife,
I will disjoin the match, or lose my life. 189

Exeunt [LINCOLN *and* OTLEY.]

Firke. Adieu, Monsieur Dodger, farewell, fools. Ha,
ha! Oh, if they had stayed I would have so lammed
them with flouts.11 Oh, heart! My codpiece point is
ready to fly in pieces every time I think upon Mistress
Rose. But let that pass, as my Lady Mayoress says.

Hod. This matter is answered. Come, Rafe, home
with thy wife. Come, my fine shoemakers. Let's to our
master's, the new Lord Mayor, and there swagger this
Shrove Tuesday. I'll promise you wine enough, for
Madge keeps the cellar.

All. Oh, rare! Madge is a good wench. 200

Firke. And I'll promise you meat enough, for simpering Susan keeps the larder. I'll lead you to victuals, my brave soldiers. Follow your captain. Oh, brave! Hark! hark!

 Bell rings.

All. The pancake bell rings! The pancake bell! Trilil, my hearts!

Firke. Oh, brave, oh, sweet bell! oh, delicate pancakes! Open the doors, my hearts, and shut up the windows. Keep in the house, let out the pancakes. Oh rare, my hearts, let's march together for the honor 210 of Saint Hugh to the great new hall[12] in Gracious Street corner, which our master, the new Lord Mayor, hath built.

Rafe. Oh, the crew of good fellows that will dine at my Lord Mayor's cost today!

Hod. By the Lord, the Lord Mayor is a most brave man. How shall prentices be bound to pray for him, and the honor of the gentlemen shoemakers! Let's feed and be fat with my lord's bounty. 219

Firke. Oh, musical bell still! oh, Hodge! oh, my brethren! There's cheer for the heavens. Venison pasties walk up and down piping hot like sergeants. Beef and brewis comes marching in dry fats.[13] Fritters and pancakes come trolling in in wheelbarrows. Hens and oranges hopping in porters' baskets, collops and eggs[14] in scuttles, and tarts and custards come quavering in in malt shovels.

 Enter more Prentices.

All. Whoop! look here, look here!

Hod. How now, mad lads? Whither away so fast?

1 Pren. Whither? Why, to the great new hall. 230 Know you not why? The Lord Mayor hath bidden all the prentices in London to breakfast this morning.

All. Oh, brave shoemaker! oh, brave lord of incomprehensible good fellowship! Whoo! hark you, the pancake bell rings.

 [They] cast up caps.

Firke. Nay, more, my hearts. Every Shrove Tuesday is our year of jubilee. And when the pancake bell rings, we are as free as my Lord Mayor. We may shut up our shops and make holiday. I'll have it called Saint Hugh's Holiday. 240

All. Agreed, agreed! Saint Hugh's Holiday!

Hod. And this shall continue for ever.

All. Oh, brave! Come, come, my hearts. Away, away!

Firke. Oh, eternal credit to us of the gentle craft. March fair, my hearts! oh, rare!

 Exeunt.

[V.iii]

 Enter KING *and his train over the stage.*

King. Is our Lord Mayor of London such a gallant?

Noble. One of the merriest madcaps in your land.

Your grace will think, when you behold the man, He's rather a wild ruffian than a mayor; Yet thus much I'll insure your majesty, In all his actions that concern his state He is as serious, provident and wise, As full of gravity amongst the grave, As any mayor hath been these many years. 9

King. I am with child[1] till I behold this huff-cap.[2] But all my doubt is, when we come in presence His madness will be dashed clean out of countenance.

Noble. It may be so, my liege.

King. Which to prevent, Let someone give him notice 'tis our pleasure That he put on his wonted merriment. Set forward.

All. On afore!

 Exeunt.

[V.iv]

 Enter EYRE, HODGE, FIRKE, RAFE, *and other* Shoemakers, *all with napkins on their shoulders.*

Eyre. Come, my fine Hodge, my jolly gentlemen shoemakers. Soft, where be these cannibals, these varlets my officers? Let them all walk and wait upon my brethren; for my meaning is that none but shoemakers, none but the livery of my company, shall in their satin hoods wait upon the trencher of my sovereign.

Firke. Oh, my lord, it will be rare!

Eyre. No more, Firke. Come lively. Let your fellow prentices want no cheer. Let wine be plentiful as 10 beer and beer as water. Hang these penny-pinching fathers that cram wealth in innocent lamb-skins.[1] Rip, knaves! avaunt! Look to my guests.

Hod. My lord, we are at our wits' end for room. Those hundred tables will not feast the fourth part of them.

Eyre. Then cover me those hundred tables again, and again till all my jolly prentices be feasted. Avoid, Hodge. Run, Rafe. Frisk about, my nimble Firke. Carouse me fadom healths[2] to the honor of the 20 shoemakers. Do they drink lively, Hodge? Do they tickle it, Firke?

Firke. Tickle it? Some of them have taken their liquor standing so long that they can stand no longer. But for meat, they would eat it and they had it.

Eyre. Want they meat? Where's this swag-belly, this greasy kitchen-stuff cook? Call my varlet to me.

[12] *great new hall:* Leadenhall, supposed to have been built by Eyre. [13] *dry fats:* casks.

[14] *collops and eggs:* bacon and eggs (originally the meaning of collop); the day before Shrove Tuesday was called Collop Monday.

V.iii.

 [1] *with child:* impatient. [2] *huff-cap:* blowhard.

V.iv.

 [1] *lamb-skins:* purses.

 [2] *fadom healths:* draughts a fathom deep.

Want meat! Firke, Hodge, lame Rafe! run, my tall men, beleaguer the shambles.[3] Beggar all Eastcheap, serve me whole oxen in chargers and let sheep whine 30 upon the table like pigs for want of good fellows to eat them. Want meat! Vanish, Firke. Avaunt, Hodge.

Hod. Your lordship mistakes my man Firke. He means their bellies want meat, not the boards, for they have drunk so much they can eat nothing.

Enter [LACY *in the attire of*]Hans, ROSE, *and* [EYRE'S] *Wife* [MARGERY].

Marg. Where is my lord?

Eyre. How now, Lady Madgy?

Marg. The King's most excellent majesty is new done. He sends me for thy honor. One of his most worshipful peers bade me tell thou must be merry and so forth, but let that pass. 41

Eyre. Is my sovereign come? Vanish, my tall shoemakers, my nimble brethren. Look to my guests, the prentices—yet stay a little. How now, Hans? How looks my little Rose?

Lacy. Let me request you to remember me.
I know your honor easily may obtain
Free pardon of the King for me and Rose,
And reconcile me to my uncle's grace. 49

Eyre. Have done, my good Hans. My honest journeyman, look cheerly. I'll fall upon both my knees till they be as hard as horn, but I'll get thy pardon.

Marg. Good my lord, have a care what you speak to his grace.

Eyre. Away, you Islington whitepot.[4] Hence, you happerarse,[5] you barley pudding full of maggots, you broiled carbonado,[6] avaunt! Avaunt, avoid, Mephostophilus! Shall Sim Eyre learn to speak of you, Lady Madgy? Vanish, Mother Miniver[7]-Cap, vanish. Go! trip and go. Meddle with your partlets[8] and your 60 pishery-pashery, your flues[9] and your whirligigs. Go! rub![10] out of mine alley![11] Sim Eyre knows how to speak to a pope, to Sultan Soliman, to Tamburlaine and he were here. And shall I melt, shall I droop before my sovereign? No. Come, my Lady Madgy; follow me, Hans. About your business, my frolic free-booters. Firke, frisk about and about and about, for the honor of mad Simon Eyre, Lord Mayor of London.

Firke. Hey for the honor of the shoemakers!

Exeunt.

[3] *beleaguer the shambles:* besiege the meat-markets.
[4] *whitepot:* a kind of custard or milk-pudding.
[5] *happerarse:* with a bum shaped like a brewer's vat.
[6] *carbonado:* meat or fish scored across and broiled.
[7] *Miniver:* ermine. [8] *partlets:* linen neckbands.
[9] *flues:* skirt flaps. [10] *rub:* be off.
[11] *alley:* suggested by pun on "rub," a bowling term for an obstruction on the ground.

V.v.
[1] *Dioclesian:* Roman Emperor, A.D. 286–305, famous for his reforms.
[2] *hump:* a nonsense word not recorded elsewhere in the period. [3] *pie:* magpie.
[4] *Tamar Cham's:* referring to Timur Khan, hero of a recent play.

[V.v]

A long flourish or two. Enter KING, *Nobles,* EYRE, *his Wife* [MARGERY], LACY [*as himself*], *and* ROSE. LACY *and* ROSE *kneel.*

King. Well, Lacy, though the fact was very foul
Of your revolting from our kingly love
And your own duty, yet we pardon you.
Rise both, and Mistress Lacy, thank my Lord Mayor
For your young bridegroom here.

Eyre. So, my dear liege, Sim Eyre and my brethren, the gentlemen shoemakers, shall set your sweet majesty's image cheek by jowl by Saint Hugh for this honor you have done poor Simon Eyre. I beseech your grace pardon my rude behavior. I am a handicrafts 10 man, yet my heart is without craft. I would be sorry at my soul that my boldness should offend my King.

King. Nay, I pray thee, good Lord Mayor, be even
as merry
As if thou wert among thy shoemakers.
It does me good to see thee in this humor.

Eyre. Say'st thou so, my sweet Dioclesian?[1] Then hump![2] Prince am I none, yet am I princely born. By the Lord of Ludgate, my liege, I'll be as merry as a pie.[3] 19

King. Tell me, in faith, mad Eyre, how old thou art.

Eyre. My liege, a very boy, a stripling, a yonker. You see not a white hair on my head, not a gray in this beard. Every hair, I assure thy majesty, that sticks in this beard, Sim Eyre values at the King of Babylon's ransom. Tamar Cham's[4] beard was a rubbing brush to't. Yet I'll shave it off and stuff tennis balls with it to please my bully King.

King. But all this while I do not know your age.

Eyre. My liege, I am six and fifty year old, yet can I cry hump with a sound heart for the honor of Saint 30 Hugh. Mark this old wench, my King: I danced the shaking of the sheets with her six and thirty years ago, and yet I hope to get two or three young Lord Mayors ere I die. I am lusty still, Sim Eyre still. Care and cold lodging bring white hairs. My sweet majesty, let care vanish! Cast it upon thy nobles, it will make thee always young like Apollo. And cry hump; prince am I none, yet am I princely born.

King. Ha ha! Say, Cornwall, didst thou ever see his like? 40

Noble. Not I, my lord.

Enter LINCOLN *and* [*former*] LORD MAYOR.

King. Lincoln, what news with you?

Linc. My gracious lord, have care unto yourself,
For there are traitors here.

All. Traitors? Where? Who?

Eyre. Traitors in my house? God forbid! Where be my officers? I'll spend my soul ere my King feel harm.

King. Where is the traitor, Lincoln?

Linc. Here he stands.

King. Cornwall, lay hold on Lacy. Lincoln, speak.
What canst thou lay unto thy nephew's charge?

Linc. This, my dear liege. Your grace, to do me
honor, 50

Heaped on the head of this degenerous[5] boy
Desertless favors. You made choice of him
To be commander over powers in France.
But he—
 King. Good Lincoln, prithee pause awhile.
Even in thine eyes I read what thou wouldst speak.
I know how Lacy did neglect our love,
Ran himself deeply, in the highest degree,
Into vile treason.
 Linc. Is he not a traitor?
 King. Lincoln, he was. Now have we pardoned him.
'Twas not a base want of true valor's fire 60
That held him out of France, but love's desire.
 Linc. I will not bear his shame upon my back.
 King. Nor shalt thou, Lincoln. I forgive you both.
 Linc. Then, good my liege, forbid the boy to wed
One whose mean birth will much disgrace his bed.
 King. Are they not married?
 Linc. No, my liege.
 Rose and Lacy. We are!
 King. Shall I divorce them? Oh, be it far
That any hand on earth should dare untie
The sacred knot knit by God's majesty.
I would not for my crown disjoin their hands 70
That are conjoined in holy nuptial bands.
How say'st thou, Lacy? Wouldst thou lose thy Rose?
 Lacy. Not for all India's[6] wealth, my sovereign.
 King. But Rose, I am sure, her Lacy would forgo.
 Rose. If Rose were asked that question, she'd say No.
 King. You hear them, Lincoln?
 Linc. Yes, my liege, I do.
 King. Yet canst thou find i'the heart to part these
 two?
Who seeks, besides you, to divorce these lovers?
 L. Ma. I do, my gracious lord; I am her father.
 King. Sir Roger Otley, our last mayor, I think? 80
 Noble. The same, my liege.
 King. Would you offend love's
 laws?
Well, you shall have your wills. You sue to me
To prohibit the match. Soft; let me see.
You are both married, Lacy, art thou not?
 Lacy. I am, dread sovereign.
 King. Then, upon thy life,
I charge thee not to call this woman wife.
 L. Ma. I thank your grace.
 Rose. Oh, my most gracious
 lord!
 Kneels.
 King. Nay, Rose, never woo me. I tell you true,
Although as yet I am a bachelor,
Yet I believe I shall not marry you. 90
 Rose. Can you divide the body from the soul,
Yet make the body live?
 King. Yea, so profound?
I cannot, Rose, but you I must divide.
Fair maid, this bridegroom cannot be your bride.
Are you pleased, Lincoln? Otley, are you pleased?
 Both. Yes, my lord.
 King. Then must my heart be eased.
For, credit me, my conscience lives in pain

Till these whom I divorced be joined again.
Lacy, give me thy hand. Rose, lend me thine.
Be what you would be. Kiss now. So, that's fine. 100
At night, lovers, to bed. Now let me see,
Which of you all mislikes this harmony?
 L. Ma. Will you then take from me my child
 perforce?
 King. Why, tell me, Otley, shines not Lacy's name
As bright in the world's eye as the gay beams
Of any citizen?
 Linc. Yea, but, my gracious lord,
I do mislike the match far more than he.
Her blood is too too base.
 King. Lincoln, no more;
Dost thou not know that love respects no blood,
Cares not for difference of birth or state? 110
The maid is young, well-born, fair, virtuous,
A worthy bride for any gentleman.
Besides, your nephew for her sake did stoop
To bare necessity, and, as I hear,
Forgetting honors and all courtly pleasures,
To gain her love became a shoemaker.
As for the honor which he lost in France,
Thus I redeem it. Lacy, kneel thee down.
Arise, Sir Rowland Lacy. Tell me now,
Tell me in earnest, Otley, canst thou chide, 120
Seeing thy Rose a Lady and a bride?
 L. Ma. I am content with what your grace hath
 done.
 Linc. And I, my liege, since there's no remedy.
 King. Come on, then; all shake hands. I'll have you
 friends.
Where there is much love, all discord ends.
What says my mad Lord Mayor to all this love?
 Eyre. Oh, my liege, this honor you have done to my
fine journeyman here, Rowland Lacy, and all these
favors which you have shown to me this day in my poor
house, will make Simon Eyre live longer by one dozen
of warm summers more than he should. 131
 King. Nay, my mad Lord Mayor—that shall be thy
 name—
If any grace of mine can length thy life,
One honor more I'll do thee. That new building
Which at thy cost in Cornhill is erected
Shall take a name from us. We'll have it called
The Leadenhall,[7] because in digging it
You found the lead that covereth the same.
 Eyre. I thank your majesty.
 Marg. God bless your grace. 140
 King. Lincoln, a word with you.

 Enter HODGE, FIRKE, RAFE, *and more*
 Shoemakers.

 Eyre. How now, my mad knaves? Peace! Speak
 softly!
Yonder is the King.

 [5] *degenerous:* degenerate. [6] *India's:* Q "Indians."
 [7] *Leadenhall:* The lead-roofed building actually stood on
the site of a Roman building at the principal crossing of the
Roman city.

King. With the old troop which there we keep in pay
We will incorporate a new supply.
Before one summer more pass o'er my head,
France shall repent England was injurèd.
What are all those?
Lacy. All shoemakers, my liege,
Sometimes[8] my fellows. In their companies
I lived as merry as an emperor. 150
King. My mad Lord Mayor, are all these shoemakers?
Eyre. All shoemakers, my liege. All gentlemen of
the gentle craft, true Trojans, courageous cordwainers.
They all kneel to the shrine of holy Saint Hugh.
All the Shoemakers. God save your majesty.
King. Mad Simon, would they any thing with us?
Eyre. Mum, mad knaves! not a word! I'll do't, I
warrant you. They are all beggars, my liege, all for
themselves. And I for them all on both knees do entreat,
that for the honor of poor Simon Eyre and the 160
good of his brethren, these mad knaves, your grace
would vouchsafe some privilege to my new Leadenhall:
that it may be lawful for us to buy and sell leather there
two days a week.
King. Mad Sim, I grant your suit. You shall have
 patent
To hold two market days in Leadenhall.
Mondays and Fridays, those shall be the times.
Will this content you?
All. Jesus bless your grace. 169
Eyre. In the name of these my poor brethren shoe-
makers, I most humbly thank your grace. But before I
rise, seeing you are in the giving vein and we in the
begging, grant Sim Eyre one boon more.
King. What is it, my Lord Mayor?
Eyre. Vouchsafe to taste of a poor banquet that
stands sweetly waiting for your sweet presence.
King. I shall undo thee, Eyre, only with feasts.
Already have I been too troublesome,
Say, have I not? 179
Eyre. Oh, my dear King, Sim Eyre was taken un-
awares upon a day of shroving[9] which I promised long
ago to the prentices of London. For and't please your
highness, in time past I bare the water tankard, and
my coat sits not a whit the worse upon my back. And
then upon a morning some mad boys—it was a Shrove-
tide even as 'tis now—gave me my breakfast, and I
swore then by the stopple of my tankard, if ever I came
to be Lord Mayor of London, I would feast all the
prentices. This day, my liege, I did it, and the slaves
had an hundred tables five times covered. 190
They are gone home and vanished.
Yet add more honor to the gentle trade:
Taste of Eyre's banquet, Simon's happy made.
King. Eyre, I will taste of thy banquet and will say
I have not met more pleasure on a day.
Friends of the gentle craft, thanks to you all.
Thanks, my kind Lady Mayoress, for our cheer.
Come, lords, awhile let's revel it at home.
When all our sports and banquetings are done, 199
Wars must right wrongs which Frenchmen have begun.
 Exeunt.

F I N I S

⁸ *Sometimes:* Formerly. ⁹ *shroving:* making merry.

Thomas Heywood

[c. 1573–1641]

A WOMAN KILLED WITH KINDNESS

ONLY the most meager facts survive Heywood's long and productive life. He was a member of a Lincolnshire family that may (or may not) have been related to the earlier dramatist John Heywood; according to his own testimony he studied at Cambridge, though no records survive. He may have begun publishing in 1594. By 1596 he was receiving payments from Philip Henslowe, manager of the Admiral's Men, and in 1598 he signed on with Henslowe for two years as an actor. He acted perhaps until 1619, and wrote most of his plays during his acting years for the Earl of Worcester's Company, subsequently Queen Anne's Men, which performed at the Rose, the Curtain, and the Red Bull. There seems to have been a gap in his writing between 1616 and 1624, when he began writing plays again, both independently and in collaboration. One of the plays of his late years, *The English Traveler* (c. 1627), is one of the best tragicomedies of the entire period, and *The Wise Woman of Hogsdon* (1604) is a first-rate comedy.

Something between twenty-three and twenty-seven extant plays can be confidently attributed to Heywood, but because he seems to have been generally uninterested in the preservation or publication of his work they represent only a fraction of his output. In publishing *The English Traveler* in 1633 he described it as "one reserved amongst two hundred and twenty in which I have had an entire hand or at least a main finger," and even discounting the probable exaggeration he was obviously a prolific writer who worked rapidly and steadily without earning much glory. His *oeuvre* includes plays in every genre to be found on the popular stage. Heywood has earned a new distinction: in 1973 a manuscript play turned up among a group of papers with which it had been gathered since 1634. The only play of the period to have been discovered in the twentieth century, the tragicomedy, called *Tom a Lincoln*, appears to have been influenced by Shakespeare's *The Winter's Tale* and to have been performed at Christmas 1611–12, and it has been confidently proclaimed by its first reader, P. J. Croft of Sotheby's, to be the work of Heywood, who as a matter of fact imitated Shakespeare perhaps more frequently than any other playwright of the period.

Heywood also wrote a number of pamphlets, among them *An Apology for Actors* (1612), a passionate defense of the theater against Puritan detractors, and made a number of translations; not the least regrettable loss among his writings is his unpublished "Lives of All the Poets Modern and Foreign."

Two early editions of A WOMAN KILLED WITH KINDNESS survive, the first published in 1607 and the other, which claims on its title page to be the third edition, in 1617; the present edition is based on the first quarto, though several readings have been taken from the second, which appears not to have been based on the first but rather on a manuscript or a missing second edition. A few emendations by editors from the eighteenth century to ours have been adopted; in each such case, the Q1 reading is given in the notes. The play was composed and acted for the first time in early 1603, according to entries in Henslowe's diary, which record payments made to Heywood on behalf of Worcester's company. There is some evidence that this bourgeois play was popular in its own day, a surmise supported by the late date of the second extant edition. A WOMAN KILLED WITH KINDNESS has been rather successful in the twentieth century; since the famous Jacques Copeau production at the Vieux-Colombier in Paris in 1913 there have been a number of well-received productions in England, France, and the United States, including one by the BBC. The source of the subplot is a story in Painter's *Palace of Pleasure* (1566), a collection of translations of stories by Bandello and others; no source for the main plot is known, though it may have been suggested by several stories in the same collection.

Though the play's notion of what constitutes kindness in the punishment of a spouse might be imagined to strike modern audiences as unsympathetically as its concern with female chastity, the play continues to attract readers. Sentimental and flat in language as it may be, it is distinguished by efficient plotting and characterization, an extraordinarily carefully worked out double plot rich in thematic parallels, almost cinematically detailed presentations of everyday activities such as dancing, hawking, and card-playing, and an atmosphere—consistent with the swiftness and shock of some of its scenes—in which outbursts of murderous violence, extreme forms of honor, and sudden betrayal of self and others seem natural. For all of its tenderness and its interest in the forms of civility, it both depicts and reflects a society in which violence was never far from the surface. T. S. Eliot admired some of the dramatic poetry of A WOMAN KILLED WITH KINDNESS while deprecating its subplot (which he judged too harshly) and its sentimentality, and saw Heywood as a playwright of the pathetic rather than the tragic. A notable feature of the play is its conventional assumption that in two hours an audience can watch years pass

in the lives of a group of characters. Underlying this assumption is an ethical idea: that what is significant in character is what happens to it in the course of time. Heywood did not have to begin with a wedding in order to dramatize the betrayal of a marriage that has already produced children; he chose to do so because he and his audience were interested in the development of his characters, believing that character changes and drama portrays the process. This assumption underlies the novel as well as Shakespeare's plays; it does not underlie classical culture or classical drama, or the plays of Ben Jonson, where time is treated very differently.

N. R.

A Woman Killed with Kindness

DRAMATIS PERSONÆ

SIR FRANCIS ACTON
SIR CHARLES MOUNTFORD
JOHN FRANKFORD
WENDOLL } *his friends*
CRANWELL
MALBY, *friend to Sir Francis*
OLD MOUNTFORD, *uncle to Sir Charles*
TYDY, *cousin to Sir Charles*
SANDY, *former friend to Sir Charles*
RODER, *former tenant to Sir Charles*
SHAFTON, *false friend to Frankford*
NICHOLAS } *servants to Frankford*
JENKIN
SPIGGOT, *butler to Frankford*

ROGER BRICKBAT } *country fellows*
JACK SLIME
Sheriff
Keeper of the Prison
Sergeant
Officer, Falconers, Huntsmen, Coachman, Carters,
 Musicians, Servants, Children
ANNE, *wife to Frankford and sister to Sir Francis*
SUSAN, *sister to Sir Charles*
SISLY MILK-PAIL, *servingwoman to Frankford*
JOAN MINIVER }
JANE TRUBKIN } *country wenches*
ISBEL MOTLEY
Servingwomen

THE PROLOGUE

I come but like a harbinger, being sent
To tell you what these preparations mean.
Look for no glorious state; our muse is bent
Upon a barren subject, a bare scene.
We could afford [1] this twig a timber-tree,
Whose strength might boldly on your favors build;
Our russet,[2] tissue;[3] drone, a honey-bee;
Our barren plot, a large and spacious field;
Our coarse fare, banquets; our thin water, wine;
Our brook, a sea; our bat's eyes, eagle's sight; 10
Our poet's dull and earthy muse, divine;
Our ravens, doves; our crow's black feathers, white.
 But gentle thoughts, when they may give the foil,[4]
 Save them that yield, and spare where they may spoil.[5]

[i]

Enter MASTER JOHN FRANKFORD, MISTRESS
ANNE, SIR FRANCIS ACTON, SIR CHARLES
MOUNTFORD, MASTER MALBY, MASTER
WENDOLL, *and* MASTER CRANWELL.

Sir Fra. Some music there! none lead the bride a
 dance?
Sir Cha. Yes, would she dance "The Shaking of the
 Sheets,"[1]

But that's the dance her husband means to lead her.
 Wen. That's not the dance that every man must
 dance,
According to the ballad.
 Sir Fra. Music ho!
By your leave, sister—by your husband's leave,
I should have said—the hand that but this day
Was given you in church I'll borrow. Sound!
This marriage music hoists me from the ground.
 Frank. Ay, you may caper, you are light and
 free; 10
Marriage hath yoked my heels; pray then pardon me.
 Sir Fra. I'll have you dance too, brother.
 Sir Cha. Master
 Frankford,
You are a happy man, sir, and much joy

PROLOGUE
 [1] *afford:* wish to have.
 [2] *russet:* coarse homespun cloth. [3] *tissue:* fine cloth.
 [4] *foil:* overthrow. [5] The Prologue is a sonnet.
i.
 [1] *"The . . . Sheets":* popular ballad.

Succeed your marriage mirth; you have a wife
So qualified and with such ornaments
Both of the mind and body. First, her birth
Is noble, and her education such
As might become the daughter of a prince.
Her own tongue speaks all tongues, and her own hand
Can teach all strings to speak in their best grace, 20
From the shrill treble to the hoarsest bass.
To end her many praises in one word,
She's beauty and perfection's eldest daughter,
Only found by yours, though many a heart hath sought
 her.
 Frank. But that I know your virtues and chaste
 thoughts,
I should be jealous of your praise, Sir Charles.
 Cran. He speaks no more than you approve.[2]
 Mal. Nor flatters he that gives to her her due.
 Anne. I would your praise could find a fitter theme
Than my imperfect beauty to speak on. 30
Such as they be, if they my husband please,
They suffice me now I am married.
His sweet content is like a flattering glass,
To make my face seem fairer to mine eye;
But the least wrinkle from his stormy brow
Will blast the roses in my cheeks that grow.
 Sir Fra. A perfect wife already, meek and patient.
How strangely the word "husband" fits your mouth,
Not married three hours since, sister. 'Tis good;
You that begin betimes thus must needs prove 40
Pliant and duteous in your husband's love.
Godamercies, brother, wrought her to it already?
"Sweet husband," and a curtsey the first day.
Mark this, mark this, you that are bachelors
And never took the grace[3] of honest man,
Mark this against[4] you marry, this one phrase:
"In a good time that man both wins and woos
That takes his wife down[5] in her wedding shoes."
 Frank. Your sister takes not after you, Sir Francis.
All his wild blood your father spent on you; 50
He got[6] her in his age when he grew civil.
All his mad tricks were to his land entailed,
And you are heir to all; your sister, she
Hath to her dower her mother's modesty.
 Sir Cha. Lord, sir, in what a happy state live you;
This morning, which to many seems a burden
Too heavy to bear, is unto you a pleasure.
This lady is no clog, as many are;
She doth become you like a well-made suit
In which the tailor hath used all his art, 60
Not like a thick coat of unseasoned[7] frieze,[8]
Forced on your back in summer; she's no chain
To tie your neck and curb you to the yoke,
But she's a chain of gold to adorn your neck.
You both adorn each other, and your hands
Methinks are matches. There's equality
In this fair combination; you are both scholars,
Both young, both being descended nobly.
There's music in this sympathy, it carries
Consort and expectation of much joy, 70
Which God bestow on you, from this first day,
Until your dissolution—that's for aye.

 Sir Fra. We keep you here too long, good brother
 Frankford.
Into the hall! away, go, cheer your guests!
What, bride and bridegroom both withdrawn at once?
If you be missed, the guests will doubt their welcome
And charge you with unkindness.
 Frank. To prevent it,
I'll leave you here, to see the dance within.
 Anne. And so will I.
 [*Exeunt* FRANKFORD *and* ANNE.]
 Sir Fra. To part you it were sin.
Now gallants, while the town musicians 80
Finger their frets[9] within, and the mad lads
And country lasses, every mother's child
With nosegays and bride-laces[10] in their hats,
Dance all their country measures, rounds, and jigs,
What shall we do? Hark, they are all on the hoigh,[11]
They toil like millhorses[12] and turn as round—
Marry, not on the toe, Ay, and they caper,
But without cutting.[13] You shall see tomorrow
The hall floor pecked and dinted like a millstone,
Made with their high shoes; though their skill be small,
Yet they tread heavy where their hobnails fall. 91
 Sir Cha. Well, leave them to their sports. Sir Francis
 Acton,
I'll make a match with you. Meet me to-morrow
At Chevy Chase; I'll fly my hawk with yours.
 Sir Fra. For what? For what?
 Sir Cha. Why, for a hundred
 pound.
 Sir Fra. Pawn[14] me some gold of that.
 Sir Cha. Here are ten
 angels.
I'll make them good a hundred pound to-morrow
Upon my hawk's wing.
 Sir Fra. 'Tis a match, 'tis done.
Another hundred pound upon your dogs;
Dare you, Sir Charles?
 Sir Cha. I dare. Were I sure to lose 100
I durst do more than that. Here's my hand,
The first course[15] for a hundred pound.
 Sir Fra. A match.
 Wen. Ten angels on Sir Francis Acton's hawk;
As much upon his dogs.
 Cran. I am for Sir Charles Mountford; I have seen
His hawk and dog both tried. What, clap you hands?[16]
Or is't no bargain?
 Wen. Yes, and stake them down.[17]
Were they five hundred they were all my own.

 [2] *approve:* prove.
 [3] *took the grace:* assumed the dignity.
 [4] *against:* in expectation of the time when.
 [5] *takes . . . down:* tames. [6] *got:* begot.
 [7] *unseasoned:* unseasonable. [8] *frieze:* coarse cloth.
 [9] *frets:* divisions of fingerboard on string instrument.
 [10] *bride-laces:* ribbons, given as favors to bind up sprigs of
rosemary worn at weddings.
 [11] *on the hoigh:* in a state of excitement.
 [12] *millhorses:* by walking in a circle they turn the mill.
 [13] *cutting:* twirling the feet properly.
 [14] *Pawn:* Pledge. [15] *course:* match.
 [16] *clap you hands:* shake on it.
 [17] *stake them down:* put money down as a stake.

Sir Fra. Be stirring early with the lark tomorrow;
I'll rise into my saddle ere the sun 110
Rise from his bed.
 Sir Cha. If there you miss me, say
I am no gentleman; I'll hold my day.[18]
 Sir Fran. It holds on all sides; come, tonight let's
 dance.
Early tomorrow let's prepare to ride;
We had need be three hours up before the bride.

 [*Exeunt.*]

[ii]

 Enter NICHOLAS *and* JENKINS, JACK SLIME,
 ROGER BRICKBAT, *with country* Wenches, *and*
 two or three Musicians.

Jenk. Come, Nick, take you Joan Miniver[1] to trace[2]
withal; Jack Slime, traverse[3] you with Sisly Milk-pail;
I will take Jane Trubkin,[4] and Roger Brickbat shall
have Isbel Motley;[5] and now that they are busy in the
parlor, come, strike up, we'll have a crash[6] here in the
yard.
 Nich. My humor[7] is not compendious;[8] dancing I
possess not, though I can foot it;[9] yet since I am fallen
into the hands of Sisly Milk-pail, I assent. 9
 Jack. Truly, Nick, though we were never brought up
like serving courtiers, yet we have been brought up
with serving creatures, ay and God's creatures too, for
we have been brought up to serve sheep, oxen, horses,
and hogs, and such like; and though we be but country
fellows, it may be in the way of dancing we can do the
horse-trick[10] as well as servingmen.
 Roger. Ay, and the crosspoint,[11] too.
 Jenk. O Slime, O Brickbat, do not you know that
comparisons are odious? Now we are odious ourselves,
too; therefore there are no comparisons to be made
betwixt us. 21
 Nich. I am sudden and not superfluous;
I am quarrelsome and not seditious;
I am peaceable and not contentious;
I am brief and not compendious.
Slime, foot it quickly. If the music overcome not my

melancholy, I shall quarrel; and if they suddenly[12] do
not strike up, I shall presently strike thee down.
 Jenk. No quarreling, for God's sake! truly, if you do,
I shall set a knave[13] between you. 30
 Jack. I come to dance, not to quarrel. Come, what
shall it be? "Rogero"?[14]
 Jenk. "Rogero"? No. We will dance "The Begin-
ning of the World."
 Sisly. I love no dance so well as "John, Come Kiss
Me Now."
 Nich. I, that have ere now deserved a cushion,[15] call
for "The Cushion Dance."
 Roger. For my part, I like nothing so well as "Tom
Tyler." 40
 Jenk. No, we'll have "The Hunting of the Fox."
 Jack. "The Hay," "The Hay," there's nothing like
"The Hay."
 Nich. I have said, I do say, and I will say again—
 Jenk. Every man agree to have it as Nick says.
 All. Content.
 Nich. It hath been, it now is, and it shall be—
 Sisly. What, Master Nich'las, what?
 Nich. "Put on Your Smock a Monday." 49
 Jenk. So the dance will come cleanly off. Come, for
God's sake agree of something. If you like not that, put
it to the musicians, or let me speak for all, and we'll
have "Sellenger's Round."
 All. That, that, that!
 Nich. No, I am resolved thus it shall be:
First take hands, then take you to your heels.
 Jenk. Why, would you have us run away?
 Nich. No, but I would have you shake your heels.
Music, strike up. 59

 They dance; NICHOLAS, *dancing, speaks stately and
 scurvily,*[16] *the rest after the country fashion.*

 Jenk. Hey! lively, my lasses! here's a turn for thee!

 [*Exeunt.*]

[iii]

 Wind[1] *horns. Enter* SIR CHARLES, SIR FRANCIS,
 MALBY, CRANWELL, WENDOLL, Falconers,
 and Huntsmen.

 Sir Cha. So! well cast off. Aloft, aloft! well flown!
Oh, now she takes her at the souse,[2] and strikes her
Down to the earth, like a swift thunder clap.
 Wen. She hath stroke ten angels out of my way.
 Sir Fra. A hundred pound from me.
 Sir Cha. What, falconer?
 Falc. At hand, sir.
 Sir Cha. Now she hath seized the fowl and 'gins to
 plume[3] her.
Rebeck[4] her not; rather stand still and cherk[5] her.
So! seize her gets, her jesses, and her bells.[6]
Away! 10
 Sir Fra. My hawk killed, too.
 Sir Cha. Ay, but 'twas at the
 querre,[7]
Not at the mount like mine.
 Sir Fra. Judgment, my masters.

[18] *hold my day:* keep my engagement.
ii.
 [1] *Miniver:* fur worn on ceremonial occasions.
 [2] *trace:* dance. [3] *traverse:* dance.
 [4] *Trubkin:* slovenly, squat little woman.
 [5] *Motley:* Coarse cloth. [6] *crash:* frolic.
 [7] *humor:* temperament.
 [8] *compendious:* Nicholas's error for "comprehensive."
 [9] *foot it:* dance, but not as well as if I had mastered the art.
 [10] *horse-trick:* dance step.
 [11] *crosspoint:* another dance step.
 [12] *suddenly:* immediately. [13] *knave:* servant (himself).
 [14] *"Rogero":* The tunes and dances named in this scene
were all popular.
 [15] *deserved a cushion:* been entitled to comfort.
 [16] *scurvily:* with unconvincingly affected sophistication.
iii.
 [1] *Wind:* Blow. [2] *souse:* swoop.
 [3] *plume:* pluck feathers.
 [4] *Rebeck:* Call back. [5] *cherk:* calm by chirping.
 [6] *gets . . . jesses . . . bells:* parts of the harness.
 [7] *at the querre:* while still on the ground.

Cran. Yours missed her at the ferre.[8]
Wen. Ay, but our merlin[9] first had plumed the
 fowl,
And twice renewed[10] her from the river, too.
Her bells, Sir Francis, had not both one weight,
Nor was one semitune[11] above the other;
Methinks these Milan[12] bells do sound too full,
And spoil the mounting of your hawk.
Sir Cha. 'Tis lost.
Sir Fra. I grant it not. Mine likewise seized a fowl
Within her talents,[13] and you saw her paws 21
Full of the feathers; both her petty singles[14]
And her long singles[15] gripped her more than other.
The terrials[16] of her legs were stained with blood,
Not of the fowl only; she did discomfit[17]
Some of her feathers, but she brake away.
Come, come, your hawk is but a rifler.[18]
Sir Cha. How?
Sir Fra. Ay, and your dogs are trindle-tails[19] and
 curs.
Sir Cha. You stir my blood.
You keep not a good hound in all your kennel, 30
Nor one good hawk upon your perch.
Sir Fra. How, knight?
Sir Cha. So, knight? You will not swagger, sir?
Sir Fra. Why, say I did?
Sir Cha. Why, sir, I say you would gain as much by
 swagg'ring
As you have got by wagers on your dogs;
You will come short in all things.
Sir Fra. Not in this!
Now I'll strike home.
Sir Cha. Thou shalt to thy long home,
Or I will want my will.
Sir Fra. All they that love Sir Francis follow me.
Sir Cha. All that affect Sir Charles draw my part.
Cran. On this side heaves my hand.
Wen. Here goes my
 heart. 41

They divide themselves.

SIR CHARLES, CRANWELL, Falconer, *and* Huntsman
fight against SIR FRANCIS, WENDOLL, *his* Falconer,
and Huntsman, *and* SIR CHARLES *hath the better, and
beats them away, killing both of* SIR FRANCIS *his men.*

[*Exeunt all except* SIR CHARLES.]

Sir Cha. My God! what have I done? What have I
 done?
My rage hath plunged into a sea of blood,
In which my soul lies drowned. Poor innocents,
For whom we are to answer. Well, 'tis done,
And I remain the victor. A great conquest,
When I would give this right hand, nay, this head,
To breathe in them new life whom I have slain.
Forgive me, God, 'twas in the heat of blood,
And anger quite removes me from myself: 50
It was not I, but rage, did this vile murder,
Yet I, and not my rage, must answer it.
Sir Francis Acton he is fled the field,
With him, all those that did partake his quarrel,

And I am left alone, with sorrow dumb,
And in my height of conquest overcome.

Enter SUSAN.

Susan. O God, my brother wounded among the
 dead!
Unhappy jest[20] that in such earnest ends.
The rumor of this fear[21] stretched to my ears,
And I am come to know if you be wounded. 60
Sir Cha. O sister, sister, wounded at the heart.
Susan. My God forbid!
Sir Cha. In doing that thing which He forbade,
I am wounded, sister.
Susan. I hope not at the heart.
Sir Cha. Yes, at the heart.
Susan. O God! a surgeon there!
Sir Cha. Call me a surgeon, sister, for my soul;
The sin of murder it hath pierced my heart,
And made a wide wound there; but for these scratches,
They are nothing, nothing.
Susan. Charles, what have you done?
Sir Francis hath great friends and will pursue you 70
Unto the utmost danger[22] of the law.
Sir Cha. My conscience is become my enemy
And will pursue me more than Acton can.
Susan. Oh, fly, sweet brother.
Sir Cha. Shall I fly from thee?
What, Sue, art weary of my company?
Susan. Fly from your foe.
Sir Cha. You, sister, are my friend,
And flying you, I shall pursue my end.
Susan. Your company is as my eyeball dear;
Being far from you, no comfort can be near.
Yet fly to save your life; what would I care 80
To spend my future age in black despair,
So you were safe? And yet to live one week
Without my brother Charles, through every cheek
My streaming tears would downwards run so rank[23]
Till thy could set on either side a bank,
And in the midst a channel; so my face
For two salt water brooks shall still[24] find place.
Sir Cha. Thou shalt not weep so much, for I will stay
In spite of danger's teeth; I'll live with thee,
Or I'll not live at all. I will not sell 90
My country and my father's patrimony,
No, thy sweet sight, for a vain hope of life.

Enter Sheriff *with* Officers.

Sher. Sir Charles, I am made the unwilling
 instrument
Of your attach[25] and apprehension.

[8] *ferre:* opposite riverbank. [9] *merlin:* kind of hawk.
[10] *renewed:* driven by a fresh attack.
[11] *semitune:* semitone. [12] *Milan:* made of silver.
[13] *talents:* talons. [14] *petty singles:* outer claws.
[15] *long singles:* middle claws.
[16] *terrials:* error for "terriets," leather bell-straps(?).
[17] *discomfit:* tear out. [18] *rifler:* bungler.
[19] *trindle-tails:* curly-tails, a sign of low breeding.
[20] *jest:* deed. [21] *fear:* fearful event.
[22] *danger:* penalty. [23] *rank:* profusely.
[24] *still:* ever. [25] *attach:* arrest.

I am sorry that the blood of innocent men
Should be of you exacted. It was told me
That you were guarded with a troop of friends,
And therefore I come armed.
 Sir Cha. O master sheriff,
I came into the field with many friends,
But, see, they all have left me; only one 100
Clings to my sad misfortune, my dear sister.
I know you for an honest gentleman;
I yield my weapons and submit to you.
Convey me where you please.
 Sher. To prison then,
To answer for the lives of these dead men.
 Susan. O God! O God!
 Sir Cha. Sweet sister, every strain
Of sorrow from your heart augments my pain.
Your grief abounds [26] and hits against my breast.
 Sher. Sir, will you go?
 Sir Cha. Even where it likes [27] you
 best.
 [*Exeunt.*]

[iv]

Enter MASTER FRANKFORD *in a study.*

 Frank. How happy am I amongst other men
That in my mean [1] estate embrace content.
I am a gentleman, and by my birth
Companion [2] with a king; a king's no more.
I am possessed of many fair revenues, [3]
Sufficient to maintain a gentleman.
Touching my mind, I am studied in all arts,
The riches of my thoughts, and of my time
Have been a good proficient. [4] But the chief
Of all the sweet felicities on earth, 10
I have a fair, a chaste, and loving wife,
Perfection all, all truth, all ornament.
If man on earth may truly happy be,
Of these at once possessed, sure I am he.

Enter NICHOLAS.

 Nich. Sir, there's a gentleman attends without to
speak with you.
 Frank. On horseback?
 Nich. Ay, on horseback.
 Frank. Entreat him to alight; I will attend him.
Knowest thou him, Nick?
 Nich. I know him; his name's
 Wendoll. 20

It seems he comes in haste: his horse is booted [5]
Up to the flank in mire, himself all spotted
And stained with plashing. Sure he rid in fear
Or for a wager; horse and man both sweat;
I ne'er saw two in such a smoking heat.
 Frank. Entreat him in—about it instantly.
 [*Exit* NICHOLAS.]
This Wendoll I have noted, and his carriage
Hath pleased me much; by observation
I have noted many good deserts in him—
He's affable and seen [6] in many things, 30
Discourses well, a good companion,
And though of small means, yet a gentleman
Of a good house, somewhat pressed by want.
I have preferred [7] him to a second place
In my opinion and my best regard.

Enter WENDOLL, ANNE, *and* NICHOLAS.

 Anne. O Master Frankford, Master Wendoll here
Brings you the strangest news that e'er you heard.
 Frank. What news, sweet wife? What news, good
 Master Wendoll?
 Wen. You knew the match made 'twixt Sir Francis
 Acton
And Sir Charles Mountford.
 Frank. True, with their hounds
 and hawks. 40
 Wen. The matches were both played.
 Frank. Ha! and which
 won?
 Wen. Sir Francis, your wife's brother, had the worst
And lost the wager.
 Frank. Why, the worse his chance;
Perhaps the fortune of some other day
Will change his luck.
 Wen. Oh, but [8] you hear not all.
Sir Francis lost, and yet was loath to yield;
In brief the two knights grew to difference,
From words to blows, and so to banding [9] sides,
Where [10] valorous Sir Charles slew in his spleen
Two of your brother's men—his falconer 50
And his good huntsman, whom he lov'd so well.
More men were wounded, no more slain outright.
 Frank. Now trust me I am sorry for the knight;
But is my brother safe?
 Wen. All whole and sound,
His body not being blemished with one wound.
But poor Sir Charles is to the prison led,
To answer at th' assize for them that's dead.
 Frank. I thank your pains, sir; had the news been
 better,
Your will was to have brought it, [11] Master Wendoll.
Sir Charles will find hard friends; his case is heinous,
And will be most severely censured on. [12] 61
I am sorry for him. Sir, a word with you.
I know you, sir, to be a gentleman
In all things, your possibilities [13] but mean;
Please you to use my table and my purse—
They are yours.
 Wen. O Lord, sir, I shall never deserve it.
 Frank. O sir, disparage not your worth too much;

You are full of quality [14] and fair desert.
Choose of my men which shall attend on you,
And he is yours. I will allow you, sir, 70
Your man, your gelding, and your table, all
At my own charge; be my companion.
 Wen. Master Frankford, I have oft been bound to you
By many favors; this exceeds them all
That [15] I shall never merit your least favor.
But when your last remembrance I forget,
Heaven at my soul exact that weighty debt.
 Frank. There needs no protestation, for I know you
Virtuous and therefore grateful. Prithee, Nan,
Use him with all thy loving'st courtesy. 80
 Anne. As far as modesty may well extend,
It is my duty to receive your friend.
 Frank. To dinner. Come, sir, from this present day
Welcome to me for ever; come, away.
 [*Exeunt* MASTER FRANKFORD, WENDOLL, *and*
 ANNE.]
 Nich. I do not like this fellow by no means;
I never see him but my heart still earns.[16]
Zounds! I could fight with him, yet know not why;
The Devil and he are all one in my eye.

Enter JENKIN.

 Jenk. O Nick, what gentleman is that comes to lie at
our house? My master allows him one to wait on him,
and I believe it will fall to thy lot. 91
 Nich. I love my master—by these hilts I do—
But rather than I'll ever come to serve him,
I'll turn away my master.

Enter SISLY.

 Sisly. Nich'las, where are you, Nich'las? You must
come in, Nich'las, and help the young gentleman off
with his boots.
 Nich. If I pluck off his boots, I'll eat the spurs,
And they shall stick fast in my throat like burrs.
 Exit.
 Sisly. Then, Jenkin, come you. 100
 Jenk. 'Tis no boot [17] for me to deny it. My master
hath given me a coat here, but he takes pains himself to
brush it [18] once or twice a day with a holly wand.
 Sisly. Come, come, make haste, that you may wash
your hands again and help to serve in dinner.
 [*Exit.*]
 Jenk. [*To the audience*] You may see, my masters,
though it be afternoon with you, 'tis but early days with
us, for we have not dined yet. Stay but a little; I'll but
go in and help to bear up the first course and come to
you again presently. 110
 Exit.

[v]

Enter MALBY *and* CRANWELL.

 Mal. This is the sessions day; pray, can you tell me
How young Sir Charles hath sped?[1] Is he acquit,
Or must he try the law's strict penalty?
 Cran. He's cleared of all, 'spite of his enemies,
Whose earnest labors was to take his life;

But in this suit of pardon he hath spent
All the revenues that his father left him,
And he is now turned a plain countryman,
Reformed [2] in all things. See, sir, here he comes.

Enter SIR CHARLES *and his* Keeper.

 Keep. Discharge your fees, and you are then at
 freedom. 10
 Sir Cha. Here, master keeper, take the poor
 remainder
Of all the wealth I have. My heavy foes
Have made my purse light, but, alas, to me
'Tis wealth enough that you have set me free.
 Mal. God give you joy of your delivery;
I am glad to see you abroad, Sir Charles.
 Sir Cha. The poorest knight in England, Master
 Malby.
My life hath cost me all the patrimony
My father left his son. Well, God forgive them
That are the authors of my penury. 20

Enter SHAFTON.

 Shaf. Sir Charles, a hand, a hand [3]—at liberty.
Now, by the faith I owe,[4] I am glad to see it.
What want [5] you? Wherein may I pleasure you?
 Sir Cha. O me! O most unhappy gentleman!
I am not worthy to have friends stirred up
Whose hands may help me in this plunge [6] of want.
I would I were in heaven, to inherit there
Th'immortal birthright which my Savior keeps
And by no unthrift [7] can be bought and sold,
For here on earth, what pleasures should we trust? 30
 Shaf. To rid you from these contemplations,
Three hundred pounds you shall receive of me—
Nay, five for fail.[8] Come, sir, the sight of gold
Is the most sweet receipt [9] for melancholy
And will revive your spirits. You shall hold law [10]
With your proud adversaries. Tush, let Frank Acton
Wage, with knighthood, like expense with me,
And he will sink, he will. Nay, good Sir Charles,
Applaud your fortune and your fair escape
From all these perils.
 Sir Cha. O sir, they have undone me. 40
Two thousand and five hundred pound a year
My father at his death possessed me of,
All which the envious Acton made me spend,
And notwithstanding all this large expense,
I had much ado to gain my liberty;
And I have now only a house of pleasure,
With some five hundred pounds, reserved
Both to maintain me and my loving sister.

14 *quality:* endowments. 15 *That:* i.e., So much that.
16 *earns:* grieves. 17 *boot:* avail, with pun.
18 *brush it:* i.e., thrash him.

v.
1 *sped:* fared. 2 *Reformed:* Transformed.
3 *a . . . hand:* give me a hand. 4 *owe:* own.
5 *want:* lack. 6 *plunge:* strait.
7 *unthrift:* spendthrift.
8 *for fail:* as a precaution against failure.
9 *receipt:* prescription.
10 *hold law:* engage in litigation.

Shaf. [*Aside*] That must I have; it lies convenient for
 me.
If I can fasten but one finger on him, 50
With my full hand I'll gripe him to the heart.
'Tis not for love I proffered him this coin,
But for my gain and pleasure.—[*To* SIR CHARLES]
 Come, Sir Charles,
I know you have need of money; take my offer.
 Sir Cha. Sir, I accept it, and remain indebted
Even to the best of my unable[11] power.
Come, gentleman, and see it tendered down.[12]

 Exeunt.

[vi]

Enter WENDOLL *melancholy.*

 Wen. I am a villain if I apprehend[1]
But such a thought; then to attempt the deed—
Slave, thou art damned without redemption.
I'll drive away this passion with a song.
A song! ha, ha! a song, as if, fond man,
Thy eyes could swim in laughter, when thy soul
Lies drenched and drowned in red tears of blood.
I'll pray, and see if God within my heart
Plant better thoughts. Why, prayers are meditations,
And when I meditate—O God, forgive me— 10
It is on her divine perfections.
I will forget her. I will arm myself
Not to entertain a thought of love to her,
And when I come by chance into her presence,
I'll hale[2] these balls[3] until my eyestrings crack
From being pulled and drawn to look that way.

Enter over the stage FRANKFORD, ANNE, *and*
NICHOLAS.

O God! O God! with what a violence
I am hurried to my own destruction.
There goes thou the most perfect'st man
That ever England bred a gentleman— 20
And shall I wrong his bed? Thou God of thunder,
Stay in Thy thoughts of vengeance and of wrath
Thy great almighty and all-judging hand
From speedy execution on a villain,
A villain and a traitor to his friend.

Enter JENKIN [*behind*].

 Jenk. Did your worship call?

[WENDOLL *does not notice* JENKIN.]

 Wen. He doth maintain me, he allows me largely[4]
Money to spend—
 Jenk. [*Aside*] By my faith, so do not you me; I cannot
get a cross[5] of you. 30

 Wen. My gelding and my man.
 Jenk. [*Aside*] That's Sorrel and I.
 Wen. This kindness grows of no alliance[6] 'twixt us—
 Jenk. [*Aside*] Nor is my service of any great acquain-
tance,[7]
 Wen. I never bound him to me by desert—
Of a mere stranger, a poor gentleman,
A man by whom in no kind[8] he could gain!
He hath placed me in the height of all his thoughts,
Made me companion with the best and chiefest 40
In Yorkshire. He cannot eat without me,
Nor laugh without me. I am to his body
As necessary as his digestion,
And equally do make him whole or sick.
And shall I wrong this man? Base man! ingrate!
Hast thou the power straight with thy gory hands
To rip thy image from his bleeding heart?
To scratch thy name from out the holy book
Of his remembrance, and to wound his name
That holds thy name so dear, or rend his heart 50
To whom thy heart was joined and knit together?
And yet I must. Then, Wendoll, be content;
Thus villains, when they would, cannot repent.
 Jenk. [*Aside*] What a strange humor is my new
master in. Pray God he be not mad. If he should be so,
I should never have any mind to serve him in Bedlam[9]
It may be he is mad for missing of me.

[WENDOLL *sees* JENKIN.]

 Wen. What, Jenkin? Where's your mistress?
 Jenk. Is your worship married?
 Wen. Why dost thou ask? 60
 Jenk. Because you are my master, and if I have a mis-
tress, I would be glad like a good servant to do my duty
to her.
 Wen. I mean, where's Mistress Frankford?
 Jenk. Marry, sir, her husband is riding out of town,
and she went very lovingly to bring him on his way to
horse. Do you see, sir, here she comes, and here I go.
 Wen. Vanish.

 [*Exit* JENKIN.]

Enter ANNE.

 Anne. You are well met, sir. Now, in troth, my
 husband
Before he took horse had a great desire 70
To speak with you. We sought about the house,
Hallowed[10] into the fields, sent every way,
But could not meet you; therefore he enjoined me
To do unto you his most kind commends.
Nay, more, he will you, as you prize his love,
Or hold in estimation his kind friendship,
To make bold in his absence and command
Even as himself were present in the house;
For you must keep his table, use his servants,
And be a present Frankford in his absence. 80
 Wen. I thank him for his love.
[*Aside*] Give me a name, you whose infectious tongues
Are tipped with gall and poison; as you would
Think on a man that had your father slain,
Murdered thy children, made your wives base strumpets,

[11] *unable:* feeble. [12] *tendered down:* paid.

vi.
 [1] *apprehend:* conceive. [2] *hale:* pull, hold.
 [3] *balls:* eyeballs. [4] *largely:* generously.
 [5] *cross:* coin. [6] *alliance:* kinship.
 [7] *acquaintance:* personal familiarity. [8] *kind:* way.
 [9] *Bedlam:* Bethlehem hospital for the insane, in London.
 [10] *Hallowed:* Called.

So call me, call me so! print in my face
The most stigmatic[11] title of a villain
For hatching treason to so true a friend.

Anne. Sir, you are much beholding[12] to my husband
You are a man most dear in his regard. 90

Wen. I am bound unto your husband and you too.
[*Aside*] I will not speak to wrong a gentleman
Of that good estimation,[13] my kind friend.
I will not! zounds, I will not! I may choose,
And I will choose. Shall I be so misled?
Or shall I purchase[14] to[15] my father's crest
The motto of a villain? If I say
I will not do it, what thing can enforce me?
Who can compel me? What sad[16] destiny
Hath such command upon my yielding thoughts? 100
I will not. Ha! some fury pricks me on;
The swift Fates drag me at their chariot wheel
And hurry me to mischief. Speak I must—
Injure myself, wrong her, deceive his trust.

Anne. Are you not well, sir, that you seem thus
 troubled?
There is sedition[17] in your countenance.

Wen. And in my heart, fair angel, chaste and wise.
I love you. Start not, speak not, answer not.
I love you—nay, let me speak the rest.
Bid me to swear, and I will call to record 110
The host of heaven.

Anne. The host of heaven forbid
Wendoll should hatch such a disloyal thought.

Wen. Such is my fate; to this suit I was born,
To wear rich Pleasure's crown, or Fortune's scorn.

Anne. My husband loves you.

Wen. I know it.

Anne. He esteems
 you
Even as his brain, his eyeball, or his heart.

Wen. I have tried[18] it.

Anne. His purse is your exchequer, and his table
Doth freely serve you.

Wen. So I have found it.

Anne. O with what face of brass, what brow of
 steel, 120
Can you unblushing speak this to the face
Of the espoused wife of so dear a friend?
It is my husband that maintains your state;
Will you dishonor him? I am his wife
That in your power hath left his whole affairs;
It is to me you speak.

Wen. Oh, speak no more,
For more than this I know and have recorded
Within the red-leaved table[19] of my heart.
Fair, and of all beloved, I was not fearful
Bluntly to give my life into your hand 130
And at one hazard all my earthly means.
Go, tell your husband; he will turn me off,
And I am then undone. I care not, I—
'Twas for your sake. Perchance in rage he'll kill me.
I care not—'twas for you. Say I incur
The general name of villain through the world,
Of traitor to my friend—I care not, I.
Beggary, shame, death, scandal, and reproach—

For you I'll hazard all. Why, what care I?
For you I'll live, and in your love I'll die. 140

Anne. You move me, sir, to passion[20] and to pity;
The love I bear my husband is as precious
As my soul's health.

Wen. I love your husband too,
And for his love I will engage my life.
Mistake me not, the augmentation
Of my sincere affection borne to you
Doth no whit lessen my regard of him.
I will be secret, lady, close as night,
And not the light of one small glorious[21] star
Shall shine here in my forehead to bewray 150
That act of night.

Anne. [*Aside*] What shall I say?
My soul is wand'ring and hath lost her way.—
[*To him*] Oh, Master Wendoll, oh.

Wen. Sigh not, sweet saint,
For every sigh you breathe draws from my heart
A drop of blood.

Anne [*Aside*] I ne'er offended yet;
My fault, I fear, will in my brow be writ:
Women that fall not quite bereft of grace
Have their offenses noted in their face.
I blush and am ashamed.—[*To him*] O Master Wendoll,
Pray God I be not born to curse your tongue 160
That hath enchanted me. This maze I am in
I fear will prove the labyrinth of sin.

Enter NICHOLAS [*behind*].

Wen. The path of pleasure and the gate to bliss,
Which on your lips I knock at with a kiss.

 [*Kisses her.*]

Nich. [*Aside*] I'll kill the rogue.

Wen. Your husband is from home, your bed's no
 blab—
Nay, look not down and blush.

 [*Exeunt* WENDOLL *and* ANNE.]
Nich. Zounds, I'll stab.
Ay, Nick, was it thy chance to come just in the nick?
I love my master, and I hate that slave;
I love my mistress, but these tricks I like not. 170
My master shall not pocket up this wrong;
I'll eat fingers first. What say'st thou, metal?

 [*Draws his dagger.*]

Does not the rascal Wendoll go on legs
That thou must cut off? Hath he not hamstrings
That thou must hock?[22] Nay, metal, thou shalt stand
To all I say. I'll henceforth turn a spy,
And watch them in their close[23] conveyances.[24]
I never looked for better of that rascal
Since he came miching[25] first into our house.

[11] *stigmatic:* condemnatory. [12] *beholding:* indebted.
[13] *estimation:* reputation. [14] *purchase:* acquire.
[15] *to:* for. [16] *sad:* steadfast.
[17] *sedition:* inner conflict, turbulence. [18] *tried:* tested.
[19] *table:* notebook. [20] *passion:* anger.
[21] *glorious:* boastful. [22] *hock:* cut. [23] *close:* secret.
[24] *conveyances:* dishonest activities.
[25] *miching:* sneaking.

It is that Satan hath corrupted her, 180
For she was fair and chaste. I'll have an eye
In all their gestures. Thus I think of them—
If they proceed as they have done before,
Wendoll's a knave, my mistress is a &c.

 Exit.

[vii]

 Enter SIR CHARLES *and* SUSAN.

Sir Cha. Sister, you see we are driven to hard shift
To keep this poor house we have left unsold;
I am now enforced to follow husbandry,[1]
And you to milk; and do we not live well?
Well, I thank God.
Susan. O brother, here's a change,
Since old Sir Charles died, in our father's house.
Sir Cha. All things on earth thus change, some up,
 some down;
Content's a kingdom, and I wear that crown.

 Enter SHAFTON *with a* Sergeant.

Shaf. Good morrow, good morrow, Sir Charles—
What, with your sister
Plying your husbandry?—Sergeant, stand off— 10
You have a pretty house here, and a garden,
And goodly ground about it. Since it lies
So near a lordship[2] that I lately bought,
I would fain buy it of you. I will give you—
Sir Cha. Oh, pardon me, this house successively
Hath 'longed to me and my progenitors
Three hundred year. My great-great-grandfather,
He in whom first our gentle style[3] began,
Dwelt here, and in this ground increased this molehill
Unto that mountain which my father left me. 20
Where he the first of all our house begun,
I now the last will end and keep this house,
This virgin title never yet deflowered
By any unthrift of the Mountfords' line.
In brief, I will not sell it for more gold
Than you could hide or pave the ground withal.
Shaf. Ha, ha! a proud mind and a beggar's purse.
Where's my three hundred pounds—besides the use?[4]
I have brought it to an execution
By course of law. What, is my money ready? 30
Sir Cha. An execution, sir, and never tell me
You put my bond in suit?[5] You deal extremely.[6]
Shaf. Sell me the land and I'll acquit you straight.
Sir Cha. Alas, alas! 'tis all trouble hath left me
To cherish me and my poor sister's life.
If this were sold, our names[7] should then be quite

Razed from the bead-roll[8] of gentility.
You see what hard shift we have made to keep it
Allied still to our own name. This palm you see
Labor hath glowed within, her silver brow, 40
That never tasted a rough winter's blast
Without a mask or fan, doth with a grace
Defy cold winter and his storms outface.
Susan. Sir, we feed sparing, and we labor hard,
We lie uneasy, to reserve to us
And our succession[9] this small plot of ground.
Sir Cha. I have so bent my thoughts to husbandry
That I protest I scarcely can remember
What a new fashion is, how silk or satin
Feels in my hand; why, pride is grown to us 50
A mere,[10] mere stranger. I have quite forgot
The names of all that ever waited on me;
I cannot name ye any of my hounds,
Once from whose echoing mouths I heard all the music
That e'er my heart desired. What should I say?
To keep this place I have changed myself away.
Shaf. [*To the* Sergeant] Arrest him at my suit. [*To
 SIR CHARLES*] Actions and actions
Shall keep thee in perpetual bondage fast.
Nay, more, I'll sue thee by a late appeal[11]
And call thy former life in question. 60
The keeper is my friend; thou shalt have irons,
And usage such as I'll deny to dogs.
Away with him!
Sir Cha. You are too timorous;[12] but trouble is my
 master,
And I will serve him truly. My kind sister,
Thy tears are of no force to mollify
This flinty man. Go to my father's brother,
My kinsmen and allies;[13] entreat them from me
To ransom me from this injurious man
That seeks my ruin.
Shaf. Come, irons, irons, away! 70
I'll see thee lodged far from the sight of day.
 Exeunt. [*Manet* SUSAN.]

 Enter SIR FRANCIS *and* MALBY [*behind*].

Susan. My heart's so hardened with the frost of grief
Death cannot pierce it through. Tyrant too fell!
So lead the fiends condemnèd souls to hell.
Sir Fra. Again to prison! Malby, hast thou seen
A poor slave better tortured? Shall we hear
The music of his voice cry from the grate
"Meat[14] for the Lord's sake"? No, no, yet I am not
Throughly[15] revenged. They say he hath a pretty
 wench
Unto his sister; shall I, in mercy sake 80
To him and to his kindred, bribe the fool
To shame herself by lewd, dishonest[16] lust?
I'll proffer largely, but, the deed being done,
I'll smile to see her base confusion.[17]
Mal. Methinks, Sir Francis, you are full revenged
For greater wrongs than he can proffer you.
See where the poor sad gentlewoman stands.
Sir Fra. Ha, ha! now I will flout her poverty,
Deride her fortunes, scoff her base estate;
My very soul the name of Mountford hates. 90

vii.
 [1] *husbandry:* farming. [2] *lordship:* estate.
 [3] *gentle style:* title to gentility. [4] *use:* interest.
 [5] *in suit:* in a law court. [6] *extremely:* harshly.
 [7] *names:* Qq "means." [8] *bead-roll:* list.
 [9] *succession:* descendants. [10] *mere:* total.
 [11] *by . . . appeal:* after the normal time for prosecution has
passed. [12] *timorous:* dreadful.
 [13] *allies:* relatives. [14] *Meat:* Food.
 [15] *Throughly:* Thoroughly. [16] *dishonest:* unchaste.
 [17] *confusion:* ruin.

But stay, my heart; oh, what a look did fly
To strike my soul through with thy piercing eye.
I am enchanted, all my spirits are fled,
And with one glance my envious spleen [18] stroke dead.

[SUSAN *sees them.*]

Susan. Acton, that seeks our blood!
 Runs away.
Sir Fra. O chaste and fair!
Mal. Sir Francis; why, Sir Francis! zounds, in a
 trance?
Sir Francis, what cheer, man? Come, come, how is't?
Sir Fra. Was she not fair? Or else this judging eye
Cannot distinguish beauty.
Mal. She was fair.
Sir Fra. She was an angel in a mortal's shape, 100
And ne'er descended from old Mountford's line.
But soft, soft, let me call my wits together.
A poor, poor wench, to my great adversary
Sister, whose very souls denounce [19] stern war
One against other. How now, Frank, turned fool
Or madman, whether? [20] But no! master of
My perfect senses and directest wits.
Then why should I be in this violent humor
Of passion and of love? And with a person
So different every way, and so opposed 110
In all contractions [21] and still-warring actions?
Fie, fie, how I dispute against my soul.
Come, come, I'll gain her, or in her fair quest
Purchase my soul free and immortal rest.
 Exeunt.

[viii]

Enter 3 or 4 Servingmen [*including* SPIGGOT *the* Butler
and NICHOLAS], *one with a voider* [1] *and a wooden knife
to take away all, another the salt and bread, another the
tablecloth and napkins, another the carpet.* [2] JENKIN
with two lights after them.

Jenk. So, march in order and retire in battle 'ray.
My master and the guests have supped already; all's
taken away. Here, now spread for the servingmen in the
hall. Butler, it belongs to your office.
Spig. I know it, Jenkins. What do you call the gentle-
man that supped there tonight?
Jenk. Who, my master?
Spig. No, no, Master Wendoll, he is a daily guest; I
mean the gentleman that came but this afternoon. 9
Jenk. His name is Master Cranwell. God's light!
Hark, within there, my master calls to lay more billets [3]
on the fire. Come, come! Lord how we that are in office [4]
here in the house are troubled. One spread the carpet
in the parlor and stand ready to snuff the lights; the rest
be ready to prepare their stomachs. [5] More lights in the
hall there. Come, Nich'las.
 [*Exeunt. Manet* NICHOLAS.]
Nich. I cannot eat, but had I Wendoll's heart
I would eat that; the rogue grows impudent.
Oh, I have seen such vile, [6] notorious tricks,
Ready to make my eyes dart from my head. 20
I'll tell my master, by this air I will;
Fall what may fall, I'll tell him. Here he comes.

Enter FRANKFORD, *as it were brushing the crumbs
from his clothes with a napkin, and newly risen from
supper.*

Frank. Nich'las, what make [7] you here? Why are not
 you
At supper in the hall there with your fellows?
Nich. Master, I stayed [8] your rising from the board
To speak with you.
Frank. Be brief, then, gentle Nich'las,
My wife and guests attend me in the parlor.
Why dost thou pause? Now, Nich'las, you want money,
And unthrift-like would eat into your wages
Ere you have earned it. Here's, sir, half a crown; 30
Play the good husband, [9] and away to supper.
Nich. [*Aside*] By this hand, an honorable gentleman.
I will not see him wronged.—[*To him*] Sir, I have served
you long; you entertained [10] me seven years before
your beard. You knew me, sir, before you knew my
mistress.
Frank. What of this, good Nich'las?
Nich. I never was a make-bate [11] or a knave;
I have no fault but one—I am given to quarrel,
But not with women. I will tell you, master, 40
That which will make your heart leap from your breast,
Your hair to startle from your head, your ears to tingle.
Frank. What preparation's this to dismal news?
Nich. 'Sblood, sir, I love you better than your wife—
I'll make it good.
Frank. Thou art a knave, and I have much ado
With wonted patience to contain my rage
And not to break thy pate. Thou art a knave;
I'll turn you with your base comparisons
Out of my doors. 50
Nich. Do, do. There's not room for Wendoll and me
too both in one house. O master, master, that Wendoll
is a villain.
 [FRANKFORD *strikes him.*]
Frank. Ay, saucy!
Nich. Strike, strike, do strike; yet hear me: I am no
 fool;
I know a villain when I see him act
Deeds of a villain. Master, master, that base slave
Enjoys my mistress and dishonors you.
Frank. Thou hast killed me with a weapon whose
 sharpened point
Hath pricked quite through and through my shivering
 heart. 60
Drops of cold sweat sit dangling on my hairs
Like morning's dew upon the golden flowers,
And I am plunged into a strange agony.

[18] *envious spleen:* malicious anger.
[19] *denounce:* proclaim. [20] *whether:* which.
[21] *contractions:* transactions.
viii.
[1] *voider:* tray or basket for removing table scraps.
[2] *carpet:* tablecloth. [3] *billets:* logs.
[4] *office:* service. [5] *stomachs:* appetites.
[6] *vile:* Qq "vild." [7] *make:* do.
[8] *stayed:* waited for. [9] *husband:* thrifty person.
[10] *entertained:* took into service.
[11] *make-bate:* troublemaker.

What didst thou say? If any word that touched
His credit or her reputation,
It is as hard to enter my belief
As Dives [12] into heaven.
 Nich. I can gain nothing;
They are two that never wronged me. I knew before
'Twas but a thankless office, and perhaps
As much as is my service or my life 70
Is worth. All this I know, but this and more,
More by a thousand dangers could not hire me
To smother such a heinous wrong from you.
I saw, and I have said.
 Frank. [*Aside*] 'Tis probable; though blunt, yet he is
 honest.
Though I durst pawn my life and on their faith
Hazard the dear salvation of my soul,
Yet in my trust I may be too secure.
May this be true? Oh, may it? Can it be?
Is it by any wonder possible? 80
Man, woman, what thing mortal may we trust
When friends and bosom wives prove so unjust?—
[*To him*] What instance [13] hast thou of this strange
 report?
 Nich. Eyes, eyes.
 Frank. Thy eyes may be deceived, I tell thee,
For should an angel from the heavens drop down
And preach this to me that thyself hast told,
He should have much ado to win belief,
In both their loves I am so confident. 89
 Nich. Shall I discourse the same by circumstance?
 Frank. No more. To supper, and command your
 fellows
To attend us and the strangers. [14] Not a word;
I charge thee on thy life, be secret then,
For I know nothing.
 Nich. I am dumb, and now that I have eased my
stomach, I will go fill my stomach.

 Exit.

 Frank. Away, begone.
She is well born, descended nobly;
Virtuous her education; her repute
Is in the general voice of all the country 100
Honest and fair; her carriage, her demeanor
In all her actions that concern the love
To me her husband, modest, chaste, and godly.
Is all this seeming gold plain copper?
But he, that Judas that hath borne my purse,
And sold me for a sin—O God, O God,
Shall I put up [15] these wrongs? No, shall I trust

[12] *Dives*: rich man sent to hell in Jesus' parable, Luke xvi:
19–31. [13] *instance*: evidence.
 [14] *strangers*: visitors. [15] *put up*: put up with.
 [16] *double gilt*: refined gold (with pun).
 [17] *well-hatched*: richly inlaid. [18] *loose*: get rid of.
 [19] *balk*: avoid. [20] *pair*: pack. [21] *said*: done.
 [22] *take my part*: be my partner.
 [23] *take them up*: play against them.
 [24] *taken . . . false*: caught cheating.
 [25] *noddy*: card game; fool. All the card game language in
the rest of the scene involves similar puns.
 [26] *lodam*: also called "load 'em," a card game based on the
Italian game *carica l'asino*, "load the ass"; Wendoll is
punning.

The bare report of this suspicious groom
Before the double gilt, [16] the well-hatched [17] ore
Of their two hearts? No, I will loose [18] these thoughts;
Distraction I will banish from my brow 111
And from my looks exile sad discontent.
Their wonted favors in my tongue shall flow.
Till I know all, I'll nothing seem to know.
Lights and a table there. Wife, Master Wendoll, and
gentle Master Cranwell—

 Enter Anne, Master Wendoll, Master
 Cranwell, Nicholas *and* Jenkin, *with cards,*
 carpet, stools, and other necessaries.

 Frank. Oh, you are a stranger, Master Cranwell, you,
And often balk [19] my house; faith, you are a churl.
Now we have supped, a table and to cards.
 Jenk. A pair [20] of cards, Nich'las, and a carpet to
 cover the table. 120
Where's Sisly with her counters and her box? Candles
and candlesticks there!

 [*Enter* Sisly *and a* Servingman
 with counters and candles.]

Fie, we have such a household of serving creatures!
Unless it be Nick and I, there's not one amongst them
all can say "bo" to a goose; [*To* Nicholas] well
said, [21] Nick.

 They spread a carpet, set down lights and cards.

 [*Exeunt all the* Servants *except* Nicholas.]
 Anne. Come, Master Frankford, who shall take my
 part? [22]
 Frank. Marry, that will I, sweet wife.
 Wen. No, by my faith, sir, when you are together I
sit out; it must be Mistress Frankford and I, or else it is
no match. 131
 Frank. I do not like that match.
 Nich. [*Aside*] You have no reason, marry, knowing all.
 Frank. 'Tis no great matter, neither. Come, Master
Cranwell, shall you and I take them up? [23]
 Cran. At your pleasure, sir.
 Frank. I must look to you, Master Wendoll, for you
will be playing false—nay, so will my wife, too.
 Nich. [*Aside*] Ay, I will be sworn she will.
 Anne. Let them that are taken playing false [24] forfeit
the set. 141
 Frank. Content; [*Aside*] it shall go hard but I'll take
 you.
 Cran. Gentlemen, what shall our game be?
 Wen. Master Frankford, you play best at noddy. [25]
 Frank. You shall not find it so; [*Aside*] indeed you
 shall not!
 Anne. I can play at nothing so well as double ruff.
 Frank. If Master Wendoll and my wife be together,
there's no playing against them at double hand.
 Nich. I can tell you, sir, the game that Master Wen-
doll is best at. 150
 Wen. What game is that, Nick?
 Nich. Marry, sir, knave out of doors.
 Wen. She and I will take you at lodam. [26]
 Anne. Husband, shall we play at saint?

Frank. [*Aside*] My saint's turn'd devil;—[*To her*] no, we'll none of saint. You're best at new-cut, wife; [*Aside*] you'll play at that!

Wen. If you play at new-cut, I am soonest hitter[27] of any here, for a wager.

Frank. [*Aside*] 'Tis me they play on. [*To them.*] Well, you may draw out, 160
For all your cunning; 'twill be to your shame.
I'll teach you at your new-cut a new game.
Come, come.

Cran. If you cannot agree upon the game, to post and pair.

Wen. We shall be soonest pairs, and my good host, When he comes late home, he must kiss the post.[28]

Frank. Whoever wins, it shall be to thy cost.

Cran. Faith, let it be vide-ruff, and let's make honors.[29]

Frank. If you make honors, one thing let me crave: Honor the king and queen; except the knave. 171

Wen. Well, as you please for that. Lift[30] who shall deal.

Anne. The least in sight. What are you, Master Wendoll?

[WENDOLL *cuts the cards.*]

Wen. I am a knave.

Nich. [*Aside*] I'll swear it.

[ANNE *cuts.*]

Anne. I a queen.

Frank. [*Aside*] A quean[31] thou should'st say; [*To them*] well, the cards are mine.
They are the grossest pair that e'er I felt.

Anne. Shuffle, I'll cut; [*Aside*] would I had never dealt![32]

Frank. I have lost[33] my dealing.

[FRANKFORD *deals.*]

Wen. Sir, the fault's in me.
This queen I have more than my own, you see.
Give me the stock.[34]

[WENDOLL *deals.*]

Frank. My mind's not on my game; 180
[*Aside*] Many a deal I have lost, the more's your shame.
[*To them*] You have served me a bad trick, Master Wendoll.

Wen. Sir, you must take your lot. To end this strife, I know I have dealt better with your wife.

Frank. [*Aside*] Thou hast dealt falsely, then.

Anne. What's trumps?

Wen. Hearts. Partner, I rub.[35]

Frank. [*Aside*] Thou robb'st me of my soul, of her chaste love;
In thy false dealing thou hast robbed my heart.
Booty you play;[36] I like a loser stand, 190
Having no heart, or here or in my hand.—
[*To them*] I will give o'er the set; I am not well.
Come, who will hold my cards?

Anne. Not well, sweet Master Frankford?
Alas, what ail you? 'Tis some sudden qualm.

Wen. How long have you been so, Master Frankford?

Frank. Sir, I was lusty[37] and had my health,
But I grew ill when you began to deal.
Take hence this table.

[*The* Servants *enter and remove the table, cards, etc.*]

 Gentle Master Cranwell,
You are welcome; see your chamber at your pleasure.
I am sorry that this megrim[38] takes me so 201
I cannot sit and bear you company.
Jenkin, some lights, and show him to his chamber.

 [*Exeunt* CRANWELL *and* JENKIN.]

Anne. A night gown[39] for my husband, quickly there.

[*Enter a* Servant *with a gown, and exit.*]

It is some rheum or cold.

Wen. Now, in good faith,
This illness you have got by sitting late
Without your gown.

Frank. I know it, Master Wendoll.
Go, go to bed, lest you complain like me.
Wife, prithee wife, into my bedchamber.
The night is raw and cold and rheumatic. 210
Leave me my gown and light; I'll walk away my fit.

Wen. Sweet sir, good night.

Frank. Myself, good night.

 [*Exit* WENDOLL.]

Anne. Shall I attend you, husband?

Frank. No, gentle wife, thou'lt catch cold in thy head;
Prithee, begone, sweet; I'll make haste to bed.

Anne. No sleep will fasten on mine eyes, you know, Until you come.

Frank. Sweet Nan, I prithee, go.

 [*Exit* ANNE.]

[*To* NICHOLAS] I have bethought me; get me by degrees
The keys of all my doors, which I will mold
In wax and take their fair impression 220
To have by them new keys. This being compassed,
At a set hour a letter shall be brought me,
And when they think they may securely play,
They are nearest to danger. Nick, I must rely
Upon thy trust and faithful secrecy.

Nich. Build on my faith.

Frank. To bed then, not to rest;
Care lodges in my brain, grief in my breast.

 Exeunt.

[ix]

 Enter SUSAN, OLD MOUNTFORD, SANDY,
 RODER, *and* TYDY.

Old Mount. You say my nephew is in great distress. Who brought it to him but his own lewd life?

27 *hitter:* point-maker(?). 28 *kiss the post:* be shut out.
29 *make honors:* name the highest cards(?). 30 *Lift:* Cut.
31 *quean:* whore. 32 *dealt:* had sexual intercourse.
33 *lost:* made a mistake in.
34 *stock:* cards left after the deal.
35 *rub:* take all the cards of one suit.
36 *Booty you play:* You unite to play false.
37 *lusty:* healthy. 38 *megrim:* migraine, severe headache.
39 *nightgown:* dressing gown.

I cannot spare a cross. I must confess
He was my brother's son; why, niece, what then?
This is no world in which to pity men.
 Susan. I was not born a beggar, though his extremes[1]
Enforce this language from me; I protest
No fortune of mine own could lead my tongue
To this base key. I do beseech you, uncle,
For the name's sake, for Christianity, 10
Nay, for God's sake, to pity his distress.
He is denied the freedom of the prison,
And in the hole[2] is laid with men condemned;
Plenty he hath of nothing but of irons,
And it remains in you to free him thence.
 Old Mount. Money I cannot spare; men should take
 heed.
He lost my kindred when he fell to need.
 Exit.
 Susan. Gold is but earth; thou earth enough shalt
 have
When thou hast once took measure of thy grave.
You know me, Master Sandy, and my suit. 20
 Sandy. I knew you, lady, when the old man lived;
I knew you ere your brother sold his land.
Then you were Mistress Sue, tricked up in jewels;
Then you sung well, played sweetly on the flute;
But now I neither know you nor your suit.
 [Exit.]
 Susan. You, Master Roder, was my brother's tenant.
Rent-free he placed you in that wealthy farm
Of which you are possessed.
 Roder. True, he did,
And have I not there dwelt still for his sake?
I have some business now, but without doubt 30
They that have hurled him in will help him out.
 Exit.
 Susan. Cold comfort still. What say you, cousin
 Tydy?
 Tydy. I say this comes of roisting,[3] swagg'ring.
Call me not cousin; each man for himself.
Some men are born to mirth and some to sorrow;
I am no cousin unto them that borrow.
 Exit.
 Susan. O Charity, why art thou fled to heaven,
And left all things on this earth uneven?
Their scoffing answers I will ne'er return,
But to myself his grief in silence mourn. 40

 Enter SIR FRANCIS *and* MALBY.

 Sir Fra. She is poor; I'll therefore tempt her with
 this gold.
Go, Malby, in my name deliver it,
And I will stay thy answer.
 Mal. Fair mistress, as I understand your grief

Doth grow from want, so I have here in store
A means to furnish you, a bag of gold
Which to your hands I freely tender you.
 Susan. I thank you, heavens; I thank you, gentle sir.
God make me able to requite this favor.
 Mal. This gold Sir Francis Acton sends by me, 50
And prays you &c.[4]
 Susan. Acton! O God, that name I am born to curse.
Hence, bawd; hence, broker![5] see, I spurn his gold;
My honor never shall for gain be sold.
 Sir Fra. Stay, lady, stay!
 Susan. From you I'll posting[6] hie,
Even as the doves from feathered eagles fly.
 [Exit.]
 Sir Fra. She hates my name, my face; how should I
 woo?
I am disgraced in everything I do.
The more she hates me and disdains my love,
The more I am rapt in admiration 60
Of her divine and chaste perfections.
Woo her with gifts I cannot, for all gifts
Sent in my name she spurns. With looks I cannot,
For she abhors my sight. Nor yet with letters,
For none she will receive. How then? How then?
Well, I will fasten such a kindness on her
As shall o'ercome her hate and conquer it.
Sir Charles, her brother, lies in execution[7]
For a great sum of money; and, besides,
The appeal is sued still for my huntsmen's death, 70
Which only I have power to reverse.
In her I'll bury all my hate of him.
Go seek the keeper, Malby; bring me to him.
To save his body, I his debts will pay;
To save his life, I his appeal will stay.
 Exeunt.

[x]

 Enter SIR CHARLES *in prison, with irons; his feet*
 bare, his garments all ragged and torn.

 Sir Cha. Of all on the earth's face most miserable,
Breathe in the hellish dungeon thy laments.
Thus like a slave ragged, like a felon gyved[1]—
O unkind uncle! O my friends ingrate,
That hurls thee headlong to this base estate.
Unthankful kinsmen! Mountfords all too base,
To let thy name lie fettered in disgrace.
A thousand deaths here in this grave I die:
Fear, hunger, sorrow, cold—all threat my death
And join together to deprive my breath. 10
But that which most torments me, my dear sister
Hath left[2] to visit me, and from my friends
Hath brought no hopeful answer; therefore I
Divine they will not help my misery.
If it be so, shame, scandal, and contempt
Attend their covetous thoughts, need make their graves.
Usurers they live, and may they die like slaves.

 Enter Keeper.

 Keep. Knight, be of comfort, for I bring thee freedom
From all thy troubles.
 Sir Cha. Then I am doomed to die;

ix.
 [1] *extremes:* extremities.
 [2] *hole:* worst cell, used for poorest prisoners.
 [3] *roisting:* reveling riotously.
 [4] *&c:* indicating whispering. [5] *broker:* pander.
 [6] *posting:* quickly. [7] *in execution:* imprisoned.
x.
 [1] *gyved:* shackled. [2] *left:* ceased.

Death is th'end of all calamity. 20
 Keep. Live! your appeal is stayed, the execution
Of all your debts discharged, your creditors
Even to the utmost penny satisfied,
In sign whereof your shackles I knock off.
You are not left so much indebted to us
As for your fees;[3] all is discharged, all paid.
Go freely to your house or where you please;
After long miseries embrace your ease.
 Sir Cha. Thou grumblest out the sweetest music to
 me
That ever organ played. Is this a dream, 30
Or do my waking senses apprehend
The pleasing taste of these applausive[4] news?
Slave that I was to wrong such honest friends,
My loving kinsmen and my near allies.
Tongue, I will bite thee for the scandal breathed[5]
Against such faithful kinsmen; they are all
Composed of pity and compassion,
Of melting charity, and of moving ruth.
That which I spake before was in my rage;
They are my friends, the mirrors[6] of this age, 40
Bounteous and free.[7] The noble Mountford's race
Ne'er bred a covetous thought or humor base.

 Enter SUSAN.

 Susan. I can no longer stay from visiting
My woeful brother; while I could I kept
My hapless tidings from his hopeful ear.
 Sir Cha. Sister, how much am I indebted to thee
And to thy travail!
 Susan. What, at liberty?
 Sir Cha. Thou seest I am, thanks to thy industry.
Oh, unto which of all my courteous friends
Am I thus bound? My uncle Mountford, he 50
Even of an infant loved me; was it he?
So did my cousin Tydy; was it he?
So Master Roder, Master Sandy too.
Which of all these did this high kindness do?
 Susan. Charles, can you mock me in your poverty,
Knowing your friends deride your misery?
Now I protest I stand so much amazed
To see your bonds free and your irons knocked off
That I am rapt into a maze of wonder,
The rather for I know not by what means 60
This happiness hath chanced.
 Sir Cha. Why, by my uncle,
My cousins, and my friends; who else, I pray,
Would take upon them all my debts to pay?
 Susan. O brother, they are men all of flint,
Pictures[8] of marble, and as void of pity
As chasèd[9] bears. I begged, I sued, I kneeled,
Laid open all your griefs and miseries,
Which they derided—more than that, denied us
A part in their alliance, but in pride
Said that our kindred with our plenty died. 70
 Sir Cha. Drudges too much![10] what, did they?
 O known evil:
Rich fly the poor as good men shun the devil.
Whence should my freedom come? Of whom alive,
Saving of those, have I deserved so well?

Guess, sister, call to mind, remember[11] me.
These I have raised, these follow the world's guise,
Whom, rich in honor, they in woe despise.
 Susan. My wits have lost themselves; let's ask the
 keeper.
 Sir Cha. Jailer!
 Keep. At hand, sir. 80
 Sir Cha. Of courtesy resolve me one demand—
What[12] was he took the burden of my debts
From off my back, stayed my appeal to death,
Discharged my fees, and brought me liberty?
 Keep. A courteous knight, one called Sir Francis
 Acton.
 Susan. Acton!
 Sir Cha. Ha! Acton! O me more distressed in this
Than all my troubles. Hale me back,
Double my irons, and my sparing meals
Put into halves, and lodge me in a dungeon 90
More deep, more dark, more cold, more comfortless.
By Acton freed! not all thy manacles
Could fetter so my heels as this one word
Hath thralled my heart, and it must now lie bound
In more strict prison than thy stony jail.
I am not free, I go but under bail.
 Keep. My charge is done, sir, now I have my fees;
As we get little, we will nothing leese.[13]

 Exit.
 Sir Cha. By Acton freed, my dangerous opposite.[14]
Why, to what end? Or what occasion? Ha! 100
Let me forget the name of enemy
And with indifference[15] balance[16] this high favor. Ha!
 Susan [*Aside*] His love to me, upon my soul 'tis so;
That is the root from whence these strange things grow.
 Sir Cha. [*Aside*] Had this proceeded from my father,
 he
That by the law of nature is most bound
In offices of love, it had deserved
My best employment to requite that grace.
Had it proceeded from my friends, or him,
From them this action had deserved my life— 110
And from a stranger more, because from such
There is less expectation[17] of good deeds.
But he, nor father, nor ally, nor friend,
More than a stranger, both remote in blood
And in his heart opposed my enemy,
That this high bounty should proceed from him—
Oh, there I lose myself. What should I say,
What think, what do, his bounty to repay?
 Susan. You wonder, I am sure, whence this strange
 kindness
Proceeds in Acton. I will tell you, brother: 120
He dotes on me and oft hath sent me gifts,

Letters, and tokens; I refused them all.
 Sir Cha. I have enough; though poor, my heart is set
In one rich gift to pay back all my debt.
 Exeunt.

[xi]

Enter FRANKFORD *with a letter in his hand,
and* NICHOLAS *with keys.*

 Frank. This is the night, and I must play the touch,¹
To try two seeming angels. Where's my keys?
 Nich. They are made according to your mold in wax.
I bade the smith be secret, gave him money,
And there they are. The letter, sir.
 Frank. True, take it; there it is.
And when thou seest me in my pleasant'st vein
Ready to sit to supper, bring it me.
 Nich. I'll do't; make no more question but I'll do't.
 Exit.

Enter ANNE, CRANWELL, WENDOLL, *and*
JENKIN.

 Anne. Sirrah, 'tis six o'clock already stroke; 10
Go bid them spread the cloth and serve in supper.
 Jenk. It shall be done forsooth, mistress. Where is
Spiggot the butler to give us out salt and trenchers?²
 [Exit.]
 Wen. We that have been a-hunting all the day
Come with preparèd stomachs, Master Frankford;
We wished you at our sport.
 Frank. My heart was with you, and my mind was on you;
Fie, Master Cranwell, you are still thus sad.
A stool, a stool! where's Jenkin, and where's Nick?
'Tis supper time at least an hour ago. 20
What's the best news abroad?
 Wen. I know none good.
 Frank. [*Aside*] But I know too much bad.

Enter [SPIGGOT *the*] Butler *and* JENKIN *with a
tablecloth, bread, trenchers, and salt* [, *then exeunt*].

 Cran. Methinks, sir, you might have that interest
In³ your wife's brother to be more remiss⁴
In this hard dealing against poor Sir Charles,
Who, as I hear, lies in York Castle, needy
And in great want.
 Frank. Did not more weighty business of my own
Hold me away, I would have labored peace
Betwixt them, with all care; indeed I would, sir. 30
 Anne. I'll write unto my brother earnestly
In that behalf.
 Wen. A charitable deed,
And will beget the good opinion

Of all your friends that love you, Mistress Frankford.
 Frank. That's you for one; I know you love Sir Charles.
[*Aside*] And my wife too well.
 Wen. He deserves the love
Of all true gentlemen; be yourselves judge.
 Frank. But supper, ho! now, as thou lovest me, Wendoll,
Which I am sure thou dost, be merry, pleasant,
And frolic it tonight. Sweet Master Cranwell, 40
Do you the like. Wife, I protest, my heart
Was ne'er more bent on sweet alacrity.⁵
Where be those lazy knaves to serve in supper?

Enter NICHOLAS.

 Nich. Sir, here's a letter.
 Frank. Whence comes it? And who brought it?
 Nich. A stripling that below attends your answer,
And as he tells me it is sent from York.
 Frank. Have him into the cellar; let him taste
A cup of our March beer.⁶ Go, make him drink.

 [Reads the letter.]

 Nich. I'll make him drunk, if he be a Trojan.⁷ 50
 [Exit.]
 Frank. My boots and spurs! Where's Jenkin? God forgive me,
How I neglect my business. Wife, look here;
I have a matter to be tried tomorrow
By eight o'clock, and my attorney writes me
I must be there betimes with evidence,
Or it will go against me. Where's my boots?

Enter JENKIN *with boots and spurs.*

 Anne. I hope your business craves no such dispatch
That you must ride tonight.
 Wen. [*Aside*] I hope it doth.
 Frank. God's me! no such dispatch?
Jenkin, my boots. Where's Nick? Saddle my roan, 60
And the gray dapple for himself. Content ye,
It much concerns me.
 [Exit JENKIN.]
Gentle Master Cranwell
And Master Wendoll, in my absence use
The very ripest pleasure of my house.
 Wen. Lord, Master Frankford, will you ride tonight?
The ways are dangerous.
 Frank. Therefore will I ride
Appointed⁸ well, and so shall Nick, my man.
 Anne. I'll call you up by five o'clock tomorrow.
 Frank. No, by my faith, wife, I'll not trust to that;
'Tis not such easy rising in a morning 70
From one I love so dearly. No, by my faith,
I shall not leave so sweet a bedfellow
But with much pain. You have made me a sluggard
Since I first knew you.
 Anne. Then if you needs will go
This dangerous evening, Master Wendoll,
Let me entreat you bear him company.
 Wen. With all my heart, sweet mistress. My boots there!

xi.
 ¹ *play the touch:* test (gold). ² *trenchers:* plates.
 ³ *interest/In:* influence/On. ⁴ *remiss:* lenient.
 ⁵ *alacrity:* cheerfulness.
 ⁶ *March beer:* strong beer brewed in March.
 ⁷ *Trojan:* good fellow. ⁸ *Appointed:* Armed.

Frank. Fie, fie, that for my private business
I should disease⁹ my friend and be a trouble
To the whole house. Nick! 80
 Nich. [*Within*] Anon, sir.
 Frank. Bring forth my gelding—[*To* WENDOLL] as
 you love me, sir,
Use no more words; a hand, good Master Cranwell.
 Cran. Sir, God be your good speed.
 Frank. Good night, sweet Nan; nay, nay, a kiss and
 part.
[*Aside*] Dissembling lips, you suit not with my heart.
 [*Exit.*]
 Wen. [*Aside*] How business, time, and hours all
 gracious proves
And are the furtherers to my newborn love.
I am husband now in Master Frankford's place
And must command the house.—[*To* ANNE] My
 pleasure is 90
We will not sup abroad so publicly,
But in your private chamber, Mistress Frankford.
 Anne. [*To* WENDOLL] O sir, you are too public in
 your love,
And Master Frankford's wife—
 Cran. Might I crave favor,
I would entreat you I might see my chamber;
I am on the sudden grown exceeding ill
And would be spared from supper.
 Wen. Light there, ho!
See you want nothing, sir, for if you do,
You injure that good man, and wrong me too.
 Cran. I will make bold. Good night.
 [*Exit.*]
 Wen. How all conspire
To make our bosom¹⁰ sweet and full entire. 101
Come, Nan, I prithee let us sup within.
 Anne. Oh, what a clog unto the soul is sin.
We pale¹¹ offenders are still full of fear;
Every suspicious eye brings danger near
When they whose clear heart from offense are free
Despise report, base scandals to outface,
And stand at mere defiance with disgrace.
 Wen. Fie, fie, you talk too like a Puritant.¹²
 Anne. You have tempted me to mischief, Master
 Wendoll; 110
I have done I know not what. Well, you plead custom;
That which for want of wit I granted erst
I now must yield through fear. Come, come, let's in.
Once o'er shoes, we are straight o'er head in sin.
 Wen. My jocund soul is joyful above measure;
I'll be profuse in Frankford's richest treasure.
 Exeunt.

[xii]

Enter SISLY, JENKIN, [SPIGGOT *the*] Butler,
 and other Servingmen.

 Jenk. My mistress and Master Wendoll, my master,
sup in her chamber tonight; Sisly, you are preferred
from being the cook to be chambermaid. Of all the loves
betwixt thee and me, tell me what thou thinkest of this.
 Sisly. Mum; there's an old proverb, "When the cat's
away the mouse may play."

 Jenk. Now you talk of a cat, Sisly, I smell a rat.
 Sisly. Good words, Jenkin, lest you be called to
answer them. 9
 Jenk. Why, "God make my mistress an honest
woman." Are not these good words? "Pray God my
new master play not the knave with my old master."
Is there any hurt in this? "God send no villainy in-
tended, and if they do sup together, pray God they do
not lie together. God keep my mistress chaste and make
us all His servants." What harm is there in all this?
Nay, more, here is my hand; thou shalt never have my
heart unless thou say "Amen."
 Sisly. "Amen, I pray God," I say. 19

Enter Servingmen.

 Serv. My mistress sends that you should make less
noise, to lock up the doors, and see the household all
got to bed. You, Jenkin, for this night are made the
porter, to see the gates shut in.¹
 Jenk. Thus by little and little I creep into office.
Come to kennel, my masters, to kennel; 'tis eleven
o'clock already.
 Serv. When you have locked the gates in, you must
send up the keys to my mistress.
 Sisly. Quickly, for God's sake, Jenkin; for I must
carry them. I am neither pillow nor bolster, but I know
more than both. 31
 Jenk. To bed, good Spiggot; to bed, good honest
serving creatures, and let us sleep as snug as pigs in
pease-straw.²
 Exeunt.

[xiii]

Enter FRANKFORD *and* NICHOLAS.

 Frank. Soft, soft. We have tied our geldings to a tree
Two flight-shoot¹ off, lest by their thund'ring hooves
They blab our coming back. Hear'st thou no noise?
 Nich. Hear? I hear nothing but the owl and you.
 Frank. So; now my watch's hand points upon
 twelve,
And it is dead midnight. Where are my keys?
 Nick. Here, sir.
 Frank. This is the key that opes my outward gate,
This is the hall door, this my withdrawing chamber.²
But this, that door that's bawd unto my shame, 10
Fountain and spring of all my bleeding thoughts,
Where the most hallowed order and true knot
Of nuptial sanctity hath been profaned.
It leads to my polluted bedchamber,

⁹ *disease:* inconvenience. ¹⁰ *bosom:* intimacy.
¹¹ *pale:* weak.
¹² *Puritant:* i.e., prude; modeled on "Protestant."
xii.
 ¹ *shut in:* closed.
 ² *pease-straw:* stalks and leaves of the pea plant, used as
fodder.
xiii.
 ¹ *flight-shoot:* long bow-shots.
 ² *withdrawing chamber:* private room attached to a more
public one.

Once my terrestrial heaven, now my earth's hell,
The place where sins in all their ripeness dwell—
But I forget myself; now to my gate.
 Nich. It must ope with far less noise than Cripplegate,[3]
or your plot's dashed.
 Frank. So, reach me my dark-lantern to the rest.[4]
Tread softly, softly.
 Nich. I will walk on eggs this pace. 21
 Frank. A general silence hath surprised the house,
And this is the last door. Astonishment,
Fear, and amazement play against my heart,
Even as a madman beats upon a drum.
O keep my eyes, you heavens, before I enter,
From any sight that may transfix my soul;
Or if there be so black a spectacle,
O strike mine eyes stark blind; or if not so,
Lend me such patience to digest my grief 30
That I may keep this white and virgin hand
From any violent outrage or red murder.
And with that prayer I enter.
 [*Exit.*]

 Nich. Here's a circumstance![5]
A man may be made cuckold in the time
That he's about it. And[6] the case were mine
As 'tis my master's—'sblood, that he makes me swear—
I would have placed his action,[7] entr'd there;
I would, I would.

[*Enter* FRANKFORD.]

 Frank. Oh, oh! 40
 Nich. Master's blood, master! master!
 Frank. O me unhappy, I have found them lying
Close in each other's arms, and fast asleep.
But that I would not damn two precious souls
Bought with my Savior's blood and send them laden
With all their scarlet sins upon their backs
Unto a fearful judgment, their two lives
Had met upon my rapier.
 Nich. 'Sblood, master, have you left them sleeping
still? Let me go wake them. 50
 Frank. Stay, let me pause awhile.
O God, O God, that it were possible
To undo things done, to call back yesterday;
That Time could turn up his swift sandy glass,
To untell[8] the days, and to redeem these hours;
Or that the sun
Could, rising from the west, draw his coach backward,
Take from the account of time so many minutes,
Till he had all these seasons called again,
Those minutes and those actions done in them, 60
Even from her first offence; that I might take her

As spotless as an angel in my arms.
But oh! I talk of things impossible,
And cast beyond the moon.[9] God give me patience,
For I will in to wake them.
 Exit.

 Nich. Here's patience perforce;
He needs must trot afoot that tires his horse.

Enter WENDOLL, *running over the stage in a night gown,
 he* [FRANKFORD] *after him with his sword drawn; the*
 Maid *in her smock stays his hand and clasps hold on him.*
 He pauses awhile.

 Frank. I thank thee, maid; thou like the angel's[10]
 hand
Hast stayed me from a bloody sacrifice.
Go, villain, and my wrongs sit on thy soul 70
As heavy as this grief doth upon mine.
When thou record'st my many courtesies
And shalt compare them with thy treacherous heart,
Lay them together, weigh them equally,
'Twill be revenge enough. Go, to thy friend
A Judas; pray, pray, lest I live to see
Thee, Judas-like, hanged on an elder tree.

Enter ANNE *in her smock, night gown, and
 night attire.*

 Anne. Oh, by what word, what title, or what name
Shall I entreat your pardon? Pardon! Oh,
I am as far from hoping such sweet grace 80
As Lucifer from heaven. To call you husband—
O me most wretched, I have lost that name;
I am no more your wife.
 Nich. 'Sblood, sir, she swoons.
 Frank. Spare thou thy tears, for I will weep for thee;
And keep thy countenance, for I'll blush for thee.
Now I protest I think 'tis I am tainted,
For I am most ashamed, and 'tis more hard
For me to look upon thy guilty face
Than on the sun's clear brow. What wouldst thou
 speak?
 Anne. I would I had no tongue, no ears, no eyes, 90
No apprehension, no capacity.[11]
When do you spurn me like a dog? When tread me
Under your feet? When drag me by the hair?
Though I deserve a thousand thousand fold
More than you can inflict, yet, once my husband,
For womanhood—to which I am a shame,
Though once an ornament—even for His sake
That hath redeemed our souls, mark not my face
Nor hack me with your sword, but let me go
Perfect and undeformèd to my tomb. 100
I am not worthy that I should prevail
In the least suit, no, not to speak to you,
Nor look on you, nor to be in your presence.
Yet as an abject this one suit I crave;
This granted I am ready for my grave.
 Frank. My God with patience arm me. Rise, nay,
 rise,
And I'll debate with thee. Was it for want
Thou playedst the strumpet? Wast thou not supplied
With every pleasure, fashion, and new toy[12]—

[3] *Cripplegate:* a London gate near some of the theaters.
[4] *rest:* along with the keys, etc.
[5] *circumstance:* beating about the bush. [6] *And:* If.
[7] *placed his action:* established his case.
[8] *untell:* count backwards.
[9] *cast . . . moon:* conjecture wildly.
[10] *angel's:* referring to the angel who prevented Abraham
from killing Isaac, Genesis xxii:11.
[11] *capacity:* mental receptivity as opposed to the active
seizing of knowledge, apprehension.
[12] *toy:* trifle, trinket.

Nay, even beyond my calling?[13]
 Anne. I was. 110
 Frank. Was it then disability in me,
Or in thine eye seemed he a properer[14] man?
 Anne. Oh, no.
 Frank. Did I not lodge thee in my bosom?
Wear thee here in my heart?
 Anne. You did.
 Frank. I did indeed; witness my tears I did.
Go bring my infants hither.

 [*Exit* Maid *and return with two* Children.]

 O Nan, O Nan,
If either fear of shame, regard of honor,
The blemish of my house, nor my dear love
Could have withheld thee from so lewd a fact,[15]
Yet for these infants, these young harmless souls, 120
On whose white brows thy shame is charactered
And grows in greatness as they wax in years—
Look but on them, and melt away in tears.
Away with them, lest as her spotted body
Hath stained their names with stripe of bastardy,
So her adult'rous breath may blast their spirits
With her infectious thoughts. Away with them!
 [*Exeunt* Maid *and* Children.]
 Anne. In this one life I die ten thousand deaths.
 Frank. Stand up, stand up: I will do nothing rashly.
I will retire awhile into my study, 130
And thou shalt hear thy sentence presently.[16]
 Exit.
 Anne. 'Tis welcome, be it death. O me base strumpet,
That having such a husband, such sweet children,
Must enjoy neither. Oh, to redeem my honor
I would have this hand cut off, these my breasts seared,
Be racked, strappadoed,[17] put to any torment;
Nay, to whip but this scandal out, I would hazard
The rich and dear redemption of my soul.
He cannot be so base as to forgive me,
Nor I so shameless to accept his pardon. 140
O women, women, you that have yet kept
Your holy matrimonial vow unstained,
Make me your instance: when you tread awry,
Your sins like mine will on your conscience lie.

 Enter SISLY, SPIGGOT, *all the* Servingmen, *and*
 JENKIN, *as newly come out of bed.*

 All. O mistress, mistress, what have you done,
 mistress?
 Nich. 'Sblood, what a caterwauling keep you here!
 Jenk. O Lord, mistress, how comes this to pass? My
master is run away in his shirt,[18] and never so much as
called me to bring his clothes after him.
 Anne. See what guilt is: here stand I in this place,
Ashamed to look my servants in the face. 151

 Enter MASTER FRANKFORD *and* CRANWELL,
 whom seeing she falls on her knees.

 Frank. My words are registered in heaven already.
With patience hear me: I'll not martyr thee
Nor mark thee for a strumpet, but with usage
Of more humility torment thy soul.

And kill thee even with kindness.
 Cran. Master Frankford—
 Frank. Good Master Cranwell—woman, hear thy
 judgment:
Go make thee ready in thy best attire;
Take with thee all thy gowns, all thy apparel;
Leave nothing that did ever call thee mistress, 160
Or by whose sight being left here in the house
I may remember such a woman by.
Choose thee a bed and hangings for a chamber,
Take with thee everything that hath thy mark,
And get thee to my manor seven mile off,
Where live. 'Tis thine; I freely give it thee.
My tenants by[19] shall furnish thee with wains[20]
To carry all thy stuff within two hours;
No longer will I limit[21] thee my sight.
Choose which of all my servants thou likest best, 170
And they are thine to attend thee.
 Anne. A mild sentence.
 Frank. But as thou hop'st for heaven, as thou
 believ'st
Thy name's recorded in the Book of Life,[22]
I charge thee never after this sad day
To see me, or to meet me, or to send
By word, or writing, gift, or otherwise
To move me, by thyself or by thy friends,
Nor challenge any part in my two children.
So farewell, Nan, for we will henceforth be
As we had never seen, ne'er more shall see. 180
 Anne. How full my heart is in my eyes appears;
What wants in words, I will supply in tears.
 Frank. Come, take your coach, your stuff; all must
 along.
Servants and all make ready, all be gone.
It was thy hand cut two hearts out of one.
 [*Exeunt.*]

[xiv]

 Enter SIR CHARLES, *gentlemanlike, and*
 [SUSAN] *his* Sister, *gentlewomanlike.*
 Susan. Brother, why have you tricked[1] me like a
 bride?
Bought me this gay attire, these ornaments?
Forget you our estate, our poverty?
 Sir Cha. Call me not brother, but imagine me
Some barbarous outlaw or uncivil kern,[2]
For if thou shut'st thy eye and only hear'st
The words that I shall utter, thou shalt judge me
Some staring[3] ruffin,[4] not thy brother Charles.
O Susan!

[13] *calling:* station in life. [14] *properer:* worthier.
[15] *fact:* deed. [16] *presently:* at once.
[17] *strappadoed:* tortured by being raised on a rope tied to
the hands bound behind the back and then dropped.
[18] *shirt:* night dress. [19] *by:* nearby.
[20] *wains:* wagons. [21] *limit:* allow.
[22] *Book of Life:* record of names of those who shall live
eternally, Philippians iv: 3.
xiv.
 [1] *tricked:* dressed.
 [2] *kern:* Irish foot-soldier, peasant.
 [3] *staring:* wild-eyed. [4] *ruffin:* devil.

Susan. O brother, what doth this strange language
mean? 10
Sir Cha. Dost love me, sister? Wouldst thou see me
live
A bankrupt beggar in the world's disgrace
And die indebted to my enemies?
Wouldst thou behold me stand like a huge beam
In the world's eye, a byword and a scorn?
It lies in thee of these to acquit me free,
And all my debt I may outstrip by thee.
Susan. By me? Why I have nothing, nothing left;
I owe even for the clothes upon my back;
I am not worth—
Sir Cha. O sister, say not so. 20
It lies in you my downcast state to raise,
To make me stand on even points with the world.
Come, sister, you are rich! indeed you are,
And in your power you have without delay
Acton's five hundred pound back to repay.
Susan. Till now I had thought you loved me. By
mine honor,
Which I had kept as spotless as the moon
I ne'er was mistress of that single doit [5]
Which I reserved not to supply your wants.
And do you think that I would hoard from you? 30
Now by my hopes in heaven, knew I the means
To buy you from the slavery of your debts,
Especially from Acton, whom I hate,
I would redeem it with my life or blood.
Sir Cha. I challenge it, and, kindred set apart,
Thus ruffian-like I lay siege to your heart.
What do I owe to Acton?
Susan. Why, some five hundred pounds, toward
which I swear
In all the world I have not one denier. [6]
Sir Cha. It will not prove so. Sister, now resolve [7]
me: 40
What do you think—and speak your conscience—
Would Acton give might he enjoy your bed?
Susan. He would not shrink to spend a thousand
pound
To give the Mountfords' name so deep a wound.
Sir Cha. A thousand pound! I but five hundred owe;
Grant him your bed, he's paid with interest so.
Susan. O brother!
Sir Cha. O sister! only this one way,
With that rich jewel you my debts may pay.
In speaking this my cold heart shakes with shame,
Nor do I woo you in a brother's name, 50
But in a stranger's. Shall I die in debt
To Acton, my grand foe, and you still wear
The precious jewel that he holds so dear?
Susan. My honor I esteem as dear and precious
As my redemption.
Sir Cha. I esteem you, sister,
As dear for so dear prizing it.

Susan. Will Charles
Have me cut off my hands and send them Acton?
Rip up my breast and with my bleeding heart
Present him as a token?
Sir Cha. Neither, sister,
But hear me in my strange assertion: 60
Thy honor and my soul are equal in my regard,
Nor will thy brother Charles survive thy shame.
His kindness like a burden hath surcharged me,
And under his good deeds I stooping go,
Not with an upright soul. Had I remained
In prison still, there doubtless I had died;
Then unto him that freed me from that prison
Still do I owe that life. What moved my foe
To enfranchise [8] me? 'Twas, sister, for your love!
With full five hundred pounds he bought your love, 70
And shall he not enjoy it? Shall the weight
Of all this heavy burden lean on me,
And will not you bear part? You did partake
The joy of my release; will you not stand
In joint-bond [9] bound to satisfy the debt?
Shall I be only charged?
Susan. But that I know
These arguments come from an honored mind,
As in your most extremity of need,
Scorning to stand in debt to one you hate—
Nay, rather would engage [10] your unstained honor 80
Than to be held ingrate—I should condemn you.
I see your resolution and assent;
So Charles will have me, and I am content.
Sir Cha. For this I tricked you up.
Susan. But here's a knife,
To save mine honor, shall slice out my life.
Sir Cha. I know thou pleasest me a thousand times
More in that resolution than thy grant.
[*Aside*] Observe her love: to soothe it to my suit
Her honor she will hazard though not lose;
To bring me out of debt, her rigorous hand 90
Will pierce her heart. O wonder, that will choose,
Rather than stain her blood, her life to lose.—
[*To her*] Come, you sad sister to a woeful brother,
This is the gate; I'll bear him such a present,
Such an acquittance for the knight to seal,
As will amaze his senses and surprise
With admiration [11] all his fantasies.

Enter SIR FRANCIS *and* MALBY.

Susan. Before his unchaste thoughts shall seize on
me,
'Tis here shall my imprisoned soul set free.
Sir Fra. How! Mountford with his sister hand in
hand! 100
What miracle's afoot?
Mal. It is a sight
Begets in me much admiration.
Sir Cha. Stand not amazed to see me thus attended.
Acton, I owe thee money, and being unable
To bring thee the full sum in ready coin,
Lo! for thy more assurance here's a pawn,
My sister, my dear sister, whose chaste honor
I prize above a million. Here—nay, take her;

[5] *doit:* coin worth half a farthing.
[6] *denier:* small coin. [7] *resolve:* tell.
[8] *enfranchise:* free from confinement.
[9] *In joint-bond:* Jointly. [10] *engage:* expose to risk.
[11] *admiration:* wonder.

She's worth your money, man; do not forsake her.

Sir Fra. [*Aside*] I would he were in earnest. 110
Susan. Impute it not to my immodesty.
My brother being rich in nothing else
But in his interest that he hath in me,
According to his poverty hath brought you
Me, all his store, whom howsoe'er you prize
As forfeit to your hand, he values highly,
And would not sell but to acquit your debt
For any emperor's ransom.

Sir Fra. Stern heart, relent;
Thy former cruelty at length repent.
Was ever known in any former age 120
Such honorable wrested[12] courtesy?
Lands, honors, lives, and all the world forgo
Rather than stand engaged to such a foe.

Sir Cha. Acton, she is too poor to be thy bride,
And I too much opposed to be thy brother.
There, take her to thee; if thou hast the heart
To seize her as a rape or lustful prey,
To blur our house that never yet was stained,
To murder her that never meant thee harm,
To kill me now whom once thou savedst from death,
Do them at once on her; all these rely 131
And perish with her spotted chastity.

Sir Fra. You overcome me in your love, Sir Charles.
I cannot be so cruel to a lady
I love so dearly. Since you have not spared
To engage your reputation to the world,
Your sister's honor which you prize so dear,
Nay, all the comforts which you hold on earth,
To grow out of my debt, being your foe,
Your honored thoughts, lo, thus I recompense: 140
Your metamorphosed foe receives your gift
In satisfaction of all former wrongs.
This jewel I will wear here in my heart,
And where before I thought her for her wants[13]
Too base to be my bride, to end all strife
I seal you my dear brother, her my wife.

Susan. You still exceed us. I will yield to fate
And learn to love where I till now did hate.

Sir Cha. With that enchantment you have charmed
 my soul
And made me rich even in those very words. 150
I pay no debt but am indebted more;
Rich in your love I never can be poor.

Sir Fra. All's mine is yours; we are alike in state.
Let's knit in love what was opposed in hate.
Come, for our nuptials we will straight provide,
Blessed only in our brother and fair bride.

 [*Exeunt.*]

[xv]

Enter CRANWELL, FRANKFORD, *and* NICHOLAS.

Cran. Why do you search each room about your
 house,
Now that you have dispatched your wife away?

Frank. O sir, to see that nothing may be left
That ever was my wife's. I loved her dearly,
And when I do but think of her unkindness,

My thoughts are all in hell, to avoid which torment,
I would not have a bodkin[1] or a cuff,
A bracelet, necklace, or rebato wire,[2]
Nor anything that ever was called hers
Left me by which I might remember her. 10
Seek round about.

Nich. 'Sblood, master, here's her lute flung in a
 corner.

Frank. Her lute! O God, upon this instrument
Her fingers have run quick division,[3]
Sweeter than that which now divides our hearts.
These frets have made me pleasant,[4] that have now
Frets of my heartstrings made. O Master Cranwell,
Oft hath she made this melancholy wood,
Now mute and dumb for[5] her disastrous chance,
Speak sweetly many a note, sound many a strain 20
To her own ravishing voice, which being well strung,
What pleasant, strange airs have they jointly sung.
Post with it after her. Now nothing's left;
Of her and hers I am at once bereft.

Nich. I'll ride and overtake her, do my message,
And come back again.

 [*Exit.*]

Cran. Meantime, sir, if you please
I'll to Sir Francis Acton and inform him
Of what hath passed betwixt you and his sister.

Frank. Do as you please. How ill am I bestead
To be a widower ere my wife be dead. 30

 [*Exeunt.*]

[xvi]

Enter ANNE, *with* JENKIN, *her maid* SISLY, *her*
 Coachman, *and three* Carters.

Anne. Bid my coach stay. Why should I ride in state,
Being hurled so low down by the hand of fate?
A seat like to my fortunes let me have,
Earth for my chair, and for my bed a grave.

Jenk. Comfort, good mistress; you have watered your
coach with tears already. You have but two mile now
to go to your manor. A man cannot say by[1] my old
Master Frankford as he may say by me, that he wants
manors, for he hath three or four, of which this is one
that we are going to. 10

Sisly. Good mistress, be of good cheer. Sorrow you
see hurts you, but helps you not; we all mourn to see
you so sad.

Cart. Mistress, I spy one of my landlord's men
Come riding post;[2] 'tis like he brings some news.

Anne. Come he from Master Frankford, he is
 welcome;
So are his news, because they come from him.

Enter NICHOLAS. [*He hands her the lute*]

[12] *wrested:* distorted. [13] *wants:* circumstances of **want**.
xv.
 [1] *bodkin:* ornamental hairpin.
 [2] *rebato wire:* wire for supporting ruff.
 [3] *division:* melodic passage. [4] *pleasant:* merry.
 [5] *for:* because of.
xvi.
 [1] *by:* of. [2] *post:* fast.

Nich. There.

Anne. I know thee,[3] lute. Oft have I sung to thee;
We both are out of tune, both out of time. 20

Nich. Would that had been the worst instrument
that e'er you played on. My master commends him to
ye; there's all he can find that was ever yours. He hath
nothing left that ever you could lay claim to but his own
heart—and he could afford you that. All that I have to
deliver you is this: he prays you to forget him, and so
he bids you farewell.

Anne. I thank him; he is kind and ever was.
All you that have true feeling of my grief,
That know my loss, and have relenting hearts, 30
Gird me about, and help me with your tears
To wash my spotted sins. My lute shall groan;
It cannot weep, but shall lament my moan.

 [*She plays.*]

 Enter WENDOLL [*behind*].

Wen. Pursued with horror of a guilty soul
And with the sharp scourge of repentance lashed,
I fly from my own shadow. O my stars!
What have my parents in their lives deserved
That you should lay this penance on their son?
When I but think of Master Frankford's love
And lay[4] it to my treason, or compare 40
My murd'ring him for his relieving me,
It strikes a terror like a lightning's flash
To scorch my blood up. Thus I like the owl
Ashamed of day, live in these shadowy woods
Afraid of every leaf or murmuring blast,
Yet longing to receive some perfect[5] knowledge
How he hath dealt with her.

 [*Sees* ANNE.]
 O my sad fate!
Here, and so far from home, and thus attended!
O God, I have divorced the truest turtles[6]
That ever lived together, and being divided 50
In several places make their several moan;
She in the fields laments and he at home.
So poets write that Orpheus made the trees
And stones to dance to his melodious harp,
Meaning the rustic and the barbarous hinds,[7]
That had no understanding part in them;
So she from these rude carters tears extracts,
Making their flinty hearts with grief to rise
And draw down rivers from their rocky eyes.

Anne. [*To* NICHOLAS] If you return unto your
 master, say— 60
Though not from me, for I am all unworthy
To blast his name so with a strumpet's tongue—
That you have seen me weep, wish myself dead.
Nay, you may say too—for my vow is passed[8]—
Last night you saw me eat and drink my last.
This to your master you may say and swear,
For it is writ in heaven and decreed here.

[3] *thee:* Qq "the." [4] *lay:* compare. [5] *perfect:* correct.
[6] *turtles:* turtledoves. [7] *hinds:* country folk.
[8] *passed:* made. [9] *unto your power:* as well as you can.
[10] *commendations:* greetings. [11] *cates:* food.
[12] *fiend:* Qq "sinne."

Nich. I'll say you wept; I'll swear you made me sad.
Why how now, eyes? What now? What's here to do?
I am gone, or I shall straight turn baby too. 70

Wen. [*Aside*] I cannot weep; my heart is all on fire.
Cursed be the fruits of my unchaste desire.

Anne. Go break this lute upon my coach's wheel,
As the last music that I e'er shall make—
Not as my husband's gift, but my farewell
To all earth's joy; and so your master tell.

Nich. If I can for crying.

Wen. [*Aside*] Grief, have done,
Or like a madman I shall frantic run.

Anne. You have beheld the woefullest wretch on
 earth,
A woman made of tears. Would you had words 80
To express but what you see; my inward grief
No tongue can utter, yet unto your power[9]
You may describe my sorrow and disclose
To thy sad master my abundant woes.

Nich. I'll do your commendations.[10]

Anne. Oh, no.
I dare not so presume; nor to my children.
I am disclaimed in both; alas, I am.
Oh, never teach them when they come to speak
To name the name of mother; chide their tongue
If they by chance light on that hated word; 90
Tell them 'tis naught, for when that word they name,
Poor pretty souls, they harp on their own shame.

Wen. [*Aside*] To recompense her wrongs, what canst
 thou do?
Thou hast made her husbandless and childless too.

Anne. I have no more to say. Speak not for me,
Yet you may tell your master what you see.

Nich. I'll do't.

 Exit.

Wen. [*Aside*] I'll speak to her and comfort her in
 grief.
Oh, but her wound cannot be cured with words.
No matter though, I'll do my best good will 100
To work a cure on her whom I did kill.

Anne. So, now unto my coach, then to my home,
So to my deathbed, for from this sad hour
I never will nor eat, nor drink, nor taste
Of any cates[11] that may preserve my life;
I never will nor smile, nor sleep, nor rest,
But when my tears have washed my black soul white,
Sweet Savior, to Thy hands I yield my sprite.

 [WENDOLL *comes forward.*]

Wen. O Mistress Frankford—

Anne. Oh, for God's sake fly!
The devil doth come to tempt me ere I die. 110
My coach! This fiend[12] that with an angel's face
Courted mine honor till he sought my wrack,
In my repentant eyes seems ugly black.

 Exeunt all [*except* WENDOLL *and* JENKIN],
 the Carters *whistling.*

Jenk. What, my young master that fled in his shirt!
how come you by your clothes again? You have made
our house in a sweet pickle, have you not, think you?
What, shall I serve you still or cleave to the old house?

Wen. Hence, slave! away with thy unseasoned mirth;
Unless thou canst shed tears, and sigh, and howl,
Curse thy sad fortunes, and exclaim on fate, 120
Thou art not for my turn.

Jenk. Marry, and you will not, another will; farewell
and be hanged. Would you had never come to have
kept this coil 13 within our doors. We shall ha' you run
away like a sprite again.

 [*Exit.*]

Wen. She's gone to death, I live to want and woe,
Her life, her sins, and all upon my head,
And I must now go wander like a Cain
In foreign countries and remoted 14 climes,
Where the report of my ingratitude 130
Cannot be heard. I'll over, first to France,
And so to Germany, and Italy,
Where when I have recovered, and by travel
Gotten those perfect tongues, 15 and that these rumors
May in their height abate, I will return;
And I divine, however now dejected,
My worth and parts being by some great man praised,
At my return I may in court be raised.

 Exit.

[xvii]
Enter SIR FRANCIS, SIR CHARLES, CRANWELL,
 [MALBY,] *and* SUSAN.

Sir Fra. Brother, and now my wife, I think these
 troubles
Fall on my head by justice of the heavens,
For being so strict to you in your extremities,
But we are now atoned.1 I would my sister
Could with like happiness o'ercome her griefs
As we have ours.

Susan. You tell us, Master Cranwell, wondrous
 things
Touching the patience of that gentleman,
With what strange virtue he demeans 2 his grief.

Cran. I told you what I was witness of; 10
It was my fortune to lodge there that night.

Sir Fra. O that same villain Wendoll! 'twas his
 tongue
That did corrupt her; she was of herself
Chaste and devoted well.3 Is this the house?

Cran. Yes sir, I take it here your sister lies.4

Sir Fra. My brother Frankford showed too mild a
 spirit
In the revenge of such a loathèd crime;
Less than he did, no man of spirit could do.
I am so far from blaming his revenge
That I commend it; had it been my case, 20
Their souls at once had from their breasts been freed;
Death to such deeds of shame is the due meed.

 Enter JENKIN *and* SISLY.

Jenk. O my mistress, my mistress, my poor mistress!

Sisly. Alas that ever I was born! what shall I do for
my poor mistress?

Sir Cha. Why, what of her?

Jenk. O Lord, sir, she no sooner heard that her
brother and his friends were come to see how she did,

but she for very shame of her guilty conscience fell into
a swoon, and we had much ado to get life into her. 30

Susan. Alas that she should bear so hard a fate;
Pity it is repentance comes too late.

Sir Fra. Is she so weak in body?

Jenk. O sir, I can assure you there's no help of life in
her, for she will take no sustenance. She hath plainly
starved herself, and now she is as lean as a lath. She ever
looks for the good hour. Many gentlemen and gentle-
women of the country are come to comfort her.

 Enter ANNE *in her bed.*

Mal. How fare you, Mistress Frankford?

Anne. Sick, sick, oh, sick! give me some air I pray
 you. 40
Tell me, O tell me, where's Master Frankford?
Will not he deign see me ere I die?

Mal. Yes, Mistress Frankford; divers gentlemen,
Your loving neighbors, with that just request
Have moved and told him of your weak estate,
Who, though with much ado to get belief,
Examining of the general circumstance,
Seeing your sorrow and your penitence,
And hearing therewithal the great desire
You have to see him ere you left the world, 50
He gave to us his faith 5 to follow us,
And sure he will be here immediately.

Anne. You half revived me with those pleasing news.
Raise me a little higher in my bed.
Blush I not, brother Acton? Blush I not, Sir Charles?
Can you not read my fault writ in my cheek?
Is not my crime there? Tell me, gentlemen.

Sir Cha. Alas, good mistress, sickness hath not left
 you
Blood in your face enough to make you blush.

Anne. Then sickness like a friend my fault would
 hide. 60
Is my husband come? My soul but tarries
His arrive and I am fit for heaven.

Sir Fra. I came to chide you, but my words of hate
Are turned to pity and compassionate grief;
I came to rate 6 you, but my brawls,7 you see,
Melt into tears, and I must weep by thee.

 Enter FRANKFORD.

Here's Master Frankford now.

Frank. Good morrow, brother; good morrow,
 gentlemen.
God, that hath laid this cross upon our heads,
Might, had He pleased, have made our cause of
 meeting 70
On a more fair and a more contented ground;
But He that made us, made us to this woe.

Anne. And is he come? Methinks that voice I know.

13 *coil:* turmoil. 14 *remoted:* remote.
15 *Gotten . . . tongues:* Learned those languages perfectly.
xvii.
 1 *atoned:* reconciled. 2 *demeans:* expresses.
 3 *devoted well:* faithful. 4 *lies:* lives.
 5 *faith:* promise. 6 *rate:* berate.
 7 *brawls:* reproaches.

Frank. How do you, woman?

Anne. Well, Master Frankford, well; but shall be
 better,
I hope, within this hour. Will you vouchsafe,
Out of your grace and your humanity,
To take a spotted strumpet by the hand?

Frank. That hand once held my heart in faster bonds
Than now 'tis gripped by me. God pardon them 80
That made us first break hold.

Anne. Amen, amen.
Out of my zeal to heaven, whither I am now bound,
I was so impudent to wish you here,
And once more beg your pardon. O good man,
And father to my children, pardon me.
Pardon, oh pardon me! my fault so heinous is
That if you in this world forgive it not,
Heaven will not clear it in the world to come.
Faintness hath so usurped upon my knees
That kneel I cannot; but on my heart's knees 90
My prostrate soul lies thrown down at your feet
To beg your gracious pardon. Pardon, oh pardon me!

Frank. As freely from the low depth of my soul
As my Redeemer hath forgiven His death,
I pardon thee. I will shed tears for thee,
Pray with thee, and in mere pity
Of thy weak state I'll wish to die with thee.

All. So do we all.

Nich. [*Aside*] So will not I;
I'll sigh and sob, but, by my faith, not die. 100

Sir Fra. O Master Frankford, all the near alliance
I lose by her shall be supplied in thee.
You are my brother by the nearest way;
Her kindred hath fallen off, but yours doth stay.

Frank. Even as I hope for pardon at that day
When the great Judge of heaven in scarlet sits,
So be thou pardoned. Though thy rash offence
Divorced our bodies, thy repentant tears
Unite our souls.

Sir Cha. Then comfort, Mistress Frankford;
You see your husband hath forgiven your fall; 110
Then rouse your spirits and cheer your fainting soul.

Susan. How is it with you?

Sir Fra. How do you feel yourself?

Anne. Not of this world.

Frank. I see you are not, and I weep to see it.
My wife, the mother to my pretty babes,
Both those lost names I do restore thee back,
And with this kiss I wed thee once again.
Though thou art wounded in thy honored name,
And with that grief upon thy deathbed liest,
Honest in heart, upon my soul, thou diest. 120

Anne. Pardoned on earth, soul, thou in heaven art
 free;
Once more thy wife, dies thus embracing thee.
 [*Dies.*]

Frank. New married and new widowed; oh, she's
 dead,
And a cold grave must be our nuptial bed.

Sir Cha. Sir, be of good comfort, and your heavy
 sorrow
Part equally amongst us; storms divided
Abate their force, and with less rage are guided.

Cran. Do, Master Frankford; he that hath least part
Will find enough to drown one troubled heart.

Sir Fra. Peace with thee, Nan. Brothers and
 gentlemen, 130
All we that can plead interest in her grief,
Bestow upon her body funeral tears.
Brother, had you with threats and usage bad
Punished her sin, the grief of her offence
Had not with such true sorrow touched her heart.

Frank. I see it had not; therefore on her grave
I will bestow this funeral epitaph,
Which on her marble tomb shall be engraved.
In golden letters shall these words be filled:[8] 139
"Here lies she whom her husband's kindness killed."

THE EPILOGUE

An honest crew, disposèd to be merry,
Came to a tavern by and called for wine.
The drawer brought it, smiling like a cherry,
And told them it was pleasant, neat,[1] and fine.
 "Taste it," quoth one. He did so. "Fie!" quoth he,
 "This wine was good; now 't runs too near the lee."[2]

Another sipped, to give the wine his due,
And said unto the rest it drunk too flat.
The third said it was old, the fourth too new.
"Nay," quoth the fifth, "the sharpness likes me not."
 Thus, gentlemen, you see how in one hour 11
 The wine was new, old, flat, sharp, sweet, and sour.

[8] *filled:* i.e., the engraved letters shall be filled in with
gold.

EPILOGUE
 [1] *neat:* pure. [2] *lee:* sediment.

Unto this wine we do allude[3] our play,
Which some will judge too trivial, some too grave.
You as our guests we entertain this day
And bid you welcome to the best we have.
 Excuse us, then; good wine may be disgraced
 When every several mouth hath sundry taste.

FINIS

[3] *allude:* compare.